GARDNER'S

ART

THROUGH THE

AGES

A GLOBAL HISTORY

THIRTEENTH EDITION

VOLUME I

FRED S. KLEINER

About the Author

Fred S. Kleiner (Ph.D., Columbia University) is the co-author of the 10th, 11th, and 12th editions of Art through the Ages and more than a hundred publications on Greek and Roman art and architecture, including A History of Roman Art, also published by Wadsworth. He has taught the art history survey course for more than three decades, first at the University of Virginia and, since 1978, at Boston University, where he is currently Professor of Art History and Archaeology and Chair of the Art History Department. Long recognized for his inspiring lectures and devotion to students, Professor Kleiner won Boston University's Metcalf Award for Excellence in Teaching as well as the College Prize for Undergraduate Advising in the Humanities in 2002. He was Editor-in-Chief of the American Journal of Archaeology from 1985 to 1998.

Also by Fred Kleiner: A History of Roman Art (Wadsworth 2007; ISBN 0534638465), winner of the 2007 Texty Prize as the best new college textbook in the humanities and social sciences. In this authoritative and lavishly illustrated volume, Professor Kleiner traces the development of Roman art and architecture from Romulus' foundation of Rome in the eighth century BCE to the death of Constantine in the fourth century CE, with special chapters devoted to Pompeii and Herculaneum, Ostia, funerary and provincial art and architecture, and the earliest Christian art.

About the Cover Art

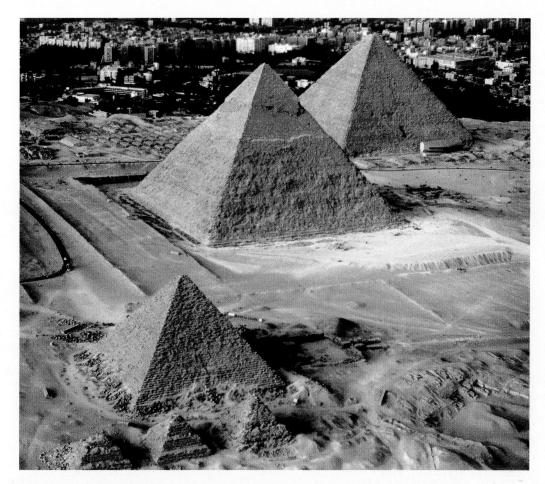

Great Pyramids, Gizeh, Egypt, *From bottom:* Pyramids of Menkaure, ca. 2490–2472 BCE; Khafre, ca. 2520–2494 BCE; and Khufu, ca. 2551–2528 BCE.

The three Great Pyramids of Gizeh are the oldest of the Seven Wonders of the World. Constructed over a period of about 75 years, they are the final resting places of the Old Kingdom pharaohs Khufu, Khafre, and Menkaure. Their shape emulates that of the sacred emblem of the sun god Re, the ben-ben. The Egyptians believed that the sun's rays were the ramp that the pharaohs used to ascend to the heavens after their death and rebirth.

The erection of the Gizeh pyramids was one of the most ambitious construction projects of all time. Khufu's pyramid, the largest, is approximately 775 feet wide at the base on each side. It occupies 13 acres of land in the Nile River Valley. It originally reached about 480 feet in height and contained 2.3 million blocks of stone, each weighing an average of 2.5 tons. Construction of the tombs began with the quarrying of the stone, which skilled workers had to pry from the Gizeh plateau using stone or copper chisels and wooden mallets and wedges. Next, workers had to transport the rough stone blocks to the building site using wooden rollers and sleds and then cut the blocks to the exact size needed for each stone's position in the pyramid and polish the surfaces smooth to ensure a perfect fit. The Great Pyramids attest to not only the genius of the pharaohs' architects but the Egyptians' ability to organize a vast work force.

Gigantic undertakings like the construction of the pyramids occurred at many other times and in many other places during the history of art, but they are not typical. Most artworks created during the past 30 millennia are the work of individual artists, many toiling in anonymity in the service of their patrons, others—especially since the 14th century—celebrated as creative geniuses. *Art through the Ages* surveys the art of all periods and places from prehistory to the present and examines how artworks of all kinds, whether large or small, anonymous or signed, have always reflected the historical contexts in which they were created.

Gardner's Art through the Ages: A Global History, Thirteenth Edition, Volume I Fred S. Kleiner

Publisher: Clark Baxter

Senior Development Editor: Sharon Adams Poore

Assistant Editor: *Erikka Adams* Editorial Assistant: *Nell Pepper*

Development Project Manager: *Julie Iannacchino* Executive Marketing Manager: *Diane Wenckebach* Marketing Communications Manager: *Heather Baxley*

Senior Content Project Manager: *Lianne Ames* Exective Art Director: *Maria Epes*

© 2009, 2005 Thomson Wadsworth, a part of The Thomson Corporation. Thomson, the Star logo, and Wadsworth are trademarks used herein under license.

ALL RIGHTS RESERVED. No part of this work covered by the copyright hereon may be reproduced or used in any form or by any means—graphic, electronic, or mechanical, including photocopying, recording, taping, web distribution, information storage and retrieval systems, or in any other manner—without the written permission of the publisher.

Printed in the United States of America 1 2 3 4 5 6 7 11 10 09 08 07

Library of Congress Control Number: 2007935090

ISBN-13: 978-0-495-11549-6 ISBN-10: 0-495-11549-5 Senior Print Buyer: *Judy Inouye* Permissions Editor: *Bob Kauser*

Production Service: Joan Keyes, Dovetail Publishing Services

Text/Cover Designer: Tani Hasegawa

Photo Researchers: Sarah Evertson, Stephen Forsling

Text/Cover Printer: R.R. Donnelly/Willard

Compositor: Thompson Type

Cover Art: Great Pyramids, Gizeh, Egypt. © Yann Arthus-Bertrand/Corbis.

Thomson Higher Education 25 Thomson Place Boston, MA 02210-1202 USA

For more information about our products, contact us at:

Thomson Learning Academic Resource Center

1-800-423-0563

For permission to use material from this text or product, submit a

request online at http://www.thomsonrights.com.

Any additional questions about permissions can be submitted

by e-mail to thomsonrights@thomson.com.

Credits appear on pages 538–540, which constitute a continuation of the copyright page.

BRIEF CONTENTS

PREFACE x

INTRODUCTION

WHAT IS ART HISTORY? 1

CHAPTER 1

ART BEFORE HISTORY 15

CHAPTER 2

THE ANCIENT NEAR EAST 31

CHAPTER 3

EGYPT UNDER THE PHARAOHS 53

CHAPTER 4

THE PREHISTORIC AEGEAN 81

CHAPTER 5

ANCIENT GREECE 99

CHAPTER 6

SOUTH AND SOUTHEAST ASIA BEFORE 1200 157

CHAPTER 7

CHINA AND KOREA TO 1279 181

CHAPTER 8

JAPAN BEFORE 1333 207

CHAPTER 9

THE ETRUSCANS 223

CHAPTER 10

THE ROMAN EMPIRE 237

CHAPTER 11

LATE ANTIQUITY 289

CHAPTER 12

BYZANTIUM 311

CHAPTER 13

THE ISLAMIC WORLD 341

CHAPTER 14

NATIVE ARTS OF THE AMERICAS BEFORE 1300 365

CHAPTER 15

AFRICA BEFORE 1800 393

CHAPTER 16

EARLY MEDIEVAL EUROPE 407

CHAPTER 17

ROMANESQUE EUROPE 431

CHAPTER 18

GOTHIC EUROPE 461

CHAPTER 19

ITALY, 1200 TO 1400 497

NOTES 518

GLOSSARY 519

BIBLIOGRAPHY 530

CREDITS 538

INDEX 541

CONTENTS

PREFACE x

INTRODUCTION

WHAT IS ART HISTORY? 1

Art History in the 21st Century 2

Different Ways of Seeing 12

CHAPTER 1

ART BEFORE HISTORY 15

Paleolithic Art 15

Neolithic Art 24

- MATERIALS AND TECHNIQUES: Paleolithic Cave Painting 20
- ART AND SOCIETY: Art in the Old Stone Age 21
- MATERIALS AND TECHNIQUES: The World's Oldest Paintings? 22

THE BIG PICTURE 29

CHAPTER 2

THE ANCIENT NEAR EAST 31

Sumer 32

Akkad and the Third Dynasty of Ur 39

Second Millennium BCE 43

Assyria 45

Neo-Babylonia and Persia 47

- RELIGION AND MYTHOLOGY: The Gods and Goddesses of Mesopotamia 33
- MATERIALS AND TECHNIQUES: Mesopotamian Seals 39
- ART AND SOCIETY: Enheduanna, Priestess and Poet 41
- WRITTEN SOURCES: The Piety of Gudea 42
- ART AND SOCIETY: Hammurabi's Law Code 43

WRITTEN SOURCES: Babylon, City of Wonders 48

THE BIG PICTURE 51

CHAPTER 3

EGYPT UNDER The Pharaohs 53

The Predynastic and Early Dynastic Periods 54

The Old Kingdom 59

The Middle Kingdom 64

The New Kingdom 67

First Millennium BCE 77

- RELIGION AND MYTHOLOGY: The Gods and Goddesses of Egypt 54
- ART AND SOCIETY: Mummification and Immortality 57
- ARCHITECTURAL BASICS: Building the Great Pyramids 60
- ART AND SOCIETY: Hatshepsut, the Woman Who Would Be King 68

THE BIG PICTURE 79

CHAPTER 4

THE PREHISTORIC AEGEAN 81

Cycladic Art 82

Minoan Art 84

Mycenaean Art 90

- ART AND SOCIETY: Archaeology, Art History, and the Art Market 83
- ART AND SOCIETY: The Theran Eruption and the Chronology of Aegean Art 87

THE BIG PICTURE 97

CHAPTER 5

ANCIENT GREECE 99

Geometric and Orientalizing Periods 100

Archaic Period 105

Early and High Classical Periods 118

Late Classical Period 137

Hellenistic Period 145

- RELIGION AND MYTHOLOGY: The Gods and Goddesses of Mount Olympus 101
- MATERIALS AND TECHNIQUES: Greek Vase Painting 104
- ARCHITECTURAL BASICS: Greek Temple Plans 109
- ARCHITECTURAL BASICS: Doric and Ionic Orders 110
- RELIGION AND MYTHOLOGY: Herakles, Greatest of Greek Heroes 120
- MATERIALS AND TECHNIQUES: Hollow-Casting Life-Size Bronze Statues 122
- WRITTEN SOURCES: Polykleitos's Prescription for the Perfect Statue 124
- ART AND SOCIETY: The Hegeso Stele 134
- ARCHITECTURAL BASICS: The Corinthian Capital 144

THE BIG PICTURE 155

CHAPTER 6

SOUTH AND SOUTHEAST ASIA BEFORE 1200 157

India and Pakistan 157

Southeast Asia 174

- RELIGION AND MYTHOLOGY: Buddhism and Buddhist lconography 161
- WRITTEN SOURCES: Ashoka's Conversion to Buddhism 162
- ARCHITECTURAL BASICS: The Stupa 163
- MATERIALS AND TECHNIQUES: The Painted Caves of Ajanta 167
- RELIGION AND MYTHOLOGY: Hinduism and Hindu lconography 168
- ARCHITECTURAL BASICS: Hindu Temples 172

THE BIG PICTURE 179

CHAPTER 7

CHINA AND KOREA TO 1279 181

China 181

Korea 202

- MATERIALS AND TECHNIQUES: Shang Bronze-Casting 183
- MATERIALS AND TECHNIQUES: Chinese Jade 185
- RELIGION AND MYTHOLOGY: Daoism and Confucianism 186
- MATERIALS AND TECHNIQUES: Silk and the Silk Road 188
- ARCHITECTURAL BASICS: Chinese Wooden Construction 189
- MATERIALS AND TECHNIQUES: Chinese Painting Materials and Formats 190
- ARTISTS ON ART: Xie He's Six Canons 191
- MATERIALS AND TECHNIQUES: Chinese Earthenwares and Stonewares 196
- RELIGION AND MYTHOLOGY Chan Buddhism 201

THE BIG PICTURE 205

CHAPTER 8

JAPAN BEFORE 1333 207

Japan before Buddhism 207

Buddhist Japan 210

- RELIGION AND MYTHOLOGY: Shinto 211
- ART AND SOCIETY: Heian Court Culture 217
- ART AND SOCIETY: Heian and Kamakura Artistic Workshops 219

THE BIG PICTURE 221

CHAPTER 9

THE ETRUSCANS 223

Early Etruscan Art 224

Later Etruscan Art 231

- RELIGION AND MYTHOLOGY: Etruscan Counterparts of Greco-Roman Gods and Heroes 225
- WRITTEN SOURCES: Etruscan Artists in Rome 226
- ART AND SOCIETY: The "Audacity" of Etruscan Women 227

THE BIG PICTURE 235

vii

CHAPTER 10

THE ROMAN EMPIRE 237

Republic 239

Pompeii and the Cities of Vesuvius 244

Early Empire 254

High Empire 263

Late Empire 276

■ ART AND SOCIETY: An Outline of Roman History 239

■ ARCHITECTURAL BASICS: Roman Concrete Construction 241

■ ART AND SOCIETY: Art for Former Slaves 243

WRITTEN SOURCES: An Eyewitness Account of the Eruption of Mount Vesuvius 245

■ ARCHITECTURAL BASICS: The Roman House 247

■ ART AND SOCIETY: Role Playing in Roman Portraiture 254

WRITTEN SOURCES: The Golden House of Nero 259

■ ART AND SOCIETY: Spectacles in the Colosseum 260

WRITTEN SOURCES: Hadrian and Apollodorus of Damascus 269

MATERIALS AND TECHNIQUES: laia of Cyzicus and the Art of Encaustic Painting 275

THE BIG PICTURE 287

CHAPTER 11

LATE ANTIQUITY 289

Dura-Europos 289

The Catacombs and Funerary Art 291

Architecture and Mosaics 295

Luxury Arts 304

RELIGION AND MYTHOLOGY: Jewish Subjects in Christian Art 293

■ RELIGION AND MYTHOLOGY: The Life of Jesus in Art 296

MATERIALS AND TECHNIQUES: Mosaics 303

■ MATERIALS AND TECHNIQUES: Medieval Manuscript Illumination 305

■ MATERIALS AND TECHNIQUES: Ivory Carving 307

THE BIG PICTURE 309

CHAPTER 12

BYZANTIUM 311

Early Byzantine Art 312

Middle Byzantine Art 327

Late Byzantine Art 335

■ ARCHITECTURAL BASICS: Pendentives and Squinches 315

■ ART AND SOCIETY: Theodora, a Most Unusual Empress 320

WRITTEN SOURCES: The Emperors of New Rome 323

ART AND SOCIETY: Icons and Iconoclasm 326

THE BIG PICTURE 339

CHAPTER 13

THE ISLAMIC WORLD 341

Early Islamic Art 342

Later Islamic Art 352

■ RELIGION AND MYTHOLOGY: Muhammad and Islam 343

ARCHITECTURAL BASICS: The Mosque 345

ARTISTS ON ART: Sinan the Great and the Mosque of Selim II 354

MATERIALS AND TECHNIQUES: Islamic Tilework 357

■ ART AND SOCIETY: Christian Patronage of Islamic Art 362

THE BIG PICTURE 363

CHAPTER 14

NATIVE ARTS OF THE AMERICAS BEFORE 1300 365

Mesoamerica 366

Intermediate Area 379

South America 380

North America 387

■ ART AND SOCIETY: The Mesoamerican Ball Game 372

MATERIALS AND TECHNIQUES: Andean Weaving 382

ART AND SOCIETY: Serpent Mound 389

THE BIG PICTURE 391

CHAPTER 15

AFRICA BEFORE 1800 393

Prehistory and Early Cultures 394

11th to 18th Centuries 399

- ART AND SOCIETY: Dating African Art and Identifying African Artists 395
- ART AND SOCIETY: Art and Leadership in Africa 397
- ART AND SOCIETY: Idealized Naturalism at Ile-Ife 398

THE BIG PICTURE 405

CHAPTER 16

EARLY MEDIEVAL EUROPE 407

Art of the Warrior Lords 407

Christian Art: Scandinavia, British Isles, Spain 410

Carolingian Art 415

Ottonian Art 422

- ART AND SOCIETY: Medieval Books 411
- RELIGION AND MYTHOLOGY: The Four Evangelists 412
- ART AND SOCIETY: Charlemagne's Renovatio Imperii Romani 416
- RELIGION AND MYTHOLOGY: Medieval Monasteries and Benedictine Rule 420
- ART AND SOCIETY: Theophanu, a Byzantine Princess in Ottonian Germany 428

THE BIG PICTURE 429

CHAPTER 17

ROMANESQUE EUROPE 431

France and Northern Spain 433

Holy Roman Empire 445

Italy 450

Normandy and England 453

- ART AND SOCIETY: Pilgrimages and the Cult of Relics 432
- **WRITTEN SOURCES: Timber Roofs and Stone Vaults** 435
- WRITTEN SOURCES: Bernard of Clairvaux on Cloister Sculpture 438
- ARCHITECTURAL BASICS: The Romanesque Church
 Portal 439
- RELIGION AND MYTHOLOGY: The Crusades 442

- ART AND SOCIETY: Romanesque Countesses, Queens, and Nuns 448
- MATERIALS AND TECHNIQUES: Embroidery and Tapestry 456

THE BIG PICTURE 459

CHAPTER 18

GOTHIC EUROPE 461

French Gothic 462

Gothic outside of France 486

- WRITTEN SOURCES: Abbot Suger and the Rebuilding of Saint-Denis 463
- ARCHITECTURAL BASICS: The Gothic Rib Vault 464
- ART AND SOCIETY: Scholasticism and Gothic Art and Architecture 466
- ARCHITECTURAL BASICS: The Gothic Cathedral 469
- MATERIALS AND TECHNIQUES: Stained-Glass Windows 472
- ART AND SOCIETY: Louis IX, the Saintly King 482

THE BIG PICTURE 495

CHAPTER 19

ITALY, 1200 TO 1400 497

The 13th Century 497

The 14th Century 502

- ART AND SOCIETY: Italian Artists' Names 498
- RELIGION AND MYTHOLOGY: The Great Schism, Mendicant Orders, and Confraternities 501
- MATERIALS AND TECHNIQUES: Fresco Painting 504
- WRITTEN SOURCES: Artists' Guilds, Commissions, and Contracts 506
- ART AND SOCIETY: Artistic Training in Renaissance Italy 510

THE BIG PICTURE 517

NOTES 518

GLOSSARY 519

BIBLIOGRAPHY 530

CREDITS 538

INDEX 541

PREFACE

When Helen Gardner published the first edition of Art through the Ages in 1926, she could not have imagined that more than 80 years later instructors all over the world would still be using her textbook in their classrooms. Indeed, if she were alive today, she would not recognize the book that long ago became—and remains—the most widely read introduction to the history of art and architecture in the English language. During the past half century, successive authors have constantly reinvented Helen Gardner's groundbreaking global survey, always keeping it fresh and current, and setting an ever-higher standard in both content and publication quality with each new edition. I hope both professors and students will agree that this 13th edition lives up to that venerable tradition.

Certainly, this latest edition offers much that is fresh and new (enumerated below), but some things have not changed, including the fundamental belief that guided Helen Gardner—namely, that the primary goal of an introductory art history textbook should be to foster an appreciation and understanding of historically significant works of art of all kinds from all periods and from all parts of the globe. Because of the longevity and diversity of the history of art, it is tempting to assign responsibility for telling its story to a large team of specialists. The Gardner publishers themselves took this approach for the first edition they produced after Helen Gardner's death, and it has now become the norm for introductory art history surveys. But students overwhelmingly say that the very complexity of the global history of art makes it all the more important for the story to be told with a consistent voice if they are to master so much diverse material. I think Helen Gardner would be pleased to know that this new edition of Art through the Ages once again has a single storyteller.

Along with the late Richard Tansey and my more recent collaborator, Christin Mamiya, with whom I had the honor and pleasure of working on the 10th, 11th, and 12th editions, I continue to believe that the most effective way to tell the story of art through the ages, especially to someone studying art history for the first time, is to organize the vast array of artistic monuments according to the civilizations that produced them and to consider each work in roughly chronological order. This approach has not merely stood the test of time. It is the most appropriate way to narrate the *history* of art. The principle that underlies my approach to every period of art history is that the enormous variation in the form and meaning of the paintings, sculptures, buildings, and other artworks men and women have produced over the past 30,000 years is largely the result of the constantly changing contexts in which artists and architects worked. A

historically based narrative is therefore best suited for a global history of art because it permits the author to situate each work discussed in its historical, social, economic, religious, and cultural context. That is, after all, what distinguishes art history from art appreciation.

In the first (1926) edition of Art through the Ages, Helen Gardner discussed Henri Matisse and Pablo Picasso in a chapter entitled "Contemporary Art in Europe and America." Since then many other artists have emerged on the international scene, and the story of art through the ages has grown longer and even more complex. More important, perhaps, the discipline of art history has changed markedly in recent decades, and so too has Helen Gardner's book. The 13th edition fully reflects the latest art historical research emphases while maintaining the traditional strengths that have made previous editions of Art through the Ages so popular. While sustaining attention to style, chronology, iconography, and technique, I also ensure that issues of patronage, function, and context loom large in every chapter. I treat artworks not as isolated objects in sterile 21stcentury museum settings but with a view toward their purpose and meaning in the society that produced them at the time they were produced. I examine not only the role of the artist or architect in the creation of a work of art or a building, but also the role of the individuals or groups who paid the artists and influenced the shape the monuments took. Further, I devote more space than previously to the role of women and women artists in societies worldwide over time. In every chapter, I have tried to choose artworks and buildings that reflect the increasingly wide range of interests of scholars today, while not rejecting the traditional list of "great" works or the very notion of a "canon." Consequently, the selection of works in this edition encompasses every artistic medium and almost every era and culture, and includes many works that until recently art historians would not have considered to be "art" at all.

The 12th edition of *Art through the Ages* was the number-one choice for art history survey courses and the best-selling version of the book in its long history, and for this 13th edition I have retained all of the features that made its predecessor so successful. Once again, this edition boasts roughly 1,400 photographs, plans, and drawings, virtually all in color and reproduced according to the highest standards of clarity and color fidelity. The 13th edition, however, also features hundreds of new or upgraded photos by a host of new photographers as well as redesigned maps and plans and an extraordinary new set of architectural drawings prepared exclusively for *Art through the Ages* by John Burge.

The captions to the illustrations in this edition of *Art through the* Ages, as before, contain a wealth of information, including the name of the artist or architect, if known; the formal title (printed in italics), if assigned, description of the work, or name of the building; the provenance or place of production of the object or location of the building; the date; the material(s) used; the size; and the current location if the work is in a museum or private collection. As in previous editions, scales accompany all plans, but for the first time scales now also appear next to each photograph of a painting, statue, or other artwork. The works illustrated vary enormously in size, from colossal sculptures carved into mountain cliffs and paintings that cover entire walls or ceilings to tiny figurines, coins, and jewelry that one can hold in the hand. Although the captions contain the pertinent dimensions, it is hard for students who have never seen the paintings or statues in person to translate those dimensions into an appreciation of the real size of the objects. The new scales provide an effective and direct way to visualize how big or how small a given artwork is and its relative size compared with other objects in the same chapter and throughout the book.

Also new to this edition are the Quick-Review Captions that students found so useful when these were introduced in 2006 in the first edition of Art through the Ages: A Concise History. These brief synopses of the most significant aspects of each artwork or building illustrated accompany the captions to all images in the book. They have proved invaluable to students preparing for examinations in one-semester art history survey courses, and I am confident they will be equally useful to students enrolled in yearlong courses. In the 13th edition, however, I have provided two additional tools to aid students in reviewing and mastering the material. Each chapter now ends with a full-page feature called The Big Picture, which sets forth in bullet-point format the most important characteristics of each period or artistic movement discussed in the chapter. Small illustrations of characteristic works discussed accompany the summary of major points. Finally, I have attempted to tie all of the chapters together by providing with each copy of Art through the Ages a poster-size Global Timeline. This too features illustrations of key monuments of each age and geographical area as well as a brief enumeration of the most important art historical developments during that period. The timeline has four major horizontal bands corresponding to Europe, the Americas, Asia, and Africa, and 34 vertical columns for the successive chronological periods from 30,000 BCE to

Another pedagogical tool not found in any other introductory art history textbook is the *Before 1300* section that appears at the beginning of the second volume of the paperbound version of the 13th edition. Because many students taking the second half of a yearlong survey course will not have access to volume one, I have provided a special set of concise primers on religion and mythology and on architectural terminology and construction methods in the ancient and medieval worlds—information that is essential for understanding the history of art after 1300, both in the West and the East. The subjects of these special boxes are The Gods and Goddesses of Mount Olympus; Buddhism and Buddhist Iconography; Hinduism and Hindu Iconography; The Life of Jesus in Art; Greco-Roman Temple Design and the Classical Orders; Arches and Vaults; and Medieval Church Design.

Boxed essays once again appear throughout the book as well. This popular feature first appeared in the 11th edition of *Art through the Ages*, which won both the Texty and McGuffey Prizes of the Text and Academic Authors Association for the best college textbook of 2001 in the humanities and social sciences. In this edition the essays are more closely tied to the main text than ever before. Consistent with that greater integration, most boxes now incorporate photographs of

important artworks discussed in the text proper that also illustrate the theme treated in the boxed essays. These essays fall under six broad categories, one of which is new to the 13th edition.

Architectural Basics boxes provide students with a sound foundation for the understanding of architecture. These discussions are concise explanations, with drawings and diagrams, of the major aspects of design and construction. The information included is essential to an understanding of architectural technology and terminology. The boxes address questions of how and why various forms developed, the problems architects confronted, and the solutions they used to resolve them. Topics discussed include how the Egyptians built the pyramids, the orders of classical architecture, Roman concrete construction, and the design and terminology of mosques, stupas, and Gothic cathedrals.

Materials and Techniques essays explain the various media artists employed from prehistoric to modern times. Since materials and techniques often influence the character of artworks, these discussions contain essential information on why many monuments appear as they do. Hollow-casting bronze statues; fresco painting; Chinese silk; Andean weaving; Islamic tile work; embroidery and tapestry; engraving, etching, and lithography; and daguerreotype and calotype photography are among the many subjects treated.

Religion and Mythology boxes introduce students to the principal elements of the world's great religions, past and present, and to the representation of religious and mythological themes in painting and sculpture of all periods and places. These discussions of belief systems and iconography give readers a richer understanding of some of the greatest artworks ever created. The topics include the gods and goddesses of Egypt, Mesopotamia, Greece, and Rome; the life of Jesus in art; Buddha and Buddhism; Muhammad and Islam; and Aztec religion.

Art and Society essays treat the historical, social, political, cultural, and religious context of art and architecture. In some instances, specific monuments are the basis for a discussion of broader themes, as when the Hegeso stele serves as the springboard for an exploration of the role of women in ancient Greek society. Another essay discusses how people's evaluation today of artworks can differ from those of the society that produced them by examining the problems created by the contemporary market for undocumented archaeological finds. Other subjects include Egyptian mummification, Etruscan women, Byzantine icons and iconoclasm, artistic training in Renaissance Italy, 19th-century academic salons and independent art exhibitions, the Mesoamerican ball game, Japanese court culture, and art and leadership in Africa.

Written Sources present and discuss key historical documents illuminating important monuments of art and architecture throughout the world. The passages quoted permit voices from the past to speak directly to the reader, providing vivid and unique insights into the creation of artworks in all media. Examples include Bernard of Clairvaux's treatise on sculpture in medieval churches, Giovanni Pietro Bellori's biographies of Annibale Carracci and Caravaggio, Jean François Marmontel's account of 18th-century salon culture, as well as texts that bring the past to life, such as eyewitness accounts of the volcanic eruption that buried Roman Pompeii and of the fire that destroyed Canterbury Cathedral in medieval England.

A new category is *Artists on Art* in which artists and architects throughout history discuss both their theories and individual works. Examples include Sinan the Great discussing the mosque he designed for Selim II, Leonardo da Vinci and Michelangelo debating the relative merits of painting and sculpture, Artemisia Gentileschi talking about the special problems she confronted as a woman artist, Jacques-Louis David on Neoclassicism, Gustave Courbet on Realism, Henri

Matisse on color, Pablo Picasso on Cubism, Diego Rivera on art for the people, and Judy Chicago on her seminal work *The Dinner Party*.

Instructors familiar with previous editions of *Art through the Ages* will also find that many of the chapters in the 13th edition have been reorganized, especially in volume two. For example, the treatment of European 17th-century art now appears in two discrete chapters, one devoted to Baroque Italy and Spain, the other to Northern Europe. A single chapter is devoted to the 18th century, another to the period from 1800 to 1870, and a third to 1870 to 1900. In addition, in recognition that different instructors at different colleges and universities end the first semester and begin the second semester at different points, for the first time *both* volumes of *Art through the Ages* include Chapter 19 on Italian art from 1200 to 1400.

Rounding out the features in the book itself is a Glossary containing definitions of all terms introduced in the text in italics and a Bibliography of books in English, including both general works and a chapter-by-chapter list of more focused studies. In this edition I have also taken care to italicize and define in the text all Glossary terms that appear in volume two even if they have been used and defined in volume one, because many students enrolled in the second semester of a yearlong course will not have taken the first semester and will not be familiar with those terms.

The 13th edition of *Art through the Ages* is not, however, a standalone text, but one element of a complete package of learning tools. In addition to the Global Timeline, every new copy of the book comes with a password to *ArtStudy Online*, a web site with access to a host of multimedia resources that students can employ throughout the entire course, including image flashcards, tutorial quizzes, podcasts, vocabulary, and more. Instructors have access to a host of teaching materials, including digital images with zoom capabilities, video, and Google EarthTM coordinates.

A work as extensive as a global history of art could not be undertaken or completed without the counsel of experts in all areas of world art. As with previous editions, the publisher has enlisted more than a hundred art historians to review every chapter of Art through the Ages in order to ensure that the text lived up to the Gardner reputation for accuracy as well as readability. I take great pleasure in acknowledging here the invaluable contributions to the 13th edition made by the following for their critiques of various chapters: Charles M. Adelman, University of Northern Iowa; Kirk Ambrose, University of Colorado-Boulder; Susan Ashbrook, Art Institute of Boston; Zainab Bahrani, Columbia University; Susan Bakewell, University of Texas-Austin; James J. Bloom, Florida State University; Suzaan Boettger, Bergen Community College; Colleen Bolton, Mohawk Valley Community College; Angi Elsea Bourgeois, Mississippi State University; Kimberly Bowes, Fordham University; Lawrence E. Butler, George Mason University; Alexandra Carpino, Northern Arizona University; Jane Carroll, Dartmouth College; Hipolito Rafael Chacon, The University of Montana; Catherine M. Chastain, North Georgia College & State University; Violaine Chauvet, Johns Hopkins University; Daniel Connolly, Augustana College; Michael A. Coronel, University of Northern Colorado; Nicole Cox, Rochester Institute of Technology; Jodi Cranston, Boston University; Kathy Curnow, Cleveland State University; Giovanna De Appolonia, Boston University; Marion de Koning, Grossmont College; John J. Dobbins, University of Virginia; Erika Doss, University of Colorado-Boulder; B. Underwood DuRette, Thomas Nelson Community College; Daniel Ehnbom, University of Virginia; Lisa Farber, Pace University; James Farmer, Virginia Commonwealth University; Jerome Feldman, Hawaii Pacific University; Sheila ffolliott, George Mason University; Ferdinanda Florence, Solano Community College; William B. Folkestad, Central Washington University; Jeffery Fontana, Austin College; Mitchell Frank, Carleton University; Sara L. French, Wells

College; Norman P. Gambill, South Dakota State University; Elise Goodman, University of Cincinnati; Kim T. Grant, University of Southern Maine; Elizabeth ten Grotenhuis, Silk Road Project; Sandra C. Haynes, Pasadena City College; Valerie Hedquist, The University of Montana; Susan Hellman, Northern Virginia Community College; Marian J. Hollinger, Fairmont State University; Cheryl Hughes, Alta High School; Heidrun Hultgren, Kent State University; Joseph M. Hutchinson, Texas A&M University; Julie M. Johnson, Utah State University; Sandra L. Johnson, Citrus College; Deborah Kahn, Boston University; Fusae Kanda, Harvard University; Catherine Karkov, Miami University; Wendy Katz, University of Nebraska-Lincoln; Nita Kehoe-Gadway, Central Wyoming College; Nancy L. Kelker, Middle Tennessee State University; Cathie Kelly, University of Nevada-Las Vegas; Katie Kempton, Ohio University; John F. Kenfield, Rutgers University; Herbert L. Kessler, Johns Hopkins University; Monica Kjellman-Chapin, Emporia State University; Ellen Konowitz, State University of New York-New Paltz; Kathryn E. Kramer, State University of New York-Cortland; Carol Krinsky, New York University; Lydia Lehr, Atlantic Cape Community College; Krist Lien, Shelton State Community College; Ellen Longsworth, Merrimack College; David A. Ludley, Clayton State University; Henry Luttikhuizen, Calvin College; Christina Maranci, University of Wisconsin-Milwaukee; Dominic Marner, University of Guelph; Jack Brent Maxwell, Blinn College; Anne McClanan, Portland State University; Brian McConnell, Florida Atlantic University; Amy McNair, University of Kansas; Patrick McNaughton, Indiana University; Heather McPherson, University of Alabama–Birmingham; Cynthia Millis, Houston Community College-Southwest; Cynthia Taylor Mills, Brookhaven College; Keith N. Morgan, Boston University; Johanna D. Movassat, San Jose State University; Helen Nagy, University of Puget Sound; Heidi Nickisher, Rochester Institute of Technology; Bonnie Noble, University of North Carolina-Charlotte; Abigail Noonan, Rochester Institute of Technology; Marjorie Och, University of Mary Washington; Karen Michelle O'Day, University of Wisconsin-Eau Claire; Edward J. Olszewski, Case Western Reserve University; Allison Lee Palmer, University of Oklahoma; Martin Patrick, Illinois State University; Glenn Peers, University of Texas–Austin; Jane Peters, University of Kentucky; Julie Anne Plax, University of Arizona; Frances Pohl, Pomona College; Virginia C. Raguin, College of the Holy Cross; Donna Karen Reid, Chemeketa Community College; Albert W. Reischuch, Kent State University; Jonathan Ribner, Boston University; Cynthea Riesenberg, Washington Latin School; James G. Rogers Jr., Florida Southern College; Carey Rote, Texas A&M University–Corpus Christi; David J. Roxburgh, Harvard University; Conrad Rudolph, University of California-Riverside; Catherine B. Scallen, Case Western Reserve University; Denise Schmandt-Besserat, University of Texas-Austin; Natasha Seaman, Berklee College of Music; Malia E. Serrano, Grossmont College; Laura Sommer, Daemen College; Natasha Staller, Amherst College; Nancy Steele-Hamme, Midwestern State University; Andrew Stewart, University of California-Berkeley; John R. Stocking, University of Calgary; Francesca Tronchin, Ohio State University; Frances Van Keuren, University of Georgia; Kelly Wacker, University of Montevallo; Carolynne Whitefeather, Utica College; Nancy L. Wicker, University of Mississippi; Alastair Wright, Princeton University; John G. Younger, University of Kansas; Michael Zell, Boston University.

I am also happy to have this opportunity to express my gratitude to the extraordinary group of people at Wadsworth involved with the editing, production, and distribution of *Art through the Ages*. Some of them I have now worked with on various projects for more than a decade and feel privileged to count among my friends. The success of the Gardner series in all of its various permutations depends in no small part on the expertise and unflagging commitment of these dedicated professionals: Sean Wakely, president Thomson Arts and

Sciences; P. J. Boardman, vice president and editor-in-chief Wadsworth Publishing; Clark Baxter, publisher; Sharon Adams Poore, senior development editor; Helen Triller-Yambert, development editor; Lianne Ames, senior content project manager; Julie Iannacchino, development project manager; Erikka Adams, assistant editor; Nell Pepper, editorial assistant; Maria Epes, executive art director; Scott Stewart, vice president managing director sales; Diane Wenckebach, executive marketing manager; as well as Kim Adams, Heather Baxley, Doug Easton, Tani Hasegawa, Aimee Alcorn Lewis, Sarah Perkins, Ellen Pettengell, Emily A. Ryan, Kathryn Stewart, and Joy Westberg.

I am also deeply grateful to the following for their significant contributions to the 13th edition of *Art through the Ages*: Joan Keyes, Dovetail Publishing Services; Ida May Norton, copy editor; Sarah Evertson and Stephen Forsling, photo researchers; Pete Shanks and Jon Peck, accuracy readers; Pat Lewis, proofreader; John Pierce, Thompson Type; Rick Stanley, Digital Media Inc., U.S.A; Don Larson,

Mapping Specialists; Anne Draus, Scratchgravel; Cindy Geiss, Graphic World; and, of course, John Burge, for his superb architectural drawings. I also wish to acknowledge my debt to Edward Tufte for an illuminating afternoon spent discussing publication design and production issues and for his invaluable contribution to the creation of the scales that accompany all reproductions of paintings, sculptures, and other artworks in this edition.

Finally, I owe thanks to my colleagues at Boston University and to the thousands of students and the scores of teaching fellows in my art history courses during the past three decades. From them I have learned much that has helped determine the form and content of *Art through the Ages* and made it a much better book than it otherwise might have been.

Fred S. Kleiner

RESOURCES

FOR FACULTY

Digital Image Library

DVD ISBN 0495504904 CD ISBN 0495505412

Bring digital images into the classroom with this one-stop lectureand class-presentation tool that makes it easy to assemble, edit, and present customized lectures for your course using Microsoft Power-Point. Available on DVD or multiple CD-ROMs, the Digital Image Library provides high-resolution images (maps, illustrations, and most of the fine-art images from the text) for lectures, either in PowerPoint presentation format or in individual file formats compatible with other image-viewing software. The zoom feature allows you to magnify selected portions of an image for more detailed display, and another setting enables you to show images side by side for purposes of comparison and contrast. You can readily customize your classroom presentation by adding your personal visuals to those from the text. The Digital Image Library also includes Google Earth™ coordinates that enable you to zoom in on an entire city as well as key monuments and buildings within it. Also included are flash video clips of architectural landmarks discussed in the text. Using a navigation bar on the video, you can move around the structure and zoom in/out and right/left to add a three-dimensional experience to your presentation.

PowerLecture

ISBN 0495503975

This CD includes a Resource Integration Guide, an electronic Instructor's Manual, and a Test Bank with multiple-choice, matching, short-answer, and essay questions in ExamView® computerized format.

JoinIn™ on Turning Point®

ISBN: 0495564737

Text-specific Microsoft PowerPoint slides have been created for use with JoinIn™ on Turning Point® software for classroom personal-response systems ("clickers").

Contact your Wadsworth representative.

WebTutor on Blackboard or WebCT

WebTutor ISBN: 0495566780 BlackBoard ISBN: 0495566799

This package allows you to assign preformatted, text-specific content that is available as soon as you log on, or to customize the learning environment in any way you choose—from uploading images and other resources to adding Web links to creating your own practice materials.

Contact your Wadsworth representative.

Slides Contact your Wadsworth representative.

FOR STUDENTS

ArtStudy Online

This tool gives access to a host of multimedia resources, including **flashcards** of works in the text that can be magnified with a new zoom feature and, with a compare-and-contrast feature, two works also can be displayed side by side for more in-depth analysis. Other features include critical-thinking questions, interactive maps, architectural basics materials, video clips of selected architectural monuments, museum with links, **Google Earth**TM coordinates with exercises, Student Test Packet, audio study tools, vocabulary of art history, a guide to researching art history online, links to beneficial Web sites on art, artists, architecture, and more, and tips on becoming a successful student of art and art history.

Slide Guide Contact your Wadsworth representative.

This lecture companion allows students to take notes alongside representations of the art images shown in class. New to this edition's slide guide are two features—(1) **Google Earth**TM coordinates to link satellite images of historical sites and images to textual references, and (2) end-of-chapter questions.

Study Guide

Volume 1 ISBN: 0495503916 Volume 2 ISBN: 0495503924

This tool focuses on critical analysis of the subject that includes discussion, maps, timelines, study questions, self-quizzes, and test questions. Complete answers and page references are at the end of the guide.

Web Site

Instructors and students have access to a comprehensive array of teaching and learning resources, including chapter-by-chapter online tutorial quizzes, a final exam, chapter reviews, chapter-by-chapter Web links, glossary flashcards, and more.

If you are interested in bundling any of the preceding student resources with the text, contact your Wadsworth sales representative.

To order student editions packaged with the Timeline and ArtStudy Online at no extra cost to students, use the ISBNs listed below:

Gardner's Art through the Ages: A Global History, 13e ISBN: 0495093076

Gardner's Art through the Ages: A Global History, 13e Volume I ISBN: 0495115495

Gardner's Art through the Ages: A Global History, 13e Volume II ISBN: 0495115509

GARDNER'S ART ART THROUGH THE AGES

Clyfford Still painted this abstract composition without knowing who would purchase it or where it would be displayed, but throughout history most artists created works for specific patrons and settings.

I-1 Clyfford Still, 1948-C, PH-15, 1948. Oil on canvas, 6' $8\frac{7}{8}$ " \times 5' $10\frac{3}{4}$ ". Hirshhorn Museum and Sculpture Garden, Smithsonian Institution, Washington, D.C. (purchased with funds of Joseph H. Hirshhorn, 1992).

INTRODUCTION: WHAT IS ART HISTORY?

Except when referring to the modern academic discipline, people do not often juxtapose the words "art" and "history." They tend to think of history as the record and interpretation of past human actions, particularly social and political actions. Most think of art, quite correctly, as part of the present—as something people can see and touch. Of course, people cannot see or touch history's vanished human events, but a visible, tangible artwork is a kind of persisting event. One or more artists made it at a certain time and in a specific place, even if no one today knows just who, when, where, or why. Although created in the past, an artwork continues to exist in the present, long surviving its times. The first painters and sculptors died 30,000 years ago, but their works remain, some of them exhibited in glass cases in museums built only a few years ago.

Modern museum visitors can admire these objects from the remote past—and countless others humankind has produced over the millennia—without any knowledge of the circumstances that led to the creation of those works. The beauty or sheer size of an object can impress people, the artist's virtuosity in the handling of ordinary or costly materials can dazzle them, or the subject depicted can move them. Viewers can react to what they see, interpret the work in the light of their own experience, and judge it a success or a failure. These are all valid responses to a work of art. But the enjoyment and appreciation of artworks in museum settings are relatively recent phenomena, as is the creation of artworks solely for museum-going audiences to view.

Today, it is common for artists to work in private studios and to create paintings, sculptures, and other objects commercial art galleries will offer for sale. This is what the American painter Clyfford Still (1904–1980) did when he created large canvases of pure color (Fig. I-1) titled simply with the year of their creation. Usually, someone the artist has never met will purchase the artwork and display it in a setting the artist has never seen. This practice is not a new phenomenon in the history of art—an ancient potter decorating a vase for sale at a village market stall probably did not know who would buy the pot or where it would be housed—but it is not at all typical. In fact, it is exceptional. Throughout history, most artists created paintings, sculptures, and other objects for specific patrons and settings and to fulfill a specific purpose, even if today no one knows the original contexts of most of those works. Museum visitors can appreciate the visual and tactile qualities of these objects, but they cannot understand why

they were made or why they appear as they do without knowing the circumstances of their creation. Art *appreciation* does not require knowledge of the historical context of an artwork (or a building). Art *history* does.

Thus, a central aim of art history is to determine the original context of artworks. Art historians seek to achieve a full understanding not only of why these "persisting events" of human history look the way they do but also of why the artistic events happened at all. What unique set of circumstances gave rise to the erection of a particular building or led an individual patron to commission a certain artist to fashion a singular artwork for a specific place? The study of history is therefore vital to art history. And art history is often very important to the study of history. Art objects and buildings are historical documents that can shed light on the peoples who made them and on the times of their creation in a way other historical documents cannot. Furthermore, artists and architects can affect history by reinforcing or challenging cultural values and practices through the objects they create and the structures they build. Thus, the history of art and architecture is inseparable from the study of history, although the two disciplines are not the same.

The following pages introduce some of the distinctive subjects art historians address and the kinds of questions they ask, and explain some of the basic terminology they use when answering these questions. Readers armed with this arsenal of questions and terms will be ready to explore the multifaceted world of art through the ages.

ART HISTORY IN THE 21ST CENTURY

Art historians study the visual and tangible objects humans make and the structures humans build. Scholars traditionally have classified such works as architecture, sculpture, the pictorial arts (painting, drawing, printmaking, and photography), and the craft arts, or arts of design. The craft arts comprise utilitarian objects, such as ceramics, metalwork, textiles, jewelry, and similar accessories of ordinary living. Artists of every age have blurred the boundaries among these categories, but this is especially true today, when multimedia works abound.

From the earliest Greco-Roman art critics on, scholars have studied objects that their makers consciously manufactured as "art" and to which the artists assigned formal titles. But today's art historians also study a vast number of objects that their creators and owners almost certainly did not consider to be "works of art." Few ancient Romans, for example, would have regarded a coin bearing their emperor's portrait as anything but money. Today, an art museum may exhibit that coin in a locked case in a climate-controlled room, and scholars may subject it to the same kind of art historical analysis as a portrait by an acclaimed Renaissance or modern sculptor or painter.

The range of objects art historians study is constantly expanding and now includes, for example, computer-generated images, whereas in the past almost anything produced using a machine would not have been regarded as art. Most people still consider the performing arts—music, drama, and dance—as outside art history's realm because these arts are fleeting, impermanent media. But recently even this distinction between "fine art" and "performance art" has become blurred. Art historians, however, generally ask the same kinds of questions about what they study, whether they employ a restrictive or expansive definition of art.

The Questions Art Historians Ask

HOW OLD IS IT? Before art historians can construct a history of art, they must be sure they know the date of each work they study. Thus, an indispensable subject of art historical inquiry is *chronology*,

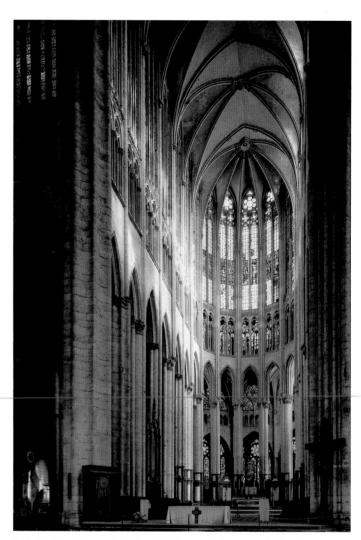

1-2 Choir of Beauvais Cathedral, Beauvais, France, rebuilt after 1284.

The style of an object or building often varies from region to region. This cathedral has towering stone vaults and large stained-glass windows typical of 13th-century French architecture.

the dating of art objects and buildings. If researchers cannot determine a monument's age, they cannot place the work in its historical context. Art historians have developed many ways to establish, or at least approximate, the date of an artwork.

Physical evidence often reliably indicates an object's age. The material used for a statue or painting—bronze, plastic, or oil-based pigment, to name only a few—may not have been invented before a certain time, indicating the earliest possible date someone could have fashioned the work. Or artists may have ceased using certain materials—such as specific kinds of inks and papers for drawings—at a known time, providing the latest possible dates for objects made of those materials. Sometimes the material (or the manufacturing technique) of an object or a building can establish a very precise date of production or construction. Studying tree rings, for instance, usually can help scholars determine within a narrow range the date of a wood statue or a timber roof beam.

Documentary evidence can help pinpoint the date of an object or building when a dated written document mentions the work. For example, official records may note when church officials commissioned a new altarpiece—and how much they paid to which artist.

Internal evidence can play a significant role in dating an artwork. A painter might have depicted an identifiable person or a kind of hairstyle, clothing, or furniture fashionable only at a certain

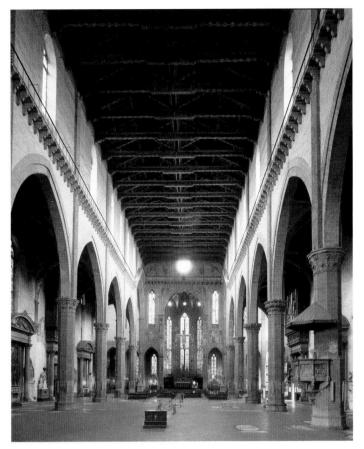

1-3 Interior of Santa Croce, Florence, Italy, begun 1294.

In contrast to Beauvais Cathedral (FIG. I-2), this contemporaneous Florentine church conforms to the quite different regional style of Italy. The building has a low timber roof and small windows.

time. If so, the art historian can assign a more accurate date to that painting.

Stylistic evidence is also very important. The analysis of style—an artist's distinctive manner of producing an object—is the art historian's special sphere. Unfortunately, because it is a subjective assessment, stylistic evidence is by far the most unreliable chronological criterion. Still, art historians find style a very useful tool for establishing chronology.

WHAT IS ITS STYLE? Defining artistic style is one of the key elements of art historical inquiry, although the analysis of artworks solely in terms of style no longer dominates the field as it once did. Art historians speak of several different kinds of artistic styles.

Period style refers to the characteristic artistic manner of a specific time, usually within a distinct culture, such as "Archaic Greek" or "Late Byzantine." But many periods do not manifest any stylistic unity at all. How would someone define the artistic style of the opening decade of the new millennium in North America? Far too many crosscurrents exist in contemporary art for anyone to describe a period style of the early 21st century—even in a single city such as New York.

Regional style is the term art historians use to describe variations in style tied to geography. Like an object's date, its provenance, or place of origin, can significantly determine its character. Very often two artworks from the same place made centuries apart are more similar than contemporaneous works from two different regions. To cite one example, usually only an expert can distinguish between an Egyptian statue carved in 2500 BCE and one made in 500 BCE. But no

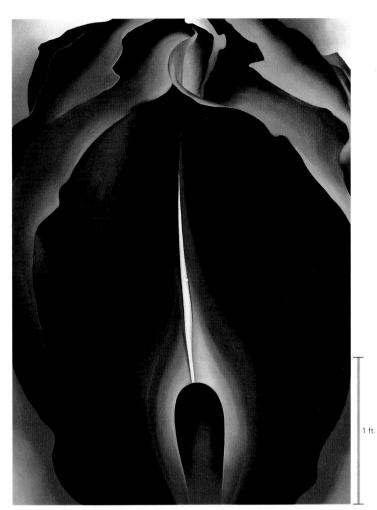

I-4 Georgia O'Keeffe, *Jack-in-the-Pulpit No. 4*, 1930. Oil on canvas, $3' 4'' \times 2' 6''$. National Gallery of Art, Washington, D.C. (Alfred Stieglitz Collection, bequest of Georgia O'Keeffe).

O'Keeffe's paintings feature close-up views of petals and leaves in which the organic forms become powerful abstract compositions. This approach to painting typifies the artist's distinctive personal style.

one would mistake an Egyptian statue of 500 BCE for one of the same date made in Greece or Mexico.

Considerable variations in a given area's style are possible, however, even during a single historical period. In late medieval Europe, French architecture differed significantly from Italian architecture. The interiors of Beauvais Cathedral (FIG. 1-2) and the Florentine church of Santa Croce (FIG. 1-3) typify the architectural styles of France and Italy, respectively, at the end of the 13th century. The rebuilding of the east end of Beauvais Cathedral began in 1284. Construction commenced on Santa Croce only 10 years later. Both structures employ the *pointed arch* characteristic of this era, yet the two churches differ strikingly. The French church has towering stone ceilings and large expanses of colored windows, whereas the Italian building has a low timber roof and small, widely separated windows. Because the two contemporaneous churches served similar purposes, regional style mainly explains their differing appearance.

Personal style, the distinctive manner of individual artists or architects, often decisively explains stylistic discrepancies among monuments of the same time and place. In 1930 the American painter Georgia O'Keeffe (1887–1986) produced a series of paintings of flowering plants. One of them was Jack-in-the-Pulpit No. 4 (Fig. 1-4), a sharply focused close-up view of petals and leaves. O'Keeffe captured the growing plant's slow, controlled motion while converting

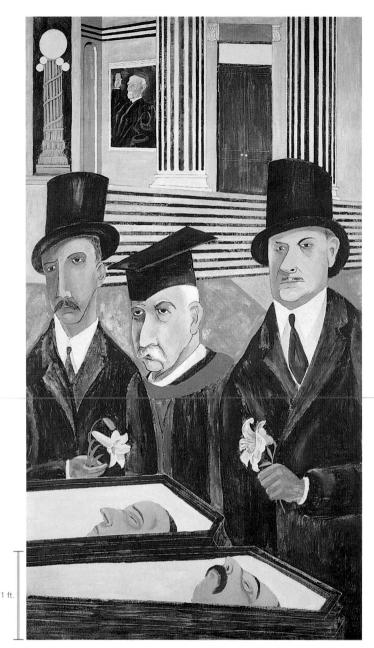

I-5 Ben Shahn, *The Passion of Sacco and Vanzetti*, 1931–1932. Tempera on canvas, $7'\frac{1}{2}''\times 4'$. Whitney Museum of American Art, New York (gift of Edith and Milton Lowenthal in memory of Juliana Force).

A contemporary of O'Keeffe's, Shahn developed a style of painting that differed markedly from hers. His paintings are often social commentaries on current events and incorporate readily identifiable people.

the plant into a powerful abstract composition of lines, forms, and colors (see the discussion of art historical vocabulary in the next section). Only a year later, another American artist, Ben Shahn (1898–1969), painted *The Passion of Sacco and Vanzetti* (Fig. 1-5), a stinging commentary on social injustice inspired by the trial and execution of two Italian anarchists, Nicola Sacco and Bartolomeo Vanzetti. Many people believed Sacco and Vanzetti had been unjustly convicted of killing two men in a holdup in 1920. Shahn's painting compresses time in a symbolic representation of the trial and its aftermath. The two executed men lie in their coffins. Presiding over them are the three members of the commission (headed by a college president wearing academic cap and gown) that declared the original trial fair and cleared the way for the executions. Behind, on the wall of a stately government building, hangs the framed portrait of the judge who pronounced the

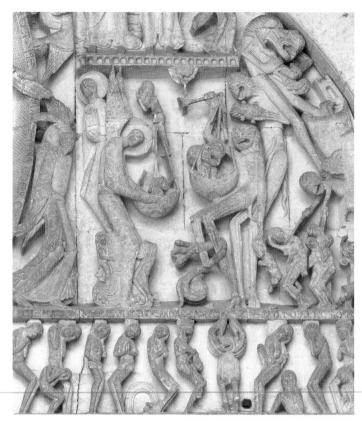

I-6 GISLEBERTUS, The weighing of souls, detail of Last Judgment (FIG. 17-12), west tympanum of Saint-Lazare, Autun, France, ca. 1120–1135.

In this high relief portraying the weighing of souls on Judgment Day, Gislebertus used disproportion and distortion to dehumanize the devilish figure yanking on the scales of justice.

initial sentence. Personal style, not period or regional style, sets Shahn's canvas apart from O'Keeffe's. The contrast is extreme here because of the very different subjects the artists chose. But even when two artists depict the same subject, the results can vary widely. The *way* O'Keeffe painted flowers and the *way* Shahn painted faces are distinctive and unlike the styles of their contemporaries. (See the "Who Made It?" discussion on page 5.)

The different kinds of artistic styles are not mutually exclusive. For example, an artist's personal style may change dramatically during a long career. Art historians then must distinguish among the different period styles of a particular artist, such as the "Blue Period" and the "Cubist Period" of the prolific 20th-century artist Pablo Picasso.

WHAT IS ITS SUBJECT? Another major concern of art historians is, of course, subject matter, encompassing the story, or narrative; the scene presented; the action's time and place; the persons involved; and the environment and its details. Some artworks, such as modern abstract paintings (FIG. I-1), have no subject, not even a setting. The "subject" is the artwork itself. But when artists represent people, places, or actions, viewers must identify these aspects to achieve complete understanding of the work. Art historians traditionally separate pictorial subjects into various categories, such as religious, historical, mythological, *genre* (daily life), portraiture, *landscape* (a depiction of a place), *still life* (an arrangement of inanimate objects), and their numerous subdivisions and combinations.

Iconography—literally, the "writing of images"—refers both to the content, or subject of an artwork, and to the study of content in art. By extension, it also includes the study of *symbols*, images that stand for other images or encapsulate ideas. In Christian art, two intersecting

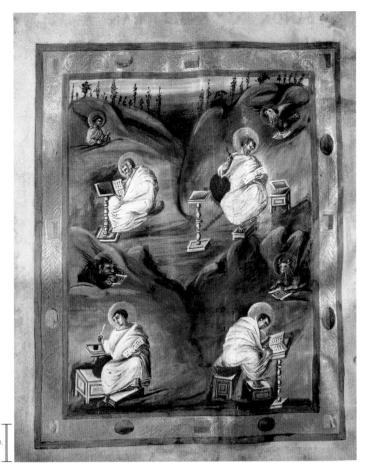

I-7 The four evangelists, folio 14 verso of the *Aachen Gospels*, ca. 810. Ink and tempera on vellum, $1' \times 9\frac{1}{2}''$. Cathedral Treasury, Aachen.

Artists depict figures with attributes in order to identify them for viewers. The authors of the four gospels have distinctive attributes—John an eagle, Luke an ox, Mark a lion, and Matthew a winged man.

lines of unequal length or a simple geometric cross can serve as an emblem of the religion as a whole, symbolizing the cross of Jesus Christ's crucifixion. A symbol also can be a familiar object the artist imbued with greater meaning. A balance or scale, for example, may symbolize justice or the weighing of souls on Judgment Day (FIG. I-6).

Artists may depict figures with unique *attributes* identifying them. In Christian art, for example, each of the authors of the New Testament Gospels, the four evangelists (FIG. 1-7), has a distinctive attribute. People can recognize Saint John by the eagle associated with him, Luke by the ox, Mark by the lion, and Matthew by the winged man.

Throughout the history of art, artists have used *personifications*—abstract ideas codified in human form. Worldwide, people visualize Liberty as a robed woman with a torch because of the fame of the colossal statue set up in New York City's harbor in the 19th century. *The Four Horsemen of the Apocalypse* (FIG. I-8) is a terrifying late-15th-century depiction of the fateful day at the end of time when, according to the Bible's last book, Death, Famine, War, and Pestilence will annihilate the human race. The German artist Albrecht Dürer (1471–1528) personified Death as an emaciated old man with a pitchfork. Dürer's Famine swings the scales that will weigh human souls (compare FIG. I-6), War wields a sword, and Pestilence draws a bow.

Even without considering style and without knowing a work's maker, informed viewers can determine much about the work's period and provenance by iconographical and subject analysis alone. In *The Passion of Sacco and Vanzetti* (FIG. 1-5), for example, the two

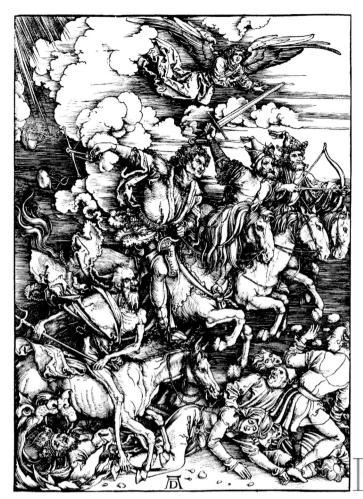

I-8 Albrecht Dürer, *The Four Horsemen of the Apocalypse*, ca. 1498. Woodcut, 1' $3\frac{1}{4}$ " \times 11". Metropolitan Museum of Art, New York (gift of Junius S. Morgan, 1919).

Personifications are abstract ideas codified in human form. Here, Albrecht Dürer represented Death, Famine, War, and Pestilence as four men on charging horses, each carrying an identifying attribute.

coffins, the trio headed by an academic, and the robed judge in the background are all pictorial clues revealing the painting's subject. The work's date must be after the trial and execution, probably while the event was still newsworthy. And because the two men's deaths caused the greatest outrage in the United States, the painter–social critic was probably American.

WHO MADE IT? If Ben Shahn had not signed his painting of Sacco and Vanzetti, an art historian could still assign, or attribute (make an attribution of), the work to him based on knowledge of the artist's personal style. Although signing (and dating) works is quite common (but by no means universal) today, in the history of art countless works exist whose artists remain unknown. Because personal style can play a large role in determining the character of an artwork, art historians often try to attribute anonymous works to known artists. Sometimes they assemble a group of works all thought to be by the same person, even though none of the objects in the group is the known work of an artist with a recorded name. Art historians thus reconstruct the careers of artists such as "the Achilles Painter," the anonymous ancient Greek vase painter whose masterwork is a depiction of the hero Achilles. Scholars base their attributions on internal evidence, such as the distinctive way an artist draws or carves drapery folds, earlobes, or flowers. It requires a keen, highly trained eye and long experience to become a connoisseur, an expert in

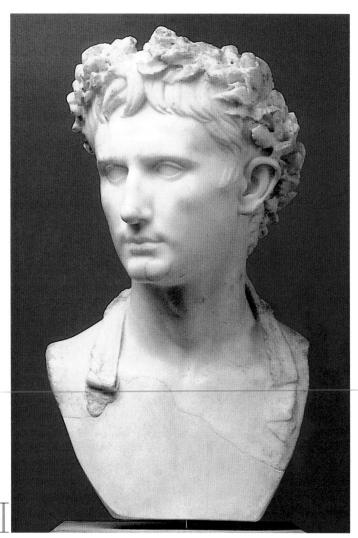

I-9 Augustus wearing the corona civica, early first century CE. Marble, 1' 5" high. Glyptothek, Munich.

Patrons frequently dictate the form their portraits will take. The Roman emperor Augustus demanded that he always be portrayed as a young, godlike head of state even though he lived to age 76.

assigning artworks to "the hand" of one artist rather than another. Attribution is subjective, of course, and ever open to doubt. At present, for example, international debate rages over attributions to the famous 17th-century Dutch painter Rembrandt.

Sometimes a group of artists works in the same style at the same time and place. Art historians designate such a group as a *school*. "School" does not mean an educational institution. The term connotes only chronological, stylistic, and geographic similarity. Art historians speak, for example, of the Dutch school of the 17th century and, within it, of subschools such as those of the cities of Haarlem, Utrecht, and Leyden.

WHO PAID FOR IT? The interest many art historians show in attribution reflects their conviction that the identity of an artwork's maker is the major reason the object looks the way it does. For them, personal style is of paramount importance. But in many times and places, artists had little to say about what form their work would take. They toiled in obscurity, doing the bidding of their *patrons*, those who paid them to make individual works or employed them on a continuing basis. The role of patrons in dictating the content and shaping the form of artworks is also an important subject of art historical inquiry.

In the art of portraiture, to name only one category of painting and sculpture, the patron has often played a dominant role in deciding how the artist represented the subject, whether that person was the patron or another individual, such as a spouse, son, or mother. Many Egyptian pharaohs and some Roman emperors, for example, insisted that artists depict them with unlined faces and perfect youthful bodies no matter how old they were when portrayed. In these cases, the state employed the sculptors and painters, and the artists had no choice but to depict their patrons in the officially approved manner. This is why Augustus, who lived to age 76, looks so young in his portraits (FIG. I-9). Although Roman emperor for more than 40 years, Augustus demanded that artists always represent him as a young, godlike head of state.

All modes of artistic production reveal the impact of patronage. Learned monks provided the themes for the sculptural decoration of medieval church portals (FIG. I-6). Renaissance princes and popes dictated the subject, size, and materials of artworks destined for buildings constructed according to their specifications. An art historian could make a very long list of commissioned works, and it would indicate that throughout the history of art, patrons have had diverse tastes and needs and demanded different kinds of art. Whenever a patron contracts an artist or architect to paint, sculpt, or build in a prescribed manner, personal style often becomes a very minor factor in the ultimate appearance of the painting, statue, or building. In these cases, the identity of the patron reveals more to art historians than does the identity of the artist or school. The portrait of Augustus wearing a corona civica, or civic crown (FIG. I-9), was the work of a virtuoso sculptor, a master wielder of hammer and chisel. But scores of similar portraits of that emperor exist today. They differ in quality but not in kind from this one. The patron, not the artist, determined the character of these artworks. Augustus's public image never varied.

The Words Art Historians Use

Like all specialists, art historians have their own specialized vocabulary. That vocabulary consists of hundreds of words, but certain basic terms are indispensable for describing artworks and buildings of any time and place. They make up the essential vocabulary of *formal analysis*, the visual analysis of artistic form. Definitions of the most important of these art historical terms follow.

FORM AND COMPOSITION *Form* refers to an object's shape and structure, either in two dimensions (for example, a figure painted on a canvas) or in three dimensions (such as a statue carved from a marble block). Two forms may take the same shape but may differ in their color, texture, and other qualities. *Composition* refers to how an artist organizes (*composes*) forms in an artwork, either by placing shapes on a flat surface or by arranging forms in space.

MATERIAL AND TECHNIQUE To create art forms, artists shape materials (pigment, clay, marble, gold, and many more) with tools (pens, brushes, chisels, and so forth). Each of the materials and tools available has its own potentialities and limitations. Part of all artists' creative activity is to select the *medium* and instrument most suitable to the artists' purpose—or to develop new media and tools, such as bronze and concrete in antiquity and cameras and computers in modern times. The processes artists employ, such as applying paint to canvas with a brush, and the distinctive, personal ways they handle materials constitute their *technique*. Form, material, and technique interrelate and are central to analyzing any work of art.

LINE Among the most important elements defining an artwork's shape or form is *line*. A line can be understood as the path of a point moving in space, an invisible line of sight. More commonly, however, artists and architects make a line tangible by drawing (or chiseling) it

on a *plane*, a flat surface. A line may be very thin, wirelike, and delicate. It may be thick and heavy. Or it may alternate quickly from broad to narrow, the strokes jagged or the outline broken. When a continuous line defines an object's outer shape, art historians call it a *contour line*. All of these line qualities are present in Dürer's *Four Horsemen of the Apocalypse* (FIG. 1-8). Contour lines define the basic shapes of clouds, human and animal limbs, and weapons. Within the forms, series of short broken lines create shadows and textures. An overall pattern of long parallel strokes suggests the dark sky on the frightening day when the world is about to end.

COLOR Light reveals all colors. Light in the world of the painter and other artists differs from natural light. Natural light, or sunlight, is whole or *additive light*. As the sum of all the wavelengths composing the visible *spectrum*, natural light may be disassembled or fragmented into the individual colors of the spectral band. The painter's light in art—the light reflected from pigments and objects—is *subtractive light*. Paint pigments produce their individual colors by reflecting a segment of the spectrum while absorbing all the rest. Green pigment, for example, subtracts or absorbs all the light in the spectrum except that seen as green.

Hue is the property that gives a color its name. Although the spectrum colors merge into each other, artists usually conceive of their hues as distinct from one another. Color has two basic variables—the apparent amount of light reflected and the apparent purity. A change in one must produce a change in the other. Some terms for these variables are value, or tonality (the degree of lightness or darkness), and intensity, or saturation (the purity of a color, or its brightness or dullness).

Artists call the three basic colors—red, yellow, and blue—the *primary colors*. The *secondary colors* result from mixing pairs of primaries: orange (red and yellow), purple (red and blue), and green (yellow and blue). *Complementary colors* represent the pairing of a primary color and the secondary color created from mixing the two other primary colors—red and green, yellow and purple, and blue and orange. They "complement," or complete, each other, one absorbing colors the other reflects.

Artists can manipulate the appearance of colors, however. One artist who made a systematic investigation of the formal aspects of art, especially color, was Josef Albers (1888-1976), a German-born artist who emigrated to the United States in 1933. In connection with his studies, Albers created the series *Homage to the Square*—hundreds of paintings, most of which are color variations on the same composition of concentric squares, as in the illustrated example (FIG. I-10). The series reflected Albers's belief that art originates in "the discrepancy between physical fact and psychic effect." Because the composition in most of these paintings remains constant, the works succeed in revealing the relativity and instability of color perception. Albers varied the hue, saturation, and value of each square in the paintings in this series. As a result, the sizes of the squares from painting to painting appear to vary (although they remain the same), and the sensations emanating from the paintings range from clashing dissonance to delicate serenity. Albers explained his motivation for focusing on color juxtapositions:

They [the colors] are juxtaposed for various and changing visual effects.... Such action, reaction, interaction... is sought in order to make obvious how colors influence and change each other; that the same color, for instance—with different grounds or neighbors—looks different.... Such color deceptions prove that we see colors almost never unrelated to each other.²

Albers's quotation is only one example of how artists' comments on their own works are often invaluable to art historians. In *Art through*

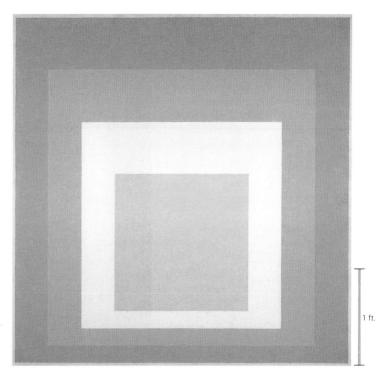

I-10 Josef Albers, *Homage to the Square: "Ascending,*" 1953. Oil on composition board, $3' 7\frac{1''}{2} \times 3' 7\frac{1''}{2}$. Whitney Museum of American Art, New York.

Josef Albers painted hundreds of canvases with the same composition but employed variations in hue, saturation, and value in order to reveal the relativity and instability of color perception.

the Ages, artist commentaries appear frequently in boxed features called "Artists on Art."

TEXTURE The term *texture* refers to the quality of a surface, such as rough or shiny. Art historians distinguish between true texture, or the tactile quality of the surface, and represented texture, as when painters depict an object as having a certain texture even though the pigment is the true texture. Sometimes artists combine different materials of different textures on a single surface, juxtaposing paint with pieces of wood, newspaper, fabric, and so forth. Art historians refer to this mixed-media technique as *collage*. Texture is, of course, a key determinant of any sculpture's character. A viewer's first impulse is usually to handle a piece of sculpture—even though museum signs often warn "Do not touch!" Sculptors plan for this natural human response, using surfaces varying in texture from rugged coarseness to polished smoothness. Textures are often intrinsic to a material, influencing the type of stone, wood, plastic, clay, or metal sculptors select.

SPACE, MASS, AND VOLUME *Space* is the bounded or boundless "container" of objects. For art historians, space can be the literal three-dimensional space occupied by a statue or a vase or contained within a room or courtyard. Or space can be *illusionistic*, as when painters depict an image (or illusion) of the three-dimensional spatial world on a two-dimensional surface.

Mass and volume describe three-dimensional objects and space. In both architecture and sculpture, mass is the bulk, density, and weight of matter in space. Yet the mass need not be solid. It can be the exterior form of enclosed space. Mass can apply to a solid Egyptian pyramid or stone statue, to a church, synagogue, or mosque—architectural shells enclosing sometimes vast spaces—and to a hollow metal statue or baked clay pot. Volume is the space that mass organizes, divides, or encloses. It may be a building's interior spaces, the

I-11 CLAUDE LORRAIN, Embarkation of the Queen of Sheba, 1648. Oil on canvas, $4'\ 10'' \times 6'\ 4''$. National Gallery, London.

To create the illusion of a deep landscape, Claude Lorrain employed perspective, reducing the size of and blurring the most distant forms. Also, all diagonal lines converge on a single point.

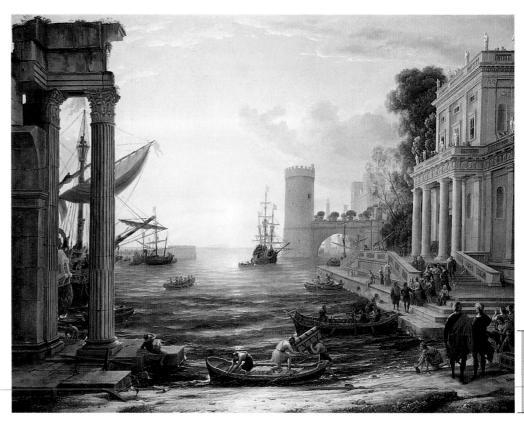

1 ft.

intervals between a structure's masses, or the amount of space occupied by three-dimensional objects such as sculpture, pottery, or furniture. Volume and mass describe both the exterior and interior forms of a work of art—the forms of the matter of which it is composed and the spaces immediately around the work and interacting with it.

PERSPECTIVE AND FORESHORTENING *Perspective* is one of the most important pictorial devices for organizing forms in space. Throughout history, artists have used various types of perspec-

tive to create an illusion of depth or space on a two-dimensional surface. The French painter Claude Lorrain (1600–1682) employed several perspectival devices in *Embarkation of the Queen of Sheba* (FIG. I-11), a painting of a biblical episode set in a 17th-century European harbor with a Roman ruin in the left foreground. For example, the figures and boats on the shoreline are much larger than those in the distance. Decreasing the size of an object makes it appear farther away. Also, the top and bottom of the port building at the painting's right side are not parallel horizontal lines, as they are

1 ft

I-12 OGATA KORIN, White and Red Plum Blossoms, Edo period, ca. 1710–1716. Pair of twofold screens. Ink, color, and gold leaf on paper, each screen $5'1\frac{5''}{8}'' \times 5'7\frac{7}{8}''$. MOA Art Museum, Shizuoka-ken.

Ogata Korin was more concerned with creating an interesting composition of shapes on a surface than with locating objects in space. Asian artists rarely employed Western perspective.

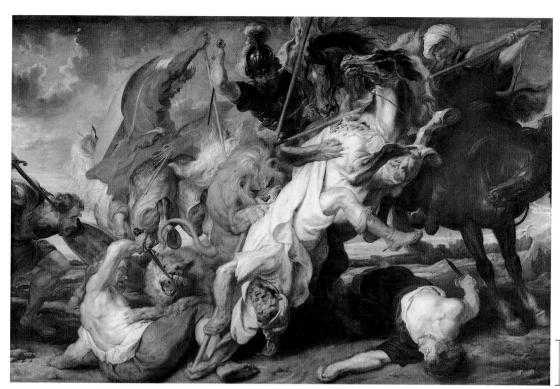

I-13 PETER PAUL RUBENS, Lion Hunt, 1617–1618. Oil on canvas, 8' 2" × 12' 5". Alte Pinakothek, Munich.

Foreshortening—the representation of a figure or object at an angle to the picture plane—is a common device in Western art for creating the illusion of depth. Foreshortening is a type of perspective.

1 ft.

in an actual building. Instead, the lines converge beyond the structure, leading viewers' eyes toward the hazy, indistinct sun on the horizon. These perspectival devices—the reduction of figure size, the convergence of diagonal lines, and the blurring of distant forms—have been familiar features of Western art since the ancient Greeks. But it is important to note at the outset that all kinds of perspective are only pictorial conventions, even when one or more types of perspective may be so common in a given culture that people accept them as "natural" or as "true" means of representing the natural world.

In White and Red Plum Blossoms (FIG. 1-12), a Japanese land-scape painting on two folding screens, OGATA KORIN (1658–1716) used none of these Western perspective conventions. He showed the two plum trees as seen from a position on the ground, but viewers look down on the stream between them from above. Less concerned with locating the trees and stream in space than with composing shapes on a surface, the painter played the water's gently swelling curves against the jagged contours of the branches and trunks. Neither the French nor the Japanese painting can be said to project "correctly" what viewers "in fact" see. One painting is not a "better" picture of the world than the other. The European and Asian artists simply approached the problem of picture-making differently.

Artists also represent single figures in space in varying ways. When the Flemish artist Peter Paul Rubens (1577–1640) painted Lion Hunt (FIG. I-13), he used foreshortening for all the hunters and animals—that is, he represented their bodies at angles to the picture plane. When in life one views a figure at an angle, the body appears to contract as it extends back in space. Foreshortening is a kind of perspective. It produces the illusion that one part of the body is farther away than another, even though all the forms are on the same surface. Especially noteworthy in Lion Hunt are the gray horse at the left, seen from behind with the bottom of its left rear hoof facing viewers and most of its head hidden by its rider's shield, and the fallen hunter at the painting's lower right corner, whose barely visible legs and feet recede into the distance.

The artist who carved the portrait of the ancient Egyptian official Hesire (FIG. 1-14) did not employ foreshortening. That artist's

purpose was to present the various human body parts as clearly as possible, without overlapping. The lower part of Hesire's body is in profile to give the most complete view of the legs, with both the heels and toes of the foot visible. The frontal torso, however, allows viewers

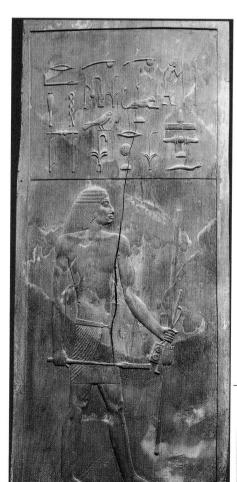

1-14 Hesire, relief from his tomb at Saqqara, Egypt, Third Dynasty, ca. 2650 BCE. Wood, 3′ 9″ high. Egyptian Museum, Cairo.

Egyptian artists combined frontal and profile views to give a precise picture of the parts of the human body, as opposed to depicting how an individual body appears from a specific viewpoint.

1 ft.

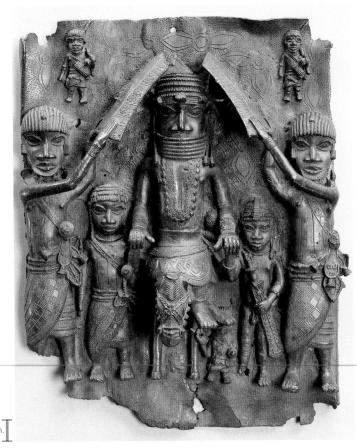

I-15 King on horseback with attendants, from Benin, Nigeria, ca. 1550–1680. Bronze, 1' $7\frac{1}{2}$ " high. Metropolitan Museum of Art, New York (Michael C. Rockefeller Memorial Collection, gift of Nelson A. Rockefeller).

This African artist used hierarchy of scale to distinguish the relative rank of the figures, making the king the largest. The sculptor created the relief by casting (pouring bronze into a mold).

to see its full shape, including both shoulders, equal in size, as in nature. (Compare the shoulders of the hunter on the gray horse or those of the fallen hunter in *Lion Hunt's* left foreground.) The result, an "unnatural" 90-degree twist at the waist, provides a precise picture of human body parts. Rubens and the Egyptian sculptor used very different means of depicting forms in space. Once again, neither is the "correct" manner.

PROPORTION AND SCALE *Proportion* concerns the relationships (in terms of size) of the parts of persons, buildings, or objects. People can judge "correct proportions" intuitively ("that statue's head seems the right size for the body"). Or proportion can be a mathematical relationship between the size of one part of an artwork or building and the other parts within the work. Proportion in art implies using a *module*, or basic unit of measure. When an artist or architect uses a formal system of proportions, all parts of a building, body, or other entity will be fractions or multiples of the module. A module might be a *column*'s diameter, the height of a human head, or any other component whose dimensions can be multiplied or divided to determine the size of the work's other parts.

In certain times and places, artists have formulated *canons*, or systems, of "correct" or "ideal" proportions for representing human figures, constituent parts of buildings, and so forth. In ancient Greece,

many sculptors devised canons of proportions so strict and allencompassing that they calculated the size of every body part in advance, even the fingers and toes, according to mathematical ratios.

Proportional systems can differ sharply from period to period, culture to culture, and artist to artist. Part of the task art history students face is to perceive and adjust to these differences. In fact, many artists have used disproportion and distortion deliberately for expressive effect. In the medieval French depiction of the weighing of souls on Judgment Day (FIG. 1-6), the devilish figure yanking down on the scale has distorted facial features and stretched, lined limbs with animal-like paws for feet. Disproportion and distortion make him appear "inhuman," precisely as the sculptor intended.

In other cases, artists have used disproportion to focus attention on one body part (often the head) or to single out a group member (usually the leader). These intentional "unnatural" discrepancies in proportion constitute what art historians call hierarchy of scale, the enlarging of elements considered the most important. On a bronze plaque from Benin, Nigeria (FIG. 1-15), the sculptor enlarged all the heads for emphasis and also varied the size of each figure according to its social status. Central, largest, and therefore most important is the Benin king, mounted on horseback. The horse has been a symbol of power and wealth in many societies from prehistory to the present. That the Benin king is disproportionately larger than his horse, contrary to nature, further aggrandizes him. Two large attendants fan the king. Other figures of smaller size and status at the Benin court stand on the king's left and right and in the plaque's upper corners. One tiny figure next to the horse is almost hidden from view beneath the king's feet.

One problem that students of art history—and professional art historians too—confront when studying illustrations in art history books is that although the relative sizes of figures and objects in a painting or sculpture are easy to discern, it is impossible to determine the absolute size of the works reproduced because they all appear at approximately the same size on the page. Readers of *Art through the Ages* can learn the size of all artworks from the dimensions given in the captions and, more intuitively, from the scales that appear—for the first time in this 13th edition—at the lower left or right corner of the illustration.

CARVING AND CASTING Sculptural technique falls into two basic categories, *subtractive* and *additive*. *Carving* is a subtractive technique. The final form is a reduction of the original mass of a block of stone, a piece of wood, or another material. Wooden statues were once tree trunks, and stone statues began as blocks pried from mountains. An unfinished marble statue of a bound slave (FIG. I-16) by the Italian artist MICHELANGELO BUONARROTI (1475–1564) clearly reveals the original shape of the stone block. Michelangelo thought of sculpture as a process of "liberating" the statue within the block. All sculptors of stone or wood cut away (subtract) "excess material." When they finish, they "leave behind" the statue—in this example, a twisting nude male form whose head Michelangelo never freed from the stone block.

In additive sculpture, the artist builds up the forms, usually in clay around a framework, or *armature*. Or a sculptor may fashion a *mold*, a hollow form for shaping, or *casting*, a fluid substance such as bronze or plaster. The ancient Greek sculptor who made the bronze statue of a warrior found in the sea near Riace, Italy, cast the head (FIG. I-17), limbs, torso, hands, and feet in separate molds and then *welded* them together (joined them by heating). Finally, the artist added features, such as the pupils of the eyes (now missing), in other materials. The warrior's teeth are silver, and his lower lip is copper.

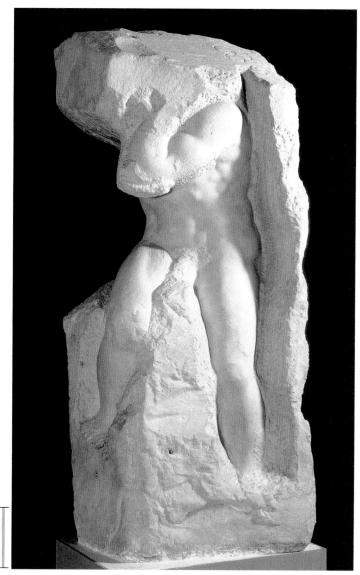

I-16 MICHELANGELO BUONARROTI, unfinished captive, 1527–1528. Marble, 8' $7\frac{1}{2}$ " high. Galleria dell'Accademia, Florence.

Carving a freestanding figure from stone or wood is a subtractive process. Michelangelo thought of sculpture as a process of "liberating" the statue within the block of marble.

RELIEF SCULPTURE *Statues* that exist independent of any architectural frame or setting and that viewers can walk around are *freestanding* sculptures, or *sculptures in the round*, whether the artist produced the piece by carving (FIG. I-9) or casting (FIG. I-17). In *relief* sculpture, the subjects project from the background but remain part of it. In *high-relief* sculpture, the images project boldly. In the medieval weighing-of-souls scene (FIG. I-6), the relief is so high that not only do the forms cast shadows on the background, but some parts are even in the round, which explains why some pieces, for example the arms of the scale, broke off centuries ago. In *low relief*, or *basrelief*, such as the portrait of Hesire (FIG. I-14), the projection is slight. Relief sculpture, like sculpture in the round, can be produced either by carving or casting. The plaque from Benin (FIG. I-15) is an example of bronze casting in high relief.

ARCHITECTURAL DRAWINGS Buildings are groupings of enclosed spaces and enclosing masses. People experience architecture both visually and by moving through and around it, so they

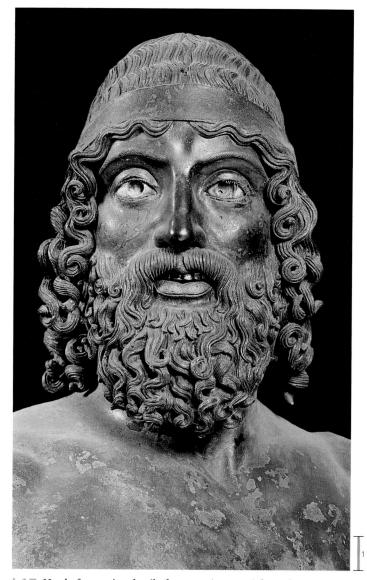

I-17 Head of a warrior, detail of a statue (FIG. 5-35) from the sea off Riace, Italy, ca. 460–450 BCE. Bronze, full statue 6′ 6″ high. Museo Nazionale della Magna Grecia, Reggio Calabria.

The sculptor of this life-size statue of a bearded Greek warrior cast the head, limbs, torso, hands, and feet in separate molds, then welded the pieces together and added the eyes in a different material.

perceive architectural space and mass together. Architects can represent these spaces and masses graphically in several ways, including as plans, sections, elevations, and cutaway drawings.

A plan, essentially a map of a floor, shows the placement of a structure's masses and, therefore, the spaces they circumscribe and enclose. A section, like a vertical plan, depicts the placement of the masses as if someone cut through the building along a plane. Drawings showing a theoretical slice across a structure's width are lateral sections. Those cutting through a building's length are longitudinal sections. Illustrated here are the plan and lateral section of Beauvais Cathedral (FIG. I-18), which may be compared to the photograph of the church's choir (FIG. I-2). The plan shows not only the choir's shape and the location of the piers dividing the aisles and supporting the vaults above but also the pattern of the crisscrossing vault ribs. The lateral section shows both the interior of the choir with its vaults and tall stained-glass windows as well as the roof structure and the form of the exterior flying buttresses that hold the vaults in place.

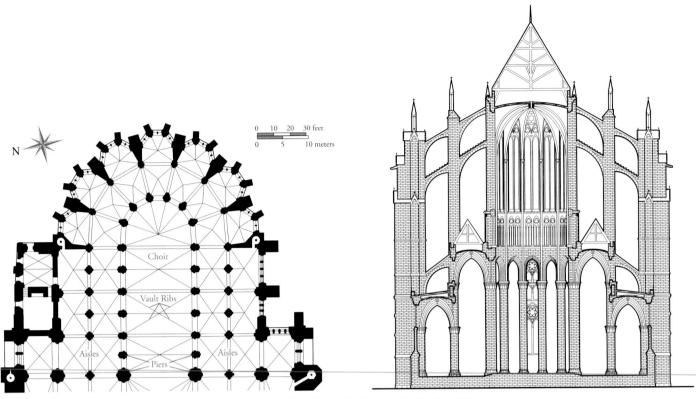

1-18 Plan (left) and lateral section (right) of Beauvais Cathedral, Beauvais, France, rebuilt after 1284.

Architectural drawings are indispensable aids for the analysis of buildings. Plans are maps of floors, recording the structure's masses. Sections are vertical "slices," across either a building's width or length.

Other types of architectural drawings appear throughout this book. An *elevation* drawing is a head-on view of an external or internal wall. A *cutaway* combines in a single drawing an exterior view with an interior view of part of a building.

This overview of the art historian's vocabulary is not exhaustive, nor have artists used only painting, drawing, sculpture, and architecture as media over the millennia. Ceramics, jewelry, textiles, photography, and computer art are just some of the numerous other arts. All of them involve highly specialized techniques described in distinct vocabularies. As in this introductory chapter, new terms are in *italics* where they first appear. The comprehensive Glossary at the end of the book contains definitions of all italicized terms.

Art History and Other Disciplines

By its very nature, the work of art historians intersects with that of others in many fields of knowledge, not only in the humanities but also in the social and natural sciences. To do their job well today, art historians regularly must go beyond the boundaries of what the public and even professional art historians of previous generations traditionally considered the specialized discipline of art history. In short, art historical research in the 21st century is typically interdisciplinary in nature. To cite one example, in an effort to unlock the secrets of a particular statue, an art historian might conduct archival research hoping to uncover new documents shedding light on who paid for the work and why, who made it and when, where it originally stood, how its contemporaries viewed it, and a host of other questions. Realizing, however, that the authors of the written documents often were not objective recorders of fact but rather observers with their own biases and agendas, the art historian may also use methodologies developed in

such fields as literary criticism, philosophy, sociology, and gender studies to weigh the evidence the documents provide.

At other times, rather than attempt to master many disciplines at once, art historians band together with other specialists in multidisciplinary inquiries. Art historians might call in chemists to date an artwork based on the composition of the materials used or might ask geologists to determine which quarry furnished the stone for a particular statue. X-ray technicians might be enlisted in an attempt to establish whether a painting is a forgery. Of course, art historians often reciprocate by contributing their expertise to the solution of problems in other disciplines. A historian, for example, might ask an art historian to determine—based on style, material, iconography, and other criteria—if any of the portraits of a certain king date to after his death. That would help establish the ruler's continuing prestige during the reigns of his successors. (Some portraits of Augustus, FIG. I-9, the founder of the Roman Empire, postdate his death by decades, even centuries.)

DIFFERENT WAYS OF SEEING

The history of art can be a history of artists and their works, of styles and stylistic change, of materials and techniques, of images and themes and their meanings, and of contexts and cultures and patrons. The best art historians analyze artworks from many viewpoints. But no art historian (or scholar in any other field), no matter how broad-minded in approach and no matter how experienced, can be truly objective. Like artists, art historians are members of a society, participants in its culture. How can scholars (and museum visitors and travelers to foreign locales) comprehend cultures unlike their own? They can try to reconstruct the original cultural contexts of artworks, but they are limited by their distance from the thought

I-19 *Left:* John Henry Sylvester, *Portrait of Te Pehi Kupe*, 1826. Watercolor, $8\frac{1}{4}$ ". National Library of Australia, Canberra (Rex Nan Kivell Collection). *Right:* Te Pehi Kupe, *Self-Portrait*, 1826. From Leo Frobenius, *The Childhood of Man* (New York: J. B. Lippincott, 1909).

These strikingly different portraits of the same Maori chief reveal how differently Western and non-Western artists "see" a subject. Understanding the cultural context of artworks is vital to art history.

patterns of the cultures they study and by the obstructions to understanding—the assumptions, presuppositions, and prejudices peculiar to their own culture—their own thought patterns raise. Art historians may reconstruct a distorted picture of the past because of culture-bound blindness.

A single instance underscores how differently people of diverse cultures view the world and how various ways of seeing can cause sharp differences in how artists depict the world. Illustrated here are two contemporaneous portraits of a 19th-century Maori chieftain (FIG. I-19)—one by an Englishman, JOHN SYLVESTER (active early 19th century), and the other by the New Zealand chieftain himself, TE PEHI KUPE (d. 1829). Both reproduce the chieftain's facial tattooing. The European artist (FIG. I-19, *left*) included the head and shoulders and underplayed the tattooing. The tattoo pattern is one aspect of the likeness among many, no more or less important than the chieftain's European attire. Sylvester also recorded his subject's momentary glance toward the right and the play of light on his hair, fleeting aspects that have nothing to do with the figure's identity.

In contrast, Te Pehi Kupe's self-portrait (FIG. I-19, right)—made during a trip to Liverpool, England, to obtain European arms to take back to New Zealand—is not a picture of a man situated in space and bathed in light. Rather, it is the chieftain's statement of the supreme importance of the tattoo design that symbolizes his rank among his people. Remarkably, Te Pehi Kupe created the tattoo patterns from memory, without the aid of a mirror. The splendidly composed insignia, presented as a flat design separated from the body and even from the head, is Te Pehi Kupe's image of himself. Only by understanding the cultural context of each portrait can viewers hope to understand why either representation appears as it does.

As noted at the outset, the study of the context of artworks and buildings is one of the central concerns of art historians. *Art through the Ages* seeks to present a history of art and architecture that will help readers understand not only the subjects, styles, and techniques of paintings, sculptures, buildings, and other art forms created in all parts of the world for 30 millennia but also their cultural and historical contexts. That story now begins.

1-1 Aerial view of the ruins of Hagar Qim, Malta, ca. 3200–2500 BCE.

One of the earliest stone temples in the world is on the island of Malta. The 5,000-year-old structure is remarkably sophisticated for its date, especially in the combination of rectilinear and curved forms.

ART BEFORE History

Humankind seems to have originated in Africa in the very remote past. From that great continent also comes the earliest evidence of human recognition of abstract images in the natural environment, if not the first examples of what people generally call "art." In 1925, explorers of a cave at Makapansgat in South Africa (MAP 15-1) discovered bones of *Australopithecus*, a predecessor of modern humans who lived some three million years ago. Associated with the bones was a waterworn reddish-brown jasperite pebble (FIG. 1-2) that bears an uncanny resemblance to a human face. The nearest known source of this variety of ironstone is 20 miles away from the cave. One of the early humans who took refuge in the rock shelter at Makapansgat must have noticed the pebble in a streambed and, awestruck by the "face" on the stone, brought it back for safekeeping.

Is the Makapansgat pebble art? In modern times, many artists have created works people universally consider art by removing objects from their normal contexts, altering them, and then labeling them. In 1917, for example, Marcel Duchamp took a ceramic urinal, set it on its side, called it *Fountain* (FIG. **35-27**), and declared his "ready-made" worthy of exhibition among more conventional artworks. But the artistic environment of the past century cannot be projected into the remote past. For art historians to declare a found object such as the Makapansgat pebble an "artwork," it must have been modified by human intervention beyond mere selection—and it was not. In fact, evidence indicates that, with few exceptions, it was not until three million years later, around 30,000 BCE, when large parts of northern Europe were still covered with glaciers during the Ice Age, that humans intentionally manufactured sculptures and paintings. That is when the story of art through the ages really begins.

PALEOLITHIC ART

The several millennia following 30,000 BCE saw a powerful outburst of creativity. The works produced by the peoples of the Old Stone Age or *Paleolithic* period (from the Greek *paleo*, "old," and *lithos*, "stone") are of an astonishing variety. They range from simple shell necklaces to human and animal forms in ivory, clay, and stone to monumental paintings, engravings, and relief sculptures covering the huge wall surfaces of caves. During the Paleolithic period, humankind went beyond the *recognition* of human and animal

1-2 Waterworn pebble resembling a human face, from Makapansgat, South Africa, ca. 3,000,000 BCE. Reddish-brown jasperite, $2\frac{3}{8}$ " wide.

Three million years ago someone recognized a face in this pebble and brought it to a rock shelter for safekeeping, but the stone is not an artwork because it was neither manufactured nor modified.

forms in the natural environment to the *representation* (literally, the presenting again—in different and substitute form—of something observed) of humans and animals. The immensity of this achievement cannot be exaggerated.

Africa

Some of the earliest paintings yet discovered come from Africa, and, like the treasured pebble in the form of a face found at Makapansgat, the oldest African paintings were portable objects.

APOLLO 11 CAVE Between 1969 and 1972, scientists working in the Apollo 11 Cave in Namibia (MAP 15-1) found seven fragments of stone plaques with paint on them, including four or five recognizable images of animals. In most cases, including the example illustrated here (FIG. 1-3), the species is uncertain, but the forms are always carefully rendered. One plaque depicts a striped beast, possibly a zebra. The charcoal from the archaeological layer in which the Namibian plaques were found has been dated to around 23,000 BCE.

Like every artist in every age in every medium, the painter of the Apollo 11 plaque had to answer two questions before beginning work: What shall be my subject? How shall I represent it? In Paleolithic art, the almost universal answer to the first question was an animal—bison, mammoth, ibex, and horse were most common. In fact, Paleolithic painters and sculptors depicted humans infrequently and men almost never. In equally stark contrast to today's world, there was also agreement on the best answer to the second question. Artists presented virtually every animal in every Paleolithic, Mesolithic (Middle Stone Age), and Neolithic (New Stone Age) painting in the same manner—in strict profile. The profile is the only view of an animal wherein the head, body, tail, and all four legs can be seen. A frontal view would have concealed most of the body, and a three-quarter view would not have shown either the front or side fully. Only the profile view is completely informative about the animal's shape, and this is why the Stone Age painter chose it. A very long time passed before artists placed any pre-

1-3 Animal facing left, from the Apollo 11 Cave, Namibia, ca. 23,000 BCE. Charcoal on stone, $5'' \times 4\frac{1}{4}''$. State Museum of Namibia, Windhoek.

Like most other paintings for thousands of years, this very early example from Africa represents an animal in strict profile so that the head, body, tail, and all four legs are clearly visible.

mium on "variety" or "originality," either in subject choice or in representational manner. These are quite modern notions in the history of art. The aim of the earliest painters was to create a convincing image of the subject, a kind of pictorial definition of the animal capturing its very essence, and only the profile view met their needs.

Western Europe

Even older than the Namibian painted plaques are some of the first sculptures and paintings of western Europe (MAP 1-1), although examples of still greater antiquity may yet be found in Africa, bridging the gap between the Makapansgat pebble and the Apollo 11 painted plaques.

MAP 1-1 Prehistoric sites in Europe.

1-4 Human with feline head, from Hohlenstein-Stadel, Germany, ca. 30,000–28,000 BCE. Mammoth ivory, $11\frac{5}{8}"$ high. Ulmer Museum, Ulm.

One of the oldest known sculptures is this large ivory figure of a human with a feline head. It is uncertain whether the work depicts a composite creature or a human wearing an animal mask.

HOHLENSTEIN-STADEL

One of the earliest sculptures discovered yet is an extraordinary ivory statuette (FIG. 1-4), which may date back as far as 30,000 BCE. It was found in fragments inside a cave at Hohlenstein-Stadel in Germany and

has been meticulously restored. Carved out of mammoth ivory and nearly a foot tall—a truly huge image for its era—the statuette represents something that existed only in the vivid imagination of the unknown sculptor who conceived it. It is a human (whether male or female is debated) with a feline head. Such composite creatures with animal heads and human bodies (and vice versa) were common in the art of the ancient Near East and Egypt (compare, for example, FIGS. 2-10, right, and 3-36). In those civilizations, surviving texts usually allow historians to name the figures and describe their role in contemporary religion and mythology. But for Stone Age representations, no one knows what their makers had in mind. The animalheaded humans of Paleolithic art sometimes have been called sorcerers and described as magicians wearing masks. Similarly, Paleolithic human-headed animals have been interpreted as humans dressed up as animals. In the absence of any Stone Age written explanations this is a time before writing, before (or pre-) history—researchers can only speculate on the purpose and function of a statuette such as that from Hohlenstein-Stadel.

Art historians are certain, however, that these statuettes were important to those who created them, because manufacturing an ivory figure, especially one a foot tall, was a complicated process. First, a tusk had to be removed from the dead animal by cutting into the ivory where it joined the head. The sculptor then cut the tusk to the desired size and rubbed it into its approximate final shape with sandstone. Finally, a sharp stone blade was used to carve the body, limbs, and head, and a stone *burin* (a pointed engraving tool) to *incise* (scratch) lines into the surfaces, as on the Hohlenstein-Stadel creature's arms. All this probably required at least several days of skilled work.

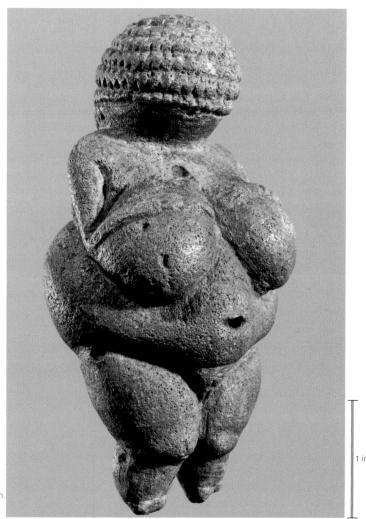

1-5 Nude woman (*Venus of Willendorf*), from Willendorf, Austria, ca. 28,000–25,000 BCE. Limestone, $4\frac{1}{4}''$ high. Naturhistorisches Museum, Vienna.

The anatomical exaggerations in this tiny figurine from Willendorf are typical of Paleolithic representations of women, whose child-bearing capabilities ensured the survival of the species.

VENUS OF WILLENDORF The composite feline-human from Germany is exceptional for the Stone Age. The vast majority of prehistoric sculptures depict either animals or humans. In the earliest art, humankind consists almost exclusively of women as opposed to men, and the painters and sculptors almost invariably showed them nude, although scholars generally assume that during the Ice Age both women and men wore garments covering parts of their bodies. When archaeologists first discovered Paleolithic statuettes of women, they dubbed them "Venuses," after the Greco-Roman goddess of beauty and love, whom artists usually depicted nude (FIG. 5-62). The nickname is inappropriate and misleading. It is doubtful that the Old Stone Age figurines represented deities of any kind.

One of the oldest and the most famous of the prehistoric female figures is the tiny limestone figurine of a woman that long has been known as the *Venus of Willendorf* (FIG. 1-5) after its *findspot* in Austria. Its cluster of almost ball-like shapes is unusual, the result in part of the sculptor's response to the natural shape of the stone selected for carving. The anatomical exaggeration has suggested to many that this and similar statuettes served as fertility images. But other Paleolithic stone women of far more slender proportions exist, and the meaning of these images is as elusive as everything else about Paleolithic

art. Yet the preponderance of female over male figures in the Old Stone Age seems to indicate a preoccupation with women, whose child-bearing capabilities ensured the survival of the species.

One thing at least is clear. The *Venus of Willendorf* sculptor did not aim for naturalism in shape and proportion. As with most Paleolithic figures, the sculptor did not carve any facial features. Here the carver suggested only a mass of curly hair or, as some researchers have recently argued, a hat woven from plant fibers—evidence for the art of textile manufacture at a very early date. In either case, the emphasis is on female anatomy. The breasts of the Willendorf woman are enormous, far larger than the tiny forearms and hands that rest upon them. The carver also took pains to scratch into the stone the outline of the pubic triangle. Sculptors often omitted this detail in other early figurines, leading some scholars to question the nature of these figures as fertility images. Whatever the purpose of these statuettes, the makers' intent seems to have been to represent not a specific woman but the female form.

LAUSSEL Because precision in dating is impossible for the Paleolithic era, art historians usually can be no more specific than assigning a range of several thousand years to each artifact. But probably later in date than the *Venus of Willendorf* is a female figure (FIG. 1-6) from Laussel in France. The Willendorf and Hohlenstein-Stadel figures were *sculpted in the round* (that is, they are *freestanding sculptures*). The Laussel woman is one of the earliest *relief sculptures* known. The sculptor employed a stone *chisel* to cut into the relatively flat surface of a large rock and create an image that projects from its background.

Today the Laussel relief is exhibited in a museum, divorced from its original context, a detached piece of what once was a much more imposing monument. When the relief was discovered, the Laussel woman (who is about $1\frac{1}{2}$ feet tall, more than four times larger than the Willendorf statuette) was part of a great stone block that measured about 140 cubic feet. The carved block stood in the open air in front of a Paleolithic rock shelter. Rock shelters were a common type of dwelling for early humans, along with huts and the mouths of caves. The Laussel relief is one of many examples of open-air art in the Old Stone Age. The popular notions that early humans dwelled exclusively in caves and that all Paleolithic art comes from mysterious dark caverns are false.

After chiseling out the female form and incising the details with a sharp burin, the Laussel sculptor applied red ocher, a naturally colored mineral, to the body. (The same color is also preserved on parts of the *Venus of Willendorf.*) Contrary to modern misconceptions about ancient art, stone sculptures were frequently painted in antiquity. The Laussel woman has the same bulbous forms as the earlier Willendorf figurine, with a similar exaggeration of the breasts, abdomen, and hips. The head is once again featureless, but the arms have taken on greater importance. The left arm draws attention to the midsection and pubic area, and the raised right hand holds what most scholars identify as a bison horn. The meaning of the horn is debated.

LE TUC D'AUDOUBERT Paleolithic sculptors sometimes created reliefs by building up forms out of clay rather than by cutting into stone blocks or stone walls. Sometime 12,000 to 17,000 years ago in the low-ceilinged circular space at the end of a succession of cave chambers at Le Tuc d'Audoubert, a master sculptor modeled a pair of bison (FIG. 1-7) in clay against a large, irregular freestanding rock. The two bison, like the much older painted animal (FIG. 1-3) from the Apollo 11 Cave, are in strict profile. Each is about two feet long. They are among the largest Paleolithic sculptures known. The sculptor brought the clay from elsewhere in the cave complex and modeled it by hand into the overall shape of the animals. The artist then

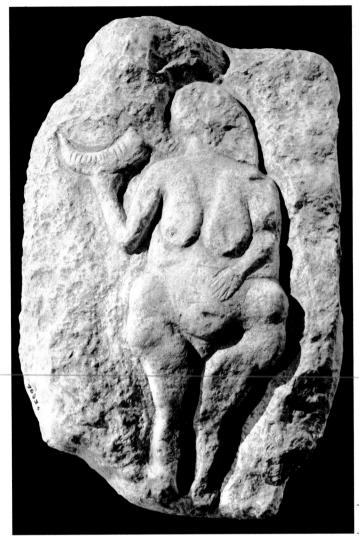

1-6 Woman holding a bison horn, from Laussel, France, ca. 25,000–20,000 BCE. Painted limestone, 1' 6" high. Musée d'Aquitaine, Bordeaux.

One of the oldest known relief sculptures depicts a woman who holds a bison horn and whose left arm draws attention to her belly. Scholars continue to debate the meaning of the gesture and the horn.

smoothed the surfaces with a spatula-like tool and finally used fingers to shape the eyes, nostrils, mouths, and manes. The cracks in the two animals resulted from the drying process and probably appeared within days of the sculptures' completion.

LA MADELEINE As already noted, sculptors fashioned ivory mammoth tusks into human and animal (FIG. 1-4) forms from very early times. Prehistoric carvers also used antlers as a sculptural medium, even though it meant they were forced to work on a very small scale. The broken spearthrower (FIG. 1-8) in the form of a bison found at La Madeleine in France is only four inches long and was carved from reindeer antler. The sculptor incised lines into the bison's mane using a sharp burin. Compared to the bison at Le Tuc d'Audoubert, the engraving is much more detailed and extends to the horns, eye, ear, nostrils, mouth, and the hair on the face. Especially interesting is the engraver's decision to represent the bison with the head turned. The small size of the reindeer horn may have been the motivation for this space-saving device. Whatever the reason, it is noteworthy that the sculptor turned the neck a full 180 degrees to maintain the strict profile Paleolithic sculptors and painters insisted on for the sake of clarity and completeness.

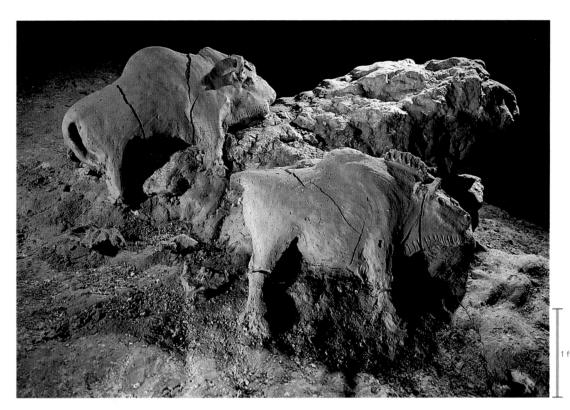

1-7 Two bison, reliefs in a cave at Le Tuc d'Audoubert, France, ca. 15,000–10,000 BCE. Clay, each 2' long.

Representations of animals are far more common than of humans in Paleolithic European art. The sculptor built up these clay bison using a stone spatula-like smoothing tool and fingers to shape the details.

ALTAMIRA The works examined here thus far, whether portable or fixed to rocky outcroppings or cave walls, are all small. They are dwarfed by the "herds" of painted animals that roam the cave walls of southern France and northern Spain, where some of the most spectacular prehistoric art has been discovered (see "Paleolithic Cave Painting," page 20). The first examples of cave paintings were found accidentally by an amateur archaeologist in 1879 at Altamira, Spain. Don Marcelino Sanz de Sautuola was exploring a cave where he had already found specimens of flint and carved bone. His little daughter Maria was with him when they reached a chamber some 85 feet from the cave's entrance. Because it was dark and the ceiling of the debrisfilled cavern was only a few inches above the father's head, the child was the first to discern, from her lower vantage point, the shadowy forms of painted beasts on the cave roof (FIG. 1-9, a detail of a much

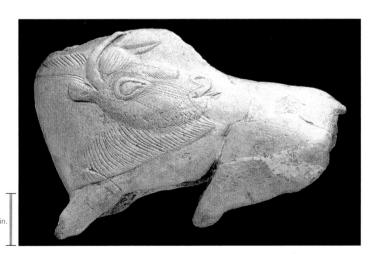

1-8 Bison with turned head, fragmentary spearthrower, from La Madeleine, France, ca. 12,000 BCE. Reindeer horn, 4" long.

This fragment of a spearthrower was carved from reindeer antler. Details were incised with a stone burin. The sculptor turned the bison's head a full 180 degrees to maintain the profile view.

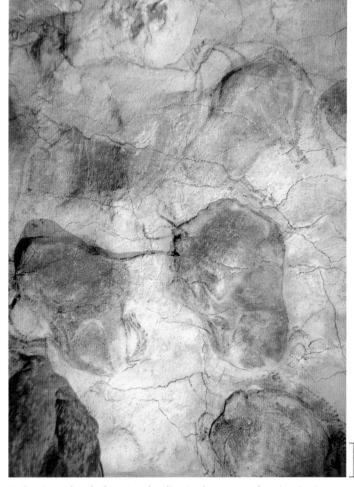

1-9 Bison, detail of a painted ceiling in the cave at Altamira, Spain, ca. 12,000–11,000 BCE. Each bison 5' long.

As in other Paleolithic caves, the painted ceiling at Altamira has no ground line or indication of setting. The artist's sole concern was representing the animals, not locating them in a specific place.

Paleolithic Cave Painting

The caves of Altamira (FIG. 1-9), Pech-Merle (FIG. 1-10), Lascaux (FIGS. 1-11 and 1-13), and other sites in prehistoric Europe are a few hundred to several thousand feet long. They are often choked, sometimes almost impassably, by deposits, such as stalactites and stalagmites. Far inside these caverns, well removed from the cave mouths early humans often chose for habitation, painters sometimes made pictures on the walls. Examples of Paleolithic painting now have been found at more than 200 sites, but prehistorians still regard painted caves as rare occurrences, because the images in them, even if they number in the hundreds, were created over a period of some 10,000 to 20,000 years.

To illuminate the surfaces while working, the Paleolithic painters used stone lamps filled with marrow or fat, with a wick, perhaps, of moss. For drawing, they used chunks of red and yellow ocher. For painting, they ground these same ochers into powders they mixed with water before applying. Recent analyses of the pigments used show that Paleolithic painters employed many different minerals, attesting to a technical sophistication surprising at so early a date.

Large flat stones served as *palettes*. The painters made brushes from reeds, bristles, or twigs, and may

1-10 Spotted horses and negative hand imprints, wall painting in the cave at Pech-Merle, France, ca. 22,000 BCE. 11' 2" long.

The purpose and meaning of Paleolithic art are unknown. Some researchers think the painted hands near the Pech-Merle horses are "signatures" of community members or of individual painters.

have used a blowpipe of reeds or hollow bones to spray pigments on out-of-reach surfaces. Some caves have natural ledges on the rock walls upon which the painters could have stood in order to reach the upper surfaces of the naturally formed chambers and corridors. One Lascaux gallery has holes in one of the walls that once probably anchored a scaffold made of saplings lashed together. Despite the difficulty of making the tools and pigments, modern attempts at replicating the techniques of Paleolithic painting have demonstrated that skilled workers could cover large surfaces with images in less than a day.

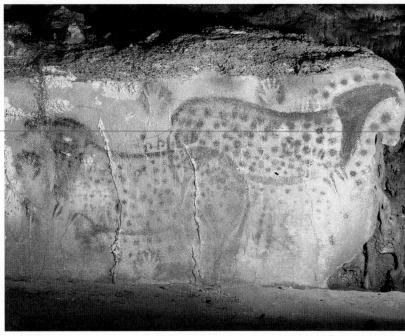

1 f

larger painting approximately 60 feet long). Sanz de Sautuola was certain the bison painted on the ceiling of the cave on his estate dated back to prehistoric times. Professional archaeologists, however, doubted the authenticity of these works, and at the Lisbon Congress on Prehistoric Archaeology in 1880, they officially dismissed the paintings as forgeries. But by the close of the century, other caves had been discovered with painted walls partially covered by mineral deposits that would have taken thousands of years to accumulate. This finally persuaded skeptics that the first paintings were of an age far more remote than they had ever dreamed.

The bison at Altamira are 13,000 to 14,000 years old, but the painters of Paleolithic Spain approached the problem of representing an animal in essentially the same way as the painter of the Namibian stone plaque (FIG. 1-3), who worked in Africa more than 10,000 years earlier. Every one of the Altamira bison is in profile, whether alive and standing or curled up on the ground (probably dead, although this is disputed; one suggestion is that these bison are giving birth). To maintain the profile in the latter case, the painter had to adopt a viewpoint above the animal, looking down, rather than the view a person standing on the ground would have.

Modern critics often refer to the Altamira animals as a "group" of bison, but that is very likely a misnomer. In FIG. 1-9, the several

bison do not stand on a common ground line (a painted or carved baseline on which figures appear to stand in paintings and reliefs), nor do they share a common orientation. They seem almost to float above viewers' heads, like clouds in the sky. And the dead(?) bison are seen in an "aerial view," while the others are seen from a position on the ground. The painting has no setting, no background, no indication of place. The Paleolithic painter was not at all concerned with where the animals were or with how they related to one another, if at all. Instead, several separate images of a bison adorn the ceiling, perhaps painted at different times, and each is as complete and informative as possible—even if their meaning remains a mystery (see "Art in the Old Stone Age," page 21).

PECH-MERLE That the paintings did have meaning to the Paleolithic peoples who made and observed them cannot, however, be doubted. In fact, signs consisting of checks, dots, squares, or other arrangements of lines often accompany the pictures of animals. Representations of human hands also are common. At Pech-Merle in France, painted hands accompany representations of spotted horses (FIG. 1-10). These and the majority of painted hands at other sites are "negative;" that is, the painter placed one hand against the wall and then brushed or blew or spat pigment around it. Occasionally,

Art in the Old Stone Age

rom the moment in 1879 that cave paintings were discovered at Altamira (FIG. 1-9), scholars have wondered why the hunters of the Old Stone Age decided to cover the walls of dark caverns with animal images like those found at Altamira, Pech-Merle (FIG. 1-10), Lascaux (FIGS. 1-11 and 1-13), and Vallon-Pont-d'Arc (FIG. 1-12). Scholars have proposed various theories including that the painted and engraved animals were mere decoration, but this explanation cannot account for the narrow range of subjects or the inaccessibility of many of the representations. In fact, the remoteness and difficulty of access of many of the images, and indications that the caves were used for centuries, are precisely why many researchers have suggested that the prehistoric hunters attributed magical properties to the images they painted and sculpted. According to this argument, by confining animals to the surfaces of their cave walls, the Paleolithic hunters believed they were bringing the beasts under their control. Some prehistorians have even hypothesized that rituals or dances were performed in front of the images and that these rites served to improve the hunters' luck. Still others have stated that the animal representations may have served as teaching tools to instruct new hunters about the character of the various species they would encounter or even to serve as targets for spears.

In contrast, some scholars have argued that the magical purpose of the paintings and reliefs was not to facilitate the *destruction* of bison and other species. Instead, they believe prehistoric painters and sculptors created animal images to assure the *survival* of the herds on which Paleolithic peoples depended for their food supply and for their clothing. A central problem for both the hunting-magic and food-creation theories is that the animals that seem to have been diet staples of Old Stone Age peoples are not those most frequently portrayed. For example, faunal remains show that the Altamirans ate red deer, not bison.

Other scholars have sought to reconstruct an elaborate mythology based on the cave paintings and sculptures, suggesting that Paleolithic humans believed they had animal ancestors. Still others have equated certain species with men and others with women and postulated various meanings for the abstract signs that sometimes accompany the images. Almost all of these theories have been discredited over time, and most prehistorians admit that no one knows the intent of these representations. In fact, a single explanation for all Paleolithic animal images, even ones similar in subject, style, and *composition* (how the motifs are arranged on the surface), is unlikely to apply universally. The works remain an enigma—and always will, because before the invention of writing, no contemporaneous explanations could be recorded.

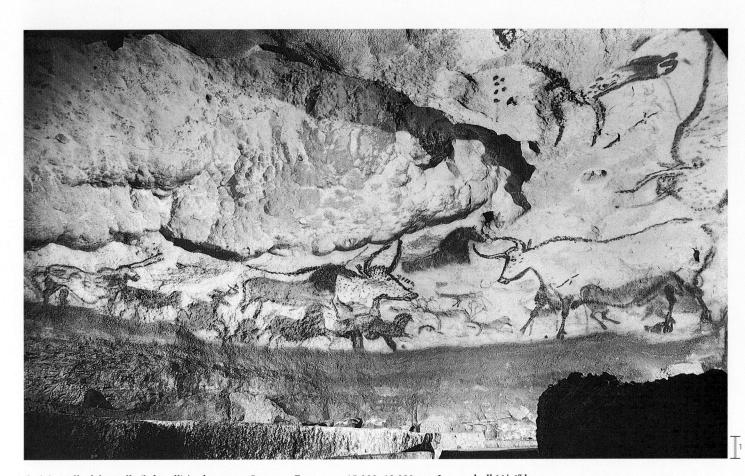

1-11 Hall of the Bulls (left wall) in the cave at Lascaux, France, ca. 15,000–13,000 BCE. Largest bull 11' 6" long.

Several species of animals appear together in the Hall of the Bulls. Many are colored silhouettes, but others were created by outline alone—the two basic approaches to painting in the history of art.

The World's Oldest Paintings?

ne of the most spectacular archaeological finds of the past century came to light in December 1994 at Vallon-Pont-d'Arc, France, and was announced at a press conference in Paris on January 18, 1995. Unlike some other recent "finds" of prehistoric art that proved to be forgeries, the paintings in the Chauvet Cave (named after the leader of the exploration team, Jean-Marie Chauvet) seemed to be authentic. But no one, including Chauvet and his colleagues, guessed at the time of their discovery that *radiocarbon dating* (a measure of the rate of degeneration of carbon 14 in organic materials) of the paintings might establish that the murals in the cave were more than 15,000 years older than those at Altamira (FIG. 1-9). When the scientific tests were completed, the French archaeologists announced that the Chauvet Cave paintings were the oldest yet found anywhere, datable around 30,000–28,000 BCE.

This new early date immediately caused scholars to reevaluate the scheme of "stylistic development" from simple to more complex forms that had been nearly universally accepted for decades. In the Chauvet Cave, in contrast to Lascaux (FIG. 1-11), the horns of the aurochs (extinct long-horned wild oxen) are shown naturalistically,

one behind the other, not in the twisted perspective thought to be universally characteristic of Paleolithic art. Moreover, the two rhinoceroses at the lower right of FIG. 1-12 appear to confront each other, suggesting to some observers that the artist intended a narrative, another "first" in either painting or sculpture. If the paintings are twice as old as those of Lascaux, Altamira (FIG. 1-9), and Pech-Merle (FIG. 1-10), the assumption that Paleolithic art "evolved" from simple to more sophisticated representations is wrong.

Much research remains to be conducted in the Chauvet Cave, but already the paintings have become the subject of intense controversy. Recently, some archaeologists have contested the early dating of the Chauvet paintings on the grounds that the tested samples were contaminated. If the Chauvet animals were painted later than those at Lascaux, their advanced stylistic features can be more easily explained. The dispute exemplifies the frustration—and the excitement—of studying the art of an age so remote that almost nothing remains and almost every new find causes art historians to reevaluate what had previously been taken for granted.

1-12 Aurochs, horses, and rhinoceroses, wall painting in the Chauvet Cave, Vallon-Pont-d'Arc, France, ca. 30,000–28,000 or ca. 15,000–13,000 BCE.

The date of the Chauvet Cave paintings is the subject of much controversy. If the murals are the oldest paintings known, they exhibit surprisingly advanced features, such as overlapping animal horns.

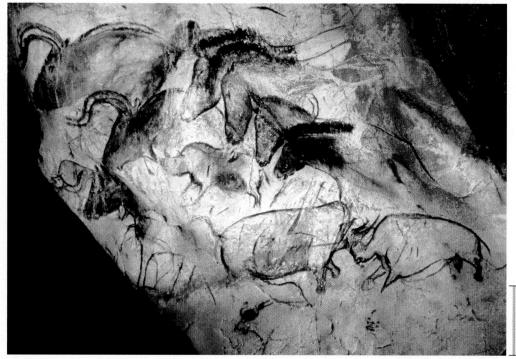

1 ft.

the painter dipped a hand in the pigment and then pressed it against the wall, leaving a "positive" imprint. These handprints, too, must have had a purpose. Some researchers have considered them "signatures" of cult or community members or, less likely, of individual painters. But like everything else in Paleolithic art, their meaning is unknown.

The *mural* (wall) paintings at Pech-Merle also allow some insight into the reason certain subjects may have been chosen for a specific location. One of the horses (at the right in FIG. 1-10) may have been inspired by the rock formation in the wall surface resembling a horse's head and neck. Old Stone Age painters and sculptors

frequently and skillfully used the caves' naturally irregular surfaces to help give the illusion of real presence to their forms. Many of the Altamira bison (FIG. 1-9), for example, were painted over bulging rock surfaces. In fact, prehistorians have observed that bison and cattle appear almost exclusively on convex surfaces, whereas nearly all horses and hands are painted on concave surfaces. What this signifies has yet to be determined.

LASCAUX Perhaps the best-known Paleolithic cave is that at Lascaux, near Montignac, France. It is extensively decorated, but most of the paintings are hundreds of feet from any entrance, far removed

from the daylight. The largest painted area at Lascaux is the so-called Hall of the Bulls (FIG. 1-11), although not all of the animals depicted are bulls. Many are represented using colored silhouettes, as at Altamira (FIG. 1-9) and on the Apollo 11 plaque (FIG. 1-3). Others—such as the great bull at the right in FIG. 1-11—were created by outline alone, as were the Pech-Merle horses (FIG. 1-10). On the walls of the Lascaux cave one sees, side by side, the two basic approaches to drawing and painting found repeatedly in the history of art. These differences in style and technique alone suggest that the animals in the Hall of the Bulls were painted at different times, and the modern impression of a rapidly moving herd of beasts was probably not the original intent. In any case, the "herd" consists of several different kinds of animals of various sizes moving in different directions.

Another feature of the Lascaux paintings deserves attention. The bulls there show a convention of representing horns that has been called *twisted perspective* or a *composite view*, because viewers see the heads in profile but the horns from the front. Thus, the painter's approach is not strictly or consistently optical (seen from a fixed viewpoint). Rather, the approach is descriptive of the fact that cattle have two horns. Two horns are part of the concept "bull." In strict optical-perspective profile, only one horn would be visible, but to paint the animal in that way would amount to an incomplete definition of it. This kind of twisted perspective was the norm in prehistoric painting, but it was not universal. In fact, the recent discovery at Vallon-Pont-d'Arc in France of Paleolithic paintings (FIG. 1-12) in the Chauvet Cave, where the painters represented horns in a more natural way, has caused art historians to rethink many of the assumptions they had made about Paleolithic art (see "The World's Oldest Paintings?" page 22).

Perhaps the most perplexing painting (FIG. 1-13) in the Paleolithic caves of Europe is deep in a well shaft at Lascaux, where man (as opposed to woman) makes one of his earliest appearances in prehistoric art. At the left, and moving to the left, is a rhinoceros, rendered with all the skilled attention to animal detail customarily seen in cave art. Beneath its tail are two rows of three dots of uncertain significance. At the right is a bison, also facing left but more schematically painted, probably by someone else. The second painter nonetheless successfully suggested the bristling rage of the animal, whose bowels are hanging from it in a heavy coil. Between the two beasts is a bird-faced (masked?) man (compare the feline-headed human, FIG. 1-4, from Hohlenstein-Stadel) with outstretched arms and hands with only four fingers. The man is depicted with far less care and detail than either animal, but the painter made the hunter's gender explicit by the prominent penis. The position of the man is ambiguous. Is he wounded or dead or merely tilted back and unharmed? Do the staff(?) with the bird on top and the spear belong to him? Is it he or the rhinoceros who has gravely wounded the bison—or neither? Which animal, if either, has knocked the man down, if indeed he is on the ground? Are these three images related at all? Researchers can be sure of nothing, but if the painter placed the figures beside each other to tell a story, then this is evidence for the creation of complex narrative compositions involving humans and animals at a much earlier date than anyone had imagined only a few generations ago. Yet it is important to remember that even if the artist intended to tell a story, very few people would have been able to "read" it. The painting, in a deep shaft, is very difficult to reach and could have been viewed only in flickering lamplight. Like all Paleolithic art, the scene in the Lascaux well shaft remains enigmatic.

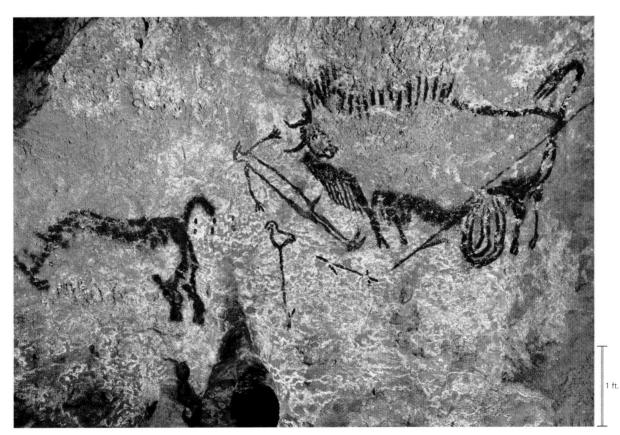

1-13 Rhinoceros, wounded man, and disemboweled bison, painting in the well of the cave at Lascaux, France, ca. 15,000–13,000 BCE. Bison 3' 8" long.

If these paintings of two animals and a bird-faced (masked?) man deep in a Lascaux well shaft depict a hunting scene, they constitute the earliest example of narrative art ever discovered.

NEOLITHIC ART

Around 9000 BCE, the ice that covered much of northern Europe during the Paleolithic period melted as the climate grew warmer. The sea level rose more than 300 feet, separating England from continental Europe and Spain from Africa. The reindeer migrated north, and the woolly mammoth disappeared. The Paleolithic gave way to a transitional period, the Mesolithic, and then, for several thousand years at different times in different parts of the globe, a great new age, the Neolithic, dawned.* Human beings began to domesticate plants and animals and to settle in fixed abodes. Their food supply assured, many groups changed from hunters to herders, to farmers, and finally to townspeople. Wandering hunters settled down to organized community living in villages surrounded by cultivated fields.

The basis for the conventional division of prehistory into the Paleolithic, Mesolithic, and Neolithic periods is the development of stone implements. However, a different kind of distinction may be made between an age of food gathering and an age of food production. In this scheme, the Paleolithic period corresponds roughly to the age of food gathering, and the Mesolithic period, the last phase of that age, is marked by intensified food gathering and the taming of the dog. In the Neolithic period, agriculture and stock raising became humankind's major food sources. The transition to the Neolithic occurred first in the ancient Near East.

Ancient Near East

The remains of the oldest known settled communities have been found in the grassy foothills of the Antilebanon, Taurus, and Zagros mountains in present-day Turkey, Syria, Iraq, and Iran (MAP 1-2). These regions provided the necessary preconditions for the development of agriculture. Species of native plants, such as wild wheat and barley, were plentiful, as were herds of animals (goats, sheep, and pigs) that could be domesticated. Sufficient rain occurred for the raising of crops. When village farming life was well developed, some settlers, attracted by the greater fertility of the soil and perhaps also by the need to find more land for their rapidly growing populations, moved into the valleys and deltas of the Tigris and Euphrates rivers.

In addition to systematic agriculture, the new sedentary societies of the Neolithic Age originated weaving, metalworking, pottery, and counting and recording with clay tokens. Soon, these innovations spread with remarkable speed throughout the Near East. Village farming communities such as Jarmo in Iraq and Çatal Höyük in southern Anatolia date back to the mid-seventh millennium BCE. The remarkable fortified town of Jericho, before whose walls the biblical Joshua appeared thousands of years later, is even older. Archaeologists are constantly uncovering surprises, and the discovery and exploration of new sites each year are compelling them to revise their views about the emergence of Neolithic society. But three sites known for some time—Jericho, Ain Ghazal, and Çatal Höyük—offer a fascinating picture of the rapid and exciting transformation of human society and of art during the Neolithic period.

JERICHO By 7000 BCE, agriculture was well established from Anatolia to ancient Palestine and Iran. Its advanced state by this date presupposes a long development. Indeed, the very existence of a major settlement such as Jericho gives strong support to this assumption. The site of Jericho—a plateau in the Jordan River valley with a spring that provided a constant water supply—was occupied by a small village as early as the ninth millennium BCE. This village

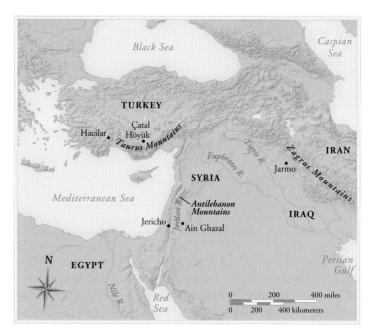

MAP 1-2 Neolithic sites in Anatolia and the Near East.

underwent spectacular development around 8000 BCE, when the inhabitants built a new Neolithic settlement covering about 10 acres. Its mud-brick houses sat on round or oval stone foundations and had roofs of branches covered with earth.

1-14 Great stone tower built into the settlement wall, Jericho, ca. 8000–7000 BCE.

Neolithic Jericho was protected by 5-foot-thick walls and at least one stone tower 30 feet high and 33 feet in diameter—an outstanding achievement that marks the beginning of monumental architecture.

^{*}This chapter treats the Neolithic art of Europe and the Near East only. For the Neolithic art of Africa, see Chapter 15; for Asia, see Chapters 6 to 8.

As Jericho's wealth grew, the need for protection against marauding nomads resulted in the first known permanent stone fortifications. By approximately 7500 BCE, a wide rock-cut ditch and a 5-foot-thick wall surrounded the town, estimated to have had a population of more than 2,000 people. Into the circuit wall, which has been preserved to a height of almost 13 feet, was built a great circular tower (FIG. 1-14) of roughly shaped stones laid without mortar and originally about 30 feet high. Almost 33 feet in diameter at the base, the tower has an inner stairway leading to its summit. (Today, a grate covers the entrance to the stairway.) Not enough of the site has been excavated to determine whether this tower was solitary or one of several similar towers that formed a complete defense system. In either case, a structure as large as this was a tremendous technological achievement and a testimony to the builders' ability to organize a significant workforce. The walls and tower(s) of Jericho mark the beginning of the long history of monumental architecture.

AIN GHAZAL Near Amman, Jordan, the construction of a highway in 1974 revealed another important Neolithic settlement in ancient Palestine at the site of Ain Ghazal, occupied from ca. 7200 to ca. 5000 BCE. The inhabitants built houses of irregularly shaped stones, but carefully plastered and then painted their floors and walls red. The most striking finds at Ain Ghazal, however, are two caches containing three dozen plaster statuettes (FIG. 1-15) and busts, some with two heads, datable to ca. 6500 BCE. The sculptures appear to have been ritually buried. The figures were fashioned of white plaster, which was built up over a core of reeds and twine. The sculptors used black bitumen, a tarlike substance, to delineate the pupils of the eyes. On some of the later figures painters added clothing. Only rarely did the artists indicate the gender of the figures. Whatever their purpose, by their size (as much as three feet tall) and sophisticated technique, the Ain Ghazal statuettes and busts are distinguished from Paleolithic figurines such as the tiny Venus of Willendorf (FIG. 1-5) and even the foot-tall Hohlenstein-Stadel ivory statuette (FIG. 1-4). They mark the beginning of monumental sculpture in the ancient Near East.

ÇATAL HÖYÜK Remarkable discoveries also have been made in Anatolia. Excavations at Hacilar, Çatal Höyük, and elsewhere have shown that the central Anatolian plateau was the site of a flourishing Neolithic culture between 7000 and 5000 BCE. Twelve successive building levels excavated at Çatal Höyük between 1961 and 1965 have been dated between 6500 and 5700 BCE. On a single site, it is possible to retrace the evolution of a Neolithic culture over a period of 800 years. An

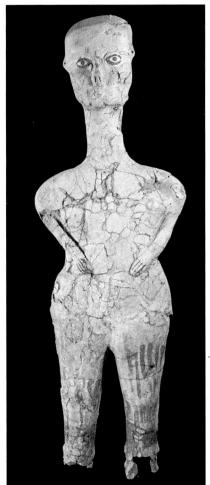

1-15 Human figure, from Ain Ghazal, Jordan, ca. 6750–6250 BCE. Plaster, painted and inlaid with bitumen, 3' 5 $\frac{3}{8}''$ high. Louvre, Paris.

The dozens of large white plaster statuettes, some with two heads and with details added in paint, found at Ain Ghazal date to the mid-seventh millennium BCE and are the earliest large sculptures known.

1 ft

important source of Çatal Höyük's wealth was trade, especially in obsidian, a glasslike volcanic stone Neolithic toolmakers and weapon makers valued highly because it could be chipped into fine cutting edges. Along with Jericho, Çatal Höyük seems to have been one of the first experiments in urban living. The regularity of its plan suggests that the town was built according to some predetermined scheme. A peculiar feature is the settlement's complete lack of streets. The houses adjoin one another and have no doors (FIG. 1-16). Openings in the roofs provided access to the interiors. The openings also served as chimneys to ventilate the hearth in the combination living room and kitchen that

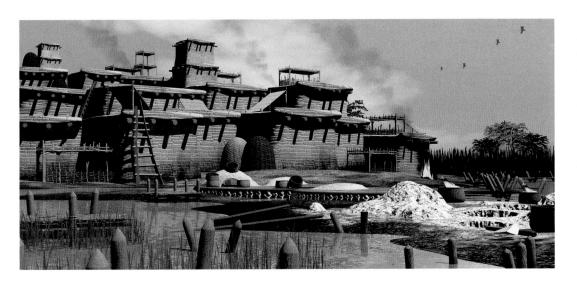

1-16 Restored view of a section of Level VI, Çatal Höyük, Turkey, ca. 6000–5900 BCE (John Swogger).

Archaeologists have discovered 12 successive building levels at Çatal Höyük. The houses in this early city adjoined one another and had no doors. Openings in the roofs provided access to the interiors.

formed the core of the house. Impractical as such an arrangement may appear today, it did offer some advantages. The attached buildings were more stable than freestanding structures and, at the limits of the town site, formed a defensive perimeter wall. If enemies managed to breach the exterior wall, they would find themselves not inside the town but above the houses with the defenders waiting there on the roof.

The houses, constructed of mud brick strengthened by sturdy timber frames, varied in size but repeated the same basic plan. Walls and floors were plastered and painted, and platforms along walls served as sites for sleeping, working, and eating. The dead were buried beneath the same platforms. A great number of decorated rooms have been found at Çatal Höyük. The excavators called these rooms shrines, but their function is uncertain. Their number suggests that these rooms played an important role in the life of Çatal Höyük's inhabitants.

The "shrines" are distinguished from the house structures by the greater richness of their interior decoration, which consisted of wall paintings, plaster reliefs, animal heads, and *bucrania* (bovine skulls). Bulls' horns, widely thought to be symbols of masculine potency, are the most common motif in these rooms. In some cases they are displayed next to plaster breasts, symbols of female fertility, projecting from the walls. Many statuettes of stone or *terracotta* (baked clay) also have been found at Çatal Höyük. Most are quite small (2 to 8 inches high) and primarily depict female figures. A few reach 12 inches.

Although animal husbandry was well established, hunting continued to play an important part in the early Neolithic economy of Çatal Höyük. The importance of hunting as a food source (until about 5700 BCE) is reflected also in wall paintings, where, in the older decorated rooms, hunting scenes predominate. In style and concept, however, the deer hunt mural (FIG. 1-17) at Çatal Höyük is worlds apart from the wall paintings the hunters of the Paleolithic period produced. Perhaps what is most strikingly new about the Çatal Höyük painting and others like it is the regular appearance of the human figure—not only singly but also in large, coherent groups

with a wide variety of poses, subjects, and settings. As noted earlier, humans were unusual in Paleolithic cave paintings, and pictorial narratives have almost never been found. Even the "hunting scene" (FIG. 1-13) in the well at Lascaux is doubtful as a narrative. In Neolithic paintings, human themes and concerns and action scenes with humans dominating animals are central.

In the Çatal Höyük hunt, the group of hunters—and no one doubts it is, indeed, an organized hunting party, not a series of individual figures—shows a tense exaggeration of movement and a rhythmic repetition of basic shapes customary for the period. The painter took care to distinguish important descriptive details—for example, bows, arrows, and garments—and the heads have clearly defined noses, mouths, chins, and hair. The Neolithic painter placed all the heads in profile for the same reason Paleolithic painters universally chose the profile view for representations of animals. Only the side view of the human head shows all its shapes clearly. However, at Çatal Höyük the torsos are presented from the front—again, the most informative viewpoint—whereas the painter chose the profile view for the legs and arms. This composite view of the human body is quite artificial because the human body cannot make an abrupt 90-degree shift at the hips. But it is very descriptive of what a human body is—as opposed to what it looks like from a particular viewpoint. The technique of painting also changed dramatically since Paleolithic times. The pigments were applied with a brush to a white background of dry plaster. The careful preparation of the wall surface is in striking contrast to the direct application of pigment to the irregularly shaped walls and ceilings of caves.

More remarkable still is a painting (FIG. 1-18 is a watercolor copy) in one of the older rooms at Çatal Höyük that art historians generally have acclaimed as the world's first *landscape* (a picture of a natural setting in its own right, without any narrative content). As such, it remained unique for thousands of years. According to radiocarbon dating, the painting was executed around 6150 BCE. The foreground has been interpreted as a town with rectangular houses neatly laid out side by side, probably representing Çatal Höyük itself.

1-17 Deer hunt, detail of a wall painting from Level III, Çatal Höyük, Turkey, ca. 5750 BCE. Museum of Anatolian Civilization, Ankara.

This Neolithic painter depicted human figures as a composite of frontal and profile views, the most descriptive picture of the shape of the human body. This format would become the rule for millennia.

1-18 Landscape with volcanic eruption(?), watercolor copy of a wall painting from Level VII, Çatal Höyük, Turkey, ca. 6150 BCE.

This late-seventh-millennium BCE mural painting may represent Çatal Höyük during a volcanic eruption. It is the first known landscape painting in which neither humans nor animals appear.

Behind the town appears a mountain with two peaks. Many archaeologists think that the dots and lines issuing from the higher of the two cones represent a volcanic eruption, and have suggested that the mountain is the 10,600-foot-high Hasan Dağ. It is located within view of Çatal Höyük and is the only twin-peaked volcano in central Anatolia. The conjectured volcanic eruption shown in the mural does not necessarily depict a specific historical event. If, however, the Çatal Höyük painting relates a story, even a recurring one, then it cannot be considered a pure landscape. Nonetheless, this mural is the first depiction of a place devoid of both humans and animals.

The rich finds at Çatal Höyük give the impression of a prosperous and well-ordered society that practiced a great variety of arts and crafts. In addition to painting and sculpture, weaving and pottery were well established, and even the technique of smelting lead in small quantities was known before 6000 BCE. The conversion to an agricultural economy appears to have been completed by about 5700 BCE.

Western Europe

In western Europe, where Paleolithic paintings and sculptures abound, no comparably developed towns of the time of Çatal Höyük have been found. However, in succeeding millennia, perhaps as early as 4000 BCE, the local Neolithic populations in several areas developed a monumental architecture employing massive rough-cut stones. The very dimensions of the stones, some as high as 17 feet and weighing as much as 50 tons, have prompted historians to call them *megaliths* (great stones) and to designate Neolithic architecture employing megaliths as *megalithic*.

NEWGRANGE One of the most impressive megalithic monuments in Europe is also one of the oldest. The megalithic tomb at Newgrange in Ireland, north of Dublin, may have been constructed as early as 3200 BCE and is one of the oldest burial monuments in Europe. It takes the form of a *passage grave*, that is, a tomb with a long stone corridor (FIG. 1-19) leading to a burial chamber, all covered by a great *tumulus* (earthen burial mound). Passage graves have been found also in England, France, Spain, and Scandinavia. All attest to the importance of honoring the dead in Neolithic society. Some mounds contain more than one passage grave. The Newgrange

1-19 Gallery leading to the main chamber of the passage grave, Newgrange, Ireland, ca. 3200–2500 BCE.

The Newgrange passage grave is an early example of corbeled vaulting. The megaliths of the corridor leading to the burial chamber beneath the tumulus are held in place by their own weight.

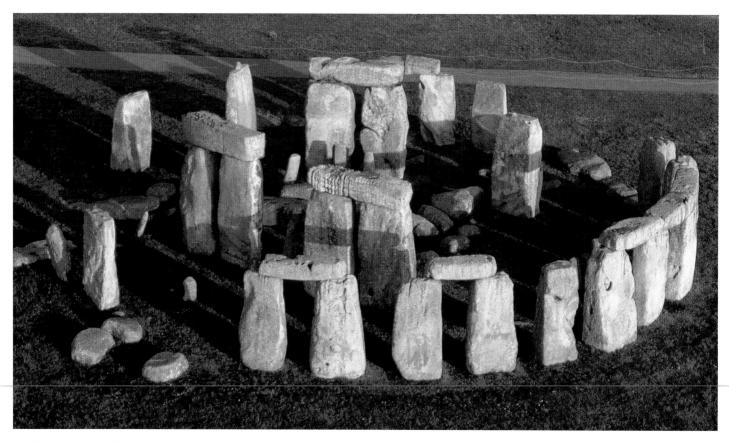

1-20 Aerial view of Stonehenge, Salisbury Plain, England, ca. 2550-1600 BCE. Circle is 97' in diameter; trilithons 24' high.

The circles of trilithons at Stonehenge probably functioned as an astronomical observatory and solar calendar. The sun rises over its "heel stone" at the summer solstice. Some of the megaliths weigh 50 tons.

tumulus is 280 feet in diameter and 44 feet tall. Its passageway is 62 feet long and is an early example of a construction technique used in other later ancient cultures and even today—the *corbeled vault* (FIGS. **4-16** and **4-17***b*). At Newgrange, huge megaliths form the ceiling of the passage and the burial chamber. The stones are held in place by their own weight, those on one side countering the weight of the megaliths on the other side of the passageway. Some of the stones are decorated with incised spirals and other abstract motifs (not visible in FIG. **1-19**). A special feature of the Newgrange tomb is that at the winter solstice the sun illuminates the passageway and the burial chamber.

HAGAR QIM Contemporary with Newgrange but on an island far to the south is the megalithic temple (FIG. 1-1) of Hagar Qim, one of many constructed on Malta between 3200 and 2500 BCE and one of the oldest stone temples anywhere in the world. The Maltese builders constructed their temples by piling carefully cut stone blocks in *courses* (stacked horizontal rows). The doorways at Hagar Qim were built using the *post-and-lintel* system (FIG. 4-17a) in which two upright stones (posts) support a horizontal beam (*lintel*). The layout of this and other Neolithic Maltese temples is especially noteworthy for the combination of rectilinear and curved forms, including multiple *apses* (semicircular recesses). Inside the Hagar Qim temple archaeologists found altars (hence the identification of the structure as a religious shrine) and several stone statues of headless

nude women, one standing, the others seated. The level of architectural and sculptural sophistication seen on this isolated island at so early a date is extraordinary.

STONEHENGE The most famous megalithic monument in Europe is Stonehenge (FIG. 1-20) on the Salisbury Plain in southern England. A henge is an arrangement of megalithic stones in a circle, often surrounded by a ditch. The type is almost entirely limited to Britain. Stonehenge is a complex of rough-cut sarsen (a form of sandstone) stones and smaller "bluestones" (various volcanic rocks) built in several stages over hundreds of years. The final henge took the form of concentric post-and-lintel circles. The outer ring, almost 100 feet in diameter, consists of huge sarsen megaliths. Inside is a ring of bluestones, which in turn encircle a horseshoe (open end facing east) of trilithons (three-stone constructions)—five linteltopped pairs of the largest sarsens, each weighing 45 to 50 tons. Standing apart and to the east (outside the aerial view in FIG. 1-20) is the "heel stone," which, for a person looking outward from the center of the complex, would have marked the point where the sun rose at the summer solstice. Stonehenge seems to have been a kind of astronomical observatory and a remarkably accurate solar calendar.

The megalithic tombs, temples, and henges of Europe are enduring testaments to the rapidly developing intellectual powers of Neolithic humans as well as to their capacity for heroic physical effort.

ART BEFORE HISTORY

PALEOLITHIC (OLD STONE AGE) ART, ca. 30,000-9000 BCE

- The first sculptures and paintings antedate the invention of writing by tens of thousands of years. Paleolithic humans' decision to represent the world around them initiated an intellectual revolution of enormous consequences.
- No one knows why humans began to paint and carve images or what role those images played in the lives of Paleolithic hunters. Women were far more common subjects than men, but animals, not humans, dominate Paleolithic art.
- The works created range in size from tiny figurines like the so-called *Venus of Willendorf* to painted walls and ceilings covered with over-life-size animals, as in the cave at Lascaux.
- Artists always depicted animals in profile so that the image was complete, including the head, body, tail, and all four legs. This format persisted for millennia.

Nude woman (Venus of Willendorf), ca. 28,000–25,000 BCE

Hall of the Bulls, Lascaux, ca. 15,000–13,000 BCE

NEOLITHIC (NEW STONE AGE) ART, ca. 8000-2300 BCE

- Around 9000 BCE, the ice that had covered much of northern Europe for millennia receded. After a transitional period, the Neolithic Age began, but at different times in different places. It also continued longer in remote places like Stonehenge in England and Hagar Qim on Malta.
- The Neolithic Age revolutionized human life with the beginning of agriculture and the formation of the first settled communities, like that at Çatal Höyük in Anatolia.
- In art, the Neolithic period saw the birth of monumental sculpture, notably the painted plaster figurines from Ain Ghazal, and of monumental stone architecture in the walls and tower(s) of Jericho.
- In painting, coherent narratives became common and artists began to represent human figures as composites of frontal and profile views—another formula that would remain universal for a very long time.

Plaster figurine, Ain Ghazal, ca. 6750–6250 BCE

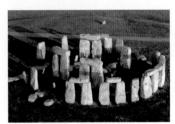

Stonehenge, Salisbury Plain, ca. 2550–1600 BCE

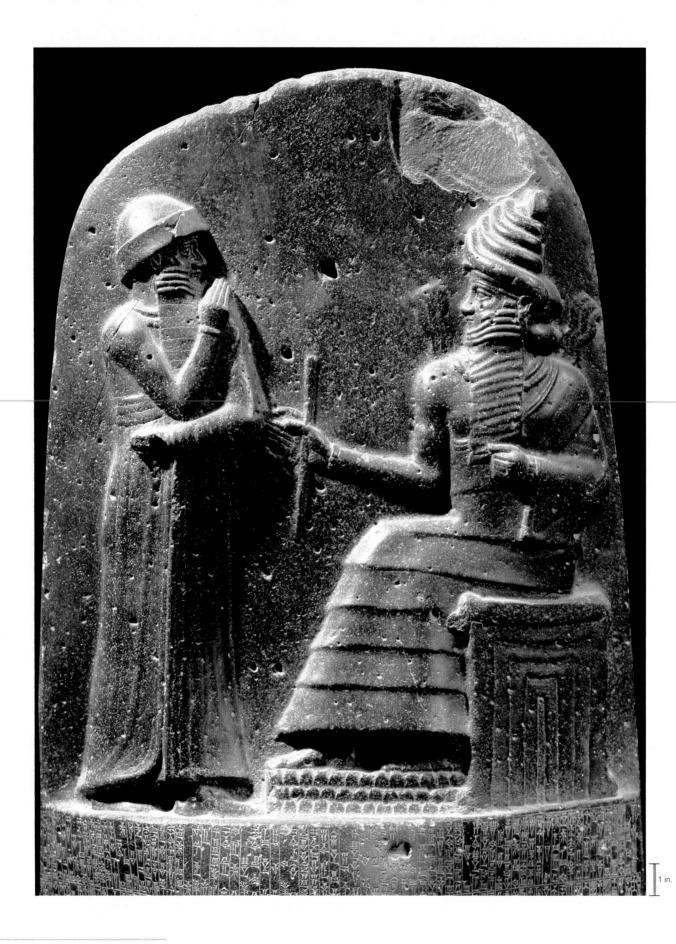

2-1 Hammurabi and Shamash, detail of the stele of Hammurabi (FIG. 2-17), from Susa, Iran, ca. 1780 BCE.

The relationship between king and god in the ancient Near East is set out on this Babylonian stele representing the sun god extending to Hammurabi the symbols of his authority to govern and enact laws.

THE ANCIENT NEAR EAST

When humans first gave up the dangerous and uncertain life of the hunter and gatherer for the more predictable and stable life of the farmer and herder, the change in human society was so significant that it justly has been called the Neolithic Revolution. This fundamental change in the nature of daily life first occurred in Mesopotamia—a Greek word that means "the land between the [Tigris and Euphrates] rivers." Mesopotamia is at the core of the region often called the Fertile Crescent, a land mass that forms a huge arc from the mountainous border between Turkey and Syria through Iraq to Iran's Zagros Mountains (MAP 2-1). There, humans first learned how to use the wheel and the plow and how to control floods and construct irrigation canals. The land became a giant oasis, the presumed locale of the biblical Garden of Eden.

As the region that gave birth to three of the world's great modern faiths—Judaism, Christianity, and Islam—the Near East has long been of interest to historians. But not until the 19th century did systematic excavation open the public's eyes to the extraordinary art and architecture of the ancient land between the rivers. After the first discoveries, the great museums of Europe, consistent with the treasure-hunting spirit of the era, began to acquire Mesopotamian artworks as quickly as possible. The instructions the British Museum gave to Austen Henry Layard, one of the pioneers of Near Eastern archaeology, were typical: Obtain as many well-preserved artworks as you can while spending the least possible amount of time and money doing so. Interest heightened with each new find, and soon North American museums also began to collect Near Eastern art.

The most popular 19th-century acquisitions were the stone reliefs depicting warfare and hunting (FIGS. 2-22 and 2-23) and the colossal statues of monstrous human-headed bulls (FIG. 2-21) from the palaces of the Assyrians, rulers of a northern Mesopotamian empire during the ninth to the seventh centuries BCE. But nothing that emerged from the Near Eastern soil attracted as much attention as the treasures Leonard Woolley discovered in the 1920s at the Royal Cemetery at Ur in southern Mesopotamia. The interest in the lavish third-millennium Sumerian burials he unearthed rivaled the fascination with the 1922 discovery of the tomb of the Egyptian boy-king Tutankhamen (see Chapter 3). The Ur cemetery yielded gold objects, jewelry, artworks, and musical instruments (FIGS. 2-8 to 2-11) of the highest quality.

SUMER

The discovery of the treasures of ancient Ur put the Sumerians once again in a prominent position on the world stage. They had been absent for more than 4,000 years. The Sumerians were the people who in the fourth millennium BCE transformed the vast and previously sparsely inhabited valley between the Tigris and Euphrates into the Fertile Crescent of the ancient world. Ancient Sumer, which roughly corresponds to southern Iraq today, was not a unified nation. Rather, it was made up of a dozen or so independent *city-states*. Each was thought to be under the protection of a different Mesopotamian deity (see "The Gods and Goddesses of Mesopotamia," page 33). The Sumerian rulers were the gods' representatives on earth and the stewards of their earthly treasure.

The rulers and priests directed all communal activities, including canal construction, crop collection, and food distribution. The development of agriculture to the point that only a portion of the population had to produce food meant that some members of the community could specialize in other activities, including manufacturing, trade, and administration. Specialization of labor is a hallmark of the first complex urban societies. In the city-states of ancient Sumer, activities that once had been individually initiated became institutionalized for the first time. The community, rather than the family, assumed functions such as defense against enemies and against the caprices of nature. Whether ruled by a single person or a council chosen from among the leading families, these communities gained permanent identities as discrete cities. The city-state was one of the great Sumerian inventions.

Another was writing. The oldest written documents known are Sumerian records of administrative acts and commercial transactions. At first, around 3400–3200 BCE, the Sumerians made inventories of cattle, food, and other items by scratching *pictographs* (simplified pictures standing for words) into soft clay with a sharp tool, or *stylus*. The clay plaques hardened into breakable, yet nearly indestructible, tablets. Thousands of these plaques dating back nearly five millennia exist today. The Sumerians wrote their pictorial signs from the top down and arranged them in boxes they read from right to left. By 3000–2900 BCE, they had further simplified the pictographic signs by reducing them to a group of wedge-shaped (*cuneiform*) signs

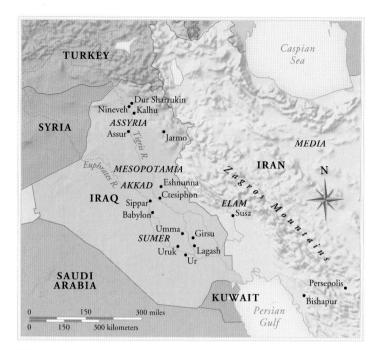

MAP 2-1 The ancient Near East.

(FIG. 2-7 is an early example; see also FIGS. 2-1, 2-16, and 2-17). The development of cuneiform marked the beginning of writing, as historians strictly define it. The surviving cuneiform tablets testify to the far-flung network of Sumerian contacts reaching from southern Mesopotamia eastward to the Iranian plateau, northward to Assyria, and westward to Syria. Trade was essential for the Sumerians, because despite the fertility of their land, it was poor in such vital natural resources as metal, stone, and wood.

The Sumerians also produced great literature. Their most famous work, known from fragmentary cuneiform texts, is the late-third-millennium *Epic of Gilgamesh*, which antedates Homer's *Iliad* and *Odyssey* by some 1,500 years. It recounts the heroic story of Gilgamesh, legendary king of Uruk and slayer of the monster Huwawa. Translations of the Sumerian epic into several other ancient Near Eastern languages attest to the fame of the original version.

2-2 White Temple and ziggurat, Uruk (modern Warka), Iraq, ca, 3200–3000 BCE.

Using only mud bricks, the Sumerians erected temple platforms called ziggurats several centuries before the Egyptians built stone pyramids. The most famous ziggurat was the biblical Tower of Babel.

The Gods and Goddesses of Mesopotamia

The Sumerians and their successors in the ancient Near East worshiped numerous deities, mostly nature gods. Listed here are the Mesopotamian gods and goddesses discussed in this chapter.

- Anu. The chief deity of the Sumerians, Anu was the god of the sky and of the city of Uruk. One of the earliest Sumerian temples (FIGS. 2-2 and 2-3) may have been dedicated to his worship.
- *Enlil*. Anu's son, Enlil was the lord of the winds and the earth. He eventually replaced his father as king of the gods.
- *Inanna*. The Sumerian goddess of love and war, Inanna was later known as *Ishtar*. She is the most important female deity in all periods of Mesopotamian history. As early as the fourth millennium BCE, the Sumerians constructed a sanctuary to Inanna at Uruk. Amid the ruins, excavators uncovered fourth-millennium statues and reliefs (FIGS. 2-4 and 2-5) connected with her worship.
- **Nanna.** The moon god, Nanna was also known as **Sin.** He was the chief deity of Ur, where his most important shrine was located.
- Utu. The sun god, Utu was known later as Shamash and was especially revered at Sippar. On a Babylonian stele (FIG. 2-1) of

- ca. 1780 BCE, King Hammurabi presents his law code to Shamash, who is depicted with flames radiating from his shoulders.
- *Marduk, Nabu,* and *Adad.* Marduk was the chief god of the Babylonians. His son Nabu was the god of writing and wisdom. Adad was the Babylonian god of storms. Representations of Marduk and Nabu's dragon and Adad's sacred bull adorn the sixth-century BCE Ishtar Gate (FIG. 2-24) at Babylon.
- Ningirsu. The local god of Lagash and Girsu, Ningirsu helped Eannatum, one of the early rulers of Lagash, defeat an enemy army. Ningirsu's role in the victory is recorded on the *Stele of the Vultures* (FIG. 2-7) of ca. 2600–2500 BCE. Gudea (FIG. 2-16), one of Eannatum's Neo-Sumerian successors, built a great temple about 2100 BCE in honor of Ningirsu after the god instructed him to do so in a dream.
- *Ashur.* The local deity of Assur, the city that took his name, Ashur became the king of the Assyrian gods. He sometimes is identified with Enlil.

WHITE TEMPLE, URUK The layout of Sumerian cities reflected the central role of the gods in daily life. The main temple to each state's chief god formed the city's monumental nucleus. In fact, the temple complex was a kind of city within a city, where a staff of priests and scribes carried on official administrative and commercial business, as well as oversaw all religious functions.

The outstanding preserved example of early Sumerian temple architecture is the 5,000-year-old White Temple (FIG. 2-2) at Uruk, a city that in the late fourth millennium BCE had a population of about 40,000. Usually only the foundations of early Mesopotamian temples can still be recognized. The White Temple is a rare exception. Sumerian builders did not have access to stone quarries and instead formed mud bricks for the superstructures of their temples and other buildings. Almost all these structures have eroded over the course of time. The fragile nature of the building materials did not, however, prevent the Sumerians from erecting towering works, such as the Uruk temple, several centuries before the Egyptians built their famous stone pyramids. This says a great deal about the Sumerians' desire to provide monumental settings for the worship of their deities.

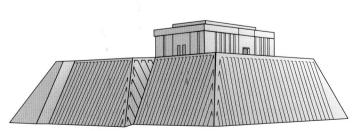

2-3 Reconstruction drawing of the White Temple and ziggurat, Uruk (modern Warka), Iraq, ca. 3200–3000 BCE.

The White Temple at Uruk was probably dedicated to Anu, the sky god. It has a central hall (cella) with a stepped altar where the Sumerian priests would await the apparition of the deity.

Enough of the Uruk complex remains to permit a fairly reliable reconstruction (FIG. 2-3). The temple (whose whitewashed walls lend it its modern nickname) stands atop a high platform, or *ziggu-rat*, 40 feet above street level in the city center. A stairway on one side leads to the top but does not end in front of any of the temple doorways, necessitating two or three angular changes in direction. This *bent-axis plan* is the standard arrangement for Sumerian temples, a striking contrast to the linear approach the Egyptians preferred for their temples and tombs (see Chapter 3).

Like other Sumerian temples, the corners of the White Temple are oriented to the cardinal points of the compass. The building, probably dedicated to Anu, the sky god, is of modest proportions $(61 \times 16 \text{ feet})$. By design, it did not accommodate large throngs of worshipers but only a select few, the priests and perhaps the leading community members. The temple has several chambers. The central hall, or *cella*, was set aside for the divinity and housed a stepped altar. The Sumerians referred to their temples as "waiting rooms," a reflection of their belief that the deity would descend from the heavens to appear before the priests in the cella. Whether the Uruk temple had a roof and, if it did, what kind, are uncertain.

The Sumerian idea that the gods reside above the world of humans is central to most of the world's religions. Moses ascended Mount Sinai to receive the Ten Commandments from the Hebrew God, and the Greeks placed the home of their gods and goddesses on Mount Olympus. The elevated placement of Mesopotamian temples on giant platforms reaching toward the sky is consistent with this widespread religious concept. Eroded ziggurats still dominate most of the ruined cities of Sumer. The loftiness of the great temple platforms made a profound impression on the peoples of the ancient Near East. The tallest ziggurat of all, at Babylon, was about 270 feet high. Known to the Hebrews as the Tower of Babel, it became the centerpiece of a biblical story about the insolent pride of humans (see "Babylon, City of Wonders," page 48).

INANNA A fragmentary white marble female head (FIG. 2-4) from Uruk is also an extraordinary achievement at so early a date. The head, one of the treasures of the Iraq Museum in Baghdad, disappeared during the Iraq war of 2003 but was later recovered. (FIG. 2-4, which shows the head during its presentation at a press conference after its recovery, gives an excellent idea of its size. Other missing items from the museum that were later recovered, in some cases damaged, include FIGS. 2-5 and 2-12.) The lustrous hard stone used to carve the head had to be brought to Uruk at great cost, and the Sumerians used the stone sparingly. The "head" is actually only a face with a flat back. It has drilled holes for attachment to the rest of the head and the body, which may have been wood. Although found in the sacred precinct of the goddess Inanna, the subject is unknown. Many scholars have suggested that the face is an image of Inanna, but a mortal woman, perhaps a priestess, may be portrayed.

Often the present condition of an artwork can be very misleading, and the Uruk head is a dramatic example. Its original appearance would have been much more vibrant than the pure white fragment preserved today. Colored shell or stone filled the deep recesses for the eyebrows and the large eyes. The deep groove at the top of the head anchored a wig, probably made of gold leaf. The hair strands engraved in the metal fell in waves over the forehead and sides of the face. The bright coloration of the eyes, brows, and hair likely over-

shadowed the soft modeling of the cheeks and mouth. The missing body was probably clothed in expensive fabrics and bedecked with jewels.

WARKA VASE The Sumerians, pioneers in so many areas, also may have been the first to use pictures to tell coherent stories. Sumerian narrative art goes far beyond the Stone Age artists' tentative efforts at storytelling. The so-called *Warka Vase* (FIG. 2-5) from Uruk (modern Warka) is the first great work of narrative relief

2-5 Presentation of offerings to Inanna (*Warka Vase*), from Uruk (modern Warka), Iraq, ca. 3200–3000 BCE. Alabaster, $3'\frac{1}{4}''$ high. Iraq Museum, Baghdad.

In this oldest known example of Sumerian narrative art, the sculptor divided the tall stone vase's reliefs into registers, a significant break with the haphazard figure placement found in earlier art.

2-4 Female head (Inanna?), from Uruk (modern Warka), Iraq, ca. 3200–3000 BCE. Marble, 8" high. Iraq Museum, Baghdad.

The Sumerians imported the marble for this head at great cost. It may represent the goddess Inanna and originally had inlaid colored shell or stone eyes and brows, and a wig, probably of gold leaf.

sculpture known. Found within the Inanna temple complex, it depicts a religious festival in honor of the goddess.

The sculptor divided the vase's reliefs into several bands (also called *registers* or *friezes*), and the figures stand on a *ground line* (the horizontal base of the composition). This new kind of composition marks a significant break with the haphazard figure placement found in earlier art. The register format for telling a story was to have a very long future. In fact, artists still employ registers today in modified form in comic books.

The lowest band on the *Warka Vase* shows crops above a wavy line representing water. Then comes a register with ewes and rams—in strict profile, consistent with an approach to representing animals that was then some 20,000 years old. The crops and the alternating male and female animals were the staple commodities of the Sumerian economy, but they were also associated with fertility. They underscore that Inanna had blessed Uruk's inhabitants with good crops and increased herds.

A procession of naked men fills the band at the center of the vase. The men carry baskets and jars overflowing with the earth's abundance. They will present their bounty to the goddess as a votive offering (gift of gratitude to a deity usually made in fulfillment of a vow) and will deposit it in her temple. The spacing of each figure involves no overlapping. The Uruk men, like the Neolithic deer hunters at Çatal Höyük (FIG. 1-17), are a composite of frontal and profile views, with large staring frontal eyes in profile heads. The artist indicated those human body parts necessary to communicate the human form and avoided positions, attitudes, or views that would conceal the characterizing parts. For example, if the figures were in strict profile, an arm and perhaps a leg would be hidden. The body would appear to have only half its breadth. And the eye would not "read" as an eye at all, because it would not have its distinctive oval shape. Art historians call this characteristic early approach to representation conceptual (as opposed to optical) because artists who used it did not record the immediate, fleeting aspect of figures. Instead, they rendered the human body's distinguishing and fixed properties. The fundamental forms of figures, not their accidental appearance, dictated the artist's selection of the composite view as the best way to represent the human body.

In the uppermost (and tallest) band is a female figure with a tall horned headdress next to two large poles that are the sign of the goddess Inanna. (Some scholars think the woman is a priestess and not the goddess herself.) A nude male figure brings a large vessel brimming with offerings to be deposited in the goddess's shrine. At the far right and barely visible in FIG. 2-5 is an only partially preserved clothed man. Near him is the early pictograph for the Sumerian official that is usually, if ambiguously, called a "priest-king," that is, both a religious and secular leader. The greater height of the priest-king and Inanna compared to the offering bearers indicates their greater importance, a convention called *hierarchy of scale*. Some scholars interpret the scene as a symbolic marriage between the priest-king and the goddess, ensuring her continued goodwill—and reaffirming the leader's exalted position in society.

religious beliefs and rituals comes from a cache of sculptures reverently buried beneath the floor of a temple at Eshnunna (modern Tell Asmar) when the structure was remodeled. Carved of soft gypsum and inlaid with shell and black limestone, the statuettes range in size from well under a foot to about 30 inches tall. The two largest figures are shown in FIG. 2-6. All of the statuettes represent mortals, rather than deities, with their hands folded in front of their chests in a ges-

ture of prayer, usually holding the small beakers the Sumerians used in religious rites. Hundreds of similar goblets have been found in the temple complex at Eshnunna. The men wear belts and fringed skirts. Most have beards and shoulder-length hair. The women wear long robes, with the right shoulder bare. Similar figurines from other sites bear inscriptions giving information such as the name of the donor and the god or even specific prayers to the deity on the owner's behalf. With their heads tilted upward, they wait in the Sumerian "waiting room" for the divinity to appear.

The sculptors of the Eshnunna statuettes employed simple forms, primarily cones and cylinders, for the figures. The statuettes are not portraits in the strict sense of the word, but the sculptors did distinguish physical types. At least one child was portrayed—next to the woman in FIG. 2-6 are the remains of two small legs. Most striking is the disproportionate relationship between the inlaid oversized eyes and the tiny hands. Scholars have explained the exaggeration of the eye size in various ways. But because the purpose of these votive figures was to offer constant prayers to the gods on their donors' behalf, the open-eyed stares most likely symbolize the eternal wakefulness necessary to fulfill their duty.

2-6 Statuettes of two worshipers, from the Square Temple at Eshnunna (modern Tell Asmar), Iraq, ca. 2700 BCE. Gypsum inlaid with shell and black limestone, male figure 2' 6" high. Iraq Museum, Baghdad.

The oversized eyes probably symbolized the perpetual wakefulness of these substitute worshipers offering prayers to the deity. The beakers the figures hold were used to pour libations in honor of the gods.

35

STELE OF THE VULTURES The city-states of ancient Sumer were often at war with one another, and warfare is the theme of the so-called Stele of the Vultures (FIG. 2-7) from Girsu. A stele is a carved stone slab erected to commemorate a historical event or, in some cultures, to mark a grave. The Girsu stele presents a labeled historical narrative with cuneiform inscriptions filling almost every blank space on the stele. (It is not, however, the first historical representation in the history of art. That honor belongs—at the moment—to an Egyptian relief (FIG. 3-3) carved more than three centuries earlier.) The inscriptions reveal that the Stele of the Vultures celebrates the victory of Eannatum, the ensi (ruler; king?) of Lagash, over the neighboring city-state of Umma. The stele has reliefs on both sides and takes its nickname from a fragment with a gruesome scene of vultures carrying off the severed heads and arms of the defeated enemy soldiers. Another fragment shows the giant figure of the local god Ningirsu holding tiny enemies in a net and beating one of them on the head with a mace.

The fragment in FIG. 2-7 depicts Eannatum leading an infantry battalion into battle (above) and attacking from a war chariot (below). The foot soldiers are protected behind a wall of shields and trample naked enemies as they advance. (The fragment that shows vultures devouring corpses belongs just to the right in the same register.) Both on foot and in a chariot, Eannatum is larger than anyone else, except Ningirsu on the other side of the stele. The artist presented him as the fearless general who paves the way for his army. Lives were lost, however, and Eannatum himself was wounded in the campaign, but the outcome was never in doubt because Ningirsu fought with the men of Lagash.

Despite its fragmentary state, the *Stele of the Vultures* is an extraordinary document, not only as a very early effort to record historical events in relief but also for the insight it yields about Sumerian society. Through both words and pictures, it provides information about warfare and the special nature of the Sumerian ruler. Eannatum was greater in stature than other men, and Ningirsu watched over him. According to the text, the ensi was born from the god Enlil's semen, which Ningirsu implanted in the womb. When Eannatum was wounded in battle, it says, the god shed tears for him. He was a divinely chosen ruler who presided over all aspects of his citystate, both in war and in peace. This also seems to have been the role of the ensi in the other Sumerian city-states.

STANDARD OF UR Agriculture and trade brought considerable wealth to some of the city-states of ancient Sumer. Nowhere is this clearer than in the so-called Royal Cemetery at Ur, the city that was home to the biblical Abraham. In the third millennium BCE, the leading families of Ur buried their dead in chambers beneath the earth. Scholars still debate whether these deceased were true kings and queens or simply aristocrats and priests, but the Sumerians laid them to rest in regal fashion. Archaeologists exploring the Ur cemetery uncovered gold helmets and daggers with handles of lapis lazuli (a rich azure-blue stone imported from Afghanistan), golden beakers and bowls, jewelry of gold and lapis, musical instruments, chariots, and other luxurious items. Dozens of bodies were also found in the richest tombs. A retinue of musicians, servants, charioteers, and soldiers was sacrificed in order to accompany the "kings and queens" into the afterlife. (Comparable rituals are documented in other societies, for example, in ancient America; see Chapter 14.)

Not the costliest object found in the "royal" graves, but probably the most significant from the viewpoint of the history of art, is the so-called *Standard of Ur* (FIGS. 2-8 and 2-9). This rectangular box of uncertain function has sloping sides inlaid with shell, lapis lazuli, and red limestone. The excavator, Leonard Woolley, thought the object was

2-7 Fragment of the victory stele of Eannatum (*Stele of the Vultures*), from Girsu (modern Telloh), Iraq, ca. 2600–2500 BCE. Limestone, fragment 2' 6" high, full stele 5' 11" high. Louvre, Paris.

Cuneiform inscriptions on this stell describe the victory of Eannatum of Lagash over the city of Umma. This fragment shows Eannatum leading his army into battle. The artist depicted the king larger than his soldiers.

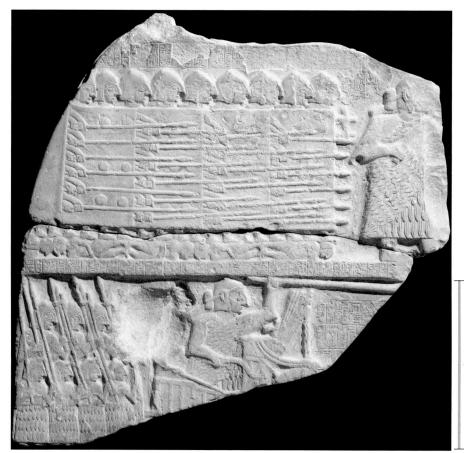

1 ft.

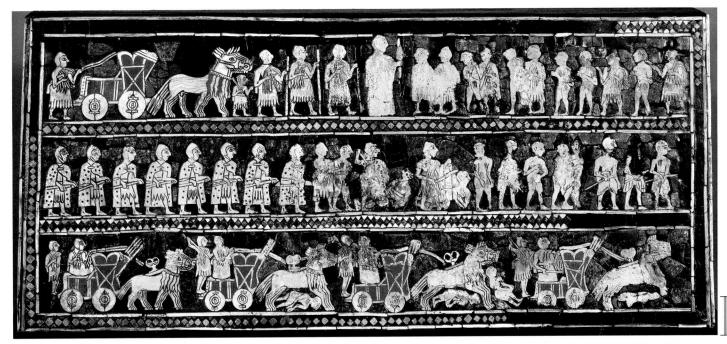

2-8 War side of the *Standard of Ur*, from tomb 779, Royal Cemetery, Ur (modern Tell Muqayyar), Iraq, ca. 2600 BCE. Wood inlaid with shell, lapis lazuli, and red limestone, $8'' \times 1'$ 7". British Museum, London.

Using a mosaic-like technique, this Sumerian artist depicted a battlefield victory in three registers. In the top band, soldiers present bound captives to a kinglike figure who is larger than everyone else.

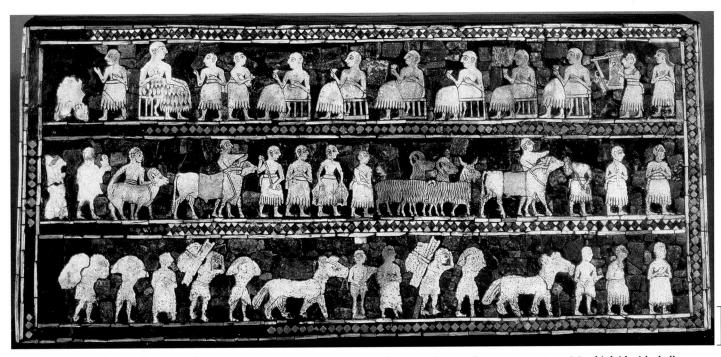

2-9 Peace side of the Standard of Ur, from tomb 779, Royal Cemetery, Ur (modern Tell Muqayyar), Iraq, ca. 2600 BCE. Wood inlaid with shell, lapis lazuli, and red limestone, $8'' \times 1'$ 7". British Museum, London.

The feast on the peace side of the *Standard of Ur* may be a victory celebration. The narrative again reads from bottom to top, and the size of the figures varies with their importance in Sumerian society.

originally mounted on a pole, and he considered it a kind of military standard—hence its nickname. Art historians usually refer to the two long sides of the box as the "war side" and "peace side," but the two sides may represent the first and second parts of a single narrative. The artist divided each into three horizontal bands. The narrative reads from left to right and bottom to top. On the war side (FIG. 2-8), four ass-drawn four-wheeled war chariots mow down enemies, whose bodies appear

on the ground in front of and beneath the animals. The gait of the asses accelerates along the band from left to right. Above, foot soldiers gather up and lead away captured foes. In the uppermost register, soldiers present bound captives (who have been stripped naked to degrade them) to a kinglike figure, who has stepped out of his chariot. His central place in the composition and his greater stature (his head breaks through the border at the top) set him apart from all the other figures.

In the lowest band on the peace side (FIG. 2-9), men carry provisions, possibly war booty, on their backs. Above, attendants bring animals, perhaps also spoils of war, and fish for the great banquet depicted in the uppermost register. There, seated dignitaries and a larger-than-life "king" (third from the left) feast, while a lyre player and singer entertain the group. Art historians have interpreted the scene both as a victory celebration and as a banquet in connection with cult ritual. The two are not necessarily incompatible. The absence of an inscription prevents connecting the scenes with a specific event or person, but the *Standard of Ur* undoubtedly is another early example of historical narrative.

BULL-HEADED LYRE From the "King's Grave" at Ur comes a fragmentary lyre (FIG. **2-10**) that, when intact, probably resembled the instrument depicted in the feast scene (FIG. **2-9**, *top right*) on the *Standard of Ur.* A magnificent bull's head (FIG. **2-10**, *left*) caps the instrument's sound box. It is fashioned of gold leaf over a wooden core. The hair, beard, and details are lapis lazuli. The sound box (FIG. **2-10**, *right*) also features bearded—but here human-headed—bulls in the uppermost of its four inlaid panels. Imaginary composite creatures are commonplace in the art of the ancient Near East and Egypt. On the Ur lyre, a heroic figure embraces the two man-bulls in a *heraldic composition* (symmetrical on either side of a central figure). His body and that of the scorpion-man in the lowest panel are in composite view. The animals are, equally characteristically, solely in profile: the dog wearing a dagger and carrying a laden table, the lion bringing in the beverage service, the ass playing the lyre, the

jackal playing the zither, the bear steadying the lyre (or perhaps dancing), and the gazelle bearing goblets. The banquet animals almost seem to be burlesquing the kind of regal feast reproduced on the peace side of the *Standard of Ur*. The meaning of the sound-box scenes is unclear. Some scholars have suggested, for example, that the creatures inhabit the land of the dead and that the narrative has a funerary significance. In any event, the sound box is a very early specimen of the recurring theme in both literature and art of animals acting as people. Later examples include Aesop's fables in ancient Greece, medieval *bestiaries*, and Walt Disney's cartoon animal actors.

CYLINDER SEALS A banquet is also the subject of a *cylinder seal* (FIG. 2-11) found in the tomb of "Queen" Pu-abi and inscribed with her name. (Many historians prefer to designate her more conservatively and ambiguously as "Lady" Pu-abi.) The seal is typical of the period, consisting of a cylindrical piece of stone engraved to produce a raised impression when rolled over clay (see "Mesopotamian Seals," page 39). In the upper zone, a woman, probably Pu-abi, and a man sit and drink from beakers, attended by servants. Below, male attendants serve two more seated men. Even in miniature and in a medium very different from that of the *Standard of Ur*, the Sumerian artist employed the same figure types and followed the same compositional rules. All the figures are in composite views with large frontal eyes in profile heads, and the seated dignitaries are once again larger in scale to underscore their elevated position in the social hierarchy.

2-10 Bull-headed lyre from tomb 789 ("King's Grave"), Royal Cemetery, Ur (modern Tell Muqayyar), Iraq, са. 2600 все. Lyre (*left*): Gold leaf and lapis lazuli over a wooden core, 5' 5" high. Sound box (right): Wood with inlaid gold, lapis lazuli, and shell, 1' 7" high. University of Pennsylvania Museum of Archaeology and Anthropology, Philadelphia.

This lyre from a royal grave at Ur is adorned with a bearded bull's head of gold leaf and lapis lazuli, and inlaid figures of a Gilgameshlike hero and animals acting out scenes of uncertain significance.

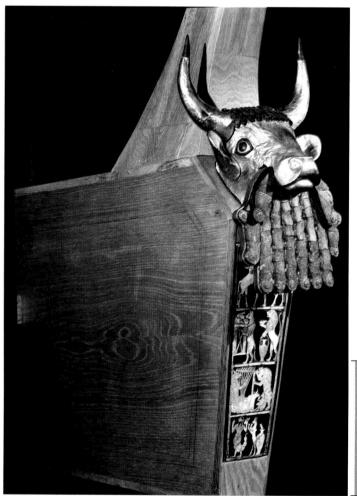

Mesopotamian Seals

eals have been unearthed in great numbers at sites throughout Mesopotamia. Generally made of stone, seals of ivory, glass, and other materials also survive. The seals take two forms: flat *stamp seals* and *cylinder seals*. The latter have a hole drilled lengthwise through the center of the cylinder so that they could be strung and worn around the neck or suspended from the wrist. Cylinder seals (FIG. 2-11) were prized possessions, signifying high positions in society, and they frequently were buried with the dead.

The primary function of cylinder seals, however, like the earlier stamp seals, was not to serve as items of adornment. The Sumerians (and other peoples of the Near East) used both stamp and cylinder seals to identify their documents and protect storage jars and doors against unauthorized opening. The oldest seals predate the invention of writing and conveyed their messages with pictographs that ratified ownership. Later seals often bear long cuneiform inscriptions and record the names and titles of rulers, bureaucrats, and deities. Although sealing is increasingly rare, the tradition lives on today whenever a letter is sealed with a lump of wax and then stamped with a monogram or other identifying mark. Customs officials often still seal packages and sacks with official stamps when goods cross national borders.

In the ancient Near East, artists decorated both stamp and cylinder seals with incised designs, producing a raised pattern when the seal was pressed into soft clay. (Cylinder seals largely displaced stamp seals because they could be rolled over the clay and thus cover a greater area more quickly.) Fig. 2-11 shows a cylinder seal from the Royal Cemetery at Ur and a modern impression made from it. Note how cracks in the stone cylinder become raised lines in the impression and how the engraved figures, chairs, and cuneiform characters appear in relief. Continuous rolling of the seal over a clay strip results in a repeating design, as the illustration also demonstrates at the edges.

The miniature reliefs the seals produce are a priceless source of information about Mesopotamian religion and society. Without them, archaeologists would know much less about how Mesopotamians dressed and dined; what their shrines looked like; how they depicted their gods, rulers, and mythological figures; how they fought wars; and what role women played in ancient Near Eastern society. Clay seal impressions excavated in architectural contexts shed a welcome light on the administration and organization of Mesopotamian city-states. Mesopotamian seals are also an invaluable resource for art historians, providing them with thousands of miniature examples of relief sculpture that span roughly 3,000 years.

2-11 Banquet scene, cylinder seal (*left*) and its modern impression (*right*), from the tomb of Pu-abi (tomb 800), Royal Cemetery, Ur (modern Tell Muqayyar), Iraq, ca. 2600 BCE. Lapis lazuli, 2" high. British Museum, London.

Seals were widely used in Mesopotamia to identify and secure goods. Artists incised designs into stone cylinders and then rolled them over clay to produce miniature artworks like this banquet scene.

AKKAD AND THE THIRD DYNASTY OF UR

In 2332 BCE, the loosely linked group of cities known as Sumer came under the domination of a great ruler, Sargon of Akkad (r. 2332–2279 BCE). Archaeologists have yet to locate the specific site of the city of Akkad, but it was in the vicinity of Babylon. The Akkadians were Semitic in origin—that is, they were a Near Eastern people who spoke a language related to Hebrew and Arabic. Their language,

Akkadian, was entirely different from the language of Sumer, but they used the Sumerians' cuneiform characters for their written documents. Under Sargon (whose name means "true king") and his followers, the Akkadians introduced a new concept of royal power based on unswerving loyalty to the king rather than to the city-state. During the rule of Sargon's grandson, Naram-Sin (r. 2254–2218 BCE), governors of cities were considered mere servants of the king, who in turn called himself "King of the Four Quarters"—in effect, ruler of the earth, akin to a god.

2-12 Head of an Akkadian ruler, from Nineveh (modern Kuyunjik), Iraq, ca. 2250–2200 BCE. Copper, 1' $2\frac{3}{8}"$ high. Iraq Museum, Baghdad.

The sculptor of this first known life-size hollow-cast head captured the distinctive features of the ruler while also displaying a keen sense of abstract pattern. The head was vandalized in antiquity.

AKKADIAN PORTRAITURE A magnificent copper head of an Akkadian king (FIG. 2-12) found at Nineveh embodies this new concept of absolute monarchy. The head is all that survives of a statue that was knocked over in antiquity, perhaps when the Medes, a people that occupied the land south of the Caspian Sea (MAP 2-1), sacked Nineveh in 612 BCE. But the damage to the portrait was not due solely to the statue's toppling. There are also signs of deliberate mutilation. To make a political statement, the enemy gouged out the eyes (once inlaid with precious or semiprecious stones), broke off the lower part of the beard, and slashed the ears of the royal portrait. Nonetheless, the king's majestic serenity, dignity, and authority are evident. So, too, is the masterful way the sculptor balanced naturalism and abstract patterning. The artist carefully observed and recorded the man's distinctive features—the profile of the nose and the long, curly beard—and brilliantly communicated the differing textures of flesh and hair, even the contrasting textures of the mustache, beard, and braided hair on the top of the head. The coiffure's triangles, lozenges, and overlapping disks of hair and the great arching eyebrows that give so much character to the portrait reveal that the sculptor was also sensitive to formal pattern.

No less remarkable is the fact this is a life-size, hollow-cast metal sculpture (see "Hollow-Casting Life-Size Bronze Statues," Chapter 5, page 122), one of the earliest known. The head demonstrates the artisan's sophisticated skill in casting and polishing copper and in engraving the details. The portrait is the earliest known great monumental work of hollow-cast sculpture.

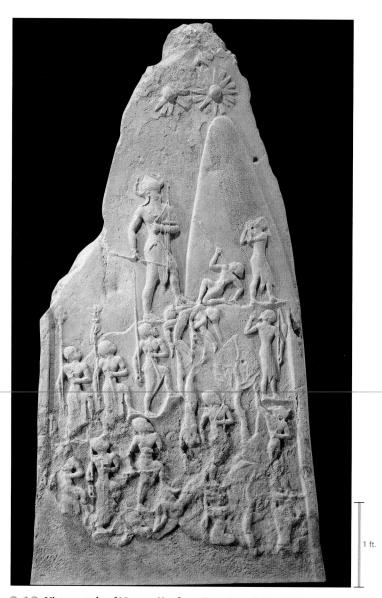

2-13 Victory stele of Naram-Sin, from Susa, Iran, 2254–2218 BCE. Pink sandstone, 6' 7" high. Louvre, Paris.

To commemorate his conquest of the Lullubi, Naram-Sin set up this stele showing him leading his army up a mountain. The sculptor staggered the figures, abandoning the traditional register format.

NARAM-SIN STELE The godlike sovereignty the kings of Akkad claimed is also evident in the victory stele (FIG. 2-13) Naram-Sin set up at Sippar. The stele commemorates his defeat of the Lullubi, a people of the Iranian mountains to the east. It is inscribed twice, once in honor of Naram-Sin and once by an Elamite king who had captured Sippar in 1157 BCE and taken the stele as booty back to Susa in south-western Iran (MAP 2-1), where it was found. On the stele, the grandson of Sargon leads his victorious army up the slopes of a wooded mountain. His routed enemies fall, flee, die, or beg for mercy. The king stands alone, far taller than his men, treading on the bodies of two of the fallen Lullubi. He wears the horned helmet signifying divinity—the first time a king appears as a god in Mesopotamian art. At least three favorable stars (the stele is damaged at the top) shine on his triumph.

By storming the mountain, Naram-Sin seems also to be scaling the ladder to the heavens, the same conceit that lies behind the great ziggurat towers of the ancient Near East. His troops march up the mountain behind him in orderly files, suggesting the discipline and organization of the king's forces. The enemy, in contrast, is in disarray, depicted in a great variety of postures—one falls headlong down

Enheduanna, Priestess and Poet

In the man's world of ancient Akkad, one woman stands out prominently—Enheduanna, daughter of King Sargon and priestess of the moon god Nanna at Ur. Her name appears in several inscriptions, and she was the author of a series of hymns in honor of the goddess Inanna. Enheduanna's is the oldest recorded name of a poet, male or female. Indeed, hers is the earliest known name of the author of any literary work in world history.

The most important surviving object associated with Enheduanna is the alabaster disk (FIG. 2-14) found at Ur in several fragments in the residence of the priestess of Nanna. The reverse bears a cuneiform inscription identifying Enheduanna as the "wife of Nanna" and "daughter of Sargon, king of the world" and credits Enheduanna with erecting an altar to Nanna in his temple. The dedication of the relief to the moon god explains its unusual round format, which corresponds to the shape of the full moon. The front of the disk shows four figures approaching a four-story ziggurat. The first figure is a nude man who is either a priest or Enheduanna's assistant. He pours a libation into a plant stand. The second figure, taller than the rest and wearing the headgear of a priestess, is Enheduanna herself. She raises her right hand in a gesture of greeting and respect for the god. Two figures, probably female attendants, follow her.

Artworks created to honor women are rare in Mesopotamia and in the ancient world in general, and Enheduanna's is the oldest known. Enheduanna was, however, a princess and priestess, not a ruler in her own right, and her disk pales in comparison to the monuments erected almost a thousand years later in honor of Queen Hatshepsut of Egypt (see "Hatshepsut," Chapter 3, page 68).

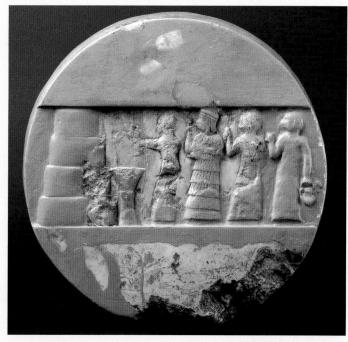

2-14 Votive disk of Enheduanna, from Ur (modern Tell Muqayyar), Iraq, ca. 2300–2275 BCE. Alabaster, diameter 10". University of Pennsylvania Museum of Archaeology and Anthropology, Philadelphia.

Enheduanna, daughter of Sargon of Akkad and priestess of Nanna at Ur, is the first author whose name is known. She is the tallest figure on this disk that she dedicated in honor of the moon god.

the mountainside. The Akkadian artist adhered to older conventions in many details, especially by portraying the king and his soldiers in composite views and by placing a frontal two-horned helmet on Naram-Sin's profile head. But the sculptor showed daring innovation in creating a landscape setting for the story and placing the figures on successive tiers within that landscape. For the first time, an artist rejected the standard way of telling a story in a series of horizontal registers, the compositional formula that had been the rule for a millennium. The traditional frieze format was used, however, for an alabaster disk (FIG. 2-14) that is in other respects one of the

most remarkable discoveries ever made in the ancient Near East (see "Enheduanna, Priestess and Poet," above).

ZIGGURAT, UR Around 2150 BCE, a mountain people, the Gutians, brought Akkadian power to an end. The cities of Sumer, however, soon united in response to the alien presence, drove the Gutians out of Mesopotamia, and established a Neo-Sumerian state ruled by the kings of Ur. This age, which historians call the Third Dynasty of Ur, saw the construction of the ziggurat (FIG. **2-15**) at Ur, one of the largest in Mesopotamia. Built about a millennium later than that at

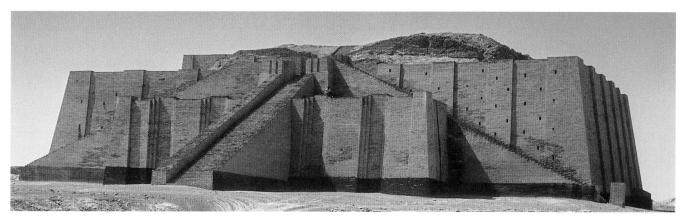

2-15 Ziggurat (northeastern facade with restored stairs), Ur (modern Tell Muqayyar), Iraq, ca. 2100 BCE.

The Ur ziggurat is one of the largest in Mesopotamia. It has three ramplike stairways of a hundred steps each that originally ended at a gateway to a brick temple, which does not survive.

The Piety of Gudea

ne of the central figures of the Neo-Sumerian age was Gudea of Lagash. Nearly two dozen portraits of him survive. All stood in temples where they could render perpetual service to the gods and intercede with the divine powers on his behalf. Although a powerful ruler, Gudea rejected the regal trappings of Sargon of Akkad and his successors in favor of a return to the Sumerian votive tradition of the Eshnunna statuettes (FIG. 2-6). Like the earlier examples, many of Gudea's statues are inscribed with messages to the gods of Sumer. One from Girsu says, "I am the shepherd loved by my king [Ningirsu, the god of Girsu]; may my life be prolonged." Another, also from Girsu, as if in answer to the first, says, "Gudea, the builder of the temple, has been given life." Some of the inscriptions help explain why Gudea was portrayed the way he was. For example, his large chest is a sign that the gods have given him fullness of life and his muscular arms reveal his god-given strength. Other inscriptions underscore that his large eyes signify that his gaze is perpetually fixed on the gods (compare FIG. 2-6).

Gudea built or rebuilt, at great cost, all the temples in which he placed his statues. One characteristic portrait (FIG. 2-16) depicts the pious ruler of Lagash seated with his hands clasped in front of him in a gesture of prayer. The head is unfortunately lost, but the statue is of unique interest because Gudea has a temple plan drawn on a tablet on his lap. It is the plan for a new temple dedicated to Ningirsu. Gudea buried accounts of his building enterprises in the temple foundations. The surviving texts describe how the Neo-Sumerians prepared and purified the sites, obtained the materials, and dedicated the completed temples. They also record Gudea's dreams of the gods asking him to erect temples in their honor, promising him prosperity if he fulfilled his duty. In one of these dreams, Ningirsu addresses Gudea:

When, O faithful shepherd Gudea, thou shalt have started work for me on Erinnu, my royal abode [Ningirsu's new temple], I will call up in heaven a humid wind. It shall bring the abundance from on high.... All the great fields will bear for thee; dykes and canals will swell for thee; ... good weight of wool will be given in thy time.*

*Translated by Thorkild Jacobsen, in Henri Frankfort, *The Art and Architecture of the Ancient Orient*, 5th ed. (New Haven: Yale University Press, 1996), 98.

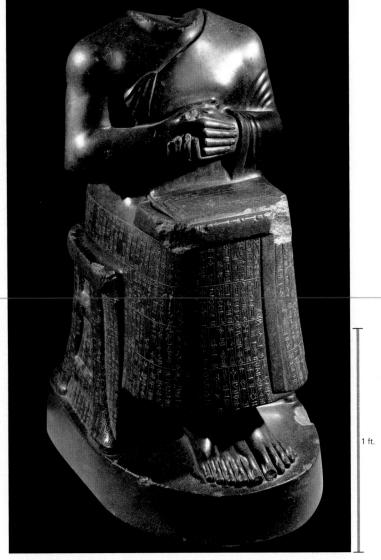

2-16 Seated statue of Gudea holding temple plan, from Girsu (modern Telloh), Iraq, ca. 2100 BCE. Diorite, 2' 5" high. Louvre, Paris.

Gudea of Lagash built or rebuilt many temples and placed statues of himself in all of them. In this seated portrait, Gudea has on his lap a plan of the new temple he erected to Ningirsu.

Uruk (FIGS. 2-2 and 2-3), the Ur ziggurat is much grander. The base is a solid mass of mud brick 50 feet high. The builders used baked bricks laid in bitumen, an asphaltlike substance, for the facing of the entire monument. Three ramplike stairways of a hundred steps each converge on a tower-flanked gateway. From there another flight of steps probably led to the temple proper, which does not survive.

GUDEA OF LAGASH The most conspicuous preserved sculptural monuments of the Neo-Sumerian age portray Gudea, the ensi of Lagash around 2100 BCE (see "The Piety of Gudea," above). His statues (FIG. 2-16) show him seated or standing, hands tightly

clasped, head shaven, sometimes wearing a woolen brimmed hat, and always dressed in a long garment that leaves one shoulder and arm exposed. Gudea was zealous in granting the gods their due, and the numerous statues he commissioned are an enduring testimony to his piety—and to his wealth and pride. All his portraits are of polished diorite, a rare and costly dark stone that had to be imported. Diorite is also extremely hard and difficult to carve. The prestige of the material—which in turn lent prestige to Gudea's portraits—is evident from an inscription on one of Gudea's statues: "This statue has not been made from silver nor from lapis lazuli, nor from copper nor from lead, nor yet from bronze; it is made of diorite."

Hammurabi's Law Code

n the early 18th century BCE, King Hammurabi of Babylon formulated a comprehensive law code for his people. At the time, parts of Europe were still in the Stone Age. Even in Greece, it was not until more than 1,000 years later that Draco provided Athens with its first written set of laws. Two earlier Sumerian law codes survive in part, but Hammurabi's laws are the only ones known in great detail, thanks to the chance survival of a tall black-basalt stele (FIG. 2-17) that was carried off as booty to Susa in 1157 BCE, together with the Naram-Sin stele (FIG. 2-13). At the top (FIG. 2-1) is a representation in high relief of Hammurabi in the presence of Shamash, the flame-shouldered sun god. The king raises his hand in respect. The god extends to Hammurabi the rod and ring that symbolize authority. The symbols derive from builders' tools-measuring rods and coiled rope-and connote the ruler's capacity to build the social order and to measure people's lives, that is, to render judgments and enforce the laws spelled out on the stele. The judicial code, written in Akkadian, was inscribed in 3,500 lines of cuneiform characters. Hammurabi's laws governed all aspects of Babylonian life, from commerce and property to murder and theft to marital fidelity, inheritances, and the treatment of slaves.

Here is a small sample of the infractions described and the penalties imposed (which vary with the person's standing in society):

- If a man puts out the eye of another man, his eye shall be put out.
- If he kills a man's slave, he shall pay one-third of a mina.
- If someone steals property from a temple, he will be put to death, as will the person who receives the stolen goods.
- If a man rents a boat and the boat is wrecked, the renter shall replace the boat with another.
- If a married woman dies before bearing any sons, her dowry shall be repaid to her father, but if she gave birth to sons, the dowry shall belong to them.
- If a man's wife is caught in bed with another man, both will be tied up and thrown in the water.

Hammurabi's stele is noteworthy artistically as well. The sculptor depicted Shamash (FIG. 2-1) in the familiar convention of combined front and side views, but with two important exceptions. His great headdress with its four pairs of horns is in true profile so that only four, not all eight, of the horns are visible. And the artist seems

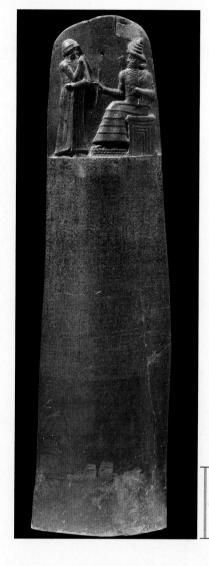

2-17 Stele with law code of Hammurabi, from Susa, Iran, ca. 1780 BCE. Basalt, 7' 4" high. Louvre, Paris.

The stele that records Hammurabi's remarkably early law code also is one of the first examples of an artist employing foreshortening—the representation of a figure or object at an angle (compare FIG. 2-1).

to have tentatively explored the notion of *foreshortening*—a means of suggesting depth by representing a figure or object at an angle, instead of frontally or in profile. Shamash's beard is a series of diagonal rather than horizontal lines, suggesting its recession from the picture plane, and the sculptor represented the side of his throne at an angle.

SECOND MILLENNIUM BCE

The resurgence of Sumer was short-lived. The last of the kings of the Third Dynasty of Ur fell at the hands of the Elamites, who ruled the territory east of the Tigris River. The following two centuries witnessed the reemergence of the traditional Mesopotamian political pattern of several independent city-states existing side by side.

HAMMURABI Babylon was one of those city-states until its most powerful king, Hammurabi (r. 1792–1750 BCE), reestablished a centralized government in southern Mesopotamia. Perhaps the most renowned king in Mesopotamian history, Hammurabi was famous

for his conquests. But he is best known today for his law code (FIGS. 2-1 and 2-17), which prescribed penalties for everything from adultery and murder to the cutting down of a neighbor's trees (see "Hammurabi's Law Code," above).

LION GATE, HATTUSA The Babylonian Empire toppled in the face of an onslaught by the Hittites, an Anatolian people who conquered and sacked Babylon around 1595 BCE. They then retired to their homeland, leaving Babylon in the hands of the Kassites. Remains of the strongly fortified capital city of the Hittites still may be seen at Hattusa near modern Boghazköy, Turkey. Constructed of large blocks

2-18 Lion Gate, Hattusa (modern Boghazköy), Turkey, ca. 1400 BCE.

The Hittites conquered and sacked Babylon around 1595 BCE. Their fortified capital at Boghazköy in Anatolia had seven-foot-tall stone lions guarding the main gateway (compare FIGS. 2-21 and 4-19).

of heavy stone—a striking contrast to the brick architecture of Mesopotamia—the walls and towers of the Hittites effectively protected them from attack. Symbolically guarding the gateway (FIG. 2-18) to the Hattusa citadel are two huge (seven-foothigh) lions. Their simply carved forequarters project from massive stone blocks on

either side of the entrance. These Hittite guardian beasts are early examples of a theme that was to be echoed on many Near Eastern gates. Notable are those of Assyria (FIG. 2-21), one of the greatest empires of the ancient world, and of the reborn Babylon (FIG. 2-24) in the first millennium BCE. But the idea of protecting a city, palace, temple, or tomb from evil by placing wild beasts or fantastic monsters before an entranceway was not unique to the Near Eastern world. Examples abound in Egypt, Greece, Italy, and elsewhere.

NAPIR-ASU OF ELAM To the east of Sumer, Akkad, and Babylon was Elam, which appears in the Bible as early as Genesis 10:22. During the second half of the second millennium BCE, Elam reached the height of its political and military power. At this time the Elamites were strong enough to plunder Babylonia and to carry off the stelae of Naram-Sin and Hammurabi (FIGS. 2-13 and 2-17) and display them as war booty at their capital city, Susa.

In the ruins of Susa, archaeologists discovered a life-size bronze-and-copper statue (FIG. 2-19) of Queen Napir-Asu, wife of one of the most powerful Elamite kings, Untash-Napirisha. The statue weighs 3,760 pounds even in its fragmentary and mutilated state, because the sculptor, incredibly, cast the statue with a solid bronze core inside a hollow-cast copper shell. The bronze core increased the cost of the statue enormously, but the queen wished her portrait to be a permanent, immovable votive offering in the temple where it was found. In fact, the Elamite inscription on the queen's skirt explicitly asks the gods to protect the statue:

He who would seize my statue, who would smash it, who would destroy its inscription, who would erase my name, may he be smitten by the curse of [the gods], that his name shall become extinct, that his offspring be barren. . . . This is Napir-Asu's offering. ¹

Napir-Asu's portrait thus falls within the votive tradition going back to the third-millennium BCE Eshnunna figurines (FIG. 2-6). In the Elamite statue, the Mesopotamian instinct for cylindrical volume is again evident. The tight silhouette, strict frontality, and firmly crossed hands held close to the body are all enduring characteristics common to the Sumerian statuettes. Yet within these rigid conventions of form and pose, the Elamite artist managed to create refinements that must

an hoosts are early as the sequence from close observation. The sculptor conveyed the femi-

have come from close observation. The sculptor conveyed the feminine softness of arm and bust, the grace and elegance of the long-fingered hands, the supple and quiet bend of the wrist, the ring and bracelets, and the gown's patterned fabric. The loss of the head is especially unfortunate. The figure presents a portrait of the ideal queen. The hands crossed over the belly may allude to fertility and the queen's role in assuring peaceful dynastic succession.

2-19 Statue of Queen Napir-Asu, from Susa, Iran, ca. 1350–1300 BCE. Bronze and copper, 4' 2 3/4" high. Louvre,

Paris.

This life-size bronzeand-copper statue of the wife of one of the most powerful Elamite kings weighs 3,760 pounds. The queen wanted her portrait to be an immovable votive offering in a temple.

ASSYRIA

During the first half of the first millennium BCE, the fearsome Assyrians vanquished the various warfaring peoples that succeeded the Babylonians and Hittites, including the Elamites, whose capital of Susa they sacked in 641 BCE. The Assyrians took their name from Assur, the city on the Tigris River in northern Iraq named for the god Ashur. At the height of their power, the Assyrians ruled an empire that extended from the Tigris River to the Nile and from the Persian Gulf to Asia Minor.

The royal citadel (FIG. 2-20) of Sargon II (r. 721–705 BCE) at Dur Sharrukin reveals in its ambitious layout the confidence of the Assyrian kings in their all-conquering might. Its strong defensive walls also reflect a society ever fearful of attack during a period of almost constant warfare. The city measures about a square mile in area. The palace, elevated on a mound 50 feet high, covered some 25 acres and had more than 200 court-

yards and rooms. Timber-roofed rectangular halls were grouped around square and rectangular courts. Behind the main courtyard, whose sides each measured 300 feet, were the residential quarters of the king, who received foreign emissaries in the long, high, brightly painted throne room. All visitors entered from another large courtyard, where over-life-size figures of the king and his courtiers lined the walls.

Sargon II regarded his city and palace as an expression of his grandeur. The Assyrians cultivated an image of themselves as merciless to anyone who dared oppose them, although they were forgiving to those who submitted to their will. Sargon, for example, wrote in an inscription, "I built a city with [the labors of] the peoples subdued by my hand, whom Ashur, Nabu, and Marduk had caused to lay themselves at my feet and bear my yoke." And in another text, he proclaimed, "Sargon, King of the World, has built a city. Dur Sharrukin he has named it. A peerless palace he has built within it."

In addition to the complex of courtyards, throne room, state chambers, service quarters, and guard rooms that made up the palace, the citadel included a great ziggurat and six sanctuaries for six different

gods. The ziggurat at Dur Sharrukin may have had as many as seven stories. Four remain, each 18 feet high and painted a different color. A continuous ramp spiraled around the building from its base to the temple at its summit. Here, the legacy of the Sumerian bent-axis plan may be seen more than two millennia after the erection of the White Temple (FIG. 2-3) on the ziggurat at Uruk.

Guarding the gate to Sargon's palace were colossal limestone monsters (FIG. 2-21), which the Assyrians probably called *lamassu*. These winged, manheaded bulls served to ward off the king's enemies. The task of moving and installing these immense stone sculptures was so daunting that several reliefs in the palace of Sargon's successor celebrate the feat,

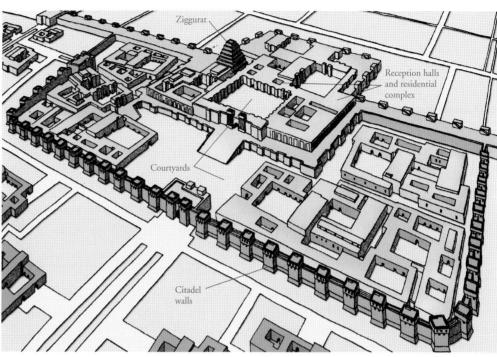

2-20 Reconstruction drawing of the citadel of Sargon II, Dur Sharrukin (modern Khorsabad), Iraq, ca. 720–705 BCE (after Charles Altman).

The fortified walls of the vast royal citadel of Sargon II enclosed courtyards, a throne room, service quarters, guard rooms, a great ziggurat, and six sanctuaries for six different gods.

2-21 Lamassu (winged, human-headed bull), from the citadel of Sargon II, Dur Sharrukin (modern Khorsabad), Iraq, ca. 720–705 BCE. Limestone, 13′ 10″ high. Louvre, Paris.

Ancient sculptors insisted on showing complete views of animals. This four-legged Assyrian palace guardian has five legs—two when seen from the front and four in profile view.

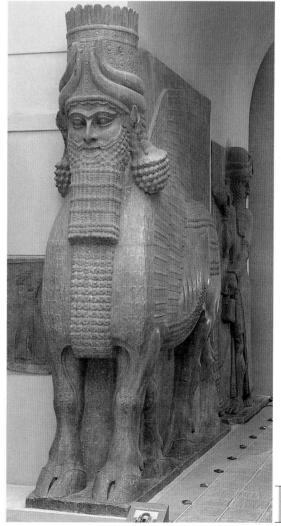

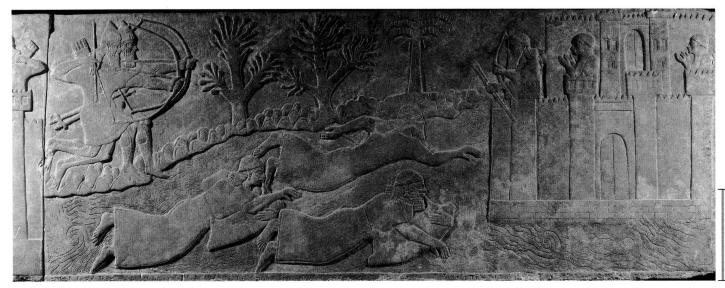

2-22 Assyrian archers pursuing enemies, relief from the Northwest Palace of Ashurnasirpal II, Kalhu (modern Nimrud), Iraq, ca. 875–860 BCE. Gypsum, $2' 10\frac{5}{8}''$ high. British Museum, London.

Assyrian palaces were adorned with extensive series of narrative reliefs exalting the king and recounting his great deeds. This one depicts Assyrian archers driving the enemy into the Euphrates River.

showing scores of men dragging lamassu figures with the aid of ropes and sledges. The Assyrian lamassu sculptures are partly in the round, but the sculptor nonetheless conceived them as high reliefs on adjacent sides of a corner. They combine the front view of the animal at rest with the side view of it in motion. Seeking to present a complete picture of the lamassu from both the front and the side, the sculptor gave the monster five legs—two seen from the front, four seen from the side. This sculpture, then, is yet another case of early artists' providing a conceptual picture of an animal or person and of all its important parts, as opposed to an optical view of the lamassu as it actually would stand in space.

PALACE OF ASHURNASIRPAL II For their palace walls the Assyrian kings commissioned extensive series of painted narrative re-

liefs exalting royal power. The degree of documentary detail in the Assyrian reliefs is without parallel in the ancient world before the Roman Empire (see Chapter 10). One of the earliest and most extensive cycles of reliefs comes from the palace of Ashurnasirpal II (r. 883–859 BCE) at Kalhu. Throughout the palace, painted gypsum reliefs sheathed the lower parts of the mud-brick walls below brightly colored plaster. Rich textiles on the floors contributed to the luxurious ambience. Every relief celebrated the king and bore an inscription naming Ashurnasirpal and describing his accomplishments.

Fig. 2-22 probably depicts an episode that occurred in 878 BCE when Ashurnasirpal drove his enemy's forces into the Euphrates River. In the relief, two Assyrian archers shoot arrows at the fleeing foe. Three enemy soldiers are in the water. One swims with an arrow in his back. The other two attempt to float to safety by inflating animal

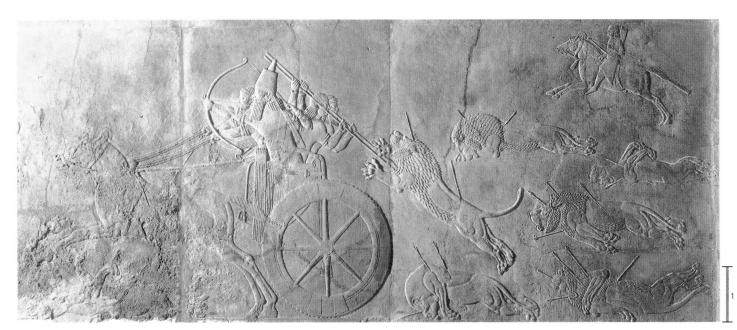

2-23 Ashurbanipal hunting lions, relief from the North Palace of Ashurbanipal, Nineveh (modern Kuyunjik), Iraq, ca. 645–640 BCE. Gypsum, 5' 4" high. British Museum, London.

In addition to ceremonial and battle scenes, the hunt was a common subject of Assyrian palace reliefs. The Assyrians considered the hunting and killing of lions manly royal virtues on a par with victory in warfare.

skins. Their destination is a fort where their compatriots await them. The artist showed the fort as if it were in the middle of the river, but it must, of course, have been on land, perhaps at some distance from where the escapees entered the water. The artist's purpose was to tell the story clearly and economically. In art, distances can be compressed and the human actors enlarged so that they stand out from their environment. Literally interpreted, the defenders of the fort are too tall to walk through its archway. (Compare Naram-Sin and his men scaling a mountain, FIG. 2-13.) The sculptor also combined different viewpoints in the same frame, just as the figures are composites of frontal and profile views. The river is seen from above; the men, trees, and fort from the side. The artist also made other adjustments for clarity. The archers' bowstrings are in front of their bodies but behind their heads in order not to hide their faces. The men will snare their own heads in their bows when they launch their arrows! All these liberties with optical reality result, however, in a vivid and easily legible retelling of a decisive moment in the king's victorious campaign. This was the artist's primary goal.

PALACE OF ASHURBANIPAL Two centuries later, sculptors carved hunting reliefs for the Nineveh palace of the conqueror of Elamite Susa, Ashurbanipal (r. 668-627 BCE). The Assyrians, like many other societies before and after, regarded prowess in hunting as a manly virtue on a par with success in warfare. The royal hunt did not take place in the wild, however, but in a controlled environment, ensuring the king's safety and success. In FIG. 2-23, lions released from cages in a large enclosed arena charge the king, who, in his chariot and with his attendants, thrusts a spear into a savage lion. The animal leaps at the king even though it already has two arrows in its body. All around the royal chariot is a pathetic trail of dead and dying animals, pierced by what appear to be far more arrows than needed to kill them. Blood streams from some of the lions, but they refuse to die. The artist brilliantly depicted the straining muscles, the swelling veins, the muzzles' wrinkled skin, and the flattened ears of the powerful and defiant beasts. Modern sympathies make this scene of carnage a kind of heroic tragedy, with the lions as protagonists. It is unlikely, however, that the king's artists had any intention other

than to glorify their ruler by showing the king of men pitting himself against and repeatedly conquering the king of beasts. Portraying Ashurbanipal's beastly foes as possessing courage and nobility as well as the power to kill made the king's accomplishments that much grander.

The Assyrian Empire was never very secure, and most of its kings had to fight revolts in large sections of the Near East. Assyria's conquest of Elam in the seventh century BCE and frequent rebellions in Babylonia apparently overextended its resources. During the last years of Ashurbanipal's reign, the empire began to disintegrate. Under his successors, it collapsed from the simultaneous onslaught of the Medes from the east and the resurgent Babylonians from the south. Neo-Babylonian kings held sway over the former Assyrian Empire until the Persian conquest.

NEO-BABYLONIA AND PERSIA

The most renowned of the Neo-Babylonian kings was Nebuchadnezzar II (r. 604–562 BCE), whose exploits the biblical Book of Daniel recounts. Nebuchadnezzar restored Babylon to its rank as one of the great cities of antiquity. The city's famous hanging gardens were among the Seven Wonders of the ancient world, and the Bible immortalized its enormous ziggurat as the Tower of Babel (see "Babylon, City of Wonders," page 48).

ISHTAR GATE, BABYLON Nebuchadnezzar's Babylon was a mud-brick city, but dazzling blue-glazed bricks faced the most important monuments, such as the Ishtar Gate (FIG. **2-24**), actually a pair of gates, one of which has been restored and installed in a German museum. The Ishtar Gate consists of a large *arcuated* (*arch*-shaped) opening flanked by towers, and features *glazed* bricks with molded reliefs of animals, real and imaginary. Each Babylonian brick was molded and glazed separately, then set in proper sequence on the wall. On the Ishtar Gate, profile figures of Marduk and Nabu's dragon and Adad's bull alternate. Lining the processional way leading up to the gate were reliefs of Ishtar's sacred lion, glazed in yellow, brown, and red against a blue background.

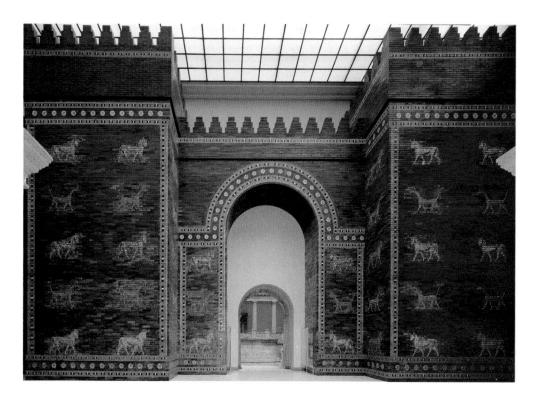

2-24 Ishtar Gate (restored), Babylon, Iraq, ca. 575 BCE. Staatliche Museen, Berlin.

Babylon under King Nebuchadnezzar II was one of the greatest cities of the ancient world. Its arcuated Ishtar Gate featured glazed bricks depicting Marduk and Nabu's dragon and Adad's bull.

Babylon, City of Wonders

he uncontested list of the Seven Wonders of the ancient world was not codified until the 16th century. But already in the second century BCE, Antipater of Sidon, a Greek poet, compiled a roster of seven must-see monuments, including six of the seven later Wonders. All of the Wonders were of colossal size and constructed at great expense. Three of them were of great antiquity: the pyramids of Gizeh (FIG. 3-8), which Antipater described as "man-made mountains," and "the hanging gardens" and "walls of impregnable Babylon."

Babylon was the only site on Antipater's list that could boast two Wonders. Later list makers preferred to distribute the Seven Wonders among seven different cities. Most of these Wonders date to Greek times—the Temple of Artemis at Ephesos, with its 60-foot-tall columns; Phidias's colossal gold-and-ivory statue of Zeus at Olympia; the grandiose tomb of Mausolus (the "Mausoleum") at Halikarnassos; the Colossus of Rhodes, a bronze statue of the sun god 110 feet tall; and the lighthouse at Alexandria, perhaps the tallest building in the ancient world. The pyramids are the oldest and the Babylonian gardens the only Wonder in the category of "landscape architecture."

Several ancient texts describe Babylon's gardens. Quintus Curtius

Rufus, writing in the mid-first century CE, reported:

On the top of the citadel are the hanging gardens, a wonder celebrated in the tales of the Greeks.... Columns of stone were set up to sustain the whole work, and on these was laid a floor of squared blocks, strong enough to hold the earth which is thrown upon it to a great depth, as well as the water with which they irrigate the soil; and the structure supports trees of such great size that the thickness of their trunks equals a measure of eight cubits [about twelve feet]. They tower to a height of fifty feet, and they yield as much fruit as if they

were growing in their native soil. . . . To those who look upon [the trees] from a distance, real woods seem to be overhanging their native mountains.*

Not qualifying as a Wonder, but in some ways no less impressive, was Babylon's Marduk ziggurat, the biblical Tower of Babel. According to the Bible, humankind's arrogant desire to build a tower to Heaven angered God. The Lord put an end to it by causing the workers to speak different languages, preventing them from communicating with one another. The fifth-century BCE Greek historian Herodotus described the Babylonian temple complex:

In the middle of the sanctuary [of Marduk] has been built a solid tower . . . which supports another tower, which in turn supports another, and so on: there are eight towers in all. A stairway has been constructed to wind its way up the outside of all the towers; halfway up the stairway there is a shelter with benches to rest on, where people making the ascent can sit and catch their breath. In the last tower there is a huge temple. The temple contains a large couch, which is adorned with fine coverings and has a golden table standing beside it, but there are no statues at all standing there. . . . [The Babylonians] say that the god comes in person to the temple [compare the Sumerian notion of the temple as a "waiting room"] and rests on the couch; I do not believe this story myself.†

*Translated by John C. Rolfe, Quintus Curtius I (Cambridge, Mass.: Harvard University Press, 1971), 337-339.

†Translated by Robin Waterfield, Herodotus: The Histories (New York: Oxford University Press, 1998), 79-80.

THE PERSIAN EMPIRE Although Nebuchadnezzar, "King of Kings" of the biblical Daniel, had boasted that he "caused a mighty wall to circumscribe Babylon . . . so that the enemy who would do evil would not threaten," Cyrus of Persia (r. 559-529 BCE) captured the city in the sixth century. Cyrus, who may have been descended from an Elamite line, was the founder of the Achaemenid dynasty and traced his ancestry back to a mythical King Achaemenes. Babylon was but one of the Persians' conquests. Egypt fell to them in 525 BCE, and by 480 BCE the Persian Empire was the largest the world had yet known, extending from the Indus River in South Asia to the Danube River in northeastern Europe. Only the successful Greek resistance in the fifth century BCE prevented Persia from embracing southeastern Europe as well. The Achaemenid line ended with the death of Darius III in 330 BCE, after his defeat at the hands of Alexander the Great (FIG. 5-70).

PERSEPOLIS The most important source of knowledge about Persian art and architecture is the ceremonial and administrative complex on the citadel at Persepolis (FIG. 2-25), which the successors of Cyrus, Darius I (r. 522-486 BCE) and Xerxes (r. 486-465 BCE), built between 521 and 465 BCE. Situated on a high plateau, the heavily fortified complex of royal buildings stood on a wide platform overlooking the plain. Alexander the Great razed the site in a gesture symbolizing the destruction of Persian imperial power. Some said it was an act of revenge for the Persian sack of the Athenian Acropolis in the early fifth century BCE (see Chapter 5). But even in ruins, the Persepolis citadel is impressive.

The approach to the citadel led through a monumental gateway called the Gate of All Lands, a reference to the harmony among the peoples of the vast Persian Empire. Assyrian-inspired colossal manheaded winged bulls flanked the great entrance. Broad ceremonial stairways provided access to the platform and the royal audience hall, or apadana, a huge hall 60 feet high and 217 feet square, containing 36 colossal columns. An audience of thousands could have stood within the hall.

The reliefs (FIG. 2-26) decorating the walls of the terrace and staircases leading to the apadana represent processions of royal guards, Persian nobles and dignitaries, and representatives from 23 subject nations bringing the king tribute. Every one of the emissaries wears his national costume and carries a typical regional gift for the conqueror. The carving of the Persepolis reliefs is technically superb, with subtly modeled surfaces and crisply chiseled details. Traces of color prove that the reliefs were painted, and the original effect must have been even more striking than it is today. Although the Persepolis sculptures may have been inspired by those in Assyrian palaces, they are different in style. The forms are more rounded, and they project more from the background. Some of the details, notably the treatment of drapery folds, echo forms characteristic of Archaic Greek sculpture (see Chapter 5), and Greek influence seems to be one of the many ingredients of Achaemenid style. Persian art testifies to the active exchange of ideas and artists among all the Mediterranean and Near Eastern civilizations at this date. A building inscription at Susa, for example, names Ionian Greeks, Medes, Egyp-

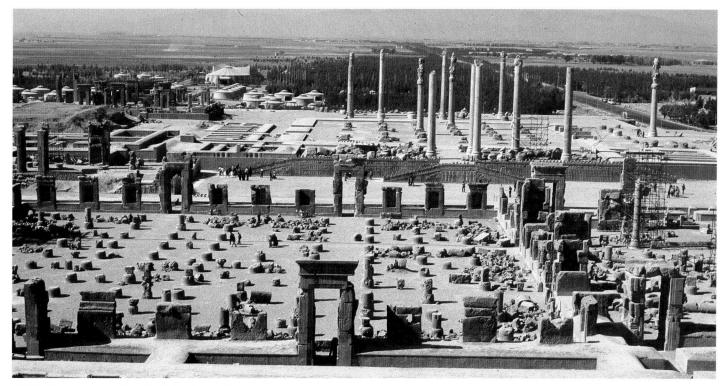

2-25 Persepolis (apadana in the background), Iran, ca. 521–465 BCE.

The heavily fortified complex of Persian royal buildings on a high plateau at Persepolis contained a royal audience hall, or apadana, 60 feet high and 217 feet square with 36 colossal columns.

tians, and Babylonians among those who built and decorated the palace. Under the single-minded direction of its Persian masters, this heterogeneous workforce, with a widely varied cultural and artistic background, created a new and coherent style that perfectly suited the expression of Persian imperial ambitions.

SASANIAN CTESIPHON Alexander the Great's conquest of Persia in 330 BCE marked the beginning of a long period of first Greek and then Roman rule of large parts of the ancient Near East,

beginning with one of Alexander's former generals, Seleucus I (r. 312–281 BCE), founder of the Seleucid dynasty. In the third century CE, however, a new power rose up in Persia that challenged the Romans and sought to force them out of Asia. The new rulers called themselves Sasanians. They traced their lineage to a legendary figure named Sasan, said to be a direct descendant of the Achaemenid kings. Their New Persian Empire was founded in 224 CE, when the first Sasanian king, Artaxerxes I (r. 211–241), defeated the Parthians (another of Rome's eastern enemies).

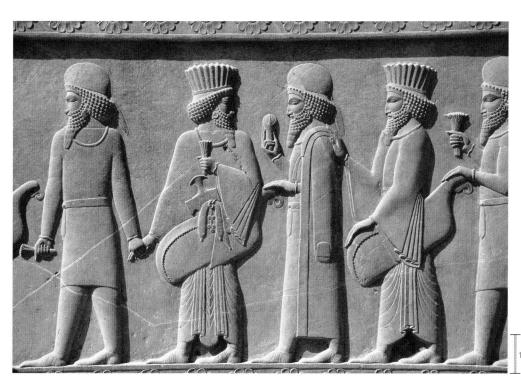

2-26 Processional frieze (detail) on the terrace of the apadana, Persepolis, Iran, ca. 521–465 BCE. Limestone, 8' 4" high.

The reliefs decorating the walls of the terrace and staircases leading up to the Persepolis apadana included depictions of representatives of 23 subject nations bringing tribute to the Persian king.

ft.

2-27 Palace of Shapur I, Ctesiphon, Iraq, ca. 250 ce.

The last great pre-Islamic civilization of the Near East was that of the Sasanians. Their palace at Ctesiphon, near Baghdad, features a brick audience hall (iwan) covered by an enormous pointed vault.

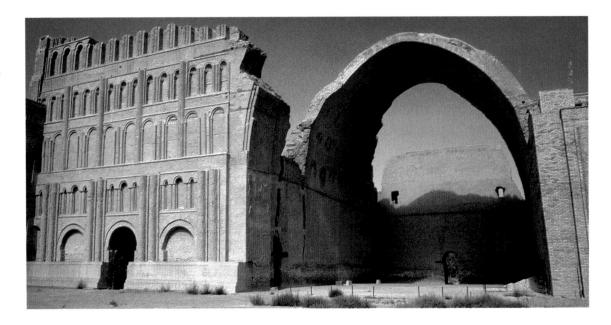

The son and successor of Artaxerxes, Shapur I (r. 241–272), succeeded in further extending Sasanian territory. He also erected a great palace (FIG. 2-27) at Ctesiphon, the capital his father had established near modern Baghdad in Iraq. The central feature of Shapur's palace was the monumental *iwan*, or brick audience hall, covered by a *vault* (here, a deep arch over an oblong space) that came almost to a point more than 100 feet above the ground. The facade to the left and right of the iwan was divided into a series of horizontal bands made up of *blind arcades*, a series of arches without actual openings, applied as wall decoration. A thousand years later, Islamic architects looked at Shapur's palace and especially its soaring iwan and established it as the standard for judging their own engineering feats (see Chapter 13).

SHAPUR I AND ROME So powerful was the Sasanian army that in 260 CE Shapur I even succeeded in capturing the Roman emperor Valerian near Edessa (Turkey). His victory over Valerian was

such a significant event that Shapur commemorated it in a series of rock-cut reliefs in the cliffs of Bishapur in Iran, far from the site of his triumph. Fig. 2-28 reproduces one of the Bishapur reliefs. Shapur appears larger than life, riding in from the right wearing the distinctive tall Sasanian crown, which breaks through the relief 's border and draws attention to the king. At the left, Valerian kneels before Shapur and begs for mercy. Similar scenes of kneeling enemies before triumphant generals are commonplace in Roman art—but at Bishapur the roles are reversed. This appropriation of Roman compositional patterns and motifs in a relief celebrating the Sasanian defeat of the Romans adds another, ironic, level of meaning to the political message in stone.

The New Persian Empire endured more than 400 years, until the Arabs drove the Sasanians out of Mesopotamia in 636 CE, just four years after the death of Muhammad. Thereafter, the greatest artists and architects of Mesopotamia worked in the service of Islam (see Chapter 13).

2-28 Triumph of Shapur I over Valerian, rock-cut relief, Bishapur, Iran, ca. 260 CE.

The Sasanian king Shapur I humiliated the Roman emperor Valerian in 260 CE and commemorated his surrender in over-life-size reliefs cut into the cliffs outside Persepolis.

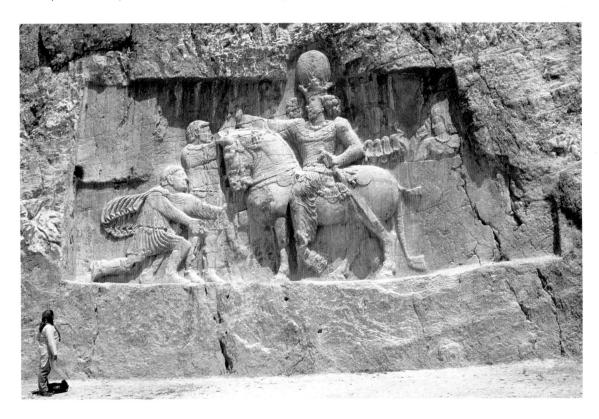

THE ANCIENT NEAR EAST

SUMERIAN ART, ca. 3500-2332 BCE

- The Sumerians founded the world's first city-states in the valley between the Tigris and Euphrates rivers and invented writing in the fourth millennium BCE.
- They were also the first to build towering temple platforms, called ziggurats, and to place figures in registers to tell coherent stories.

Standard of Ur, ca. 2600 BCE

AKKADIAN ART, ca. 2332-2150 BCE

- The Akkadians were the first Near Eastern rulers to call themselves kings of the world and to assume divine attributes. The earliest recorded name of an author is the Akkadian priestess Enheduanna.
- Akkadian artists may have been the first to cast hollow life-size bronze sculptures and to place figures at different levels in a landscape setting.

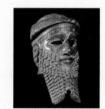

Portrait of an Akkadian king, ca. 2250–2200 BCE

NEO-SUMERIAN AND BABYLONIAN ART, ca. 2150-1600 BCE

- During the Third Dynasty of Ur, the Sumerians rose again to power and constructed one of the largest ziggurats in Mesopotamia at Ur.
- Gudea of Lagash (r. ca. 2100 BCE) built numerous temples and placed diorite portraits of himself in all of them as votive offerings to the gods.
- Babylon's greatest king, Hammurabi (r. 1792–1750 BCE), established a comprehensive law code for the empire he ruled. Babylonian artists were among the first to experiment with foreshortening.

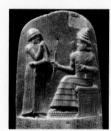

Stele of Hammurabi, ca. 1780 BCE

ASSYRIAN ART, ca. 900-612 BCE

- At the height of their power, the Assyrians ruled an empire that extended from the Persian Gulf to the Nile and Asia Minor.
- Assyrian palaces were fortified citadels with gates guarded by monstrous lamassu. Painted reliefs depicting the king in battle and hunting lions decorated the walls of the ceremonial halls.

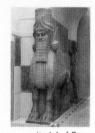

Lamassu, citadel of Sargon II, Dur Sharrukin, ca. 720–705 BCE

NEO-BABYLONIAN AND PERSIAN ART, ca. 612-330 BCE

- In the sixth century BCE, the Babylonians constructed two of the Seven Wonders of the ancient world. The Ishtar Gate, with its colorful glazed brick reliefs, gives an idea of how magnificent Babylon was under Nebuchadnezzar II (r. 604–562 BCE).
- The capital of the Achaemenid Persians was at Persepolis, where Darius I (r. 522–486 BCE) and Xerxes (r. 486–465 BCE) built a huge palace complex with an audience hall that could accommodate thousands. Painted reliefs of subject nations bringing tribute decorated the terraces.
- Alexander the Great conquered the Persian Empire in 330 BCE.

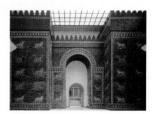

Ishtar Gate, Babylon, ca. 575 BCE

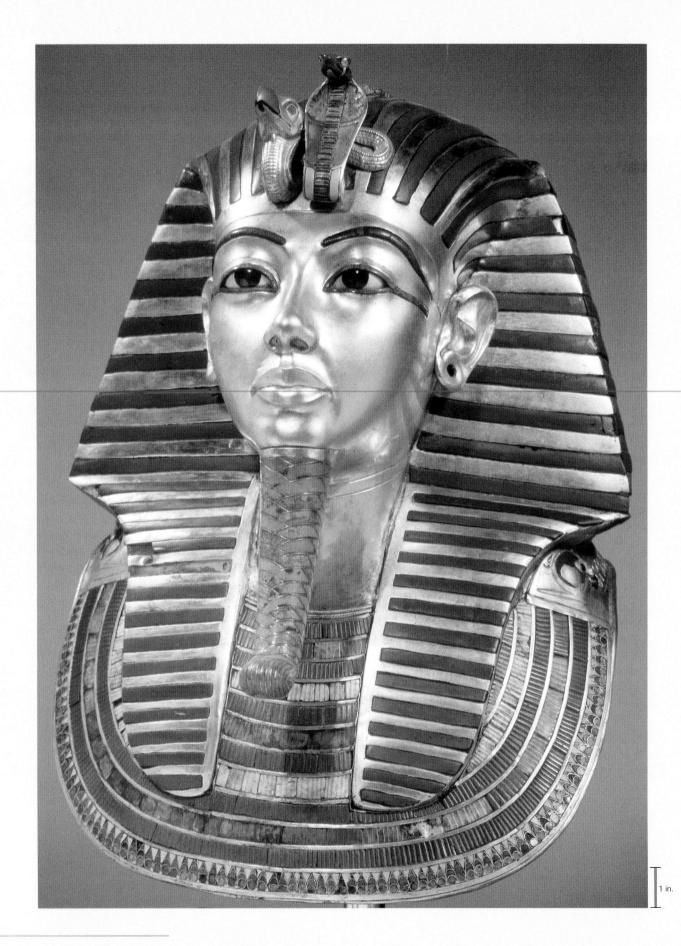

3-1 Death mask of Tutankhamen, from the innermost coffin in his tomb at Thebes, Egypt, 18th Dynasty, ca. 1323 BCE. Gold with inlay of semiprecious stones, 1' $9\frac{1}{4}''$ high. Egyptian Museum, Cairo.

The extraordinary treasures in the boy-king Tutankhamen's tomb attest to the wealth the Egyptian pharaohs lavished on preparing for the afterlife. Tutankhamen's mask is gold with inlaid gems.

EGYPT UNDER THE PHARAOHS

Nearly 2,500 years ago, the Greek historian Herodotus wrote, "Concerning Egypt itself I shall extend my remarks to a great length, because there is no country that possesses so many wonders, nor any that has such a number of works that defy description." Even today, many would agree with this assessment. The ancient Egyptians left to the world a profusion of spectacular monuments dating across three millennia. From the cliffs of the Libyan and Arabian deserts they cut giant blocks of stone and erected grand temples to their immortal gods (see "The Gods and Goddesses of Egypt," page 54). From the same imperishable material that symbolized the timelessness of their world, the Egyptians set up countless statues of their equally immortal god-kings and built thousands of tombs to serve as eternal houses of the dead. The solemn and ageless art of the Egyptians expresses the unchanging order that, for them, was divinely established.

The backbone of Egypt was, and still is, the Nile River, whose annual floods supported all life in that ancient land (MAP 3-1). Even more than the Tigris and the Euphrates rivers of Mesopotamia, the Nile defined the cultures that developed along its banks. Originating deep in Africa, the world's longest river flows through regions that may not receive a single drop of rainfall in a decade. Yet crops thrive from the rich soil that the Nile brings thousands of miles from the African hills. In the time of the *pharaohs*, the ancient Egyptian kings, the land bordering the Nile consisted of marshes dotted with island ridges. The Egyptians hunted the amphibious animals that swarmed through the tall forests of *papyrus* and rushes in the marshes. Egypt's fertility was famous. When Egypt became a province of the Roman Empire after Queen Cleopatra's death (r. 51–30 BCE), it served as the granary of the Mediterranean world.

Even in the Middle Ages, Egypt's reputation as an ancient land of wonders and mystery lived on. Until the late 18th century, people regarded its undeciphered writing and exotic monuments as treasures of occult wisdom, locked away from any but those initiated in the mystic arts. Scholars knew something of Egypt's history from references in the Old Testament, from Herodotus and other Greco-Roman authors, and from preserved portions of a history of Egypt written in Greek in the third century BCE by an Egyptian high priest named Manetho. Manetho described the succession of pharaohs, dividing them into the still-useful groups called dynasties, but his chronology was inaccurate, and the absolute dates of the pharaohs are still debated. The chronologies scholars have proposed for the earliest Egyptian dynasties

The Gods and Goddesses of Egypt

The worldview of the Egyptians was distinct from those of their neighbors in the ancient Mediterranean and Near Eastern worlds. Egyptians believed that before the beginning of time the primeval waters, called *Nun*, existed alone in the darkness. At the moment of creation, a mound rose out of the limitless waters—just as muddy mounds emerge from the Nile after the annual flood recedes. On this mound the creator god appeared and brought light to the world. In later times, the mound was formalized as a pyramidal stone called the *ben-ben* supporting the supreme god, *Amen*, the god of the sun (*Re*).

The supreme god also created the first of the other gods and goddesses of Egypt. According to one version of the myth, the creator masturbated and produced *Shu* and *Tefnut*, the primary male and female forces in the universe. They coupled to give birth to *Geb* (Earth) and *Nut* (Sky), who bore Osiris, Seth, Isis, and Nephthys. The eldest, *Osiris*, was the god of order and was revered as the king who brought civilization to Egypt. His brother, *Seth*, was his evil opposite, the god of chaos. Seth murdered Osiris and cut him into pieces, which he scattered across Egypt. *Isis*, the sister and consort of Osiris, with the help of *Nephthys*, Seth's wife, succeeded in collecting Osiris's body parts, and with her powerful magic brought him back to life.

The resurrected Osiris fathered a son with Isis—*Horus*, who avenged his father's death and displaced Seth as king of Egypt. Osiris then became the lord of the Underworld. Horus is represented in art either as a falcon, considered the noblest bird of the sky, or as a falcon-headed man. All Egyptian pharaohs were identified with Horus while alive and with Osiris after they died.

Other Egyptian deities included *Mut*, the consort of the sun god Amen, and *Khonsu*, the moon god, who was their son. *Thoth*, another lunar deity and the god of knowledge and writing, appears in art as an ibis, a baboon, or an ibis-headed man crowned with the crescent moon and the moon disk. When Seth tore out Horus's falcon-eye (*wedjat*), Thoth restored it. He, too, was associated with rebirth and the afterlife. *Hathor*, daughter of Re, was a divine mother of the pharaoh, nourishing him with her milk. She appears in Egyptian art as a cow-headed woman or as a woman with a cow's horns. *Anubis*, a jackal or jackal-headed deity, was the god of the Underworld and of mummification. *Maat*, another daughter of Re, was the goddess of truth and justice. Her feather was used to measure the weight of the deceased's heart on Anubis's scales to determine if the *ka* (life force) would be blessed in the afterlife.

can vary by as much as two centuries. Exact years cannot be assigned to the reigns of individual pharaohs until 664 BCE (26th Dynasty).²

At the end of the 18th century, when Europeans rediscovered Egypt, the land of the Nile became the first subject of archaeological

200 miles 100 Mediterranean Sea 200 kilometers Rosetta Alexandria LOWER EGYPT • Heliopolis New Kingdom Gizeh. Saqqara—— Dashur Memphis Dashur FAIYUM 1550-1070 BCE ARABIA Bahariya Akhetaton (Tell el-Amarna) Hierakonpolis UPPER Edfu EGYPT Abu Simbel NUBIA

MAP 3-1 Ancient Egypt.

exploration. In 1799, Napoleon Bonaparte, on a military expedition to Egypt, took with him a small troop of scholars, linguists, antiquarians, and artists. The chance discovery of the famed *Rosetta Stone*, now in the British Museum, provided the key to deciphering Egyptian *hieroglyphic* writing. The stone bears an inscription in three sections: one in Greek, which the Frenchmen easily read; one in *demotic* (Late Egyptian); and one in formal hieroglyphic. On the assumption that the text was the same in all three sections, scholars attempted to decipher the two non-Greek sections. Eventually, Jean-François Champollion deduced that the hieroglyphs were not simply pictographs but the signs of a once-spoken language whose traces survived in Coptic, the language of Christian Egypt. The ability to read hieroglyphic inscriptions revolutionized the study of Egyptian civilization and art.

THE PREDYNASTIC AND EARLY DYNASTIC PERIODS

The Predynastic, or prehistoric, beginnings of Egyptian civilization are chronologically vague. But tantalizing remains of tombs, paintings, pottery, and other artifacts attest to the existence of a sophisticated culture on the banks of the Nile around 3500 BCE.

Painting and Sculpture

In Predynastic times, Egypt was divided geographically and politically into Upper Egypt (the southern, upstream part of the Nile Valley), a narrow tract of grassland that encouraged hunting, and Lower (northern) Egypt, where the rich soil of the Nile Delta islands encouraged agriculture and animal husbandry. The major finds of Predynastic art come from Upper Egypt, especially Hierakonpolis.

TOMB 100, HIERAKONPOLIS Archaeologists exploring the Predynastic cemetery at Hierakonpolis found extraordinary mural paintings on three interior walls of tomb 100. The tomb is no longer preserved, but a watercolor copy (FIG. 3-2) of the murals records

3-2 People, boats, and animals, detail of a watercolor copy of a wall painting from tomb 100 at Hierakonpolis, Egypt, Predynastic, ca. 3500–3200 BCE. Paint on plaster, entire painting 16' $4'' \times 3'$ $7\frac{8}{3}''$. Egyptian Museum, Cairo.

The oldest Egyptian mural painting depicts boats, a heraldic group of a human and animals, and a man striking prisoners.

The random arrangement of the motifs is characteristic of Neolithic painting.

1

their original appearance. The paintings formed a frieze running around three adjacent walls of the tomb and represented what seems to be, at least in part, a funerary scene with people, animals, and large boats. The stick figures and their apparently random arrangement recall the Neolithic painted hunters (FIG. 1-17) of Çatal Höyük. One black and five white boats, symbolic of the journey down the river of life and death, carry cargo of uncertain significance. The figures include a heraldic grouping of two animals flanking a human figure (at the lower left) and a man striking three prisoners with a mace (lower left corner). The heraldic group, a compositional type usually associated with Mesopotamian art (FIG. 2-10, *right*), suggests that influences from Mesopotamia not only had reached Egypt by this time but

also already had made the thousand-mile journey up the Nile. The second group, however, is characteristically Egyptian, and the motif was to have a long history in Egyptian painting and sculpture alike.

PALETTE OF KING NARMER The Predynastic period ended with the unification of Upper and Lower Egypt, which until recently scholars thought occurred during the rule of the First Dynasty pharaoh Menes, identified by many Egyptologists with King Narmer. Narmer's image and name appear on both sides of a ceremonial *palette* (stone slab with a circular depression) found at Hierakonpolis. The palette (FIG. 3-3) is one of the earliest historical (versus prehistorical) artworks preserved, but Egyptologists still debate

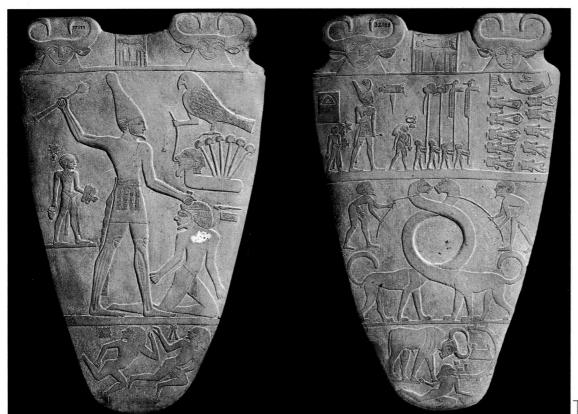

3-3 Palette of King Narmer (*left*, back; *right*, front), from Hierakonpolis, Egypt, Predynastic, ca. 3000–2920 BCE. Slate, 2' 1" high. Egyptian Museum, Cairo.

These earliest preserved labeled historical reliefs commemorate the unification of Upper and Lower Egypt. Narmer, the largest figure, effortlessly defeats a foe on one side, and on the other surveys the beheaded enemy.

1 in.

exactly what event is depicted. No longer regarded as commemorating the foundation of the first of Egypt's 31 dynasties around 2920 BCE (the last ended in 332 BCE), the reliefs probably record the unification of the two kingdoms. Scholars now believe this unification occurred over several centuries, but the palette depicts the creation of the "Kingdom of the Two Lands" as a single great event.

Narmer's palette is an elaborate, formalized version of a utilitarian object commonly used in the Predynastic period to prepare eye makeup. (Egyptians used makeup to protect their eyes against irritation and the glare of the sun.) Narmer's palette is important not only as a document marking the transition from the prehistorical to the historical period in ancient Egypt but also as a kind of early blueprint of the formula for figure representation that characterized most Egyptian art for 3,000 years. At the top of each side of the palette are two heads of a cow with a woman's face, usually identified as the goddess Hathor but sometimes as the sky goddess Bat. Between the two heads is a hieroglyph giving Narmer's name (catfish = *nar*; chisel = *mer*) within a frame representing the royal palace, making Narmer's palette the earliest existing labeled work of historical art.

On the back (FIG. 3-3, *left*) of the palette, the king, wearing the high, white, bowling-pin—shaped crown of Upper Egypt and accompanied by an official who carries his sandals, slays an enemy. The motif closely resembles the group at the lower left of the Hierakonpolis mural (FIG. 3-2) and became the standard pictorial formula signifying the inevitable triumph of the Egyptian god-kings over their enemies. Above and to the right, the falcon with human arms is Horus, the king's protector. The falcon-god takes captive a man-headed hieroglyph with a papyrus plant growing from it that stands for the land of Lower Egypt. Below the king are two fallen enemies.

On the front (FIG. 3-3, right) of the palette, the elongated necks of two felines form the circular depression that would have held eye makeup in an ordinary palette not made for display. The intertwined necks of the animals (a motif common in Mesopotamian art) may be another pictorial reference to Egypt's unification. In the uppermost register, Narmer, wearing the red crown of Lower Egypt, reviews the beheaded bodies of the enemy. The dead are seen from above, as are the bison (FIG. 1-9) lying on the ground on the ceiling of the Altamira cave. The artist depicted each body with its severed head neatly placed between its legs. By virtue of his superior rank, the king, on both sides of the palette, performs his ritual task alone and towers over his own men and the enemy. The king's superhuman strength is symbolized in the lowest band by a great bull knocking down a rebellious city whose fortress walls also are seen in an "aerial view." Specific historical narrative was not the artist's goal in this work. What was important was the characterization of the king as supreme, isolated from and larger than all ordinary men and solely responsible for the triumph over the enemy. Here, at the very beginning of Egyptian history, is evidence of the state policy that established the pharaoh as a divine ruler.

The artist's portrayal of Narmer on both sides of the palette combines profile views of his head, legs, and arms with front views of his eye and torso—the same composite view of the human figure found in Mesopotamian art and even some Stone Age paintings. Although the proportions of the human figure changed, this composite representation of the body's parts became standard in Egyptian art as well. In the Hierakonpolis painting (FIG. 3-2), the artist scattered the figures across the wall more or less haphazardly. On Narmer's palette, the sculptor subdivided the surface into registers and inserted the pictorial elements into their organized setting in a

neat and orderly way. The horizontal lines separating the narratives also define the ground supporting the figures. This too was the preferred mode for narrative art in the ancient Near East. Narmer's palette established it as the norm in Egyptian art for millennia. Egyptian artists who departed from this compositional scheme did so deliberately, usually to express the absence of order, as in a chaotic battle scene (FIG. 3-35).

Architecture

Narmer's palette is exceptional among surviving Egyptian artworks because it is commemorative rather than funerary in nature. Far more typical is the Predynastic mural from Hierakonpolis. In fact, Egyptian tombs provide the principal, if not the exclusive, evidence for the historical reconstruction of Egyptian civilization. The majority of monuments the Egyptians left behind were dedicated to ensuring safety and happiness in the next life (see "Mummification and Immortality," page 57).

The standard tomb type in early Egypt was the *mastaba* (FIG. 3-4). The mastaba (Arabic for "bench") was a rectangular brick or stone structure with sloping sides erected over an underground burial chamber. The form probably developed from earthen mounds that had covered even earlier tombs. Although mastabas originally housed single burials, as in FIG. 3-4, they later accommodated multiple family burials and became increasingly complex. The main feature of the tomb, other than the burial chamber itself, was the

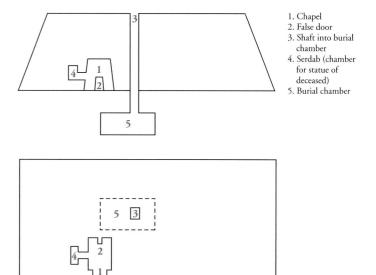

3-4 Section (*top*), plan (*center*), and restored view (*bottom*) of typical Egyptian mastaba tombs.

The standard early Egyptian tomb had an underground burial chamber and rooms to house a portrait statue and offerings to the deceased. Scenes of daily life often decorated the interior walls.

Mummification and Immortality

The Egyptians did not make the sharp distinction between body and soul that is basic to many religions. Rather, they believed that from birth a person was accompanied by a kind of other self, the ka (life force), which, on the death of the body, could inhabit the corpse and live on. For the ka to live securely, however, the body had to remain as nearly intact as possible. To ensure that it did, the Egyptians developed the technique of embalming (mummification) to a high art. Although the Egyptians believed that the god Anubis invented embalming to preserve the body of the murdered Osiris (see "The Gods and Goddesses of Egypt," page 54), they did not practice mummification systematically until the Fourth Dynasty.

The first step in the 70-day process was the surgical removal of the lungs, liver, stomach, and intestines through an incision in the left flank. The Egyptians thought these organs were most subject to decay. The organs were individually wrapped and placed in four containers known as *canopic jars* for eventual deposit in the burial chamber with the corpse. (The jars take their name from the Egyptian port of Canopus, where human-headed jars were worshiped as personifications of Osiris. These jars were not, however, used in embalming.) The brain was extracted through the nostrils and discarded. The Egyptians did not attach any special significance to the brain. But they left in place the heart, necessary for life and regarded as the seat of intelligence.

Next, the body was treated for 40 days with natron, a naturally occurring salt compound that dehydrated the body. Then the corpse was filled with resin-soaked linens, and the embalming incision was closed and covered with a representation of the *wedjat* eye of Horus, a powerful *amulet* (a device to ward off evil and promote rebirth). Finally, the body was treated with lotions and resins and then wrapped tightly with hundreds of yards of linen bandages to maintain its shape. The Egyptians often placed other amulets within the bandages or on the corpse. The most important were heart *scarabs* (gems in the shape of beetles). Spells written on them ensured that the heart would be returned to its owner if it were ever lost. A scroll copy of the *Book of the Dead* (FIG. 3-36) frequently was placed between the legs of the deceased. It contained some 200 spells intended to protect the mummy and the ka in the afterlife. The mummies of the wealthy had their faces covered with funerary masks (FIG. 3-1).

The Egyptian practice of mummification endured for thousands of years, even under Greek and Roman rule. Roman mummies with painted portraits (FIG. 10-62) dating to the first three centuries CE have long been known, but the discovery in 1996 of a cemetery at Bahariya Oasis in the desert southwest of Cairo greatly expanded their number. The site—at least four square miles in size—has come to be called the Valley of the Golden Mummies. The largest tomb found to date contained 32 mummies, but another held 43, some stacked on top of others because the tomb housed several generations of Egyptians and space ran out.

The care with which the Egyptians laid the dead to rest in the Bahariya cemetery varied markedly with the social position and wealth of the deceased. The bodies of the poorer members of the community were carelessly wrapped in linen and have almost completely decayed. The 60 most elaborate mummies, probably those of successful merchants and their families, have gilded *stucco* masks. Some also have gilded chest plates with reliefs depicting Egyptian deities, including Thoth holding Maat's feather (compare the weighing scene in FIG. 3-36). Others have painted decoration, and some have eyes of white marble with black obsidian irises and copper eyelashes. The excavators believe the cemetery was still in use as late as the fourth or fifth century CE.

Preserving the deceased's body by mummification was only the first requirement for immortality in ancient Egypt. Food and drink also had to be provided, as did clothing, utensils, and furniture. Nothing that had been enjoyed on earth was to be lacking. Statuettes called *ushabtis* (answerers) also were placed in the tomb. These figurines performed any labor required of the deceased in the afterlife, answering whenever his or her name was called.

Beginning in the third millennium BCE, the Egyptians also set up statues of the dead in their tombs. The statues were meant to guarantee the permanence of the person's identity by providing substitute dwelling places for the ka in case the mummy disintegrated. Wall paintings and reliefs recorded the recurring round of human activities. The Egyptians hoped and expected that the images and inventory of life, collected within the protective stone walls of the tomb, would ensure immortality.

chapel, which had a false door through which the ka could join the world of the living and partake in the meals placed on an offering table. Some mastabas also had a *serdab*, a small room housing a statue of the deceased.

IMHOTEP AND DJOSER One of the most renowned figures in Egyptian history is IMHOTEP, the builder for King Djoser (r. 2630–2611 BCE) of the Third Dynasty. Imhotep was a man of legendary talent who served also as the pharaoh's chancellor and high priest of the sun god. After his death, the Egyptians revered Imhotep as a god and in time may have inflated the list of his achievements, but his is the first recorded name of an artist in history.

The historian Manetho states that Imhotep designed the Stepped Pyramid of Djoser at Saqqara, the ancient *necropolis* (Greek for "city of

the dead") for Memphis, Egypt's capital at the time. Built before 2600 BCE, the pyramid (FIG. 3-5) is one of the oldest stone structures in Egypt and, in its final form, the first truly grandiose royal tomb. Begun as a large mastaba with each of its faces oriented toward one of the cardinal points of the compass, the tomb was enlarged at least twice before taking on its ultimate shape. About 200 feet high, the Stepped Pyramid seems to be composed of a series of mastabas of diminishing size, stacked one atop another to form a structure that resembles the great Mesopotamian ziggurats (FIGS. 2-15 and 2-20, top center). Unlike the ziggurats, however, Djoser's pyramid is a tomb, not a temple platform, and its dual function was to protect the mummified king and his possessions and to symbolize, by its gigantic presence, his absolute and godlike power. Beneath the pyramid was a network of several hundred underground rooms and galleries cut out of the Saqqara

3-5 IMHOTEP, Stepped Pyramid and mortuary precinct of Djoser, Saqqara, Egypt, Third Dynasty, ca. 2630–2611 BCE.

Imhotep, the first artist whose name is recorded, built the first pyramid during the Third Dynasty for King Djoser. Djoser's pyramid resembles a series of stacked mastabas of diminishing size.

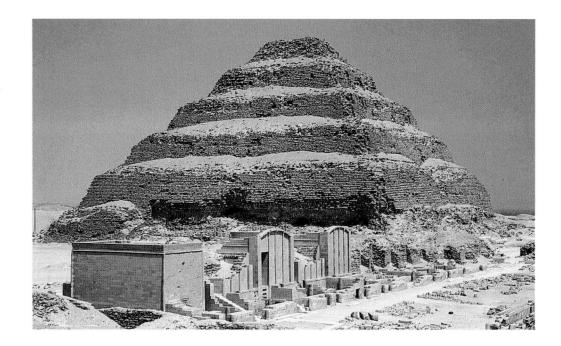

3-6 Plan (*top*) and restored view (*bottom*) of the mortuary precinct of Djoser, Saqqara, Egypt, Third Dynasty, ca. 2630–2611 BCE.

Djoser's pyramid was the centerpiece of an immense funerary complex that included a mortuary temple, other buildings, and courtyards. Its network of underground galleries resembled a palace.

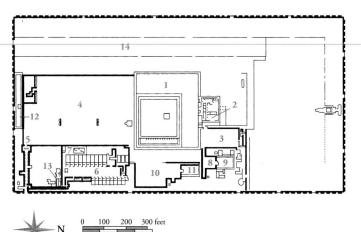

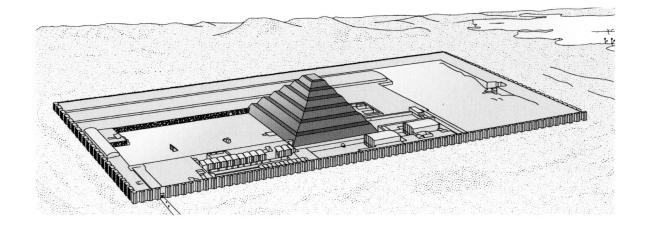

 bedrock. The vast subterranean complex resembles a palace. It was to be Djoser's new home in the afterlife.

Befitting the god-king's majesty, Djoser's pyramid (FIG. 3-5) stands near the center of an immense (37-acre) rectangular enclosure (FIG. 3-6) surrounded by a 34-foot-high and 5,400-foot-long wall of white limestone. The huge precinct, with its protective walls and tightly regulated access, stands in sharp contrast to the roughly contemporary Sumerian Royal Cemetery at Ur, where no barriers kept people away from the burial area. Nor did the Mesopotamian cemetery have a temple for the worship of the deified dead. At

Saqqara, a funerary temple (FIG. **3-6**, no. 2) stands against the northern face of Djoser's pyramid. Priests performed daily rituals at the temple in celebration of the divine pharaoh.

Stepped pyramid
 Funerary temple of Djoser

3. Court with serdab

7. Small temple

9. North Palace 10. Court before South Palace

11. South Palace

12. South tomb13. Royal Pavilion14. Magazines

4. Large court with altar5. Entrance portico

6. Heb-Sed court and sham chapels

8. Court before North Palace

Djoser's funerary temple was but one of many buildings arranged around several courts. Most of the others were dummy structures (FIG. 3-6, no. 6) with stone walls enclosing fills of rubble, sand, or gravel. The buildings imitated in stone masonry various types of temporary structures made of plant stems and mats erected in Upper and Lower Egypt to celebrate the Jubilee Festival, which perpetually reaffirmed the royal existence in the hereafter. The trans-

3-7 Detail of the facade of the North Palace of the mortuary precinct of Djoser, Saqqara, Egypt, Third Dynasty, ca. 2630–2611 BCE.

The earliest known stone columns are in Djoser's funerary precinct. Those on the North Palace facade are engaged (attached) to the walls and have shafts and capitals resembling papyrus stalks and blossoms.

lation into stone of structural forms previously made out of plants may be seen in the *columns* (FIG. 3-7) of the North Palace (FIG. 3-6, no. 9) of Djoser's funerary precinct. The columns end in *capitals* ("heads") that take the form of the papyrus blossoms of Lower Egypt. The column *shafts* resemble papyrus stalks. Djoser's columns are not freestanding, as are most later columns. They are *engaged* (attached) to walls, but are nonetheless the earliest known stone columns in the history of architecture.

THE OLD KINGDOM

The Old Kingdom is the first of the three great periods of Egyptian history, called the Old, Middle, and New Kingdoms, respectively. Many Egyptologists now begin the Old Kingdom with the first pharaoh of the Fourth Dynasty, Sneferu (r. 2575–2551 BCE), although the traditional division of kingdoms places Djoser and the Third Dynasty in the Old Kingdom. It ended with the demise of the Eighth Dynasty around 2134 BCE.

Architecture

The pharaohs of the Old Kingdom amassed great wealth and expended it on grandiose architectural projects, of which the most spectacular were the Great Pyramids of Gizeh, the oldest of the Seven Wonders of the ancient world (see "Babylon, City of Wonders," Chapter 2, page 48). The prerequisites for membership in this elite club were colossal size and enormous cost.

GREAT PYRAMIDS, GIZEH The three pyramids (FIGS. 3-8 and 3-9) of Gizeh were built in the course of about 75 years (see "Building the Great Pyramids," page 60) as the tombs of the

Fourth Dynasty pharaohs Khufu (r. 2551–2528 BCE), Khafre (r. 2520–2494 BCE), and Menkaure (r. 2490–2472 BCE). They represent the culmination of an architectural evolution that began with the mastaba, but the classic pyramid form is not simply a refinement of the stepped pyramid. The new tomb shape probably reflects the influence of Heliopolis, the seat of the powerful cult of Re, whose emblem was a pyramidal stone, the *ben-ben* (see "The Gods and

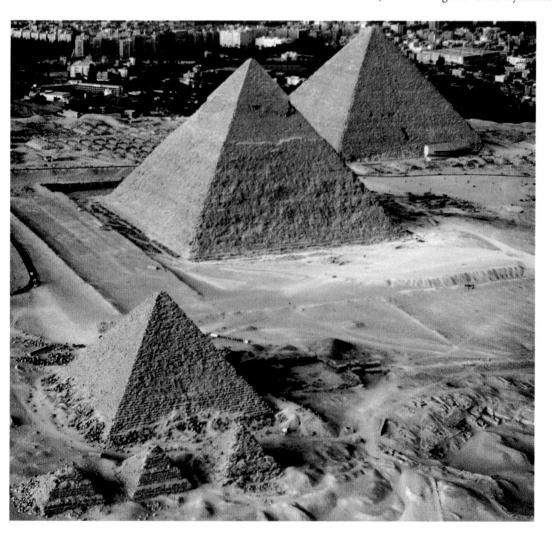

3-8 Great Pyramids, Gizeh, Egypt, Fourth Dynasty. *From bottom:* Pyramids of Menkaure, ca. 2490–2472 BCE; Khafre, ca. 2520–2494 BCE; and Khufu, ca. 2551–2528 BCE.

The Great Pyramids of Gizeh took the shape of the ben-ben, the emblem of the sun, Re. The sun's rays were the ramp the Egyptian pharaohs used to ascend to the heavens after their death and rebirth.

Building the Great Pyramids

he Great Pyramids (FIG. 3-8) across the Nile from modern Cairo attest to the extraordinary engineering and mathematical expertise of the Egyptians of the mid-third millennium BCE. They also are testaments to the Old Kingdom builders' mastery of stone masonry and ability to mobilize, direct, house, and feed a huge workforce engaged in one of the most labor-intensive enterprises ever undertaken. Like all building projects of this type, the process of erecting the pyramids began with the quarrying of stone, in this case primarily the limestone of the Gizeh plateau itself. Teams of skilled workers had to cut into the rock and remove large blocks of roughly equal size using stone or copper chisels and wooden mallets and wedges. Often, the artisans had to cut deep tunnels to find high-quality stone free of cracks and other flaws. To remove a block, the workers cut channels on all sides and partly underneath. Then they pried the stones free from the bedrock with wooden levers.

After workers liberated the stones, the rough blocks had to be transported to the building site and dressed (shaped to the exact dimensions required, with smooth faces for a perfect fit). Small blocks could be carried on a man's shoulders or on the back of a donkey, but the massive blocks used to construct the Great Pyramids were moved using wooden rollers and sleds. The artisans dressed the blocks by chiseling and pounding the surfaces and, in the last stage, by rubbing and grinding the surfaces with fine polishing stones. This kind of construction, in which carefully cut and regularly shaped blocks of stone are piled in successive rows, or courses, is called ashlar masonry.

To set the ashlar blocks in place, workers erected great rubble ramps against the core of the pyramid. Their size and slope were adjusted as work progressed and the tomb grew in height. Scholars debate whether the Egyptians used simple linear ramps inclined at a right angle to one face of the pyramid or zigzag or spiral ramps akin to staircases. Linear ramps would have had the advantage of simplicity and would have left three sides of the pyramid unobstructed. But zigzag ramps placed against one side of the structure or spiral ramps winding around the pyramid would have greatly reduced the slope of the incline and would have made the dragging of the blocks easier. Some scholars also have suggested a combination of straight and spiral ramps.

The Egyptians used ropes, pulleys, and levers both to lift and to lower the stones, guiding each block into its designated place. Finally, the pyramid received a casing of white limestone blocks (FIG. 3-9, no. 1), cut so precisely that the eye could scarcely detect the joints. The reflection of sunlight on the facing would have been dazzling,

underscoring the pyramid's solar symbolism. A few casing stones still can be seen in the cap that covers the Pyramid of Khafre (FIGS. 3-8, center, and 3-11, left).

Of the three Fourth Dynasty pyramids at Gizeh, the tomb of Khufu (FIGS. 3-9 and 3-10, no. 7) is the oldest and largest. Except for the galleries and burial chamber, it is an almost solid mass of limestone masonry. Some dimensions will suggest the immensity of the Gizeh pyramids: At the base, the length of one side of Khufu's tomb is approximately 775 feet, and its area is some 13 acres. Its present height is about 450 feet (originally 480 feet). The structure contains roughly 2.3 million blocks of stone, each weighing an average of 2.5 tons. Some of the stones at the base weigh about 15 tons. Napoleon's scholars calculated that the blocks in the three Great Pyramids were sufficient to build a wall 1 foot wide and 10 feet high around France.

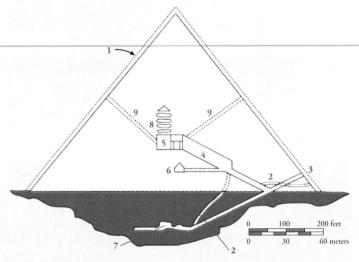

- 1. Silhouette with original facing stone
- 2. Thieves' tunnels
- 3. Entrance
- 4. Grand gallery
- 5. King's chamber

- 6. So-called Queen's chamber
- 7. False tomb chamber
- 8. Relieving blocks
- 9 Airshafts(?)

3-9 Section of the Pyramid of Khufu, Gizeh, Egypt, Fourth Dynasty, са. 2551-2528 все.

Khufu's pyramid is the largest at Gizeh. Constructed of roughly 2.3 million blocks of stone weighing an average of 2.5 tons, the structure is an almost solid mass of stone quarried from the Gizeh plateau itself.

Goddesses of Egypt," page 54). The Great Pyramids are symbols of the sun. The Pyramid Texts, inscribed on the burial chamber walls of many royal tombs beginning with the Fifth Dynasty Pyramid of Unas (r. 2356–2323 BCE), refer to the sun's rays as the ramp the pharaoh uses to ascend to the heavens. Djoser's Stepped Pyramid (FIG. 3-5) may also have been conceived as a giant stairway. The pyramids were where Egyptian kings were reborn in the afterlife, just as the sun is reborn each day at dawn. As with Djoser's pyramid, the four sides of each of the Great Pyramids are oriented to the cardinal points of the compass. But the funerary temples associated with the three Gizeh pyramids are not placed on the north side, facing

the stars of the northern sky, as was Djoser's temple. The temples sit on the east side, facing the rising sun and underscoring their connection with Re.

From the remains surrounding the Pyramid of Khafre at Gizeh, archaeologists have been able to reconstruct an entire funerary complex (FIG. 3-10). The complex included the pyramid itself with the pharaoh's burial chamber; the mortuary temple adjoining the pyramid on the east side, where offerings were made to the dead king, ceremonies performed, and cloth, food, and ceremonial vessels stored; the roofed causeway leading to the mortuary temple; and the valley temple at the edge of the floodplain. According to one theory,

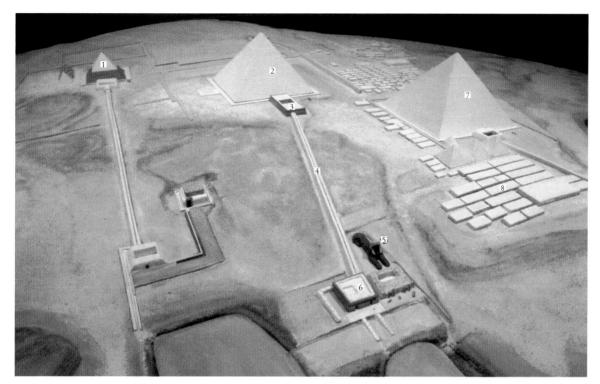

3-10 Model of the Fourth Dynasty pyramid complex, Gizeh, Egypt. Harvard University Semitic Museum, Cambridge. 1) Pyramid of Menkaure, 2) Pyramid of Khafre, 3) mortuary temple of Khafre, 4) causeway, 5) Great Sphinx, 6) valley temple of Khafre, 7) Pyramid of Khufu, 8) pyramids of the royal family and mastabas of nobles.

Like Djoser's pyramid (FIG. 3-5), the Great Pyramids were not isolated tombs but parts of funerary complexes with a valley temple, a covered causeway, and a mortuary temple adjoining the pyramid.

3-11 Great Sphinx (with Pyramid of Khafre in the background at left), Gizeh, Egypt, Fourth Dynasty, ca. 2520–2494 BCE. Sandstone, 65' × 240'.

Carved out of the Gizeh stone quarry, the Great Sphinx is the largest statue in the Near East. The sphinx is associated with the sun god, and joins the body of a lion with the head of a pharaoh.

the complex served not only as the king's tomb and temple but also as his palace in the afterlife.

GREAT SPHINX Beside the causeway and dominating the valley temple of Khafre rises the Great Sphinx (FIG. 3-11). Carved from a spur of rock in an ancient quarry, the colossal statue—the largest in the ancient Near East—represents a pharaoh, probably Khafre (origi-

nally complete with the pharaoh's ceremonial beard and uraeus head-dress), although some scholars believe it portrays Khufu and was carved before construction of Khafre's complex began. Whoever it portrays, the *sphinx*—a lion with a human head—was associated with the sun god and therefore was an appropriate image for a pharaoh. The composite form suggests that the pharaoh combines human intelligence with the immense strength and authority of the king of beasts.

Sculpture

Old Kingdom statues survive in significant numbers because they fulfilled an important function in Egyptian tombs as substitute abodes for the ka (see "Mummification and Immortality," page 57). Although Egyptian sculptors used wood, clay, and other materials, mostly for images of those not of the royal or noble classes, the primary material for funerary statuary was stone.

KHAFRE ENTHRONED The seated statue of Khafre (FIG. 3-12) is one of a series of similar statues carved for the pharaoh's valley temple (FIG. 3-10, no. 6) near the Great Sphinx. The stone is diorite, an exceptionally hard dark stone brought some 400 miles down the Nile from royal quarries in the south. (The Neo-Sumerian ruler Gudea, FIG. 2-16, so admired diorite that he imported it to faraway Girsu.) Khafre wears a simple kilt and sits rigidly upright on a throne formed of two stylized lions' bodies. Intertwined lotus and papyrus plants—symbolic of the united Egypt—appear between the throne's legs. The falcon-god Horus extends his protective wings to shelter the pharaoh's head. Khafre has the royal false beard fastened to his chin and wears the royal linen nemes headdress with the uraeus cobra of kingship on the front. The headdress covers his forehead and falls in pleated folds over his shoulders. (The head of the Great Sphinx is similarly attired.) As befitting a divine ruler, the sculptor portrayed Khafre with a well-developed, flawless body and a perfect face, regardless of his actual age and appearance. The Egyptians considered ideal proportions appropriate for representing their godkings, and the statue of Khafre is not a true portrait and was not intended to be. The purpose of pharaonic portraiture was not to record individual features or the distinctive shapes of bodies, but rather to proclaim the divine nature of Egyptian kingship.

The enthroned Khafre radiates serenity. The sculptor created this effect, common to Egyptian royal statues, in part by giving the

3-12 Khafre enthroned, from Gizeh, Egypt, Fourth Dynasty, ca. 2520-2494 BCE. Diorite, 5' 6" high. Egyptian Museum, Cairo.

This portrait from his pyramid complex depicts Khafre as an enthroned divine ruler with a perfect body. The rigidity of the pose creates the effect of eternal stillness, appropriate for the timeless afterlife.

3-13 Menkaure and Khamerernebty(?), from Gizeh, Egypt, Fourth Dynasty, ca. 2490–2472 BCE. Graywacke, 4' $6\frac{1}{2}$ " high. Museum of Fine Arts, Boston.

The double portrait of Menkaure and his wife displays the conventional postures used for statues designed as substitute homes for the ka. The frozen gestures signify that the man and woman are married.

figure great compactness and solidity, with few projecting, breakable parts. The form manifests the purpose: to last for eternity. Khafre's body is one with the unarticulated slab that forms the back of the king's throne. His arms are held close to the torso and thighs, and his legs are close together. Part of the original stone block still connects the king's legs to his chair. Khafre's pose is frontal, rigid, and *bilaterally symmetrical* (the same on either side of an axis, in this case the vertical axis). The sculptor suppressed all movement and with it the notion of time, creating an eternal stillness.

To produce the statue, the artist first drew the front, back, and two profile views of the pharaoh on the four vertical faces of the stone block. Next, apprentices chiseled away the excess stone on each side, working inward until the planes met at right angles. Finally, the master sculpted the parts of Khafre's body, the falcon, and so forth. The finishing was done by *abrasion* (rubbing or grinding the surface). This *subtractive* method of creating the pharaoh's portrait accounts in large part for the blocklike look of the standard Egyptian statue. Nevertheless, other sculptors, both ancient and modern, with different aims, have transformed stone blocks into dynamic, twisting human forms (for example, FIGS. I-16 and 5-84).

MENKAURE AND KHAMERERNEBTY The seated statue is one of only a small number of basic formulaic types that Old Kingdom sculptors employed to represent the human figure. Another is the image of a person or deity standing, either alone or in a group, for example the double portrait (FIG. 3-13) of Menkaure and one of his wives, probably Khamerernebty. The statue once stood in the valley temple of Menkaure's pyramid complex at Gizeh. Here, too, the figures remain wedded to the stone block from which they were carved. In fact, the statue could be classified as a high-relief sculpture. Menkaure's pose, which is duplicated in countless other Egyptian statues, is rigidly frontal with the arms hanging straight down and close to his well-built body. His hands are clenched into fists with the thumbs forward. His left leg is slightly advanced, but no shift occurs in the angle of the hips to correspond to the uneven distribution of weight. Khamerernebty stands in a similar position. Her right arm, however, encircles the king's waist, and her left hand gently rests on his left arm. This frozen stereotypical gesture indicates their marital status. The husband and wife show no other sign of affection or emotion and look not at each other but out into space. The artist's aim was not to portray living figures, but to suggest the timeless nature of the stone statue

timeless nature of the stone statue that was designed to provide an eternal substitute home for the ka.

SEATED SCRIBE Traces of paint remain on the portraits of Menkaure and Khamerernebty. Most Egyptian statues were painted, although sometimes the stone was left its natural color, enhancing the sense of abstraction and timelessness. A striking example of painted statuary is the seated portrait (FIG. 3-14) of a Fourth Dynasty scribe found at Saqqara. Despite the stiff upright posture and the frontality of head and body, the color lends a lifelike quality to the stone statue. The head displays an extraordinary sensitivity. The sculptor conveyed the personality of a sharply intelligent and alert individual with a penetration and sympathy seldom achieved at this early date. The scribe sits directly on the ground, not on a throne or even on a chair. Although he occupied

3-14 Seated scribe, from Saqqara, Egypt, Fourth Dynasty, ca. 2500 BCE. Painted limestone, 1' 9" high. Louvre, Paris.

The idealism that characterizes the portraiture of the Egyptian godkings did not extend to the portrayal of non-elite individuals. This more realistic painted portrait of a scribe shows clear signs of aging.

a position of honor in a largely illiterate society, the scribe was a much lower figure in the Egyptian hierarchy than the pharaoh, whose divinity made him superhuman. In the history of art, especially portraiture, it is almost a rule that as a human subject's importance decreases, formality is relaxed and realism is increased. It is telling that the sculptor portrayed the scribe with sagging chest muscles and a protruding belly. These signs of age would have been disrespectful and wholly inappropriate in a depiction of an Egyptian god-king. But the statue of the scribe is not a true portrait either. Rather, it is a composite of conventional types. Obesity, for example, characterizes many nonroyal Old Kingdom portraits, perhaps because it attested to the comfortable life of the person represented and his relatively high position in society.

TOMB OF TI, SAQQARA In Old Kingdom tombs, images of the deceased also frequently appear in relief sculpture and in mural painting, sometimes alone (FIG. I-14) and sometimes in a narrative context. The painted limestone relief scenes that decorate the walls of the mastaba of a Fifth Dynasty official named Ti typify the subjects Old Kingdom patrons favored for the adornment of their final resting places. Depictions of agriculture and hunting fill Ti's tomb. These activities were associated with the provisioning of the ka in the hereafter, but they also had powerful symbolic overtones. In ancient Egypt, success in the hunt, for example, was a metaphor for triumph over the forces of evil.

On one wall (FIG. 3-15), Ti, his men, and his boats move slowly through the marshes, hunting hippopotami and birds in a dense growth of towering papyrus. The sculptor delineated the reedy stems of the plants with repeated fine grooves that fan out gracefully at the top into a commotion of frightened birds and stalking foxes. The water beneath the boats, signified by a pattern of wavy lines, is crowded with hippopotami and fish. Ti's men seem frantically busy with their spears, while Ti, depicted twice their size, stands aloof. The basic conventions of Egyptian figure representation used a half millennium earlier for the palette of King Narmer (FIG. 3-3) are seen again here. As on the Predynastic palette, the artist exaggerated the size of Ti to announce his rank, and combined frontal and profile views of Ti's body to show its most characteristic parts clearly. This approach to representation was well suited for Egyptian funerary art because it emphasized the essential nature of the deceased, not his accidental appearance. Ti's conventional pose contrasts with the realistically rendered activities of his tiny servants and with the naturalistically carved and painted birds and animals among the papyrus buds. Ti's immobility suggests that he is not an actor in the hunt. He does not do anything. He simply is, a figure apart from time and an impassive observer of life, like his ka.

The idealized and stiff image of Ti is typical of Egyptian relief sculpture. Egyptian artists regularly ignored the endless variations in body types of real human beings. Painters and sculptors did not sketch their subjects from life but applied a strict *canon*, or system of proportions, to the human figure. They first drew a grid on the wall. Then they placed various human body parts at specific points on the network of squares. The height of a figure, for example, was a fixed number of squares, and the head, shoulders, waist, knees, and other parts of the body also had a predetermined size and place within the scheme. This approach to design lasted for thousands of years. Specific proportions might vary from workshop to workshop and change over time, but the principle of the canon persisted.

On another wall (FIG. 3-16) of Ti's mastaba, the artist represented in two registers goats treading in seeds and cattle fording a canal in the Nile. Once again, the scenes may be interpreted on

3-15 Ti watching a hippopotamus hunt, relief in the mastaba of Ti, Saqqara, Egypt, Fifth Dynasty, ca. 2450–2350 BCE. Painted limestone, 4' high.

In Egypt, a successful hunt was a metaphor for triumph over evil. In this painted tomb relief, the deceased stands aloof from the hunters busily spearing hippopotami. Ti's size reflects his high rank.

a symbolic as well as a literal level. The fording of the Nile, for example, was a metaphor for the deceased's passage from life to the hereafter. Ti is absent from the scenes, and all the men and animals participate in the narrative. Despite the sculptor's repeated use of similar poses for most of the human and animal figures, the reliefs are full of anecdotal details. Especially charming is the group at the lower right. A youth, depicted in a complex unconventional posture, carries a calf on his back. The animal, not a little afraid, turns its head back a full 180 degrees (compare FIG. 1-8) to seek reassurance from its mother, who returns the calf's gaze. Scenes such as this demonstrate that Egyptian artists could be close observers of daily life. The suppression of the anecdotal (that is, of the timebound) from their representations of the deceased both in relief and in the round was a deliberate choice. Their primary purpose was to suggest the deceased's eternal existence in the afterlife, not to portray nature.

THE MIDDLE KINGDOM

About 2150 BCE, the Egyptians challenged the pharaohs' power, and for more than a century the land was in a state of civil unrest and near anarchy. But in 2040 BCE, the pharaoh of Upper Egypt, Mentuhotep II (r. 2050–1998 BCE), managed to unite Egypt again under the rule of a single king and established the so-called Middle Kingdom (11th to 14th Dynasties).

3-16 Goats treading seed and cattle fording a canal, reliefs in the mastaba of Ti, Saqqara, Egypt, Fifth Dynasty, ca. 2450–2350 BCE. Painted limestone.

The fording of the Nile was a metaphor for the passage to the afterlife. These reliefs combine stereotypical poses for humans and animals with unconventional postures and anecdotal details.

Sculpture

Although in most respects Middle Kingdom sculptors adhered to the conventions established during the Old Kingdom, there were some notable innovations.

SENUSRET III One of Mentuhotep II's successors was Senusret III (r. 1878–1859 BCE), who fought four brutal military campaigns in Nubia (MAP 3-1). Although Egyptian armies devastated the land and poisoned the wells, Senusret III never fully achieved secure control over the Nubians. In Egypt itself, he attempted, with greater success, to establish a more powerful central government. His portraits (FIG. 3-17) are of special interest because they represent a sharp break from Old Kingdom practice. Although the king's preserved statues have idealized bodies, the sculptors brought a stunning and unprecedented realism to the rendition of Senusret III's features. His pessimistic expression reflects the dominant mood of the time and is

echoed in Middle Kingdom literature. The strong mouth, the drooping lines about the nose and eyes, and the shadowy brows show a determined ruler who had also shared in the cares of the world, sunk in brooding meditation. The portrait is different in kind from the typically impassive faces of the Old Kingdom. It is personal, almost intimate, in its revelation of the mark of anxiety that a troubled age might leave on the soul of a king.

3-17 Fragmentary head of Senusret III, 12th Dynasty, ca. 1860 BCE. Red quartzite, $6\frac{1}{2}$ high. Metropolitan Museum of Art, New York.

The portraits of Senusret III exhibit an unprecedented realism. The king's brooding expression reflects the dominant mood of the time and contrasts sharply with the impassive faces of Old Kingdom pharaohs.

Architecture

Senusret III's tomb, at Dashur, is a mud-brick pyramid, but the most characteristic funerary monuments of the Middle Kingdom are rock-cut tombs. These tombs, which also existed during the Old Kingdom, became especially popular during the Middle Kingdom and largely replaced the mastaba as the standard Egyptian tomb type.

BENI HASAN Some of the best-preserved Middle Kingdom tombs are at Beni Hasan. Hollowed out of the cliffs, these tombs (FIG. 3-18) often have a shallow columnar porch, which led into a

columned hall and then into a burial chamber. In the 12th Dynasty tomb of Amenemhet, the columns in the hall (FIG. 3-19) serve no supporting function because, like the porch columns, they are continuous parts of the rock fabric. (Note the broken column in the rear suspended from the ceiling like a stalactite.) The column shafts are fluted with vertical channels in a manner similar to later Greek columns, and there is no doubt that the Greeks knew about and emulated many aspects of Egyptian architecture (see Chapter 5). Archaeologists believe fluting derived from the dressing of softwood trunks with the rounded cutting edge of the adze. Fluted stone

3-18 Rock-cut tombs BH 3-5, Beni Hasan, Egypt, 12th Dynasty, ca. 1950–1900 BCE.

The tombs of Beni Hasan are characteristic of the Middle Kingdom. Hollowed out of the cliffs, these tombs often have a shallow columnar porch, which leads into a columned hall and burial chamber.

3-19 Interior hall of the rock-cut tomb of Amenemhet (tomb BH 2), Beni Hasan, Egypt, 12th Dynasty, ca. 1950–1900 BCE.

The columnar hall of Amenemhet's tomb was carved out of the living rock, which explains the suspended broken column at the rear. The shafts are fluted in a manner Greek architects later emulated.

columns are yet another case of Egyptian builders' translating perishable natural forms into permanent architecture. Artists decorated the tomb walls with paintings and painted reliefs, as in former times, and placed statues of the deceased in niches.

THE NEW KINGDOM

Like its predecessor, the Middle Kingdom disintegrated, and power passed to the Hyksos, or shepherd kings, who descended on Egypt from the Syrian and Mesopotamian uplands. They brought with them a new and influential culture and that practical animal, the horse. Their innovations in weaponry and war techniques ironically contributed to their own overthrow by native Egyptian kings of the 17th Dynasty around 1600–1550 BCE. Ahmose I (r. 1550–1525 BCE), final conqueror of the Hyksos and first king of the 18th Dynasty, ushered in the New Kingdom, the most brilliant period in Egypt's long history. At this time, Egypt extended its borders by conquest from the Euphrates River in the east deep into Nubia to the south. A new capital—Thebes, in Upper Egypt—became a great and luxurious metropolis with magnificent palaces, tombs, and temples along both banks of the Nile.

Architecture

If the most impressive monuments of the Old Kingdom are its pyramids, those of the New Kingdom are its grandiose temples, often built to honor pharaohs and queens as well as gods. Great pharaonic

mortuary temples arose along the Nile in the Thebes district. These shrines provided the rulers with a place for worshiping their patron gods during their lifetime and then served as temples in their own honor after their death. The temples were elaborate and luxuriously decorated, befitting both the pharaohs and the gods.

TEMPLE OF HATSHEPSUT The most majestic of these royal mortuary temples (FIG. 3-20), at Deir el-Bahri, honored the female pharaoh Hatshepsut, one of the most remarkable women of the ancient world (see "Hatshepsut, the Woman Who Would Be King," page 68). Some have attributed the temple to Senmut (FIG. 3-27), Hatshepsut's chancellor and possible lover, who is described in two inscriptions as royal architect. His association with this project is uncertain, however. Hatshepsut's temple rises from the valley floor in three colonnaded terraces connected by ramps on the central axis. It is remarkable how visually well suited the structure is to its natural setting. The long horizontals and verticals of the *colonnades* and their rhythm of light and dark repeat the pattern of the limestone cliffs above. The colonnade *pillars*, which are either simply rectangular or *chamfered* (beveled, or flattened at the edges) into 16 sides, are well proportioned and rhythmically spaced.

In Hatshepsut's day, the terraces were not the barren places they are now but gardens with frankincense trees and rare plants the pharaoh brought from the faraway "land of Punt" on the Red Sea. Her expedition to Punt figures prominently in the poorly preserved

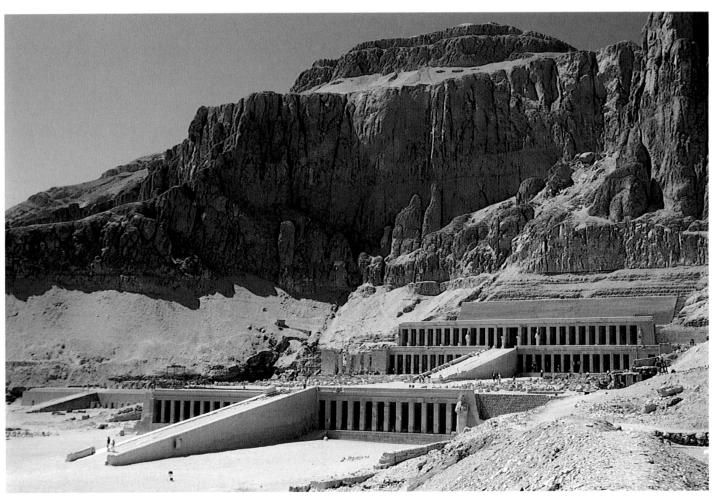

3-20 Mortuary temple of Hatshepsut (with the Middle Kingdom mortuary temple of Mentuhotep II at left), Deir el-Bahri, Egypt, 18th Dynasty, ca. 1473–1458 BCE.

Hatshepsut was the first great female monarch whose name is recorded. Painted reliefs recounting her divine birth and significant achievements adorned her immense funerary temple.

Hatshepsut, the Woman Who Would Be King

n 1479 BCE, Thutmose II, the fourth pharaoh of the 18th Dynasty (r. 1492–1479 BCE), died. His principal wife (and half sister), Queen Hatshepsut (r. 1473–1458 BCE), had not given birth to any sons who survived, so the title of king went to Thutmose III, son of Thutmose II by a minor wife. Hatshepsut was named regent for the boy-king. Within a few years, however, the queen proclaimed herself pharaoh and insisted that her father Thutmose I had actually chosen her as his successor during his lifetime. Underscoring her claim, one of the reliefs decorating Hatshepsut's enormous funerary complex (FIG. 3-20) depicts Thutmose I crowning his daughter as king in the presence of the Egyptian gods. Hatshepsut is the first great female monarch whose name has been recorded. (In the 12th Dynasty, Sobekneferu was crowned king of Egypt, but she reigned as pharaoh for only a few years.) Hatshepsut boasted of having made the "Two Lands to labor with bowed back" for her, and for two decades she ruled what was then the most powerful and prosperous empire in

Hatshepsut commissioned numerous building projects, and sculptors produced portraits of the female pharaoh in great numbers for display in those complexes. Unfortunately, Thutmose III (r. 1458–1425 BCE), for reasons still not fully understood, late in his reign ordered Hatshepsut's portraits destroyed. In her surviving portraits, Hatshepsut uniformly wears the costume of the male pharaohs, with royal headdress and kilt, and in some cases (FIG. 3-21) even a false ceremonial beard. Many inscriptions refer to Hatshepsut as "*His* Majesty"! In other statues, however, Hatshepsut has delicate features, a slender frame, and breasts, leaving no doubt that artists also represented her as a woman.

3-21 Hatshepsut with offering jars, from the upper court of her mortuary temple, Deir el-Bahri, Egypt, 18th Dynasty, ca. 1473–1458 BCE. Red granite, 8' 6" high. Metropolitan Museum of Art, New York.

Many of Hatshepsut's portraits were destroyed after her death. Conservators reassembled this one, which depicts the queen as a male pharaoh with false beard, consistent with inscriptions calling her "His Maiesty."

1 ft

but once brightly painted low reliefs that cover many walls of the complex. In addition to representing great deeds, the reliefs also show Hatshepsut's coronation and divine birth. She was said to be the daughter of the god Amen-Re, whose sanctuary was situated on the temple's uppermost level. The painted reliefs of Hatshepsut's mortuary temple constituted the first great tribute to a woman's achievements in the history of art. Their defacement after her death is therefore especially unfortunate.

HATSHEPSUT'S PORTRAITS As many as 200 statues in the round depicting Hatshepsut in various guises complemented the extensive relief program. On the lowest terrace, to either side of the processional way, Hatshepsut repeatedly appeared as a sphinx. On the uppermost level, sculptors represented the female pharaoh standing or seated or in the form of a mummy. At least eight colossal kneeling statues in red granite lined the way to the entrance of the Amen-Re sanctuary.

The statue in FIG. 3-21 suffered the same fate as most of Hatshepsut's portraits during the reign of Thutmose III. It was smashed and the pieces were thrown in a dump, but the portrait has been skillfully reassembled. Hatshepsut holds a globular offering jar in each hand as she takes part in a ritual in honor of the sun god. (A king kneeled only before a god, never a mortal.) She wears the royal male nemes headdress (compare FIGS. 3-11 to 3-13) and the pharaoh's ceremonial beard. The agents of Thutmose III hacked off

the uraeus cobra that once adorned the front of the headdress. The figure is also anatomically male, although other surviving portraits of Hatshepsut represent her with a woman's breasts. The male imagery is, however, consistent with the queen's formal assumption of the title of king and with the many inscriptions that address her as a man.

TEMPLE OF RAMSES II The sheer size of Hatshepsut's mortuary temple never fails to impress visitors, and this is no less true of the immense rock-cut temple (FIG. 3-22) of Ramses II (r. 1290-1224 BCE) at Abu Simbel. In 1968, engineers moved the immense Nubian temple nearly 700 feet—an amazing feat in its own right to save it from submersion in the Aswan High Dam reservoir. Ramses was Egypt's last great warrior pharaoh, and he ruled for twothirds of a century, an extraordinary accomplishment in an era when life expectancy was far less than it is today. The pharaoh, proud of his many campaigns to restore the empire, proclaimed his greatness by placing four colossal images of himself on the temple facade. The portraits are almost eight times as large as Hatshepsut's kneeling statues and, at 65 feet tall, almost a dozen times the height of an ancient Egyptian, even though the pharaoh is seated. Spectacular as they are, the rock-cut statues nonetheless lack the refinement of earlier periods, because much was sacrificed to overwhelming size. This is a characteristic of colossal statuary of every period and every place.

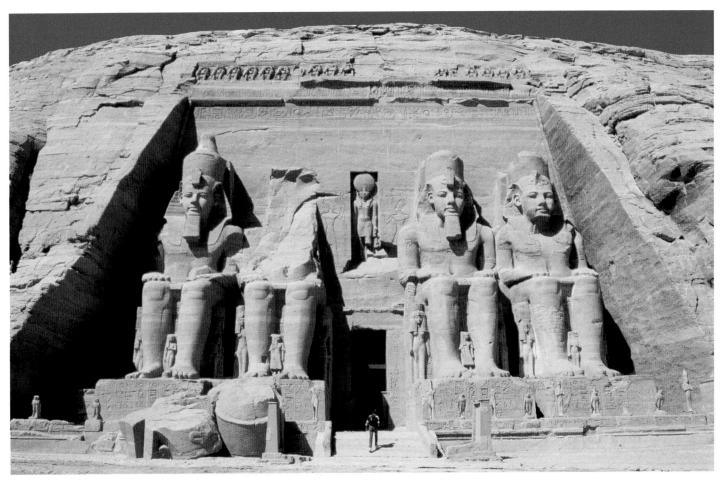

3-22 Temple of Ramses II, Abu Simbel, Egypt, 19th Dynasty, ca. 1290–1224 BCE. Sandstone, colossi 65′ high.

Four rock-cut images of Ramses II dominate the facade of his mortuary temple at Abu Simbel in Nubia. The colossal portraits are a dozen times the height of a man, even though the pharaoh is seated.

The rock-cut interior (FIG. 3-23) of the temple is also of colossal size. The distance from the facade to the back wall is an astounding 206 feet. In the main gallery there are 32-foot-tall figures of the king in the guise of Osiris, carved as one with the pillars, facing each other across the narrow corridor. The pillars, carved from the cliff like the pharaoh's facade portraits, have no load-bearing function. In this respect, they resemble the columns in the tombs at Beni Hasan (FIG. 3-19). The statue-column, in its male (*atlantid*) or female (*caryatid*) variants, reappears throughout the history of art. Often, as here, the human figure is attached to a column or pier. At other times the figure replaces the architectural member and forms the sole source of support (FIG. 5-54).

FAMILY OF RAMSES Ramses, like other pharaohs, had many wives, and he fathered scores of sons. The pharaoh honored the most important members of his family with immense monuments

3-23 Interior of the temple of Ramses II, Abu Simbel, Egypt, 19th Dynasty, ca. 1290–1224 BCE. Sandstone, pillar statues 32' high.

Inside Ramses II's mortuary temple are 32-foot-tall figures of the longreigning pharaoh in the guise of Osiris, carved as one with the pillars, facing each other across the narrow corridor.

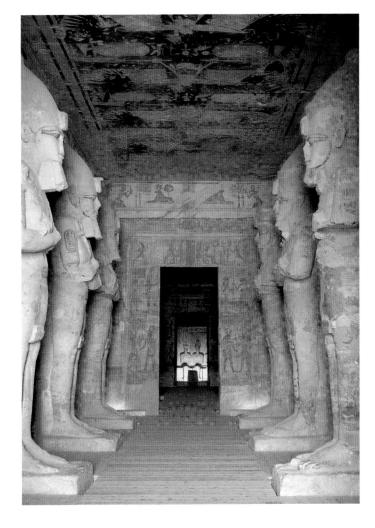

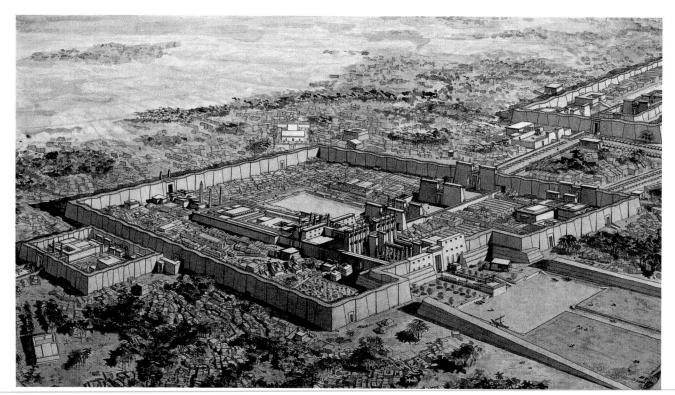

3-24 Restored view of the temple of Amen-Re, Karnak, Egypt, begun 15th century BCE (Jean Claude Golvin).

The vast Karnak temple complex contains an artificial lake associated with the primeval waters of the Egyptian creation myth and a pylon temple with a bilaterally symmetrical axial plan.

of their own. At Abu Simbel, for example, north of his own temple, Ramses ordered the construction of a grand temple for his principal wife, Nefertari. Huge rock-cut statues—four standing images of the king and two of the queen—dominated the temple's facade. For his sons, Ramses constructed a huge underground tomb complex in the Valley of the Kings at Thebes, which an American archaeological team rediscovered in 1987. The tomb, however, was looted within a half century of its construction, but the excavators have yet to find the royal burial chambers themselves, so the tomb may one day yield important artworks.

TEMPLE OF AMEN-RE, KARNAK Distinct from the temples honoring pharaohs and queens are the edifices built to honor one or more of the gods. Successive kings often added to them until they reached gigantic size. The temple of Amen-Re (Fig. 3-24) at Karnak, for example, was largely the work of the 18th Dynasty pharaohs, including Thutmose I and III and Hatshepsut, but Ramses II (19th Dynasty) and others also contributed sections. Chapels were added to the complex as late as the 26th Dynasty. The artificial sacred lake within the precinct of the Karnak temple is a reference to the primeval waters before creation (see "The Gods and Goddesses of Egypt," page 54). The temple rises from the earth as the original sacred mound rose from the waters at the beginning of time.

The New Kingdom temples all had similar axial plans. A typical pylon temple (the name derives from the simple and massive gateways, or pylons, with sloping walls) is bilaterally symmetrical along a single axis that runs from an approaching avenue through a colonnaded court and hall into a dimly lit sanctuary. Only the pharaohs and the priests could enter the sanctuary. A chosen few were admitted to the great columnar hall. The majority of the people were allowed only as far as the open court, and a high wall shut off the site from the outside world. The central feature of the New Kingdom pylon temple

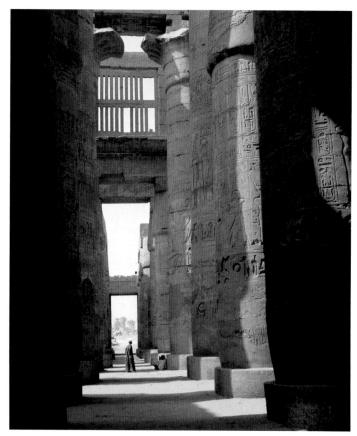

3-25 Hypostyle hall, temple of Amen-Re, Karnak, Egypt, 19th Dynasty, ca. 1290–1224 BCE.

The hypostyle hall of the Amen-Re temple is crowded with columns. The tallest are 66 feet high and have capitals that are 22 feet in diameter. The columns support a roof of stone slabs carried on lintels.

plan—a narrow axial passageway through the complex—is characteristic of much of Egyptian architecture. Axial corridors are also the approaches to the Great Pyramids (FIG. 3-10) and to Hatshepsut's multilevel mortuary temple (FIG. 3-20).

The dominating feature of the statuary-lined approach to a New Kingdom temple was the monumental facade of the pylon, which sculptors routinely covered with reliefs glorifying Egypt's rulers (FIG. 3-38). Inside was an open court with columns on two or more sides, followed by a hall between the court and sanctuary, its long axis placed at right angles to the corridor of the entire building complex. This hypostyle hall (one where columns support the roof) was crowded with massive columns, which supported a roof of stone slabs carried on lintels. In Karnak's hypostyle hall (FIGS. 3-25 and 3-26), the columns have bud-cluster or bell-shaped capitals resembling lotus or papyrus, the plants of Upper and Lower Egypt. The central columns are 66 feet high, and the capitals are 22 feet in diameter at the top, large enough to hold a hundred people. The Egyptians, who used no cement, depended on precise cutting of the joints and the weight of the huge stone blocks to hold the columns in place. The two central rows of columns are taller than those at the sides. Raising the roof's central section created a clerestory. Openings in the clerestory permitted sunlight to filter into the interior, although the stone grilles (FIG. 3-25) would have blocked much of the light. This method of construction appeared in primitive form in the Old Kingdom valley temple of Khafre at Gizeh. The clerestory is evidently an Egyptian innovation, and its significance hardly can be overstated. Before the invention of the electric light bulb, illuminating a building's interior was always a challenge for architects. The clerestory played a key role in the history of architecture until very recently.

In the hypostyle hall at Karnak, the columns are indispensable structurally, unlike the rock-cut columns of the tombs at Beni Hasan (FIGS. 3-18 and 3-19) and Abu Simbel (FIG. 3-23). But horizontal bands of painted *sunken relief* sculpture almost hide their function as vertical supports. To create these reliefs, the New Kingdom sculptors chiseled deep outlines below the stone's surface, rather than cut back the stone around the figures to make the figures project from the surface. Sunken reliefs preserve the contours of the columns they adorn. Otherwise, the Karnak columns would have had an irregular, wavy profile. Despite this effort to maintain sharp architectural lines, the

3-26 Model of the hypostyle hall, temple of Amen-Re, Karnak, Egypt, 19th Dynasty, ca. 1290–1224 BCE. Metropolitan Museum of Art, New York.

The two central rows of columns of Karnak's hypostyle hall are taller than the rest. Raising the roof's central section created a clerestory that admitted light to the interior through windows with stone grilles.

overwhelming of the surfaces with reliefs indicates that the architects' intention was not to emphasize the functional role of the columns. Instead, they used columns as image- and message-bearing surfaces.

Sculpture and Painting

Although the great temple complexes of the New Kingdom were lavishly decorated with statues and painted reliefs, many of the finest examples of statuary and mural painting were produced for tombs, as in the Old and Middle Kingdoms.

SENMUT AND NEFRURA *Block statues* were extremely popular during the New Kingdom. In these works the idea that the ka could find an eternal home in the cubic stone image of the deceased was expressed in an even more radical simplification of form than was common in Old Kingdom statuary. In the statue (FIG. 3-27) of Senmut and Princess Nefrura, the streamlined design concentrates attention on the heads and treats the two bodies as a single cubic block, given over to inscriptions. Hatshepsut's chancellor holds the pharaoh's daughter by Thutmose II in his "lap" and envelops the

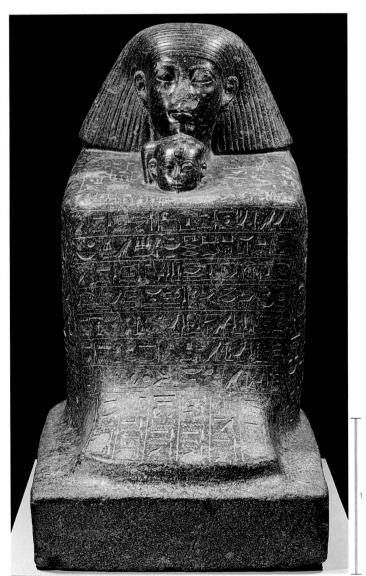

3-27 Senmut with Princess Nefrura, from Thebes, Egypt, 18th Dynasty, ca. 1470–1460 BCE. Granite, $3'\frac{1}{2}''$ high. Ägyptisches Museum, Berlin.

New Kingdom block statues exhibit an even more radical simplification of form than do Old Kingdom statues. Here, Hatshepsut's chancellor holds the queen's daughter in his "lap" and envelops her in his cloak.

3-28 Fowling scene, from the tomb of Nebamun, Thebes, Egypt, 18th Dynasty, ca. 1400–1350 BCE. Fresco on dry plaster, 2′8″ high. British Museum, London.

Nebamun's wife and daughter—depicted smaller than the deceased—accompany him on his hunt for fowl. A painted inscription states that Nebamun is enjoying recreation in his eternal afterlife.

girl in his cloak. The polished stone shape has its own simple beauty, with the surfaces turning subtly about smoothly rounded corners. The work—one of many surviving statues depicting Senmut with Hatshepsut's daughter—is also a reflection of the power of Egypt's female ruler. The frequent depiction of Senmut with Nefrura

was meant to enhance Senmut's stature through his association with the princess (he was her tutor) and, by implication, with Hatshepsut herself.

TOMB OF NEBAMUN Some of the best-preserved mural paintings of the New Kingdom come from the 18th Dynasty Theban tomb of Nebamun, whose official titles were "scribe and counter of grain." On one wall (FIG. 3-28), the painter depicted Nebamun standing in his boat, flushing birds from a papyrus swamp. The hieroglyphic text beneath his left arm says that Nebamun is enjoying recreation in his eternal afterlife. (Here, as elsewhere in Egyptian art, the accompanying text amplifies the message of the picture—and

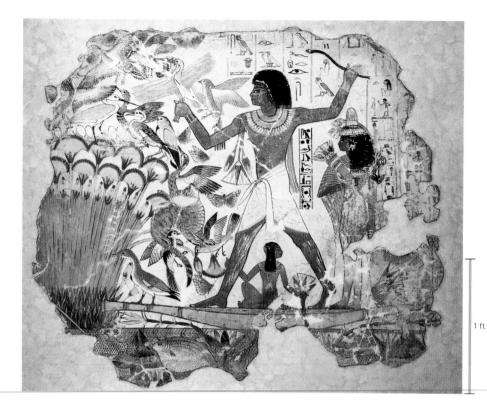

vice versa.) In contrast to the static pose of Ti watching others hunt hippopotami (FIG. 3-15), the painter showed Nebamun striding forward and vigorously swinging his throwing stick. In his right hand, he holds three birds he has caught. A wild cat, impossibly perched on a papyrus stem just in front of and below him, has caught two more in its claws and is holding the wings of a third in its teeth. Nebamun's wife and daughter accompany him on this hunt and hold the lotuses they have gathered. The artist scaled down their figures in proportion to their rank, as did Old Kingdom artists. And, as in Ti's tomb, the animals show a naturalism based on careful observation.

The painting technique, also employed in earlier Egyptian tombs, is *fresco secco* (dry fresco), whereby artists let the plaster dry

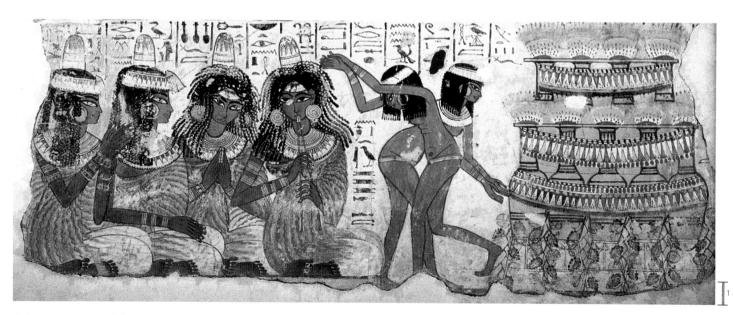

3-29 Musicians and dancers, from the tomb of Nebamun, Thebes, Egypt, 18th Dynasty, ca. 1400–1350 BCE. Fresco on dry plaster, $1' \times 2'$ 3". British Museum, London.

A second fresco in Nebamun's tomb represents a funerary banquet in which the artist experimented with frontal views of faces and bodies—a relaxation of the Old Kingdom's stiff rules of representation.

before painting on it. This procedure, in contrast to true fresco painting on wet plaster (see "Fresco Painting," Chapter 19, page 504), permitted slower and more meticulous work than painting on wet plaster, which had to be completed before the plaster dried. Fresco secco, however, is not as durable as true fresco painting, because the colors do not fuse with the wall surface.

Another fresco fragment (FIG. 3-29) from Nebamun's tomb shows four noblewomen watching and apparently participating in a musicale and dance where two nimble and almost nude dancing girls perform at a banquet. When Nebamun was buried, his family must have eaten the customary ceremonial meal at his tomb. They would have returned one day each year to partake in a commemorative banquet for the living to commune with the dead. This fresco represents one of these funerary feasts, with an ample supply of wine jars at the right. It also shows that New Kingdom artists did not always adhere to the old standards for figural representation. This painter carefully recorded the dancers' overlapping figures, their facing in opposite directions, and their rather complicated gyrations, producing a pleasing intertwined motif at the same time. The profile view of the dancers is consistent with their lower stature in the Egyptian hierarchy. The painter still reserved the composite view for Nebamun and his family. Of the four seated women, the artist represented the two at the left conventionally, but the other two face the observer in what is a rarely attempted frontal pose. They clap and beat time to the dance, while one of them plays the reeds. The painter took careful note of the soles of their feet as they sat crosslegged and suggested the movement of the women's heads by the loose arrangement of their hair strands. This informality constituted a relaxation of the Old Kingdom's stiff rules of representation.

The frescoes in Nebamun's tomb testify to the luxurious life of the Egyptian nobility, filled with good food and drink, fine musicians, lithe dancers, and leisure time to hunt and fish in the marshes. But, as in the earlier tomb of Ti, the scenes should be read both literally and allegorically. Although Nebamun is shown enjoying himself in the afterlife, the artist symbolically asked viewers to recall how he got there. Hunting scenes reminded Egyptians of Horus, the son of Osiris, hunting down his father's murderer, Seth, the god of disorder. Successful hunts were metaphors for triumphing over death and disorder, ensuring a happy existence in the afterlife. Music and dance were sacred to Hathor, who aided the dead in their passage to the other world. The sensual women at the banquet are a reference to fertility, rebirth, and regeneration.

Akhenaton and the Amarna Period

Not long after Nebamun was laid to rest in his tomb at Thebes, a revolution occurred in Egyptian society and religion. In the mid-14th century BCE, the pharaoh Amenhotep IV, later known as Akhenaton (r. 1353–1335 BCE), abandoned the worship of most of the Egyptian gods in favor of Aton, identified with the sun disk, whom he declared to be the universal and only god. Akhenaton blotted out the name of Amen from all inscriptions and even from his own name and that of his father, Amenhotep III. He emptied the great temples, enraged the priests, and moved his capital downriver from Thebes to a site he named Akhetaton (after his new god), where he built his own city and shrines. It is now called Amarna. The pharaoh claimed to be both the son and sole prophet of Aton. To him alone could the god make revelation. Moreover, in stark contrast to earlier practice, artists represented Akhenaton's god neither in animal nor in human form but simply as the sun disk emitting life-giving rays. The pharaohs who followed Akhenaton reestablished the cult and priesthood of Amen and restored the temples and the inscriptions. The gigantic temple complex at Karnak (FIG. 3-24), for example, was dedicated to the re-

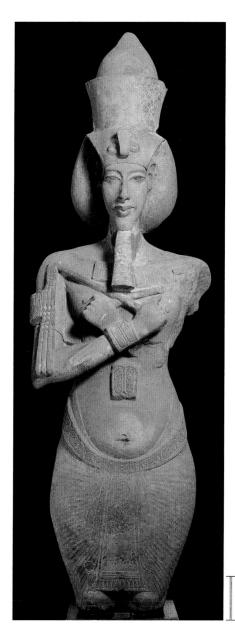

3-30 Akhenaton, from the temple of Aton, Karnak, Egypt, 18th Dynasty, ca. 1353–1335 BCE. Sandstone, 13' high. Egyptian Museum, Cairo.

Akhenaton initiated a religious revolution, and his art is also a deliberate reaction against tradition. This curious androgynous image may be an attempt to portray the pharaoh as Aton, the sexless sun disk.

newed worship of the Theban god Amen. Akhenaton's brief religious revolution was soon undone, and his new city was largely abandoned.

During the brief heretical episode of Akhenaton, however, profound changes occurred in Egyptian art. A colossal statue (FIG. 3-30) of Akhenaton from Karnak, toppled and buried after his death, retains the standard frontal pose of canonical pharaonic portraits. But the effeminate body, with its curving contours, and the long face with full lips and heavy-lidded eyes are a far cry indeed from the heroically proportioned figures of the pharaoh's predecessors (compare FIG. 3-13). Akhenaton's body is curiously misshapen, with weak arms, a narrow waist, protruding belly, wide hips, and fatty thighs. Modern doctors have tried to explain his physique by attributing a variety of illnesses to the pharaoh. They cannot agree on a diagnosis, and their premise—that the statue is an accurate depiction of a physical deformity—is probably faulty. Some art historians think that Akhenaton's portrait is a deliberate artistic reaction against the established style, paralleling the suppression of traditional religion. They argue that Akhenaton's artists tried to formulate a new androgynous image of the pharaoh as the manifestation of Aton, the sexless sun disk. But no consensus exists other than that the style was revolutionary and short-lived.

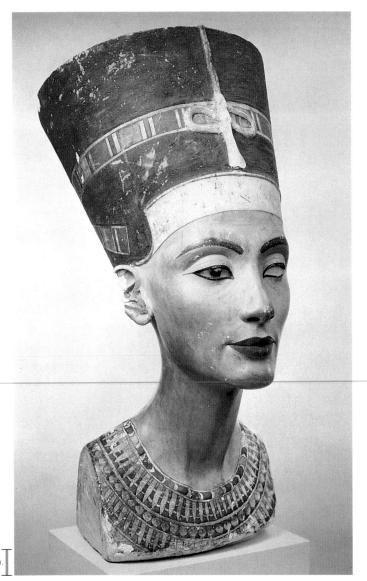

3-31 Тнитмоѕе, Nefertiti, from Amarna, Egypt, 18th Dynasty, ca. 1353–1335 все. Painted limestone, 1' 8" high. Ägyptisches Museum, Berlin.

Nefertiti, Akhenaton's influential wife, is portrayed here as an elegant beauty, with a pensive expression and a long, delicately curved neck. The unfinished portrait was found in Thutmose's workshop.

NEFERTITI AND TIYE A painted limestone bust (FIG. 3-31) of Akhenaton's queen, Nefertiti (her name means "The Beautiful One Has Come"), exhibits a similar expression of entranced musing and an almost mannered sensitivity and delicacy of curving contour. The piece was found at Amarna in the workshop of the sculptor Thutmose and is a deliberately unfinished model very likely by the master's own hand. The left eye socket still lacks the inlaid eyeball, making the portrait a kind of before-and-after demonstration piece. With this elegant bust, Thutmose may have been alluding to a heavy flower on its slender stalk by exaggerating the weight of the crowned head and the length of the almost serpentine neck. The sculptor seems to have adjusted the actual likeness of his subject to meet the era's standard of spiritual beauty.

A moving portrait of old age is preserved in the miniature head (FIG. 3-32) of Queen Tiye, mother of Akhenaton. Although not of royal birth, Tiye was the daughter of a high-ranking official and became the chief wife of Amenhotep III. Her portrait, carved of dark yew wood, probably to match her complexion, was found at Ghurab

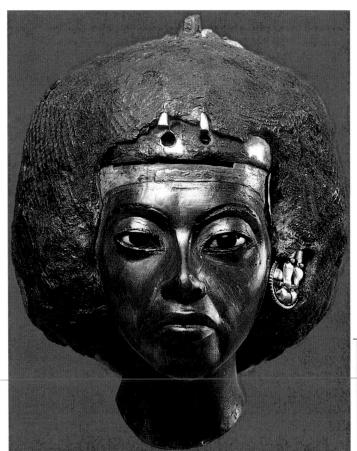

3-32 Tiye, from Ghurab, Egypt, 18th Dynasty, ca. 1353–1335 BCE. Wood, with gold, silver, alabaster, and lapis lazuli, $3\frac{3}{4}''$ high. Ägyptisches Museum, Berlin.

This portrait of Akhenaton's mother is carved of dark yew wood, probably to match the queen's complexion. The head was remodeled during her son's reign to remove all references to traditional deities.

with other objects connected with the funerary cult of Amenhotep III. Another artist probably remodeled the work during her son's reign to eliminate all reference to deities of the old religion. That is when the head acquired the present wig of plaster and linen with small blue beads. Tiye is shown as an older woman with lines and furrows, consistent with the new relaxation of artistic rules in the Amarna age. Her heavy-lidded slanting eyes are inlaid with alabaster and ebony, the lips are painted red, and the earrings (one is hidden by the later wig) are of gold and lapis lazuli. The wig covers what was originally a silver-foil headdress. A gold band still adorns the forehead. Such luxurious materials were common for royal portraits.

Both Nefertiti and Tiye figured prominently in the art and life of the Amarna age. Tiye, for example, regularly appeared in art beside her husband during his reign, and she apparently played an important role in his administration as well as her son's. Letters survive from foreign rulers advising the young Akhenaton to seek his mother's counsel in the conduct of international affairs. Nefertiti too was an influential woman. She frequently appears in the decoration of the Aton temple at Karnak, and she not only equals her husband in size but also sometimes wears pharaonic headgear.

FAMILY PORTRAITURE A sunken relief stele (FIG. 3-33), perhaps from a private shrine, provides a rare look at this royal family. The style is familiar from the colossus of Akhenaton (FIG. 3-30) and the portrait head of Nefertiti (FIG. 3-31). Undulating curves replace rigid lines, and the figures possess the prominent bellies that

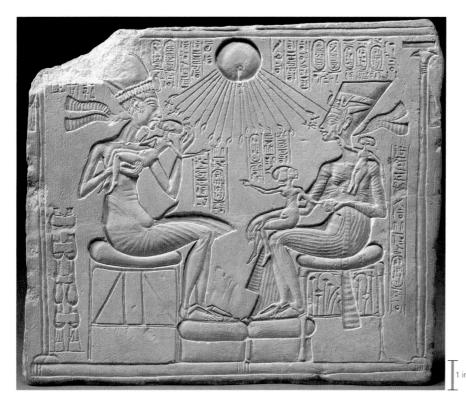

3-33 Akhenaton, Nefertiti, and three daughters, from Amarna, Egypt, 18th Dynasty, ca. 1353–1335 BCE. Limestone, $1'\frac{1}{4}''$ high. Ägyptisches Museum, Berlin.

In this sunken relief the Amarna artist provided a rare intimate look at the royal family in a domestic setting. Akhenaton, Nefertiti, and three of their daughters bask in the life-giving rays of Aton, the sun disk.

characterize figures of the Amarna period. The pharaoh, his wife, and three of their daughters bask in the life-giving rays of Aton, the sun disk. The mood is informal and anecdotal. Akhenaton lifts one of his daughters in order to kiss her. Another daughter sits on Nefertiti's lap and gestures toward her father while the youngest daughter reaches out to touch a pendant on her mother's crown. This kind of intimate portrayal of the pharaoh and his family is unprecedented in Egyptian art. The political and religious revolution under Akhenaton was matched by an equally radical upheaval in art.

The Tomb of Tutankhamen and the Post-Amarna Period

The most famous figure of the Post-Amarna period is Tutankhamen (r. 1333–1323 BCE), who was probably Akhenaton's son by a minor wife. Tutankhamen ruled for a decade and died at age 18. (Although some people speculated foul play, examination of the king's mummy in 2005 ruled out murder.) Tutankhamen was a very minor figure in Egyptian history, however. The public remembers him today solely because in 1922 Howard Carter, a British archaeologist, discovered the boy-king's tomb with its fabulously rich treasure of sculpture, furniture, and jewelry largely intact.

TOMB OF TUTANKHAMEN The principal item that Carter found in Tutankhamen's tomb is the enshrined body of the pharaoh himself. The royal mummy reposed in the innermost of three coffins, nested one within the other. The innermost coffin (FIG. 3-34) was the most luxurious of the three. Made of beaten gold (about a quarter ton of it) and inlaid with semiprecious stones such as lapis lazuli, turquoise, and carnelian, it is a supreme monument to the sculptor's and goldsmith's crafts. The portrait mask (FIG. 3-1), which covered the king's face, is also made of gold with inlaid semiprecious stones. It is a sensitive portrayal of the serene adolescent king dressed in his official regalia, including the nemes headdress and false beard. The general effects of the mask and of the tomb treasures as a whole are of grandeur and richness expressive of Egyptian power, pride, and affluence.

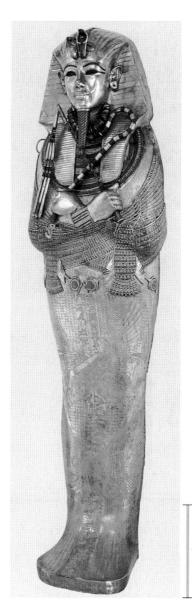

3-34 Innermost coffin of Tutankhamen, from his tomb at Thebes, Egypt, 18th Dynasty, ca. 1323 BCE. Gold with inlay of enamel and semiprecious stones, 6′ 1″ long. Egyptian Museum, Cairo.

The boy-king Tutankhamen's fame today is due to the discovery of his treasure-laden tomb. His mummy was encased in three nested coffins. The innermost one, made of gold, portrays the pharaoh as Osiris.

3-35 Painted chest, from the tomb of Tutankhamen, Thebes, Egypt, 18th Dynasty, ca. 1333–1323 BCE. Wood, 1' 8" long. Egyptian Museum, Cairo.

Tutankhamen is here represented triumphing over Asian enemies. The artist contrasted the orderly registers of Egyptian chariots with the chaotic pile of foreign soldiers who fall before the king.

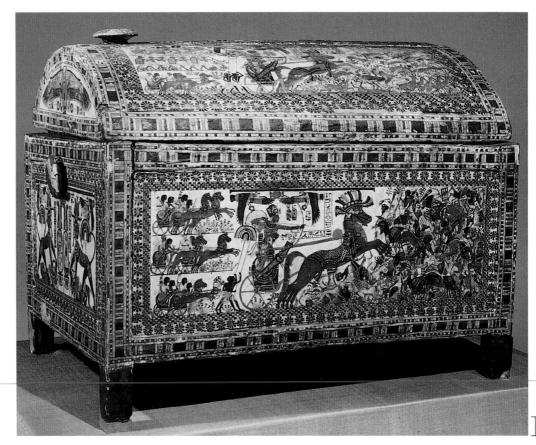

1 in.

Although Tutankhamen probably was considered too young to fight, his position as king required that he be represented as a conqueror. He is shown as such in the panels of a painted chest (FIG. 3-35) deposited in his tomb. The lid panel shows the king as a successful hunter pursuing droves of fleeing animals in the desert, and the side panel shows him as a great warrior. From a war chariot pulled by spirited, plumed horses, the pharaoh, shown larger than all other figures on

the chest, draws his bow against a cluster of bearded Asian enemies, who fall in confusion before him. (The absence of a ground line in an Egyptian painting or relief implies chaos and death.) Tutankhamen slays the enemy, like game, in great numbers. Behind him are three tiers of undersized war chariots, which serve to magnify the king's figure and to increase the count of his warriors. The themes are traditional, but the fluid, curvilinear forms are features reminiscent of the Amarna style.

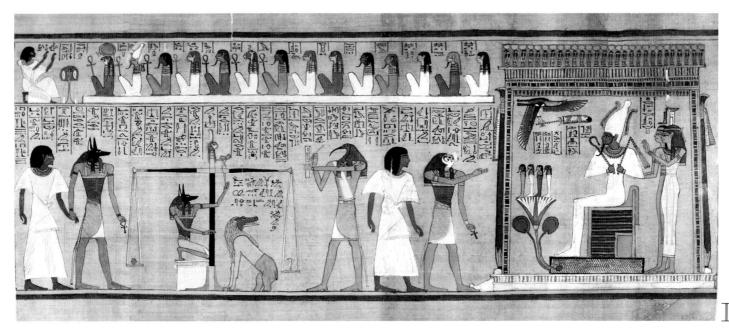

3-36 Last judgment of Hu-Nefer, from his tomb at Thebes, Egypt, 19th Dynasty, ca. 1290–1280 все. Painted papyrus scroll, 1′ 6″ high. British Museum, London.

The Book of the Dead contained spells and prayers. This scroll depicts the weighing of Hu-Nefer's heart against Maat's feather before the deceased can be brought before Osiris, god of the Underworld.

SCROLL OF HU-NEFER Tutankhamen's mummy case (FIG. **3-34**) shows the boy-king in the guise of Osiris, god of the dead and king of the Underworld, as well as giver of eternal life. The ritual of the cult of Osiris is recorded in the so-called *Book of the Dead*, a collection of spells and prayers. Illustrated papyrus scrolls, some as long as 70 feet, containing these texts were the essential equipment of the tombs of well-to-do persons (see "Mummification and Immortality," page 57).

The scroll (FIG. 3-36) of Hu-Nefer, the royal scribe and steward of Seti I, was found in his tomb in the Theban necropolis and represents the final judgment of the deceased. At the left, Anubis, the jackal-headed god of embalming, leads Hu-Nefer into the hall of judgment. The god then adjusts the scales to weigh the dead man's heart against the feather of the goddess Maat, protectress of truth and right. A hybrid crocodile-hippopotamus-lion monster, Ammit, devourer of the sinful, awaits the decision of the scales. If the weighing had been unfavorable to the deceased, the monster would have eaten his heart. The ibis-headed god Thoth records the proceedings. Above, the gods of the Egyptian pantheon are arranged as witnesses, while Hu-Nefer kneels in adoration before them. Having been justified by the scales, Hu-Nefer is brought by Osiris's son, the falconheaded Horus, into the presence of the green-faced Osiris and his sisters Isis and Nephthys to receive the award of eternal life.

In Hu-Nefer's scroll, the figures have all the formality of stance, shape, and attitude of traditional Egyptian art. Abstract figures and hieroglyphs alike are aligned rigidly. Nothing here was painted in the flexible, curvilinear style suggestive of movement that was evident in the art of Amarna and Tutankhamen. The return to conservatism is unmistakable.

FIRST MILLENNIUM BCE

During the first millennium BCE, Egypt lost the commanding role it once had played in the ancient Near East. The empire dwindled away, and foreign powers invaded, occupied, and ruled the land, until it was taken over by Alexander the Great of Macedon and his Greek successors and, eventually, by the emperors of Rome.

Kingdom of Kush

One of those foreign powers was Egypt's gold-rich neighbor to the south, the kingdom of Kush, part of which is in present-day Sudan. Called Nubia by the Romans, perhaps from the Egyptian word for "gold," Kush is mentioned in Egyptian texts as early as the Old Kingdom. During the New Kingdom, the pharaohs colonized Nubia and appointed a viceroy to administer the Kushite kingdom, which included Abu Simbel (FIG. 3-22) and controlled the major trade route between Egypt and sub-Saharan Africa. But in the eighth century BCE, the Nubians conquered Egypt and ruled the land of the Nile as the 25th Dynasty.

TAHARQO Around 680 BCE, the Kushite pharaoh Taharqo (r. 690–664 BCE) constructed a temple at Kawa and placed a portrait of himself in it. Emulating traditional Egyptian types, the sculptor portrayed Taharqo as a sphinx (FIG. 3-37; compare FIG. 3-11) with the ears, mane, and body of a lion but with a human face and a headdress with two uraeus cobras. The king's name is inscribed on his chest, and his features are distinctly African, although, as in all pharaonic portraiture, they should be considered generic and idealized rather than a specific likeness.

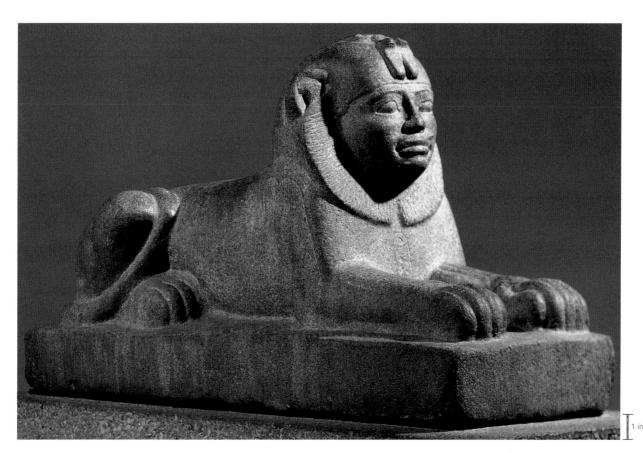

3-37 Taharqo as a sphinx, from temple T, Kawa, Sudan, 25th Dynasty, ca. 680 BCE. Granite, $1'4'' \times 2'4\frac{3}{4}''$. British Museum, London.

Nubian kings ruled Egypt during the 25th Dynasty and adopted traditional Egyptian artistic types, but the sculptor of the Tahargo sphinx reproduced the Kushite pharaoh's distinctly African features.

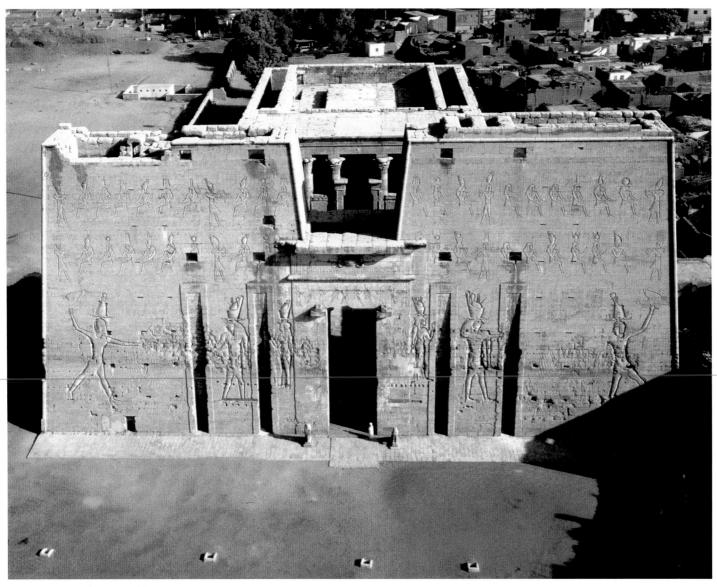

3-38 Temple of Horus, Edfu, Egypt, ca. 237-47 BCE.

The pylon temple at Edfu is more than a thousand years later than that at Karnak (FIG. 3-24), but it adheres to the same basic architectural scheme. Egyptian artistic forms tended to have very long lives.

After Alexander

Once formulated, Egyptian traditions tended to have very long lives, in architecture as in the other arts—even after Alexander the Great established Greek rule in the land of the Nile.

TEMPLE OF HORUS, EDFU The temple of Horus at Edfu (FIG. 3-38), built during the third, second, and first centuries BCE, after Alexander the Great's conquest of Egypt, still follows the basic pylon temple scheme architects worked out more than a thousand years before (compare the temple of Amen-Re at Karnak, FIG. 3-24). The great entrance pylon at Edfu is especially impressive. The broad sur-

face of its massive facade, with its sloping walls, is broken only by the doorway with its overshadowing *moldings* at the top and sides, deep channels to hold great flagstaffs, and sunken reliefs. The reliefs depict Horus and Hathor witnessing an oversized King Ptolemy XIII (r. 51–47 BCE) smiting undersized enemies. It is a striking monument to the persistence of Egyptian architectural and sculptural types.

Indeed, the exceptional longevity of formal traditions in Egypt is one of the marvels of the history of art. It testifies to the invention of an artistic style so satisfactory that it endured in Egypt for millennia. Everywhere else in the ancient Mediterranean world, stylistic change was the only common denominator.

EGYPT UNDER THE PHARAOHS

PREDYNASTIC AND EARLY DYNASTIC PERIODS, ca. 3500-2575 BCE

- The unification of Upper and Lower Egypt into a single kingdom under the rule of a divine pharaoh occurred around 3000–2920 BCE. The event was commemorated on the earliest preserved work of narrative art, the palette of King Narmer, which also established the basic principles of Egyptian representational art for 3,000 years.
- Imhotep, the first artist in history whose name is known, established the tradition of monumental stone architecture in Egypt in the funerary complex and Stepped Pyramid he built for King Djoser (r. 2630–2611 BCE) at Saggara.

Palette of King Narmer, ca. 3000–2920 BCE

OLD KINGDOM, ca. 2575-2134 BCE

- The Old Kingdom was the first golden age of Egyptian art and architecture, the time when three pharaohs of the Fourth Dynasty erected the Great Pyramids at Gizeh, the oldest of the Seven Wonders of the ancient world. The pyramids were emblems of the sun on whose rays the pharaohs ascended to the heavens after their death.
- Old Kingdom sculptors created seated and standing statuary types in which all movement was suppressed in order to express the eternal nature of pharaonic kingship. These types would dominate Egyptian art for 2,000 years.

Great Sphinx and Pyramids, Gizeh, ca. 2550–2475 BCE

MIDDLE KINGDOM, ca. 2040-1640 BCE

- After an intermediate period of civil war, Mentuhotep II (r. 2050–1998 BCE) reestablished central rule and founded the Middle Kingdom.
- The major artistic innovation of this period was the rock-cut tomb in which both the facade and interior chambers were hewn out of the living rock. The fluted columns in Middle Kingdom tombs closely resemble the columns later used in Greek temples.

Tomb of Amenemhet, Beni Hasan, ca. 1950–1900 BCE

NEW KINGDOM, ca. 1550-1070 BCE

- During the New Kingdom, Egypt extended its borders to the Euphrates River in the east and deep into Nubia in the south.
- The most significant architectural innovation of this period was the axially planned pylon temple incorporating an immense gateway, columnar courtyards, and a hypostyle hall with clerestory windows.
- Powerful pharaohs such as Hatshepsut (r. 1473–1458 BCE) and Ramses II (r. 1290–1224 BCE) erected gigantic temples in honor of their patron gods and, after their deaths, for their own worship.
- Akhenaton (r. 1353–1335 BCE) abandoned the traditional Egyptian religion in favor of Aton, the sun disk, and initiated a short-lived artistic revolution in which undulating curves and anecdotal content replaced the cubic forms and impassive stillness of earlier Egyptian art.

Akhenaton, Nefertiti, and three daughters, ca. 1353–1335 BCE

FIRST MILLENNIUM BCE

- After the demise of the New Kingdom, Egypt's power in the ancient world declined and it came under the control of foreigners, such as the Kushite kings of Nubia and, after 332 BCE, Alexander the Great and his Greek successors. In 30 BCE, Egypt became a province of the Roman Empire.
- The traditional forms of Egyptian art and architecture lived on even under foreign rule—for example, in the pylon temple erected at Edfu in honor of Horus.

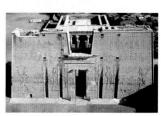

Temple of Horus, Edfu, ca. 237–47 BCE

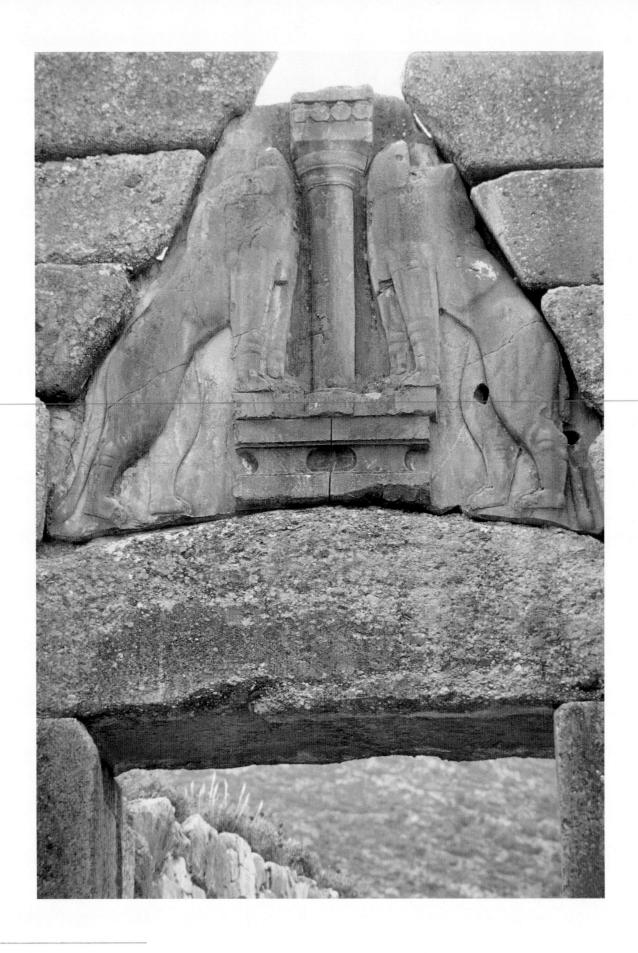

4-1 Relieving triangle with confronting lions, detail of Lion Gate (FIG. 4-19), Mycenae, Greece, ca. 1300–1250 BCE.

The gateway to the citadel of Mycenae, legendary home of King Agamemnon of Homer's *Iliad*, was built of such large stones that the later Greeks believed that giants, not mortals, erected it.

THE PREHISTORIC AEGEAN

 \mathbf{I}^{n} the *Iliad*, Homer describes the might and splendor of the Greek armies poised before the walls of Troy.

Clan after clan poured out from the ships and huts onto the plain . . . innumerable as the leaves and blossoms in their season . . . the Athenians . . . the men of Argos and Tiryns of the Great Walls . . . troops from the great stronghold of Mycenae, from wealthy Corinth . . . from Knossos . . . Phaistos . . . and the other troops that had their homes in Crete of the Hundred Towns. ¹

The Greeks had come from far and wide, from the mainland and the islands (MAP 4-1), to seek revenge against Paris, the Trojan prince who had abducted Helen, wife of King Menelaus of Sparta. Composed around 750 BCE, the *Iliad* is the first great work of Greek literature. In fact, until about 1870, Homer's epic poem was generally regarded as pure fiction. Scholars discounted the bard as a historian, attributing the profusion of names and places in his writings to the rich abundance of his imagination. The prehistory of Greece remained shadowy and lost in an impenetrable world of myth.

TROY AND MYCENAE In the late 1800s, however, a wealthy German businessman turned archaeologist proved that scholars had done less than justice to the truth of Homer's account. Between 1870 and his death 20 years later, Heinrich Schliemann (whose methods have sometimes been harshly criticized) uncovered some of the very cities Homer named. In 1870, he began work at Hissarlik on the northwestern coast of Turkey, which a British archaeologist, Frank Calvert, had postulated was the site of Homer's Troy. Schliemann dug into a vast mound and found a number of fortified cities built on the remains of one another. One of them had been destroyed by fire in the 13th century BCE. This, scholars now generally agree, was the Troy of King Priam and his son Paris, the city Homer celebrated some 500 years later.

Schliemann continued his excavations at Mycenae on the Greek mainland, where, he believed, King Agamemnon, Menelaus's brother, had once ruled. Here his finds were even more startling. A massive fortress-palace with a monumental gateway (FIGS. 4-1 and 4-19); domed tombs beneath earthen mounds (FIGS. 4-20 and 4-21); quantities of gold jewelry, masks (FIG. 4-22), and cups; and inlaid bronze weapons

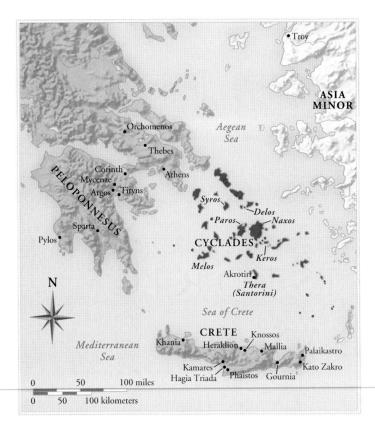

MAP 4-1 The prehistoric Aegean.

(FIG. 4-23) revealed a magnificent civilization far older than the famous vestiges of Classical Greece that had remained visible in Athens and elsewhere. Further discoveries proved that Mycenae had not been the only center of this fabulous civilization.

MINOAN CRETE Another legendary figure was King Minos of Knossos on the island of Crete. He had exacted from Athens a tribute of youths and maidens to be fed to the *Minotaur*, a creature half bull and half man housed in a vast labyrinth. Might this story, too, be based on fact? In 1900, an English archaeologist, Arthur Evans, began work at Knossos, where he uncovered a palace (FIGS. 4-4 and 4-5) that did indeed resemble a maze. Evans named its builders the Minoans, after their mythological king. Further evidence of the Minoans was soon uncovered at Phaistos, Hagia Triada, and other sites, including Gournia, which Harriet Boyd Hawes, an American archaeologist (and one of the first women of any nationality to direct a major excavation), explored between 1901 and 1904.

More recently, important Minoan remains have been excavated at many other locations on Crete, and contemporary sites have been discovered on other islands in the Aegean, most notably on Santorini (ancient Thera). Art historians now have many buildings, paintings, and, to a lesser extent, sculptures that attest to the wealth and sophistication of the people who lived in that once-obscure heroic age celebrated in later Greek mythology.

AEGEAN ARCHAEOLOGY TODAY Less glamorous than the palaces and art objects, but arguably more important for the understanding of Aegean society, are the many documents archaeologists have found written in scripts dubbed Linear A and Linear B. The progress made during the past several decades in deciphering these texts has provided a welcome corrective to the romanticism that characterized the work of Schliemann and Evans. Linear B can now be read as an early form of Greek, and scholars have begun to reconstruct Aegean civilization by referring to contemporaneous records and not just to Homer's heroic account. Archaeologists now also know that humans

inhabited Greece as far back as the late Paleolithic period and that village life was firmly established in Greece and on Crete in Neolithic times. But the heyday of the ancient Aegean was not until the second millennium BCE, well after the emergence of the river valley civilizations of Mesopotamia, Egypt, and South Asia (see Chapters 2, 3, and 6).

The prehistoric Aegean has three geographic areas, and each has its own distinctive artistic identity. *Cycladic* art is the art of the Cycladic Islands (so named because they *circle* around Delos), as well as of the adjacent islands in the Aegean, excluding Crete. *Minoan* art encompasses the art of Crete. *Helladic* art is the art of the Greek mainland (*Hellas* in Greek). Scholars subdivide each area chronologically into early, middle, and late periods, with the art of the Late Helladic period designated Mycenaean after Agamemnon's great citadel of Mycenae.

CYCLADIC ART

Marble was abundantly available in the superb quarries of the Aegean Islands, especially on Naxos and Paros. The sculptors of the Early Cycladic period used that marble to produce statuettes (FIGS. 4-2 and 4-3) that collectors highly admire today (see "Archaeology, Art History, and the Art Market," page 83) because of their striking abstract forms, which call to mind the simple and sleek shapes of some modern sculptures (FIG. 35-20).

WOMAN FROM SYROS Most of the Cycladic sculptures, like many of their Stone Age predecessors in the Aegean, the Near East, and western Europe (FIG. 1-5), represent nude women with their arms folded across their abdomens. They have been found both in graves and in settlements and vary in height from a few inches to almost life-size. The statuette illustrated here (FIG. 4-2) is about a foot and a half tall—but only about a half inch thick—and comes from a grave on the island of Syros. The sculptor rendered the human body in a highly schematic manner. Large simple triangles dominate

the form—the head, the body itself (which tapers from exceptionally broad shoulders to tiny feet), and the incised triangular pubis. The feet are too fragile to support the figurine. It must have been placed on its back in the grave—lying down, like the deceased. Whether the Syros statuette and the many other similar Cycladic figurines known

4-2 Figurine of a woman, from Syros (Cyclades), Greece, ca. 2500–2300 BCE. Marble, 1' 6" high. National Archaeological Museum, Athens.

Most Cycladic statuettes depict nude women. This one comes from a grave, but whether it represents the deceased is uncertain. The sculptor rendered the female body schematically as a series of large triangles.

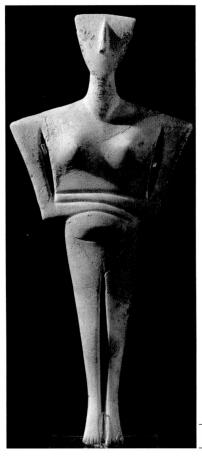

Archaeology, Art History, and the Art Market

ne way the ancient world is fundamentally different from the world today is that ancient art is largely anonymous and undated. No equivalent exists in antiquity for the systematic signing and dating of artworks commonplace in the contemporary world. That is why the role of archaeology in the study of ancient art is so important. Only the scientific excavation of ancient monuments can establish their context. Exquisite and strikingly "modern" sculptures such as the marble Cycladic figurines illustrated in FIGS. 4-2 and 4-3 may be appreciated as masterpieces when displayed in splendid isolation in glass cases in museums or private homes. But to understand the role these or any other artworks played in ancient society in many cases, even to determine the date and place of origin of an object—the art historian must know where the piece was uncovered. Only when the context of an artwork is known can one go beyond an appreciation of its formal qualities and begin to analyze its place in art history—and in the society that produced it.

The extraordinary popularity of Cycladic figurines in recent decades has had unfortunate consequences. Clandestine treasure hunters, eager to meet the insatiable demands of modern collectors, have plundered many sites and smuggled their finds out of Greece to sell to the highest bidder on the international art market. Entire prehistoric cemeteries and towns have been destroyed because of the high esteem in which these sculptures are now held. Two British scholars have calculated that only about 10 percent of the known Cycladic marble statuettes come from secure archaeological contexts. Many of the rest could be forgeries produced after World War II when developments in modern art fostered a new appreciation of these abstract renditions of human anatomy and created a boom in demand for "Cycladica" among collectors. For some categories of Cycladic sculptures—those of unusual type or size—not a single piece with a documented provenance exists. Those groups may be 20th-century inventions designed to fetch even higher prices due to their rarity. Consequently, most of the conclusions art historians have drawn about chronology, attribution to different workshops, range of types, and how the figurines were used are purely speculative. The importance of the information the original contexts would have provided cannot be overestimated. That information, however, can probably never be recovered.

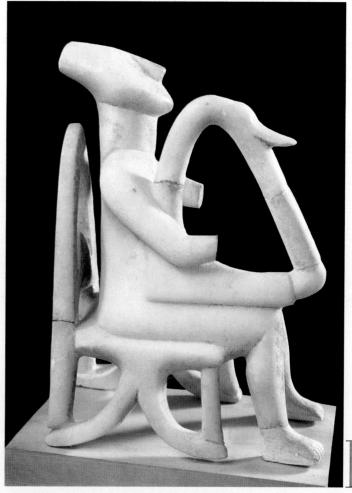

4-3 Male lyre player, from Keros (Cyclades), Greece, ca. 2700–2500 BCE. Marble, 9" high. National Archaeological Museum, Athens.

The meaning of all Cycladic figurines is elusive, but this seated musician may be playing for the deceased in the afterlife. The statuette displays the same simple geometric shapes and flat planes as FIG. 4-2.

today represent dead women or fertility figures or goddesses is still debated. In any case, the sculptors took pains to emphasize the breasts as well as the pubic area. In the Syros statuette, a slight swelling of the belly may suggest pregnancy. Traces of paint found on some of the Cycladic figurines indicate that at least parts of these sculptures were colored. The now almost featureless faces would have had painted eyes and mouths in addition to the sculpted noses. Red and blue necklaces and bracelets, as well as painted dots on the cheeks and necks, characterize a number of the surviving figurines.

LYRE PLAYER FROM KEROS Male figures also occur in the Cycladic repertoire. The most elaborate of these take the form of seated musicians, such as the lyre player (FIG. 4-3) from Keros. Wedged between the echoing shapes of chair and instrument, he may be playing for the deceased in the afterlife, although, again, the meaning of these statuettes remains elusive. The harpist reflects

the same preference for simple geometric shapes and large flat planes as the female figures. Still, the artist showed a keen interest in recording the elegant shape of what must have been a prized possession: the harp with a duck-bill or swan-head ornament at the apex of its sound box. (Animal-headed instruments are well documented in contemporary Mesopotamia [FIG. 2-10] and Egypt.)

In one instance, figurines of both a musician and a reclining woman were placed in a woman's grave. This suggests that the lyre players are not images of dead men, but it does not prove that the female figurines represent dead women. The man might be entertaining the deceased herself, not her image. Given the absence of written documents in Greece at this date, as everywhere else in prehistoric times, and the lack of information about the provenance of most finds, art historians cannot be sure of the meaning of the Cycladic sculptures. It is likely, in fact, that the same form took on different meanings in different contexts.

MINOAN ART

During the third millennium BCE, both on the Aegean Islands and on the Greek mainland, most settlements were small and consisted only of simple buildings. Only rarely were the dead buried with costly offerings such as the Cycladic statuettes just examined. In contrast, the construction of large palaces marked the opening centuries of the second millennium (the Middle Minoan period on Crete).

Architecture

The first, or Old Palace, period came to an abrupt end around 1700 BCE, when fire destroyed these grand structures, probably following an earthquake. Rebuilding began almost immediately, and the ensu-

ing Late Minoan (New Palace) period is the golden age of Crete, an era when the first great Western civilization emerged. The rebuilt palaces were large, comfortable, and handsome, with residential suites for the king and his family and courtyards for pageants, ceremonies, and games. They also had storerooms, offices, and shrines that permitted these huge complexes to serve as the key administrative, commercial, and religious centers of Minoan life. The principal palace sites on Crete are at Knossos, Phaistos, Mallia, Kato Zakro, and Khania. All of the complexes were laid out along similar lines. Their size and number, as well as the rich finds they have yielded, attest to the power and prosperity of the Minoans.

PALACE AT KNOSSOS The largest of the palaces, at Knossos (FIGS. 4-4 and 4-5), was the legendary home of King Minos. Here,

4-4 Aerial view (looking northeast) of the palace at Knossos (Crete), Greece, ca. 1700–1400 BCE.

The Knossos palace is the largest on Crete and was the legendary home of King Minos. Its layout features a large central court, around which all the residential and administrative units were grouped.

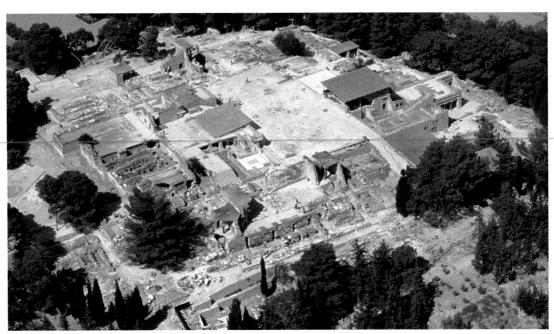

4-5 Plan of the palace at Knossos (Crete), Greece, ca. 1700–1400 BCE.

The mazelike plan of the Knossos palace gave rise to the Greek myth of the Cretan labyrinth inhabited by the Minotaur, a half-man half-bull monster that the Athenian king Theseus killed.

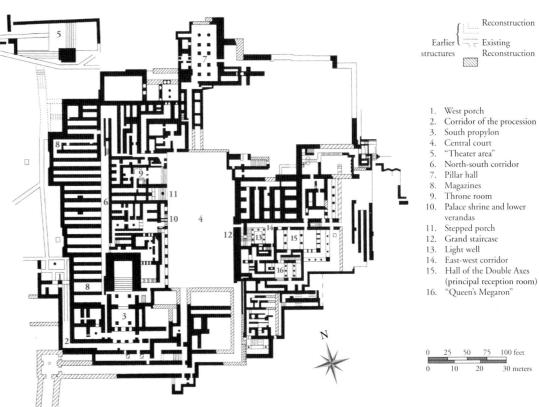

the hero Theseus was said to have battled with the bull-man Minotaur. According to the myth, after defeating the monster, Theseus found his way out of the mazelike complex only with the aid of the king's daughter, Ariadne. She had given Theseus a spindle of thread to mark his path through the labyrinth and thus to find his way out safely again. In fact, the English word *labyrinth* derives from the intricate plan and scores of rooms of the Knossos palace. *Labrys* means "double ax," and it is a recurring motif in the Minoan palace, referring to sacrificial slaughter. The labyrinth was the "House of the Double Axes."

The Knossos palace was a rambling structure built against the upper slopes and across the top of a low hill that rises from a fertile plain (FIG. 4-4). All around the palace proper were mansions and villas of the Minoan elite. The great rectangular court (FIG. 4-5, no. 4), with the palace units grouped around it, had been leveled in the time of the old palace. The new layout suggests that the later palace was carefully planned, with the court serving as the major organizing element. A secondary organization of the palace plan involves two long corridors. On the west side of the court, a north-south corridor (FIG. 4-5, no. 6) separates official and ceremonial rooms from the storerooms (no. 8), where wine, grain, oil, and honey were stockpiled in large jars. On the east side of the court, a smaller east-west corridor (no. 14) separates the administrative areas (to the south) from the workrooms (to the north). At the northwest corner of the palace is a theaterlike area (no. 5) with steps on two sides that may have served as seats. This form is a possible forerunner of the later Greek theater (FIG. 5-71). Its purpose is unknown, but it is a feature paralleled in the Phaistos palace.

The Knossos palace was complex in elevation as well as plan. It had as many as three stories around the central court and even more on the south and east sides where the terrain sloped off sharply. Interior light and air wells with staircases (FIG. 4-6) provided necessary illumination and ventilation. The Minoans also gave thought to issues such as drainage of rainwater. At Knossos, a remarkably efficient system of terracotta pipes underlies the enormous building.

The Cretan palaces were well constructed, with thick walls composed of rough, unshaped fieldstones embedded in clay. The builders used ashlar masonry at corners and around door and window openings. The painted wooden columns (which Evans restored in cement at Knossos) have distinctive capitals and shafts. The bulbous, cushionlike Minoan capitals resemble those of the later Greek Doric order (FIG. 5-14), but the column shafts—essentially stylized inverted tree trunks—taper from a wide top to a narrower base, the opposite of both Egyptian and later Greek columns.

Painting

Mural paintings liberally adorn the palace at Knossos, constituting one of its most striking features. The brightly painted walls and the red shafts and black capitals of the wooden columns provided an extraordinarily rich effect. The paintings depict many aspects of Minoan life (bull-leaping, processions, and ceremonies) and of nature (birds, animals, flowers, and marine life).

LA PARISIENNE From a ceremonial scene of uncertain significance comes the fragment (FIG. 4-7) dubbed *La Parisienne* (The Parisian Woman) on its discovery because of the elegant dress, elaborate coiffure, and full rouged lips of the young woman depicted. Some have argued that she is a priestess taking part in a religious ritual, but because the figure has no arms, it is most likely a statue of a goddess. Although the representation is still convention-bound (note especially the oversized frontal eye in the profile head), the charm and freshness of the mural are undeniable. Unlike the

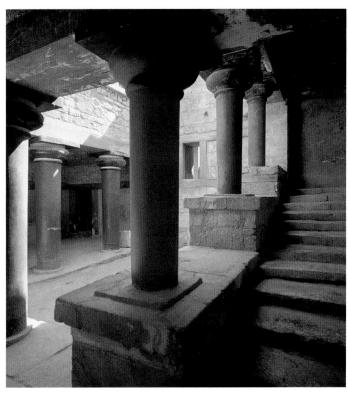

4-6 Stairwell in the residential quarter of the palace at Knossos (Crete), Greece, ca. 1700–1400 BCE.

The Knossos palace was complex in elevation as well as plan. It had at least three stories on all sides of the court. Minoan columns taper from top to bottom, the opposite of Egyptian and Greek columns.

4-7 Minoan woman or goddess (*La Parisienne*), from the palace at Knossos (Crete), Greece, ca. 1450–1400 BCE. Fragment of a fresco, 10" high. Archaeological Museum, Herakleion.

Frescoes
decorated the
Knossos palace
walls. This fragment depicts
a woman or a
goddess—perhaps
a statue—with a
large frontal eye in
her profile head,
as seen also in
Near Eastern and
Egyptian art.

1 in.

4-8 Bull-leaping, from the palace at Knossos (Crete), Greece, ca. 1450– 1400 BCE. Fresco, 2' 8" high, including border. Archaeological Museum, Herakleion.

The subjects of the Knossos frescoes are often ceremonial scenes, like this one of bull-leaping. The women have fair skin and the man has dark skin, a common convention in ancient painting.

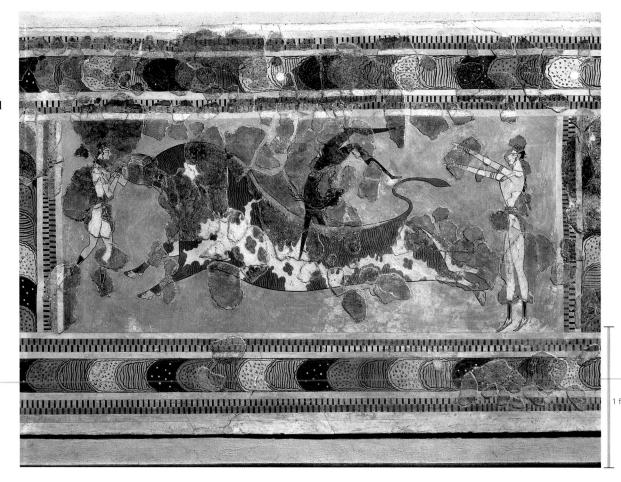

Egyptians, who painted in *fresco secco* (dry fresco), the Minoans coated the rough fabric of their rubble walls with a fine white lime plaster and used a true (wet) fresco method in which the pigments are mixed with water and become chemically bound to the plaster after it dries (see "Fresco Painting," Chapter 19, page 504). Consequently, the Minoan painters had to execute their work rapidly while the walls were still wet, in contrast to Egyptian practice.

 $\boldsymbol{BULL\text{-}LEAPING}$ Another fresco (FIG. 4-8) from the palace at Knossos depicts the Minoan ceremony of bull-leaping, in which young men grasped the horns of a bull and vaulted onto its back—a perilous and extremely difficult acrobatic maneuver. Only fragments of the full composition have been recovered (the dark patches are original; the rest is a modern restoration). The Minoan artist painted the young women (with fair skin) and the youth (with dark skin) according to the widely accepted ancient convention for distinguishing male and female. The painter brilliantly suggested the powerful charge of the bull by elongating the animal's shape and using sweeping lines to form a funnel of energy, beginning at the very narrow hindquarters of the bull and culminating in its large, sharp horns and galloping forelegs. The human figures also have stylized shapes, with typically Minoan pinched waists, and are highly animated. Although the profile pose with the full-view eye was a familiar convention in Egypt and Mesopotamia, the elegance of the Cretan figures, with their long, curly hair and proud and self-confident bearing, distinguishes them from all other early figure styles. In contrast to the angularity of the figures in Egyptian wall paintings, the curving lines the Minoan artist employed suggest the elasticity of living and moving beings.

THERA FRESCOES Much better preserved than the Knossos frescoes are those Greek archaeologists discovered in excavations begun in 1967 and still in progress at Akrotiri on the volcanic island of Santorini (ancient Thera) in the Cyclades, some 60 miles north of Crete. In the Late Cycladic period, Thera was artistically, and possibly also politically, within the Minoan orbit. The mural paintings from Akrotiri are invaluable additions to the fragmentary and frequently misrestored frescoes from Crete. The excellent condition of the Theran paintings is due to an enormous seismic explosion on Santorini that buried Akrotiri in volcanic pumice and ash, making it a kind of Pompeii of the prehistoric Aegean (see "The Theran Eruption and the Chronology of Aegean Art," page 87). The Akrotiri frescoes decorated the walls of houses, not the walls of a great palace such as that at Knossos, and therefore the number of painted walls from the site is especially impressive.

The almost perfectly preserved mural painting from Akrotiri known as the *Spring Fresco* (FIG. **4-9**) is one of the earliest examples of a pure landscape painting (compare FIG. **1-18**). The artist's aim, however, was not to render the rocky island terrain realistically but rather to capture the landscape's essence. The irrationally undulating and vividly colored rocks, the graceful lilies swaying in the cool island breezes, and the darting swallows express the vigor of growth, the delicacy of flowering, and the lightness of birdsong and flight. In the lyrical language of curving line, the artist celebrated the rhythms of spring. The *Spring Fresco* represents the polar opposite of the first efforts at mural painting in the caves of Paleolithic Europe (see Chapter 1), where animals (and occasionally humans) appeared as isolated figures without any indication of setting.

The Theran Eruption and the Chronology of Aegean Art

Today, ships bound for the beautiful Greek island of Santorini, with its picture-postcard white houses, churches, shops, and restaurants, weigh anchor in a bay beneath steep, crescent-shaped cliffs. Until about 20,000 BCE, however, ancient Thera had a roughly circular shape and gentler slopes. Then, suddenly, a volcanic eruption blew out the center of the island, leaving behind the moonshaped main island and several lesser islands grouped around a bay that roughly corresponds to the shape of the gigantic ancient volcano. The volcano erupted again, thousands of years later, during the zenith of Aegean civilization.

In that eruption, the site of Akrotiri, which Greek excavators gradually are uncovering, was buried by a layer of pumice more than a yard deep in some areas and by an even larger volume of volcanic ash (*tephra*) that often exceeds five yards in depth, even after nearly 37 centuries of erosion. Tephra filled whole rooms, and boulders the volcano spewed forth pelted the walls of some houses. Closer to the volcano's cone, the tephra is almost 60 yards deep in places. In fact, the force of the eruption was so powerful that sea currents carried the pumice and wind blew the ash throughout the ancient Mediterranean, not only to Crete, Rhodes, and Cyprus but also as far away as Anatolia, Egypt, Syria, and Israel.

Until recently, most scholars embraced the theory formulated decades ago by Spyridon Marinatos, an eminent Greek archaeolo-

gist, that the otherwise unexplained demise of Minoan civilization on Crete around 1500 BCE was the by-product of the volcanic eruption on Thera. According to Marinatos, devastating famine followed the rain of ash that fell on Crete. But archaeologists now know that after the eruption, life went on in Crete, if not on Thera. At one Cretan site, the Minoans collected Theran pumice and deposited it in conical cups on a monumental stairway, possibly as a votive offering.

Teams of researchers, working closely in an impressive and most welcome interdisciplinary effort, have pinpointed 1628 BCE as the date of a major climatic event. They have studied tree rings at sites in Europe and in North America for evidence of retarded growth and have examined ice cores in Greenland for peak acidity layers. Both kinds of evidence testify to a significant disruption in weather patterns in that year. Most scholars now believe the cause of this disruption was the cataclysmic volcanic eruption on Thera. The discovery in 2006 of a datable olive tree in the Santorini tephra brought welcome confirmation for this theory.

The new 17th-century BCE date has profound consequences for the chronology of Aegean art. The Akrotiri frescoes (FIG. 4-9) must be around 150 years older than scholars thought when they were first discovered. The frescoes predate by many decades the Knossos palace murals (FIGS. 4-7 and 4-8).

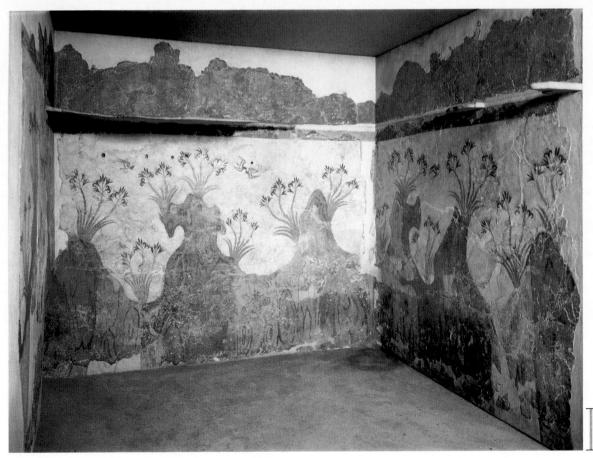

4-9 Landscape with swallows (*Spring Fresco*), from room Delta 2, Akrotiri, Thera (Cyclades), Greece, ca. 1650 BCE. Fresco, 7' 6" high. National Archaeological Museum, Athens.

Aegean muralists painted in wet fresco, which required rapid execution. In this first known pure landscape, the Theran painter used vivid colors and undulating lines to capture the essence of springtime.

1 ft.

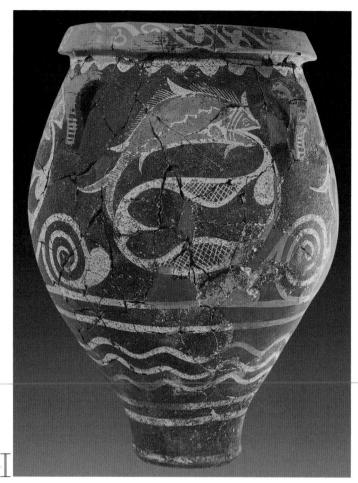

4-10 Kamares-ware jar, from Phaistos (Crete), Greece, ca. 1800–1700 BCE. 1' 8" high. Archaeological Museum, Herakleion.

Kamares vases have creamy white and reddish-brown decoration on a black background. This jar combines a fish (and a net?) with curvilinear abstract patterns including spirals and waves.

MINOAN POTTERY The love of nature manifested itself in Crete on the surfaces of painted vases even before the period of the new palaces. During the Middle Minoan period, Cretan potters fashioned sophisticated shapes using newly introduced potters' wheels, and decorated their vases in a distinctive and fully polychromatic style. These Kamares-ware vessels, named for the cave on the slope of Mount Ida where they were first discovered, have been found in quantity at Phaistos and Knossos and at sites throughout the Mediterranean and Near East. On the illustrated jar (FIG. 4-10), as on other Kamares vases, the painter set creamy white and reddishbrown decoration against a rich black ground. The central motif is a great leaping fish and perhaps a fishnet surrounded by a host of curvilinear abstract patterns including waves and spirals. The swirling lines evoke life in the sea, and both the abstract and the natural forms beautifully complement the shape of the vessel.

The sea and the creatures that inhabit it also inspired the Late Minoan Marine Style octopus jar (FIG. 4-11) from Palaikastro, which is contemporary with the new palaces at Knossos and elsewhere. The tentacles of the octopus reach out over the curving surfaces of the vessel, embracing the piece and emphasizing its volume. This is a masterful realization of the relationship between the vessel's decoration and its shape, always a problem for the vase painter. This later jar differs markedly from its Kamares-ware predecessor in color. Not only is the octopus vase more muted in tone, but the Late

4-11 Marine Style octopus jar, from Palaikastro (Crete), Greece, ca. 1500 BCE. 11" high. Archaeological Museum, Herakleion.

Marine Style vases have dark figures on a light ground. On this octopus jar the tentacles of the sea creature reach out over the curving surface of the vessel to fill the shape perfectly.

Minoan artist also reversed the earlier scheme and placed dark silhouettes on a light ground. This dark-on-light format remained the norm for about a millennium in Greece, until about 530 BCE when, albeit in a very different form, light figures and a dark background emerged once again as the preferred manner (compare FIG. 5-22, *left* and *right*).

Sculpture

In contrast to Mesopotamia and Egypt, no temples or monumental statues of gods, kings, or monsters have been found in Minoan Crete. Large wooden images may once have existed—*La Parisienne* (FIG. 4-7) may depict one of them—but what remains of Minoan sculpture is uniformly small in scale.

SNAKE GODDESS One of the most striking finds at the palace at Knossos was the *faience* (low-fired opaque glasslike silicate) statuette popularly known as the *Snake Goddess* (FIG. 4-12). Reconstructed from many pieces, it is one of several similar figurines that some scholars believe may represent mortal attendants rather than a deity, although the prominently exposed breasts suggest that these figurines stand in the long line of prehistoric fertility images usually considered divinities. The Knossos woman holds snakes in her hands and also supports a leopardlike feline on her head. This implied power over the animal world also seems appropriate for a

4-12 *Snake Goddess*, from the palace at Knossos (Crete), Greece, ca. 1600 BCE. Faience, 1' $1\frac{1}{2}''$ high. Archaeological Museum, Herakleion.

This figurine may represent a priestess, but it is more likely a barebreasted goddess. The snakes in her hands and the feline on her head imply that she has power over the animal world.

deity. The frontality of the figure is reminiscent of Egyptian and Near Eastern statuary, but the costume, with its open bodice and flounced skirt, is distinctly Minoan. If the statuette represents a goddess, as seems likely, then it is yet another example of how human beings fashion their gods in their own image.

PALAIKASTRO YOUTH British excavations at Palaikastro between 1987 and 1990 yielded fragments of one of the most remarkable objects ever found on Crete. It is a statuette (FIG. 4-13) nearly 20 inches tall, fashioned from hippopotamus-tusk ivory, gold, serpentine, and rock crystal. The figurine is a very early example of *chryselephantine* (gold and ivory) sculpture, a technique that the Greeks would later use for their largest and costliest cult images (FIG. 5-46). The ivory and gold were probably imported from Egypt, the source also of the pose with left foot advanced (FIG. 3-13), but the style and iconography are unmistakably Cretan. The work is the creation of a sculptor of extraordinary ability who delighted in rendering minute details of muscles and veins. The Palaikastro youth (his

4-13 Young god(?), from Palaikastro (Crete), Greece, ca. 1500–1475 BCE. Ivory, gold, serpentine, and rock crystal, restored height 1' $7\frac{1}{2}''$. Archaeological Museum, Siteia.

This statuette, probably representing a young god, is a very early example of chryselephantine (gold and ivory) sculpture, a technique later used for the largest and costliest Greek cult statues.

coiffure, with shaved head save for a central braid, indicates his age) was displayed alone in a shrine and therefore seems to have been a god rather than a mortal. Archaeologists found the statuette in scattered and blackened fragments, suggesting fire following an act of vandalism in the 15th century BCE.

HARVESTERS VASE The finest surviving example of Minoan relief sculpture is the so-called Harvesters Vase (FIG. 4-14) from Hagia Triada. Only the upper half of the egg-shaped body and neck of the vessel are preserved. Missing are the lower parts of the harvesters (or, as some think, sowers) and the ground on which they stand as well as the gold leaf that originally covered the relief figures. Formulaic scenes of sowing and harvesting were staples of Egyptian funerary art (FIG. 3-16), but the Minoan artist shunned static repetition in favor of a composition that bursts with the energy of its individually characterized figures. The relief shows a riotous crowd singing and shouting as they go to or return from the fields. The artist vividly captured the forward movement and lusty exuberance of the youths.

4-14 Harvesters Vase, from Hagia Triada (Crete), Greece, ca. 1500 BCE. Steatite, originally with gold leaf, greatest diameter 5". Archaeological Museum, Herakleion.

The relief sculptor of the singing harvesters on this small stone vase was one of the first artists in history to represent the underlying muscular and skeletal structure of the human body.

Although most of the figures conform to the age-old convention of combined profile and frontal views, the sculptor singled out one figure (FIG. 4-14, *right*) from his companions. He shakes a rattle to beat time, and the artist depicted him in full profile with his lungs so inflated with air that his ribs show. This is one of the first

instances in the history of art of a sculptor showing a keen interest in the underlying muscular and skeletal structure of the human body. The artist's painstaking study of human anatomy is a remarkable achievement, especially given the size of the *Harvesters Vase*, barely five inches at its greatest diameter. Equally noteworthy is how the sculptor recorded the tension and relaxation of facial muscles with astonishing exactitude, not just for this figure but for his three closest companions as well. This degree of animation of the human face is without precedent in ancient art.

MINOAN DECLINE Scholars dispute the circumstances ending the Minoan civilization, although they now widely believe that Mycenaeans had already moved onto Crete and established themselves at Knossos at the end of the New Palace period. From the palace at Knossos, these intruders appear to have ruled the island for at least a half century, perhaps much longer. Parts of the palace continued to be occupied until its final destruction around 1200 BCE, but its importance as a cultural center faded soon after 1400 BCE, as the focus of Aegean civilization shifted to the Greek mainland.

MYCENAEAN ART

The origins of the Mycenaean culture are still debated. The only certainty is the presence of these forerunners of the Greeks on the mainland about the time the old palaces were built on Crete—that is, about the beginning of the second millennium BCE. Doubtless, Cretan civilization influenced these people even then, and some believe that the mainland was a Minoan economic dependency for a long time. In any case, Mycenaean power developed on the mainland in the days of the new palaces on Crete, and by 1500 BCE a distinctive Mycenaean culture was flourishing in Greece. Several centuries later, Homer described Mycenae as "rich in gold." The dramatic discoveries of Schliemann and his successors have fully justified this characterization, even if today's archaeologists no longer view the Mycenaeans solely through the eyes of Homer.

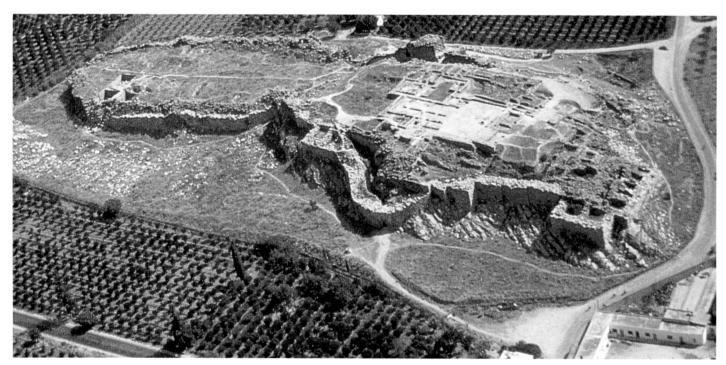

4-15 Aerial view of the citadel at Tiryns, Greece, ca. 1400–1200 BCE.

In the *Iliad,* Homer called the fortified citadel of Tiryns the city "of the great walls." Its huge, roughly cut stone blocks are examples of Cyclopean masonry, named after the mythical one-eyed giants.

Architecture

The destruction of the Cretan palaces left the mainland culture supreme. Although this Late Helladic civilization has come to be called Mycenaean, Mycenae was but one of several large palace complexes. Archaeologists have also unearthed Mycenaean remains at Tiryns, Orchomenos, Pylos, and elsewhere, and Mycenaean fortification walls have even been found on the Acropolis of Athens. The best-preserved and most impressive Mycenaean remains are those of the fortified palaces at Tiryns and Mycenae. Both were built beginning about 1400 BCE and burned (along with all the others) between 1250 and 1200 BCE, when the Mycenaeans seem to have been overrun by northern invaders or to have fallen victim to internal warfare.

TIRYNS Homer knew the citadel of Tiryns (FIG. 4-15), located about 10 miles from Mycenae, as Tiryns of the Great Walls. In the second century CE, when Pausanias, author of an invaluable guidebook to Greece, visited the long-abandoned site, he marveled at the towering fortifications and considered the walls of Tiryns as spectacular as the pyramids of Egypt. Indeed, the Greeks of the historical age believed mere humans could not have erected such edifices and instead attributed the construction of the great Mycenaean citadels to the

4-16 Corbeled gallery in the walls of the citadel, Tiryns, Greece, ca. 1400–1200 BCE.

The walls of Tiryns contain a long corbel-vaulted gallery in which irregular Cyclopean blocks were piled in horizontal courses and then cantilevered inward until the two walls met in a pointed arch.

mythical *Cyclopes*, a race of one-eyed giants. Historians still refer to the huge, roughly cut stone blocks forming the massive fortification walls of Tiryns and other Mycenaean sites as *Cyclopean masonry*.

The heavy walls of Tiryns and Mycenae contrast sharply with the open Cretan palaces (FIG. 4-4) and clearly reveal their defensive character. Those of Tiryns average about 20 feet in thickness, and in one section they house a long gallery (FIG. 4-16) covered by a corbeled vault (FIG. 4-17b) similar to that constructed long before at Neolithic Newgrange (FIG. 1-19). At Tiryns, the builders piled the large, irregular Cyclopean blocks in horizontal courses and then cantilevered them inward until the two walls met in a pointed arch. No mortar was used, and the vault is held in place only by the weight of the blocks (often several tons each), by the smaller stones used as wedges, and by the clay that fills some of the empty spaces. This primitive but effective vaulting scheme possesses an earthy monumentality. It is easy to see how a later

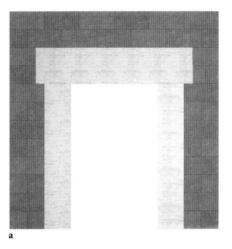

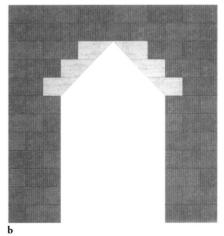

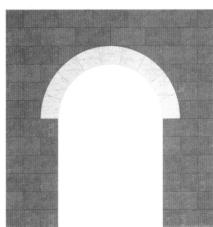

4-17
Three methods
of spanning a
passageway:
(a) post and lintel,
(b) corbeled arch,
(c) arch.

Post-and-lintel construction (a) was the norm in ancient Greece, but the Mycenaeans also used corbeled arches (b). The round arch (c), used already in the Near East, was popular in Rome.

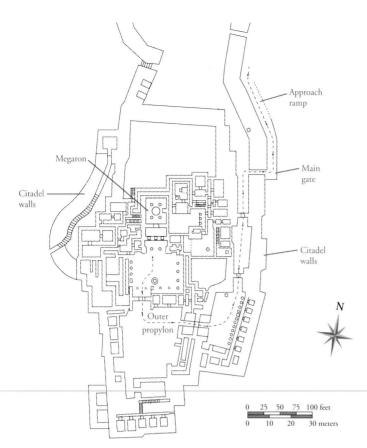

4-18 Plan of the palace and southern part of the citadel, Tiryns, Greece, ca. 1400–1200 BCE.

The king's reception and throne room, or megaron, was the main feature of Mycenaean palaces. Its plan, consisting of a hall with a columnar porch, is similar to that of early Greek temples (FIG. 5-6).

age came to believe that the uncouth Cyclopes were responsible for these massive but unsophisticated fortifications.

Would-be attackers at Tiryns were compelled to approach the palace (FIG. 4-18) within the walls via a long ramp that forced the (usually right-handed, as in FIG. 4-25) soldiers to expose their unshielded sides to the Mycenaean defenders above. Then—if they got that far—they had to pass through a series of narrow gates that also could be defended easily. Inside, at Tiryns as elsewhere, the most important element in the palace plan was the *megaron*, or reception hall and throne room, of the king. The main room of the megaron had a throne against the right wall and a central hearth bordered by four Minoan-style wooden columns serving as supports for the roof. A vestibule with a columnar facade preceded the throne room. A variation of this plan later formed the core of some of the earliest Greek temple plans (FIG. 5-6), suggesting some architectural continuity between the Mycenaean age and historical Greece.

LION GATE, MYCENAE The severity of these fortress-palaces was relieved by frescoes, as in the Cretan palaces, and, at Agamemnon's Mycenae at least, by monumental architectural sculpture. The so-called Lion Gate (FIG. 4-19) is the outer gateway of the stronghold at Mycenae. It is protected on the left by a wall built on a natural rock outcropping and on the right by a projecting bastion of large blocks. Any approaching enemies would have had to enter this 20-foot-wide channel and face Mycenaean defenders above them on both sides. The gate itself consists of two great monoliths capped with a huge lintel (FIG. 4-17a). Above the lintel, the masonry courses form a corbeled arch (FIG. 4-17b), leaving an opening that lightens the weight the lintel carries. Filling this relieving triangle (FIG. 4-1) is a great limestone slab where two lions carved in high relief stand on the sides of a Minoan-type column. The whole design admirably matches its triangular space, harmonizing in dignity, strength, and scale with the mas-

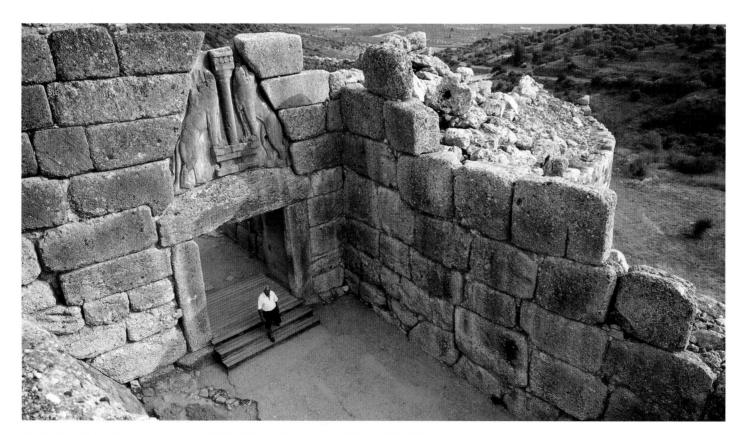

4-19 Lion Gate, Mycenae, Greece, ca. 1300–1250 BCE. Limestone, relief panel 9' 6" high.

The largest sculpture in the prehistoric Aegean is the relief of confronting lions (FIG. 4-1) that fills the relieving triangle of Mycenae's main gate. The gate itself consists of two great monoliths and a huge lintel.

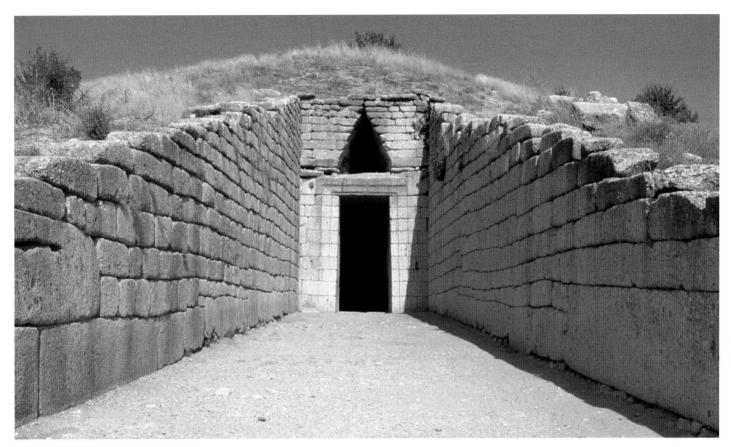

4-20 Treasury of Atreus, Mycenae, Greece, ca. 1300–1250 BCE.

The best-preserved Mycenaean tholos tomb is named for Homer's King Atreus. An earthen mound covers the burial chamber, which is accessed through a doorway at the end of a long passageway.

sive stones that form the walls and gate. Similar groups appear in miniature on Cretan seals, but the idea of placing monstrous guardian figures at the entrances to palaces, tombs, and sacred places has its origin in the Near East and Egypt (FIGS. 2-18, 2-21, and 3-11). At Mycenae the animals' heads were fashioned separately and are lost. Some scholars have suggested that the "lions" were actually composite beasts in the Eastern tradition, possibly sphinxes.

TREASURY OF ATREUS The Lion Gate at Mycenae and the towering fortification wall circuit of which it formed a part were constructed a few generations before the presumed date of the Trojan War. At that time, wealthy Mycenaeans were laid to rest outside the citadel walls in beehive-shaped tombs covered by enormous earthen mounds. Nine are preserved at Mycenae and scores more at other sites. The best-preserved of these tholos tombs is Mycenae's socalled Treasury of Atreus (FIG. 4-20), which already in antiquity was mistakenly believed to be the repository of the treasure of Atreus, father of Agamemnon and Menelaus. Approached by a long passageway (dromos), the tomb chamber was entered through a doorway surmounted by a relieving triangle similar to that employed in the roughly contemporary Lion Gate. (As in the Lion Gate, the open triangle was originally covered. Both the doorway and the relieving triangle also once had engaged columns on each side, preserved in fragments today.) The tholos (FIG. 4-21) is composed of a series of

4-21 Vault of the tholos of the Treasury of Atreus, Mycenae, Greece, ca. 1300–1250 BCE.

The beehive-shaped tholos of the Treasury of Atreus is composed of corbeled courses of stone blocks laid on a circular base. The 43-foothigh dome was the largest in the world for almost 1,500 years.

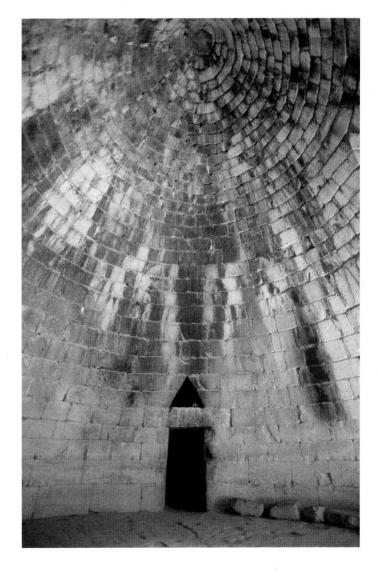

stone corbeled courses laid on a circular base to form a lofty *dome*. The builders probably constructed the vault using rough-hewn blocks. After they set the stones in place, the masons had to finish the surfaces with great precision to make them conform to both the horizontal and vertical curves of the wall. The principle involved is no different from that of the corbeled gallery (FIG. 4-16) of Tiryns. But the problem of constructing a complete dome is much more complicated, and the execution of the vault in the Treasury of Atreus is far more sophisticated than that of the vaulted gallery at Tiryns. About 43 feet high, this was at the time the largest vaulted space without interior supports that had ever been built. The achievement was not surpassed until the Romans constructed the Pantheon (FIG. 10-51) almost 1,500 years later using a new technology—concrete construction—unknown to the Mycenaeans.

Metalwork, Sculpture, and Painting

The Treasury of Atreus had been thoroughly looted long before its modern rediscovery, but excavators have found spectacular grave goods elsewhere at Mycenae. Just inside the Lion Gate, Schliemann uncovered what archaeologists now designate as Grave Circle A. It predates the Lion Gate and the walls of Mycenae by some three centuries. Grave Circle A encloses six deep shafts that had served as tombs for kings and their families. The Mycenaeans laid their dead to rest on the floors of these shaft graves with masks covering their faces, recalling the Egyptian funerary practice. They buried women with their jewelry and men with their weapons and golden cups.

MASKS AND DAGGERS Among the most spectacular of Schliemann's finds is a gold mask (FIG. 4-22), one of several from

the royal burial complex. The Mycenaean masks were made using the repoussé technique, that is, the goldsmiths hammered the shape from a single sheet of metal and pushed the features out from behind. The mask illustrated here has often been compared to Tutankhamen's gold mummy mask (FIG. 3-1). The treatment of the human face is, of course, more primitive in the Mycenaean mask. But this was one of the first attempts in Greece to render the human face at life-size, whereas Tutankhamen's mask stands in a long line of monumental Egyptian sculptures going back more than a millennium. It is not known whether the Mycenaean masks were intended as portraits, but the goldsmiths recorded different physical types with care. They portrayed youthful faces as well as mature ones. The illustrated example (FIG. 4-22), with its full beard, must depict a mature man, perhaps a king—although not Agamemnon, as Schliemann wished. If Agamemnon was a real king, he lived some 300 years after this mask was fashioned. Clearly the Mycenaeans were "rich in gold" long before Homer's heroes fought at Troy.

Also found in Grave Circle A were several magnificent bronze dagger blades inlaid with gold, silver, and *niello* (a black metallic alloy), again attesting to the wealth of the Mycenaean kings as well as to their warlike nature. The largest and most elaborate of the group is decorated on one side (FIG. 4-23) with a scene of four hunters attacking a lion that has struck down a fifth hunter, while two other lions flee. The other side shows lions attacking deer. The slimwaisted, long-haired figures are Minoan in style, but the artist borrowed the subject from the repertoire of the ancient Near East. It is likely that a Minoan metalworker made the dagger for a Mycenaean patron who admired Minoan art but whose taste in subject matter differed from that of his Cretan counterparts.

4-22 Funerary mask, from Grave Circle A, Mycenae, Greece, ca. 1600–1500 BCE. Beaten gold, 1' high. National Archaeological Museum, Athens.

Homer described the Mycenaeans as "rich in gold." This beaten gold (repoussé) mask of a bearded man comes from a royal shaft grave. It is one of the first attempts at life-size sculpture in Greece.

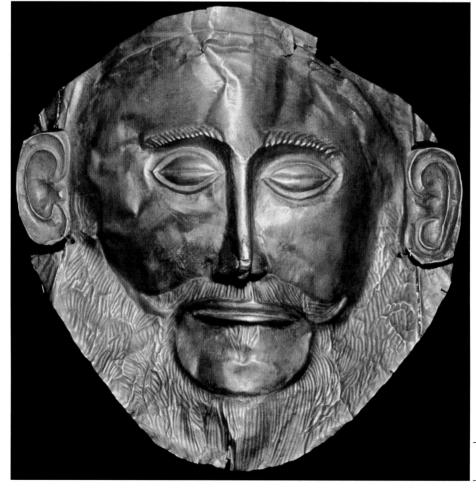

1 in

4-23 Inlaid dagger blade with lion hunt, from Grave Circle A, Mycenae, Greece, ca. 1600–1500 BCE. Bronze, inlaid with gold, silver, and niello, 9" long. National Archaeological Museum, Athens.

The treasures buried with the Mycenaean kings attest to their wealth. The lion hunters on this bronze dagger are Minoan in style, but the metalworker borrowed the subject from the artistic repertory of the Near East.

PLASTER SCULPTURE Large-scale figural art is very rare on the Greek mainland, as on Crete, other than the Minoan-style paintings that once adorned the walls of Mycenaean palaces. The triangular relief (Fig. 4-1) of the Lion Gate at Mycenae is exceptional, as is the painted plaster head (Fig. 4-24) of a woman, goddess, or, perhaps, sphinx found at Mycenae. The white flesh tone indicates that the head is female. The hair and eyes are dark blue, almost black, and the lips, ears, and headband are red. The artist decorated the cheeks and chin with red circles surrounded by a ring of red dots, recalling

the facial paint or tattoos recorded on Early Cycladic figurines of women. Although the large staring eyes give the face a menacing, if not terrifying, expression appropriate for a guardian figure such as a sphinx, the closest parallels to this work in the prehistoric Aegean are terracotta images of goddesses. This head may therefore be a very early example of a monumental cult statue in Greece.

Were it not for this plaster head and a few other exceptional pieces, art historians might have concluded—wrongly—that the Mycenaeans had no monumental freestanding statuary—a reminder that it is

4-24 Female head, from Mycenae, Greece, ca. 1300–1250 BCE. Painted plaster, $6\frac{1}{2}''$ high. National Archaeological Museum, Athens.

This painted white plaster head of a woman with large staring eyes may be a very early example of a monumental statue of a goddess in Greece, but some scholars think it is the head of a sphinx.

1 in.

4-25 Warriors Vase, from Mycenae, Greece, ca. 1200 BCE. 1' 4" high. National Archaeological Museum, Athens.

This krater, or mixing bowl, shows a woman bidding farewell to a column of heavily armed Mycenaean warriors depicted using both silhouette and outline and a combination of frontal and profile views.

always dangerous to generalize from the fragmentary remains of an ancient civilization. Nonetheless, life-size Aegean statuary must have been rare. After the collapse of Mycenaean civilization and for the next several hundred years, no attempts at monumental statuary are evident until, after the waning of the so-called Dark Ages, Greek sculptors were exposed to the great sculptural tradition of Egypt (see Chapter 5).

WARRIORS VASE An art form that did continue throughout the period after the downfall of the Mycenaean palaces was vase painting. One of the latest examples of Mycenaean painting is the krater (bowl for mixing wine and water) commonly called the Warriors Vase (FIG. 4-25) after its prominent frieze of soldiers marching off to war. At the left a woman bids farewell to the column of heavily

armed warriors moving away from her. The painting on this vase reveals no setting and lacks the landscape elements that characterized earlier Minoan and Mycenaean art. All the soldiers also repeat the same pattern, a far cry from the variety and anecdotal detail of the lively procession of the Minoan *Harvesters Vase* (FIG. 4-14).

This simplification of narrative has parallels in the increasingly schematic and abstract treatment of marine life on other painted vases. The octopus, for example, eventually became a stylized motif composed of concentric circles and spirals that are almost unrecognizable as a sea creature. By Homer's time, the heyday of Aegean civilization was but a distant memory, and the men and women of Crete and Mycenae—Minos and Ariadne, Agamemnon and Helen—had assumed the stature of heroes from a lost golden age.

THE PREHISTORIC AEGEAN

EARLY CYCLADIC ART, ca. 3000-2000 BCE

- Marble statuettes are the major surviving artworks of the Cycladic Islands during the third millennium BCE, but little is known about their function.
- Many of the Cycladic figurines were buried in graves and may represent the deceased, but others, for example, musicians, almost certainly do not. Whatever their meaning, these statuettes mark the beginning of the long history of marble sculpture in Greece.

Lyre player, Keros, ca. 2700–2500 BCE

LATE MINOAN ART, ca. 1700-1200 BCE

- The so-called Old Palace period (ca. 2000–1700 BCE) on Crete saw the construction of the first palaces on the island, but the golden age of Crete was the Late Minoan period.
- The greatest Late Minoan palace was at Knossos. A vast multistory structure arranged around a central court, the Knossos palace was so complex in plan that it gave rise to the myth of the Minotaur in the labyrinth of King Minos.
- The largest art form in the Minoan world was fresco painting on walls, usually illustrating palace rituals like bull-leaping.
- Vase painting also flourished. Sea motifs, for example, the octopus, were popular subjects.
- Minoan sculpture was of small scale, consisting of statuettes of "snake goddesses" and reliefs on stone vases.

Bull-leaping fresco, Knossos ca. 1450–1400 BCE

Snake Goddess, Knossos, ca. 1600 BCE

MYCENAEAN (LATE HELLADIC) ART, ca. 1700-1200 BCE

- The Mycenaeans, who with their Greek allies later waged war on Troy, were already by 1600–1500 BCE burying their kings in deep shaft graves with gold funerary masks and bronze daggers inlaid with gold and silver.
- By 1450 BCE, the Mycenaeans had occupied Crete, and between 1400 and 1200 BCE, they erected great citadels at Mycenae, Tiryns, and elsewhere with "Cyclopean" walls of huge, irregularly shaped stone blocks.
- Masters of corbel vaulting, the Mycenaeans also erected beehive-shaped tholos tombs like the so-called Treasury of Atreus, which had the largest dome in the pre-Roman world.
- The oldest preserved monumental sculptures in Greece, most notably Mycenae's Lion Gate, date to the end of the Mycenaean period.

Gold funerary mask, Mycenae, ca. 1600–1500 BCE

Vault of the Treasury of Atreus, Mycenae, ca. 1300–1250 BCE

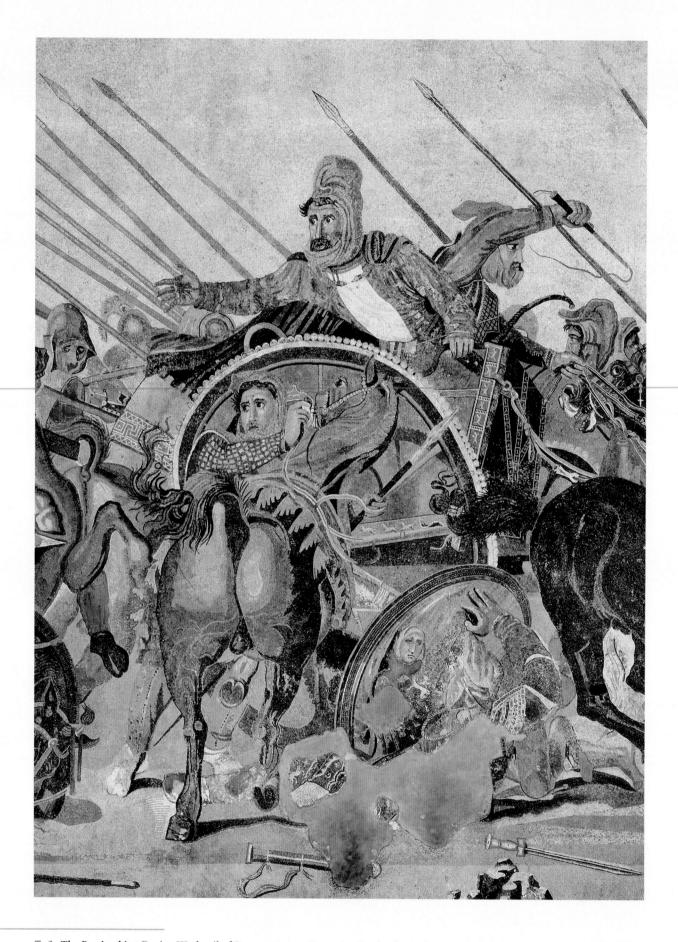

5-1 The Persian king Darius III, detail of Philoxenos of Eretria, *Battle of Issus* (fig. 5-70), Roman mosaic copy of a painting of ca. 310 BCE. Museo Archeologico Nazionale, Naples.

Greek painters were the first to employ foreshortening consistently, to model figures in color, and to depict reflections and shadows—practices that became standard in later painting in the Western world.

ANCIENT GREECE

A ncient Greek art occupies a special place in the history of art through the ages. Many of the Cultural values of the Greeks, especially the exaltation of humanity as the "measure of all things," remain fundamental tenets of Western civilization. This humanistic worldview led the Greeks to create the concept of democracy (rule by the *demos*, the people) and to make seminal contributions in the fields of art, literature, and science. Ancient Greek ideas are so completely part of modern Western habits of mind that most people are scarcely aware that the concepts originated in Greece more than 2,500 years ago.

The Greeks, or *Hellenes*, as they called themselves, appear to have been the product of an intermingling of Aegean peoples and Indo-European invaders. They never formed a single nation but instead established independent city-states, or *poleis* (singular, *polis*). The Dorians of the north, who many believe brought an end to Mycenaean civilization, settled in the Peloponnesos (MAP 5-1). The Ionians settled the western coast of Asia Minor (modern Turkey) and the islands of the Aegean Sea. The origin of the Ionians is disputed. Some say the northern invaders forced the Ionians out of Greece and that they then sailed eastward from Athens to their new homes. Others hold that the Ionians developed in Asia Minor between the 11th and 8th centuries BCE out of a mixed stock of settlers.

Whatever the origins of the various regional populations, in 776 BCE the separate Greek-speaking states held their first ceremonial games in common at Olympia. The later Greeks calculated their chronology from these first Olympic Games—the first Olympiad. From then on, despite their differences and rivalries, the Greeks regarded themselves as citizens of *Hellas* (the ancient name of Greece), distinct from the surrounding "barbarians" who did not speak Greek.

Even the gods of the Greeks (see "The Gods and Goddesses of Mount Olympus," page 101) differed in kind from those of neighboring civilizations. Unlike Egyptian and Mesopotamian deities, the Greek gods and goddesses differed from human beings only in that they were immortal. It has been said that the Greeks made their gods into humans and their humans into gods. The perfect individual became the Greek ideal—and the portrayal of beautiful humans became the focus of many of the greatest Greek artists.

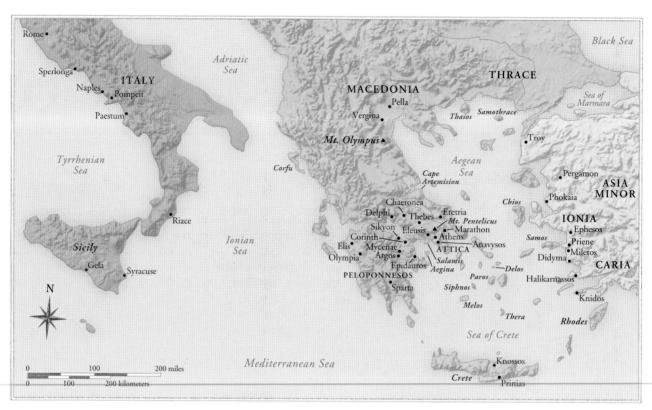

MAP 5-1 The Greek world.

Although the sculptures, paintings, and buildings discussed in this chapter were made and built all over Greece and in its many colonies abroad (MAP 5-1), Athens, the capital of Greece today, has justifiably become the symbol of ancient Greek culture. Athens is where the great plays of Aeschylus, Sophocles, and Euripides were first performed. And there, in the city's central square (agora), covered colonnades (stoas), and gymnasiums (palaestras), Socrates engaged his fellow citizens in philosophical argument, and Plato formulated his prescription for the ideal form of government in the Republic. Complementing the rich intellectual life of ancient Athens was a strong interest in physical exercise, which played a large role in education, as well as in daily life. The Athenian aim of achieving a balance of intellectual and physical discipline, an ideal of humanistic education, is well expressed in the familiar phrase "a sound mind in a sound body."

The distinctiveness and originality of Greek contributions to art, science, and politics should not, however, obscure the enormous debt the Greeks owed to the cultures of Egypt and the Near East. Scholars today increasingly recognize this debt, and the ancient Greeks themselves readily acknowledged borrowing ideas, motifs, conventions, and skills from those older civilizations. Nor should a high estimation of Greek art and culture blind anyone to the realities of Hellenic life and society. Even Athenian "democracy" was a political reality for only one segment of the demos. Slavery was regarded as natural, even beneficial, and was a universal institution among the Greeks. Greek women were in no way the equals of Greek men. Women normally remained secluded in their homes, emerging usually only for weddings, funerals, and religious festivals. They played little part in public or political life. Despite the fame of the poet Sappho, only a handful of female artists' names are known, and none of their works survive. Both the existence of slavery and the exclusion of women from public life are reflected in Greek art. On many occasions freeborn men and women appear with their slaves in monumental sculpture. The *symposium* (a dinner party that only men and prostitutes attended) is a popular subject on painted vases.

Although the Greeks invented and passed on to future generations the concept and practice of democracy, most Greek states, even those constituted as democracies, were dominated by wellborn white males, and the most admired virtues were not wisdom and justice but statecraft and military valor. Greek men were educated in the values of Homer's heroes and in the athletic exercises of the palaestra. War among the city-states was chronic. Fighting among themselves, the Greeks eventually fell victim to the Macedonians and Romans.

GEOMETRIC AND ORIENTALIZING PERIODS

Disintegration of the Bronze Age social order accompanied the destruction of the Mycenaean palaces. The disappearance of powerful kings and their retinues led to the loss of the knowledge of how to cut masonry, to construct citadels and tombs, to paint frescoes, and to sculpt in stone. Even the arts of reading and writing were forgotten. Depopulation, poverty, and an almost total loss of contact with the outside world characterized the succeeding centuries, sometimes called the Dark Age of Greece. Only in the eighth century BCE did economic conditions improve and the population begin to grow again. This era was in its own way a heroic age, a time when the poleis of Classical Greece took shape; when the Greeks broke out of their isolation and once again began to trade with cities both in the east and the west; when Homer's epic poems, formerly memorized and passed down from bard to bard, were recorded in written form; and when the Olympic Games were established.

The Gods and Goddesses of Mount Olympus

The names of scores of Greek gods and goddesses were recorded as early as the eighth century BCE in Homer's epic tales of the war against Troy (*Iliad*) and of the adventures of the Greek hero Odysseus on his long and tortuous journey home (*Odyssey*). Even more are enumerated in the poems of Hesiod, especially his *Theogony* (*Genealogy of the Gods*) composed around 700 BCE.

The Greek deities most often represented in art are all ultimately the offspring of the two key elements of the Greek universe, Earth (Gaia/Ge; all names are given in their Greek and Latin, that is, Greek and Roman forms) and Heaven (Ouranos/Uranus). Earth and Heaven mated to produce 12 Titans, including Ocean (Okeanos/Oceanus) and his youngest brother Kronos (Saturn). Kronos castrated his father in order to rule in his place, married his sister Rhea, and then swallowed all his children as they were born, lest one of them seek in turn to usurp him. When Zeus (Jupiter) was born, Rhea deceived Kronos by feeding him a stone wrapped in clothes in place of the infant. After growing to manhood, Zeus forced Kronos to vomit up Zeus's siblings. Together they overthrew their father and the other Titans and ruled the world from their home on Mount Olympus, Greece's highest peak.

This cruel and bloody tale of the origin of the Greek gods has parallels in Near Eastern mythology and is clearly pre-Greek in origin, one of many Greek borrowings from the East. The Greek version of the creation myth, however, appears infrequently in painting and sculpture. Instead, the later 12 Olympian gods and goddesses, the chief deities of Greece, figure most prominently in art—not only in Greek, Etruscan, and Roman times but also in the Middle Ages, the Renaissance, and up to the present.

The 12 Olympian deities were

- Zeus (Jupiter) King of the gods, Zeus ruled the sky and allotted the sea to his brother Poseidon and the Underworld to his other brother Hades. His weapon was the thunderbolt, and with it he led the other gods to victory over the giants, who had challenged the Olympians for control of the world. Jupiter was also the chief god of the Romans.
- Hera (Juno) Wife and sister of Zeus, Hera was the goddess of marriage.
- Poseidon (Neptune) Poseidon was one of the three sons of Kronos and Rhea and was lord of the sea. He controlled waves, storms, and earthquakes with his three-pronged pitchfork (trident).
- *Hestia* (*Vesta*) Sister of Zeus, Poseidon, and Hera, Hestia was goddess of the hearth.
- **Demeter (Ceres)** Third sister of Zeus, Demeter was the goddess of grain and agriculture. She taught humans how to sow and plow.
- Ares (Mars) God of war, Ares was the son of Zeus and Hera and the lover of Aphrodite. Mars, father of the twin founders of Rome, Romulus and Remus, looms much larger in Roman mythology and religion than Ares does in Greek.

- Athena (Minerva) Goddess of wisdom and warfare, Athena was a virgin (parthenos in Greek), born not from a woman's womb but from the head of her father, Zeus. She competed with Poseidon for the honor of becoming the patron deity of Athens. She won the contest and the city bears her name.
- Hephaistos (Vulcan) God of fire and of metalworking, Hephaistos fashioned the armor Achilles wore in battle against Troy. He also provided Zeus his scepter and Poseidon his trident, and was the "surgeon" who split open Zeus's head when Athena was born. In some accounts, Hephaistos is the son of Hera without a male partner. In others, he is the son of Hera and Zeus. He was born lame and, uncharacteristically for a god, ugly. His wife Aphrodite was unfaithful to him.
- Apollo (Apollo) God of light and music, and a great archer, Apollo was the son of Zeus with Leto/Latona, daughter of one of the Titans. His epithet Phoibos means "radiant," and the young, beautiful Apollo was sometimes identified with the sun (Helios/Sol).
- Artemis (Diana) Sister of Apollo, Artemis was goddess of the hunt and of wild animals. As Apollo's twin, she was occasionally regarded as the moon (Selene/Luna).
- Aphrodite (Venus) Daughter of Zeus and Dione (daughter of Okeanos and one of the nymphs—the goddesses of springs, caves, and woods), Aphrodite was the goddess of love and beauty. In one version of her myth, she was born from the foam (aphros in Greek) of the sea. She was the mother of Eros by Ares and of the Trojan hero Aeneas by Anchises.
- Hermes (Mercury) Son of Zeus and another nymph, Hermes was the fleet-footed messenger of the gods and possessed winged sandals. He was also the guide of travelers, including the dead journeying to the Underworld. He carried the *caduceus*, a magical herald's rod, and wore a traveler's hat, often also shown with wings.

Other important Greek gods and goddesses were

- Hades (Pluto) One of the children of Kronos who fought with his brothers against the Titans, Hades was equal in stature to the Olympians but never resided on Mount Olympus. Hades was the lord of the Underworld and god of the dead.
- *Dionysos* (*Bacchus*) The son of Zeus and a mortal woman, Dionysos was the god of wine. In Roman times, an important mystery religion centered on Dionysos.
- Eros (Amor or Cupid) The son of Aphrodite and Ares, Eros was the winged child-god of love. In early representations, he appears as an adolescent, but artists normally depicted him as an infant.
- Asklepios (Aesculapius) The son of Apollo and a mortal woman, Asklepios was the Greek god of healing, whose serpent-entwined staff is the emblem of modern medicine.

Geometric Art

Also during the eighth century BCE, the human figure returned to Greek art—not in monumental statuary, which was exceedingly rare even in Bronze Age Greece, but in small bronze figurines and in paintings on ceramic pots.

DIPYLON KRATER One of the earliest examples of Greek figure painting is a huge krater (FIG. 5-2) that marked the grave of a man buried around 740 BCE in the Dipylon cemetery of Athens. At well over three feet tall, this vase is a considerable technical achievement and a testament both to the potter's skill and to the wealth and position of the deceased's family in the community. The bottom of the great vessel is open, perhaps to permit visitors to the grave to pour libations in honor of the dead, perhaps simply to provide a drain for rainwater, or both.

The artist covered much of the krater's surface with precisely painted abstract angular motifs in horizontal bands. Especially prominent is the *meander*, or key, pattern around the rim of the krater. Most early Greek painters decorated vases exclusively

5-2 Geometric krater, from the Dipylon cemetery, Athens, Greece, ca. 740 BCE. 3' $4\frac{1}{2}$ " high. Metropolitan Museum of Art, New York.

Figure painting reappeared in Greece in the Geometric period, named for the abstract ornamentation on vessels like this krater, which features a mourning scene and procession in honor of the deceased.

with abstract motifs. The nature of the ornament has led art historians to designate this formative period of Greek art as *Geometric*. The earliest examples of the Geometric style date to the ninth century BCE.

On this krater, the artist reserved the widest part of the vase for two bands of human figures and horse-drawn chariots rather than for geometric ornament. Befitting the vase's function as a grave marker, the scenes depict the mourning for a man laid out on his bier and the grand chariot procession in his honor. The painter filled every empty surface with circles and M-shaped designs, negating any sense that the mourners or soldiers inhabit open space. The human figures, animals, and furniture are as two-dimensional as the geometric shapes elsewhere on the vessel. For example, in the upper band, the shroud, raised to reveal the corpse, is an abstract checkerboard-like backdrop. The figures are silhouettes constructed of triangular (frontal) torsos with attached profile arms, legs, and heads (with a single large frontal eye in the center), following the age-old convention. To distinguish male from female, the painter added a penis growing out of one of the deceased's thighs. The mourning women, who tear their hair out in grief, have breasts emerging beneath their armpits. In both cases the artist's concern was specifying gender, not anatomical accuracy. Below, the warriors look like walking shields, and in the old conceptual manner, both wheels of the chariots are shown. The horses have the correct number of heads and legs but seem to share a common body, so that there is no sense of overlapping or depth. Despite the highly stylized and conventional manner of representation, this vessel marks a significant turning point in the history of Greek art. Not only was the human figure reintroduced into the painter's repertoire, but the art of storytelling also was revived.

HERAKLES AND NESSOS One of the most impressive surviving Geometric sculptures is a characteristically small solid-cast bronze group (FIG. 5-3) made up of two schematic figures locked in a hand-to-hand struggle. The man is a hero, probably Herakles (see "Herakles," page 120). His opponent is a centaur (a mythological beast that was part man, part horse), possibly Nessos, the centaur who had volunteered to carry the hero's bride across a river and then assaulted her. Whether or not the hero is Herakles and the centaur is Nessos, the mythological nature of the group is certain. The repertoire of the Geometric artist was not limited to scenes inspired by daily life (and death). Composite monsters were enormously popular in the ancient Near East and Egypt, and renewed contact with foreign cultures may have inspired the human-animal monsters of Geometric Greece. The centaur, however, is a purely Greek invention—and one that posed a problem for the artist, who, of course, had never seen such a creature. The Geometric artist conceived the centaur as a man in front and a horse in back, a rather unhappy and unconvincing configuration that results in the forelegs belonging to a different species from the hind legs. In this example, the sculptor rendered the figure of the hero and the human part of the centaur in a similar fashion. Both are bearded and wear helmets, but (contradictory to nature) the man is larger than the horse, probably to suggest that he will be the victor. Like other Geometric male figures, both painted and sculpted, this hero is nude, in contrast to the Near Eastern statuettes that might have inspired the Greek works. Here, at the very beginning of Greek figural art, one can recognize the Hellenic instinct for the natural beauty of the human figure. In fact, Greek athletes exercised without their clothes and even competed nude in the Olympic Games from very early times.

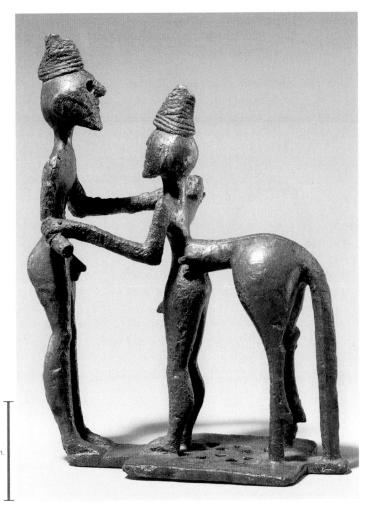

5-3 Hero and centaur (Herakles and Nessos?), from Olympia, Greece, ca. 750–730 BCE. Bronze, $4\frac{1}{2}$ high. Metropolitan Museum of Art, New York (gift of J. Pierpont).

Sculpture of the Geometric period is small scale, and the figures have simple stylized shapes. This solid-cast bronze statuette depicts a hero battling a centaur—an early example of mythological narrative.

Orientalizing Art

During the 600s BCE, the pace and scope of Greek trade and colonization accelerated and Greek artists became exposed more than ever before to Eastern artworks, especially small portable objects such as Syrian ivory carvings. The closer contact had a profound effect on the development of Greek art. Indeed, so many motifs borrowed from or inspired by Egyptian and Near Eastern art entered the Greek pictorial vocabulary at this time that art historians have dubbed the seventh century BCE the *Orientalizing* period.

MANTIKLOS APOLLO One of the masterworks of the early seventh century BCE is the Mantiklos Apollo (FIG. 5-4), a small bronze statuette dedicated to Apollo at Thebes by an otherwise unknown man named Mantiklos. With characteristic pride in the ability to write, the sculptor (or another) scratched into the thighs of the figure a message from the dedicator to the deity: "Mantiklos dedicated me as a tithe to the far-shooting Lord of the Silver Bow; you, Phoibos [Apollo], might give some pleasing favor in return." Because the Greeks conceived their gods in human form, it is uncertain whether the figure represents the youthful Apollo or Mantiklos

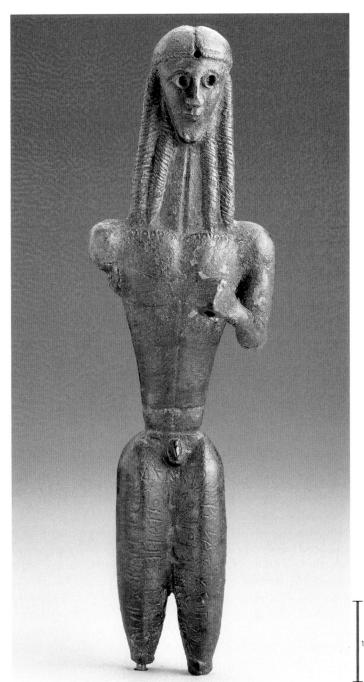

5-4 Mantiklos Apollo, statuette of a youth dedicated by Mantiklos to Apollo, from Thebes, Greece, ca. 700–680 BCE. Bronze, 8" high. Museum of Fine Arts, Boston.

Mantiklos dedicated this statuette to Apollo, and it probably represents the god. The treatment of the body reveals the interest seventh-century BCE Greek artists had in reproducing details of human anatomy.

(or neither). But if the left hand at one time held a bow, then the statuette is certainly an image of the deity. In any case, the purpose of the votive offering is clear. Equally apparent is the increased interest Greek artists at this time had in reproducing details of human anatomy, such as the long hair framing the unnaturally elongated neck, and the pectoral and abdominal muscles, which define the stylized triangular torso. The triangular face has eye sockets that were once inlaid, and the head may have had a separately fashioned helmet on it.

Greek Vase Painting

he techniques Greek ceramists used to shape and decorate fine vases required great skill, which they acquired over many years as apprentices in the workshops of master potters. During the Archaic and Classical periods, when the art of vase painting was at its zenith in Greece, both potters and painters frequently signed their work. These signatures reveal the pride of the artists.

The signatures also might have functioned as "brand names" for a large export market. The products of the workshops in Corinth and Athens in particular were highly prized and have been found all over the Mediterranean world. The Corinthian Orientalizing amphora shown here (FIG. 5-5) was found on Rhodes, an island at the opposite side of the Aegean from mainland Corinth (MAP 5-1). The Etruscans of central Italy (MAP 9-1) were especially good customers. Athenian vases were staples in Etruscan tombs, and all but one of the illustrated examples (FIGS. 5-20 to 5-24, 5-59, and 5-60) came from an Etruscan site. Other painted Athenian pots have been found as far away as France, Russia, and the Sudan.

The first step in manufacturing a Greek vase was to remove any impurities found in the natural clay and then to knead it, like dough, to remove air bubbles and make it flexible. The Greeks used dozens of different kinds and shapes of pots, and most were produced in several parts. Potters formed the vessel's body by placing the clay on a rotating horizontal wheel. While an apprentice turned the wheel by hand, the potter pulled up the clay with the fingers until the desired shape was achieved. The handles were shaped separately and attached to the vase body by applying *slip* (liquefied clay) to the joints.

Then a specialist, the painter, was called in, although many potters decorated their own work. (Today most people tend to regard painters as more elevated artists than potters, but in Greece the potters owned the shops and employed the painters.) Art historians customarily refer to the "pigment" the painter applied to the clay surface as glaze, but the black areas on Greek pots are neither pigment nor glaze but a slip of finely sifted clay that originally was of the same rich red-orange color as the clay of the pot. In the three-phase firing process Greek potters used, the first (oxidizing) phase turned both pot and slip red. During the second (reducing) phase, the potter shut off the oxygen supply into the kiln, and both pot and slip turned black. In the final (reoxidizing) phase, the pot's coarser material reabsorbed oxygen and became red again, whereas the smoother, silica-laden slip did not and remained black. After long experiment, Greek potters developed a velvety jet-black "glaze" of this kind, produced in kilns heated to temperatures as high as 950° Celsius (about 1,742° Fahrenheit).

The firing process was the same whether the painter worked in black-figure or in red-figure. In fact, sometimes Greek artists employed both manners on the same vase (FIG. 5-22).

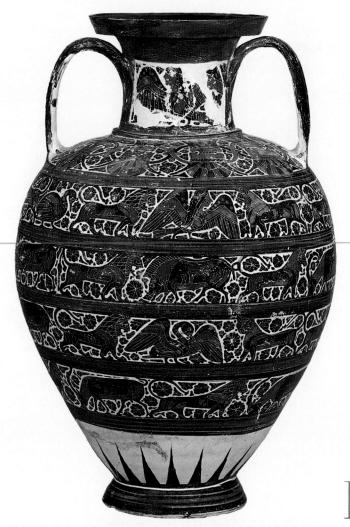

5-5 Corinthian black-figure amphora with animal friezes, from Rhodes, Greece, ca. 625–600 BCE. 1' 2" high. British Museum, London.

The Corinthians invented the black-figure technique of vase painting in which artists painted black silhouettes and then incised linear details within the forms. This early example features Orientalizing animals.

ORIENTALIZING AMPHORA An elaborate Corinthian *amphora* (FIG. 5-5), or two-handled storage jar, typifies the new Greek fascination with the Orient. In a series of registers recalling the organization of Geometric painted vases, animals such as the native boar appear beside exotic lions and panthers and composite creatures inspired by Eastern monsters such as the sphinx and lamassu. In this instance, the painter prominently displayed a *siren* (part bird, part woman) on the amphora's neck. The wide appeal of such vases was not due solely to their Orientalizing animal friezes. They owed their popularity also to a new ceramic technique the Corinthi-

ans invented. Art historians call this type of vase decoration *black-figure painting* (see "Greek Vase Painting," above). The black-figure painter first put down black silhouettes on the clay surface of the vessel, as in Geometric times, but then used a sharp pointed instrument to incise linear details within the forms, usually adding highlights in white or purplish-red over the black figures before firing the vase. The combination of the weighty black silhouettes with the delicate detailing and the bright polychrome overlay proved to be irresistible, and Athenian painters soon copied the technique the Corinthians pioneered.

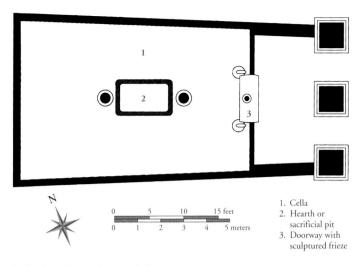

5-6 Plan of Temple A, Prinias, Greece, ca. 625 BCE.

The first Greek stone temples, like this one at Prinias, were similar in plan to the megarons of Mycenaean palaces, with a porch and a main room with two columns flanking a hearth or sacrificial pit.

TEMPLE A, PRINIAS The foundation of the Greek trading colony of Naukratis in Egypt (MAP 3-1) before 630 BCE brought the Greeks into direct contact with the monumental stone architecture of the Egyptians. Not long after that, construction began in Greece of the first stone buildings since the fall of the Mycenaean kingdoms. At Prinias on Crete, for example, the Greeks built a stone temple, called Temple A (FIG. 5-6), around 625 BCE to honor an unknown deity. Although the inspiration for the structure may have come from the East, the form resembles that of a typical Mycenaean megaron, such as that at Tiryns (FIG. 4-18), with two interior columns flanking a hearth or sacrificial pit. The facade consisted of three great piers. The roof was probably flat. Temple A at Prinias is the earliest known example of a Greek temple with sculptured decoration. Above the doorway was a huge limestone lintel with a relief frieze of Orientalizing panthers with frontal heads—the same motif as that on the contemporary Corinthian black-figure amphora (FIG. 5-5), underscoring the stylistic unity of Greek art at this time.

LADY OF AUXERRE Probably also originally from Crete is a limestone statuette of a goddess or maiden (kore; plural, korai) popularly known as the Lady of Auxerre (FIG. 5-7) after the French town that is her oldest recorded location. As with the figure Mantiklos dedicated (FIG. 5-4), it is uncertain whether the young woman is a mortal or a deity. She is clothed, as are all Greek goddesses and women of this period, but she does not wear a headdress, as a goddess probably would. Moreover, the placement of the right hand across the chest is probably a gesture of prayer, also indicating that this is a kore. The style is much more naturalistic than in Geometric times, but the love of abstract shapes can still be seen. Note, for example, the triangular flat-topped head framed by long strands of hair that form triangles complementary to the shape of the face, and the decoration of the long skirt with its incised concentric squares, once brightly painted, as were all Greek stone statues. The modern notion that Greco-Roman statuary was pure white is mistaken. The Greeks did not, however, color their statues garishly. The flesh was left in the natural color of the stone, which was waxed and polished, while eyes, lips, hair, and drapery were painted in encaustic (see "Iaia of Cyzicus and the Art of Encaustic Painting," Chapter 10, page 275). In this technique, the painter mixed the pigment with hot wax and applied the tinted wax to the statue to produce a durable coloration.

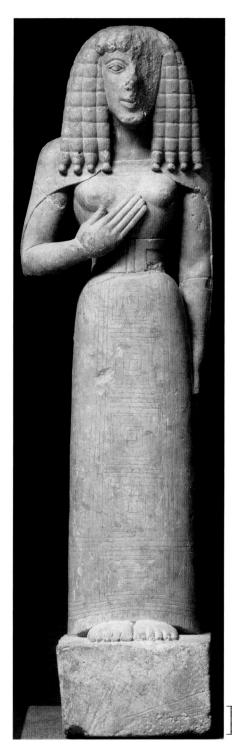

5-7 Lady of Auxerre, ca. 650–625 BCE. Limestone, 2' $1\frac{1}{2}''$ high. Louvre, Paris.

Probably from Crete, this kore (maiden) typifies the so-called Daedalic style of the seventh century BCE with its triangular face and hair and lingering Geometric fondness for abstract pattern.

ARCHAIC PERIOD

The *Lady of Auxerre* is the masterpiece of the style that art historians usually refer to as *Daedalic*, after the legendary artist Daedalus, whose name means "the skillful one." In addition to having been a great sculptor, Daedalus was said to have built the labyrinth (FIG. 4-5) in Crete to house the Minotaur and also to have designed a temple at Memphis in Egypt (MAP 3-1). The historical Greeks attributed to him almost all the great achievements in early sculpture and architecture before the names of artists and architects were recorded. The story that Daedalus worked in Egypt reflects the enormous impact of Egyptian art and architecture on the Greeks of the aptly named Orientalizing age of the seventh century, as well as on their offspring in the succeeding *Archaic* period of the sixth century BCE.

Statuary

According to one Greek writer, Daedalus used the same compositional patterns for his statues as the Egyptians used for theirs, and the first truly monumental stone statues of the Greeks follow very closely the canonical Egyptian format.

NEW YORK KOUROS One of the earliest examples (FIG. 5-8) of life-size statuary in Greece is the marble *kouros* ("youth"; plural, *kouroi*) now in New York. The Greek kouros emulates the stance of

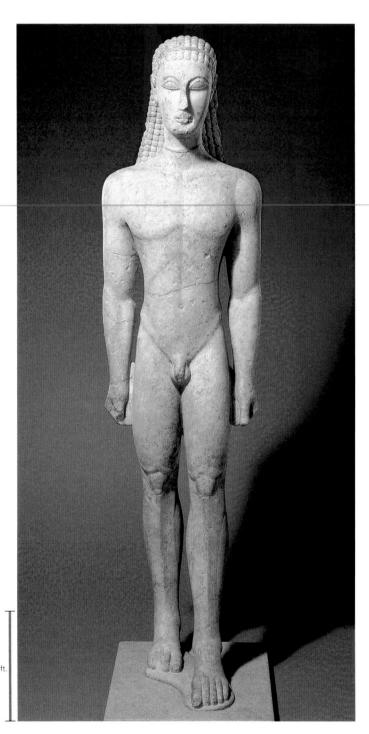

5-8 Kouros, ca. 600 BCE. Marble, $6'\frac{1}{2}''$ high. Metropolitan Museum of Art, New York.

The sculptors of the earliest life-size statues of kouroi (young men) adopted the Egyptian pose for standing figures (Fig. 3-13), but the kouroi are nude and liberated from the original block of stone.

Egyptian statues (FIG. 3-13). In both Egypt and Greece, the figure is rigidly frontal with the left foot advanced slightly. The arms are held beside the body, and the fists are clenched with the thumbs forward. The New York kouros, like most Egyptian statues, was also a funerary statue. It stood over a grave in the countryside somewhere near Athens. Statues like this one replaced the huge vases (FIG. 5-2) of Geometric times as the preferred form of grave marker in the sixth century BCE. The Greeks also used kouroi as votive offerings in sanctuaries. The kouros type, because of its generic quality, could be employed in several different contexts.

Despite the adherence to Egyptian prototypes, Greek kouros statues differ from their models in two important ways. First, the Greek sculptors liberated them from their original stone block. The Egyptian obsession with permanence was alien to the Greeks, who were preoccupied with finding ways to represent motion rather than stability in their sculpted figures. Second, the kouroi are nude, and in the absence of identifying attributes, they, like the bronze statuette (FIG. 5-4) Mantiklos dedicated, are formally indistinguishable from Greek images of deities with their perfect bodies exposed for all to see.

The New York kouros shares many traits with the *Mantiklos Apollo* and other Orientalizing works such as the *Lady of Auxerre* (FIG. 5-7), especially the triangular shape of head and hair and the flatness of the face—the hallmarks of the Daedalic style. Eyes, nose, and mouth all sit on the front of the head, and the ears on the sides. The long hair forms a flat backdrop behind the head. The placement of the various anatomical parts is the result of the sculptor's having drawn these features on four independent sides of the marble block, following the same workshop procedure used in Egypt for millennia. The New York kouros also has the slim waist of earlier Greek statues and exhibits the same love of pattern. The pointed arch of the rib cage, for example, echoes the V-shaped ridge of the hips, which suggests but does not accurately reproduce the rounded flesh and muscle of the human body.

CALF BEARER A generation later than the New York kouros is the statue (FIG. 5-9) of a moschophoros, or calf bearer, found in fragments on the Athenian Acropolis. Its inscribed base (not visible in the photograph) states that a man named Rhonbos dedicated the statue. Rhonbos is almost certainly the calf bearer himself, bringing an offering to Athena in thanksgiving for his prosperity. He stands in the left-foot-forward manner of the kouroi, but he has a beard and therefore is no longer a youth. He wears a thin cloak (once painted to set it off from the otherwise nude body). No one dressed this way in ancient Athens. The sculptor adhered to the artistic convention of male nudity and attributed to the calf bearer the noble perfection that nudity suggests while also indicating that this mature gentleman is clothed, as any respectable citizen would be in this context. The Archaic sculptor's love of pattern may be seen once again in the handling of the difficult problem of representing man and animal together. The calf's legs and the moschophoros's arms form a bold X that unites the two bodies both physically and formally.

The calf bearer's face differs markedly from those of earlier Greek statues (and those of Egypt and the Near East) in one notable way. The man smiles—or at least seems to. From this time on, Archaic Greek statues always smile, even in the most inappropriate contexts (see, for example, FIG. 5-28, where a dying warrior with an arrow piercing his chest grins broadly at the spectator). This so-called *Archaic smile* has been variously interpreted, but it is not to be taken literally. Rather, the smile seems to be the Archaic sculptor's way of indicating that the person portrayed is alive. By adopting this

convention, the Greek artist signaled a very different intention from any Egyptian counterpart.

ANAVYSOS KOUROS Sometime around 530 BCE a young man named Kroisos died a hero's death in battle, and his family erected a kouros statue (FIG. 5-10) over his grave at Anavysos, not far from Athens. Fortunately, some of the paint is preserved, giving a better sense of the statue's original appearance. The inscribed base invites visitors to "stay and mourn at the tomb of dead Kroisos, whom raging Ares destroyed one day as he fought in the foremost ranks." The statue, with its distinctive Archaic smile, is no more a portrait of a specific youth than is the New York kouros. But two generations later, without rejecting the Egyptian stance, the Greek

5-9 Calf bearer, dedicated by Rhonbos on the Acropolis, Athens, Greece, ca. 560 BCE. Marble, restored height 5' 5"; fragment 3' $11\frac{1}{2}$ " high. Acropolis Museum, Athens.

This statue of a bearded man bringing a calf to sacrifice in thanksgiving to Athena is one of the first to employ the so-called Archaic smile, the Archaic Greek sculptor's way of indicating a person is alive.

sculptor rendered the human body in a far more naturalistic manner. The head is no longer too large for the body, and the face is more rounded, with swelling cheeks replacing the flat planes of the earlier work. The long hair does not form a stiff backdrop to the head but falls naturally over the back. Rounded hips replace the V-shaped ridges of the New York kouros.

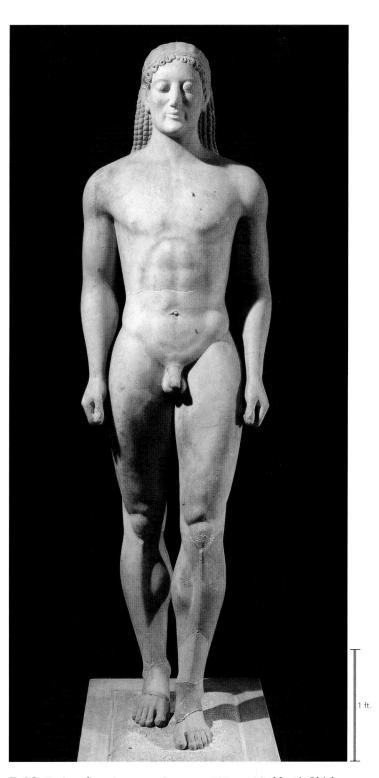

5-10 Kroisos, from Anavysos, Greece, са. 530 все. Marble, 6^\prime $4^{\prime\prime}$ high. National Archaeological Museum, Athens.

This later kouros stood over the grave of Kroisos, a young man who died in battle. The statue displays increased naturalism in its proportions and more rounded modeling of face, torso, and limbs.

PEPLOS KORE A stylistic "sister" to the Anavysos kouros is the statue of a woman traditionally known as the *Peplos Kore* (FIG. 5-11) because until recently scholars thought this kore wore a peplos. A *peplos* is a simple, long, woolen belted garment. Careful examination of the statue has revealed, however, that she wears four different garments, one of which only goddesses wore. The attribute the goddess once held in her left hand would immediately have identified her. Whoever she is, the contrast with the *Lady of Auxerre* (FIG. 5-7) is striking. Although in both cases the drapery conceals the entire body save for head, arms, and feet, the sixth-century BCE sculptor rendered the soft female form much more naturally. This softer treatment of the flesh also sharply differentiates later korai from contemporary kouroi, which have hard, muscular bodies.

Traces of paint are preserved on the *Peplos Kore*. Like the Anavysos kouros, this Athenian statue was buried for more than two millennia. The earthen "grave" protected the painted surface from the destructive effects of exposure to the atmosphere and to bad weather. The *Peplos Kore*—along with the calf bearer (FIG. 5-9) and many other statues—had been knocked over by the Persians during their sack of the Acropolis in 480 BCE (see page 118). Shortly thereafter, the Athenians buried all the damaged Archaic sculptures. Before that time, they stood as votive offerings in Athena's sanctuary.

KORE IN IONIAN DRESS By the late sixth century BCE, the light linen Ionian *chiton*, worn in conjunction with a heavier *himation* (mantle), was the garment of choice for fashionable women. Archaic

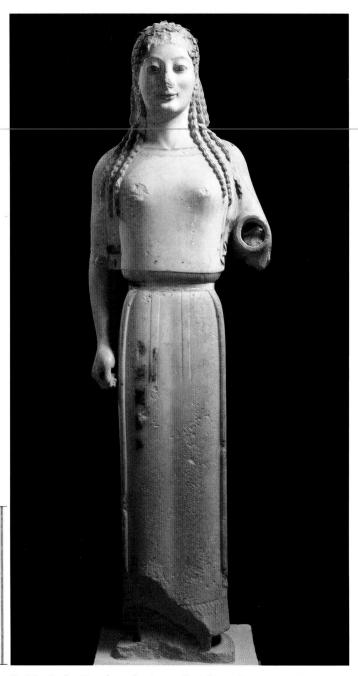

5-11 *Peplos Kore*, from the Acropolis, Athens, Greece, ca. 530 BCE. Marble, 4' high. Acropolis Museum, Athens.

Unlike men, women are always clothed in Archaic statuary. This kore is a votive statue of a goddess wearing four garments. She once held her identifying attribute in her missing left hand.

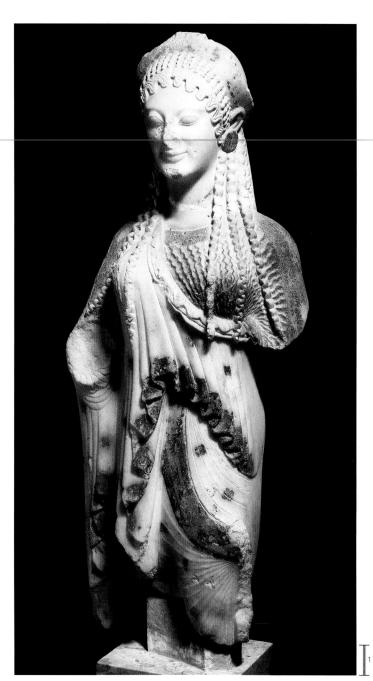

5-12 Kore, from the Acropolis, Athens, Greece, ca. 520–510 BCE. Marble, 1' 9" high. Acropolis Museum, Athens.

Archaic sculptors delighted in rendering the intricate asymmetrical patterns created by the cascading folds of garments like the Ionian chiton and himation worn by this smiling Acropolis kore.

Greek Temple Plans

The core of an ancient Greek temple plan (FIG. 5-13) was the *naos*, or *cella*, a room with no windows that usually housed the cult statue of the deity. It was preceded by a *pronaos*, or porch, often with two columns between the *antae*, or extended walls (columns *in antis*). A smaller second room might be placed behind the cella (FIG. 5-16), but in its canonical form, the Greek temple had a porch at the rear (*opisthodomos*) set against the blank back wall of the cella. The purpose was not functional but decorative, satisfying the Greek passion for balance and symmetry. A colonnade could be placed across the front of the temple (*prostyle*; FIG. 5-52), across both front and back (*amphiprostyle*; FIG. 5-55), or, more commonly, all around the cella and its porch(es) to form a *peristyle*, as in FIG. 5-13 (compare FIG. 5-15). Single (*peripteral*) colonnades were the norm, but double (*dipteral*) colonnades were features of especially elaborate temples (FIG. 5-75).

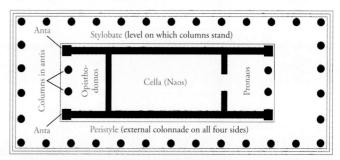

5-13 Plan of a typical Greek peripteral temple.

The basic form of the canonical Greek temple derives from that of the megaron of a Mycenaean palace (FIG. 4-18), but Greek temples housed statues of deities and most were surrounded by columns.

sculptors delighted in rendering the intricate patterns created by the cascading folds of thin, soft material. In another Acropolis kore (FIG. 5-12), the asymmetry of the folds greatly relieves the stiff frontality of the body and makes the figure appear much more lifelike than contemporary kouroi. The sculptor achieved added variety by showing the kore grasping part of her chiton in her left hand (unfortunately broken off) to lift it off the ground in order to take a step forward. This is the equivalent of the advanced left foot of the kouroi and became standard for statues of korai. Despite the varied surface treatment of brightly colored garments on the korai, the kore postures are as fixed as those of their male counterparts.

Architecture and Architectural Sculpture

Many of the earliest Greek temples do not survive because they were built of wood and mud brick. Pausanias noted in his second-century CE guidebook to Greece that in the even-then-ancient Temple of Hera at Olympia, one oak column was still in place. (Stone columns had replaced the others.) Archaic and later Greek temples, however, were constructed of more permanent materials—limestone, in many cases, and, where it was available, marble, which was more impressive and durable (and more expensive). In Greece proper, if not in its western colonies, marble was readily at hand. Bluish-white marble came from Hymettus, just east of Athens. Glittering white marble particularly adapted for carving was brought from Pentelicus, northeast of the city, and from the Aegean Islands, especially Paros.

Already in the Orientalizing seventh century BCE, the Greeks had built at Prinias a stone temple (FIG. 5-6) embellished with stone sculptures, but the Cretan temple resembled the megaron of a Mycenaean palace more than anything Greek traders had seen in their travels overseas. In the Archaic age of the sixth century, with the model of Egyptian columnar halls such as that at Karnak (FIG. 3-25) before them, Greek architects began to build the columnar stone temples that became more influential on the later history of architecture in the Western world than any other building type ever devised.

Greek temples differed in function from most later religious shrines. The altar lay outside the temple—at the east end, facing the rising sun—and the Greeks gathered outside, not inside, the building to worship. The temple proper housed the so-called *cult statue* of

the deity, the grandest of all votive offerings. Both in its early and mature manifestations, the Greek temple was the house of the god or goddess, not of his or her followers.

TEMPLE PLANS In basic plan (see "Greek Temple Plans," above, and FIG. 5-13), the Greek temple still discloses a close affinity with the Mycenaean megaron (FIG. 4-18), and, even in its most elaborate form, it retains the latter structure's basic simplicity. In all cases, the remarkable order, compactness, and symmetry of the Greek scheme strike the eye first, reflecting the Greeks' sense of proportion and their effort to achieve ideal forms in terms of regular numerical relationships and geometric rules. Whether the plan is simple or more complex, no fundamental change occurs in the nature of the units or of their grouping. Classical Greek architecture, like classical music, has a simple core theme with a series of complex, but always quite intelligible, variations developed from it.

The Greeks' insistence on proportional order guided their experiments with the proportions of temple plans. The earliest temples tended to be long and narrow, with the proportion of the ends to the sides roughly expressible as 1:3. From the sixth century BCE on, plans approached but rarely had a proportion of exactly 1:2. Classical temples tended to be a little longer than twice their width. To the Greek mind, proportion in architecture and sculpture was much the same as harmony in music, reflecting and embodying the cosmic order.

TEMPLE ORNAMENTATION Figural sculpture played a major role in the exterior program of the Greek temple from early times, partly to embellish the god's shrine, partly to tell something about the deity symbolized within, and partly to serve as a votive offering. But the building itself, with its finely carved capitals and moldings, also was conceived as sculpture, abstract in form and possessing the power of sculpture to evoke human responses. The commanding importance of the sculptured temple, its inspiring function in public life, was emphasized in its elevated site, often on a hill above the city (*acropolis* means "high city").

Sculptural ornament was concentrated on the upper part of the building, in the frieze and pediments (see "Doric and Ionic Orders," page 110). Architectural sculpture, like freestanding statuary, was painted (FIG. 5-27, *right*) and usually was placed only in the building parts that had no structural function. This is true particularly of the

Doric and Ionic Orders

rchitectural historians describe the elevation (FIG. 5-14) of a Greek temple in terms of the platform, the colonnade, and the superstructure (*entablature*). In the Archaic period, two basic systems evolved for articulating the three units. These are the so-called *orders* of Greek architecture. The orders are differentiated both in the nature of the details and in the relative proportions of the parts. The names of the orders derive from the Greek regions where they were most commonly employed. The *Doric*, formulated on the mainland, remained the preferred manner there and in the western colonies of the Greeks. The *Ionic* was the order of choice in the Aegean Islands and on the western coast of Asia Minor. The geographical distinctions are by no means absolute. The Ionic order, for example, was often used in Athens (where, according to some, the Athenians considered themselves Ionians who never migrated).

In both orders, the columns rest on the *stylobate*, the uppermost course of the platform. Metal clamps held together the stone blocks in each horizontal course, and metal dowels joined vertically the blocks of different courses. The columns have two or three parts, depending on the order: the *shaft*, which is marked with vertical channels (*flutes*); the *capital*; and, in the Ionic order, the *base*. Greek column shafts, in contrast to their Minoan and Mycenaean forebears, taper gradually from bottom to top. They usually are composed of separate *drums*

joined by metal dowels to prevent turning as well as shifting, although instances of *monolithic* (single-piece) columns are known. The capital has two elements. The lower part (the *echinus*) varies with the order. In the Doric, it is convex and cushionlike, similar to the echinus of Minoan (FIG. 4-6) and Mycenaean (FIG. 4-1) capitals. In the Ionic, it is small and supports a bolster ending in scroll-like spirals (the *volutes*). The upper element, present in both orders, is a flat, square block (the *abacus*) that provides the immediate support for the entablature.

The entablature has three parts: the *architrave*, the main weight-bearing and weight-distributing element; the *frieze*; and the *cornice*, a molded horizontal projection that together with two sloping (*raking*) cornices forms a triangle that enframes the *pediment*. In the Ionic order, the architrave is usually subdivided into three horizontal bands. In the Doric order, the frieze is subdivided into *triglyphs* and *metopes*, whereas in the Ionic the frieze is left open to provide a continuous field for relief sculpture.

The Doric order is massive in appearance, its sturdy columns firmly planted on the stylobate. Compared with the weighty and severe Doric, the Ionic order seems light, airy, and much more decorative. Its columns are more slender and rise from molded bases. The most obvious differences between the two orders are, of course, in the capitals—the Doric, severely plain, and the Ionic, highly ornamental.

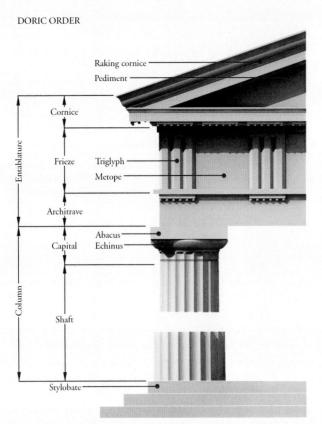

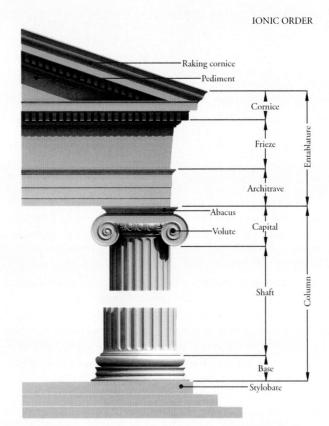

5-14 Elevations of the Doric and Ionic orders.

The major differences between the Doric and Ionic orders are the form of the capitals and the treatment of the frieze. The Doric frieze is divided into triglyphs and metopes.

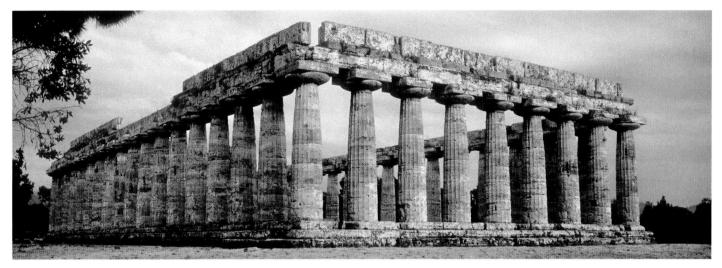

5-15 Temple of Hera I ("Basilica"), Paestum, Italy, ca. 550 BCE.

The peristyle of this huge early Doric temple consists of heavy, closely spaced, cigar-shaped columns with bulky, pancakelike capitals, characteristic features of Archaic Greek architecture.

Doric order (FIG. 5-14, left), where decorative sculpture appears only in the metope and pediment "voids." Ionic (FIG. 5-14, right) builders, less severe in this respect as well, were willing to decorate the entire frieze and sometimes even the lower column drums. Occasionally, they replaced their columns with female figures (caryatids; FIGS. 5-18 and 5-54). Capitals, decorative moldings, and other architectural elements were also painted. By painting parts of the building, the designer could bring out more clearly the relationships of the structural parts and soften the stone's glitter at specific points, as well as provide a background to set off the figures.

Although the Greeks used color for emphasis and to relieve what might have seemed too bare a simplicity, Greek architecture primarily depended on clarity and balance. To the Greeks, it was unthinkable to use surfaces in the way the Egyptians used their gigantic columns—as fields for complicated ornamentation (FIG. 3-25). The history of Greek temple architecture is the history of Greek architects' unflagging efforts to find the most satisfactory (that is, what they believed were perfect) proportions for each part of the building and for the structure as a whole.

BASILICA, PAESTUM The prime example of early Greek efforts at Doric temple design is not in Greece but in Italy, south of Naples, at Paestum (Greek Poseidonia). The huge (80×170 feet) Archaic temple (FIG. 5-15) erected there around 550 BCE retains its entire peripteral colonnade, but most of the entablature, including the frieze, pediment, and all of the roof, has vanished. Called the "Basilica" after the Roman columnar hall building type (see Chapter 10) that early investigators felt it resembled, the structure was actually a temple of Hera. Scholars refer to it as the Temple of Hera I to distinguish it from its later neighbor, the Temple of Hera II (FIG. 5-30). The misnomer is partly due to the building's plan (FIG. 5-16), which differs from that of most other Greek temples. The unusual feature, found only in early Archaic temples, is the central row of columns that divides the cella into two aisles. Placing columns underneath the ridgepole (the timber beam running the length of the building below the peak of the gabled roof) might seem the logical way to provide interior support for the roof structure, but it resulted in several disadvantages. Among these was that this interior arrangement allowed no place for a central statue of the deity to whom the temple was

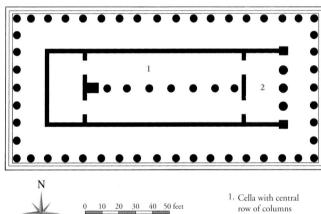

2. Pronaos with three

5-16 Plan of the Temple of Hera I, Paestum, Italy, ca. 550 BCE.

The Hera temple's plan also reveals its early date. The temple has an odd number of columns on the facade and a single row of columns in the cella, leaving no place for a central cult statue.

dedicated. Also, the peripteral colonnade, in order to correspond with the interior, required an odd number of columns (nine in this case) across the building's facade. At Paestum, the builders also set three columns in antis instead of the standard two, which in turn ruled out a central doorway for viewing the statue. (Some scholars have suggested, however, that this design was well suited for two statues, perhaps of Zeus and Hera.) The architect nonetheless achieved a simple 1:2 ratio of facade and flank columns by erecting 18 columns on each side of the temple.

Another early aspect of the Paestum temple is the shape of its heavy, closely spaced columns (FIG. 5-15) with their large, bulky, pancakelike Doric capitals, which seem compressed by the overbearing weight of the entablature. The columns have a pronounced swelling (entasis) at the middle of the shafts, giving them a profile akin to that of a cigar. If the temple's immense roof were preserved, the columns would seem even more compressed, squatting beneath

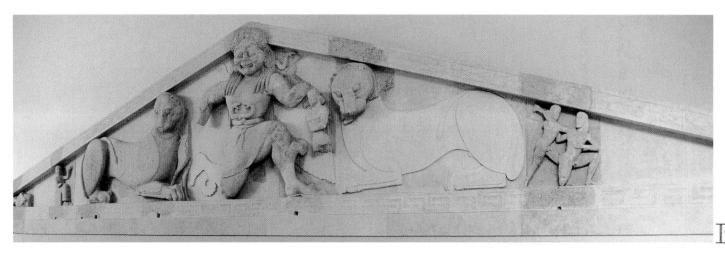

5-17 West pediment from the Temple of Artemis, Corfu, Greece, ca. 600–580 BCE. Limestone, greatest height 9' 4". Archaeological Museum, Corfu. The hideous Medusa and two panthers at the center of this early pediment serve as temple guardians. To either side, and much smaller, are scenes from the Trojan War and the battle of gods and giants.

what must have been a high and massive entablature. The columns and capitals thus express in a vivid manner their weight-bearing function. One structural reason, perhaps, for the heaviness of the design and the narrowness of the spans between the columns might be that the Archaic builders were afraid thinner and more widely spaced columns would result in the superstructure's collapse. In later Doric temples (FIGS. 5-25, 5-30, and 5-44), the builders placed the columns farther apart and refined the forms. The shafts became more slender, the entasis subtler, the capitals smaller, and the entablature lighter. Greek architects sought the ideal proportional relationship among the parts of their buildings. The sculptors of Archaic kouroi and korai grappled with similar problems. Architecture and sculpture developed in a parallel manner in the sixth century BCE.

TEMPLE OF ARTEMIS, CORFU Architects and sculptors were also frequently called on to work together, as at Corfu (ancient Corcyra), where the Greeks constructed a great Doric temple dedicated to Artemis in the sixth century BCE. Corfu, an island off the western coast of Greece, was an important stop on the trade route between the mainland and the Greek settlements in Italy (MAP 5-1). Prosperity made possible the erection of one of the earliest stone peripteral temples in Greece, one also lavishly embellished with sculpture. Reliefs (unfortunately very fragmentary today) decorated the metopes, and huge high-relief sculptures (more than nine feet high at the center) filled both pediments. The pediments appear to have been decorated in an identical manner. The west pediment (FIG. 5-17) is better preserved.

Designing figural decoration for a pediment was never an easy task for the Greek sculptor because of the pediment's awkward triangular shape. The central figures had to be of great size. In contrast, as the pediment tapered toward the corners, the available area became increasingly cramped. At the center of the Corfu pediment is the *gorgon* Medusa, a demon with a woman's body and a bird's wings. Medusa also had a hideous face and snake hair, and anyone who gazed at her turned into stone. The sculptor depicted her in the conventional Archaic bent-leg, bent-arm, pinwheel-like posture that signifies running or, for a winged creature, flying. To her left and right are two great felines. Together they serve as temple guardians, repulsing all enemies from the sanctuary of the goddess. Similar panthers

stood sentinel on the lintel of the seventh-century BCE temple at Prinias. The Corfu felines are in the tradition of the guardian lions of the citadel gate (FIG. 4-1) at Mycenae and the beasts that stood guard at the entrances to Near Eastern palaces (FIGS. 2-18 and 2-21). The triad of Medusa and the felines recalls as well Mesopotamian heraldic human-and-animal compositions (FIG. 2-10). The Corfu figures are, in short, still further examples of the Orientalizing manner in early Greek sculpture.

Between Medusa and the two felines are two smaller figures the human Chrysaor at her left and the winged horse Pegasus at her right (only the rear legs are preserved next to Medusa's right foot). Chrysaor and Pegasus were Medusa's children. According to legend, they sprang from her head when the Greek hero Perseus severed it with his sword. Their presence here on either side of the living Medusa is therefore a chronological impossibility. The Archaic artist had less interest in telling a coherent story than in identifying the central figure by depicting her offspring. Narration was, however, the purpose of the much smaller groups situated in the pediment corners. To the viewer's right is Zeus, brandishing his thunderbolt and slaying a kneeling giant. In the extreme corner (not preserved) was probably a dead giant. The gigantomachy (battle of gods and giants) was a popular theme in Greek art from Archaic through Hellenistic times and was a metaphor for the triumph of reason and order over chaos. In the pediment's left corner is one of the Trojan War's climactic events: Achilles' son Neoptolemos kills the enthroned King Priam. The fallen figure to the left of this group may be a dead Trojan.

The master responsible for the Corfu pediments was a pioneer, and the composition shows all the signs of experimentation. The lack of narrative unity and the figures' extraordinary diversity of scale eventually gave way to pedimental designs with freestanding figures in place of reliefs all acting out a single event and appearing the same size. But the Corfu designer already had shown the way, by realizing, for example, that the area beneath the raking cornice could be filled with gods and heroes of similar size if a combination of standing, leaning, kneeling, seated, and prostrate figures were employed in the composition. The Corfu master also discovered that animals could be very useful space fillers because, unlike humans, they have one end taller than the other.

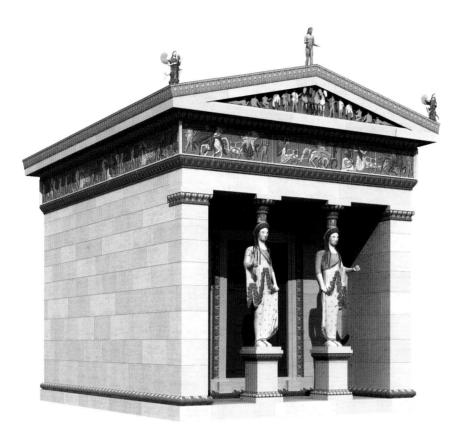

5-18 Reconstruction drawing of the Siphnian Treasury, Delphi, Greece, ca. 530 BCE (John Burge).

Treasuries were storehouses in sanctuaries for a city's votive offerings. The lonic treasury the Siphnians erected at Delphi featured caryatids in the porch, and sculptures in the pediment and frieze.

Doric columns in the porch and sculptured metopes in the frieze. The Siphnians equally characteristically employed the Ionic order for their Delphic treasury. Wealth from the island's gold and silver mines made the luxurious building possible. In the porch, where one would expect to find fluted Ionic columns, far more elaborate *caryatids* were employed instead. Caryatids are rare, even in Ionic architecture, but they are unknown in Doric architecture, where they would have been discordant elements in that much more severe order. The Siphnian statue-columns resemble contemporary korai dressed in Ionian chitons and himations (FIG. 5-12).

Another Ionic feature of the Siphnian Treasury is the continuous sculptured frieze on all four sides of the building. The north frieze represents the

popular theme of the gigantomachy, but the rendition is much more detailed than that in the corner of the Corfu pediment. In the section reproduced here (FIG. 5-19), Apollo and Artemis pursue a fleeing giant at the right, while behind them one of the lions pulling a goddess's chariot attacks a giant and bites into his midsection. Paint originally enlivened the crowded composition, and painted labels identified the various protagonists. Some figures had metal weapons. The effect must have been dazzling. On one of the shields the sculptor inscribed his name (unfortunately lost), a clear indication of pride in accomplishment.

SIPHNIAN TREASURY, DELPHI The sixth century BCE also saw the erection of grandiose Ionic temples on the Aegean Islands and the west coast of Asia Minor. The gem of Archaic Ionic architecture and architectural sculpture, however, is not a temple but a treasury erected by the city of Siphnos in the Sanctuary of Apollo at Delphi. It can be reliably reconstructed (FIG. 5-18) based on the surviving fragments now on display in the Delphi museum. Greek *treasuries* were small buildings set up for the safe storage of votive offerings. At Delphi many poleis expressed their civic pride by erecting these templelike but nonperipteral structures. Athens built one with

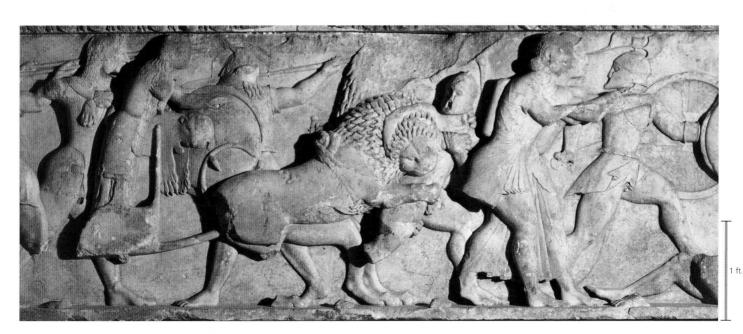

5-19 Gigantomachy, detail of the north frieze of the Siphnian Treasury, Delphi, Greece, ca. 530 BCE. Marble, 2' 1" high. Archaeological Museum, Delphi.

Greek friezes were brightly painted. As in contemporaneous vase painting, the Siphnian frieze also had painted labels identifying the various gods and giants. Some of the figures held metal weapons.

Vase Painting

Labeled figures and artists' signatures also appear on Archaic painted vases. By the mid-sixth century BCE, the Athenians, having learned the black-figure technique from the Corinthians (FIG. 5-5), had taken over the export market for fine painted ceramics.

FRANÇOIS VASE The masterpiece of early Athenian black-figure painting is the François Vase (FIG. 5-20), named for the excavator who uncovered it in an Etruscan tomb at Chiusi. The vase is a new kind of krater with volute-shaped handles, probably inspired by costly metal prototypes. It was signed by both its painter ("KLEITIAS painted me") and potter ("Ergotimos made me"), whose signatures each appear twice among the more than 200 figures in six registers. Labels abound, naming humans and animals alike, even some inanimate objects. The painter devoted only one of the bands to the Orientalizing repertoire of animals and sphinxes. The rest constitute a selective encyclopedia of Greek mythology, focusing on the exploits of Peleus and his son Achilles, the great hero of Homer's Iliad, and of Theseus, the legendary king of Athens.

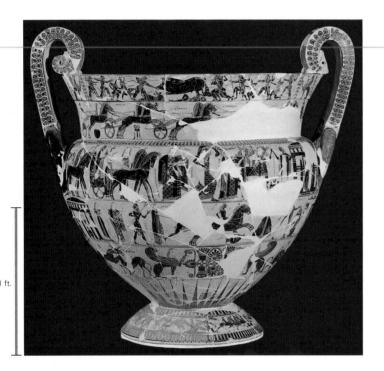

In the detail shown here (FIG. 5-20, bottom), Lapiths (a northern Greek tribe) and centaurs battle (centauromachy) after a wedding celebration where the man-beasts, who were invited guests, got drunk and attempted to abduct the Lapith maidens and young boys. Theseus, also on the guest list, was prominent among the centaurs' Greek adversaries. Kleitias did not fill the space between his figures with decorative ornament, as did his Geometric predecessors (FIG. 5-2). But his heroes still conform to the age-old composite type (profile heads with frontal eyes, frontal torsos, and profile legs and arms). His centaurs, however, are much more believable than their Geometric counterparts (FIG. 5-3). The man-horse combination is top/bottom rather than front/back. The lower (horse) portion has four legs of uniform type, and the upper part of the monster is fully human. In characteristic fashion, Kleitias painted the animal section of the centaur in strict profile, whereas the human head and torso are a composite of frontal and profile views. (He used a consistent profile for the more adventurous detail of the collapsed centaur at the right.)

EXEKIAS The acknowledged master of the black-figure technique was an Athenian named Exekias, whose vases were not only widely exported but copied as well. Perhaps his greatest work is an amphora (FIG. 5-21), found in an Etruscan tomb at Vulci, that Exekias signed as both painter and potter. Unlike Kleitias, Exekias did not divide the surface of the vase into a series of horizontal bands. Instead, he placed figures of monumental stature in a single large framed panel. At the left is Achilles, fully armed. He plays a dice game with his comrade Ajax. From the lips of Achilles comes the word tesara (four). Ajax calls out tria (three). Although Ajax has taken off his helmet, both men hold their spears, and their shields are close at hand. Each man is ready for action at a moment's notice. This depiction of "the calm before the storm" is the antithesis of the Archaic preference for dramatic action. The gravity and tension that will characterize much Classical Greek art of the next century, but that are absent in Archaic art, already may be seen in this vase.

Exekias had no equal as a black-figure painter. This is evident in such details as the extraordinarily intricate engraving of the patterns on the heroes' cloaks (highlighted with delicate touches of white) and in the brilliant composition. The arch formed by the backs of the two warriors echoes the shape of the rounded shoulders of the amphora. The shape of the vessel (compare FIG. 5-22) is echoed again in the void between the heads and spears of Achilles and Ajax. Exekias also used the spears to lead the viewer's eyes toward the thrown dice, where the heroes' eyes are fixed. Of course, those eyes

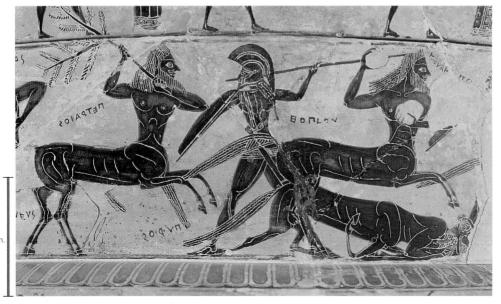

5-20 KLEITIAS and ERGOTIMOS, *François Vase* (Athenian black-figure volute krater), from Chiusi, Italy, ca. 570 BCE. General view (*top*) and detail of centauromachy on other side of vase (*bottom*). 2' 2" high. Museo Archeologico, Florence.

Found in an Etruscan tomb, this huge krater is signed by both the painter and the potter and has more than 200 mythological figures presented in registers, as on Geometric and Orientalizing vases.

5-21 EXEKIAS, Achilles and Ajax playing a dice game (detail from an Athenian black-figure amphora), from Vulci, Italy, ca. 540–530 BCE. Whole vessel 2' high; detail $8\frac{1}{2}$ " high. Musei Vaticani, Rome.

The dramatic tension, adjustment of figures' poses to the vase's shape, and intricacy of the engraved patterns of the cloaks are hallmarks of Exekias, the greatest master of black-figure painting.

do not really look down at the table but stare out from the profile heads in the old manner. For all his brilliance, Exekias was still wedded to many of the old conventions. True innovation in figure drawing would have to await the invention of a new ceramic painting technique of greater versatility than black-figure, with its dark silhouettes and incised details.

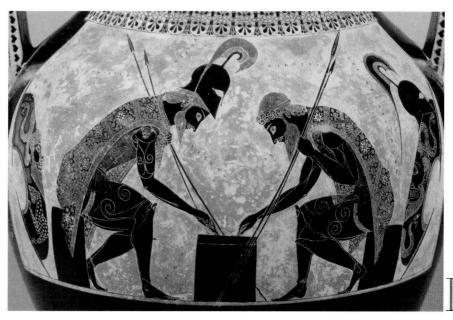

1 in.

BILINGUAL PAINTING The birth of this new technique came around 530 BCE from an artist known as the Andokides Painter, that is, the anonymous painter who decorated the vases signed by the potter Andokides. The differences between the two techniques can best be studied on a series of experimental vases with the same composition painted on both sides, once in black-figure and once in the new technique, *red-figure*. Such vases, nicknamed *bilingual vases*, were produced for only a short time. An especially interesting example is an amphora (FIG. 5-22) by the Andokides Painter that features copies of the Achilles and Ajax panel by Exekias, his teacher.

In neither black-figure nor red-figure did the Andokides Painter capture the intensity of the model, and the treatment of details is decidedly inferior. Yet the new red-figure technique had obvious advantages over the old black-figure treatment. Red-figure is the opposite

of black-figure. What was previously black became red, and vice versa. The artist employed the same black glaze but instead of using it to create the silhouettes of figures, the painter outlined the figures and then colored the background black. The artist reserved the red clay for the figures themselves. Interior details were then drawn with a soft brush in place of a stiff metal graver, giving the painter much greater flexibility. The artist could vary the thickness of the lines and even build up the glaze to give relief to curly hair or dilute it to create brown shades, thereby expanding the chromatic range of the Greek vase painter's craft. The Andokides Painter—many think he was the potter Andokides himself—did not yet appreciate the full potential of his invention. But he created a technique that, in the hands of other, more skilled artists, helped revolutionize the art of drawing.

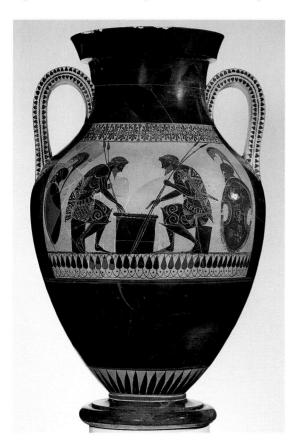

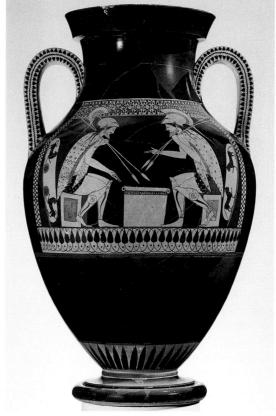

5-22 Andokides
Painter, Achilles and
Ajax playing a dice
game (Athenian
bilingual amphora),
from Orvieto, Italy,
ca. 525–520 BCE. Blackfigure side (*left*) and
red-figure side (*right*).
1' 9" high. Museum of
Fine Arts, Boston.

Around 530 BCE, the Andokides Painter invented the redfigure technique. Some of his early vases are "bilingual"—that is, the same scene appears on both sides, one in black-figure and one in red-figure.

1 in.

5-23 Euphronios, Herakles wrestling Antaios (detail of an Athenian red-figure calyx krater), from Cerveteri, Italy, ca. 510 BCE. Whole vessel 1' 7" high; detail $7\frac{3}{4}$ " high. Louvre, Paris.

Euphronios rejected the age-old composite view for his depiction of Herakles and the giant Antaios and instead attempted to reproduce how the human body is seen from a particular viewpoint.

EUPHRONIOS One of these younger and more adventurous painters was EUPHRONIOS, whose krater depicting the struggle between Herakles and Antaios (FIG. 5-23) reveals the exciting possibili-

ties of the new red-figure technique. Antaios was a Libyan giant, a son of Earth, and he derived his power from contact with the ground. To defeat him, Herakles had to lift him into the air and strangle him while no part of the giant's body touched the earth. In the scene on the krater, the two wrestle on the ground, and Antaios still possesses enormous strength. Nonetheless, Herakles has the upper hand. The giant's face is a mask of pain. His eyes roll and his teeth are bared. His right arm is paralyzed, with the fingers limp.

Euphronios used diluted glaze to show Antaios's unkempt golden brown hair—intentionally contrasted with the neat coiffure and carefully trimmed beard of the emotionless Greek hero. The artist also used thinned glaze to delineate the muscles of both figures. But rendering human anatomy convincingly was not his only interest. Euphronios also wished to show that his figures occupy space. He deliberately rejected the conventional composite posture for the human figure, which communicates so well the specific parts of the human body, and attempted instead to reproduce how a particular human body is seen. He presented, for example, not only Antaios's torso but also his right thigh from the front. The lower leg disappears behind the giant, and one glimpses only part of the right foot. The viewer must mentally make the connection between the upper leg and the foot. The red-figure painter did not create a twodimensional panel filled with figures in stereotypical postures, as his Archaic and pre-Greek predecessors always did. His panel is a window onto a mythological world with protagonists moving in threedimensional space—a revolutionary new conception of what a picture was supposed to be.

EUTHYMIDES A preoccupation with the art of drawing per se may be seen in a remarkable amphora (FIG. 5-24) painted by EUTHYMIDES, a rival of Euphronios. The subject is appropriate for a wine storage jar—three tipsy revelers. But the theme was little more than an excuse for the artist to experiment with the representation of unusual positions of the human form. It is no coincidence that the bodies do not overlap, for each is an independent figure study. Euthymides cast aside the conventional frontal and profile composite views. Instead, he painted torsos that are not two-dimensional surface patterns but are *foreshortened*, that is, drawn in a three-quarter view. Most noteworthy is the central figure, who is shown from the rear with a twisting spinal column and buttocks in three-quarter view. Earlier artists had no interest in attempting such postures because they not only are incomplete but also do not show the "main"

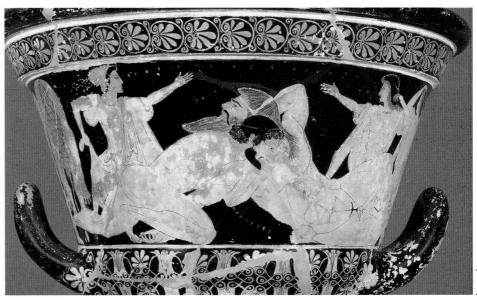

1 in.

side of the human body. But for Euthymides the challenge of drawing the figure from such an unusual viewpoint was a reward in itself. With understandable pride he proclaimed his achievement by adding to the formulaic signature "Euthymides painted me" the phrase "as never Euphronios [could do!]"

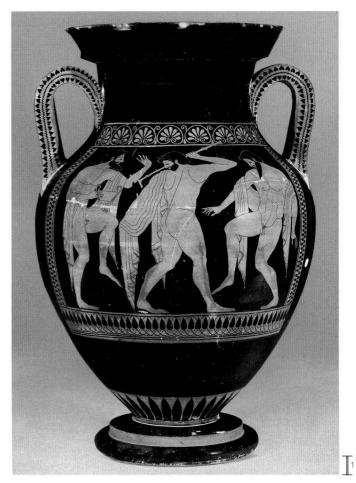

5-24 EUTHYMIDES, Three revelers (Athenian red-figure amphora), from Vulci, Italy, ca. 510 BCE. 2' high. Staatliche Antikensammlungen, Munich.

Euthymides chose this theme as an excuse to represent bodies in unusual positions, including a foreshortened three-quarter view from the rear. He claimed to have surpassed Euphronios as a draftsman.

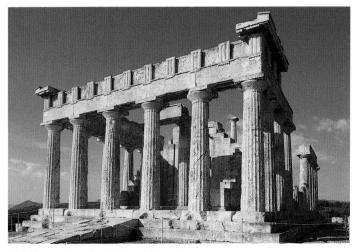

5-25 Temple of Aphaia, Aegina, Greece, ca. 500-490 BCE.

In this refined early-fifth-century BCE Doric design (compare FIG. 5-15), the columns are more slender and widely spaced, and there are only 6 columns on the facade and 12 on the flanks.

Aegina and the Transition to the Classical Period

The years just before and after 500 BCE were also a time of dynamic transition in architecture and architectural sculpture. Some of the changes were evolutionary in nature, others revolutionary. Both kinds are evident in the Temple at Aegina dedicated to Aphaia, a local goddess.

TEMPLE OF APHAIA, AEGINA The temple (FIG. **5-25**) sits on a prominent ridge with dramatic views out to the sea. The colonnade is 45×95 feet and consists of 6 Doric columns on the facade and 12 on the flanks. This is a much more compact structure than the impressive but ungainly Archaic Temple of Hera I (FIG. **5-15**) at Paestum, even though the ratio of width to length is similar. Doric architects had learned a great deal in the half century that elapsed between construction of the two temples. The columns

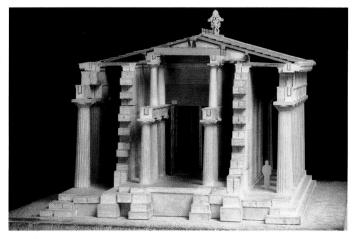

5-26 Model of the Temple of Aphaia, Aegina, Greece, ca. 500–490 BCE, showing internal elevation. Glyptothek, Munich.

Later Doric architects also modified the plan of their temples (compare Fig. 5-16). The Aegina temple's cella has two colonnades of two stories each (originally with a statue of the deity between them).

of the Aegina temple are more widely spaced and more slender. The capitals create a smooth transition from the vertical shafts below to the horizontal architrave above. Gone are the Archaic flattened echinuses and bulging shafts of the Paestum columns. The Aegina architect also refined the internal elevation (FIG. **5-26**) and plan (FIG. **5-27**, *left*). In place of a single row of columns down the center of the cella is a double colonnade—and each row has two stories. This arrangement allowed a statue to be placed on the central axis and also gave worshipers gathered in front of the building an unobstructed view through the pair of columns in the pronaos.

Both pediments featured painted life-size statuary (FIG. 5-27, right) in place of the high reliefs characteristic of Archaic temple pediments. The theme of both statuary groups was the battle of Greeks and Trojans, but the sculptors depicted different episodes. The compositions were nonetheless almost identical, with Athena at the center of the bloody combat. She is larger than all the other figures because she is superhuman, but all the mortal heroes are the

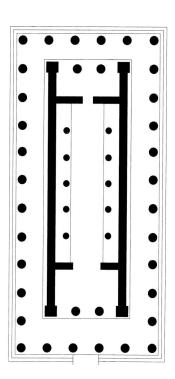

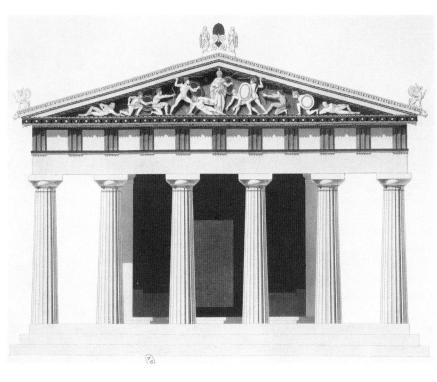

5-27 Plan (*left*) and GUILLAUME-ABEL BLOUET'S 1828 restored view of the facade (*right*) of the Temple of Aphaia, Aegina, Greece, ca. 500–490 BCE.

The restored view suggests how colorful Greek temples were. The designer solved the problem of composing figures in a pediment by using the whole range of body postures from upright to prostrate.

5-28 Dying warrior, from the west pediment of the Temple of Aphaia, Aegina, Greece, ca. 490 BCE. Marble, $5' 2\frac{1}{2}''$ long. Glyptothek, Munich.

The statues of the west pediment of the early-fifth-century BCE temple at Aegina exhibit Archaic features. This fallen warrior still has a rigidly frontal torso and an Archaic smile on his face.

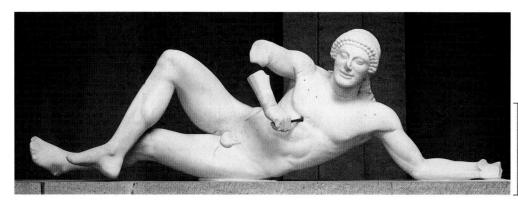

1 ft.

5-29 Dying warrior, from the east pediment of the Temple of Aphaia, Aegina, Greece, ca. 480 BCE. Marble, 6' 1" long. Glyptothek, Munich.

The eastern dying warrior already belongs to the Classical era. His posture is more natural, and he exhibits a new self-consciousness. Concerned with his own pain, he does not face the viewer.

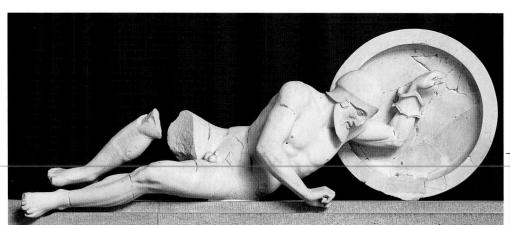

1 ft.

same size, regardless of the statue's position in the pediment. Unlike the experimental design at Corfu (FIG. 5-17), the Aegina pediments feature a unified theme and consistent scale. The designer was able to keep the size of the figures constant by using the whole range of body postures from upright (Athena) to leaning, falling, kneeling, and lying (Greeks and Trojans).

The sculptures of the Aegina pediments were probably set in place when the temple was completed around 490 BCE. Many scholars believe the statues at the eastern end were damaged and replaced with a new group a decade or two later, although some think both groups were installed after 480 BCE. Whatever the precise dates of the sculptures, it is very instructive to compare the eastern and western figures. The west pediment's dying warrior (FIG. 5-28) was still conceived in the Archaic mode. His torso is rigidly frontal, and he looks out directly at the spectator—with his face set in an Archaic smile in spite of the bronze arrow that punctures his chest. He is like a mannequin in a store window whose arms and legs have been arranged by someone else for effective display. There is no sense whatsoever of a thinking and feeling human being.

The comparable figure (FIG. **5-29**) in the east pediment is radically different. His posture is more natural and more complex, with the torso placed at an angle to the viewer. (He is on a par with the painted figures of Euphronios, FIG. **5-23**.) Moreover, he reacts to his wound as a flesh-and-blood human would. He knows that death is inevitable, but he still struggles to rise once again, using his shield for support. And he does not look out at the spectator. He is concerned with his pain, not with the viewer. No more than a decade separates the two statues, but they belong to different eras. The eastern warrior is not a creation of the Archaic world, when sculptors imposed anatomical patterns (and smiles) on statues from without. This statue belongs to the Classical world, where statues move as humans move and

possess the self-consciousness of real men and women. This was a radical change in the conception of what a statue was meant to be. In sculpture, as in painting, the Classical revolution had occurred.

EARLY AND HIGH CLASSICAL PERIODS

Art historians mark the beginning of the Classical* age from a historical event: the defeat of the Persian invaders of Greece by the allied Hellenic city-states. Shortly after the Persians occupied and sacked Athens in 480 BCE, the Greeks won a decisive naval victory over the Persians at Salamis. It had been a difficult war, and at times it had seemed as though Asia would swallow up Greece, and the Persian king Xerxes (see Chapter 2) would rule over all. When the Persians destroyed the Greek city Miletos in 494 BCE, they killed the male inhabitants and sold the women and children into slavery. The narrow escape of the Greeks from domination by Asian "barbarians" nurtured a sense of Hellenic identity so strong that from then on the history of European civilization would be distinct from the civilization of Asia, even though they continued to interact. Typical of the time were the views of the great dramatist Aeschylus, who celebrated, in his Oresteia trilogy, the triumph of reason and law over barbarous crimes, blood feuds, and mad vengeance. Himself a veteran of the epic battle of Marathon, Aeschylus repudiated in majestic verse all the slavish and inhuman traits of nature that the Greeks at that time of crisis associated with the Persians.

*Note: In *Art through the Ages*, the adjective "Classical," with uppercase C, refers specifically to the Classical period of ancient Greece, 480–323 BCE. Lowercase "classical" refers to Greco-Roman antiquity in general, that is, the period treated in Chapters 5, 9, and 10.

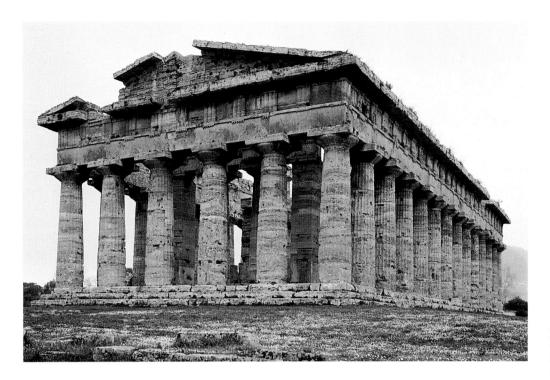

5-30 Temple of Hera II, Paestum, Italy, ca. 460 BCE.

The second Hera temple at Paestum was modeled on Libon's Temple of Zeus at Olympia. The Paestum temple reflects the Olympia design, but the later building lacks the pedimental sculpture of its model.

The subject of the Temple of Zeus's east pediment (FIG. **5-31**) had deep local significance: the chariot race between Pelops (from whom the Peloponnesos takes its name) and King Oinomaos. The story is a sinis-

ter one. Oinomaos had one daughter, Hippodameia, and it was foretold that he would die if she married. Consequently, Oinomaos challenged any suitor who wished to make Hippodameia his bride to a chariot race from Olympia to Corinth. If the suitor won, he also won the hand of the king's daughter. But if he lost, he was killed. The outcome of each race was predetermined, because Oinomaos possessed the divine horses of his father Ares. To ensure his victory when all others had failed, Pelops resorted to bribing the king's groom, Myrtilos, to rig the royal chariot so that it would collapse during the race. Oinomaos was killed and Pelops won his bride, but he drowned Myrtilos rather than pay his debt to him. Before he died, Myrtilos brought a curse on Pelops and his descendants. This curse led to the murder of Pelops's son Atreus and to events that figure prominently in some of the greatest Greek tragedies of the Classical era, Aeschylus's three plays known collectively as the Oresteia: the sacrifice by Atreus's son Agamemnon of his daughter Iphigeneia; the slaying of Agamemnon by Aegisthus, lover of Agamemnon's wife Clytaemnestra; and the murder of Aegisthus and Clytaemnestra by Orestes, the son of Agamemnon and Clytaemnestra.

Indeed, the pedimental statues (FIG. 5-31), which faced toward the starting point of all Olympic chariot races, are posed as actors on a stage—Zeus in the center, Oinomaos and his wife on one side, Pelops and Hippodameia on the other, and their respective chariots to each side. All are quiet. The horrible events known to every

Architecture and Architectural Sculpture

The decades following the removal of the Persian threat are universally considered the high point of Greek civilization. This is the era of the dramatists Sophocles and Euripides, as well as Aeschylus; the historian Herodotus; the statesman Pericles; the philosopher Socrates; and many of the most famous Greek architects, sculptors, and painters.

TEMPLE OF ZEUS, OLYMPIA The first great monument of Classical art and architecture is the Temple of Zeus at Olympia, site of the Olympic Games. The temple was begun about 470 BCE and was probably completed by 457 BCE. The architect was Libon of Elis. Today the structure is in ruins, its picturesque tumbled column drums an eloquent reminder of the effect of the passage of time on even the grandest monuments humans have built. A good idea of its original appearance can be gleaned, however, from a slightly later Doric temple modeled closely on the Olympian shrine of Zeus—the second Temple of Hera (FIG. 5-30) at Paestum. The plans and elevations of both temples follow the pattern of the Temple of Aphaia (FIGS. 5-26 and 5-27) at Aegina: an even number of columns (six) on the short ends, two columns in antis, and two rows of columns in two stories inside the cella. But the Temple of Zeus was more lavishly decorated than even the Aphaia temple. Statues filled both pediments, and the six metopes over the doorway in the pronaos and the matching six of the opisthodomos were adorned with reliefs.

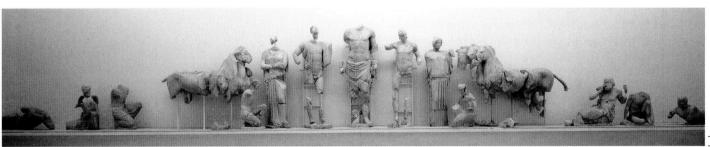

1 ft.

5-31 East pediment from the Temple of Zeus, Olympia, Greece, ca. 470-456 BCE. Marble, 87' wide. Archaeological Museum, Olympia.

The east pediment of the Zeus temple depicts the chariot race between Pelops and Oinomaos, which began at Olympia. The actors in the pediment faced the starting point of Olympic chariot races.

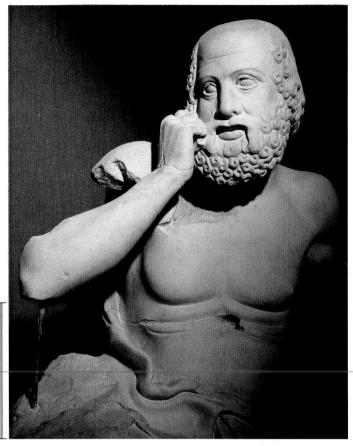

5-32 Seer, from the east pediment of the Temple of Zeus, Olympia, Greece, ca. 470–456 BCE. Marble, full figure 4' 6" high; detail 3' $2\frac{1}{2}$ " high. Archaeological Museum, Olympia.

The balding seer in the Olympia east pediment is a rare depiction of old age in Classical sculpture. He has a shocked expression because he foresees the tragic outcome of the chariot race.

spectator have yet to occur. Only one man reacts—a seer who knows the future (FIG. 5-32). He is a remarkable figure. Unlike the gods, heroes, and noble youths and maidens who are the almost exclusive subjects of Archaic and Classical Greek statuary, this seer is a rare depiction of old age. He has a balding, wrinkled head and sagging musculature—and a shocked expression on his face. This is a true show of emotion, unlike the stereotypical Archaic smile, without precedent in earlier Greek sculpture and not a regular feature of Greek art until the Hellenistic age.

The metopes of the Zeus temple are also thematically connected with the site, for they depict the 12 labors of Herakles (see "Herakles, Greatest of Greek Heroes," right), the legendary founder of the Olympic Games. In the metope illustrated here (FIG. 5-33), Herakles holds up the sky (with the aid of the goddess Athena—and a cushion) in place of Atlas, who had undertaken the dangerous journey to fetch the golden apples of the Hesperides for the hero. The load soon will be transferred back to Atlas (at the right, still holding the apples), but now each of the very high relief figures in the metope stands quietly with the same serene dignity as the statues in the Olympia pediment. In both attitude and dress (simple Doric peplos for the women), all the Olympia figures display a severity that contrasts sharply with the smiling and elaborately clad figures of the Late Archaic period. Many art historians call this Early Classical phase of Greek art the Severe Style.

Herakles, Greatest of Greek Heroes

reek heroes were a class of mortals of intermediate status between ordinary humans and the immortal gods. Most often the children of gods, some were great warriors, such as those who fought at Troy and were celebrated in Homer's epic poems. Others pursued one fabulous adventure after another, ridding the world of monsters and generally benefiting humankind. Many heroes were worshiped after their deaths, and the greatest of them were honored with shrines, especially in the cities with which they were most closely associated.

The greatest Greek hero was Herakles (the Roman Hercules), born in Thebes and the son of Zeus and Alkmene, a mortal woman. Zeus's jealous wife Hera hated Herakles and sent two serpents to attack him in his cradle, but the infant strangled them. Later, Hera caused the hero to go mad and to kill his wife and children. As punishment he was condemned to perform 12 great labors. In the first, he defeated the legendary lion of Nemea and ever after wore its pelt. The lion's skin and his weapon, a club, are Herakles' distinctive attributes (FIG. 5-66). His last task was to obtain the golden apples Gaia gave to Hera at her marriage (FIG. 5-33). They grew from a tree in the garden of the Hesperides at the western edge of the ocean, where a dragon guarded them. After completion of the 12 seemingly impossible tasks, Herakles was awarded immortality. Athena, who had watched over him carefully throughout his life and assisted him in performing the labors, introduced him into the realm of the gods on Mount Olympus. According to legend, it was Herakles who established the Olympic Games.

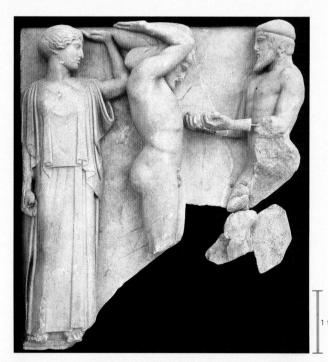

5-33 Athena, Herakles, and Atlas with the apples of the Hesperides, metope from the Temple of Zeus, Olympia, Greece, ca. 470–456 BCE. Marble, 5′ 3″ high. Archaeological Museum, Olympia.

Herakles founded the Olympic Games, and his 12 labors were the subjects of the 12 Doric metopes of the Zeus temple. This one shows the hero holding up the world (with Athena's aid) for Atlas.

Statuary

Early Classical sculptors were also the first to break away from the rigid and unnatural Egyptian-inspired pose of the Archaic kouroi. This change is evident in the postures of the Olympia figures, but it occurred even earlier in independent statuary.

KRITIOS BOY Although it is well under life-size, the marble statue known as the Kritios Boy (FIG. 5-34)—so titled because it was once thought the sculptor Kritios carved it—is one of the most important works of Greek sculpture. Never before had a sculptor been concerned with portraying how a human being (as opposed to a stone image) actually stands. Real people do not stand in the stiff-legged pose of the kouroi and korai or their Egyptian predecessors. Humans shift their weight and the position of the main body parts around the vertical but flexible axis of the spine. When humans move, the body's elastic musculoskeletal structure dictates a harmonious, smooth motion of all its elements. The sculptor of the Kritios

Boy was among the first to grasp this fact and to represent it in statuary. The youth has a slight dip to the right hip, indicating the shifting of weight onto his left leg. His right leg is bent, at ease. The head also turns slightly to the right and tilts, breaking the unwritten rule of frontality dictating the form of virtually all earlier statues. This weight shift, which art historians describe as *contrapposto* (counterbalance), separates Classical from Archaic Greek statuary.

RIACE WARRIOR The innovations of the *Kritios Boy* were carried even further in the bronze statue (FIG. 5-35) of a warrior found in the sea near Riace at the "toe" of the Italian "boot." It is one of a pair of statues divers accidentally discovered in the cargo of a ship that sank in antiquity on its way from Greece probably to Rome, where Greek sculpture was much admired. Known as the Riace Bronzes, they had to undergo several years of cleaning and restoration after nearly two millennia of submersion in salt water, but they are nearly intact. The statue shown here lacks only its shield, spear, and helmet. It is a masterpiece of hollow-casting (see "Hollow-Casting Life-Size Bronze

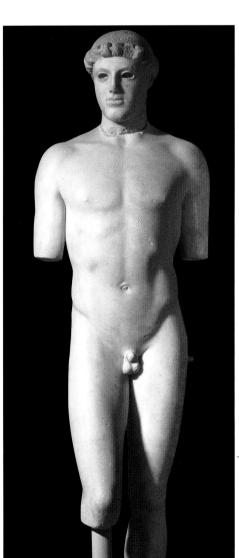

5-34 Kritios Boy, from the Acropolis, Athens, Greece, ca. 480 BCE. Marble, 2' 10" high. Acropolis Museum, Athens.

This is the first statue to show how a person naturally stands. The sculptor depicted the shifting of weight from one leg to the other (contrapposto). The head turns slightly, and the Archaic smile is gone.

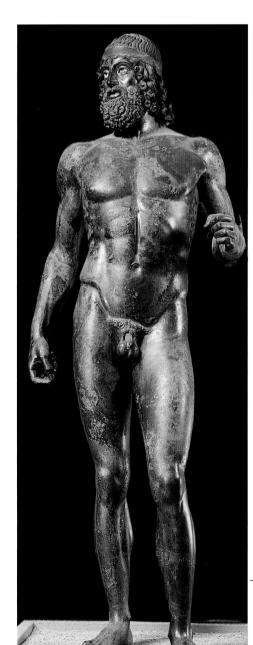

5-35 Warrior, from the sea off Riace, Italy, ca. 460–450 BCE. Bronze, 6' 6" high. Museo Archeologico Nazionale, Reggio Calabria.

The bronze Riace warrior statue has inlaid eyes, silver teeth and eyelashes, and copper lips and nipples (FIG. I-17). The contrapposto is more pronounced than in the *Kritios Boy* (FIG. 5-34).

1

1 ft.

Hollow-Casting Life-Size Bronze Statues

onumental bronze statues such as the Riace warrior (FIG. 5-35), the Delphi charioteer (FIG. 5-37), and the Artemision god (FIG. 5-38) required great technical skill to produce. They could not be manufactured using a single simple mold, as were small-scale Geometric and Archaic figures (FIGS. 5-3 and 5-4). Weight, cost, and the tendency of large masses of bronze to distort when cooling made life-size castings in solid bronze impractical, if not impossible. Instead, large statues were hollow-cast by the *cire perdue* (*lost-wax*) method. The lost-wax process entailed several steps and had to be repeated many times, because monumental statues were typically cast in parts—head, arms, hands, torso, and so forth.

First, the sculptor fashioned a full-size clay model of the intended statue. Then a clay master mold was made around the model and removed in sections. When dry, the various pieces of the master mold were reassembled for each separate body part. Next, a layer of beeswax was applied to the inside of each mold. When the wax cooled, the mold was removed, and the sculptor was left with a hollow wax model in the shape of the original clay model. The artist could then correct or refine details—for example, engrave fingernails on the wax hands or individual locks of hair on the head.

In the next stage, a final clay mold (*investment*) was applied to the exterior of the wax model, and a liquid clay core was poured inside the hollow wax. Metal pins (*chaplets*) were driven through the new mold to connect the investment with the clay core (FIG. 5-36a). Then the wax was melted out ("lost") and molten bronze poured into the mold in its place (FIG. 5-36b). When the bronze hardened and assumed the shape of the wax model, the investment and as much of the core as possible were removed, and the casting process was complete. Finally, the individually cast pieces were fitted together and soldered, surface imperfections smoothed, eyes inlaid, teeth and eyelashes added, attributes such as spears and wreaths provided, and so forth. Bronze statues were costly to make and highly prized.

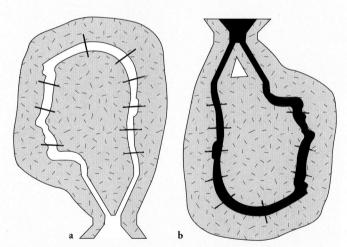

5-36 Two stages of the lost-wax method of bronze casting (after Sean A. Hemingway).

Drawing a shows a clay mold (investment), wax model, and clay core connected by chaplets. Drawing b shows the wax melted out and the molten bronze poured into the mold to form the cast bronze head.

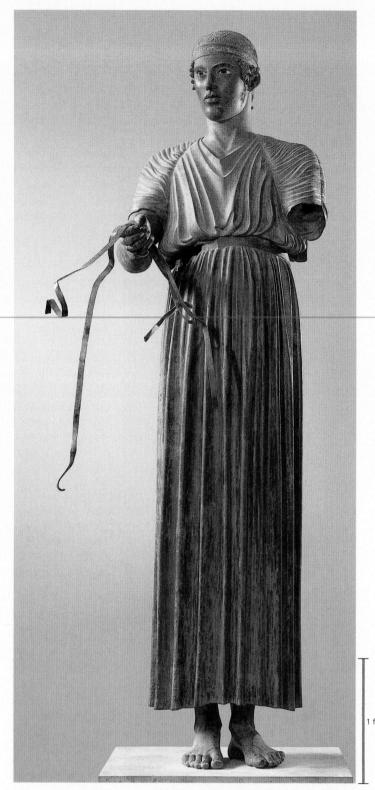

5-37 Charioteer, from a group dedicated by Polyzalos of Gela in the sanctuary of Apollo, Delphi, Greece, ca. 470 BCE. Bronze, 5' 11" high. Archaeological Museum, Delphi.

The charioteer is almost all that remains of a large bronze group that also included a chariot, a team of horses, and a groom, requiring hundreds of individually cast pieces soldered together.

Statues," page 122), and FIG. **5-36**), with inlaid eyes, silver teeth and eyelashes, and copper lips and nipples (FIG. I-17). The weight shift is more pronounced than in the *Kritios Boy*. The warrior's head turns more forcefully to the right, his shoulders tilt, his hips swing more markedly, and his arms have been freed from the body. Natural motion in space has replaced Archaic frontality and rigidity.

CHARIOTEER OF DELPHI The high technical quality of the Riace warrior is equaled in another bronze statue set up a decade or two earlier to commemorate the victory of the tyrant Polyzalos of Gela (Sicily) in a chariot race at Delphi. The statue (FIG. 5-37) is almost all that remains of a large group composed of Polyzalos's driver, the chariot, the team of horses, and a young groom. The charioteer stands in an almost Archaic pose, but the turn of the head and feet in opposite directions as well as a slight twist at the waist are in keeping with the Severe Style. The moment chosen for depiction is not during the frenetic race but after, when the driver quietly and modestly holds his horses still in the winner's circle. He grasps the reins in his outstretched right hand (the lower left arm, cast separately, is missing), and he wears the standard charioteer's garment,

girdled high and held in at the shoulders and the back to keep it from flapping. The folds emphasize both the verticality and calm of the figure and recall the flutes of a Greek column. A band inlaid with silver, tied around the head, confines the hair. Delicate bronze lashes shade the eyes made of glass paste.

ARTEMISION ZEUS The male human form in motion is, in contrast, the subject of another Early Classical bronze statue (FIG. 5-38), which, like the Riace warrior, divers found in an ancient shipwreck, this time off the coast of Greece itself at Cape Artemision. The bearded god once hurled a weapon held in his right hand, probably a thunderbolt, in which case he is Zeus. A less likely suggestion is that this is Poseidon with his trident. The pose could be employed equally well for a javelin thrower. Both arms are boldly extended, and the right heel is raised off the ground, underscoring the lightness and stability of hollow-cast monumental statues.

MYRON, *DISKOBOLOS* A bronze statue similar to the Artemision Zeus was the renowned *Diskobolos* (*Discus Thrower*) by the Early Classical master Myron. The original is lost. Only marble copies (FIG. 5-39) survive, made in Roman times, when demand so

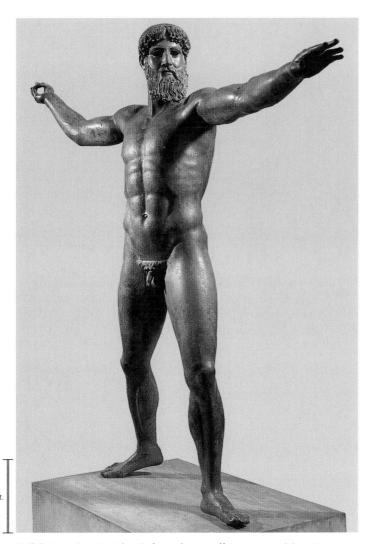

5-38 Zeus (or Poseidon?), from the sea off Cape Artemision, Greece, ca. 460–450 BCE. Bronze, 6′ 10″ high. National Archaeological Museum, Athens.

In this Early Classical statue of Zeus hurling a thunderbolt, both arms are boldly extended and the right heel is raised off the ground, underscoring the lightness and stability of hollow-cast bronze statues.

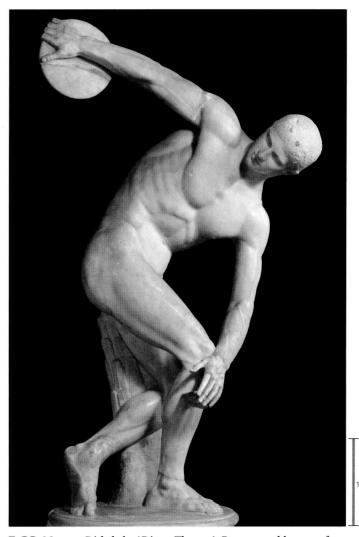

5-39 Myron, *Diskobolos* (*Discus Thrower*). Roman marble copy of a bronze original of ca. 450 BCE, 5′ 1″ high. Museo Nazionale Romano–Palazzo Massimo alle Terme.

This marble copy of Myron's lost bronze statue captures how the sculptor froze the action of discus throwing and arranged the nude athlete's body and limbs so that they formed two intersecting arcs.

Polykleitos's Prescription for the Perfect Statue

ne of the most influential philosophers of the ancient world was Pythagoras of Samos, who lived during the latter part of the sixth century BCE. A famous geometric theorem still bears his name. Pythagoras also is said to have discovered that harmonic chords in music are produced on the strings of a lyre at regular intervals that may be expressed as ratios of whole numbers—2:1, 3:2, 4:3. He and his followers, the Pythagoreans, believed more generally that underlying harmonic proportions could be found in all of nature, determining the form of the cosmos as well as of things on earth, and that beauty resided in harmonious numerical ratios.

By this reasoning, a perfect statue would be one constructed according to an all-encompassing mathematical formula. In the midfifth century BCE, the sculptor Polykleitos of Argos set out to make just such a statue (FIG. **5-40**). He recorded the principles he followed and the proportions he used in a treatise titled the *Canon* (that is, the standard of perfection). His treatise is unfortunately lost, but Galen, a physician who lived during the second century CE, summarized the sculptor's philosophy as follows:

[Beauty arises from] the commensurability [symmetria] of the parts, such as that of finger to finger, and of all the fingers to the palm and the wrist, and of these to the forearm, and of the forearm to the upper arm, and, in fact, of everything to everything else, just as it is written in the *Canon* of Polykleitos. . . . Polykleitos supported his treatise [by making] a statue according to the tenets of his treatise, and called the statue, like the work, the *Canon*.*

This is why Pliny the Elder, writing in the first century CE, maintained that Polykleitos "alone of men is deemed to have rendered art itself [that is, the theoretical basis of art] in a work of art." †

Polykleitos's belief that a successful statue resulted from the precise application of abstract principles is reflected in an anecdote (probably a later invention) told by the Roman historian Aelian:

Polykleitos made two statues at the same time, one which would be pleasing to the crowd and the other according to the principles of his art. In accordance with the opinion of each person who came into his workshop, he altered something and changed its form, sub-

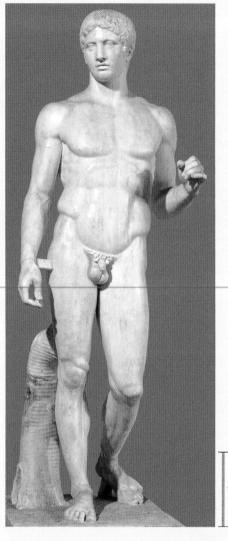

5-40 POLYKLEITOS, Doryphoros (Spear Bearer). Roman marble copy from Pompeii, Italy, after a bronze original of ca. 450–440 BCE, 6′11″ high. Museo Archeologico Nazionale, Naples.

Polykleitos sought to portray the perfect man and to impose order on human movement. He achieved his goals by employing harmonic proportions and a system of cross balance for all parts of the body.

mitting to the advice of each. Then he put both statues on display. The one was marvelled at by everyone, and the other was laughed at. Thereupon Polykleitos said, "But the one that you find fault with, you made yourselves; while the one that you marvel at, I made." ‡

*Galen, *De placitis Hippocratis et Platonis*, 5. Translated by J. J. Pollitt, *The Art of Ancient Greece: Sources and Documents* (New York: Cambridge University Press, 1990), 76. †Pliny the Elder, *Natural History*, 34.55. Translated by Pollitt, 75.

[‡]Aelian, Varia historia, 14.8. Translated by Pollitt, 79.

far exceeded the supply of Greek statues that a veritable industry was born to meet the call for Greek statuary to display in public places and private villas alike. The copies usually were made in less costly marble. The change in medium resulted in a different surface appearance. In most cases, the copyist also had to add an intrusive tree trunk to support the great weight of the stone statue and struts between arms and body to strengthen weak points. The copies rarely approach the quality of the originals, and the Roman sculptors sometimes took liberties with their models to conform to their own tastes and needs. Occasionally, for example, a mirror image of the

original was created for a specific setting. Nevertheless, the copies are indispensable today. Without them it would be impossible to reconstruct the history of Greek sculpture after the Archaic period.

Myron's *Diskobolos* is a vigorous action statue, like the Artemision Zeus, but it is composed in an almost Archaic manner, with profile limbs and a nearly frontal chest, suggesting the tension of a coiled spring. Like the arm of a pendulum clock, the right arm of the *Diskobolos* has reached the apex of its arc but has not yet begun to swing down again. Myron froze the action and arranged the body and limbs to form two intersecting arcs (one from the discus to the

left hand, one from the head to the right knee), creating the impression of a tightly stretched bow a moment before the string is released. This tension is not, however, mirrored in the athlete's face, which remains expressionless. Once again, as in the warrior statue (FIG. 5-29) from the Aegina temple's east pediment, the head is turned away from the spectator. In contrast to Archaic athlete statues, the Classical *Diskobolos* does not perform for the spectator but concentrates on the task at hand.

POLYKLEITOS, DORYPHOROS One of the most frequently copied Greek statues was the *Doryphoros* (*Spear Bearer*) by the sculptor Polykleitos, whose work epitomizes the intellectual rigor of Classical art. The best marble replica (FIG. **5-40**) stood in a palaestra at Pompeii, where it served as a model for Roman athletes. The *Doryphoros* was the embodiment of Polykleitos's vision of the ideal statue of a nude male athlete or warrior. In fact, the sculptor made it as a demonstration piece to accompany a treatise on the subject. *Spear Bearer* is a modern descriptive title for the statue. The name Polykleitos assigned to it was *Canon* (see "Polykleitos's Prescription for the Perfect Statue," page 124).

The Doryphoros is the culmination of the evolution in Greek statuary from the Archaic kouros to the Kritios Boy to the Riace warrior. The contrapposto is more pronounced than ever before in a standing statue, but Polykleitos was not content with simply rendering a figure that stood naturally. His aim was to impose order on human movement, to make it "beautiful," to "perfect" it. He achieved this through a system of cross balance. What appears at first to be a casually natural pose is, in fact, the result of an extremely complex and subtle organization of the figure's various parts. Note, for instance, how the statue's straight-hanging arm echoes the rigid supporting leg, providing the figure's right side with the columnar stability needed to anchor the left side's dynamically flexed limbs. If read anatomically, however, the tensed and relaxed limbs may be seen to oppose each other diagonally—the right arm and the left leg are relaxed, and the tensed supporting leg opposes the flexed arm, which held a spear. In like manner, the head turns to the right while the hips twist slightly to the left. And although the Doryphoros seems to take a step forward, the figure does not move. This dynamic asymmetrical balance, this motion while at rest, and the resulting harmony of opposites are the essence of the Polykleitan style.

The Athenian Acropolis

While Polykleitos was formulating his *Canon* in Argos, the Athenians, under the leadership of Pericles, were at work on one of the most ambitious building projects ever undertaken, the reconstruction of the Acropolis after the Persian sack of 480 BCE. Athens, despite the damage it suffered at the hands of the army of Xerxes, emerged from the war with enormous power and prestige. The Athenian commander Themistocles had decisively defeated the Persian navy off the island of Salamis, southwest of Athens, and forced it to retreat to Asia.

In 478 BCE, in the aftermath of the Persians' expulsion from the Aegean, the Greeks formed an alliance for mutual protection against any renewed threat from the east. The new confederacy came to be known as the Delian League, because its headquarters were on the sacred island of Delos, midway between the Greek mainland and the coast of Asia Minor. Although at the outset each league member had an equal vote, Athens was "first among equals," providing the allied fleet commander and determining which cities were to furnish ships and which were instead to pay an annual tribute to the treasury at Delos. Continued fighting against the Persians kept the alliance intact, but Athens gradually assumed a dominant role. In 454 BCE the Delian treasury was transferred to Athens, ostensibly for security rea-

sons. Pericles, who was only in his teens when the Persians laid waste to the Acropolis, was by midcentury the recognized leader of the Athenians, and he succeeded in converting the alliance into an Athenian empire. Tribute continued to be paid, but the surplus reserves were not expended for the common good of the allied Greek states. Instead, Pericles expropriated the money to pay the enormous cost of executing his grand plan to embellish the Acropolis of Athens.

The reaction of the allies—in reality the subjects of Athens was predictable. Plutarch, who wrote a biography of Pericles in the early second century CE, indicated the wrath the Greek victims of Athenian tyranny felt by recording the protest voiced against Pericles' decision even in the Athenian assembly. Greece, Pericles' enemies said, had been dealt "a terrible, wanton insult" when Athens used the funds contributed out of necessity for a common war effort to "gild and embellish itself with images and extravagant temples, like some pretentious woman decked out with precious stones."1 The source of funds for the Acropolis building program is important to keep in mind when examining those great and universally admired buildings erected in accordance with Pericles' vision of his polis reborn from the ashes of the Persian sack. They are not the glorious fruits of Athenian democracy but are instead the by-products of tyranny and the abuse of power. Too often art and architectural historians do not ask how a monument was financed. The answer can be very revealing—and very embarrassing.

PORTRAIT OF PERICLES A number of Roman copies are preserved of a famous portrait statue of Pericles by Kresilas, who was born on Crete but who worked in Athens. The bronze portrait was set up on the Acropolis, probably immediately after the leader's death in 429 BCE, and depicted Pericles in heroic nudity. The statue must have resembled the Riace warrior (FIG. 5-35). The copies, in marble, reproduce the head only, sometimes in the form of a *herm* (a bust on a square pillar, FIG. 5-41), a popular format in Roman times

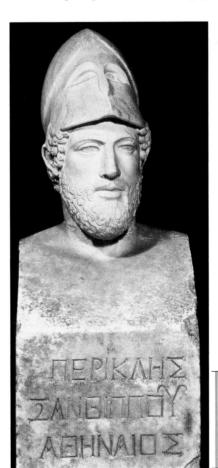

5-41 Kresilas, Pericles. Roman marble herm copy of a bronze original of ca. 429 BCE. Full herm 6' high; detail 4' $6\frac{1}{2}''$ high. Musei Vaticani, Rome.

In his portrait of Pericles, Kresilas was said to have made a noble man appear even nobler. Classical Greek portraits were not likenesses but idealized images in which humans appeared godlike.

l ft.

for abbreviated copies of famous statues. The herm is inscribed "Pericles, son of Xanthippos, the Athenian," leaving no doubt as to the identification. Pericles wears the helmet of a *strategos* (general), the position he was elected to 15 times. The Athenian leader was said to have had an abnormally elongated skull, and Kresilas recorded this feature (while also concealing it) by providing a glimpse through the helmet's eye slots of the hair at the top of the head. This, together with the unblemished features of Pericles' Classically aloof face and, no doubt, his body's perfect physique, led Pliny to assert that Kresilas had the ability to make noble men appear even more noble in their portraits. This praise was apt because the Pericles herm is not a portrait at all in the modern sense of a record of actual features. Pliny referred to Kresilas's "portrait" as "the Olympian Pericles," for in this image Pericles appeared almost godlike.²

PERICLEAN ACROPOLIS The centerpiece of the Periclean building program on the Acropolis (FIG. **5-42**) was the Parthenon (FIG. **5-43**, no. 1), or the Temple of Athena Parthenos, erected in the remarkably short period between 447 and 438 BCE. (Work on the great temple's ambitious sculptural ornamentation continued until 432 BCE.) As soon as the Parthenon was completed, construction commenced on a grand new gateway to the Acropolis from the west (the only accessible side of the natural plateau), the Propylaia (FIG. **5-43**, no. 2). Begun in 437 BCE, it was left unfinished in 431 at the outbreak of the Peloponnesian War between Athens and Sparta. Two later temples, the Erechtheion (FIG. **5-43**, no. 4) and the Temple of Athena Nike (FIG. **5-43**, no. 5), built after Pericles died, were probably also part of the original design. The greatest Athenian architects and sculptors of the Classical period focused their attention on the construction and decoration of these four buildings.

That these fifth-century BCE buildings exist at all today is something of a miracle. In the Middle Ages, the Parthenon, for example, was converted into a Byzantine and later a Roman Catholic church and then, after the Ottoman conquest of Greece, into a mosque. Each time the building was remodeled for a different religion, it was modified structurally. The Christians early on removed the colossal statue of Athena inside. The churches had a great curved *apse* at the east end

housing the altar, and the mosque had a minaret (tower used to call Muslims to prayer). In 1687 the Venetians besieged the Acropolis, which at that time was in Turkish hands. Venetian weaponry scored a direct hit on the ammunition depot the Turks had installed in part of the Parthenon. The resultant explosion blew out the building's center. To make matters worse, the Venetians subsequently tried to remove some of the statues from the Parthenon's pediments. In more than one case, they dropped statues, which then smashed on the ground. From 1801 to 1803, Lord Elgin brought most of the surviving sculptures to England. For the past two centuries they have been on exhibit in the British Museum (FIGS. 5-47 to 5-50), although Greece has appealed many times for the return of the "Elgin Marbles." Today, a uniquely modern blight threatens the Parthenon and the other buildings of the Periclean age. The corrosive emissions of factories and automobiles are decomposing the ancient marbles. A major campaign has been under way for decades to protect the columns and walls from further deterioration. What little original sculpture remained in place when modern restoration began, the Greeks transferred to the Acropolis Museum's climate-controlled rooms.

PARTHENON: ARCHITECTURE Despite the ravages of time and humanity, most of the Parthenon's peripteral colonnade (FIG. **5-44**) is still standing (or has been reerected), and art historians know a great deal about the building and its sculptural program. The architects were IKTINOS and KALLIKRATES. The statue of Athena (FIG. **5-46**) in the cella was the work of PHIDIAS, who was also the overseer of the temple's sculptural decoration. In fact, Plutarch claimed that Phidias was in charge of the entire Acropolis project.

Just as the contemporary *Doryphoros* (FIG. **5-40**) may be seen as the culmination of nearly two centuries of searching for the ideal proportions of the various human body parts, so, too, the Parthenon may be viewed as the ideal solution to the Greek architect's quest for perfect proportions in Doric temple design. Its well-spaced columns, with their slender shafts, and the capitals, with their straight-sided conical echinuses, are the ultimate refinement of the bulging and squat Doric columns and compressed capitals of the Archaic Hera temple at Paestum (FIG. **5-15**). The Parthenon architects and Poly-

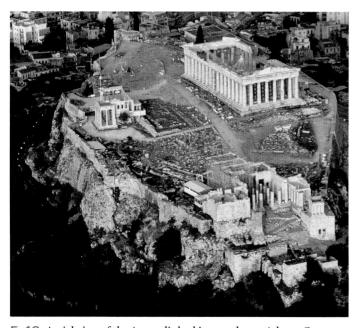

5-42 Aerial view of the Acropolis looking southeast, Athens, Greece. Under the leadership of Pericles, the Athenians undertook the costly project of reconstructing the Acropolis after the Persian sack of 480 BCE. The funds came from the Delian League treasury.

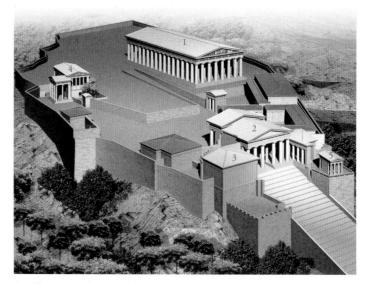

5-43 Restored view of the Acropolis, Athens, Greece (John Burge).
(1) Parthenon, (2) Propylaia, (3) pinakotheke, (4) Erechtheion,

(5) Temple of Athena Nike.

Of the four main fifth-century BCE buildings on the Acropolis, the first to be erected was the Parthenon, followed by the Propylaia, the Erechtheion, and the Temple of Athena Nike.

kleitos were kindred spirits in their belief that beautiful proportions resulted from strict adherence to harmonious numerical ratios, whether in a temple more than 200 feet long or a life-size statue of a nude man. For the Parthenon, the controlling ratio for the *symmetria* of the parts may be expressed algebraically as x = 2y + 1. Thus, for example, the temple's short ends have 8 columns and the long sides have 17, because $17 = (2 \times 8) + 1$. The stylobate's ratio of length to width is 9:4, because $9 = (2 \times 4) + 1$. This ratio also characterizes the cella's proportion of length to width, the distance between the centers of two adjacent column drums (the *interaxial*) in proportion to the columns' diameter, and so forth.

The Parthenon's harmonious design and the mathematical precision of the sizes of its constituent elements tend to obscure the fact that this temple, as actually constructed, is quite irregular in shape. Throughout the building are pronounced deviations from the strictly horizontal and vertical lines assumed to be the basis of all Greek postand-lintel structures. The stylobate, for example, curves upward at the center on the sides and both facades, forming a kind of shallow dome, and this curvature is carried up into the entablature. Moreover, the peristyle columns lean inward slightly. Those at the corners have a diagonal inclination and are also about two inches thicker than the rest. If their lines continued, they would meet about 1.5 miles above the

temple. These deviations from the norm meant that virtually every Parthenon block and drum had to be carved according to the special set of specifications dictated by its unique place in the structure. This was obviously a daunting task, and a reason must have existed for these so-called refinements in the Parthenon. Some modern observers note, for example, how the curving of horizontal lines and the tilting of vertical ones create a dynamic balance in the building—a kind of architectural contrapposto—and give it a greater sense of life. The oldest recorded explanation, however, may be the most likely. Vitruvius, a Roman architect of the late first century BCE who claimed to have had access to Iktinos's treatise on the Parthenon—again note the kinship with the Canon of Polykleitos—maintained that the builders made these adjustments to compensate for optical illusions. Vitruvius noted, for example, that if a stylobate is laid out on a level surface, it will appear to sag at the center, and that the corner columns of a building should be thicker because they are surrounded by light and would otherwise appear thinner than their neighbors.

The Parthenon is "irregular" in other ways as well. One of the ironies of this most famous of all Doric temples is that it is "contaminated" by Ionic elements (FIG. **5-45**). Although the cella had a two-story Doric colonnade, the back room (which housed the goddess's treasury and the tribute collected from the Delian League) had four

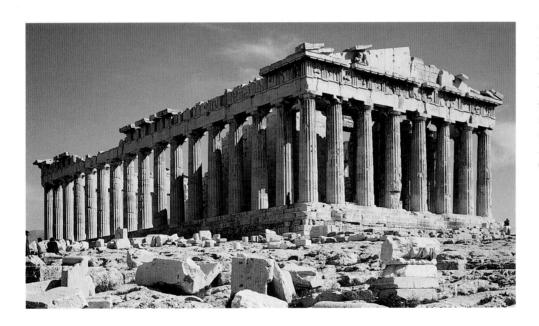

5-44 IKTINOS and KALLIKRATES, Parthenon (Temple of Athena Parthenos, looking southeast), Acropolis, Athens, Greece, 447–438 BCE.

The architects of the Parthenon believed that perfect beauty could be achieved by using harmonic proportions. The ratio for larger and smaller parts was x = 2y + 1 (for example, a plan of 17×8 columns).

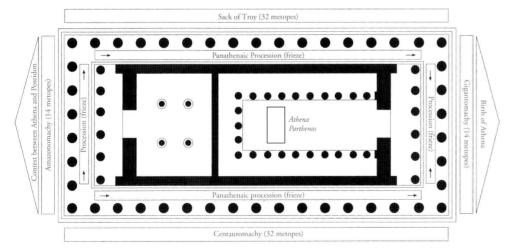

5-45 Plan of the Parthenon, Acropolis, Athens, Greece, with diagram of the sculptural program (after Andrew Stewart), 447–432 BCE.

The Parthenon was lavishly decorated under the direction of Phidias. Statues filled both pediments, and figural reliefs adorned all 92 metopes. There was also an inner 524-foot sculptured lonic frieze.

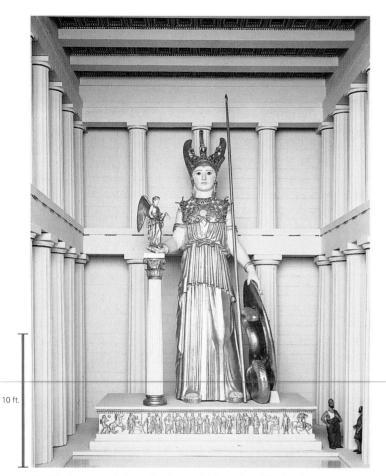

5-46 Phidias, *Athena Parthenos*, in the cella of the Parthenon, Acropolis, Athens, Greece, ca. 438 BCE. Model of the lost chryselephantine statue. Royal Ontario Museum, Toronto.

Inside the cella of the Parthenon was Phidias's 38-foot-tall gold-and-ivory statue of Athena Parthenos (the Virgin), fully armed and holding Nike (Victory) in her extended right hand.

tall and slender Ionic columns as sole supports for the superstructure. And whereas the temple's exterior had a canonical Doric frieze, the inner frieze that ran around the top of the cella wall was Ionic. Perhaps this fusion of Doric and Ionic elements reflects the Athenians' belief that the Ionians of the Aegean Islands and Asia Minor were descended from Athenian settlers and were therefore their kin. Or it may be Pericles' and Iktinos's way of suggesting that Athens was the leader of *all* the Greeks. In any case, a mix of Doric and Ionic features characterizes the fifth-century BCE buildings of the Acropolis as a whole.

ATHENA PARTHENOS The costly decision to incorporate two sculptured friezes in the Parthenon's design is symptomatic. This Pentelic-marble temple was more lavishly adorned than any Greek temple before it, Doric or Ionic. Every one of the 92 Doric metopes was decorated with relief sculpture. So, too, was every inch of the 524-foot-long Ionic frieze. The two pediments were filled with dozens of larger-than-life-size statues. And inside was the most expensive item of all—Phidias's gold-and-ivory (chryselephantine) statue of Athena Parthenos, the Virgin. Art historians know a great deal about Phidias's lost statue from descriptions by Greek and Latin authors and from Roman copies. A model (FIG. 5-46) gives a good idea of its appearance and setting. Athena stood 38 feet tall, and to a large extent the Parthenon was designed around her. To accommodate the statue's huge size, the cella had to be wider than usual. This,

in turn, dictated the width of the facade—eight columns at a time when six columns were the norm.

Athena was fully armed with shield, spear, and helmet, and she held Nike (the winged female personification of Victory) in her extended right hand. No one doubts that this Nike referred to the victory of 479 BCE. The memory of the Persian sack of the Acropolis was still vivid, and the Athenians were intensely conscious that by driving back the Persians, they were saving their civilization from the eastern "barbarians" who had committed atrocities at Miletos. In fact, the *Athena Parthenos* had multiple allusions to the Persian defeat. On the thick soles of Athena's sandals was a representation of a centauromachy. The exterior of her shield was emblazoned with high reliefs depicting the battle of Greeks and Amazons (*Amazonomachy*), in which Theseus drove the Amazons out of Athens. And Phidias painted a gigantomachy on the shield's interior. Each of these mythological contests was a metaphor for the triumph of order over chaos, of civilization over barbarism, and of Athens over Persia.

PARTHENON: METOPES Phidias took up these same themes again in the Parthenon's Doric metopes (FIG. 5-45). The best-preserved metopes—although the paint on these and all the other Parthenon marbles long ago disappeared—are those of the south side, which depicted the battle of Lapiths and centaurs, a combat in which Theseus of Athens played a major role. On one extraordinary slab (FIG. 5-47), a triumphant centaur rises up on its hind legs, exulting over the crumpled body of the Greek it has defeated. The relief is so high that parts are fully in the round. Some have broken off. The sculptor knew how to distinguish the vibrant, powerful form of the living beast from the lifeless corpse on the ground. In other metopes the Greeks have the upper

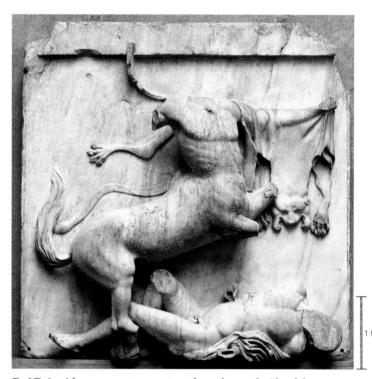

5-47 Lapith versus centaur, metope from the south side of the Parthenon, Acropolis, Athens, Greece, ca. 447–438 BCE. Marble, 4' 8" high. British Museum, London.

The Parthenon's centauromachy metopes allude to the Greek defeat of the Persians. The sculptor of this metope knew how to distinguish the vibrant living centaur from the lifeless Greek corpse.

hand, but the full set suggests that the battle was a difficult one against a dangerous enemy and that losses as well as victories occurred. The same was true of the war against the Persians.

PARTHENON: PEDIMENTS The subjects of the two pediments were especially appropriate for a temple that celebrated Athena—and the Athenians. The east pediment depicted the birth of the goddess. At the west was the contest between Athena and Poseidon to determine which one would become the city's patron deity. Athena won, giving her name to the polis and its citizens. It is significant that in the story and in the pediment the Athenians are the judges of the relative merits of the two gods. The choice of theme reflects the same arrogance that led to the Athenians' use of Delian League funds to adorn the Acropolis.

The center of the east pediment was damaged when the apse was added to the Parthenon at the time of its conversion into a church. What remains are the spectators to the left and the right who witnessed Athena's birth on Mount Olympus. At the far left (FIG. 5-48) are the head and arms of Helios (the Sun) and his chariot horses rising from the pediment floor. Next to them is a powerful male figure usually identified as Dionysos or possibly Herakles, who entered the realm of the gods on completion of his 12 labors. At the right (FIG.

5-49) are three goddesses, probably Hestia, Dione, and Aphrodite, and either Selene (the Moon) or Nyx (Night) and more horses, this time sinking below the pediment's floor. Here, Phidias, who designed the composition even if his assistants executed it, discovered an entirely new way to deal with the awkward triangular frame of the pediment. Its bottom line is the horizon line, and charioteers and their horses move through it effortlessly. The individual figures, even the animals, are brilliantly characterized. The horses of the Sun, at the beginning of the day, are energetic. Those of the Moon or Night, having labored until dawn, are weary. The reclining figures fill the space beneath the raking cornice beautifully. Dionysos/Herakles and Aphrodite in the lap of her mother Dione are monumental Olympian presences yet totally relaxed organic forms. The sculptors fully understood not only the surface appearance of human anatomy, both male and female, but also the mechanics of how muscles and bones make the body move. The Phidian school also mastered the rendition of clothed forms. In the Dione-Aphrodite group, the thin and heavy folds of the garments alternately reveal and conceal the main and lesser body masses while swirling in a compositional tide that subtly unifies the two figures. The articulation and integration of the bodies produce a wonderful variation of surface and play of light and shade.

5-48 Helios and his horses, and Dionysos (Herakles?), from the east pediment of the Parthenon, Acropolis, Athens, Greece, ca. 438–432 BCE. Marble, greatest height 4′3″. British Museum, London.

The east pediment of the Parthenon depicts the birth of Athena. At the left, the horses of Helios (the Sun) emerge from the pediment's floor, suggesting the sun rising above the horizon at dawn.

5-49 Three goddesses (Hestia, Dione, and Aphrodite?), from the east pediment of the Parthenon, Acropolis, Athens, Greece, ca. 438–432 BCE. Marble, greatest height 4' 5". British Museum, London.

The statues of Hestia, Dione, and Aphrodite conform perfectly to the sloping right side of the east pediment. The thin and heavy folds of the garments alternately reveal and conceal the body forms.

PARTHENON: IONIC FRIEZE In many ways the most remarkable part of the Parthenon's sculptural program is the inner Ionic frieze (FIG. **5-50**). Scholars still debate its subject, but most agree that it represents the Panathenaic Festival procession that took place every four years in Athens. If this identification is correct, the Athenians judged themselves fit for inclusion in the temple's sculptural decoration. It is another example of the extraordinarily high opinion the Athenians had of their own worth.

The procession began at the Dipylon Gate, passed through the agora (central square), and ended on the Acropolis, where the Atheni-

ans placed a new peplos on an ancient wooden statue of Athena. That statue (probably similar in general appearance to the *Lady of Auxerre*, FIG. 5-7) was housed in the Archaic temple the Persians razed in 480 BCE. The statue had been removed from the Acropolis before the Persian attack for security reasons, and eventually it was installed in the Erechtheion (FIG. 5-53, no. 1). On the Parthenon frieze the procession begins on the west, that is, at the temple's rear, the side facing the gateway to the Acropolis. It then proceeds in parallel lines down the long north and south sides of the building and ends at the center of the east frieze, over the doorway to the cella housing Phidias's statue of Athena. It is noteworthy that the upper part of the frieze is in higher relief than the lower part so that the more distant and more shaded upper zone is as legible from the ground as the lower part of the frieze. This is another instance of the architects' taking optical effects into consideration.

The frieze vividly communicates the procession's acceleration and deceleration. At the outset, on the west side, marshals gather and youths mount their horses. On the north (FIG. 5-50, *top*) and south, the momentum picks up as the cavalcade moves from

5-50 Details of the Panathenaic Festival procession frieze, from the Parthenon, Acropolis, Athens, Greece, ca. 447–438 BCE. Marble, 3′ 6″ high. Horsemen of north frieze (top), British Museum, London; seated gods and goddesses (Poseidon, Apollo, and Artemis) of east frieze (center), Acropolis Museum, Athens; and elders and maidens of east frieze (bottom), Louvre, Paris.

The Parthenon's Ionic frieze represents the procession of citizens on horseback and on foot that took place every four years under the watchful eyes of the gods. The temple celebrated the Athenians as much as Athena.

the lower town to the Acropolis, accompanied by chariots, musicians, jar carriers, and animals destined for sacrifice. On the east, seated gods and goddesses (FIG. 5-50, center), the invited guests, watch the procession slow almost to a halt (FIG. 5-50, bottom) as it nears its goal at the shrine of Athena's ancient wooden idol. Most remarkable of all is the role assigned to the Olympian deities. They do not take part in the festival or determine its outcome but are merely spectators. Aphrodite, in fact, extends her left arm to draw her son Eros's attention to the Athenians, just as today a parent at a parade would point out important people to a child. And the Athenian people were important—

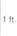

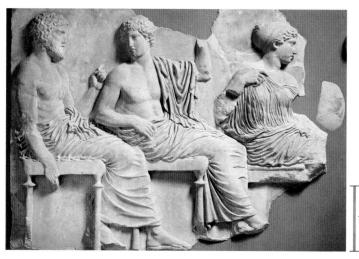

l ft.

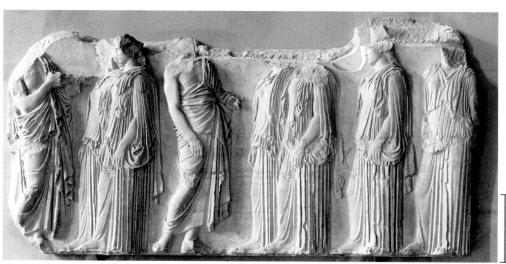

1 ft

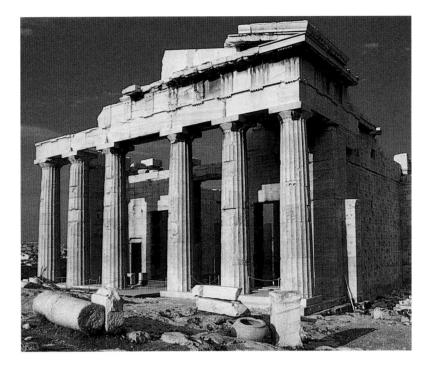

self-important, some might say. They were the masters of an empire, and in Pericles' famous funeral oration he painted a picture of Athens that elevated its citizens almost to the stature of gods. The Parthenon celebrated the greatness of Athens and the Athenians as much as it honored Athena.

PROPYLAIA Even before all the sculpture was in place on the Parthenon, work began on a new monumental entrance to the Acropolis, the Propylaia (FIG. 5-51). The architect entrusted with this important commission was MNESIKLES. The site was a difficult one, on a steep slope, but Mnesikles succeeded in disguising the change in ground level by splitting the building into eastern and

5-51 MNESIKLES, Propylaia (looking southwest), Acropolis, Athens, Greece, 437–432 BCE.

Mnesikles disguised the change of ground level by splitting the Propylaia into eastern and western sections. Each facade resembles a Doric temple but with a wider space between the central columns.

western sections (FIG. 5-43, no. 2), each one resembling a Doric temple facade. Practical considerations dictated that the space between the central pair of columns on each side be enlarged. This was the path the chariots and animals of the Panathenaic Festival procession took, and they required a wide ramped causeway. To either side of the central ramp were stairs for pedestrian traffic. Inside, tall, slender Ionic columns supported the split-level roof. Once again an Athenian architect mixed the two orders on the Acropolis. But as with the Parthenon, he used the Doric order for the stately exterior and the Ionic only for the interior.

Mnesikles' full plan for the Propylaia was never executed because of a change in the fortunes of Athens after the outbreak of the Peloponnesian War in 431 BCE. Of the side wings that were part of the original project, only the northwest one (FIG. 5-43, no. 3) was completed. That wing

is of special importance in the history of art. In Roman times it housed a *pinakotheke* (picture gallery). In it were displayed paintings on wooden panels by some of the major artists of the fifth century BCE. It is uncertain whether this was the wing's original function. If it was, the Propylaia's pinakotheke is the first recorded structure built for the specific purpose of displaying paintings, and it is the forerunner of modern museums.

ERECHTHEION In 421 BCE work finally began on the temple that was to replace the Archaic Athena temple the Persians had destroyed. The new structure, the Erechtheion (FIGS. **5-52** and

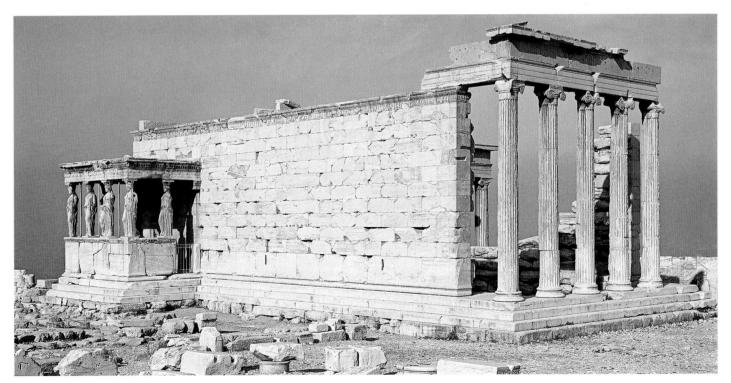

5-52 Erechtheion (looking northwest), Acropolis, Athens, Greece, ca. 421–405 BCE.

The Erechtheion is in many ways the antithesis of the Doric Parthenon directly across from it. An Ionic temple, it has some of the finest decorative details of any ancient Greek building.

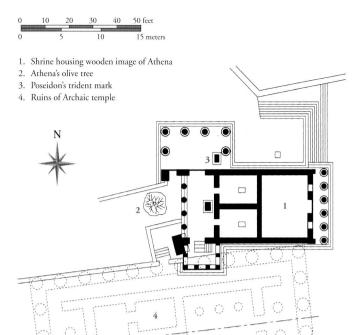

5-53 Plan of the Erechtheion, Acropolis, Athens, Greece, ca. 421–405 BCE.

The asymmetrical form of the Erechtheion is unique for a Greek temple. It reflects the need to incorporate preexisting shrines into the plan, including those of the kings Erechtheus and Kekrops.

5-53), built to the north of the old temple's remains, was, however, to be a multiple shrine. It honored Athena and housed the ancient wooden image of the goddess that was the goal of the Panathenaic Festival procession. But it also incorporated shrines to a host of other gods and demigods who loomed large in the city's legendary past. Among these were Erechtheus, an early king of Athens, during whose reign the ancient wooden idol of Athena was said to have fallen from the heavens, and Kekrops, another king of Athens, who served as judge of the contest between Athena and Poseidon. In fact, the site chosen for the new temple was the very spot where that contest occurred. Poseidon had staked his claim to Athens by striking the Acropolis rock with his trident and producing a salt-water spring. The imprint of his trident remained for Athenians of the historical period to see. Nearby, Athena had miraculously caused an olive tree to grow. This tree still stood as a constant reminder of her victory over Poseidon.

The asymmetrical plan (FIG. 5-53) of the Ionic Erechtheion is unique for a Greek temple and the antithesis of the simple and harmoniously balanced plan of the Doric Parthenon across the way. Its irregular form reflected the need to incorporate the tomb of Kekrops and other preexisting shrines, the trident mark, and the olive tree into a single complex. The unknown architect responsible for the building also had to struggle with the problem of uneven terrain. The area could not be made level by terracing because that would disturb the ancient sacred sites. As a result, the Erechtheion has four sides of very different character, and each side rests on a different ground level.

Perhaps to compensate for the awkward character of the building as a whole, the architect took great care with the Erechtheion's decorative details. The frieze, for example, was given special treat-

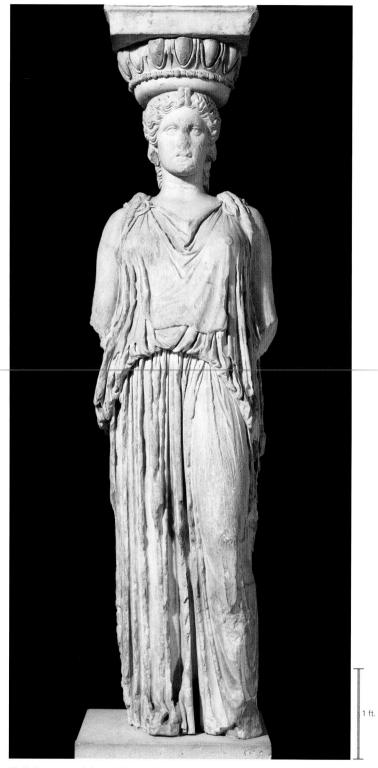

5-54 Caryatid from the south porch of the Erechtheion, Acropolis, Athens, Greece, ca. 421–405 BCE. Marble, 7' 7" high. British Museum, London.

The south porch of the Erechtheion features caryatids, updated Classical versions with contrapposto stances of the Archaic caryatids of the porch of the Siphnian Treasury (FIG. 5-18) at Delphi.

ment. The stone chosen was the dark-blue limestone of Eleusis to contrast with the white Pentelic marble of the walls and columns and the marble relief figures attached to the dark frieze. But the temple's most striking and famous feature is its south porch, where cary-

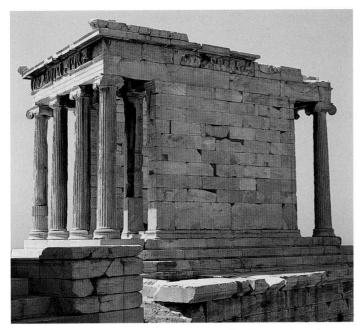

5-55 Kallikrates, Temple of Athena Nike (looking southwest), Acropolis, Athens, Greece, ca. 427–424 BCE.

The lonic temple at the entrance to the Acropolis is an unusual amphiprostyle building. It celebrated Athena as bringer of victory, and one of the friezes depicts the Persian defeat at Marathon.

atids (FIG. 5-54) replaced Ionic columns, as they did a century earlier on the Ionic Siphnian Treasury (FIG. 5-18) at Delphi. The Delphi caryatids resemble Archaic korai, and their Classical counterparts equally characteristically look like Phidian-era statues. Although they exhibit the weight shift that was standard for the fifth century BCE, the role of the caryatids as architectural supports for the unusual flat roof is underscored by the vertical flutelike drapery folds concealing their stiff, weight-bearing legs. The Classical architect-sculptor successfully balanced the dual and contradictory functions of these female statue-columns. The figures have enough rigidity to suggest the structural column and just the degree of flexibility needed to suggest the living body.

TEMPLE OF ATHENA NIKE Another Ionic building on the Athenian Acropolis is the little Temple of Athena Nike (FIG. 5-55), designed by Kallikrates, who worked with Iktinos on the Parthenon (and perhaps was responsible for the Ionic elements of that Doric temple). The temple is amphiprostyle with four columns on both the east and west facades. It stands on what used to be a Mycenaean bastion near the Propylaia and greets all visitors entering Athena's great sanctuary. As on the Parthenon, reference was made here to the victory over the Persians—and not just in the temple's name. Part of its frieze was devoted to a representation of the decisive battle at Marathon that turned the tide against the Persians—a human event, as in the Parthenon's Panathenaic Festival procession frieze. But now the sculptors chronicled a specific occasion, not a recurring event involving anonymous citizens.

Around the building, at the bastion's edge, was a *parapet* decorated with exquisite reliefs. The theme of the balustrade matched that of the temple proper—victory. Nike's image was repeated dozens of times, always in different attitudes, sometimes erecting trophies bedecked with Persian spoils and sometimes bringing for-

5-56 Nike adjusting her sandal, from the south side of the parapet of the Temple of Athena Nike, Acropolis, Athens, Greece, ca. 410 BCE. Marble, 3' 6'' high. Acropolis Museum, Athens.

The image of winged Victory was repeated dozens of times on the parapet around the Athena Nike temple. Here, the sculptor carved a figure whose garments appear almost transparent.

ward sacrificial bulls to Athena. One relief (FIG. 5-56) shows Nike adjusting her sandal—an awkward posture that the sculptor rendered elegant and graceful. Here, the artist carried the style of the Parthenon pediments (FIG. 5-49) even further and created a figure whose garments cling so tightly to the body that they seem almost transparent, as if drenched with water. The sculptor was, however, interested in much more than revealing the supple beauty of the young female body. The drapery folds form intricate linear patterns unrelated to the body's anatomical structure and have a life of their own as abstract designs.

HEGESO STELE Although the decoration of the great building projects on the Acropolis must have occupied most of the finest sculptors of Athens in the second half of the fifth century BCE, other

The Hegeso Stele

n Geometric times, huge painted vases (FIG. 5-2) marked the graves of wealthy Athenians. In the Archaic period, kouroi (FIGS. 5-8 and 5-10) and, to a lesser extent, korai were placed over Greek burials, as were grave stelae ornamented with relief depictions of the deceased. The grave stele (FIG. 5-57) of Hegeso is in this tradition. It was erected at the end of the fifth or beginning of the fourth century BCE to commemorate the death of Hegeso, daughter of Proxenos. Both names are inscribed on the cornice of the pediment that crowns the stele. Antae at left and right complete the architectural framework.

Hegeso is the well-dressed woman seated on an elegant chair (with footstool). She examines a piece of jewelry (once rendered in paint, not now visible) selected from a box a servant girl brings to her. The maid's simple unbelted chiton contrasts sharply with the more elaborate attire of her mistress. The garments of both women reveal the body forms beneath them. The faces are serene, without a trace of sadness. Indeed, both mistress and maid are shown in a characteristic shared moment out of daily life. Only the epitaph reveals that Hegeso is the one who has departed.

The simplicity of the scene on the Hegeso stele is deceptive, however. This is not merely a bittersweet scene of tranquil domestic life before an untimely death. The setting itself is significant—the secluded women's quarters of a Greek house, from which Hegeso rarely would have emerged. Contemporary grave stelae of men regularly show them in the public domain, as warriors. And the servant girl is not so much the faithful companion of the deceased in life as she is Hegeso's possession, like the jewelry box. The slave girl may look solicitously at her mistress, but Hegeso has eyes only for her ornaments. Both slave and jewelry attest to the wealth of Hegeso's father, unseen but prominently cited in the epitaph. (It is noteworthy that the mother's name is not mentioned.) Indeed, even the jewelry box carries a deeper significance, for it probably represents the dowry Proxenos would have provided to his daughter's husband when she left her father's home to enter her husband's home. In the patriarchal society of ancient Greece, the dominant position of men is manifest even when only women are depicted.

5-57 Grave stele of Hegeso, from the Dipylon cemetery, Athens, Greece, ca. 400 BCE. Marble, 5^{\prime} 2" high. National Archaeological Museum, Athens.

On her tombstone, Hegeso examines jewelry from a box her servant girl holds. Mistress and maid share a serene moment of daily life. Only the epitaph reveals that Hegeso is the one who died.

commissions were available in the city, notably in the Dipylon cemetery. There, around 400 BCE, a beautiful and touching grave stele (FIG. **5-57**) in the style of the Temple of Athena Nike parapet reliefs was set up in memory of a woman named Hegeso. Its subject—a young woman in her home, attended by her maid (see "The Hegeso Stele," above)—and its composition have close parallels in contemporary vase painting.

Painting

In the Classical period, some of the most renowned artists were the painters of monumental wooden panels displayed in public buildings, both secular and religious. Such works are by nature perishable, and all of the great panels of the masters are unfortunately lost. Nonetheless, one can get some idea of the polychrome nature of those panel paintings by studying Greek vases, especially those painted using the *white-ground* technique, which takes its name from the chalky-white clay slip used to provide a background for the painted figures. Experiments with white-ground painting date back to the Andokides Painter, but the method became popular only toward the middle of the fifth century BCE.

ACHILLES PAINTER One of the masters of white-ground painting was the so-called ACHILLES PAINTER, who decorated the lekythos (flask containing perfumed oil) in FIG. 5-58. White-ground is essentially a variation of the red-figure technique. First the painter covered the pot with a slip of very fine white clay, then applied black glaze to outline the figures and colored them with diluted brown, purple, red, and white. Other colors—for example, the yellow chosen for the garments of both figures on the Achilles Painter's lekythos—also could be employed, but these had to be applied after firing because the Greeks did not know how to make them withstand the heat of the kiln. Despite the obvious attractions of the technique, the impermanence of the expanded range of colors discouraged white-ground painting on everyday vessels, such as drinking cups and kraters. In fact, artists explored the full polychrome possibilities of the white-ground technique almost exclusively on lekythoi, which were commonly placed in Greek graves as offerings to the deceased. For vessels designed for short-term use, the fragile nature of white-ground painting was of little concern.

The Achilles Painter's lekythos is decorated with a scene appropriate for its funerary purpose. A youthful warrior takes leave of his

5-58 ACHILLES PAINTER, Warrior taking leave of his wife (Athenian white-ground lekythos), from Eretria, Greece, ca. 440 BCE. 1′ 5″ high. National Archaeological Museum, Athens.

White-ground painters applied the colors after firing because most colored glazes could not withstand the kiln's heat. The Achilles Painter here displayed his mastery at drawing an eye in profile.

wife. The red scarf, mirror, and jug hanging on the wall behind the woman indicate that the setting is the interior of their home. The motif of the seated woman is strikingly similar to that of Hegeso on her grave stele (FIG. 5-57), but here the woman is the survivor. It is her husband, preparing to go to war with helmet, shield, and spear, who will depart, never to return. On his shield is a large painted eye, roughly life-size. Greek shields often were decorated with devices such as the horrific face of snake-haired Medusa, intended to ward off evil spirits and frighten the enemy. This eye undoubtedly was meant to recall this tradition, but it was little more than an excuse for the Achilles Painter to display superior drawing skills. Since the

5-59 NIOBID PAINTER, Artemis and Apollo slaying the children of Niobe (Athenian red-figure calyx krater), from Orvieto, Italy, ca. 450 BCE. 1' 9" high. Louvre, Paris.

The placement of figures on different levels in a landscape on this red-figure krater depicting the massacre of Niobe's children reflects the compositions of the lost panel paintings of Polygnotos of Thasos.

late sixth century BCE, Greek painters had abandoned the Archaic habit of placing frontal eyes on profile faces and attempted to render the eyes in profile. The Achilles Painter's mastery of this difficult problem in foreshortening is on exhibit here.

POLYGNOTOS The leading painter of the first half of the fifth century BCE was Polygnotos of Thasos, whose works adorned important buildings both in Athens and Delphi. One of these was the pinakotheke of Mnesikles' Propylaia, but the most famous was a portico in the Athenian marketplace that came to be called the Stoa Poikile (Painted Stoa). Descriptions of Polygnotos's paintings make clear that he introduced a revolutionary compositional style. Before Polygnotos, figures stood on a common ground line at the bottom of the picture plane, whether they appeared in horizontal bands or single panels. Polygnotos placed his figures on different levels, staggered in tiers in the manner of Ashurbanipal's lion-hunt relief (FIG. 2-23) of two centuries before. He also incorporated landscape elements into his paintings, making his pictures true "windows onto the world" and not simply surface designs peopled with foreshortened figures. Polygnotos's abandonment of a single ground line was as momentous a break from the past as Early Classical Greek sculptors' rejection of frontality in statuary.

NIOBID PAINTER Polygnotos's influence is evident on a redfigure krater (FIG. **5-59**) painted around the middle of the fifth century BCE by the NIOBID PAINTER—so named because one side of the krater depicts the massacre of the Niobids, the children of Niobe. Niobe, who had at least a dozen children, had boasted that she was superior to the goddess Leto, who had only two offspring, Apollo

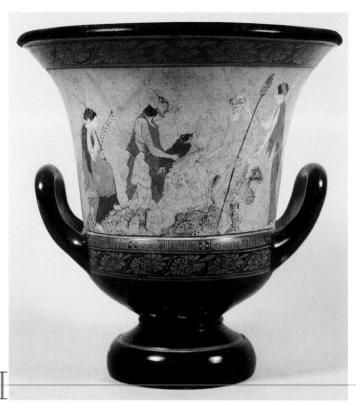

5-60 Phiale Painter, Hermes bringing the infant Dionysos to Papposilenos (Athenian white-ground calyx krater), from Vulci, Italy, ca. 440–435 BCE. 1' 2" high. Musei Vaticani, Rome.

In the Phiale Painter's white-ground representation of Hermes and the infant Dionysos at Nysa, the use of diluted brown to color and shade the rocks may also reflect the work of Polygnotos.

and Artemis. To punish Niobe's *hubris* (arrogance) and teach the lesson that no mortal could be superior to a god or goddess, Leto sent her two children to slay all of Niobe's many sons and daughters. On the Niobid Painter's krater, the horrible slaughter occurs in a schematic landscape setting of rocks and trees. The figures are disposed on several levels, and they actively interact with their setting. One slain son, for example, not only has fallen upon a rocky outcropping but is partially hidden by it. The Niobid Painter also drew the son's face in a three-quarter view, something that not even Euphronios and Euthymides had attempted.

PHIALE PAINTER Further insight into the appearance of monumental panel painting of the fifth century BCE comes from a whiteground krater (FIG. 5-60) by the so-called PHIALE PAINTER. The subject is Hermes handing over his half brother, the infant Dionysos, to Papposilenos ("grandpa-satyr"). The other figures represent the nymphs in the shady glens of Nysa, where Zeus had sent Dionysos, one of his numerous natural sons, to be raised, safe from the possible wrath of his wife Hera. Unlike the decorators of funerary lekythoi, the Phiale Painter used for this krater only colors that could survive the heat of a Greek kiln—reds, brown, purple, and a special snowy white reserved for the flesh of the nymphs and for such details as the hair, beard, and shaggy body of Papposilenos. The use of diluted brown wash to color and shade the rocks may reflect the coloration of Polygnotos's land-scapes. This vase and the Niobid krater together provide a shadowy idea of the character and magnificence of Polygnotos's great paintings.

TOMB OF THE DIVER, PAESTUM Although all of the panel paintings of the masters disappeared long ago, some Greek mural paintings are preserved today. An early example is in the so-called Tomb of the Diver at Paestum. The four walls of this small, coffinlike tomb are decorated with banquet scenes such as appear

5-61 Youth diving, painted ceiling of the Tomb of the Diver, Paestum, Italy, ca. 480 BCE. 3' 4" high. Museo Archeologico Nazionale, Paestum.

This tomb in Italy is a rare example of Classical mural painting. The diving scene most likely symbolizes the deceased's plunge into the Underworld. The trees resemble those on the Niobid krater (FIG. 5-59).

regularly on Greek vases. On the tomb's ceiling (FIG. **5-61**), a youth dives from a stone platform into a body of water. The scene most likely symbolizes the plunge from this life into the next. Trees resembling those on the Niobid krater are included within the decorative frame.

LATE CLASSICAL PERIOD

The Peloponnesian War, which began in 431 BCE, ended in 404 BCE with the complete defeat of a plague-weakened Athens. The victor, Sparta, and then Thebes undertook the leadership of Greece, both unsuccessfully. In the middle of the fourth century BCE, a threat from without caused the rival Greek states to put aside their animosities and unite for their common defense, as they had earlier against the Persians. But at the battle of Chaeronea in 338 BCE, the Greek cities suffered a devastating loss and had to relinquish their independence to the Macedonian king, Philip II. Philip was assassinated in 336, and his son, Alexander III, better known simply as Alexander the Great, succeeded him. In the decade before his death in 323 BCE, Alexander led a powerful army on an extraordinary campaign that overthrew the Persian Empire (the ultimate revenge for the Persian invasion of Greece in the early fifth century BCE), wrested control of Egypt, and even reached India (see Chapter 6).

Sculpture

The fourth century BCE was thus a time of political upheaval in Greece, and the chaos had a profound impact on the psyche of the Greeks and on the art they produced. In the fifth century BCE, Greeks had generally believed that rational human beings could impose order on their environment, create "perfect" statues such as the *Canon* of Polykleitos, and discover the "correct" mathematical formulas for constructing temples such as the Parthenon. The Parthenon frieze celebrated the Athenians as a community of citizens with shared values. The Peloponnesian War and the unceasing strife of the fourth century BCE brought an end to the serene idealism of the previous century. Disillusionment and alienation followed. Greek thought and Greek art began to focus more on the individual and on the real world of appearances rather than on the community and the ideal world of perfect beings and perfect buildings.

PRAXITELES The new approach to art is immediately apparent in the work of Praxiteles, one of the great masters of the fourth century BCE. Praxiteles did not reject the themes favored by the sculptors of the High Classical period. His Olympian gods and goddesses retained their superhuman beauty, but in his hands they lost some of their solemn grandeur and took on a worldly sensuousness. Nowhere is this new humanizing spirit plainer than in the statue of Aphrodite (FIG. **5-62**) that Praxiteles sold to the Knidians after another city had rejected it. The lost original, carved from Parian marble, is known only through copies of Roman date, but Pliny considered it "superior to all the works, not only of Praxiteles, but indeed in the whole world." It made Knidos famous, and many people sailed there just to see the statue in its round temple (compare FIG. **5-72**), where "it was possible to view the image of the goddess from every side." According to Pliny, some visitors were "overcome with love for the statue." "

The Aphrodite of Knidos caused such a sensation in its time because Praxiteles took the unprecedented step of representing the goddess of love completely nude. Female nudity was rare in earlier Greek art and had been confined almost exclusively to paintings on vases designed for household use. The women so depicted also tended to be courtesans or slave girls, not noblewomen or goddesses, and no one had dared place a statue of an unclothed goddess in a

temple. Moreover, Praxiteles' Aphrodite is not a cold and remote image. In fact, the goddess engages in a trivial act out of everyday life. She has removed her garment, draped it over a large *hydria* (water pitcher), and is about to step into the bath.

Although shocking in its day, the *Aphrodite of Knidos* is not openly erotic (the goddess modestly shields her pelvis with her right hand), but she is quite sensuous. Lucian wrote in the second century CE that she had a "welcoming look" and a "slight smile" and that Praxiteles was renowned for his ability to transform marble into soft and radiant flesh. Lucian mentioned, for example, the "dewy quality of Aphrodite's eyes." Unfortunately, the rather mechanical Roman copies do not capture the quality of Praxiteles' modeling of the stone.

Those qualities are evident, however, in a statue once thought to be by the hand of the master himself but now generally considered either a copy of the highest quality or an original work by a son or grandson of Praxiteles. Found in the Temple of Hera at Olympia, the

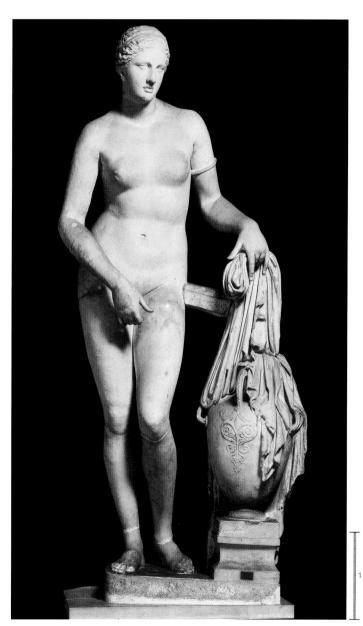

5-62 Praxiteles, *Aphrodite of Knidos*. Roman marble copy of an original of ca. 350–340 BCE, 6′ 8″ high. Musei Vaticani, Rome.

The first nude statue of a goddess caused a sensation in the fourth century BCE. But Praxiteles was also famous for his ability to transform marble into soft and radiant flesh. His Aphrodite had "dewy eyes."

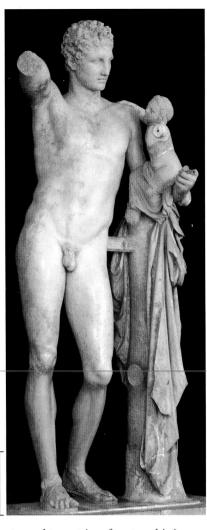

5-63 Praxiteles(?), Hermes and the infant Dionysos, from the Temple of Hera, Olympia, Greece. Copy of a statue by Praxiteles of ca. 340 BCE or an original work of ca. 330–270 BCE by a son or grandson. Marble, 7' 1" high. Archaeological Museum, Olympia.

Praxiteles humanized the Olympian deities. This Hermes is as sensuous as the sculptor's Aphrodite. The god gazes dreamily into space while he dangles grapes as temptation for the infant god of wine.

followers. But other sculptors pursued very different interests. One of these was Skopas of Paros, and although his work reflects the general trend toward the humanization of the Greek gods and heroes, his hallmark was intense emotionalism. None of Skopas's statues survives, but a grave stele (FIG. 5-64) found near the Ilissos River in Athens exhibits the psychological tension for which the master's works were famous. The stele was originally set into an architectural frame similar to that of the earlier Hegeso stele (FIG. 5-57). A comparison between the two works is very telling. In the Ilissos stele, the relief is much higher, with parts of the figures carved fully in the round. But the major difference is the pronounced change in mood, which reflects the innovations of Skopas. The later work makes a clear distinction between the living and the dead, and depicts overt mourning. The deceased is a young hunter who has the large, deeply set eyes and fleshy overhanging brows that characterized Skopas's sculpted figures. At his feet a small boy, either his servant or perhaps a younger brother, sobs openly. The hunter's dog also droops its head in sorrow. Beside the youth, an old man, undoubtedly his father, leans on a walking stick and, in a gesture reminiscent of that of the Olympia seer (FIG. 5-32), ponders the irony of fate that has taken the life of his powerful son and preserved him in

statue of Hermes and the infant Dionysos (FIG. **5-63**) brings to the realm of monumental statuary the theme the Phiale Painter had chosen for a white-ground krater (FIG. **5-60**) a century earlier. Hermes has

stopped to rest in a forest on his journey to Nysa to entrust the upbringing of Dionysos to Papposilenos and the nymphs. Hermes leans on a tree trunk (here it is an integral part of the composition and not a copyist's addition), and his slender body forms a sinuous, shallow S-curve that is the hallmark of many of Praxiteles' statues. He looks off dreamily into space while he dangles a bunch of grapes (now missing) as a temptation for the infant, who is to become the Greek god of the vine. This is the kind of tender and very human interaction between an adult and a child that is common in real life but that had been absent from Greek statuary before the fourth century BCE.

The quality of the carving is superb. The modeling is deliberately smooth and subtle, producing soft shadows that follow the planes as they flow almost imperceptibly one into another. The delicacy of the marble facial features stands in sharp contrast to the metallic precision of Polykleitos's bronze *Doryphoros* (FIG. 5-40). Even the *Spear Bearer*'s locks of hair were subjected to the fifth-century sculptor's laws of symmetry and do not violate the skull's perfect curve. A comparison of these two statues reveals how broad was the change in artistic attitude and intent from the fifth to the fourth century BCE. In the statues of Praxiteles, the deities of Mount Olympus still possess a beauty mortals can aspire to, although not achieve, but they are no longer remote. Praxiteles' gods have stepped off their fifth-century pedestals and entered the fourth-century BCE world of human experience.

SKOPAS In the Archaic period and throughout most of the Early and High Classical periods, Greek sculptors generally shared common goals, but in the Late Classical period of the fourth century BCE, distinctive individual styles emerged. The dreamy, beautiful divinities of Praxiteles had enormous appeal, and the master had many

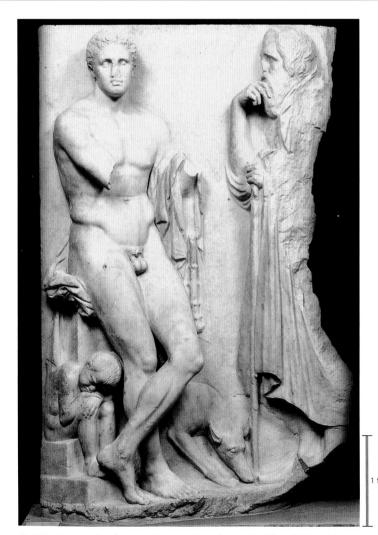

5-64 Grave stele of a young hunter, found near the Ilissos River, Athens, Greece, ca. 340–330 все. Marble, 5′ 6″ high. National Archaeological Museum, Athens.

The emotional intensity of this stele representing an old man mourning the loss of his son and the figures' large, deeply set eyes with fleshy overhanging brows reflect the style of Skopas of Paros.

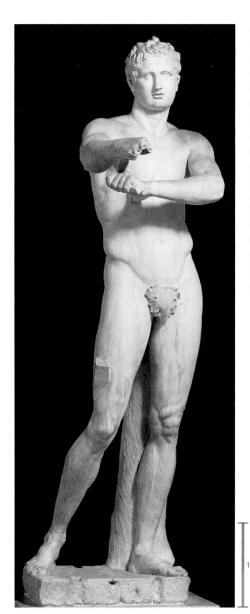

5-65 Lysippos, Apoxyomenos (Scraper). Roman marble copy of a bronze original of ca. 330 BCE, 6′ 9″ high. Musei Vaticani, Rome.

Lysippos introduced a new canon of proportions and a nervous energy to his statues. He also broke down the dominance of the frontal view and encouraged viewing his statues from multiple angles.

scrape his left arm. At the same time, he will shift his weight and reverse the positions of his legs. Lysippos also began to break down the dominance of the frontal view in statuary and encouraged the observer to look at his athlete from multiple angles. Because Lysippos represented the athlete with his right arm boldly thrust forward, the figure breaks out of the shallow rectangular box that defined the boundaries of earlier statues. To comprehend the action, the observer must move to the side and view Lysippos's work at a three-quarter angle or in full profile.

To grasp the full meaning of another work of Lysippos, a colossal statue (FIG. **5-66**) depicting a weary Herakles, the viewer must walk around it. Once again, the original is lost. The most impressive of the surviving marble copies is nearly twice life-size and was exhibited in the Baths of Caracalla in Rome. Like the marble copy of Polykleitos's *Doryphoros* (FIG. **5-40**) from the Roman palaestra at

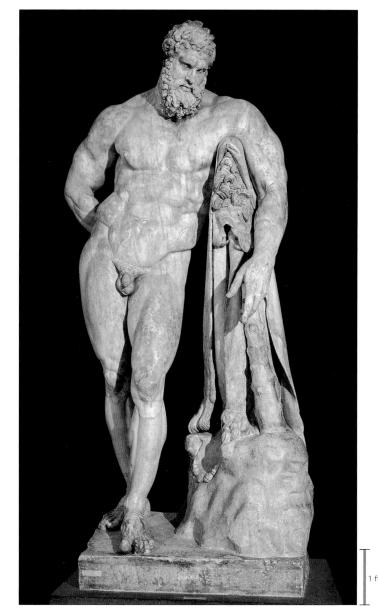

5-66 Lysippos, Weary Herakles (*Farnese Herakles*). Roman marble copy from Rome, Italy, signed by Glykon of Athens, of a bronze original of ca. 320 BCE, 10' 5" high. Museo Archeologico Nazionale, Naples.

Lysippos's portrayal of Herakles after the hero obtained the golden apples of the Hesperides ironically shows the mythological strong man as so weary that he must lean on his club for support.

his frail old age. Most remarkable of all, the hunter himself looks out at the viewer, inviting sympathy and creating an emotional bridge between the spectator and the artwork inconceivable in the art of the High Classical period.

LYSIPPOS The third great Late Classical sculptor, LYSIPPOS OF Sikyon, won such renown that Alexander the Great selected him to create his official portrait. (Alexander could afford to employ the best. The Macedonian kingdom enjoyed vast wealth. King Philip hired the leading thinker of his age, Aristotle, as the young Alexander's tutor.) Lysippos introduced a new canon of proportions in which the bodies were more slender than those of Polykleitos whose own canon continued to exert enormous influence—and the heads roughly one-eighth the height of the body rather than oneseventh, as in the previous century. The new proportions are apparent in one of Lysippos's most famous works, a bronze statue of an apoxyomenos (an athlete scraping oil from his body after exercising), known, as usual, only from Roman copies in marble (FIG. 5-65). A comparison with Polykleitos's Doryphoros (FIG. 5-40) reveals more than a change in physique. A nervous energy, lacking in the balanced form of the *Doryphoros*, runs through Lysippos's *Apoxyomenos*. The strigil (scraper) is about to reach the end of the right arm, and at any moment the athlete will switch it to the other hand so that he can Pompeii, Lysippos's muscle-bound Greek hero provided inspiration for Romans who came to the baths to exercise. (The copyist, GLYKON OF ATHENS, signed the statue. Lysippos's name is not mentioned, but the educated Roman public did not need a label to identify the famous work.) In the hands of Lysippos, however, the exaggerated muscular development of Herakles is poignantly ironic, for the sculptor depicted the strong man as so weary that he must lean on his club for support. Without that prop, Herakles would topple over. Lysippos and other fourth-century BCE artists rejected stability and balance as worthy goals for statuary.

Herakles holds the golden apples of the Hesperides in his right hand behind his back—unseen unless the viewer walks around the statue. Lysippos's subject is thus the same as that of the metope (FIG. 5-33) of the Early Classical Temple of Zeus at Olympia, but the fourth-century BCE Herakles is no longer serene. Instead of expressing joy, or at least satisfaction, at having completed one of the impossible 12 labors, he is almost dejected. Exhausted by his physical efforts, he can think only of his pain and weariness, not of the reward of immortality that awaits him. Lysippos's portrayal of Herakles in this statue is an eloquent testimony to Late Classical sculptors' interest in humanizing the great gods and heroes of the Greeks. In this respect, despite their divergent styles, Praxiteles, Skopas, and Lysippos followed a common path.

Alexander the Great and Macedonian Court Art

Alexander the Great's favorite book was the *Iliad*, and his own life was very much like an epic saga, full of heroic battles, exotic places, and unceasing drama. Alexander was a man of singular character, an inspired leader with boundless energy and an almost foolhardy courage. He personally led his army into battle on the back of Bucephalus, the wild and mighty steed only he could tame and ride (FIG. 5-70).

ALEXANDER'S PORTRAITS Ancient sources reveal that Alexander believed only Lysippos had captured his essence in a portrait, and that is why only he was authorized to sculpt the king's image. Lysippos's most famous portrait of the Macedonian king was a full-length heroically nude bronze statue of Alexander holding a lance and turning his head toward the sky. Plutarch reported that an epigram inscribed on the base stated that the statue depicted Alexander gazing at Zeus and proclaiming, "I place the earth under my sway. You, O Zeus, keep Olympus." Plutarch further stated that the portrait had "leonine" hair and a "melting glance." The Lysippan original is lost, and because Alexander was portrayed so many times for centuries after his death, it is very difficult to determine which of the many surviving images is most faithful to the fourth-century BCE portrait. A leading candidate is a third-century BCE marble head (FIG. 5-67) from Pella, the capital of Macedonia and Alexander's birthplace. It has the sharp turn of the head and thick mane of hair that were key ingredients of Lysippos's portrait. The sculptor's treatment of the features also is consistent with the style of the later fourth century BCE. The deep-set eyes and parted lips recall the manner of Skopas, and the delicate handling of the flesh brings to mind the faces of Praxitelean statues. Although not a copy, this head very likely approximates the young king's official portrait and provides insight into Alexander's personality as well as the art of Lysippos.

PELLA MOSAICS Alexander's palace has not been excavated, but the sumptuousness of life at the Macedonian court is evident from the costly objects found in Macedonian graves and from the abundance of mosaics (see "Mosaics," Chapter 11, page 303)

5-67 Head of Alexander the Great, from Pella, Greece, third century BCE. Marble, 1' high. Archaeological Museum, Pella.

Lysippos was the official portrait sculptor of Alexander the Great. This third-century BCE sculpture has the sharp turn of the head and thick mane of hair of Lysippos's statue of Alexander with a lance.

5-68 GNOSIS, Stag hunt, from Pella, Greece, ca. 300 BCE. Pebble mosaic, figural panel 10′ 2″ high. Archaeological Museum, Pella.

The floor mosaics at the Macedonian capital of Pella are of the early type made with pebbles of various natural colors. This stag hunt by Gnosis bears the earliest known signature of a mosaicist.

uncovered at Pella in the homes of the wealthy. The Pella mosaics are *pebble mosaics*. The floors consist of small stones of various colors collected from beaches and riverbanks and set into a thick coat of cement. The finest pebble mosaic yet to come to light has a stag hunt (FIG. **5-68**) as its *emblema* (central framed panel), bordered in turn by an intricate floral pattern and a stylized wave motif (not shown in the illustration). The artist signed his work in the same manner as proud Greek vase painters and potters did: "Gnosis made it." This is the earliest mosaicist's signature known, and its prominence in the design undoubtedly attests to the artist's reputation. The house owner wanted guests to know that Gnosis himself, and not an imitator, created this floor.

The Pella stag hunt, with its light figures against a dark ground, has much in common with red-figure painting. In the pebble mosaic, however, thin strips of lead or terracotta define most of the contour lines and some of the interior details. Subtle gradations of yellow, brown, and red, as well as black, white, and gray pebbles suggest the interior volumes. The musculature of the hunters, and even their billowing cloaks and the animals' bodies, are modeled by shading. Such use of light and dark to suggest volume is rarely seen on Greek

painted vases, although examples do exist. Monumental painters, however, commonly used shading. The Greek term for shading was *skiagraphia* (literally, "shadow painting"), and it was said to have been invented by an Athenian painter of the fifth century BCE named Apollodoros. Gnosis's emblema, with its sparse landscape setting, probably reflects contemporaneous panel painting.

HADES AND PERSEPHONE Recent excavations at Vergina have provided valuable additional information about Macedonian art and about Greek mural painting. One of the most important finds is a painted tomb with a representation of Hades, lord of the Underworld, abducting Persephone, the daughter of Demeter, the goddess of grain. The mural (FIG. 5-69) is remarkable for its intense drama and for the painter's use of foreshortening and shading. Hades holds the terrified seminude Persephone in his left arm and steers his racing chariot with his right as Persephone's garments and hair blow in the wind. The artist depicted the heads of both figures and even the chariot's wheels in three-quarter views. The chariot, in fact, seems to be bursting into the viewer's space. Especially noteworthy is the way the painter used short dark brush strokes to

5-69 Hades abducting Persephone, detail of a wall painting in tomb 1, Vergina, Greece, mid-fourth century BCE. $3' 3\frac{1}{2}''$ high.

The intense drama, three-quarter views, and shading in this representation of the lord of the Underworld kidnapping Demeter's daughter are characteristics of mural painting at the time of Alexander.

5-70 Philoxenos of Eretria, *Battle of Issus*, ca. 310 BCE. Roman copy (*Alexander Mosaic*) from the House of the Faun, Pompeii, Italy, late second or early first century BCE. Tessera mosaic, 8′ 10″ × 16′ 9″. Museo Archeologico Nazionale, Naples.

Philoxenos's Battle of Issus (see also FIG. 5-1) was considered one of the greatest paintings of antiquity. In it he captured the psychological intensity of the confrontation between the two kings.

suggest shading on the under side of Hades' right arm, on Persephone's torso, and elsewhere. Although fragmentary, the Vergina mural is a precious document of the almost totally lost art of monumental painting in ancient Greece.

BATTLE OF ISSUS Further insight into developments in painting at the time of Alexander comes from a large mosaic that decorated the floor of one room of a lavishly appointed Roman house at Pompeii. In the Alexander Mosaic (FIG. 5-70), as it is usually called, the mosaicist employed tesserae (tiny stones or pieces of glass cut to the desired size and shape) instead of pebbles (see "Mosaics," Chapter 11, page 303). The subject is a great battle between the armies of Alexander the Great and the Persian king Darius III, probably the battle of Issus in southeastern Turkey, when Darius fled the battlefield in his chariot in humiliating defeat. The mosaic dates to the late second or early first century BCE. It is widely believed to be a reasonably faithful copy of Battle of Issus, a famous panel painting of ca. 310 BCE made by PHILOXENOS OF ERETRIA for King Cassander, one of Alexander's successors. Some scholars have proposed, however, that the mosaic is a copy of a painting by one of the few Greek female artists whose name is known, Helen of Egypt.

Battle of Issus is notable for the artist's technical mastery of problems that had long fascinated Greek painters. Even Euthymides would have marveled at the fourth-century BCE painter's depiction of the rearing horse (FIG. 5-1) seen in a three-quarter rear view below Darius. The subtle modulation of the horse's rump through shading in browns and yellows is much more accomplished than the comparable attempts at shading in the Pella mosaic (FIG. 5-68) or the Vergina mural (FIG. 5-69). Other details are even more impres-

sive. The Persian to the right of the rearing horse has fallen to the ground and raises, backward, a dropped Macedonian shield to protect himself from being trampled. Philoxenos recorded the reflection of the man's terrified face on the polished surface of the shield. Everywhere in the scene, men, animals, and weapons cast shadows on the ground. The interest of Greek painters in the reflection of insubstantial light on a shiny surface, and in the absence of light (shadows), was far removed from earlier painters' preoccupation with the clear presentation of weighty figures seen against a blank background. The Greek painter here truly opened a window into a world filled not only with figures, trees, and sky but also with light. This Classical Greek notion of what a painting should be characterizes most of the history of art in the Western world from the Renaissance on.

Most impressive about *Battle of Issus*, however, is the psychological intensity of the drama unfolding before the viewer's eyes. Alexander is on horseback leading his army into battle, recklessly one might say, without even a helmet to protect him. He drives his spear through one of Darius's trusted "Immortals," who were sworn to guard the king's life, while the Persian's horse collapses beneath him. The Macedonian king is only a few yards away from Darius, and Alexander directs his gaze at the Persian king, not at the man impaled on his now-useless spear. Darius has called for retreat. In fact, his charioteer is already whipping the horses and speeding the king to safety. Before he escapes, Darius looks back at Alexander and in a pathetic gesture reaches out toward his brash foe. But victory has slipped from his hands. Pliny said Philoxenos's painting of the battle between Alexander and Darius was "inferior to none." It is easy to see why he reached that conclusion.

5-71 POLYKLEITOS THE YOUNGER, Theater, Epidauros, Greece, ca. 350 BCE.

The Greeks always situated their theaters on hillsides, which supported the cavea of stone seats overlooking the circular orchestra. The Epidauros theater is the finest in Greece. It accommodated 12,000 spectators.

Architecture

In architecture, as in sculpture and painting, the Late Classical period was a time of innovation and experimentation.

THEATER OF EPIDAUROS In ancient Greece, plays were not performed repeatedly over months or years as they are today but only during sacred festivals. Greek drama was closely associated with religious rites and was not pure entertainment. At Athens in the fifth century BCE, for example, the great tragedies of Aeschylus, Sophocles, and Euripides were performed at the Dionysos festival in the theater dedicated to the god on the southern slope of the Acropolis. The finest theater in Greece, however, constructed shortly after Alexander the Great was born, is located at Epidauros in the Peloponnesos. The architect was Polykleitos the Younger, possibly a nephew of the great fifth-century sculptor. His theater (FIG. 5-71) is still used for performances of ancient Greek dramas.

The precursor of the formal Greek theater was a place where ancient rites, songs, and dances were performed. This circular piece of earth with a hard, level surface later became the orchestra of the theater. Orchestra literally means "dancing place." The actors and the chorus performed there, and at Epidauros an altar to Dionysos stood at the center of the circle. The spectators sat on a slope overlooking the orchestra—the theatron, or "place for seeing." When the Greek theater took architectural shape, the auditorium (cavea, Latin for "hollow place, cavity") was always situated on a hillside. The cavea at Epidauros, composed of wedge-shaped sections (cunei, singular cuneus) of stone benches separated by stairs, is somewhat greater than a semicircle in plan. The auditorium is 387 feet in diameter, and its 55 rows of seats accommodated about 12,000 spectators. They entered the theater via a passageway between the seating area and the scene building (skene), which housed dressing rooms for the actors and also formed a backdrop for the plays. The design is simple but perfectly suited to its function. Even in antiquity the Epidauros theater won renown for the harmony of its proportions. Although spectators sitting in some of the seats would have had a poor view of the skene, all had unobstructed views of the orchestra. Because of the open-air cavea's excellent acoustics, everyone could hear the actors and chorus.

CORINTHIAN CAPITALS The theater at Epidauros is situated some 500 yards southeast of the sanctuary of Asklepios, and Polykleitos the Younger worked there as well. He was the architect of the *tholos*, the circular shrine that probably housed the sacred snakes of the healing god. That building lies in ruins today, its architectural fragments removed to the local museum, but an approximate idea of its original appearance can be gleaned from the somewhat earlier and partially reconstructed tholos (FIG. **5-72**) at Delphi that Theodoros of Phokaia designed. Both tholoi had an exterior colonnade of Doric columns. Inside, however, the columns had

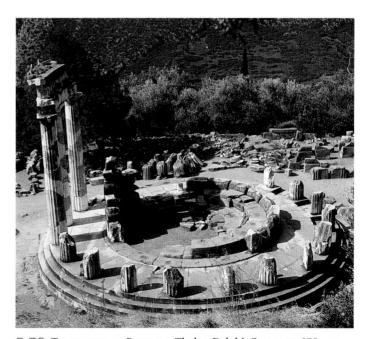

5-72 Theodoros of Phokaia, Tholos, Delphi, Greece, ca. 375 BCE.

Theodoros of Phokaia's tholos at Delphi, although in ruins, is the best-preserved example of a round temple of the Classical period. It had Doric columns on the exterior and Corinthian columns inside.

The Corinthian Capital

The Corinthian capital (FIG. 5-73) is more ornate than either the Doric or Ionic (FIG. 5-14). It consists of a double row of acanthus leaves, from which tendrils and flowers emerge, wrapped around a bell-shaped echinus. Although this capital often is cited as the distinguishing feature of the Corinthian order, in strict terms no such order exists. Architects simply substituted the new capital type for the volute capital in the Ionic order.

The sculptor Kallimachos invented the Corinthian capital during the second half of the fifth century BCE. Vitruvius recorded the circumstances that supposedly led to its creation:

A maiden who was a citizen of Corinth . . . died. After her funeral, her nurse collected the goblets in which the maiden had taken delight while she was alive, and after putting them together in a basket, she took them to the grave monument and put them on top of it. In order that they should remain in place for a long time, she covered them with a tile. Now it happened that this basket was placed over the root of an acanthus. As time went on the acanthus root, pressed down in the middle by the weight, sent forth, when it was about springtime, leaves and stalks; its stalks growing up along the sides of the basket and being pressed out from the angles because of the weight of the tile, were forced to form volute-like curves at their extremities. At this point, Kallimachos happened to be going by and noticed the basket with this gentle growth of leaves around it. Delighted with the order and the novelty of the form, he made columns using it as his model and established a canon of proportions for it.*

Kallimachos worked on the Acropolis in Pericles' great building program. Many scholars believe that a Corinthian column supported the outstretched right hand of Phidias's *Athena Parthenos* (FIG. **5-46**) because some of the Roman copies of the lost statue include a Corinthian column. In any case, the earliest preserved Corinthian capital dates to the time of Kallimachos. The new type was rarely used before the mid-fourth century BCE, however, and did not become popular until Hellenistic and especially Roman times. Later architects favored the Corinthian capital because of its ornate character and because it eliminated certain problems of both the Doric and Ionic orders.

The Ionic capital, unlike the Doric, has two distinct profiles the front and back (with the volutes) and the sides. The volutes always faced outward on a Greek temple, but architects met with a vexing problem at the corners of their buildings, which had two adjacent "fronts." They solved the problem by placing volutes on

*Vitruvius, *De architectura*, 4.1.8–10. Translated by J. J. Pollitt, *The Art of Ancient Greece: Sources and Documents* (New York: Cambridge University Press, 1990), 193–194.

both outer faces of the corner capitals (as on the Erechtheion, FIG. 5-52, and the Temple of Athena Nike, FIG. 5-55), but the solution was an awkward one.

Doric design rules also presented problems for Greek architects at the corners of buildings. The Doric frieze was organized according to three supposedly inflexible rules:

- A triglyph must be exactly over the center of each column.
- A triglyph must be over the center of each *intercolumniation* (the space between two columns).
- Triglyphs at the corners of the frieze must meet so that no space is left over.

These rules are contradictory, however. If the corner triglyphs must meet, then they cannot be placed over the center of the corner column (FIGS. 5-25, 5-30, and 5-44).

The Corinthian capital eliminated both problems. Because the capital's four sides have a similar appearance, corner Corinthian capitals do not have to be modified, as do corner Ionic capitals. And because the Ionic frieze is used for the Corinthian "order," architects do not have to contend with metopes or triglyphs.

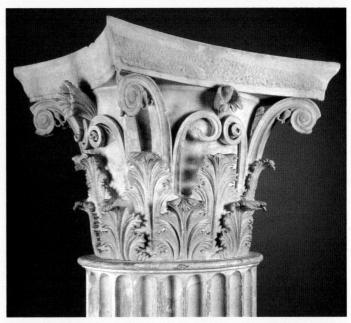

5-73 POLYKLEITOS THE YOUNGER, Corinthian capital, from the tholos, Epidauros, Greece, ca. 350 BCE. Archaeological Museum, Epidauros.

Corinthian capitals, invented in the fifth century BCE by the sculptor Kallimachos, are more ornate than Doric and Ionic capitals. They feature a double row of acanthus leaves with tendrils and flowers.

Corinthian capitals (FIG. **5-73**; see "The Corinthian Capital," above), an invention of the second half of the fifth century BCE.

Consistent with the extremely conservative nature of Greek temple design, architects did not readily embrace the Corinthian capital. Until the second century BCE, Corinthian capitals were employed, as at Delphi and Epidauros, only for the interiors of sacred buildings. The earliest instance of a Corinthian capital on the exterior of a Greek building is the Choragic Monument of Lysikrates

(FIG. **5-74**), which is not really a building at all. Lysikrates had sponsored a chorus in a theatrical contest in 334 BCE, and after he won, he erected a monument to commemorate his victory. The monument consists of a cylindrical drum resembling a tholos on a rectangular base. Engaged Corinthian columns adorn the drum of Lysikrates' monument, and a huge Corinthian capital sits atop the roof. The freestanding capital once supported the victor's trophy, a bronze *tripod* (a deep bowl on a tall three-legged stand).

5-74 Choragic Monument of Lysikrates, Athens, Greece, 334 BCE.

The first known instance of the use of the Corinthian capital on the exterior of a building is the monument Lysikrates erected in Athens to commemorate the victory his chorus won in a theatrical contest.

HELLENISTIC PERIOD

Alexander the Great's conquest of the Near East and Egypt (where the Macedonian king was buried) ushered in a new cultural age that historians and art historians alike call *Hellenistic*. The Hellenistic period opened with the death of Alexander in 323 BCE and lasted nearly three centuries, until the double suicide of Queen Cleopatra of Egypt and her Roman consort Mark Antony in 30 BCE after their

decisive defeat at the battle of Actium by Antony's rival Augustus. That year, Augustus made Egypt a province of the Roman Empire.

The cultural centers of the Hellenistic period were the court cities of the Greek kings who succeeded Alexander and divided his far-flung empire among themselves. Chief among them were Antioch in Syria, Alexandria in Egypt, and Pergamon in Asia Minor. An international culture united the Hellenistic world, and its language was Greek. Hellenistic kings became enormously rich on the spoils of the East, priding themselves on their libraries, art collections, scientific enterprises, and skills as critics and connoisseurs, as well as on the learned men they could assemble at their courts. The world of the small, austere, and heroic city-state passed away, as did the power and prestige of its center, Athens. A cosmopolitan ("citizen of the world," in Greek) civilization, much like today's, replaced it.

Architecture

The greater variety, complexity, and sophistication of Hellenistic culture called for an architecture on an imperial scale and of wide diversity, something far beyond the requirements of the Classical polis, even beyond that of Athens at the height of its power. Building activity shifted from the old centers on the Greek mainland to the opulent cities of the Hellenistic monarchs in the East.

TEMPLE OF APOLLO, DIDYMA Great scale, a theatrical element of surprise, and a willingness to break the rules of canonical temple design characterize one of the most ambitious temple projects of the Hellenistic period, the Temple of Apollo at Didyma. The Hellenistic temple was built to replace the Archaic temple at the site the Persians had burned down in 494 BCE when they sacked nearby Miletos. Construction began in 313 BCE according to the design of two architects who were natives of the area, PAIONIOS OF EPHESOS and DAPHNIS OF MILETOS. So vast was the undertaking, however, that work on the temple continued off and on for more than 500 years—and still the project was never completed.

The temple was dipteral in plan (FIG. **5-75**, *left*) and had an unusually broad facade of 10 huge Ionic columns almost 65 feet tall. The sides had 21 columns, consistent with the Classical formula for

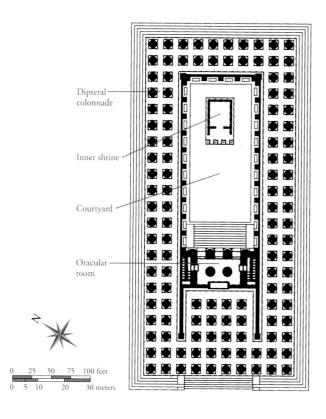

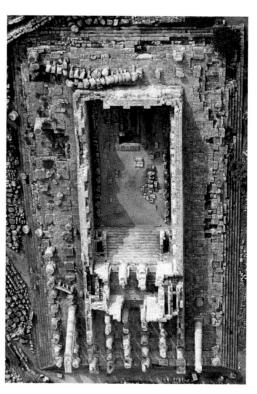

5-75 PAIONIOS OF EPHESOS and DAPHNIS OF MILETOS, Temple of Apollo, Didyma, Turkey, begun 313 BCE. Plan (*left*) and aerial view (*right*).

This unusual Hellenistic temple was hypaethral (open to the sky) and featured a double peripteral (dipteral) colonnade with a smaller temple inside the interior courtyard of the larger temple.

5-76 Restored view of the city of Priene, Turkey, fourth century BCE and later (John Burge).

Despite its irregular terrain, Priene had a strict grid plan conforming to the principles of Hippodamos of Miletos, whom Aristotle singled out as the father of rational city planning.

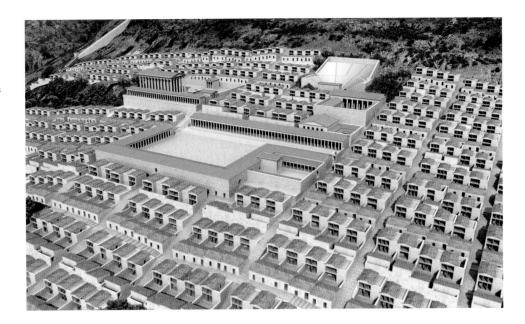

perfect proportions used for the Parthenon— $21 = (2 \times 10) + 1$ —but nothing else about the design is Classical. One anomaly immediately apparent to anyone who approached the building was that it had no pediment and no roof—it was hypaethral, or open to the sky. Also, the grand doorway to what should be the temple's cella was elevated nearly five feet off the ground so that it could not be entered. The explanation for these peculiarities is that the doorway served rather as a kind of stage where the oracle of Apollo could be announced to those assembled in front of the temple. The unroofed dipteral colonnade was really only an elaborate frame for a central courtyard (FIG. 5-75, right) with a small prostyle shrine containing a statue of Apollo. Entrance to the interior court was through two smaller doorways to the left and right of the great portal and down two narrow vaulted tunnels that could accommodate only a single file of people. From these dark and mysterious lateral passageways, worshipers emerged into the clear light of the courtyard, which also had a sacred spring and laurel trees in honor of Apollo. Opposite Apollo's inner temple, a stairway some 50 feet wide rose majestically toward three portals leading into the oracular room that also opened onto the front of the temple. This complex spatial planning marked a sharp departure from Classical Greek architecture, which stressed a building's exterior almost as a work of sculpture and left its interior relatively undeveloped.

HIPPODAMOS OF MILETOS When the Persians were finally expelled from Asia Minor in 479 BCE, the Greek cities there were in near ruin. Reconstruction of Miletos began after 466 BCE according to a plan laid out by Hippodamos of Miletos, whom Aristotle singled out as the father of rational city planning. Hippodamos imposed a strict grid plan on the site, regardless of the terrain, so that all streets met at right angles. Such orthogonal plans actually predate Hippodamos, not only in Archaic Greece and Etruscan Italy but also in the ancient Near East and Egypt. But Hippodamos was so famous that his name has ever since been synonymous with such urban plans. The so-called Hippodamian plan also designated separate quarters for public, private, and religious functions. A "Hippodamian city" was logically as well as regularly planned. This desire to impose order on nature and to assign a proper place in the whole to each of the city's constituent parts was very much in keeping with the philosophical tenets of the fifth century BCE. Hippodamos's formula for the ideal city was another manifestation of the same outlook that produced Polykleitos's Canon and Iktinos's Parthenon.

PRIENE Hippodamian planning was still the norm in Late Classical and Hellenistic Greece. The city of Priene (FIG. **5-76**), also in Asia Minor, was laid out during the fourth century BCE. It had fewer than 5,000 inhabitants (Hippodamos thought 10,000 was the ideal number). Situated on sloping ground, many of its narrow north-south streets were little more than long stairways. Uniformly sized city blocks, the standard planning unit, were nonetheless imposed on the irregular terrain. More than one unit was reserved for major structures such as the Temple of Athena and the theater. The central agora was allotted six blocks.

STOA OF ATTALOS, ATHENS Priene's agora was bordered by *stoas*. These covered colonnades, or *porticos*, which often housed shops and civic offices, were ideal vehicles for shaping urban spaces, and they were staples of Hellenistic cities. Even the agora of Athens, an ancient city notable for its haphazard, unplanned development, was eventually framed to the east and south by stoas placed at right angles to one another. These new porticos joined the famous Painted Stoa (see page 135), where the Hellenistic philosopher Zeno and his successors taught. The *Stoic* school of Greek philosophy took its name from that building.

The finest of the new Athenian stoas was the Stoa of Attalos II (FIG. 5-77), a gift to the city by a grateful alumnus, the king of Pergamon, who had studied at Athens in his youth. The stoa was meticulously reconstructed under the direction of the American School of Classical Studies at Athens and today has a second life as a museum housing more than seven decades of finds from the Athenian agora, as well as the offices of the American excavation team. The stoa has two stories, each with 21 shops opening onto the colonnade. The facade columns are Doric on the ground level and Ionic on the second story. The mixing of the two orders on a single facade had occurred even in the Late Classical period. But it became increasingly common in the Hellenistic period, when architects showed greatly diminished respect for the old rules of Greek architecture, and a desire for variety and decorative effects often prevailed. Practical considerations also governed the form of the Stoa of Attalos. The columns are far more widely spaced than in Greek temple architecture, to allow for easy access. And the builders left the lower third of every Doric column shaft unfluted to guard against damage from constant traffic.

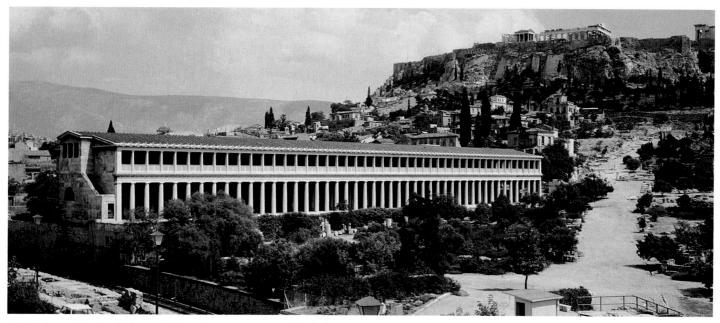

5-77 Stoa of Attalos II, Agora, Athens, Greece, ca. 150 BCE (with the Acropolis in the background).

The Stoa of Attalos II in the Athenian agora has been meticulously restored. Greek stoas were covered colonnades that housed shops and civic offices. They were also ideal vehicles for shaping urban spaces.

Pergamon

Pergamon, the kingdom of Attalos II (r. 159–138 BCE), was one of those born in the early third century BCE after the breakup of Alexander's empire. Founded by Philetairos, the Pergamene kingdom embraced almost all of western and southern Asia Minor. Upon the death in 133 BCE of its last king, Attalos III (r. 138–133 BCE), Pergamon was bequeathed to Rome, which by then was the greatest power in the Mediterranean world. The Attalids enjoyed immense wealth, and much of it was expended on embellishing their capital city, especially its acropolis. Located there were the royal palace, an arsenal and barracks, a great library and theater, an agora, and the sacred precincts of Athena and Zeus.

ALTAR OF ZEUS, PERGAMON The Altar of Zeus at Pergamon, erected about 175 BCE, is the most famous Hellenistic sculp-

tural ensemble. The monument's west front (FIG. 5-78) has been reconstructed in Berlin. The altar proper was on an elevated platform and framed by an Ionic stoalike colonnade with projecting wings on either side of a broad central staircase. All around the altar platform was a sculpted frieze almost 400 feet long, populated by about a hundred larger-than-life-size figures. The subject is the battle of Zeus and the gods against the giants. It is the most extensive representation Greek artists ever attempted of that epic conflict for control of the world. A similar subject appeared on the shield of Phidias's *Athena Parthenos* and on some of the Parthenon metopes, where the Athenians wished to draw a parallel between the defeat of the giants and the defeat of the Persians. In the third century BCE, King Attalos I (r. 241–197 BCE) had successfully turned back an invasion of the Gauls in Asia Minor. The gigantomachy of the Altar of Zeus alluded to that Pergamene victory over those barbarians.

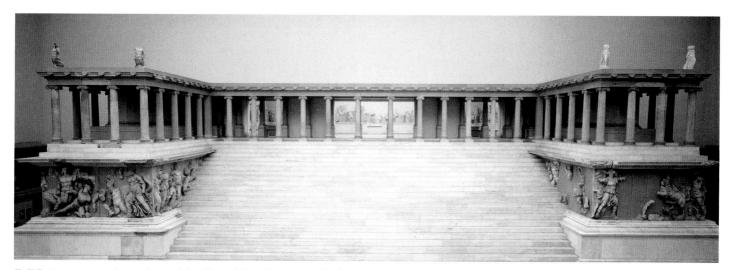

5-78 Reconstructed west front of the Altar of Zeus, Pergamon, Turkey, ca. 175 BCE. Staatliche Museen, Berlin.

The gigantomachy frieze of Pergamon's monumental Altar of Zeus is almost 400 feet long. The battle of gods and giants alluded to the victory of King Attalos I over the Gauls of Asia Minor.

5-79 Athena battling Alkyoneos, detail of the gigantomachy frieze, from the Altar of Zeus, Pergamon, Turkey, ca. 175 BCE. Marble, 7' 6" high. Staatliche Museen, Berlin.

The tumultuous battle scenes of the Pergamon altar have an emotional power unparalleled in earlier Greek art. Violent movement, swirling draperies, and vivid depictions of suffering fill the frieze.

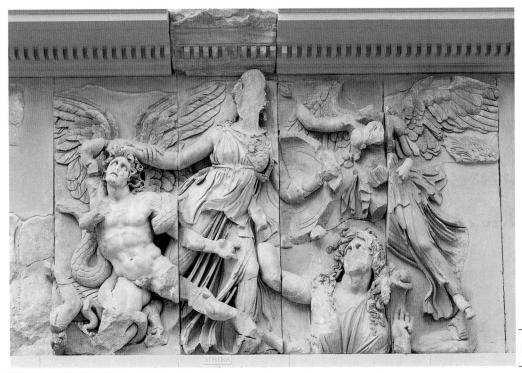

1 ft

A deliberate connection was also made with Athens, whose earlier defeat of the Persians was by then legendary, and with the Parthenon, which already was recognized as a Classical monument in both senses of the word. The figure of Athena (FIG. 5-79), for example, is a variation of the Athena from the Parthenon's east pediment. While Ge, the earth goddess and mother of all the giants, emerges from the ground and looks on with horror, Athena grabs the hair of the giant Alkyoneos as Nike flies in to crown her. Zeus himself (not illustrated) was based on the Poseidon of the west pediment. But the Pergamene frieze is not a dry series of borrowed motifs. On the contrary, its tumultuous narrative has an emotional intensity that has no parallel in earlier sculpture. The battle rages everywhere, even up and down the very steps one must ascend to reach Zeus's altar (FIG. 5-78). Violent movement, swirling draperies, and vivid depictions of death and suffering are the norm. Wounded figures writhe in pain, and their faces reveal their anguish. When Zeus hurls his thunderbolt, one can almost hear the thunderclap. Deep carving creates dark shadows. The figures project from the background like bursts of light. These features have been justly termed "baroque" and reappear in 17th-century European sculpture (see Chapter 24). One can hardly imagine a greater contrast than between the Pergamene gigantomachy frieze and that of the Archaic Siphnian Treasury (FIG. 5-19) at Delphi.

DYING GAULS On the Altar of Zeus, sculptors presented the victory of Attalos I over the Gauls in mythological disguise. An earlier Pergamene statuary group explicitly represented the defeat of the barbarians. Roman copies of some of these figures survive. The sculptor carefully studied and reproduced the distinctive features of the foreign Gauls, most notably their long, bushy hair and mustaches and the *torques* (neck bands) they frequently wore. The Pergamene victors were apparently not included in the group. The viewer saw only their foes and their noble and moving response to defeat.

In what was probably the centerpiece of the Attalid group, a heroic Gallic chieftain (FIG. 5-80) defiantly drives a sword into his own chest just below the collarbone, preferring suicide to surrender. He already has taken the life of his wife, who, if captured, would have been sold as a slave. In the best Lysippan tradition, the group can be fully appreci-

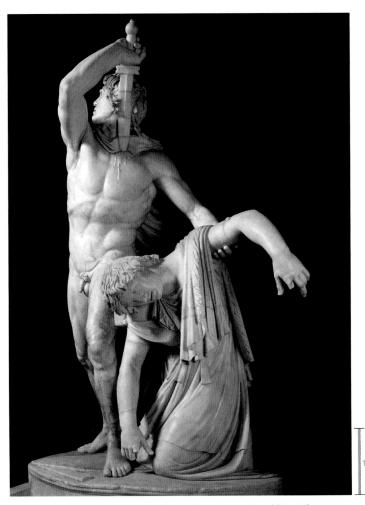

5-80 Epigonos(?), Gallic chieftain killing himself and his wife. Roman marble copy of a bronze original of ca. 230–220 BCE, 6′ 11″ high. Museo Nazionale Romano–Palazzo Altemps, Rome.

The defeat of the Gauls was also the subject of Pergamene statuary groups. The centerpiece of one group was a Gallic chieftain committing suicide after taking his wife's life. He preferred death to surrender.

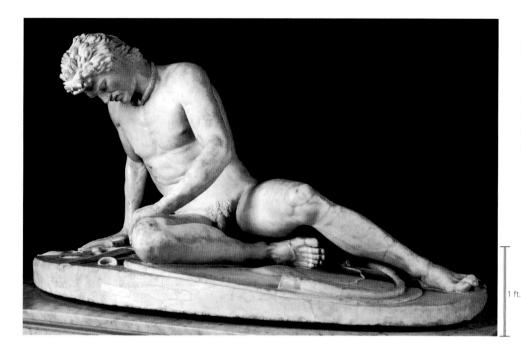

5-81 EPIGONOS(?), Dying Gaul. Roman marble copy of a bronze original of ca. 230–220 BCE, 3' ½" high. Museo Capitolino, Rome.

The Gauls in the Pergamene victory groups were shown as barbarians with bushy hair, mustaches, and neck bands, but they were also portrayed as noble foes who fought to the end.

ated only by walking around it. From one side, the observer sees the Gaul's intensely expressive face, from another his powerful torso, and from a third the woman's limp and almost lifeless body. The man's twisting posture, the almost theatrical gestures, and the emotional intensity of the suicidal act are hallmarks of the Pergamene baroque style and have close parallels in the later frieze of Zeus's altar.

The third Gaul from this group is a trumpeter (FIG. **5-81**) who collapses upon his large oval shield as blood pours from the gash in his chest. He stares at the ground with a pained expression. The Hellenistic figure recalls the dying warrior (FIG. **5-29**) from the east pediment of the Temple of Aphaia at Aegina, but the pathos and drama of the suffering Gaul are far more pronounced. As in the suicide group and the gigantomachy frieze, the sculptor rendered the male musculature in an exaggerated manner. Note the tautness of the chest and the bulging veins of the left leg—implying that the unseen Attalid hero who has struck down this noble and savage foe must have been an extraordinary warrior. If this figure is the *tubicen* (trumpeter) Pliny mentioned as the work of the Pergamene master Epigonos, then Epigonos may be the sculptor of the entire group and the creator of the dynamic Hellenistic baroque style.

Sculpture

In different ways, Praxiteles, Skopas, and Lysippos had already taken bold steps in redefining the nature of Greek statuary. But Hellenistic sculptors went still further, both in terms of style and in expanding the range of subjects considered suitable for monumental sculpture.

NIKE OF SAMOTHRACE One of the masterpieces of Hellenistic baroque sculpture was set up in the Sanctuary of the Great Gods on the island of Samothrace. The *Nike of Samothrace* (FIG. **5-82**) has just alighted on the prow of a Greek warship. Her missing right arm was once raised high to crown the naval victor, just as Nike placed a wreath on Athena on the Altar of Zeus (FIG. **5-79**). But the Pergamene

5-82 Nike alighting on a warship (*Nike of Samothrace*), from Samothrace, Greece, ca. 190 BCE. Marble, figure 8′ 1″ high. Louvre, Paris.

Victory has just landed on a prow to crown a victor at sea. Her wings still beat, and the wind sweeps her drapery. The placement of the statue in a fountain of splashing water heightened the dramatic visual effect.

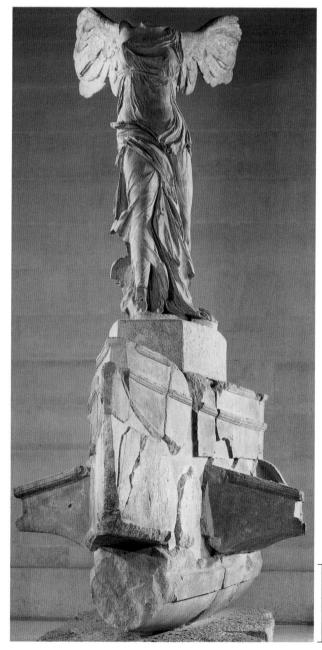

1 ft.

relief figure seems calm by comparison. The Samothracian Nike's wings still beat, and the wind sweeps her drapery. Her himation bunches in thick folds around her right leg, and her chiton is pulled tightly across her abdomen and left leg.

The statue's setting amplified its theatrical effect. The war galley was displayed in the upper basin of a two-tiered fountain. In the lower basin were large boulders. The fountain's flowing water created

5-83 Alexandros of Antioch-on-the-Meander, Aphrodite (Venus de Milo), from Melos, Greece, ca. 150–125 BCE. Marble, 6' 7'' high. Louvre, Paris.

Displaying the eroticism of many Hellenistic statues, this Aphrodite is more overtly sexual than the Knidian Aphrodite (FIG. 5-62). The goddess has a slipping garment to tease the spectator.

the illusion of rushing waves dashing up against the prow of the ship. The statue's reflection in the shimmering water below accentuated the sense of lightness and movement. The sound of splashing water added an aural dimension to the visual drama. Art and nature were here combined in one of the most successful sculptures ever fashioned. In the *Nike of Samothrace* and other works in the Hellenistic baroque manner, sculptors resoundingly rejected the Polykleitan conception of a statue as an ideally proportioned, self-contained entity on a bare pedestal. The Hellenistic statues interact with their environment and appear as living, breathing, and intensely emotive human (or divine) presences.

VENUS DE MILO In the Hellenistic period, sculptors regularly followed Praxiteles' lead in undressing Aphrodite, but they also openly explored the eroticism of the nude female form. The famous *Venus de Milo* (FIG. **5-83**) is a larger-than-life-size marble statue of Aphrodite found on Melos together with its inscribed base (now lost) signed by the sculptor, Alexandros of Antioch-on-the-Meander. In this statue, the goddess of love is more modestly draped than the *Aphrodite of Knidos* (FIG. **5-62**) but is more overtly sexual. Her left hand (separately preserved) holds the apple Paris awarded her when he judged her the most beautiful goddess of all. Her right hand may have lightly grasped the edge of her drapery near the left hip in a half-hearted attempt to keep it from slipping farther down her body. The

5-84 Sleeping satyr (*Barberini Faun*), from Rome, Italy, ca. 230–200 BCE. Marble, 7' 1" high. Glyptothek, Munich.

In this statue of a restlessly sleeping, drunken satyr, a Hellenistic sculptor portrayed a semihuman in a suspended state of consciousness—the antithesis of the Classical ideals of rationality and discipline.

sculptor intentionally designed the work to tease the spectator, imbuing his partially draped Aphrodite with a sexuality absent from Praxiteles' entirely nude image of the goddess.

BARBERINI FAUN Archaic statues smile at their viewers, and even when Classical statues look away from the viewer they are always awake and alert. Hellenistic sculptors often portrayed sleep. The suspension of consciousness and the entrance into the fantasy world of dreams—the antithesis of the Classical ideals of rationality and discipline—had great appeal for them. This newfound interest can be seen in a statue of a drunken, restlessly sleeping satyr (a semihuman follower of Dionysos) known as the Barberini Faun (FIG. 5-84) after the Italian cardinal who once owned it. The statue was found in Rome in the 17th century and restored (not entirely accurately) by Gianlorenzo Bernini, the great Italian Baroque sculptor (see Chapter 24). Bernini no doubt felt that this dynamic statue in the Pergamene manner was the work of a kindred spirit. The satyr has consumed too much wine and has thrown down his panther skin on a convenient rock and then fallen into a disturbed, intoxicated sleep. His brows are furrowed, and one can almost hear him snore.

Eroticism also comes to the fore in this statue. Although men had been represented naked in Greek art for hundreds of years, Archaic kouroi and Classical athletes and gods do not exude sexuality. Sensuality surfaced in the works of Praxiteles and his followers in the fourth century BCE. But the dreamy and supremely beautiful Hermes playfully dangling grapes before the infant Dionysos (FIG. 5-63) has nothing of the blatant sexuality of the *Barberini Faun*, whose wantonly spread legs focus attention on his genitals. Homosexuality was common in the man's world of ancient Greece. It is not surprising that when Hellenistic sculptors began to explore the sexuality of the human body, they turned their attention to both men and women.

DEFEATED BOXER Although Hellenistic sculptors tackled an

DEFEATED BOXER Although Hellenistic sculptors tackled an expanded range of subjects, they did not abandon such traditional themes as the Greek athlete. But they often rendered the old subjects in novel ways. This is certainly true of the magnificent bronze statue (FIG. 5-85) of a seated boxer, a Hellenistic original found in Rome and perhaps at one time part of a group. The boxer is not a victorious young athlete with a perfect face and body but a heavily battered, defeated veteran whose upward gaze may have been directed at the man

who had just beaten him. Too many punches from powerful hands wrapped in leather thongs—Greek boxers did not use the modern sport's cushioned gloves—have distorted the boxer's face. His nose is broken, as are his teeth. He has smashed, "cauliflower" ears. Inlaid copper blood drips from the cuts on his forehead, nose, and cheeks. How radically different is this rendition of a powerful bearded man from that of the noble warrior from Riace (FIGS. 5-35 and l-17) of the Early Classical period. The Hellenistic sculptor appealed not to the intellect but to the emotions when striving to evoke compassion for the pounded hulk of a oncemighty fighter.

5-85 Seated boxer, from Rome, Italy, ca. 100–50 BCE. Bronze, 4′ 2″ high. Museo Nazionale Romano–Palazzo Massimo alle Terme, Rome.

Even when Hellenistic artists treated traditional themes, they approached them in novel ways. This bronze statue represents an older, defeated boxer with a broken nose and battered ears.

5-86 Old market woman, ca. 150–100 BCE. Marble, $4'\frac{1}{2}''$ high. Metropolitan Museum of Art, New York.

Consistent with the realism of much Hellenistic art, many statues portrayed old men and women from the lowest rungs of society. They were never considered suitable subjects in earlier Greek statuary.

OLD MARKET WOMAN The realistic bent of much of Hellenistic sculpture—the very opposite of the Classical period's idealism—is evident above all in a series of statues of old men and women from the lowest rungs of the social order. Shepherds, fishermen, and drunken beggars are common—the kinds of people pictured earlier on red-figure vases but never before thought worthy of monumental statuary. One of the finest preserved statues of this type depicts a haggard old woman (FIG. **5-86**) bringing chickens and a basket of fruits and vegetables to sell in the market. Her face is wrinkled, her body bent with age, and her spirit broken by a lifetime of poverty. She carries on because she must, not because she derives any pleasure from life. No one knows the purpose of these statues, but they attest to an interest in social realism absent in earlier Greek statuary.

Statues of the aged and the ugly are, of course, the polar opposites of the images of the young and the beautiful that dominated Greek art until the Hellenistic age, but they are consistent with the period's changed character. The Hellenistic world was a cosmopolitan place, and the highborn could not help but encounter the poor and a growing number of foreigners (non-Greek "barbarians") on a daily basis. Hellenistic art reflects this different social climate in the depiction of a much wider variety of physical types, including different ethnic types. The sensitive portrayal of Gallic warriors with their

5-87 Росувиктоs, Demosthenes. Roman marble copy of a bronze original of ca. 280 все, 6′ $7\frac{1}{2}$ ″ high. Ny Carlsberg Glyptotek, Copenhagen.

One of the earliest Hellenistic portraits, frequently copied, was Polyeuktos's representation of the great orator Demosthenes as a frail man who possessed great courage and moral conviction.

shaggy hair, strange mustaches, and golden torques (FIG. 5-80 and 5-81) has already been noted. Africans, Scythians, and others, formerly only the occasional subject of vase painters, also entered the realm of monumental sculpture in Hellenistic art.

DEMOSTHENES These sculptures of foreigners and the urban poor, however realistic, are not portraits. Rather, they are sensitive studies of physical types. But the growing interest in the individual beginning in the Late Classical period did lead in the Hellenistic era to the production of true likenesses of specific persons. In fact, one of the

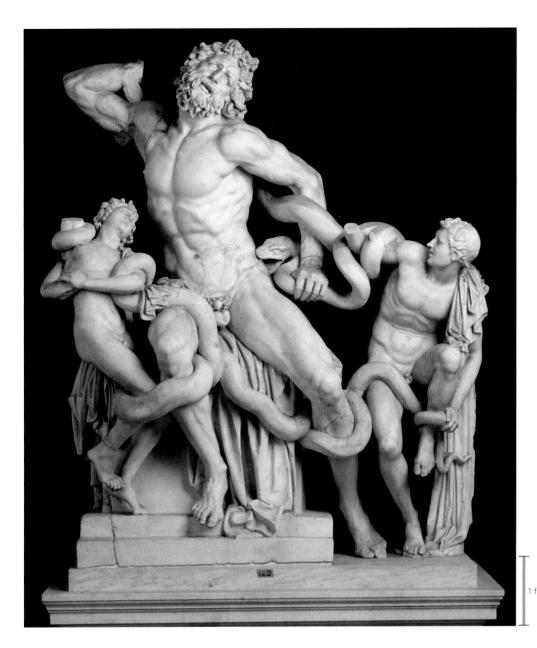

5-88 ATHANADOROS, HAGESANDROS, and POLYDOROS OF RHODES, Laocoön and his sons, from Rome, Italy, early first century CE. Marble, 7' $10\frac{1}{2}''$ high. Musei Vaticani, Rome.

Hellenistic style lived on in Rome. Although stylistically akin to Pergamene sculpture, this statue of sea serpents attacking Laocoön and his two sons matches the account given only in the *Aeneid*.

great achievements of Hellenistic artists was the redefinition of portraiture. In the Classical period, Kresilas was admired for having made the noble Pericles appear even nobler in his portrait (FIG. 5-41). But in Hellenistic times sculptors sought not only to record the actual appearance of their subjects in bronze and stone but also to capture the essence of their personalities in likenesses that were at once accurate and moving.

One of the earliest of these, perhaps the finest of the Hellenistic age and frequently copied in Roman times, was a bronze portrait statue of Demosthenes (FIG. 5-87) by POLYEUKTOS. The original was set up in the Athenian agora in 280 BCE, 42 years after the great orator's death. Demosthenes was a frail man and in his youth even suffered from a speech impediment, but he had enormous courage and great moral conviction. A veteran of the disastrous battle against Philip II at Chaeronea, he repeatedly tried to rally opposition to Macedonian imperialism, both before and after Alexander's death. In the end, when it was clear the Macedonians would capture him, he took his own life by drinking poison.

Polyeuktos rejected Kresilas's and Lysippos's notions of the purpose of portraiture and did not attempt to portray a supremely confident leader with a magnificent physique. His Demosthenes has an aged and slightly stooped body. The orator clasps his hands nervously in front of him as he looks downward, deep in thought. His

face is lined, his hair is receding, and his expression is one of great sadness. Whatever physical discomfort Demosthenes felt is here joined by an inner pain, his deep sorrow over the tragic demise of democracy at the hands of the Macedonian conquerors.

Hellenistic Art under Roman Patronage

In the opening years of the second century BCE, the Roman general Flaminius defeated the Macedonian army and declared the old poleis of Classical Greece free once again. The city-states never regained their former glory, however. Greece became a Roman province in 146 BCE. When, 60 years later, Athens sided with King Mithridates VI of Pontus (r. 120–63 BCE) in his war against Rome, the general Sulla crushed the Athenians. Thereafter, Athens retained some of its earlier prestige as a center of culture and learning, but politically it was just another city in the ever-expanding Roman Empire. Nonetheless, Greek artists continued to be in great demand, both to furnish the Romans with an endless stream of copies of Classical and Hellenistic masterpieces and to create new statues à la grecque (in the Greek style) for Roman patrons.

LAOCOÖN One such work is the famous group (FIG. 5-88) of the Trojan priest Laocoön and his sons, which was unearthed in Rome in

1506 in the presence of the great Italian Renaissance artist Michelangelo. The marble group, long believed an original of the second century BCE, was found in the remains of the palace of the emperor Titus (r. 79-81 CE), exactly where Pliny had seen it more than 14 centuries before. Pliny attributed the statue to three sculptors—Athanadoros, Hagesandros, and Polydoros of Rhodes—whom most art historians now think worked in the early first century CE. They probably based their group on a Hellenistic masterpiece depicting Laocoön and only one son. Their variation on the original added the son at Laocoön's left (note the greater compositional integration of the two other figures) to conform with the Roman poet Vergil's account in the Aeneid. Vergil vividly described the strangling of Laocoön and his two sons by sea serpents while sacrificing at an altar. The gods who favored the Greeks in the war against Troy had sent the serpents to punish Laocoön, who had tried to warn his compatriots about the danger of bringing the Greeks' wooden horse within the walls of their city.

In Vergil's graphic account, Laocoön suffered in terrible agony, and the sculptors communicated the torment of the priest and his sons in a spectacular fashion in the marble group. The three Trojans writhe in pain as they struggle to free themselves from the death grip of the serpents. One bites into Laocoön's left hip as the priest lets out a ferocious cry. The serpent-entwined figures recall the suffering giants of the great frieze of the Altar of Zeus at Pergamon, and Laocoön himself is strikingly similar to Alkyoneos (FIG. 5-79), Athena's opponent. In fact, many scholars believe that a Pergamene statuary group of the second century BCE was the inspiration for the three Rhodian sculptors.

SPERLONGA That the work seen by Pliny and displayed in the Vatican Museums today was made for Romans rather than Greeks was confirmed in 1957 by the discovery of fragments of several Hellenistic-style groups illustrating scenes from Homer's Odyssey. These fragments were found in a grotto that served as the picturesque summer banquet hall of the seaside villa of the Roman emperor Tiberius (r. 14–37 CE) at Sperlonga, some 60 miles south of Rome. One of these groups—depicting the monster Scylla attacking Odysseus's ship—is signed by the same three sculptors Pliny cited as the creators of the Laocoön group. Another of the groups, installed around a central pool in the grotto, depicted the blinding of the Cyclops Polyphemos by Odysseus and his comrades, an incident also set in a cave in the Homeric epic. The head of Odysseus (FIG. 5-89) from this theatrical group is one of the finest sculptures of antiquity. The hero's cap can barely contain his swirling locks of hair. Even Odysseus's beard seems to be swept up in the emotional intensity of the moment. The parted lips and the deep shadows produced by sharp undercutting add drama to the head, which complemented Odysseus's agitated body.

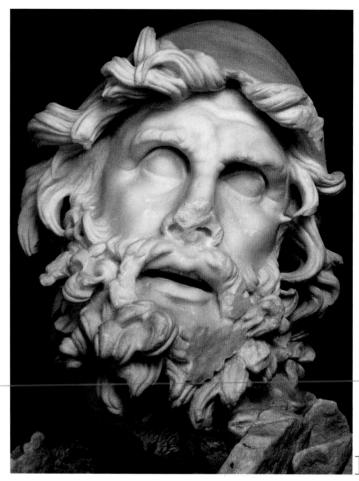

5-89 Athanadoros, Hagesandros, and Polydoros of Rhodes, head of Odysseus, from Sperlonga, Italy, early first century ce. Marble, $2'1\frac{1}{4}''$ high. Museo Archeologico, Sperlonga.

This emotionally charged depiction of Odysseus was part of a mythological statuary group that the Laocoön sculptors made for a grotto at the emperor Tiberius's seaside villa at Sperlonga.

At Tiberius's villa in Sperlonga and in Titus's palace in Rome, the baroque school of Hellenistic sculpture lived on long after Greece ceased to be a political force. When Rome inherited the Pergamene kingdom from the last of the Attalids in 133 BCE, it also became heir to the Greek artistic legacy, and what Rome adopted from Greece it in turn passed on to the medieval and modern worlds. If Greece was peculiarly the inventor of the European spirit, Rome surely was its propagator and amplifier.

ANCIENT GREECE

GEOMETRIC AND ORIENTALIZING ART, ca. 900-600 BCE

- Homer lived during the eighth century BCE, the era when the city-states of Classical Greece took shape, the Olympic Games were founded (776 BCE), and the Greeks began to trade with their neighbors to both east and west.
- Also at this time, the human figure returned to Greek art in the form of bronze statuettes and simple silhouettes amid other abstract motifs on Geometric vases.
- Increasing contact with the civilizations of the Near East precipitated the so-called Orientalizing phase (ca. 700–600 BCE) of Greek art, when Eastern monsters began to appear on black-figure vases.

ARCHAIC ART, ca. 600-480 BCE

- Around 600 BCE, the first life-size stone statues appeared in Greece. The earliest kouroi emulated the frontal poses of Egyptian statues, but artists depicted the young men nude, the way Greek athletes competed at Olympia.
- During the course of the sixth century BCE, Greek sculptors refined the proportions and added "Archaic smiles" to the faces of their statues to make them seem more lifelike.
- The Archaic age also saw the erection of the first stone temples with peripteral colonnades and the codification of the Doric and Ionic orders.
- The Andokides Painter invented red-figure vase painting around 530 BCE. Euphronios and Euthymides rejected the age-old composite view for the human figure and experimented with foreshortening.

EARLY AND HIGH CLASSICAL ART, ca. 480-400 BCE

- The Classical period opened with the Persian sack of the Athenian Acropolis in 480 BCE and the Greek victory a year later. The fifth century BCE was the golden age of Greece, when Aeschylus, Sophocles, and Euripides wrote their plays, and Herodotus, the "father of history," lived.
- During the Early Classical period (480–450 BCE), sculptors revolutionized statuary by introducing contrapposto (weight shift) to their figures.
- In the High Classical period (450–400 BCE), Polykleitos developed a canon of proportions for the perfect statue. Iktinos and Kallikrates similarly applied mathematical formulas to temple design in the belief that beauty resulted from the use of harmonic numbers.
- Under the patronage of Pericles and the artistic directorship of Phidias, the Athenians rebuilt the Acropolis after 447 BCE. The Parthenon, Phidias's *Athena Parthenos*, and the works of Polykleitos have defined what it means to be "Classical" ever since.

LATE CLASSICAL ART, ca. 400-323 BCE

- In the aftermath of the Peloponnesian War, which ended in 404 BCE, Greek artists, while still adhering to the philosophy that humanity was the "measure of all things," began to focus more on the real world of appearances than on the ideal world of perfect beings.
- Late Classical sculptors humanized the remote deities, athletes, and heroes of the fifth century BCE. Praxiteles, for example, caused a sensation when he portrayed Aphrodite undressed. Lysippos depicted Herakles as a strong man so weary that he needed to lean on his club for support.
- In architecture, the ornate Corinthian capital became increasingly popular, breaking the monopoly of the Doric and Ionic orders.
- The period closed with Alexander the Great, who transformed the Mediterranean world politically and ushered in a new artistic age as well.

HELLENISTIC ART, ca. 323-30 BCE

- The Hellenistic age extends from the death of Alexander until the death of Cleopatra, when Egypt became a province of the Roman Empire. The great cultural centers of the era were no longer the city-states of Archaic and Classical Greece but royal capitals such as Alexandria in Egypt and Pergamon in Asia Minor.
- In art, both architects and sculptors broke most of the rules of Classical design. At Didyma, for example, a temple to Apollo was erected that had no roof and contained a smaller temple within it.
- Hellenistic sculptors explored new subjects—Gauls with strange mustaches and necklaces, impoverished old women—and treated traditional subjects in new ways—athletes with battered bodies and faces, openly erotic goddesses. Artists delighted in depicting violent movement and unbridled emotion.

Dipylon krater, Athens, ca. 740 BCE

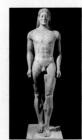

Kroisos, kouros from Anavysos,

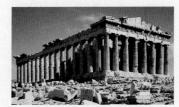

Parthenon, Acropolis, Athens, 447–438 BCE

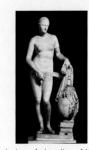

Praxiteles, Aphrodite of Knidos, ca. 350–340 BCE

Altar of Zeus, Pergamon ca. 175 BCE

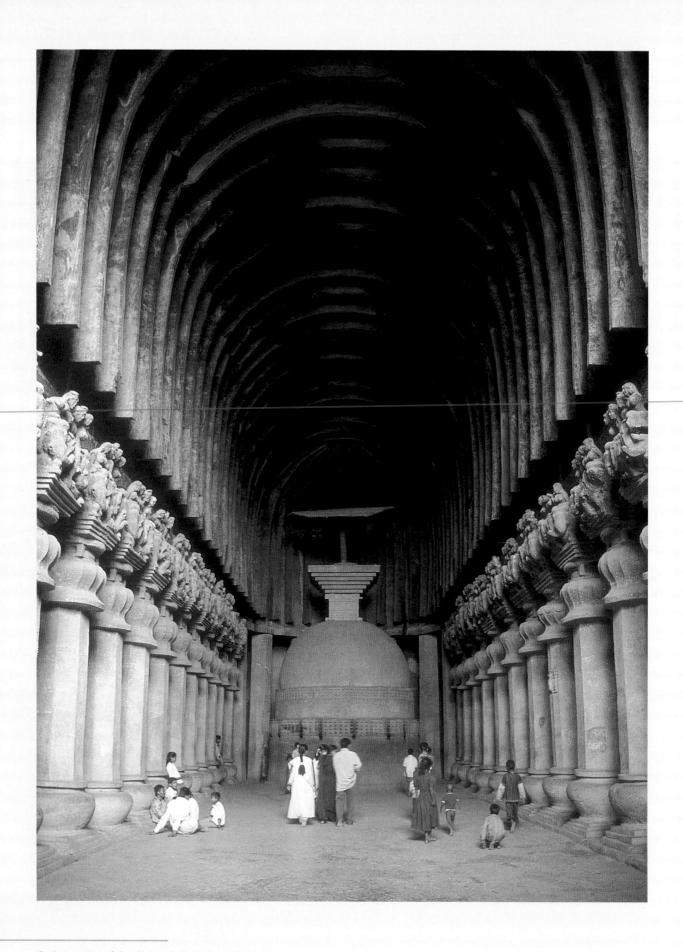

6-1 Interior of the chaitya hall, Karle, India, ca. 50 ce.

An early example of Buddhist architecture, the chaitya hall at Karle is carved out of the living rock. It has a pillared ambulatory that allows worshipers to circumambulate the stupa in the apse of the cave.

SOUTH AND SOUTHEAST ASIA BEFORE 1200

South and Southeast Asia is a vast geographic area comprising, among others, the nations of India, Pakistan, Sri Lanka, Thailand, Vietnam, Cambodia, Bangladesh, and Indonesia (MAP 6-1). Not surprisingly, the region's inhabitants display tremendous cultural and religious diversity. The people of India alone speak more than 20 different major languages. Those spoken in the north belong to the Indo-European language family, whereas those in the south form a completely separate linguistic family called Dravidian. The art of South and Southeast Asia is equally diverse—and very ancient. When Alexander the Great and his army reached India in 326 BCE, the civilization they encountered was already more than two millennia old. The remains of the first cities in the Indus Valley predate the palaces (FIGS. 4-15 and 4-19) of Homer's Trojan War heroes by a millennium. Covered in this chapter are the art and architecture of South and Southeast Asia from their beginnings almost five millennia ago through the 12th century. Chapter 26 treats the later art of the region up to the present day.

INDIA AND PAKISTAN

In the third millennium BCE, a great civilization arose over a wide geographic area along the Indus River in Pakistan and extended into India as far south as Gujarat and east beyond Delhi. Archaeologists have dubbed this early South Asian culture the Indus Civilization.

Indus Civilization

The Indus Civilization flourished from about 2600 to 1500 BCE, and evidence indicates there was active trade during this period between the peoples of the Indus Valley and Mesopotamia. The most important excavated Indus sites are Harappa and Mohenjo-daro. These early, fully developed cities featured streets oriented to compass points and multistoried houses built of carefully formed and precisely laid kiln-baked bricks. But in sharp contrast to the contemporaneous civilizations of Mesopotamia and Egypt, no surviving Indus building has yet been identified as a temple or a palace.

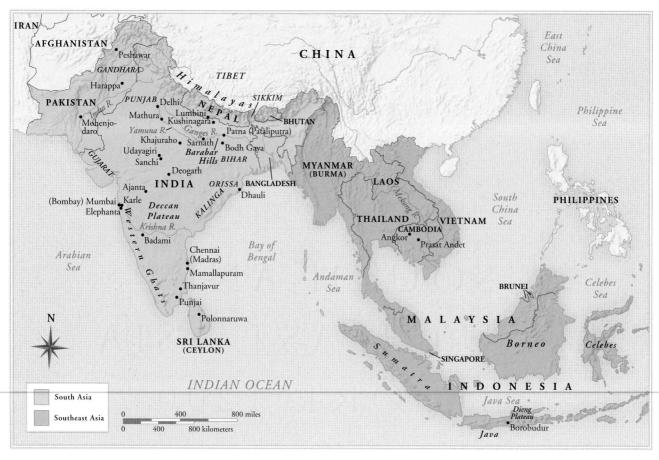

MAP 6-1 South and Southeast Asian sites before 1200.

MOHENJO-DARO The Indus cities boasted one of the world's first sophisticated systems of water supply and sewage. Throughout Mohenjo-daro, hundreds of wells provided fresh water to homes that featured some of the oldest recorded private bathing areas and toilet facilities with drainage into public sewers. In the heart of the city stood the so-called Great Bath, a complex of rooms centered on a sunken brick pool (FIG. **6-2**) 39 feet long, 23 feet wide, and 8 feet

deep. The builders made the pool watertight by sealing the joints between the bricks with bitumen, an asphaltlike material also used in Mesopotamia. The bath probably was not a purely recreational facility but rather a place for ritual bathing of the kind still practiced in the region today.

Excavators have discovered surprisingly little art from the longlived Indus Civilization, and all of the objects found are small.

6-2 Great Bath, Mohenjo-daro, Pakistan, ca. 2600–1900 BCE.

The Indus cities of the third millennium BCE had sophisticated water-supply and sewage systems, which made possible this brick complex used for ritual bathing of a kind still practiced in South Asia today.

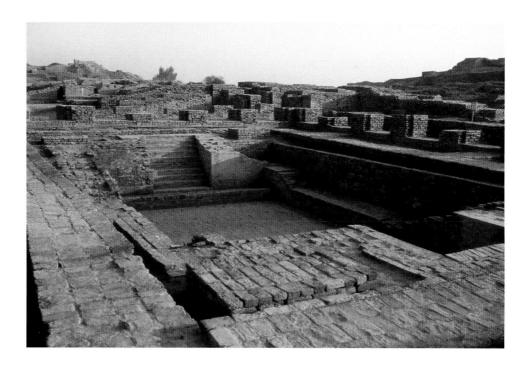

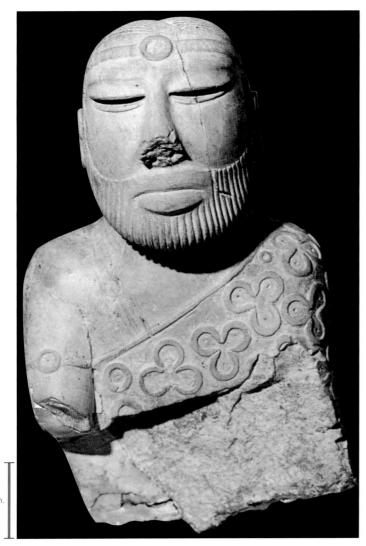

6-3 Robed male figure, from Mohenjo-daro, Pakistan, ca. 2000–1900 BCE. Steatite, $6\frac{7}{8}$ high. National Museum of Pakistan, Karachi.

Little art survives from the Indus Civilization, and all of it is of small scale. This bearded figure, which scholars think represents a priest-king, has iconographic similarities to some Sumerian sculptures.

Perhaps the most impressive sculpture discovered is a robed male figure (FIG. 6-3) with half-closed eyes, a low forehead, and a closely trimmed beard with shaved upper lip. He wears a headband with a central circular emblem, matched by a similar armband. Holes on each side of his neck suggest that he also wore a necklace of precious metal. *Trefoils* (cloverlike designs with three stylized leaves) decorate his elegant robe. They, as well as the circles of the head- and armbands, originally held red paste and shell inlays, as did the eyes. Art historians often compare the Mohenjo-daro statuette to Sumerian sculptures, in which the trefoil motif appears in sacred contexts, and scholars usually refer to the person portrayed as a "priest-king," the ambiguous term used for some Sumerian leaders. The identity and rank of the Mohenjo-daro figure, however, are uncertain. Nonetheless, the elaborate costume and precious materials make clear that he too was an elite individual.

HARAPPA Quite different in style is the miniature red-sand-stone torso of a nude male figure (FIG. 6-4) found at Harappa. Scholars usually compare this figure, which is less than four inches tall, to Greek statues of much later date, but the treatment of anatomy separates it sharply from the classical tradition. The highly

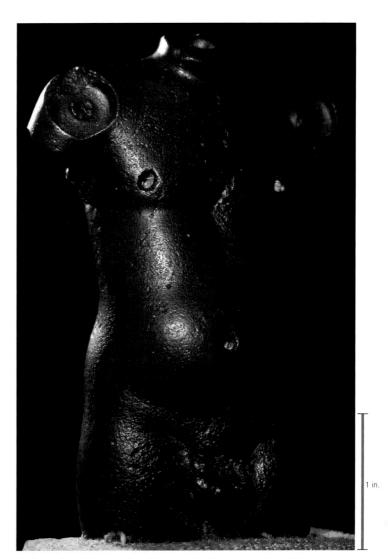

6-4 Nude male torso, from Harappa, Pakistan, ca. 2000–1900 BCE. Red sandstone, $3\frac{3}{4}$ " high. National Museum, New Delhi.

This miniature figure, with its emphasis on sensuous polished surfaces and swelling curves, already displays many of the stylistic traits that would characterize South Asian sculpture for thousands of years.

polished surface of the stone and the swelling curves of the abdomen reveal the Indus artist's interest in the fluid movement of a living body, not in the logical anatomical structure of Greek sculpture. This sense of pulsating vigor and the emphasis on sensuous surfaces would continue to be chief characteristics of South Asian sculpture for thousands of years.

INDUS SEALS The most common Indus art objects are steatite seals with incised designs. They are similar in many ways to the stamp seals found at contemporaneous sites in Mesopotamia (see "Mesopotamian Seals," Chapter 2, page 39). Most of the Indus examples have an animal or tiny narrative carved on the face, along with an as-yet-untranslated script. On the back, a boss (circular knob) with a hole permitted insertion of a string so that the seal could be worn or hung on a wall. As in the ancient Near East, the Indus peoples sometimes used the seals to make impressions on clay, apparently for securing trade goods wrapped in textiles. The animals most frequently represented include the humped bull, elephant, rhinoceros, and tiger. Each is portrayed in strict profile, as in the paintings and reliefs of all other early cultures. Some of the narrative seals appear to show that the Indus peoples considered trees sacred, as both Buddhists and

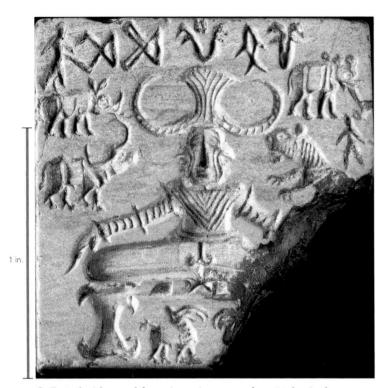

6-5 Seal with seated figure in yogic posture, from Mohenjo-daro, Pakistan, ca. 2300–1750 BCE. Steatite coated with alkali and baked, $1\frac{3}{8}'' \times 1\frac{3}{8}''$. National Museum, New Delhi.

This seal depicting a figure (with three faces?) wearing a horned headdress and seated in a posture used in yoga is evidence that this important Indian meditative practice began as early as the Indus Civilization.

Hindus later did. Many historians have suggested religious and ritual continuities between the Indus Civilization and later Indian culture.

One of the most elaborate seals (FIG. 6-5) depicts a male figure with a horned headdress and, perhaps, three faces, seated (with erect penis) among the profile animals that regularly appear alone on other seals. The figure's folded legs with heels pressed together and his arms resting on the knees suggest a yogic posture (compare FIG. 6-12). Yoga is a method for controlling the body and relaxing the mind used in later Indian religions to yoke, or unite, the practitioner to the divine. Although most scholars reject the identification of this figure as a prototype of the multiheaded Hindu god Shiva (FIG. 6-18) as Lord of Beasts, the yogic posture argues that this important Indian meditative practice began as early as the Indus Civilization.

Vedic and Upanishadic Period

By 1700 BCE, the urban phase of the Indus Civilization had ended in most areas. The production of sculptures, seals, and script gradually ceased, and village life replaced urban culture. Very little art survives from the next thousand years, but the religious foundations laid during this period helped define most later South and Southeast Asian art.

VEDAS The basis for the new religious ideas were the oral hymns of the Aryans, a mobile herding people from Central Asia who occupied the Punjab, an area of northwestern India, in the second millennium BCE. The Aryans ("Noble Ones") spoke Sanskrit, the earliest

language yet identified in South Asia. Around 1500 BCE, they composed the first of four Vedas. These Sanskrit compilations of religious learning (Veda means "knowledge") included hymns intended for priests (called Brahmins) to chant or sing. The Brahmins headed a social hierarchy, perhaps of pre-Aryan origin, that became known as the caste system, which still forms the basis of Indian society today. Below the priests were the warriors, traders, and manual laborers (including artists and architects), respectively. The Aryan religion centered on sacrifice, the ritual enactment of often highly intricate and lengthy ceremonies in which the priests placed materials, such as milk and soma (an intoxicating drink), into a fire that took the sacrifices to the gods in the heavens. If the Brahmins performed these rituals accurately, the gods would fulfill the prayers of those who sponsored the sacrifices. These gods, primarily male, included Indra, Varuna, Surya, and Agni, gods associated, respectively, with the rains, the ocean, the sun, and fire. There is no evidence to indicate the Aryans made images of these deities.

UPANISHADS The next phase of South Asian urban civilization developed east of the Indus heartland, in the Ganges River Valley. Here, from 800 to 500 BCE, religious thinkers composed a variety of texts called the *Upanishads*. Among the innovative ideas of the Upanishads were *samsara*, *karma*, and *moksha* (or *nirvana*). Samsara is the belief that individuals are born again after death in an almost endless round of rebirths. The type of rebirth can vary. One can be reborn as a human being, an animal, or even a god. An individual's past actions (karma), either good or bad, determine the nature of future rebirths. The ultimate goal of a person's religious life is to escape from the cycle of birth and death by merging the individual self into the vital force of the universe. This escape is called either moksha (liberation, for Hindus) or nirvana (cessation, for Buddhists).

HINDUISM AND BUDDHISM Hinduism and Buddhism, the two major modern religions originating in Asia, developed in the late centuries BCE and the early centuries CE. Hinduism, the dominant religion in India today, discussed in more detail later, has its origins in Aryan religion. The founder of Buddhism was the Buddha, a historical figure who advocated the path of *asceticism*, or self-discipline and self-denial, as the means to free oneself from attachments to people and possessions, thus ending rebirth (see "Buddhism and Buddhist Iconography," page 161). Unlike their predecessors in South Asia, both Hindus and Buddhists use images of gods and holy persons in religious rituals. To judge from surviving works, Buddhism has the older artistic tradition. The earliest Buddhist monuments date to the Maurya period.

Maurya Dynasty

When Alexander the Great reached the Indus River in 326 BCE, his troops refused to go forward. Reluctantly, Alexander abandoned his dream of conquering India and headed home. After Alexander's death three years later, his generals divided his empire among themselves. One of them, Seleucus Nicator, reinvaded India, but Chandragupta Maurya (r. 323–298 BCE), founder of the Maurya dynasty, defeated him in 305 BCE and eventually consolidated almost all of present-day India under his domain. Chandragupta's capital was Pataliputra (modern Patna) in northeastern India, far from the center of the Indus Civilization. Megasthenes, Seleucus's ambassador to the Maurya court, described Pataliputra in his book on India as a large and wealthy city enclosed within mighty wooden walls so extensive that the circuit had 64 gates and 570 towers.

Buddhism and Buddhist Iconography

THE BUDDHA AND BUDDHISM

The Buddha (Enlightened One) was born around 563 BCE as Prince Siddhartha Gautama, the eldest son of the king of the Shakya clan. A prophecy foretold that he would grow up to be either a world conqueror or a great religious leader. His father preferred the secular role for young Siddhartha and groomed him for kingship by shielding the boy from the hardships of the world. When he was 29, however, the prince rode out of the palace, abandoned his wife and family, and encountered firsthand the pain of old age, sickness, and death. Siddhartha responded to the suffering he witnessed by renouncing his opulent life and becoming a wandering ascetic searching for knowledge through meditation. Six years later, he achieved complete enlightenment, or buddhahood, while meditating beneath a pipal tree (the Bodhi tree) at Bodh Gaya ("place of enlightenment") in eastern India. Known from that day on as Shakyamuni (Wise Man of the Shakya clan), the Buddha preached his first sermon in the Deer Park at Sarnath. There he set in motion the Wheel (chakra) of the Law (dharma) and expounded the Four Noble Truths that are the core insights of Buddhism: (1) Life is suffering; (2) the cause of suffering is desire; (3) one can overcome and extinguish desire; (4) the way to conquer desire and end suffering is to follow the Buddha's Eightfold Path of right understanding, right thought, right speech, right action, right livelihood, right effort, right mindfulness, and right concentration. The Buddha's path leads to nirvana, the cessation of the endless cycle of painful life, death, and rebirth. The Buddha continued to preach until his death at 80 at Kushinagara. His disciples carried on his teaching and established monasteries where others could follow the Buddha's path to enlightenment and nirvana.

This earliest form of Buddhism is called Theravada (the Path of the Elders) Buddhism. The new religion developed and changed over time as the Buddha's teachings spread from India throughout Asia. The second major school of Buddhist thought, Mahayana (Great Path) Buddhism, emerged around the beginning of the Christian era. Mahayana Buddhists refer to Theravada Buddhism as Hinayana (Lesser Path) Buddhism and believe in a larger goal than nirvana for an individual—namely, buddhahood for all. Mahayana Buddhists also revere *bodhisattvas* ("Buddhas-to-be"), exemplars of compassion who restrain themselves at the threshold of nirvana to aid others in earning merit and achieving buddhahood. Theravada Buddhism became the dominant sect in southern India, Sri Lanka, and mainland Southeast Asia, whereas Mahayana Buddhism took root in northern India and spread to China, Korea, Japan, and Nepal.

A third important Buddhist sect, especially popular in East Asia, venerates the Amitabha Buddha (Amida in Japanese), the Buddha of

Infinite Light and Life. The devotees of this Buddha hope to be reborn in the Pure Land Paradise of the West, where the Amitabha resides and can grant them salvation. Pure Land teachings maintain that people have no possibility of attaining enlightenment on their own but can achieve paradise by faith alone.

BUDDHIST ICONOGRAPHY

The earliest (first century CE) depictions of the Buddha in human form show him as a robed monk. Artists distinguished the Enlightened One from monks and bodhisattvas by *lakshanas*, body attributes indicating the Buddha's suprahuman nature. These distinguishing marks include an *urna*, or curl of hair between the eyebrows, shown as a dot; an *ushnisha*, a cranial bump shown as hair on the earliest images (FIGS. 6-10 to 6-12) but later as an actual part of the head (FIG. 6-13); and, less frequently, palms and soles imprinted with a wheel (FIG. 6-12). The Buddha is also recognizable by his elongated ears, the result of wearing heavy royal jewelry in his youth, but the enlightened Shakyamuni is rarely bejeweled, as are many bodhisattvas (FIG. 6-15). Sometimes the Buddha appears with a halo, or sun disk, behind his head (FIGS. 6-10, 6-12, and 6-13).

Representations of the Buddha also feature a repertory of *mudras*, or hand gestures, conveying fixed meanings. These include the *dhyana* (meditation) mudra, with the right hand over the left, palms upward (FIG. 6-10); the *bhumisparsha* (earth-touching) mudra, right hand down reaching to the ground, calling the earth to witness the Buddha's enlightenment (FIG. 6-11b); the *dharmachakra* (Wheel of the Law, or teaching) mudra, a two-handed gesture with right thumb and index finger forming a circle (FIG. 6-13); and the *abhaya* (do not fear) mudra, right hand up, palm outward, a gesture of protection or blessing (FIGS. 6-11c and 6-12).

Episodes from the Buddha's life are among the most popular subjects in all Buddhist artistic traditions. No single text provides the complete or authoritative narrative of the Buddha's life and death. Thus, numerous versions and variations exist, allowing for a rich artistic repertory. Four of the most important events are his birth at Lumbini from the side of his mother, Queen Maya (FIG. 6-11a); his achievement of buddhahood while meditating beneath the Bodhi tree at Bodh Gaya (FIG. 6-11b); his first sermon as the Buddha at Sarnath (FIGS. 6-11c and 6-13); and his attainment of nirvana when he died (*parinirvana*) at Kushinagara (FIGS. 6-11d and 6-26). Buddhists erected monasteries and monuments at the four sites where these key events occurred, although the Buddha himself disapproved of all luxury, including lavish religious shrines with costly figural art. Monks and lay pilgrims from throughout the world continue to visit these places today.

ASHOKA The greatest Maurya ruler was Ashoka (r. 272–231 BCE), who left his imprint on history by converting to Buddhism and spreading the Buddha's teaching throughout and beyond India (see "Ashoka's Conversion to Buddhism," page 162). Ashoka formulated a legal code based on the Buddha's dharma and inscribed his laws on enormous *monolithic* (one-piece stone) columns erected throughout his kingdom. Ashoka's pillars reached 30 to 40 feet high and are the first mon-

umental stone artworks in India. The pillars penetrated deep into the ground, connecting earth and sky, forming an "axis of the universe," a pre-Buddhist concept that became an important motif in Buddhist architecture. The columns stood along pilgrimage routes to sites associated with the Buddha and on the roads leading to Pataliputra. Capping Ashoka's pillars were elaborate capitals, also carved from a single block of stone. The finest of these comes from Sarnath, where the Buddha

Ashoka's Conversion to Buddhism

The reign of the Maurya king Ashoka marks both the beginning of monumental stone art and architecture (FIG. 6-6) in India and the first official sponsorship of Buddhism. The impact of Ashoka's conversion to Buddhism on the later history of art and religion in Asia cannot be overstated.

An edict carved into a rock at Dhauli in the ancient region of Kalinga (roughly equivalent to the modern state of Orissa on the Bay of Bengal) records Ashoka's embrace of nonviolence and of the teachings of the Buddha after an especially bloody conquest that claimed more than 100,000 lives. The inscription also captures Ashoka's missionary zeal, which spread Buddhism far beyond the boundaries of his kingdom.

The Beloved of the Gods [Ashoka], conqueror of the Kalingas, is moved to remorse now. For he has felt profound sorrow and regret because the conquest of a people previously unconquered involves slaughter, death, and deportation... [King Ashoka] now thinks that even a person who wrongs him must be forgiven... [and he] considers moral conquest [conquest by dharma] the most important conquest. He has achieved this moral conquest repeatedly both here and among the peoples living beyond the borders of his kingdom... Even in countries which [King Ashoka's] envoys have not reached, people have heard about dharma and about [the king's] ordinances and instructions in dharma.... This edict on dharma has been inscribed so that my sons and great-grandsons who may come after me should not think new conquests worth achieving.... Let them consider moral conquest the only true conquest.*

The story of Ashoka at Kalinga and his renunciation of violent aggression still resonates today. It inspired one of the most important 20th-century Indian sculptors to take up the theme and imbue it with contemporary meaning (FIG. 26-15).

*Rock Edict XIII. Translated by N. A. Nikam and Richard McKeon, *The Edicts of Aśoka* (Chicago: University of Chicago Press, 1959), 27–30.

gave his first sermon and set the Wheel of the Law in motion. It is a seven-foot lion capital (FIG. 6-6). Stylistically, Ashoka's capital owes much to the ancient Near East, especially the Achaemenid art of Persepolis (see Chapter 2), but its iconography is Buddhist. Two pairs of back-to-back lions (the Buddha is often referred to as "the lion") stand on a round abacus decorated with four wheels and four animals symbolizing the four quarters of the world. The lions once carried a large stone wheel on their backs. The wheel (chakra) referred to the Wheel of the Law but also indicated Ashoka's stature as a *chakravartin* ("holder of the wheel"), a universal king imbued with divine authority. The open mouths of the four lions that face the four quarters of the world may signify the worldwide announcement of the Buddha's message.

Shunga, Andhra, and Kushan Dynasties

The Maurya dynasty came to an abrupt end when its last ruler was assassinated by one of his generals, who founded a new dynasty in his own name. The Shungas, however, never ruled an empire as extensive as that of the Mauryas. Their realm was confined to central

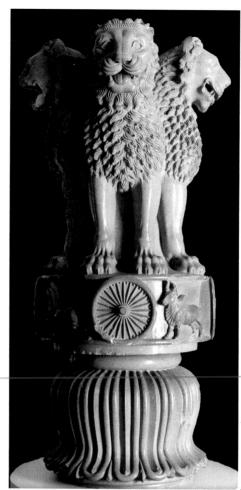

6-6 Lion capital of the column erected by Ashoka at Sarnath, India, ca. 250 BCE. Polished sandstone, 7' high. Archaeological Museum, Sarnath.

Ashoka formulated a legal code based on the Buddha's teachings and inscribed those laws on columns erected throughout his kingdom. The lions on this capital once supported the Buddha's Wheel of the Law.

1 f

India. They were succeeded by the Andhras, who also controlled the Deccan plateau to the south. By the middle of the first century CE, an even greater empire, the Kushan, rose in northern India. Its most celebrated king was Kanishka, who came to power during the late first or early second century CE and who set up capitals at Peshawar and other sites in Gandhara, a region largely in Pakistan today, close to the Afghanistan border. The Kushans grew rich on trade between China and the west along one of the main caravan routes bringing the luxuries of the Orient to the Roman Empire (see "Silk and the Silk Road," Chapter 7, page 188). Kanishka even struck coins modeled on the imperial coinage of Rome, some featuring Greco-Roman deities, but Kanishka's coins also carried portraits of himself and images of the Buddha and various Hindu deities.

SANCHI The unifying characteristic of this age of regional dynasties in South Asia was the patronage of Buddhism. One of the most important Buddhist monasteries, founded during Ashoka's reign and in use for more than a thousand years, is at Sanchi in central India. It consists of many buildings constructed over the centuries, including *viharas* (celled structures where monks live), large *stupas* (see "The Stupa," page 163), *chaitya halls* (halls with rounded, or *apsidal*, ends for housing smaller stupas), and temples for sheltering images.

The Great Stupa at Sanchi dates originally to Ashoka's reign, but its present form (FIG. 6-7), with its tall stone fence and four gates, dates from ca. 50 BCE to 50 CE. The solid earth-and-rubble dome stands 50 feet high. Worshipers enter through one of the gateways, walk on the lower circumambulation path, then climb the stairs on the south side to circumambulate at the second level. Carved onto the different parts of the Great Stupa are more than 600 brief inscriptions showing that the donations of hundreds of individuals (more than a

The Stupa

n essential element of Buddhist sanctuaries is the stupa, a grand circular mound modeled on earlier South Asian burial mounds of a type familiar in many other ancient cultures (FIGS. 4-20 and 9-6). The stupa was not a tomb, however, but a monument housing relics of the Buddha. When the Buddha died, his cremated remains were placed in eight reliquaries, or containers, similar in function to the later reliquaries housed in medieval churches at pilgrimage sites throughout the Christian world (see "Pilgrimages and the Cult of Relics," Chapter 17, page 432). But unlike their Western equivalents, which were put on display, the Buddha's relics were buried in solid earthen mounds (stupas) that could not be entered. In the mid-third century BCE, Ashoka opened the original eight stupas and spread the Buddha's relics among thousands of stupas in all corners of his realm. Buddhists venerated the Buddha's remains by circumambulation, walking around the stupa in a clockwise direction. The circular movement, echoing the movement of the earth and the sun, brought the devotee into harmony with the cosmos. Stupas come in many sizes, from tiny handheld objects to huge structures, such as the Great Stupa at Sanchi (FIG. 6-7), constructed originally by Ashoka and later enlarged.

The monumental stupas are three-dimensional *mandalas*, or sacred diagrams of the universe. The domed stupa itself represents the world mountain, with the cardinal points marked by *toranas*, or gateways. The *harmika*, positioned atop the stupa dome, is a stone fence or railing that encloses a square area symbolizing the sacred domain of the gods. At the harmika's center, a *yasti*, or pole, corresponds to the axis of the universe, a motif already present in Ashoka's pillars. Three *chatras*, or stone disks, assigned various meanings, crown the yasti. The yasti rises from the mountain-dome and passes through the harmika, thus uniting this world with the heavenly paradise. A stone fence often encloses the entire structure, clearly separating the sacred space containing the Buddha's relics from the profane world outside.

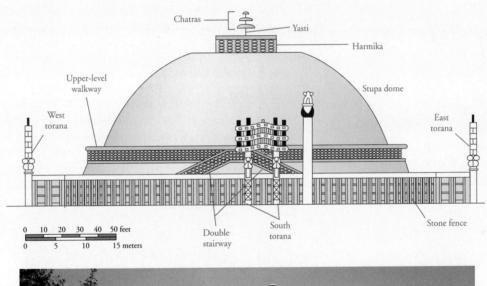

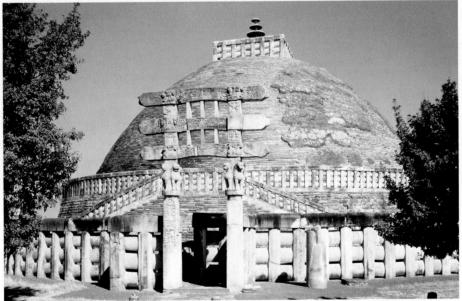

6-7 Diagram (top) and view from the south (bottom) of the Great Stupa, Sanchi, India, third century BCE to first century CE.

The sanchi stupa is an earthen mound containing relics of the Buddha. Buddhists walk around stupas in a clockwise direction. They believe that the circular movement brings the devotee into harmony with the cosmos.

6-8 Yakshi, detail of the east torana, Great Stupa, Sanchi, India, mid-first century BCE to early first century CE. Sandstone, 5' high.

Yakshis personify fertility and vegetation. The Sanchi yakshis are scantily clad women who make mango trees flower. The yakshis' pose was later used to represent Queen Maya giving birth to the Buddha.

third of them women) made the monument's construction possible. Veneration of the Buddha was open to all, not just the monks, and most of the dedications were by common laypeople, who hoped to accrue merit for future rebirths with their gifts.

The reliefs on the four toranas at Sanchi depict the story of the Buddha's life and those of his past lives (*jatakas*). In Buddhist belief, everyone has had innumerable past lives, including Siddhartha. During Siddhartha's former lives, as recorded in the jatakas, he accumulated sufficient merit to achieve enlightenment and become the Buddha. In the life stories recounted in the Great Stupa reliefs, however, the Buddha never appears in human form. Instead, the artists used symbols—for example, footprints, a parasol, or an empty seat—to indicate the Buddha's presence. Some scholars regard these symbols as markers of where the Buddha once was, enabling others to follow in his footsteps.

Also carved on the east torana is a scantily clad, sensuous woman called a *yakshi* (FIG. 6-8). These goddesses, worshiped throughout India, personify fertility and vegetation. The Sanchi yakshi reaches up to hold on to a mango tree branch while pressing her left foot against the trunk, an action that has brought the tree to flower. Buddhists later adopted this pose, with its rich associations of procreation and abundance, for representing the Buddha's mother, Maya, giving birth (FIG. 6-11a). Thus, the Buddhists adopted pan-Indian symbolism, such as the woman under the tree, and the sensuality of the Indus sculptural tradition (FIG. 6-4) when creating their own Buddhist iconography.

6-9 Plan (*top*) and section (*bottom*) of the chaitya hall (FIG. 6-1), Karle, India, ca. 50 CE.

Chaitya halls in Buddhist monasteries house stupas. The form of the rock-cut cave at Karle imitates earlier wooden halls. The massive interior (45 feet tall, 125 feet long) has excellent acoustics for devotional chanting.

KARLE The chaitya hall (FIGS. 6-1 and 6-9) carved out of the living rock at Karle in imitation of earlier wooden structures is the best early example of a Buddhist stupa hall. Datable around 100 CE, the Karle hall has a pillared *ambulatory* (walking path) that allows worshipers to circumambulate the stupa placed at the back of the sacred cave. The hall also has excellent acoustics for devotional chanting. It is nearly 45 feet high and 125 feet long and surpasses in size even the rock-cut chamber (FIG. 3-23) of the temple of the Egyptian pharaoh Ramses II. Elaborate capitals atop the rock-cut pillars depict men and women riding on elephants. Outside, amorous couples (*mithunas*) flank the entrance. Like the yakshis at Sanchi, these auspicious figures symbolize the creative life force.

GANDHARA The first anthropomorphic representations of the Buddha probably appeared in the first century CE. Scholars still debate what brought about this momentous shift in Buddhist iconography, but one factor may have been the changing perception of the Buddha himself. Originally revered as an enlightened mortal, the Buddha increasingly became regarded as a divinity. Consequently, the Buddha's followers desired images of him to worship.

Many of the early portrayals of the Buddha in human form come from the Gandhara region. A second-century CE statue (FIG. 6-10) carved in gray schist, the local stone, shows the Buddha, with ushnisha and urna, dressed in a monk's robe, seated in a cross-legged yogic posture similar to that of the ancient figure on the Indus seal in FIG. 6-5. The Buddha's hands overlap, palms upward, in the dhyana mudra, the gesture of meditation (see "Buddhism," page 161). This statue (and Gandharan sculpture in general) owes much to Greco-Roman art, both in the treatment of body forms, such as the sharp, arching brows and continuous profile of forehead and nose (FIG. 5-41), and in the draping of the togalike garment (FIG. 10-71).

One of the earliest pictorial narrative cycles in which the Buddha appears in human form also comes from Gandhara. The schist frieze (FIG. 6-11) depicts, in chronological order from left to right, the

6-10 Meditating Buddha, from Gandhara, Pakistan, second century CE. Gray schist, 3' $7\frac{1}{2}''$ high. National Museums of Scotland, Edinburgh.

Many of the earliest portrayals of the Buddha in human form come from Gandhara and depict the Enlightened One as a robed monk. The style of this Gandharan Buddha owes much to Greco-Roman art.

Buddha's birth at Lumbini, his enlightenment at Bodh Gaya, his first sermon at Sarnath, and the Buddha's death at Kushinagara. At the left, Queen Maya, in a posture derived from that of earlier South Asian yakshis (FIG. 6-8), gives birth to Prince Siddhartha, who emerges from her right hip, already with his attributes of ushnisha, urna, and halo. Receiving him is the god Indra. Elegantly dressed ladies, one with a fan of peacock feathers, suggest the opulent court life the Buddha left behind. In the next scene, the Buddha sits beneath the Bodhi tree while the soldiers and demons of the evil Mara attempt to distract him from his quest for knowledge. They are unsuccessful, and the Buddha reaches down to touch the earth (bhumisparsha mudra) as witness to his enlightenment. Next, the Buddha preaches the Eightfold Path to nirvana in the Deer Park at Sarnath. The sculptor set the scene by placing two deer and the Wheel of the Law beneath the figure of the Buddha, who raises his right hand (abhaya mudra) to bless the monks and other devotees who have come to hear his first sermon. In the final section of the frieze, the parinirvana, the Buddha lies dying among his devotees, some of whom wail in grief, while one monk, who realizes that the Buddha has been permanently released from suffering, remains tranquil in meditation.

Although the iconography of the frieze is Buddhist, Roman reliefs must have served as stylistic models for the sculptor. For example, the distribution of standing and equestrian figures over the relief ground, with those behind the first row seemingly suspended in the

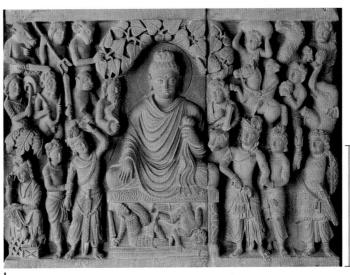

1 ft.

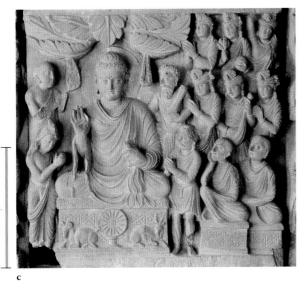

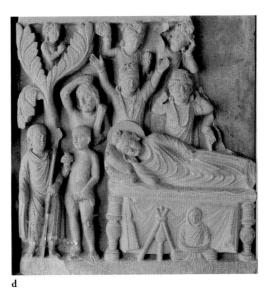

6-11 The life and death of the Buddha, frieze from Gandhara, Pakistan, second century ce. Schist, $2' 2\frac{3}{8}'' \times 9' 6\frac{1}{8}''$. Freer Gallery of Art, Washington, D.C. (a) birth at Lumbini, (b) enlightenment at Bodh Gaya, (c) first sermon at Sarnath, (d) death at Kushinagara.

This Gandharan frieze is one of the earliest pictorial narrative cycles in which the Buddha appears in human form. It recounts the Buddha's life story from his birth at Lumbini to his death at Kushinagara.

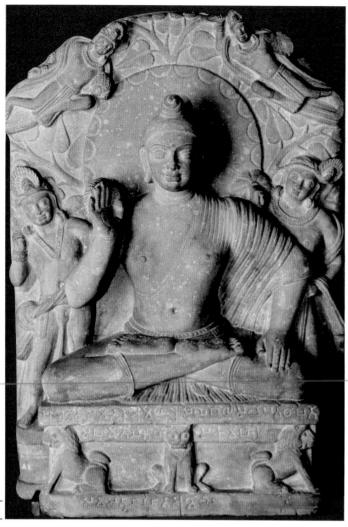

6-12 Buddha seated on lion throne, from Mathura, India, second century CE. Red sandstone, 2' $3\frac{1}{2}''$ high. Archaeological Museum, Muttra.

Stylistically distinct from the Gandharan Buddhas are those of Mathura, where the Buddha has the body type of a yaksha but wears a monk's robe. This example depicts the Buddha under the Bodhi tree.

air, is familiar in Roman art of the second and third centuries CE (FIGS. 10-65 and 10-70). The figure of the Buddha on his deathbed finds parallels in the reclining figures on the lids of Roman sarcophagi (FIG. 10-61). The type of hierarchical composition in which a large central figure sits between balanced tiers of smaller onlookers is also common in Roman imperial art (FIG. 10-76).

MATHURA Contemporary to but stylistically distinct from the Gandharan sculptures are the Buddha images of Mathura, a city about 90 miles south of Delhi that was also part of the Kushan Empire. The Mathura statues (for example, FIG. 6-12) are more closely linked to the Indian portrayals of *yakshas*, the male equivalents of the yakshis. Indian artists represented yakshas as robust, powerful males with broad shoulders and open, staring eyes. Mathura Buddhas, carved from red sandstone like the Harappa nude male (FIG. 6-4), retain these characteristics but wear a monk's robe (with right shoulder bare) and lack the jewelry and other signs of wealth of the yakshas. The robe appears almost transparent, revealing the full, fleshy body beneath. In FIG. 6-12, the Buddha sits in a yogic posture on a lion throne under the Bodhi tree, attended by fly-whisk bearers. He raises his right hand palm outward in the abhaya gesture, indicating to worshipers that they need have no fear. His hands and feet bear the mark of the Wheel of the Law.

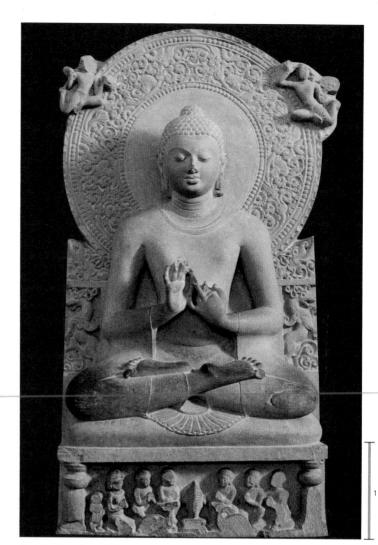

6-13 Seated Buddha preaching first sermon, from Sarnath, India, second half of fifth century. Tan sandstone, 5′ 3″ high. Archaeological Museum, Sarnath.

Under the Guptas, artists formulated the canonical image of the Buddha, combining the Gandharan monastic-robe type with the Mathuran type of soft, full-bodied figure attired in clinging garments.

The Gupta and Post-Gupta Periods

Around 320^* a new empire arose in north-central India. The Gupta emperors chose Pataliputra as their capital, deliberately associating themselves with the prestige of the former Maurya Empire. The heyday of this dynasty was under Chandragupta II (r. 375–415), whose very name recalled the first Maurya emperor. The Guptas were great patrons of art and literature.

SARNATH Under the Guptas, artists formulated what became the canonical image of the Buddha, combining the Gandharan monastic robe covering both shoulders with the Mathuran tradition of soft, full-bodied Buddha figures dressed in clinging garments. These disparate styles beautifully merge in a fifth-century statue (FIG. 6-13) of the Buddha from Sarnath. The statue's smooth, unadorned surfaces conform to the Indian notion of perfect body form and emphasize the figure's spirituality. The Buddha's eyes are downcast in meditation, and he holds his hands in front of his body in the Wheel-turning gesture, preaching his first sermon. Below the Buddha is a scene with the Wheel of the Law at the center between two (now partially broken) deer sym-

^{*}From this point on, all dates in this chapter are CE unless otherwise stated.

bolizing the Deer Park at Sarnath. Buddha images such as this one became so popular that temples housing Buddha statues seem largely to have displaced the stupa as the norm in Buddhist sacred architecture.

AJANTA The new popularity of Buddha imagery may be seen in the interior of a chaitya hall (FIG. 6-14) carved out of the mountainside at Ajanta, northeast of Bombay, at about the same time a Gupta sculptor created the classic seated Buddha at Sarnath. Ajanta had been the site of a small Buddhist monastery for centuries, but royal patrons of the local Vakataka dynasty, allied to the Guptas by marriage, added more than 20 new caves in the second half of the fifth century. The typological similarity of the fifth-century Ajanta chaitya halls to the earlier example at Karle (FIG. 6-1) is immediately evident and consistent with the conservative nature of religious architecture in all cultures. At Ajanta, however, sculptors carved into the front of the stupa an image of the Buddha standing between columns. Ajanta's fame, however, stems from the many caves that retain their painted wall (FIG. 6-15) and ceiling decoration (see "The Painted Caves of Ajanta," below).

Buddhists and Hindus (and adherents of other faiths) practiced their religions side by side in India, often at the same site. For example, the Hindu Vakataka king Harishena (r. 462–481) and members of his court were the sponsors of new caves at the

6-14 Interior of cave 19, Ajanta, India, second half of fifth century.

The popularity of Gupta Buddha statues led to a transformation in Indian religious architecture. Cave 19 at Ajanta is a chaitya hall with an image of the Buddha carved on the front of its stupa.

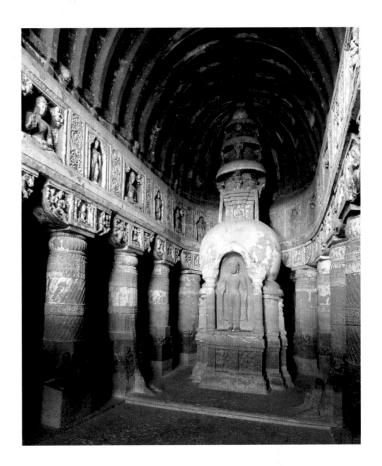

MATERIALS AND TECHNIQUES

The Painted Caves of Ajanta

rt historians assume India had a rich painting tradition in ancient times, but because early Indian artists often used perishable materials, such as palm leaf and wood, and because of the tropical climate in much of India, nearly all early Indian painting has been lost. At Ajanta in the Deccan, however, paintings cover the walls, pillars, and ceilings of several caves datable to the second half of the fifth century. Fig. 6-15 reproduces a detail of one of the restored murals in cave 1 at Ajanta. The bodhisattva Padmapani sits among a crowd of devotees, both princes and commoners. With long, dark hair hanging down below a jeweled crown, he stands holding his attribute, a blue lotus flower, in his right hand. The painter rendered with finesse the sensuous form of the richly attired bodhisattva, gently modeling the figure with gradations of color and delicate highlights and shading, especially evident in the face and neck. The artist also carefully considered the placement of the painting in the cave. The bodhisattva gazes downward at worshipers passing through the entrance to the shrine on their way to the rock-cut Buddha image in a cell at the back of the cave.

To create the Ajanta murals, the painters first applied two layers of clay mixed with straw and other materials to the walls. They then added a third layer of fine white lime plaster. Unlike true fresco painting (see "Fresco Painting," Chapter 19, page 504), in which the painters apply colors to wet plaster, the Indian painters waited for the lime to dry. This method produces less durable results, and the Ajanta murals have suffered water damage over the centuries. The painters next outlined the figures in dark red and then painted in the details of faces, costumes, and jewelry. They used water-soluble colors produced primarily from local minerals, including red and yellow ocher. Blue, used sparingly, came from costly lapis lazuli imported from Afghanistan. The last step was to polish the painted surface with a smooth stone.

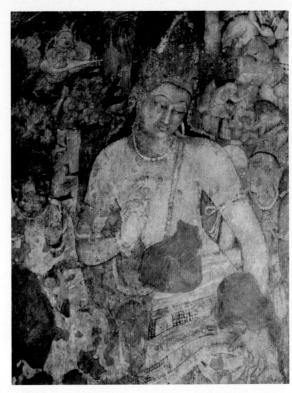

6-15 Bodhisattva Padmapani, detail of a wall painting in cave 1, Ajanta, India, second half of fifth century.

In this early example of Indian painting in an Ajanta cave, the artist rendered the sensuous form of the richly attired bodhisattva with gentle gradations of color and delicate highlights and shadows.

Hinduism and Hindu Iconography

nlike Buddhism (and Christianity, Islam, and other religions), Hinduism recognizes no founder or great prophet. Hinduism also has no simple definition but means "the religion of the Indians." Both "India" and "Hindu" have a common root in the name of the Indus River. The practices and beliefs of Hindus vary tremendously, but the literary origins of Hinduism can be traced to the Vedic period, and some aspects of Hindu practice seem already to have been present in the Indus Civilization of the third millennium BCE. Ritual sacrifice by Brahmin priests is central to Hinduism, as it was to the Aryans. The goal of sacrifice is to please a deity in order to achieve release (moksha, or liberation) from the endless cycle of birth, death, and rebirth (samsara) and become one with the universal spirit.

Not only is Hinduism a religion of many gods, but the Hindu deities have various natures and take many forms. This multiplicity suggests the all-pervasive nature of the Hindu gods. The three most important deities are the gods Shiva and Vishnu and the goddess Devi. Each of the three major sects of Hinduism today considers one of these three to be supreme—Shiva in Shaivism, Vishnu in Vaishnavism, and Devi in Shaktism. (*Shakti* is the female creative force.)

Shiva is the Destroyer, but, consistent with the multiplicity of Hindu belief, he is also a regenerative force and, in the latter role, can be represented in the form of a *linga* (a phallus or cosmic pillar). When Shiva appears in human form in Hindu art, he frequently has multiple limbs and heads (FIGS. 6-17, 6-18, and 6-25), signs of his suprahuman nature, and matted locks piled atop his head, crowned

by a crescent moon. Sometimes he wears a serpent scarf and has a third eye on his forehead (the emblem of his all-seeing nature). Shiva rides the bull *Nandi* (FIG. 6-17) and often carries a *trident*, a three-pronged pitchfork.

Vishnu is the Preserver of the Universe. Artists frequently portray him with four arms (FIGS. 6-20 and 6-29) holding various attributes, including a conch-shell trumpet and discus. He sometimes reclines on a serpent floating on the waters of the cosmic sea (FIGS. 6-20 and 6-29). When the evil forces of the universe become too strong, he descends to earth to restore balance and assumes different forms (*avatars*, or incarnations), including a boar (FIG. 6-16), fish, and tortoise, as well as *Krishna*, the divine lover (FIG. 26-7), and even the Buddha himself.

Devi is the Great Goddess who takes many forms and has many names. Hindus worship her alone or as a consort of male gods (**Parvati** or **Uma**, wife of Shiva; **Lakshmi**, wife of Vishnu), as well as **Radha**, lover of Krishna (FIG. 26-7). She has both benign and horrific forms. She both creates and destroys. In one manifestation, she is **Durga**, a multiarmed goddess who often rides a lion. Her son is the elephantheaded **Ganesha** (FIG. 6-17).

The stationary images of deities in Hindu temples are often made of stone. Hindus periodically remove portable images of their gods, often of bronze (FIG. 6-25), from the temple, particularly during festivals to enable many worshipers to take *darshan* (seeing the deity and being seen by the deity) at one time. In temples dedicated to Shiva, the stationary form is the linga.

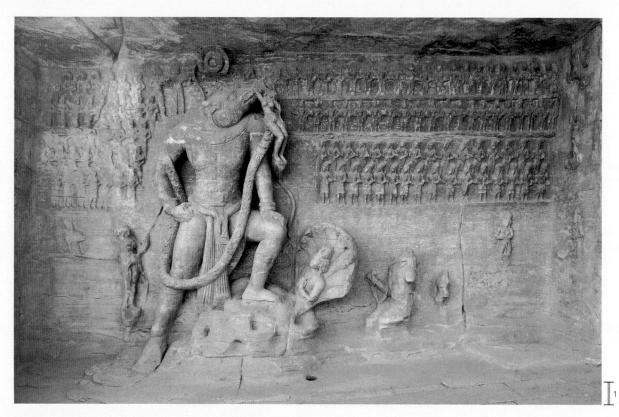

6-16 Boar avatar of Vishnu rescuing the earth, cave 5, Udayagiri, India, early fifth century. Relief $13' \times 22'$; Vishnu 12' 8" high.

The oldest Hindu cave temples are at Udayagiri, a site that also boasts some of the earliest Hindu stone sculptures, such as this huge relief of Vishnu as the boar Varaha rescuing the earth.

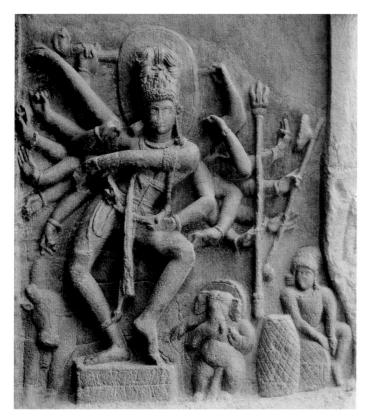

6-17 Dancing Shiva, rock-cut relief in cave temple, Badami, India, late sixth century.

Shiva here dances the cosmic dance and has 18 arms, some holding objects, others forming mudras. Hindu gods often have multiple limbs to indicate their suprahuman nature and divine powers.

Buddhist monastery at Ajanta. Buddhism and Hinduism are not monotheistic religions, such as Judaism, Christianity, and Islam. Instead, Buddhists and Hindus approach the spiritual through many gods and varying paths, which permits mutually tolerated differences. In fact, in Hinduism, the Buddha was one of the 10 incarnations of Vishnu, one of the three principal Hindu deities (see "Hinduism and Hindu Iconography," page 168).

UDAYAGIRI More early Buddhist than Hindu art has survived in India because the Buddhists constructed large monastic institutions with durable materials such as stone and brick. But in the Gupta period, Hindu stone sculpture and architecture began to rival the great Buddhist monuments of South Asia. The oldest Hindu cave temples are at Udayagiri, near Sanchi. They date to the early fifth century, some 600 years after the first Buddhist examples. Although the Udayagiri temples are architecturally simple and small, the site boasts monumental relief sculptures showing an already fully developed religious iconography. One of these reliefs (FIG. 6-16), carved in a shallow niche of rock, shows a 13-foot-tall Vishnu in his incarnation as the boar Varaha. The avatar has a human body and a boar's head. Vishnu assumed this form when he rescued the earth—personified as the goddess Bhudevi clinging to the boar's tusk—from being carried off to the bottom of the ocean. Vishnu stands with one foot resting on the coils of a snake king (note the multiple hoods behind his human head), who represents the conquered demon that attempted to abduct the earth. Rows of gods and sages form lines to witness the event.

The relief served a political as well as a religious purpose. The patron of the relief was a local king who honored the great Gupta king Chandragupta II in a nearby inscription dated to the year 401. Many scholars believe that the local king wanted viewers to see

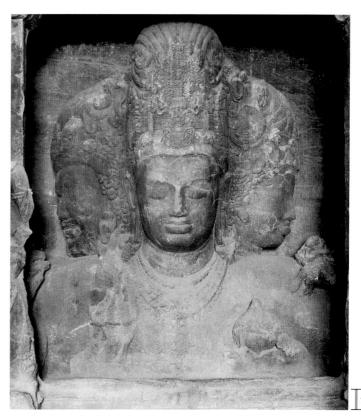

6-18 Shiva as Mahadeva, cave 1, Elephanta, India, ca. 550–575. Basalt, Shiva 17′ 10″ high.

This immense rock-cut image of Shiva as Mahadeva ("Great God") emerges out of the depths of the Elephanta cave as worshipers' eyes adjust to the darkness. The god has both male and female faces.

Chandragupta (he is known to have visited the site) as saving his kingdom by ridding it of its enemies in much the same way Varaha saved the earth.

BADAMI During the sixth century, the Huns brought down the Gupta Empire, and various regional dynasties rose to power. In the Deccan plateau of central India, the Chalukya kings ruled from their capital at Badami. There, Chalukya sculptors carved a series of reliefs in the walls of halls cut into the cliff above the city. One relief (FIG. 6-17), datable to the late sixth century, shows Shiva dancing the cosmic dance, his 18 arms swinging rhythmically in an arc. Some of the hands hold objects, and others form prescribed mudras. At the lower right, the elephant-headed Ganesha tentatively mimics Shiva. Nandi, Shiva's bull mount, stands at the left. Artists often represented Hindu deities as part human and part animal (FIG. 6-16) or, as in the Badami relief, as figures with multiple body parts. Such composite and multilimbed forms indicate that the subjects are not human but suprahuman gods with supernatural powers.

ELEPHANTA Another portrayal of Shiva as a suprahuman being is found at a third Hindu cave site, on Elephanta, an island in Bombay's harbor that early Portuguese colonizers named after a life-size stone elephant sculpture there. A king of the Kalachuri dynasty that took control of Elephanta in the sixth century may have commissioned the largest of the island's cave temples. Just inside the west entrance to the cave is a shrine housing Shiva's linga, the god's emblem. Deep within the temple, in a niche once closed off with wooden doors, is a nearly 18-foot-high rock-cut image (FIG. 6-18) of Shiva as Mahadeva, the "Great God" or Lord of Lords. Mahadeva appears to emerge out of the depths of the cave as worshipers' eyes become accustomed to the darkness. This image of

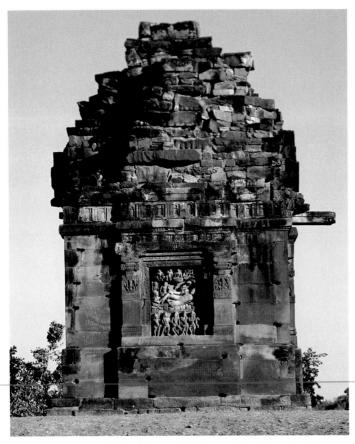

6-19 Vishnu Temple (looking north), Deogarh, India, early sixth century.

One of the first masonry Hindu temples, the Vishnu Temple at Deogarh is a simple square building with a tower. Sculpted guardians protect its entrance. Narrative reliefs adorn the three other sides.

Shiva has three faces, each showing a different aspect of the deity. (A fourth, unseen at the back, is implied—the god has not emerged fully from the rock.) The central face expresses Shiva's quiet, balanced demeanor. The clean planes of the face contrast with the richness of the piled hair encrusted with jewels. The two side faces differ significantly. That on the right is female, with framing hair curls. The left face is a grimacing male with a curling mustache who wears a cobra as an earring. The female (Uma) indicates the creative aspect of Shiva. The fierce male (Bhairava) represents Shiva's destructive side. Shiva holds these two opposing forces in check, and the central face expresses their balance. The cyclic destruction and creation of the universe, which the side faces also symbolize, are part of Indian notions of time, matched by the cyclic pattern of death and rebirth (samsara).

DEOGARH The excavated cave shrines just considered are characteristic of early Hindu religious architecture, but temples constructed using quarried stone became more important as Hinduism evolved over the centuries. As they did with the cave temples, the Hindus initially built rather small and simple temples but decorated them with narrative reliefs displaying a fully developed iconography. The Vishnu Temple (FIG. 6-19) at Deogarh in north-central India, erected in the early sixth century, is among the first Hindu temples constructed with stone blocks. A simple square building, it has an elaborately decorated doorway at the front and a relief in a niche on each of the other three sides. Sculpted guardians and mithunas protect the doorway at Deogarh, because it is the transition point be-

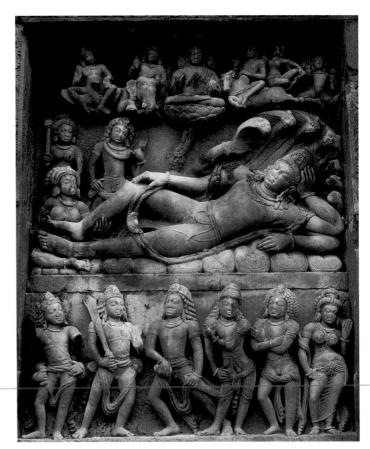

6-20 Vishnu asleep on the serpent Ananta, relief panel on the south facade of the Vishnu Temple, Deogarh, India, early sixth century.

Sculptors carved the reliefs of the Vishnu Temple at Deogarh in classic Gupta style. In this one, the four-armed Vishnu sleeps on the serpent Ananta as he dreams the universe into reality.

tween the dangerous outside and the sacred. The temple culminates in a tower that was originally at least 40 feet tall.

The reliefs in the three niches of the Deogarh temple depict important episodes in the saga of Vishnu. On the south (FIG. 6-20), Vishnu sleeps on the coils of the giant serpent Ananta, whose multiple heads form a kind of umbrella around the god's face. While Lakshmi massages her husband's legs (he has cramps as he gives birth), the four-armed Vishnu dreams the universe into reality. A lotus plant (said to have grown out of Vishnu's navel) supports the four-headed Hindu god of creation, Brahma. Flanking him are other important Hindu divinities, including Shiva on his bull. Below are six figures. The four at the right are personifications of Vishnu's various powers. They will defeat the two armed demons at the left. The sculptor carved all the figures in the classic Gupta style, with smooth bodies and clinging garments (compare FIG. 6-13).

Early Medieval Period

During the several centuries corresponding to the early medieval period in western Europe (see Chapter 16), the early Islamic period in the Near East (see Chapter 13), the Tang and Song dynasties in China (see Chapter 7), and the Nara and Heian periods in Japan (see Chapter 8), regional dynasties ruled parts of India. Among the most important of these kingdoms were the Palas and Chandellas in northern India and the Pallavas and Cholas in the south. Whereas Buddhism spread rapidly throughout eastern Asia, in medieval India it gradually

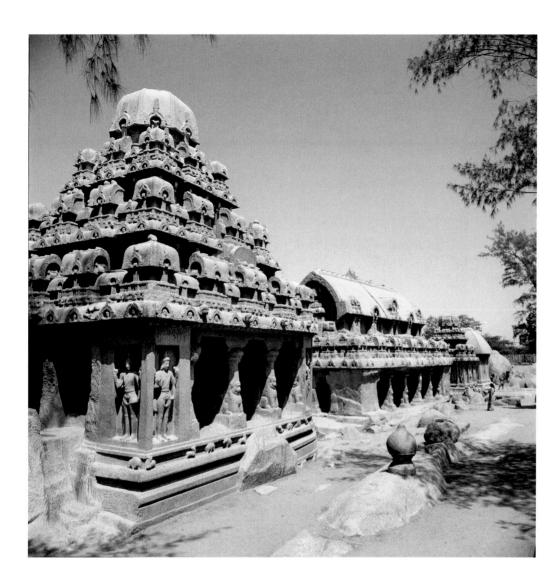

6-21 Rock-cut rathas, Mamallapuram, India, second half of seventh century. From *left* to *right*: Dharmaraja, Bhima, Arjuna, and Draupadi rathas.

Indian architects also created temples by sculpting them from the living rock. The seventh-century rathas ("chariots" of the gods) at Mamallapuram were all carved from a single huge granite outcropping.

declined, and the various local kings vied with one another to erect glorious shrines to the Hindu gods.

MAMALLAPURAM In addition to cave temples and masonry temples, Indian architects created a third type of monument: free-standing temples carved out of rocky outcroppings. Sculpted monolithic temples are rare. Some of the earliest and most impressive are at Mamallapuram, south of Madras on the Bay of Bengal, where they are called *rathas*, or "chariots" (that is, vehicles of the gods). In the late seventh century, the Pallava dynasty had five rathas (FIG. 6-21) carved out of a single huge granite boulder jutting out from the sand. The group is of special interest because it illustrates the variety of temple forms at this period, based on earlier wooden structures, before a standard masonry type of temple became the rule in southern India.

The largest Mamallapuram ratha, the Dharmaraja (FIG. 6-21, *left*), dedicated to Shiva, is an early example of the typical southern-style temple with stepped-pyramid vimana (see "Hindu Temples," page 172). The tower ascends in pronounced tiers of cornices decorated with miniature shrines. The lower walls include carved columns and figures of deities inside niches. The Bhima ratha to the right, dedicated to Vishnu, has a rectangular plan and a rounded roof; the next ratha, the Arjuna, is a smaller example of the southern Indian type. At the end of the row sits the very small Draupadi ratha, which was modeled on a thatched hut and is dedicated to Durga, a form of the goddess Devi. The two largest temples were never finished.

THANJAVUR Under the Cholas, whose territories extended into part of Sri Lanka and even Java, architects constructed temples of unprecedented size and grandeur in the southern Indian tradition. The Rajarajeshvara Temple (FIG. 6-22) at Thanjavur, dedicated in 1010 to Shiva as the Lord of Rajaraja, was the largest and tallest temple (210 feet high) in India at its time. The temple stands inside a walled precinct. It consists of a stairway leading to two flat-roofed mandapas, the larger one having 36 pillars, and to the garbha griha in the base of the enormous pyramidal vimana that is as much an emblem of the Cholas' secular power as of their devotion to Shiva. On the exterior walls of the lower stories are numerous reliefs in niches depicting the god in his various forms.

KHAJURAHO At the same time the Cholas were building the Rajarajeshvara Temple at Thanjavur in the south, the Chandella dynasty was constructing temples—in northern style—at Khajuraho. The Vishvanatha Temple (FIG. 6-23) is one of more than 20 large and elaborate temples at that site. Vishvanatha ("Lord of the World") is another of the many names for Shiva. Dedicated in 1002, the structure has three towers over the mandapas, each rising higher than the preceding one, leading to the tallest tower at the rear, in much the same way the foothills of the Himalayas, Shiva's home, rise to meet their highest peak. The mountain symbolism applies to the interior of the Vishvanatha Temple as well. Under the tallest tower, the shikhara, is the garbha griha, the small and dark inner sanctuary chamber, like a cave, which houses the image of the deity. Thus,

Hindu Temples

The Hindu temple is the home of the gods on earth and the place where they make themselves visible to humans. At the core of all Hindu temples is the *garbha griha*, the "womb chamber," which houses images or symbols of the deity—for example, Shiva's linga (see "Hinduism," page 168). Only the Brahmin priests can enter this inner sanctuary to make offerings to the gods. The worshipers can

only stand at the threshold and behold the deity as manifest by its image. In the elaborate multi-roomed temples of later Hindu architecture, the worshipers and priests progress through a series of ever more sacred spaces, usually on an east-west axis. Hindu priests and architects attached great importance to each temple's plan and sought to make it conform to the sacred geometric diagram (mandala) of the universe.

Architectural historians, following ancient Indian texts, divide Hindu temples into two major typological groups tied to geography. The most important distinguishing feature of the **northern** style of temple (FIG. 6-23) is its bee-hivelike tower or *shikhara* ("mountain peak"), capped by an *amalaka*, a ribbed cushionlike form, derived from the shape of the amala fruit (believed to have medicinal powers). Amalakas appear on the corners of the lower levels of the

6-22 Rajarajeshvara Temple, Thanjavur, India, ca. 1010.

The Rajarajeshvara Temple at Thanjavur is an example of the southern type of Hindu temple. Two flat-roofed mandapas lead to the garbha griha in the base of its 210-foot-tall pyramidal vimana.

shikhara too. Northern temples also have smaller towerlike roofs over the halls (*mandapas*) leading to the garbha griha.

Southern temples (FIG. 6-22) can easily be recognized by the flat roofs of their pillared mandapas and by their shorter towered shrines, called *vimanas*, which lack the curved profile of their northern counterparts and resemble multilevel pyramids.

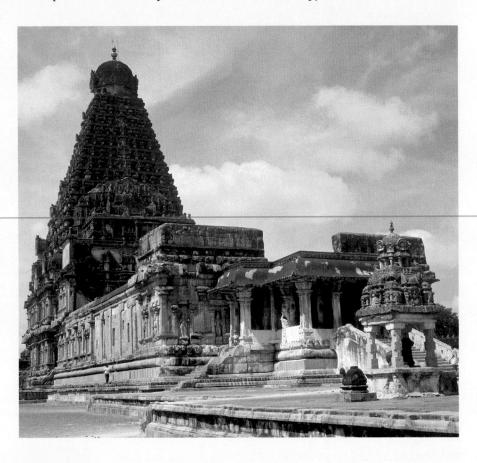

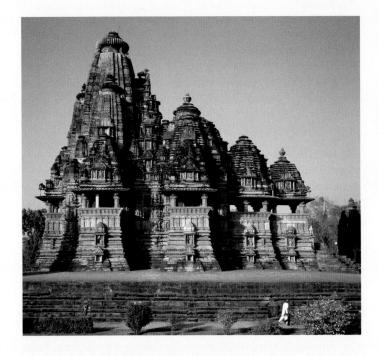

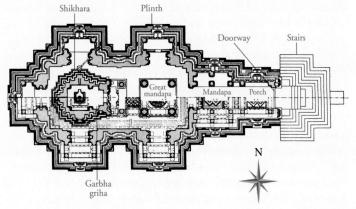

6-23 Vishvanatha Temple (view looking north, *left*, and plan, *above*), Khajuraho, India, ca. 1000.

The Vishvanatha Temple is a northern Hindu temple type. It has four towers, each taller than the preceding one, symbolizing Shiva's mountain home. The largest tower is the beehive-shaped shikara.

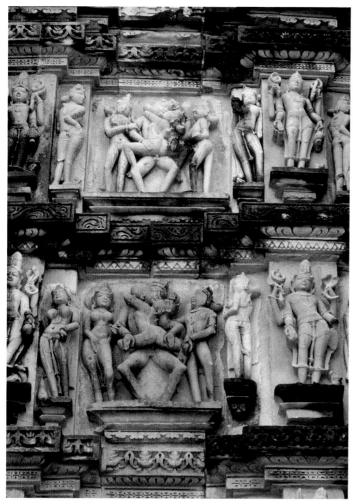

6-24 Mithuna reliefs, detail of the north side of the Vishvanatha Temple, Khajuraho, India, ca. 1000.

Northern Hindu temples are usually decorated with reliefs depicting deities and amorous couples (mithunas). The erotic sculptures suggest the propagation of life and serve as protectors of the sacred precinct.

temples such as the Vishvanatha symbolize constructed mountains with caves, comparable to the actual cave temples at Elephanta and other Indian sites. In all cases, the deity manifests himself or herself within the cave and takes various forms in sculptures. The temple mountains, however, are not intended to appear natural but rather are perfect mountains designed using ideal mathematical proportions.

The reliefs of Thanjavur's Rajarajeshvara Temple are typical of southern temple decoration, which is generally limited to images of deities. The exterior walls of Khajuraho's Vishvanatha Temple are equally typical of northern temples in the profusion of sculptures (FIG. 6-24) depicting mortals as well as gods, especially pairs of men and women (mithunas) embracing or engaged in sexual intercourse in an extraordinary range of positions. The use of seminude yakshis and amorous couples as motifs on religious buildings in India has a very long history, going back to the earliest architectural traditions, both Hindu and Buddhist (Sanchi, FIG. 6-8, and Karle). As in the earlier examples, the erotic sculptures of Khajuraho suggest fertility and the propagation of life and serve as auspicious protectors of the sacred precinct.

SHIVA AS NATARAJA Portable objects also play an important role in Hinduism. The statuette (FIG. 6-25) of Shiva in the Naltunai Ishvaram Temple in Punjai, cast in solid bronze around 1000, recalls the sixth-century relief (FIG. 6-17) in the Badami cave, but it is one of

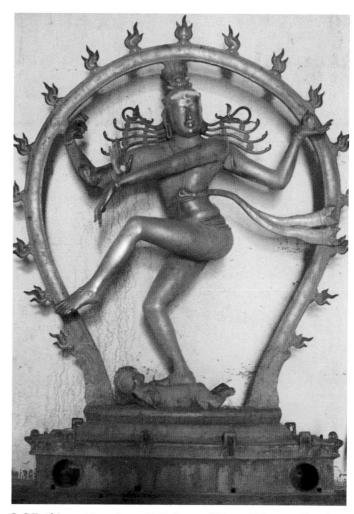

6-25 Shiva as Nataraja, ca. 1000. Bronze. Naltunai Ishvaram Temple, Punjai.

One of many portable images of the gods used in Hindu worship, this solid-bronze statuette of Shiva as Lord of the Dance depicts the god balancing on one leg atop a dwarf representing ignorance.

many examples of moveable images of deities created under the Chola kings and still used in Hindu rituals today. Here, Shiva dances as Nataraja ("Lord of the Dance") by balancing on one leg atop a dwarf representing ignorance, which the god stamps out as he dances. Shiva extends all four arms, two of them touching the flaming *nimbus* (light of glory) encircling him. These two upper hands also hold a small drum (at right) and a flame (at left). Shiva creates the universe to the drumbeat's rhythm, while the small fire represents destruction. His lower left hand points to his upraised foot, indicating the foot as the place where devotees can find refuge and enlightenment. Shiva's lower right hand, raised in the abhaya mudra, tells worshipers to come forward without fear. As Shiva spins, his matted hair comes loose and spreads like a fan on both sides of his head.

At times, worshipers insert poles into the holes on the base of the Punjai Shiva to carry it, but even when stationary, the statuette would not appear as it does in FIG. 6-25. Rather, when Hindus worship the Shiva Nataraja, they dress the image, cover it with jewels, and garland it with flowers. The only bronze part visible is the face, marked with colored powders and scented pastes. Considered the embodiment of the deity, the image is not a symbol of the god but the god itself. All must treat the image as a living being. Worship of the deity involves taking care of him as if he were an honored person. Bathed, clothed, given foods to eat, and taken for outings, the image also receives such gifts as melodic songs, bright lights (lit oil lamps),

6-26 Death of the Buddha (Parinirvana), Gal Vihara, near Polonnaruwa, Sri Lanka, 11th to 12th century. Granulite, Buddha 46' long \times 10' high.

The sculptor of this colossal recumbent Sri Lankan Buddha emulated the classic Gupta style of a half millennium earlier in the figure's clinging robe, rounded face, and coiffure.

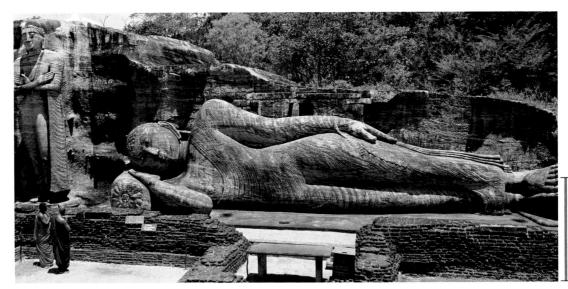

10 ft.

pleasing aromas (incense), and beautiful flowers—all things the god can enjoy through the senses. The food given to the god is particularly important, as he eats the "essence," leaving the remainder for the worshiper. The food is then *prasada* (grace), sacred because it came in contact with the divine. In an especially religious household, the deity resides as an image and receives the food for each meal before the family eats. When the god resides in a temple, it is then the duty of the priests to feed, clothe, and take care of him.

The Chola dynasty ended in the 13th century, a time of political, religious, and cultural change in South Asia. At this point, Buddhism survived in only some areas of India. It soon died out completely there, although the late form of northern Indian Buddhism continued in Tibet and Nepal. At the same time, Islam, which had arrived in India as early as the eighth century, became a potent political force with the establishment of the Delhi Sultanate in 1206. Hindu and Islamic art assumed preeminent roles in India in the 13th century (see Chapter 26).

SOUTHEAST ASIA

Art historians once considered the art of Southeast Asia an extension of Indian civilization. Because of the Indian character of many Southeast Asian monuments, scholars hypothesized that Indian artists had constructed and decorated them and that Indians had colonized Southeast Asia. Today, researchers have concluded that no Indian colonization occurred. The expansion of Indian culture to Southeast Asia during the first millennium CE was peaceful and nonimperialistic, a by-product of trade. In the early centuries CE, ships bringing trade goods from India and China to Rome passed through Southeast Asia on the monsoon winds. The local tribal chieftains quickly saw an opportunity to participate, mainly with their own forest products, such as aromatic woods, bird feathers, and spices. Accompanying the trade goods from India were Sanskrit, Buddhism, and Hinduism-and Buddhist and Hindu art. But the Southeast Asian peoples soon modified Indian art to make it their own. Art historians now recognize Southeast Asian art and architecture as a distinctive and important tradition.

Sri Lanka

Sri Lanka (formerly Ceylon) is an island located at the very tip of the Indian subcontinent. Theravada Buddhism, the oldest form of Buddhism, stressing worship of the historical Buddha, Shakyamuni Buddha, arrived in Sri Lanka as early as the third century BCE. From there it spread to other parts of Southeast Asia. With the demise of Buddhism in India in about the 13th century, Sri Lanka now has the longest-lived Buddhist tradition in the world.

GAL VIHARA One of the largest sculptures in Southeast Asia is the 46-foot-long recumbent Buddha (FIG. 6-26) carved out of a rocky outcropping at Gal Vihara in the 11th or 12th century. To the left of the Buddha, much smaller in scale, stands his cousin and chief disciple, Ananda, arms crossed, mourning Shakyamuni's death. Although more than a half millennium later in date, the Sri Lankan representation of the Buddha's parinirvana reveals its sculptor's debt to the classic Gupta sculptures of India, with their clinging garments, rounded faces, and distinctive renditions of hair (compare FIG. 6-13). Other Southeast Asian monuments, in contrast, exhibit a marked independence from Indian models.

Java

On the island of Java, part of the modern nation of Indonesia, the period from the 8th to the 10th centuries witnessed the erection of both Hindu and Buddhist monuments.

BOROBUDUR Borobudur (FIG. 6-27), a Buddhist monument unique in both form and meaning, is colossal in size, measuring about 400 feet per side at the base and about 98 feet tall. Built over a small hill on nine terraces accessed by four stairways aligned with the cardinal points, the structure contains literally millions of blocks of volcanic stone. Visitors ascending the massive monument on their way to the summit encounter more than 500 life-size Buddha images, at least 1,000 relief panels, and some 1,500 stupas of various sizes.

Scholars debate the intended meaning of Borobudur. Most think the structure is a constructed cosmic mountain, a three-dimensional mandala where worshipers pass through various realms on their way to ultimate enlightenment. As they circumambulate Borobudur, pilgrims first see reliefs illustrating the karmic effects of various kinds of human behavior, then reliefs depicting jatakas of the Buddha's earlier lives, and, farther up, events from the life of Shakyamuni. On the circular terraces near the summit, each stupa is hollow and houses a statue of the seated Buddha, who has achieved spiritual enlightenment and preaches using the Wheel-turning mudra. At the very top is the largest, sealed stupa. It may once have contained another Buddha image, but some think it was left empty to symbolize the formlessness of true enlightenment. Although

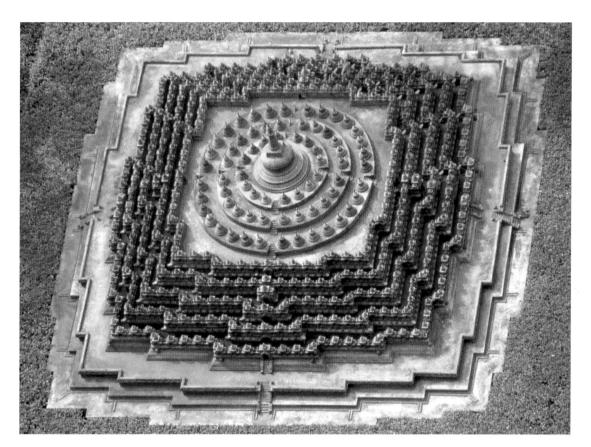

6-27 Aerial view of Borobudur, Java, Indonesia, ca. 800.

Borobudur is a colossal Buddhist monument of unique form. Built on nine terraces with more than 1,500 stupas and 1,500 statues and reliefs, it takes the form of a cosmic mountain, which worshipers circumambulate.

scholars have interpreted the iconographic program in different ways, all agree on two essential points: the dependence of Borobudur on Indian art, literature, and religion, and the fact that nothing comparable exists in India itself. Borobudur's sophistication, complexity, and originality underline how completely Southeast Asians had absorbed, rethought, and reformulated Indian religion and art by 800.

Cambodia

In 802, at about the same time the Javanese built Borobudur, the Khmer King Jayavarman II (r. 802–850) founded the Angkor dynasty, which ruled Cambodia for the next 400 years and sponsored the construction of hundreds of monuments, including gigantic Buddhist monasteries (*wats*). For at least two centuries before the founding of Angkor, the Khmer (the predominant ethnic group in Cambodia) produced Indian-related sculpture of exceptional quality. Images of Vishnu were particularly important during the pre-Angkorian period.

HARIHARA A statue of Vishnu (FIG. 6-28) from Prasat Andet shows the Hindu god in his manifestation as Harihara (Shiva-Vishnu). To represent Harihara, the sculptor divided the statue vertically, with Shiva on the god's right side, Vishnu on his left. The tall headgear reflects the division most clearly. The Shiva half, embell-ished with the winding locks of an ascetic, contrasts with the kingly Vishnu's plain miter. Attributes (now lost) held in the four hands also helped differentiate the two sides. Stylistically, the Cambodian statue, like the Sri Lankan parinirvana group (FIG. 6-26), derives from Indian sculptures (FIG. 6-13) of Gupta style. But unlike almost all stone sculpture in India, carved in relief on slabs or steles, this Khmer image is in the round. The Harihara's broken arms and ankles vividly attest to the vulnerability of this format. The Khmer sculptors, however, wanted their statues to be seen from all sides in the center of the garbha grihas of brick temples.

6-28 Harihara, from Prasat Andet, Cambodia, early seventh century. Stone, 6' 3" high. National Museum, Phnom Penh.

Harihara is a composite of Shiva (the god's right side) and Vishnu (on the left). Although stylistically indebted to Gupta sculpture, the Khmer statue is freestanding so that it could be viewed from all sides.

1 ft.

6-29 Vishnu lying on the cosmic ocean, from the Mebon temple on an island in the western baray, Angkor, Cambodia, 11th century. Bronze, 8' long.

This fragmentary hollow-cast bronze statue was originally more than 20 feet long and inlaid with gold, silver, and jewels. It portrays Vishnu asleep on the cosmic ocean at the moment of the universe's creation.

RECLINING VISHNU The Khmer kings were exceedingly powerful and possessed enormous wealth. A now-fragmentary statue (FIG. 6-29) portraying Vishnu lying on the cosmic ocean testifies to both the luxurious nature of much Khmer art and to the mastery of Khmer bronze casters. The surviving portion is about 8 feet long. In complete form, at well over 20 feet long, the Vishnu statue was among the largest bronzes of the ancient and medieval worlds, surpassed only by such lost wonders as the statue of Athena (FIG. 5-46) in the Parthenon and the 120-foot-tall colossus of the Roman emperor Nero (see "The Golden House of Nero," Chapter 10, page 259). Originally, gold and silver inlays and jewels embellished the image, and the god wore a separate miter on his head. The subject of the gigantic statue is the same as that carved in relief (FIG. 6-20) on the Deogarh Vishnu Temple. Vishnu lies asleep on the cosmic ocean at the moment of the creation of the universe. In the myth, a lotus stem grows from Vishnu's navel, its flower supporting Brahma, the creator god. In this statue, Vishnu probably had a waterspout emerging from his navel, indicating his ability to create the waters as well as to create Brahma and protect the earth. The statue was displayed in an island temple in the western baray (reservoir) of Angkor.

ANGKOR WAT For more than four centuries, successive kings worked on the construction of the site of Angkor. Founded by Indravarman (r. 877-889), Angkor is an engineering marvel, a grand complex of temples and palaces within a rectangular grid of canals and reservoirs fed by local rivers. Each of the Khmer kings built a temple mountain at Angkor and installed his personal god-Shiva, Vishnu, or the Buddha—on top and gave the god part of his own

royal name, implying that the king was a manifestation of the deity. When the king died, the Khmer believed that the god reabsorbed him, because he had been the earthly portion of the deity during his lifetime, so they worshiped the king's image as the god. This concept of kingship approaches an actual deification of the ruler, familiar in many other societies, such as pharaonic Egypt (see Chapter 3).

Of all the monuments the Khmer kings erected, Angkor Wat (FIG. 6-30) is the most spectacular. Built by Suryavarman II (r. 1113-1150), it is the largest of the many Khmer temple complexes. Angkor Wat rises from a huge rectangle of land delineated by a moat measuring about $5,000 \times 4,000$ feet. Like the other Khmer temples, its purpose was to associate the king with his personal god, in this case Vishnu. The centerpiece of the complex is a tall stepped tower surrounded by four smaller towers connected by covered galleries. The five towers symbolize the five peaks of Mount Meru, the sacred mountain at the center of the universe. Two more circuit walls with galleries, towers, and gates enclose the central block. Thus, as one progresses inward through the complex, the towers rise ever higher, in similar manner as the towers of Khajuraho's Vishvanatha Temple (FIG. 6-23) but in a more complex sequence and on a much grander scale.

Throughout Angkor Wat, stone reliefs glorify both Vishnu in his various avatars and Suryavarman II. A detail of a relief (FIG. 6-31) on the inner wall of the lowest gallery shows the king holding court. Suryavarman II sits on an elaborate wooden throne, its bronze legs rising as cobra heads. Kneeling retainers, smaller than the king because they are lesser figures in the Khmer hierarchy, hold a forest of umbrellas and fans, emblems of Suryavarman's exalted rank. In the reliefs of Angkor Wat, religion and politics are united.

6-30 Aerial view of Angkor Wat, Angkor, Cambodia, first half of 12th century.

Angkor Wat, built by Suryavarman II to associate the Khmer king with the god Vishnu, has five towers symbolizing the five peaks of Mount Meru, the sacred mountain at the center of the universe.

6-31 King Suryavarman II holding court, detail of a stone relief, lowest gallery, south side, Angkor Wat, Angkor, Cambodia, first half of 12th century.

The reliefs of Angkor Wat glorify Vishnu in his various avatars, or incarnations, and Suryavarman II, whom the sculptor depicted holding court and surrounded by his attendants, all of smaller scale than the king.

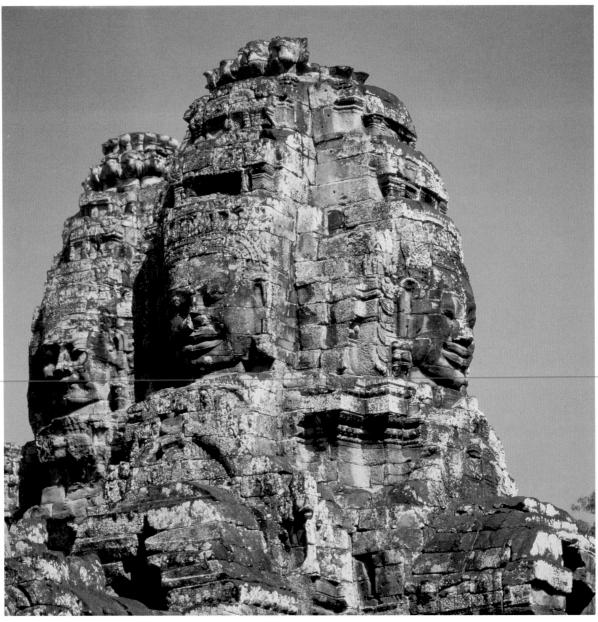

6-32 Towers of the Bayon, Angkor Thom, Cambodia, ca. 1200.

Jayavarman VII embraced Buddhism instead of Hinduism. His most important temple, the Bayon, has towers carved with giant faces that probably depict either the bodhisattva Lokeshvara or the king himself.

BAYON Jayavarman VII (r. 1181–1219), Suryavarman II's son, ruled over much of mainland Southeast Asia and built more during his reign than all the Khmer kings preceding him combined. His most important temple, the Bayon, is a complicated monument constructed with unique circular terraces surmounted by towers carved with giant faces (FIG. 6-32). Jayavarman turned to Buddhism from the Hinduism the earlier Khmer rulers embraced, but he adapted Buddhism so that the Buddha and the bodhisattva Lokeshvara ("Lord of the World") were seen as divine prototypes of the king, in the Khmer tradition. The faces on the Bayon towers perhaps portray Lokeshvara, intended to indicate the watchful compassion emanating in all directions from the capital. Other researchers

have proposed that the faces depict Jayavarman himself. The king's great experiment in religion and art was short-lived, but it also marked the point of change in Southeast Asia when Theravada Buddhism began to dominate most of the mainland. Chapter 26 chronicles this important development.

During the first to fourth centuries, Buddhism also spread to other parts of Asia—to China, Korea, and Japan. Although the artistic traditions in these countries differ greatly from one another, they share, along with Southeast Asia, a tradition of Buddhist art and an ultimate tie with India. Chapters 7 and 8 trace the changes Buddhist art underwent in East Asia, along with the region's other rich artistic traditions.

SOUTH AND SOUTHEAST ASIA BEFORE 1200

INDUS CIVILIZATION, ca. 2600-1500 BCE

- One of the world's earliest civilizations arose in the Indus Valley in the third millennium BCE. Indus cities had streets oriented to the compass points and sophisticated water-supply and sewage systems.
- Little Indus art survives, mainly seals with incised designs and small-scale sculptures like the statue of a "priest-king" from Mohenjo-daro.

Robed male figure, Mohenjo-daro, ca. 2000–1900 BCE

MAURYA DYNASTY, 323-185 BCE

- The first Maurya king repelled the Greeks from India in 305 BCE. The greatest Maurya ruler was Ashoka (r. 272–231 BCE), who converted to Buddhism and spread the Buddha's teaching throughout South Asia.
- Ashoka's pillars are the first monumental stone artworks in India. Ashoka was also the builder of the original Great Stupa at Sanchi.

Lion capital of Ashoka, Sarnath, ca. 250 BCE

SHUNGA, ANDHRA, AND KUSHAN DYNASTIES, ca. 185 BCE-320 CE

- The unifying characteristic of this age of regional dynasties in South Asia was the patronage of Buddhism. In addition to the stupa, the chief early type of Buddhist sacred architecture was the pillared rock-cut chaitya hall.
- The first representations of the Buddha in human form probably date to the first century ce. Gandharan Buddha statues owe a strong stylistic debt to Greco-Roman art.
- By the second century CE, the iconography of the life of the Buddha from his birth at Lumbini to his death at Kushinagara was well established.

The Buddha's first sermon at Sarnath, Gandhara, second century CE

GUPTA AND POST-GUPTA PERIODS, ca. 320-647

- Gupta sculptors established the canonical Buddha image in the fifth century, combining Gandharan iconography with a soft, full-bodied figure in clinging garments.
- The Gupta-period Buddhist caves of Ajanta are the best surviving examples of early mural painting in India.
- The oldest Hindu monumental stone temples and sculptures date to the fifth and sixth centuries, including the rock-cut reliefs of Udayagiri, Badami, and Elephanta, and the Vishnu Temple at Deogarh.

Bodhisattva Padmapani, Ajanta, second half of fifth century

MEDIEVAL PERIOD, 7th to 12th Centuries

- As various dynasties ruled South Asia for several hundred years, distinctive regional styles emerged in Hindu religious architecture. Northern temples, such as the Vishvanatha Temple at Khajuraho, have a series of small towers leading to a tall beehive-shaped tower, or shikhara, over the garbha griha. Southern temples have flat-roofed pillared halls (mandapas) leading to a pyramidal tower (vimana).
- Medieval Southeast Asian art and architecture reflect Indian prototypes, but many local styles developed. The most distinctive monuments of the period are Borobudur on Java and the Buddhist temple complexes of the Khmer kings at Angkor in Cambodia.

Vishvanatha Temple, Khajuraho, ca. 1000

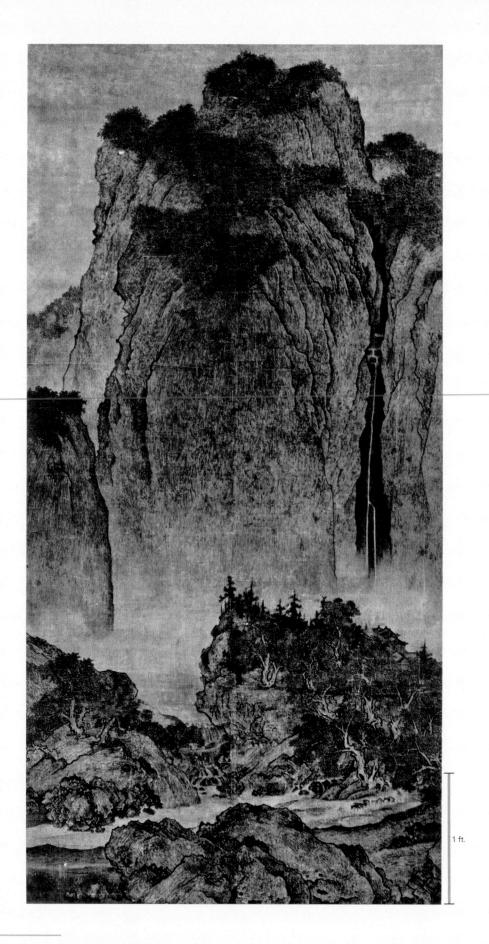

7-1 Fan Kuan, *Travelers among Mountains and Streams*, Northern Song period, early 11th century. Hanging scroll, ink and colors on silk, 6' $7\frac{1}{4}$ " × 3' $4\frac{1}{4}$ ". National Palace Museum, Taibei.

Landscape painting was one of the premier art genres in China. Chinese painters, however, did not aim to represent specific places but to capture the essence of nature using brush and ink on silk.

CHINA AND KOREA TO 1279

East Asia is a vast area, varied in both topography and climate. Dominated by the huge land mass of China, the region also encompasses the peninsula of Korea and the islands of Japan (MAP 7-1). The early arts of China and Korea are discussed in this chapter, and early Japanese art and architecture are treated in Chapter 8. Chapters 27 and 28 examine later developments in China and Korea and in Japan.

CHINA

China's landscape includes sandy plains, mighty rivers, towering mountains, and fertile farmlands. Its political and cultural boundaries have varied over the millennia, and at times its territory has grown to about twice the area of the United States, encompassing Tibet, Chinese Turkestan (Xinjiang), Mongolia, Manchuria, and parts of Korea. China boasts the world's largest population and is ethnically diverse. The spoken language varies so much that speakers of different dialects do not understand one another. However, the written language, which employs *characters* (signs that record spoken words, even if those words are spoken differently in the various dialects), has made possible a shared Chinese literary, philosophic, and religious tradition.

Neolithic Age through Shang Dynasty

China is the only continuing civilization that originated in the ancient world. The Chinese archaeological record, extraordinarily rich, begins in Neolithic times. Discoveries in recent years have expanded the early record enormously and have provided evidence of settled village life as far back as the seventh or early sixth millennium BCE. Excavators have uncovered sites with large multifamily houses constructed of wood, bamboo, wattle, daub, and mud plaster and equipped with hearths. These early villages also had pens for domesticated animals, kilns for pottery production, pits for storage and refuse, and cemeteries for the dead. Chinese Neolithic artisans produced impressive artworks, especially from jade and clay.

YANGSHAO POTTERY Mastery of the art of pottery occurred at a very early date in China. The potters of the Yangshao Culture, which arose along the Yellow River in northeastern China, produced fine

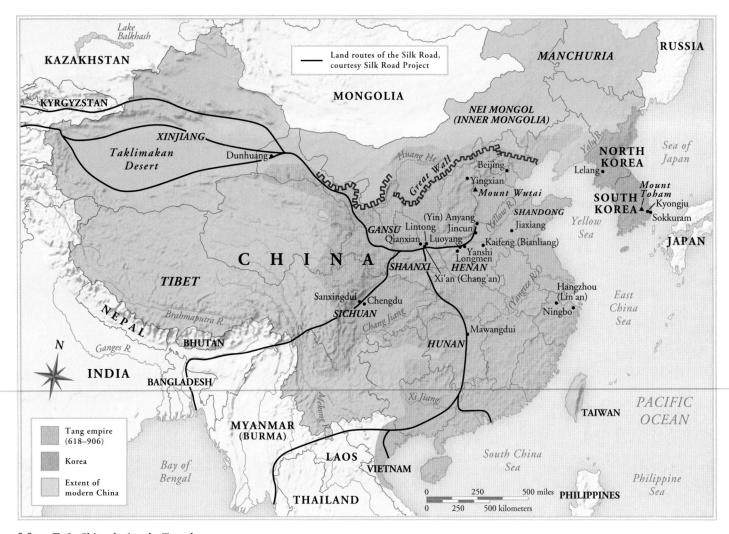

MAP 7-1 China during the Tang dynasty.

decorated *earthenware* bowls (see "Chinese Earthenwares and Stonewares," page 196) even before the invention of the potter's wheel in the fourth millennium BCE. In the third millennium, the Yangshao potters of Gansu Province formed by hand and then painted vessels (FIG. 7-2) of astonishing sophistication. The multiplicity of shapes suggests that the vessels served a wide variety of functions in daily life, but most of the finds come from graves. Decoration is in red and brownish-black on a cream-colored ground. Some pots and bowls include stylized animal motifs, but most feature abstract designs. The painters reveal a highly refined aesthetic sensibility, effectively integrating a variety of angular and curvilinear geometric motifs, including stripes, zigzags, lozenges, circles, spirals, and waves.

SHANG DYNASTY During the past century, archaeologists have begun to confirm China's earliest royal dynasties, long thought to have been mythical. In 1959 excavators found what they believe to be traces of the Xia (ca. 2000–1600 BCE), China's oldest dynasty, at Yanshi in Henan Province. Much better documented, however, is the Shang dynasty (ca. 1600–1050 BCE), the first great Chinese dynasty of

7-2 Yangshao Culture vases, from Gansu Province, China, mid-third millennium BCE.

Neolithic Chinese artists produced vessels of diverse shapes even before the invention of the potter's wheel and decorated them with abstract motifs in red and brownish-black on a cream-colored ground.

Shang Bronze-Casting

mong the finest bronzes of the second millennium BCE are those that Shang artists created using piece molds. The Shang bronze-workers began the process by producing a solid clay model of the desired object. When the model dried to durable hardness, they pressed damp clay around it to form a mold that hardened but remained somewhat flexible. At that point, they carefully cut the mold in pieces, removed the pieces from the model, and baked the pieces in a

7-3 Guang, probably from Anyang, China, Shang dynasty, 12th or 11th century BCE. Bronze, $6\frac{1}{2}$ high. Asian Art Museum of San Francisco, San Francisco (Avery Brundage Collection).

Shang artists perfected the casting of elaborate bronze vessels decorated with animal motifs. The animal forms, real and imaginary, on this libation guang are probably connected with the world of spirits.

kiln to form hard earthenware sections. Sculptors then carved the intricate details of the relief decoration into the inner surfaces of the piece molds. Next, the artists shaved the model to reduce its size to form a core for the piece mold. They then reassembled the mold around the model using bronze spacers to preserve a void between the model and the mold—a space equivalent to the layer of wax used in the lost-wax method (see "Hollow-Casting Life-Size Bronze Statues," Chapter 5, page 122). The Shang bronze-casters then added a final clay layer on the outside to hold everything together, leaving open ducts for pouring molten bronze into the space between the model and the mold and to permit gases to escape. Once the mold cooled, they broke it apart, removed the new bronze vessel, and cleaned and polished it.

Shang bronzes show a mastery in casting rivaling that of any other ancient civilization. The great numbers of cast-bronze vessels strongly suggest well-organized workshops. Shang bronzes held wine, water, grain, or meat for sacrificial rites. Each vessel's shape matched its intended purpose. All were highly decorated with abstract and animal motifs. On the guang illustrated here (FIG. 7-3), the multiple designs and their fields of background spirals integrate so closely with the form of the libation-pouring vessel that they are not merely an external embellishment but an integral part of the

1 in

sculptural whole. Some motifs on the guang's side may represent the eyes of a tiger and the horns of a ram. A horned animal forms the front of the lid, and at the rear is a horned head with a bird's beak. Another horned head appears on the handle. Fish, birds, elephants, rabbits, and more abstract composite creatures swarm over the surface against a background of spirals. The fabulous animal forms, real and imaginary, on Shang bronzes are unlikely to have been purely decorative. They are probably connected with the world of spirits addressed in the rituals.

the Bronze Age. The Shang kings ruled from a series of royal capitals in the Yellow River valley and vied for power and territory with the rulers of neighboring states. In 1928 excavations at Anyang (ancient Yin) brought to light the last Shang capital. There, archaeologists found a large number of objects—turtle shells, animal bones, and bronze containers—inscribed in the earliest form of the Chinese language. These fragmentary records and the other finds at Anyang provide important information about the Shang kings and their affairs. They reveal a warlike, highly stratified society. Walls of pounded earth protected Shang cities. Servants, captives, and even teams of charioteers with chariots and horses accompanied Shang kings to their tombs, a practice also documented at the Royal Cemetery at Ur (see Chapter 2).

The excavated tomb furnishings include weapons and a great wealth of objects in jade, ivory, lacquer, and bronze. Not only the kings received lavish burials. The tomb of Fu Hao, the wife of Wu Ding (r. ca. 1215–1190 BCE), contained an ivory beaker inlaid with

turquoise and more than a thousand jade and bronze objects. Many of the vessels found in Shang tombs, for example, the *guang* (FIG. 7-3), shaped like a covered gravy boat, were used in sacrifices to ancestors and in funerary ceremonies. In some cases families erected shrines for ancestor worship above the burial places. Shang artists cast their elaborate bronze vessels in piece molds (see "Shang Bronze-Casting," above).

SANXINGDUI Recent excavations in other regions of China have greatly expanded historical understanding of the Bronze Age. They suggest that at the same time Anyang flourished under its Shang rulers in northern China, so did other major centers with distinct aesthetic traditions. In 1986, pits at Sanxingdui, near Chengdu in southwestern China, yielded a treasure of elephant tusks and objects in gold, bronze, jade, and clay of types never before discovered. They attest to an independent kingdom of enormous wealth contemporary with the better-known Shang dynasty.

7-4 Standing male figure, from pit 2, Sanxingdui, China, ca. 1200–1050 BCE. Bronze, 8' 5" high, including base. Museum, Sanxingdui. Excavations at Sanxingdui have revealed a Chinese civilization contemporary to the Shang but with a different artistic aesthetic.

This huge statue has elongated proportions and large, staring eyes.

The most dramatic find, a bronze statue (FIG. **7-4**) more than eight feet tall, matches anything from Anyang in masterful casting technique. Very different in subject and style from the Shang bronzes, it initially shocked art historians who had formed their ideas about Bronze Age Chinese aesthetics based on Shang material. This figure—of unknown identity—is highly stylized, with elon-

gated proportions and large, staring eyes. It stands on a base composed of four legs formed of fantastic animal heads with horns and trunklike snouts. The statue tapers gently as it rises, and the figure gradually becomes rounder. Just below the neck, great arms branch dramatically outward, ending in oversized hands that once held an object, most likely one of the many elephant tusks buried with the bronze statue. Chinese representations of the human figure on this scale are otherwise unknown at this early date. Surface decoration of squared spirals and hook-pointed curves is all that links this gigantic statue with the intricate Shang piece-mold bronze vessels (FIG. 7-3). Systematic excavations and chance finds will probably produce more surprises in the future and cause art historians to revise once again their picture of Chinese art in the second half of the second millennium BCE.

Zhou and Qin Dynasties

Around 1050 BCE, the Zhou, former vassals of the Shang, captured Anyang and overthrew their Shang overlords. The Zhou dynasty proved to be the longest lasting in China's history—so long that historians divide the Zhou era into two periods: Western Zhou (ca. 1050–771 BCE) and Eastern Zhou (770–256 BCE). The dividing event is the transfer of the Zhou capital from Chang'an (modern Xi'an) in the west to Luoyang in the east. The closing centuries of Zhou rule include a long period of warfare among competing states (Warring States Period, ca. 475–221 BCE). The Zhou fell to one of these states, the Qin, in 256 BCE.

ZHOU JADE Under the Zhou, the development of markets and the introduction of bronze coinage brought heightened prosperity and a taste for lavish products, such as bronzes inlaid with gold and silver. Late Zhou bronzes featured scenes of hunting, religious rites, and magic practices. These may relate to the subjects and compositions of lost paintings mentioned in Zhou literature. Other materials favored in the late Zhou period were lacquer, a varnishlike substance made from the sap of the Asiatic sumac, used to decorate wood furniture and other objects (see "Lacquered Wood," Chapter 27, page 724), and jade (see "Chinese Jade," page 185). The carving of jade objects for burial with the dead, beginning in Neolithic times, reached a peak of technical perfection during the Zhou dynasty. Among the most common finds in tombs of the period are bi disks (FIG. 7-5)—thin, flat circular pieces of jade with a hole in the center, which may have symbolized the circle of Heaven. Bi disks were status symbols in life as well as treasured items the dead took with them to the afterlife. After a battle, for example, the victors forced their defeated foes to surrender their bi disks as symbols of their submission. The disks also had a high monetary value.

THE FIRST EMPEROR During the Warring States Period, China endured more than two centuries of political and social turmoil. This was also a time of intellectual and artistic upheaval, when conflicting schools of philosophy, including Legalism, Daoism, and Confucianism, emerged (see "Daoism and Confucianism," page 186). Order was finally restored when the powerful armies of the ruler of the state of Qin (from which the modern name "China" derives) conquered all rival states. Known to history by his title, Qin Shi Huangdi (the First Emperor of Qin), between 221 and 210 BCE he controlled an area equal to about half of modern China, much larger than the territories of any of the earlier Chinese dynasties. During his reign, Shi Huangdi ordered the linkage of active fortifications along the northern border of his realm to form the famous Great Wall. The wall defended China against the fierce nomadic peoples of the north, especially the Huns, who eventually made their

Chinese Jade

he Chinese first used jade—or, more precisely, nephrite—for artworks and ritual objects in the Neolithic period. Nephrite polishes to a more lustrous, slightly buttery finish than jadeite (the stone Chinese sculptors preferred from the 18th century on), which is quite glassy. Both stones are beautiful and come in colors other than the well-known green and are tough, hard, and heavy. In China, such qualities became metaphors for the fortitude and moral perfection of superior persons. The Chinese also believed jade possessed magical qualities that could protect the dead. In a Han dynasty tomb, for example, archaeologists discovered the bodies of a prince and princess dressed in suits composed of more than 2,000 jade pieces sewn together with gold wire.

Because of its extreme hardness, jade could not be carved with the Neolithic sculptor's stone tools. Researchers can only speculate on how these early artists were able to cut, shape, and incise the nephrite objects found at many Neolithic Chinese sites. The sculptors probably used cords embedded with sand to incise lines into the surfaces. Sand placed in a bamboo tube drill could perforate the hard stone, but the process would have been long and arduous, requiring great patience as well as superior skill.

Even after the invention of bronze tools, Chinese sculptors still had to rely on grinding and abrasion rather than simple drilling and chiseling to produce the intricately shaped, pierced, and engraved works such as the *bi* (FIG. 7-5) said to have come from a royal Eastern Zhou tomb at Jincun. Rows of raised spirals, created by laborious grinding and polishing, decorate the disk itself. Within the inner circle and around the outer edge of the bi are elegant dragons. The Chinese thought dragons inhabited the water and flew between Heaven and Earth, bringing rain, so these animals long have been symbols of good fortune in East Asia. They also symbolized the rulers' power to mediate between Heaven and Earth. To sculpt the dragons on the bi from Jincun required long hours of work to pierce through the hard jade. The bi testifies to the Zhou sculptor's mastery of this difficult material.

7-5 Bi disk with dragons, from Jincun(?), near Luoyang, China, Eastern Zhou dynasty, fourth to third century BCE. Nephrite, $6\frac{1}{2}$ in diameter. Nelson-Atkins Museum of Art, Kansas City.

This intricately shaped jade bi required long hours of grinding, piercing, engraving, and polishing to produce. The Chinese believed dragons were symbols of good fortune and flew between Heaven and Earth.

way to eastern Europe. By sometimes brutal methods, the First Emperor consolidated rule through a centralized bureaucracy and adopted standardized written language, weights and measures, and coinage. He also repressed schools of thought other than Legalism, which espoused absolute obedience to the state's authority and advocated strict laws and punishments. Chinese historians long have condemned the First Emperor, but the bureaucratic system he put in place had a long-lasting impact. Its success was due in large part to Shi Huangdi's decision to replace the feudal lords with talented salaried administrators and to reward merit rather than favor high birth.

TERRACOTTA ARMY, LINTONG In 1974 excavations started at the site of the immense burial mound of the First Emperor of Qin at Lintong. For its construction, the ruler conscripted more than 700,000 laborers and had the tomb filled with treasure. The project continued after his death. The mound itself remains unexcavated except for some test trenches, but researchers believe it contains a vast underground funerary palace designed to match the fabulous palace the emperor occupied in life. The historian Sima

Qian (136–85 BCE) described both palaces, but scholars did not take his account seriously until the discovery of pits around the tomb filled with more than 6,000 life-size painted terracotta figures (FIG. 7-6) of soldiers and horses, as well as bronze horses and chariots. The terracotta army served as the First Emperor's bodyguard deployed in perpetuity outside his tomb.

The Lintong army, composed of cavalry, chariots, archers, lancers, and hand-to-hand fighters, was one of the 20th century's greatest archaeological discoveries. Lesser versions of Shi Huangdi's army have since been uncovered at other Chinese sites, suggesting that the First Emperor's tomb became the model for many others. The huge assemblage at Lintong testifies to a very high degree of organization in the Qin imperial workshop. Manufacturing this army of statues required a veritable army of sculptors and painters as well as a large number of huge kilns. The First Emperor's artisans could have opted to use the same molds over and over again to produce thousands of identical soldiers standing in strict formation. In fact, they did employ the same molds repeatedly for different parts of the statues but assembled the parts in many different combinations. Consequently, the stances, arm positions, garment folds, equipment,

Daoism and Confucianism

aoism and Confucianism are both philosophies and religions native to China. Both schools of thought attracted wide followings during the Warring States Period (ca. 475–221 BCE), when political turbulence led to social unrest.

Daoism emerged out of the metaphysical teachings attributed to Laozi (604?–531? BCE) and Zhuangzi (370?–301? BCE). It takes its name from Laozi's treatise *Daodejing* (*The Way and Its Power*). Daoist philosophy stresses an intuitive awareness, nurtured by harmonious contact with nature, and shuns everything artificial. Daoists seek to follow the universal path, or principle, called the Dao, whose features cannot be described but only suggested through analogies. For example, the Dao is said to be like water, always yielding but eventually wearing away the hard stone that does not yield. For Daoists, strength comes from flexibility and inaction. Historically, Daoist principles encouraged retreat from society in favor of personal cultivation in nature and the achievement of a perfect balance between *yang*, active masculine energy, and *yin*, passive feminine energy.

Confucius (551–479 BCE) was born in the state of Lu (roughly modern Shandong Province) to an aristocratic family that had fallen on hard times. From an early age, he showed a strong interest in the rites and ceremonies that helped unite people into an orderly society. As he grew older, he developed a deep concern for the suffering the civil conflict of his day caused. Thus, he adopted a philosophy he hoped would lead to order and stability. The *junzi* ("superior person" or "gentleman"), who possesses *ren* ("human-heartedness"), personifies the ideal social order Confucius sought. Although the term *junzi* originally assumed noble birth, in Confucian thought anyone can

become a junzi by cultivating the virtues Confucius espoused, especially empathy for suffering, pursuit of morality and justice, respect for ancient ceremonies, and adherence to traditional social relationships, such as those between parent and child, elder and younger sibling, husband and wife, and ruler and subject.

Confucius's disciple Mencius (or Mengzi, 371?–289? BCE) developed the master's ideas further, stressing that the deference to age and rank that is at the heart of the Confucian social order brings a reciprocal responsibility. For example, a king's legitimacy depends on the goodwill of his people. A ruler should share his joys with his subjects and will know his laws are unjust if they bring suffering to the people.

Confucius spent much of his adult life trying to find rulers willing to apply his teachings, but he died in disappointment. However, he and Mencius had a profound impact on Chinese thought and social practice. Chinese traditions of venerating deceased ancestors and outstanding leaders encouraged the development of Confucianism as a religion as well as a philosophic tradition. Eventually, Emperor Wu (r. 140–87 BCE) of the Han dynasty established Confucianism as the state's official doctrine. Thereafter, it became the primary subject of the civil service exams required for admission into and advancement within government service.

"Confucian" and "Daoist" are broad, imprecise terms scholars often use to distinguish aspects of Chinese culture stressing social responsibility and order (Confucian) from those emphasizing cultivation of individuals, often in reclusion (Daoist). But both philosophies share the idea that anyone can cultivate wisdom or ability, regardless of birth.

coiffures, and facial features vary, sometimes slightly, sometimes markedly, from statue to statue. Additional hand modeling of the cast body parts before firing permitted the sculptors to differentiate the figures even more. The Qin painters undoubtedly added further variations to the appearance of the terracotta army. The result of these efforts was a brilliant balance of uniformity and individuality.

7-6 Army of the First Emperor of Qin in pits next to his burial mound, Lintong, China, Qin dynasty, ca. 210 BCE. Painted terracotta, average figure 5' $10\frac{7}{8}''$ high.

The First Emperor was buried beneath an immense mound guarded by more than 6,000 life-size terracotta soldiers. Although produced from common molds, every figure has an individualized appearance.

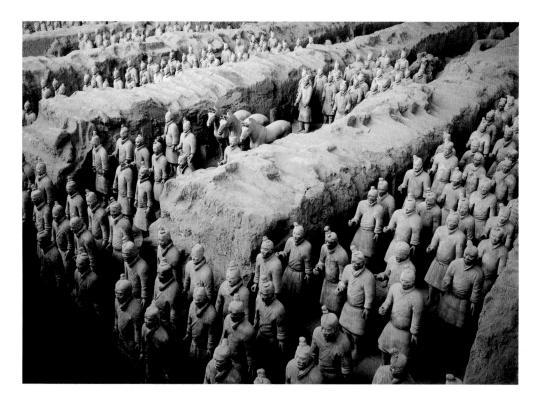

Han Dynasty

Soon after the First Emperor's death, the people who had suffered under his reign revolted, assassinated his corrupt and incompetent son, and founded the Han dynasty in 206 BCE. The Han ruled China for four centuries, integrating many of the Qin reforms in a more liberal governing policy. They also extended China's southern and western boundaries, penetrating far into Central Asia (modern Xinjiang). Han merchants even traded indirectly with distant Rome (via the so-called Silk Road (see "Silk and the Silk Road, p. 188).

THE MARQUISE OF DAI In 1972 archaeologists excavated the tomb of the Marquise of Dai at Mawangdui in Hunan Province. The tomb contained a rich array of burial goods used during the funerary ceremonies and to accompany the deceased woman into the afterlife. Among the many finds were decorated lacquer utensils, various textiles, and an astonishingly well-preserved corpse in the innermost of four nested sarcophagi. Most remarkable, however, was the discovery of a painted T-shaped silk banner (FIG. 7-7) draped over the marquise's coffin. Scholars generally agree that the area within the cross at the top of the T represents Heaven. Most of the vertical section below is the human realm. At the very bottom is the Underworld. In the heavenly realm, dragons and immortal beings appear between and below two orbs—the red sun and its symbol, the raven, on the right, and the silvery moon and its symbol, the toad, on the left. Below, the standing figure on the first white platform near the center of the vertical section is probably the Marquise of Dai herself—one of the first portraits in Chinese art. The woman awaits her ascent to Heaven, where she can attain immortality. Nearer the bottom, the artist depicted her funeral. Between these two sections is a form resembling a bi disk (FIG. 7-5) with two intertwining dragons. Their tails reach down to the Underworld and their heads point to Heaven, unifying the whole composition.

WU FAMILY SHRINES Even more extensive Han pictorial narratives appear on the walls of the Wu family shrines at Jiaxiang in Shandong Province, dating between 147 and 168 CE. The shrines document the emergence of private, nonaristocratic families as patrons of religious and mythological art with political overtones. Dedicated to deceased male family members, the Wu shrines consist of three low walls and a pitched roof. On the interior surfaces, carved images of flat polished stone stand out against an equally flat,

7-7 Funeral banner, from tomb 1 (tomb of the Marquise of Dai), Mawangdui, China, Han dynasty, ca. 168 BCE. Painted silk, $6' \ 8\frac{3}{4}'' \times 3' \frac{1}{4}''$. Hunan Provincial Museum, Changsha.

This T-shaped silk banner was draped over the coffin of the Marquise of Dai, who is shown at the center awaiting her ascent to immortality in Heaven, the realm of the red sun and silvery moon.

though roughly textured, ground. The historical scenes include a representation of the third-century BCE hero Jing Ke's attempt to assassinate the tyrannical First Emperor of Qin. On the slab shown in FIG. 7–8, a *rubbing* (an impression made by placing paper over the surface and rubbing with a pencil or crayon) taken from the stone

7-8 The archer Yi(?) and a reception in a mansion, Wu family shrine, Jiaxiang, China, Han dynasty, 147–168 CE. Rubbing of a stone relief, 3' × 5'.

The Wu family shrines depict historical, legendary, and contemporaneous subjects. Here, the hero Yi shoots down suns to save the Earth from scorching. To the right is a ceremonial scene in a Han mansion.

1 ft

Silk and the Silk Road

ilk is the finest natural fabric ever produced. It comes from the cocoons of caterpillars called silkworms. The manufacture of silk was a well-established industry in China by the second millennium BCE. The basic procedures probably have not changed much since then. Farmers today still raise silkworms from eggs, which they place in trays. The farmers also must grow mulberry trees or purchase mulberry leaves, the silkworms' only food source. Eventually, the silkworms form cocoons out of very fine filaments they extrude as liquid from their bodies. The filaments soon solidify with exposure to air. Before the transformed caterpillars emerge as moths and badly damage the silk, the farmers kill them with steam or high heat. They soften the cocoons in hot water and unwind the filaments onto a reel. The filaments are so fine that workers generally unwind those from five to ten cocoons together to bond into a single strand while the filaments are still soft and sticky. Later, the silkworkers twist several strands together to form a thicker yarn and then weave the yarn on a loom to produce silk cloth. Both the yarn and the cloth can be dyed, and the silk fabric can be decorated by weaving threads of different colors together in special patterns (brocades) or by stitching in threads of different colors (embroidery). Many Chinese artists painted directly on plain silk.

Greatly admired throughout most of Asia, Chinese silk and the secrets of its production gradually spread throughout the ancient world. The Romans knew of silk as early as the second century BCE and treasured it for garments and hangings. Silk came to the Romans along the ancient fabled Silk Road, a network of caravan tracts across Central Asia linking China and the Mediterranean world (MAP 7-1). The western part, between the Mediterranean region and India, developed first, due largely to the difficult geographic conditions to India's northeast. In Central Asia, the caravans had to skirt the Taklimakan Desert, one of the most inhospitable environments on earth, as well as to climb high, dangerous mountain passes. Very few traders traveled the entire route. Along the way, goods usually passed through the hands of people from many lands, who often only dimly understood the ultimate origins and destinations of what they traded. The Roman passion for silk ultimately led to the modern name for the caravan tracts, but silk was by no means the only product traded along the way. Gold, ivory, gems, glass, lacquer, incense, furs, spices, cotton, linens, exotic animals, and other merchandise precious enough to warrant the risks passed along the Silk Road.

Ideas moved along these trade routes as well. Most important perhaps, travelers on the Silk Road brought Buddhism to China from India in the first century CE, opening up a significant new chapter in both the history of religion and the history of art in China.

relief, the archer at the upper left is probably the hero Yi. He saves the Earth from scorching by shooting down the nine extra suns, represented as crows in the Fusang tree. (The small orbs below the sun on the Mawangdui banner, FIG. 7-7, probably allude to the same story.) The lowest zone shows a procession of umbrella-carriages moving to the left. Above, underneath the overhanging eaves of a two-story mansion, robed men bearing gifts pay homage to a central figure of uncertain identity, who is represented as larger and therefore more important. Two men kneel before the larger figure. Women occupy the upper story. Again, one figure, at the center and facing forward, is singled out as the most important. The identities of the individual figures are unknown. Interpretations vary widely, and in the past decade scholars have discovered that some of the Wu reliefs have recarved inscriptions, leading them to question even the traditional date of the slabs. Nonetheless, these scenes of homage and loyalty are consistent with the Confucian ideals of Han society.

HAN HOUSES AND PALACES No actual remains of Han buildings survive, but ceramic models of houses deposited in Han tombs, together with representations such as those in the Wu family shrines, provide a good idea of Chinese architecture during the early centuries CE. An especially large painted earthenware model (FIG. 7-9) reproduces a Han house with sharply projecting tiled roofs resting on a framework of timber posts, lintels, and brackets. This construction method (FIG. 7-10) typifies much Chinese architecture even today (see "Chinese Wooden Construction," page 189). Descriptions of Han palaces suggest they were grandiose versions of the type of house reproduced in this model but with more luxurious decoration, including walls of lacquered wood and mural paintings.

Period of Disunity

For three and a half centuries, from 220 to 581,* civil strife divided China into competing states. Scholars variously refer to this era as the Period of Disunity or the period of the Six Dynasties or of the Northern and Southern Dynasties. The history of this era is extremely complex, but one development deserves special mention—the occupation of the north by peoples who were not ethnically Han Chinese and who spoke non-Chinese languages. It was in the northern states, connected to India by the desert caravan routes of the Silk Road (see "Silk and the Silk Road," above), that Buddhism first took root in China during the Han dynasty. Certain practices shared with Daoism, such as withdrawal from ordinary society, helped Buddhism gain an initial foothold in the north. But Buddhism's promise of hope beyond the troubles of this world earned it an ever broader audience during the upheavals of the Period of Disunity. In addition, the fully developed Buddhist system of thought attracted intellectuals. Buddhism never fully displaced Confucianism and Daoism, but it did prosper throughout China for centuries and had a profound effect on the further development of the religious forms of those two native traditions.

ZHAO BUDDHA A gilded bronze statuette (FIG. 7-11) of Shakyamuni Buddha, the historical Buddha, bears an inscription giving its date as 338. Although some scholars have questioned whether the inscription is a later addition, many art historians still accept the statuette as the earliest precisely datable Chinese image of the Buddha, created during the Later Zhao dynasty (319-351). The oldest Chinese Buddhist texts describe the Buddha as golden and radiating

^{*}From this point on, all dates in this chapter are CE unless otherwise stated.

Chinese Wooden Construction

Ithough the basic unit of Chinese architecture, the rectangular hall with columns supporting a roof, was common in many ancient civilizations, Chinese buildings are distinguished by the curving silhouettes of their roofs and by their method of construction. The Chinese, like other ancient peoples, used wood to construct their earliest buildings. Although those structures do not survive, scholars believe many of the features giving East Asian architecture its specific character may date to the Zhou dynasty. Even the simple buildings reproduced on Han stone carvings (FIG. 7-8) and in clay models (FIG. 7-9) reveal a style and a method of construction long basic to China.

The typical Chinese hall has a pitched roof with projecting eaves. Wooden columns, lintels, and brackets provide the support. The walls serve no weight-bearing function. They act only as screens separating inside from outside and room from room. The colors of Chinese buildings, predominantly red, black, yellow, and white, are also distinctive. Chinese timber architecture is customarily multi-

7-9 Model of a house, Han dynasty, first century CE. Painted earthenware, 4' 4" high. Nelson-Atkins Museum of Art, Kansas City.

1 ft

This model of a Han house provides invaluable information about the form, coloration, and construction methods of Chinese architecture. The flat profile of the rooflines is typical of earlier Chinese buildings.

colored throughout, save for certain parts left in natural color, such as railings made of white marble. The builders usually painted the screen walls and the columns red. Chinese designers often chose dazzling combinations of colors and elaborate patterns for the beams, brackets, eaves, rafters, and ceilings. The builders painted or lacquered the surfaces to protect the timber from rot and wood parasites, as well as to produce an arresting aesthetic effect.

Fig. 7-10 shows the basic construction method of Chinese architecture, with the major components of a Chinese building labeled. The builders laid beams (no. 1) between columns, decreasing the length of the beams as the structure rose. The beams supported vertical struts (no. 2), which in turn supported higher beams and eventually the purlins (no. 3) running the length of the building and carrying the roof's sloping rafters (no. 4). Unlike the rigid elements of the triangular trussed timber roof common in the West, which produce flat sloping rooflines, the varying lengths of the Chinese structure's cross beams and the variously placed purlins can create curved profiles. Early Chinese roofs have flat profiles (FIGS. 7-8 and 7-9), but curving rafters (FIGS. 7-10 and 7-23) later became the norm, not only in China but throughout East Asia. The interlocking clusters of brackets were capable of supporting roofs with broad overhanging eaves (no. 5), another typical feature of Chinese architecture. Multiplication of the bays (spaces between the columns) could extend the building's length to any dimension desired, although each bay could be no wider or longer than the length of a single tree trunk. The proportions of the structural elements could be fixed into modules, allowing for standardization of parts. This enabled rapid construction of a building. Remarkably, the highly skilled Chinese workers fit the parts together without using any adhesive substance, such as mortar or glue.

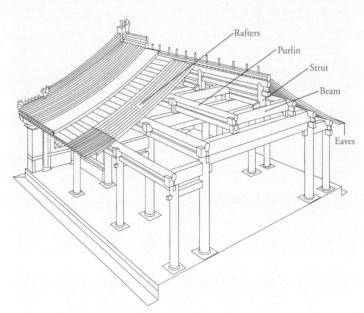

7-10 Chinese raised-beam construction (after L. Liu).

Chinese walls serve no weight-bearing function. They act only as screens separating inside from outside and room from room. Tang dynasty and later buildings usually have curved rafters and eaves.

Chinese Painting Materials and Formats

ural paintings in caves (FIG. 7-15) were popular in China, as they were in South Asia (FIG. 6-15), but Chinese artists also employed several distinctive materials and formats for their paintings.

The basic requirements for paintings not on walls were the same as for writing—a round tapered brush, soot-based ink, and either silk or paper. The Chinese were masters of the brush. Sometimes Chinese painters used modulated lines for contours and interior details that elastically thicken and thin to convey depth and mass. In other works, they used iron-wire lines (thin, unmodulated lines with a suggestion of tensile strength) to define each individual figure in their paintings.

Chinese painters also used richly colored minerals as pigments, finely ground and suspended in a gluey medium, and watery washes of mineral and vegetable dyes.

The formats of Chinese paintings on silk or paper tend to be personal and intimate, and they are usually best viewed by only one or two people at a time. The most common types are

Hanging scrolls (FIGS. 7-1, 7-25, and 7-26). Chinese painters often mounted pictures on, or painted directly on, unrolled vertical scrolls for display on walls.

Handscrolls (FIGS. 7-12, 7-17, and 7-21). Paintings were also frequently attached to or painted on long, narrow scrolls that the viewer unrolled horizontally, section by section from right to left.

Album leaves (FIGS. 7-24 and 27-14). Many Chinese artists painted small panels on paper leaves, which were collected in albums.

Fans (FIG. 27-13). Stiff round or arched folding fans were also popular painting formats.

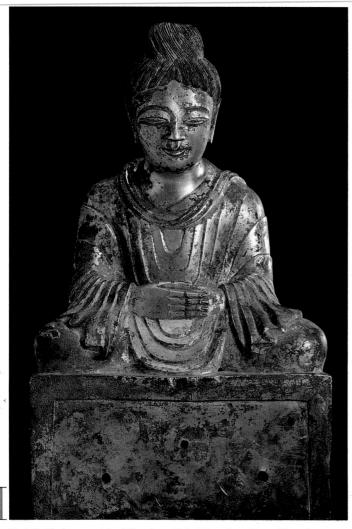

7-11 Shakyamuni Buddha, from Hebei Province, Later Zhao dynasty, Period of Disunity, 338. Gilded bronze, 1' $3\frac{1}{2}$ " high. Asian Art Museum of San Francisco, San Francisco (Avery Brundage Collection).

This earliest datable Chinese Buddha image is stylistically indebted to Gandharan prototypes (FIG. 6-10), but the sculptor, unfamiliar with Buddhist iconography, misrepresented the dhyana mudra.

light, characteristics that no doubt account for the choice of gilded bronze as the sculptor's medium. In both style and iconography, this early Buddha resembles the prototype conceived and developed at Gandhara (FIG. 6-10). The Chinese figure recalls its presumed South Asian models in the flat, relieflike handling of the robe's heavy concentric folds, the ushnisha (cranial bump) on the head, and the crosslegged position. So new were the icon and its meaning, however, that the Chinese sculptor misrepresented the canonical dhyana mudra, or meditation gesture (see "Buddhism and Buddhist Iconography," Chapter 6, page 161). Here, the Buddha clasps his hands across his stomach. In South Asian art, they are turned palms upward, with thumbs barely touching in front of the torso.

LADY FENG'S HEROISM Secular arts also flourished in the Period of Disunity, as rulers sought calligraphers and painters to lend prestige to their courts. The most famous early Chinese painter with whom extant works can be associated was Gu Kaizhi (ca. 344-406). Gu was a friend of important members of the Eastern Jin dynasty (317-420) and won renown as a calligrapher, a painter of court portraits, and a pioneer of landscape painting. A handscroll (see "Chinese Painting Materials and Formats," above) attributed to Gu Kaizhi in the 11th century is not actually by his hand, but it provides a good idea of the key elements of his art. Called Admonitions of the Instructress to the Court Ladies, the horizontal scroll contains painted scenes and accompanying explanatory text. Like all Chinese handscrolls, this one was unrolled and read from right to left, with only a small section exposed for viewing at one time.

The handscroll section illustrated here (FIG. 7-12) records a well-known act of heroism, the Lady Feng saving her emperor's life by placing herself between him and an attacking bear-a perfect model of Confucian behavior. As in many early Chinese paintings, the artist set the figures against a blank background with only a minimal setting for the scene, although in other works Gu provided landscape settings for his narratives. The figures' poses and fluttering drapery ribbons, in concert with individualized facial expressions, convey a clear quality of animation. This style accords well with painting ideals expressed in texts of the time, when representing inner vitality and spirit took precedence over reproducing surface appearances (see "Xie He's Six Canons," page 191).

Xie He's Six Canons

hina has a long and rich history of scholarship on painting, preserved today in copies of texts from as far back as the fourth century and in citations to even earlier sources. Few of the first texts on painting survive, but later authors often quoted them, preserving the texts for posterity. Thus, educated Chinese painters and their clients could steep themselves in a rich art historical tradition. Perhaps the most famous subject of later commentary is a set of six "canons," or "laws," of painting that Xie He formulated in the early sixth century. The canons, as translated by James Cahill,* are as follows:

- 1. Engender a sense of movement through spirit consonance.
- 2. Use the brush with the bone method.
- 3. Responding to things, depict their forms.
- 4. According to kind, describe appearances [with color].
- 5 Dividing and planning, positioning and arranging.
- 6. Transmitting and conveying earlier models through copying and transcribing.

Several variant translations have also been proposed, and scholars actively debate the precise meaning of these succinct (Xie He employed only four characters for each) and cryptic laws. Interpreting the canons in connection with existing paintings is often difficult but nonetheless offers valuable insights into what the Chinese valued in painting.

The simplest canons to understand are the third, fourth, and fifth, because they show Chinese painters' concern for accuracy in rendering forms and colors and for care in composition, concerns common in many cultures. However, separating form and color into different laws gives written expression to a distinctive feature of early Chinese painting. Painters such as Gu Kaizhi (FIG. 7-12) and Yan Liben (FIG. 7-17) used an outline-and-color technique. Their brushed-ink outline drawings employ flat applications of color. To suggest volume, they used ink shading along edges, such as drapery folds.

Also noteworthy is the order of the laws, suggesting Chinese painters' primary concern: to convey the vital spirit of their subjects and their own sensitivity to that spirit. Next in importance was the handling of the brush and the careful placement of strokes, especially of ink. The sixth canon also speaks to a standard Chinese painting practice: copying. Chinese painters, like painters in other cultures throughout history, trained by copying the works of their teachers and other painters. In addition, artists often copied famous paintings as sources of forms and ideas for their own works and to preserve great works created using fragile materials. In China, as elsewhere, change and individual development occurred in constant reference to the past, the artists always preserving some elements of it.

*James Cahill, "The Six Laws and How to Read Them," Ars Orientalis 4 (1961), 372–381.

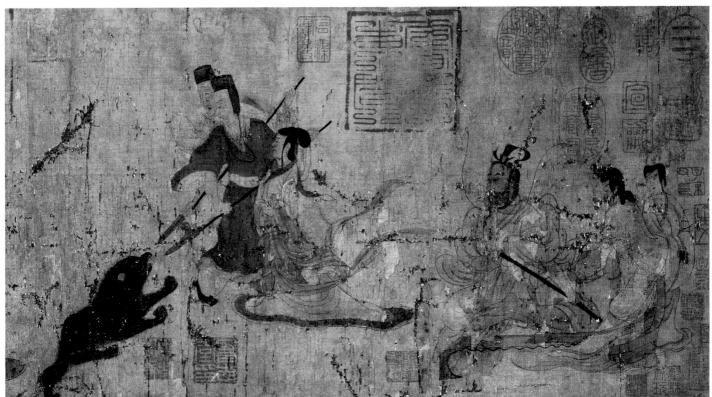

7-12 Gu Kaizhi, Lady Feng and the Bear, detail of Admonitions of the Instructress to the Court Ladies, Period of Disunity, late fourth century. Handscroll, ink and colors on silk, entire scroll $9\frac{3}{4}" \times 11' 4\frac{1}{2}"$. British Museum, London.

Lady Feng's act of heroism to save the life of her emperor was a perfect model of Confucian behavior. In this early Chinese representation of the episode, the painter set the figures against a blank background.

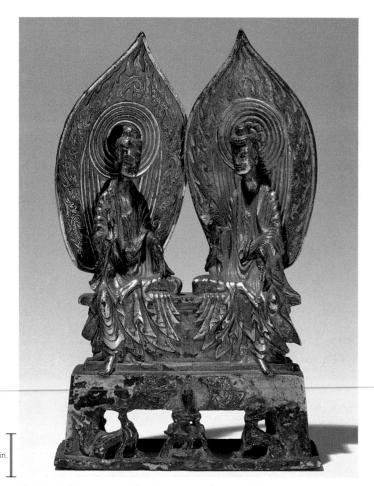

7-13 Shakyamuni and Prabhutaratna, from Hebei Province, Northern Wei dynasty, 518. Gilded bronze, $10\frac{1}{4}$ high. Musée Guimet, Paris.

The sculptor of this statuette transformed the Gandhara-derived style of earlier Chinese Buddhist art (FIG. 7-11). The bodies have elongated proportions, and the garment folds form sharp ridges.

MEETING OF TWO BUDDHAS A gilded bronze statuette (FIG. 7-13) shows how the sculptors of the Northern Wei dynasty (386–534) transformed the Gandhara-derived style of earlier Buddhist art in China (FIG. 7-11). Dated 518, the piece was probably made for private devotion in a domestic setting or as a votive offering in a temple. It represents the meeting of Shakyamuni Buddha (at the viewer's right) and Prabhutaratna, the Buddha who had achieved nirvana in the remote past, as recounted in the most famous *sutra*, the *Lotus Sutra*, an encyclopedic collection of Buddhist thought and poetry. When Shakyamuni was preaching on Vulture Peak, Prabhutaratna's stupa miraculously appeared in the sky. Shakyamuni opened it and revealed Prabhutaratna himself, who had promised to be present whenever the Lotus Law was preached. Shakyamuni sat beside him and continued to expound the law. The meeting of the two Buddhas symbolized the continuity of Buddhist thought across the ages.

Behind each Buddha is a flamelike nimbus (*mandorla*). Both figures sit in the *lalitasana* pose—one leg folded and the other hanging down. This standard pose, which indicates relaxation, underscores the ease of communication between the two Buddhas. Their bodies have elongated proportions, and their smiling faces have sharp noses and almond eyes. The folds of the garments drop like a waterfall from their shoulders to their knees and spill over onto the pedestal, where they form sharp ridges resembling the teeth of a saw. The rhythmic sweep and linear elegance of the folds recall the brushwork of contemporaneous painting.

Tang Dynasty

The emperors of the short-lived Sui dynasty (581–618) succeeded in reuniting China and prepared the way for the brilliant Tang dynasty (618–907). Under the Tang emperors, China entered a period of unequaled magnificence (MAP 7-1). Chinese armies marched across Central Asia, prompting an influx of foreign peoples, wealth, and ideas into China. Traders, missionaries, and other travelers journeyed to the cosmopolitan Tang capital at Chang'an, and the Chinese, in turn, ventured westward. Chang'an was laid out on a grid scheme and occupied more than 30 square miles. It was the greatest city in the world during the seventh and eighth centuries.

LONGMEN CAVES In its first century, the new dynasty continued to support Buddhism and to sponsor great monuments for Buddhist worshipers. Cave complexes decorated with reliefs and paintings, modeled on those of India (see Chapter 6), were especially popular. One of the most spectacular Tang Buddhist sculptures is carved into the face of a cliff in the great Longmen Caves complex near Luoyang. Work at Longmen had begun almost two centuries earlier, during the Period of Disunity, under the Northern Wei dynasty (386–534). The site's 2,345 shrines and more than 100,000 statues and 2,800 inscriptions attest to its importance as a Buddhist center.

The colossal relief (FIG. 7-14) that dominates the Longmen complex features a central figure of the Buddha that is 44 feet tall—seated. An inscription records that the project was completed in 676 when Gaozong (r. 649–683) was the Tang emperor and that in 672 the empress Wu Zetian underwrote a substantial portion of the considerable cost with her private funds. Wu Zetian was an exceptional woman by any standard, and when Gaozong died in 683, she declared herself emperor and ruled until 705, when she was forced to abdicate at age 82.

Wu Zetian's Buddha is the Vairocana Buddha, not the historical Buddha of Figs. 7-11 and 7-13 but the Mahayana Cosmic Buddha, the Buddha of Boundless Space and Time (see "Buddhism," Chapter 6, page 161). Flanking him are two of his monks, attendant bodhisattvas, and guardian figures—all smaller than the Buddha but still of colossal size (shown in Fig. 7-14 are visitors to the site, whose size underscores the scale of the work). The sculptors represented the Buddha in serene majesty. An almost geometric regularity of contour and smoothness of planes emphasize the volume of the massive figure. The folds of his robes fall in a few concentric arcs. The artists suppressed surface detail in the interest of monumental simplicity and dignity.

DUNHUANG GROTTOES The westward expansion of the Tang Empire increased the importance of Dunhuang, the westernmost gateway to China on the Silk Road. Dunhuang long had been a wealthy, cosmopolitan trade center, a Buddhist pilgrimage destination, and home to thriving communities of Buddhist monks and nuns of varied ethnicity, as well as to adherents of other religions. In the course of several centuries, the Chinese cut hundreds of sanctuaries with painted murals into the soft rock of the cliffs near Dunhuang. Known today as the Mogao Grottoes and in antiquity as the Caves of a Thousand Buddhas, the Dunhuang grottoes also contain sculptured images of painted unfired clay and stucco. The earliest recorded cave at Dunhuang was dedicated in 366, but the oldest extant caves date to the early fifth century. The Dunhuang caves are especially important because in 845 the emperor Wuzong instituted a major persecution, destroying 4,600 Buddhist temples and 40,000 shrines and forcing the return of 260,500 monks and nuns to lay life. Wuzong's policies did not affect Dunhuang, then under Tibetan rule, so the site preserves much of the type of art lost elsewhere.

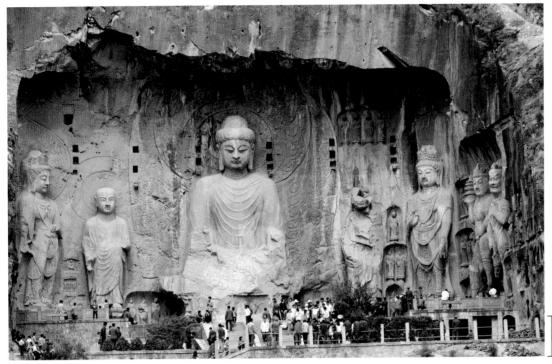

7-14 Vairocana Buddha, disciples, and bodhisattvas, Fengxian Temple, Longmen Caves, Luoyang, China, Tang dynasty, completed 676. Limestone, Buddha 44' high.

Empress Wu Zetian sponsored these colossal rock-cut sculptures. The Tang artists represented the Mahayana Cosmic Buddha in serene majesty, suppressing surface detail in the interest of monumental simplicity.

10 1

Paradise of Amitabha (FIG. 7-15), on the wall of one of the Dunhuang caves, shows how the splendor of the Tang era and religious teachings could come together in a powerful image. Buddhist Pure Land sects, especially those centered on Amitabha, Buddha of the West, had captured the popular imagination in the Period of Disunity under the Six Dynasties and continued to flourish during the Tang dynasty. Pure Land teachings asserted that individuals had no hope of attaining enlightenment through their own power because of the waning of the Buddha's Law. Instead, they could obtain rebirth in a realm free from spiritual corruption simply through

faith in Amitabha's promise of salvation. Richly detailed, brilliantly colored pictures steeped in the opulence of the Tang dynasty, such as this one, greatly aided worshipers in gaining faith by visualizing the wonders of the Pure Land Paradise. Amitabha sits in the center of a raised platform, his principal bodhisattvas and lesser divine attendants surrounding him. Before them a celestial dance takes place. Bodhisattvas had strong appeal in East Asia as compassionate beings ready to achieve buddhahood but dedicated to humanity's salvation. Some received direct worship and became the main subjects of sculpture and painting.

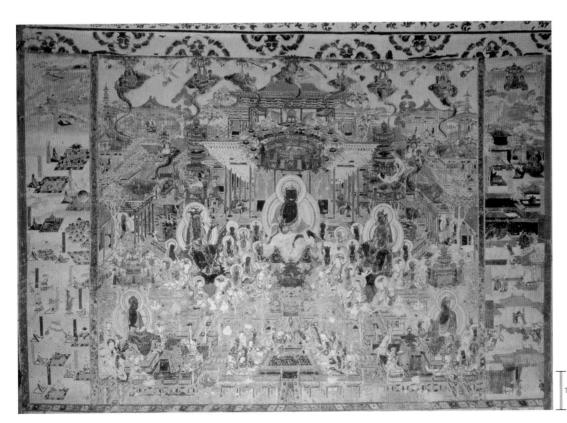

7-15 Paradise of Amitabha, cave 172, Dunhuang, China, Tang dynasty, mid-eighth century. Wall painting 10' high.

This richly detailed, brilliantly colored mural aided Tang worshipers at Dunhuang in visualizing the wonders of the Pure Land Paradise promised to those who had faith in Amitabha, the Buddha of the West.

ft.

7-16 Schematic cross-section and perspective drawing of east main hall, Foguang Si (Buddha Radiance Temple), Mount Wutai, China, Tang dynasty, ca. 857 (after L. Liu).

A complex grid of beams and purlins and a thicket of interlocking brackets support the 14-foot overhang of the eaves of the timbered and tiled curved roof of this early Chinese Buddhist temple.

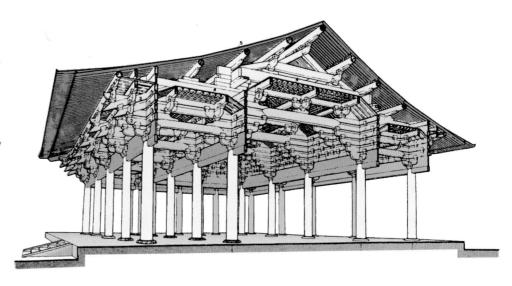

MOUNT WUTAI In the Dunhuang mural, Amitabha appears against a backdrop of ornate buildings characteristic of the Tang era. The Tang rulers embellished their empire with extravagant wooden structures, colorfully painted and of colossal size, decorated with furnishings of great luxury and elaborate gold, silver, and bronze ornaments. Unfortunately, few Tang buildings survive. Among them is the Foguang Si (Buddha Radiance Temple) on Mount Wutai, one of the oldest surviving Buddhist temples in China. It lacks the costly embellishment of imperial structures in the capital, but its east main

hall (FIG. **7-16**) displays the distinctive curved roofline of later Chinese architecture (FIG. **7-10**), which was not present in the Han examples (FIGS. **7-8** and **7-9**) discussed earlier. A complex grid of beams and purlins and a thicket of interlocking brackets support the overhang of the eaves—some 14 feet out from the column faces—as well as the timbered and tiled roof.

YAN LIBEN The Tang emperors also fostered a brilliant tradition of painting. Although few examples are preserved, many art his-

7-17 Attributed to Yan Liben, *Emperor Xuan and Attendants*, detail of *The Thirteen Emperors*, Tang dynasty, ca. 650. Handscroll, ink and colors on silk, detail 1' $8\frac{1}{4}'' \times 1' 5\frac{1}{2}''$; entire scroll 17' 5" long. Museum of Fine Arts, Boston.

This handscroll portrays 13 Chinese rulers as Confucian exemplars of moral and political virtue. Yan Liben, a celebrated Tang painter, was a master of line drawing and colored washes.

torians regard the early Tang dynasty as the golden age of Chinese figure painting. In perfect accord with contemporary and later Chinese poets' and critics' glowing descriptions of Tang painting style are the unrestored portions of *The Thirteen Emperors* (FIG. **7-17**), a masterpiece of line drawing and colored washes. The painting has long been attributed to Yan Liben (d. 673). Born into an aristocratic family and the son of a famous artist, Yan Liben was prime minister under the emperor Gaozong as well as a celebrated painter. This handscroll depicts 13 Chinese rulers from the Han to the Sui dynasties. Its purpose was to portray these historical figures as exemplars of moral and political virtue, in keeping with the Confucian ideal of learning from the past. Each emperor stands or sits in an undefined space. The emperor's great size relative to his attendants immediately establishes his superior stature. Simple shading in the faces and the robes gives the figures an added semblance of volume and presence.

The detail in FIG. 7-17 represents the emperor Xuan of the Chen dynasty (557–589) seated among his attendants, two of whom carry the ceremonial fans that signify his rank and focus the viewer's attention on him. Xuan stands out from the others also because of his dark robes. His majestic serenity contrasts with his attendants' animated poses, which vary sharply from figure to figure, lending vitality to the composition.

TOMB OF YONGTAI Wall paintings in the tomb of the Tang princess Yongtai (684–701) at Qianxian, near Chang'an, permit an analysis of court painting styles unobscured by problems of authenticity and reconstruction. When she was 17 years old, Yongtai was either

murdered or forced to commit suicide by Wu Zetian. Her underground tomb dates to 706, however, because her formal burial had to await Wu Zetian's own death. The detail illustrated here (FIG. 7-18) depicts palace ladies and their attendants, images of pleasant court life to accompany the princess into her afterlife. The figures appear as if on a shallow stage. The artist did not provide any indications of background or setting, but intervals between the two rows and the figures' grouping in an oval suggest a consistent ground plane. The women assume a variety of poses, seen in full-face and in three-quarter views, from the front or the back. The device of paired figures facing into and out of the space of the picture appears often in paintings of this period and effectively conveys depth. Thick, even contour lines describe full-volumed faces and suggest solid forms beneath the drapery, all with the utmost economy. This simplicity of form and line, along with the measured cadence of the poses, creates an air of monumental dignity.

TANG CERAMIC SCULPTURE Tang ceramists also achieved renown and produced thousands of earthenware figures of people, domesticated animals, and fantastic creatures for burial in tombs. These statuettes attest to a demand for ceramic sculpture by a much wider group of patrons than ever before, but terracotta funerary sculpture has a long history in China. The most spectacular example is the ceramic army (FIG. 7-6) of the First Emperor of Qin. The subjects of the Tang figurines are also much more diverse than in earlier periods. The depiction of a broad range of foreigners, including Semitic traders and Central Asian musicians on camels, accurately reflects the cosmopolitanism of Tang China.

7-18 Palace ladies, detail of a wall painting, tomb of Princess Yongtai, Qianxian, China, Tang dynasty, 706. Detail 5' 10" high.

The paintings in this Tang princess's tomb depict scenes of pleasant court life. The muralist used thick, even contour lines and did not provide any setting, but the composition effectively conveys depth.

Chinese Earthenwares and Stonewares

hina has no rival in the combined length and richness of its ceramic history. Beginning with the makers of the earliest pots in prehistoric villages, ancient Chinese potters showed a flair for shaping carefully prepared and kneaded clay into diverse, often dramatic and elegant vessel forms. Until Chinese potters developed true *porcelains* (extremely fine, hard, white ceramics; see "Chinese Porcelain," Chapter 27, page 722) in about 1300, they produced only two types of clay vessels or objects—earthenwares and stonewares. For both types, potters used clays colored by mineral impurities, especially iron compounds ranging from yellow to brownish-black.

The clay bodies of *earthenwares* (FIG. **7-2**), fired at low temperatures in open pits or simple kilns, remain soft and porous, thus allowing liquids to seep through. Chinese artists also used the low-fire technique to produce terracotta sculptures, even life-size figures of humans and animals (FIG. **7-6**). Over time, Chinese potters developed kilns capable of firing clay vessels at much higher temperatures—more than 2,000° Fahrenheit. High temperatures produce *stonewares*, named for their stonelike hardness and density.

Potters in China excelled at the various techniques commonly used to decorate earthenwares and stonewares. Most of these decorative methods depend on changes occurring in the kiln to chemical compounds found in clay as natural impurities. When fired, many compounds change color dramatically, depending on the conditions in the kiln. For example, if little oxygen remains in a hot kiln, iron oxide (rust) turns either gray or brownish-black, whereas an abundance of oxygen produces a reddish hue.

Chinese potters also decorated vessels simply by painting their surfaces. In one of the oldest decorative techniques, the potters applied *slip* (a mixture of clay and water like a fine, thin mud)—by painting, pouring, or dipping—to a clay body not yet fully dry. The

7-19 Neighing horse, Tang dynasty, eighth to ninth century. Glazed earthenware, 1' 8" high. Victoria & Albert Museum, London.

Tang ceramists achieved renown for their earthenware figurines decorated with colorful lead glazes that ran in dramatic streams down the sides when a piece was fired, as in this statuette.

natural varieties of clay produced a broad, if not bright, range of colors, as seen in Neolithic vessels (FIG. 7-2). But Chinese potters often added compounds such as iron oxide to the slip to change or intensify the colors. After the vessels had partially dried, the potters could incise lines through the slip down to the clay body to produce designs such as those seen in later Chinese stonewares (FIG. 7-22). Chinese artists also inlaid designs, carving them into plain vessel surfaces and then filling them with slip or soft clay of a contrasting color. These techniques spread throughout East Asia (FIG. 7-29).

To produce a hard, glassy surface after firing, potters coated plain or decorated vessels with a *glaze*, a finely ground mixture of minerals. Clear or highly translucent glazes were often used, but so too were opaque, richly colored glazes. Sometimes the painters allowed the thick glazes to run down the side of a vase or a figurine (FIG. 7-19) to produce dramatic effects.

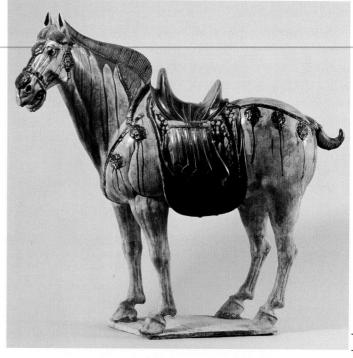

1 in.

The artists painted some figurines with colored slips and decorated others, such as the spirited, handsomely adorned neighing horse in FIG. **7-19**, with colorful lead glazes that ran in dramatic streams down the objects' sides when fired (see "Chinese Earthenwares and Stonewares," above). The popularity of the horse as a subject of Chinese art reflects the importance the emperors placed on the quality of their stables. The breed represented here is powerful in build. Its beautifully arched neck terminates in a small, elegant head. Richly harnessed and saddled, the horse testifies to its rider's nobility.

Song Dynasty

The last century of Tang rule brought many popular uprisings and the empire's gradual disintegration. After an interim of internal strife known as the Five Dynasties period (907–960), General Zhao

Kuangyin succeeded in consolidating the country once again. He established himself as the first emperor (r. 960–976) of the Song dynasty (960–1279), which ruled China from a capital in the north at Bianliang (modern Kaifeng) during the Northern Song period (960–1127). Under the Song emperors, many of the hereditary privileges of the elite class were curtailed. Political appointments were made on the basis of scores on civil service examinations, and education came to be a more important prerequisite for Song officials than high birth.

The three centuries of Song rule, including the Southern Song period (1127–1279) when the capital was at Lin'an (modern Hangzhou) in southern China, were also a time of extraordinary technological innovation. Under the Song emperors, the Chinese invented the magnetic compass for sea navigation, printing with movable clay type, paper money, and gunpowder. Song China was the most

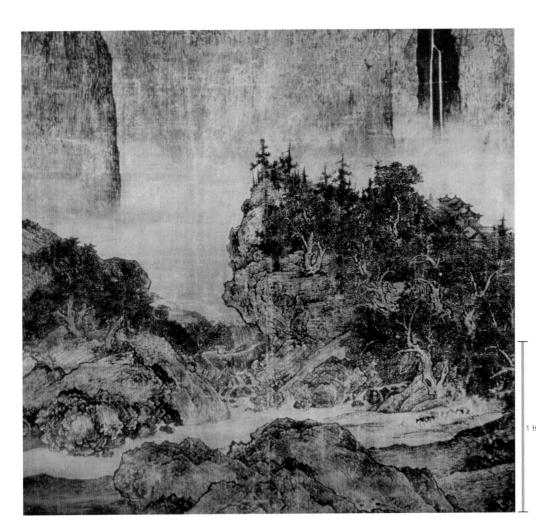

7-20 Fan Kuan, detail of *Travelers among Mountains and Streams* (FIG. 7-1), Northern Song period, early 11th century. Hanging scroll, ink and colors on silk, entire scroll 6' $7\frac{1}{4}'' \times 3'$ $4\frac{1}{4}''$; detail 2' $10\frac{1}{4}''$ high. National Palace Museum, Taibei.

Fan Kuan, a Daoist recluse, spent long days in the mountains studying the effects of light on rock formations and trees. He was one of the first masters at recording light, shade, distance, and texture.

technologically advanced society in the world in the early second millennium.

FAN KUAN For many observers, the Song dynasty also marks the apogee of Chinese landscape painting, which first emerged as a major subject during the Period of Disunity. Although many of the great Northern Song masters worked for the imperial court, Fan Kuan (ca. 960-1030) was a Daoist recluse (see "Daoism and Confucianism," page 186) who shunned the cosmopolitan life of Bianliang. He believed nature was a better teacher than other artists, and he spent long days in the mountains studying configurations of rocks and trees and the effect of sunlight and moonlight on natural forms. Just as centuries later Giorgio Vasari would credit Italian Renaissance painters with the conquest of naturalism (see Chapter 21), so too did Song critics laud Fan Kuan and other leading painters of the day as the first masters of the recording of light, shade, distance, and texture. Yet the comparison with 15th- and 16th-century Italy is misleading. Chinese landscape painters such as Fan Kuan did not aim to produce portraits of specific places. They did not seek to imitate or to reproduce nature. Rather, they sought to capture the essence of nature and of its individual elements using brush and ink on silk. Their paintings are tributes to nature, not representations of individual rock or tree formations.

In *Travelers among Mountains and Streams* (FIG. 7-1), datable to the early 11th century, Fan Kuan painted a vertical landscape of massive mountains rising from the distance. The overwhelming natural forms dwarf the few human and animal figures (for example, the mule train in the lower right corner; FIG. 7-20), which the artist reduced to minute proportions. The nearly seven-foot-long silk hanging scroll cannot contain nature's grandeur, and the landscape

continues in all directions beyond its borders. The painter showed some elements from level ground (for example, the great boulder in the foreground), and others obliquely from the top (the shrubbery on the highest cliff). The shifting perspectives lead the viewer on a journey through the mountains. To appreciate the painted landscape fully, the viewer must focus not only on the larger composition but also on intricate details and on the character of each brush stroke. Numerous "texture strokes" help model massive forms and convey a sense of tactile surfaces. For the face of the mountain, for example, Fan Kuan employed small, pale brush marks, the kind of texture stroke the Chinese call "raindrop strokes."

HUIZONG A century after Fan Kuan painted in the mountains of Shanxi, Huizong (1082-1135; r. 1101-1126) assumed the Song throne at Bianliang. Less interested in governing than in the arts, he brought the country to near bankruptcy and lost much of China's territory to the armies of the Tartar Jin dynasty (1115-1234), who captured the Song capital in 1126 and took Huizong prisoner. He died in their hands nine years later. An accomplished poet, calligrapher, and painter, Huizong reorganized the imperial painting academy and required the study of poetry and calligraphy as part of the official training of court painters. Calligraphy, or the art of writing, was highly esteemed in China throughout its history, and prominent inscriptions are frequent elements of Chinese paintings (see "Calligraphy and Inscriptions on Chinese Paintings," Chapter 27, page 726). Huizong also promoted the careful study both of nature and of the classical art of earlier periods, and was an avid art collector as well as the sponsor of a comprehensive catalogue of the vast imperial art holdings.

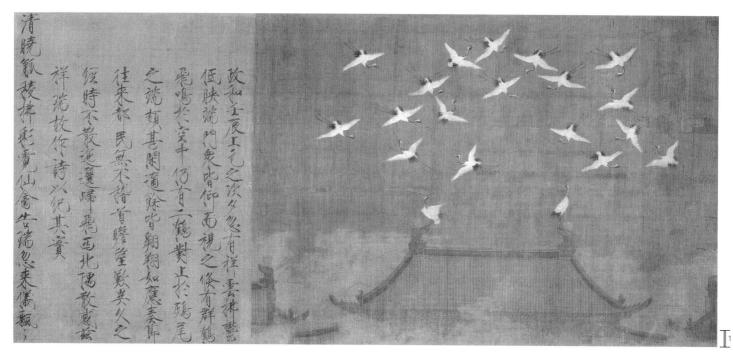

7-21 Attributed to Huizong, *Auspicious Cranes*, Northern Song period, 1112. Section of a handscroll, ink and colors on silk, $1' 8\frac{1}{8}'' \times 4' 6\frac{3}{8}''$. Liaoning Provincial Museum, Shenyang.

The Chinese regarded the 20 white cranes that appeared at Huizong's palace in 1112 as an auspicious sign. This painting of that event is a masterful combination of elegant composition and realistic observation.

A short handscroll (FIG. 7-21) usually attributed to Huizong is more likely the work of court painters under his direction, but it displays the emperor's style as both calligrapher and painter. Huizong's characters represent one of many styles of Chinese calligraphy. They are made up of thin strokes, and each character is meticulously aligned with its neighbors to form neat vertical rows. The painting depicts cranes flying over the roofs of Bianliang. It is a masterful combination of elegant composition and realistic observation. The painter carefully recorded the black and red feathers of the white cranes and depicted the birds from a variety of viewpoints to suggest they were circling around the roof. Huizong did not, however, choose this subject because of his interest in the anatomy and flight patterns of birds. The painting was a propaganda piece com-

memorating the appearance of 20 white cranes at the palace gates during a festival in 1112. The Chinese regarded the cranes as an auspicious sign, proof that Heaven had blessed Huizong's rule. Although few would ever have viewed the handscroll, the cranes were also displayed on painted banners on special occasions, where they could be seen by a larger public.

CIZHOU POTTERY Song-era artists also produced superb ceramics. Some reflect their patrons' interests in antiquities and imitate the powerful forms of the Shang and Zhou bronzes. Song ceramics, however, more commonly had elegant shapes with fluid silhouettes. Many featured monochromatic glazes, such as the famous celadon wares, also produced in Korea (FIG. 7-29). A quite different kind of pottery, loosely classed as Cizhou, emerged

7-22 Meiping vase, from Xiuwi, China, Northern Song period, 12th century. Stoneware, Cizhou type, with sgraffito decoration, 1' $7\frac{1}{2}''$ high. Asian Art Museum of San Francisco, San Francisco (Avery Brundage Collection).

Chinese potters developed the technique of sgraffito (incising the design through a colored slip) during the Northern Song period. This Cizhou vase features vines and flowers created by cutting through a black slip.

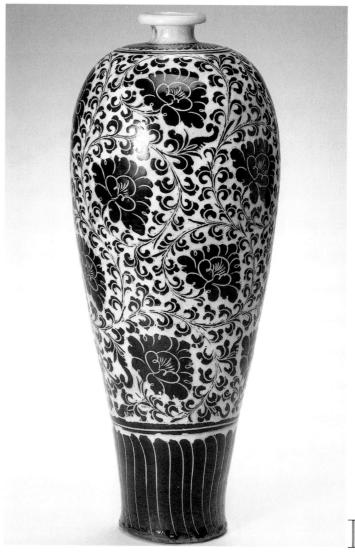

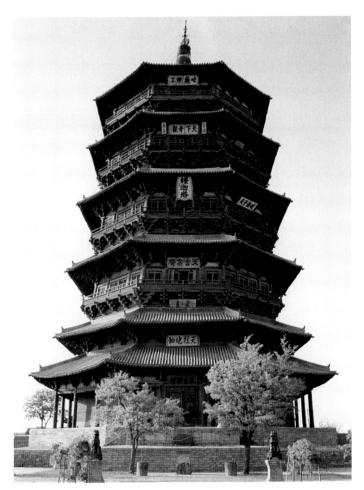

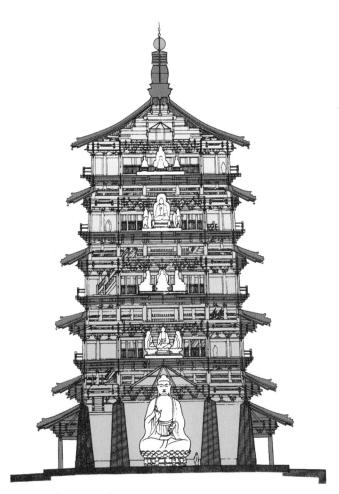

7-23 View (left) and cross-section (right; after L. Liu) of Foguang Si Pagoda, Yingxian, China, Liao dynasty, 1056.

The tallest wooden building in the world is this pagoda in the Yingxian Buddhist temple complex. The nine-story tower shows the Chinese wooden beam-and-bracket construction system at its most ingenious.

in northern China. The example shown (FIG. **7-22**) is a vase of the high-shouldered shape known as *meiping*. Chinese potters developed the subtle techniques of *sgraffito* (incising the design through a colored slip) during the Northern Song period. They achieved the intricate black-and-white design here by cutting through a black slip (see "Chinese Earthenwares and Stonewares," page 196). The tightly twining vine and flower-petal motifs on this vase closely embrace the vessel in a perfect accommodation of surface design to vase shape.

FOGUANG SI PAGODA For two centuries during the Northern Song period, the Liao dynasty (907–1125) ruled part of northern China. In 1056 the Liao rulers built the Foguang Si Pagoda (FIG. 7-23), the tallest wooden building ever constructed, at Yingxian in Shanxi Province. The *pagoda*, or tower, the building type most often associated with Buddhism in China and other parts of East Asia, is the most eye-catching feature of a Buddhist temple complex. It somewhat resembles the tall towers of Indian temples and their distant ancestor, the Indian stupa (see "The Stupa," Chapter 6, page 163). Like stupas, many early pagodas housed relics and provided a focus for devotion to the Buddha. Later pagodas served other functions, such as housing sacred images and texts. The Chinese and Koreans built both stone and brick pagodas, but wooden pagodas were also common and became the standard in Japan.

The nine-story octagonal pagoda at Yingxian is 216 feet tall and made entirely of wood (see "Chinese Wooden Construction," page

189). Sixty giant four-tiered bracket clusters carry the floor beams and projecting eaves of the five main stories. They rest on two concentric rings of columns at each level. Alternating main stories and windowless mezzanines with cantilevered balconies, set back farther on each story as the tower rises, form an elevation of nine stories altogether. Along with the open veranda on the ground level and the soaring pinnacle, the balconies visually lighten the building's mass. The cross-section (FIG. 7-23, right) shows the symmetrical placement of statues of the Buddha inside, the colossal scale of the ground-floor statue, and the intricacy of the beam-and-bracket system at its most ingenious.

SOUTHERN SONG PERIOD When the Jin captured Bianliang and Emperor Huizong in 1126 and took control of northern China, Gaozong (r. 1127–1162), Huizong's sixth son, escaped and eventually established a new Song capital in the south at Lin'an. From there, he and his successors during the Southern Song period ruled their reduced empire until 1279.

Court sponsorship of painting continued in the new capital, and, as in the Northern Song period, some of the emperors were directly involved with the painters of the imperial painting academy. During the reign of Ningzong (r. 1194–1224), members of the court, including Ningzong himself and Empress Yang, frequently added brief poems to the paintings created under their direction. Some of the painters belonged to families that had worked for the Song emperors for several generations.

7-24 Ma Yuan, On a Mountain Path in Spring, Southern Song period, early 13th century. Album leaf, ink and colors on silk, $10\frac{3}{4}$ " \times 17". National Palace Museum, Taibei.

Unlike Fan Kuan (Fig. 7-1), Ma Yuan reduced the landscape on this silk album leaf to a few elements and confined them to one part of the page. A tall solitary figure gazes out into the infinite distance.

MA YUAN The most famous Song family of painters was the Ma family, which began working for the Song dynasty during the Northern Song period. Ma Yuan (ca. 1160–1225) painted *On a Mountain Path in Spring* (FIG. 7-24), a silk album leaf, for Ningzong in the early 13th century. In his composition, in striking contrast to Fan Kuan's much larger *Travelers among Mountains and Streams* (FIG. 7-1), the landscape is reduced to a few elements and confined to the foreground and left side of the page. A tall solitary figure gazes out into the infinite distance. Framing him are the carefully placed diagonals of willow branches. Near the upper right corner a bird flies toward the couplet that Ningzong added in ink, demonstrating his mastery of both poetry and calligraphy:

Brushed by his sleeves, wild flowers dance in the wind; Fleeing from him, hidden birds cut short their songs.

Some scholars have suggested that the author of the two-line poem is actually Empress Yang, but the inscription is in Ningzong's hand. In any case, landscape paintings such as this one are perfect embodiments of the Chinese ideals of peace and unity with nature.

LIANG KAI Religious painting was also popular under the Southern Song emperors. Neo-Confucianism, a blend of traditional Chinese thought and selected Buddhist concepts, became the leading philosophy, but many painters still depicted Buddhist themes. Chan

Buddhism (see "Chan Buddhism," page 201), which stressed the quest for personal enlightenment through meditation, flourished under the Song dynasty. LIANG KAI (active early 13th century) was a master of an abbreviated, expressive style of ink painting that found great favor among Chan monks in China, Korea, and Japan. He served in the painting academy of the imperial court in Hangzhou, and his early works include poetic landscapes typical of the Southern Song. Later in life, he left the court and concentrated on figure painting, including Chan subjects.

Surviving works attributed to Liang Kai include an ink painting (FIG. 7-25) of the Sixth Chan Patriarch, Huineng, crouching as he chops bamboo. In Chan thought, the performance of even such mundane tasks had the potential to become a spiritual exercise. More specifically, this scene represents the patriarch's "Chan moment," when the sound of the blade striking the bamboo resonates within his spiritually attuned mind to propel him through the final doorway to enlightenment. The scruffy, caricature-like representation of the revered figure suggests that worldly matters, such as physical appearance or signs of social status, do not burden Huineng's mind. Liang Kai used a variety of brushstrokes in the execution of this deceptively simple picture. Most are pale and wet, ranging from the fine lines of Huineng's beard to the broad texture strokes of the tree. A few darker strokes, which define the vine growing around the tree and the patriarch's clothing, offer visual accents in the painting. This kind of quick

Chan Buddhism

nder the Song emperors (960–1279), the new school of *Chan* Buddhism gradually gained importance, until it was second only to Neo-Confucianism.

The Chan school traced its origins through a series of patriarchs (the founder and early leaders, joined in a master–pupil lineage). The First Chan Patriarch was Bodhidharma, a semilegendary sixth-century Indian missionary. By the time of the Sixth Chan Patriarch, Huineng (638–713; FIG. 7-25), in the early Tang period, the religious forms and practices of the school were already well established.

Although Chan monks adapted many of the rituals and ceremonies of other schools over the course of time, they focused on the cultivation of the mind or spirit of the individual in order to break through the illusions of ordinary reality, especially by means of meditation.

In Chan thought, the means of enlightenment lie within the individual, and direct personal experience with some ultimate reality is the necessary step to its achievement. Meditation is a critical practice. In fact, the word "Chan" is a translation of the Sanskrit word for meditation. Bodhidharma is said to have meditated so long in a cave that his arms and legs withered away.

The "Northern School" of Chan holds that enlightenment comes only gradually after long meditation. The "Southern School" believes that the breakthrough to enlightenment can be sudden and spontaneous.

These beliefs influenced art and aesthetics as they developed in China and spread to Korea and Japan. In Japan, Chan (Japanese Zen) had an especially extensive, long-term impact on the arts and remains an important school of Buddhism there today (see "Zen Buddhism," Chapter 28, page 736).

7-25 Liang Kai, Sixth Chan Patriarch Chopping Bamboo, Southern Song period, early 13th century. Hanging scroll, ink on paper, 2' $5\frac{1}{4}''$ high. Tokyo National Museum, Tokyo.

Liang Kai was a master of an expressive style of ink painting. Here, he depicted the Sixth Chan Patriarch's "Chan moment," when the chopping sound of his blade propelled the patriarch to enlightenment.

1 in

and seemingly casual execution of paintings has traditionally been interpreted as a sign of a painter's ability to produce compelling pictures spontaneously as a result of superior training and character, or, in the Chan setting, progress toward enlightenment.

ZHOU JICHANG Another leading Southern Song painter of Buddhist themes was Zhou Jichang (ca. 1130–1190), who painted *Lohans Giving Alms to Beggars* (Fig. **7-26**) around 1178. The scroll was one in a series of 100 scrolls produced at the southern coastal city of Ningbo for an abbot who invited individual donors to pay for the paintings as offerings in the nearby Buddhist temple. *Lohans* are enlightened disciples of the Buddha who have achieved freedom

from rebirth (nirvana) by suppression of all desire for earthly things. They were charged with protecting the Buddhist Law until the arrival of the Buddha of the Future. In his Ningbo scroll, Zhou Jichang arranged the foreground, middle ground, and background vertically to clarify the lohans' positions relative to one another and to the beggars. The lohans move with slow dignity in a plane above the ragged wretches who scramble miserably for the alms their serene benefactors throw down. The extreme difference in deportment between the two groups distinguishes their status, as do their contrasting features. The lohans' vividly colored attire, flowing draperies, and quiet gestures set them off from the dirt-colored and jagged shapes of the people physically and spiritually beneath them. In this painting,

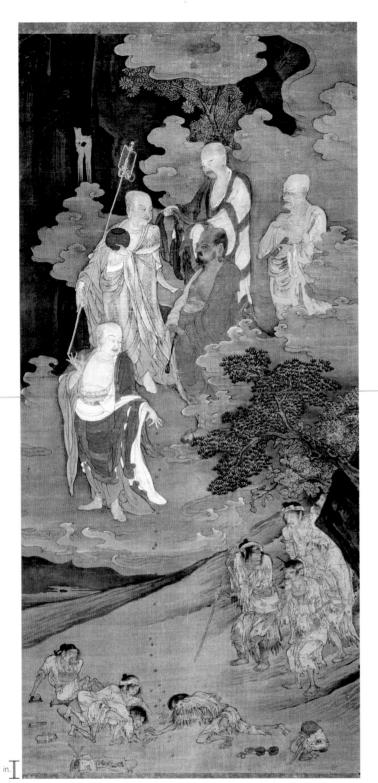

7-26 Zhou Jichang, Lohans Giving Alms to Beggars, Southern Song period, ca. 1178. Hanging scroll, ink and colors on silk, $3' 7\frac{7}{8}'' \times 1' 8\frac{7}{8}''$. Museum of Fine Arts, Boston.

In this hanging scroll made for a Buddhist monastery, Zhou Jichang arranged the fore-, middle-, and background vertically to elevate the lohans in their bright attire above the ragged, dirt-colored beggars.

consistent with Xie He's principles (see "Xie He's Six Canons," page 191), Zhou Jichang used color for symbolic and decorative purposes, not to imitate nature or depict the appearance of individual forms. The composition of the landscape—the cloudy platform and lofty peaks of the lohans and the desertlike setting of the beggars—also distinguishes the two spheres of being.

KOREA

Korea is a northeast Asian peninsula that shares borders with China and Russia and faces the islands of Japan (MAP 7-1). Korea's pivotal location is a key factor in understanding the relationship of its art to that of China and the influence of its art on that of Japan. Ethnically, the Koreans are related to the peoples of eastern Siberia and Mongolia as well as to the Japanese. At first, the Koreans used Chinese characters to write Korean words, but later they invented their own phonetic alphabet. Korean art, although frequently based on Chinese models, is not merely derivative but has, like Korean civilization, a distinct identity.

Three Kingdoms Period

Pottery-producing cultures appeared on the Korean peninsula in the Neolithic period no later than 6000 BCE, and the Korean Bronze Age dates from ca. 1000 BCE. Bronze technology was introduced from the area that is today northeastern China (formerly known as Manchuria). About 100 BCE, during the Han dynasty, the Chinese established outposts in Korea. The most important was Lelang, which became a prosperous commercial center. By the middle of the century, however, three native kingdoms—Koguryo, Paekche, and Silla—controlled most of the Korean peninsula and reigned for more than seven centuries until Silla completed its conquest of its neighbors in 668. During this era, known as the Three Kingdoms period (ca. 57 BCE–688 CE), Korea remained in continuous contact with both China and Japan. Buddhism was introduced into Korea from China in the fourth century CE. The Koreans in turn transmitted it from the peninsula to Japan in the sixth century.

SILLA CROWN Tombs of the Silla kingdom have yielded spectacular artifacts representative of the wealth and power of its rulers. Finds in the region of Kyongju justify the city's ancient name—Kumsong ("City of Gold"). The gold-and-jade crown (FIG. 7-27) from a tomb at Hwangnamdong, near Kyongju, dated to the fifth or sixth century, also attests to the high quality of artisanship among Silla artists. The crown's major elements, the band and the uprights, as well as the myriad spangles adorning them, were cut from sheet gold and embossed along the edges. Gold rivets and wires secure the whole, as do the comma-shaped pieces of jade further embellishing the crown. Archaeologists interpret the uprights as stylized tree and antler forms believed to symbolize life and supernatural power. The Hwangnamdong crown has no counterpart in China, although the technique of working sheet gold may have come to Korea from northeast China.

Unified Silla Kingdom

Aided by China's emperor, the Silla kingdom conquered the Koguryo and Paekche kingdoms and unified Korea in 668. The era of the Unified Silla Kingdom (688–935) is roughly contemporary with the Tang dynasty's brilliant culture in China, and many consider it to be Korea's golden age.

BUDDHIST SOKKURAM The Silla rulers embraced Buddhism both as a source of religious enlightenment and as a protective force. They considered the magnificent Buddhist temples they constructed in and around their capital of Kyongju to be supernatural defenses against external threats as well as places of worship. Unfortunately, none of these temples survived Korea's turbulent history.

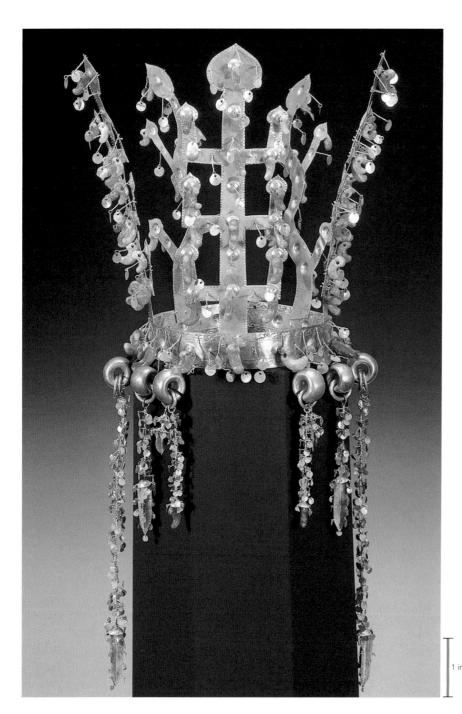

7-27 Crown, from north mound of tomb 98, Hwangnamdong, near Kyongju, Korea, Three Kingdoms period, fifth to sixth century. Gold and jade, $10\frac{3}{4}$ " high. Kyongju National Museum, Kyongju.

This gold-and-jade crown from a Silla tomb attests to the wealth of that kingdom and the skill of its artists. The uprights may be stylized tree and antler forms symbolizing life and supernatural power.

However, at Sokkuram, near the summit of Mount Toham, northeast of the city, a splendid granite Buddhist monument is preserved. Scant surviving records suggest that Kim Tae-song, a member of the royal family who served as prime minister, supervised its construction. He initiated the project in 742 to honor his parents in his previous life. Certainly the intimate scale of Sokkuram and the quality of its reliefs and freestanding figures support the idea that the monument was a private chapel for royalty.

The main *rotunda* (circular area under a dome; FIG. 7-28) measures about 21 feet in diameter. Despite its modest size, the Sokkuram project required substantial resources. Unlike the Chinese Buddhist caves at Longmen (FIG. 7-14), the interior wall surfaces and sculpture were not cut from the rock in the process of excavation. Instead, workers assembled hundreds of granite pieces of various shapes and sizes, attaching them with stone rivets instead of mortar.

Sculpted images of bodhisattvas, lohans, and guardians line the lower zone of the wall. Above, 10 niches contain miniature statues of seated bodhisattvas and believers. All these figures face inward toward the 11-foot-tall statue of Shakyamuni, the historical Buddha, which dominates the chamber and faces the entrance. Carved from a single block of granite, the image represents the Buddha as he touched the earth to call it to witness the realization of his enlightenment at Bodh Gaya (FIG. 6-11b). Although remote in time and place from the Sarnath Buddha (FIG. 6-13) in India, this majestic image remains faithful to its iconographic prototype. More immediately, the Korean statue draws on the robust, round-faced figures (FIG. 7-14) of Tang China, and its drapery is a more schematic version of the fluid type found in Tang sculpture. However, the figure has a distinctly broadshouldered dignity combined with harmonious proportions that are without close precedents. Art historians consider it one of the finest images of the Buddha in East Asia.

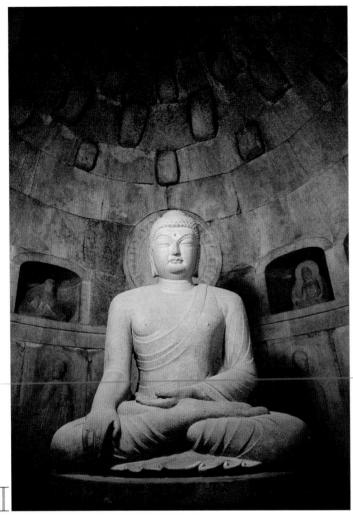

7-28 Shakyamuni Buddha, in the rotunda of the cave temple, Sokkuram, Korea, Unified Silla Kingdom, 751–774. Granite, 11' high.

Unlike rock-cut Chinese Buddhist shrines, this Korean cave temple was constructed using granite blocks. Dominating the rotunda is a huge statue depicting the Buddha at the moment of his enlightenment.

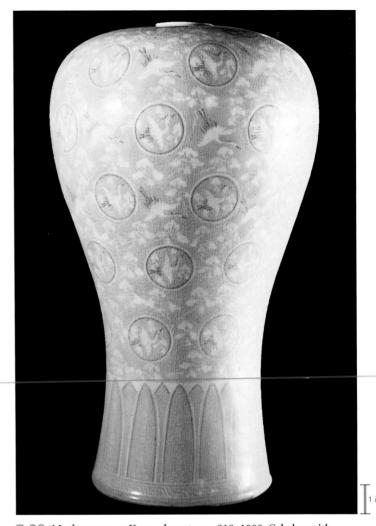

7-29 Maebyong vase, Koryo dynasty, ca. 918–1000. Celadon with inlaid decoration, 1' $4\frac{1}{2}$ " tall. Kansong Art Museum, Seoul.

Celadon wares feature highly translucent iron-pigmented glazes with incised designs. This green maebyong vase is decorated with engraved cranes highlighted by white and colored slip in the incised lines.

Koryo Dynasty

Although Buddhism was the established religion of Korea, Confucianism, introduced from China during the Silla era, increasingly shaped social and political conventions. In the ninth century, the three old kingdoms began to reemerge as distinct political entities, but by 935 the Koryo (from Koguryo) had taken control, and they dominated for the next three centuries. The Unified Silla and Koryo kingdoms overlap slightly (the period ca. 918–935) because both kingdoms existed during these shifts in power. In 1231 the Mongols, who had invaded China, pushed into Korea, beginning a war lasting 30 years. In the end, the Koryo had to submit to forming an alliance with the Mongols, who eventually conquered all of China (see Chapter 27).

CELADON WARE Koryo potters in the 12th century produced the famous Korean *celadon* wares, admired worldwide. Celadon wares feature highly translucent iron-pigmented glazes, fired in an oxygen-deprived kiln to become gray, pale blue, pale green, or brownish-olive. Incised or engraved designs in the vessel alter the thickness of the glaze to produce elegant tonal variations.

A vase in the shape called *maebyong* in Korean (FIG. **7-29**; *meiping* in Chinese, FIG. **7-22**) probably dates to the early Koryo period (ca. 918–1000). It is decorated using the inlay technique for which Koryo potters were famous. The artist incised delicate motifs of flying cranes—some flying down and others, in *roundels* (circular frames), flying up—into the clay's surface and then filled the grooves with white and colored slip. Next, the potter covered the incised areas with the celadon green glaze. Variation in the spacing of the motifs shows the potter's sure sense of the dynamic relationship between ornamentation and ceramic volume.

KOREA, CHINA, AND JAPAN China's achievements in virtually every field spread beyond even the boundaries of the vast empires it at various times controlled. Although Buddhism began in India, the Chinese adaptations and transformations of its teachings, religious practices, and artistic forms were those that spread farther east. The cultural debt of China's neighbors to China is immense. Nevertheless, Korea was the crucial artistic, cultural, and religious link between the mainland and the islands of Japan, the subject of Chapter 8.

CHINA AND KOREA TO 1279

SHANG DYNASTY, ca. 1600-1050 BCE

- The Shang dynasty was the first great Chinese dynasty of the Bronze Age. The Shang kings ruled from a series of capitals in the Yellow River valley.
- Shang bronze-workers were among the best in the ancient world and created a wide variety of elaborately decorated vessels using a sophisticated piece-mold casting process.

ZHOU AND QIN DYNASTIES, ca. 1050-206 BCE

- The Zhou dynasty was the longest in China's history. The Western Zhou kings (ca. 1050–771 BCE) ruled from Chang'an and the Eastern Zhou kings (770–256 BCE) from Luoyang. During the last centuries of Zhou rule, Daoism and Confucianism gained wide followings in China.
- Zhou artists produced lavish works in bronze, lacquer, and especially jade.
- China's First Emperor founded the short-lived Qin dynasty (221–206 BCE) after defeating the Zhou and all other rival states.
- A terracotta army of more than 6,000 soldiers guarded the First Emperor's burial mound at Lintong. The tomb itself remains unexcavated.

Guang, from Anyang, 12th or 11th century BCE

Army of the First Emperor of Qin, Lintong, ca. 210 BCE

HAN DYNASTY AND PERIOD OF DISUNITY, 206 BCE-581 CE

- The Han dynasty (206 BCE-220 CE) extended China's boundaries to the south and west and even traded indirectly with Rome via the fabled Silk Road.
- Earthenware models found in tombs give a good idea of the appearance and construction methods of Han wooden buildings.
- Civil strife divided China into competing states from 220 to 581 ce. The earliest Chinese images of the Buddha and the first paintings that can be associated with an artist whose name was recorded date to this so-called Period of Disunity.
- In the early sixth century, Xie He formulated his six canons of Chinese painting.

Model of a Han dynasty house, first century CE

TANG DYNASTY, 618-907

- China enjoyed unequaled prosperity and power under the Tang emperors, whose capital at Chang'an became the greatest and most cosmopolitan city in the world.
- The Tang dynasty was the golden age of Chinese figure painting. The few surviving works include Yan Liben's The Thirteen Emperors handscroll illustrating historical figures as exemplars of Confucian ideals. The Dunhuang caves provide evidence of the magnificence of Tang Buddhist art, especially mural painting.
- Korea also enjoyed an artistic golden age at this time under the Unified Silla Kingdom (688–935).

Yan Liben, *The Thirteen Emperors,* ca. 650

SONG DYNASTY, 960-1279

- Song China (Northern Song, 960–1127, capital at Bianliang; Southern Song, 1127–1279, capital at Lin'an) was the most technologically advanced society in the world in the early second millennium.
- In art, the Song era marked the apogee of Chinese landscape painting. Fan Kuan, a Daoist recluse, was a pioneer in recording light, shade, distance, and texture in his hanging scrolls.
- For part of this period, the Liao dynasty (907–1125) ruled northern China and erected the tallest wooden building in the world, the Foguang Si Pagoda at Yingxian.

Fan Kuan, *Travelers among Mountains* and *Streams*, early 11th century

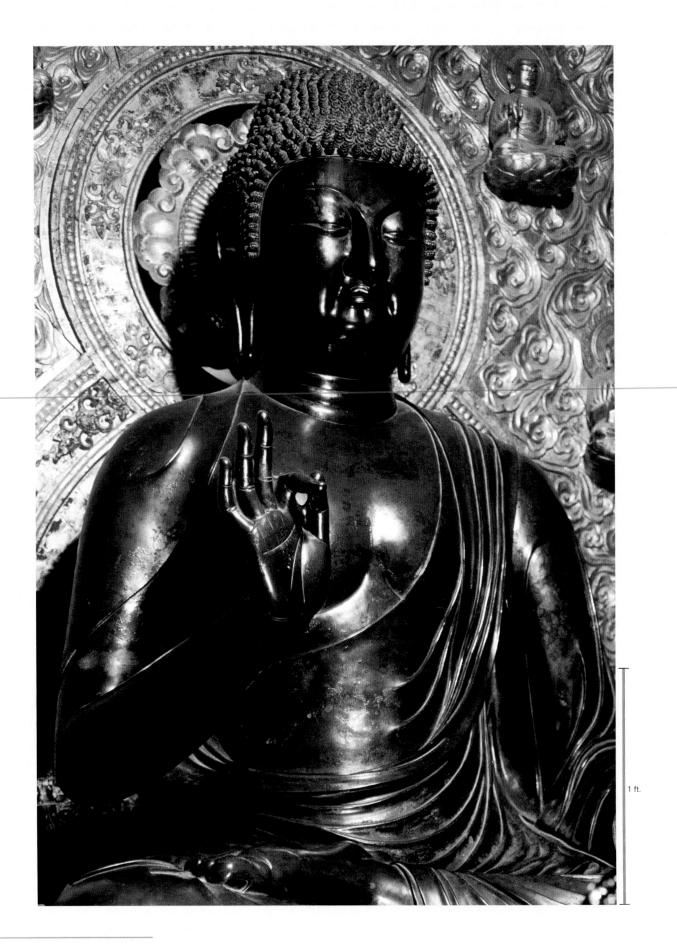

8-1 Detail of Yakushi, Yakushi triad (FIG. 8-8), kondo, Yakushiji, Nara Prefecture, Japan, Nara period, late seventh or early eighth century CE. Bronze, detail 3′ 10″ high.

The introduction of Buddhism in 552 ce profoundly changed the character of Japanese art and architecture. This early masterpiece of Japanese Buddhist sculpture reveals debts to both China and India.

JAPAN BEFORE 1333

The Japanese archipelago (MAP 8-1) consists of four main islands—Hokkaido, Honshu, Shikoku, and Kyushu—and hundreds of smaller ones, a surprising number of them inhabited. Over the centuries, the Japanese have demonstrated a remarkable ability to surmount geographical challenges, such as Japan's mountainous island terrain that makes travel and communication difficult. Japanese culture, however, does not reveal the isolation typical of some island civilizations but rather reflects a responsiveness to imported ideas, such as Buddhism and Chinese writing systems, that filtered in from continental eastern Asia. Acknowledging this responsiveness to mainland influences does not suggest that Japan simply absorbed these imported ideas and practices. Indeed, throughout its history, Japan has developed a truly distinct culture. Ultimately, Japan's close proximity to the continent has promoted extensive exchange with mainland cultures, but the sea has helped protect it from outright invasions and allowed it to develop an individual and unique character.

JAPAN BEFORE BUDDHISM

The introduction of Buddhism to Japan in 552 CE so profoundly changed the character of Japanese art and architecture that art historians traditionally divide the early history of art in Japan into pre-Buddhist and Buddhist eras.

Jomon and Yayoi Periods

Japan's earliest distinct culture, the Jomon (ca. 10,500–300 BCE), emerged roughly 10,000 years before the Buddha's birth. The term *jomon* ("cord markings") refers to the technique Japanese potters of this era used to decorate earthenware vessels. The Jomon people were hunter-gatherers, but unlike most huntergatherer societies, which were nomadic, the Jomon enjoyed surprisingly settled lives. Their villages consisted of pit dwellings—shallow round excavations with raised earthen rims and thatched roofs. Their settled existence permitted the Jomon people to develop distinctive ceramic technology, even before their

development of agriculture. In fact, archaeologists have dated some ceramic *sherds* (pottery fragments) found in Japan to before 10,000 BCE—older than sherds from any other area of the world.

MIDDLE JOMON POTTERY In addition to rope markings, incised lines and applied coils of clay adorned Jomon pottery surfaces. The most impressive examples come from the Middle Jomon period (2500–1500 BCE). Much of the population then lived in the mountainous inland region, where lo-cal variations in ceramic form and surface treatment flourished. However, all Jomon potters shared a highly developed feeling for modeled, rather than painted, ceramic ornament. Jomon pottery displays such a wealth of applied clay coils, striped incisions, and sometimes quasifigural motifs that the sculptural treatment in certain instances even jeopardizes the basic functionality of the vessel. Jomon vessels served a wide variety of purposes, from storage to cooking to bone burial. Some of the most elaborate pots may have served ceremonial functions. A dramatic example (FIG. 8-2) from Miyanomae shows a characteristic,

intricately modeled surface and a partially sculpted rim. Jomon pottery contrasts strikingly with China's most celebrated Neolithic earthenwares (FIG. 7-2) in that the Japanese vessels are extremely thick and heavy. The harder, thinner, and lighter Neolithic Chinese earthenware emphasizes basic ceramic form and painted decoration.

YAYOI Jomon culture gradually gave way to Yayoi (ca. 300 BCE-300 CE). The period takes its name from the Yayoi district of Tokyo, where evidence of this first post-Jomon civilization was discovered, but the culture emerged in Kyushu, the southernmost of the main Japanese islands, and spread northward. Increased interaction with both China and Korea and immigration from Korea brought dramatic social and technological transformations during the Yayoi period. People continued to live in pit dwellings, but their villages grew in size, and they developed fortifications, indicating a perceived need for defense. In the third century CE, Chinese visitors noted that Japan had walled towns, many small kingdoms, and a highly stratified social structure. Wet-rice agriculture provided the social and economic foundations for such development. The Yayoi period was a time of tremendous change in Japanese material culture as well. The Yayoi produced pottery that was less sculptural than Jomon ceramics and sometimes polychrome, and they developed bronze casting and loom weaving.

8-2 Vessel, from Miyanomae, Nagano Prefecture, Japan, Middle Jomon period, 2500–1500 BCE. Earthenware, 1' $11\frac{2}{3}"$ high. Tokyo National Museum, Tokyo.

Jomon pottery is the earliest art form of Japan. Characteristic features are the applied clay coils, striped incisions, and quasi-figural motifs that in some examples jeopardize the functionality of the vessel.

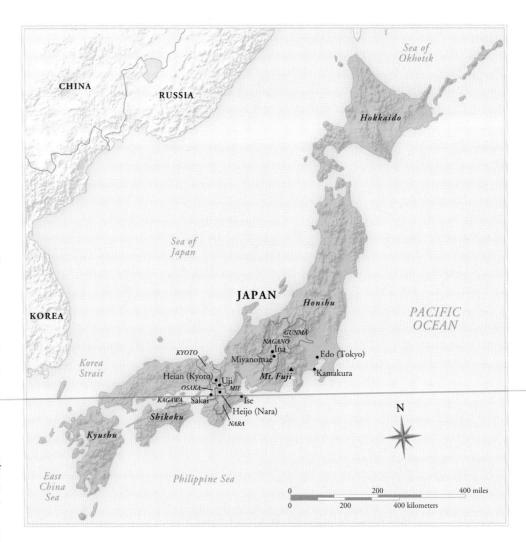

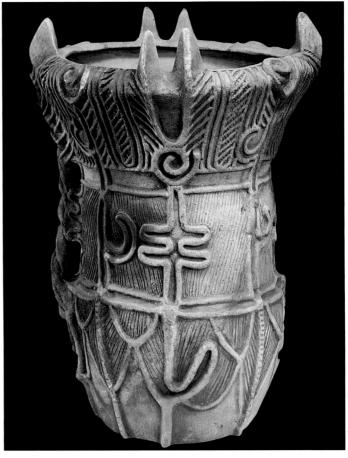

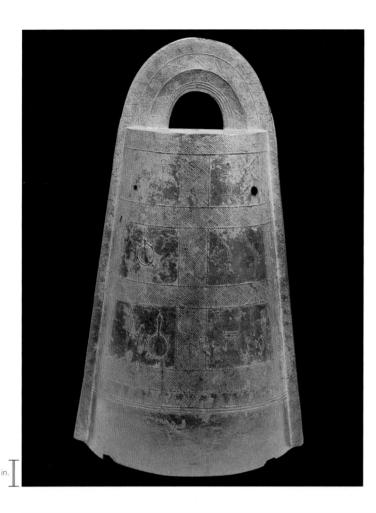

8-3 Dotaku with incised figural motifs, from Kagawa Prefecture, Japan, late Yayoi period, 100–300 CE. Bronze, $1' \frac{4^n}{8}$ high. Tokyo National Museum, Tokyo.

Yayoi dotaku were based on Han Chinese bells, but they were ceremonial objects, not musical instruments. They feature geometric decoration and the earliest Japanese images of people and animals.

DOTAKU Among the most intriguing objects Yayoi artisans produced were *dotaku*, or bells. They resemble Han Chinese bell forms, but the Yayoi did not use dotaku as musical instruments. The bells were treasured ceremonial bronzes and the Japanese often deposited them in graves. Cast in clay molds, these bronzes generally featured raised geometric decoration presented in bands or blocks. On some of the hundreds of surviving dotaku, including the example illustrated here (FIG. 8-3), the ornament consists of

simple line drawings of people and animals. Scholars have reached no consensus on the meaning of these images. In any case, the dotaku engravings are the earliest extant examples of pictorial art in Japan.

Kofun Period

Historians named the succeeding Kofun period (ca. 300–552)* after the enormous earthen burial mounds, or *tumuli*, that had begun to appear in the third century (*ko* means "old"; *fun* means "tomb"). The tumuli recall the earlier Jomon practice of placing the dead on sacred mountains. The mounds grew dramatically in number and scale in the fourth century.

TOMB OF NINTOKU The largest tumulus (FIG. 8-4) in Japan is at Sakai and is usually identified as the tomb of Emperor Nintoku, although many scholars think the tumulus postdates his death in

399. The central mound, which takes the "keyhole" form standard for tumuli during the Kofun period, is approximately 1,600 feet long and rises to a height of 90 feet. Surrounded by three moats, the entire site covers 458 acres. Numerous objects were placed with the coffin in a stone-walled burial chamber near the summit of the mound to assist in the deceased's transition to the next life. For exalted individuals like Emperor Nintoku, objects buried included important symbolic items and imperial regalia—mirrors, swords, and comma-shaped jewels. Numerous bronze mirrors came from China, but the form of the tombs themselves and many of the burial goods suggest even closer connections with Korea. For example, the comma-shaped jewels are quite similar to those found on Korean Silla crowns (FIG. 7-27), whose simpler gilt bronze counterparts lay in the Japanese tombs.

*From this point on, all dates in this chapter are CE unless otherwise stated.

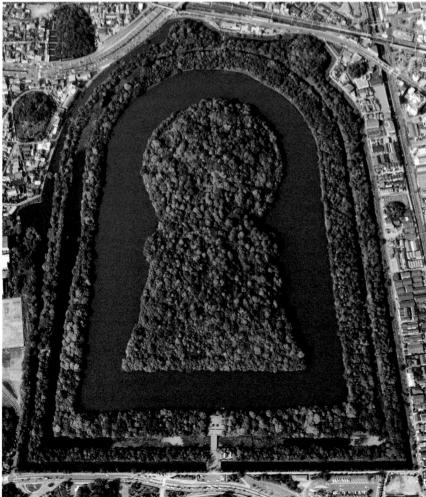

8-4 Tomb of Emperor Nintoku, Sakai, Osaka Prefecture, Japan, Kofun period, late fourth to early fifth century.

The largest Kofun tumulus, attributed to Emperor Nintoku, has a keyhole shape and three surrounding moats. About 20,000 clay haniwa (Fig. 8-5) were originally displayed on the giant earthen mound.

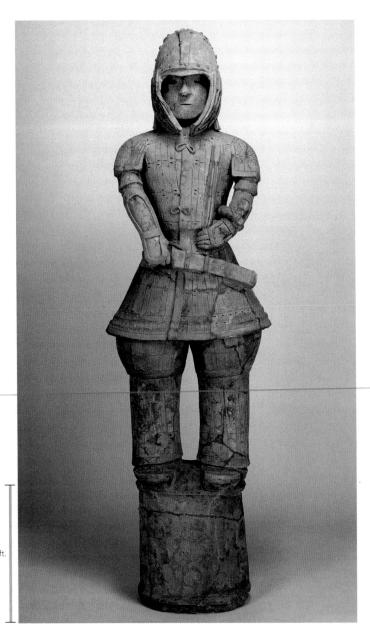

8-5 Haniwa warrior, from Gunma Prefecture, Japan, Kofun period, fifth to mid-sixth century. Low-fired clay, $4'\ 3\frac{1}{4}''$ high. Tokyo National Museum, Tokyo.

During the Kofun period, the Japanese set up cylindrical clay statues (haniwa) of humans, animals, and objects on burial tumuli. They served as a protective spiritual barrier between the living and the dead.

HANIWA The Japanese also placed unglazed ceramic sculptures called *haniwa* on and around the Kofun tumuli. These sculptures, usually several feet in height, as is the warrior shown here (FIG. 8-5), are distinctly Japanese. Compared with the Chinese terracotta soldiers and horses (FIG. 7-6) buried with the First Emperor of Qin, these statues appear deceptively whimsical as variations on a cylindrical theme (*hani* means "clay"; *wa* means "circle"). Yet haniwa sculptors skillfully adapted the basic clay cylinder into a host of forms, from abstract shapes to objects, animals (for example, deer, bears, horses, and monkeys), and human figures, such as warriors and female shamans. These artists altered the shapes of the cylinders, emblazoned them with applied ornaments, excised or built up forms, and then painted the haniwa. The variety of figure types suggests that haniwa functioned not as military guards but as a spiritual barrier protecting both the living and the dead from contamination.

The Japanese of the Kofun period set the statues both in curving rows around the tumulus and in groups around a haniwa house placed directly over the deceased's burial chamber. Presumably, the number of sculptures reflected the stature of the dead person. Emperor Nintoku's tumulus had about 20,000 haniwa statues placed around the mound.

SHRINE OF AMATERASU The religious system the Japanese embraced during the Yayoi and Kofun eras is known as Shinto (see "Shinto," page 211). The Japanese imperial clan traces its origins to the Shinto sun goddess Amaterasu. Her shrine (FIG. 8-6) at Ise is the most important Shinto religious center. The location, use, and ritual reconstruction of this shrine every 20 years reflect the primary characteristics of Shinto-sacred space, ritual renewal, and purification. The Ise shrine is traditionally dated to the Kofun period. Many scholars now favor a later date, but the shrine still serves as a representative example of sacred architecture in ancient Japan. Although Japanese shrine architecture varies tremendously, scholars believe the Ise shrine preserves some of the very earliest design elements. Yet the Ise shrine is unique. Because of its connection to the Japanese imperial family, no other shrines may be constructed with the identical design. The original source for the form of the Ise complex's main hall appears to be Japanese granaries. Granaries were among the most important buildings in Japan's early agrarian society. Although not every aspect of the Ise shrine is equally ancient, the three main structures of the inner shrine convey some sense of Japanese architecture before the introduction of Buddhism and before the development of more elaborately constructed and adorned buildings.

Aside from the thatched roofs and some metallic decorations, the sole construction material at Ise is wood, fitted together in a mortise-and-tenon system, in which the builders slip the wallboards into slots in the pillars. Two massive freestanding posts (once great cypress trunks), one at each end of the main sanctuary, support most of the weight of the *ridgepole*, the beam at the crest of the roof. The golden-hued cypress columns and planks contrast in color and texture with the white gravel covering the sacred grounds. The roof was originally constructed of thatch, which was smoked, sewn into bundles, and then laid in layers. The smooth shearing of the entire surface produced a gently changing contour. Today, cypress bark covers the roof. Decorative elements (originally having a structural function) enhance the roofline and include chigi, extensions of the rafters at each end of the roof, and katsuogi, wooden logs placed at right angles across the ridgepole to hold the thatch of the roof in place. The Amaterasu shrine highlights the connection, central to Shinto, between nature and spirit. Not only are the construction materials derived from the natural world, but the shrine also stands at a specific location where a kami is believed to have taken up residence.

BUDDHIST JAPAN

In 552, according to traditional interpretation, the ruler of Paekche, one of Korea's Three Kingdoms (see Chapter 7), sent Japan's ruler a gilded bronze statue of the Buddha along with *sutras* (Buddhist scriptures) translated into Chinese, at the time the written language of eastern Asia. This event marked the beginning of the Asuka period (552–645), when Japan's ruling elite embraced major elements of continental Asian culture that had been gradually filtering into Japan. These cultural components became firmly established in Japan and included Chinese writing, Confucianism (see "Daoism and Confucianism," Chapter 7, page 186), and Buddhism (see "Buddhism and Buddhist Iconography," Chapter 6, page 161). In 645 a

Shinto

The early beliefs and practices of pre-Buddhist Japan, which form a part of the belief system later called Shinto ("Way of the Gods"), did not derive from the teachings of any individual founding figure or distinct leader. Formal scriptures, in the strict sense, do not exist for these beliefs and practices either. Shinto developed in Japan in conjunction with the advent of agriculture during the Yayoi period. Shinto thus originally focused on the needs of this agrarian society and included agricultural rites surrounding planting and harvesting. Villagers venerated and prayed to a multitude of local deities or spirits called *kami*. The early Japanese believed kami existed in mountains, waterfalls, trees, and other features of nature, as well as in charismatic people, and they venerated not only the kami themselves but also the places the kami occupy, which are considered sacred.

Each clan (a local group claiming a common ancestor, and the basic societal unit during the Kofun period) had its own protector kami, to whom members offered prayers in the spring for successful planting and in the fall for good harvests. Clan members built shrines consisting of several buildings for the veneration of kami. Priests made offerings of grains and fruits at these shrines and prayed on behalf of the clans. Rituals of divination, water purification, and ceremonial purification at the shrines proliferated. Visitors

to the shrine area had to wash before entering in a ritual of spiritual and physical cleansing.

Purity was such a critical aspect of Japanese religious beliefs that people would abandon buildings and even settlements if negative events, such as poor harvests, suggested spiritual defilement. Even the early imperial court moved several times to newly built towns to escape impurity and the trouble it caused. Such purification concepts are also the basis for the cyclical rebuilding of the sanctuaries at grand shrines. The buildings of the inner shrine (FIG. 8-6) at Ise, for example, have been rebuilt every 20 years for more than a millennium with few interruptions. Rebuilding rids the sacred site of physical and spiritual impurities that otherwise might accumulate. During construction, the old shrine remains standing until the carpenters erect an exact duplicate next to it. In this way, the Japanese have preserved ancient forms with great precision.

When Buddhism arrived in Japan from the mainland in the sixth century, Shinto practices changed under its influence. For example, until the introduction of Buddhism, painted or carved images of Shinto deities did not exist. Yet despite the eventual predominance of Buddhism in Japan, Shinto continues to exist as a vital religion for many Japanese, especially those living in rural areas.

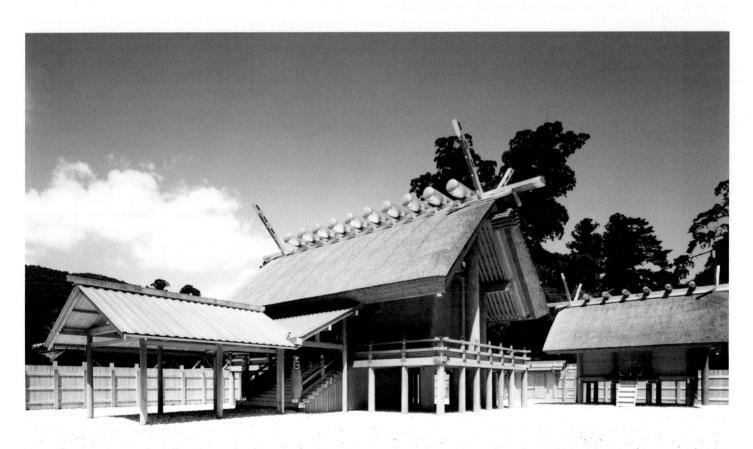

8-6 Main hall, Amaterasu shrine, Ise, Mie Prefecture, Japan, Kofun period or later; rebuilt in 1993.

The most important Shinto shrine in Japan is that of the sun goddess Amaterasu at Ise. Constructed of wood with a thatch roof, the shrine reflects the form of early Japanese granaries.

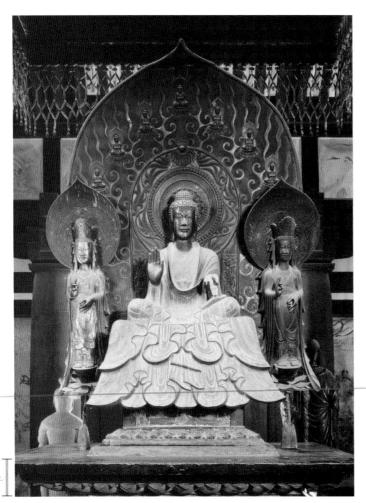

8-7 Tori Busshi, Shaka triad, kondo, Horyuji, Nara Prefecture, Japan, Asuka period, 623. Bronze, central figure 5' $9\frac{1}{2}''$ high.

Tori Busshi's Shaka triad (the historical Buddha and two bodhisattvas) is among the earliest Japanese Buddhist sculptures. The elongated heads and elegant swirling drapery reflect the sculptural style of China.

series of reforms led to the establishment of a centralized government in place of the individual clans that controlled the different regions of Japan. This marked the beginning of the Nara period (645–784), when the Japanese court, ruling from a series of capitals south of modern Kyoto, increasingly adopted the forms and rites of the Chinese court. In 710 the Japanese finally established what they intended as a permanent capital at Heijo (present-day Nara). City planners laid out the new capital on a symmetrical grid closely modeled on the plan of the Chinese capital of Chang'an.

For a half century after 552, Buddhism met with opposition, but by the end of that time, the new religion was established firmly in Japan. Older beliefs and practices (those that came to be known as Shinto) continued to have significance, especially as agricultural rituals and imperial court rites. As time passed, Shinto deities even gained new identities as local manifestations of Buddhist deities.

Asuka and Nara Periods

In the arts associated with Buddhist practices, Japan followed Korean and Chinese prototypes very closely, especially during the Asuka and Nara periods. In fact, early Buddhist architecture in Japan adhered so closely to mainland standards (although generally with a

considerable time lag) that surviving Japanese temples have helped greatly in the reconstruction of what was almost completely lost on the continent.

TORI BUSSHI Among the earliest extant examples of Japanese Buddhist sculpture is a bronze Buddha triad (Buddha flanked by two bodhisattvas; FIG. 8-7) dated 632. Empress Suiko commissioned the work as a votive offering when Prince Shotuku fell ill in 621. When he died, the empress dedicated the triad to the prince's well-being in his next life and to his hoped-for rebirth in paradise. The central figure in the triad is Shaka (the Indian/Chinese Sakyamuni), the historical Buddha, seated with his right hand raised in the abhaya mudra (fear-not gesture; see "Buddhism and Buddhist Iconography," Chapter 6, page 161). Behind Shaka is a flaming mandorla (a lotus-petalshaped nimbus) incorporating small figures of other Buddhas. The sculptor, Tori Busshi (busshi means "maker of Buddhist images"), was a descendant of a Chinese immigrant. Tori's Buddha triad reflects the style of the early to mid-sixth century in China and Korea and is characterized by elongated heads and elegantly stylized drapery folds that form gravity-defying swirls.

YAKUSHI TRIAD In the early Nara period, Japanese sculptors began to move beyond the style of the Asuka period in favor of new ideas and forms coming out of Tang China and Korea. More direct relations with China also narrowed the time lag between developments there and their transfer to Japan. In the triad of Yakushi (the Indian Bhaisajyaguru, the Buddha of Healing who presides over the Eastern Pure Land; Fig. 8-8) in the Yakushiji temple of the late seventh century in Nara, the sculptor favored greater anatomical definition and shape-revealing drapery (Fig. 8-1) over the dramatic stylizations of Tori Busshi's triad. The statues of the attendant bodhisattvas Nikko and Gakko, especially, reveal the long stylistic trail back through China (Fig. 7-14) to the sensuous fleshiness (Fig. 6-13) and outthrust-hip poses (Fig. 6-8) of Indian sculpture.

HORYUJI KONDO Tori Busshi created his Shaka triad for an Asuka Buddhist temple complex at Horyuji, seven miles south of modern Nara, but fire destroyed the temple. The statue was reinstalled around 680 in the kondo (Golden Hall; the main hall for worship that contained statues of the Buddha and the bodhisattvas to whom the temple was dedicated; FIG. 8-9, left) of the successor Nara period complex (FIG. 8-9, right). Although periodically repaired and somewhat altered (the covered porch is an eighthcentury addition; the upper railing dates to the 17th century), the structure retains its graceful but sturdy forms beneath the modifications. The main pillars (not visible in FIG. 8-9, left, due to the porch addition) decrease in diameter from bottom to top. The tapering provides an effective transition between the more delicate brackets above and the columns' stout forms. Also somewhat masked by the added porch is the harmonious reduction in scale from the first to the second story. Following Chinese models, the builders used ceramic tiles as roofing material and adopted the distinctive curved roofline of Tang (FIG. 7-16) and later Chinese architecture. Other buildings at the site include a five-story pagoda (FIG. 8-9, right) that serves as a reliquary.

Until a disastrous fire in 1949, the interior walls of the Golden Hall at Horyuji preserved some of the finest examples of Buddhist wall painting in eastern Asia. Executed around 710, when Nara became the Japanese capital, these paintings now survive only in color photographs. The most important paintings depicted the Buddhas of the four directions. Like the other three, Amida (Indian

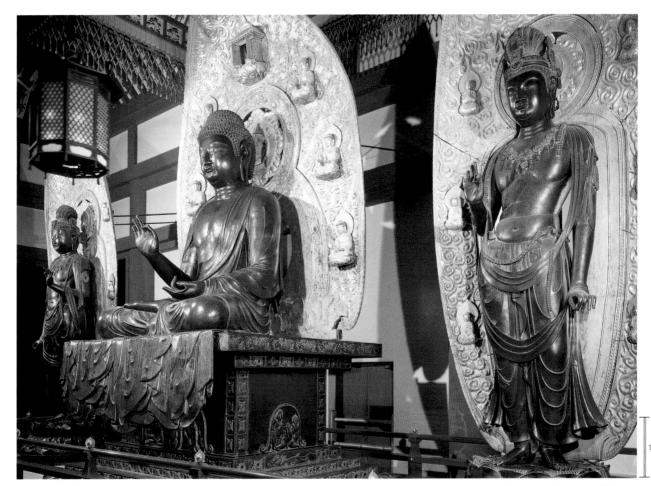

8-8 Yakushi triad, kondo, Yakushiji, Nara Prefecture, Japan, Nara period, late seventh or early eighth century. Bronze, central figure 8' 4" high, including base and mandorla.

The sculptor of this Nara Buddha triad favored greater anatomical definition and shape-revealing drapery than the Asuka artist Tori Busshi (FIG. 8-7). The Nara statues display the sensuous fleshiness of Indian sculpture.

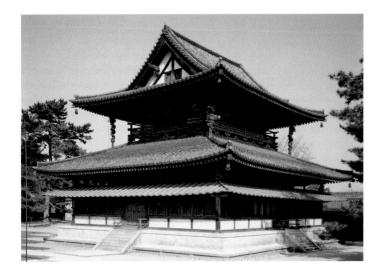

8-9 Kondo (*above*) and aerial view of the temple complex (*right*), Horyuji, Nara Prefecture, Japan, Nara period, ca. 680.

The kondo, or Golden Hall, of a Buddhist temple complex housed statues of the Buddha and bodhisattvas. The Horyuji kondo follows Chinese models in its construction method and its curved roofline.

8-10 Amida triad, wall painting formerly in the kondo, Horyuji, Nara Prefecture, Japan, Nara period, ca. 710. Ink and colors, 10' $3'' \times 8'$ 6''. Horyuji Treasure House, Nara.

The murals of the Horyuji kondo represented the Buddhas of the four directions. Amida, the Buddha of the Western Pure Land, has red ironwire lines and reflects Chinese Tang painting style.

Amitabha; FIG. 8-10), the Buddha of immeasurable light and infinite life, ruler of the Western Pure Land, sits enthroned in his paradisical land, attended by bodhisattvas. The exclusive worship of Amida later became a major trend in Japanese Buddhism, and much grander depictions of his paradise appeared, resembling those at Dunhuang (FIG. 7-15) in China. Here, however, the representation is simple and iconic. Although executed on a dry wall, the painting process involved techniques similar to fresco, such as transferring

designs from paper to wall by piercing holes in the paper and pushing colored powder through the perforations (pouncing). As with the Buddha triad (FIG. 8-8) at Yakushiji, the mature Tang style, with its echoes of Indian sensuality, surfaces in this work. The smooth brush lines, thoroughly East Asian, give the figures their substance and life. These lines, often seen in Buddhist painting, are called iron-wire lines because they are thin and of unvarying width with a suggestion of tensile strength. As in many other Buddhist paintings, the lines are red instead of black. The identity of the painters of these pictures is unknown, but some scholars have suggested they were Chinese or Korean rather than Japanese.

DAIBUTSUDEN, TODAIJI At the Todaiji temple complex at Nara, the kondo is known as the Daibutsuden (FIG. 8-11), or Great Buddha Hall. Originally constructed in the eighth century, the Daibutsuden was rebuilt in the early 18th century. The Nara period temple housed a 53-foot bronze image of the Cosmic Buddha, Roshana (Vairocana), inspired by Chinese colossal stone statues (FIG. 7-14) of this type. The commissioning of Todaiji and its Great Buddha statue (Daibutsu) by Emperor Shomu in 743 was historically important as part of an imperial attempt to unify and strengthen the country by using religious authority to reinforce imperial power. The temple served as the administrative center of a network of branch temples built in every province. Thus, the consolidation of imperial authority and thorough penetration of Buddhism throughout the country went hand in hand. The dissemination of a common religion contributed to the eventual disruption of the clan system and the unification of disparate political groups. So important was the erection of both the building and the Daibutsu that court and government officials as well as Buddhist dignitaries from China and India were present at the opening ceremonies in 752. Chinese Buddhist monks also came to Japan in large numbers and were instrumental in spreading Buddhist teachings throughout Japan. Sadly, the current building is significantly smaller than the original. Today the Daibutsuden has 7 bays. The original had 11. Yet even in its diminished size, the Todaiji Great Buddha Hall is the largest wooden building in the world.

8-11 Daibutsuden, Todaiji, Nara, Japan, Nara period, 743; rebuilt ca. 1700.

The Great Buddha Hall of the Todaiji temple complex at Nara is the largest wooden building in the world.
Constructed by Emperor Shomu in 743, it originally had 11 bays instead of the current 7.

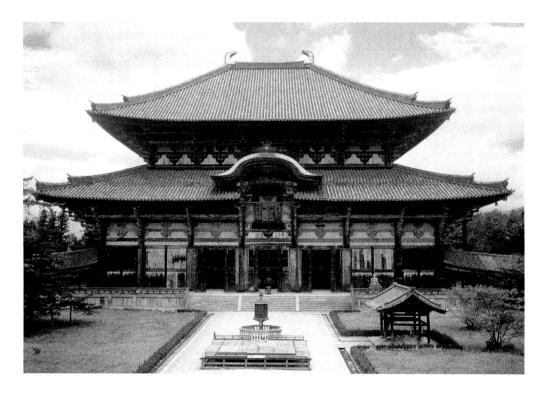

Heian Period

In 784, possibly to escape the power of the Buddhist priests in Nara, the imperial house moved its capital north, eventually relocating in 794 in what became its home until modern times. Originally called Heiankyo ("capital of peace and tranquility"), it is known today as Kyoto. The Heian period (794–1185) of Japanese art takes its name from the new capital. Early in the period, Japan maintained fairly close ties with China, but from the middle of the ninth century on, relations between the two deteriorated so rapidly that court-sponsored contacts had ceased by the end of that century. Japanese culture became much more self-directed than it had been in the preceding few centuries.

ESOTERIC BUDDHISM Among the major developments during the early Heian period was the introduction of Esoteric Buddhism to Japan from China. Esoteric Buddhism is so named because of the secret transmission of its teachings. Two Esoteric sects made their appearance in Japan at the beginning of the Heian period: Tendai in 805 and Shingon in 806. The teachings of Tendai were based on the *Lotus Sutra*, one of the Buddhist scriptural narratives, and Shingon (True Word) teachings on two other sutras. Both Tendai and Shingon Buddhists believe that all individuals possess buddha nature and can achieve enlightenment through meditation rituals and careful living. To aid focus during meditation, Shingon disciples use special hand gestures (mudras) and recite particular words or syllables (*mantras* in Sanskrit, *shingon* in Japanese). Shingon became the primary form of Buddhism in Japan through the mid-10th century.

TAIZOKAI MANDARA Because of the emphasis on ritual and meditation in Shingon, the arts flourished during the early Heian period. Both paintings and sculptures provided followers with visualizations of specific Buddhist deities and allowed them to contemplate the transcendental concepts central to the religion. Of particular importance in Shingon meditation was the mandara (mandala in Sanskrit), a diagram of the cosmic universe. Among the most famous Japanese mandaras is the Womb World (Taizokai), which usually hung on the wall of a Shingon kondo. The Womb World is composed of 12 zones, each representing one of the various dimensions of buddha nature (for example, universal knowledge, wisdom, achievement, and purity). The mandara illustrated here (FIG. 8-12) is among the oldest and best preserved in Japan and is located at Kyoogokokuji (Toji), the Shingon teaching center established at Kyoto in 823. Many of the figures hold lightning bolts, symbolizing the power of the mind to destroy human passion. The Womb World mandara is one of a pair of paintings. The other depicts the Diamond World (Kongokai). The central motif in the Womb World is the lotus of compassion. In the Diamond World the central motif is the diamond scepter of wisdom. Both of the Toji mandaras reflect Chinese models.

PHOENIX HALL, UJI During the middle and later Heian period, belief in the vow of Amida, the Buddha of the Western Pure Land, to save believers through rebirth in his realm gained great prominence among the Japanese aristocracy. Eventually, the simple message of Pure Land Buddhism—universal salvation—facilitated the spread of Buddhism to all classes of Japanese society. The most

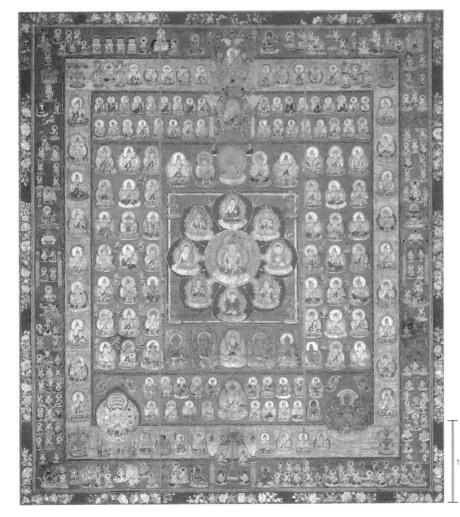

8-12 Taizokai (Womb World) mandara, Kyoogokokuji (Toji), Kyoto, Japan, Heian period, second half of ninth century. Hanging scroll, color on silk, $6' \times 5' \frac{5''}{8}$.

The Womb World mandara is a diagram of the cosmic universe, composed of 12 zones, each representing one dimension of Buddha nature. Mandaras played a central role in Esoteric Buddhist rituals and meditation.

8-13 Phoenix Hall, Byodoin, Uji, Kyoto Prefecture, Japan, Heian period, 1053.

The Phoenix Hall's elaborate winged form evokes images of Amida's palace in the Western Pure Land. Situated on a reflective pond, the temple suggests the floating weightlessness of celestial architecture.

important surviving monument in Japan related to Pure Land beliefs is the so-called Phoenix Hall (FIG. 8-13) of the Byodoin. Fujiwara Yorimichi, the powerful regent for three emperors between 1016 and 1068, built the temple in memory of his father, Michinaga, on the grounds of Michinaga's summer villa at Uji. Dedicated in 1053, the Phoenix Hall houses a wooden statue of Amida carved from multiple joined blocks, the predominant wooden sculpture technique by this time. The building's elaborate winged form evokes images of the Buddha's palace in his Pure Land, as depicted in East Asian paintings (FIG. 7-15) in which the architecture reflects the design of Chinese palaces. By placing only light pillars on the exterior, elevating the wings, and situating the whole on a reflective pond, the Phoenix Hall builders suggested the floating weightlessness of celestial architecture. The building's name derives from its overall birdlike shape and from two bronze phoenixes decorating the ridgepole ends. In eastern Asia, these birds were believed to alight on lands properly ruled. Here, they represent imperial might, sometimes associated especially with the empress. The authority of the Fujiwara family derived primarily from the marriage of daughters to the imperial line.

TALE OF GENJI Japan's most admired literary classic is Tale of Genji, written around 1000 by Murasaki Shikubu (usually referred

to as Lady Murasaki), a lady-in-waiting at the court. Recounting the lives and loves of Prince Genji and his descendants, Tale of Genji provides readers with a view of Heian court culture (see "Heian Court Culture," page 217). The oldest extant examples of illustrated copies are fragments from a deluxe set of early-12th-century handscrolls (see "Chinese Painting Materials and Formats," Chapter 7, page 190). From textual and physical evidence, scholars have suggested that the set originally consisted of about 10 handscrolls produced by five teams of artisans. Each team consisted of a nobleman talented in calligraphy, a chief painter who drew the compositions in ink, and assistants who added the color. The script is primarily hiragana, a sound-based writing system developed in Japan from Chinese characters. Hiragana originally served the needs of women (who were not taught Chinese) and became the primary script for Japanese court poetry. In these handscrolls, pictures alternate with text, as in Gu Kaizhi's Admonitions scrolls (FIG. 7-12). However, the Japanese work focuses on emotionally charged moments in personal relationships rather than on lessons in exemplary behavior.

In the scene illustrated here (FIG. 8-14), Genji meets with his greatest love near the time of her death. The bush-clover in the garden identifies the season as autumn, the season associated with the fading of life and love. A radically upturned ground plane and strong

Heian Court Culture

uring the Nara and especially the Heian periods, the Japanese imperial court developed as the center of an elite culture. In a time of peace and prosperity, the aristocracy had the leisure to play musical instruments and write poetry. Exchanging poems became a common social practice and a frequent preoccupation of lovers. Both men and women produced poems as well as paintings and calligraphy that critics generally consider "classical" today. Heian court members, especially those from the great Fujiwara clan that dominated the court for a century and a half and built the Phoenix Hall (FIG. 8-13) at Uji, compiled the first great anthologies of Japanese poetry and wrote Japan's most influential secular prose.

A lady-in-waiting to an empress of the early 11th century wrote the best-known work of literature in Japan, *Tale of Genji*. Known as Lady Murasaki, the author is one of many important Heian women writers, including especially diarists and poets. Generally considered the world's first lengthy novel (the English translation is almost a thousand pages), *Tale of Genji* tells of the life and loves of Prince Genji and, after his death, of his heirs. The novel and much of Japanese literature consistently display a sensitivity to the sadness in the world caused by the transience of love and life. These human sentiments are often intertwined with the seasonality of nature. For example, the full moon, flying geese, crying deer, and certain plants symbolize autumn, which in turn evokes somber emotions, fading love, and dying. These concrete but evocative images frequently appear in paintings, such as the illustrated scrolls of *Tale of Genji* (FIG. 8-14).

8-14 *Genji Visits Murasaki*, from the Minori chapter, *Tale of Genji*, Heian period, first half of 12th century. Handscroll, ink and color on paper, $\frac{5}{8}$ high. Goto Art Museum, Tokyo.

In this handscroll illustrating Lady Murasaki's *Tale of Genji*, the upturned ground plane and diagonal lines suggest three-dimensional space. Flat fields of color emphasize the painting's two-dimensional character.

diagonal lines suggest three-dimensional space. The painter omitted roofs and ceilings to allow a privileged view of the interior spaces where the action takes place. The unusual angles were also intended as metaphors for the emotions of the characters depicted. Flat fields of unshaded color emphasize the painting's two-dimensional character. Rich patterns in the textiles and architectural ornament give a feeling of sumptuousness. The human figures appear constructed of stiff layers of contrasting fabrics, and the artist simplified and generalized the aristocratic faces, using a technique called "a line for the eye and a hook for the nose." This lack of individualization may reflect societal restrictions on looking directly at exalted persons.

Several formal features of the *Genji* illustrations—native subjects, bright mineral pigments, lack of emphasis on strong brushwork, and general flatness—were later considered typical of *yamato-e* (nativestyle painting; the term *yamato* means "Japan" and is used to describe anything that is characteristically Japanese).

LEGENDS OF MOUNT SHIGI Heian painting was diverse in both style and subject matter. *Legends of Mount Shigi*, painted during the late 12th century, represents a different facet of Heian narrative handscroll painting. The stories belong to a genre of pious Buddhist tales devoted to miraculous events involving virtuous

8-15 The flying storehouse, from Legends of Mount Shigi, Heian period, late 12th century. Handscroll, ink and colors on paper, $1'\frac{1}{2}''$ high. Chogosonshiji, Nara.

This Heian handscroll is very different from the *Genji* scroll (FIG. 8-14) in both subject and style. The artist exaggerated each feature of the gesticulating and scurrying figures in this Buddhist miracle story.

individuals. Unlike the *Genji* scrolls, short segments of text and pictures do not alternate. Instead, the painters took advantage of the scroll format to present several scenes in a long, unbroken stretch. For example, the first scroll shows the same travelers at several stages of their journey through a continuous landscape.

The Mount Shigi scrolls illustrate three miracles associated with a Buddhist monk named Myoren and his mountaintop temple. The first relates the story of the flying storehouse (FIG. 8-15) and depicts Myoren's begging bowl lifting the rice-filled granary of a greedy farmer and carrying it off to the monk's hut in the mountains. The painter depicted the astonished landowner, his attendants, and several onlookers in various poses—some grimacing, others gesticulating wildly and scurrying about in frantic amazement. In striking contrast to the *Genji* scroll figures, the artist exaggerated each feature of the painted figures, but still depicted the actors and architecture seen from above.

Kamakura Period

In the late 12th century, a series of civil wars between rival warrior families led to the end of the Japanese imperial court as a major political and social force. The victors, headed by the Minamoto family, established their *shogunate* (military government) at Kamakura in eastern Japan. The imperial court remained in Kyoto as the theoretical source of political authority, but actual power resided with the *shoguns*. The first shogun was Minamoto Yoritomo, on whom the emperor officially bestowed the title in 1185. The ensuing period of Japanese art is called the Kamakura period (1185–1332), named for

the locale. During the Kamakura shogunate, more frequent and positive contact with China brought with it an appreciation for more recent cultural developments there, ranging from new architectural styles to Zen Buddhism.

SHUNJOBO CHOGEN Rebuilding in Nara after the destruction the civil wars inflicted presented an early opportunity for architectural experimentation. A leading figure in planning and directing the reconstruction efforts was the priest Shunjobo Chogen (1121-1206), who is reputed to have made three trips to China between 1166 and 1176. After learning about contemporary Chinese architecture, he oversaw the rebuilding of Todaiji, among other projects, with generous donations from Minamoto Yoritomo. Chogen's portrait statue (FIG. 8-16) is one of the most striking examples of the high level of naturalism prevalent in the early Kamakura period. Characterized by finely painted details, a powerful rendering of the signs of aging, and the inclusion of such personal attributes as prayer beads, the statue of Chogen exhibits the carving skill and style of the Kei School of sculptors (see "Heian and Kamakura Artistic Workshops," page 219). The Kei School traced its lineage to Jocho, a famous sculptor of the mid-11th century. Its works display fine Heian carving techniques combined with an increased concern for natural volume and detail learned from studying, among other sources, surviving Nara period works and sculptures imported from Song China. Enhancing the natural quality of Japanese portrait statues is the use of inlaid rock crystal for the eyes, a technique found only in Japan.

Heian and Kamakura Artistic Workshops

Intil the late Heian period, major artistic commissions came almost exclusively from the imperial court or the great temples. As shogun warrior families gained wealth and power, they too became great art patrons—in many cases closely following the aristocrats' precedents in subject and style.

Artists, for the most part, did not work independently but rather were affiliated with workshops. Indeed, until recently, hierarchically organized male workshops produced most Japanese art. Membership in these workshops was often based on familial relationships. Each workshop was dominated by a master, and many of his main assistants and apprentices were relatives. Outsiders of considerable skill sometimes joined workshops, often through marriage or adoption. The eldest son usually inherited the master's position, after rigorous training in the necessary skills from a very young age. Therefore, one meaning of the term "school of art" in Japan is a network of workshops tracing their origins back to the same master, a kind of artistic clan. Inside the workshops, the master and senior assistants handled the most important production stages, but artists of lower rank helped with the more routine work. The Kamakura portrait statue (FIG. 8-16) of Shunjobo Chogen, for example, is the creation of a workshop based on familial ties.

Artistic cooperation also surfaced in court bureaus, an alternative to family workshops. These official bureaus, located at the imperial palace, had emerged by the Heian period. The painting bureau accrued particular fame. Teams of court painters, led by the bureau director, produced pictures such as the scenes in the Tale of Genji handscrolls (FIG. 8-14). This system remained vital into the Kamakura period and well beyond. Under the direction of a patron or the patron's representative, the master painter laid out the composition by brushing in the initial outlines and contours. Under his supervision, junior painters applied the colors. The master then completed the work by brushing in fresh contours and details such as

facial features. Very junior assistants and apprentices assisted in the process by preparing paper, ink, and pigments. Unlike mastership in hereditarily run workshops, competition among several families determined control of the court painting bureau during the Heian and Kamakura periods.

Not all art was controlled by the bureaus or by family workshops. Priest-artists were trained in temple workshops to produce

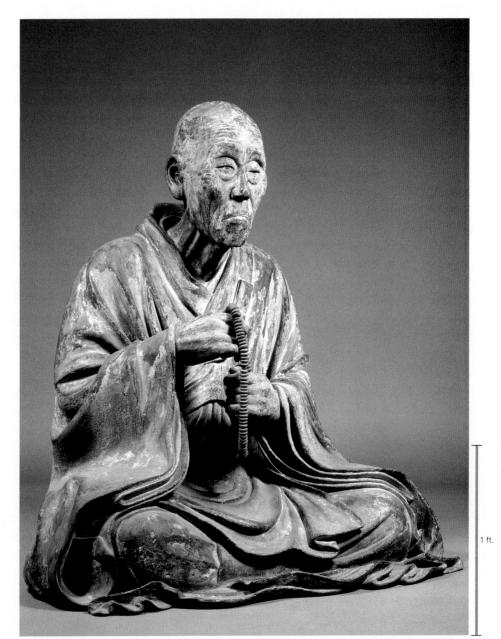

8-16 Portrait statue of the priest Shunjobo Chogen, Todaiji, Nara, Japan, Kamakura period, early 13th century. Painted cypress wood, $2' 8\frac{3}{8}''$ high.

The Kei School's interest in naturalism is seen in this moving portrait of a Kamakura priest. The wooden statue is noteworthy for its finely painted details and powerful rendering of the signs of aging.

Buddhist art objects for public viewing as well as images for private priestly meditation. Amateur painting was common among aristocrats of all ranks. As they did for poetry composition and calligraphy, aristocrats frequently held elegant competitions in painting. Both women and men participated in these activities. In fact, court ladies probably played a significant role in developing the painting style seen in the *Genji* scrolls, and a few participated in public projects.

8-17 Night Attack on the Sanjo Palace, from Events of the Heiji Period, Kamakura period, 13th century. Handscroll, ink and colors on paper, 1' 4½" high; complete scroll 22' 10" long. Museum of Fine Arts, Boston (Fenollosa-Weld Collection).

The Heiji scroll is an example of Japanese historical narrative painting. Staccato brushwork and vivid flashes of color beautifully capture the drama of the night attack and burning of Emperor Goshirakawa's palace.

1 in.

ATTACK ON SANJO PALACE All the painting types flourishing in the Heian period continued to prosper in the Kamakura period. A striking example of handscroll painting is *Events of the Heiji Period*, which dates to the 13th century and illustrates another facet of Japanese painting—historical narrative. The scroll depicts some of the battles in the civil wars at the end of the Heian period. The section reproduced here (FIG. 8-17) represents the attack on the Sanjo palace in the middle of the night in which the retired emperor Goshirakawa was taken prisoner and his palace burned. Swirling flames and billowing clouds of smoke dominate the composition. Below, soldiers on horseback and on foot do battle. As in other Heian and Kamakura scrolls, the artist represented the buildings seen from above at a sharp angle. Noteworthy here are the painter's staccato brushwork and the vivid flashes of color that beautifully capture the drama of the event.

AMIDA DESCENDING Buddhism and Buddhist painting also remained vital in the Kamakura period, and elite patrons continued to commission major Pure Land artworks. Pure Land Buddhism in Japan stressed the saving power of Amida, who, if called on, hastened to believers at the moment of death and conveyed them to his Pure Land. Pictures of this scene often hung in the presence of

a dying person, who recited Amida's name to ensure salvation. In *Amida Descending over the Mountains* (FIG. 8-18), a gigantic Amida rises from behind the mountains against the backdrop of a dark sky. His two main attendant bodhisattvas, Kannon and Seishi, have already descended and are depicted as if addressing the deceased directly. Below, two boys point to the approaching divinities. In contrast to these gesticulating figures, Amida is still and frontal, which gives his image an iconic quality. Particularly striking

8-18 Amida Descending over the Mountains, Kamakura period, 13th century. Hanging scroll, ink and colors on silk, $4' 3\frac{1}{8}'' \times 3' 10\frac{1}{2}''$. Zenrinji, Kyoto.

Pictures of Amida descending to convey the dead to the Buddhist Pure Land Paradise often hung in the room of a dying person. In this hanging scroll the representation of Amida has an iconic character.

is the way in which his halo (nimbus) resembles a rising moon, an image long admired in Japan for its spiritual beauty.

MUROMACHI The Kamakura period ended the way it began—with civil war. After several years of conflict, one shogun emerged supreme and governed Japan from his headquarters in the Muramachi district of Kyoto. The art and architecture of the Muromachi period to the present are the subject of Chapter 28.

1 ft

JAPAN BEFORE 1333

JOMON AND YAYOI PERIODS, ca. 10,500 BCE-300 CE

- The Jomon (ca. 10,500–300 BCE) is Japan's earliest distinct culture. It takes its name from the applied clay cordlike coil decoration of Jomon pottery.
- Archaeologists unearthed the first evidence for the Yayoi culture (ca. 300 BCE–300 CE) in the Yayoi district of Tokyo, but the culture emerged in Kyushu and spread northward. Increasing contact with the East Asian mainland is evident in the form of Yayoi dotaku, which were modeled on Han Chinese bells.

Middle Jomon vessel, ca. 2500–1500 BCE

KOFUN PERIOD, ca. 300-552

- Kofun means "old tomb," and great earthen burial mounds are the primary characteristic of the last pre-Buddhist period of Japanese art. The largest tumulus in Japan, attributed to Emperor Nintoku, who died in 399, is at Sakai.
- About 20,000 clay cylindrical figures (haniwa) stood around and on top of the Sakai tumulus. Haniwa sculptures represent inanimate objects and animals as well as human figures, including warriors. They formed a protective spiritual barrier between the living and the dead.

Haniwa warrior, fifth to mid-sixth century

ASUKA AND NARA PERIODS, 552-784

- Buddhism was introduced to Japan in 552, and the first Japanese Buddhist artworks, such as Tori Busshi's Shaka triad at Horyuji, date to the Asuka period (552–645).
- During the Nara period (645–784), a centralized imperial government was established, whose capital was at Nara from 710 to 784.
- Nara architecture, for example, the Horyuji kondo, followed Tang Chinese models in the use of ceramic roof tiles and the adoption of a curved roofline. The Daibutsuden constructed at Todaiji in 743 is the largest wooden building in the world.

Kondo, Horvuji, ca. 680

HEIAN PERIOD, 794-1185

- In 794 the imperial house moved its capital to Heiankyo (Kyoto). Shortly thereafter, Esoteric Buddhism was introduced to Japan. Painted mandaras of the Womb World and the Diamond World facilitated meditation.
- A masterpiece of Heian Buddhist architecture is the Phoenix Hall at Uji, which evokes images of the celestial architecture of the Buddha's Pure Land of the West.
- Narrative scroll painting was a major Heian art form. Illustrated scrolls of Lady Murasaki's Tale of Genji feature elevated viewpoints that suggest three-dimensional space and flat colors that emphasize the painting's two-dimensional character.

Tale of Genji, first half of 12th century

KAMAKURA PERIOD, 1185-1332

- In 1185 power shifted from the Japanese emperor to the first shogun of Kamakura. The shoguns became great patrons of art and architecture.
- Kamakura painting is diverse in both subject and style and includes historical narratives, such as Events of the Heiji Period, and Buddhist hanging scrolls.
- Kamakura wooden portraits—for example, the seated statue of the priest Shunjobo Chogen—are noteworthy for their realism and the use of rock crystal for the eyes.

Shunjobo Chogen, early 13th century

9-1 Double-flute player, detail of a mural painting in the Tomb of the Leopards, Tarquinia, Italy, ca. 480–470 BCE. Detail 3' $3\frac{1}{2}$ " high.

Although Etruscan art owes an obvious stylistic debt to Greek art, painted murals in monumental tombs such as the Tomb of the Leopards at Tarquinia are unknown in Greece at the same time.

THE ETRUSCANS

The Etruscans, as everyone knows, were the people who occupied the middle of Italy in early Roman days, and whom the Romans, in their usual neighborly fashion, wiped out entirely." So opens D. H. Lawrence's witty and sensitive *Etruscan Places* (1929), one of the earliest modern essays to value Etruscan art highly and treat it as much more than a debased form of the art of the contemporaneous city-states of Greece and southern Italy. ("Most people despise everything B.C. that isn't Greek, for the good reason that it ought to be Greek if it isn't," Lawrence quipped.) Today it is no longer necessary to argue the importance and originality of Etruscan art. Deeply influenced by, yet different from, Greek art, Etruscan sculpture, painting, and architecture not only provided the models for early Roman art and architecture but also had an impact on the art of the Greek colonies in Italy.

The heartland of the Etruscans was the territory between the Arno and Tiber rivers of central Italy (MAP 9-1). The lush green hills still bear their name—Tuscany, the land of the people the Romans called Tusci, the region centered on Florence, birthplace of Renaissance art. So do the blue waters that splash against the western coastline of the Italian peninsula, for the Greeks referred to the Etruscans as Tyrrhenians and gave that name to the sea off Tuscany. The origin of the Tusci—the enduring "mystery of the Etruscans"—is not clear at all, however. Their language, although written in a Greek-derived script and extant in inscriptions that are still in large part obscure, is unrelated to the Indo-European linguistic family. Ancient authors, as fascinated by the puzzle as modern scholars are, generally felt that the Etruscans emigrated from the east. Herodotus, the fifth-century BCE Greek historian, specifically declared they came from Lydia in Asia Minor and that King Tyrsenos was their leader—hence their Greek name. But Dionysius of Halicarnassus, writing at the end of the first century BCE, maintained the Tusci were native Italians. And some modern researchers have theorized the Etruscans came into Italy from the north.

All these theories are current today, and no doubt some truth exists in each one. The Etruscan people of historical times were very likely the result of a gradual fusion of native and immigrant populations. This mixing of peoples occurred in the early first millennium BCE. At that time the Etruscans emerged as a people with a culture related to but distinct from those of other Italic peoples and from the civilizations of Greece and the Orient.

MAP 9-1 Italy in Etruscan times.

During the eighth and seventh centuries BCE, the Etruscans, as highly skilled seafarers, enriched themselves through trade abroad. By the sixth century, they controlled most of northern and central Italy from such strongholds as Tarquinia (ancient Tarquinii), Cerveteri (Caere), Vulci, and Veii. But these cities never united to form a state, so it is inaccurate to speak of an Etruscan "nation" or "kingdom," only of Etruria, the territory the Etruscans occupied. Their cities coexisted, flourishing or fading independently. Any semblance of unity among them was based primarily on common linguistic ties and religious beliefs and practices. This lack of political cohesion eventually made the Etruscans relatively easy prey for the Romans.

EARLY ETRUSCAN ART

Although recognizing the distinctive character of Etruscan painting, sculpture, and architecture, art historians still usually divide the history of Etruscan art into periods mirroring those of Greek art. The seventh century BCE is the Orientalizing period of Etruscan art (followed by Archaic, Classical, and Hellenistic periods).

Orientalizing Art

During the seventh century BCE, the Etruscans successfully mined iron, tin, copper, and silver, creating great mineral wealth that transformed Etruscan society. Villages with agriculturally based econo-

mies gave way to prosperous cities engaged in international commerce. Elite families could afford to acquire foreign goods, and Etruscan aristocrats quickly developed a taste for luxury objects incorporating Eastern motifs. To satisfy the demand, local artisans, inspired by imported goods, produced magnificent objects for both homes and tombs. As in Greece at the same time, the locally produced Orientalizing artifacts cannot be mistaken for their foreign models.

REGOLINI-GALASSI TOMB About 650–640 BCE, a wealthy Etruscan family stocked the so-called Regolini-Galassi Tomb (named for its excavators) at Cerveteri with bronze cauldrons and gold jewelry of Etruscan manufacture and Orientalizing style. The most spectacular of the many luxurious objects in the family tomb is a golden *fibula* (clasp or safety pin; FIG. 9-2) of unique shape used to fasten a woman's gown at the shoulder. The giant fibula is in the Italic tradition, but the five lions that stride across the gold surface are motifs originating in the Orient. The technique, also emulating Eastern imports, is masterful, combining *repoussé* (hammered relief) and *granulation* (the fusing of tiny metal balls, or granules, to a metal surface). The Regolini-Galassi fibula equals or exceeds in quality anything that might have served as a model.

9-2 Fibula with Orientalizing lions, from the Regolini-Galassi Tomb, Cerveteri, Italy, ca. 650–640 BCE. Gold, $1'\frac{1}{2}''$ high. Musei Vaticani, Rome.

This huge gold pin found with other Orientalizing jewelry in a Cerveteri tomb combines repoussé and granulation and is the work of an Etruscan artist, but the lions are Near Eastern motifs.

The jewelry from the Regolini-Galassi Tomb also includes a golden *pectoral* that covered a deceased woman's chest, and two gold circlets that may be earrings, although they are large enough to be bracelets. A taste for this kind of ostentatious display is frequently the hallmark of newly acquired wealth, and this was certainly the case in seventh-century BCE Etruria.

Archaic Art and Architecture

Etruscan artists looking eastward for inspiration were also greatly impressed by the art and architecture of Greece. But however eager they may have been to emulate Greek works, the distinctive Etruscan temperament always manifested itself. The vast majority of Archaic Etruscan artworks depart markedly from their prototypes.

ETRUSCAN TEMPLES The design of Etruscan temples superficially owes much to Greece, but the differences far outweigh the similarities. Because of the materials Etruscan architects employed, usually only the foundations of Etruscan temples have survived. These are nonetheless sufficient to reveal the plans of the edifices. Supplementing the archaeological record is the Roman architect Vitruvius's treatise on architecture written near the end of the first century BCE. In it, Vitruvius provided an invaluable chapter on Etruscan temple design.

Archaeologists have constructed a model (FIG. 9-3) of a typical Archaic Etruscan temple based on Vitruvius's account. The sixth-century BCE Etruscan temple resembled contemporary Greek stone gable-roofed temples (see Chapter 5), but it had wooden columns and a terracotta-tiled wooden roof, and its walls were of sun-dried brick. Entrance was possible only via a narrow staircase at the center of the front of the temple, which sat on a high podium, the only part of the building made of stone. Columns, often three times a man's height or more, also were restricted to the front of the building, creating a deep porch that occupied roughly half the podium and setting off one side of the structure as the main side. In contrast, the front and rear of Greek temples were indistinguishable, and builders placed steps and columns on all sides (FIG. 5-13). The Etruscan

Etruscan Counterparts of Greco-Roman Gods and Heroes

Etruscan	Greek	Roman
Tinia	Zeus	Jupiter
Uni	Hera	Juno
Menrva	Athena	Minerva
Apulu	Apollo	Apollo
Artumes	Artemis	Diana
Hercle	Herakles	Hercules

temple was not intended to be viewed as a sculptural mass from the outside and from all directions, as Greek temples were. Instead it functioned primarily as an ornate home for grand statues of Etruscan gods. It was a place of shelter, protected by the wide overhang of its roof.

Etruscan temples differed in other ways from those of Greece. Etruscan (or Tuscan) columns resembled Greek Doric columns (FIG. 5-14, *left*), but *Tuscan columns* were made of wood, were unfluted, and had bases. Because of the lightness of the superstructure they had to support, Tuscan columns were, as a rule, much more widely spaced than Greek columns. Unlike their Greek counterparts, Etruscan temples frequently had three cellas—one for each of their chief gods, Tinia, Uni, and Menrva (see "Etruscan Counterparts of Greco-Roman Gods and Heroes," above). And pedimental statuary was exceedingly rare in Etruria. The Etruscans normally placed life-size narrative statuary—in terracotta instead of stone—on the peaks of their temple roofs.

9-3 Model of a typical sixth-century BCE Etruscan temple as described by Vitruvius. Istituto di Etruscologia e di Antichità Italiche, Università di Roma, Rome.

Etruscan temples resembled Greek temples but had widely spaced unfluted wooden columns only at the front, walls of sun-dried mud brick, and a narrow staircase at the center of the facade.

Etruscan Artists in Rome

n 616 BCE, according to the traditional chronology, Tarquinius Priscus of Tarquinia became Rome's first Etruscan king. He ruled for almost 40 years. His grandson, Tarquinius Superbus ("the Arrogant"), was Rome's last king. Outraged by his tyrannical behavior, the Romans drove him out in 509 BCE. Before his expulsion, however, Tarquinius Superbus embarked on a grand program to embellish the city he ruled.

The king's most ambitious undertaking was the erection of a magnificent temple on the Capitoline Hill for the joint worship of Jupiter, Juno, and Minerva. For this great commission, he summoned architects, sculptors, and workers from all over Etruria. Rome's first great religious shrine was Etruscan in patronage, in manufacture, and in form. The architect's name is unknown, but several sources preserve the identity of the Etruscan sculptor brought in to adorn the temple. His name was Vulca of Veii, and he may also have made a statue of the god Apulu (FIG. 9-4) for his native city. Pliny the Elder described his works as "the finest images of deities of that era . . . more admired than gold."* The Romans entrusted Vulca with making the

statue of Jupiter that stood in the central cella of the Capitoline temple's three cellas. He also fashioned the enormous terracotta statuary group of Jupiter in a four-horse chariot, which was mounted on the roof at the highest point directly over the center of the temple facade. The fame of Vulca's redfaced (painted terracotta) portrayal of Jupiter was so great that Roman generals would paint their faces red in emulation of his Jupiter when they paraded in triumph through Rome after a battlefield victory. (The model of a three-cella Etruscan temple in FIG. 9-3 also gives an approximate idea of the appearance of the Capitoline Jupiter temple and of Vulca's roof statue.)

9-4 Apulu (Apollo), from the roof of the Portonaccio temple, Veii, Italy, ca. 510–500 BCE. Painted terracotta, 5' 11" high. Museo Nazionale di Villa Giulia, Rome.

The Veii Apulu was part of a statuary group depicting a Greek myth. Distinctly Etruscan, however, are the god's vigorous motion and gesticulating arms and the placement of the statue on a temple roof.

Vulca is the only Etruscan artist any ancient writer names, but the signatures of other Etruscan artists appear on preserved artworks. One of these is Novios Plautios (FIG. 9-13), who also worked in Rome, although a few centuries later. By then the Etruscan kings

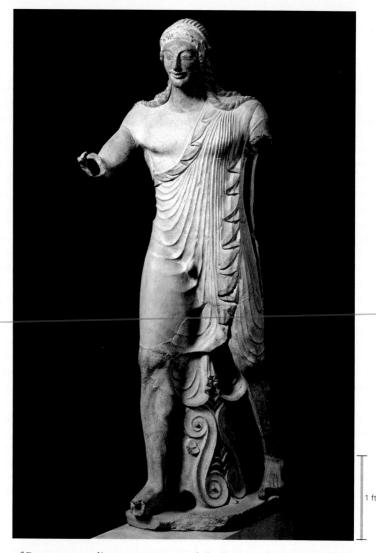

of Rome were a distant memory, and the Romans had captured Veii and annexed its territory.

*Pliny, Natural History, 35.157.

APULU OF VEII The finest of these rooftop statues to survive today is the life-size image of Apulu (FIG. 9-4), which displays the energy and excitement that characterize Archaic Etruscan art in general. The statue comes from a temple in the Portonaccio sanctuary at Veii. It is but one of a group of at least four painted terracotta figures that adorned the top of the temple roof and depicted one of the 12 labors of Herakles/Hercles (see "Herakles," Chapter 5, page 120). The god confronts Hercle for possession of the Ceryneian hind, a wondrous beast with golden horns that was sacred to Apulu's sister Artumes. The bright paint and the rippling folds of Apulu's garment call to mind the Archaic korai of the Acropolis in Ionian garb (FIG. 5-12). But Apulu's vigorous striding motion, gesticulating arms, fanlike calf muscles, and animated face are distinctly Etruscan. Some scholars have attributed the Apulu statue to Vulca of Veii, the most

famous Etruscan sculptor of the time (see "Etruscan Artists in Rome," above). The statue's discovery in 1916 was instrumental in prompting a reevaluation of the originality of Etruscan art.

CERVETERI SARCOPHAGUS Although life-size terracotta statuary was known in Greece, this medium was especially favored in Etruria. Another Archaic Etruscan terracotta masterwork is the sarcophagus (FIG. 9-5) from a Cerveteri tomb in the form of a husband and wife reclining on a banquet couch. The sarcophagus, which was once brightly painted, was cast in four sections and is of monumental size, but it contained only the ashes of the deceased. Cremation was the most common means of disposing of the dead in Italy at this time. This kind of funerary monument had no parallel at this date in Greece, where there were no monumental tombs that

The "Audacity" of Etruscan Women

t the instigation of the emperor Augustus at the end of the first century BCE, Titus Livy wrote a history of Rome from its legendary founding in 753 BCE to his own day. In the first book of his great work, Livy recounted the tale of Tullia, daughter of Servius Tullius, an Etruscan king of Rome in the sixth century BCE. The princess had married the less ambitious of two brothers of the royal Tarquinius family, while her sister had married the bolder of the two princes. Together, Tullia and her brother-in-law, Tarquinius Superbus, arranged for the murder of their spouses. They then married each other and plotted the overthrow and death of Tullia's father. After the king's murder, Tullia ostentatiously drove her carriage over her father's corpse, spraying herself with his blood. (The Roman road where the evil deed occurred is still called the Street of Infamy.) Livy, though condemning Tullia's actions, placed them in the context of the famous "audacity" of Etruscan women.

The independent spirit and relative freedom women enjoyed in Etruscan society similarly horrified (and threatened) other Greco-Roman male authors. The stories the fourth-century BCE Greek historian Theopompus heard about the debauchery of Etruscan women appalled him. They epitomized immorality for Theopompus, but much of what he reported is untrue. Etruscan women did

not, for example, exercise naked alongside Etruscan men. But archaeological evidence confirms the accuracy of at least one of his "slurs": Etruscan women did attend banquets and recline with their husbands on a common couch (FIGS. 9-5 and 9-9). Aristotle also remarked on this custom. It was so foreign to the Greeks that it both shocked and frightened them. Only men, boys, slave girls, and prostitutes attended Greek symposiums. The wives remained at home, excluded from most aspects of public life. In Etruscan Italy, in striking contrast to contemporaneous Greece, women also regularly attended sporting events with men. This, too, is well documented in Etruscan paintings and reliefs.

Etrusia as compared with Greece. They often give the names of both the father and mother of the person commemorated (for example, the inscribed portrait of Aule Metele, Fig. 9-16), a practice unheard of in Greece (witness the grave stele of "Hegeso, daughter of Proxenos," Fig. 5-57). Etruscan women, moreover, retained their own names and could legally own property independently of their husbands. The frequent use of inscriptions on Etruscan mirrors and other toiletry items (Fig. 9-13) buried with women seems to attest to a high degree of female literacy as well.

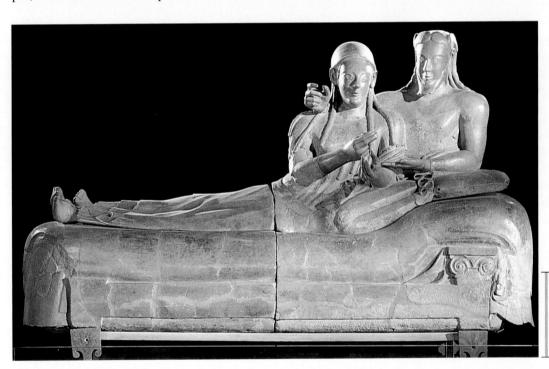

9-5 Sarcophagus with reclining couple, from Cerveteri, Italy, ca. 520 BCE. Painted terracotta, $3' 9\frac{1}{2}'' \times 6' 7''$. Museo Nazionale di Villa Giulia, Rome.

Sarcophagi in the form of a husband and wife on a dining couch have no parallels in Greece. The artist's focus on the upper half of the figures and the emphatic gestures are Etruscan hallmarks.

could house large sarcophagi. The Greeks buried their dead in simple graves marked by a stele or a statue. Moreover, although banquets were common subjects on Greek vases (which, by the late sixth century BCE, the Etruscans imported in great quantities and regularly deposited in their tombs), only men dined at Greek symposiums. The image of a husband and wife sharing the same banquet couch is uniquely Etruscan (see "The 'Audacity' of Etruscan Women," above).

The man and woman on the Cerveteri sarcophagus are as animated as the Veii Apulu (FIG. 9-4), even though they are at rest. They are the antithesis of the stiff and formal figures encountered in Egyptian tomb sculptures (compare FIG. 3-13). Also typically Etruscan, and in striking contrast to contemporaneous Greek statues with their emphasis on proportion and balance, is the manner in which the Cerveteri sculptor rendered the upper and lower parts of each body. The legs were only summarily modeled, and the transition to

9-6 Tumuli in the Banditaccia necropolis, Cerveteri, Italy, seventh to second centuries BCE.

In the Banditaccia necropolis (city of the dead) at Cerveteri, the Etruscans buried several generations of families in multichambered rock-cut underground tombs covered by great earthen mounds (tumuli).

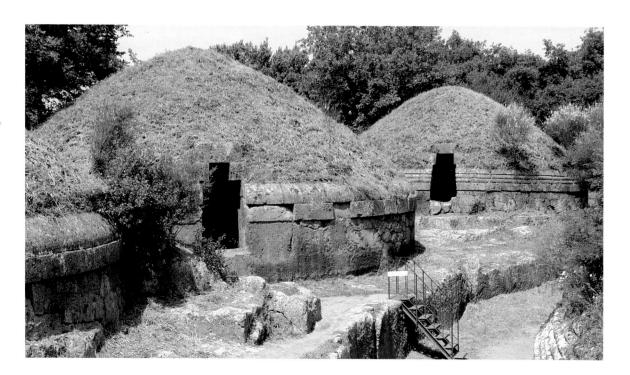

the torso at the waist is unnatural. The Etruscan artist's interest focused on the upper half of the figures, especially on the vibrant faces and gesticulating arms. Gestures are still an important ingredient of Italian conversation today, and the Cerveteri banqueters and the Veii Apulu speak to the viewer in a way that Greek statues of similar date, with their closed contours and calm demeanor, never do.

BANDITACCIA NECROPOLIS The exact findspot of the Cerveteri sarcophagus is not known, but the kind of tomb that housed such sarcophagi is well documented. The typical tomb in Cerveteri's Banditaccia necropolis (FIG. 9-6) took the form of a mound, or tumulus, not unlike the Mycenaean Treasury of Atreus (FIG. 4-20). But whereas the Mycenaean tholos tomb was constructed of masonry blocks and then covered by an earthen mound, each Etruscan tumulus covered one or more subterranean multichambered tombs cut out of the dark local limestone called tufa. These burial mounds sometimes reached colossal size, with diameters in excess of 130 feet. They were arranged in cemeteries in an orderly manner along a network of streets, producing the effect of veritable "cities of the dead" (the literal meaning of the Greek word necropolis), and were always located some distance from the cities of the living.

The underground tomb chambers cut into the rock resembled the houses of the living. In the plan (FIG. 9-7) of the Tomb of the Shields and Chairs, for example, the central entrance and the smaller chambers opening onto a large central space mirror the axial sequence of rooms in Etruscan dwellings of the time. The effect of a domestic interior was enhanced by the beds and grand armchairs with curved backs and footstools (clearly visible on the plan), as well as the ceiling beams, framed doorways, and even windows that the sculptors cut out of the rock. The technique recalls that of rock-cut Egyptian tombs (FIG. 3-19) and highlights the very different values of the Etruscans and the Greeks. The Etruscans' temples no longer stand because they constructed them of wood and mud brick, but their grand subterranean tombs are as permanent as the bedrock itself. The Greeks employed stone for the shrines of their gods but only rarely built monumental tombs for their dead.

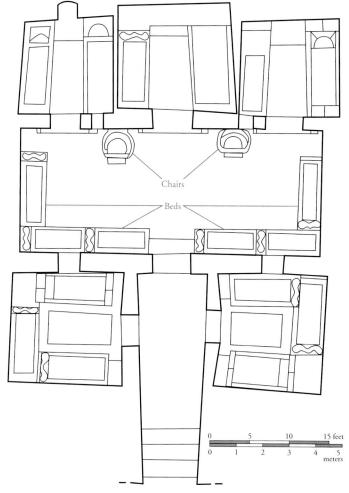

9-7 Plan of the Tomb of the Shields and Chairs, Cerveteri, Italy, second half of the sixth century BCE.

In plan, the subterranean tombs of Cerveteri resemble the houses of the living. Sculptors enhanced the effect of a domestic interior by carving beds, chairs, doors, and ceiling beams out of the bedrock.

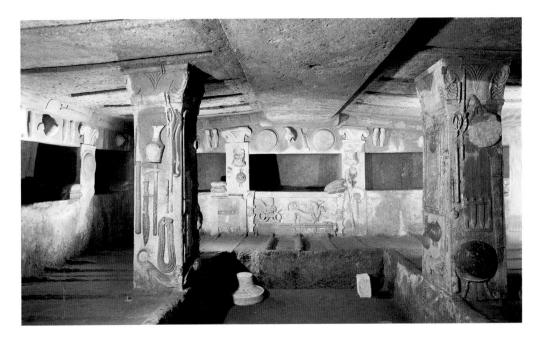

9-8 Interior of the Tomb of the Reliefs, Cerveteri, Italy, third century BCE.

The Tomb of the Reliefs takes its name from the painted stucco reliefs covering its walls and piers. The stools, mirrors, drinking cups, and other items are reminders of the houses of the living.

TOMB OF THE RELIEFS The most elaborate of the Cerveteri tombs, in decoration if not in plan, is the so-called Tomb of the Reliefs (FIG. 9-8). Like the much earlier Tomb of the Shields and Chairs, it accommodated several generations of a single family. The walls and piers of this tomb were, as usual, gouged out of the tufa bedrock, but in this instance painted stucco reliefs covered the stone. The stools, mirrors, drinking cups, pitchers, and knives effectively suggest a domestic context, underscoring the connection between Etruscan houses of the dead and those of the living. Other reliefs, such as the helmet and shields over the main funerary couch (the pillows are also shallow reliefs), are signs of the elite status of this Cerveteri family. The three-headed dog Cerberus, guardian of the gate to the Underworld, beneath the same couch is a reference to the passage from this life to the next.

TARQUINIA Large underground burial chambers hewn out of the natural rock were also the norm at Tarquinia. Earthen mounds

may once have covered the Tarquinia tombs too, but the tumuli are no longer preserved. In contrast to Cerveteri, the subterranean rooms at Tarquinia do not have carvings imitating the appearance of Etruscan houses. In some cases, however, paintings decorate the walls. Painted tombs are statistically rare, the privilege of only the wealthiest Etruscan families. Nevertheless, archaeologists have discovered many paintings at Tarquinia by using periscopes to explore tomb interiors from the surface before considering time-consuming and costly excavation. Consequently, art historians have an almost unbroken record of monumental painting in Etruria from Archaic to Hellenistic times.

TOMB OF THE LEOPARDS A characteristic example dating to the early fifth century BCE is the Tomb of the Leopards (FIG. 9-9), named for the beasts that guard the interior of the painted chamber from their perch within the pediment of the rear wall. They

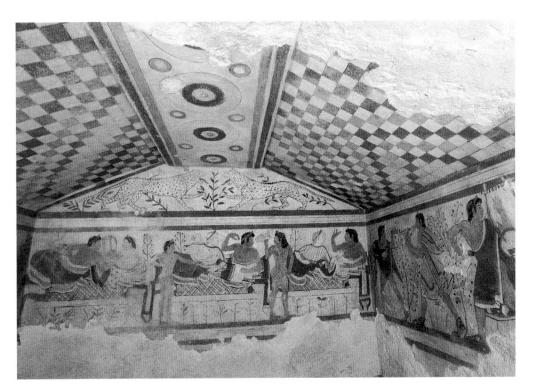

9-9 Interior of the Tomb of the Leopards, Tarquinia, Italy, ca. 480–470 BCE.

Mural paintings adorn many of the underground tombs at Tarquinia. In this tomb, banqueting couples, servants, and musicians celebrate the joys of the good life. The men have dark skin, the women fair skin.

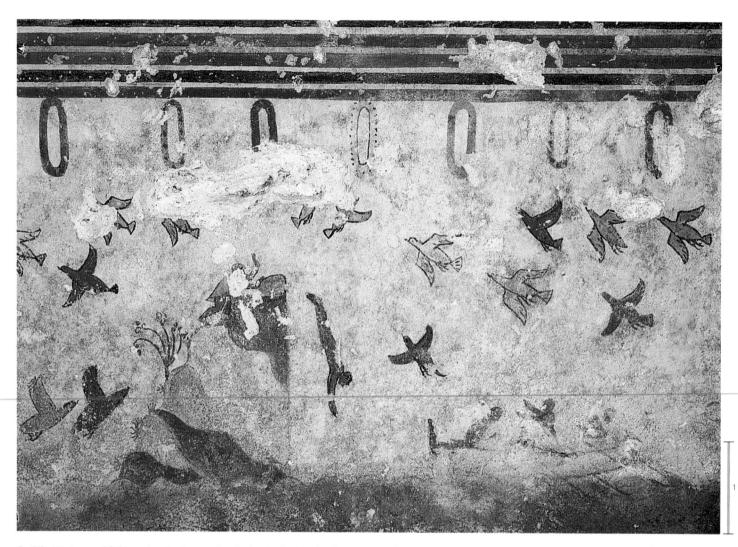

9-10 Diving and fishing, detail of a mural painting in the Tomb of Hunting and Fishing, Tarquinia, Italy, ca. 530–520 BCE. Detail, 5' $6\frac{1}{2}$ " high. Scenes of young men enjoying the pleasures of nature cover the walls of this Tarquinian tomb. The Etruscan diving scene predates a similar landscape painting (Fig. 5-61) in a Greek tomb at Paestum.

are reminiscent of the panthers on each side of Medusa in the pediment (FIG. 5-17) of the Temple of Artemis at Corfu. But mythological figures, whether Greek or Etruscan, are uncommon in Tarquinian murals, and the Tomb of the Leopards has none. Instead, banqueting couples (the men with dark skin, the women with light skin, in conformity with the age-old convention) adorn the walls—painted versions of the terracotta sarcophagus (FIG. 9-5) from Cerveteri. Pitcherand cup-bearers serve the guests, and musicians entertain them. The banquet takes place in the open air or perhaps in a tent set up for the occasion. In characteristic Etruscan fashion, the banqueters, servants, and entertainers all make exaggerated gestures with unnaturally enlarged hands (FIG. 9-1). The man on the couch at the far right on the rear wall holds up an egg, the symbol of regeneration. The tone is joyful. The painting is a celebration of life, food, wine, music, and dance, rather than a somber contemplation of death.

In stylistic terms, the Etruscan figures are comparable to those on sixth-century Greek vases before Late Archaic painters became preoccupied with the problem of foreshortening. Etruscan painters may be considered somewhat backward in this respect, but in other ways they seem to have outpaced their counterparts in Greece, especially in their interest in rendering nature. In the Tomb of the Leopards, the landscape is but a few trees and shrubs placed between the

entertainers (and leopards) and behind the banquet couches. But elsewhere the natural environment was the chief interest of Tarquinian painters.

TOMB OF HUNTING AND FISHING Scenes of Etruscans enjoying the pleasures of nature decorate all the walls of the main chamber of the aptly named Tomb of Hunting and Fishing at Tarquinia. In the detail reproduced here (FIG. 9-10), a youth dives off a rocky promontory, while others fish from a boat and birds fill the sky all around. On another wall, youthful hunters aim their slingshots at the brightly painted birds. The scenes of hunting and fishing recall the paintings in Egyptian tombs (FIGS. 3-15 and 3-28) and may indicate knowledge of that Eastern funerary tradition. The multicolored rocks resemble those of the Theran Spring Fresco (FIG. 4-9), but art historians know of nothing similar in contemporaneous Greek art save the Tomb of the Diver (FIG. 5-61) at Paestum. That exceptional Greek work, however, is from a tomb in Italy dated about a half century later than the Tarquinian tomb. In fact, the Paestum composition probably emulated older Etruscan designs, undermining the now-outdated judgment of art historians that Etruscan art was merely derivative and that Etruscan artists never set the standard for Greek artists.

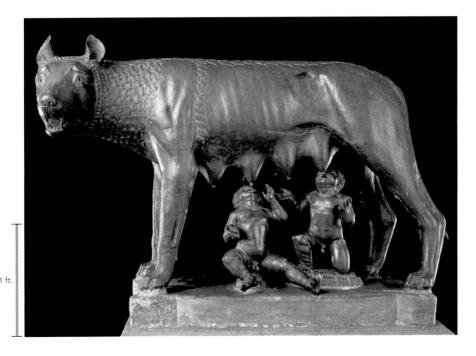

LATER ETRUSCAN ART

The fifth century BCE was a golden age in Greece but not in Etruria. In 509 BCE the Romans expelled the last of their Etruscan kings, Tarquinius Superbus (see "Etruscan Artists in Rome," page 226), replacing the monarchy with a republican form of government. In 474 BCE an alliance of Cumaean Greeks and Hieron I of Syracuse (Sicily) defeated the Etruscan fleet off Cumae, effectively ending Etruscan dominance of the seas—and with it Etruscan prosperity.

Classical Art

These events had important consequences in the world of art and architecture. The number of Etruscan tombs, for example, decreased sharply, and the quality of the furnishings declined markedly. No longer were tombs filled with golden jewelry and imported Greek vases or decorated with mural paintings of the first rank. But art did not cease in Etruria. Indeed, in specialties in which Etruscan artists excelled, especially the casting of statues in bronze and terracotta,

9-11 *Capitoline Wolf*, from Rome, Italy, ca. 500–480 BCE. Bronze, $2' 7\frac{1}{2}''$ high. Musei Capitolini, Rome.

An Etruscan sculptor cast this bronze statue of the she-wolf that nursed the infants Romulus and Remus, founders of Rome. The animal has a tense, gaunt body and an unforgettable psychic intensity.

they continued to produce impressive works, even though fewer in number.

CAPITOLINE WOLF The best-known of these later Etruscan statues—one of the most memorable portrayals of an animal in the history of world art—is the Capitoline Wolf (FIG. 9-11). The statue is a somewhat larger than life-size hollow-cast bronze portrayal of the she-wolf that, according to legend, nursed Romulus and Remus after they were abandoned as infants. When the

twins grew to adulthood, they quarreled, and Romulus killed his brother. On April 21, 753 BCE, Romulus founded Rome and became the city's king. The statue of the she-wolf seems to have been made, however, for the new Roman Republic after the expulsion of Tarquinius Superbus. The appropriately defiant image became the new government's totem and has remained the emblem of Rome to this day.

The Capitoline Wolf, however, is not a work of Roman art, which had not yet developed a distinct identity, but rather is the product of an Etruscan workshop. (The suckling infants are 15th-century additions.) The vitality accorded the human figure in Etruscan art is here concentrated in the tense, watchful animal body of the she-wolf, with her spare flanks, gaunt ribs, and taut, powerful legs. The lowered neck and head, alert ears, glaring eyes, and ferocious muzzle capture the psychic intensity of the fierce and protective beast as danger approaches. Not even the great animal reliefs of Assyria (FIG. 2-23) match this profound characterization of animal temperament.

CHIMERA OF AREZZO Another masterpiece of Etruscan bronze-casting is the *Chimera of Arezzo* (FIG. 9-12), which dates about a century later than the *Capitoline Wolf*. The *chimera* is a monster of Greek invention with a lion's head and body and a serpent's tail (restored in this case). A second head, that of a goat, grows out of the lion's left side. The goat's neck bears the wound the Greek hero Bellerophon inflicted when he hunted

9-12 *Chimera of Arezzo*, from Arezzo, Italy, first half of fourth century BCE. Bronze, 2' $7\frac{1}{2}''$ high. Museo Archeologico Nazionale, Florence.

The chimera was a composite monster slain by the Greek hero Bellerophon. In this Etruscan statue, the artist depicted the wounded beast poised to attack and growling ferociously.

1 f

9-13 Novios Plautios, *Ficoroni Cista*, from Palestrina, Italy, late fourth century BCE. Bronze, 2' 6" high. Museo Nazionale di Villa Giulia, Rome.

Novios Plautios made this container for a woman's toiletry articles in Rome and engraved it with the myth of the Argonauts. The composition is probably an adaptation of a Greek painting.

and slew the composite beast. As rendered by the Etruscan sculptor, the chimera, although injured and bleeding, is far from defeated. Like the earlier shewolf statue, the bronze chimera has muscles that are stretched tightly over its rib cage. The monster prepares to attack, and a ferocious cry emanates from its open jaws. Some scholars have postulated that the statue was part of a group that originally included Bellerophon, but the chimera could just as well have stood alone. The menacing gaze upward toward an unseen adversary need not have been answered. In this respect, too, the chimera is in the tradition of the *Capitoline Wolf.*

Etruscan Art and the Rise of Rome

At about the time the *Chimera of Arezzo* was fashioned, Rome began to appropriate Etruscan territory. Veii fell to the Romans in 396 BCE, after a terrible 10-year siege. Peace was concluded with Tarquinia in 351, but by the beginning of the next century, Rome had annexed Tarquinia too, and in 273 BCE the Romans conquered Cerveteri.

FICORONI CISTA Rome's growing power in central Italy is indicated indirectly by the engraved

inscription on the *Ficoroni Cista* (FIG. 9-13). Etruscan artists began to produce such *cistae* (cylindrical containers for a woman's toiletry articles), made of sheet bronze with cast handles and feet and elaborately engraved bodies, in large numbers in the fourth century BCE. Along with engraved bronze mirrors, they were popular gifts for both the living and the dead. The center of the Etruscan bronze cista industry was Palestrina (ancient Praeneste), where the *Ficoroni Cista* was found. The inscription on the handle states that Dindia Macolnia, a local noblewoman, gave the bronze container to her daughter and that the artist was Novios Plautios. According to the inscription, his workshop was not in Palestrina but in Rome, which by this date was becoming an important Italian cultural as well as political center.

The engraved frieze of the *Ficoroni Cista* depicts an episode from the Greek story of the expedition of the Argonauts in search of the Golden Fleece. Scholars generally agree that the composition is an adaptation of a lost Greek panel painting, perhaps one then on display in Rome—additional testimony to the burgeoning wealth and prestige of the city Etruscan kings once ruled. The Greek source for Novios Plautios's engraving is evident in the figures seen entirely

from behind or in three-quarter view, and in the placement of the protagonists on several levels in the Polygnotan manner (FIG. 5-59).

PORTA MARZIA, PERUGIA In the third century BCE, the Etruscan city of Perugia (ancient Perusia) formed an alliance with Rome and was spared the destruction that Veii, Cerveteri, and other Etruscan towns suffered. Portions of Perugia's ancient walls are still standing, as are some of its gates. One of these, the so-called Porta Marzia (Gate of Mars), was dismantled during the Renaissance, but the upper part of the gate (FIG. 9-14) is preserved, embedded in a later wall. The archway is formed by a series of trapezoidal stone *voussoirs* held in place by the weight of the blocks pressing against one another (FIG. 4-17c). Earlier architects built arches in Greece as well as in Mesopotamia (FIG. 2-24), but in Italy, first under the Etruscans and later under the Romans, *arcuated* (arch-shaped) gateways and freestanding ("triumphal") arches became a major architectural type.

The use of Hellenic-inspired *pilasters* (flat columns) to frame the rounded opening of the Porta Marzia typifies the Etruscan adaptation of Greek motifs. Arches bracketed by engaged columns or

9-14 Porta Marzia (Gate of Mars), Perugia, Italy, second century BCE.

The arch has a long history in ancient architecture, but it was most commonly used in Etruscan and Roman buildings. Often Greek pilasters or engaged columns frame an arcuated opening.

pilasters have a long and distinguished history in Roman and later times. In the Porta Marzia, sculpted half-figures of Jupiter and his sons Castor and Pollux and their steeds look out from between the fluted pilasters. The divine twins had appeared miraculously on a battlefield in 484 BCE to turn the tide in favor of the Romans. The presence of these three deities at the apex of the Porta Marzia may reflect the new Roman practice of erecting triumphal arches with gilded bronze statues on top.

SARCOPHAGUS OF LARS PULENA In Hellenistic Etruria, the counterparts of the magnificent Archaic terracotta sarcophagus (FIG. 9-5) from Cerveteri were made of local stone. The leading production center was Tarquinia, where an Etruscan sculptor fashioned the sarcophagus of Lars Pulena (FIG. 9-15) early in the second century BCE. The scene sculpted on the front of the coffin shows the deceased in the Underworld between two *charuns* (Etruscan death demons) swinging hammers. It signifies that Lars Pulena has successfully made the

9-15 Sarcophagus of Lars Pulena, from Tarquinia, Italy, early second century BCE. Tufa, 6' 6" long. Museo Archeologico Nazionale, Tarquinia.

Images of the deceased on late Etruscan sarcophagi are much more somber than those on Archaic examples (FIG. 9-5), but Lars Pulena proudly displays a list of his life's achievements on an open scroll.

ft.

9-16 Aule Metele (*Arringatore*), from Cortona, near Lake Trasimeno, Italy, early first century BCE. Bronze, 5' 7" high. Museo Archeologico Nazionale, Florence.

Inscribed in
Etruscan, this
bronze statue of an
orator is Etruscan
in name only. Aule
Metele wears the
short toga and high
boots of a Roman
magistrate, and the
style of the portrait
is also Roman.

journey to the afterlife. Above, the deceased is shown in a reclining position, but he is not at a festive banquet, and his wife is not present. His somber expression contrasts sharply with the smiling, confident faces of the Archaic era when Etruria enjoyed its greatest prosperity. Similar heads—realistic but generic types, not true portraits—are found on all later Etruscan sarcophagi and in tomb paintings. They are symptomatic of the economic and political decline of the oncemighty Etruscan city-states. Nonetheless, Lars Pulena is a proud man. He wears a wreath around his neck and displays a partially unfurled scroll inscribed with the record of his life's accomplishments.

AULE METELE An even later Etruscan portrait is the statue (FIG. 9-16) of the magistrate Aule Metele raising his arm to address an assembly—hence his modern nickname *Arringatore* (*Orator*).

This life-size statue proves that Etruscan artists continued to be experts at bronze-casting long after the heyday of Etruscan prosperity. The *Arringatore* was most likely produced at about the time the Romans achieved total hegemony over the Etruscans. The so-called Social War of the early first century BCE ended in 89 BCE with the conferring of Roman citizenship on all of Italy's inhabitants. In fact, Aule Metele—his Etruscan name and his father's and mother's names are inscribed on the hem of his garment—wears the short toga and high laced boots of a Roman magistrate. His head, with its close-cropped hair and signs of age in the face, resembles portraits produced in Rome at the time. This orator is Etruscan in name only. If the origin of the Etruscans remains debatable, the question of their demise has a ready answer. Aule Metele and his compatriots became Romans, and Etruscan art became Roman art.

THE ETRUSCANS

ORIENTALIZING ART, ca. 700-600 BCE

- During the early first millennium BCE, the Etruscans emerged as a people with a culture distinct from those of other Italic peoples and the Greeks.
- In the seventh century BCE, the Etruscans traded metals from their mines for foreign goods and began to produce jewelry and other luxury objects decorated with motifs modeled on those found on imports from the Near East.

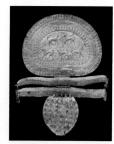

Regolini-Galassi fibula, Cerveteri, ca. 650–640 BCE

ARCHAIC ART, ca. 600-480 BCE

- The sixth century BCE was the apex of Etruscan power in Italy. Etruscan kings even ruled Rome until 509 BCE.
- The Etruscans admired Greek art and architecture but did not copy Greek works. Etruscan temples were made of wood and mud brick instead of stone and had columns and stairs only at the front. Terracotta statuary decorated the roof.

At Tarquinia, painters covered the tomb walls with monumental frescoes, usually depicting funerary banquets attended by both men and women.

A typical sixth-century BCE Etruscan temple

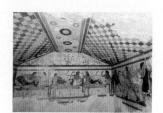

Tomb of the Leopards, Tarquinia, ca. 480–470 BCE

CLASSICAL AND HELLENISTIC ART, ca. 480-489 BCE

- The Greek defeat of the Etruscan fleet off Cumae in 474 BCE ended Etruscan domination of the sea and marked the beginning of Etruria's decline. Rome destroyed Veii in 396 BCE and conquered Cerveteri in 273 BCE. All of Italy became Romanized by 89 BCE.
- A very different, more somber, mood pervades Etruscan art during the fifth through first centuries BCE, as seen, for example, in the sarcophagus of Lars Pulena.
- Later Etruscan architecture is noteworthy for the widespread use of the stone arch, often framed with Greek pilasters or columns, as on the Porta Marzia at Perugia.

Sarcophagus of Lars Pulena, early second century BCE

Porta Marzia, Perugia, second century BCE

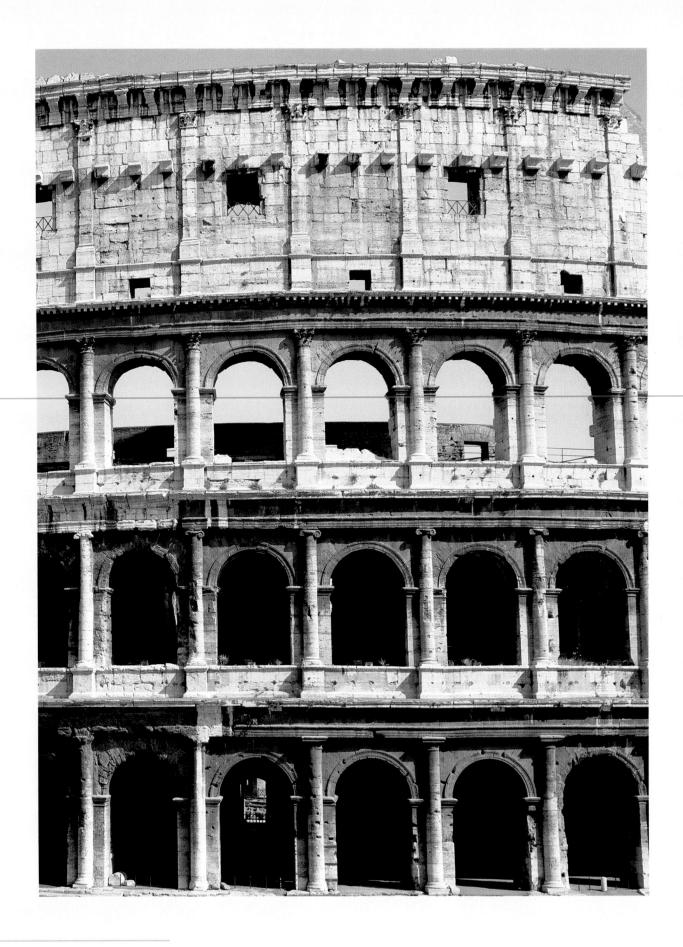

10-1 Detail of the facade of the Colosseum (Flavian Amphitheater), Rome, Italy, ca. 70-80 ce.

Rome's most famous landmark (Fig. 10-36) is a prime example of Roman eclecticism. The architect mixed Greek columns and Roman arches on the facade, which masked a skeleton of concrete vaults.

THE ROMAN EMPIRE

With the rise and triumph of Rome, a single government ruled, for the first time in history, from the Strait of Gibraltar to the Nile, from the Tigris and Euphrates to the Rhine, Danube, Thames and beyond (MAP 10-1). Within the Roman Empire's borders lived millions of people of numerous races, religions, tongues, and cultures: Britons and Gauls, Greeks and Egyptians, Africans and Syrians, Jews and Christians, to name but a few. Of all the ancient civilizations, the Roman most closely approximated today's world in its multicultural character.

Roman monuments of art and architecture, spread throughout the vast territory the Romans governed, are the most conspicuous and numerous of all the remains of ancient civilization. In Europe, the Middle East, and Africa today, Roman temples and basilicas have an afterlife as churches. The powerful concrete vaults of ancient Roman buildings form the cores of modern houses, stores, restaurants, factories, and museums. Bullfights, sports events, operas, and rock concerts are staged in Roman amphitheaters. Ships dock in what were once Roman ports, and Western Europe's highway system still closely follows the routes of Roman roads.

Ancient Rome also lives on in the Western world in concepts of law and government, in languages, in the calendar—even in the coins used daily. Roman art speaks in a language almost every Western viewer can readily understand. Its diversity and eclecticism foreshadowed the modern world. The Roman use of art, especially portraits and narrative reliefs, to manipulate public opinion is similar to the carefully crafted imagery of contemporary political campaigns. And the Roman mastery of concrete construction began an architectural revolution still felt today.

The center of the far-flung Roman Empire was the city on the Tiber River that, according to legend, Romulus and his twin brother Remus founded on April 21, 753 BCE. Their Rome consisted only of small huts clustered together on the Palatine Hill (FIG. 10-2, no. 3) overlooking what was then uninhabited marshland. In the Archaic period, Rome was essentially an Etruscan city, both politically and culturally. Its greatest shrine, the Temple of Jupiter Optimus Maximus (Best and Greatest) on the Capitoline Hill, was built by an Etruscan king, designed by an Etruscan architect, made of wood and mud brick in the Etruscan manner, and decorated with terracotta statuary created by an Etruscan sculptor (see "Etruscan Artists in Rome," Chapter 9, page 226).

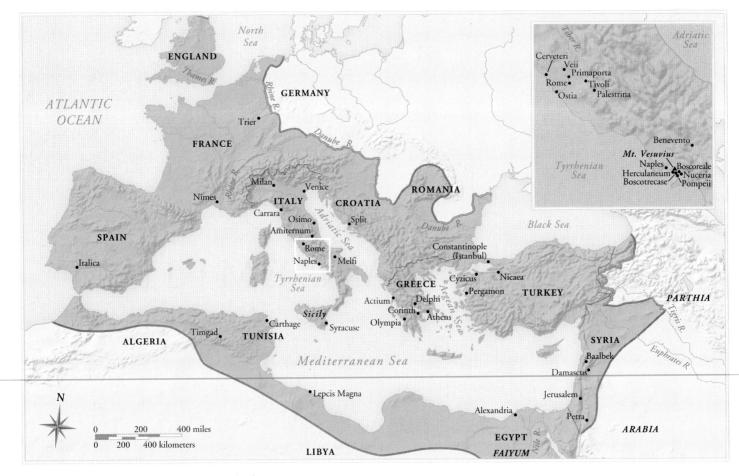

MAP 10-1 The Roman Empire at the death of Trajan in 117 CE.

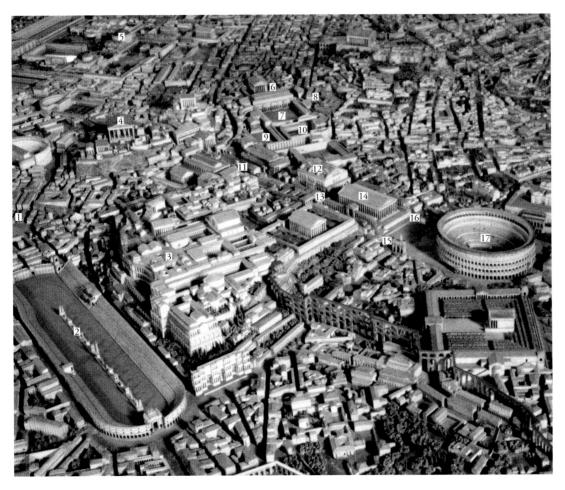

- 10-2 Model of the city of Rome during the early fourth century CE. Museo della Civiltà Romana, Rome.
- (1) Temple of Portunus,
 - (2) Circus Maximus,
- (3) Palatine Hill, (4) Temple of Jupiter Capitolinus,
- (5) Pantheon, (6) Column of Trajan, (7) Forum of Trajan,
- (8) Markets of Trajan,
- (9) Forum of Julius Caesar,
- (10) Forum of Augustus,
- (11) Forum Romanum,
- (12) Basilica Nova, (13) Arch of Titus, (14) Temple of Venus and Roma, (15) Arch of Constantine, (16) Colossus of Nero, (17) Colosseum.

By the time of Constantine, the city of Rome was densely packed with temples, forums, triumphal arches, theaters, baths, racetracks, aqueducts, markets, private homes, and apartment houses.

An Outline of Roman History

Monarchy (753-509 BCE)

Latin and Etruscan kings ruled Rome from the city's founding by Romulus and Remus until the revolt against Tarquinius Superbus (exact dates of rule unreliable).

REPUBLIC (509-27 BCE)

The Roman Republic lasted from the expulsion of Tarquinius Superbus until the bestowing of the title of Augustus on Octavian, the grand-nephew of Julius Caesar and victor over Mark Antony in the civil war that ended the Republic. Some major figures were

- Marcellus, b. 268(?), d. 208 BCE, consul
- Marius, b. 157, d. 86 BCE, consul
- Sulla, b. 138, d. 79 BCE, consul and dictator
- Pompey, b. 106, d. 48 BCE, consul
- Julius Caesar, b. 100, d. 44 BCE, consul and dictator
- Mark Antony, b. 83, d. 30 BCE, consul

EARLY EMPIRE (27 BCE-96 CE)

The Early Empire began with the rule of Augustus and his Julio-Claudian successors and continued until the end of the Flavian dynasty. Selected emperors and their dates of rule (with names of the most influential empresses in parentheses) were

- Augustus (Livia), r. 27 BCE-14 CE
- **■** Tiberius, r. 14–37
- Caligula, r. 37–41
- Claudius (Agrippina the Younger), r. 41–54
- Nero, r. 54–68
- **■** Vespasian, r. 69–79

- Titus, r. 79–81
- **■** Domitian, r. 81–96

HIGH EMPIRE (96-192 CE)

The High Empire began with the rule of Nerva and the Spanish emperors, Trajan and Hadrian, and ended with the last emperor of the Antonine dynasty. The emperors (and empresses) of this period were

- Nerva, r. 96–98
- Trajan (Plotina), r. 98–117
- Hadrian (Sabina), r. 117–138
- Antoninus Pius (Faustina the Elder), r. 138–161
- Marcus Aurelius (Faustina the Younger), r. 161–180
- Lucius Verus, coemperor with Marcus Aurelius, r. 161–169
- Commodus, r. 180–192

LATE EMPIRE (193-337 CE)

The Late Empire began with the Severan dynasty and included the so-called soldier emperors of the third century, the tetrarchs, and Constantine, the first Christian emperor. Selected emperors (and empresses) were

- Septimius Severus (Julia Domna), r. 193–211
- Caracalla (Plautilla), r. 211–217
- Severus Alexander, r. 222–235
- Trajan Decius, r. 249–251
- Trebonianus Gallus, r. 251–253
- Diocletian, r. 284–305
- **■** Constantine I, r. 306–337

REPUBLIC

In 509 BCE the Romans overthrew Tarquinius Superbus, the last of Rome's Etruscan kings, and established a constitutional government (see "An Outline of Roman History," above). The new Roman Republic vested power mainly in a *senate* (literally, "a council of elders," *senior* citizens) and in two elected *consuls*. Under extraordinary circumstances, a *dictator* could be appointed for a specified time and a specific purpose, such as commanding the army during a crisis. All leaders came originally from among the wealthy landowners, or *patricians*, but later also from the *plebeian* class of small farmers, merchants, and freed slaves.

Before long, the descendants of Romulus conquered Rome's neighbors one by one: the Etruscans and the Gauls to the north, the Samnites and the Greek colonists to the south. Even the Carthaginians of North Africa, who under Hannibal's dynamic leadership had annihilated some of Rome's legions and almost brought down the Republic, fell before the mighty Roman armies.

Architecture

The year 211 BCE was a turning point both for Rome and for Roman art. Breaking with precedent, Marcellus, conqueror of the fabulously wealthy Sicilian Greek city of Syracuse, brought back to Rome not only the usual spoils of war—captured arms and armor, gold and silver coins, and the like—but also the city's artistic patrimony. Thus began, in the words of the historian Livy, "the craze for works of

Greek art." Exposure to Greek sculpture and painting and to the splendid marble temples of the Greek gods increased as the Romans expanded their conquests beyond Italy. Greece became a Roman province in 146 BCE, and in 133 BCE the last Attalid king of Pergamon willed his kingdom to Rome (see Chapter 5). Nevertheless, although the Romans developed a virtually insatiable taste for Greek "antiques," the Etruscan basis of Roman art and architecture was never forgotten. The buildings and statues of the Roman Republic are highly eclectic, drawing on both Greek and Etruscan traditions.

TEMPLE OF PORTUNUS, ROME Eclecticism is the primary characteristic of the Republican temple on the east bank of the Tiber popularly known as the Temple of Fortuna Virilis (FIGS. 10-2, no. 1, and 10-3). It is actually a temple dedicated to Portunus, the Roman god of harbors. Its plan follows the Etruscan pattern with a high podium and a flight of steps only at the front. Freestanding columns are confined to the deep porch. But the structure is built of stone (local tufa and travertine), overlaid originally with stucco in imitation of Greek marble. The columns are not Tuscan but Ionic, complete with flutes and bases, and there is a matching Ionic frieze (see "Doric and Ionic Orders," Chapter 5, page 110). Moreover, in an effort to approximate a peripteral Greek temple vet maintain the basic Etruscan plan, the architect added a series of engaged Ionic half columns to the sides and back of the cella. The result was a pseudoperipteral temple. Although the design combines Etruscan and Greek elements, the resultant mix is uniquely Roman.

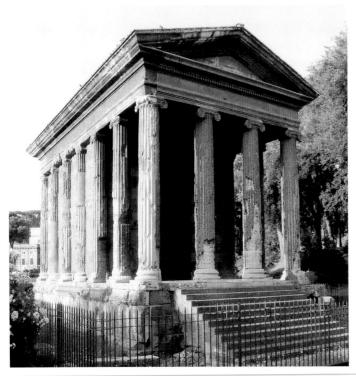

10-3 Temple of Portunus (Temple of "Fortuna Virilis"), Rome, Italy, ca. 75 BCE.

Republican temples combine Etruscan plans and Greek elevations. This pseudoperipteral stone temple employs the lonic order, but it has a staircase and freestanding columns only at the front.

TEMPLE OF VESTA, TIVOLI The Romans' admiration for the Greek temples they encountered in their conquests also led to the importation into Republican Italy of a temple type unknown in Etruscan architecture—the round, or tholos, temple. At Tivoli (ancient Tibur), on a dramatic site overlooking a deep gorge, a Republican architect erected such a Greek-inspired temple (FIG. 10-4) early in the first century BCE. The temple is circular in plan—standard for shrines of Vesta—and has travertine Corinthian columns. The frieze is carved with garlands held up by oxen heads, also in emulation of Greek models. But the high podium can be reached only via a narrow stairway leading to the cella door. This arrangement introduced an axial alignment not found in Greek tholoi (FIG. 5-72),

Fortuna's hillside sanctuary at Palestrina was made possible by the use of concrete barrel vaults for terraces, ramps, shops, and porticos spread out over several levels. A tholos temple crowned the complex.

10-4 Temple of Vesta(?), Tivoli, Italy, early first century BCE.

The round, or tholos, temple type is unknown in Etruria. The models for the Tivoli temple's builders were in Greece (FIG. 5-72), but the Roman building has a frontal orientation and a concrete cella.

where, as in Greek rectangular temples, steps continue all around the structure. Also in contrast with the Greeks, the Roman builders constructed the cella wall not with masonry blocks but with a new material of recent invention: concrete (see "Roman Concrete Construction," page 241).

SANCTUARY OF FORTUNA, PALESTRINA The most impressive and innovative use of concrete during the Republic was in the Sanctuary of Fortuna Primigenia (FIG. 10-5), the goddess of good fortune, at Palestrina (ancient Praeneste, formerly an Etruscan city). The great complex was constructed in the late second century BCE. Spread out over several terraces leading up the hillside to a tho-

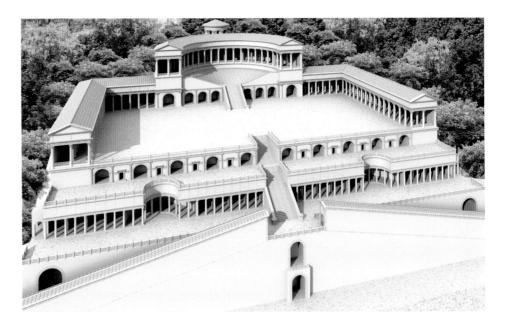

Roman Concrete Construction

he history of Roman architecture would be very different had the Romans been content to use the same building materials as the Greeks, Etruscans, and other ancient peoples. Instead, the Romans developed concrete construction, which revolutionized architectural design. Roman *concrete* was made from a changing recipe of lime mortar, volcanic sand, water, and small stones (*caementa*, from which the English word *cement* derives). Builders placed the mixture in wooden frames and left it to dry. When the concrete hardened completely, they removed the wooden molds, leaving behind a solid mass of great strength, though rough in appearance. The Romans often covered the rough concrete with stucco or with marble *revetment* (facing). Despite this lengthy procedure, concrete walls were much less costly to construct than walls of imported Greek marble or even local tufa and travertine.

The advantages of concrete go well beyond cost, however. It is possible to fashion concrete shapes that masonry construction cannot achieve, especially huge vaulted and domed rooms without internal supports. Concrete enabled Roman builders to think of architecture in revolutionary ways. Roman concrete became a vehicle for shaping architectural space.

The most common types of Roman concrete vaults and domes are

■ Barrel Vaults Also called the tunnel vault, the barrel vault (FIG. 10-6a) is an extension of a simple arch, creating a semicylindrical ceiling over parallel walls. Pre-Roman builders constructed barrel vaults using traditional ashlar masonry (FIG. 2-24), but those earlier vaults were less stable than concrete barrel vaults. If even a single block of a cut-stone vault comes loose, the whole vault may collapse. Also, masonry barrel vaults can be illuminated only by light entering at either end of the tunnel. Using concrete, Roman builders could place windows at any point in a barrel vault, because once the concrete hardens, it forms a seamless sheet of "artificial stone" in which the openings do not lessen the vault's structural integrity. Whether made of stone or concrete, barrel vaults

- require *buttressing* (lateral support) of the walls below the vaults to counteract their downward and outward *thrust*.
- Groin Vaults A groin or cross vault (FIG. 10-6b) is formed by the intersection at right angles of two barrel vaults of equal size. Besides appearing lighter than the barrel vault, the groin vault needs less buttressing. The barrel vault's thrust is concentrated along the entire length of the supporting wall. The groin vault's thrust, however, is concentrated along the groins, the lines at the juncture of the two barrel vaults. Buttressing is needed only at the points where the groins meet the vault's vertical supports, usually piers. The system leaves the area between the supports open, permitting light to enter. Groin vaults, like barrel vaults, can be built using stone blocks—but with the same structural limitations when compared with concrete vaulting.

When a series of groin vaults covers an interior hall (FIG. 10-6c; compare FIG. 10-46), the open lateral arches of the vaults form the equivalent of a *clerestory* of a traditional timber-roofed structure (for example, FIG. 11-10). Such a *fenestrated* (with openings or windows) sequence of groin vaults has a major advantage over wooden clerestories. Concrete vaults are relatively fireproof, always an important consideration given that fires were common occurrences (see "Timber Roofs and Stone Vaults," Chapter 17, page 435).

Hemispherical Domes The largest domed space in the ancient world for more than a millennium was the corbeled, beehive-shaped tholos (FIG. 4-21) of the Treasury of Atreus at Mycenae. The Romans were able to surpass the Mycenaeans by using concrete to construct hemispherical domes (FIG. 10-6d), which usually rested on concrete cylindrical drums. If a barrel vault is described as a round arch extended in a line, then a hemispherical dome may be described as a round arch rotated around the full circumference of a circle. Masonry domes, like masonry vaults, cannot accommodate windows without threatening their stability. Concrete domes can be opened up even at their apex with a circular oculus ("eye"), allowing much-needed light to reach the vast spaces beneath (FIGS. 10-35 and 10-51).

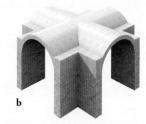

Concrete domes and vaults of varying designs enabled Roman builders to revolutionize the history of architecture by shaping interior spaces in novel ways.

los at the peak of an ascending triangle, the layout reflects the new Republican familiarity with the terraced sanctuaries of the Hellenistic East. The means of construction, however, was distinctly Roman. The builders used concrete barrel vaults (FIG. 10-6a) of enormous strength to support the imposing terraces and to cover the great ramps leading to the grand central staircase, as well as to give shape

to the shops selling food, souvenirs, and the like, aligned on two consecutive levels. In this way, the Romans transformed the entire hill-side, subjecting nature itself to human will and rational order. The Palestrina sanctuary is emblematic of the growing dominance of Rome in the Mediterranean world. By the end of the second century BCE, Romulus's village of huts belonged to the legendary past.

Sculpture

Nearly all the builders of Republican temples and sanctuaries were men from old and distinguished families. Often they were victorious generals who used the spoils of war to finance public works. These aristocratic patricians were fiercely proud of their lineage. They kept likenesses (*imagines*) of their ancestors in wooden cupboards in their homes and paraded them at the funerals of prominent relatives. Portraiture was one way the patrician class celebrated its elevated position in society. The case of Marius, a renowned Republican general who lacked a long and distinguished genealogy, underscores the importance of ancestral imagines in elite circles. Marius's patrician colleagues in the Senate ridiculed him as a man who had no portraits in his home.

VERISM The subjects of these portraits were almost exclusively men (and to a lesser extent women) of advanced age, for generally only elders held power in the Republic. These patricians did not ask sculptors to make them appear nobler than they were, as Kresilas portrayed Pericles (FIG. 5-41). Instead, they requested brutally realistic images with distinctive features, in the tradition of the treasured household *imagines*. One of the most striking of these so-called *veristic* (superrealistic) portraits is the head (FIG. 10-7) of an unidentified patrician from Osimo. The sculptor painstakingly recorded each rise and fall, each bulge and fold, of the facial surface, like a mapmaker who did not want to miss the slightest detail of surface change. Scholars debate whether such portraits were truly blunt records of actual features or exaggerated types designed to make a statement about personality: serious, experienced, determined, loyal to family and state—virtues that were much admired during the Republic.

10-7 Head of an old man, from Osimo, mid-first century BCE. Marble, life-size. Palazzo del Municipio, Osimo.

Veristic (superrealistic) portraits of old men from distinguished families were the norm during the Republic. The sculptor of this head pain-stakingly recorded every detail of the elderly man's face.

10-8 Portrait of a Roman general, from the Sanctuary of Hercules, Tivoli, Italy, ca. 75–50 BCE. Marble, 6' 2" high. Museo Nazionale Romano–Palazzo Massimo alle Terme, Rome.

The sculptor based this life-size portrait of a general on idealized Greek statues of heroes and athletes, but the man's head is a veristic likeness. The eclectic combination is typical of Republican art.

TIVOLI GENERAL The Osimo head also illustrates that the Romans believed the head alone was enough to constitute a portrait. The Greeks, in contrast, believed the head and body were inseparable parts of an integral whole, so their portraits were always full length (FIG. 5-87). In fact, in Republican portraiture, veristic heads were often—although incongruously—placed on bodies to which they could not possibly belong. Such is the case in the curious and discordant portrait of a general (FIG. 10-8) found at Tivoli. The cuirass (leather breastplate) at his side, which serves as a prop for the heavy marble statue, is the emblem of his rank. But the general does not appear as he would in life. Although he has a typically stern and lined Republican head, it sits atop a powerful, youthful, almost nude body. The sculptor modeled the portrait on the statues of Greek athletes and heroes the Romans admired so much and often copied (see Chapter 5). The incorporation of references to Greek art in these portrait statues evoked the notion of patrician cultural superiority and elevated the person portrayed to heroic status.

NONELITE PORTRAITURE In stark contrast to this elite tradition of publicly displaying portraits, slaves and former slaves could not possess *any* family portraits, because under Roman law, their parents and grandparents were not people but property. Freed slaves, however, often ordered portrait reliefs (FIGS. 10-9 and 10-10) for their tombs to commemorate their new status as Roman citizens (see "Art for Former Slaves," page 243).

Art for Former Slaves

istorians and art historians alike tend to focus on the lives and monuments of famous individuals, but some of the most interesting remains of ancient Roman civilization are the artworks commissioned by ordinary people, especially former slaves, or *freedmen* and *freedwomen*. Slavery was common in the Roman world. Indeed, researchers estimate that Italy at the end of the Republic had some two million slaves, or roughly one slave for every three citizens. The very rich might own hundreds of slaves, but slaves could be found in all but the poorest households. The practice was so much a part of Roman society that even slaves often became slave owners when their former masters freed them. Some gained freedom in return for meritorious service. Others were only freed in their masters' wills. Most slaves died as slaves in service to their original or new owners.

The most noteworthy artworks that Roman freedmen and freedwomen commissioned are the stone reliefs that regularly adorned their tomb facades. One of these reliefs (FIG. 10-9) depicts three people, all named Gessius. At the left is Gessia Fausta, at the right Gessius Primus. Both are the freed slaves of Publius Gessius, the freeborn citizen in the center, shown wearing a general's cuirass and portrayed in the standard Republican veristic fashion (FIGS. 10-7 and 10-8). As slaves this couple had no legal standing. They were the property of Publius Gessius. After they were freed, however, they became people by law. These stern frontal portraits proclaim their new status as legal members of Roman society—and, by including him in the relief, their gratitude to Publius Gessius for granting them that status

As was the custom, the two former slaves bear their patron's name, but whether they are sister and brother, wife and husband, or unrelated is unclear. The inscriptions on the relief explicitly state that the monument was paid for with funds provided by the will of Gessius Primus and that the work was directed by Gessia Fausta, the only survivor of the three. The relief thus depicts the living and the dead side by side, indistinguishable except by the accompanying message. This theme is common in Roman art and affirms that death does not break bonds formed in life.

More rarely, freed slaves commissioned tomb reliefs that were narrative in character. A relief (FIG. 10-10) from Amiternum depicts the honorary funeral cortege, complete with musicians, professional female mourners who pull their hair in a display of feigned grief, and the deceased's wife and children. The deceased is laid out on a bier with a canopy as a backdrop, much like the figures on Greek Geometric vases (FIG. 5-2). Surprisingly, however, the dead man here props himself up as if still alive, surveying his own funeral. This may be an effigy, like the reclining figures on the lids of Etruscan sarcophagi (FIGS. 9-5 and 9-15), rather than the deceased himself.

Compositionally, the relief is also unexpected. Mourners and musicians stand on floating ground lines, as if on flying carpets. They are not to be viewed as suspended in space, however, but as situated behind the front row of pallbearers and musicians. This sculptor, in striking contrast to the (usually Greek) artists the patrician aristocracy employed, had little regard for the rules of Classical art. The Amiternum artist studiously avoided overlapping and placed the figures wherever they fit, so long as they were clearly visible. This approach to making pictures was characteristic of pre-Classical art, but it had been out of favor for several centuries. There are no similar compositions in the art of the consuls and senators of the Roman Republic. In ancient Rome's cosmopolitan world, as today, stylistic tastes often were tied to a person's political and social status.

10-9 Funerary relief with portraits of the Gessii, from Rome(?), Italy, ca. 30 BCE. Marble, $2' 1\frac{1}{2}''$ high. Museum of Fine Arts, Boston.

Roman freedmen often placed reliefs depicting themselves and their former owners on the facades of their tombs. The portraits and inscriptions celebrated their freedom and new status as citizens.

10-10 Relief with funerary procession, from Amiternum, Italy, second half of first century BCE. Limestone, 2' 2" high. Museo Nazionale d'Abruzzo, L'Aquila.

This depiction of a procession of mourners and musicians in honor of a dead freedman has figures standing on floating ground lines. The sculptor ignored the rules of Classical art that elite patrons favored.

1 :

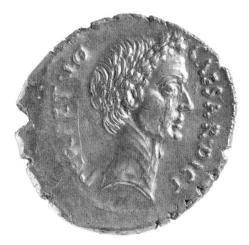

10-11 Denarius with portrait of Julius Caesar, 44 BCE. Silver, diameter $\frac{3}{4}$ ". American Numismatic Society, New York.

Julius Caesar was the first to place his own portrait on the Roman coinage during his lifetime. This denarius, issued just before his assassination, shows the dictator with a deeply lined face and neck.

JULIUS CAESAR Beginning early in the first century BCE, the Roman desire to vaunt distinguished ancestry led to the placement of portraits of illustrious forebears on Republican coins. These ancestral portraits supplanted the earlier Roman tradition (based on Greek convention) of using images of divinities on coins. No Roman, however, dared to place his own likeness on a coin until 44 BCE, when Julius Caesar, shortly before his assassination on the Ides of March, issued coins featuring his portrait and his newly acquired title, dictator perpetuo (dictator for life). The denarius (the standard Roman silver coin, from which the word *penny* ultimately derives) illustrated here (FIG. 10-11) records Caesar's aging face and receding hairline in conformity with the Republican veristic tradition. But placing the likeness of a living person on a coin violated all the norms of Republican propriety. Henceforth, Roman coins, which circulated throughout the vast territories under Roman control, would be used to mold public opinion in favor of the ruler by announcing his achievements—both real and fictional.

10-12 Aerial view of the forum (looking northeast), Pompeii, Italy, second century BCE and later. (1) forum, (2) Temple of Jupiter (Capitolium), (3) basilica.

The center of Roman civic life was the forum. At Pompeii, colonnades frame a rectangular plaza with the Capitolium at the northern end. At the southwestern corner is the basilica, Pompeii's law court.

POMPEII AND THE CITIES OF VESUVIUS

On August 24, 79 CE, Mount Vesuvius, a long-dormant volcano, suddenly erupted (see "An Eyewitness Account of the Eruption of Mount Vesuvius," page 245). Many prosperous towns around the Bay of Naples (the ancient Greek city of Neapolis), among them Pompeii, were buried in a single day. This event was a catastrophe for the inhabitants of the Vesuvian cities but became a boon for archaeologists and art historians. When researchers first explored the buried cities in the 18th century, the ruins had been undisturbed for nearly 1,700 years. The Vesuvian sites permit a reconstruction of the art and life of Roman towns of the Late Republic and Early Empire to a degree impossible anywhere else.

The Oscans, one of the many Italic tribes that occupied Italy during the peak of Etruscan culture, were the first to settle at Pompeii. Toward the end of the fifth century BCE, the Samnites, another Italic people, took over the town. Under the influence of their Greek neighbors, the Samnites greatly expanded the original settlement and gave monumental shape to the city center. Pompeii fought with other Italian cities on the losing side against Rome in the so-called Social War that ended in 89 BCE, and in 80 BCE Sulla founded a new Roman colony on the site, with Latin as its official language. The colony's population had grown to between 10,000 and 20,000 when, in February 62 CE, an earthquake shook the city, causing extensive damage. When Mount Vesuvius erupted 17 years later, repairs were still in progress.

Architecture

Walking through Pompeii today is an unforgettable experience. The streets, with their heavy flagstone pavements and sidewalks, are still there, as are the stepping stones that enabled pedestrians to cross the streets without having to step in puddles. Ingeniously, the city planners placed these stones in such a way that vehicle wheels could straddle them, enabling supplies to be brought directly to the shops, taverns, and bakeries. Tourists still can visit the impressive concrete-vaulted rooms of Pompeii's public baths, sit in the seats of its theater and amphitheater, enter the painted bedrooms and statue-filled gardens of private homes, even walk among the tombs outside the city's walls. Pompeii has been called the living city of the dead for good reason.

An Eyewitness Account of the Eruption of Mount Vesuvius

liny the Elder, whose *Natural History* is one of the most important sources for the history of Greek art, was among those who tried to rescue others from danger when Mount Vesuvius erupted. He was overcome by fumes the volcano spewed forth, and died. His nephew, Pliny the Younger, a government official under the emperor Trajan, left an account of the eruption and his uncle's death:

[The volcanic cloud's] general appearance can best be expressed as being like a pine . . . for it rose to a great height on a sort of trunk and then split off into branches. . . . Sometimes it looked white, sometimes blotched and dirty, according to the amount of soil and ashes it carried with it. . . . The buildings were now shaking with

violent shocks, and seemed to be swaying to and fro as if they were torn from their foundations. Outside, on the other hand, there was the danger of falling pumice-stones, even though these were light and porous. . . . Elsewhere there was daylight, [but around Vesuvius, people] were still in darkness, blacker and denser than any night that ever was. . . . When daylight returned on the 26th—two days after the last day [my uncle] had been seen—his body was found intact and uninjured, still fully clothed and looking more like sleep than death.*

*Betty Radice, trans., *Pliny the Younger: Letters and Panegyricus*, vol. 1 (Cambridge, Mass.: Harvard University Press, 1969), 427–433.

FORUM The center of civic life in any Roman town was its *forum*, or public square, usually located at the city's geographic center at the intersection of the main north-south street, the cardo, and the main east-west avenue, the decumanus (FIG. 10-42). The forum, however, generally was closed to all but pedestrian traffic. Pompeii's forum (FIG. 10-12) lies in the southwest corner of the expanded Roman city but at the heart of the original town. The forum probably took on monumental form in the second century BCE when the Samnites, inspired by Hellenistic architecture, erected two-story colonnades on three sides of the long and narrow plaza. At the north end they constructed a temple of Jupiter (FIG. 10-12, no. 2). When Pompeii became a Roman colony in 80 BCE, the Romans converted the temple into a Capitolium—a triple shrine of Jupiter, Juno, and Minerva, the chief Roman gods. The temple is of standard Republican type, constructed of tufa covered with fine white stucco and combining an Etruscan plan with Corinthian columns. It faces into the civic square, dominating the area. This arrangement contrasts with the siting of Greek temples (FIGS. 5-42 and 5-43), which stood in isolation and could be approached and viewed from all sides, like colossal statues on giant stepped pedestals. The Roman forum, like the Etrusco-Roman temple, has a chief side, a focus of attention.

The area within the porticos of the forum at Pompeii was empty, except for statues portraying local dignitaries and, later, Roman emperors. This is where the citizens conducted daily commerce and held festivities. All around the square, behind the colonnades, were secular and religious structures, including the town's administrative offices. Most noteworthy is the *basilica* (FIG. 10-12, no. 3) at the southwest corner, the earliest well-preserved building of its kind. Constructed during the late second century BCE, the basilica housed the law court of Pompeii and also was used for other official purposes. In plan it resembles the forum itself: long and narrow, with two stories of internal columns dividing the space into a central *nave* and flanking *aisles*. This scheme had a long afterlife in architectural history and will be familiar to anyone who has ever entered a church.

AMPHITHEATER Shortly after the Romans took control of Pompeii, two of the town's wealthiest officials, Quinctius Valgus and Marcus Porcius, used their own funds to erect a large amphitheater (FIG. 10-13) at the southeastern end of town. It is the earliest amphitheater known and could seat some 20,000 spectators—more

than the entire population of the town even a century and a half after its construction. The donors would have enjoyed choice reserved seats in the new entertainment center. In fact, seating was assigned by rank, both civic and military, so that the Roman social hierarchy was on display at every event.

The word *amphitheater* means "double theater," and Roman amphitheaters closely resemble two Greek theaters put together. Greek theaters were situated on natural hillsides (FIG. 5-71), but supporting an amphitheater's continuous elliptical *cavea* (seating area) required building an artificial mountain. Only concrete, unknown to the Greeks, could meet that requirement. In the Pompeii amphitheater, a series of shallow concrete barrel vaults forms a giant retaining wall that holds up the earthen mound and stone seats. Barrel vaults

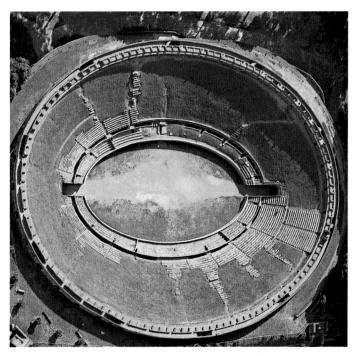

10-13 Aerial view of the amphitheater, Pompeii, Italy, ca. 70 BCE.

Pompeii's amphitheater is the oldest known. It is also an early example of Roman concrete technology. In the arena, bloody gladiatorial combats and wild animal hunts were staged for 20,000 spectators.

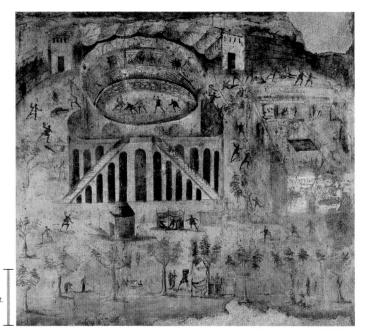

10-14 Brawl in the Pompeii amphitheater, wall painting from House I,3,23, Pompeii, Italy, ca. 60–79 ce. Fresco, 5' $7'' \times 6'$ 1". Museo Archeologico Nazionale, Naples.

This mural painting records a brawl that broke out in the Pompeii amphitheater in 59 cs. The painter included the cloth awning that could be rolled down to shield the audience from the sun and rain.

running all the way through the mountain of earth form the tunnels leading to the *arena*, the central area where bloody gladiatorial combats and wild animal hunts (see "Spectacles in the Colosseum," page 260) occurred. (*Arena* is Latin for "sand," which soaked up the blood of the wounded and killed.) The Roman amphitheater stands in sharp contrast, both architecturally and functionally, to the Greek theater, home of refined performances of comedies and tragedies.

A painting (FIG. 10-14) on the wall of a Pompeian house records an unfortunate incident that occurred in the amphitheater. A brawl broke out between the Pompeians and their neighbors, the Nucerians, during a gladiatorial contest in 59 CE. The fighting left many seriously wounded and led to the closing of the amphitheater for a decade. The painting shows the cloth awning (*velarium*) that could be rolled down from the top of the cavea to shield spectators from sun and rain. It also features the distinctive external double staircases (not visible in FIG. 10-13) that enabled large numbers of people to enter and exit the cavea in an orderly fashion.

HOUSE OF THE VETTII The evidence from Pompeii regarding Roman domestic architecture (see "The Roman House," page 247) is unparalleled anywhere else and is the most precious byproduct of the catastrophic volcanic eruption of 79 ce. One of the best-preserved houses at Pompeii, partially rebuilt, is the House of the Vettii, an old Pompeian house remodeled and repainted after the 62 CE earthquake. A photograph (FIG. 10-15) taken in the fauces (foyer; see FIG. 10-16) shows the impluvium in the center of the atrium, the opening in the roof above, and, in the background, the peristyle garden with its marble tables and splendid mural paintings dating to the last years of the Vesuvian city. At that time, two brothers, Aulus Vettius Restitutus and Aulus Vettius Conviva, probably freedmen who had made their fortune as merchants, owned the house. Their wealth enabled them to purchase and furnish the kind of fashionable townhouse that in an earlier era only patricians could have acquired.

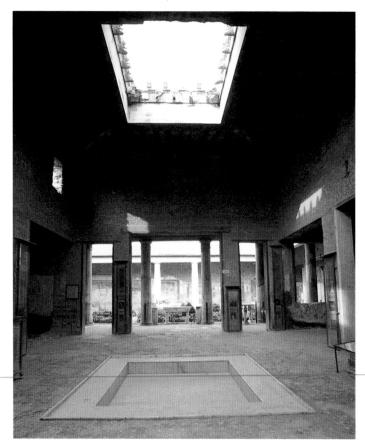

10-15 Atrium of the House of the Vettii, Pompeii, Italy, second century BCE, rebuilt 62–79 CE.

Roman townhouses had a central atrium with an impluvium to collect rainwater. Cubicula (bedrooms) opened onto the atrium, and in Hellenized houses such as this one, builders added a peristyle garden at the rear.

Painting

The houses and villas around Mount Vesuvius have yielded a treasure trove of mural paintings, the most complete record of the changing fashions in interior decoration found anywhere in the ancient world. The sheer quantity of these paintings tells a great deal about both the prosperity and the tastes of the times. How many homes today, even of the very wealthy, have custom-painted murals in nearly every room? Roman wall paintings were true frescoes (see "Fresco Painting," Chapter 19, page 504), with the colors applied while the plaster was still damp. The process was painstaking. First the painter had to prepare the wall by applying the plaster (mixed with marble dust if the patron could afford it) in several layers with a smooth trowel. Only then could painting begin. Finally, when the surface dried, the painter polished the wall to achieve a marblelike finish.

In the early years of exploration at Pompeii and nearby Herculaneum, excavators focused almost exclusively on the figural panels that formed part of the overall mural designs, especially those depicting Greek heroes and famous myths. Workers cut the panels out of the walls and transferred them to the Naples Archaeological Museum. In time, more enlightened archaeologists halted the practice of cutting pieces out of the walls and began to give serious attention to the mural designs as a whole. Toward the end of the 19th century, August Mau, a German art historian, divided the various mural painting schemes into four so-called Pompeian Styles. Mau's classification system, although later refined and modified in detail, still serves as the basis for the study of Roman painting.

The Roman House

The Roman house was more than just a place to live. It played an important role in Roman societal rituals. In the Roman world, individuals were frequently bound to others in a patron-client relationship whereby a wealthier, better-educated, and more powerful patronus would protect the interests of a cliens, sometimes large numbers of them. The standing of a patron in Roman society often was measured by clientele size. Being seen in public accompanied by a crowd of clients was a badge of honor. In this system, a plebeian might be bound to a patrician, a freed slave to a former owner, or even one patrician to another. Regardless of rank, all clients were obligated to support their patron in political campaigns and to perform specific services on request, as well as to call on and salute the patron at the patron's home.

A client calling on a patron would enter the typical Roman *domus* (private house) through a narrow *fauces* (the "jaws" of the house), which led to a large central reception area, the *atrium*. The rooms flanking the fauces could open onto the atrium, as in Fig. 10-16, or onto the street, in which case they were rented out as shops. The roof over the atrium was partially open to the sky, not only to admit light but also to channel rainwater into a basin (*impluvium*) below. The water could be stored in cisterns for household use. Opening onto the atrium was a series of small bedrooms called *cubicula* (cubicles). At the back were two recessed areas (*alae*, wings) and the patron's *tablinum* or "home office," a dining room (*triclinium*), a kitchen, and sometimes a small garden.

Endless variations of the same basic plan exist, dictated by an owner's personal tastes and means, the size and shape of the lot purchased, and so forth, but all Roman houses of this type were inward-looking in nature. The design shut off the street's noise and dust, and all internal activity focused on the brightly illuminated atrium at the center of the residence. This basic module (only the front half of the typical house in Fig. 10-16) resembles the plan of the typical Etruscan house as reflected in the Tomb of the Shields and Chairs (Fig. 9-7) and other tombs at Cerveteri. Thus, few scholars doubt that the early Roman house, like the early Roman temple, grew out of the Etruscan tradition.

During the second century BCE, when Roman architects were beginning to construct stone temples with Greek columns, the Roman house also took on Greek airs. Builders added a *peristyle* garden behind the Etruscan-style house, providing a second internal source of illumination as well as a pleasant setting for meals served in a summer triclinium. The axial symmetry of the plan meant that on entering the fauces of the house, a visitor could be greeted by a vista through the atrium directly into the peristyle garden (as in Fig. 10-15), which often boasted a fountain or pool, marble statuary, mural paintings, and mosaic floors.

While such private houses were typical of Pompeii and other Italian towns, they were very rare in large cities such as Rome, where the masses lived instead in multistory apartment houses (FIG. 10-54).

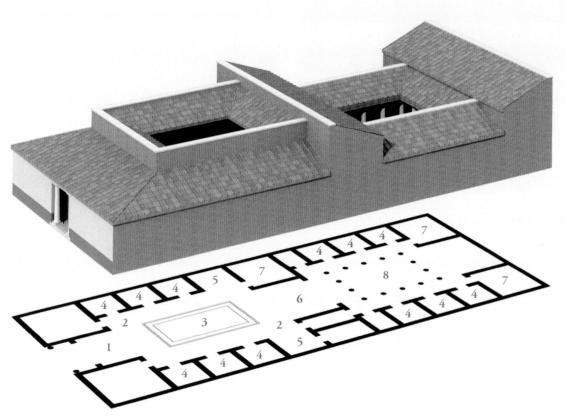

10-16 Restored view and plan of a typical Roman house of the Late Republic and Early Empire (John Burge). (1) fauces, (2) atrium, (3) impluvium, (4) cubiculum, (5) ala, (6) tablinum, (7) triclinium, (8) peristyle.

Older Roman houses closely followed Etruscan models and had atriums and small gardens, but during the Late Republic and Early Empire, Roman builders added peristyles with Greek columns.

10-17 First Style wall painting in the fauces of the Samnite House, Herculaneum, Italy, late second century BCE.

In First Style murals, the decorator's aim was to imitate costly marble panels using painted stucco relief. The style is Greek in origin and another example of the Hellenization of Republican architecture.

FIRST STYLE The *First Style* is also called the Masonry Style because the decorator's aim was to imitate costly marble panels using painted stucco relief. The fauces (FIG. 10-17) of the Samnite House at Herculaneum greets the visitor with a stunning illusion of walls constructed, or at least faced, with marbles imported from quarries all over the Mediterranean. This approach to wall decoration is comparable to the modern practice, employed in private libraries and corporate meeting rooms alike, of using cheaper manufactured materials to approximate the look and shape of genuine wood paneling. The practice is not, however, uniquely Pompeian or Roman. First Style walls are well documented in the Greek world from the late fourth century BCE on. The use of the First Style in Republican houses is yet another example of the Hellenization of Roman architecture.

SECOND STYLE The First Style never went completely out of fashion, but after 80 BCE a new approach to mural design became more popular. The *Second Style* is in most respects the antithesis of the First Style. Some scholars have argued that the Second Style also has precedents in Greece, but most believe it is a Roman invention. Certainly, the Second Style evolved in Italy and was popular until around 15 BCE, when Roman painters introduced the Third Style. Second Style painters did not aim to create the illusion of an elegant marble wall, as First Style painters sought to do. Rather, they wanted to dissolve a room's confining walls and replace them with the illusion of an imaginary three-dimensional world.

VILLA OF THE MYSTERIES An early example of the new style is the room (FIG. 10-18) that gives its name to the Villa of the Mysteries at Pompeii. Many scholars believe this chamber was used to celebrate, in private, the rites of the Greek god Dionysos (Roman Bacchus). Dionysos was the focus of an unofficial mystery religion popular among women in Italy at this time. The precise nature of the Dionysiac rites is unknown, but the figural cycle in the Villa of the Mysteries, illustrating mortals (all female save for one boy) interacting with mythological figures, probably provides some evidence for the cult's initiation rites. In these rites young women, emulating Ariadne, daughter of King Minos (see Chapter 4), united in marriage with Dionysos.

The backdrop for the nearly life-size figures is a series of painted panels imitating marble revetment, just as in the First Style but without the modeling in relief. In front of this marble wall (but actually on the same two-dimensional surface), the painter created the illusion of a shallow ledge on which the human and divine actors move around the room. Especially striking is the way some of the figures interact across the corners of the room. For example, a seminude winged woman at the far right of the rear wall lashes out with her whip across the space of the room at a kneeling woman with a bare back (the initiate and bride-to-be of Dionysos) on the left end of the right wall. Nothing comparable to this room existed in Hellenistic Greece. Despite the presence of Dionysos, satyrs, and other figures from Greek mythology, this is a Roman design.

VILLA AT BOSCOREALE In the early Second Style Dionysiac mystery frieze, the spatial illusionism is confined to the painted platform that projects into the room. But in mature Second Style designs, Roman painters created a three-dimensional setting that also extends beyond the wall. An example is a cubiculum (FIG. 10-19) from the Villa of Publius Fannius Synistor at Boscoreale, near Pompeii, decorated between 50 and 40 BCE. The excavators removed the frescoes soon after their discovery, and today they are part of a reconstructed Roman bedroom in the Metropolitan Museum of Art. All around the room the Second Style painter opened up the walls with vistas of Italian towns, marble temples, and colonnaded courtyards. Painted doors and gates invite the viewer to walk through the wall into the magnificent world the painter created.

Although the Boscoreale painter was inconsistent in applying it, this Roman artist, like many others around the Bay of Naples, demonstrated a knowledge of single-point *linear perspective*, often incorrectly said to be an innovation of Italian Renaissance artists (see "Renaissance Perspectival Systems," Chapter 21, page 547). In this kind of perspective, all the receding lines in a composition converge on a single point along the painting's central axis to show depth and distance. Ancient writers noted that Greek painters of the fifth century BCE first used linear perspective for the design of Athenian stage sets (hence its Greek name, *skenographia*, "scene painting"). In the Boscoreale cubiculum, the painter most successfully employed the device in the far corners, where a low gate leads to a

10-18 Dionysiac mystery frieze, Second Style wall paintings in room 5 of the Villa of the Mysteries, Pompeii, Italy, ca. 60–50 BCE. Fresco, frieze 5′ 4″ high.

Second Style painters created the illusion of an imaginary three-dimensional world on the walls of Roman houses. The figures in this room are acting out the initiation rites of the Dionysiac mysteries.

10-19 Second Style wall paintings (general view, *left*, and detail of tholos, *right*) from cubiculum M of the Villa of Publius Fannius Synistor, Boscoreale, Italy, ca. 50–40 BCE. Fresco, 8′ 9″ high. Metropolitan Museum of Art, New York.

In this Second Style bedroom, the painter opened up the walls with vistas of towns, temples, and colonnaded courtyards. The convincing illusionism is due in part to the use of linear perspective.

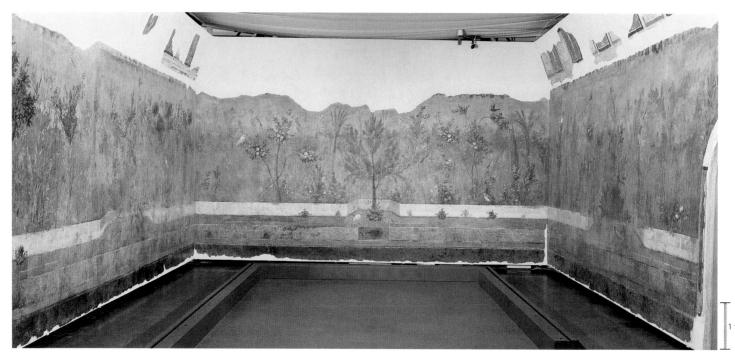

10-20 Gardenscape, Second Style wall paintings, from the Villa of Livia, Primaporta, Italy, ca. 30–20 BCE. Fresco, 6' 7" high. Museo Nazionale Romano–Palazzo Massimo alle Terme, Rome.

The ultimate example of a Second Style "picture-window" wall is Livia's gardenscape. To suggest recession, the painter used atmospheric perspective, intentionally blurring the most distant forms.

peristyle framing a tholos temple (FIG. 10-19, *right*). Linear perspective was a favored tool of Second Style painters seeking to transform the usually windowless walls of Roman houses into "picture-window" vistas that expanded the apparent space of the rooms.

VILLA OF LIVIA, PRIMAPORTA The ultimate example of a Second Style picture-window mural (FIG. 10-20) comes from the Villa of Livia, wife of the emperor Augustus, at Primaporta, just north of Rome. There, imperial painters decorated all the walls of a vaulted room with lush gardenscapes. The only architectural element is the flimsy fence of the garden itself. To suggest recession, the painter mastered another kind of perspective, atmospheric perspective, indicating depth by the increasingly blurred appearance of objects in the distance. At Livia's villa, the artist precisely painted the fence, trees, and birds in the foreground, whereas the details of the dense foliage in the background are indistinct. Among the wall paintings examined so far, only the landscape fresco (FIG. 4-9) from Thera offers a similar wraparound view of nature. But the Aegean fresco's white sky and red, yellow, and blue rock formations do not create a successful illusion of a world filled with air and light just a few steps away.

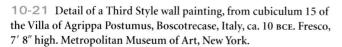

In the Third Style, Roman painters decorated walls with delicate linear fantasies sketched on predominantly monochromatic backgrounds. Here, a tiny floating landscape on a black ground is the central motif.

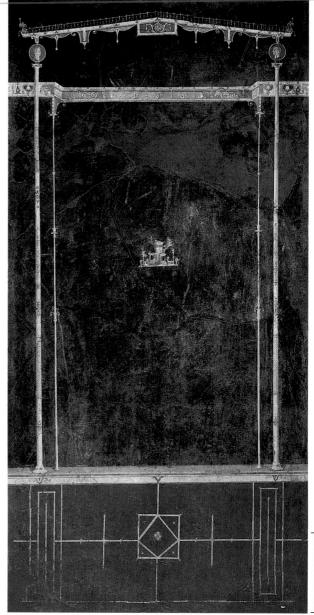

THIRD STYLE The Primaporta gardenscape is the polar opposite of First Style designs, which reinforce, rather than deny, the heavy presence of confining walls. But tastes changed rapidly in the Roman world, as in society today. Not long after Livia had her villa painted, Roman patrons began to favor mural designs that reasserted the primacy of the wall surface. In the *Third Style* of Pompeian painting, artists no longer attempted to replace the walls with three-dimensional worlds of their own creation. Nor did they seek to imitate the appearance of the marble walls of Hellenistic kings. Instead they decorated walls with delicate linear fantasies sketched on predominantly *monochromatic* (one-color) backgrounds.

VILLA AT BOSCOTRECASE One of the earliest examples of the new style is a cubiculum (FIG. 10-21) in the Villa of Agrippa Postumus at Boscotrecase. The villa was probably painted just before 10 BCE. Nowhere did the artist use illusionistic painting to penetrate the wall. In place of the stately columns of the Second Style are insubstantial and impossibly thin *colonnettes* supporting featherweight canopies barely reminiscent of pediments. In the center of this delicate and elegant architectural frame is a tiny floating landscape painted directly on the jet black ground. It is hard to imagine a sharper contrast with the panoramic gardenscape at Livia's villa. On other Third Style walls, landscapes and mythological scenes appear

in frames, like modern canvas paintings hung on walls. Never could these framed panels be mistaken for windows opening onto a world beyond the room.

FOURTH STYLE In the Fourth Style, however, a taste for illusionism returned once again. This style became popular in the 50s CE, and it was the preferred manner of mural decoration at Pompeii when the eruption of Vesuvius buried the town in volcanic ash in 79. Some examples of the new style, such as room 78 (FIG. 10-22) in the emperor Nero's Golden House in Rome (see page 259), display a kinship with the Third Style. All the walls are an austere creamy white. In some areas the artist painted sea creatures, birds, and other motifs directly on the monochromatic background, much like the landscape in the Boscotrecase villa (FIG. 10-21). Landscapes appear here too—as framed paintings in the center of each large white subdivision of the wall. Views through the wall are also part of the design, but the Fourth Style architectural vistas are irrational fantasies. The viewer looks out not on cityscapes or round temples set in peristyles but at fragments of buildings-columns supporting halfpediments, double stories of columns supporting nothing at allpainted on the same white ground as the rest of the wall. In the Fourth Style, architecture became just another motif in the painter's ornamental repertoire.

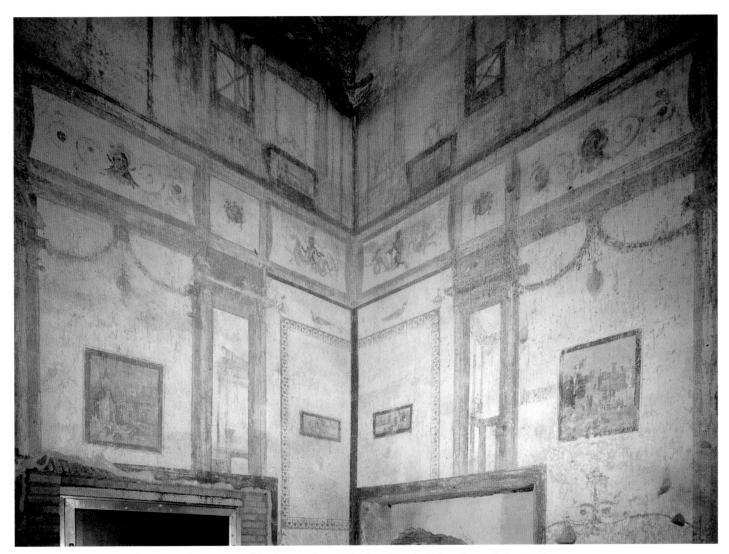

10-22 Fourth Style wall paintings in room 78 of the Domus Aurea (Golden House) of Nero, Rome, Italy, 64-68 CE.

The creamy white walls of this room in Nero's Golden House display a kinship with the Third Style, but views through the wall revealing irrational architectural vistas characterize the new Fourth Style.

10-23 Fourth Style wall paintings in the Ixion Room (triclinium P) of the House of the Vettii, Pompeii, Italy, ca. 70–79 CE.

Late Fourth Style murals are often garishly colored, crowded, and confused compositions with a mixture of architectural views, framed mythological panel paintings, and First and Third Style motifs.

IXION ROOM In the latest Fourth Style designs, Pompeian painters rejected the quiet elegance of the Third Style and early Fourth Style in favor of crowded and confused compositions and sometimes garish color combinations. The Ixion Room (FIG. 10-23) of the House of the Vettii at Pompeii was decorated in this manner just before the eruption of Mount Vesuvius. The room served as a triclinium in the house the Vettius brothers remodeled after the earthquake. It opened onto the peristyle seen in the background of FIG. 10-15.

The decor of the Ixion Room serves as a synopsis of all the previous styles, another instance of the eclecticism noted earlier as characteristic of Roman art in general. The lowest zone, for example, is one of the most successful imitations anywhere of costly multicolored imported marbles, despite the fact that the painter created the illusion without recourse to relief, as in the First Style. The large white panels in the corners of the room, with their delicate floral frames and floating central motifs, would fit naturally into the most elegant Third Style design. Unmistakably Fourth Style, however, are the fragmentary architectural vistas of the

central and upper zones of the walls. They are unrelated to one another, do not constitute a unified cityscape beyond the wall, and incorporate figures that would tumble into the room if they took a single step forward.

The Ixion Room takes its name from the mythological panel painting at the center of the rear wall (FIG. 10-23). Ixion had attempted to seduce Hera, and Zeus punished him by binding him to a perpetually spinning wheel. The panels on the two side walls also have Greek myths as subjects. The Ixion Room may be likened to a small private art gallery with paintings decorating the walls, as in many modern homes. Scholars long have believed that these and the many other mythological paintings on Third and Fourth Style walls were based on lost Greek panels. They attest to the Romans' continuing admiration for Greek artworks three centuries after Marcellus brought the treasures of Syracuse to Rome. But few, if any, of these mythological paintings can be described as true copies of "Old Masters," as are the many Roman replicas of famous Greek statues that have been found throughout the Roman world, including Pompeii (FIG. 5-40).

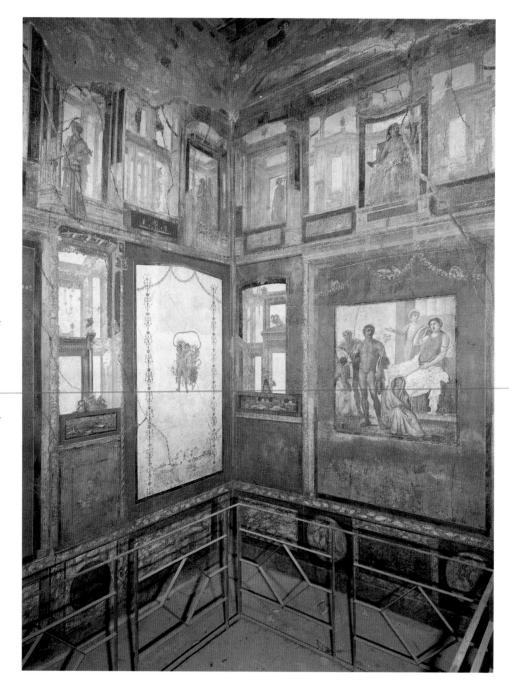

WALL MOSAICS Mythological figures were on occasion also the subject of Roman mosaics. In the ancient world, mosaics were usually confined to floors (as was the Pompeian Alexander Mosaic, FIG. 5-70), where the tesserae formed a durable as well as decorative surface. In Roman times, however, mosaics also decorated walls and even ceilings, foreshadowing the extensive use of wall and vault mosaics in the Middle Ages (see "Mosaics," Chapter 11, page 303). The mosaic shown in FIG. 10-24 adorns a wall in the House of Neptune and Amphitrite at Herculaneum. The statuesque figures of the sea god and his wife preside over the running water of the fountain in the courtyard in front of them where the home's owners and guests enjoyed outdoor dining in warm weather.

PRIVATE PORTRAITS The subjects chosen for Roman wall paintings and mosaics were diverse. Although mythological themes were immensely popular, Romans commissioned a vast range of other subjects. As noted, landscape paintings frequently appear on Second, Third, and Fourth Style walls. Paintings and mosaics depicting scenes from history include the *Alexander Mosaic* (FIG. 5-70) and

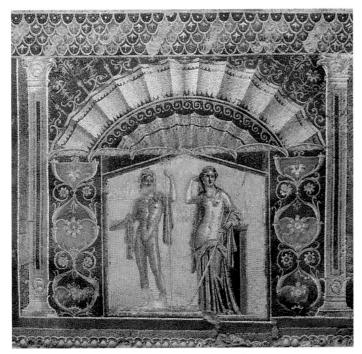

10-24 Neptune and Amphitrite, wall mosaic in the summer triclinium of the House of Neptune and Amphitrite, Herculaneum, Italy, ca. 62–79 ce.

In the ancient world, mosaics were usually confined to floors, but this example depicting Neptune and Amphitrite decorates the wall of a private house. The sea deities fittingly overlook an elaborate fountain.

the mural painting (FIG. 10-14) of the brawl in the amphitheater of Pompeii. Given the Roman custom of keeping imagines of illustrious ancestors in atriums, it is not surprising that painted portraits also appear in Pompeian houses. The portrait of a husband and wife illustrated here (FIG. 10-25) originally formed part of a Fourth Style wall of an exedra, or recessed area, opening onto the atrium of a Pompeian house. The man holds a scroll and the woman a stylus (writing instrument) and a wax writing tablet, standard attributes in Roman marriage portraits. They suggest the fine education of those depicted—even if, as was sometimes true, the individuals were uneducated or even illiterate. Such portraits were thus the Roman equivalent of modern wedding photographs of the bride and groom posing in rented formal garments that they never wore before or afterward (see "Role Playing in Roman Portraiture," page 254). In contrast, the heads are not standard types but sensitive studies of the couple's individual faces. This is another instance of a realistic portrait placed on a conventional figure type (compare FIG. 10-8), a recurring phenomenon in Roman portraiture.

STILL-LIFE PAINTING The Roman interest in recording the unique appearance of individual people extended to everyday objects. This explains the frequent inclusion of *still-life* paintings (representations of inanimate objects, artfully arranged) in the mural schemes of the Second, Third, and Fourth Styles. A still life with peaches and a carafe (FIG. 10-26), a detail of a painted wall from Herculaneum, demonstrates that Roman painters sought to create illusionistic effects when depicting small objects as well as buildings and landscapes. The artist paid as much attention to shadows and highlights on the fruit, the stem and leaves, and the glass jar as to the objects themselves. Art historians have not found evidence of paintings comparable to these Roman studies of food and other inanimate objects until the Dutch still lifes of the 17th and 18th centuries (FIGS. 25-22 and 25-23).

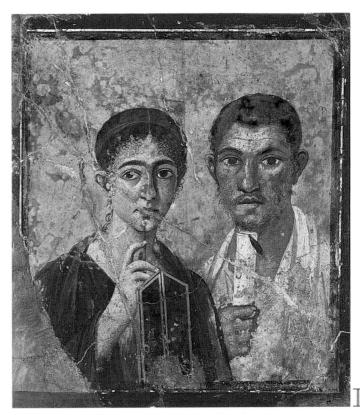

10-25 Portrait of a husband and wife, wall painting from House VII,2,6, Pompeii, Italy, ca. 70–79 ce. Fresco, 1' 11" \times 1' $8\frac{1}{2}$ ". Museo Archeologico Nazionale, Naples.

This husband and wife wished to present themselves to their guests as thoughtful and well-read. The portraits are individualized likenesses, but the poses and attributes they hold are standard types.

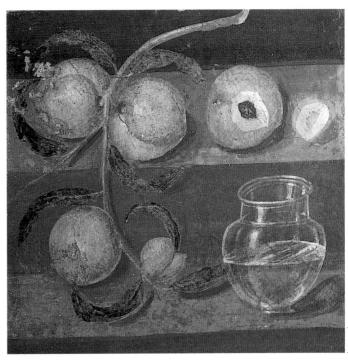

10-26 Still life with peaches, detail of a Fourth Style wall painting, from Herculaneum, Italy, ca. 62–79 CE. Fresco, 1' $2'' \times 1'$ $1\frac{1}{2}''$. Museo Archeologico Nazionale, Naples.

The Roman interest in illusionism explains the popularity of still-life paintings. This painter paid scrupulous attention to the play of light and shadow on different shapes and textures.

Role Playing in Roman Portraiture

n every town throughout the vast Roman Empire, portraits of the emperors and empresses and their families were on display—in forums, basilicas, baths, and markets; in front of temples; atop triumphal arches—anywhere a statue could be placed. The rulers' heads varied little from Britain to Syria. All were replicas of official images, either imported or scrupulously copied by local artists. But the Roman sculptors placed the portrait heads on many types of bodies. The type chosen depended on the position the person held in Roman society or the various fictitious guises members of the imperial family assumed. Portraits of Augustus, for example, show him not only as armed general (FIG. 10-27) but also as recipient of the civic crown for saving the lives of fellow citizens (FIG. I-9). Other statues show him as veiled priest, toga-clad magistrate, traveling commander on horseback, heroically nude warrior, and various Roman gods, including Jupiter, Apollo, and Mercury.

Such role playing was not confined to emperors and princes but extended to their wives, daughters, sisters, and mothers. Portraits of Livia (FIG. 10-28) depict her as many goddesses, including Ceres, Juno, Venus, and Vesta. She also appears as the personification of Health, Justice, and Piety. In fact, it was common for imperial women to appear on Roman coins as goddesses or as embodiments of feminine virtue. Faustina the Younger, for example, the wife of Marcus Aurelius and mother of 13 children, appears as Venus and Fecundity, among many other roles. Julia Domna (FIG. 10-63), Septimius Severus's wife, is Juno, Venus, Peace, or Victory in some portraits.

Ordinary citizens also engaged in role playing. Some assumed literary pretensions, as did a husband and wife (FIG. 10-25) in their Pompeian home. Others equated themselves with Greek heroes (FIG. 10-60) or Roman deities (FIG. 10-61) on their coffins. The common people followed the lead of the emperors and empresses.

10-27 Portrait of Augustus as general, from Primaporta, Italy, early-first-century CE copy of a bronze original of ca. 20 BCE. Marble, 6' 8" high. Musei Vaticani, Rome.

Augustus's idealized portraits were modeled on Classical Greek statues (FIG. 5-40) and depict him as a never-aging son of a god. This portrait presents the emperor in armor in his role as general.

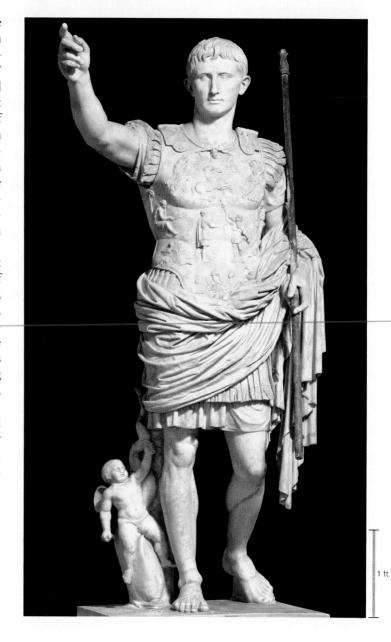

EARLY EMPIRE

The murder of Julius Caesar on the Ides of March, 44 BCE, plunged the Roman world into a bloody civil war. The fighting lasted until 31 BCE when Octavian (better known as Augustus), Caesar's grandnephew and adopted son, crushed the naval forces of Mark Antony and Queen Cleopatra of Egypt at Actium in northwestern Greece. Antony and Cleopatra committed suicide, and in 30 BCE, Egypt, once the wealthiest and most powerful kingdom of the ancient world, became another province in the ever-expanding Roman Empire.

Historians mark the passage from the Roman Republic to the Roman Empire from the day in 27 BCE when the Senate conferred the majestic title of Augustus (r. 27 BCE—14 CE) on Octavian. The Empire was ostensibly a continuation of the Republic, with the same constitutional offices, but in fact Augustus, whom the Senate recog-

nized as *princeps* (first citizen), occupied all the key positions. He was consul and *imperator* (commander in chief; root of the word *emperor*) and even, after 12 BCE, *pontifex maximus* (chief priest of the state religion). These offices gave Augustus control of all aspects of Roman public life.

PAX ROMANA With powerful armies keeping order on the Empire's frontiers and no opposition at home, Augustus brought peace and prosperity to a war-weary Mediterranean world. Known in his own day as the *Pax Augusta* (Augustan Peace), the peace Augustus established prevailed for two centuries. It came to be called simply the *Pax Romana*. During this time the emperors commissioned a huge number of public works throughout the Empire: roads, bridges, theaters, amphitheaters, and bathing complexes, all on an unprecedented scale. The erection of imperial portrait statues and monuments covered with reliefs recounting the rulers' great

10-28 Portrait bust of Livia, from Arsinoe, Egypt, early first century CE. Marble, $1'1\frac{1}{2}''$ high. Ny Carlsberg Glyptotek, Copenhagen.

Although Livia sports the latest Roman coiffure, her youthful appearance and sharply defined features derive from images of Greek goddesses. She lived until 87, but, like Augustus, never aged in her portraits.

deeds reminded people everywhere of the source of this beneficence. These portraits and reliefs often presented a picture of the emperors and their achievements that bore little resemblance to historical fact. Their purpose, however, was not to provide an objective record but to mold public opinion. The Roman emperors and the artists they employed have had few equals in the effective use of art and architecture for propagandistic ends.

Augustus and the Julio-Claudians

When Augustus vanquished Antony and Cleopatra at Actium and became undisputed master of the Mediterranean world, he was not yet 32 years old. The rule by elders that had characterized the Roman Republic for nearly a half millennium came to an abrupt end. Suddenly, Roman portraitists were called on to produce images of a youthful head of state. But Augustus was not merely young. Caesar had been made a god after his death, and Augustus, though never claiming to be a god himself, widely advertised himself as the son of a god. His portraits were designed to present the image of a godlike leader who miraculously never aged. Although Augustus lived until 14 CE, even official portraits made near the end of his life show him as a handsome youth (FIG. I-9). Such fictional portraits might seem ridiculous today, when the media circulate pictures of world leaders as they truly appear, but in antiquity few people had actually seen the emperor. His official image was all most knew. It therefore could be manipulated at will.

AUGUSTUS AS IMPERATOR The portraits of Augustus depict him in his many different roles in the Roman state (see "Role Playing in Roman Portraiture," page 254), but the models for many of them were Classical Greek statues. The portrait (FIG. 10-27) of the emperor found at his wife Livia's villa (FIG. 10-20) at Primaporta portrays Augustus as general, standing in the pose of Polykleitos's Doryphoros (FIG. 5-40) but with his right arm raised to address his troops in the manner of the orator Aule Metele (FIG. 9-16). Augustus's head, although portraying a recognizable individual, also emulates the idealized head of the Polykleitan spear bearer in its overall shape, the sharp ridges of the brows, and the tight cap of layered hair. Augustus is not a nude athlete, however, and the details of the statue carry political messages. The reliefs on the cuirass advertise an important diplomatic victory—the return of the Roman military standards the Parthians had captured from a Republican general—and the Cupid at Augustus's feet alludes to his divine descent. (Caesar's family, the Julians, traced their ancestry back to Venus. Cupid was the goddess's son.)

LIVIA A marble portrait (FIG. 10-28) of Livia shows that the imperial women of the Augustan age shared the emperor's eternal youthfulness. Although she sports the latest Roman coiffure, with the hair rolled over the forehead and knotted at the nape of the neck, Livia's blemish-free skin and sharply defined features derive from images of Classical Greek goddesses. Livia outlived Augustus by 15 years, dying at age 87. In her portraits, the coiffure changed with the introduction of each new fashion, but her face remained ever young, befitting her exalted position in the Roman state.

10-29 Ara Pacis Augustae (Altar of Augustan Peace; looking northeast), Rome, Italy, 13-9 BCE.

Augustus sought to present his new order as a Golden Age equaling that of Athens under Pericles. The Ara Pacis celebrates the emperor's most important achievement, the establishment of peace.

10-30 Female personification (Tellus?), panel from the east facade of the Ara Pacis Augustae, Rome, Italy, 13–9 BCE. Marble, 5′ 3″ high.

This female personification with two babies on her lap epitomizes the fruits of the Pax Augusta. All around her the bountiful earth is in bloom, and animals of different species live together peacefully.

ARA PACIS AUGUSTAE On Livia's birthday in 9 BCE, Augustus dedicated the Ara Pacis Augustae (Altar of Augustan Peace; FIG. 10-29), the monument celebrating his most significant achievement, the establishment of peace. Figural reliefs and acanthus tendrils adorn the altar's

marble precinct walls. Four panels on the east and west ends depict carefully selected mythological subjects, including (at the right in FIG. 10-29) a relief of Aeneas making a sacrifice. Aeneas was the son of Venus and one of Augustus's forefathers. The connection between the emperor and Aeneas was a key element of Augustus's political ideology for his new Golden Age. It is no coincidence that Vergil wrote the *Aeneid* during the rule of Augustus. The epic poem glorified the young emperor by celebrating the founder of the Julian line.

A second panel (FIG. 10-30), on the other end of the altar enclosure, depicts a seated matron with two lively babies on her lap. Her identity is uncertain. She is usually called Tellus (Mother Earth), although some scholars have named her Pax (Peace), Ceres (goddess of grain), or even Venus. Whoever she is, she epitomizes the fruits of the Pax Augusta. All around her the bountiful earth is in bloom, and animals of different species live peacefully side by side. Personifications of refreshing breezes (note their windblown drapery) flank her. One

e all ele-

rides a bird, the other a sea creature. Earth, sky, and water are all elements of this picture of peace and fertility in the Augustan cosmos.

Processions of the imperial family (FIG. 10-31) and other important dignitaries appear on the long north and south sides of the Ara Pacis. These parallel friezes were clearly inspired to some degree by the Panathenaic procession frieze (FIG. 5-50, bottom) of the Parthenon. Augustus sought to present his new order as a Golden Age equaling that of Athens under Pericles in the mid-fifth century BCE. The emulation of Classical models thus made a political statement as well as an artistic one.

Even so, the Roman procession is very different in character from that on the Greek frieze. On the Parthenon, anonymous figures act out an event that recurred every four years. The frieze stands for *all* Panathenaic Festival processions. The Ara Pacis depicts a specific event—possibly the inaugural ceremony of 13 BCE when work on the altar began—and recognizable contemporary figures. Among those

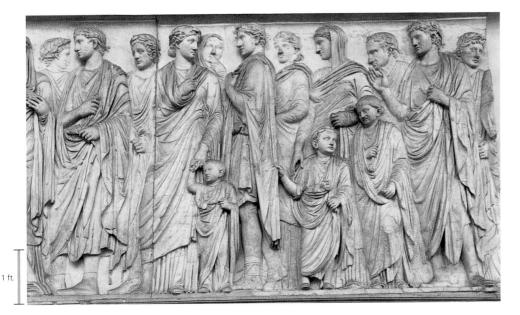

10-31 Procession of the imperial family, detail of the south frieze of the Ara Pacis Augustae, Rome, Italy, 13–9 BCE. Marble, 5′ 3″ high.

Although inspired by the Panathenaic procession frieze (FIG. 5-50) of the Parthenon, the Ara Pacis friezes depict recognizable individuals, including children. Augustus promoted marriage and childbearing.

Luna). Prior to the opening of these quarries in the second half of the first century BCE, marble had to be imported at great cost from abroad, and the Romans used it sparingly. The ready availability of Italian marble under Augustus made possible the that he found Rome a city of brick and

emperor's famous boast that he found Rome a city of brick and transformed it into a city of marble.

The extensive use of Carrara marble for public monuments (including the Ara Pacis) must be seen as part of Augustus's larger program to make his city the equal of Periclean Athens. In fact, the Forum of Augustus incorporated several explicit references to Classical Athens and to the Acropolis in particular, most notably copies of the caryatids (FIG. 5-54) of the Erechtheion in the upper story of the porticos. The forum also evoked Roman history. The porticos contained dozens of portrait statues, including images of all the major figures of the Julian family going back to Aeneas. Augustus's forum became a kind of public atrium filled with *imagines*. His family history thus became part of the Roman state's official history.

NÎMES The Forum of Augustus is in ruins today, but many scholars believe some workers on that project also erected the so-called Maison Carrée (Square House; FIG. 10-32) at Nîmes (ancient

portrayed are children, who restlessly tug on their elders' garments and talk to one another when they should be quiet on a solemn occasion—in short, children who act like children and not like miniature adults, as they frequently do in the history of art. Their presence lends a great deal of charm to the procession, but that is not why children were included on the Ara Pacis when they had never before appeared on any Greek or Roman state monument. Augustus was concerned about a decline in the birthrate among the Roman nobility, and he enacted a series of laws designed to promote marriage, marital fidelity, and raising children. The portrayal of men with their families on the Altar of Peace served as a moral exemplar. Once again, the emperor used art to further his political and social agendas.

FORUM OF AUGUSTUS Augustus's most ambitious project in the capital was the construction of a new forum (FIG. 10-2, no. 10) next to Julius Caesar's forum (FIG. 10-2, no. 9), which Augustus completed. Both forums featured white marble from Carrara (ancient

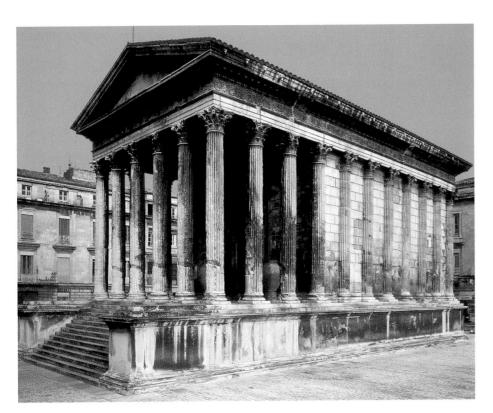

10-32 Maison Carrée, Nîmes, France, ca. 1–10 CE.

This exceptionally well preserved Corinthian pseudoperipteral temple in France, modeled on the Temple of Mars Ultor in Rome, exemplifies the conservative Neo-Classical Augustan architectural style.

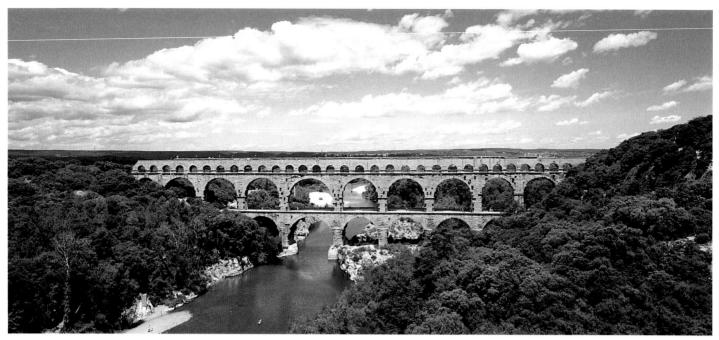

10-33 Pont-du-Gard, Nîmes, France, ca. 16 BCE.

Roman engineers constructed roads and bridges throughout the empire. This aqueduct bridge brought water from a distant mountain spring to Nîmes—about 100 gallons a day for each inhabitant.

Nemausus) in southern France (ancient Gaul). This exceptionally well preserved Corinthian pseudoperipteral temple, which dates to the opening years of the first century CE, is the best surviving example of the Augustan Neo-Classical architectural style.

An earlier Augustan project at Nîmes was the construction of the great aqueduct-bridge known today as the Pont-du-Gard (FIG. 10-33). Beginning in the fourth century BCE, the Romans built aqueducts to carry water from mountain sources to their city on the Tiber River. As Rome's power spread through the Mediterranean world, its architects constructed aqueducts, roads, and bridges to serve colonies throughout the far-flung empire. The Pont-du-Gard demonstrates the skill of Rome's engineers. The aqueduct provided about 100 gallons of water a day for each inhabitant of Nîmes from a source some 30 miles away. The water was carried over the considerable distance by gravity alone, which required channels built with a continuous gradual decline over the entire route from source to city. The three-story bridge at Nîmes maintained the height of the water channel where the water crossed the Gard River. Each large arch spans some 82 feet and is constructed of blocks weighing up to two tons each. The bridge's uppermost level consists of a row of smaller arches, three above each of the large openings below. They carry the water channel itself. Their quickened rhythm and the harmonious proportional relationship between the larger and smaller arches reveal that the Roman engineer had a keen aesthetic as well as practical sense.

PORTA MAGGIORE Many aqueducts were required to meet the demand for water in the capital. Under the emperor Claudius (r. 41–54 CE), a grandiose gate, the Porta Maggiore (FIG. 10-34), was constructed at the point where two of Rome's water lines (and two intercity trunk roads) converged. Its huge *attic* (uppermost story) bears a wordy dedicatory inscription that conceals the conduits of both aqueducts, one above the other. The gate is the outstanding example of the Roman *rusticated* (rough) masonry style. Instead of using the precisely shaped blocks Greek and Augustan architects preferred, the designer of the Porta Maggiore combined smooth and rusticated surfaces. These created an exciting, if eccen-

tric, facade with crisply carved pediments resting on engaged columns composed of rusticated drums.

NERO'S GOLDEN HOUSE In 64 CE, when Nero (r. 54–68 CE), stepson and successor of Claudius, was emperor, a great fire destroyed large sections of Rome. Architects carried out the rebuilding in accordance with a new code that required greater fireproofing, resulting in the widespread use of concrete, which was both cheap and fire resistant. Increased use of concrete gave Roman builders the opportunity to explore the possibilities opened up by the still relatively new material.

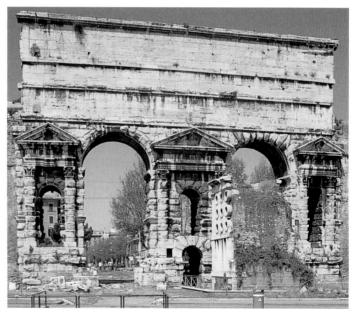

10-34 Porta Maggiore, Rome, Italy, ca. 50 CE.

This double gateway, which supports the water channels of two important aqueducts, is the outstanding example of Roman rusticated (rough) masonry, which was especially popular under Claudius.

The Golden House of Nero

ero's Domus Aurea (FIG. 10-35), or Golden House, was a vast and notoriously extravagant country villa in the heart of Rome. The second-century CE Roman biographer Suetonius described it vividly:

The entrance-hall was large enough to contain a huge statue [of Nero in the guise of Sol, the sun god, by Zenodorus; FIG. 10-2, no. 16], 120 feet high; and the pillared arcade ran for a whole mile. An enormous pool, like a sea, was surrounded by buildings made to resemble cities, and by a landscape garden consisting of ploughed fields, vineyards, pastures, and woodlands—where every variety of domestic and wild animal roamed about. Parts of the house were overlaid with gold and studded with precious stones and mother-of-pearl. All the dining-rooms had ceilings of fretted ivory, the panels of which could slide back and let a rain of flowers, or of perfume from hidden sprinklers, shower upon [Nero's] guests. The main

dining-room was circular, and its roof revolved, day and night, in time with the sky. Sea water, or sulphur water, was always on tap in the baths. When the palace had been decorated throughout in this lavish style, Nero dedicated it, and condescended to remark: "Good, now I can at last begin to live like a human being!"*

Suetonius's description is a welcome reminder that the Roman ruins tourists flock to see are but a dim reflection of the magnificence of the original structures. Only in rare instances, such as the Pantheon, with its marble-faced walls and floors (FIG. 10-51), can visitors experience anything approaching the architects' intended effects. Even there, much of the marble paneling is of later date, and the gilding is missing from the dome.

*Suetonius, *Nero*, 31. Translated by Robert Graves, *Suetonius: The Twelve Caesars* (New York: Penguin, 1957; illustrated edition, 1980), 197–198.

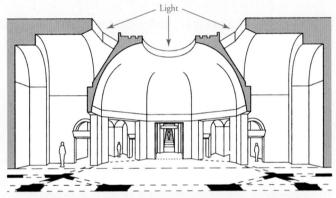

10-35 SEVERUS and CELER, section (*left*) and plan (*right*) of the octagonal hall of the Domus Aurea (Golden House) of Nero, Rome, Italy, 64–68 CE.

Nero's architects illuminated this octagonal room by placing an oculus in its concrete dome, and ingeniously lit the rooms around it by leaving spaces between their vaults and the dome's exterior.

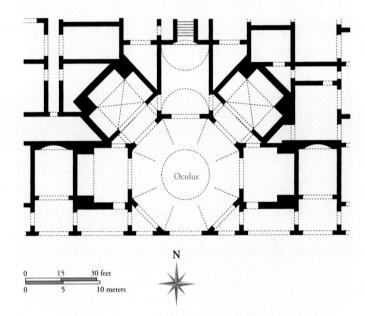

After the great fire, Nero asked Severus and Celer, two brilliant architect-engineers, to construct a grand new palace for him on a huge confiscated plot of fire-ravaged land near the Forum Romanum (see "The Golden House of Nero," above). Nero's Domus Aurea had scores of rooms, many adorned with frescoes (FIG. 10-22) in the Fourth Style, others with marble paneling or painted and gilded stucco reliefs. Structurally, most of these rooms, although built of concrete, are unremarkable. One octagonal hall (FIG. 10-35), however, stands apart from the rest and testifies to Severus and Celer's entirely new approach to architectural design.

The ceiling of the octagonal room is a dome that modulates from an eight-sided to a hemispherical form as it rises toward the *oculus*—the circular opening that admitted light to the room. Radiating outward from the five inner sides (the other three, directly or indirectly, face the outside) are smaller, rectangular rooms, three covered by barrel vaults, two others (marked by a broken-line X on the plan; FIG. 10-35, *right*) by the earliest known concrete groin

vaults. Severus and Celer ingeniously lit these satellite rooms by leaving spaces between their vaulted ceilings and the central dome's exterior. But the most significant aspect of the design is that here, for the first time, the architects appear to have thought of the walls and vaults not as limiting space but as shaping it.

Today, the octagonal hall no longer has its stucco decoration and marble *incrustation* (veneer). The concrete shell stands bare, but this serves to focus the visitor's attention on the design's spatial complexity. Anyone walking through the rooms sees that the central domed octagon is defined not by walls but by eight angled piers. The wide square openings between the piers are so large that the rooms beyond look like extensions of the central hall. The grouping of spatial units of different sizes and proportions under a variety of vaults creates a dynamic three-dimensional composition that is both complex and unified. Nero's architects were not only inventive but also progressive in their recognition of the malleable nature of concrete, a material not limited to the rectilinear forms of traditional architecture.

Spectacles in the Colosseum

main kinds of spectacles: gladiatorial combats and animal hunts. *Gladiators* were professional fighters, usually slaves who had been purchased to train as hand-to-hand combatants in gladiatorial schools. Their owners, seeking to turn a profit, rented them out for performances. Beginning with Domitian, however, all gladiators who competed in Rome were state-owned to ensure that they could not be used as a private army to overthrow the government. Although every gladiator faced death every time he entered the arena, some had long careers and achieved considerable fame. Others, for example, criminals or captured enemies, were sent into the amphitheater without any training and without any defensive weapons. Those "gladiatorial games" were a form of capital punishment coupled with entertainment for the masses.

Wild animal hunts (*venationes*) were also immensely popular. Many of the hunters were also professionals, but often the hunts, like the gladiatorial games, were executions in thin disguise involving helpless prisoners who were easy prey for the animals. Sometimes no one would enter the arena with the animals. Instead, skilled archers shot the beasts with arrows from positions in the stands. Other times animals would be pitted against other animals—bears versus bulls, lions versus elephants, and such—to the delight of the crowds.

The Colosseum (FIG. 10-36) was the largest and most important amphitheater in the world, and the kinds of spectacles staged there were costlier and more impressive than those held anywhere else. There are even accounts of the Colosseum being flooded so that naval battles could be staged before an audience of tens of thousands, although some scholars have doubted that the arena could be made watertight or that ships could maneuver in the space available.

In the early third century, the historian Dio Cassius described the ceremonies Titus sponsored at the inauguration of the Colosseum in 80.

There was a battle between cranes and also between four elephants; animals both tame and wild were slain to the number of nine thousand; and women... took part in despatching them. As for the men, several fought in single combat and several groups contended together both in infantry and naval battles. For Titus suddenly filled [the arena] with water and brought in horses and bulls and some other domesticated animals that had been taught to behave in the liquid element just as on land. He also brought in people on ships, who engaged in a sea-

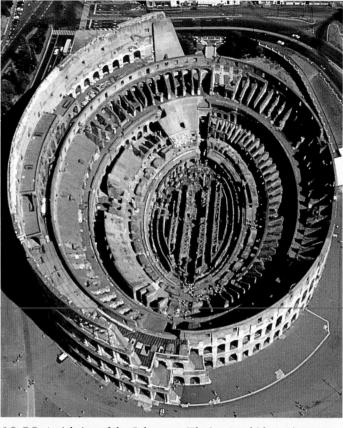

10-36 Aerial view of the Colosseum (Flavian Amphitheater), Rome, Italy, ca. 70-80 ce.

A complex system of concrete barrel vaults once held up the seats in the world's largest amphitheater, where 50,000 spectators could watch gladiatorial combats and wild animal hunts.

fight there.... On the first day there was a gladiatorial exhibition and wild-beast hunt.... On the second day there was a horse-race, and on the third day a naval battle between three thousand men, followed by an infantry battle.... These were the spectacles that were offered, and they continued for a hundred days.*

*Dio Cassius, Roman History, 66.25. Translated by Earnest Cary, Dio's Roman History, vol. 8 (Cambridge, Mass.: Harvard University Press, 1925), 311, 313.

The Flavians

Because of his outrageous behavior, Nero was forced to commit suicide in 68 CE, bringing the Julio-Claudian dynasty to an end. A year of renewed civil strife followed. The man who emerged triumphant in this brief but bloody conflict was Vespasian (r. 69–79 CE), a general who had served under Claudius and Nero. Vespasian, whose family name was Flavius, had two sons, Titus (r. 79–81 CE) and Domitian (r. 81–96 CE). The Flavian dynasty ruled Rome for more than a quarter century.

COLOSSEUM The Flavians left their mark on the capital in many ways, not the least being the construction of the Colosseum (FIGS. 10-2, no. 17, and 10-36), the monument that, for most people, still represents Rome more than any other building. In the past it

was identified so closely with Rome and its empire that in the early Middle Ages there was a saying, "While stands the Colosseum, Rome shall stand; when falls the Colosseum, Rome shall fall; and when Rome falls—the World." The Flavian Amphitheater, as it was known in its day, was one of Vespasian's first undertakings after becoming emperor. The decision to build the Colosseum was very shrewd politically. The site chosen was the artificial lake on the grounds of Nero's Domus Aurea, which engineers drained for the purpose. By building the new amphitheater there, Vespasian reclaimed for the public the land Nero had confiscated for his private pleasure and provided Romans with the largest arena for gladiatorial combats and other lavish spectacles that had ever been constructed. The Colosseum takes its name, however, not from its size—it could

10-37 Portrait of Vespasian, ca. 75–79 CE. Marble, 1' 4" high. Ny Carlsberg Glyptotek, Copenhagen.

Vespasian's sculptors revived the veristic tradition of the Republic to underscore the elderly new emperor's Republican values in contrast to Nero's self-indulgence and extravagance.

10-38 Portrait bust of a Flavian woman, from Rome, Italy, ca. 90 CE. Marble, 2' 1" high. Musei Capitolini, Rome.

The Flavian sculptor reproduced the elaborate coiffure of this elegant woman by drilling deep holes for the corkscrew curls and carved the rest of the hair and the face with hammer and chisel.

hold more than 50,000 spectators—but from its location beside the Colossus of Nero (FIG. 10-2, no. 16), the huge statue at the entrance to his urban villa. Vespasian did not live to see the Colosseum in use. Titus completed and formally dedicated the amphitheater in 80 CE with great fanfare (see "Spectacles in the Colosseum," page 260).

The Colosseum, like the much earlier amphitheater at Pompeii (FIG. 10-13), could not have been built without concrete. A complex system of barrel-vaulted corridors holds up the enormous oval seating area. This concrete "skeleton" is apparent today to anyone who enters the amphitheater (FIG. 10-36). In the centuries following the fall of Rome, the Colosseum served as a convenient quarry for ready-made building materials. Almost all its marble seats were hauled away, exposing the network of vaults below. Hidden in antiquity but visible today are the arena substructures, which in their present form date to the third century. They housed waiting rooms for the gladiators, animal cages, and machinery for raising and lowering stage sets as well as animals and humans. Cleverly designed lifting devices brought beasts from their dark dens into the arena's bright light. Above the seats a great velarium, as at Pompeii (FIG. 10-14), once shielded the spectators. Poles affixed to the Colosseum's facade held up the giant awning.

The exterior travertine shell (FIG. 10-1) is approximately 160 feet high, the height of a modern 16-story building. Numbered entrances led to the cavea, where the spectators sat according to their place in the social hierarchy. The relationship of the 76 gateways to the tiers of seats within was carefully thought out and resembles the systems seen in modern sports stadiums. The decor of the exterior, however, had nothing to do with function. The facade is divided into four bands, with large arched openings piercing the lower three. Ornamental Greek orders frame the arches in the standard Roman sequence for multistoried buildings: from the ground up, Tuscan, Ionic, and then Corinthian. This sequence is based on the proportions of the orders, with the Tuscan viewed as capable of supporting the heaviest load. Corinthian pilasters (and between them the brackets for the wooden poles that held up the velarium) circle the uppermost story.

The use of engaged columns and a lintel to frame the openings in the Colosseum's facade is a variation of the scheme seen on the Etruscan Porta Marzia (FIG. 9-14) at Perugia. The Romans commonly used this scheme from Late Republican times on. Like the pseudoperipteral temple, which is an eclectic mix of Greek orders and Etruscan plan, this manner of decorating a building's facade combined Greek orders with an architectural form foreign to Greek post-and-lintel architecture, namely the arch. The Roman practice of framing an arch with an applied Greek order had no structural purpose, but it added variety to the surface. It also unified a multistoried facade by casting a net of verticals and horizontals over it.

FLAVIAN PORTRAITURE Vespasian was an unpretentious career army officer who desired to distance himself from Nero's extravagant misrule. His portraits (FIG. 10-37) reflect his much simpler tastes. They also made an important political statement. Breaking with the tradition Augustus established of depicting the Roman emperor as an eternally youthful god on earth, Vespasian's sculptors resuscitated the veristic tradition of the Republic, possibly at his specific direction. Although not as brutally descriptive as many Republican likenesses, Vespasian's portraits frankly recorded his receding hairline and aging, leathery skin—proclaiming his traditional Republican values in contrast to Nero's.

Portraits of people of all ages survive from the Flavian period, in contrast to the Republic, when only elders were deemed worthy of depiction. A portrait bust (FIG. 10-38) of a young woman is a case in point. Its purpose was to project not Republican virtues but rather idealized beauty—through contemporary fashion rather than by reference to images of Greek goddesses. The portrait is notable for its elegance and delicacy and for the virtuoso way the sculptor rendered the differing textures of hair and flesh. The elaborate Flavian coiffure,

10-39 Arch of Titus, Rome, Italy, after 81 CE.

Domitian erected this arch on the road leading into the Roman Forum to honor his brother, the emperor Titus, who became a god after his death. Victories fill the spandrels of the arcuated passageway.

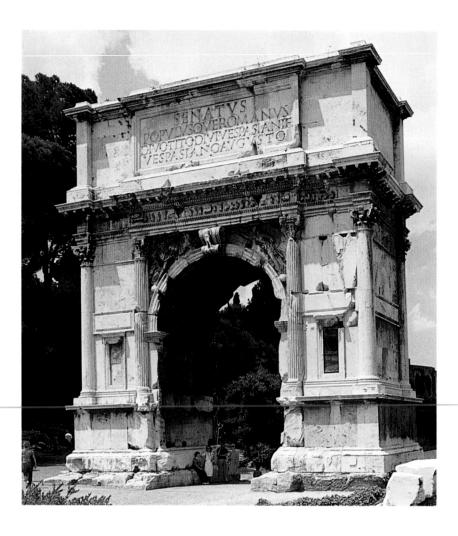

with its corkscrew curls punched out using a drill instead of a chisel, creates a dense mass of light and shadow set off boldly from the softly modeled and highly polished skin of the face and swanlike neck. The drill played an increasing role in Roman sculpture in succeeding periods and in time was used even for portraits of men, when much longer hair and full beards became fashionable.

ARCH OF TITUS When Titus died in 81 CE, only two years after becoming emperor, his younger brother, Domitian, succeeded him. Domitian erected an arch (FIGS. 10-2, no. 13, and 10-39) in Titus's honor on the Sacred Way leading into the Republican Forum Romanum (FIG. 10-2, no. 11). This type of arch, the so-called *triumphal arch*, has a long history in Roman art and architecture, beginning in the second century BCE. The term is something of a misnomer, however, because Roman arches celebrated more than just military victories. Freestanding arches, usually crowned by gilded-bronze statues, commemorated a wide variety of events, ranging from victories abroad to the building of roads and bridges at home.

The Arch of Titus is typical of the early triumphal arch and consists of one passageway only. As on the Colosseum, engaged columns frame the arcuated opening, but their capitals are the *Composite* type, an ornate combination of Ionic volutes and Corinthian acanthus leaves that became popular at about the same time as the Fourth Style in Roman painting. Reliefs depicting personified Victories (winged women, as in Greek art) fill the *spandrels* (the area between the arch's curve and the framing columns and entablature). A dedicatory inscription stating that the arch was erected to honor the god Titus, son of the god Vespasian, dominates the attic. Roman

emperors normally were proclaimed gods after they died, unless they ran afoul of the Senate and were damned. The statues of those who suffered *damnatio memoriae* were torn down, and their names were erased from public inscriptions. This was Nero's fate.

Inside the passageway of the Arch of Titus are two great relief panels. They represent the triumphal parade of Titus down the Sacred Way after his return from the conquest of Judaea at the end of the Jewish Wars in 70 CE. One of the reliefs (FIG. 10-40) depicts Roman soldiers carrying the spoils-including the sacred sevenbranched candelabrum, the menorah—from the Temple in Jerusalem. Despite considerable damage to the relief, the illusion of movement is convincing. The parade moves forward from the left background into the center foreground and disappears through the obliquely placed arch in the right background. The energy and swing of the column of soldiers suggest a rapid march. The sculptor rejected the Classical low-relief style of the Ara Pacis (FIG. 10-31) in favor of extremely deep carving, which produces strong shadows. The heads of the forward figures have broken off because they stood free from the block. Their high relief emphasized their different placement in space compared with the heads in low relief, which are intact. The play of light and shadow across the protruding foreground and receding background figures enhances the sense of movement.

The panel (FIG. 10-41) on the other side of the passageway shows Titus in his triumphal chariot. The seeming historical accuracy of the spoils panel—it closely corresponds to the Jewish historian Josephus's contemporaneous description of Titus's triumph—gave way in this panel to allegory. Victory rides with Titus in the four-horse chariot and places a wreath on his head. Below her is a

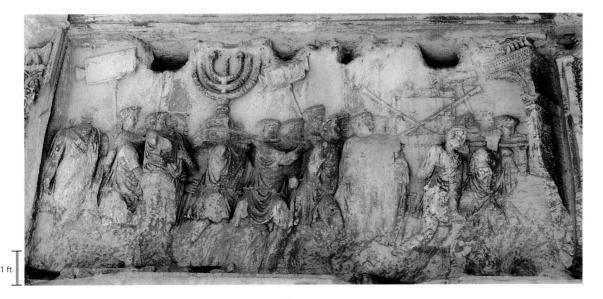

10-40 Spoils of Jerusalem, relief panel from the Arch of Titus, Rome, Italy, after 81 CE. Marble, 7' 10" high.

The reliefs inside the bay of the Arch of Titus commemorate the emperor's greatest achievement—the conquest of Judaea. Here, Roman soldiers carry the spoils from the Jewish temple in Jerusalem.

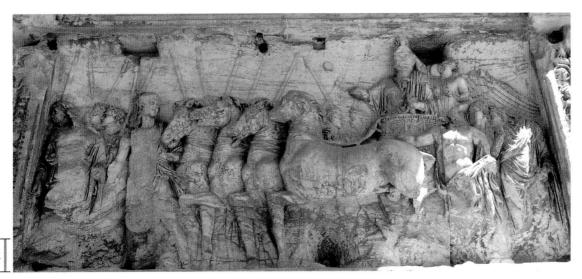

10-41 Triumph of Titus, relief panel from the Arch of Titus, Rome, Italy, after 81 CE. Marble, 7' 10" high.

Victory crowns Titus in his triumphal chariot. Also present are personifications of Honor and Valor in this first known instance of the intermingling of human and divine figures in a Roman historical relief.

bare-chested youth who is probably a personification of Honor (*Honos*). A female personification of Valor (*Virtus*) leads the horses. These allegorical figures transform the relief from a record of Titus's battlefield success into a celebration of imperial virtues. Such an intermingling of divine and human figures occurs on the Republican Villa of the Mysteries frieze (FIG. 10-18) at Pompeii, but the Arch of Titus panel is the first known instance of divine beings interacting with humans on an official Roman historical relief. (On the Ara Pacis, FIG. 10-29, Aeneas and "Tellus" appear in separate framed panels, carefully segregated from the procession of living Romans.) The Arch of Titus was erected after the emperor's death, and its reliefs were carved when Titus was already a god. Soon afterward, however, this kind of interaction between mortals and immortals became a staple of Roman narrative relief sculpture, even on monuments honoring a living emperor.

HIGH EMPIRE

In the second century CE, under Trajan, Hadrian, and the Antonines, the Roman Empire reached its greatest geographic extent (MAP 10-1) and the height of its power. Rome's might was unchallenged in the Mediterranean world, although the Germanic peoples in Europe, the Berbers in Africa, and the Parthians and Persians in the Near East

constantly applied pressure. Within the empire's secure boundaries, the Pax Romana meant unprecedented prosperity for all who came under Roman rule.

Trajan

Domitian's extravagant lifestyle and ego resembled Nero's. He demanded to be addressed as dominus et deus (lord and god) and so angered the senators that he was assassinated in 96 CE. The Senate chose the elderly Nerva, one of its own, as emperor. Nerva ruled for only 16 months, but before he died he established a pattern of succession by adoption that lasted for almost a century. Nerva picked Trajan, a capable and popular general born in Italica (Spain), as the next emperor. Trajan was the first non-Italian to rule Rome. Under Trajan, imperial armies brought Roman rule to ever more distant areas (MAP 10-1), and the imperial government took on ever greater responsibility for its people's welfare by instituting a number of farsighted social programs. Trajan was so popular that the Senate granted him the title Optimus (the Best), an epithet he shared with Jupiter (who was said to have instructed Nerva to choose Trajan as his successor). In Late Antiquity, Augustus, the founder of the Roman Empire, and Trajan became the yardsticks for success. The goal of new emperors was to be felicior Augusto, melior Traiano (luckier than Augustus, better than Trajan).

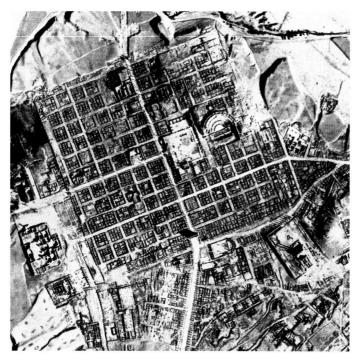

10-42 Aerial view of Timgad (Thamugadi), Algeria, founded 100 CE.

Timgad, like other new Roman colonies, was planned with great precision. Its strict grid scheme features two main thoroughfares, the cardo and the decumanus, with the forum at their intersection.

TIMGAD In 100 CE, Trajan founded a new colony for army veterans at Timgad, ancient Thamugadi (FIG. **10-42**), in what is today Algeria. Like other colonies, Timgad became the physical embodiment of Roman authority and civilization for the local population and served as a key to the Romanization of the provinces. The town

was planned with great precision, its design resembling that of a Roman military encampment or *castrum*. (Scholars still debate which came first. The castrum may have been based on the layout of Roman colonies.) Unlike the sprawling unplanned cities of Rome and Pompeii, Timgad is a square divided into equal quarters by its two main streets, the cardo and the decumanus. They cross at right angles and are bordered by colonnades. Monumental gates once marked the ends of the two avenues. The forum is located at the point where the streets intersect. The quarters are subdivided into square blocks, and the forum and public buildings, such as the theater and baths, occupy areas sized as multiples of these blocks. The Roman plan is a modification of the Hippodamian plan of Greek cities (FIG. 5-76), though more rigidly ordered.

The fact that most of these colonial settlements were laid out in the same manner, regardless of whether they were in North Africa, Mesopotamia, or England, expresses concretely the unity and centralized power of the Roman Empire at its height. But even the Romans could not regulate human behavior completely. As the aerial view reveals, when the population of Timgad grew sevenfold and burst through the Trajanic colony's walls, rational planning was ignored, and the city and its streets branched out haphazardly.

FORUM OF TRAJAN Trajan completed several major building projects in Rome, including the remodeling of the Circus Maximus (FIG. 10-2, no. 2), Rome's giant chariot-racing stadium, and the construction of a vast new bathing complex near the Colosseum constructed on top of Nero's Golden House. His most important undertaking, however, was a huge new forum (FIGS. 10-2, no. 7, and 10-43), roughly twice the size of the century-old Forum of Augustus (FIG. 10-2, no. 10)—even excluding the enormous market complex next to the forum. The new forum glorified Trajan's victories in his two wars against the Dacians (who lived in what is now Romania) and was paid for with the spoils of those campaigns. The archi-

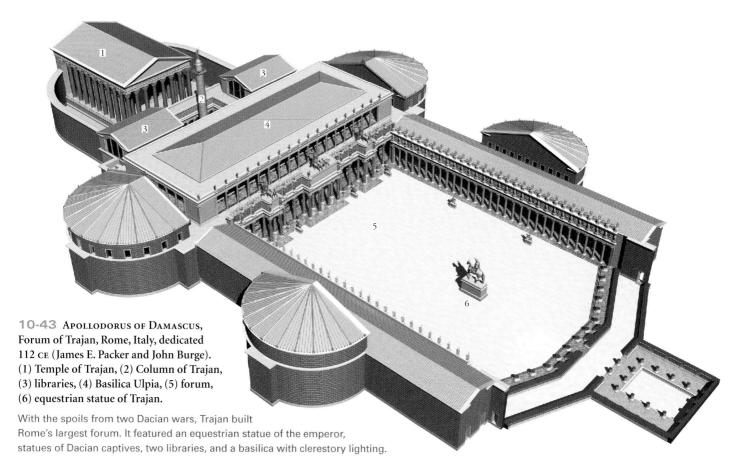

tect was Apollodorus of Damascus, Trajan's chief military engineer during the Dacian Wars. Apollodorus's plan incorporated the main features of most early forums (FIG. 10-12), except that a huge basilica, not a temple, dominated the colonnaded open square. The temple (completed after the emperor's death and dedicated to the newest god in the Roman pantheon, Trajan himself) was set instead behind the basilica. It stood at the rear end of the forum in its own courtyard, with two libraries and a giant commemorative column, the Column of Trajan (FIGS. 10-43, no. 2, and 10-44).

Entry to Trajan's forum was through an impressive gateway resembling a triumphal arch. Inside the forum were other reminders of Trajan's military prowess. A larger-than-life-size gilded-bronze equestrian statue of the emperor stood at the center of the great court in front of the basilica. Statues of captive Dacians stood above the columns of the forum porticos.

The Basilica Ulpia (Trajan's family name was Ulpius) was a much larger and far more ornate version of the basilica in the forum of Pompeii (FIG. 10-12, no. 3). As shown in FIG. 10-43, no. 4, it had *apses*, or semicircular recesses, on each short end. Two aisles flanked the nave on each side. In contrast to the Pompeian basilica, the entrances were on the long side facing the forum. The building was vast: about 400 feet long (without the apses) and 200 feet wide. Light entered through clerestory windows, made possible by elevating the timber-roofed nave above the colonnaded aisles. In the Republican basilica at Pompeii, light reached the nave only indirectly through aisle windows. The clerestory (used millennia before at Karnak in Egypt, FIG. 3-26) provided much better illumination.

COLUMN OF TRAJAN The Column of Trajan (FIG. 10-44) was probably also the brainchild of Apollodorus of Damascus. The idea of covering the shaft of a colossal freestanding column with a continuous spiral narrative frieze seems to have been invented for this monument, but it was often copied in antiquity, the Middle Ages (FIG. 16-25), and as late as the 19th century. Trajan's column is 128 feet high. It once featured a heroically nude statue of the emperor at the top. (The present statue of Saint Peter dates to the 16th century.) The tall pedestal, decorated with captured Dacian arms and armor, served as Trajan's tomb.

Scholars have likened the 625-foot band that winds around the column to an illustrated scroll of the type housed in the neighboring libraries (and that Lars Pulena holds on his sarcophagus, FIG. 9-15). The reliefs depict Trajan's two successful campaigns against the Dacians. The story unfolds in more than 150 episodes in which some 2,500 figures appear. The band increases in width as it winds to the top of the column, so that it is easier to see the upper portions. Throughout, the relief is very low so as not to distort the contours of the shaft. Paint enhanced the legibility of the figures, but a viewer still would have had difficulty following the narrative from beginning to end.

Much of the spiral frieze is given over to easily recognizable compositions such as those found on coin reverses and on historical relief panels: Trajan addressing his troops, sacrificing to the gods, and so on. The narrative is not a reliable chronological account of the Dacian Wars, as was once thought. The sculptors nonetheless accurately recorded the general character of the campaigns. Notably, battle scenes take up only about a quarter of the frieze. As is true of modern military operations, the Romans spent more time constructing forts, transporting men and equipment, and preparing for battle than fighting. The focus is always on the emperor, who appears throughout the frieze, but the enemy is not belittled. The Romans won because of their superior organization and more powerful army, not because they were inherently superior beings.

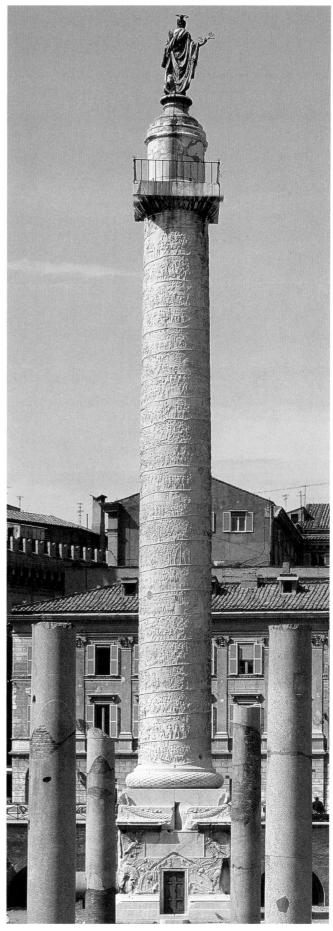

10-44 Column of Trajan, Forum of Trajan, Rome, Italy, dedicated 112 CE.

The spiral frieze of Trajan's column tells the story of the Dacian Wars in 150 episodes. All aspects of the campaigns were represented, from battles to sacrifices to road and fort construction.

10-45 APOLLODORUS OF DAMASCUS, aerial view of the Markets of Trajan, Rome, Italy, ca. 100–112 ce.

Apollodorus of Damascus used brick-faced concrete to transform the Quirinal Hill overlooking Trajan's forum in Rome into a vast multilevel complex of barrel-vaulted shops and administrative offices.

MARKETS OF TRAJAN On the Quirinal Hill overlooking the forum, Apollodorus built the Markets of Trajan (FIGS. 10-2, no. 8, and 10-45) to house both shops and administrative offices. As earlier at Palestrina (FIG. 10-5), concrete made possible the transformation of a natural slope into a multilevel complex. Trajan's architect was a master of this modern medium as well as of the traditional stone-and-timber post-and-lintel architecture of the forum below. The basic unit was the taberna, a single-room shop covered by a barrel vault. Each taberna had a wide doorway, usually with a window above it that allowed light to enter a wooden inner attic used for storage. The shops were on several levels. They opened either onto a hemispherical facade winding around one of the great exedras of Trajan's forum, onto a paved street farther up the hill, or onto a great in-

door market hall (FIG. 10-46) resembling a modern shopping mall. The hall housed two floors of shops, with the upper shops set back on each side and lit by skylights. Light from the same sources reached the ground-floor shops through arches beneath the great umbrella-like groin vaults (FIG. 10-6c) covering the hall.

ARCH OF TRAJAN, BENEVENTO In 109 CE, Trajan opened a new road, the Via Traiana, in southern Italy. Several years later the Senate erected a great arch (FIG. 10-47) honoring Trajan at the point where the road entered Benevento (ancient Beneventum). Architecturally, the Arch of Trajan at Benevento is almost identical

to Titus's arch (FIG. 10-39) in Rome, but relief panels cover both facades of the Trajanic arch, giving it a billboardlike function. Every inch of the surface heralded the emperor's achievements. In one panel, he enters Rome after a successful military campaign. In another, he distributes largesse to needy children. In still others, he is portrayed as the founder of colonies for army veterans and as the builder of a new port at Ostia, Rome's harbor at the mouth of the Tiber. The reliefs present Trajan as the guarantor of peace and security in the empire, the benefactor of the poor, and the patron of soldiers and merchants alike. In short, the emperor is all things to all people. In several of the panels, Trajan freely intermingles with

10-46 APOLLODORUS OF DAMASCUS, interior of the great hall, Markets of Trajan, Rome, Italy, ca. 100-112 CE.

The great hall of Trajan's markets resembles a modern shopping mall. It housed two floors of shops, with the upper ones set back and lit by skylights. Concrete groin vaults cover the central space.

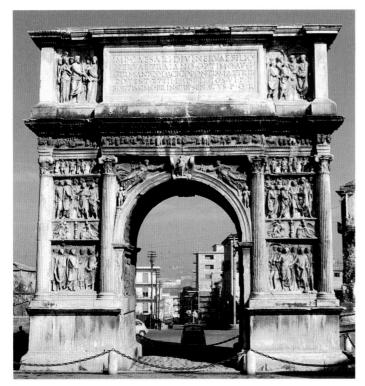

10-47 Arch of Trajan, Benevento, Italy, ca. 114-118 CE.

Unlike Titus's arch (Fig. 10-39), Trajan's has relief panels covering both facades, transforming it into a kind of advertising billboard featuring the emperor's many achievements on and off the battlefield.

divinities, and on the arch's attic (which may have been completed after his death and deification), Jupiter hands his thunderbolt to the emperor, awarding him dominion over Earth. Such scenes, depicting the "first citizen" of Rome as a divinely sanctioned ruler in the company of the gods, henceforth became the norm, not the exception, in official Roman art.

Hadrian

Hadrian, Trajan's chosen successor and fellow Spaniard, was a connoisseur and lover of all the arts as well as an author and architect. He greatly admired Greek culture and traveled widely as emperor, often in the Greek East. Everywhere he went, statues and arches were set up in his honor.

HADRIANIC PORTRAITURE More portraits of Hadrian exist today than of any other emperor except Augustus. Hadrian, who was 41 years old at the time of Trajan's death and who ruled for more than two decades, is always depicted in his portraits as a mature adult who never ages. Hadrian's portraits (FIG. 10-48) more closely resemble Kresilas's portrait of Pericles (FIG. 5-41) than those of any Roman emperor before him. Fifth-century BCE statues also provided the prototypes for the idealizing official portraits of Augustus, but the Augustan models were Greek images of young athletes. The models for Hadrian's artists were Classical statues of mature Greek men. Hadrian himself wore a beard—a habit that, in its Roman context, must be viewed as a Greek affectation. Beards then became the norm for all subsequent Roman emperors for more than a century and a half.

PANTHEON Soon after Hadrian became emperor, work began on the Pantheon (FIGS. 10-2, no. 5, and 10-49), the temple of all the gods, one of the best-preserved buildings of antiquity and most

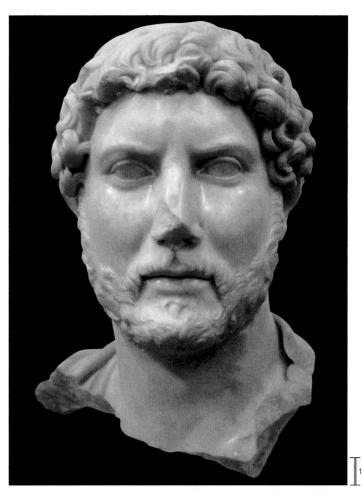

10-48 Portrait bust of Hadrian, from Rome, ca. 117–120 CE. Marble, 1' $4\frac{3}{4}$ " high. Museo Nazionale Romano–Palazzo Massimo alle Terme, Rome.

Hadrian, a lover of all things Greek, was the first Roman emperor to wear a beard. His artists modeled his idealizing official portraits on Classical Greek statues like Kresilas's Pericles (FIG. 5-41).

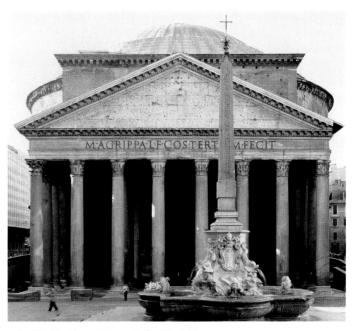

10-49 Pantheon, Rome, Italy, 118-125 CE.

Originally, the approach to Hadrian's "temple of all gods" in Rome was from a columnar courtyard. Like a temple in a Roman forum (FIG. 10-12), the Pantheon stood at one narrow end of the enclosure.

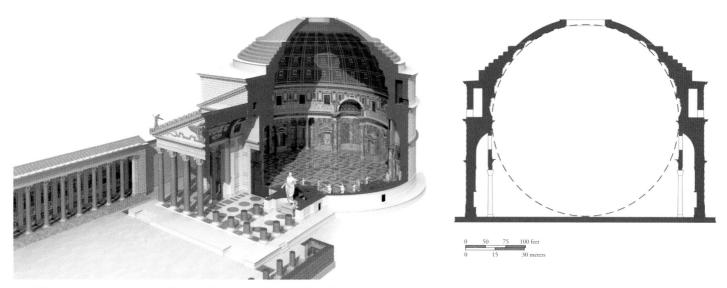

10-50 Restored cutaway view (left) and lateral section (right) of the Pantheon, Rome, Italy, 118–125 ce (John Burge).

The Pantheon's traditional facade masked its revolutionary cylindrical drum and its huge hemispherical dome. The interior symbolized both the orb of the earth and the vault of the heavens.

influential designs in architectural history. The Pantheon reveals the full potential of concrete, both as a building material and as a means for shaping architectural space. Originally, visitors approached the Pantheon from a columnar courtyard, and the temple itself, like temples in Roman forums, stood at one narrow end of the enclosure (FIG. 10-50, *left*). Its facade of eight Corinthian columns—almost all that could be seen from ground level in antiquity—was a bow to tradition. Everything else about the Pantheon was revolutionary. Behind the columnar porch is an immense concrete cylinder covered by a huge hemispherical dome 142 feet in diameter. The dome's top is also 142 feet from the floor (FIG. 10-50, *right*). The design is thus based on the intersection of two circles (one horizontal, the other vertical) so that the interior space can be imagined as the orb of the earth and the dome as the vault of the heavens.

If the Pantheon's design is simplicity itself, executing that design required all the ingenuity of Hadrian's engineers. They built up the cylindrical drum level by level using concrete of varied composition. Extremely hard and durable basalt went into the mix for the foundations, and the builders gradually modified the "recipe" until, at the top, featherweight pumice replaced stones to lighten the load. The dome's thickness also decreases as it nears the oculus, the circular opening 30 feet in diameter that is the only light source for the interior (FIG. 10-51). The use of *coffers* (sunken decorative panels) lessened the dome's weight without weakening its structure. The coffers further reduced the dome's mass and also provided a handsome pattern of squares within the vast circle. Renaissance drawings suggest that each coffer once had a glistening gilded-bronze rosette at its center, enhancing the symbolism of the dome as the starry heavens.

Below the dome, much of the original marble veneer of the walls, niches, and floor has survived. In the Pantheon, visitors can get a sense, as almost nowhere else, of how magnificent the interiors of Roman concrete buildings could be. But despite the luxurious skin of the Pantheon's interior, the sense experienced on first entering the structure is not the weight of the enclosing walls but the space they enclose. In pre-Roman architecture, the form of the enclosed space was determined by the placement of the solids, which did not so much shape space as interrupt it. Roman architects were the first to conceive of architecture in terms of units of space that could be

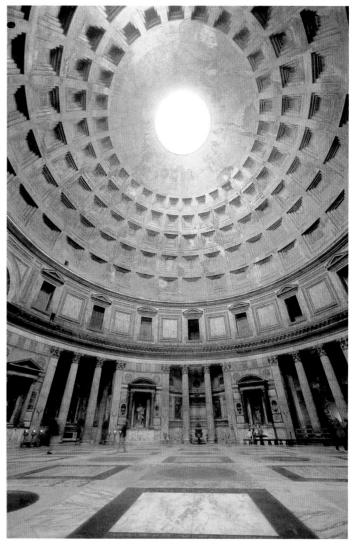

10-51 Interior of the Pantheon, Rome, Italy, 118-125 CE.

The coffered dome of the Pantheon is 142 feet in diameter and 142 feet high. The light entering through its oculus forms a circular beam that moves across the dome as the sun moves across the sky.

Hadrian and Apollodorus of Damascus

io Cassius, a third-century CE senator who wrote a history of Rome from its foundation to his own day, recounted a revealing anecdote about Hadrian and Apollodorus of Damascus, architect of the Forum of Trajan (FIG. 10-43):

Hadrian first drove into exile and then put to death the architect Apollodorus who had carried out several of Trajan's building projects.... When Trajan was at one time consulting with Apollodorus about a certain problem connected with his buildings, the architect said to Hadrian, who had interrupted them with some advice, "Go away and draw your pumpkins. You know nothing about these problems." For it so happened that Hadrian was at that time priding himself on some sort of drawing. When he became emperor he remembered this insult and refused to put up with Apollodorus's outspokenness. He sent him [his own] plan for the temple of Venus and Roma [FIG. 10-2, no. 14], in order to demonstrate that it was possible for a great work to be conceived without his [Apollodorus's]

help, and asked him if he thought the building was well designed. Apollodorus sent a [very critical] reply.... [The emperor did not] attempt to restrain his anger or hide his pain; on the contrary, he had the man slain.*

The story says a great deal both about the absolute power Roman emperors wielded and about how seriously Hadrian took his architectural designs. But perhaps the most interesting detail is the description of Hadrian's drawings of "pumpkins." These must have been drawings of concrete domes like the one in the Serapeum (FIG. 10-52) at Hadrian's Tivoli villa. Such vaults were too adventurous for Apollodorus, or at least for a public building in Trajanic Rome, and Hadrian had to try them out later at home at his own expense.

*Dio Cassius, Roman History, 69.4.1–5. Translated by J. J. Pollitt, *The Art of Rome, c. 753 B.C.–A.D. 337: Sources and Documents* (New York: Cambridge University Press, 1983), 175–176.

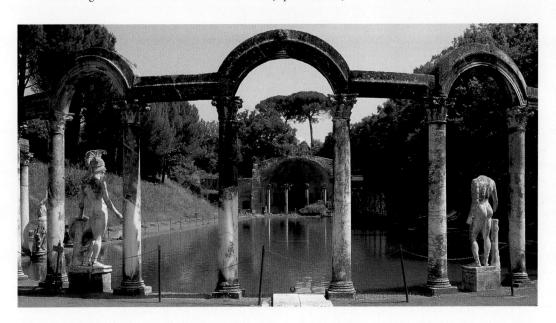

10-52 Canopus and Serapeum, Hadrian's Villa, Tivoli, Italy, ca. 125–128 CE.

Hadrian was an architect and may have personally designed some buildings at his private villa at Tivoli. The Serapeum features the kind of pumpkin-shaped concrete dome the emperor favored.

shaped by the enclosures. The Pantheon's interior is a single unified, self-sufficient whole, uninterrupted by supporting solids. It encloses visitors without imprisoning them, opening through the oculus to the drifting clouds, the blue sky, the sun, and the gods. In this space, the architect used light not merely to illuminate the darkness but to create drama and underscore the interior shape's symbolism. On a sunny day, the light that passes through the oculus forms a circular beam, a disk of light that moves across the coffered dome in the course of the day as the sun moves across the sky itself. Escaping from the noise and torrid heat of a Roman summer day into the Pantheon's cool, calm, and mystical immensity is an experience almost impossible to describe and one that should not be missed.

HADRIAN'S VILLA, TIVOLI Hadrian, the amateur architect, was not the designer of the Pantheon, but the emperor was deeply involved with the construction of his private country villa at Tivoli. One of his projects there was the construction of a pool and

an artificial grotto, called the Canopus and Serapeum (FIG. 10-52), respectively. Canopus was an Egyptian city connected to Alexandria by a canal. Its most famous temple was dedicated to the god Serapis. Nothing about the Tivoli design, however, derives from Egyptian architecture. The grotto at the end of the pool is made of concrete and has an unusual pumpkin-shaped dome that Hadrian probably designed himself (see "Hadrian and Apollodorus of Damascus," above). Yet, in keeping with the persistent eclecticism of Roman art and architecture, Greek columns and marble copies of famous Greek statues lined the pool, as would be expected from a lover of Greek art. The Corinthian colonnade at the curved end of the pool, however, is of a type unknown in Classical Greek architecture. The colonnade not only lacks a superstructure but has arcuated (curved or arched) lintels, as opposed to traditional Greek horizontal lintels, between alternating pairs of columns. This simultaneous respect for Greek architecture and willingness to break its rules are typical of much Roman architecture of the High and Late Empire.

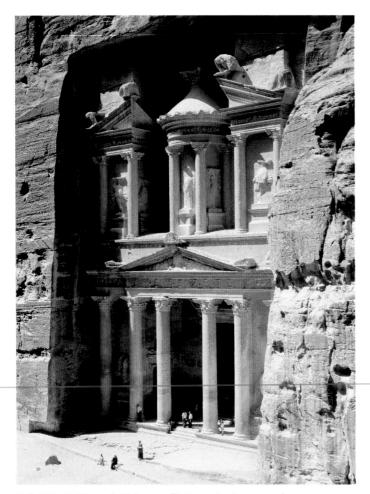

10-53 Al-Khazneh ("Treasury"), Petra, Jordan, second century CE.

This rock-cut tomb facade is a prime example of Roman "baroque" architecture. The designer used Greek architectural elements in a purely ornamental fashion and with a studied disregard for Classical rules.

AL-KHAZNEH, PETRA An even more extreme example of what many scholars have called Roman "baroque" architecture (because of the striking parallels with 17th-century Italian buildings; see Chapter 24) is the second-century CE tomb nicknamed Al-Khazneh, the "Treasury" (FIG. 10-53), at Petra, Jordan. It is one of the most elaborate of many tomb facades cut into the sheer rock faces of the local rose-colored mountains. As at Hadrian's villa, Greek architectural elements are used here in a purely ornamental fashion and with a studied disregard for Classical rules.

10-54 Model of an insula, Ostia, Italy, second century ce. Museo della Civiltà Romana, Rome.

Rome and Ostia were densely populated cities, and most Romans lived in multistory brick-faced concrete insulae (apartment houses) with shops on the ground floor. Private toilet facilities were rare.

Ostia

The average Roman, of course, did not own a luxurious country villa and was not buried in a grand tomb. About 90 percent of Rome's population of close to one million lived in multistory apartment blocks (*insulae*). After the great fire of 64 CE, these were brick-faced concrete buildings. The rents were not cheap, as the law of supply and demand in real estate was just as valid in antiquity as it is today. Juvenal, a Roman satirist of the early second century CE, commented that people willing to give up chariot races and the other diversions Rome had to offer could purchase a fine home in the countryside "for a year's rent in a dark hovel" in a city so noisy that "the sick die mostly from lack of sleep." Conditions were much the same for the inhabitants of Ostia, Rome's harbor city. After its new port opened under Trajan, Ostia's prosperity increased dramatically and so did its population. A burst of building activity began under Trajan and continued under Hadrian and throughout the second century CE.

APARTMENT HOUSES Ostia had many multistory insulae (FIG. 10-54). Shops occupied the ground floors. Above were up to four floors of apartments. Although many of these were large, they had neither the space nor the light of the typical Pompeian private domus (see "The Roman House," page 247). In place of peristyles, insulae had only narrow light wells or small courtyards. Consequently, instead of looking inward, large numbers of glass windows faced the city's noisy streets. The residents cooked their food in the hallways. Only deluxe apartments had private toilets. Others shared latrines, often on a different floor from the apartment. Still, these insulae were quite similar to modern apartment houses, which also sometimes have shops on the ground floor.

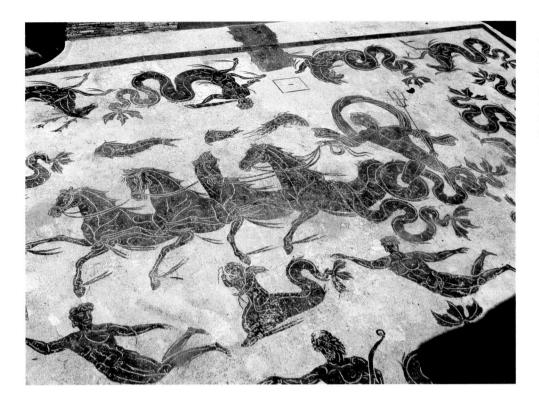

10-55 Neptune and creatures of the sea, detail of a floor mosaic in the Baths of Neptune, Ostia, Italy, ca. 140 CE.

Black-and-white floor mosaics were very popular during the second and third centuries. The artists conceived them as surface decorations, not as illusionistic compositions meant to rival paintings.

Another strikingly modern feature of these multifamily residences is their brick facades, which were not concealed by stucco or marble veneers. When a classical motif was desired, builders could add brick pilasters or engaged columns, but always left the brick exposed. Ostia and Rome have many examples of apartment houses, warehouses, and tombs with intricate moldings and contrasting colors of brick. In the second century CE, brick came to be appreciated as attractive in its own right.

BATHS OF NEPTUNE Although the decoration of Ostian insulae tended to be more modest than that of the private houses of Pompeii, the finer apartments had mosaic floors and painted walls and ceilings. The most popular choice for elegant pavements at Ostia in both private and public edifices was the black-and-white mosaic. One of the largest and best-preserved examples is in the so-called Baths of Neptune, named for the grand mosaic floor (FIG. 10-55) showing four seahorses pulling the Roman god of the sea across the waves. Neptune needs no chariot to support him as he speeds along, his mantle blowing in the strong wind. All about the god are other sea denizens, positioned so that wherever a visitor enters the room, some figures appear right side up. The second-century artist rejected the complex polychrome modeling of figures seen in Pompeian mosaics such as Battle of Issus (FIG. 5-70) and used simple black silhouettes enlivened by white interior lines. Roman artists conceived black-andwhite mosaics as surface decorations, not as three-dimensional windows, and thus they were especially appropriate for floors.

ISOLA SACRA The tombs in Ostia's Isola Sacra cemetery were usually constructed of brick-faced concrete, and the facades of these houses of the dead resembled those of the contemporary insulae of the living. These were normally communal tombs, not the final resting places of the very wealthy. Many of them were adorned with small painted terracotta plaques immortalizing the activities of middle-class merchants and professional people. A characteristic example (FIG. 10-56) depicts a vegetable seller behind a counter. The artist had little interest in the Classical-revival style of contemporary imperial art and tilted the counter forward so that the observer can see the produce clearly. Such scenes of daily life appear on Roman

funerary reliefs all over Europe. They were as much a part of the artistic legacy to the later history of Western art as the monuments of the Roman emperors, which until recently were the exclusive interest of art historians.

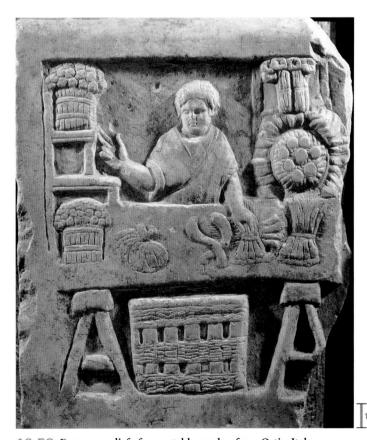

10-56 Funerary relief of a vegetable vendor, from Ostia, Italy, second half of second century ce. Painted terracotta, 1' 5" high. Museo Ostiense, Ostia.

Terracotta plaques illustrating the activities of middle-class merchants frequently adorned Ostian tomb facades. In this relief of a vegetable seller, the artist tilted the counter to display the produce clearly.

The Antonines

Early in 138 CE, Hadrian adopted the 51-year-old Antoninus Pius (r. 138–161 CE). At the same time, he required that Antoninus adopt Marcus Aurelius (r. 161–180 CE) and Lucius Verus (r. 161–169 CE), thereby assuring a peaceful succession for at least another generation. When Hadrian died later in the year, the Senate proclaimed him a god, and Antoninus Pius became emperor. Antoninus ruled the Roman world with distinction for 23 years. After his death and deification, Marcus Aurelius and Lucius Verus became the Roman Empire's first co-emperors.

COLUMN OF ANTONINUS PIUS Shortly after Antoninus Pius's death, Marcus and Lucius erected a memorial column in his

honor. Its pedestal has a dedicatory inscription on one side and a relief illustrating the *apotheosis* (FIG. 10-57), or ascent to Heaven, of Antoninus and his wife Faustina the Elder on the opposite side. On the adjacent sides are two identical representations of the *decursio* (FIG. 10-58), or ritual circling of the imperial funerary pyre.

The two figural compositions are very different. The apotheosis relief remains firmly in the Classical tradition with its elegant, well-proportioned figures, personifications, and single ground line corresponding to the panel's lower edge. The Campus Martius (Field of Mars), personified as a youth holding the Egyptian obelisk that stood in that area of Rome, reclines at the lower left corner. Roma (Rome personified) leans on a shield decorated with the she-wolf suckling Romulus and Remus (compare FIG. 9-11). Roma bids

10-57 Apotheosis of Antoninus Pius and Faustina, pedestal of the Column of Antoninus Pius, Rome, Italy, ca. 161 CE. Marble, 8' $1\frac{1}{2}$ " high. Musei Vaticani, Rome.

This representation of the apotheosis (ascent to Heaven) of Antoninus Pius and Faustina is firmly in the Classical tradition with its elegant, well-proportioned figures, personifications, and single ground line.

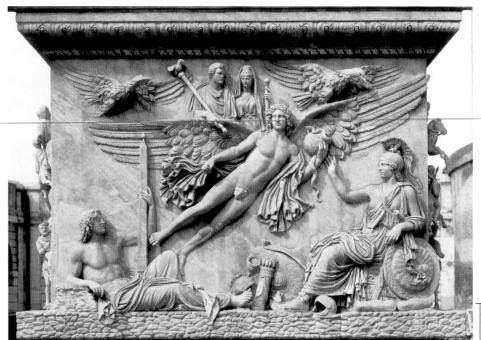

1 ft.

10-58 Decursio, pedestal of the Column of Antoninus Pius, Rome, Italy, ca. 161 CE. Marble, 8' $1\frac{1}{2}$ " high. Musei Vaticani, Rome.

In contrast to FIG. 10-57, the Antonine decursio reliefs break sharply with Classical art conventions. The ground is the whole surface of the relief, and the figures stand on floating patches of earth.

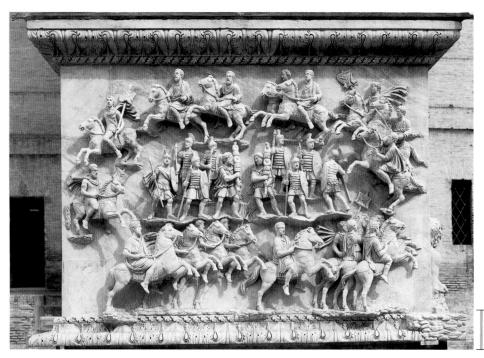

1 ft

farewell to the couple being lifted into the realm of the gods on the wings of a personification of uncertain identity. All this was familiar from earlier scenes of apotheosis. New to the imperial repertoire, however, was the fusion of time the joint apotheosis represents. Faustina had died 20 years before Antoninus Pius. By depicting the two as ascending together, the artist wished to suggest that Antoninus had been faithful to his wife for two decades and that now they would be reunited in the afterlife.

The decursio reliefs (FIG. 10-58) break even more strongly with Classical convention. The figures are much stockier than those in the apotheosis relief, and the panel was not conceived as a window onto the world. The ground is the whole surface of the relief, and marching soldiers and galloping horses alike stand on floating patches of earth. This, too, had not occurred before in imperial art, only in plebeian art (FIG. 10-10). After centuries of following the rules of Classical design, elite Roman artists and patrons finally became dissatisfied with them. When seeking a new direction, they adopted some of the non-Classical conventions of the art of the lower classes.

MARCUS AURELIUS Another break with the past occurred in the official portraits of Marcus Aurelius, although his images retain the pompous trappings of imperial iconography. In a largerthan-life-size gilded-bronze equestrian statue (FIG. 10-59), the emperor possesses a superhuman grandeur and is much larger than any normal human would be in relation to his horse. Marcus stretches out his right arm in a gesture that is both a greeting and an offer of clemency. Some evidence suggests that beneath the horse's raised right foreleg an enemy once cowered, begging the emperor for mercy. Marcus's portrait owed its preservation throughout the Middle Ages to the fact that it was mistakenly thought to portray Constantine, the first Christian emperor of Rome. Most ancient bronze statues were melted down for their metal value, because Christians regarded them as impious images from the pagan world. Even today, after centuries of new finds, only a few bronze equestrian statues survive. The type was, however, often used for imperial portraits—an equestrian statue of Trajan stood in the middle of his forum (FIG. 10-43, no. 6). Perhaps more than any other statuary type, the equestrian portrait expresses the Roman emperor's majesty and authority.

This message of supreme confidence is not conveyed, however, by the portrait head of Marcus's equestrian statue or any of the other portraits of the emperor in the years just before his death. Portraits of aged emperors were not new (FIG. 10-37), but Marcus's were the first ones in which a Roman emperor appeared weary, saddened, and even worried. For the first time, the strain of constant warfare on the frontiers and the burden of ruling a worldwide empire show in the emperor's face. The Antonine sculptor ventured beyond Republican verism, exposing the ruler's character, his thoughts, and his soul for all to see, as Marcus revealed them himself in his Meditations, a deeply moving philosophical treatise setting forth the emperor's personal worldview. This was a major turning point in the history of ancient art, and, coming as it did when the Classical style was being challenged in relief sculpture (FIG. 10-58), it marked the beginning of the end of Classical art's domination in the Greco-Roman world.

ORESTES SARCOPHAGUS Other profound changes also were taking place in Roman art and society at this time. Beginning under Trajan and Hadrian and especially during the rule of the Antonines, Romans began to favor burial over cremation. This reversal of funerary practices may reflect the influence of Christianity and

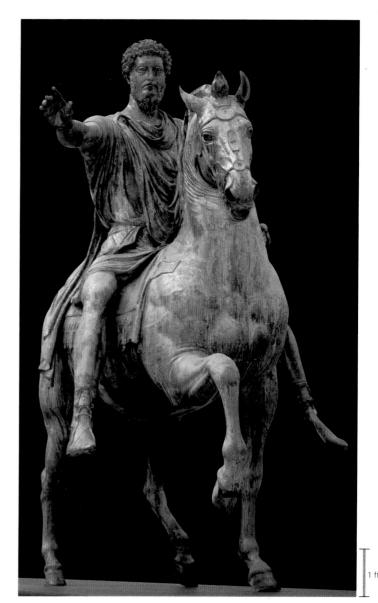

10-59 Equestrian statue of Marcus Aurelius, from Rome, Italy, ca. 175 CE. Bronze, 11' 6" high. Musei Capitolini, Rome.

In this equestrian portrait of Marcus Aurelius as omnipotent conqueror, the emperor stretches out his arm in a gesture of clemency. An enemy once cowered beneath the horse's raised foreleg.

other Eastern religions, whose adherents believed in an afterlife for the human body. Although the emperors themselves continued to be cremated in the traditional Roman manner, many private citizens opted for burial. Thus they required larger containers for their remains than the ash urns that were the norm until the second century CE. This in turn led to a sudden demand for sarcophagi, which are more similar to modern coffins than are any other ancient type of burial container.

Greek mythology was one of the most popular subjects for the decoration of these sarcophagi. In many cases, especially in the late second and third centuries CE, the Greek heroes and heroines were given the portrait features of the Roman men and women interred in the marble coffins. These private patrons were following the model of imperial portraiture, where emperors and empresses frequently masqueraded as gods and goddesses and heroes and heroines (see "Role Playing in Roman Portraiture," page 254). An early example of the type (although it lacks any portraits) is the sarcophagus

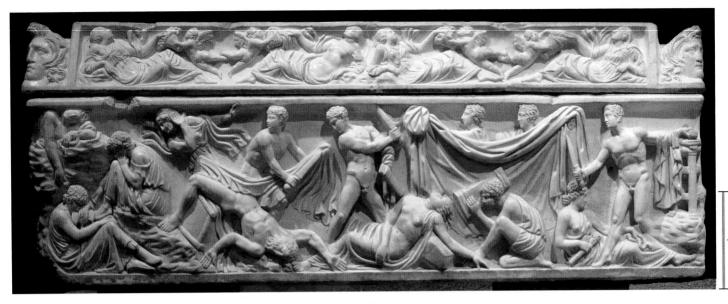

10-60 Sarcophagus with the myth of Orestes, ca. 140-150 CE. Marble, 2' 7½" high. Cleveland Museum of Art, Cleveland.

Under the Antonines, Romans began to favor burial over cremation, and sarcophagi became very popular. Themes from Greek mythology, such as the tragic saga of Orestes, were common subjects.

(FIG. 10-60) now in Cleveland, one of many decorated with the story of the tragic Greek hero Orestes. All the examples of this type use the same basic composition. Orestes appears more than once in every case. Here, at the center, Orestes slays his mother Clytaemnestra and her lover Aegisthus to avenge their murder of his father Agamemnon, and then, at the right, takes refuge at Apollo's sanctuary at Delphi (symbolized by the god's tripod).

The repetition of sarcophagus compositions indicates that sculptors had access to pattern books. In fact, sarcophagus production was a major industry during the High and Late Empire. Several important regional manufacturing centers existed. The sarcophagi produced in the Latin West, such as the Cleveland Orestes sarcophagus, differ in for-

mat from those made in the Greek-speaking East. Western sarcophagi have reliefs only on the front and sides, because they were placed in floor-level niches inside Roman tombs. Eastern sarcophagi have reliefs on all four sides and stood in the center of the burial chamber. This contrast parallels the essential difference between Etrusco-Roman and Greek temples. The former were set against the wall of a forum or sanctuary and approached from the front, whereas the latter could be reached (and viewed) from every side.

MELFI SARCOPHAGUS An elaborate example (FIG. 10-61) of a sarcophagus of the Eastern type comes from Rapolla, near Melfi in southern Italy. It was manufactured, however, in Asia Minor and

10-61 Asiatic sarcophagus with kline portrait of a woman, from Rapolla, near Melfi, Italy, ca. 165–170 ce. Marble, 5' 7" high. Museo Nazionale Archeologico del Melfese, Melfi.

Sarcophagi were produced in several regional centers. Western sarcophagi were decorated only on the front. Eastern sarcophagi, such as this one with a woman's portrait on the lid, have reliefs on all four sides.

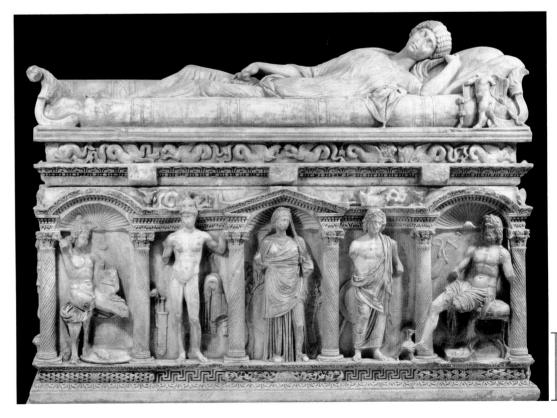

1 ft

laia of Cyzicus and the Art of Encaustic Painting

The names of very few Roman artists are known. Those that are tend to be names of artists and architects who directed major imperial building projects (Severus and Celer, Domus Aurea; Apollodorus of Damascus, Forum of Trajan), worked on a gigantic scale (Zenodorus, Colossus of Nero), or made precious objects for famous patrons (Dioscurides, gem cutter for Augustus).

An interesting exception to this rule is Iaia of Cyzicus. Pliny the Elder reported the following about this renowned painter from Asia Minor who worked in Italy during the Republic:

Iaia of Cyzicus, who remained a virgin all her life, painted at Rome during the time when M. Varro [116–27 BCE; a renowned Republican scholar and author] was a youth, both with a brush and with a cestrum on ivory, specializing mainly in portraits of women; she also painted a large panel in Naples representing an old woman and a portrait of herself done with a mirror. Her hand was quicker than that of any other painter, and her artistry was of such high quality that she commanded much higher prices than the most celebrated painters of the same period.*

The *cestrum* Pliny mentioned is a small spatula used in *encaustic* painting, a technique of mixing colors with hot wax and then applying them to the surface. Pliny knew of encaustic paintings of considerable antiquity, including those of Polygnotos of Thasos (see Chapter 5, page 135). The best evidence for the technique, however, comes from Roman Egypt, where mummies were routinely furnished with portraits painted with encaustic on wooden panels (FIG. **10-62**).

Artists applied encaustic to marble as well as to wood. According to Pliny, when Praxiteles was asked which of his statues he preferred, the fourth-century BCE Greek artist, perhaps the ancient world's greatest marble sculptor, replied: "Those that Nikias painted." This anecdote underscores the importance of coloration in ancient statuary.

*Pliny the Elder, *Natural History*, 35.147–148. Translated by J. J. Pollitt, *The Art of Rome*, c. 753 B.C.–A.D. 337: Sources and Documents (New York: Cambridge University Press, 1983), 87.

†Pliny the Elder, Natural History, 35.133.

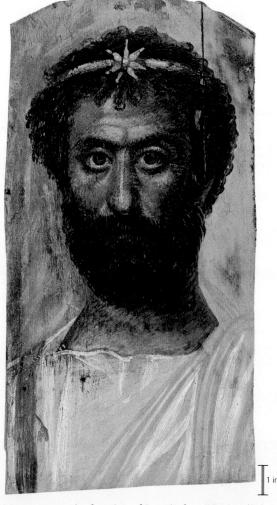

10-62 Mummy portrait of a priest of Serapis, from Hawara (Faiyum), Egypt, ca. 140–160 ce. Encaustic on wood, 1' $4\frac{3}{4}'' \times 8\frac{3}{4}''$. British Museum, London.

In Roman times, the Egyptians continued to bury their dead in mummy cases, but painted portraits replaced the traditional masks. This portrait was painted in encaustic—colors mixed with hot wax.

attests to the vibrant export market for such luxury items in Antonine times. The decoration of all four sides of the marble box with statuesque images of Greek gods and heroes in architectural frames is distinctively Asiatic. The figures portrayed include Venus and the legendary beauty Helen of Troy. The lid portrait, which carries on the tradition of Etruscan sarcophagi (FIGS. 9-5 and 9-15), is also a feature of the most expensive Western Roman coffins. Here the deceased, a woman, reclines on a *kline* (bed). With her are her faithful little dog (only its forepaws remain at the left end of the lid) and Cupid (at the right). The winged infant-god mournfully holds a downturned torch, a reference to the death of a woman whose beauty rivaled that of his mother, Venus, and of Homer's Helen.

MUMMY PORTRAITS In Egypt, burial had been practiced for millennia. Even after the Kingdom of the Nile was reduced to a Roman province in 30 BCE, Egyptians continued to bury their dead in mummy

cases (see "Mummification," Chapter 3, page 57). In Roman times, however, painted portraits on wood often replaced the traditional stylized portrait masks (see "Iaia of Cyzicus and the Art of Encaustic Painting," above). Hundreds of Roman mummy portraits have been preserved in the cemeteries of the Faiyum district. One of them (FIG. 10-62) depicts a priest of the Egyptian god Serapis, whose curly hair and beard closely emulate Antoine fashion in Rome. Such portraits, which mostly date to the second and third centuries CE, were probably painted while the subjects were still alive. This one exhibits the painter's refined use of the brush and spatula, mastery of the depiction of varied textures and of the play of light over the soft and delicately modeled face, and sensitive portrayal of the deceased's calm demeanor. Art historians use the Faiyum mummies to trace the evolution of portrait painting after Mount Vesuvius erupted in 79 CE (compare FIG. 10-25).

The Western and Eastern Roman sarcophagi and the mummy cases of Roman Egypt all served the same purpose, despite their

differing shape and character. In an empire as vast as Rome's, regional differences are to be expected. As will be discussed later, geography also played a major role in the Middle Ages, when Western and Eastern Christian art differed sharply.

LATE EMPIRE

By the time of Marcus Aurelius, two centuries after Augustus established the Pax Romana, Roman power was beginning to erode. It was increasingly difficult to keep order on the frontiers, and even within the Empire the authority of Rome was being challenged. Marcus's son Commodus (r. 180–192 CE), who succeeded his father, was assasinated, bringing the Antonine dynasty to an end. The economy was in decline, and the efficient imperial bureaucracy was disintegrating. Even the official state religion was losing ground to Eastern cults, Christianity among them, which were beginning to gain large numbers of converts. The Late Empire was a pivotal era in world history during which the pagan ancient world was gradually transformed into the Christian Middle Ages.

The Severans

Civil conflict followed Commodus's death. When it ended, an Africanborn general named Septimius Severus (r. 193–211 CE) was master of the Roman world. He succeeded in establishing a new dynasty that ruled the Empire for nearly a half century.

SEVERAN PORTRAITURE Anxious to establish his legitimacy after the civil war, Septimius Severus adopted himself into the Antonine dynasty, declaring that he was Marcus Aurelius's son. It is not surprising, then, that official portraits of the emperor in bronze and marble depict him with the long hair and beard of his Antonine "father"—whatever Severus's true appearance may have been. That is also how he appears in the only preserved painted portrait of an em-

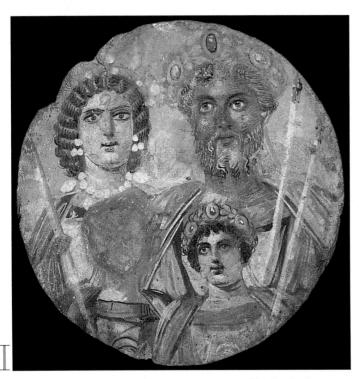

10-63 Painted portrait of Septimius Severus and his family, from Egypt, ca. 200 CE. Tempera on wood, 1^{\prime} 2" diameter. Staatliche Museen, Berlin.

The only known painted portrait of an emperor shows Septimius Severus with gray hair. With him are his wife Julia Domna and their two sons, but Geta's head was removed after his damnatio memoriae.

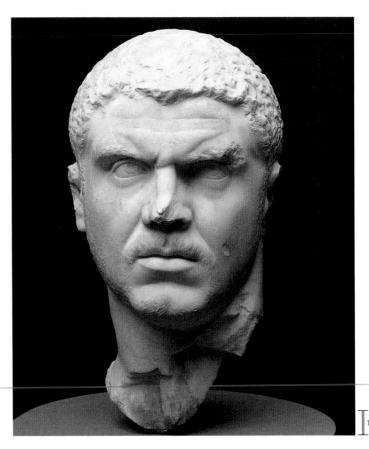

10-64 Portrait of Caracalla, ca. 211–217 ce. Marble, 1′ 2″ high. Metropolitan Museum of Art, New York.

Caracalla's suspicious personality is brilliantly captured in this portrait. The emperor's brow is knotted, and he abruptly turns his head over his left shoulder, as if he suspects danger from behind.

peror. The portrait (FIG. 10-63), discovered in Egypt and painted in *tempera* (pigments in egg yolk) on wood (as were many of the mummy portraits from Faiyum), shows Severus with his wife Julia Domna, the daughter of a Syrian priest, and their two sons, Caracalla and Geta. Painted imperial likenesses must have been quite common all over the empire, but their perishable nature explains their almost total loss.

The Severan family portrait is of special interest for two reasons beyond its survival. Severus's hair is tinged with gray, suggesting that his marble portraits—which, like all marble sculptures in antiquity, were painted—also may have revealed his advancing age in this way. (The same was very likely true of the marble likenesses of the elderly Marcus Aurelius.) The group portrait is also notable because the face of the emperor's younger son, Geta, was erased. When Caracalla (r. 211-217 CE) succeeded his father as emperor, he had his brother murdered and the Senate damn his memory. (Caracalla also ordered the death of his wife Plautilla.) The painted tondo (circular format, or roundel) portrait from Egypt is an eloquent testimony to that damnatio memoriae and to the long arm of Roman authority. This kind of defacement of a political rival's portrait is not new. Thutmose III of Egypt, for example, destroyed Hatshepsut's portraits (FIG. 3-21) after her death. But the Roman government employed damnatio memoriae as a political tool more often and more systematically than did any other civilization.

CARACALLA In the Severan painted tondo, Caracalla is portrayed as a boy with curly Antonine hair. The portraits of Caracalla as emperor are very different. In the head illustrated here (FIG. 10-64), the sculptor brilliantly suggested the texture of the emperor's short hair and close-cropped beard through deft handling of the chisel and

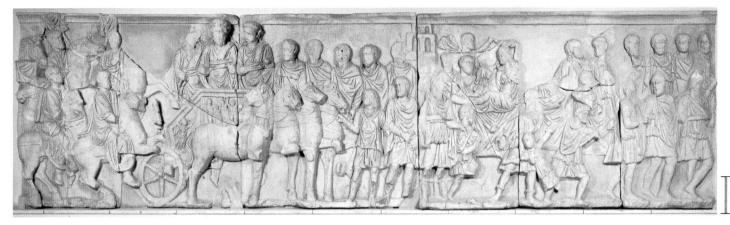

10-65 Chariot procession of Septimius Severus, relief from the attic of the Arch of Septimius Severus, Lepcis Magna, Libya, 203 CE. Marble, 5' 6" high. Castle Museum, Tripoli.

A new non-naturalistic aesthetic emerged in later Roman art. In this relief from a triumphal arch, Septimius Severus and his two sons face the viewer even though their chariot is moving to the right.

incisions into the marble surface. More remarkable, however, is the moving characterization of Caracalla's suspicious nature, a further development from the groundbreaking introspection of the portraits of Marcus Aurelius. Caracalla's brow is knotted, and he abruptly turns his head over his left shoulder, as if he suspects danger from behind. The emperor had reason to be fearful. An assassin's dagger felled him in the sixth year of his rule. Assassination would be the fate of many Roman emperors during the turbulent third century CE.

LEPCIS MAGNA The hometown of the Severans was Lepcis Magna, on the coast of what is now Libya. In the late second and early third centuries CE, the Severans constructed a modern harbor there as well as a new forum, basilica, arch, and other monuments. The Arch of Septimius Severus has been rebuilt. It features friezes on the attic on all four sides. One frieze (FIG. **10-65**) depicts the chariot procession of the emperor and his two sons on the occasion of their homecoming in 203. Unlike the triumph panel (FIG. **10-41**) on the Arch of Titus in Rome, this relief gives no sense of rushing motion. Rather, it has a

stately stillness. The chariot and the horsemen behind it are moving forward, but the emperor and his sons are detached from the procession and face the viewer. Also different is the way the figures in the second row have no connection with the ground and are elevated above the heads of those in the first row so that they can be seen more clearly.

Both the frontality and the floating figures were new to official Roman art in Antonine and Severan times, but both appeared long before in the private art of freed slaves (FIGS. 10-9 and 10-10). Once sculptors in the emperor's employ embraced these non-Classical elements, they had a long afterlife, largely (although never totally) displacing the Classical style the Romans adopted from Greece. As is often true in the history of art, the emergence of a new aesthetic was a by-product of a period of social, political, and economic upheaval. Art historians call this new non-naturalistic, more abstract style the Late Antique style.

BATHS OF CARACALLA The Severans were also active builders in the capital. The Baths of Caracalla (FIG. 10-66) in Rome were the greatest in a long line of bathing and recreational complexes

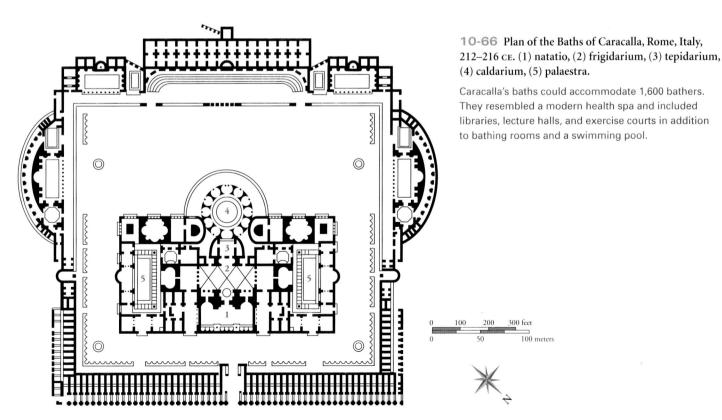

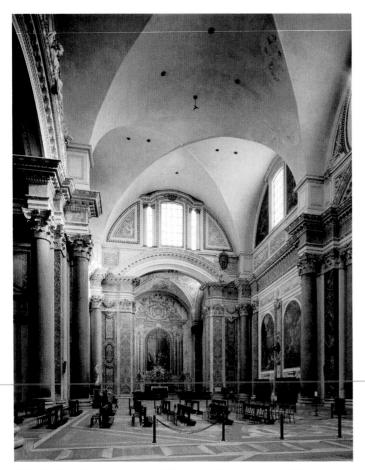

10-67 Frigidarium, Baths of Diocletian, Rome, ca. 298–306 CE (remodeled by MICHELANGELO as the nave of Santa Maria degli Angeli, 1563).

The groin-vaulted nave of the church of Santa Maria degli Angeli in Rome was once the frigidarium of the Baths of Diocletian. It gives an idea of the lavish adornment of imperial Roman baths.

erected with imperial funds to win the public's favor. Made of brickfaced concrete and covered by enormous vaults springing from thick walls up to 140 feet high, Caracalla's baths dwarfed the typical baths of cities and towns such as Ostia and Pompeii. The design was symmetrical along a central axis, facilitating the Roman custom of taking sequential plunges in warm-, hot-, and cold-water baths in, respectively, the tepidarium, caldarium, and frigidarium. The caldarium (FIG. 10-66, no. 4) was a huge circular chamber with a concrete drum even taller than the Pantheon's (FIGS. 10-49 to 10-51) and a dome almost as large. Caracalla's baths also had landscaped gardens, lecture halls, libraries, colonnaded exercise courts (palaestras), and a giant swimming pool (natatio). The entire complex covered an area of almost 50 acres. Archaeologists estimate that up to 1,600 bathers at a time could enjoy this Roman equivalent of a modern health spa. A branch of one of the city's major aqueducts supplied water, and furnaces circulated hot air through hollow floors and walls throughout the bathing rooms.

The Baths of Caracalla also featured stuccoed vaults, mosaic floors (both black-and-white and polychrome), marble-faced walls, and marble statuary. One statue on display was the 10-foot-tall copy of Lysippos's Herakles (FIG. 5-66), whose muscular body must have inspired Romans to exercise vigorously. The concrete vaults of the baths collapsed long ago, but visitors can get an excellent idea of what the central bathing hall, the frigidarium, once looked like from the nave (FIG. 10-67) of the church of Santa Maria degli Angeli in Rome, which was once the frigidarium of the later Baths of Diocle-

tian. The Renaissance interior (remodeled in the 18th century) of that church has, of course, many new elements foreign to a Roman bath, including a painted altarpiece. The ancient mosaics and marble revetment are long gone, but the present-day interior with its rich wall treatment, colossal columns with Composite capitals, immense groin vaults, and clerestory lighting gives a better sense of the character of a Roman imperial bathing complex than does any other building in the world. It takes a powerful imagination to visualize the original appearance of Roman concrete buildings from the woeful ruins of brick-faced walls and fallen vaults at ancient sites today, but Santa Maria degli Angeli makes the task much easier.

The Soldier Emperors

The Severan dynasty ended when Severus Alexander (r. 222–235 CE) was murdered. The next half century was one of almost continuous civil war. One general after another was declared emperor by his troops, only to be murdered by another general a few years or even a few months later. (In 238 CE, two co-emperors the Senate chose were dragged from the imperial palace and murdered in public after only three months in office.) In these unstable times, no emperor could begin ambitious architectural projects. The only significant building activity in Rome during the era of the "soldier emperors" occurred under Aurelian (r. 270–275 CE). He constructed a new defensive wall circuit for the capital—a military necessity and a poignant commentary on the decay of Roman power.

TRAJAN DECIUS If architects went hungry in third-century Rome, sculptors and engravers had much to do. The mint produced great quantities of coins (in debased metal) so that the troops could be paid with money stamped with the current emperor's portrait and not with that of his predecessor or rival. Each new ruler set up portrait statues and busts everywhere to assert his authority. The sculpted portraits of the third century CE are among the most moving ever made, as notable for their emotional content as they are for their technical virtuosity. Portraits of Trajan Decius (r. 249-251), such as the marble bust illustrated here (FIG. 10-68), show the emperor, who is best known for persecuting Christians, as an old man with bags under his eyes and a sad expression. In his eyes, which glance away nervously rather than engage the viewer directly, is the anxiety of a man who knows he can do little to restore order to an out-of-control world. The sculptor modeled the marble as if it were pliant clay, compressing the sides of the head at the level of the eyes, etching the hair and beard into the stone, and chiseling deep lines in the forehead and around the mouth. The portrait reveals the anguished soul of the man—and of the times.

TREBONIANUS GALLUS Decius's successor was Trebonianus Gallus (r. 251–253 CE), another short-lived emperor. In a larger-than-life-size bronze portrait (FIG. 10-69), Trebonianus appears in heroic nudity, as had so many emperors and generals before him. His physique is not, however, that of the strong but graceful Greek athletes Augustus and his successors admired so much. Instead, his is a wrestler's body with massive legs and a swollen trunk. The heavyset body dwarfs his head, with its nervous expression. In this portrait, the Greek ideal of the keen mind in the harmoniously proportioned body gave way to an image of brute force, an image well suited to the age of the soldier emperors.

THIRD-CENTURY SARCOPHAGI By the third century, burial of the dead had become so widespread that even the imperial family was practicing it in place of cremation. Sarcophagi were more popular than ever. An unusually large sarcophagus (FIG. 10-70), discovered in Rome in 1621 and purchased by Cardinal Ludovisi, is

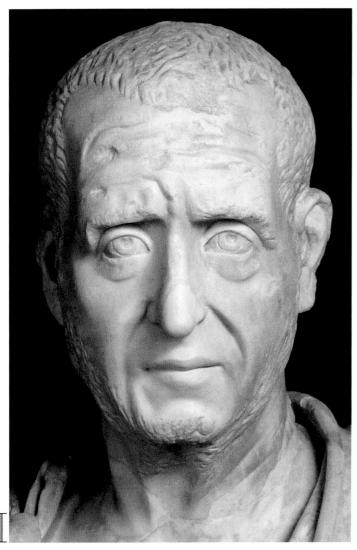

10-68 Portrait bust of Trajan Decius, 249–251 CE. Marble, full bust 2' 7" high. Musei Capitolini, Rome.

This portrait of a short-lived "soldier emperor" depicts an older man with bags under his eyes and a sad expression. The eyes glance away nervously, reflecting the anxiety of an insecure ruler.

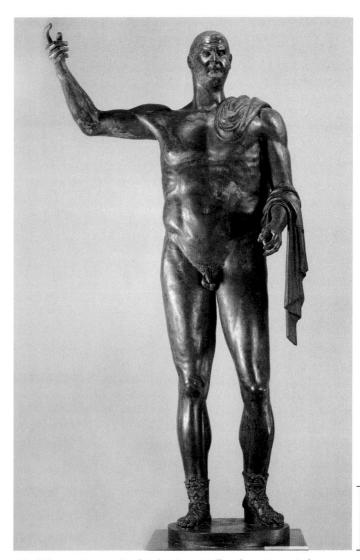

10-69 Heroic portrait of Trebonianus Gallus, from Rome, Italy, 251–253 ce. Bronze, 7′ 11″ high. Metropolitan Museum of Art, New York.

In this over-life-size heroically nude statue, Trebonianus Gallus projects an image of brute force. He has the massive physique of a powerful wrestler, but his face has a nervous expression.

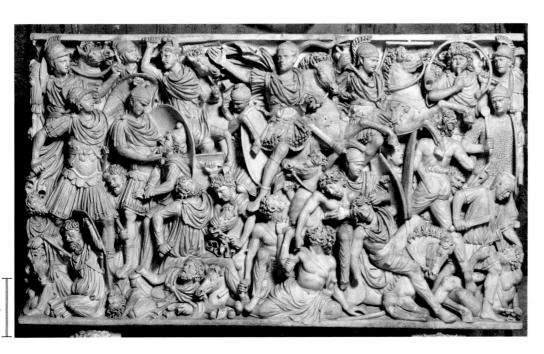

10-70 Battle of Romans and barbarians (*Ludovisi Battle Sarcophagus*), from Rome, Italy, ca. 250–260 ce. Marble, 5' high. Museo Nazionale Romano–Palazzo Altemps, Rome.

A chaotic scene of battle between Romans and barbarians decorates the front of this sarcophagus. The sculptor piled up the writhing, emotive figures in an emphatic rejection of Classical perspective. 10-71 Sarcophagus of a philosopher, ca. 270–280 CE. Marble, 4' 11" high. Musei Vaticani, Rome.

On many third-century sarcophagi, the deceased appears as a learned intellectual. Here, the seated Roman philosopher is the central frontal figure. His two female muses also have portrait features.

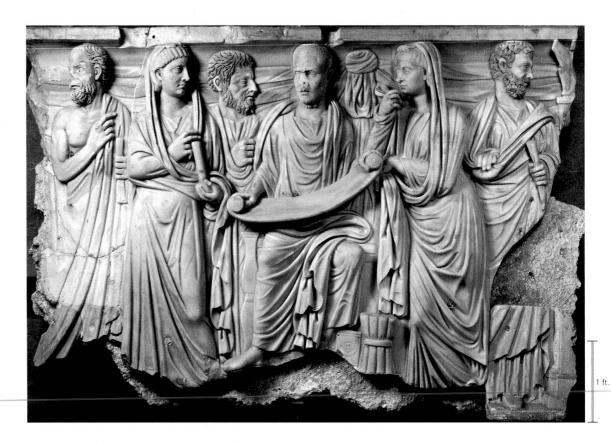

decorated on the front with a chaotic scene of battle between Romans and one of their northern foes, probably the Goths. The sculptor spread the writhing and highly emotive figures evenly across the entire relief, with no illusion of space behind them. This piling of figures is an even more extreme rejection of Classical perspective than was the use of floating ground lines on the pedestal of the Column of Antoninus Pius (FIG. 10-58). It underscores the increasing dissatisfaction Late Antique artists felt with the Classical style.

Within this dense mass of intertwined bodies, the central horseman stands out vividly. He wears no helmet and thrusts out his open right hand to demonstrate that he holds no weapon. Several scholars have identified him as one of the sons of Trajan Decius. In an age when the Roman army was far from invincible and Roman emperors were constantly felled by other Romans, the young general on the Ludovisi battle sarcophagus is boasting that he is a fearless commander assured of victory. His self-assurance may stem from his having embraced one of the increasingly popular Oriental mystery religions. On the youth's forehead is carved the emblem of Mithras, the Persian god of light, truth, and victory over death.

The insecurity of the times led many Romans to seek solace in philosophy. On many third-century sarcophagi, the deceased assumes the role of the learned intellectual. One especially large example (FIG. 10-71) depicts a seated Roman philosopher holding a scroll. Two standing women (also with portrait features) gaze at him from left and right, confirming his importance. In the background are other philosophers, students or colleagues of the central deceased teacher. The two women may be the deceased's wife and daughter, two sisters, or some other combination of family members. The composition, with a frontal central figure and two subordinate flanking figures, is typical of the Late Antique style. This type of sarcophagus became very popular for Christian burials. Sculptors used the wise-man motif not only to portray the deceased (FIG. 11-6) but also Christ flanked by his apostles (FIG. 11-7).

TEMPLE OF VENUS, BAALBEK The decline in respect for Classical art also can be seen in architecture. At Baalbek (ancient Heliopolis) in present-day Lebanon, the architect of the Temple of Venus (FIG. 10-72), following in the "baroque" tradition of the Treasury at Petra (FIG. 10-53), ignored almost every rule of Classical design. Although made of stone, the third-century building, with its circular domed cella set behind a gabled columnar facade, was in many ways a critique of the concrete Pantheon (FIG. 10-49), which by then had achieved the status of a classic. Many features of the Baalbek temple intentionally depart from the norm. The platform, for example, is scalloped all around the cella. The columns—the only known instance of five-sided Corinthian capitals with corresponding pentagonal bases—support a matching scalloped entablature (which serves to buttress the shallow stone dome). These concave forms and those of the niches in the cella walls play off against the cella's convex shape. Even the "traditional" facade of the Baalbek temple is eccentric. The unknown architect inserted an arch within the triangular pediment.

Diocletian and the Tetrarchy

In an attempt to restore order to the Roman Empire, Diocletian (r. 284–305 CE), whose troops proclaimed him emperor, decided to share power with his potential rivals. In 293 he established the *tetrarchy* (rule by four) and adopted the title of Augustus of the East. The other three *tetrarchs* were a corresponding Augustus of the West, and Eastern and Western Caesars (whose allegiance to the two Augusti was cemented by marriage to their daughters). Together, the four emperors ruled without strife until Diocletian retired in 305. Without his leadership, the tetrarchic form of government collapsed and renewed civil war followed. The division of the Roman Empire into eastern and western spheres survived, however. It persisted throughout the Middle Ages, setting the Latin West apart from the Byzantine East.

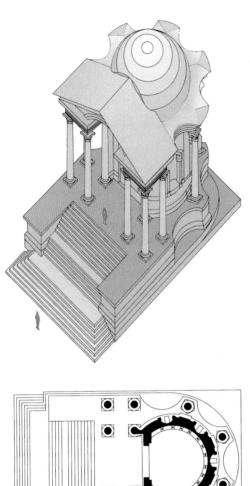

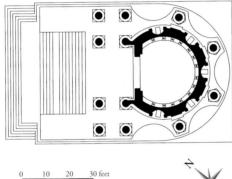

10-72 Restored view (top) and plan (bottom) of the Temple of Venus, Baalbek, Lebanon, third century CE.

This "baroque" temple violates almost every rule of Classical design. It has a scalloped platform and entablature, five-sided Corinthian capitals, and a facade with an arch inside the triangular pediment.

TETRARCHIC PORTRAITURE The four tetrarchs often were portrayed together, both on coins and in the round. Artists did not try to capture their individual appearances and personalities but sought instead to represent the nature of the tetrarchy itself—that is, to portray four equal partners in power. In the two pairs of porphyry (purple marble) portraits of the tetrarchs (FIG. 10-73) that are now embedded in the southwestern corner of Saint Mark's in Venice, it is impossible to name the rulers. Each of the four emperors has lost his identity as an individual and been subsumed into the larger entity of the tetrarchy. All the tetrarchs are identically clad in cuirass and cloak. Each grasps a sheathed sword in the left hand. With their right arms they embrace one another in an overt display of concord. The figures, like those on the decursio relief (FIG. 10-58) of the Column of Antoninus Pius, have large cubical heads on squat bodies. The drapery is schematic and the bodies are shapeless. The faces are emotionless masks, distinguished only by the beard on two of the

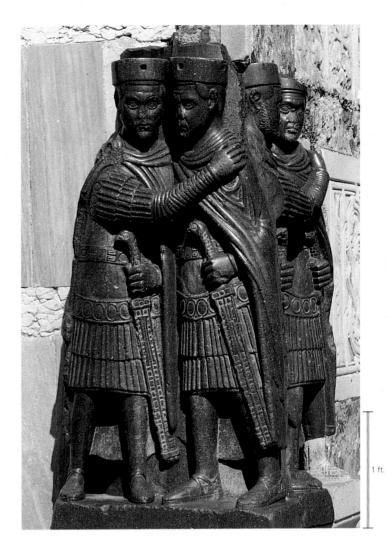

10-73 Portraits of the four tetrarchs, from Constantinople, ca. 305 ce. Porphyry, 4' 3" high. Saint Mark's, Venice.

Diocletian established the tetrarchy to bring order to the Roman world. In group portraits, artists always depicted the four co-rulers as nearly identical partners in power, not as distinct individuals.

figures (probably the older Augusti, distinguishing them from the younger Caesars). Nonetheless, each pair is as alike as freehand carving can achieve. In this group portrait, carved eight centuries after Greek sculptors first freed the human form from the formal rigidity of the Egyptian-inspired kouros stance, an artist once again conceived the human figure in iconic terms. Idealism, naturalism, individuality, and personality now belonged to the past.

PALACE OF DIOCLETIAN When Diocletian abdicated in 305, he returned to Dalmatia (roughly the area of the former Yugoslavia), where he was born. There he built a palace (FIG. 10-74) for himself at Split, near ancient Salona on the Adriatic coast of Croatia. Just as Aurelian had felt it necessary to girdle Rome with fortress walls, Diocletian instructed his architects to provide him with a wellfortified suburban palace. The complex, which covers about 10 acres, has the layout of a Roman castrum, complete with watchtowers flanking the gates. It gave the emperor a sense of security in the most insecure of times.

Within the high walls, two avenues (comparable to the cardo and decumanus of a Roman city; FIG. 10-42) intersected at the palace's center. Where a city's forum would have been situated, Diocletian's palace had a colonnaded court leading to the entrance to the

10-74 Restored view of the palace of Diocletian, Split, Croatia, ca. 298–306.

Diocletian's palace resembled a fortified Roman city (compare Fig. 10-42). Within its high walls, two avenues intersected at the forumlike colonnaded courtyard leading to the emperor's residential quarters.

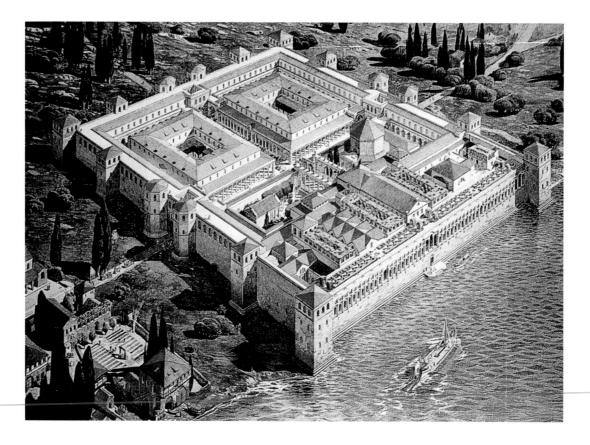

imperial residence, which had a templelike facade with an arch within its pediment, as in the Temple of Venus (FIG. 10-72) at Baalbek. Diocletian wanted to appear like a god emerging from a temple when he addressed those who gathered in the court to pay homage to him. On one side of the court was a Temple of Jupiter. On the other side was Diocletian's *mausoleum* (FIG. 10-74, *center right*), which towered above all the other structures in the complex. The emperor's huge domed tomb was a type that would become very popular in Early Christian times not only for mausoleums but eventually also for churches, especially in the Byzantine East. In fact, the tomb is a church today.

Constantine

An all-too-familiar period of conflict followed the short-lived concord among the tetrarchs that ended with Diocletian's abdication. This latest war among rival Roman armies lasted two decades. The eventual victor was Constantine I ("the Great"), son of Constantius Chlorus, Diocletian's Caesar of the West. After the death of his father, Constantine invaded Italy. In 312, at the battle of the Milvian Bridge to Rome, he defeated and killed Maxentius and took control of the capital. Constantine attributed his victory to the aid of the Christian god. The next year, he and Licinius, Constantine's coemperor in the East, issued the Edict of Milan, ending the persecution of Christians.

In time, Constantine and Licinius became foes, and in 324 Constantine defeated and executed Licinius near Byzantium (modern Istanbul, Turkey). Constantine, now unchallenged ruler of the whole Roman Empire, founded a "New Rome" at Byzantium and named it Constantinople ("City of Constantine"). In 325, at the Council of Nicaea, Christianity became the de facto official religion of the Roman Empire. From this point on, paganism declined rapidly. Constantinople was dedicated on May 11, 330, "by the commandment of

God," and in 337 Constantine was baptized on his deathbed. For many scholars, the transfer of the seat of power from Rome to Constantinople and the recognition of Christianity mark the end of antiquity and the beginning of the Middle Ages.

Constantinian art is a mirror of this transition from the classical to the medieval world. In Rome, for example, Constantine was a builder in the grand tradition of the emperors of the first, second, and early third centuries, erecting public baths, a basilica on the road leading into the Roman Forum, and a triumphal arch. But he was also the patron of the city's first churches (see Chapter 11).

ARCH OF CONSTANTINE Between 312 and 315, Constantine erected a great triple-passageway arch (FIGS. 10-2, no. 15, and 10-75) next to the Colosseum to commemorate his defeat of Maxentius. The arch was the largest erected in Rome since the end of the Severan dynasty. Much of the sculptural decoration, however, was taken from earlier monuments of Trajan, Hadrian, and Marcus Aurelius, and all of the columns and other architectural elements date to an earlier era. Sculptors refashioned the second-century reliefs to honor Constantine by recutting the heads of the earlier emperors with the features of the new ruler. They also added labels to the old reliefs, such as Liberator Urbis (liberator of the city) and Fundator Quietus (bringer of peace), references to the downfall of Maxentius and the end of civil war. The reuse of statues and reliefs on the Arch of Constantine has often been cited as evidence of a decline in creativity and technical skill in the waning years of the pagan Roman Empire. Although such a judgment is in large part deserved, it ignores the fact that the reused sculptures were carefully selected to associate Constantine with the "good emperors" of the second century. That message is underscored in one of the arch's few Constantinian reliefs. It shows Constantine on the speaker's platform in the Roman Forum between statues of Hadrian and Marcus Aurelius.

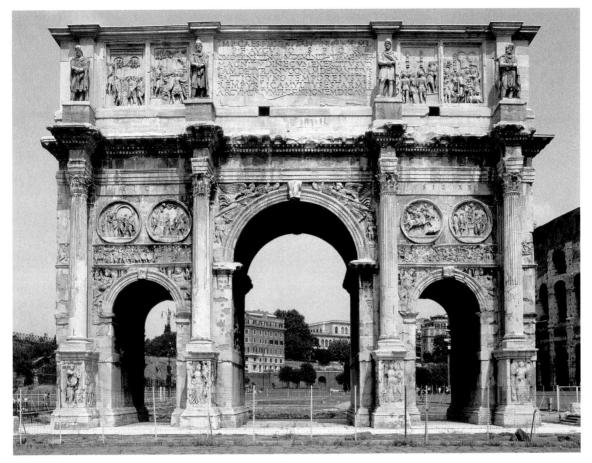

10-75 Arch of Constantine (south side), Rome, Italy, 312-315 CE.

Much of the sculptural decoration of Constantine's arch came from monuments of Trajan, Hadrian, and Marcus Aurelius. Sculptors recut the heads of the earlier emperors with Constantine's features.

In another Constantinian relief (FIG. 10-76), the emperor distributes largesse to grateful citizens who approach him from right and left. Constantine is a frontal and majestic presence, elevated on a throne above the recipients of his munificence. The figures are squat in proportion, like the tetrarchs (FIG. 10-73). They do not move according to any Classical principle of naturalistic movement but

10-76 Distribution of largesse, detail of the north frieze of the Arch of Constantine, Rome, Italy, 312–315 CE. Marble, 3' 4" high.

This Constantinian frieze is less a narrative of action than a picture of actors frozen in time. The composition's rigid formality reflects the new values that would come to dominate medieval art.

rather have the mechanical and repeated stances and gestures of puppets. The relief is very shallow, the forms are not fully modeled, and the details are incised. The frieze is less a narrative of action than a picture of actors frozen in time so that the viewer can distinguish instantly the all-important imperial donor (at the center on a throne) from his attendants (to the left and right above) and the recipients of the largesse (below and of smaller stature).

This approach to pictorial narrative was once characterized as a "decline of form," and when judged by the standards of Classical art, it was. But the composition's rigid formality, determined by the rank of those portrayed, was consistent with a new set of values. It soon became the preferred mode, supplanting the Classical notion that a picture is a window onto a world of anecdotal action. Comparing this Constantinian relief with a Byzantine icon (FIG. 12-18) reveals that the compositional principles of the Late Antique style are those of the Middle Ages. They were very different from—but not necessarily "better" or "worse" than—those of the Greco-Roman world. The Arch of Constantine is the quintessential monument of its era, exhibiting a respect for the past in its reuse of second-century sculptures while rejecting the norms of Classical design in its frieze, paving the way for the iconic art of the Middle Ages.

COLOSSUS OF CONSTANTINE After Constantine's victory over Maxentius, his official portraits broke with tetrarchic tradition as well as with the style of the soldier emperors, and resuscitated the Augustan image of an eternally youthful head of state. The most impressive of Constantine's preserved portraits is an eight-and-one-half-foot-tall head (FIG. 10-77), one of several marble

fragments of a colossal enthroned statue of the emperor composed of a brick core, a wooden torso covered with bronze, and a head and limbs of marble. Constantine's artist modeled the seminude seated portrait on Roman images of Jupiter. The emperor held an orb (possibly surmounted by the cross of Christ), the symbol of global power, in his extended left hand. The nervous glance of third-century portraits is absent, replaced by a frontal mask with enormous eyes set into the broad and simple planes of the head. The emperor's personality is lost in this immense image of eternal authority. The colossal size, the likening of the emperor to

10-77 Portrait of Constantine, from the Basilica Nova, Rome, Italy, ca. 315–330 CE. Marble, 8' 6" high. Musei Capitolini, Rome.

Constantine's portraits revive the Augustan image of an eternally youthful ruler. This colossal head is one of several fragments of an enthroned Jupiter-like statue of the emperor holding the orb of world power.

Jupiter, the eyes directed at no person or thing of this world—all combine to produce a formula of overwhelming power appropriate to Constantine's exalted position as absolute ruler.

BASILICA NOVA, ROME Constantine's gigantic portrait sat in the western apse of the Basilica Nova ("New Basilica," FIGS. 10-2, no. 12, and 10-78), a project Maxentius had begun and Constantine completed. From its position in the apse, the emperor's image dominated the interior of the basilica in much the same way that enthroned statues of Greco-Roman divinities loomed over awestruck mortals who entered the cellas of pagan temples.

10-78 Restored cutaway view of the Basilica Nova, Rome, Italy, ca. 306–312 CE (John Burge).

The lessons learned in the construction of baths and market halls were applied to the Basilica Nova, where fenestrated concrete groin vaults replaced the clerestory of a traditional stone-and-timber basilica.

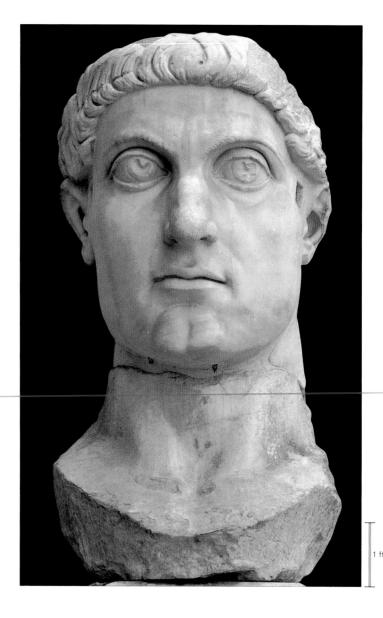

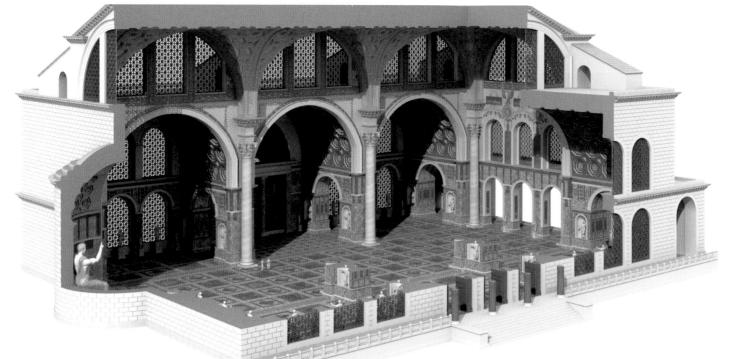

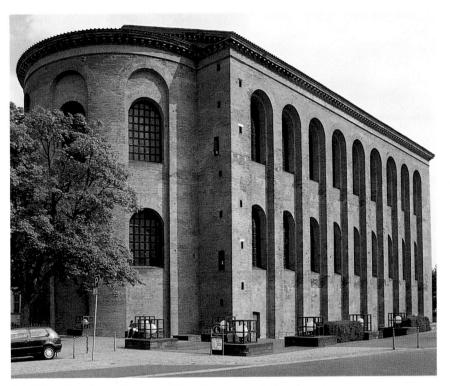

10-79 Aula Palatina (exterior), Trier, Germany, early fourth century CE.

The austere brick exterior of Constantine's Aula Palatina at Trier is typical of later Roman architecture. Two stories of windows with lead-framed panes of glass take up most of the surface area.

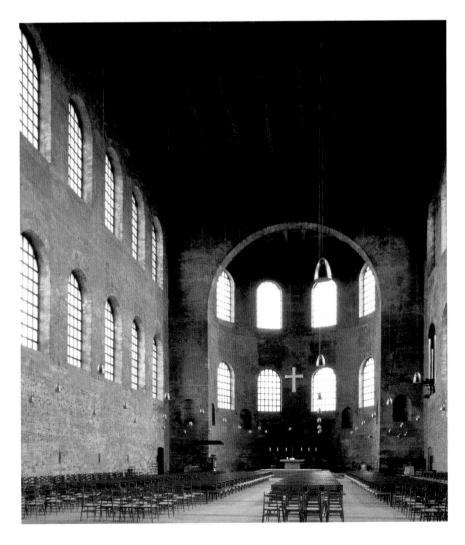

The Basilica Nova ruins never fail to impress tourists with their size and mass. The original structure was 300 feet long and 215 feet wide. Brickfaced concrete walls 20 feet thick supported coffered barrel vaults in the aisles. These vaults also buttressed the groin vaults of the nave, which was 115 feet high. The walls and floors were richly marbled and stuccoed. The reconstruction in FIG. 10-78 effectively suggests the immensity of the interior, where the great vaults dwarf even the emperor's colossal portrait. The drawing also clearly reveals the fenestration of the groin vaults, a lighting system akin to the clerestory of a traditional stoneand-timber basilica. Here, Roman builders applied to the Roman basilica the lessons learned in the design and construction of buildings such as Trajan's great market hall (FIG. 10-46) and the Baths of Diocletian (FIG. 10-67).

AULA PALATINA, TRIER At Trier (ancient Augusta Treverorum) on the Moselle River in Germany, the imperial seat of Constantius Chlorus as Caesar of the West, Constantine built a new palace complex. It included a basilica-like audience hall, the Aula Palatina (FIG. 10-79), of traditional form and materials. The Aula Palatina measures about 190 feet long and 95 feet wide and has an austere brick exterior, which was enlivened somewhat by highlighting in grayish white stucco. The use of lead-framed panes of glass for the windows enabled the builders to give life and movement to the blank exterior surfaces.

Inside (FIG. **10-80**), the audience hall was also very simple. Its flat, wooden, coffered ceiling is some 95 feet above the floor. The interior has no aisles, only a wide space with two stories of large windows that provide ample light. At the narrow north end, the main hall is divided from the semicircular apse (which also has a flat ceiling) by a so-called *chancel arch*. The Aula Palatina's interior is quite severe, although marble veneer and mosaics originally covered the arch and apse to provide a magnificent environment for the enthroned emperor. The design of both the interior and exterior has close parallels in many Early Christian churches.

10-80 Aula Palatina (interior), Trier, Germany, early fourth century CE.

The interior of the audience hall of Constantine's palace complex in Germany resembles a timber-roofed basilica with an apse at one end, but it has no aisles. The large windows provided ample illumination.

CONSTANTINIAN COINS The two portraits of Constantine on the coins in FIG. 10-81 reveal both the essential character of Roman imperial portraiture and the special nature of Constantinian art. The first (FIG. 10-81, left) was issued shortly after the death of Constantine's father, when Constantine was in his early 20s and his position was still insecure. Here, in his official portrait, he appears considerably older, because he adopted the imagery of the tetrarchs. Indeed, were it not for the accompanying label identifying this Caesar as Constantine, it would be impossible to know who was portrayed. Eight years later (FIG. 10-81, right)—after the defeat of Maxentius and the Edict of Milan-Constantine, now the unchallenged Augustus of the West, is clean-shaven and looks his actual 30 years of age, having rejected the mature tetrarchic look in favor of youth. These two coins should dispel any uncertainty about the often fictive nature of imperial portraiture and the ability of Roman emperors to choose any official image that

suited their needs. In Roman art, "portrait" is often not synonymous with "likeness."

The later coin is also an eloquent testimony to the dual nature of Constantinian rule. The emperor appears in his important role as imperator, dressed in armor, wearing an ornate helmet, and carrying a shield bearing the enduring emblem of the Roman state—the shewolf nursing Romulus and Remus (compare FIG. 9-11 and Roma's shield in FIG. 10-57). Yet he does not carry the scepter of the pagan Roman emperor. Rather, he holds a cross crowned by an orb. In addition, at the crest of his helmet, at the front, just below the grand plume, is a disk containing the *Christogram*, the monogram made up of *chi* (X), *rho* (P), and *iota* (I), the initial letters of Christ's name in Greek (compare the shield one of the soldiers holds in FIG. 12-10). Constantine was at once portrayed as Roman emperor and as a soldier in the army of the Lord. The coin, like Constantinian art in general, belongs both to the classical and to the medieval world.

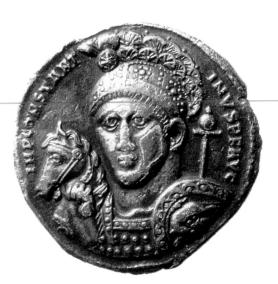

10-81 Coins with portraits of Constantine. Nummus (*left*), 307 ce. Billon, diameter 1". American Numismatic Society, New York. Medallion (*right*), ca. 315 ce. Silver, diameter 1". Staatliche Münzsammlung, Munich.

These two coins underscore that portraits of Roman emperors are rarely true likenesses. On the earlier coin, Constantine appears as a bearded tetrarch. On the later coin, he appears eternally youthful.

THE ROMAN EMPIRE

MONARCHY AND REPUBLIC, 753-27 BCE

- According to legend, Romulus and Remus founded Rome in 753 BCE. In the sixth century, Etruscan kings ruled the city and Roman art was Etruscan in character.
- In the centuries following the establishment of the Republic (509–27 BCE), Rome conquered its neighbors in Italy and then moved into Greece, bringing exposure to Greek art and architecture.
- Republican temples combined Etruscan plans with the Greek orders, and houses had peristyles with Greek columns. The Romans, however, pioneered the use of concrete as a building material.
- The First Style of mural painting derived from Greece, but the illusionism of the Second Style is distinctly Roman.
- Republican portraits were usually superrealistic likenesses of elderly patricians and celebrated traditional Roman values.

EARLY EMPIRE, 27 BCE-96 CE

- Augustus (r. 27 BCE-14 CE) became the first Roman emperor after defeating Mark Antony and Cleopatra at Actium in 31 BCE.
- Augustan art revived the Classical style with frequent references to Periclean Athens. Augustus's ambitious building program made lavish use of marble, and his portraits always depicted him as an idealized youth.
- Under the Julio-Claudians (r. 14–68 cE), the full potential of concrete began to be realized in buildings such as the Golden House of Nero.
- The Flavian emperors (r. 69–96 ce) erected the Colosseum, Rome's first and largest amphitheater, and arches and other monuments celebrating their victory in Judaea.
- Pompeii and Herculaneum were buried in 79 ce during the eruption of Mount Vesuvius. During the last quarter century of the towns' existence, the Third and Fourth Styles were used to decorate the walls of houses.

HIGH EMPIRE, 96-192 CE

- The Roman Empire reached its greatest extent under Trajan (r. 98–117 cE). The emperor's new forum and markets transformed the civic center of Rome. The Column of Trajan commemorated his two campaigns in Dacia in a spiral frieze with thousands of figures.
- Hadrian (r. 117–138 cE), emulating Greek statesmen and philosophers, was the first emperor to wear a beard. He built the Pantheon, a triumph of concrete technology.
- Under the Antonines (r. 138–192 cE), the dominance of Classical art began to erode, and imperial artists introduced new compositional schemes in relief sculpture and a psychological element in portraiture.

LATE EMPIRE, 193-337 CE

- In the art of the Severans (r. 193–235 cE), the Late Antique style took root. Artists represented the emperor as a central frontal figure disengaged from the action around him.
- During the chaotic era of the soldier emperors (r. 235–284 CE), artists revealed the anxiety and insecurity of the emperors in moving portraits.
- Diocletian (r. 284–305 ce) reestablished order by sharing power. Statues of the tetrarchs portray the four emperors as identical and equal rulers, not as individuals.
- Constantine (r. 306–337 ce) restored one-man rule, ended persecution of the Christians, and transferred the capital of the Empire from Rome to Constantinople in 330. The abstract formality of Constantinian art paved the way for the iconic art of the Middle Ages.

Villa of the Mysteries, Pompeii, ca. 60–50 BCE

Augustus as general, Primaporta, ca. 20 BCE

Arch of Titus, Rome

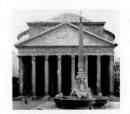

Pantheon, Rome, 118–125 CE

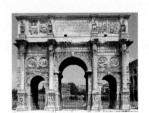

Arch of Constantine, Rome, 312–315 CE

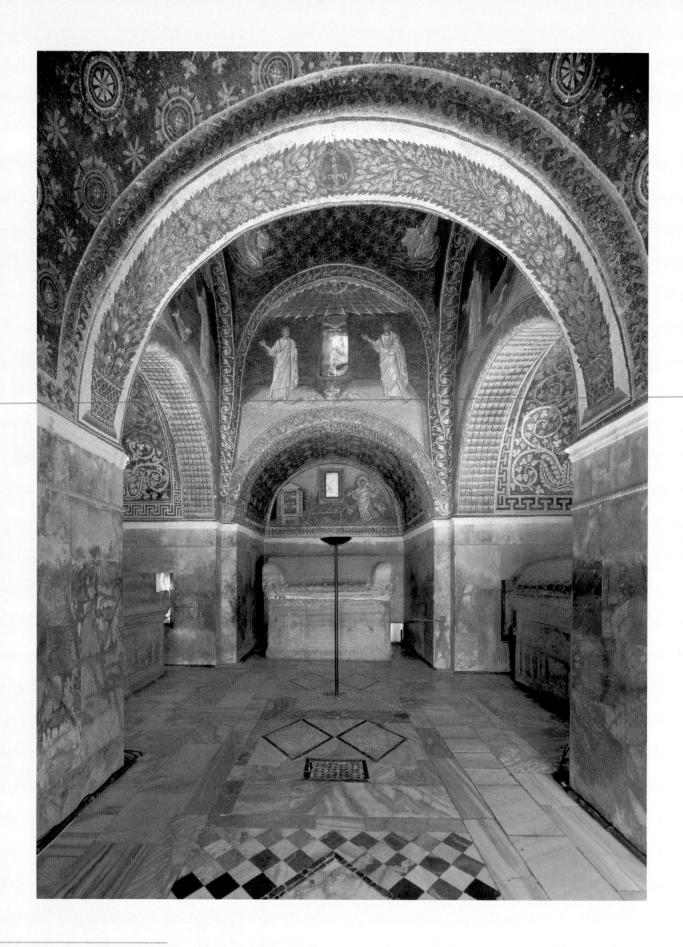

11-1 Interior of the Mausoleum of Galla Placidia, Ravenna, Italy, ca. 425.

Before Late Antiquity, mosaics were usually confined to floors. In the so-called Mausoleum of Galla Placidia (FIG. 11-15), mosaics cover every square inch of the interior above the marble-faced walls.

LATE ANTIQUITY

The Roman Empire was home to an extraordinarily diverse population. In Rome alone on any given day, someone walking through the city's various quarters would have encountered people of an astonishing range of social, ethnic, racial, linguistic, and religious backgrounds. The multicultural character of Roman society became even more pronounced as the Romans expanded their territories throughout Europe, Africa, and the Near East (MAP 10-1). The previous chapter focused on the public and private art and architecture of the pagan Roman world. During the third and fourth centuries, a rapidly growing number of Romans rejected *polytheism* (belief in multiple gods) in favor of *monotheism* (the worship of a single all-powerful god)—but they did not stop commissioning works of art. Jewish and Christian art of the Late Antique period is no less Roman than are sarcophagi with mythological scenes. Indeed, the artists may in some cases have been the same. The Jewish and Christian sculptures, paintings, and buildings of Late Antiquity are Roman in style and technique, but they differ in subject and function from contemporaneous Roman secular and religious art and architecture. For that reason, and because these Late Antique artworks and sacred buildings formed the foundation of the art and architecture of the Middle Ages, they are examined separately in this chapter.

DURA-EUROPOS

The powerful religious crosscurrents of Late Antiquity may be seen in microcosm in a distant outpost of the Roman Empire on a promontory overlooking the Euphrates River in Syria (MAP 11-1). Called Europos by the Greeks and Dura by the Romans, the town probably was founded shortly after the death of Alexander the Great by one of his successors. By the end of the second century BCE, Dura-Europos was in the hands of the Parthians. Trajan captured the city in 115,* but Dura reverted to Parthian control shortly thereafter. In 165, under Marcus Aurelius, the Romans retook the city and placed a permanent garrison there. Dura-Europos fell in 256 to Rome's new enemy in the East, the Sasanians, heirs to the Parthian Empire (see Chapter 2). The Sasanian siege of Dura is an important fixed point in the chronology of Late Antiquity because the inhabitants evacuated the town, leaving its buildings largely intact. This "Pompeii of the desert" has revealed the

^{*}In this chapter, all dates are CE unless otherwise indicated.

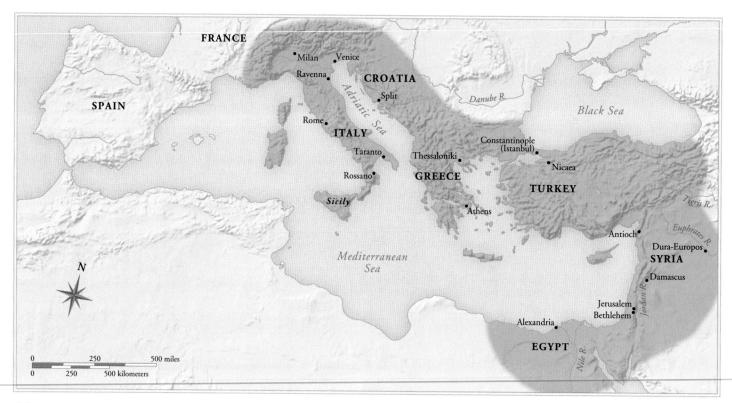

MAP 11-1 The Mediterranean world in Late Antiquity.

remains of more than a dozen different cult buildings, including many shrines of the polytheistic religions of the Mediterranean and Near East. But the excavators also discovered places of worship for the monotheistic creeds of Judaism and Christianity.

SYNAGOGUE PAINTINGS The synagogue at Dura-Europos is remarkable not only for its very existence in a Roman garrison town but also for its extensive cycle of mural paintings (FIG. 11-2) depicting biblical themes. The building, originally a private house with a central courtyard, was converted into a synagogue during the

latter part of the second century. The paintings surprised scholars when they were first reported, because they seemed to defy the Bible's Second Commandment prohibiting the making of graven images. The Dura find established that although the Jews of the Roman Empire did not worship idols as did their pagan contemporaries, biblical stories appeared on the painted walls of synagogues and probably also in painted manuscripts, though no illustrated Bible of this period survives. God (YHWH, or Yahweh in the Old Testament), however, never appears in the Dura paintings, except as a hand emerging from the top of the framed panels.

11-2 Interior of the synagogue, Dura-Europos, Syria, with wall paintings of Old Testament themes, ca. 245–256. Tempera on plaster. Reconstruction in National Museum, Damascus.

The Dura-Europos synagogue was a converted private house with a central courtyard. The niche housing the sacred Torah is at the center of one long wall adorned with paintings depicting Old and New Testament scenes.

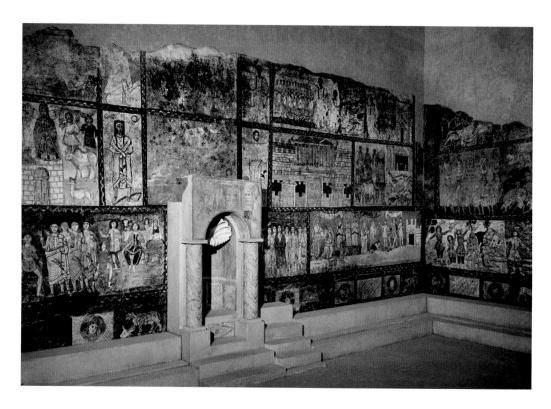

The Dura murals are mostly devoid of action, even when the subject is a narrative theme. The artists told the stories through stylized gestures, and the figures, which have expressionless features and lack both volume and shadow, tend to stand in frontal rows. The painting of Samuel anointing David (FIG. 11-3) exemplifies this Late Antique style, also seen in the friezes of the Arch of Septimius Severus (FIG. 10-65) at Lepcis Magna and the Arch of Constantine (FIG. 10-76) in Rome. The episode is just to the right of the niche (FIG. 11-2, center) that housed the sacred Jewish Torah (the scroll containing the Pentateuch, the first five books of the Hebrew Scriptures). The prophet anoints the future king of Israel, while David's six older brothers look on. The painter drew attention to Samuel by depicting him larger than all the rest, a familiar convention of Late Antique art. David and his brothers are emotionless and almost disembodied spiritual presences—their bodies do not even have enough feet. The painter, however, distinguished David from his brothers by the purple toga he wears. The color purple was associated with the Roman emperor, and the Dura artist borrowed the imperial toga to signify David's royalty.

CHRISTIAN COMMUNITY HOUSE The meeting house (FIG. 11-4) of the Christian community at Dura-Europos was also a remodeled private residence with a central courtyard (FIG. 11-4, no. 1). Its meeting hall (FIG. 11-4, no. 2)—created by removing the partition between two rooms on the courtyard's south side—could accommodate no more than about 70 people at a time. The hall had a raised platform at one end where the leader of the congregation sat or stood. Another room (FIG. 11-4, no. 3), on the opposite side of the courtyard, had a font for conducting the rite of *baptism*, the all-important ceremony initiating a new convert into the Christian community.

Although the *baptistery* had mural paintings (poorly preserved), the place where Christians gathered to worship at Dura, as elsewhere in the Roman Empire, was a modest secondhand house, in striking contrast to the grand temples of the Roman gods. Because Christian communities could not obtain the approval of the state, they remained small in number. Nonetheless, the emperor Diocletian

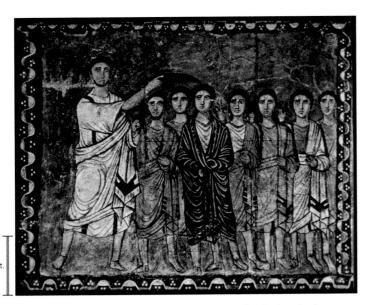

11-3 Samuel anoints David, detail of the mural paintings in the synagogue, Dura-Europos, Syria, ca. 245–256. Tempera on plaster, 4′ 7″ high.

The figures in the biblical mural paintings in the Dura-Europos synagogue lack volume and shadow, stand in frontal rows, and have stylized gestures—features also of contemporaneous pagan art.

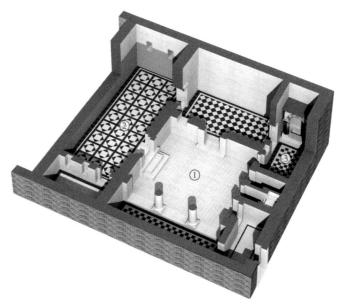

11-4 Restored cutaway view of the Christian community house, Dura-Europos, Syria, ca. 240–256 (John Burge). (1) former courtyard of private house, (2) meeting hall, (3) baptistery.

The Christian community at Dura-Europos met in a remodeled private home that could accommodate only about 70 people. The house had a central courtyard, a meeting hall, and a baptistery.

became so concerned by the growing popularity of Christianity in the Roman army ranks that he ordered a fresh round of persecutions in 303 to 305, a half century after the last great persecutions under Trajan Decius. As Christianity's appeal grew, so too did the Roman state's fear of its weakening imperial authority. The Christians refused to pay even token homage to the Roman state's official gods (which included deified emperors as well as the traditional pantheon of gods and goddesses). Persecution ended only in 311, when Galerius issued an edict of toleration, and especially in 313, when Constantine, who believed the Christian god was the source of his power rather than a threat to it (see Chapter 10), issued the Edict of Milan. That declaration established Christianity as a legal religion with equal or superior standing to the traditional Roman cults.

THE CATACOMBS AND FUNERARY ART

Very little is known about the art of the first Christians. When art historians speak about "Early Christian art," they are referring to the earliest preserved artworks having Christian subjects, not the art of Christians at the time of Jesus. Most Early Christian art in Rome dates to the third and fourth centuries and is found in the catacombs—vast subterranean networks of galleries (passageways) and chambers designed as cemeteries for burying the Christian dead. The name derives from the Latin ad catacumbas, which means "in the hollows." To a much lesser extent, the catacombs also housed the graves of Jews and others. The builders tunneled the catacombs out of the tufa bedrock, much as the Etruscans fashioned the underground tomb chambers in the Cerveteri necropolis (FIG. 9-6). The catacombs are less elaborate than the Etruscan tombs but much more extensive. The known catacombs in Rome (others exist elsewhere) comprise galleries estimated to run for 60 to 90 miles. From the second through the fourth centuries, these burial complexes were in constant use, housing as many as four million bodies.

11-5 The Good Shepherd, the story of Jonah, and orants, painted ceiling of a cubiculum in the Catacomb of Saints Peter and Marcellinus, Rome, Italy, early fourth century.

Catacomb paintings mixed Old and New Testament themes. Jonah was a popular subject because he was swallowed by a sea monster and emerged safely after three days, prefiguring Christ's Resurrection.

In accordance with Roman custom, Christians had to be buried outside a city's walls on private property, usually purchased by a *confraternity*, or association, of Christian families pooling funds. Each of the catacombs was initially of modest extent. First, the builders dug a gallery three to four feet wide around the perimeter of the burial ground at a convenient level below the surface. In the walls of these galleries, they cut *loculi* (openings to receive the bodies of the dead, one above another, like shelves). Often, small rooms carved out of the rock, called *cubicula* (as in Roman houses of the living), served as mortuary

chapels. Once the original perimeter galleries were full of loculi and cubicula, the Christians excavated other galleries at right angles to them. This process continued as long as lateral space permitted, at which point they opened lower levels connected by staircases to those above. Some catacomb systems extended as deep as five levels. When adjacent burial areas belonged to members of the same Christian confraternity, or by gift or purchase fell into the same hands, the owners cut passageways between the respective cemeteries. The galleries thus spread laterally and gradually occupied a vast expanse. After Christianity received official approval, churches rose on the land above the catacombs so that the pious could worship openly at the burial sites of some of the earliest Christian *martyrs* (individuals who chose to die rather than deny their religious beliefs; the Church declared many of them *saints*).

Painting

As already noted, Early Christian art is Roman in style but Christian in subject. The painted ceiling (FIG. 11-5) of a cubiculum in the Catacomb of Saints Peter and Marcellinus in Rome, for example, is similar in format to the painted vaults of some third-century apartment houses at Ostia that have a circular frame with a central medallion and *lunettes* (semicircular frames) around the circumference. The lunettes in this Early Christian cubiculum contain the key episodes from the Old Testament story of Jonah. The sailors throw him from his ship on the left. He emerges on the right from the "whale." (The Greek word is *ketos*, or sea dragon, and that is how the artist represented the monstrous marine creature that swallowed Jonah; compare the sea creature, FIG. 10-30, *right*.) Safe on land at the bottom, Jonah contemplates the miracle of his salvation and the mercy of God. Jonah was a popu-

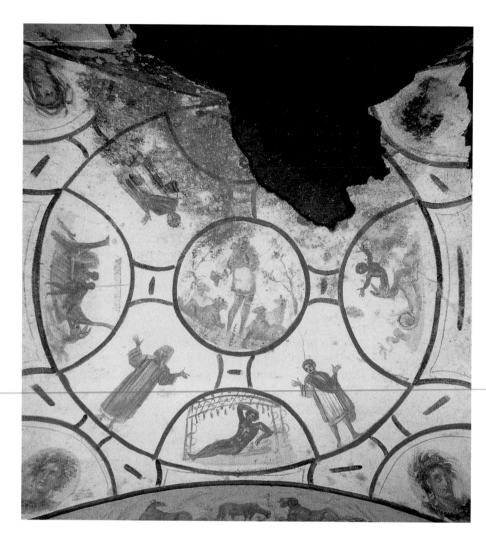

lar figure in Early Christian painting and sculpture, especially in funerary contexts. The Christians honored him as a *prefiguration* (prophetic forerunner) of Christ, who rose from death as Jonah had been delivered from the belly of the ketos, also after three days. Old Testament miracles prefiguring Christ's Resurrection abound in the catacombs and in Early Christian art in general (see "Jewish Subjects in Christian Art," page 293).

A man, a woman, and at least one child occupy the compartments between the Jonah lunettes. They are orants (praying figures), raising their arms in the ancient attitude of prayer. Together they make up a cross-section of the Christian family seeking a heavenly afterlife. The central medallion shows Christ as the Good Shepherd, whose powers of salvation are underscored by his juxtaposition with Jonah's story. The motif can be traced to Archaic Greek art, but there the pagan calf bearer (FIG. 5-9) offered his animal in sacrifice to Athena. In Early Christian art, Christ is the youthful and loyal protector of the Christian flock, who said to his disciples, "I am the good shepherd; the good shepherd gives his life for the sheep" (John 10:11). In the Christian motif, the sheep on Christ's shoulders is one of the lost sheep he has retrieved, symbolizing a sinner who has strayed and been rescued. Early Christian artists almost invariably represented Christ either as the Good Shepherd or as a teacher. Only after Christianity became the Roman Empire's official religion in 380 did representations of Christ in art take on such imperial attributes as the halo, the purple robe, and the throne, which denoted rulership. Eventually artists depicted Christ with the beard of a mature adult, which has been the standard form for centuries, supplanting the youthful imagery of most Early Christian portravals of the Savior.

Jewish Subjects in Christian Art

rom the beginning, the Old Testament played an important role in Christian life and Christian art, in part because Jesus was a Jew and so many of the first Christians were converted Jews, but also because Christians came to view many of the persons and events of the Old Testament as prefigurations of New Testament persons and events. Christ himself established the pattern for this kind of biblical interpretation, called typology, when he compared Jonah's three-day stay in the belly of the sea monster (usually translated as "whale" in English) to the comparable time he would be entombed in the earth before his Resurrection (Matt. 12:40). In the fourth century, Saint Augustine (354-430) confirmed the validity of this typological approach to the Old Testament when he stated that "the New Testament is hidden in the Old; the Old is clarified by the New."* Thus the Old Testament figured prominently in Early Christian art in all media. Biblical tales of Jewish faith and salvation were especially common in funerary contexts but appeared also in churches and on household objects.

The following are four of the most popular Old Testament stories depicted in Early Christian art:

■ Adam and Eve Eve, the first woman, tempted by a serpent, ate the forbidden fruit of the tree of knowledge and fed some to Adam, the first man. As punishment, God expelled Adam and Eve from Paradise. This "Original Sin" ultimately led to Christ's sacrifice on the cross so that all humankind could be saved. Christian

- theologians often consider Christ the new Adam and his mother, Mary, the new Eve.
- Sacrifice of Isaac God instructed Abraham, the father of the Hebrew nation, to sacrifice Isaac, his only son, as proof of his faith. When it became clear that Abraham would obey, the Lord sent an angel to restrain him and provided a ram for sacrifice in Isaac's place. Christians view this episode as a prefiguration of the sacrifice of God's only son, Jesus.
- Jonah The Old Testament prophet Jonah had disobeyed God's command. In his wrath, the Lord caused a storm while Jonah was at sea. Jonah asked the sailors to throw him overboard, and the storm subsided. A sea dragon then swallowed Jonah, but God answered his prayers, and the monster spat out Jonah after three days and nights, foretelling Christ's Resurrection.
- Daniel When Daniel, one of the most important Jewish prophets, violated a Persian decree against prayer, the Persians threw him into a den of lions. God sent an angel to shut the lions' mouths, and Daniel emerged unharmed. Like Jonah's story, this is an Old Testament salvation tale, a precursor of Christ's triumph over death.

Sculpture

Most Christians rejected cremation, and the wealthiest Christian faithful, like their pagan contemporaries, favored impressive marble sarcophagi for burial. Many of these coffins have survived in catacombs and elsewhere. Predictably, the most common themes painted on the walls and vaults of the Roman subterranean cemeteries were also the subjects that appeared on Early Christian sarcophagi. Often, the decoration of the marble coffins was a collection of significant Christian themes, just as on the painted ceiling (FIG. 11-5) in the Catacomb of Saints Peter and Marcellinus.

SANTA MARIA ANTIQUA SARCOPHAGUS On the front of a sarcophagus (FIG. 11-6) in Santa Maria Antiqua in Rome, the story of Jonah occupies the left one-third. At the center are an orant and a seated philosopher, the latter a motif borrowed directly from contemporary pagan sarcophagi (FIG. 10-71). The heads of both the praying woman and the seated man reading from a scroll are unfinished. Roman workshops often produced sarcophagi before knowing who would purchase them. The sculptors added the portraits at the time of burial, if they added them at all. This practice underscores the universal appeal of the themes chosen. At the right

1 ft

11-6 Sarcophagus with philosopher, orant, and Old and New Testament scenes, ca. 270. Marble, $1'11\frac{1}{4}'' \times 7'2''$. Santa Maria Antiqua, Rome.

This Early Christian sarcophagus depicts the salvation of Jonah, Christ as Good Shepherd, and the baptism of Christ. The two figures with unfinished heads were intended as portraits of the deceased.

^{*}Augustine, City of God, 16.26.

11-7 Sarcophagus of Junius Bassus, from Rome, Italy, ca. 359. Marble, $3'10\frac{1}{2}'' \times 8'$. Museo Storico del Tesoro della Basilica di San Pietro, Rome.

The wealthiest Christians, like the recently converted city prefect Junius Bassus, favored elaborately decorated sarcophagi. Here, biblical episodes from Adam and Eve to Christ before Pilate appear in 10 niches.

are two different, yet linked, representations of Jesus—as the Good Shepherd and as a child receiving baptism in the Jordan River, though he really was baptized at age 30 (see "The Life of Jesus in Art," pages 296–297). The sculptor suggested the future ministry of the baptized Jesus by turning the child's head toward the Good Shepherd and by placing his right hand on one of the sheep. In the early centuries of Christianity, baptism was usually delayed almost to the moment of death because it cleansed the Christian of all sin. One of those who was baptized on his deathbed was the emperor Constantine (see Chapter 10).

JUNIUS BASSUS SARCOPHAGUS Another pagan convert to Christianity was the city prefect of Rome, Junius Bassus, who, according to the inscription on his sarcophagus (FIG. 11-7), was baptized just before he died in 359. The sarcophagus is of eclectic format—decorated only on three sides in the western Roman manner (see Chapter 10), but divided into two registers of five compartments, each framed by columns in the tradition of Asiatic sarcophagi (FIG. 10-61). In contrast to the Santa Maria Antiqua sarcophagus (FIG. 11-6), the deceased does not appear on the body of the coffin. Instead, stories from the Old and New Testaments fill the niches. Christ has pride of place and appears in the central compartment of each register: as a teacher enthroned between his chief

apostles, Saints Peter and Paul (above), and triumphantly entering Jerusalem on a donkey (below). Appropriately, the sculptor placed the scene of Christ's heavenly triumph above that of his earthly triumph. Both compositions owe a great deal to official Roman art. In the center of the upper zone, Christ, like an enthroned Roman emperor, sits above a personification of the sky god holding a billowing mantle over his head, indicating that Christ is ruler of the universe. The scene below derives from portrayals of Roman emperors entering cities on horseback, but Christ's steed and the absence of imperial attributes contrast sharply with the imperial models the sculptor used as compositional sources.

All of the Old Testament scenes on the Junius Bassus sarcophagus are precursors of New Testament events (see "Jewish Subjects in Christian Art," page 293). Adam and Eve, for example, are in the second niche from the left on the lower level. Their Original Sin of eating the apple in the Garden of Eden ultimately necessitated Christ's sacrifice for the salvation of humankind. To the right of the entry into Jerusalem is Daniel, unscathed by flanking lions, saved by his faith. At the upper left, Abraham is about to sacrifice Isaac. Christians believe this Old Testament story was a prefiguration of God's sacrifice of his own son, Jesus.

The Crucifixion itself, however, does not appear on the Junius Bassus sarcophagus. Indeed, the subject was very rare in Early Chris-

11-8 Christ seated, from Civita Latina, Italy, ca. 350–375. Marble, 2' $4\frac{1}{2}$ " high. Museo Nazionale Romano–Palazzo Massimo alle Terme, Rome.

The earliest representations of Jesus show him as a young man. Statues of Christ are rare during the Early Christian period, however, because of the Second Commandment prohibition of idol worship.

tian art and unknown prior to the fifth century. Artists emphasized Christ's divinity and exemplary life as teacher and miracle worker, not his suffering and death at the hands of the Romans. This sculptor, however, alluded to the Crucifixion in the scenes in the two niches at the upper right depicting Jesus being led before Pontius Pilate for judgment. The Romans condemned Jesus to death, but he triumphantly overcame it. Junius Bassus and other Christians, whether they were converts from paganism or from Judaism, hoped for a similar salvation.

STATUETTE OF CHRIST Apart from the reliefs on privately commissioned sarcophagi, monumental sculpture became increasingly uncommon in the fourth century. The authorities continued to erect portrait statues of Roman emperors and other officials, and

artists still made statues of pagan gods and mythological figures, but the number of statues decreased sharply. In his *Apologia*, Justin Martyr, a second-century philosopher who converted to Christianity and was mindful of the Second Commandment's admonition to shun graven images, accused the pagans of worshiping statues as gods. Christians tended to suspect the freestanding statue, linking it with the false gods of the pagans, so Early Christian houses of worship had no "cult statues." Nor did the first churches have any equivalent of the pedimental statues and relief friezes of Greco-Roman temples.

The Greco-Roman experience, however, was still a living part of the Mediterranean mentality, and many Christians like Junius Bassus were recent converts from paganism who retained some of their classical values. This may account for those rare instances of freestanding Early Christian sculpture, such as the marble statuette (FIG. 11-8) of Christ seated from Civita Latina. Less than three feet tall, the figure closely resembles the Christ situated between Saints Peter and Paul on the Junius Bassus sarcophagus (FIG. 11-7, top center). As on the relief, Christ's head is that of a long-haired Apollo-like youth, but the Romans employed the statuary type only for bearded philosophers of advanced age. Like those learned men, Christ wears the Roman tunic, toga, and sandals and holds an unopened scroll in his left hand. The piece is unique, and unfortunately its original context and function are unknown. Several third- and fourth-century marble statuettes of Christ as the Good Shepherd and of Jonah also survive, but they too are exceptional.

ARCHITECTURE AND MOSAICS

Although some Christian ceremonies were held in the catacombs, regular services took place in private community houses of the type found at Dura-Europos (FIG. 11-4). Once Christianity achieved imperial sponsorship under Constantine, an urgent need suddenly arose to construct churches. The new buildings had to meet the requirements of Christian *liturgy* (the official ritual of public worship), provide a suitably monumental setting for the celebration of the Christian faith, and accommodate the rapidly growing numbers of worshipers.

Constantine was convinced that the Christian god had guided him to victory over Maxentius, and in lifelong gratitude he protected and advanced Christianity throughout the Empire as well as in the obstinately pagan capital city of Rome. As emperor, he was, of course, obliged to safeguard the ancient Roman religion, traditions, and monuments, and, as noted in Chapter 10, he was (for his time) a builder on a grand scale in the heart of the city. But eager to provide buildings to house the Christian rituals and venerated burial places, especially the memorials of founding saints, Constantine also was the first major patron of Christian architecture. He constructed elaborate basilicas, memorials, and mausoleums not only in Rome but also in Constantinople, his "New Rome" in the East, and at sites sacred to Christianity, most notably Bethlehem, the birthplace of Jesus, and Jerusalem, the site of the Crucifixion.

Rome

The major Constantinian churches in Rome stood on sites associated with the graves of Christian martyrs, which, in keeping with Roman custom, were all on the city's outskirts. The decision to erect churches at those sites also permitted Constantine to keep the new Christian shrines out of the city center and to avoid any confrontation between Rome's Christian and pagan populations.

The Life of Jesus in Art

hristians believe that Jesus of Nazareth is the son of God, the Messiah (Savior, Christ) of the Jews prophesied in the Old Testament. His life—his miraculous birth from the womb of a virgin mother, his preaching and miracle working, his execution by the Romans and subsequent ascent to Heaven—has been the subject of countless artworks from Roman times through the present day. The primary literary sources for these representations are the Gospels of the New Testament attributed to the Four Evangelists, Saints Matthew, Mark, Luke, and John (see "The Four Evangelists," Chapter 16, page 412); later apocryphal works; and medieval theologians' commentaries on these texts.

The life of Jesus dominated the subject matter of Christian art to a far greater extent than Greco-Roman religion and mythology ever did classical art. Whereas images of athletes, portraits of statesmen and philosophers, narratives of war and peace, genre scenes, and other secular subjects were staples of the classical tradition, Christian iconography held a near-monopoly in the art of the Western world in the Middle Ages.

Although many of the events of Jesus' life were rarely or never depicted during certain periods, the cycle as a whole has been one of the most frequent subjects of Western art, even after the revival of classical and secular themes in the Renaissance. Thus it is useful to summarize the entire cycle of events as they usually appear in the artworks.

INCARNATION AND CHILDHOOD

The first "cycle" of the life of Jesus consists of the events of his conception (Incarnation), birth, infancy, and childhood.

- Annunciation to Mary The archangel Gabriel announces to the Virgin Mary that she will miraculously conceive and give birth to God's son Jesus. Artists sometimes indicate God's presence at the Incarnation by a dove, the symbol of the Holy Spirit, the third "person" of the *Trinity* with God the Father and Jesus.
- *Visitation* The pregnant Mary visits Elizabeth, her older cousin, who is pregnant with the future Saint John the Baptist. Elizabeth is the first to recognize that the baby Mary is bearing is the Son of God, and they rejoice.
- Nativity, Annunciation to the Shepherds, and Adoration of the Shepherds Jesus is born at night in Bethlehem and placed in a basket. Mary and her husband Joseph marvel at the newborn in a stable or, in Byzantine art, in a cave. An angel announces the birth of the Savior to shepherds in the field, who rush to Bethlehem to adore the child.
- Adoration of the Magi A bright star alerts three wise men (magi) in the East that the King of the Jews has been born. They travel 12 days to find the Holy Family and present precious gifts to the infant Jesus.
- *Presentation in the Temple* In accordance with Jewish tradition, Mary and Joseph bring their firstborn son to the temple in

Jerusalem, where the aged Simeon, who God said would not die until he had seen the Messiah, recognizes Jesus as the prophesied Savior of humankind.

- Massacre of the Innocents and Flight into Egypt King Herod, fearful that a rival king has been born, orders the massacre of all infants in Bethlehem, but an angel warns the Holy Family and they escape to Egypt.
- Dispute in the Temple Joseph and Mary travel to Jerusalem for the feast of Passover (the celebration of the release of the Jews from bondage to the pharaohs of Egypt). Jesus, only 12 years old at the time, engages in learned debate with astonished Jewish scholars in the temple, foretelling his ministry.

PUBLIC MINISTRY

The public-ministry cycle comprises the teachings of Jesus and the miracles he performed.

- Baptism The beginning of Jesus' public ministry is marked by his baptism at age 30 by John the Baptist in the Jordan River, where the dove of the Holy Spirit appears and God's voice is heard proclaiming Jesus as his son.
- Calling of Matthew Jesus summons Matthew, a tax collector, to follow him, and Matthew becomes one of his 12 disciples, or apostles (from the Greek for "messenger"), and later the author of one of the four Gospels.
- **Miracles** In the course of his teaching and travels, Jesus performs many miracles, revealing his divine nature. These include acts of healing and raising the dead, turning water into wine, walking on water and calming storms, and creating wondrous quantities of food. In the miracle of loaves and fishes, for example, Jesus transforms a few loaves of bread and a handful of fishes into enough food to feed several thousand people.
- Delivery of the Keys to Peter The fisherman Peter was one of the first men Jesus summoned as a disciple. Jesus chooses Peter (whose name means "rock") as his successor. He declares that Peter is the rock on which his church will be built and symbolically delivers to Peter the keys to the kingdom of Heaven.
- *Transfiguration* Jesus scales a high mountain and, in the presence of Peter and two other disciples, James and John the Evangelist, is transformed into radiant light. God, speaking from a cloud, discloses that Jesus is his son.
- Cleansing of the Temple Jesus returns to Jerusalem, where he finds money changers and merchants conducting business in the temple. He rebukes them and drives them out of the sacred precinct.

PASSION

The Passion (from Latin *passio*, "suffering") cycle includes the events leading to Jesus' death, Resurrection, and ascent to Heaven.

- *Entry into Jerusalem* On the Sunday before his Crucifixion (Palm Sunday), Jesus rides triumphantly into Jerusalem on a donkey, accompanied by disciples. Crowds of people enthusiastically greet Jesus and place palm fronds in his path.
- Last Supper and Washing of the Disciples' Feet In Jerusalem, Jesus celebrates Passover with his disciples. During this Last Supper, Jesus foretells his imminent betrayal, arrest, and death and invites the disciples to remember him when they eat bread (symbol of his body) and drink wine (his blood). This ritual became the celebration of Mass (Eucharist) in the Christian Church. At the same meal, Jesus sets an example of humility for his apostles by washing their feet.
- Agony in the Garden Jesus goes to the Mount of Olives in the Garden of Gethsemane, where he struggles to overcome his human fear of death by praying for divine strength. The apostles who accompanied him there fall asleep despite his request that they stay awake with him while he prays.
- Betrayal and Arrest One of the disciples, Judas Iscariot, agrees to betray Jesus to the Jewish authorities in return for 30 pieces of silver. Judas identifies Jesus to the soldiers by kissing him, and Jesus is arrested. Later, a remorseful Judas hangs himself from a tree.
- Trials of Jesus and Denial of Peter Jesus is brought before Caiaphas, the Jewish high priest, and is interrogated about his claim to be the Messiah. Meanwhile, the disciple Peter thrice denies knowing Jesus, as Jesus predicted he would. Jesus is then brought before the Roman governor of Judaea, Pontius Pilate, on the charge of treason because he had proclaimed himself King of the Jews. Pilate asks the crowd to choose between freeing Jesus or Barabbas, a murderer. The people choose Barabbas, and the judge condemns Jesus to death. Pilate washes his hands, symbolically relieving himself of responsibility for the mob's decision.
- Flagellation and Mocking The Roman soldiers who hold Jesus captive whip (flagellate) him and mock him by dressing him as King of the Jews and placing a crown of thorns on his head.
- Carrying of the Cross, Raising of the Cross, and Crucifixion The Romans force Jesus to carry the cross on which he will be crucified from Jerusalem to Mount Calvary (Golgotha, the "place of the

- skull," where Adam was buried). He falls three times and his robe is stripped off along the way. Soldiers erect the cross and nail his hands and feet to it. Jesus' mother, John the Evangelist, and Mary Magdalene mourn at the foot of the cross, while soldiers torment Jesus. One of them (the centurion Longinus) stabs Jesus in the side with a spear. After suffering great pain, Jesus dies. The Crucifixion occurred on a Friday, and Christians celebrate the day each year as Good Friday.
- Deposition, Lamentation, and Entombment Two disciples, Joseph of Arimathea and Nicodemus, remove Jesus' body from the cross (the Deposition); sometimes those present at the Crucifixion look on. They take Jesus to the tomb Joseph had purchased for himself, and Joseph, Nicodemus, the Virgin Mary, Saint John the Evangelist, and Mary Magdalene mourn over the dead Jesus (the Lamentation). (When in art the isolated figure of the Virgin Mary cradles her dead son in her lap, it is called a Pietà—Italian for "pity.") In portrayals of the Entombment, his followers lower Jesus into a sarcophagus in the tomb.
- Descent into Limbo During the three days he spends in the tomb, Jesus (after death, Christ) descends into Hell, or Limbo, and triumphantly frees the souls of the righteous, including Adam, Eve, Moses, David, Solomon, and John the Baptist. In Byzantine art, this episode is often labeled Anastasis (Greek, "resurrection"), although the term refers to events preceding Christ's emergence from the tomb and reappearance on earth.
- Resurrection and Three Marys at the Tomb On the third day (Easter Sunday), Christ rises from the dead and leaves the tomb while the guards outside are sleeping. The Virgin Mary, Mary Magdalene, and Mary, the mother of James, visit the tomb, find it empty, and learn from an angel that Christ has been resurrected.
- Noli Me Tangere, Supper at Emmaus, and Doubting of Thomas
 During the 40 days between Christ's Resurrection and his ascent
 to Heaven, he appears on several occasions to his followers. Christ
 warns Mary Magdalene, weeping at his tomb, with the words
 "Don't touch me" (Noli me tangere in Latin), but he tells her to
 inform the apostles of his return. At Emmaus he eats supper with
 two of his astonished disciples. Later, Thomas, who cannot believe
 that Christ has risen, is invited to touch the wound in his side that
 Longinus inflicted at the Crucifixion.
- Ascension On the 40th day, on the Mount of Olives, with his mother and apostles as witnesses, Christ gloriously ascends to Heaven in a cloud.

11-9 Restored cutaway view (top) and plan (bottom) of Old Saint Peter's, Rome, Italy, begun ca. 319 (John Burge). (1) nave, (2) aisle, (3) apse, (4) transept, (5) narthex, (6) atrium.

Erected by Constantine, the first imperial patron of Christianity, this huge church stood on the spot of Saint Peter's grave. The building's plan and elevation resemble those of Roman basilicas, not pagan temples.

OLD SAINT PETER'S The greatest of Constantine's churches in Rome was Old Saint Peter's (FIG. 11-9), probably begun as early as 319. The present-day church (FIG. 24-4), one of the masterpieces of Italian Renaissance and Baroque architecture, is a replacement for the Constantinian structure. Old Saint Peter's stood on the western side of the Tiber River on the spot where Constantine and Pope Sylvester believed Peter, the first apostle and founder of the Christian

community in Rome, had been buried. Excavations in the Roman cemetery beneath the church have in fact revealed a second-century memorial erected in honor of the Christian martyr at his reputed grave. The great Constantinian church, capable of housing 3,000 to 4,000 worshipers at one time, was raised upon a terrace over the ancient cemetery on the irregular slope of the Vatican Hill. It enshrined one of the most hallowed sites in Christendom, second only to the

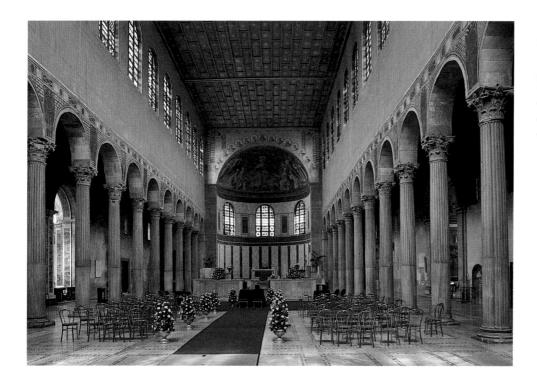

11-10 Interior of Santa Sabina, Rome, Italy, 422–432.

Early Christian basilican churches like Santa Sabina were timber roofed and illuminated by clerestory windows. The Corinthian columns of the nave focused attention on the apse, which framed the altar.

Holy Sepulchre in Jerusalem, the site of Christ's Resurrection. The project also fulfilled the figurative words Christ himself said to the first disciple: "Thou art Peter, and upon this rock I will build my church" (Matt. 16:18). Peter was Rome's first bishop and also the head of the long line of popes that extends to the present.

The plan and elevation of Old Saint Peter's resemble those of Roman basilicas and audience halls, such as the Basilica Ulpia (FIG. 10-43, no. 4) in the Forum of Trajan and Constantine's own Aula Palatina (FIGS. 10-79 and 10-80) at Trier, rather than the design of any Greco-Roman temple. The Christians, understandably, did not want their houses of worship to mimic the look of pagan shrines, but practical considerations also contributed to their shunning the form of pagan temples. Greco-Roman temples housed only the cult statue of the deity. All rituals took place outside at open-air altars. The classical temple, therefore, could have been adapted only with great difficulty as a building that accommodated large numbers of people within it. The Roman basilica, in contrast, was ideally suited as a place for congregation.

Like Roman basilicas, Old Saint Peter's had a wide central nave (FIG. 11-9, no. 1) with flanking aisles (FIG. 11-9, no. 2) and an apse (FIG. 11-9, no. 3) at the end. But unlike pagan basilicas, which sometimes had doorways on one long side, opening onto an aisle (FIG. 10-43, no. 4), all Early Christian basilicas had a pronounced longitudinal axis. Worshipers entered the basilica through a narthex (FIG. 11-9, no. 5), or vestibule. When they emerged in the 300-foot-long nave, they had an unobstructed view of the altar in the apse, framed by the *chancel arch* dividing the nave from the transept (FIG. 11-9, no. 4). The transept, or transverse aisle, an area perpendicular to the nave between the nave and apse, was a special feature of the Constantinian church. It housed the relics of Saint Peter that hordes of pilgrims came to see. (Relics are the body parts, clothing, or objects associated with a saint or Christ himself; see "Pilgrimages and the Cult of Relics," Chapter 17, page 432.) The transept became a standard design element in Western churches only much later, when it also took on, with the nave and apse, the symbolism of the Christian cross. Saint Peter's basilica also had an open colonnaded courtyard in front of the narthex, very much like the forum proper in the Forum of

Trajan (FIG. 10-43, no. 5) but called an *atrium* (FIG. 11-9, no. 6), like the central room in a Roman private house (FIG. 10-16, no. 2).

Unlike pagan temples, Old Saint Peter's was not adorned with lavish exterior sculptures. Its brick walls were as austere as those of the Aula Palatina (Fig. 10-79). Inside, however, were frescoes and mosaics, marble columns (taken from pagan buildings, as was customary at the time), and costly ornaments. The *Liber pontificalis*, or *Book of the Pontiffs* (Popes), compiled by an anonymous sixthcentury author, lists Constantine's gifts to Old Saint Peter's. They included altars, chandeliers, candlesticks, pitchers, goblets, and plates fashioned of gold and silver and sometimes embellished with jewels and pearls, as well as jeweled altar cloths for use in the Mass and gold foil to sheathe the vault of the apse. A huge marble *baldacchino* (domical canopy over an altar), supported by four spiral porphyry columns, marked the spot of Saint Peter's tomb.

SANTA SABINA Some idea of the character of the timberroofed interior of Old Saint Peter's can be gleaned from the interior (FIG. 11-10) of Santa Sabina in Rome. Santa Sabina, built a century later, is a basilican church of much more modest proportions, but it still retains its Early Christian character. The Corinthian columns of its *nave arcade* (a series of arches supported by columns separating the nave from the aisles) produce a steady rhythm that focuses all attention on the chancel arch and the apse, which frame the altar. In Santa Sabina, as in Old Saint Peter's, the nave is drenched with light from the *clerestory* windows piercing the thin upper wall beneath the timber roof. The same light would have illuminated the frescoes and mosaics that commonly adorned the nave and apse of Early Christian churches. Outside, Santa Sabina has plain brick walls. They closely resemble the exterior of Trier's Aula Palatina (FIG. 10-79).

SANTA COSTANZA The rectangular basilican church design was long the favorite of the Western Christian world, but Early Christian architects also adopted another classical architectural type: the *central-plan* building. The type is so named because the building's parts are of equal or almost equal dimensions around the center. Roman central-plan buildings were usually round or polygonal domed structures. Byzantine architects developed this form to

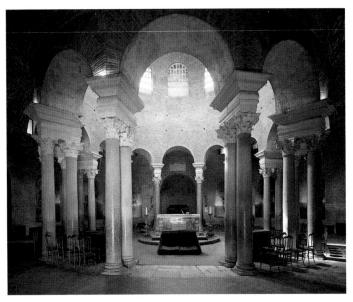

11-11 Interior of Santa Costanza, Rome, Italy, ca. 337-351.

Possibly built as the mausoleum of Constantine's daughter, Santa Costanza later became a church. Its central plan, featuring a domed interior, would become the preferred form for Byzantine churches.

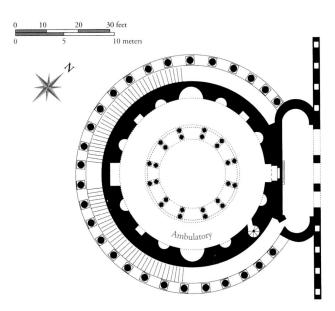

11-12 Plan of Santa Costanza, Rome, Italy, ca. 337-351.

Santa Costanza has antecedents in the domed temples (FIG. 10-51) and mausoleums (FIG. 10-74) of the Romans, but its plan, with 12 pairs of columns and an ambulatory, is unique.

monumental proportions and amplified its theme in numerous ingenious variations (see Chapter 12). In the West, builders generally used the central plan for structures adjacent to the main basilicas, such as mausoleums, baptisteries, and private chapels, rather than for churches, as in the East.

A highly refined example of the central-plan design is Santa Costanza (FIGS. 11-11 and 11-12), built on the northern outskirts of Rome in the mid-fourth century, possibly as the mausoleum for Constantina, the emperor Constantine's daughter. Recent excavations have called the traditional identification into question, but Constantina's monumental porphyry sarcophagus stood in the building, even if the structure was not originally her tomb. The mausoleum, later converted into a church, stood next to

the basilican church of Saint Agnes, who was buried in a nearby catacomb. Santa Costanza has antecedents traceable to the tholos tombs (FIGS. 4-20 and 4-21) of the Mycenaeans, but its immediate predecessors were the domed structures of the Romans, such as the Pantheon (FIGS. 10-49 to 10-51) and, especially, imperial mausoleums such as Diocletian's (FIG. 10-74) at Split. At Santa Costanza, the architect modified the interior design of the Roman buildings to accommodate an *ambulatory*, a ringlike barrel-vaulted corridor separated from the central domed cylinder by a dozen pairs of columns.

Like Early Christian basilicas, Santa Costanza has a severe brick exterior. Its interior was once richly adorned with mosaics, although most are lost. Old and New Testament themes appeared side by side, as in the catacombs and on Early Christian sarcophagi. The Santa

11-13 Detail of vault mosaic in the ambulatory of Santa Costanza, Rome, Italy, ca. 337–351.

The vault mosaics of Santa Costanza depict putti harvesting grapes and producing wine, motifs associated with Bacchus, but for a Christian such scenes brought to mind the Eucharist and Christ's blood.

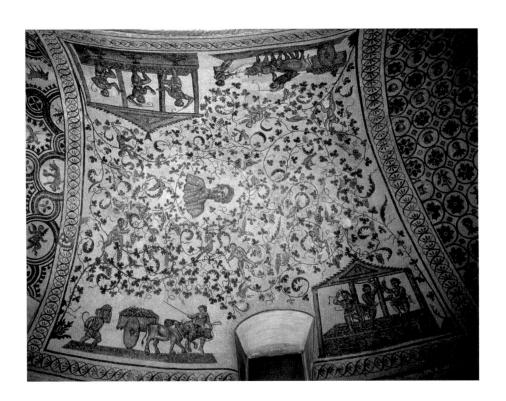

Costanza mosaic program, however, also included subjects common in Roman funerary art, although they were susceptible to a Christian interpretation. In one section (FIG. 11-13) of the mosaic in the ambulatory vault, for example, are scenes of putti harvesting grapes and producing wine. (Similar scenes decorate Constantina's sarcophagus.) A portrait bust is at the center of a rich vine scroll. There is a second bust in another section of the mosaic vault, but both are heavily restored, and the identification of the pair as Constantina and her husband is uncertain. In the Roman world, wine was primarily associated with Bacchus, but for a Christian, the vineyards brought to mind the wine of the Eucharist and the blood of Christ.

SANTA MARIA MAGGIORE Mosaic decoration (see "Mosaics," page 303) played an important role in the interiors of Early Christian buildings of all types. In churches, mosaics not only provided a beautiful setting for the Christian liturgy, but also were vehicles for instructing the congregation about biblical stories and Christian dogma. Old Testament themes are the focus of the extensive fifth-century mosaic cycle in the nave of the basilican church of Santa Maria Maggiore in Rome, the first major church in the West dedicated to the Virgin Mary. Construction of the church began in 432, the year after Mary had been officially designated as the Mother of God (*Theotokos*, "bearer of god" in Greek) at the Council of Ephesus. The council had been convened to debate whether Mary had given birth to the man Jesus or to God as man. It ruled that the divine and human coexisted in Christ and that Mary was indeed the Mother of God.

One of the mosaic panels (FIG. 11-14) in Santa Maria Maggiore dramatically represents the parting of Abraham and his nephew Lot, as set forth in Genesis, the Bible's opening book. Agreeing to disagree, Lot leads his family and followers to the right, toward the city of Sodom, while Abraham heads for Canaan, moving toward a basilica-like building (perhaps symbolizing the Christian Church) on the left. Lot's is the evil choice, and the instruments of the evil (his two daughters) are in front of him. The figure of the yet-unborn Isaac, the instrument of good (and, as noted earlier, a prefiguration of Christ), stands before his father, Abraham.

The cleavage of the two groups is emphatic, and the mosaicist represented each group using a shorthand device that could be called

a "head cluster," which had precedents in antiquity and had a long history in Christian art. The figures engage in a sharp dialogue of glance and gesture. The wide eyes turn in their sockets, and the enlarged hands make broad gestures. This kind of simplified motion, which is characteristic of Late Antique narrative art of both Roman and Christian subject matter, has great power to communicate without ambiguity. But the Abraham and Lot mosaic also reflects the heritage of classical art. The town in the background would not be out of place in a Pompeian mural (FIG. 10-19, left), and the figures themselves are modeled in light and dark, cast shadows, and still loom with massive solidity. Another century had to pass before Western Christian mosaicists portrayed figures entirely as flat images, rather than as three-dimensional bodies, finally rejecting the norms of classical art in favor of a style better suited for a focus on the spiritual instead of the natural world. Early Christian art, like Late Antique Roman art in general, vacillates between these two stylistic poles.

Ravenna

In the decades after the founding in 324 of Constantinople, the New Rome in the East, and the death of Constantine in 337, the pace of Christianization of the Roman Empire quickened. In 380 the emperor Theodosius I issued an edict finally establishing Christianity as the state religion. In 391 he enacted a ban against pagan worship, and in 394 he abolished the Olympic Games, the enduring symbol of the classical world and its values. Theodosius died in 395, and imperial power passed to his two sons, Arcadius, who became Emperor of the East, and Honorius, Emperor of the West. In 404, when the Visigoths, under their king, Alaric, threatened to overrun Italy from the northwest, Honorius moved his capital from Milan to Ravenna, an ancient Roman city (perhaps founded by the Etruscans) near Italy's Adriatic coast, some 80 miles south of Venice. In 410, Rome fell to Alaric, and in 476, Ravenna fell to Odoacer, the first Germanic king of Italy. Odoacer was overthrown in turn by Theodoric, king of the Ostrogoths, who established his capital at Ravenna in 493. Ravenna fell to the Byzantine emperor Justinian in 539, and the subsequent history of the city belongs with that of Byzantium (see Chapter 12).

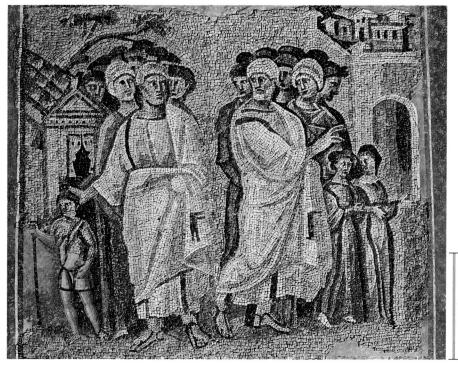

11-14 The parting of Abraham and Lot, nave of Santa Maria Maggiore, Rome, Italy, 432–440. Mosaic, 3' 4" high.

In this mosaic panel representing the Old Testament parting of Abraham and Lot, the artist included the figure of the yet-unborn Isaac because of his importance as a prefiguration of Christ.

11-15 Mausoleum of Galla Placidia, Ravenna, Italy, ca. 425.

This cruciform chapel with a domed crossing is an early example of the combination of central and longitudinal plans. The unadorned brick shell encloses a rich ensemble of mosaics (FIG. 11-1).

MAUSOLEUM OF GALLA PLACIDIA The so-called Mausoleum of Galla Placidia, Honorius's half-sister, is a rather small *cruciform* (cross-shaped) structure (FIG. 11-15) with barrel-vaulted arms and a tower at the *crossing*. Built shortly after 425, almost a quarter century before Galla Placidia's death in 450, it was probably intended as a chapel to the martyred Saint Lawrence. The building was once thought, however, to be Galla Placidia's tomb, hence its name today. Originally, the chapel adjoined the narthex of the now greatly altered palace-church of Santa Croce (Holy Cross), which was also cruci-

form in plan. The chapel's cross arms are of unequal length, so that the building has a longitudinal orientation, unlike the centrally planned Santa Costanza (FIGS. 11-11 and 11-12), but since all four arms are very short, the emphasis is on the tall *crossing tower* with its vault resembling a dome. This small, unassuming building thus represents one of the earliest successful fusions of the two basic Late Antique plans—the longitudinal, used for basilican churches, and the central, used primarily for baptisteries and mausoleums. It introduced, on a small scale, a building type that was to have a long history in church architecture: the longitudinally planned building with a vaulted or domed crossing.

The chapel's unadorned brick shell encloses one of the richest mosaic ensembles (FIG. 11-1) in Early Christian art. Mosaics (see "Mosaics," page 303) cover every square inch of the interior surfaces

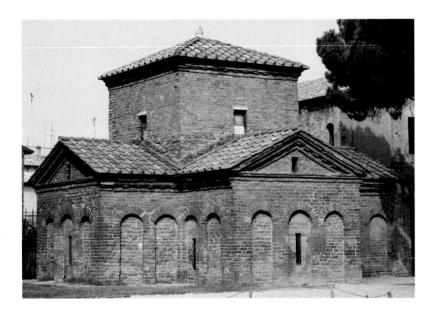

above the marble-faced walls. Garlands and decorative medallions resembling snowflakes on a dark blue ground adorn the barrel vaults of the nave and cross arms. The tower has a large golden cross set against a star-studded sky. Representations of saints and apostles cover the other surfaces. At the end of the nave is a mosaic representing Saint Lawrence next to the gridiron on which he was tortured. The martyred saint carries a cross, suggesting that faith in Christ led to his salvation.

Christ as Good Shepherd is the subject of the lunette (FIG. 11-16) above the entrance. No earlier version of the Good Shepherd is as regal as this one. Instead of carrying a lamb on his shoulders, Jesus sits among his flock, haloed and robed in gold and purple. To his left and right, the sheep are distributed evenly in groups of three. But their arrangement is rather loose and informal, and they

11-16 Christ as the Good Shepherd, mosaic from the entrance wall of the Mausoleum of Galla Placidia, Ravenna, Italy, ca. 425.

Jesus sits among his flock, haloed and robed in gold and purple. The land-scape and the figures, with their cast shadows, are the work of a mosaicist still deeply rooted in the naturalistic classical tradition.

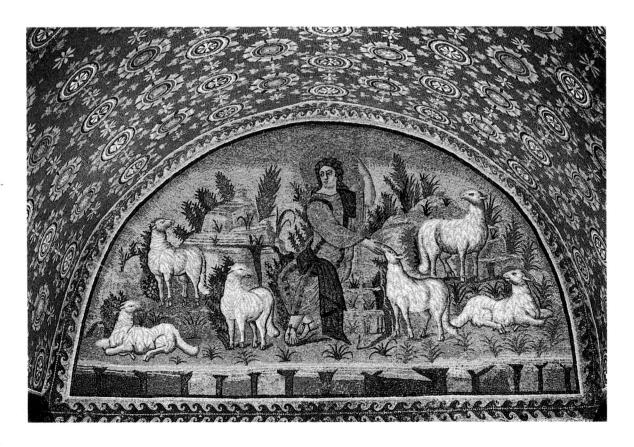

Mosaics

s an art form, *mosaic* had a rather simple and utilitarian beginning, seemingly invented primarily to provide an inexpensive and durable flooring. Originally, small beach pebbles were set, unaltered from their natural form and color, into a thick coat of cement. Artisans soon discovered, however, that the stones could be arranged in decorative patterns. At first, these *pebble mosaics* were uncomplicated and were confined to geometric shapes. Generally, the artists used only black and white stones. Examples of this type, dating to the eighth century BCE, have been found at Gordion in Asia Minor. Eventually, artists arranged the stones to form more complex pictorial designs, and by the fourth century BCE, the technique had developed to a high level of sophistication. Mosaicists depicted elaborate figural scenes using a broad range of colors—yellow, brown, and red in addition to black, white, and gray—and shaded the figures, clothing, and setting to suggest volume. Thin strips of lead provided linear definition (FIG. 5-68).

By the middle of the third century BCE, artists had invented a new kind of mosaic that permitted the best mosaicists to create designs more closely approximating true paintings. The new technique employed *tesserae* (Latin for "cubes" or "dice"). These tiny cut stones gave the artist much greater flexibility because their size and shape could be adjusted at will, eliminating the need for lead strips to indicate contours and interior details. Much more gradual gradations of color also became possible (FIG. 5-70), and mosaicists finally could aspire to rival the achievements of painters.

In Early Christian mosaics (FIGS. 11-1, 11-13, 11-14, and 11-16 to 11-18), the tesserae were usually made of glass, which reflects light and makes the surfaces sparkle. Ancient mosaicists occasionally used glass tesserae, but the Romans preferred opaque marble pieces. Mosaics quickly became the standard means of decorating walls and vaults in Early Christian buildings, although mural paintings were also popular. The mosaics caught the light flooding through the windows in vibrant reflection, producing sharp contrasts and concentrations of color that could focus attention on a composition's central, most relevant features. Mosaics worked in the Early Christian manner were not meant to incorporate the subtle tonal changes a naturalistic painter's approach would require. Color was "placed," not blended. Bright, hard, glittering texture, set within a rigorously simplified pattern, became the rule. For mosaics situated high in an apse or ambulatory vault or over the nave colonnade, far above the observer's head, as in the church of Sant'Apollinare Nuovo (FIG. 11-17) in Ravenna, the painstaking use of tiny tesserae seen in Roman floor and wall mosaics (FIGS. 5-70 and 10-24) would be meaningless. Early Christian mosaics, designed to be seen from a distance, employed larger tesserae. The pieces were also set unevenly so that their surfaces could catch and reflect the light. Artists favored simple designs for optimal legibility. For several centuries, mosaic, in the service of Christian theology, was the medium of some of the supreme masterpieces of medieval art.

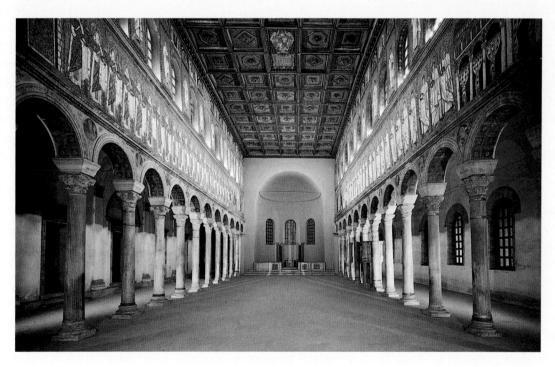

11-17 Interior of Sant'Apollinare Nuovo, Ravenna, Italy, dedicated 504.

Theodoric, king of the Ostrogoths, established his capital at Ravenna in 493. His palace-church features an extensive series of mosaics depicting Old Testament prophets and scenes from the life of Christ.

occupy a carefully described landscape that extends from fore-ground to background beneath a blue sky. As at Santa Maria Maggiore (FIG. 11-14), all the forms have three-dimensional bulk and are still deeply rooted in the classical tradition.

SANT'APOLLINARE NUOVO Around 504, soon after Theodoric settled in Ravenna, he ordered the construction of his own palace-church, a three-aisled basilica (FIG. 11-17) dedicated to

the Savior. In the ninth century, the relics of Saint Apollinaris were transferred to this church. The building has been known since that time as Sant'Apollinare Nuovo.

The rich mosaic decorations of the nave walls are divided into three zones. Only the upper two date from Theodoric's time. Old Testament patriarchs and prophets stand between the clerestory windows. Above them, scenes from Christ's life alternate with decorative panels.

11-18 Miracle of the loaves and fishes, mosaic from the top register of the nave wall (above the clerestory windows in FIG. 11-17) of Sant'Apollinare Nuovo, Ravenna, Italy, ca. 504.

In contrast to Fig. 11-16, Jesus here faces directly toward the viewer. Blue sky has given way to the otherworldly splendor of heavenly gold, the standard background color for medieval mosaics.

The mosaic depicting the miracle of the loaves and fishes (FIG. 11-18) stands in sharp contrast to the 80-year-earlier mosaics of the Mausoleum of Galla Placidia. Jesus, beardless, in the imperial dress of gold and purple, and now distinguished by the cross-inscribed *nimbus* (halo) that signifies his divinity, faces the viewer directly. With extended arms he instructs his disciples to distribute to the great crowd the miraculously increased supply of bread and fish he has produced. This Ravenna artist made no attempt

to supply details of the event. The emphasis is instead on the holy character of it, the spiritual fact that Jesus is performing a miracle by the power of his divinity. The fact of the miracle removes it from the world of time. The presence of almighty power, not anecdotal narrative, is the important aspect of this scene. The mosaicist told the story with the least number of figures necessary to make its meaning explicit, aligning the figures laterally, moving them close to the foreground, and placing them in a shallow picture box. The composition, so different from those in the lunettes of the Mausoleum of Galla Placidia, is similar to that of the Samuel and David mural (FIG. 11-3) in the Dura-Europos synagogue two and a half centuries earlier. This similarity illustrates once again that Early Christian artists inherited both classical naturalism and Late Antique abstraction from Roman art. But the Sant'Apollinare Nuovo mosaic differs from the Dura murals as well as the Galla Placidia mosaics in having a golden background. The landscape setting, which the artist who decorated the Mausoleum of Galla Placidia so explicitly depicted (FIG. 11-16), is here merely a few rocks and bushes that enclose the figure group like parentheses. The blue sky of the physical world has given way to the otherworldly splendor of heavenly gold. The ethereal golden background as well as the weightless figures with their flat, curtainlike garments would soon become the norm in Byzantine art, although even in Byzantium echoes of classical naturalism persisted (see Chapter 12).

LUXURY ARTS

Throughout history, artists have produced so-called "minor arts"—jewelry, metalwork, cameos, ivories, among other "crafts"—alongside the "major arts" of sculpture and painting. Although the terminology seems to suggest a difference in importance or quality, "minor" refers only to size. Indeed, the artists who fashioned jewelry, carved ivories and cameos, and produced gold and silver vessels by casting or hammering (repoussé) employed the costliest materials known. Some of them, for example, Dioscurides, official gem cutter of the emperor Augustus, are among the few Roman artists whose names were recorded. In Late Antiquity and the Middle Ages, the minor arts—more appropriately called "luxury arts"—had high status, and they figure prominently in the history of art through the ages.

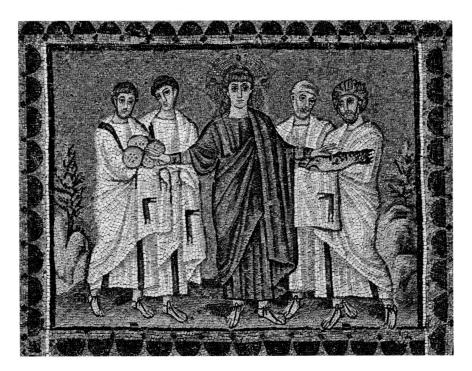

Illuminated Manuscripts

Although few examples survive, illustrated books were popular in the ancient world. The long tradition of placing pictures in manuscripts began in pharaonic Egypt (FIG. 3-36) and continued in Greek and Roman times.

VATICAN VERGIL The oldest preserved painted Greek or Latin manuscript is the Vatican Vergil, which dates from the early fifth century. It originally contained more than 200 pictures illustrating all of Vergil's works. Today only 50 painted pages of the Aeneid and Georgics survive. The manuscript is important not only because of its age. The Vatican Vergil is a prime example of the survival of traditional Roman iconography and of the classical style long after Theodosius banned all pagan cults.

The page illustrated here (FIG. 11-19) includes a section of text from the *Georgics* at the top and a framed illustration below. The poem recounts Vergil's visit to a modest farm near Tarentum (Taranto, in southern Italy) belonging to an old man from Corycus in Asia Minor. In the illustration, the old farmer sits at the left. His rustic farmhouse is in the background, rendered in a three-quarter view. The farmer speaks about the pleasures of the simple life in the country—a recurrent theme in Latin poetry—and on his methods of gardening. His audience is two laborers and, at the far right, Vergil himself in the guise of a farmhand. The style is reminiscent of Pompeian landscapes, with quick touches that suggest space and atmosphere. In fact, the heavy, dark frame has close parallels in the late Pompeian styles of mural painting (FIG. 10-22).

VIENNA GENESIS The oldest well-preserved painted manuscript containing biblical scenes is the early sixth-century Vienna Genesis, so called because of its present location. The book is sumptuous. The pages are fine calfskin dyed with rich purple, the same dye used to give imperial cloth its distinctive color. The scribe used silver ink for the Greek text (see "Medieval Manuscript Illumination," page 305).

Folio 7 (FIG. 11-20) of the *Vienna Genesis* illustrates the story of Rebecca and Eliezer (Gen. 24:15–61). When Isaac, Abraham's son, was 40 years old, his parents sent their servant Eliezer to find a wife for him. Eliezer chose Rebecca, because when he stopped at a well, she was the first woman to draw water for him and his camels. The man-

Medieval Manuscript Illumination

are as medieval books are, they are far more numerous than their ancient predecessors. An important invention during the Early Empire was the codex, which greatly aided the dissemination of manuscripts as well as their preservation. A codex is much like a modern book, composed of separate leaves (folios) enclosed within a cover and bound together at one side. The new format superseded the long manuscript scroll (rotulus) of the Egyptians, Greeks, Etruscans, and Romans. (The Etruscan magistrate Lars Pulena, FIG. 9-15; the philosophers on Roman and Early Christian sarcophagi, FIGS. 10-71 and 11-6; and Christ himself in his role as teacher, FIGS. 11-7 and 11-8, all hold rotuli in their hands.) Much more durable vellum (calfskin) and parchment (lambskin), which provided better surfaces for painting, also replaced the comparatively brittle papyrus used for ancient scrolls. As a result, luxuriousness of ornament became increasingly typical of sacred books in the Middle Ages, and at times the material beauty of the pages with

their illustrations overwhelms the spiritual beauty of the text. Art historians refer to the luxurious painted books produced before the invention of the printing press as *illuminated manuscripts*, from the Latin *illuminare*, meaning "to adorn, ornament, or brighten." The oldest preserved examples (FIGS. 11-19 to 11-21) date to the fifth and sixth centuries.

Illuminated books were costly to produce and involved many steps. Numerous artisans performed very specialized tasks, beginning with the curing and cutting (and sometimes the dyeing) of the animal skin, followed by the sketching of lines to guide the scribe and to set aside spaces for illumination, the lettering of the text, the addition of paintings, and finally the binding of the pages and attachment of covers, buckles, and clasps. The covers could be even more sumptuous than the book itself. Many covers survive that are fashioned of gold and decorated with jewels, ivory carvings, and repoussé reliefs (FIG. 16-16).

11-19 The old farmer of Corycus, folio 7 verso of the *Vatican Vergil*, ca. 400–420. Tempera on parchment, $1'\frac{1}{2}''\times 1'$. Biblioteca Apostolica Vaticana, Rome.

The earliest surviving painted Latin manuscript is a collection of the poet Vergil's works. This page includes part of the text of the *Georgics* and a pastoral scene reminiscent of Roman landscape murals.

11-20 Rebecca and Eliezer at the well, folio 7 recto of the *Vienna Genesis*, early sixth century. Tempera, gold, and silver on purple vellum, $1'\frac{1}{4}'' \times 9\frac{1}{4}''$. Österreichische Nationalbibliothek, Vienna.

This sumptuously painted book is the oldest well-preserved manuscript containing biblical scenes. Two episodes of the Rebecca story appear in a single setting filled with classical motifs.

uscript painter presented two episodes of the story within a single frame. In the first episode, at the left, Rebecca leaves the city of Nahor to fetch water from the well. In the second episode, she offers water to Eliezer and his camels, while one of them already laps water from the well. The artist painted Nahor as a walled city seen from above, like

the cityscapes in the Santa Maria Maggiore mosaics (FIG. 11-14) and innumerable earlier Roman representations of cities in painting and relief sculpture. Rebecca walks to the well along the colonnaded avenue of a Roman city. A seminude female personification of a spring is the source of the well water. These are further reminders of

the persistence of classical motifs and stylistic modes in Early Christian art. Contemporaneous with, but radically different from, the mosaic panels (FIG. 11-17) of Sant'Apollinare Nuovo, the *Vienna Genesis* incorporates many anecdotal details, such as the drinking camel and Rebecca bracing herself with her raised left foot on the rim of the well as she tips up her jug for Eliezer. Nonetheless, the figures are seen against a blank landscape except for the miniature city and the road to the well. As at Ravenna, everything necessary for bare narrative is present and nothing else.

ROSSANO GOSPELS Closely related to the Vienna Genesis is another early-sixth-century Greek manuscript, the Rossano Gospels, the earliest preserved illuminated book that contains illustrations of the New Testament. By this time a canon of New Testament iconography had been fairly well established. As in the Vienna Genesis, the text of the Rossano Gospels is in silver on purple vellum. The Rossano artist, however, attempted with considerable success to harmonize the colors with the purple background. The subject of folio 8 (FIG. 11-21) is the appearance of Jesus before Pilate, who asks the Jews to choose between Jesus and Barabbas (Matt. 27: 2–26). The vividly gesturing figures are on two levels separated by a simple ground line. In the upper level, Pilate presides over the tribunal. He sits on an elevated dais, following a long-established pattern in Roman art (FIG. 10-76). The people form an arch around

Pilate (the artist may have based the composition on a painting in an apse) and demand the death of Jesus, while a court scribe records the proceedings. Jesus (here a bearded adult, as soon became the norm for medieval and later depictions of Christ) and the bound Barabbas appear in the lower level. The painter explicitly labeled Barabbas to avoid any possible confusion so that the picture would be as readable as the text. Pilate on his magistrate's dais, flanked by painted imperial portraits, and the haloed Christ needed no further identification.

Ivory Carving

Among the other important luxury arts of Late Antiquity was ivory carving, which has an even longer history in the ancient world than manuscript illustration (see "Ivory Carving," page 307).

CRUCIFIXION OF CHRIST A century before the pages of the *Rossano Gospels* were illuminated with scenes from the Passion cycle, a Roman or northern Italian sculptor produced a series of ivory plaques for a small box that dramatically recount the suffering and triumph of Christ. The narrative on the box begins with Pilate washing his hands, Jesus carrying the cross on the road to Calvary, and Peter denying Jesus, all compressed into a single panel.

The next plaque in the sequence (FIG. 11-22) shows, at the left, Judas hanging from a tree with his open bag of silver dumped on the

11-21 Christ before Pilate, folio 8 verso of the *Rossano Gospels*, early sixth century. Tempera on purple vellum, $11'' \times 10\frac{1}{4}''$. Museo Diocesano d'Arte Sacra, Rossano.

The sources for medieval manuscript illustrations were diverse. The way the people form an arch around Pilate on this page suggests that the composition derives from a painting in a church apse.

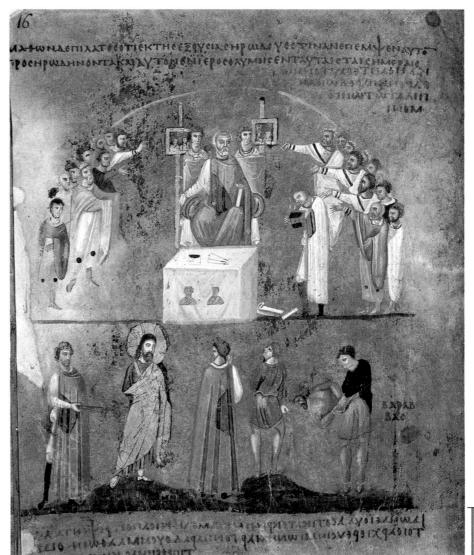

Ivory Carving

vory has been prized since the earliest times, when Ice Age artists fashioned the tusks of European mammoths into pendants, beads, and other items for body adornment, and, occasionally, statuettes (Fig. 1-4). The primary ivory sources in the historical period have been the elephants of India and especially Africa, where the species is larger than the Asian counterpart and the tusks longer, heavier, and of finer grain. African elephant tusks 5 to 6 feet in length and weighing 10 pounds are common, but tusks of male elephants can be 10 feet long or more and weigh more than 100 pounds. Carved ivories are familiar, if precious, finds at Mesopotamian and Egyptian sites, and ivory objects were manufactured and coveted in the prehistoric Aegean and throughout the classical world. Most frequently employed then for household objects, small votive offerings, and gifts to the deceased, ivory also could be used for grandiose statues such as Phidias's *Athena Parthenos* (Fig. 5-46).

The Greeks and Romans admired ivory both for its beauty and because of its exotic origin. Elephant tusks were costly imports, and Roman generals proudly displayed them in triumphal processions when they paraded the spoils of war before the people. (In FIG. 12-14

a barbarian brings tribute to a Byzantine emperor in the form of an ivory tusk.)

Adding to the expense of the material itself was the fact that only highly skilled artisans were capable of working in ivory. The tusks were very hard and of irregular shape, and the ivory workers needed a full toolbox of saws, chisels, knives, files, and gravers close at hand to cut the tusks into blocks for statuettes or thin plaques decorated with relief figures and ornament.

In Late Antiquity and the early medieval period, ivory was employed most frequently for book covers, chests and boxes (FIG. 11-22), and diptychs (FIGS. 11-23 and 12-15). A *diptych* is a pair of hinged tablets, usually of wood, with a wax layer on the inner sides for writing letters and other documents. (Both the court scribe recording Jesus' trial in the *Rossano Gospels*, FIG. 11-21, and the woman in a painted portrait from Pompeii, FIG. 10-25, hold wooden diptychs.) Diptychs fashioned out of ivory generally were created for ceremonial and official purposes—for example, to announce the election of a consul or a marriage between two wealthy families or to commemorate the death of an elevated member of society.

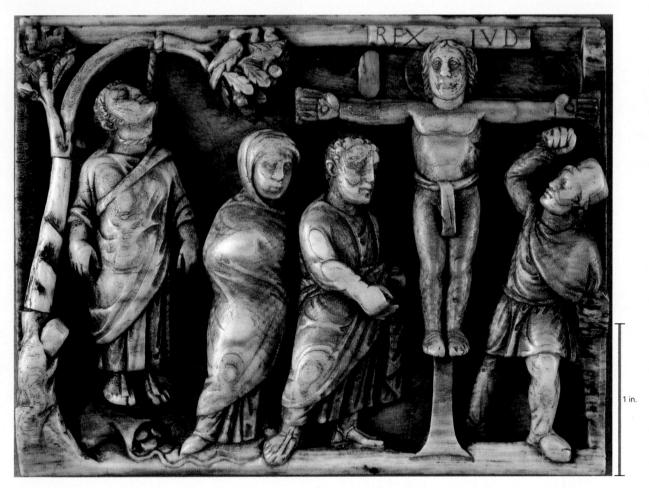

11-22 Suicide of Judas and Crucifixion of Christ, plaque from a box, ca. 420. Ivory, $3'' \times 3\frac{7}{8}''$. British Museum, London.

This plaque from a luxurious ivory box is the first known representation of the Crucifixion. Christ is a beardless youth who experiences no pain. At the left, Judas, his betrayer, hangs himself.

11-23 Woman sacrificing at an altar, right leaf of the diptych of the Nicomachi and the Symmachi, ca. 400. Ivory, $11\frac{3}{4}'' \times 5\frac{1}{2}''$. Victoria & Albert Museum, London.

Even after Theodosius banned all pagan cults in 391, some Roman families still practiced the ancient rites. The sculptor who carved this ivory plaque also carried on the classical artistic style.

ground beneath his feet. The Crucifixion is at the right. The Virgin Mary and Joseph of Arimathea are to the left of the cross. On the other side Longinus thrusts his spear into the side of the "King of the Jews" (*REX IVD* is inscribed above Jesus' head). The two remaining panels show two Marys and two soldiers at the open doors of a tomb with an empty coffin within and the doubting Thomas touching the wound of the risen Christ.

The series is one of the oldest cycles of Passion scenes preserved today. The artist who fashioned the ivory box helped establish the iconographical types for medieval narratives of Christ's life. On these plaques, Jesus always appears as a beardless youth. In the Crucifixion (FIG. 11-22), the earliest known rendition of the subject in the history of art, he exhibits a superhuman imperviousness to pain. The Savior is a muscular, nearly nude, heroic figure who appears virtually weightless. He does not *hang* from the cross; he is *displayed* on it, a divine being with open eyes who has conquered death. The striking contrast between the powerful frontal, serenely calm Jesus on the cross and the limp hanging body of his betrayer with his snapped neck is highly effective, both visually and symbolically.

DIPTYCH OF THE SYMMACHI Although after Constantine all the most important architectural projects in Italy were Christian in character, not everyone converted to the new religion, even after Theodosius closed all temples and banned all pagan cults in 391.

An ivory plaque (FIG. 11-23), probably produced in Rome around 400, strikingly exhibits the endurance of pagan themes and patrons and of the classical style. The ivory, one of a pair of leaves of a diptych, may commemorate either the marriage of members of two powerful Roman families of the senatorial class, the Nicomachi and the Symmachi, or the passing within a decade of two prominent male members of the two families. Whether or not the diptych relates to any specific event(s), the Nicomachi and the Symmachi here ostentatiously reaffirmed their faith in the old pagan gods. Certainly, the families favored the aesthetic ideals of the classical past, as exemplified by such works as the stately processional friezes of the Greek Parthenon (FIG. 5-50) and the Roman Ara Pacis (FIG. 10-31).

The leaf inscribed "of the Symmachi" (FIG. 11-23) represents a woman sacrificing at an altar in front of a tree. She wears ivy in her hair and seems to be celebrating the rites of Bacchus, although scholars dispute the identity of the divinity honored. The other diptych panel, inscribed "of the Nicomachi," also shows a woman at an open-air altar. On both panels, the precise yet fluent and graceful lines, the relaxed poses, and the mood of spiritual serenity reveal an artist who practiced within a still-vital classical tradition that idealized human beauty as its central focus. The great senatorial magnates of Rome, who resisted the empire-wide imposition of the Christian faith at the end of the fourth century, probably deliberately sustained the classical tradition.

Despite the widespread adoption during the third and fourth centuries of the new non-naturalistic Late Antique aesthetic featur-

ing wafer-thin frontal figures, the classical tradition in art lived on and was never fully extinguished in the Middle Ages. Classical art survived in intermittent revivals, renovations, and restorations side by side and in contrast with the opposing nonclassical medieval styles until it rose to dominance once again in the Renaissance.

LATE ANTIQUITY

THIRD CENTURY CE

- Christ was crucified ca. 29, but very little Christian art or architecture survives from the first centuries of Christianity. "Early Christian art" means the earliest art of Christian content, not the art of Christians at the time of Jesus.
- The Second Commandment prohibition against graven images once led scholars to think that the Jews of the Roman Empire had no figural art, but the synagogue at Dura-Europos contains biblical mural paintings.
- Excavators have also uncovered the remains of a Christian community house of the mid-third century at Dura-Europos.
- At about the same time, sarcophagi with a mixture of Old and New Testament scenes began to appear.

Synagogue, Dura-Europos, ca. 245–256

Sarcophagus with Old and New Testament scenes, ca. 270

CHRISTIAN ART UNDER CONSTANTINE, 306-337

- Constantine's Edict of Milan of 313 granted Christianity legal status equal or superior to paganism. The emperor was the first great patron of Christian art and built the first churches in Rome, including Old Saint Peter's.
- In a Christian ceremony, Constantine dedicated Constantinople as the new capital of the Roman Empire in 330. He was baptized on his deathbed in 337.
- Early Christian artists produced mural and ceiling paintings in the catacombs and sarcophagi depicting Old and New Testament stories in great numbers.

Catacomb of Saints Peter and Marcellinus, early fourth century

CHRISTIAN ART, 337-526

- The emperor Theodosius I (r. 379–395) proclaimed Christianity the official religion of the Roman Empire in 380 and banned pagan worship in 391.
- Honorius (r. 395–423) moved the capital of his Western Roman Empire to Ravenna in 404. Rome fell to the Visigothic king Alaric in 410.
- Mosaics became a major vehicle for the depiction of Christian themes in churches. Extensive mosaic cycles are preserved in Santa Maria Maggiore in Rome and in Sant'Apollinare Nuovo in Ravenna.
- The first manuscripts with illustrations of the Old and New Testaments, for example, the Vienna Genesis, date to the early sixth century. Illuminated manuscripts would become one of the major art forms of the Middle Ages.

Sant' Apollinare Nuovo, Ravenna, 504

Vienna Genesis, early sixth century

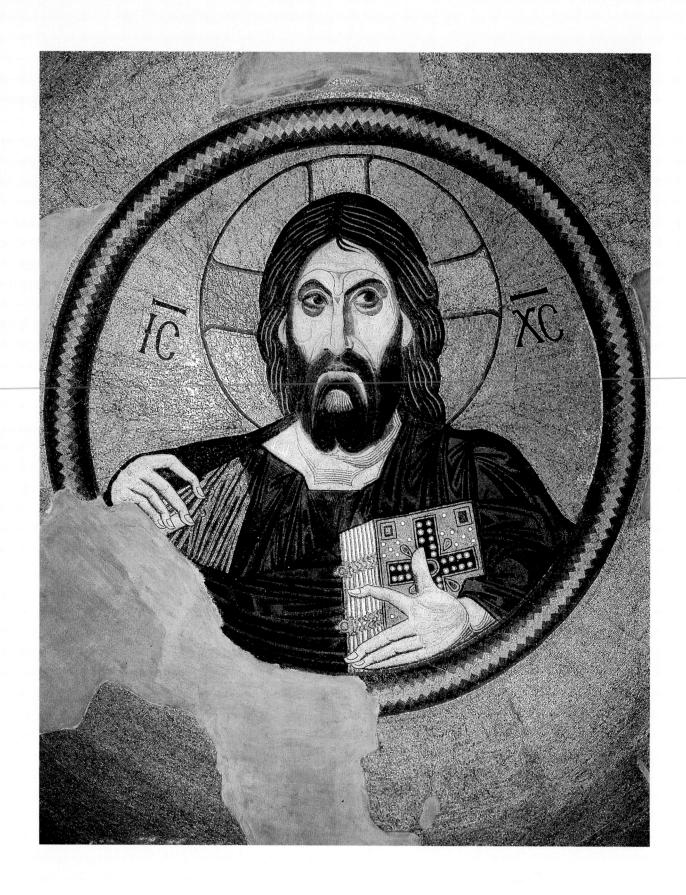

12-1 Christ as Pantokrator, dome mosaic in the Church of the Dormition, Daphni, Greece, ca. 1090–1100.

This dome mosaic of Christ as Last Judge of humankind is like a gigantic Byzantine icon hovering dramatically in space, connecting the awestruck worshiper below with Heaven through Christ.

BYZANTIUM

When Constantine I founded a "New Rome" in the East in 324 on the site of the ancient Greek city of Byzantium and called it Constantinople in honor of himself, he legitimately could claim to be ruler of a united Roman Empire. But when Theodosius I (r. 379–395) died, he bequeathed the Empire to his two sons, Arcadius, the elder, who became Emperor of the East, and Honorius, who became Emperor of the West. The Emperor of the East ruled from Constantinople. After the sack of Rome in 410, Honorius moved the western capital to Milan and later to Ravenna. Though not formally codified, Theodosius's division of the Empire (which paralleled Diocletian's century-earlier division of administrative responsibility) became permanent. Centralized government soon disintegrated in the western half and gave way to warring kingdoms (see Chapter 16). The eastern half of the Roman Empire, only loosely connected by religion to the West and with only minor territorial holdings there, had a long and complex history of its own. Centered at New Rome, the Eastern Christian Empire remained a cultural and political entity for a millennium, until the last of a long line of Eastern Roman emperors, ironically named Constantine XI, died at Constantinople in 1453, defending it in vain against the Ottoman Turks.

Historians refer to that Eastern Christian Roman Empire as Byzantium (MAP 12-1), employing Constantinople's original name, and use the term *Byzantine* to identify whatever pertains to Byzantium—its territory, its history, and its culture. The Byzantine emperors, however, did not use these terms to define themselves. They called their empire Rome and themselves Romans. Though they spoke Greek and not Latin, the Eastern Roman emperors never relinquished their claim as the legitimate successors to the ancient Roman emperors. During the long course of its history, Byzantium was the Christian buffer against the expansion of Islam into central and northern Europe, and its cultural influence was felt repeatedly in Europe throughout the Middle Ages. Byzantium Christianized the Slavic peoples of the Balkans and of Russia, giving them its Orthodox religion and alphabet, its literary culture, and its art and architecture. Byzantium's collapse in 1453 brought the Ottoman Empire into Europe as far as the Danube River, but Constantinople's fall made an impact even farther to the west. The westward flight of Byzantine scholars from the Rome of the East introduced the study of classical Greek to Italy and helped inspire there the new consciousness of antiquity that historians call the Renaissance.

MAP 12-1 The Byzantine Empire at the death of Justinian in 565.

Constantine recognized Christianity at the beginning of the fourth century, Theodosius established it as the Roman Empire's official religion at the end of the fourth century, and Justinian, in the sixth century, proclaimed it New Rome's only lawful religion. By that time it was not simply the Christian religion but the Orthodox Christian doctrine that the Byzantine emperor asserted as the only permissible creed for his subjects. In Orthodox Christianity, the central article of faith is the equality of the three aspects of the Trinity of Father, Son, and Holy Spirit (as stated in Roman Catholic, Protestant, and Eastern Orthodox creeds today). All other versions of Christianity were heresies, especially the Arian, which asserted that the Father and Son were distinct entities and that the Father created the Son and therefore Christ was not equal to God. Also classified as a heresy was the Monophysite view that Christ had only one nature, which was divine, contrary to both the Orthodox and Arian belief that Christ had a dual divine-human nature. Justinian considered it his first duty not only to stamp out the few surviving pagan cults but also to crush all those who professed any Christian doctrine other than the Orthodox.

Art historians divide the history of Byzantine art into the three periods of its greatest glory, sometimes referred to as "golden ages." The first, Early Byzantine, extends from the accession of Justinian in 527 to the onset of *iconoclasm* (the destruction of images used in religious worship) under Leo III in 726. The Middle Byzantine period begins with the renunciation of iconoclasm in 843 and ends with the western Crusaders' occupation of Constantinople in 1204. Late Byzantine corresponds to the two centuries after the Byzantines recaptured Constantinople in 1261 until its final loss in 1453 to the Ottoman Turks and the conversion of many churches to mosques (see Chapter 13).

EARLY BYZANTINE ART

The emperor Justinian (r. 527–565) briefly restored much of the Roman Empire's power and extent (MAP 12-1). His generals, Belisarius and Narses, drove the Ostrogoths out of Italy, expelled the Vandals from the African provinces, routed the Bulgars on the northern frontier, and held the Sasanians at bay on the eastern borders. At home, the emperor quelled a dangerous rebellion in 532 of political and religious factions in the city (the Nika revolt), and Orthodoxy triumphed over the Monophysite heresy. Justinian also supervised the codification of Roman law in a great work known as the Corpus juris civilis (Code of Civil Law), which became the foundation of the law systems of many modern European nations. Justinian could claim, with considerable justification, to have revived the glory of "Old Rome" in New Rome. Under Justinian, Byzantine art emerged as a recognizably novel and distinctive style, leaving behind the uncertainties and hesitations of Early Christian artistic experiment. Though still reflecting its sources in Late Antique art, it definitively expressed, with a new independence and power of invention, the unique character of the Eastern Christian culture centered at Constantinople.

Architecture and Mosaics

In Constantinople alone, Justinian built or restored more than 30 churches of the Orthodox faith, and his activities as builder extended throughout the Byzantine Empire. The historian of his reign, Procopius, declared that the emperor's ambitious building program was an obsession that cost his subjects dearly in taxation. But his grand monuments defined the Byzantine style in architecture forever after.

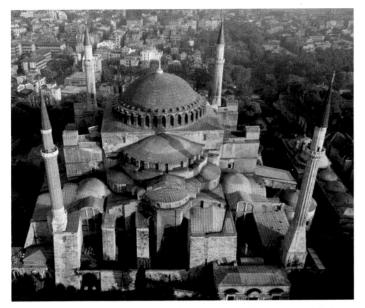

12-2 Anthemius of Tralles and Isidorus of Miletus, aerial view of Hagia Sophia (looking north), Constantinople (Istanbul), Turkey, 532-537.

The reign of Justinian marks the beginning of the first golden age of Byzantine art. Hagia Sophia was the most magnificent of the more than 30 churches that Justinian built or restored in Constantinople alone.

HAGIA SOPHIA The most important monument of Early Byzantine art is Hagia Sophia (FIG. 12-2), the Church of Holy Wisdom, in Constantinople. Anthemius of Tralles and Isidorus of MILETUS, a mathematician and a physicist—neither man an architect in the modern sense of the word-designed and built the church for Justinian between 532 and 537. They began work immediately after fire destroyed an earlier church on the site during the Nika riot in January 532. Justinian intended the new church to rival all other churches ever built and even to surpass in scale and magnificence the Temple of Solomon in Jerusalem. The result was Byzantium's grandest building and one of the supreme accomplishments of world architecture.

Hagia Sophia's dimensions are formidable for any structure not built of steel. In plan (FIG. 12-3, top), it is about 270 feet long and 240 feet wide. The dome is 108 feet in diameter, and its crown rises some 180 feet above the pavement (FIG. 12-3, bottom). (The first dome collapsed in 558. Its replacement required repair in the 9th and 14th centuries. The present dome is greater in height and more

12-3 Anthemius of Tralles and ISIDORUS OF MILETUS, plan (top) and restored cutaway view (bottom) of Hagia Sophia, Constantinople (Istanbul), Turkey, 532-537 (John Burge).

In Hagia Sophia, Justinian's architects succeeded in fusing two previously independent architectural traditions: the vertically oriented central-plan building and the longitudinally oriented basilica.

stable than the original.) In scale, Hagia Sophia rivals the architectural wonders of Rome: the Pantheon, the Baths of Caracalla, and the Basilica of Constantine (see Chapter 10). In exterior view (FIG. 12-2), the great dome dominates the structure, but the building's present external aspects are much changed from their original appearance. Huge buttresses were added to the Justinianic design, and after the Ottoman conquest of 1453, when Hagia Sophia became a mosque, the Turks constructed four towering minarets. The building, secularized in the 20th century, is now a museum.

The characteristic Byzantine plainness and unpretentiousness of the exterior (which in this case also disguise the massive scale) scarcely prepare visitors for the building's interior (FIG. 12-4). A poet and member of Justinian's court, Paul the Silentiary (an usher responsible for maintaining silence in the palace), vividly described the original magnificence of Hagia Sophia's interior:

Who . . . shall sing the marble meadows gathered upon the mighty walls and spreading pavement.... [There is stone] from the green flanks of Carystus [and] the speckled Phrygian stone, sometimes rosy mixed with white, sometimes gleaming with purple and silver

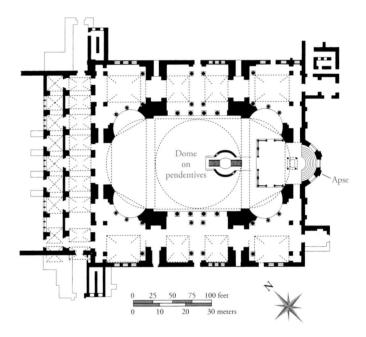

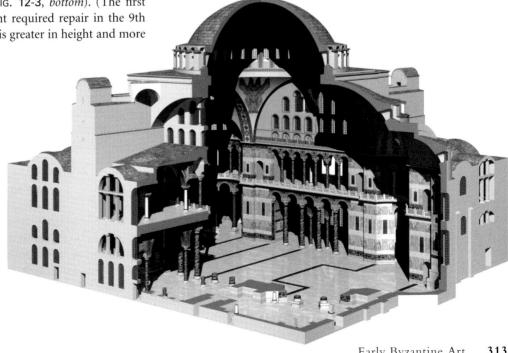

12-4 Anthemius of Tralles and Isidorus of Miletus, interior of Hagia Sophia (looking southwest), Constantinople (Istanbul), Turkey, 532-537.

Pendentive construction made possible Hagia Sophia's lofty dome, which seems to ride on a halo of light. A contemporary said the dome seemed to be suspended by "a golden chain from Heaven."

flowers. There is a wealth of porphyry stone, too, besprinkled with little bright stars. . . . You may see the bright green stone of Laconia and the glittering marble with wavy veins found in the deep gullies of the Iasian peaks, exhibiting slanting streaks of blood-red and livid white; the pale yellow with swirling red from the Lydian headland; the glittering crocus-like golden stone [of Libya]; . . . glittering [Celtic] black [with] here and there an abundance of milk; the pale onyx with glint of precious metal; and [Thessalian marble] in parts vivid green not unlike emerald. . . . It has spots resembling snow next to flashes of black so that in one stone various beauties mingle. \(^1\)

The feature that distinguishes Hagia Sophia from equally lavish Roman buildings such as the Pantheon (Fig. 10-51) is the special mystical quality of the light that floods the interior (Fig. 12-4). The soaring canopy-like dome that dominates the inside as well as the outside of the church rides on a halo of light from windows in the dome's base. Visitors to Hagia Sophia from Justinian's time to today have been struck by the light within the church and its effect on the human spirit. The 40 windows at the base of the dome create the illusion that the dome is resting on the light that pours through them. Procopius, who wrote at the emperor's request a treatise on his ambitious building program, observed that the dome looked as if it were suspended by "a golden chain from Heaven." Said he: "You might say that the space is not illuminated by the sun from the outside, but that the radiance is generated within, so great an abundance of light bathes this shrine all around."

Paul the Silentiary compared the dome to "the firmament which rests on air" and described the vaulting as covered with "gilded tesserae from which a glittering stream of golden rays pours abundantly and strikes men's eyes with irresistible force. It is as if one were gazing at the midday sun in spring." Thus, Hagia Sophia has a vastness of space shot through with light, and a central dome that appears to be supported by the light it admits. Light is the mystical element—light that glitters in the mosaics, shines forth from the marble-clad walls and floors, and pervades and defines spaces that, in themselves, seem to escape definition. Light seems to dissolve material substance and transform it into an abstract spiritual vision. Pseudo-Dionysius, perhaps the most influential mystic philosopher of the age, wrote in *The Divine Names*: "Light comes from the Good and . . . light is the visual image of God." 4

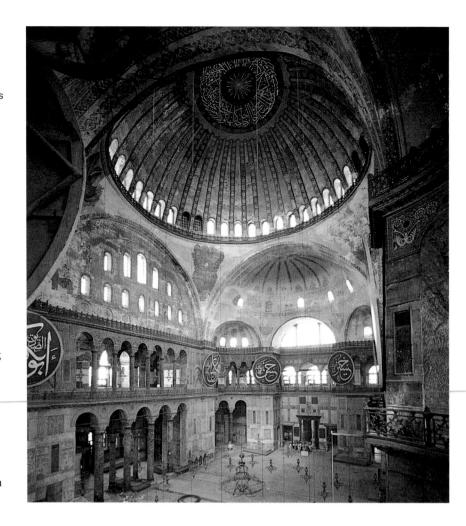

PENDENTIVES To achieve this illusion of a floating "dome of Heaven," Justinian's architects used *pendentives* (see "Pendentives and Squinches," page 315) to transfer the weight from the great dome to the piers beneath, rather than to the walls. With pendentives (FIG. 12-5, *left*), not only could the space beneath the dome be unobstructed but scores of windows also could puncture the walls themselves. Pendentives created the impression of a dome suspended above, not held up by, walls. Experts today can explain the technical virtuosity of Anthemius and Isidorus, but it remained a mystery to their contemporaries. Procopius communicated the sense of wonderment experienced by those who entered Justinian's great church: "No matter how much they concentrate their attention on this and that, and examine everything with contracted eyebrows, they are unable to understand the craftsmanship and always depart from there amazed by the perplexing spectacle." 5

By placing a hemispherical dome on a square base instead of on a circular base, as in the Pantheon, Anthemius and Isidorus succeeded in fusing two previously independent and seemingly mutually exclusive architectural traditions: the vertically oriented centralplan building and the longitudinally oriented basilica. Hagia Sophia is, in essence, a domed basilica (FIG. 12-3)—a uniquely successful conclusion to several centuries of experimentation in Christian church architecture. However, the thrusts of the pendentive construction at Hagia Sophia made external buttresses necessary, as well as huge internal northern and southern wall piers and eastern and western half-domes (FIG. 12-4). The semidomes' thrusts descend, in turn, into still smaller half-domes surmounting columned exedrae that give a curving flow to the design.

Pendentives and Squinches

erhaps the most characteristic feature of Byzantine architecture is the placement of a dome, which is circular at its base, over a square, as in the Justinianic church of Hagia Sophia (FIGS. 12-2 to 12-4) and countless later structures (for example, FIGS. 12-22 and 12-24). Two structural devices that are hallmarks of Byzantine engineering made this feat possible: *pendentives* and *squinches*.

In pendentive construction (from the Latin *pendere*, "to hang") a dome rests on what is, in effect, a second, larger dome (FIG. 12-5, *left*). The top portion and four segments around the rim of the larger dome are omitted so that four curved triangles, or pendentives, are formed. The pendentives join to form a ring and four arches whose planes bound a square. The weight of the dome is thus transferred not to the walls but rather through the pendentives and arches to the four piers from which the arches spring. The first use of pendentives on a monumental scale was in Hagia Sophia (FIG. 12-4) in the mid-sixth century, although Near Eastern architects had experimented with them earlier. In Roman and Early Christian central-plan buildings, such as the Pantheon (FIGS. 10-50 and 10-51) and Santa Costanza (FIG. 11-11), the domes spring directly from the circular top of a cylinder (FIG. 10-6*d*).

The pendentive system is a dynamic solution to the problem of setting a round dome over a square. The device made possible a union of centralized and longitudinal or basilican structures. A similar effect can be achieved using squinches (FIG. 12-5, *right*)—arches, corbels, or lintels—that bridge the corners of the supporting walls

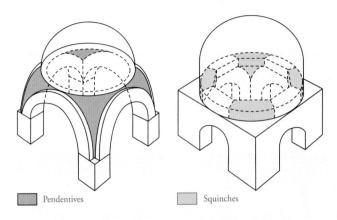

12-5 Dome on pendentives (left) and on squinches (right).

Pendentives (triangular sections of a sphere) make it possible to place a dome on a ring over a square. Squinches achieve the same goal by bridging the corners of the square to form an octagonal base.

and form an octagon inscribed within a square (FIG. 12-22). To achieve even greater height, a builder can rest a dome on a cylindrical drum that in turn rests on either pendentives or squinches, but the principle of supporting a dome over a square is the same.

The diverse vistas and screenlike ornamented surfaces mask the structural lines. The columnar arcades of the nave and second-story galleries have no real structural function. Like the walls they pierce, they are only part of a fragile "fill" between the huge piers. Structurally, although Hagia Sophia may seem Roman in its great scale and majesty, it does not have Roman organization of its masses. The very fact that the "walls" in Hagia Sophia are actually concealed (and barely adequate) piers indicates that the architects sought Roman monumentality as an *effect* and did not design the building according to Roman principles. Using brick in place of concrete marked a further departure from Roman practice and characterizes Byzantine architecture as a distinctive structural style. Hagia Sophia's eight great supporting piers are ashlar masonry, but the screen walls are brick, as are the vaults of the aisles and galleries and the dome and semicircular half-domes.

The ingenious design of Hagia Sophia provided the illumination and the setting for the solemn liturgy of the Orthodox faith. Through the large windows along the rim of the great dome, light poured down upon the interior's jeweled splendor, where priests staged the sacred spectacle. Sung by clerical choirs, the Orthodox equivalent of the Latin Mass celebrated the sacrament of the Eucharist at the altar in the apsidal sanctuary, in spiritual reenactment of Jesus' Crucifixion. Processions of chanting priests, accompanying the patriarch (archbishop) of Constantinople, moved slowly to and from the sanctuary and the vast nave. The gorgeous array of their vestments rivaled the interior's polychrome marbles; finely wrought, gleaming candlesticks and candelabra; the illuminated books bound in gold or ivory and inlaid with jewels and enamels; and the crosses, sacred vessels,

and processional banners. Each feature, with its great richness of texture and color, glowing in shafts of light from the dome, contributed to the majestic ambience of Justinian's great church.

The nave of Hagia Sophia was reserved for the clergy. The laity, segregated by sex, were confined to the shadows of the aisles and galleries, restrained in most places by marble parapets. The complex spatial arrangement allowed only partial views of the brilliant ceremony. The emperor was the only layperson privileged to enter the sanctuary. When he participated with the patriarch in the liturgical drama, standing at the pulpit beneath the great dome, his rule was again sanctified and his person exalted. Church and state were symbolically made one. The church building was then the earthly image of the court of Heaven, its light the image of God and God's holy wisdom.

At Hagia Sophia, the intricate logic of Greek theology, the ambitious scale of Rome, the vaulting tradition of the Near East, and the mysticism of Eastern Christianity combined to create a monument that is at once a summation of antiquity and a positive assertion of the triumph of Christian faith.

RAVENNA In 493, Theodoric, the Ostrogoths' greatest king, chose the Italian city of Ravenna as the capital of his kingdom, which encompassed much of the Balkans and all of Italy (see Chapter 11). During the short history of Theodoric's unfortunate successors, the importance of the city declined. But in 539, Justinian's general Belisarius captured Ravenna, initiating the third and most important stage of the city's history. Ravenna remained the Eastern Roman Empire's foothold in Italy for two centuries, until the Lombards and

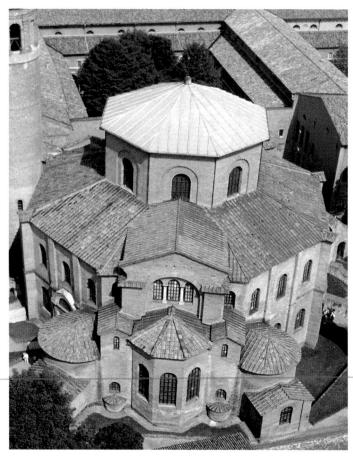

12-6 Aerial view of San Vitale (looking northwest), Ravenna, Italy, 526–547.

Justinian's general Belisarius captured Ravenna from the Ostrogoths. The city became the seat of Byzantine dominion in Italy. San Vitale honored Saint Vitalis, who was martyred at Ravenna.

then the Franks overtook it. During Justinian's reign, Ravenna enjoyed its greatest cultural and economic prosperity—at a time when repeated sieges, conquests, and sackings threatened the "eternal city" of Rome with extinction. As the seat of Byzantine dominion in Italy, Ravenna and its culture became an extension of Constantinople. Its art, even more than that of the Byzantine capital (where little other than architecture has survived), clearly reveals the transition from the Early Christian to the Byzantine style.

SAN VITALE San Vitale (FIGS. 12-6 and 12-7), dedicated by Bishop Maximianus in 547 in honor of Saint Vitalis, who was martyred at Ravenna in the second century, is the most spectacular building in Ravenna. The church is an unforgettable experience for all who have entered it and marveled at its intricate design and magnificent golden mosaics. Construction of San Vitale began under Bishop Ecclesius shortly after Theodoric's death in 526. Julianus Argentarius (Julian the Banker) provided the 26,000 gold coins (weighing more than 350 pounds) required to proceed with the work. The church is unlike any of the other sixth-century churches of Ravenna (FIG. 11-17). Indeed, it is unlike any other church in Italy. San Vitale is not a basilica. It is centrally planned, like Justinian's churches in Constantinople, and it seems, in fact, to have been loosely modeled on the earlier Church of Saints Sergius and Bacchus there.

The design features two concentric octagons. The dome-covered inner octagon rises above the surrounding octagon to provide the interior with clerestory lighting. The central space is defined by eight large piers that alternate with curved, columned exedrae that push

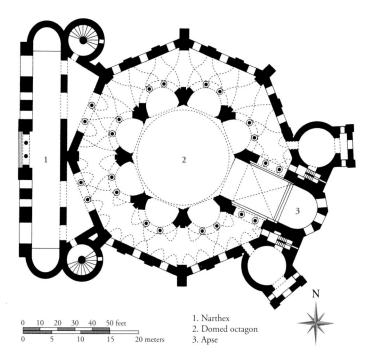

12-7 Plan of San Vitale, Ravenna, Italy, 526-547.

Centrally planned like Justinian's churches in Constantinople, San Vitale is unlike any other church in Italy. The design features two concentric octagons. A dome crowns the taller, inner octagon.

outward into the surrounding two-story ambulatory and create, on the plan, an intricate leafed design (FIG. 12-7). The exedrae closely integrate the inner and outer spaces that otherwise would have existed simply side by side as independent units. A cross-vaulted *choir* preceding the apse interrupts the ambulatory and gives the plan some axial stability. Weakening this effect, however, is the off-axis placement of the narthex, whose odd angle never has been explained fully. (The atrium, which no longer exists, may have paralleled a street that ran in the same direction as the angle of the narthex.)

San Vitale's intricate plan and elevation combine to produce an effect of great complexity. The exterior's octagonal regularity is not readily apparent inside (FIG. 12-8). A rich diversity of ever-changing perspectives greets visitors walking through the building. Arches looping over arches, curving and flattened spaces, and wall and vault shapes seem to change constantly with the viewer's position. Light filtered through alabaster-paned windows plays over the glittering mosaics and glowing marbles that cover the building's complex surfaces, producing a sumptuous effect.

The mosaics that decorate San Vitale's choir and apse (FIG. 12-9), like the building itself, must be regarded as among the most climactic achievements of Byzantine art. Completed less than a decade after the Ostrogoths surrendered Ravenna, the apse and choir decorations form a unified composition, whose theme is the holy ratification of Justinian's right to rule.

In the apse vault, Christ, youthful in the Early Christian tradition, holds a scroll with seven seals (Rev. 5:1) and sits on the orb of the world at the time of his Second Coming. The four rivers of Paradise flow beneath him, and rainbow-hued clouds float above. Christ extends the golden martyr's wreath to Vitalis, the patron saint of the church, whom an angel introduces. At Christ's left, another angel presents Bishop Ecclesius, in whose time the church foundations were laid. Ecclesius offers a model of San Vitale to Christ. The arrangement recalls Christ's prophecy of the last days of the world: "And then shall they see the Son

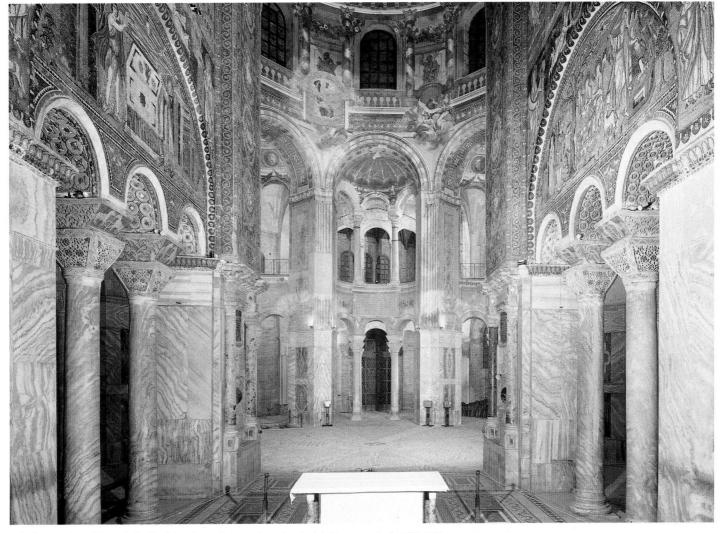

12-8 Interior of San Vitale (looking from the apse into the choir), Ravenna, Italy, 526-547.

Light filtered through alabaster-paned windows plays over the glittering mosaics and glowing marbles that cover San Vitale's complex wall and vault shapes, producing a sumptuous effect.

of Man coming in the clouds with great power and glory. And then shall he send his angels, and shall gather together his elect from the four winds, from the uttermost part of Heaven" (Mark 13:26–27).

Images and symbols covering the entire sanctuary express the single idea of Christ's redemption of humanity and the reenactment of it in the Eucharist. Below the apse mosaic (at the right in FIG. 12-8), for example, the lunette mosaic over the two columns of the choir depicts the story of Abraham and the three angels. Sarah, Abraham's wife, was 90 years old and childless when three angels visited Abraham. They announced that Sarah would bear a son, and she later miraculously gave birth to Isaac. Christians believe the Old Testament angels symbolized the Holy Trinity. Immediately to the right in the lunette is the sacrifice of Isaac, a prefiguration of Christ's Crucifixion (see "Jewish Subjects in Christian Art," Chapter 11, page 293).

JUSTINIAN AND THEODORA On the choir wall to the left of the apse mosaic appears Justinian (FIG. 12-10) and on the right wall is his empress, Theodora (FIG. 12-11). Justinian stands on the Savior's right side (FIG. 12-9). The two are united visually and symbolically by the imperial purple they wear and by their halos. A dozen attendants accompany Justinian, paralleling Christ's 12 apostles. Thus, the mosaic program underscores the dual political and religious roles of the Byzantine emperor. The laws of the Eastern Church and the laws of the

state, united in the laws of God, were manifest in the person of the emperor, whose right to rule was God-given.

The positions of the figures are all-important. They express the formulas of precedence and rank. Justinian is at the center, distinguished from the other dignitaries by his purple robe and halo. At his left (at right in the mosaic) is Bishop Maximianus, the man responsible for San Vitale's completion. The mosaicist stressed the bishop's importance by labeling his figure with the only identifying inscription in the composition. Some scholars have identified the figure behind and between Justinian and Maximianus as Julianus Argentarius, the church's benefactor. The artist divided the figures into three groups: the emperor and his staff; the clergy; and the imperial guard, bearing a shield with the *chi-rho-iota* (\mathring{X}) monogram of Christ.

Each group has a leader whose feet precede (by one foot overlapping) the feet of those who follow. The positions of Justinian and Maximianus are curiously ambiguous. Although the emperor appears to be slightly behind the bishop, the golden *paten* (large shallow bowl or plate for the Eucharist bread) he carries overlaps the bishop's arm. Thus, symbolized by place and gesture, the imperial and churchly powers are in balance. Justinian's paten, Maximianus's cross, and the attendant clerics' book and censer produce a slow forward movement that strikingly modifies the scene's rigid formality. No background is indicated. The artist wished the observer to understand the procession

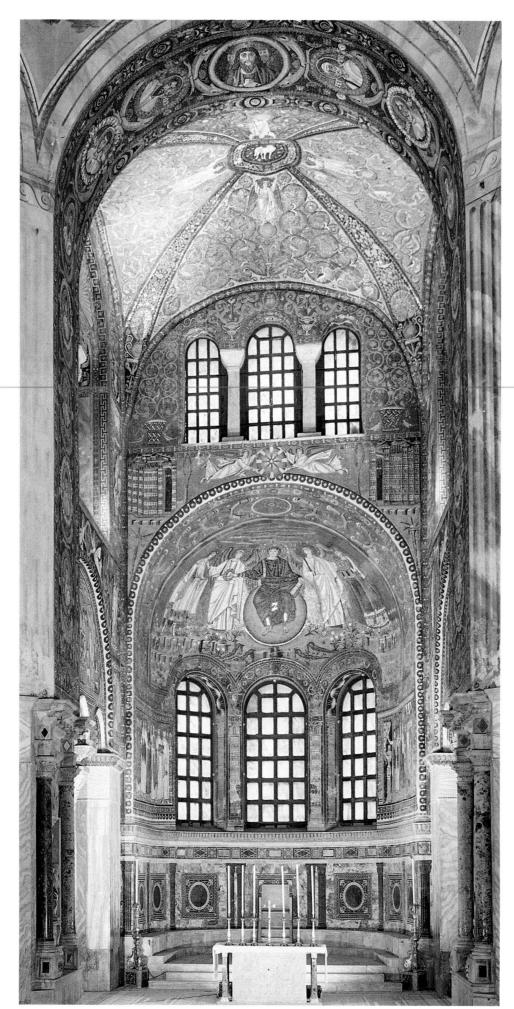

12-9 Choir and apse of San Vitale with mosaic of Christ between two angels, Saint Vitalis, and Bishop Ecclesius, Ravenna, Italy, 526–547.

In the apse vault, a youthful Christ, seated on the orb of the world at the time of his Second Coming, extends the golden martyr's wreath to Saint Vitalis. Bishop Ecclesius offers Christ a model of San Vitale.

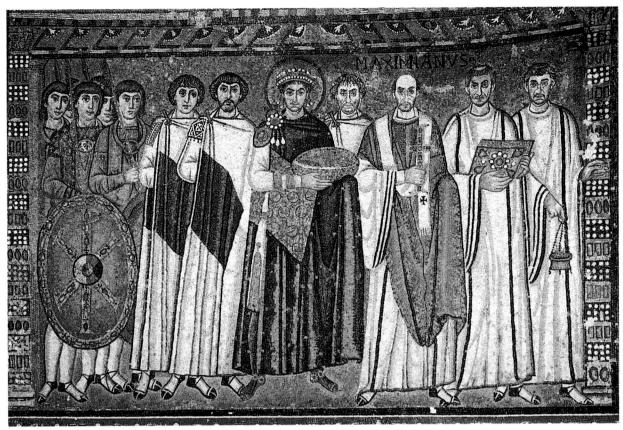

12-10 Justinian, Bishop Maximianus, and attendants, mosaic on the north wall of the apse, San Vitale, Ravenna, Italy, ca. 547. San Vitale's mosaics reveal the new Byzantine aesthetic. Justinian is foremost among the weightless and speechless frontal figures hovering before the viewer, their positions in space uncertain.

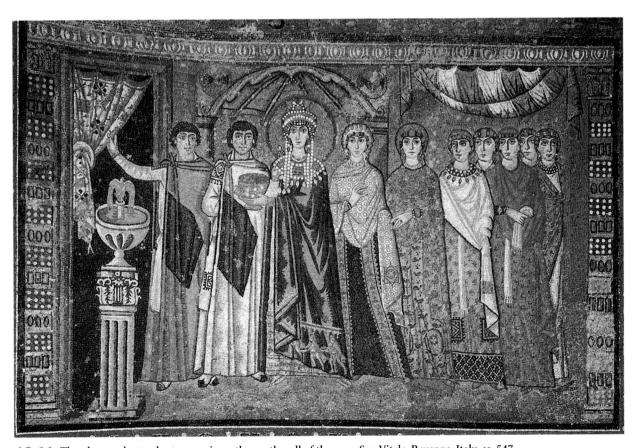

12-11 Theodora and attendants, mosaic on the south wall of the apse, San Vitale, Ravenna, Italy, ca. 547.

Justinian's counterpart on the opposite wall is the empress Theodora, a powerful figure at the Byzantine court. Neither she nor Justinian ever visited Ravenna. San Vitale's mosaics are proxies for the absent sovereigns.

Theodora, a Most Unusual Empress

heodora (FIG. 12-11), wife of Justinian and empress of Byzantium, was not born into an aristocratic family. Her father, who died when she was a child, was the "keeper of bears" for one of the circus factions (teams distinguished by color) at Constantinople. His responsibility was to prepare these animals for bear fights, bear hunts, and acrobatic performances involving bears in a long tradition rooted in ancient Rome. Theodora's mother was an actress, and after the death of her father the young Theodora took up the same career. Acting was not a profession the highborn held in esteem. At Byzantium, actresses often doubled as prostitutes, and the beautiful Theodora was no exception. In fact, actresses were so low on the Byzantine social ladder that the law prohibited senators from marrying them.

Justinian met Theodora when he was about 40 years old, she only 25. She became his mistress, but before they could wed, as they did in 525, ignoring all the social norms of the day, Justinian's uncle, the emperor Justin, first had to rewrite the law against senatorial

marriages to actresses to permit wedlock with an ex-actress. When Justin died in April 527, the patriarch of Constantinople crowned Justinian emperor, and Theodora became empress of Byzantium, capping what can be fairly described as one of the most remarkable and improbable "success stories" of any age. By all accounts, even of those openly hostile to the imperial couple, Justinian and Theodora remained faithful to each other for the rest of their lives.

It was not Theodora's beauty alone that attracted Justinian. John the Lydian, a civil servant at Constantinople at the time, described her as "surpassing in intelligence all men who ever lived." As her husband's trusted adviser, she repaid him for elevating her from poverty and disgrace to riches and prestige. During the Nika revolt in Constantinople in 532, when all of her husband's ministers counseled flight from the city, Theodora, by the sheer force of her personality, persuaded Justinian and his generals to hold their ground. The revolt was suppressed.

as taking place in this very sanctuary. Thus, the emperor appears forever as a participant in the sacred rites and as the proprietor of this royal church and the ruler of the Western Empire.

The procession at San Vitale recalls but contrasts with that of Augustus and his entourage (FIG. 10-31) on the Ara Pacis, erected more than a half millennium earlier in Rome. There the fully modeled marble figures have their feet planted firmly on the ground. The Romans talk among themselves, unaware of the viewer's presence. All is anecdote, all very human and of this world, even if the figures themselves conform to a classical ideal of beauty that cannot be achieved in reality. The frontal figures of the Byzantine mosaic, by comparison, hover before viewers, weightless and speechless, their positions in space uncertain. Tall, spare, angular, and elegant, the figures have lost the rather squat proportions characteristic of much Early Christian work. The garments fall straight, stiff, and thin from the narrow shoulders. The organic body has dematerialized, and, except for the heads, some of which seem to be true portraits, viewers see a procession of solemn spirits gliding silently in the presence of the sacrament. Indeed, the theological basis for this approach to representation was the principle that the divine is invisible and that the purpose of religious art is to stimulate spiritual seeing. Theodulf of Orleans summed up this idea around 790, when he wrote "God is beheld not with the eyes of the flesh but only with the eye of the mind." The mosaics of San Vitale reveal this new Byzantine aesthetic, one very different from that of the classical world but equally compelling. Blue sky has given way to heavenly gold, and matter and material values are disparaged. Byzantine art is an art without solid bodies or cast shadows, with blank golden spaces, and with the perspective of Paradise, which is nowhere and everywhere.

Justinian's counterpart on the opposite wall of the apse is Theodora (FIG. 12-11), one of the most remarkable women of the Middle Ages (see "Theodora, a Most Unusual Empress," above). The empress too is accompanied by her retinue. Both processions move into the apse, Justinian proceeding from left to right and Theodora from right to left, in order to take part in the Eucharist. Justinian carries the paten containing the bread, and Theodora the golden cup

with the wine. The portraits in the Theodora mosaic exhibit the same stylistic traits as those in the Justinian mosaic, but the women are represented within a definite architecture, perhaps the atrium of San Vitale. The empress stands in state beneath an imperial canopy, waiting to follow the emperor's procession. An attendant beckons her to pass through the curtained doorway. The fact that she is outside the sanctuary in a courtyard with a fountain and only about to enter attests that, in the ceremonial protocol, her rank was not quite equal to her consort's. But the very presence of Theodora at San Vitale is significant. Neither she nor Justinian ever visited Ravenna. Their participation in the liturgy at San Vitale is pictorial fiction. The mosaics are proxies for the absent sovereigns. Justinian was represented because he was the head of the Byzantine state, and by his presence he exerted his authority over his territories in Italy. But Theodora's portrayal is more surprising and testifies to her unique position in Justinian's court. Theodora's prominent role in the mosaic program of San Vitale is proof of the power she wielded at Constantinople and, by extension, at Ravenna. In fact, the representation of the three magi on the border of her robe suggests that she belongs in the elevated company of the three monarchs who approached the newborn Jesus bearing gifts.

SANT'APOLLINARE IN CLASSE Until the ninth century, Sant'Apollinare in Classe housed the body of Saint Apollinaris, who suffered his martyrdom in Classe, Ravenna's port. The church itself is Early Christian in type, a basilica with a nave and flanking aisles, like Theodoric's palace-church (FIG. 11-17) dedicated to the same saint in Ravenna. As in the earlier church, the Justinianic building's exterior is plain and unadorned, but sumptuous mosaics decorate the interior, although in this case they are confined to the apse (FIG. 12-12).

The mosaic decorating the semidome above the apse probably was completed by 549, when the church was dedicated. (The mosaics of the framing arch are of later date.) Against a gold ground, a large medallion with a jeweled cross dominates the composition. This may represent the cross Constantine erected on the hill of Calvary to commemorate the martyrdom of Jesus. Visible just above the

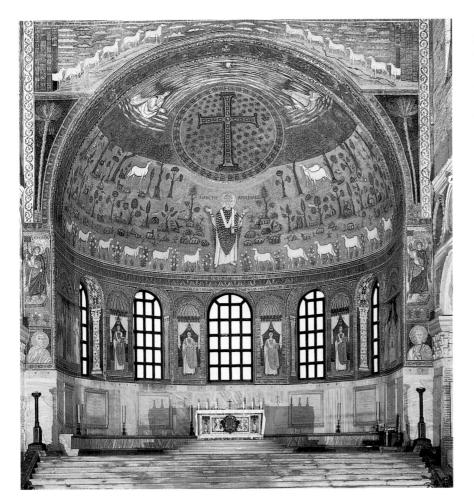

12-12 Saint Apollinaris amid sheep, apse mosaic, Sant'Apollinare in Classe, Ravenna, Italy, ca. 533–549.

Saint Apollinaris stands beneath Christ's Cross with his arms raised in prayer. Although the scene is set in a landscape, the Byzantine artist rejected the classical illusionism of early mosaics (compare Fig. 11-16).

cross is the hand of God. On either side of the medallion, in the clouds, are the Old Testament prophets Moses and Elijah, who appeared before Jesus during his Transfiguration. Below these two figures are three sheep, symbols of the disciples John, Peter, and Paul, who accompanied Jesus to the foot of the mountain he ascended in order to converse with the prophets. Beneath, amid green fields with trees, flowers, and birds, stands the church's patron saint, Apollinaris. The mosaicist portrayed him in the Early Christian manner as an orant with uplifted arms. Accompanying Apollinaris are 12 sheep, perhaps representing the Christian congregation under the saint's protection, and forming, as they march in regular file across the apse, a wonderfully decorative base.

Comparison of the Early Byzantine Sant'Apollinare in Classe mosaic with the Galla Placidia mosaic (FIG. 11-16) from the Early Christian period at Ravenna shows how the style and artists' approach to the subject changed during the course of a century. Both mosaics portray a human figure and some sheep in a landscape. But in Classe, in the mid-sixth century, the artist did not try to re-create a segment of the physical world, instead telling the story in terms of flat symbols, lined up side by side. The mosaicist carefully avoided overlapping in what must have been an intentional effort to omit all reference to the three-dimensional space of the material world and physical reality. Shapes have lost the volume seen in the earlier mosaic and instead are flat silhouettes with linear details. The effect is that of an extremely rich, flat tapestry without illusionistic devices. This new Byzantine style became the ideal vehicle for conveying the extremely complex symbolism of the fully developed Christian dogma.

The Sant'Apollinare in Classe apse mosaic, for example, carries much more meaning than first meets the eye. The cross symbolizes not only Christ's own death, with its redeeming consequences, but also the death of his martyrs (in this case, Saint Apollinaris). The lamb, also a symbol of martyrdom, appropriately represents the martyred apostles. The whole scene expands above the altar, where the priests celebrated the sacrament of the Eucharist—the miraculous recurrence of the supreme redemptive act. The very altars of Christian churches were, from early times, sanctified by the bones and relics of martyrs (see "Pilgrimages and the Cult of Relics," Chapter 17, page 432). Thus,

the mystery and the martyrdom were joined in one concept. The death of the martyr, in imitation of Christ, is a triumph over death that leads to eternal life. The images above the altar present an inspiring vision to the eyes of believers, delivered with overwhelming force. Looming above their eyes is the apparition of a great mystery, ordered to make perfectly simple and clear that humankind's duty is to seek salvation. Even the illiterate, who might not grasp the details of the complex theological program, could understand that the way of the martyr is open to the Christian faithful and that the reward of eternal life is within their reach.

MOUNT SINAI During Justinian's reign, building continued almost incessantly, not only in Constantinople and Ravenna but all over the Byzantine Empire. At about the time mosaicists in Ravenna were completing their work at San Vitale and Sant'Apollinare in Classe, Justinian's builders were reconstructing an important early *monastery* (an enclosed compound for monks) at Mount Sinai in Egypt where Moses received the Ten Commandments from God. Now called Saint Catherine's, the monastery marked the spot at the foot of the mountain where the Bible says God first spoke to the Hebrew prophet from a burning bush.

Monasticism began in Egypt in the third century and spread rapidly to Palestine and Syria in the East and as far as Ireland in the West. It began as a migration to the wilderness by those who sought a more spiritual way of life, far from the burdens, distractions, and temptations of town and city. In desert locations, these refuge seekers lived austerely as hermits, in contemplative isolation, cultivating the soul's perfection. So many thousands fled the cities that the authorities became alarmed—noting the effect on the tax base, military recruitment, and business in general.

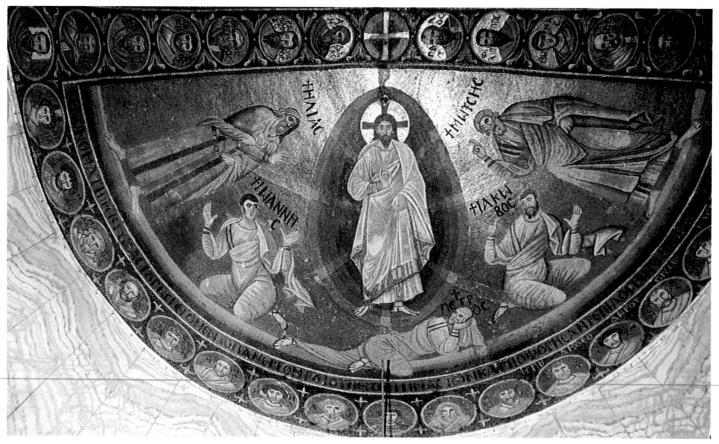

12-13 Transfiguration of Jesus, apse mosaic, Church of the Virgin, monastery of Saint Catherine, Mount Sinai, Egypt, ca. 548-565.

Unlike the Sant'Apollinare mosaicist, this Mount Sinai artist swept away all traces of landscape for a depthless field of gold. The prophets and disciples cast no shadows even though bathed in divine light.

The origins of the monastic movement are associated with Saint Anthony and Saint Pachomius in Egypt in the fourth century. By the fifth century, regulations governing monastic life began to be codified. Individual monks came together to live according to a rule within a common enclosure, a community under the direction of an abbot (see "Medieval Monasteries and Benedictine Rule," Chapter 16, page 420). The monks typically lived in a walled monastery, an architectural complex that included the monks' residence (an alignment of single cells), an *oratory* (monastic church), a *refectory* (dining hall), a kitchen, storage and service quarters, and a guest house for pilgrims (FIG. 16-19).

Justinian rebuilt the monastery at Mount Sinai between 548 and 565 and erected imposing walls around it. The site had been an important pilgrimage destination since the fourth century, and Justinian's fortress was intended to protect not only the hermit-monks but also the lay pilgrims during their visits. The Mount Sinai church was dedicated to the Virgin Mary, whom the Orthodox Church had officially recognized in the mid-fifth century as the Mother of God (*Theotokos*), putting to rest a controversy about the divine nature of Christ. The church's apse mosaic (FIG. 12-13) depicts the Transfiguration. (Other mosaics in the church depict Moses receiving the Law and standing before the burning bush.) Jesus appears in a deep-blue almond-shaped mandorla (almond-shaped aureole of light). At his feet are John, Peter, and James. At the left and right are Elijah and Moses. Portrait busts of saints and prophets in medallions frame the whole scene. The artist stressed the intense whiteness of Jesus' transfigured, spiritualized form, from which rays stream down on the disciples. The stately figures of the

prophets and the static frontality of Jesus set off the frantic terror and astonishment of the gesticulating disciples. These characteristics effectively contrast the eternal composure of heavenly beings with the distraught responses of the earthbound.

In this apse the mosaicist swept away all traces of landscape and architectural setting for a depthless field of gold, fixing the figures and their labels in isolation from one another. A rainbow band of colors graduating from yellow to blue bounds the golden field at its base. The figures are ambiguously related to this multicolor ground line. Sometimes they are placed behind it. Sometimes they overlap it. The bodies cast no shadows, even though supernatural light streams over them. This is a world of mystical vision, where the artist subtracted all substance that might suggest the passage of time or motion through physical space. In the absence of such physicality, the devout can contemplate the eternal and motionless world of religious truth.

Ivory Carving and Painting

As in the Early Christian period, ivory carving and manuscript painting were important art forms during the Early Byzantine era. Most of the finest examples date to the sixth century. They feature both secular and religious subjects.

BARBERINI IVORY Carved in five parts (one is lost), the ivory plaque known today as the Barberini Ivory (FIG. 12-14)—it was once part of the 17th-century collection of Cardinal Barberini in Rome—shows at the center an emperor, usually identified as Justinian, riding triumphantly on a rearing horse, while a startled, half-

The Emperors of New Rome

yzantine art is generally, and properly, considered to belong to the Middle Ages rather than to the ancient world, but the emperors of Byzantium, New Rome, considered themselves the direct successors of the emperors of Old Rome. Although the official state religion was Christianity and all pagan cults were suppressed, the political imagery of Byzantine art displays a striking continuity between ancient Rome and medieval Byzantium. Artists continued to portray emperors sitting on thrones holding the orb of the earth in their hands, battling foes while riding on mighty horses, and receiving tribute from defeated enemies. In the Early Byzantine period, official portraits continued to be set up in great numbers throughout the terri-

tories Byzantium controlled. But, as was true of the classical world, much of imperial Byzantine statuary is forever lost. Nonetheless, some of the lost portraits of the Byzantine emperors can be visualized from miniature versions of them on ivory reliefs such as the Barberini Ivory (FIG. 12-14) and from descriptions in surviving texts.

One especially impressive portrait in the Roman imperial tradition, melted down long ago, depicted the emperor Justinian on horseback atop a grandiose column. Cast in glittering bronze, like the equestrian statue of Marcus Aurelius (Fig. 10-59) set up nearly 400 years earlier, it attested to the continuity between the art of New Rome and Old Rome, where pompous imperial images were commonly displayed at the apex of freestanding columns. (Compare Fig. 10-44 where a statue of Saint Peter has replaced a lost statue of the emperor Trajan.) Procopius, Justinian's official historian, described the equestrian portrait:

Finest bronze, cast into panels and wreaths, encompasses the stones [of the column] on all sides, both binding them securely together and covering them with adornment.... This bronze is in color softer than pure gold, while in value it does not fall much short of an equal weight of silver. At the summit of the column stands a huge bronze horse turned towards the east, a most noteworthy sight.... Upon this horse is mounted a bronze image of the Emperor like a colossus.... He wears a cuirass in heroic fashion and his head is covered with a helmet ... and a kind of radiance flashes forth from there.... He gazes towards the rising sun, steering his course, I suppose, against the Persians. In his left hand he holds a globe, by which

12-14 Justinian as world conqueror (*Barberini Ivory*), mid-sixth century. Ivory, $1' 1\frac{1}{2}'' \times 10\frac{1}{2}''$. Louvre, Paris.

Classical style and motifs lived on in Byzantine art in ivories such as this one, where Justinian rides a rearing horse accompanied by personifications of Victory and Earth. Above, Christ blesses the emperor.

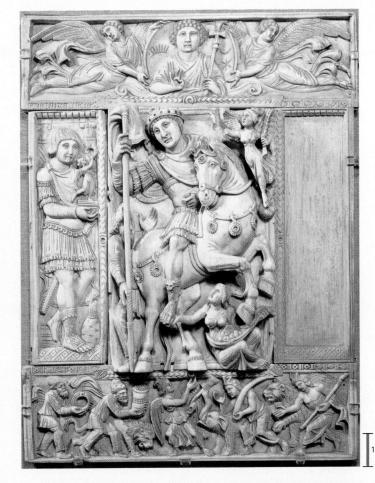

the sculptor has signified that the whole earth and sea were subject to him, yet he carries neither sword nor spear nor any other weapon, but a cross surmounts his globe, by virtue of which alone he has won the kingship and victory in war. Stretching forth his right hand towards the regions of the East and spreading out his fingers, he commands the barbarians that dwell there to remain at home and not to advance any further.*

Statues such as this are the missing links in an imperial tradition that never really died and that lived on also in the Holy Roman Empire (FIG. 16-12) and in Renaissance Italy (FIGS. 21-15 and 21-16).

*Cyril Mango, trans., *The Art of the Byzantine Empire, 312–1453: Sources and Documents* (reprint of 1972 ed., Toronto: Toronto University Press, 1986), 110–111.

hidden barbarian recoils in fear behind him. The dynamic twisting postures of both horse and rider and the motif of the equestrian emperor thrusting his spears are survivals of the pagan Roman Empire (see "The Emperors of New Rome," above), as are the personifications of bountiful Earth (below the horse) and palm-bearing Victory (flying in to crown the conqueror). Also borrowed from pagan art are the barbarians at the bottom of the plaque bearing tribute and seeking clemency. They are juxtaposed with a lion, an elephant, and

a tiger—exotic animals native to Africa and Asia, sites of Justinian's conquests. At the left, a Roman soldier carries a statuette of another Victory, reinforcing the central panel's message. The source of the emperor's strength, however, comes not from his earthly armies but from God. The uppermost panel depicts two angels holding aloft a youthful image of Christ carrying a cross in his left hand. Christ blesses Justinian with a gesture of his right hand, indicating approval of the emperor's rule.

ARCHANGEL MICHAEL IVORY Another ivory panel (FIG. **12-15**), created somewhat earlier than the *Barberini Ivory* and likewise carved in the Eastern Christian Empire, perhaps in Constantinople, offers further evidence of the persistence of classical art. The panel, the largest extant Byzantine ivory, is all that is preserved from a hinged diptych in the Early Christian tradition. It depicts Saint Michael the Archangel, patron of the imperial church of Hagia Sophia. The inscription opens with the words "Receive these gifts." The dedication is perhaps a reference to the cross-surmounted orb of power the archangel once offered to a Byzantine emperor depicted on the missing diptych leaf. The prototype of Michael must have been a pagan winged Victory, although Victory was personified as a woman in Greco-Roman art and usually carried a palm branch, as does the Victory on the *Barberini Ivory*. The Christian artist here ingeniously adapted a pagan motif and imbued it with new meaning.

The archangel's flowing drapery, which reveals the body's shape, the delicately incised wings, and the facial type and coiffure are other indications that the artist who carved this ivory was still working in the tradition of classical art. Nonetheless, the Byzantine ivory carver had little concern for the rules of naturalistic representation. The archangel dwarfs the architectural setting. Michael's feet, for example, rest on three steps at once, and his upper body, wings, and arms are in front of the column shafts while his lower body is behind the column bases at the top of the receding staircase. These spatial ambiguities, of course, do not detract from the figure's striking beauty, but they do signify the emergence of the same new aesthetic already noted in the mosaics of Ravenna. Here, as there, the Byzantine artist rejected the goal of most classical artists: to render the three-dimensional world in convincing and consistent fashion and to people that world with fully modeled figures firmly rooted on the ground. Michael seems more to float in front of the architecture than to stand in it.

VIENNA DIOSKORIDES The physical world was the focus, however, of one of the rare secular books to survive from the early Middle Ages, either in Byzantium or the West. In the mid-first century, a Greek physician named Dioskorides compiled an encyclopedia of medicinal herbs called *De materia medica*. An early-sixthcentury copy of this manual, nearly a thousand pages in length, is in the Austrian National Library. The Vienna Dioskorides, as it is called, was a gift from the people of Honoratai, near Constantinople, to Anicia Juliana, daughter of the short-lived Emperor of the West, Anicias Olybrias (r. 472). Anicia Juliana was a leading patron of the arts and had built a church dedicated to the Virgin Mary at Honoratai in 512. She also provided the funds to erect Saint Polyeuktos in Constantinople between 524 and 527. The excavated ruins of that church indicate that it was a domed basilica—an important forerunner of the pioneering design of Justinian's Hagia Sophia.

The *Vienna Dioskorides* contains 498 illustrations, almost all images of plants rendered with a scientific fidelity to nature that stands in stark contrast to contemporary Byzantine paintings and mosaics of religious subjects. It is likely that the *Vienna Dioskorides*

12-15 Saint Michael the Archangel, right leaf of a diptych, early sixth century. Ivory, $1' 5'' \times 5\frac{1}{2}''$. British Museum, London.

The sculptor who carved this largest extant Byzantine ivory panel modeled Saint Michael on a classical winged Victory, but the archangel seems to float in front of the architecture rather than stand in it.

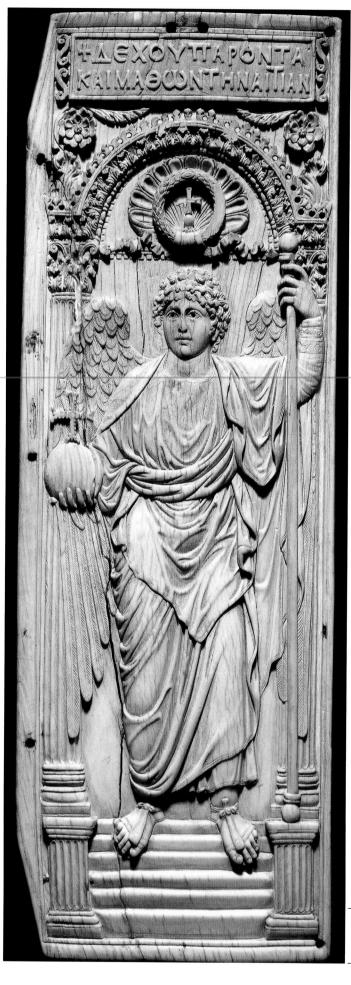

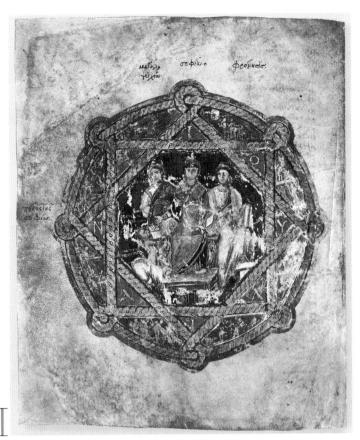

12-16 Anicia Juliana between Magnanimity and Prudence, folio 6 verso of the *Vienna Dioskorides*, from Honoratai, near Constantinople (Istanbul), Turkey, ca. 512. Tempera on parchment, $1'\ 3'' \times 1'\ 11''$. Österreichische Nationalbibliothek, Vienna.

In gratitude for her generosity, the people of Honoratai presented Anicia Juliana, a great art patron, with a book in which she appears enthroned with personifications of Magnanimity and Prudence.

painters copied the illustrations as well as the text of a classical manuscript. One page, however, cannot be a copy—the dedication page (FIG. 12-16) featuring a portrait of Anicia Juliana in an eight-pointed star and circle frame. This earliest known illustrated dedication page shows Anicia Juliana enthroned between personifications of Magnanimity and Prudence, with a kneeling figure labeled Gratitude of the Arts at her feet. The shading and modeling of the figures, the heads posed at oblique angles, the perspectival rendering of the throne's footstool, and the use of personifications establish that the painter still worked in the classical tradition that most other Byzantine artists by then had rejected.

RABBULA GOSPELS One of the essential Christian beliefs is that following his Crucifixion and entombment, Christ rose from the dead after three days and, on the 40th day, ascended from the Mount of Olives to Heaven. The Ascension is the subject of a full-page painting (FIG. 12-17) in a manuscript known as the Rabbula Gospels. Written in Syriac by the monk Rabbula at the monastery of Saint John the Evangelist at Zagba, Syria, it dates to the year 586. The composition shows Christ, bearded and surrounded by a mandorla, as in the Mount Sinai Transfiguration (FIG. 12-13), but the mandorla is here borne aloft by angels. Below, Mary, other angels, and various apostles look on. The artist set the figures into a mosaic-like frame

(compare FIGS. 12-10 and 12-11), and many art historians think the model for the manuscript page was a mural painting or mosaic in a Byzantine church somewhere in the Eastern Empire.

The account of Christ's Ascension is not part of the accompanying text of the Rabbula Gospels but is borrowed from the biblical book of Acts. And even Acts omits mention of the Virgin's presence at the miraculous event. Here, however, the Theotokos occupies a very prominent position, central and directly beneath Christ. It is an early example of the important role the Mother of God played in later medieval art, in both the East and the West. Frontal, with a nimbus, and posed as an orant, Mary stands apart from the commotion all about her and looks out at the viewer. Other details also depart from the Gospel texts. Christ, for example, does not rise in a cloud. Rather, as in the vision of Ezekiel in the book of Revelation, he ascends in a mandorla above a fiery winged chariot. The chariot carries the symbols of the Four Evangelists—the man, lion, ox, and eagle (see "The Four Evangelists," Chapter 16, page 412). This page therefore does not illustrate the Gospels but presents one of the central tenets of Christian faith. Similar compositions appear on pilgrims' flasks from Palestine that were souvenir items reproducing important monuments visited. They reinforce the theory that the Ascension page of the Rabbula Gospels was based on a lost painting or mosaic in a major church.

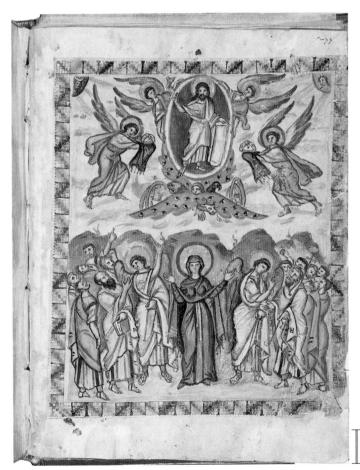

12-17 *Ascension of Christ*, folio 13 verso of the *Rabbula Gospels*, from Zagba, Syria, 586. Tempera on parchment, $1'1'' \times 10\frac{1}{2}''$. Biblioteca Medicea-Laurenziana, Florence.

The Gospels do not mention the Virgin Mary as a witness of Christ's Ascension. Her prominent position in the *Rabbula Gospels* is an early example of the important role Mary played in later medieval art.

Icons and Iconoclasm

Byzantine *icons* ("images" in Greek) are small portable paintings depicting Christ, the Virgin, or saints (or a combination of all three, as in fig. 12-18). Icons survive from as early as the fourth century. From the sixth century on, they became enormously popular in Byzantine worship, both public and private. Eastern Christians considered icons a personal, intimate, and indispensable medium for spiritual transaction with holy figures. Some icons (for example, fig. 12-29) came to be regarded as wonder-working, and believers ascribed miracles and healing powers to them.

Icons were by no means universally accepted, however. From the beginning, many Christians were deeply suspicious of the practice of imaging the divine, whether on portable panels, on the walls of churches, or especially as statues that reminded them of pagan idols. The opponents of Christian figural art had in mind the Old Testament prohibition of images the Lord dictated to Moses in the Second Commandment: "Thou shalt not make unto thee any graven image or any likeness of anything that is in heaven above, or that is in the earth beneath, or that is in the water under the earth. Thou shalt not bow down thyself to them, nor serve them" (Exod. 20:4, 5). For example, early in the fourth century, Constantia, sister of the emperor Constantine, requested an image of Christ from Eusebius, the first great historian of the Christian Church. He rebuked her, referring to the Second Commandment:

Can it be that you have forgotten that passage in which God lays down the law that no likeness should be made of what is in heaven or in the earth beneath?... Are not such things banished and excluded from churches all over the world, and is it not common knowledge that such practices are not permitted to us...lest we appear, like idol worshipers, to carry our God around in an image?*

Opposition to icons became especially strong in the eighth century, when the faithful often burned incense and knelt before them in prayer to seek protection or a cure for illness. Although icons were intended only to evoke the presence of the holy figures addressed in prayer, in the minds of many people, icons became identified with the personages represented. Icon veneration became confused with idol worship, and this brought about an imperial ban on the making of icons, followed by the wholesale wreckage of sacred images (*iconoclasm*). The *iconoclasts* (breakers of images) and the *iconophiles* (lovers of images) became bitter and irreconcilable enemies. The anguish of the latter can be gleaned from a graphic description of the deeds of the iconoclasts, written in about 754:

In every village and town one could witness the weeping and lamentation of the pious, whereas, on the part of the impious, [one saw] sacred things trodden upon, [liturgical] vessels turned to other use, churches scraped down and smeared with ashes because they contained holy images. And wherever there were venerable images of Christ or the Mother of God or the saints, these were consigned to the flames or were gouged out or smeared over.

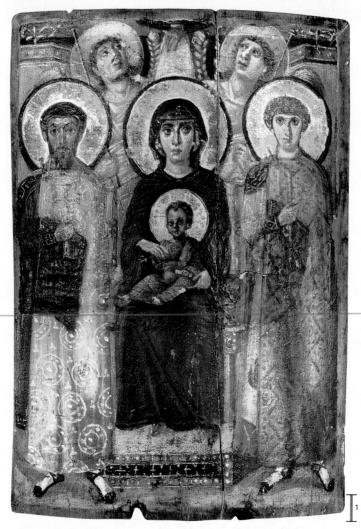

12-18 Virgin (Theotokos) and Child between Saints Theodore and George, icon, sixth or early seventh century. Encaustic on wood, 2' $3'' \times 1'$ $7\frac{3''}{8}$ ". Monastery of Saint Catherine, Mount Sinai, Egypt.

Byzantine icons continued the Roman tradition of painting on wood panels (FIGS. 10-62 and 10-63), but their style as well as the Christian subjects broke sharply from classical models.

The consequences of iconoclasm for the history of Byzantine art are difficult to overstate. For more than a century, not only did the portrayal of Christ, the Virgin, and the saints cease, but the iconoclasts also destroyed countless works from the early centuries of Christendom. Assembling a complete history of Early Byzantine art presents a great challenge to art historians.

^{*} Cyril Mango, trans., The Art of the Byzantine Empire, 312–1453: Sources and Documents (reprint of 1972 ed., Toronto: University of Toronto Press, 1986), 17–18.

ICONS Gospel books such as the Rabbula Gospels played an important role in monastic religious life. So, too, did icons, which also figured prominently in private devotion (see "Icons and Iconoclasm," page 326). Unfortunately, few early icons survive. Some of the finest early examples come from Saint Catherine's monastery at Mount Sinai. The one illustrated here (FIG. 12-18) was painted in encaustic on wood, continuing a tradition of panel painting in Egypt that, as true of so much else in the Byzantine world, has roots in the Roman Empire (FIGS. 10-62 and 10-63). In a composition reminiscent of the portrait of Anicia Juliana (FIG. 12-16) in the Vienna Dioskorides, the Sinai icon painter represented the enthroned Theotokos and Child with Saints Theodore and George. The two guardian saints intercede with the Virgin on the viewer's behalf. Behind them, two angels gaze upward to a shaft of light where the hand of God appears. The foreground figures are strictly frontal and have a solemn demeanor. Background details are few and suppressed. The forward plane of the picture dominates. Space is squeezed out. Traces of the Greco-Roman illusionism noted in the Anicia Juliana portrait remain in the Virgin's rather personalized features, in her sideways glance, and in the posing of the angels' heads. But the painter rendered the saints' bodies in the new Byzantine manner.

ICONOCLASM The preservation of the Early Byzantine icons at the Mount Sinai monastery is fortuitous but ironic, for opposition to icon worship was especially prominent in the Monophysite provinces of Syria and Egypt. There, in the seventh century, a series of calamities erupted, indirectly causing the imperial ban on images. The Sasanians (see Chapter 2), chronically at war with Rome, swept into the eastern provinces early in the seventh century. Between 611 and 617, they captured the great cities of Antioch, Jerusalem, and Alexandria. The Byzantine emperor Heraclius (r. 610-641) had barely defeated them in 627 when a new and overwhelming power appeared unexpectedly on the stage of history. The Arabs, under the banner of the new Islamic religion, conquered not only Byzantium's eastern provinces but also Persia itself, replacing the Sasanians in the age-old balance of power with the Christian West (see Chapter 13). In a few years the Arabs were launching attacks on Constantinople, and Byzantium was fighting for its life.

These were catastrophic years for the Eastern Roman Empire. They terminated once and for all the long story of imperial Rome, closed the Early Byzantine period, and inaugurated the medieval era of Byzantine history. Almost two-thirds of the Byzantine Empire's territory was lost-many cities and much of its population, wealth, and material resources. The shock of these events may have persuaded the emperor Leo III (r. 717-741) that God was punishing the Christian Roman Empire for its idolatrous worship of icons by setting upon it the merciless armies of the infidel—an enemy that, moreover, shunned the representation not only of God but of all living things in holy places (see Chapter 13). Some scholars believe that another motivation for Leo's 726 ban on picturing the divine was to assert the authority of the state over the Church. In any case, for more than a century, Byzantine artists produced little new religious figurative art. In place of images of holy figures, the iconoclasts used symbolic forms already familiar in Early Christian art, for example, the Cross (FIG. 12-12).

MIDDLE BYZANTINE ART

In the ninth century, a powerful reaction against iconoclasm set in. The destruction of images was condemned as a heresy, and restoration of the images began in 843. Shortly thereafter, under a new line of emperors, art, literature, and learning sprang to life once again. In

this great "renovation," as historians have called it, Byzantine culture returned to its ancient Hellenistic sources and accommodated them to the forms inherited from the Justinianic age. Basil I (r. 867–886), head of the new Macedonian dynasty, regarded himself as the restorer of the Roman Empire. He denounced as usurpers the Carolingian monarchs of the West (see Chapter 16) who, since 800, had claimed the title "Roman Empire" for their realm. Basil bluntly reminded their emissary that the only true emperor of Rome reigned in Constantinople. The Carolingians were not Roman emperors but merely "kings of the Germans." Iconoclasm had forced Byzantine artists westward, where doubtless they found employment at the courts of these Germanic kings (see "Theophanu, a Byzantine Princess in Ottonian Germany," Chapter 16, page 428). They strongly influenced the character of Western European art.

Architecture and Mosaics

The triumph of the iconophiles over the iconoclasts meant that Byzantine mural painters, mosaicists, book illuminators, ivory carvers, and metalworkers once again received plentiful commissions. Basil I and his successors also undertook the laborious and costly task of refurbishing the churches the iconoclasts had defaced and neglected.

THEOTOKOS, HAGIA SOPHIA In 867, the Macedonian dynasty dedicated a new mosaic (FIG. 12-19) depicting the enthroned Virgin with the Christ Child in her lap in the apse of the Justinianic church of Hagia Sophia. In the vast space beneath the dome

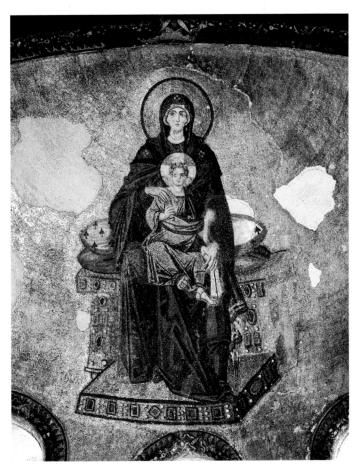

12-19 Virgin (Theotokos) and Child enthroned, apse mosaic, Hagia Sophia, Constantinople (Istanbul), Turkey, dedicated 867.

Shortly after the repeal of iconoclasm, the emperor Basil I dedicated a huge new mosaic in the apse of Hagia Sophia depicting the Virgin and Child enthroned. It replaced one the iconoclasts had destroyed.

12-20 Katholikon, Hosios Loukas, Greece, first quarter of 11th century.

Middle Byzantine churches typically are small and high shouldered, with a central dome on a drum and exterior wall surfaces with decorative patterns, probably reflecting Islamic architecture.

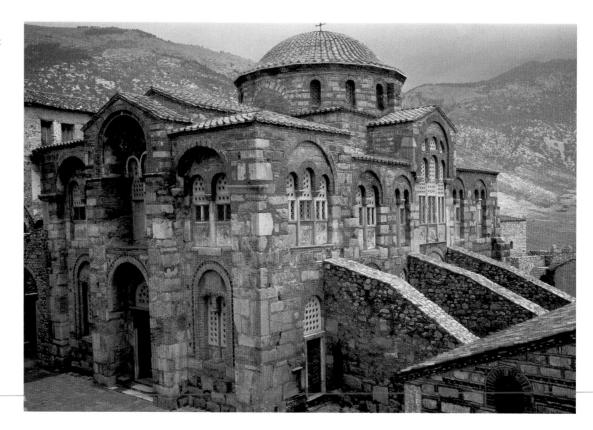

12-21 Plan of the Church of the Theotokos (top) and the Katholikon (bottom), Hosios Loukas, Greece, second half of 10th and first quarter of 11th centuries. (1) Dome on pendentives, (2) dome on squinches.

The plans of the pair of monastic churches at Hosios Loukas in Greece take the form of a domed square at the center of a cross with four equallength vaulted arms (the Greek cross).

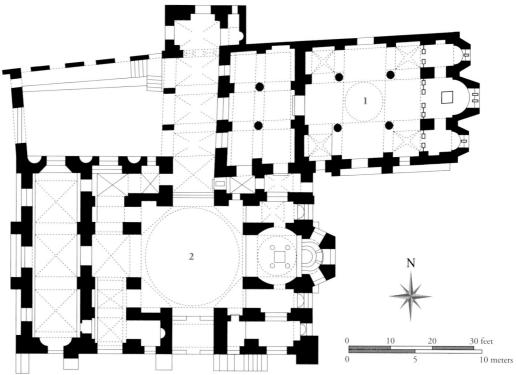

of the great church, the figures look undersized, but the seated Theotokos is more than 16 feet tall. An accompanying inscription, now fragmentary, announced that "pious emperors" (the Macedonians) had commissioned the mosaic to replace one the "impostors" (the iconoclasts) had destroyed.

The original mosaic's subject is uncertain, but the ninth-century work echoes the style and composition of the Early Byzantine icon (FIG. 12-18) at Mount Sinai of the Theotokos, Christ, and saints. In the mosaic, however, the angular placement of the throne and foot-

stool alleviate the strict frontality of Mother and (much older) Child. The mosaicist rendered the furnishings in a perspective that, although imperfect, recalls once more the Greco-Roman roots of Byzantine art. The treatment of the folds of Christ's robes is, by comparison, even more schematic and flatter than in earlier mosaics. These seemingly contradictory stylistic features are not uncommon in Byzantine paintings and mosaics. Most significant about the images in the Hagia Sophia apse is their very existence, marking the end of iconoclasm in the Byzantine Empire.

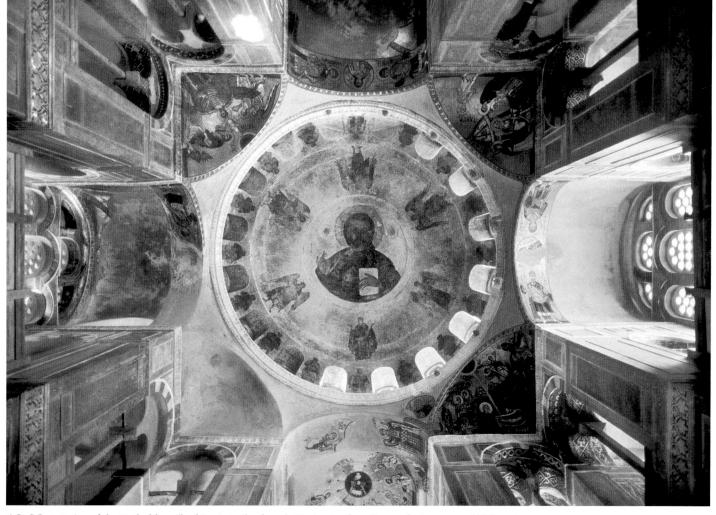

12-22 Interior of the Katholikon (looking into the dome), Hosios Loukas, Greece, first quarter of 11th century.

The dome of the Katholikon rests on an octagon formed by squinches, which play the same role as pendentives in making the transition from a square base to a round dome but create a different visual effect.

HOSIOS LOUKAS Although the new emperors did not wait long to redecorate the churches of their predecessors, they undertook little new church construction in the decades following the renunciation of iconoclasm in 843. But in the 10th century and through the 12th, a number of monastic churches arose that are the flowers of Middle Byzantine architecture. They feature a brilliant series of variations on the domed central plan. From the exterior, the typical Middle Byzantine church building is a domed cube, with the dome rising above the square on a kind of cylinder or *drum*. The churches are small, vertical, high shouldered, and, unlike earlier Byzantine buildings, have exterior wall surfaces decorated with vivid patterns, probably reflecting Islamic architecture.

The Katholikon (FIGS. 12-20 and 12-21, bottom) at Hosios Loukas (Saint Luke) in Greece, near ancient Delphi, dates to the early 11th century. One of two churches at the site—the other is the Church of the Theotokos (FIG. 12-21, top) built during the second half of the 10th century—the Katholikon exemplifies church design during this second golden age of Byzantine art and architecture. Light stones framed by dark red bricks—the so-called *cloisonné* technique, a term borrowed from enamel work (FIG. 16-3)—make up the walls. The interplay of arcuated windows, projecting apses, and varying roof lines further enhances this surface dynamism. The plans of both Hosios Loukas churches (FIG. 12-21) show the form of a domed cross in square with four equal-length, vaulted cross arms

(the *Greek cross*). The dome of the smaller Church of the Theotokos rests on pendentives. In the case of the larger and later Katholikon, the architect placed the dome (FIG. 12-22) over an octagon inscribed within a square. Forming the octagon are squinches (FIG. 12-5, *right*), which play the same role as pendentives in making the transition from a square base to a round dome but create a different visual effect on the interior. This arrangement departs from the older designs, such as Santa Costanza's circular plan (FIG. 11-12), San Vitale's octagonal plan (FIG. 12-7), and Hagia Sophia's dome on pendentives rising from a square (FIG. 12-3). The Katholikon's complex core lies within two rectangles. The outer one forms the exterior walls. Thus, in plan from the center out, a circle-octagon-square-oblong series exhibits an intricate interrelationship that is at once complex and unified.

The interior elevation of the Katholikon reflects its involved plan. Like earlier Byzantine buildings, the church creates a mystery out of space, surface, light, and dark. High and narrow, it forces the viewer's gaze to rise and revolve. The eye is drawn upward toward the dome (FIG. 12-22), but much can distract it in the interplay of flat walls and concave recesses; wide and narrow openings; groin and barrel vaults; single, double, and triple windows; and illuminated and dark spaces. Middle Byzantine architects seem to have aimed for the creation of complex interior spaces with dramatically shifting perspectives.

12-23 Crucifixion, mosaic in the Church of the Dormition, Daphni, Greece, ca. 1090–1100.

The Daphni Crucifixion is a subtle blend of Hellenistic style and the more abstract Byzantine manner. The Virgin Mary and Saint John point to Christ on the Cross as if to a devotional object.

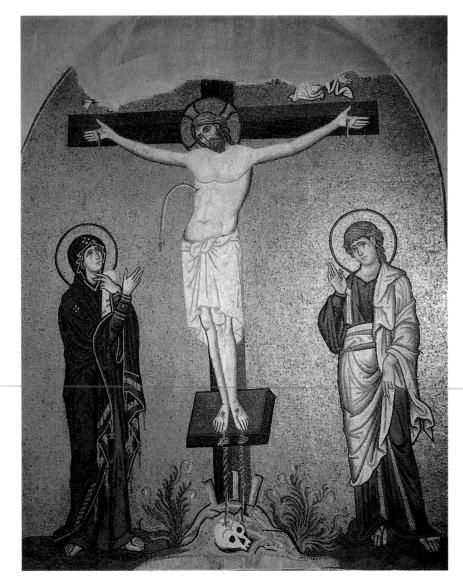

DAPHNI Much of the original mosaic decoration of the Hosios Loukas Katholikon does not survive, but at Daphni, near Athens, the mosaics produced during Byzantium's second golden age fared much better. In the Church of the Dormition (from the Latin for "sleep," referring to the ascension of the Virgin Mary to Heaven at the moment of her death), at the Daphni monastery, the main elements of the late-11th-century pictorial program are intact, although the mosaics were restored in the 19th century. Gazing down from on high in the central dome (FIG. 12-1) is the fear-

some image of Christ as *Pantokrator* (literally "ruler of all" in Greek but usually applied to Christ in his role as Last Judge of humankind). The dome mosaic is the climax of an elaborate hierarchical pictorial program including several New Testament episodes below. The Daphni Pantokrator is like a gigantic icon hovering dramatically in space. The mosaic serves to connect the awestruck worshiper in the church below with Heaven through Christ. The Pantokrator theme was a common one in churches throughout the Byzantine Empire. There was also a mosaic of the Pantokrator in the dome of the Hosios Loukas Katholikon. Today a painting (FIG. 12-22) replaces it.

On one of the walls below the Daphni dome, beneath the barrel vault of one arm of the Greek cross, an unknown artist depicted Christ's Crucifixion (FIG. 12-23) in a pictorial style characteristic of the posticonoclastic Middle Byzantine period. Like the Pantokrator mosaic in the dome, the Daphni Crucifixion is a subtle blend of the painterly Hellenistic style and the later more abstract and formalistic Byzantine style. The Byzantine artist fully assimilated classicism's simplicity, dignity, and grace into a perfect synthesis with Byzantine piety and pathos. The figures have regained the classical organic structure to a surprising degree, particularly compared with Justinianic figures (FIGS. 12-10 and 12-11). The style is a masterful adaptation of classical statuesque qualities to the linear Byzantine manner.

In quiet sorrow and resignation, the Virgin and Saint John flank the crucified Christ. A skull at the foot of the cross indicates Golgotha, the "place of skulls." The artist needed nothing else to set the scene. Symmetry and closed space combine to produce an effect of the motionless and unchanging aspect of the deepest mystery of the Christian religion, as recalled in the ceremony of the Eucharist. The picture is not a narrative of the historical event of the Crucifixion, the approach taken by the carver of the Early Christian ivory panel (FIG. 11-22) examined in the previous chapter. Nor is Christ a triumphant, beardless youth, oblivious to pain and defiant of the laws of gravity. Rather, he has a tilted head and sagging body, and although the Savior is not overtly in pain, blood and water spurt from the wound Longinus inflicted on him, as recounted in Saint John's gospel. The Virgin and John point to the figure on the cross as if to a devotional object. They act as intercessors between the viewer below and Christ, who, in the dome, appears as the Last Judge of all humans. The mosaic decoration of the church is the perfect complement to Christian liturgy.

SAINT MARK'S, VENICE The revival on a grand scale of church building, featuring vast stretches of mosaic-covered walls, was not confined to the Greek-speaking Byzantine East in the 10th to 12th centuries. A resurgence of religious architecture and of the

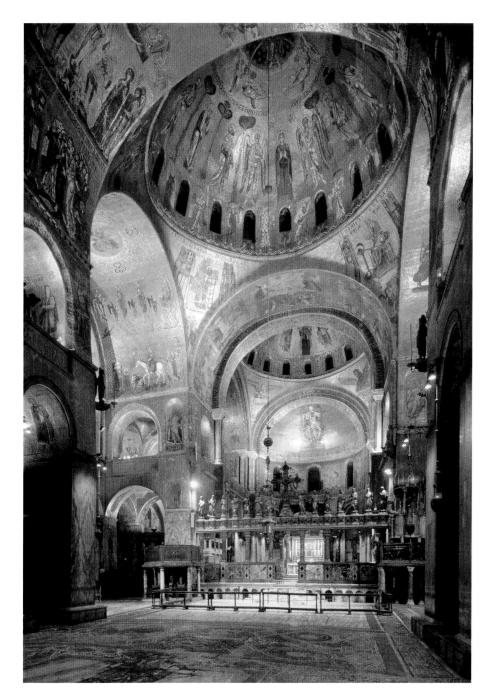

12-24 Interior of Saint Mark's (looking east), Venice, Italy, begun 1063.

Saint Mark's has a central dome over the crossing and four other domes over the four equal arms of the Greek cross. The walls and vaults are covered with 40,000 square feet of dazzling mosaics.

time. That church no longer exists, but its key elements were a cruciform plan with a central dome over the crossing and four other domes over the four equal arms of the Greek cross, as at Saint Mark's. Because of its importance to the city, the doges repeatedly remodeled the 11th-century structure, in time disguising its lower levels with Romanesque and Gothic additions. In 1807, Saint Mark's became the Cathedral of Venice.

The interior (FIG. 12-24) of Saint Mark's is, like its plan, Byzantine in effect. Light enters through a row of windows at the bases of all five domes, vividly illuminating a rich cycle of mosaics. Both Byzantine and local artists worked on Saint Mark's mosaics over the course of several centuries. Most of the mosaics date to the 12th and 13th centuries. Cleaning

and restoration on a grand scale have returned the mosaics to their original splendor, enabling visitors to experience the full radiance of mosaic (some 40,000 square feet of it) as it covers the walls, arches, vaults, and domes, as if it were a gold-brocaded figured fabric.

In the vast central dome, 80 feet above the floor and 42 feet in diameter, Christ ascends to Heaven in the presence of the Virgin Mary and the 12 apostles. The great arch framing the church crossing bears a narrative of the Crucifixion and Resurrection of Christ and of his liberation from death (Anastasis) of Adam and Eve, Saint John the Baptist, and other biblical figures. The mosaics have explanatory labels in both Latin and Greek, reflecting Venice's position as the key link between eastern and western Christendom in the later Middle Ages. The insubstantial figures on the walls, vaults, and domes appear weightless, and they project no farther from their flat field than do the elegant Latin and Greek letters above them. Nothing here reflects on the world of matter, of solids, of light and shade, of perspective space. Rather, the mosaics reveal the mysteries of the Christian faith.

mosaicist's art also occurred in areas of the former Western Roman Empire where the ties with Constantinople were the strongest. In the Early Byzantine period, Venice, about 80 miles north of Ravenna on the eastern coast of Italy, was a dependency of that Byzantine stronghold. In 751, Ravenna fell to the Lombards, who wrested control of most of northern Italy from Constantinople. Venice, however, became an independent power. Its *doges* (dukes) enriched themselves and the city through seaborne commerce, serving as the crucial link between Byzantium and the West.

Venice had obtained the relics of Saint Mark from Alexandria in Egypt in 829, and the doges constructed the first Venetian shrine dedicated to the evangelist—a palace chapel and *martyrium* (martyr's shrine)—shortly thereafter. Fire destroyed the ninth-century chapel in 976. The Venetians then built a second shrine on the site, but a grandiose new church begun in 1063 by Doge Domenico Contarini (r. 1043–1071) replaced it. This building was modeled on the Church of the Holy Apostles at Constantinople, built in Justinian's

12-25 Pantokrator, Theotokos and Child, angels, and saints, apse mosaic in the cathedral at Monreale (Sicily), Italy, ca. 1180–1190.

In centrally planned Byzantine churches, the image of the Pantokrator usually appears in the main dome, but the Monreale cathedral is a longitudinal basilica and the semidome of the apse is its only vault.

NORMAN SICILY Venetian success was matched in the western Mediterranean by the Normans, the northern French descendants of the Vikings (see Chapter 16) who, having driven the Arabs from Sicily, set up a powerful kingdom there. Though they were the enemies of Byzantium, the Normans, like the Venetians, assimilated Byzantine culture and even employed Byzantine artisans. The Normans also incorporated in their monuments elements of the Islamic art of the Arabs they had defeated (see Chapter 13). The Normans' Palatine (palace) Chapel at Palermo, with its prismatic (*muqarnas*) ceiling, a characteristic Muslim form (Fig. 13-17), is one example of the rich interplay of Western Christian, Byzantine, and Islamic cultures in Norman Sicily.

The mosaics of the great basilican church of Monreale, not far from Palermo, are striking evidence of Byzantine influence. They rival those of Saint Mark's in both quality and extent. One scholar has estimated that more than 100 million glass and stone tesserae were required for the Monreale mosaics. The Norman king William II paid for them, and he is portrayed twice, continuing the theme of royal presence and patronage of the much earlier Ravenna portraits of Justinian and Theodora (FIGS. 12-10 and 12-11) at San Vitale. In one panel, William, clearly labeled, unlike Justinian or his consort, stands next to the enthroned Christ, who places his hand on William's crown. In the second, the king kneels before the Virgin and presents her with a model of the Monreale church, a role that Bishop Ecclesius (FIG. 12-9), rather than the emperor or empress, played at San Vitale. As in the Ravenna church, the Monreale mosaic program commemorates both the piety and power of the ruler who reigns with divine authority.

The apse mosaics (FIG. 12-25) are especially impressive. The image of Christ as Pantokrator, as ruler and judge of Heaven and Earth, is in the vault. It served also as a colossal allusion to William's kingly power and a challenge to all who would dispute the royal right. In Byzantium proper, the Pantokrator's image usually appears in the main dome of centralized churches such as those at Daphni (FIG. 12-1) and Hosios Loukas (FIG. 12-22), but the Greek churches are monastic churches and were not built for the glorification of monarchs. Monreale, moreover, is a basilica—longitudinally planned in the Western tradition. The semidome of the apse, the

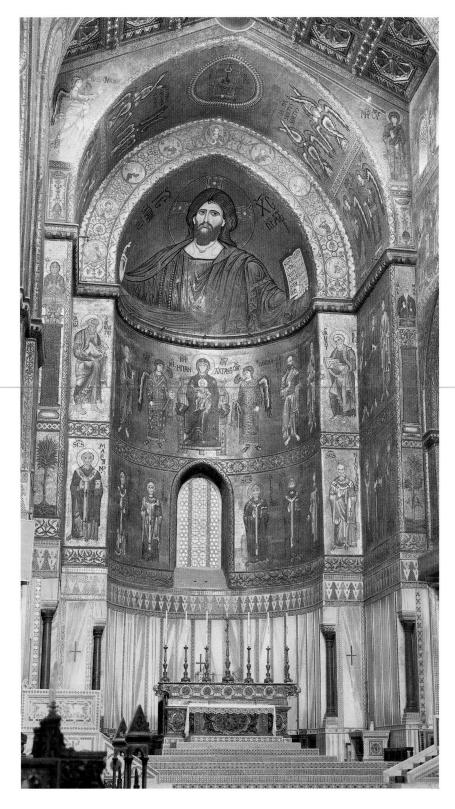

only vault in the building and its architectural focus, was the most conspicuous place for the vast image with its political overtones. Below the Pantokrator in rank and dignity, the enthroned Theotokos is flanked by archangels and the 12 apostles, symmetrically arranged in balanced groups. Lower on the wall (and less elevated in the hierarchy) are popes, bishops, and other saints. The artists observed the stern formalities of Byzantine style here, far from Constantinople. The Monreale mosaics, like those at Saint Mark's (FIG. 12-24) in Venice, testify to the stature of Byzantium and of Byzantine art in medieval Italy.

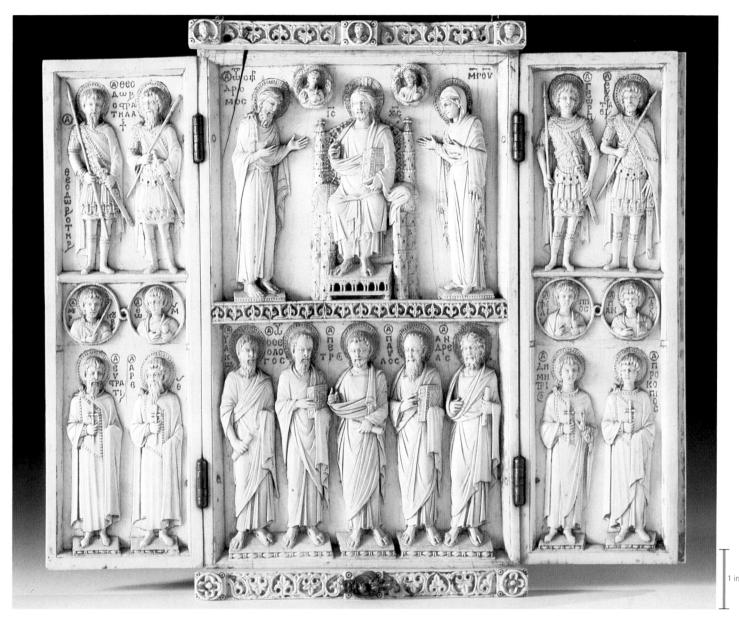

12-26 Christ enthroned with saints (*Harbaville Triptych*), ca. 950. Ivory, central panel $9\frac{1}{2} \times 5\frac{1}{2}$. Louvre, Paris.

In this small three-part shrine with hinged wings used for private devotion, the ivory carver depicted the figures with looser, more classical stances in contrast to the frontal poses of most Byzantine figures.

Ivory Carving and Painting

Costly carved ivories also were produced in large numbers in the Middle Byzantine period, when the three-part *triptych* replaced the earlier diptych as the standard format for ivory panels.

HARBAVILLE TRIPTYCH One example of this type is the Harbaville Triptych (FIG. 12-26), a portable shrine with hinged wings used for private devotion. Ivory triptychs were very popular—among people who could afford such luxurious items—and they often replaced icons for use in personal prayer. Carved on the wings of the Harbaville Triptych, both inside and out, are four pairs of full-length figures and two pairs of medallions depicting saints. A cross dominates the central panel on the back of the triptych (not illustrated). On the inside is a scene of Deësis (supplication). Saint John the Baptist and the Theotokos appear as intercessors, praying on behalf of the viewer to the enthroned Savior. Below them are five apostles.

The formality and solemnity usually associated with Byzantine art, visible in the mosaics of Ravenna and Monreale, yielded here to a softer, more fluid technique. The figures may lack true classical contrapposto, but the looser stances (most stand on bases, like free-standing statues) and three-quarter views of many of the heads relieve the hard austerity of the customary frontal pose. This more natural, classical spirit was a second, equally important, stylistic current of the Middle Byzantine period. It also surfaced in mural painting and book illumination. When the emperors lifted the ban against religious images and again encouraged religious painting at Constantinople, the impact was felt far and wide. The style varied from region to region, but a renewed enthusiasm for picturing the key New Testament figures and events was universal.

NEREZI In 1164, at Nerezi in Macedonia, Byzantine painters embellished Saint Pantaleimon with murals of great emotional power. One of these represents the Lamentation over the dead Christ

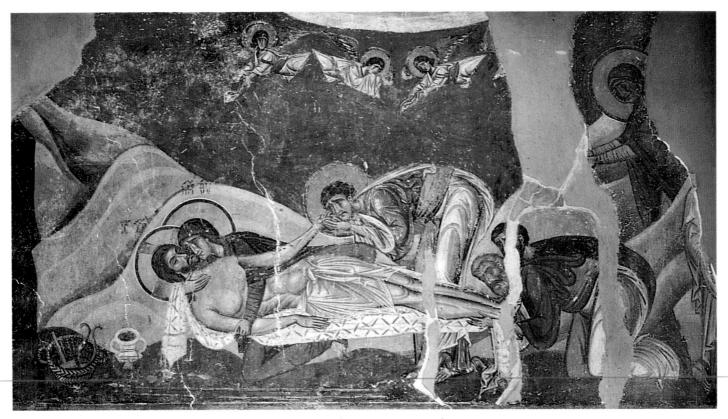

12-27 Lamentation over the dead Christ, wall painting, Saint Pantaleimon, Nerezi, Macedonia, 1164.

Working in the Balkans in an alternate Byzantine mode, this painter staged the emotional scene of the Lamentation in a hilly landscape below a blue sky and peopled it with fully modeled figures.

(FIG. 12-27). It is an image of passionate grief. The artist captured Christ's followers in attitudes, expressions, and gestures of quite human bereavement. Joseph of Arimathea and the disciple Nicodemus kneel at his feet, while Mary presses her cheek against her dead son's face and Saint John clings to Christ's left hand. In the Gospels, neither Mary nor John was present at the entombment of Christ. Their inclusion here, as elsewhere in Middle Byzantine art, intensified for the viewer the emotional impact of Christ's death. Representations such as these parallel the development of liturgical hymns recounting the Virgin's lamenting her son's death on the Cross.

At Nerezi, the painter set the scene in a hilly landscape below a blue sky—a striking contrast to the abstract golden world of the mosaics favored for church walls elsewhere in the Byzantine Empire. The artist strove to make utterly convincing an emotionally charged realization of the theme by staging the Lamentation in a more natural setting and peopling it with fully modeled actors. This alternate representational mode is no less Byzantine than the frontal, flatter figures of Ravenna. In time, this more naturalistic style would also be emulated in Italy (FIG. 19-9).

PARIS PSALTER Another example of this classical-revival style is a page from a book of the Psalms of David. The so-called *Paris Psalter* (FIG. 12-28) reasserts the artistic values of the Greco-Roman past

12-28 David composing the Psalms, folio 1 verso of the *Paris Psalter*, ca. 950–970. Tempera on vellum, 1′ $2\frac{1}{8}$ ″ \times $10\frac{1}{4}$ ″. Bibliothèque Nationale, Paris.

During the so-called Macedonian Renaissance, Byzantine painters revived the classical style. David is here portrayed as if a Greek hero and is accompanied by personifications of Melody, Echo, and Bethlehem.

with astonishing authority. Art historians believe the manuscript dates from the mid-10th century—the so-called Macedonian Renaissance, a time of enthusiastic and careful study of the language and literature of ancient Greece, and of humanistic reverence for the classical past. It was only natural that artists would once again draw inspiration from the Hellenistic naturalism of the pre-Christian Mediterranean world.

David, the psalmist, surrounded by sheep, goats, and his faithful dog, plays his harp in a rocky landscape with a town in the background. Similar settings appeared frequently in Pompeian murals. Befitting an ancient depiction of Orpheus, the Greek hero who could charm even inanimate objects with his music, allegorical figures accompany the Old Testament harpist. Melody looks over his shoulder, and Echo peers from behind a column. A reclining male figure points to a Greek inscription that identifies him as representing the mountain of Bethlehem. These allegorical figures do not appear in the Bible. They are the stock population of Greco-Roman painting. Apparently, the artist had seen a work from Late Antiquity or perhaps earlier and partly translated it into a Byzantine pictorial idiom. In works such as this, Byzantine artists kept the classical style alive in the Middle Ages.

VLADIMIR VIRGIN Nothing in Middle Byzantine art better demonstrates the rejection of the iconoclastic viewpoint than the painted icon's return to prominence. After the restoration of images, icons multiplied by the thousands to meet public and private demand. In the 11th century, the clergy began to display icons in hierarchical order (Christ, the Theotokos, John the Baptist, and then other saints, as on the *Harbaville Triptych*) in tiers on the *templon*, the low columnar screen separating the sanctuary from the main body of a Byzantine church.

The renowned Vladimir Virgin (FIG. 12-29) is a masterpiece of Middle Byzantine icon painting. Descended from works such as the Mount Sinai icon (FIG. 12-18), the Vladimir Virgin clearly reveals the stylized abstraction resulting from centuries of working and reworking the conventional image. The artist was probably a Constantinopolitan painter, and this icon exhibits all the characteristic Byzantine traits: the Virgin's long, straight nose and small mouth; the golden rays in the infant's drapery; the decorative sweep of the unbroken contour that encloses the two figures; and the flat silhouette against the golden ground. But the Vladimir Virgin is a much more tender and personalized image of the Theotokos than that in the Mount Sinai icon. Here Mary appears as the Virgin of Compassion, who presses her cheek against her son's in an intimate portrayal of Mother and Child. The image is also infused with a deep pathos as Mary contemplates the future sacrifice of her son. (The back of the icon bears images of the instruments of Christ's Passion.)

The *Vladimir Virgin*, like most icons, has seen hard service. Placed before or above altars in churches or private chapels, the icon became blackened by the incense and smoke from candles that burned before or below it. It was frequently repainted, often by inferior artists, and only the faces show the original surface. First painted in the late 11th or early 12th century, it was taken to Kiev (Ukraine) in 1131, then to Vladimir (Russia) in 1155 (hence its name), and in 1395, as a wonder-working image, to Moscow to protect that city from the Mongols. The Russians believed that the sacred picture saved the city of Kazan from later Tartar invasions and all of Russia from the Poles in the 17th century. The *Vladimir Virgin* is a historical symbol of Byzantium's religious and cultural mission to the Slavic world.

12-29 Virgin (Theotokos) and Child, icon (*Vladimir Virgin*), late 11th to early 12th centuries. Tempera on wood, original panel 2' $6\frac{1}{2}$ " × 1' 9". Tretyakov Gallery, Moscow.

In this icon, the artist depicted Mary as the Virgin of Compassion, who presses her cheek against her son's as she contemplates his future. The reverse side shows the instruments of Christ's Passion.

LATE BYZANTINE ART

When rule passed from the Macedonian to the Comnenian dynasty in the later 11th and the 12th centuries, three events of fateful significance changed Byzantium's fortunes for the worse. The Seljuk Turks conquered most of Anatolia. The Byzantine Orthodox Church broke finally with the Church of Rome. And the Crusades brought the Latins (a generic term for the peoples of the West) into Byzantine lands on their way to fight for the Cross against the Saracens (Muslims) in the Holy Land (see "The Crusades," Chapter 17, page 442).

Crusaders had passed through Constantinople many times en route to "smite the infidel" and had marveled at its wealth and magnificence. Envy, greed, religious fanaticism (the Latins called the Greeks "heretics"), and even ethnic enmity motivated the Crusaders when, during the Fourth Crusade in 1203 and 1204, the Venetians persuaded them to divert their expedition against the Muslims in Palestine and to attack Constantinople instead. The Crusaders took the city and sacked it. Nicetas Choniates, a contemporaneous historian, expressed the feelings of the Byzantines toward their attackers: "The

accursed Latins would plunder our wealth and wipe out our race. . . . Between us there can be only an unbridgeable gulf of hatred. . . . They bear the Cross of Christ on their shoulders, but even the Saracens are kinder."⁷

The Latins set up kingdoms within Byzantium, notably in Constantinople itself. What remained of Byzantium split into three small states. The Palaeologans ruled one of these, the kingdom of Nicaea. In 1261, Michael VIII Palaeologus (r. 1259–1282) succeeded in recapturing Constantinople. But his empire was no more than a fragment, and even that disintegrated during the next two centuries. Isolated from the Christian West by Muslim conquests in the Balkans and besieged by Muslim Turks to the east, Byzantium sought help from the West. It was not forthcoming. In 1453, the Ottoman Turks, then a formidable power, took Constantinople and brought to an end the long history of Byzantium (see Chapter 13). But despite the state's grim political condition under the Palaeologan dynasty, the arts flourished well into the 14th century.

Painting

During the 14th and 15th centuries, artists throughout the Byzantine world produced masterpieces of mural and icon painting rivaling those of the earlier periods. Four characteristic examples from

the old capital of Constantinople and as far away as Russia can serve to illustrate the range and quality of painting during the Late Byzantine period.

CHRIST IN CHORA A fresco (FIG. 12-30) in the apse of the parekklesion (side chapel, in this instance a funerary chapel) of the Church of Christ in Chora in Constantinople depicts the Anastasis. One of many subsidiary subjects that made up the complex mosaic program of Saint Mark's (FIG. 12-24) in Venice, the Anastasis is here central to a cycle of pictures portraying the themes of human mortality and redemption by Christ and of the intercession of the Virgin, both appropriate for a funerary chapel. Christ, trampling Satan and all the locks and keys of his prison house of Hell, raises Adam and Eve from their tombs. Looking on are John the Baptist, King David, and King Solomon on the left, and various martyr saints on the right. Christ, central and surrounded by a luminous mandorla, reaches out equally to Adam and Eve. The action is swift and smooth, the supple motions executed with the grace of a ballet. The figures float in a spiritual atmosphere, spaceless and without material mass or shadow-casting volume. This same smoothness and lightness can be seen in the modeling of the figures and the subtly nuanced coloration. The jagged abstractions of drapery found in

12-30 Anastasis, apse fresco in the parekklesion of the Church of Christ in Chora (now the Kariye Museum), Constantinople (Istanbul), Turkey, ca. 1310–1320.

In this Late Byzantine funerary chapel, Christ, a white apparition surrounded by a luminous mandorla, raises Adam and Eve from their tombs as John the Baptist and Kings David and Solomon look on.

many earlier Byzantine frescoes and mosaics are gone in a return to the fluid delineation of drapery characteristic of the long tradition of classical illusionism.

Throughout the centuries, Byzantine artists looked back to Greco-Roman illusionism. But unlike classical artists, Byzantine painters and mosaicists were not concerned with the systematic observation of material nature as the source of their representations of the eternal. They drew their images from a persistent and conventionalized vision of a spiritual world unsusceptible to change. That consistent vision is what unites works as distant in time as the sixth-century apse mosaic (FIG. 12-13) at Mount Sinai and the 14th-century fresco in the Church of Christ in Chora.

OHRID ICONS Byzantine spirituality was perhaps most intensely revealed in icon painting. In the Late Byzantine period, the Early Byzantine templon developed into an *iconostasis*, a high screen with doors and tiers of icons. As its name implies, the iconostasis supported tiers of painted devotional images, which began to be produced again in large numbers, both in Constantinople and throughout the diminished Byzantine Empire.

One example (FIG. 12-31), notable for the lavish use of finely etched silver foil to frame the painted figure of Christ as Savior of

Souls, dates to the beginning of the 14th century. It comes from Saint Clement at Ohrid in Macedonia, where many Late Byzantine icons imported from the capital have been preserved. The painter of the Ohrid Christ, in a manner consistent with Byzantine art's conservative nature, adhered to an iconographical and stylistic tradition traceable to the earliest icons from the monastery at Mount Sinai. As elsewhere (for example, FIG. 12-1), the Savior holds a bejeweled Bible in his left hand while he blesses the faithful with his right hand. The style is typical of Byzantine eclecticism. Note especially the juxtaposition of Christ's fully modeled head and neck, which reveal the Byzantine painter's Greco-Roman heritage, with the schematic linear folds of Christ's garment, which do not envelop the figure but rather seem to be placed in front of it.

In the Late Byzantine period, icons often were painted on two sides because they were intended to be carried in processions. When deposited in the church, the icons were not mounted on the iconostasis but were exhibited on stands so worshipers could view both sides. The Ohrid icon of Christ has a painting of the Crucifixion on its reverse. Another double icon from Saint Clement's, also imported from Constantinople, represents the Virgin on the front as Christ's counterpart as Savior of Souls. The Annunciation (FIG. 12-32) appears on the reverse. With a commanding gesture of heavenly

12-31 Christ as Savior of Souls, icon from Saint Clement, Ohrid, Macedonia, early 14th century. Tempera, linen, and silver on wood, $3'\frac{1}{4}'' \times 2'2\frac{1}{2}''$. Icon Gallery of Saint Clement, Ohrid.

Notable for the lavish use of finely etched silver foil, this icon typifies Byzantine eclecticism. Christ's fully modeled head and neck contrast with the schematic linear folds of his garment.

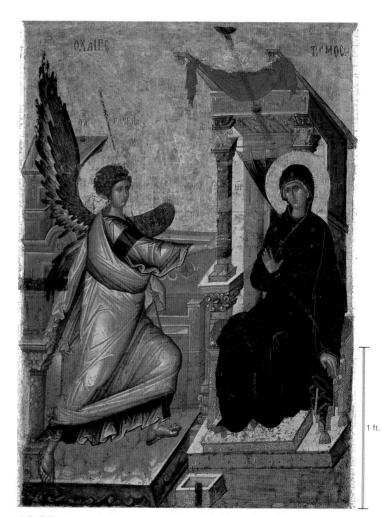

12-32 Annunciation, reverse of two-sided icon from Saint Clement, Ohrid, Macedonia, early 14th century. Tempera and linen on wood, $3'\frac{1}{4}'' \times 2'2\frac{3}{4}''$. Icon Gallery of Saint Clement, Ohrid.

Late Byzantine icons often were painted on two sides because they were intended to be carried in processions. On this icon the Virgin Mary appears on the front and this Annunciation scene on the back.

12-33 Andrei Rublyev, Three angels (Old Testament Trinity), ca. 1410. Tempera on wood, 4' 8" × 3' 9". Tretyakov Gallery, Moscow.

This exceptionally large icon, which features subtle lines and intensely vivid colors, is one of the masterworks of Russian painting. It depicts the three angels who appeared to Abraham, prefiguring the Trinity.

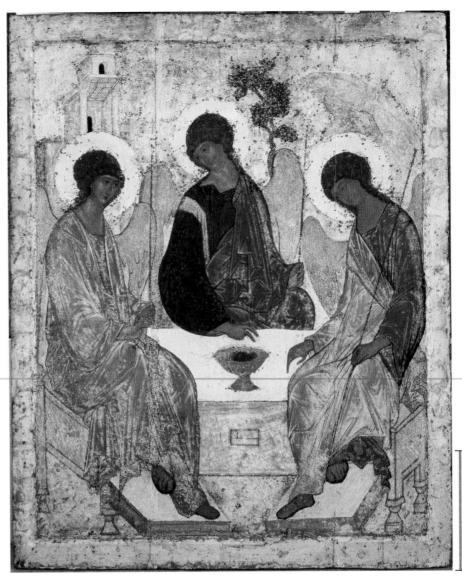

1 ft.

authority, the angel Gabriel announces to Mary that she is to be the Mother of God. She responds with a simple gesture conveying both astonishment and acceptance. The gestures and attitudes of the figures are again conventional, as are the highly simplified architectural props. The painter rendered the latter in inconsistent perspective derived from classical prototypes, but set the sturdy three-dimensional forms against an otherworldly gold sky, suggesting the sacred space in which the narrative unfolds. This icon also exemplifies the eclecticism that characterizes Byzantine art throughout its long history.

ANDREI RUBLYEV In Russia, icon painting flourished for centuries, extending the life of the Byzantine painting style well beyond the collapse of the Byzantine Empire in 1453. Russian paintings usually had strong patterns, firm lines, and intense contrasting colors. All served to heighten the legibility of the icons in the wavering candlelight and clouds of incense that worshipers encountered in church interiors. For many art historians, Russian painting reached a climax in the work of Andrei Rublyev (ca. 1370–1430). His nearly five-foot-tall panel (FIG. 12-33) depicting the three Old Testament angels who appeared to Abraham is a work of great spiritual power. It is also an unsurpassed example of subtle line in union with intensely vivid color. The angels sit about a table, each framed

with a halo and sweeping wings, three nearly identical figures distinguished only by their garment colors. The light linear play of the draperies sets off the tranquil demeanor of the figures. Color defines the forms and becomes more intense by the juxtaposition of complementary hues. The intense blue and green folds of the central figure's cloak, for example, stand out starkly against the deep-red robe and the gilded orange of the wings. In the figure on the left, the highlights of the orange cloak are an opalescent blue green. The unmodulated saturation, brilliance, and purity of the color harmonies are the hallmark of Rublyev's style.

THE THIRD ROME With the fall of Constantinople in 1453, Russia became Byzantium's self-appointed heir, defending Christendom against the infidel. The court of the tsar (the title derives from "Caesar") declared: "Because the Old Rome has fallen, and because the Second Rome, which is Constantinople, is now in the hands of the godless Turks, thy kingdom, O pious Tsar, is the Third Rome.... Two Romes have fallen, but the Third stands, and there shall be no more." Rome, Byzantium, Russia—Old Rome, New Rome, and Third Rome—were a continuum, spanning two and a half millennia during which artists and architects produced many of the most significant paintings, sculptures, and buildings in the long history of art through the ages.

BYZANTIUM

EARLY BYZANTINE ART, 527-726

- The reign of Justinian (r. 527–565) opened the first golden age of Byzantine art. Justinian was a great patron of the arts, and in Constantinople alone he built or restored more than 30 churches.
- Constructed in only five years, Hagia Sophia, a brilliant fusion of central and longitudinal plans, rivaled the architectural wonders of Rome. Its 180-foot-high dome rests on pendentives but seemed to contemporaries to be suspended "by a golden chain from Heaven."
- The seat of Byzantine power in Italy was Ravenna, which enjoyed its greatest prosperity under Justinian. San Vitale is Ravenna's greatest church. Its mosaics, with their weightless, hovering, frontal figures against a gold background, reveal the new Byzantine aesthetic.
- Justinian also rebuilt the monastery at Mount Sinai in Egypt, where the finest Early Byzantine icons are preserved. In 726, however, Leo III (r. 717–741) enacted a ban against picturing the divine, initiating the era of iconoclasm (726–843).

Hagia Sophia, Constantinople, 532–537

San Vitale, Ravenna, 526-547

MIDDLE BYZANTINE ART, 843-1204

- In 867, Basil I (r. 867–886) dedicated a new mosaic depicting the Theotokos (Mother of God) in Hagia Sophia. It marked the triumph of the iconophiles over the iconoclasts.
- Middle Byzantine art is stylistically eclectic. Mosaics with otherworldly golden backgrounds were common, but some paintings, for example those in the *Paris Psalter*, revived the naturalism of classical art.
- Middle Byzantine churches like those at Hosios Loukas have highly decorative exterior walls and feature domes that rest on drums above the center of a Greek cross. The climax of the interior mosaic programs was often an image of Christ as Pantokrator in the dome.

Paris Psalter, ca. 950-970

Katholikon, Hosios Loukas, first quarter of 11th century

LATE BYZANTINE ART, 1261-1453

- In 1204, Latin Crusaders sacked Constantinople, bringing to an end the second golden age of Byzantine art. In 1261, Michael VIII Palaeologus (r. 1259–1282) succeeded in retaking the city. Constantinople remained in Byzantine hands until the Ottoman Turks captured it in 1453.
- Important mural paintings of the Late Byzantine period are in the Constantinopolitan Church of Christ in Chora. An extensive picture cycle portrays Christ as Redeemer; in the apse he raises Adam and Eve from their tombs.
- Late Byzantine icons were displayed in tiers on an iconostasis or on individual stands so that the paintings on both sides could be seen. The great painting centers during this period were in Constantinople and Russia. The work of Andrei Rublyev is notable for its great spiritual power and intense colors.

Andrei Rublyev, Three angels, ca. 1410

13-1 Court of the Lions, Palace of the Lions, Alhambra, Granada, Spain, 1354–1391.

The Palace of the Lions, named for its fountain's unusual statues, is distinctly Islamic in the use of multilobed pointed arches and the interweaving of Arabic calligraphy and abstract ornament in its stuccoed walls.

THE ISLAMIC WORLD

The religion of Islam (an Arabic word meaning "submission to God") arose among the peoples of the Arabian Peninsula early in the seventh century (see "Muhammad and Islam," page 343). At the time, the Arabs were nomadic herders and caravan merchants traversing the vast Arabian desert and settling and controlling its coasts. They were peripheral to the Byzantine and Persian empires. Yet within little more than a century, the eastern Mediterranean, which Byzantium once ringed and ruled, had become an Islamic lake, and the armies of Islam had subdued the Middle East, long the seat of Persian dominance and influence.

The swiftness of the Islamic advance is among the wonders of world history. By 640, Muslims ruled Syria, Palestine, and Iraq in the name of Allah. In 642, the Byzantine army abandoned Alexandria, marking the Muslim conquest of Lower (northern) Egypt. In 651, the successors of Muhammad ended more than 400 years of Sasanian rule in Iran (see Chapter 2). All of North Africa was under Muslim control by 710. A victory at Jerez de la Frontera in southern Spain in 711 seemed to open all of western Europe to the Muslims. By 732, they had advanced north to Poitiers in France, but an army of Franks under Charles Martel, the grandfather of Charlemagne, opposed them successfully (see Chapter 16), halting Muslim expansion at the Pyrenees. In Spain, in contrast, the Islamic rulers of Córdoba flourished until 1031, and not until 1492 did Muslim influence and power end in the Iberian Peninsula. That year the army of King Ferdinand and Queen Isabella, the sponsors of Columbus's voyage to the New World, overthrew the caliphs of Granada. In the East, the Muslims reached the Indus River by 751, and only in Anatolia could stubborn Byzantine resistance slow their advance. Relentless Muslim pressure against the shrinking Byzantine Empire eventually caused its collapse in 1453, when the Ottoman Turks entered Constantinople (see Chapter 12).

Military might alone, however, cannot account for the relentless and far-ranging sweep of Islam from Arabia to India to North Africa and Spain (MAP 13-1). That Islam endured in the conquered lands for centuries after the initial victories can be explained only by the nature of the Islamic faith and its appeal to millions of converts. Islam remains today one of the world's great religions, with adherents on all

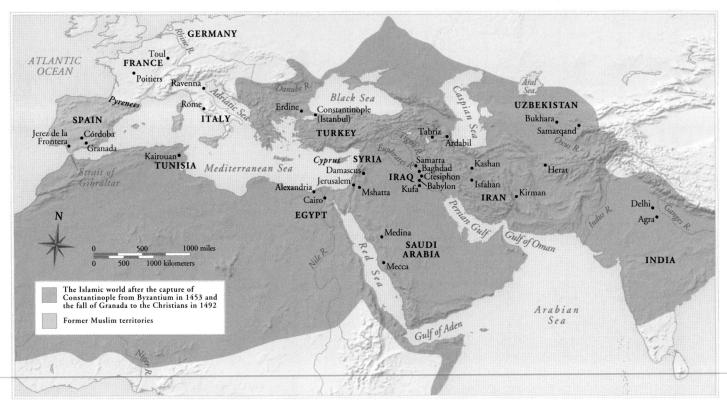

MAP 13-1 The Islamic world around 1500.

continents. Its sophisticated culture has had a profound impact around the globe. Arab scholars laid the foundations of arithmetic and algebra and made significant contributions to astronomy, medicine, and the natural sciences. Christian scholars in the West during the 12th and 13th centuries eagerly studied Arabic translations of Aristotle and other Greek writers of antiquity. Arabic love lyrics and poetic descriptions of nature inspired the early French troubadours.

The triumph of Islam also brought a new and compelling tradition to the history of world art and architecture. Like Islam itself, Islamic art spread quickly both eastward and westward from the land once inhabited by the peoples of the ancient Near East. In the Middle East and North Africa, Islamic art largely replaced Late Antique art. From a foothold in the Iberian Peninsula, Islamic art influenced Western medieval art. Islamic artists and architects also brought their distinctive style to South Asia, where a Muslim sultanate was established at Delhi in India in the early 13th century (see Chapter 26). In fact, perhaps the most famous building in Asia, the Taj Mahal (FIGS. 26-1 and 26-6) at Agra, is an Islamic mausoleum.

EARLY ISLAMIC ART

During the early centuries of Islamic history, the Muslim world's political and cultural center was the Fertile Crescent of ancient Mesopotamia (see Chapter 2). The caliphs of Damascus (capital of modern Syria) and Baghdad (capital of Iraq) appointed provincial governors to rule the vast territories they controlled. These governors eventually gained relative independence by setting up dynasties in various territories and provinces: the Umayyads in Syria (661–750) and in Spain (756–1031), the Abbasids in Iraq (750–1258, largely nominal after 945), the Fatimids in Egypt (909–1171), and so on.

Architecture

Like other potentates before and after, the Muslim caliphs were builders on a grand scale. The first Islamic buildings, both religious and secular, are in the Middle East, but important early examples of Islamic architecture still stand also in North Africa, Spain, and Central Asia.

DOME OF THE ROCK The first great Islamic building is the Dome of the Rock (FIG. 13-2) in Jerusalem. The Muslims had taken the city from the Byzantines in 638, and the Umayyad caliph Abd al-Malik (r. 685–705) erected the monumental shrine between 687 and 692 as an architectural tribute to the triumph of Islam. The Dome of the Rock marked the coming of the new religion to the city that was—and still is—sacred to both Jews and Christians. The structure rises from a huge platform known as the Noble Enclosure, where in ancient times the Hebrews built the Temple of Solomon that the Roman emperor Titus destroyed in 70 (see Chapter 10). In time, the site took on additional significance as the reputed place where Adam was buried and where Abraham prepared to sacrifice Isaac. The rock that gives the building its name also later came to be identified with the spot from which Muhammad miraculously journeyed to Heaven and then, in the same night, returned to his home in Mecca.

As Islam took much of its teaching from Judaism and Christianity, so, too, its architects and artists borrowed and transformed design, construction, and ornamentation principles long applied in Byzantium and the Middle East. The Dome of the Rock is a domed octagon resembling San Vitale (FIG. 12-6) in Ravenna in its basic design. In all likelihood, a neighboring Christian monument, Constantine's Church of the Holy Sepulchre, a domed rotunda, inspired the Dome of the Rock's designers. That fourth-century rotunda bore a family resemblance to the roughly contemporary Constantinian

Muhammad and Islam

uhammad, founder of Islam and revered as its Final Prophet, was a native of Mecca on the west coast of Arabia. Born around 570 into a family of merchants in the great Arabian caravan trade, Muhammad was inspired to prophesy. Critical of the polytheistic religion of his fellow Arabs, he preached a religion of the one and only God ("Allah" in Arabic), whose revelations Muhammad received beginning in 610 and for the rest of his life. Opposition to Muhammad's message among the Arabs was strong enough to prompt the Prophet and his followers to flee from Mecca to a desert oasis eventually called Medina ("City of the Prophet"). Islam dates its beginnings from this flight in 622, known as the Hijra ("emigration").* Barely eight years later, in 630, Muhammad returned to Mecca with 10,000 soldiers. He took control of the city, converted the population to Islam, and destroyed all the idols. But he preserved as the Islamic world's symbolic center the small cubical building that had housed the idols, the Kaaba (from the Arabic for "cube"). The Arabs associated the Kaaba with the era of Abraham and Ishmael, the common ancestors of Jews and Arabs. Muhammad died in Medina in 632.

The essential meaning of Islam is acceptance of and submission to Allah's will. Believers in Islam are called Muslims ("those who submit"). Islam requires them to live according to the rules laid down in the collected revelations communicated through Muhammad during his lifetime. The *Koran*, Islam's sacred book, codified by the Muslim ruler Uthman (r. 644–656), records Muhammad's revelations. The word "Koran" means "recitations"—a reference to the archangel Gabriel's instructions to Muhammad in 610 to "recite in the name of Allah." The Koran is composed of 114 *surahs* ("chapters") divided into verses.

The profession of faith in the one God, Allah, is the first of five obligations binding all Muslims. In addition, the faithful must worship five times daily facing in Mecca's direction, give alms to the poor, fast during the month of Ramadan, and once in a lifetime—if possible—make a pilgrimage to Mecca. The revelations in the Koran are not the only guide for Muslims. Muhammad's exemplary ways and customs, collected in the *Sunnah*, offer models to the faithful on ethical problems of everyday life. The reward for the Muslim faithful is Paradise.

Islam has much in common with Judaism and Christianity. Its adherents think of it as a continuation, completion, and in some sense a reformation of those other great monotheisms. Islam incorporates many of the Old Testament teachings, with their sober ethical standards and rejection of idol worship, and those of the New Testament Gospels. Muslims acknowledge Adam, Abraham, Moses, and Jesus as the prophetic predecessors of Muhammad, the final and greatest of the prophets. Muhammad did not claim to be divine, as did Jesus. Rather, he was God's messenger, the purifier and perfecter of the common faith of Jews, Christians, and Muslims in one God. Islam also differs from Judaism and Christianity in its simpler organization. Muslims worship God directly, without a hierarchy of rabbis, priests, or saints acting as intermediaries.

In Islam, as Muhammad defined it, religious and secular authority were united even more completely than in Byzantium. Muhammad established a new social order, replacing the Arabs' old decentralized tribal one, and took complete charge of his community's temporal as well as spiritual affairs. After Muhammad's death, the *caliphs* (from the Arabic for "successor") continued this practice of uniting religious and political leadership in one ruler.

*Muslims date events beginning with the Hijra in the same way Christians reckon events from Christ's birth, and the Romans before them began their calendar with Rome's founding by Romulus and Remus in 753 BCE. The Muslim year, however, is a 354-day year of 12 lunar months, and dates cannot be converted by simply adding 622 to Christian-era dates.

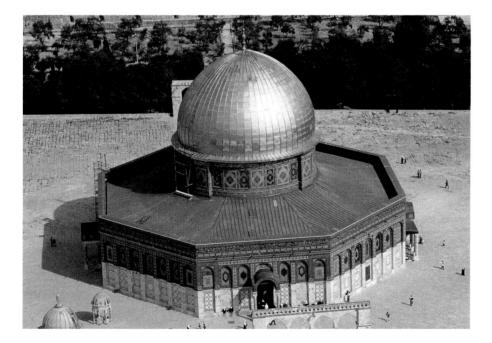

13-2 Aerial view of the Dome of the Rock, Jerusalem, 687–692.

Abd al-Malik erected the Dome of the Rock to mark the triumph of Islam in Jerusalem on a site sacred to Muslims, Christians, and Jews. The shrine takes the form of an octagon with a towering dome.

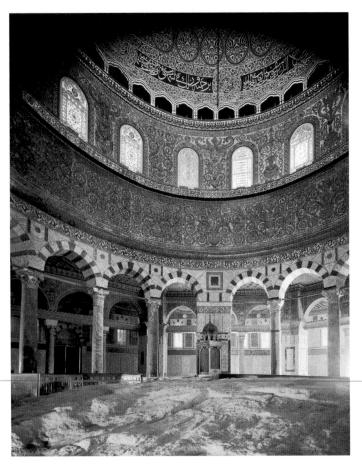

13-3 Interior of the Dome of the Rock, Jerusalem, 687–692.

Tiles from the 16th century adorn the exterior of the Dome of the Rock, but the interior's original mosaic ornament is preserved. The mosaics conjure the imagery of Paradise awaiting Muslims.

mausoleum later dedicated as Santa Costanza (FIGS. 11-11 and 11-12) in Rome. The Dome of the Rock is a member of the same extended family. Its double-shelled wooden dome, however, some 60 feet across and 75 feet high, so dominates the elevation as to reduce the octagon to function merely as its base. This soaring, majestic unit creates a decidedly more commanding effect than that produced by Late Roman and Byzantine domical structures (FIGS. 12-2 and 12-6). The silhouettes of those domes are comparatively insignificant when seen from the outside.

The building's exterior has been much restored. Tiling from the 16th century and later has replaced the original mosaic. Yet the vivid, colorful patterning that wraps the walls like a textile is typical of Islamic ornamentation. It contrasts markedly with Byzantine brickwork and Greco-Roman sculptured decoration. The interior's rich mosaic ornament (FIG. 13-3) has been preserved and suggests the original appearance of the exterior walls. Islamic practice does not significantly distinguish interior and exterior decor.

GREAT MOSQUE, DAMASCUS The Umayyads transferred their capital from Mecca to Damascus in 661. There, Abd al-Malik's son, the caliph al-Walid (r. 705–715), purchased a Byzantine church (formerly a Roman temple) and built an imposing new mosque for the expanding Muslim population (see "The Mosque," page 345). The Umayyads demolished the church, but they used the Roman precinct walls as a foundation for their own construction. Like the Dome of

the Rock, Damascus's Great Mosque (FIGS. 13-4 and 13-5) owes much to Roman and Early Christian architecture. The Islamic builders incorporated stone blocks, columns, and capitals salvaged from the earlier structures on the land al-Walid acquired for his mosque. Pier arcades reminiscent of Roman aqueducts frame the courtyard (FIG. 13-5). The minarets, two at the southern corners and one at the northern side of the enclosure—the earliest in the Islamic world—are modifications of the preexisting Roman square towers. The grand prayer hall, taller than the rest of the complex, is on the south side of the courtyard (facing Mecca). Its main entrance is distinguished by a facade with a pediment and arches, recalling Roman and Byzantine models. The facade faces into the courtyard, like a Roman forum temple (FIG. 10-12), a plan maintained throughout the long history of mosque architecture. The Damascus mosque synthesizes elements received from other cultures into a novel architectural unity, which includes the distinctive Islamic elements of mihrab, mihrab dome, minbar, and minaret.

An extensive cycle of mosaics once covered the walls of the Great Mosque. In one of the surviving sections (FIG. 13-4), a conchshell niche "supports" an arcaded pavilion with a flowering rooftop flanked by structures shown in classical perspective. Like the architectural design, the mosaics owe much to Roman, Early Christian, and Byzantine art. Indeed, some evidence indicates that the Great Mosque mosaics were the work of Byzantine mosaicists. Characteristically, temples, clusters of houses, trees, and rivers compose the

13-4 Detail of a mosaic in the courtyard arcade of the Great Mosque, Damascus, Syria, 706–715.

The mosaics of the Great Mosque at Damascus are probably the work of Byzantine artists and include buildings and landscape elements common in Late Antique art, but exclude any zoomorphic forms.

The Mosque

slamic religious architecture is closely related to Muslim prayer, an obligation laid down in the Koran for all Muslims. In Islam, worshiping can be a private act and requires neither prescribed ceremony nor a special locale. Only the *qibla*—the direction (toward Mecca) Muslims face while praying—is important. But worship also became a communal act when the first Muslim community established a simple ritual for it. To celebrate the Muslim sabbath, which occurs on Friday, the community convened each Friday at noon, probably in the Prophet's house in Medina. The main feature of Muhammad's house was a large square court with rows of palm trunks supporting thatched roofs along the north and south sides. The southern side, which faced Mecca, was wider and had a double row of trunks. The *imam*, or leader of collective worship, stood on a stepped pulpit, or *minbar*, set up in front of the southern (qibla) wall.

These features became standard in the Islamic house of worship, the *mosque* (from Arabic "masjid," a place of prostration), where the faithful gathered for the five daily prayers. The *congregational mosque* (also called the *Friday mosque* or *great mosque*) was ideally large enough to accommodate a community's entire population for the Friday noon prayer. A very important feature both of ordinary mosques and of congregational mosques is the *mihrab* (Fig. 13-8, no. 2), a semicircular niche usually set into the qibla wall. Often a dome over the bay in front of it marked its position (Figs. 13-5 and 13-8, no. 3). The niche was a familiar Greco-Roman architectural feature, generally enclosing a statue. Scholars still debate its origin, purpose, and meaning in Islamic architecture. The mihrab originally

may have honored the place where the Prophet stood in his house at Medina when he led communal worship.

In some mosques, a *maqsura* precedes the mihrab. The maqsura is the area generally reserved for the ruler or his representative and can be quite elaborate in form (FIG. 13-12). Many mosques also have one or more *minarets* (FIGS. 13-5, 13-9, AND 13-20), towers used to call the faithful to worship. When buildings of other faiths were converted into mosques, the Muslims clearly signaled the change on the exterior by the erection of minarets (FIG.12-2). *Hypostyle halls*, communal worship halls with roofs held up by a multitude of columns (FIGS. 13-8, no. 4, and 13-11), are characteristic features of early mosques. Later variations include mosques with four *iwans* (vaulted rectangular recesses), one on each side of the courtyard (FIGS. 13-22 and 13-23), and *central-plan* mosques with a single large dome-covered interior space (FIGS. 13-20 and 13-21), as in Byzantine churches, some of which later became mosques (FIG. 12-4).

The mosque's origin is still in dispute, although one prototype may well have been the Prophet's house in Medina. Today, despite many variations in design and detail (an adobe-and-wood mosque in Mali, FIGS. 15-1 and 15-8, is discussed later in the context of African architecture) and the employment of modern building techniques and materials unknown in Muhammad's day, the mosque's essential features are unchanged. All mosques, wherever they are built and whatever their plan, are oriented toward Mecca, and the faithful worship facing the qibla wall.

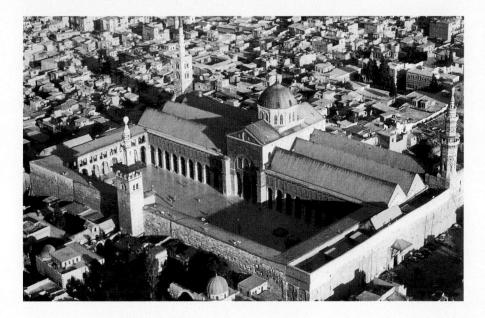

13-5 Aerial view of the Great Mosque, Damascus, Syria, 706–715.

The hypostyle type of mosque most closely recalls the layout of Muhammad's house in Medina. Damascus's Great Mosque also owes a debt to Roman and Early Christian architecture in its plan and decoration.

pictorial fields, bounded by stylized vegetal designs also found in Roman, Early Christian, and Byzantine ornament. No zoomorphic forms, human or animal, appear in either the pictorial or ornamental spaces. This is true of all the mosaics in the Great Mosque as well as the mosaics in the earlier Dome of the Rock (FIG. 13-3). Islamic tradition shuns the representation of fauna of any kind in sacred

places. Accompanying (but now lost) inscriptions explained the world shown in the Damascus mosaics, suspended miragelike in a featureless field of gold, as an image of Paradise. Many passages from the Koran describe the gorgeous places of Paradise awaiting the faithful—gardens, groves of trees, flowing streams, and "lofty chambers."

UMAYYAD PALACE, MSHATTA

The Umayyad rulers of Damascus constructed numerous palatial residences throughout their domains. The urban palaces are lost, but some rural palaces survive. The latter were not merely idyllic residences removed from the congestion, noise, and disease of the cities. They seem to have served as nuclei for the agricultural development of acquired territories and possibly as hunting lodges. In addition, the Islamic palaces were symbols of authority over new lands as well as expressions of their owners' wealth.

One of the most impressive Umayyad palaces, despite the fact that it was never completed, is at Mshatta in the Jordanian desert. Its plan (FIG. 13-6) resembles that of Diocletian's palace (FIG. 10-74) at Split, which in turn reflects the layout of a Roman fortified camp.

The high walls of the Mshatta palace incorporate 25 towers but lack parapet walkways for patrolling guards. The walls, nonetheless, offered safety from marauding nomadic tribes and provided privacy for the caliph and his entourage. Visitors entered the palace through a large portal on the south side. To the right was a mosque (FIG. 13-6, no. 2; the plan shows the mihrab niche in the qibla wall), in which the rulers and their guests could fulfill their obligation to pray five times a day. A small ceremonial area and an immense open courtyard separated the mosque from the palace's residential wing and official audience hall. Most Umayyad palaces also boasted fairly elaborate bathing facilities that displayed technical features, such as heating systems, adopted from Roman baths. Just as under the Roman Empire, these baths probably served more than merely hygienic purposes. Indeed, in several Umayyad palaces, excavators have uncovered in the baths paintings and sculptures of hunting and other secular themes, including depictions of dancing women—themes traditionally associated with royalty in the Near East. Large halls frequently attached to many of these baths seem to have been used as places of entertainment, as was the case in Roman times. Thus, the bath-spa as social center, a characteristic amenity of Roman urban culture that died out in the Christian world, survived in Islamic culture.

A richly carved stone frieze (FIG. 13-7) more than 16 feet high enlivens the facade of the Mshatta palace. Triangles contain large rosettes projecting from a field densely covered with curvilinear,

13-6 Plan of the Umayyad palace, Mshatta, Jordan, ca. 740–750 (after Alberto Berengo Gardin).

The fortified palace at Mshatta resembled Diocletian's palace (FIG. 10-74) at Split and incorporated the amenities of Roman baths but also housed a mosque in which the caliph could worship five times daily.

1. Entrance gate
2. Mosque
3. Small courtyard
4. Large courtyard
5. Audience hall

vegetal designs. No two triangles are exactly alike. Animals appear in some of them. Similar compositions of birds, felines, and vegetal scrolls can be found in Roman, Byzantine, and Sasanian art. The Mshatta frieze, however, in keeping with Islam's disavowal of representing living things in sacred contexts, has no animal figures to the right of the entrance portal—that is, on the part of the facade corresponding to the mosque's qibla wall.

BAGHDAD In 750, after years of civil war, the Abbasids, who claimed descent from Abbas, an uncle of Muhammad, overthrew the Umayyad caliphs. The new rulers moved the capital from Damascus to a site in Iraq near the old Sasanian capital of Ctesiphon (FIG. 2-27). There the caliph al-Mansur (r. 754–775) established a new capital, Baghdad, which he called Madina al-salam, the City of Peace. The city was laid out in 762 at a time astrologers determined as favorable. It

13-7 Frieze of the Umayyad palace, Mshatta, Jordan, ca. 740–750. Limestone, 16′ 7″ high. Museum für Islamische Kunst, Staatliche Museen, Berlin.

A long stone frieze richly carved with geometric, plant, and animal motifs decorated the facade of the Mshatta palace. No animals appear, however, on the exterior wall of the palace's mosque.

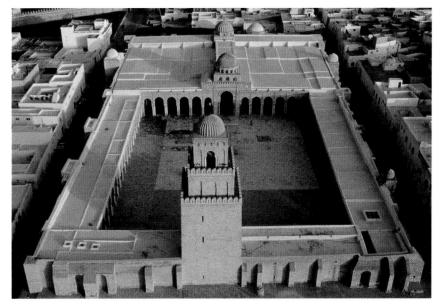

13-8 Aerial view (left) and plan (right) of the Great Mosque, Kairouan, Tunisia, ca. 836-875.

The arcaded forecourt in front of the hypostyle hall of the Kairouan mosque resembles a Roman forum (FIG. 10-43), but it incorporates the distinctive Islamic elements of mihrab, mihrab dome, minbar, and minaret.

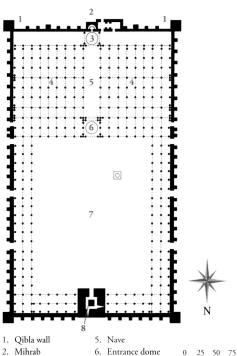

- Mihrab dome Hypostyle prayer hall 8.
- Forecourt Minaret
- 100 feet 30 meters

was round in plan, about a mile and a half in diameter. The shape signified that the new capital was the center of the universe. At the city's center was the caliph's palace, oriented to the four compass points. For almost 300 years Baghdad was the hub of Arab power and of a brilliant Islamic culture. The Abbasid caliphs were renowned throughout the world and even established diplomatic relations with Charlemagne in Germany. The Abbasids lavished their wealth on art, literature, and science and were responsible for the translation of numerous Greek texts that otherwise would have been lost. Many of these works were introduced to the medieval West through their Arabic versions.

GREAT MOSQUE, KAIROUAN Of all the variations in mosque plans, the hypostyle mosque most closely reflects the mosque's supposed origin, Muhammad's house in Medina (see "The Mosque," page 345). One of the finest hypostyle mosques, still in use today, is the mid-eighth-century Great Mosque (FIG. 13-8) at Kairouan in Abbasid Tunisia. It still houses its carved wooden minbar of 862, the oldest known. The precinct takes the form of a slightly askew parallelogram of huge scale, some 450 × 260 feet. Built of stone, its walls have sturdy buttresses, square in profile. A series of lateral entrances on the east and west lead to an arcaded forecourt (FIG. 13-8, no. 7) resembling a Roman forum (FIG. 10-43), oriented north-south on axis with the mosque's impressive minaret (no. 8) and the two domes of the hypostyle prayer hall (no. 4). The first dome (no. 6) is over the entrance bay, the second (no. 3) over the bay that fronts the mihrab (no. 2) set into the gibla wall (no. 1). A raised nave connects the domed spaces and prolongs the north-south axis of the minaret and courtyard. Eight columned aisles flank the nave on either side, providing space for a large congregation.

MALWIYA MINARET, SAMARRA The three-story minaret of the Kairouan mosque is square in plan, and scholars believe it is a near copy of a Roman lighthouse, but minarets can take a variety of forms. Perhaps the most striking and novel is that of the immense (more than 45,000 square yards) Great Mosque at Samarra, Iraq, the largest mosque in the world. The Abbasid caliph al-Mutawakkil (r. 847–861) erected it between 848 and 852. Known as the Malwiya ("snail shell" in Arabic) Minaret (FIG. 13-9) and more than 165 feet

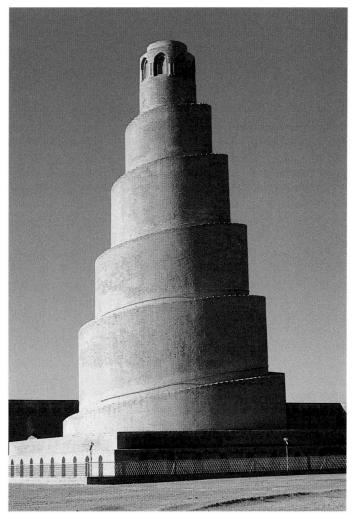

13-9 Malwiya Minaret, Great Mosque, Samarra, Iraq, 848–852.

The unique spiral Malwiya (snail shell) Minaret of Samarra's Great Mosque is more than 165 feet tall and can be seen from afar. It served to announce the presence of Islam in the Tigris Valley.

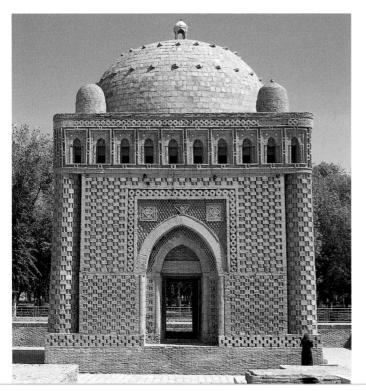

13-10 Mausoleum of the Samanids, Bukhara, Uzbekistan, early 10th century.

Monumental tombs were virtually unknown in the early Islamic period. The Samanid mausoleum at Bukhara is one of the oldest. Its dome-on-cube form had a long afterlife in Islamic funerary architecture.

tall, it now stands alone, but originally a bridge linked it to the mosque. The distinguishing feature of the brick tower is its stepped spiral ramp, which increases in slope from bottom to top. Once thought to be an ancient Mesopotamian *ziggurat*, the Samarra minaret inspired some European depictions of the biblical Tower of

Babel (Babylon's ziggurat; see "Babylon, City of Wonders," Chapter 2, page 48). Too tall to have been used to call Muslims to prayer, the Malwiya Minaret, visible from a considerable distance in the flat plain around Samarra, was probably intended to announce the presence of Islam in the Tigris Valley. Unfortunately, in 2005 the minaret suffered some damage during the Iraqi insurgency.

SAMANID MAUSOLEUM, BUKHARA Dynasties of governors who exercised considerable independence while recognizing the ultimate authority of the Baghdad caliphs oversaw the eastern realms of the Abbasid Empire. One of these dynasties, the Samanids (r. 819–1005), presided over the eastern frontier beyond the Oxus River (Transoxiana) on the border with India. In the early 10th century, they erected an impressive domed brick mausoleum (FIG. 13-10) at Bukhara in modern Uzbekistan. Monumental tombs were virtually unknown in the early Islamic period. Muhammad opposed elaborate burials and instructed his followers to bury him in a simple unmarked grave. In time, however, the Prophet's resting place in Medina acquired a wooden screen and a dome. By the ninth century, Abbasid caliphs were laid to rest in dynastic mausoleums.

The Samanid mausoleum at Bukhara is one of the earliest preserved tombs in the Islamic world. Constructed of baked bricks, it takes the form of a dome-capped cube with slightly sloping sides. With exceptional skill, the builders painstakingly shaped the bricks to create a vivid and varied surface pattern. Some of the bricks form *engaged columns* (half-round, attached columns) at the corners. A brick *blind arcade* (a series of arches in relief, with blocked openings) runs around all four sides. Inside, the walls are as elaborate as the exterior. The brick dome rests on arcuated brick *squinches* (see "Pendentives and Squinches," Chapter 12, page 315) framed by engaged *colonnettes* (thin columns). The dome-on-cube form had a long and distinguished future in Islamic funerary architecture (FIGS. 13-18 and 26-1).

GREAT MOSQUE, CÓRDOBA At the opposite end of the Muslim world, Abd al-Rahman I, the only eminent Umayyad to escape the Abbasid massacre of his clan in Syria, fled to Spain in 750.

There, the Arabs had overthrown the Christian kingdom of the Visigoths in 711. The Arab military governors of the peninsula accepted the fugitive as their overlord, and he founded the Spanish Umayyad dynasty, which lasted almost three centuries. The capital of the Spanish Umayyads was Córdoba, which became the center of a brilliant culture rivaling that of the Abbasids at Baghdad and exerting major influence on the civilization of the Christian West.

The jewel of the capital at Córdoba was its Great Mosque, begun in 784 and enlarged several times during the 9th and 10th centuries. It eventually became one of the largest mosques in the Islamic West. The hypostyle prayer hall (FIG. 13-11) has 36

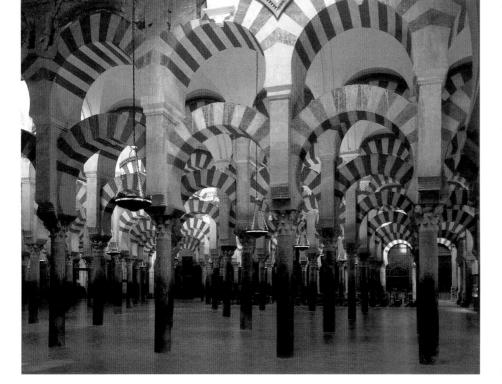

13-11 Prayer hall of the Great Mosque, Córdoba, Spain, 8th to 10th centuries.

Córdoba was the capital of the Umayyad dynasty in Spain. In the Great Mosque's hypostyle prayer hall, 36 piers and 514 columns support a unique series of double-tiered horseshoe-shaped arches.

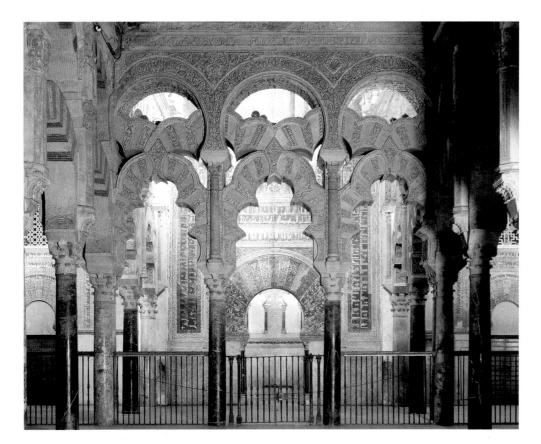

13-12 Maqsura of the Great Mosque, Córdoba, Spain, 961–965.

The magsura of the Córdoba mosque was reserved for the caliph and connected to his palace. Its design is a prime example of Islamic experimentation with highly decorative multiloped arches.

piers and 514 columns topped by a unique system of double-tiered arches that carried a wooden roof (later replaced by vaults). The two-story system was the builders' response to the need to raise the roof to an acceptable height using short columns that had been employed earlier in other structures. The lower arches are horseshoe-

shaped, a form perhaps adapted from earlier Near Eastern architecture or of Visigothic origin (FIG. 16-10). In the West, the horseshoe arch quickly became closely associated with Muslim architecture. Visually, these arches seem to billow out like windblown sails, and they contribute greatly to the light and airy effect of the Córdoba mosque's interior.

The caliph al-Hakam II (r. 961–976) undertook major renovations to the mosque. His builders expanded the prayer hall and added a series of domes. They also erected the elaborate maqsura (FIG. 13-12), the area reserved for the caliph and connected to his palace by a corridor in the qibla wall. The Córdoba maqsura is a prime example of Islamic experimentation with highly decorative, multilobed arches. The builders created rich and varied abstract patterns and further enhanced the magnificent effect of the complex arches by sheathing the walls with marbles and mosaics. The mosaicists and even the tesserae were brought to Spain from Constantinople by al-Hakam II, who wished to emulate the great mosaic-clad monuments his Umayyad predecessors had erected in Jerusalem (FIG. 13-3) and Damascus (FIG. 13-4).

The same desire for decorative effect also inspired the design of the dome (FIG. 13-13) that covers the area in front of the mihrab. One of the four domes built during the 10th century to emphasize the axis leading to the mihrab, the dome rests on an octagonal base of arcuated squinches. Crisscrossing ribs form an intricate pattern centered on two squares set at 45-degree angles to each other. The mosaics are the work of the same Byzantine artists responsible for the maqsura's decoration.

13-13 Dome in front of the mihrab of the Great Mosque, Córdoba, Spain, 961-965.

The dome in front of the Córdoba mihrab rests on an octagonal base of arcuated squinches. Crisscrossing ribs form an intricate decorative pattern. Byzantine artists fashioned the mosaic ornament.

Luxury Arts

The furnishings of Islamic mosques and palaces reflect a love of sumptuous materials and rich decorative patterns. Muslim artisans skillfully worked metal, wood, glass, and ivory into a great variety of objects for sacred spaces or the home. Glass workers used colored glass with striking effect in mosque lamps. Artisans produced numerous ornate ceramics of high quality and created basins, ewers, jewel cases, writing boxes, and other decorative items from bronze or brass, often engraving these pieces and adding silver inlays. Artists employed silk and wool to fashion textiles featuring both abstract and pictorial motifs. Because wood is scarce in most of the Islamic world, the kinds of furniture used in the West—beds, tables, and chairs—are rare in Muslim buildings. Movable furnishings, therefore, do not define Islamic architectural spaces. A room's function (eating or sleeping, for example) can be changed simply by rearranging the carpets and cushions.

SILK Silk textiles are among the glories of Islamic art. Unfortunately, because of their fragile nature, early Islamic textiles are rare today and often fragmentary. Silk thread was also very expensive. Silkworms, which can flourish only in certain temperate regions, produce silk. Silk textiles were manufactured first in China in the third millennium BCE. They were shipped over what came to be called the Silk Road through Asia to the Middle East and Europe (see "Silk and the Silk Road," Chapter 7, page 188).

One of the earliest Islamic silks (FIG. 13-14) is today in Nancy, France, and probably dates to the eighth century. Unfortunately, the textile is fragmentary, and its colors, once rich blues, greens, and oranges, faded long ago. Said to come from Zandana near Bukhara, the

13-14 Confronting lions and palm tree, fragment of a textile said to be from Zandana, near Bukhara, Uzbekistan, eighth century. Silk compound twill, 2' $11'' \times 2'$ $9\frac{1}{2}''$. Musée Historique de Lorraine, Nancy.

Early examples of Islamic silk textiles are rare because of their fragile nature. This fragmentary fabric from Uzbekistan features animal motifs that were common in secular contexts but shunned for mosques.

precious fabric survives because of its association with the relics of Saint Amon housed in Toul Cathedral. It may have been used to wrap the treasures when they were transported to France in 820. The design, perhaps based on Sasanian models, consists of repeated medallions with confronting lions flanking a palm tree. Other animals scamper across the silk between the *roundels* (*tondi*, or circular frames). Such zoomorphic motifs are foreign to the decorative vocabulary of mosque architecture, but they could be found in Muslim households—even in Muhammad's in Medina. The Prophet, however, objected to curtains decorated with human or animal figures and permitted only cushions adorned with animals or birds.

METALWORK One of the most striking examples of Islamic metalwork is the cast brass ewer (FIG. 13-15) in the form of a bird signed by Sulayman and dated 796. Some 15 inches tall, the ewer is nothing less than a freestanding statuette, although the holes between the eyes and beak function as a spout and betray its utilitarian purpose. The decoration on the body, which bears traces of silver and copper inlay, takes a variety of forms. In places, the incised lines seem to suggest natural feathers, but the rosettes on the neck, the large

13-15 Sulayman, Ewer in the form of a bird, 796. Brass with silver and copper inlay, 1' 3" high. Hermitage, Saint Petersburg.

Signed and dated by its maker, this utilitarian bird ewer resembles a freestanding statuette. The engraved decoration of the body combines natural feathers with abstract motifs and Arabic calligraphy.

13-16 Koran page with the beginning of surah 18, "Al-Kahf" (The Cave), 9th or early 10th century. Ink and gold on vellum, $7\frac{1}{4}'' \times 10\frac{1}{4}''$. Chester Beatty Library and Oriental Art Gallery, Dublin.

The stately rectilinear Kufic script was used in the oldest known Korans. This page has five text lines and a palm-tree finial but characteristically does not include any depictions of animals or humans.

medallions on the breast, and the inscribed collar have no basis in anatomy. Similar motifs appear in Islamic textiles, pottery, and architectural tiles. The ready adaptability of motifs to various scales and techniques illustrates both the flexibility of Islamic design and the relative independence of the motifs from the surfaces they decorate.

CALLIGRAPHY In the Islamic world, the art of *calligraphy*, ornamental writing, held a place of honor even higher than the art of textiles. The faithful wanted to reproduce the Koran's sacred words in as beautiful a script as human hands could contrive. Passages from the Koran appeared not only on the fragile pages of books but also on the walls of buildings, for example, in the mosaic band above the outer ring of columns inside the Dome of the Rock (FIG. 13-3). The practice of calligraphy was itself a holy task and required long and arduous training. The scribe had to possess exceptional spiritual refinement, as attested by an ancient Arabic proverb that proclaims "Purity of writing is purity of soul." Only in China does calligraphy hold as elevated a position among the arts (see "Calligraphy and Inscriptions on Chinese Paintings," Chapter 27, page 726).

Arabic script predates Islam. It is written from right to left with certain characters connected by a baseline. Although the chief

Islamic book, the sacred Koran, was codified in the mid-seventh century, the earliest preserved Korans are datable to the ninth century. Koran pages were either bound into books or stored as loose sheets in boxes. Most of the early examples feature texts written in the script form called *Kufic*, after the city of Kufa, one of the renowned centers of Arabic calligraphy. Kufic script is quite angular, with the uprights forming almost right angles with the baseline. As with Hebrew and other Semitic languages, the usual practice was to write in consonants only. But to facilitate recitation of the Koran, scribes often indicated vowels by red or yellow symbols above or below the line.

All of these features can be seen on a 9th- or early-10th-century page (FIG. 13-16) now in Dublin that carries the heading and opening lines of surah 18 of the Koran. Five text lines in black ink with red vowels appear below a decorative band incorporating the chapter title in gold and ending in a palm-tree *finial* (a crowning ornament). This approach to page design has parallels at the extreme northwestern corner of the then-known world—in the early medieval manuscripts of the British Isles, where text and ornament are similarly united (FIG. 16-8). But the stylized human and animal forms that populate those Christian books never appear in Korans.

LATER ISLAMIC ART

The great centers of early Islamic art and architecture continued to flourish in the second millennium, but important new regional artistic centers emerged, especially in Turkey and South Asia. The discussion here centers on the later art and architecture of the Islamic Middle East, Spain, and Turkey. Developments in India are treated in Chapter 26.

Architecture

In the early years of the 11th century, the Umayyad caliphs' power in Spain unraveled, and their palaces fell prey to Berber soldiers from North Africa. The Berbers ruled southern Spain for several generations but could not resist the pressure of Christian forces from the north. Córdoba fell to the Christians in 1236. From then until the final Christian triumph in 1492, the Nasrids, an Arab dynasty that had established its capital at Granada in 1230, ruled the remaining Muslim territories in Spain.

ALHAMBRA On a rocky spur at Granada, the Nasrids constructed a huge palace-fortress called the Alhambra ("the Red" in Arabic) because of the rose color of the stone used for its walls and 23 towers. By the end of the 14th century, the complex, a veritable city with a population of 40,000, included at least a half dozen royal residences. Only two of these fared well over the centuries. Paradoxically, they owe their preservation to the Christian victors, who

maintained a few of the buildings as trophies commemorating the expulsion of the Nasrids. The two palaces present a vivid picture of court life in Islamic Spain before the Christian reconquest.

The Palace of the Lions takes its name from its courtyard (FIG. 13-1) that boasts a fountain with marble lions carrying a water basin on their backs. Colonnaded courtyards with fountains and statues have a long history in the Mediterranean world, especially in the houses and villas of the Roman Empire (see Chapter 10). The Alhambra's lion fountain is an unusual instance of freestanding stone sculpture in the Islamic world, unthinkable in a sacred setting. But the design of the courtyard is distinctly Islamic and features many multilobed pointed arches and lavish stuccoed walls in which calligraphy and abstract motifs are interwoven. The palace was the residence of Muhammad V (r. 1354–1391), and its courtyards, lush gardens, and luxurious carpets and other furnishings served to conjure the image of Paradise.

The Palace of the Lions is noteworthy also for its elaborate stucco ceilings. A spectacular example is the dome (FIG. 13-17) of the so-called Hall of the Two Sisters. The dome rests on an octagonal drum supported by squinches and pierced by eight pairs of windows, but its structure is difficult to discern because of the intricate carved stucco decoration. The ceiling is covered with some 5,000 muqarnas—tier after tier of stalactite-like prismatic forms that seem aimed at denying the structure's solidity. The muqarnas ceiling was intended to catch and reflect sunlight as well as form beautiful

13-17 Muqarnas dome, Hall of the Two Sisters, Palace of the Lions, Alhambra, Granada, Spain, 1354–1391.

The structure of this dome on an octagonal drum is difficult to discern because of the intricately carved stucco muqarnas decoration. The prismatic forms catch and reflect sunlight, creating the effect of a starry sky.

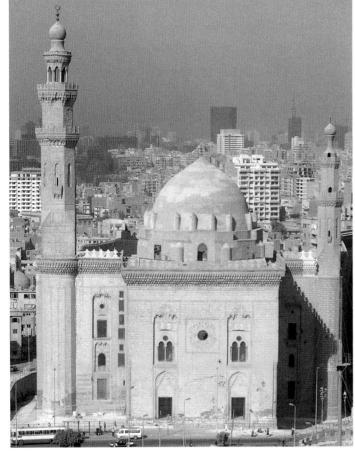

13-18 Madrasa-mosque-mausoleum complex of Sultan Hasan (looking northwest with the mausoleum in the foreground), Cairo, Egypt, begun 1356.

Hasan's mausoleum is a gigantic version of the much earlier Samanid mausoleum (FIG. 13-10). Because of its location directly south of the complex's mosque, praying Muslims faced the Mamluk sultan's tomb.

abstract patterns. The lofty vault in this hall and others in the palace symbolized the dome of Heaven. The flickering light and shadows create the effect of a starry sky as the sun's rays glide from window to window during the day. To underscore the symbolism, the palace walls bear inscriptions with verses by the court poet Ibn Zamrak (1333–1393), who compared the Alhambra's lacelike muqarnas ceilings to "the heavenly spheres whose orbits revolve."

MAUSOLEUM OF SULTAN HASAN In the mid-13th century, under the leadership of Genghis Khan, the Mongols from east-central Asia (see Chapter 27) conquered much of the eastern Islamic world. The center of Islamic power moved from Baghdad to Egypt. The lords of Egypt at the time were former Turkish slaves ("mamluks" in Arabic) who converted to Islam. The capital of the Mamluk *sultans* (rulers) was Cairo, which became the largest Muslim city of the late Middle Ages. The Mamluks were prolific builders, and Sultan Hasan, although not an important figure in Islamic history, was the most ambitious of all. He ruled briefly as a child and was deposed, but regained the sultanate in 1354. He was assassinated in 1361.

Hasan's major building project in Cairo was a huge madrasa complex (FIGS. 13-18 and 13-19) on a plot of land about 8,000 square yards in area. A *madrasa* ("place of study" in Arabic) is a theological college devoted to the teaching of Islamic law. Hasan's complex was so large that it housed not only four such colleges for the study of the four major schools of Islamic law but also a mosque,

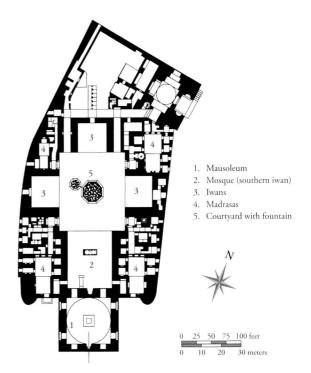

13-19 Plan of the madrasa-mosque-mausoleum complex of Sultan Hasan, Cairo, Egypt, begun 1356.

Sultan Hasan's complex comprised four madrasas as well as a mosque, his tomb, and various other buildings. The plan with four iwans opening onto a central courtyard derives from that of Iranian mosques.

mausoleum, orphanage, and hospital, as well as shops and baths. Like all Islamic building complexes incorporating religious, educational, and charitable functions, this one was supported by an endowment funded by rental properties. The income from these paid the salaries of attendants and faculty, provided furnishings and supplies such as oil for the lamps or free food for the poor, and supported scholarships for needy students.

The grandiose structure has a large central courtyard (FIG. 13-19, no. 5) with a monumental fountain in the center and four vaulted iwans opening onto it, a design used earlier for Iranian mosques (see "The Mosque," page 345). In each corner of the main courtyard, between the iwans (FIG. 13-19, no. 3), is a madrasa (no. 4) with its own courtyard and four or five stories of rooms for the students. The largest iwan (no. 2) in the complex, on the southern side, served as a mosque. Contemporaries believed the soaring vault that covered this iwan was taller than the arch of the Sasanian palace (FIG. 2-27) at Ctesiphon, which was then one of the most admired engineering feats in the world. Behind the gibla wall stands the sultan's mausoleum (FIGS. 13-18 and 13-19, no. 1), a gigantic version of the type of the Samanid tomb (FIG. 13-10) at Bukhara. The builders intentionally placed the dome-covered cube south of the mosque so that the prayers of the faithful facing Mecca would be directed toward Hasan's tomb. (Only the sultan's two sons are buried there, however. Hasan's body was not returned when he was killed.)

A muqarnas cornice crowns the exterior walls of the complex, and marble plaques of several colors cover the mihrab in the mosque and the walls of Hasan's mausoleum. But the complex as a whole is relatively austere, characterized by its massiveness and geometric clarity. It presents a striking contrast to the filigreed elegance of the contemporary Alhambra (FIGS. 13-1 and 13-17) and testifies to the diversity of regional styles within the Islamic world, especially after the end of the Umayyad and Abbasid dynasties.

Sinan the Great and the Mosque of Selim II

inan (ca. 1491–1588), called Sinan the Great, was truly the greatest Ottoman architect. Born a Christian, he was recruited for service in the Ottoman government, converted to Islam, and was trained in engineering and the art of building while in the Ottoman army. Officials quickly recognized his talent and entrusted him with increasing responsibility until, in 1538, he was appointed the chief court architect for Suleyman the Magnificent (r. 1520–1566), a generous patron of art and architecture. Architectural historians have attributed to Sinan hundreds of building projects, both sacred and secular, although he could not have been involved with all that bear his name.

The capstone of Sinan's distinguished career was the Edirne mosque (FIGS. 13-20 and 13-21) of Suleyman's son, Selim II, which Sinan designed when he was almost 80 years old. In this masterwork, he sought to surpass the greatest achievements of Byzantine architects, just as Sultan Hasan's builders in Cairo attempted to rival and exceed the Sasanian architects of antiquity. Sa'i Mustafa Çelebi, Sinan's biographer, recorded the architect's accomplishment in his own words:

Sultan Selim Khan ordered the erection of a mosque in Edirne. . . . His humble servant [I, Sinan] prepared for him a drawing depicting,

13-20 Sinan, Mosque of Selim II, Edirne, Turkey, 1568-1575.

The Ottomans developed a new type of mosque with a square prayer hall covered by a dome. Sinan's Mosque of Selim II has a taller dome than Hagia Sophia's (FIG. 12-4) and is an engineering triumph.

on a dominating site in the city, four minarets on the four corners of a dome. . . . Those who consider themselves architects among Christians say that in the realm of Islam no dome can equal that of the Hagia Sophia; they claim that no Muslim architect would be able to build such a large dome. In this mosque, with the help of God and the support of Sultan Selim Khan, I erected a dome six cubits higher and four cubits wider than the dome of the Hagia Sophia.*

The Edirne dome is, in fact, higher than Hagia Sophia's (FIG. 12-4) when measured from its base, but its crown is not as far above the pavement. Nonetheless, Sinan's feat won universal acclaim as a triumph. The Ottomans considered the Mosque of Selim II proof that they finally had outshone the Christian emperors of Byzantium in the realm of architecture.

*Aptullah Kuran, Sinan: The Grand Old Master of Ottoman Architecture (Washington, D.C.: Institute of Turkish Studies, 1987), 168–169.

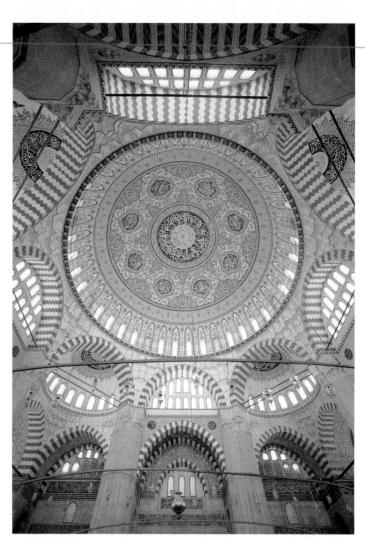

13-21 Sinan, interior of the Mosque of Selim II, Edirne, Turkey, 1568–1575.

The interior of Sinan's Edirne mosque is a fusion of an octagon and a dome-covered square with four half-domes at the corners. The plan features geometric clarity and precise numerical ratios.

OTTOMAN EMPIRE During the course of the 9th to 11th centuries, the Turkic people, of central Asian origin, largely converted to Islam. They moved into Iran and the Near East in the 11th century, and by 1055 the Seljuk Turkish dynasty had built an extensive, although short-lived, empire that stretched from India to western Anatolia. By the end of the 12th century, this empire had broken up into regional states, and in the early 13th century it came under the sway of the Mongols, led by Genghis Khan (see Chapter 27). After the downfall of the Seljuks, several local dynasties established themselves in Anatolia, among them the Ottomans, founded by Osman I (r. 1281–1326). Under Osman's successors, the Ottoman state expanded for two and a half centuries throughout vast areas of Asia, Europe, and North Africa to become, by the middle of the 15th century, one of the great world powers.

The Ottoman emperors were lavish patrons of architecture. Ottoman builders developed a new type of mosque with a square prayer hall covered by a dome as its core. In fact, the dome-covered square, which had been a dominant form in Iran and was employed for the 10th-century Samanid mausoleum (FIG. 13-10), became the nucleus of all Ottoman architecture. The combination had an appealing geometric clarity. At first used singly, the domed units came to be used in multiples, a turning point in Ottoman architecture.

After the Ottoman Turks conquered Constantinople (Istanbul) in 1453, they firmly established their architectural code. The new lords of Constantinople were impressed by Hagia Sophia (FIGS. 12-2 to 12-4), which, in some respects, conformed to their own ideals. They converted the Byzantine church into a mosque with minarets. But the longitudinal orientation of Hagia Sophia's interior never satisfied Ottoman builders, and Anatolian development moved instead toward the central-plan mosque.

SINAN THE GREAT The first examples of the central-plan mosque were built in the 1520s, eclipsed later only by the works of the most famous Ottoman architect, SINAN (ca. 1491–1588). A contemporary of the great Italian Renaissance sculptor, painter, and architect Michelangelo (see Chapter 22), and with equal aspirations to immortality, Sinan perfected the Ottoman architectural style. By his time, Ottoman builders almost universally were using the basic domed unit, which they could multiply, enlarge, contract, or combine as needed. Thus, the typical Ottoman building of Sinan's time was a creative assemblage of domical units and artfully juxtaposed geometric spaces.

Builders usually erected domes with an extravagant margin of structural safety that has since served them well in earthquake-prone Istanbul and other Ottoman cities. (Vivid demonstration of the sound construction of Ottoman mosques came in August 1999 when a powerful earthquake centered 65 miles east of Istanbul toppled hundreds of modern buildings and killed thousands of people but caused no damage to the centuries-old mosques.) Working within this architectural tradition, Sinan searched for solutions to the problems of unifying the additive elements and of creating a monumental centralized space with harmonious proportions.

Sinan's vision found ultimate expression in the Mosque of Selim II (FIG. 13-20) at Edirne, which had been the capital of the Ottoman Empire from 1367 to 1472 and where Selim II (r. 1566–1574) maintained a palace. There, Sinan designed a mosque with a massive dome set off by four slender pencil-shaped minarets (each more than 200 feet high, among the tallest ever constructed). The dome's height surpasses that of Hagia Sophia (see "Sinan the Great and the Mosque of Selim II," page 354). But it is the organization of the Edirne mosque's interior space (FIG. 13-21) that reveals the genius of its builder. The mihrab is recessed into an apselike alcove deep enough to permit window illumination from three sides, making the brilliantly colored tile panels of its lower walls sparkle as if with their own glowing light. The plan of the main hall is an ingenious fusion of an octagon with the dome-covered square. The octagon, formed by the eight massive dome supports, is pierced by the four halfdome-covered corners of the square. The result is a fluid interpenetration of several geometric volumes that represents the culminating solution to Sinan's lifelong search for a monumental unified interior space. Sinan's forms are clear and legible, like mathematical equations. Height, width, and masses are related to one another in a simple but effective ratio of 1:2, and precise numerical ratios also characterize the complex as a whole. The forecourt of the building, for example, covers an area equal to that of the mosque proper. The Mosque of Selim II is generally regarded as the climax of Ottoman architecture. Sinan proudly proclaimed it his masterpiece.

GREAT MOSQUE, ISFAHAN The Mosque of Selim II at Edirne was erected during a single building campaign under the direction of a single master architect, but the construction of many other major Islamic architectural projects extended over several centuries. A case in point is the Great Mosque (FIG. 13-22) at Isfahan

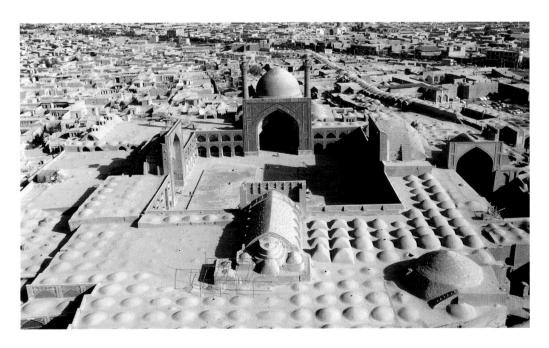

13-22 Aerial view (looking southwest) of the Great Mosque, Isfahan, Iran, 11th to 17th centuries.

The typical Iranian mosque plan with four vaulted iwans and a courtyard may have been employed for the first time in the mosque Sultan Malik Shah I built in the late 11th century at his capital of Isfahan.

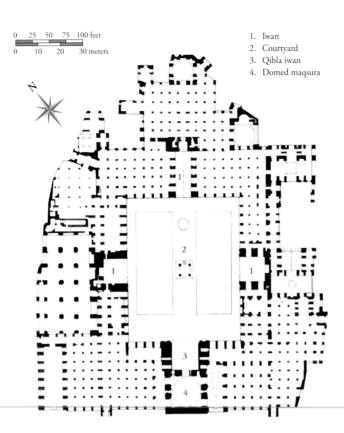

13-23 Plan of the Great Mosque, Isfahan, Iran, 11th to 17th centuries.

In the Great Mosque at Isfahan, as in other four-iwan mosques, the qibla iwan is the largest. Its size and the dome-covered maqsura in front of it indicated the proper direction for Muslim prayer.

in Iran. The earliest mosque on the site, of the hypostyle type, dates to the eighth century, during the Abbasid caliphate. But Sultan Malik Shah I (r. 1072–1092), whose capital was at Isfahan, transformed the structure in the 11th century. Later remodeling further altered the mosque's appearance. The present mosque, which retains its basic 11th-century plan (FIG. 13-23), consists of a large courtyard bordered by a two-story arcade on each side. As in the 14th-century complex (FIG. 13-19) of Sultan Hasan in Cairo, four iwans open onto the courtyard, one at the center of each side. The southwestern iwan (FIG. 13-23, no. 3) leads into a dome-covered room (no. 4) in front of the mihrab. It functioned as a magsura reserved for the sultan and his attendants. It is uncertain whether this plan, with four iwans and a dome in front of the mihrab, was employed for the first time in the Great Mosque at Isfahan, but it became standard in Iranian mosque design. In four-iwan mosques, the qibla iwan is always the largest. Its size (and the dome that often accompanied it) immediately indicated to worshipers the proper direction for prayer.

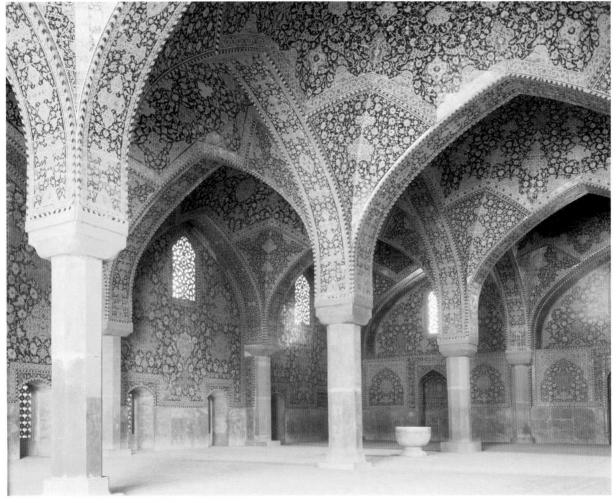

13-24 Winter prayer hall of the Shahi (Imam) Mosque, Isfahan, Iran, 1611–1638.

The ceramists who produced the cuerda seca tiles of this Isfahan mosque's winter prayer hall had to manufacture a wide variety of shapes with curved surfaces to cover the hall's arches and vaults.

Islamic Tilework

rom the Dome of the Rock (FIGS. 13-2 and 13-3), the earliest major Islamic building, to the present day, architects have used mosaics or ceramic tiles to decorate the walls and vaults of mosques, madrasas, palaces, and tombs. The golden age of Islamic tilework was the 16th and 17th centuries. At that time, Islamic artists used two basic techniques to enliven building interiors with brightly colored tiled walls and to sheathe their exteriors with gleaming tiles that reflected the sun's rays.

In *mosaic tilework* (for example, FIG. 13-25), large ceramic panels of single colors are fired in the potter's kiln and then cut into smaller pieces and set in plaster in a manner similar to the laying of mosaic tesserae of stone or glass (see "Mosaics," Chapter 11, page 303).

Cuerda seca (dry cord) tilework was introduced in Umayyad Spain during the 10th century—hence its Spanish name even in Middle Eastern and Central Asian contexts. Cuerda seca tiles (for example, FIG. 13-24) are polychrome and can more easily bear complex geometric and vegetal patterns as well as Arabic script. They are more economical to use because vast surfaces can be covered with large tiles much more quickly than they can with thousands of smaller mosaic tiles. But when such tiles are used to sheathe curved surfaces, the ceramists must fire the tiles in the exact shape required. Polychrome tiles have other drawbacks. Because all the glazes are fired at the same temperature, cuerda seca tiles are not as brilliant in color as mosaic tiles and do not reflect light the way the more irregular surfaces of tile mosaics do. The preparation of the multicolored tiles also requires greater care. To prevent the colors from running together during firing, the potters must outline the motifs on cuerda seca tiles with greased cords containing manganese, which leaves a matte black line between the colors after firing.

13-25 Mihrab from the Madrasa Imami, Isfahan, Iran, ca. 1354. Glazed mosaic tilework, 11' $3'' \times 7'$ 6''. Metropolitan Museum of Art, New York.

The Madrasa Imami mihrab is a masterpiece of mosaic tilework. Every piece had to be cut to fit its specific place in the design. It exemplifies the perfect aesthetic union between Islamic calligraphy and ornament.

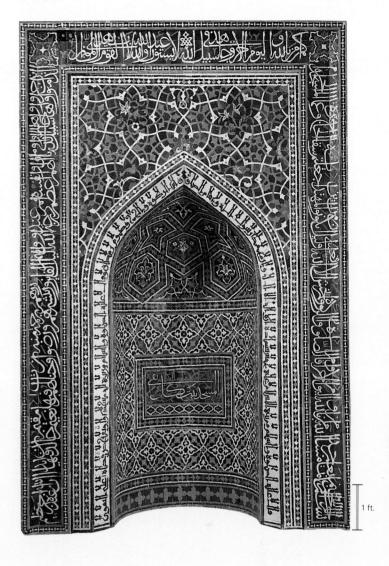

IRANIAN TILEWORK The iwans of the Isfahan mosque feature soaring pointed arches framing tile-sheathed muqarnas vaults. The muqarnas ceilings probably date to the 14th century, and the ceramic-tile revetment on the walls and vaults is the work of the 17th-century Safavid rulers of Iran. The use of glazed tiles has a long history in the Middle East. Even in ancient Mesopotamia, builders sometimes covered gates and walls with colorful baked bricks (FIG. **2-24**). In the Islamic world, the art of ceramic tilework reached its peak in the 16th and 17th centuries in Iran and Turkey (see "Islamic Tilework," above). Employed as a veneer over a brick core, tiles could sheathe entire buildings, including domes and minarets.

SHAHI MOSQUE, ISFAHAN The Shahi (or Royal) Mosque in Isfahan, now known as the Imam Mosque, which dates from the early 17th century, is widely recognized as one of the masterpieces of Islamic tilework. Its dome is a prime example of tile mosaic, and its winter prayer hall (FIG. 13-24) houses one of the finest ensembles

of cuerda seca tiles in the world. Covering the walls, arches, and vaults of the prayer hall presented a special challenge to the Isfahan ceramists. They had to manufacture a wide variety of shapes with curved surfaces to sheathe the complex forms of the hall. The result was a technological triumph as well as a dazzling display of abstract ornament.

MADRASA IMAMI, ISFAHAN As already noted, verses from the Koran appeared in the mosaics of the Dome of the Rock (Fig. 13-3) in Jerusalem and in mosaics and other media on the walls of countless later Islamic structures. Indeed, some of the masterworks of Arabic calligraphy are not in manuscripts but on walls. A 14th-century mihrab (Fig. 13-25) from the Madrasa Imami in Isfahan exemplifies the perfect aesthetic union between the Islamic calligrapher's art and abstract ornament. The pointed arch that immediately frames the mihrab niche bears an inscription from the Koran in Kufic, the stately rectilinear script used in the ninth-century Koran (Fig. 13-16) discussed earlier. Many supple cursive styles also

make up the repertoire of Islamic calligraphy. One of these styles, known as Muhaqqaq, fills the mihrab's outer rectangular frame. The mosaic tile ornament on the curving surface of the niche and the area above the pointed arch are composed of tighter and looser networks of geometric and abstract floral motifs. The mosaic technique is masterful. Every piece had to be cut to fit its specific place in the mihrab—even the tile inscriptions. The framed inscription in the center of the niche—proclaiming that the mosque is the domicile of the pious believer—is smoothly integrated with the subtly varied patterns. The mihrab's outermost inscription—detailing the five pillars of Islamic faith—serves as a fringelike extension, as well as a boundary, for the entire design. The calligraphic and geometric elements are so completely unified that only the practiced eye can distinguish them. The artist transformed the architectural surface into a textile surface—the three-dimensional wall into a two-dimensional hanging—weaving the calligraphy into it as another cluster of motifs within the total pattern.

Luxury Arts

The tile-covered mosques of Isfahan, Sultan Hasan's madrasa complex in Cairo, and the architecture of Sinan the Great in Edirne are enduring testaments to the brilliant artistic culture of the Safavid,

Mamluk, and Ottoman rulers of the Muslim world. Yet these are only some of the most conspicuous public manifestations of the greatness of later Islamic art and architecture (see Chapter 26 for the achievements of the Muslim rulers of India). In the smaller-scale, and often private, realm of the luxury arts, Muslim artists also excelled. From the vast array of manuscript paintings, ceramics, textiles, and metalwork, six masterpieces may serve to suggest both the range and the quality of the inappropriately dubbed Islamic "minor arts" of the 13th to 16th centuries.

TIMURID *BUSTAN* In the late 14th century, a new Islamic empire arose in Central Asia under the leadership of Timur (r. 1370–1405), known in the Western world as Tamerlane. Timur, a successor of the Mongol Genghis Khan, quickly extended his dominions to include Iran and parts of Anatolia. The Timurids ruled until 1501 and were great patrons of art and architecture in cities such as Herat, Bukhara, and Samarqand. Herat in particular became a leading center for the production of luxurious books under the patronage of the Timurid sultan Husayn Mayqara (r. 1470–1506).

The most famous Persian painter of his age was BIHZAD, who worked at the Herat court and illustrated the sultan's copy of Sadi's *Bustan* (*Orchard*). One page (FIG. 13-26) represents a story in both the Bible and the Koran—the seduction of Yusuf (Joseph) by

13-26 Bihzad, Seduction of Yusuf, folio 52 verso of the Bustan of Sultan Husayn Mayqara, from Herat, Afghanistan, 1488. Ink and color on paper, $11\frac{7}{8}'' \times 8\frac{5}{8}''$. National Library, Cairo.

The most famous
Timurid manuscript
painter was Bihzad.
This page displays
vivid color, intricate
decorative detailing,
and a brilliant
balance between
two-dimensional
patterning and
perspective.

Potiphar's wife Zulaykha. Sadi's text is dispersed throughout the page in elegant Arabic script in a series of beige panels. According to the tale as told by Jami (1414–1492), an influential mystic theologian and poet whose Persian text appears in blue in the white pointed arch at the lower center of the composition, Zulaykha lured Yusuf into her palace and led him through seven rooms, locking each door behind him. In the last room she threw herself at Yusuf, but he resisted and was able to flee when the seven doors opened miraculously. Bihzad's painting of the story is characterized by vivid color, intricate decorative detailing suggesting luxurious textiles and tiled walls, and a brilliant balance between two-dimensional patterning and perspectival depictions of balconies and staircases.

SAFAVID *SHAHNAMA* The successors of the Timurids in Iran were the Safavids. Shah Tahmasp (r. 1524–1576) was a great patron of books. Around 1525 he commissioned an ambitious decade-long project to produce an illustrated 742-page copy of the *Shahnama* (*Book of Kings*). The *Shahnama* is the Persian national epic poem by Firdawsi (940–1025). It recounts the history of Iran from the Creation until the Muslim conquest. Tahmasp's *Shahnama* contains 258 illustrations by many artists, including some of the most renowned painters of the day. It was eventually presented as a gift to Selim II, the Ottoman sultan who was the patron of Sinan's

mosque (FIGS. 13-20 and 13-21) at Edirne. The manuscript later entered a private collection in the West and ultimately was auctioned as a series of individual pages, destroying the work's integrity but underscoring that Western collectors viewed each page as a masterpiece.

The page reproduced here (FIG. 13-27) is the work of Sultan-MUHAMMAD and depicts Gayumars, the legendary first king of Iran, and his court. According to tradition, Gayumars ruled from a mountaintop when humans first learned to cook food and clothe themselves in leopard skins. In Sultan-Muhammad's representation of the story, Gayumars presides over his court (all the figures wear leopard skins) from his mountain throne. The king is surrounded by light amid a golden sky. His son and grandson perch on multicolored rocky outcroppings to the viewer's left and right, respectively. The court encircles the ruler and his heirs. Dozens of human faces appear within the rocks themselves. Many species of animals populate the lush landscape. According to the Shahnama, wild beasts became instantly tame in the presence of Gayumars. Sultan-Muhammad rendered the figures, animals, trees, rocks, and sky with an extraordinarily delicate touch. The sense of lightness and airiness that permeate the painting is enhanced by its placement on the page—floating, off center, on a speckled background of gold leaf. The painter gave his royal patron a singular vision of Iran's fabled past.

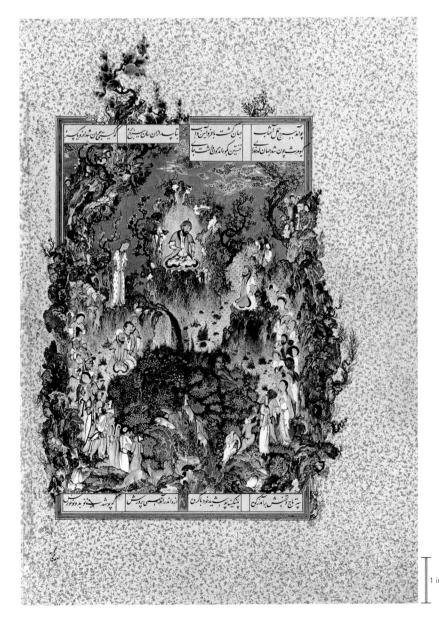

13-27 SULTAN-MUHAMMAD, Court of Gayumars, folio 20 verso of the Shahnama of Shah Tahmasp, from Tabriz, Iran, ca. 1525–1535. Ink, watercolor, and gold on paper, 1' 1" × 9". Prince Sadruddin Aga Khan Collection, Geneva.

Sultan-Muhammad painted the story of the legendary king Gayumars for the Safavid ruler Shah Tahmasp. The off-center placement on the page enhances the sense of lightness that permeates the painting.

13-28 Maqsud of Kashan, carpet from the funerary mosque of Shaykh Safi al-Din, Ardabil, Iran, 1540. Knotted pile of wool and silk, 34' $6'' \times 17'$ 7''. Victoria & Albert Museum, London.

Maqsud of Kashan's enormous Ardabil carpet required roughly 25 million knots. It presents the illusion of a heavenly dome with mosque lamps reflected in a pool of water with floating lotus blossoms.

ARDABIL CARPETS Tahmasp also elevated carpet weaving to a national industry and set up royal factories at Isfahan, Kashan, Kirman, and Tabriz. Two of the masterworks of carpet weaving that date to his reign are the pair of carpets from the two-centuries older funerary mosque of Shaykh Safi al-Din (1252–1334), the founder of the Safavid line. The name Magsud of Kashan is woven into the design of the carpet illustrated here (FIG. 13-28). He must have been the designer who supplied the master pattern to two teams of royal weavers (one for each of the two carpets). The carpet, almost 35×18 feet, consists of roughly 25 million knots, some 340 to the square inch. (Its twin has even more knots.)

The design consists of a central sunburst medallion, representing the inside of a dome, surrounded by 16 pendants. Mosque lamps (appropriate motifs for the Ardabil funerary mosque) are suspended from two pendants on the long axis of the carpet. The lamps are of different sizes. This may be an optical device to make the two appear equal in size when viewed from the end of the carpet at the room's threshold (the bottom end in FIG. 13-28). The rich blue background is covered with leaves and flowers attached to delicate stems that spread over the whole field. The entire composition presents the illusion of a heavenly dome with lamps reflected in a pool of water full of floating lotus blossoms. No human or animal figures appear, as befits a carpet intended for a mosque, although they can be found on other Islamic textiles used in secular contexts, both earlier (FIG. 13-14) and later.

MOSQUE LAMPS Mosque lamps were often made of glass and highly decorated. Islamic artists perfected this art form and fortunately, despite their exceptionally fragile nature, many examples survive, in large part because the lamps were revered by those who han-

dled them. One of the finest is the mosque lamp (FIG. 13-29) made for Sayf al-Din Tuquztimur (d. 1345), an official in the court of the Mamluk sultan al-Nasir Muhammad. The glass lamps hung on chains from the mosque's ceilings. The shape of Tuquztimur's lamp

13-29 Mosque lamp of Sayf al-Din Tuquztimur, from Egypt, 1340. Glass with enamel decoration, 1' 1" high. British Museum, London.

The enamel decoration of this glass mosque lamp includes a quotation from the Koran comparing God's light to the light in a lamp. The burning wick dramatically illuminated the sacred verse.

is typical of the period, consisting of a conical neck, wide body with six vertical handles, and a tall foot. Inside, a small glass container held the oil and wick. The *enamel* decoration (colors fused to the surfaces) includes Tuquztimur's emblem—an eagle over a cup (Tuquztimur served as the sultan's cup-bearer). Cursive Arabic calligraphy, also in enamel, gives the official's name and titles as well as a quotation of the Koranic verse (24:35) comparing God's light to the light in a lamp. When the lamp was lit, the verse (and Tuquztimur's name) would have been dramatically illuminated.

BAPTISTÈRE DE SAINT LOUIS Metalwork was another early Islamic art form (FIG. 13-15) that continued to play an important role in the later period. An example of the highest quality is a brass basin (FIG. 13-30) from Egypt inlaid with gold and silver and signed—six times—by the Mamluk artist MUHAMMAD IBN AL-ZAYN. The basin, used for washing hands at official ceremonies, must have been fashioned for a specific Mamluk patron. Some scholars think a court official named Salar ordered the piece as a gift for his sultan, but no inscription identifies him. The central band depicts Mamluk hunters and Mongol enemies. Running animals fill the friezes above and below. Stylized vegetal forms of inlaid silver fill the background of all the bands and roundels. Figures and animals also decorate the inside and underside of the basin. This Mamluk basin has long been

13-30 Muhammad ibn al-Zayn, basin (Baptistère de Saint Louis), from Egypt, ca. 1300. Brass, inlaid with gold and silver, $8\frac{3}{4}''$ high. Louvre, Paris.

Muhammad ibn al-Zayn proudly signed (six times) this basin used for washing hands at official ceremonies. The central band, inlaid with gold and silver, depicts Mamluk hunters and Mongol enemies.

Christian Patronage of Islamic Art

uring the 11th, 12th, and 13th centuries, large numbers of Christians traveled to Islamic lands, especially to the Christian holy sites in Jerusalem and Bethlehem, either as pilgrims (see "Pilgrimages," Chapter 17, page 432) or as Crusaders (see "The Crusades," Chapter 17, page 442). Many returned with mementos of their journey, usually in the form of inexpensive mass-produced souvenirs. But some wealthy individuals commissioned local Muslim artists to produce custommade pieces using costly materials.

A unique brass canteen (FIG. 13-31) inlaid with silver and decorated with scenes of the life of Christ appears to be the work of a 13th-century Ayyubid metalsmith in the employ of a Christian patron. The canteen is a luxurious version of the "pilgrim flasks" Christian visitors to the Holy Land often brought back to Europe. Four inscriptions in Arabic promise eternal glory, secure life, perfect prosperity, and increasing good luck to the canteen's owner, who is unfortunately not named. That the owner was a Christian is sug-

gested not only by the type of object but also by the choice of scenes engraved into the canteen. The Madonna and Christ Child appear enthroned in the central medallion, and three panels depicting New Testament events (see "The Life of Jesus in Art," Chapter 11, pages 296-297) fill most of the band around the medallion. The narrative unfolds in a counterclockwise sequence (Arabic is read from right to left), beginning with the Nativity (at 2 o'clock) and continuing with the Presentation in the Temple (10 o'clock) and the Entry into Jerusalem (6 o'clock). The scenes may have been chosen because the patron had visited their locales (Bethlehem and Jerusalem). Most scholars believe that the artist used Syrian Christian manuscripts as the source for the canteen's Christian iconography. Many of the decorative details, however, are common in contemporary Islamic metalwork inscribed with the names of Muslim patrons. Whoever the owner was, the canteen testifies to the fruitful artistic interaction between Christians and Muslims in 13th-century Syria.

13-31 Canteen with episodes from the life of Christ, from Syria, ca. 1240–1250. Brass, inlaid with silver, $1' 2\frac{1}{2}''$ high. Freer Gallery of Art, Washington, D.C.

This unique canteen is the work of an Ayyubid metalsmith in the employ of a Christian pilgrim to the Holy Land. The three scenes from the life of Jesus appear in counterclockwise sequence.

1 in.

known as the *Baptistère de Saint Louis*, but the association with the famous French king (see "Louis IX, the Saintly King," Chapter 18, page 482) is a myth. Louis died before the piece was made. Nonetheless, the *Baptistère*, brought to France long ago, was used in the baptismal rites of newborns of the French royal family as early as the

17th century. Like the Zandana silk (FIG. 13-14) from Toul Cathedral and a canteen (FIG. 13-31) adorned with scenes of the life of Christ (see "Christian Patronage of Islamic Art," above), Muhammad ibn al-Zayn's basin testifies to the prestige of Islamic art well outside the boundaries of the Islamic world.

THE ISLAMIC WORLD

UMAYYAD SYRIA AND ABBASID IRAQ, 661-1258

- The Umayyads (r. 661–750) were the first Islamic dynasty and ruled from their capital at Damascus in Syria until they were overthrown by the Abbasids (r. 750–1258), who established their capital at Baghdad in Iraq.
- The first great Islamic building is the Dome of the Rock. The domed octagon commemorated the triumph of Islam in Jerusalem, which the Muslims captured from the Byzantines in 638.
- Umayyad and Abbasid mosques, for example, those in Damascus and in Kairouan (Tunisia), are of the hypostyle-hall type and incorporate arcaded courtyards and minarets. The mosaic decoration of early mosques was often the work of Byzantine artists but excludes zoomorphic forms.
- The earliest preserved Korans date to the 9th century and feature Kufic calligraphy and decorative motifs but no figural illustrations.

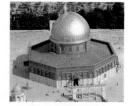

Dome of the Rock, Jerusalem, 687–692

ISLAMIC SPAIN, 756-1492

- Abd-al-Rahman I established the Umayyad dynasty (r. 756–1031) in Spain after he escaped the Abbasid massacre of his clan in 750.
- The Umayyad capital was at Córdoba, where the caliphs erected and expanded the Great Mosque between the 8th and 10th centuries. The mosque features horseshoe and multilobed arches and mosaic-clad domes that rest on arcuated squinches.
- The last Spanish Muslim dynasty was the Nasrid (r. 1230–1492), whose capital was at Granada. The Alhambra is the best surviving example of Islamic palace architecture. It is famous for its stuccoed walls and arches and its mugarnas vaults and domes.

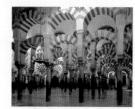

Great Mosque, Córdoba, 8th to 10th centuries

ISLAMIC EGYPT, 909-1517

- The Fatimids (r. 909–1171) established their caliphate in Egypt in 909 and ruled from their capital in Cairo. They were succeeded by the Ayyubids (r. 1171–1250) and the Mamluks (r. 1250–1517).
- The most ambitious Mamluk builder was Sultan Hasan, whose madrasa-mosque-mausoleum complex in Cairo is based on Iranian four-iwan mosque designs.
- Among the greatest works of the Islamic metalsmith's art is Muhammad ibn al-Zayn's brass basin inlaid with gold and silver and engraved with figures of Mamluk hunters and Mongol enemies.

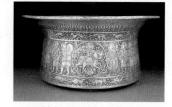

Muhammad ibn al-Zayn, brass basin, ca. 1300

TIMURID AND SAFAVID IRAN AND CENTRAL ASIA, 1370-1732

- The Timurid (r. 1370–1501) and Safavid (r. 1501–1732) dynasties ruled Iran and Central Asia for almost four centuries and were great patrons of art and architecture.
- The Timurid court at Herat, Afghanistan, employed the most famous painters of the day, who specialized in illustrating books.
- Persian painting also flourished in Safavid Iran under Shah Tahmasp (r. 1524–1576), who in addition set up royal carpet factories in several cities.
- The art of tilework reached its peak under the patronage of the Safavid dynasty, when builders frequently used mosaic and cuerda seca tiles to cover the walls and vaults of mosques, madrasas, palaces, and tombs.

Sultan-Muhammad, Court of Gayumars, ca. 1525–1535

OTTOMAN TURKEY, 1281-1924

- Osman I (r. 1281–1326) founded the Ottoman dynasty in Turkey. By the middle of the 15th century, the Ottomans had become a fearsome power and captured Byzantine Constantinople in 1453.
- The greatest Ottoman architect was Sinan (ca. 1491–1588), who perfected the design of the domed central-plan mosque. His Mosque of Selim II at Edirne is also an engineering triumph. It has a dome taller than that of Hagia Sophia.

Sinan, Mosque of Selim II, Edirne, 1568–1575

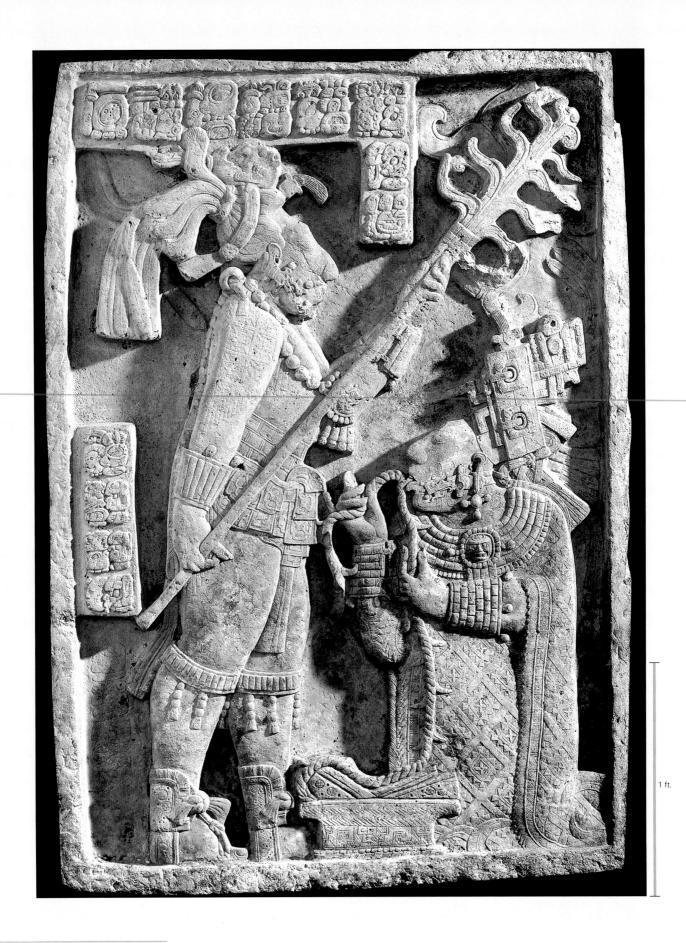

14-1 Shield Jaguar and Lady Xoc, Maya, lintel 24 of temple 23, Yaxchilán, Mexico, ca. 725 CE. Limestone, 3' $7'' \times 2'$ $6\frac{1}{2}''$. British Museum, London.

The Maya built vast complexes of temples, palaces, and plazas and decorated many with painted reliefs. This carved lintel documents the central role that elite Maya women played in religious bloodletting rituals.

NATIVE ARTS OF THE AMERICAS BEFORE 1300

The origins of the indigenous peoples of the Americas are still uncertain. Sometime no later than 30,000 to 10,000 BCE, these first Americans probably crossed the now-submerged land bridge called Beringia, which connected the shores of the Bering Strait between Asia and North America. Some migrants may have reached the Western Hemisphere via boats traveling along the Pacific coast of North America. These Stone Age nomads were hunter-gatherers. They made tools only of bone, pressure-flaked stone, and wood. They had no knowledge of agriculture but possibly some of basketry. They could control fire and probably build simple shelters. For many centuries, they spread out until they occupied the two American continents. But they were always few in number. When the first Europeans arrived at the end of the 15th century (see Chapter 32), the total population of the Western Hemisphere probably did not exceed 40 million.

Between 8000 and 2000 BCE, a number of the migrants learned to fish, farm cotton, and domesticate plants such as squash and maize (corn). The nomads settled in villages and learned to make ceramic utensils and figurines. Metal technology, although extremely sophisticated when it existed, developed only in the Andean region of South America (eventually spreading north into present-day Mexico) and generally met only the need for ornamentation, not for tools. With these skills as a base, many cultures rose and fell over long periods.

Several of the peoples of North, Central, and South America had already reached a high level of social complexity and technological achievement by the early centuries CE. Although most relied on stone tools, did not use the wheel (except for toys), and had no pack animals but the llama (in South America), the early Americans developed complex agricultural techniques and excelled in the engineering arts associated with the planning and construction of cities, civic and domestic buildings, roads and bridges, and irrigation and drainage systems. They carved monumental stone statues and reliefs, painted extensive murals, and mastered the arts of weaving, pottery, and metalwork. In Mesoamerica, the Maya and other cultural groups even had a highly developed writing system and knowledge of mathematical calculation that allowed them to keep precise records and create a sophisticated calendar and a highly accurate astronomy.

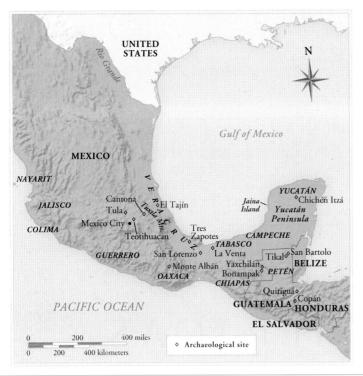

MAP 14-1 Early sites in Mesoamerica.

These advanced civilizations went into rapid decline, however, in the 16th century when the Europeans introduced new diseases to the Western Hemisphere, and Hernán Cortés, Francisco Pizarro, and their armies conquered the Aztec and Inka empires. Some native elites survived and adapted to the Spanish presence, but most of the once-glorious American cities were destroyed in the conquerors' zeal to obliterate all traces of pagan beliefs. Other sites were abandoned to the forces of nature—erosion and the encroachment of tropical forests. But despite the ruined state of the pre-Hispanic cities today, archaeologists and art historians have been able to reconstruct much of the history of art and architecture of ancient America. This chapter examines in turn the artistic achievements of the native peoples of Mesoamerica, South America, and North America before 1300. Chapter 32 treats the art and architecture of the Americas from 1300 to the present.

MESOAMERICA

The term *Mesoamerica* names the region that comprises part of present-day Mexico, Guatemala, Belize, Honduras, and the Pacific coast of El Salvador (MAP 14-1). Mesoamerica was the homeland of several of the great *pre-Columbian* civilizations—those that flourished before the arrival of Christopher Columbus and the subsequent European invasion.

The principal regions of pre-Columbian Mesoamerica are the Gulf Coast region (Olmec and Classic Veracruz cultures); the states of Jalisco, Colima, and Nayarit, collectively known as West Mexico; Chiapas, Yucatán, Quintana Roo, and Campeche states in Mexico, the Petén area of Guatemala, Belize, and Honduras (Maya culture); southwestern Mexico and the state of Oaxaca (Zapotec and Mixtec cultures); and the central plateau surrounding modern Mexico City (Teotihuacan, Toltec, and Aztec cultures). These cultures were often influential over extensive areas.

The Mexican highlands are a volcanic and seismic region. In highland Mexico, great reaches of arid plateau land, fertile for maize and other crops wherever water is available, lie between heavily forested mountain slopes, which at some places rise to a perpetual snow level. The moist tropical rain forests of the coastal plains yield rich crops, when the land can be cleared. In Yucatán, a subsoil of limestone furnishes abundant material for both building and carving. This limestone tableland merges with the vast Petén region of Guatemala, which separates Mexico from Honduras. Yucatán and the Petén, where dense rain forest alternates with broad stretches of grassland, host some of the most spectacular Maya ruins. The great mountain chains of Mexico and Guatemala extend into Honduras and slope sharply down to tropical coasts. Highlands and mountain valleys, with their chill and temperate climates, alternate dramatically with the humid climate of tropical rain forest and coastlines.

The variegated landscape of Mesoamerica may have much to do with the diversity of languages its native populations speak. Numerous languages are distributed among no fewer than 14 linguistic families. Many of the languages spoken in the pre–Spanish conquest period survive to this day. Various Mayan languages linger in Guatemala and southern Mexico. The Náhuatl of the Aztecs endures in the Mexican highlands. The Zapotec and Mixtec languages persist in Oaxaca and its environs. Diverse as the languages of these peoples were, their cultures otherwise had much in common. The Mesoamerican peoples shared maize cultivation, religious beliefs and rites, myths, social structures, customs, and arts.

Archaeologists, with ever-increasing refinement of technique, have been uncovering, describing, and classifying Mesoamerican monuments for more than a century. In the 1950s, linguists made important breakthroughs in deciphering the Maya hieroglyphic script, and epigraphers have made further progress in recent decades. Scholars can now list many Maya rulers by name and fix the dates of their reigns with precision. Other writing systems, such as that of the Zapotec, who began to record dates at a very early time, are less well understood, but researchers are making rapid progress in their interpretation. The general Mesoamerican chronology is now well established and widely accepted. The standard chronology, divided into three epochs, involves some overlapping of subperiods. The Preclassic (Formative) extends from 2000 BCE to about 300 CE. The Classic period runs from about 300 to 900. The Postclassic begins approximately 900 and ends with the Spanish conquest of 1521.

Olmec and Preclassic West Mexico

The Olmec culture of the present-day Mexican states of Veracruz and Tabasco has often been called the "mother culture" of Mesoamerica, because many distinctive Mesoamerican religious, social, and artistic traditions can be traced to it. Recent archaeological discoveries, however, have revealed other important centers during the Preclassic period. The notion of a linear evolution of all Mesoamerican art and architecture from the Olmec is giving way to a more complex multicenter picture of early Mesoamerica. Settling in the tropical lowlands of the Gulf of Mexico, the Olmec peoples cultivated a terrain of rain forest and alluvial lowland washed by numerous rivers flowing into the gulf. Here, between approximately 1500 and 400 BCE, social organization assumed the form that later Mesoamerican cultures adapted and developed. The mass of the population—food-producing farmers scattered in hinterland villages—provided the sustenance and labor that maintained a hereditary caste of rulers, hierarchies of priests, functionaries, and artisans. The nonfarming population presumably lived, arranged by rank, within precincts that served ceremonial, administrative, and resi-

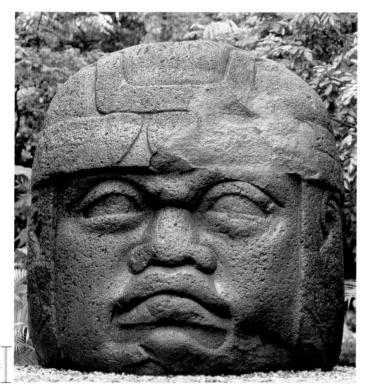

14-2 Colossal head, Olmec, La Venta, Mexico, ca. 900–400 BCE. Basalt, 9' 4" high. Museo-Parque La Venta, Villahermosa.

The identities of the Olmec colossi are uncertain, but their individualized features and distinctive headgear, as well as later Maya practice, suggest that these heads portray rulers rather than deities.

dential functions, and perhaps also as marketplaces. At regular intervals, the whole community convened for ritual observances at the religious-civic centers of towns such as San Lorenzo and La Venta. These centers were the formative architectural expressions of the structure and ideals of Olmec society.

OLMEC RULER PORTRAITS At La Venta, low clay-and-earthen platforms and stone fences enclosed two great courtyards. At one end of the larger area was a mound almost 100 feet high. Although now very eroded, this early pyramid, built of earth and adorned with colored clays, may have been intended to mimic a mountain, held sacred by Mesoamerican peoples as both a life-giving source of water and a feared destructive force. (Volcanic eruptions and earthquakes still wreak havoc in this region.) The La Venta layout is an early form of the temple-pyramid-plaza complex aligned on a north-south axis that characterized later Mesoamerican ceremonial center design.

Four colossal basalt heads (FIG. 14-2), weighing about 10 tons each and standing between 6 and 10 feet high, face out from the plaza. More than a dozen similar heads have been found at San Lorenzo and Tres Zapotes. Almost as much of an achievement as the carving of these huge stones with stone tools was their transportation across the 60 miles of swampland from the nearest known basalt source, the Tuxtla Mountains. Although the identities of the colossi are uncertain, their individualized features and distinctive headgear and ear ornaments, as well as the later Maya practice of carving monumental ruler portraits, suggest that the Olmec heads portray rulers rather than deities. The sheer size of the heads and their intensity of expression evoke great power, whether mortal or divine.

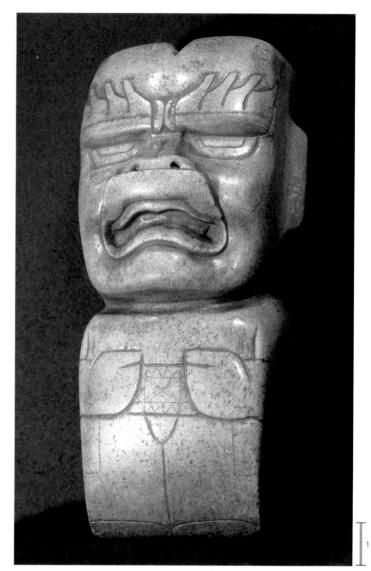

14-3 Ceremonial ax in the form of a were-jaguar, Olmec, from La Venta, Mexico, ca. 900–400 BCE. Jadeite, $11\frac{1}{2}''$ high. British Museum, London.

Olmec celts were votive offerings to the gods. The composite humananimal representations may reflect the belief that religious practitioners underwent dangerous transformations on behalf of the community.

JADE CELTS The Olmec also made paintings in caves, fashioned ceramic figurines, and carved sculptures in jade, a prized, extremely hard, dark-green stone they acquired from unknown sources far from their homeland. Sometimes the Olmec carved jade into ax-shaped polished forms art historians call celts, which they then buried as votive offerings under their ceremonial courtyards or platforms. The celt shape could be modified into a figural form, combining relief carving with incising. Olmec sculptors used stonetipped drills and abrasive materials, such as sand, to carve jade. Subjects represented include crying babies (of unknown significance) and figures combining human and animal features and postures, such as the were-jaguar illustrated here (FIG. 14-3). The Olmec human-animal representations may refer to the belief that religious practitioners underwent dangerous transformations to wrest power from supernatural forces and harness it for the good of the community.

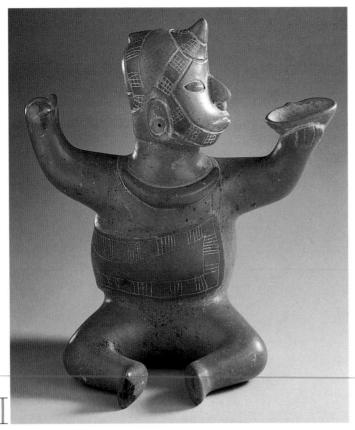

14-4 Drinker (seated figure with raised arms), from Colima, Mexico, ca. 200 $_{\rm BCE}-500$ CE. Clay with orange and red slip, 1' 1" high. Los Angeles County Museum of Art (Proctor Stafford Collection, purchased with funds provided by Mr. and Mrs. Allan C. Balch).

Preclassic West Mexico is famous for its ceramic sculptures. This one may depict a religious practitioner with a horn on his forehead or a political leader wearing a shell ornament—or someone serving both roles.

WEST MEXICO Far to the west of the tropical heartland of the Olmec are the Preclassic sites along Mexico's Pacific coast. Scholars long thought the ancient peoples of the modern West Mexican states of Nayarit, Jalisco, and Colima existed at Mesoamerica's geographic and cultural fringes. Recent archaeological discoveries, however, have revealed that although the West Mexicans did not produce large-scale stone sculpture, they did build permanent structures. These included tiered platforms and ball courts (see "The Mesoamerican Ball Game," page 372), architectural features found in nearly all Mesoamerican cultures. Yet West Mexico is best known for its rich tradition of clay sculpture. The sculptures come from tombs consisting of shafts as deep as 50 feet with chambers at their base. Because scientific excavations began only 20-30 years ago, much of what is known about West Mexican tomb contents derives primarily from the artifacts grave robbers found and sold. Researchers believe, however, that the West Mexicans built most of these tombs and filled them with elaborate offerings during the late Preclassic period, the half millennium before 300 CE.

The large ceramic figures found in the Colima tombs are consistently a highly burnished red-orange, instead of the distinctive polychrome surfaces of the majority of other West Mexican ceramics. The area also is noted for small-scale clay narrative scenes that include modeled houses and temples and numerous solid figurines shown in

a variety of lively activities. These sculptures, which may provide informal glimpses of daily life, are not found in any other ancient Mesoamerican culture. Although archaeologists often describe the subjects of the sculptures as anecdotal and secular rather than religious, the Mesoamerican belief system did not recognize such a division. Consequently, scholars are unsure whether the figure illustrated here (FIG. 14-4) is a religious practitioner with a horn on his forehead (a common indigenous symbol of special powers) or a political leader wearing a shell ornament (often a Mesoamerican emblem of rulership)—or a person serving both roles.

Teotihuacan

At Olmec sites, the characteristic later Mesoamerican temple-pyramid-plaza layout appeared in embryonic form. At Teotihuacan (FIG. 14-5), northeast of modern Mexico City, the Preclassic scheme underwent a monumental expansion into a genuine city. Teotihuacan was a large, densely populated metropolis that fulfilled a central civic, economic, and religious role for the region and indeed for much of Mesoamerica. Built up between about 100 BCE and 600 CE, when fire ravaged the city, the site's major monuments were constructed between 50 and 250 CE, during the late Preclassic period. Teotihuacan covers nine square miles, laid out in a grid pattern with the axes oriented by sophisticated surveying. Astronomical phenomena apparently dictated not only the city's orientation but also the placement of some of its key pyramids.

At its peak, around 600 CE, Teotihuacan may have had as many as 125,000-200,000 residents, which would have made it the sixthlargest city in the world at that time. Divided into numerous wardlike sectors, this metropolis must have had a uniquely cosmopolitan character, with Zapotec peoples located in the city's western wards, and merchants from Veracruz living in the eastern wards, importing their own pottery and building their houses and tombs in the style of their homelands. The city's urbanization did nothing to detract from its sacred nature. In fact, it vastly augmented Teotihuacan's importance as a religious center. The Aztecs, who visited Teotihuacan regularly and reverently long after it had been abandoned, gave it its current name, which means "the place of the gods." Because the city's inhabitants left only a handful of undeciphered hieroglyphs, and linguists do not know what language they spoke, the names of many major features of the site are unknown. The Avenue of the Dead and the Pyramids of the Sun and Moon are later Aztec designations that do not necessarily reflect the original names of these entities.

North-south and east-west axes, each four miles in length, divide the grid plan into quarters. The rational scheme recalls Hellenistic and Roman urban planning (FIGS. 5-76 and 10-42) and is an unusual feature in Mesoamerica before the Aztecs. The main north-south axis, the Avenue of the Dead (FIG. 14-5), is 130 feet wide and connects the Pyramid of the Moon complex with the Citadel and its Temple of Quetzalcoatl. This two-mile stretch is not a continuously flat street but is broken by sets of stairs, giving pedestrians a constantly changing view of the surrounding buildings and landscape.

PYRAMIDS The Pyramid of the Sun (FIG. 14-5, top left), facing west on the east side of the Avenue of the Dead, dates to the first century CE during the late Preclassic period. It is the city's centerpiece and its largest structure, rising to a height of more than 200 feet in its restored state, which may not accurately reflect the pyramid's original appearance. The Pyramid of the Moon (FIG. 14-5,

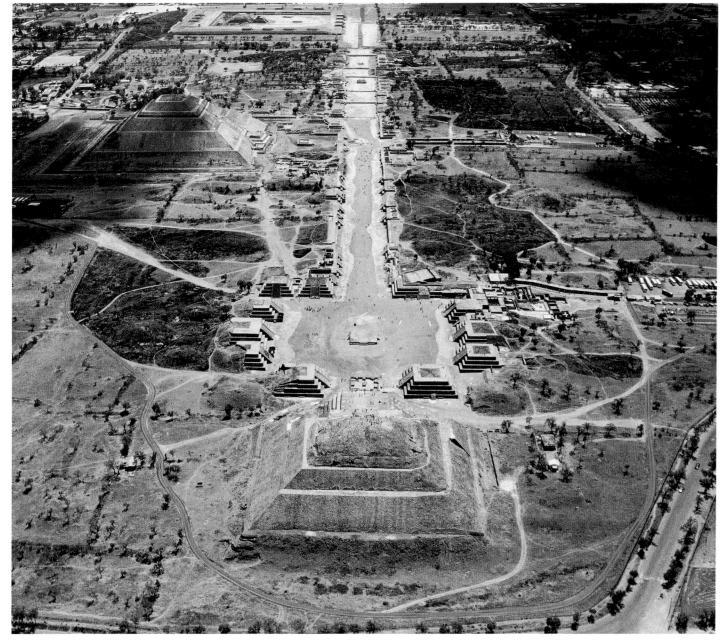

14-5 Aerial view of Teotihuacan (looking south), Mexico. Pyramid of the Moon (*foreground*), Pyramid of the Sun (*top left*), and the Citadel (*background*), all connected by the Avenue of the Dead; main structures ca. 50–250 CE.

At its peak around 600 cE, Teotihuacan was the sixth-largest city in the world. It featured a rational grid plan and a two-mile-long main avenue. Its monumental pyramids echo the shapes of surrounding mountains.

foreground) is a century or more later, about 150–250 CE. The shapes of the monumental structures at Teotihuacan echo the surrounding mountains. Their imposing mass and scale surpass those of all other Mesoamerican sites. Rubble-filled and faced with the local volcanic stone, the pyramids consist of stacked squared platforms diminishing in perimeter from the base to the top, much like the Stepped Pyramid (FIG. 3-5) of Djoser in Egyptian Saqqara. Ramped stairways led to crowning temples constructed of perishable materials such as wood and thatch, no longer preserved. A distinctive feature of Teotihuacan construction is the alternation of sloping (talud) and vertical (tablero) rubble layers. The employment of talud-tablero construction at other sites is a sure sign of Teotihuacan influence.

The Teotihuacanos built the Pyramid of the Sun over a cave, which they reshaped and filled with ceramic offerings. The pyramid may have been constructed to honor a sacred spring within the now-dry cave. Excavators found children buried at the four corners of each of the pyramid's tiers. The later Aztecs sacrificed children to bring rainfall, and Teotihuacan art abounds with references to water, so the Teotihuacanos may have shared the Aztec preoccupation with rain and agricultural fertility. The city's inhabitants rebuilt the Pyramid of the Moon (currently being excavated) at least five times in Teotihuacan's early history. The Teotihuacanos may have positioned it to mimic the shape of Cerro Gordo, the volcanic mountain behind it, undoubtedly an important source of life-sustaining streams.

14-6 Partial view of the Temple of Quetzalcoatl, the Citadel, Teotihuacan, Mexico, third century CE.

The stone heads of Quetzalcoatl decorating this pyramid are the earliest representations of the feathered-serpent god. Beneath and around the pyramid excavators found remains of sacrificial victims.

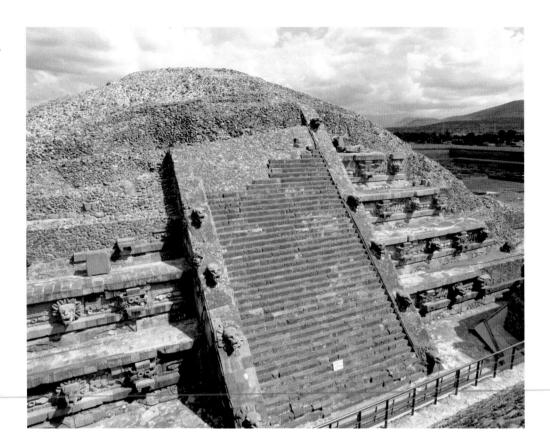

QUETZALCOATL At the south end of the Avenue of the Dead is the great quadrangle of the Citadel (FIG. 14-5, background). It encloses a smaller pyramidal shrine datable to the third century CE, the Temple of Quetzalcoatl (FIG. 14-6). Quetzalcoatl, the "feathered serpent," was a major god in the Mesoamerican pantheon at the time of the Spanish conquest, hundreds of years after the fall of Teotihuacan. The later Aztecs associated him with wind, rain clouds, and life. Beneath the temple, archaeologists found a tomb looted in antiquity, perhaps that of a Teotihuacan ruler. The discovery has led them to speculate that not only the Maya but the Teotihuacanos as well buried their elite in or under pyramids. Surrounding the tomb both beneath and around the pyramid were the remains of at least a hundred sacrificial victims. Some were adorned with necklaces made of strings of human jaws, both real and sculpted from shell. Like most other Mesoamerican groups, the Teotihuacanos invoked and appeased their gods through human sacrifice. The presence of such a large number of victims also may reflect Teotihuacan's militaristic expansion-throughout Mesoamerica, the victors often sacrificed captured warriors.

The temple's sculptured panels, which feature projecting stone heads of Quetzalcoatl alternating with heads of a long-snouted scaly creature with rings on its forehead, decorate each of the temple's six terraces. This is the first unambiguous representation of the feathered serpent in Mesoamerica. The scaly creature's identity is unclear. Linking these alternating heads are low-relief carvings of feathered-serpent bodies and seashells. The latter reflect Teotihuacan contact with the peoples of the Mexican coasts and also symbolize water, an essential ingredient for the sustenance of an agricultural economy.

MURAL PAINTING Like those of most ancient Mesoamerican cities, Teotihuacan's buildings and streets were once stuccoed over and brightly painted. Elaborate murals also covered the walls of the rooms of its elite residential compounds. The paintings chiefly depict

deities, ritual activities, and processions of priests, warriors, and even animals. Experimenting with a variety of surfaces, materials, and techniques over the centuries, Teotihuacan muralists finally settled on applying pigments to a smooth lime-plaster surface coated with clay. They then polished the surface to a high sheen. Although some Teotihuacan paintings have a restricted palette of varying tones of red (largely derived from the mineral hematite), creating subtle contrasts between figure and ground, most employ vivid hues arranged in flat, carefully outlined patterns. One mural (FIG. 14-7) depicts an earth or nature goddess who some scholars think was the city's principal deity. Always shown frontally with her face covered by a jade mask, she is dwarfed by her large feathered headdress and reduced to a bust placed upon a stylized pyramid. She stretches her hands out to provide liquid streams filled with bounty, but the stylized human hearts that flank the frontal bird mask in her headdress reflect her dual nature. They remind viewers that the ancient Mesoamericans saw human sacrifice as essential to agricultural renewal.

The influence of Teotihuacan was all-pervasive in Mesoamerica. The Teotihuacanos established colonies as far away as the southern borders of Maya civilization, in the highlands of Guatemala, some 800 miles from Teotihuacan.

Classic Maya

Strong cultural influences stemming from the Olmec tradition and from Teotihuacan contributed to the development of Classic Maya culture. As was true of Teotihuacan, the foundations of Maya civilization were laid in the Preclassic period, perhaps by 600 BCE or even earlier. At that time, the Maya, who occupied the moist low-land areas of Belize, southern Mexico, Guatemala, and Honduras, seem to have abandoned their early, somewhat egalitarian pattern of village life and adopted a hierarchical autocratic society. This system evolved into the typical Maya city-state governed by hereditary

14-7 Goddess, mural painting from the Tetitla apartment complex at Teotihuacan, Mexico, 650–750 CE. Pigments over clay and plaster.

Elaborate mural paintings adorned Teotihuacan's elite residential compound. This example may depict the city's principal deity, a goddess wearing a jade mask and a large feathered headdress.

rulers and ranked nobility. How and why this happened are still unknown.

Stupendous building projects signaled the change. Vast complexes of terraced temple-pyramids, palaces, plazas, ball courts (see "The Mesoamerican Ball Game," page 372), and residences of the governing elite dotted the Maya area. Unlike at Teotihuacan, no single Maya site ever achieved complete dominance as the center of power. The new architecture, and the art embellishing it, advertised the power of the rulers, who appropriated cosmic symbolism and stressed their descent from gods to reinforce their claims to legitimate rulership. The unified institutions of religion and kingship were established so firmly, their hold on life and custom was so tenacious, and their meaning was so fixed in the symbolism and imagery of art that the rigidly conservative system of the Classic Maya lasted 600 years. Maya civilization began to decline in the eighth century. By 900, it had vanished.

Although the causes of the beginning and end of Classic Maya civilization are obscure, researchers are gradually revealing its history, beliefs, ceremonies, conventions, and patterns of daily life through scientific excavation and progress made in decoding Mayan script. Two important breakthroughs have radically altered the understanding of both Mayan writing and the Maya worldview. The first was the realization that the Maya depicted their rulers (rather than gods or anonymous priests) in their art and noted their rulers' achievements in their texts. The second was that Mayan writing is largely phonetic—that is, the hieroglyphs are composed of signs representing sounds in the Mayan language. Fortunately, the Spaniards recorded the various Mayan languages in colonial texts and dictionaries, and most are still spoken today. Although perhaps only half of the ancient Mayan script can be translated accurately into spoken Mayan, today experts can at least grasp the general meaning of many more hieroglyphs.

The Maya possessed a highly developed knowledge of mathematical calculation and the ability to observe and record the move-

ments of the sun, the moon, and numerous planets. They contrived an intricate but astonishingly accurate calendar with a fixed-zero date, and although this structuring of time was radically different in form from the Western calendar used today, it was just as precise and efficient. With their calendar, the Maya established the all-important genealogical lines of their rulers, which certified their claim to rule, and created the only true written history in ancient America. Although other ancient Mesoamerican societies, even in the Preclassic period, also possessed calendars, only the Maya calendar can be translated directly into today's calendrical system.

ARCHITECTURE AND RITUAL The Maya erected their most sacred and majestic buildings in enclosed, centrally located precincts within their cities. The religious-civic transactions that guaranteed the order of the state and the cosmos occurred in these settings. The Maya held dramatic rituals within a sculptured and painted environment, where huge symbols and images proclaimed the nature and necessity of that order. Maya builders designed spacious plazas for vast audiences who were exposed to overwhelming propaganda. The programmers of that propaganda, the ruling families and troops of priests, nobles, and retainers, incorporated its symbolism in their costumes. In Maya paintings and sculptures, the Maya elite wear extravagant costumery of vividly colorful cotton textiles, feathers, jaguar skins, and jade, all emblematic of their rank and wealth. On the different levels of the painted and polished temple platforms, the ruling classes performed the offices of their rites in clouds of incense to the music of maracas, flutes, and drums. The Maya transformed the architectural complex at each city's center into a theater of religion and statecraft. In the stagelike layout of a characteristic Maya city center, its principal group, or "site core," was the religious and administrative nucleus for a population of dispersed farmers settled throughout a suburban area of many square miles.

The Mesoamerican Ball Game

fter witnessing the native ball game of Mexico soon after their arrival, the 16th-century Spanish conquerors took Aztec ball players back to Europe to demonstrate the novel sport. Their chronicles remark on the athletes' great skill, the heavy wagering that accompanied the competition, and the ball itself, made of rubber, a substance the Spaniards had never seen before.

The game was played throughout Mesoamerica and into the southwestern United States, beginning at least 3,400 years ago, the date of the earliest known ball court. The Olmec were apparently avid players. Their very name—a modern invention in Náhuatl, the Aztec language—means "rubber people," after the latex-growing region they inhabited. Not only do ball players appear in Olmec art, but archaeologists have found remnants of sunken earthen ball courts and even rubber balls at Olmec sites.

The Olmec earthen playing field evolved in other Mesoamerican cultures into a plastered masonry surface, I- or T-shaped in plan, flanked by two parallel sloping or straight walls. Sometimes the walls were wide enough to support small structures on top, as at Copán (FIG. 14-8). At other sites, temples stood at either end of the ball court. These structures were common features of Mesoamerican cities. At Cantona in the Mexican state of Puebla, for example, archaeologists have uncovered 22 ball courts even though only a small portion of the site has been excavated. Teotihuacan (FIG. 14-5) is an exception. Excavators have not yet found a ball court there, but mural paintings at the site illustrate people playing the game with portable markers and sticks. Most ball courts were adjacent to the important civic structures of Mesoamerican cities, such as palaces and temple-pyramids, as at Copán.

Surprisingly little is known about the rules of the ball game itself—how many players were on the field, how goals were scored and tallied, and how competitions were arranged. Unlike a modern soccer field with its standard dimensions, Mesoamerican ball courts vary widely in size. The largest known—at Chichén Itzá—is nearly 500 feet long. Copán's is about 93 feet long. Some have stone rings set high up on the walls at right angles to the ground, which a player conceivably could toss a ball through, but many courts lack this feature. Alternatively, players may have bounced the ball against the walls and into the end zones. As in soccer, the players could not touch the ball with their hands but used their heads, elbows, hips, and legs. They wore thick leather belts, and sometimes even helmets, and padded their knees and arms against the blows of the fast-moving solid rubber ball. Typically, the Maya portrayed ball players wearing heavy protective clothing and kneeling, poised to deflect the ball (FIG. 14-11).

Although widely enjoyed as a competitive spectator sport, the ball game did not serve solely for entertainment. The ball, for example, may have represented a celestial body such as the sun, its movements over the court imitating the sun's daily passage through the sky. Reliefs on the walls of ball courts at certain sites make clear that the game sometimes culminated in human sacrifice, probably of captives taken in battle and then forced to participate in a game they were predestined to lose.

Ball playing also had a role in Mesoamerican mythology. In the Maya epic known as the *Popol Vuh* (*Council Book*), first written down in Spanish in the colonial period, the evil lords of the Underworld force a legendary pair of twins to play ball. The brothers lose and are sacrificed. The sons of one twin eventually travel to the Underworld and, after a series of trials including a ball game, outwit the lords and kill them. They revive their father, buried in the ball court after his earlier defeat at the hands of the Underworld gods. The younger twins rise to the heavens to become the sun and the moon, and the father becomes the god of maize, principal sustenance of all Mesoamerican peoples. The ball game and its aftermath, then, were a metaphor for the cycle of life, death, and regeneration that permeated Mesoamerican religion.

14-8 Ball court (view looking north), Maya, Middle Plaza, Copán, Honduras, 738 CE.

Ball courts were common in Meso-american cities.
Copán's is 93 feet long. The rules of the ball game itself are unknown, but games sometimes ended in human sacrifice, probably of captives taken in battle.

14-9 Stele D portraying Ruler 13 (Waxaklajuun-Ub'aah-K'awiil), Maya, Great Plaza, Copán, Honduras, 736 CE. Stone, 11' 9" high.

Ruler 13 reigned during the heyday of Copán. On this stele he wears an elaborate headdress and holds a doubleheaded serpent bar, symbol of the sky and of his absolute power. tions of the god K'awiil." Scholars often call him Ruler 13 in the Copán dynastic sequence of 16 rulers. During his long reign, Copán may have reached its greatest physical extent and range of political influence. On Stele D, Ruler 13 wears an elaborate headdress and ornamented kilt and sandals. He holds across his chest a doubleheaded serpent bar, symbol of the sky and of his absolute power. His features are distinctly Maya, although highly idealized. The Maya elite tended to have themselves portrayed in a conventionalized manner and as eternally youthful. The dense, deeply carved ornamental details that frame the face and figure in florid profusion stand almost clear of the block and wrap around the sides of the stele. The high relief, originally painted, gives the impression of a freestanding statue, although a hieroglyphic text is carved on the flat back side of the stele. Ruler 13 erected many stelae and buildings at Copán, but the king of neighboring Quiriguá eventually captured and beheaded the powerful Copán ruler.

TIKAL Another great Maya site of the Classic period is Tikal in Guatemala, some 150 miles north of Copán. Tikal is one of the oldest and largest of the Maya cities. Together with its suburbs, Tikal originally covered some 75 square miles and served as the ceremonial center of a population of perhaps 75,000. The Maya did not lay out central Tikal on a grid plan as did the designers of contemporaneous Teotihuacan. Instead, causeways connected irregular groupings. Modern surveys have uncovered the remains of as many as 3,000 separate structures in an area of about six square miles. The site's nucleus, the Great Plaza, is studded with stelae and defined by numerous architectural complexes. The most prominent monuments are the two soaring pyramids, taller than the surrounding rain forest, that face each other across an open square. The larger pyramid (FIG. 14-10), Temple I (also called the Temple of the Giant Jaguar after a motif on one of its carved wooden lintels), reaches a height of about 150 feet. It is the temple-mausoleum of a great Tikal ruler, Hasaw Chan K'awiil, who died in 732 CE. His body rested in a

COPÁN Because Copán, on the western border of Honduras, has more hieroglyphic inscriptions and well-preserved carved monuments than any other site in the Americas, it was one of the first Maya sites excavated. It also has proved one of the richest in the trove of architecture, sculpture, and artifacts recovered, and boasts one of Mesoamerica's best-preserved (and carefully restored) ball courts (FIG. 14-8; see "The Mesoamerican Ball Game," page 372).

Conspicuous plazas dominated the heart of Copán. In the city's Great Plaza, the Maya set up tall, sculpted stone stelae. Carved with the portraits of the rulers who erected them, these stelae also recorded their names, dates of reign, and notable achievements in glyphs on the front, sides, or back. Stele D (FIG. 14-9), erected in 736 CE, represents one of the city's foremost rulers, Waxaklajuun-Ub'aah-K'awiil (r. 695–738), whose name means "18 are the appari-

14-10 Temple I (Temple of the Giant Jaguar), Maya, Tikal, Guatemala, ca. 732 CE.

Temple I at Tikal is a 150-foot-tall pyramid that was the temple-mausoleum of Hasaw Chan K'awiil, who died in 732 ce. The nine tiers of the pyramid probably symbolize the nine levels of the Underworld.

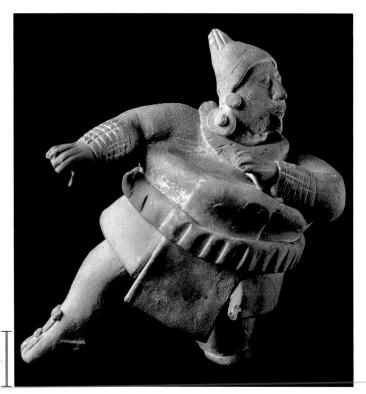

14-11 Ball player, Maya, from Jaina Island, Mexico, 700–900 CE. Painted clay, $6\frac{1}{4}$ high. Museo Nacional de Antropología, Mexico City.

Maya ceramic figurines represent a wide range of human types and activities. This kneeling ball player wears a thick leather belt and armand kneepads to protect him from the hard rubber ball.

vaulted chamber under the pyramid's base. The towering structure consists of nine sharply inclining platforms, probably a reference to the nine levels of the Underworld. A narrow stairway leads up to a three-chambered temple. Surmounting the temple is an elaborately sculpted *roof comb*, a vertical architectural projection that once bore the ruler's giant portrait modeled in stucco. The entire structure exhibits most concisely the ancient Mesoamerican formula for the stepped temple-pyramid and the compelling aesthetic and psychological power of Maya architecture.

JAINA The almost unlimited variety of figural attitude and gesture permitted in the modeling of clay explains the profusion of Maya ceramic figurines that, like their West Mexican predecessors (FIG. 14-4), may illustrate aspects of everyday life. Small-scale freestanding figures in the round, they are remarkably lifelike, carefully descriptive, and even comic at times. They represent a wider range of human types and activities than is commonly depicted on Maya stelae. Ball players (FIG. 14-11), women weaving, older men, dwarfs, supernatural beings, and amorous couples, as well as elaborately attired rulers and warriors, make up the figurine repertory. Many of the hollow figurines are also whistles. They were made in ceramic workshops on the mainland, often with molds, but graves in the island cemetery of Jaina, off the western coast of Yucatán, yielded hundreds of these figures, including the ball player illustrated here. Traces of blue remain on the figure's belt—remnants of the vivid pigments that once covered many of these figurines. The Maya used "Maya blue," a combination of a particular kind of clay and indigo, a vegetable dye, to paint both ceramics and murals. This pigment has proved virtually indestructible, unlike the other colors that largely

have disappeared over time. Like the larger terracotta figures of West Mexico, these figurines accompanied the dead on their inevitable voyage to the Underworld. The excavations at Jaina, however, have revealed nothing more that might clarify the meaning and function of the figures. Male figurines do not come exclusively from burials of male individuals, for example.

BONAMPAK The vivacity of the Jaina figurines and their variety of pose, costume, and occupation have parallels in the mural paintings of Bonampak (Mayan for "painted walls") in southeastern Mexico. Three chambers in one Bonampak structure contain murals that record important aspects of Maya court life. The example reproduced here (FIG. 14-12) shows warriors surrounding captives on a terraced platform. The figures have naturalistic proportions and overlap, twist, turn, and gesture. The artists used fluid and calligraphic line to outline the forms, working with color to indicate both texture and volume. The Bonampak painters combined their pigments—both mineral and organic—with a mixture of water, crushed limestone, and vegetable gums and applied them to their stucco walls in a technique best described as a cross between *fresco* and *tempera*.

The Bonampak murals are filled with circumstantial detail. The information given is comprehensive, explicit, and presented with the fidelity of an eyewitness report. The royal personages are identifiable by both their physical features and their costumes, and accompanying inscriptions provide the precise day, month, and year for the events recorded. All the scenes at Bonampak relate the events and ceremonies that welcome a new royal heir (shown as a toddler in some scenes). They include presentations, preparations for a royal fete, dancing, battle, and the taking and sacrificing of prisoners. On all occasions of state, public bloodletting was an integral part of Maya ritual. The ruler, his consort, and certain members of the nobility drew blood from their own bodies and sought union with the supernatural world. The slaughter of captives taken in war regularly accompanied this ceremony. Indeed, Mesoamerican cultures undertook warfare largely to provide victims for sacrifice. The torture and eventual execution of prisoners served both to nourish the gods and to strike fear into enemies and the general populace.

The scene (FIG. 14-12) in room 2 of structure 1, depicts the presentation of prisoners to Lord Chan Muwan. The painter arranged the figures in registers that may represent a pyramid's steps. On the uppermost step, against a blue background, is a file of gorgeously appareled nobles wearing animal headgear. Conspicuous among them on the right are retainers clad in jaguar pelts and jaguar headdresses. Also present is Chan Muwan's wife (third from right). The ruler himself, in jaguar jerkin and high-backed sandals, stands at the center, facing a crouching victim who appears to beg for mercy. Naked captives, anticipating death, crowd the middle level. One of them, already dead, sprawls at the ruler's feet. Others dumbly contemplate the blood dripping from their mutilated hands. The lower zone, cut through by a doorway into the structure housing the murals, shows clusters of attendants who are doubtless of inferior rank to the lords of the upper zone. The stiff formality of the victors contrasts graphically with the supple imploring attitudes and gestures of the hapless victims. The Bonampak victory was short-lived. The artists never finished the murals, and shortly after the dates written on the walls, the Maya seem to have abandoned the site.

The Bonampak murals are the most famous Maya wall paintings, but they are not unique. In 2001 at San Bartolo in northeastern Guatemala, archaeologists discovered the earliest examples yet found. They date to about 100 BCE, almost a millennium before the Bonampak murals.

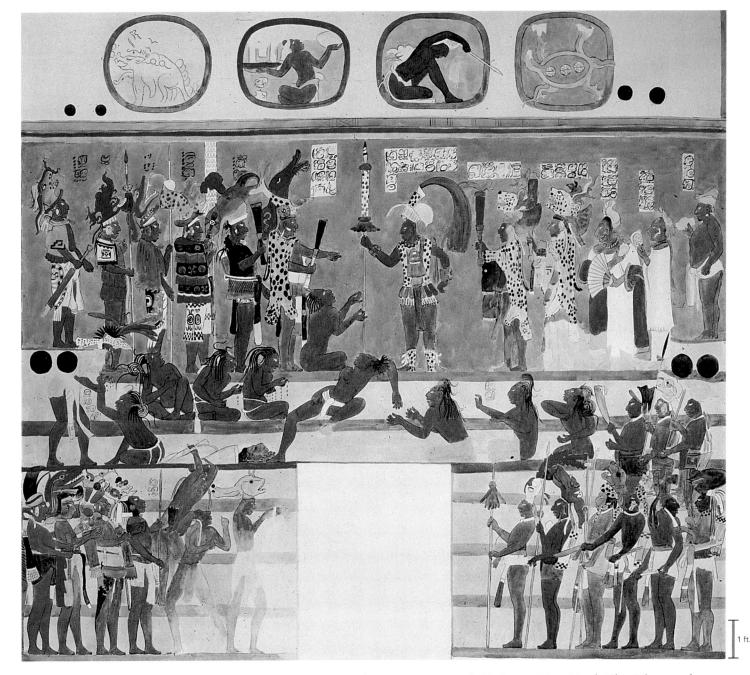

14-12 Presentation of captives to Lord Chan Muwan, Maya, room 2 of structure 1, Bonampak, Mexico, ca. 790 CE. Mural, 17' × 15'; watercolor copy by Antonio Tejeda. Peabody Museum, Harvard University, Cambridge.

The figures in this mural—a cross between fresco and tempera—may be standing on a pyramid's steps. At the top, the richly attired Chan Muwan reviews naked captives with mutilated hands awaiting their death.

YAXCHILÁN Elite women played an important role in Maya society, and some surviving artworks document their high status. The painted reliefs on the lintels of temple 23 at Yaxchilán represent a woman as a central figure in Maya ritual. Lintel 24 (FIG. 14-1) depicts the ruler Itzamna Balam II (r. 681–742 CE), known as Shield Jaguar, and his principal wife, Lady Xoc. Lady Xoc is magnificently outfitted in an elaborate woven garment, headdress, and jewels. She pierces her tongue with a barbed cord in a bloodletting ceremony that, according to accompanying inscriptions, celebrated the birth of a son to one of the ruler's other wives as well as an alignment between the planets Saturn and Jupiter. The celebration must have been held in a dark chamber or at night because Shield Jaguar provides illumination with a

blazing torch. The purpose of these ceremonies was to produce hallucinations. (Lintel 25 depicts Lady Xoc and her vision of an ancestor emerging from the mouth of a serpent.)

Classic Veracruz

Although the Maya is the most famous Classic Mesoamerican culture today and its remains are the most abundant, other cultures also flourished, and some of their surviving monuments rival those of the Maya in size and sophistication. In the Veracruz plain, for example, the heir to the Olmec culture was a civilization that archaeologists call Classic Veracruz. The name of the people that occupied the area at the time is unknown.

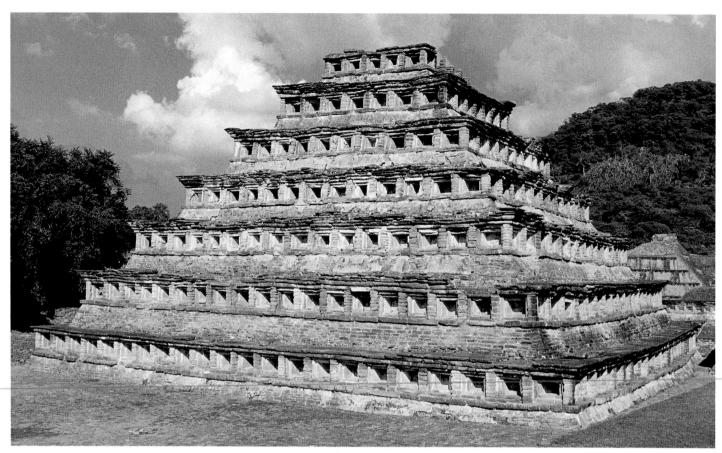

14-13 Pyramid of the Niches, Classic Veracruz, El Tajín, Mexico, sixth century CE.

The Pyramid of the Niches, although only 66 feet tall, has 365 niches on its four sides, one for each day of the solar year. It is one of many Mesoamerican monuments connected with astronomy and the calendar.

EL TAJÍN The major Classic Veracruz site is El Tajín, which was discovered in the dense rain forest of the Gulf of Mexico coast in 1785. At its peak, El Tajín was a thriving city of hundreds of acres and tens of thousands of inhabitants. Its excavated portion has already revealed 17 ball courts. The building that dominates the ceremonial center of El Tajín is the so-called Pyramid of the Niches (FIG. 14-13), a sixth-century CE structure of unusual form. In spite of its small size (only 66 feet tall), the Pyramid of the Niches encases an earlier smaller pyramid. The later structure has a steep staircase on its east side and six stories, each one incorporating a row of niches on each of the four sides, 365 in all. The number of niches, which corresponds to the number of days in a solar year, is unlikely to be coincidental. The Pyramid of the Niches is one of many examples of the close connection between the form of Mesoamerican monuments and astronomical observations and the measurement of time.

Postclassic Mexico

Throughout Mesoamerica, the Classic period ended at different times with the disintegration of the great civilizations. Teotihuacan's political and cultural empire, for example, was disrupted around 600, and its influence waned. About 600, fire destroyed the center of the great city, but the cause is still unknown. Within a century, however, Teotihuacan was deserted. Around 900, many of the great Maya sites were abandoned to the jungle, leaving a few northern Maya cities to flourish for another century or two before they, too, became depopulated. The Classic culture of the Zapotecs, centered at Monte Albán in the state of Oaxaca, came to an end around 700, and the neighboring Mixtec peoples assumed supremacy in this area during the Postclassic period. Classic El Tajín survived the general crisis that

afflicted the others but burned sometime in the 12th century. The war and confusion that followed the collapse of the Classic civilizations fractured the great states into small, local political entities isolated in fortified sites. The collapse encouraged even more warlike regimes and chronic aggression. The militant city-state of Chichén Itzá dominated Yucatán, while in central Mexico the Toltec and the later Aztec peoples, both ambitious migrants from the north, forged empires by force of arms.

CHICHÉN ITZÁ Yucatán, a flat, low, limestone peninsula covered with scrub vegetation, lies north of the rolling and densely forested region of the Guatemalan Petén. During the Classic period, Mayan-speaking peoples sparsely inhabited this northern region. For reasons scholars still debate, when the southern Classic Maya sites were abandoned after 900, the northern Maya continued to build many new temples in this area. They also experimented with building construction and materials to a much greater extent than their cousins farther south. Piers and columns appeared in doorways, and stone mosaics enlivened outer facades. The northern groups also invented a new type of construction, a solid core of coarse rubble faced on both sides with a veneer of square limestone plates.

Dominating the main plaza of Chichén Itzá today is the 98-foot-high pyramid (FIG. 14-14) that the Spaniards nicknamed the Castillo (Castle). As at Tikal (FIG. 14-10), this pyramid has nine levels. Atop the structure is a temple dedicated to Kukulkan, the Maya equivalent of Quetzalcoatl, and, as at El Tajín (FIG. 14-13), the design of the Castillo is tied to the solar year. The north side has 92 steps and the other three sides 91 steps each for a total of 365. At the winter and summer equinoxes, the sun casts a shadow along the north-

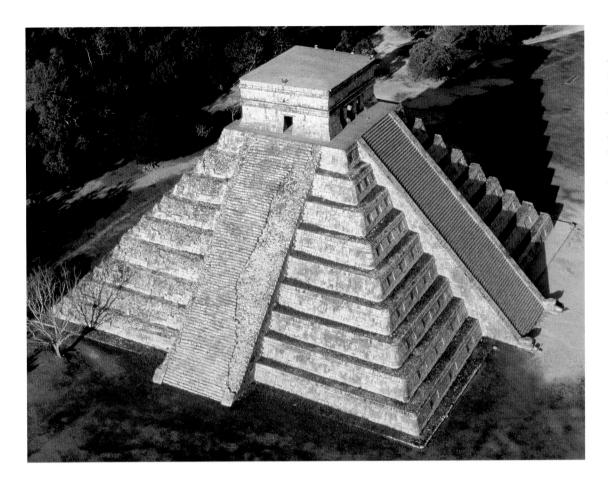

14-14 Aerial view (looking southwest) of the Castillo, Maya, Chichén Itzá, Mexico, ca. 800–900 CE.

A temple to Kukulkan sits atop this pyramid with a total of 365 stairs on its four sides. At the winter and summer equinoxes, the sun casts a shadow in the shape of a serpent along the northern staircase.

ern staircase of the pyramid. Because of the pyramid's silhouette and the angle of the sun, the shadow takes the shape of a serpent that slithers along the pyramid's face as the sun moves across the sky.

Excavations inside the Castillo in 1937 revealed an earlier ninelevel pyramid within the later and larger structure. Inside was a royal burial chamber with a throne in the form of a red jaguar and a stone figure of a type called a *chacmool* depicting a fallen warrior. Chacmools (for example, FIG. **14-15**, found near the Castillo) recline on their backs and have receptacles on their chests to receive sacrificial offerings, probably of defeated enemies. The distinctive forms of the Mesoamerican chacmools made a deep impression upon 20th-century sculptors (FIG. **35-59**).

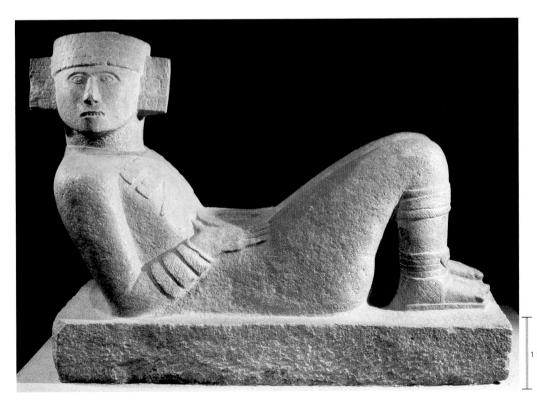

14-15 Chacmool, Maya, from the Platform of the Eagles, Chichén Itzá, Mexico, ca. 800–900 CE. Stone, 4′ 10½″ high. Museo Nacional de Antropología, Mexico City.

Chacmools represent fallen warriors reclining on their backs with receptacles on their chests to receive sacrificial offerings. Excavators discovered one in the burial chamber inside the Castillo (FIG. 14-14).

ft.

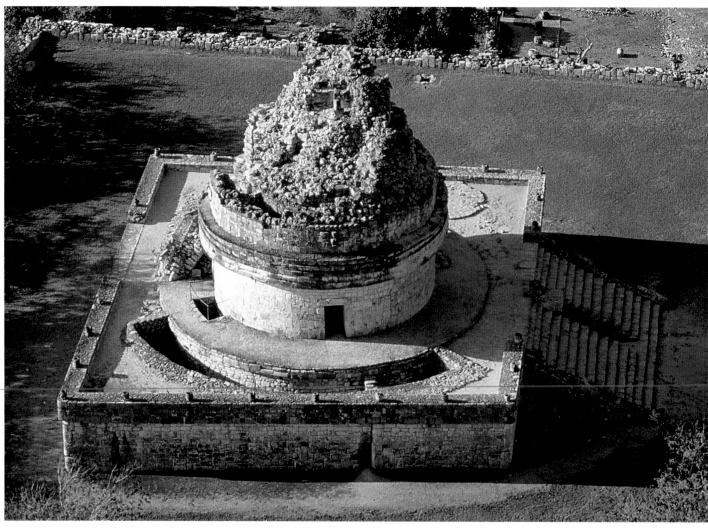

14-16 Aerial view (looking south) of the Caracol, Maya, Chichén Itzá, Mexico, ca. 800-900 CE.

Caracol means "snail shell," and this unusual round northern Maya structure encloses a circular staircase. The building may have been a temple to Kukulkan with an astronomical observatory at its summit.

The Caracol (FIG. 14-16) at Chichén Itzá establishes that the northern Maya were as inventive with architectural form as they were experimental with construction and materials. A cylindrical tower rests on a broad terrace that is in turn supported by a larger rectangular platform measuring 169 × 232 feet. The tower, composed of two concentric walls, encloses a circular staircase that leads to a small chamber near the top of the structure. In plan, the building recalls the cross-section of a conch shell. (Caracol means "snail" in Spanish.) The conch shell was an attribute of the feathered serpent, and round temples were dedicated to him in central Mexico. This building may therefore also have been a temple to Kukulkan. Windows along the Caracol's staircase and an opening at the summit probably were used for astronomical observation.

TULA The name Toltec, which signifies "makers of things," generally refers to a powerful tribe of invaders from the north, whose arrival in central Mexico coincided with the great disturbances that must have contributed to the fall of the Classic civilizations. The Toltec capital at Tula flourished from about 900 to 1200. The Toltecs were expert political organizers and military strategists, dominating large parts of north and central Mexico. They also were master artisans and farmers, and later peoples such as the Aztecs looked back on the Toltecs admiringly, proud to claim descent from them.

Archaeologists have noted many similarities between the sites of Tula and Chichén Itzá.

At Tula, four colossal *atlantids* (male statue-columns; FIG. 14-17) portraying armed warriors reflect the grim, warlike regime of the Toltecs. These images of brutal authority stand eternally at attention, warding off all hostile threats. Built up of four stone drums each, the sculptures stand atop pyramid B. They wear feathered headdresses and, as breastplates, stylized butterflies, heraldic symbols of the Toltec. In one hand they clutch a bundle of darts and in the other an *atlatl* (spear-thrower), typical weapons of highland Mexico. The figures originally supported a temple roof, now missing. Such an architectural function requires rigidity of pose, compactness, and strict simplicity of contour. The unity and regularity of architectural mass and silhouette here combine perfectly with abstraction of form.

By 1180 the last Toltec ruler abandoned Tula, and most of his people followed. Some years later, the city was catastrophically destroyed, its ceremonial buildings burned to their foundations, its walls demolished, and the straggling remainder of its population scattered. The exact reasons for the Toltecs' departure and for their city's destruction are unknown. Although the Toltec demise set the stage for the rise of the last great civilization of Mesoamerica, the Aztecs (see Chapter 32), that culture did not reach the height of its power for another 300 years.

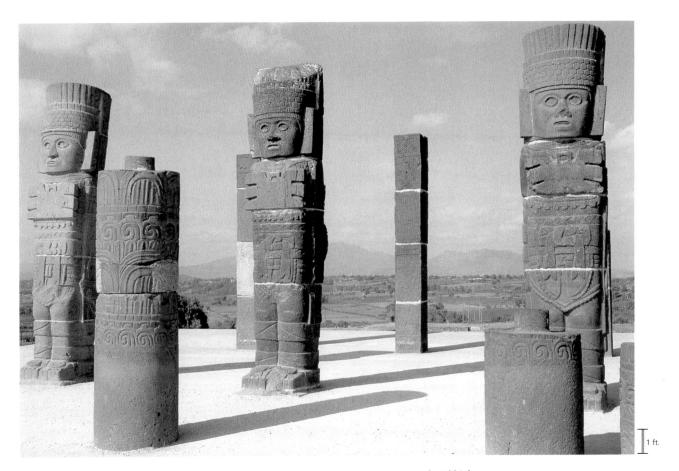

14-17 Colossal atlantids, pyramid B, Toltec, Tula, Mexico, ca. 900-1180 CE. Stone, each 16' high.

The colossal statue-columns of Tula portraying warriors armed with darts and spear-throwers reflect the military regime of the Toltecs, whose arrival in central Mexico coincided with the decline of the Maya.

INTERMEDIATE AREA

Between the highly developed civilizations of Mesoamerica and the South American Andes lies a region archaeologists have dubbed the "Intermediate Area." Comprising parts of El Salvador, Honduras, Ecuador, and Venezuela, and all of Panama, Costa Rica, Nicaragua, and Colombia, at the time of the European invasion it was by no means a unified political territory but rather was divided among many small rival chiefdoms. Although the people of the Intermediate Area did not produce monumental architecture on the scale of their neighbors to the north and south and, unlike the Mesoamericans, left no written records, they too were consummate artists. Potters in the Intermediate Area made some of the earliest ceramics of the Americas, and they continued to create an astonishing variety of terracotta vessels and figures until the time of the Spanish conquest. Among the other arts practiced in the Intermediate Area were stone sculpture and jade carving. Inhabitants throughout the region prized goldworking, and the first Europeans to make contact here were astonished to see the natives nearly naked but covered in gold jewelry. The legend of El Dorado, a Colombian chief who coated himself in gold as part of his accession rites, was largely responsible for the Spanish invaders' ruthless plunder of the region.

TAIRONA In northern Colombia (MAP 14-2), the Sierra Nevada de Santa Marta rises above the Caribbean. The topography of lofty mountains and river valleys provided considerable isolation and fostered the independent development of various groups. The inhabitants of this region after about 1000 CE included a group known as the Tairona, whose metalwork is among the finest of all the ancient American goldworking styles.

MAP 14-2 Early sites in Andean South America.

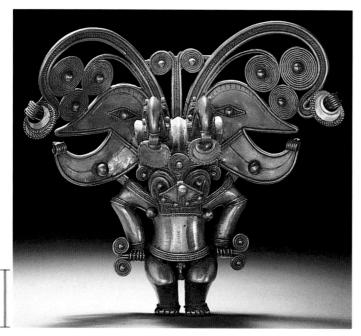

14-18 Pendant in the form of a bat-faced man, Tairona, from northeastern Colombia, after 1000 CE. Gold, $5\frac{1}{4}''$ high. Metropolitan Museum of Art, New York (Jan Mitchell and Sons Collection).

The peoples of the Intermediate Area between Mesoamerica and Andean South America were expert goldsmiths. This pendant depicting a bat-faced man with a large headdress served as an amulet.

Goldsmiths in Peru, Ecuador, and southern Colombia produced technologically advanced and aesthetically sophisticated work in gold mostly by cutting and hammering thin gold sheets. The Tairona smiths, however, who had to obtain gold by trade, used the lost-wax process in part to preserve the scarce amount of the precious metal available to them. Tairona pendants were not meant to be worn simply as rich accessories for costumes but as amulets or talismans representing powerful beings who gave the wearer protection and status. The pendant shown here (FIG. 14-18) represents a batfaced man—perhaps a masked man rather than a composite being, or a man in the process of spiritual transformation. In local mythology, the first animal created was the bat. This bat-man wears an immense headdress composed of two birds in the round, two great beaked heads, and a series of spirals crowned by two overarching stalks. The harmony of repeated curvilinear motifs, the rhythmic play of their contours, and the precise delineation of minute detail attest to the artist's technical control and aesthetic sensitivity.

SOUTH AMERICA

As in Mesoamerica, the indigenous civilizations of Andean South America (MAP 14-2) jarred against and stimulated one another, produced towering monuments and sophisticated paintings, sculptures, ceramics, and textiles, and were crushed in violent confrontations with the Spanish conquistadors. Although less well studied than the ancient Mesoamerican cultures, those of South America are actually older, and in some ways they surpassed the accomplishments of their northern counterparts. Andean peoples, for example, mastered metalworking much earlier, and their monumental architecture predates that of the earliest Mesoamerican culture, the Olmec, by more than a millennium. The peoples of northern Chile even began to mummify their dead at least 500 years before the Egyptians.

The Central Andean region of South America lies between Ecuador and northern Chile, with its western border the Pacific Ocean. It consists of three well-defined geographic zones, running north and south and roughly parallel to one another. The narrow western coastal plain is a hot desert crossed by rivers, which create habitable fertile valleys. Next, the high peaks of the great Cordillera of the Andes hem in plateaus of a temperate climate. The region's inland border, the eastern slopes of the Andes, is a hot and humid jungle.

Andean civilizations flourished both in the highlands and on the coast. Highland cave dwellers fashioned the first rudimentary art objects by 8800 BCE. Artisans started producing sophisticated textiles as early as 2500 BCE, and the firing of clay began in Peru before 1800 BCE. Beginning about 800 BCE, Andean chronology alternates between periods known as "horizons," when a single culture appears to have dominated a broad geographic area for a relatively long period, and "intermediate periods" characterized by more independent regional development. The Chavín culture (ca. 800–200 BCE) represents the first period, Early Horizon; the Tiwanaku and Wari cultures (ca. 600–1000 CE) the Middle Horizon; and the Inka Empire (see Chapter 32) the Late Horizon. Among the many regional styles that flourished between these horizons, the most important are the Early Intermediate period (ca. 200 BCE–700 CE) Paracas and Nasca cultures of the south coast of Peru, and the Moche in the north.

The discovery of complex ancient communities documented by radiocarbon dating is changing the picture of early South American cultures. Planned communities boasting organized labor systems and monumental architecture dot the narrow river valleys that drop from the Andes to the Pacific Ocean. In the Central Andes, these early sites began to develop around 3000 BCE, about a millennium before the invention of pottery there. Carved gourds and some fragmentary cotton textiles survive from this early period. They depict composite creatures, such as crabs turning into snakes, as well as doubled and then reversed images, both hallmarks of later Andean art.

The architecture of the early coastal sites typically consists of large U-shaped, flat-topped platforms—some as high as a 10-story building—around sunken courtyards. Many had numerous small chambers on top. Construction materials included both uncut fieldstones and handmade adobes (sun-dried mud bricks) in the shape of cones, laid point to point in coarse mud plaster to form walls and platforms. These complexes almost always faced toward the Andes mountains, source of the life-giving rivers on which these communities depended for survival. Mountain worship, which continues in the Andean region to this day, was probably the focus of early religious practices as well. In the highlands, archaeologists also have discovered large ceremonial complexes. In place of the numerous interconnecting rooms found atop many coastal mounds, the highland examples have a single small chamber at the top, often with a stone-lined firepit in the center. These pits probably played a role in ancient fire rituals. Excavators have found burnt offerings in the pits, often of exotic objects such as marine shells and tropical bird feathers.

Chavin

Named after the ceremonial center of Chavín de Huántar, located in the northern highlands of Peru, the Chavín culture of the Early Horizon period developed and spread throughout much of the coastal region and the highlands during the first millennium BCE. Once thought to be the "mother culture" of the Andean region, the Chavín culture is now seen as the culmination of developments that began elsewhere some 2,000 years earlier.

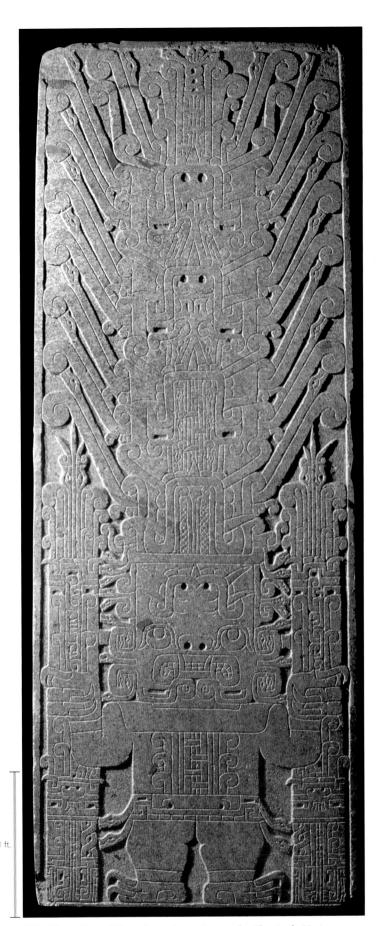

14-19 *Raimondi Stele*, from the main temple, Chavín de Huántar, Peru, ca. 800–200 BCE. Incised green diorite, 6' high. Instituto Nacional de Cultura, Lima.

The *Raimondi Stele* staff god wears a headdress of faces and snakes. Seen upside down, the god's face becomes two faces. The ability of the gods to transform themselves is a core aspect of Andean religion.

The Old Temple of Chavín de Huántar, dated to the first millennium BCE, resembles some of the sacred complexes of the earliest Andean cultures. It is a U-shaped, stone-faced structure between two rivers, with wings up to 83 yards long. Although at first glance its three stories appear to be a solid stepped platform, in fact narrow passageways, small chambers, and stairways penetrate the temple in a labyrinthine pattern. No windows, however, light the interior spaces. The few members of Chavín society with access to these rooms must have witnessed secret and sacred torch-lit ceremonies. The temple is fronted by sunken courts, an arrangement also adopted from earlier coastal sites.

The temple complex at Chavín de Huántar is famous for its extensive stone carvings. The most common subjects are composite creatures that combine feline, avian, reptilian, and human features. Consisting largely of low relief on panels, cornices, and columns, and some rarer instances of freestanding sculpture, Chavín carving is essentially shallow, linear incision. An immense oracular cult image once stood in the center of the temple's oldest part. Other examples of sculpture in the round include heads of mythological creatures, which were pegged into the exterior walls.

RAIMONDI STELE Found in the main temple at Chavin de Huántar and named after its discoverer, the Raimondi Stele (FIG. 14-19), represents a figure called the "staff god." He appears in various versions from Colombia to northern Bolivia but always holds staffs. Seldom, however, do the representations have the degree of elaboration found at Chavín. The Chavín god gazes upward, frowns, and bares his teeth. His elaborate headdress dominates the upper two-thirds of the slab. Inverting the image reveals that the headdress is composed of a series of fanged jawless faces, each emerging from the mouth of the one above it. Snakes abound. They extend from the deity's belt, make up part of the staffs, serve as whiskers and hair for the deity and the headdress creatures, and form a braid at the apex of the composition. The Raimondi Stele clearly illustrates the Andean artistic tendency toward both multiplicity and dual readings. Upside down, the god's face turns into not one but two faces. The ability of gods to transform before the viewer's eyes is a core aspect of Andean religion.

Chavín iconography spread widely throughout the Andean region via portable media such as goldwork, textiles, and ceramics. For example, more than 300 miles from Chavín on the south coast of Peru, archaeologists have discovered cotton textiles with imagery recalling Chavín sculpture. Painted staff-bearing female deities, apparently local manifestations or consorts of the highland staff god, decorate these large cloths, which may have served as wall hangings in temples. Ceramic vessels found on the north coast of Peru also carry motifs much like those found on Chavín stone carvings.

Paracas, Nasca, and Moche

Several coastal traditions developed during the millennium from ca. 400~BCE to 700~CE. The most prominent were the Paracas (ca. 400~BCE-200~CE), Nasca (ca. 200~BCE-600~CE), and Moche (ca. 1-700~CE). Together they exemplify the great variations within Peruvian art styles.

PARACAS The Paracas culture occupied a desert peninsula and a nearby river valley on the south coast of Peru. Outstanding among the Paracas arts are the funerary textiles used to wrap the bodies of the dead in multiple layers. The dry desert climate preserved the textiles, buried in shaft tombs beneath the sands. These textiles are among the enduring masterpieces of Andean art (see "Andean Weaving," page 382). Most are of woven cotton with designs embroidered onto the fabric in alpaca or vicuña wool imported from the highlands. The weavers used more than 150 vivid colors, the majority derived from

Andean Weaving

hen the Inka first encountered the Spanish conquistadors, they were puzzled by the Europeans' fixation on gold and silver. The Inka valued finely woven cloth just as highly as precious metal. Textiles and clothing dominated every aspect of their existence. Storing textiles in great warehouses, their leaders demanded cloth as tribute, gave it as gifts, exchanged it during diplomatic negotiations, and even burned it as a sacrificial offering. Although both men and women participated in cloth production, the Inka rulers selected the best women weavers from around the empire and sequestered them for life to produce textiles exclusively for the elite.

Andean weavers manufactured their textiles by spinning into yarn the cotton grown in five different shades on the warm coast and the fur sheared from highland llamas, alpacas, vicuñas, or guanacos, and then weaving the yarn into cloth. Rare tropical bird feathers and small plaques of gold and silver were sometimes sewn onto cloth destined for the nobility. Andean weavers mastered nearly every textile technique known today, many executed with a simple device known as a backstrap loom. Similar looms are still in use in the Andes. The weavers stretch the long warp (vertical) threads between two wooden bars. The top bar is tied to an upright, A belt or backstrap, attached to the bottom bar, encircles the waist of the seated weaver, who maintains the tension of the warp threads by leaning back. The weaver passes the weft (horizontal) threads over and under the warps and pushes them tightly against each other to produce the finished cloth. In ancient textiles, the sturdy cotton often formed the warp, and the wool, which can be dyed brighter colors, served to

create complex designs in the weft. *Embroidery*, the sewing of threads onto a finished ground cloth to form contrasting designs, was the specialty of the Paracas culture (FIG. 14-20).

The dry deserts of coastal Peru have preserved not only numerous textiles from different periods but also hundreds of finely worked baskets containing spinning and weaving implements. These tools are invaluable sources of information about Andean textile production processes. The baskets found in documented contexts came from women's graves, attesting to the close identity between weaving and women, the reverence for the cloth-making process, and the Andean belief that textiles were necessary in the afterlife.

A special problem all weavers confront is that they must visualize the entire design in advance and cannot easily change it during the weaving process. No records exist of how Andean weavers learned, retained, and passed on the elaborate patterns they wove into cloth, but some painted ceramics depict weavers at work, apparently copying designs from finished models. However, the inventiveness of individual weavers is evident in the endless variety of colors and patterns in surviving Andean textiles. This creativity often led Andean artists to design textiles that are highly abstract and geometric. Paracas embroideries (FIG. 14-20), for example, may depict humans, down to the patterns on the tunics they wear, yet the figures are reduced to their essentials in order to focus on their otherworldly role. The culmination of this tendency toward abstraction may be seen in the Wari compositions (FIG. 14-26) in which figural motifs become stunning blocks of color that overwhelm the subject matter itself.

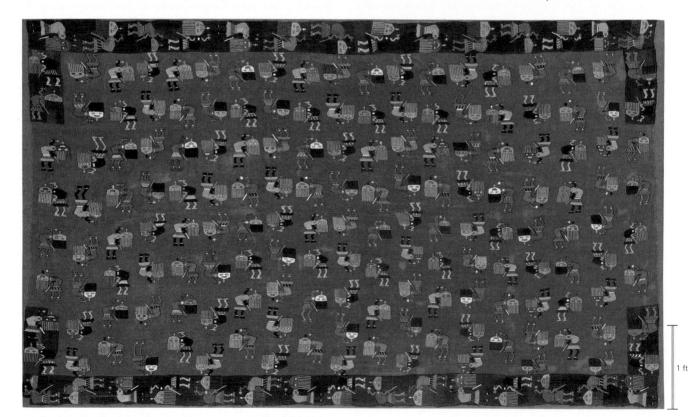

14-20 Embroidered funerary mantle, Paracas, from the southern coast of Peru, first century CE. Plain-weave camelid fiber with stem-stitch embroidery of camelid wool, $4' 7\frac{7}{8}'' \times 7' 10\frac{7}{8}''$. Museum of Fine Arts, Boston (William A. Paine Fund).

Outstanding among the Paracas arts are the woven mantles used to wrap the bodies of the dead. The flying or floating figure repeated endlessly on this mantle is probably either the deceased or a religious practitioner.

plants. Feline, bird, and serpent motifs appear on many of the textiles, but the human figure, real or mythological, predominates. Humans dressed up as or changing into animals are common motifs on the grave mantles—consistent with the Andean transformation theme noted on the *Raimondi Stele* (FIG. 14-19). On one well-preserved mantle (FIG. 14-20), a figure with prominent eyes appears scores of times over the surface. The flowing hair and the slow kicking motion of the legs suggest airy, hovering movement. The flying or floating figure carries batons and fans, or, according to some scholars, knives and hallucinogenic mushrooms. On other mantles the figures carry the skulls or severed heads of enemies. Art historians have interpreted the flying figures either as Paracas religious practitioners dancing or flying during an ecstatic trance or as images of the deceased. Despite endless repetitions of the motif, variations of detail occur throughout each textile, notably in the figures' positions and in subtle color changes.

NASCA The Nasca culture takes its name from the Nasca River valley south of Paracas. The early centuries of the Nasca civilization ran concurrently with the closing centuries of the Paracas culture, and Nasca style emulated Paracas style. The Nasca won renown for their pottery, and thousands of their ceramic vessels survive. The vases usually have round bottoms, double spouts connected by bridges, and smoothly burnished polychrome surfaces. The subjects vary greatly, but plants, animals, and composite mythological creatures, part human and part animal, are most common. Nasca painters often represented ritual impersonators, some of whom, like the Paracas flying figures, hold trophy heads and weapons. On the vessel illustrated here (FIG. 14-21) are two costumed flying figures. The painter reduced their bodies and limbs to abstract appendages and focused on the heads. The figures wear a multicolored necklace, a whiskered gold mouthpiece, circular disks hanging from the ears, and a rayed crown on the forehead. Masks or heads with streaming hair, possibly more trophy heads, flow over the impersonators' backs, increasing the sense of motion.

Nasca artists also depicted figures on a gigantic scale. Some 800 miles of lines drawn in complex networks on the dry surface of the Nasca plain have long attracted world attention because of their

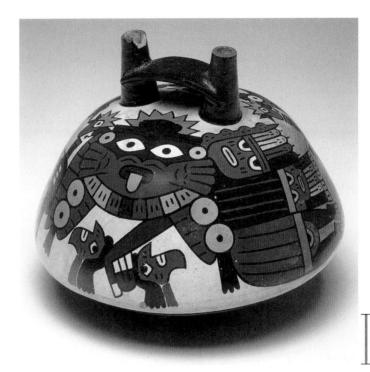

14-21 Bridge-spouted vessel with flying figures, Nasca, from Nasca River valley, Peru, ca. 50–200 CE. Painted ceramic, $5\frac{1}{2}''$ high. Art Institute of Chicago, Chicago (Kate S. Buckingham Endowment).

The Nasca were masters of pottery painting. The painter of this bridgespouted vessel depicted two crowned and bejeweled flying figures, probably ritual impersonators with trophy heads.

colossal size, which defies human perception from the ground. Preserved today are about three dozen images of birds, fish, and plants, including a hummingbird (FIG. 14-22) several hundred feet long. The Nasca artists also drew geometric forms, such as trapezoids, spirals, and straight lines running for miles. Artists produced these Nasca Lines, as the immense earth drawings are called, by selectively

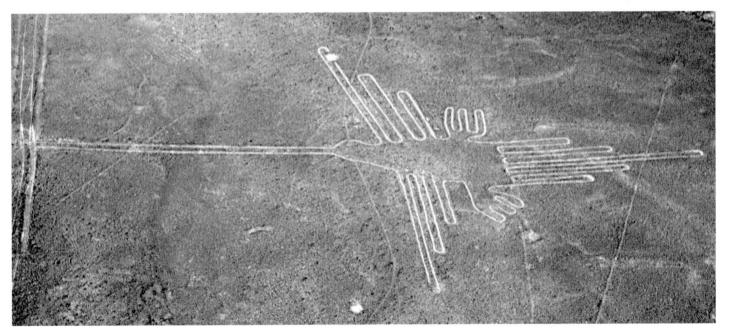

14-22 Hummingbird, Nasca, Nasca plain, Peru, ca. 500 CE. Dark layer of pebbles scraped aside to reveal lighter clay and calcite beneath.

The earth drawings known as Nasca Lines represent birds, fish, plants, and geometric forms. They may have marked pilgrimage routes leading to religious shrines, but their function is uncertain.

removing the dark top layer of stones to expose the light clay and calcite below. The Nasca created the lines quite easily from available materials and using rudimentary geometry. Small groups of workers have made modern reproductions of them with relative ease. The lines seem to be paths laid out using simple stone-and-string methods. Some lead in traceable directions across the deserts of the Nasca River drainage. Others are punctuated by many shrinelike nodes, like the knots on a cord. Some lines converge at central places usually situated close to water sources and seem to be associated with water supply and irrigation. They may have marked pilgrimage routes for those who journeyed to local or regional shrines on foot. Altogether, the vast arrangement of the Nasca Lines is a system—not a meaningless maze but a map that plotted the whole terrain of Nasca material and spiritual concerns. Remarkably, until quite recently, the peoples of highland Bolivia made and used similar ritual pathways in association with shrines, demonstrating the tenacity of the Andean indigenous belief systems.

MOCHE Among the most famous art objects the ancient Peruvians produced are the painted clay vessels of the Moche, who occupied a series of river valleys on the northern coast of Peru around the same time the Nasca flourished to the south. Among ancient civilizations, only the Greeks and the Maya surpassed the Moche in the information recorded on their ceramics. Moche pots illustrate architecture, metallurgy, weaving, the brewing of chicha (fermented maize beer), human deformities and diseases, and even sexual acts. Moche

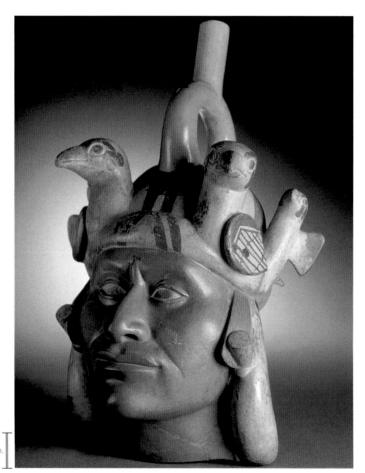

14-23 Vessel in the shape of a portrait head, Moche, from the northern coast of Peru, fifth to sixth century CE. Painted clay, $1'\frac{1}{2}''$ high. Museo Arqueológico Rafael Larco Herrera, Lima.

The Moche culture produced an extraordinary variety of painted vessels. This one in the shape of a head may depict a warrior, ruler, or royal retainer. The realistic rendering of the face is particularly striking.

vessels are predominantly flat-bottomed, stirrup-spouted jars derived from Chavín prototypes. The potters generally decorated them with a *bichrome* (two-color) slip. Although the Moche made early vessels by hand without the aid of a potter's wheel, they fashioned later ones in two-piece molds. Thus, numerous near-duplicates survive. Moche ceramists continued to refine the stirrup spout, making it an elegant slender tube, much narrower than the Chavín examples. The portrait vessel illustrated here (FIG. 14-23) is an elaborate example of a common Moche type. It may depict the face of a warrior, a ruler, or even a royal retainer whose image may have been buried with many other pots to accompany his dead master. The realistic rendering of the physiognomy is particularly striking.

SIPÁN Elite men, along with retinues of sacrificial victims, appear to be the occupants of several rich Moche tombs excavated near the village of Sipán on the arid northwest coast of Peru. The Sipán burial sites have yielded a treasure of golden artifacts and more than a thousand ceramic vessels. The discovery of the tombs in the late 1980s created a great stir in the archaeological world, contributing significantly to the knowledge of Moche culture. Beneath a large adobe platform adjacent to two high but greatly eroded pyramids, excavators found several lavish graves, including the tomb of a man known today as the Lord of Sipán, or the Warrior Priest. The splendor of the funeral trappings that adorned his body, the quantity and quality of the sumptuous accessories, and the bodies of the retainers buried with him indicate that he was a personage of the highest rank. Indeed, he may have been one of the warrior priests so often depicted on Moche ceramic wares and murals (and in this tomb on a golden pyramid-shaped rattle) assaulting his enemies and participating in sacrificial ceremonies.

An ear ornament (FIG. 14-24) of turquoise and gold found in one Sipán tomb shows a warrior priest clad much like the Lord of Sipán. Two retainers appear in profile to the left and right of the central figure. Represented frontally, he carries a war club and shield and

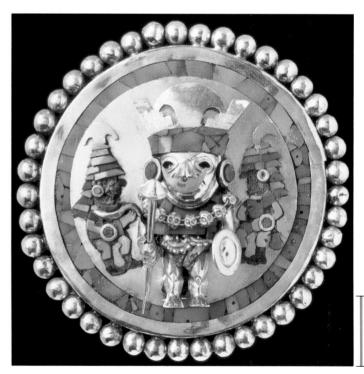

14-24 Ear ornament, Moche, from a tomb at Sipán, Peru, ca. 300 CE. Gold and turquoise, $4\frac{4}{5}$ ". Bruning Archaeological Museum, Lambayeque.

This ear ornament from a Sipán tomb depicts a Moche warrior priest and two retainers. The priest carries a war club and shield and wears a necklace of owl-head beads. The costume corresponds to actual finds.

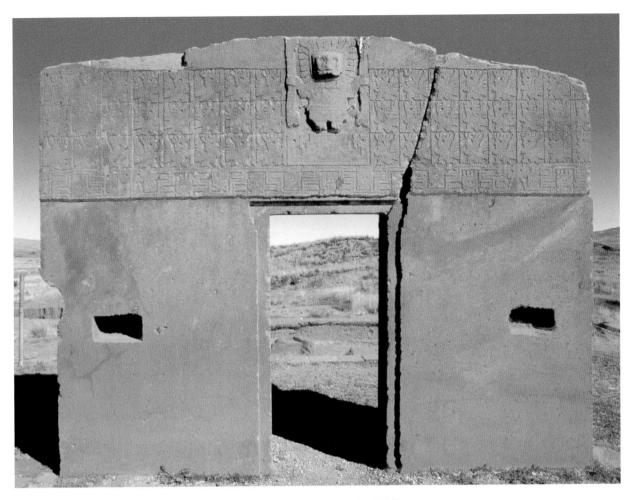

14-25 Gateway of the Sun, Tiwanaku, Bolivia, ca. 375-700 CE. Stone, 9' 10" high.

The Gateway of the Sun probably led into a sacred area at Tiwanaku. The central figure is a version of the Chavín staff god (FIG. 14-19). The relief was once painted, inlaid with turquoise, and covered with gold.

wears a necklace of owl-head beads. The figure's bladelike crescent-shaped helmet is a replica of the large golden one buried with the Sipán lord. The war club and shield also match finds in the Warrior Priest's tomb. The ear ornament of the jewelry image is a simplified version of the piece itself. Other details also correspond to actual finds—for example, the removable nose ring that hangs down over the mouth. The value of the Sipán find is incalculable for what it reveals about elite Moche culture and for its confirmation of the accuracy of the iconography of Moche artworks.

Tiwanaku and Wari

The bleak highland country of southeastern Peru and southwestern Bolivia contrasts markedly with the warm valleys of the coast. In the Bolivian mountains, the Tiwanaku culture (ca. 100–1000 CE) developed beginning in the second century CE. North of Paracas in Peru, the Wari culture (ca. 500–800 CE) dominated parts of the dry coast.

TIWANAKU Named after its principal archaeological site on the southern shore of Lake Titicaca, the Tiwanaku culture flourished for nearly a millennium. It spread to the adjacent coastal area as well as to other highland regions, eventually extending from southern Peru to northern Chile. Tiwanaku was an important ceremonial center. Its inhabitants constructed grand buildings using the region's fine sandstone, andesite, and diorite. Tiwanaku's imposing Gateway of the Sun (FIG. 14-25) is a huge monolithic block of andesite pierced by a single doorway. Moved in ancient times from its original loca-

tion within the site, the gateway now forms part of an enormous walled platform. Relief sculpture crowns the gate. The central figure is a Tiwanaku version of the Chavín staff god (FIG. 14-19). Larger than all the other figures and presented frontally, he dominates the composition and presides over the passageway. Rays project from his head. Many terminate in puma heads, representing the power of the highlands' fiercest predator. The staff god—possibly a sky and weather deity rather than the sun deity the rayed head suggests—appears in art throughout the Tiwanaku horizon, associated with smaller attendant figures. Those of the Gateway of the Sun are winged and have human or condor heads. Like the puma, the condor is an impressive carnivore, the largest raptor in the world. Sky and earth beings thus converge on the gate, which probably served as the doorway to a sacred area, a place of transformation. The reliefs were once colorfully painted. Artists apparently also inlaid the figures' eyes with turquoise and covered the surfaces with gold, producing a dazzling effect.

WARI The flat, abstract, and repetitive figures surrounding the central figure on the Gateway of the Sun recall woven textile designs. Indeed, the people of the Tiwanaku culture, like those of Paracas, were consummate weavers, although far fewer textiles survive from the damp highlands. However, excavators have recovered many examples of weaving, especially tunics, from the contemporaneous Wari culture in Peru.

Although Wari weavers fashioned cloth from both wool and cotton fibers, as did earlier Paracas weavers (FIG. 14-20), the resemblance

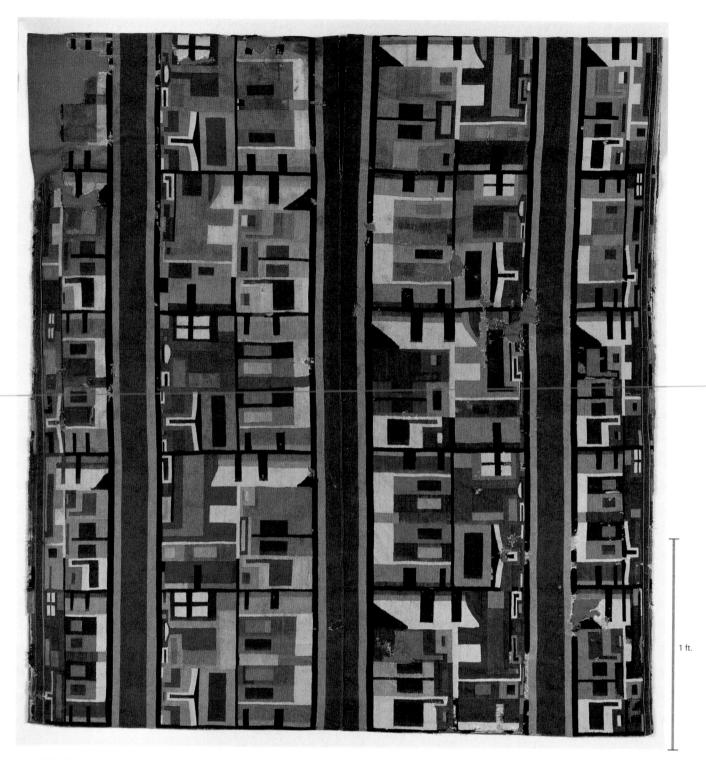

14-26 *Lima Tapestry* (tunic), Wari, from Peru, ca. 500–800 CE. 3' $3\frac{3}{8}'' \times 2'$ $11\frac{3}{8}''$. Museo Nacional de Antropología Arqueología e Historia del Perú, Lima.

Whereas Paracas mantles (Fig. 14-20) are embroideries, Wari textiles are tapestries with the motifs woven directly into the fabric. The figures on this Wari tunic are so abstract as to be nearly unrecognizable.

between the two textile styles ends there. Whereas Paracas artists embroidered motifs onto the plain woven surface, Wari artists wove designs directly into the fabric, the weft threads packed densely over the warp threads in a technique known as *tapestry*. Some particularly fine pieces have more than 200 weft threads per inch. Furthermore, unlike the relatively naturalistic individual figures depicted on Paracas mantles, those appearing on Wari textiles are so closely connected and so abstract as to be nearly unrecognizable. In the tunic

shown here, the so-called *Lima Tapestry* (FIG. 14-26), the Wari designer expanded or compressed each figure in a different way and placed the figures in vertical rows pressed between narrow red bands of plain cloth. Elegant tunics like this one must have been prestige garments made for the elite. Clothing and status were closely connected in many ancient American societies, especially in the Inka Empire that eventually came to dominate Andean South America (see Chapter 32).

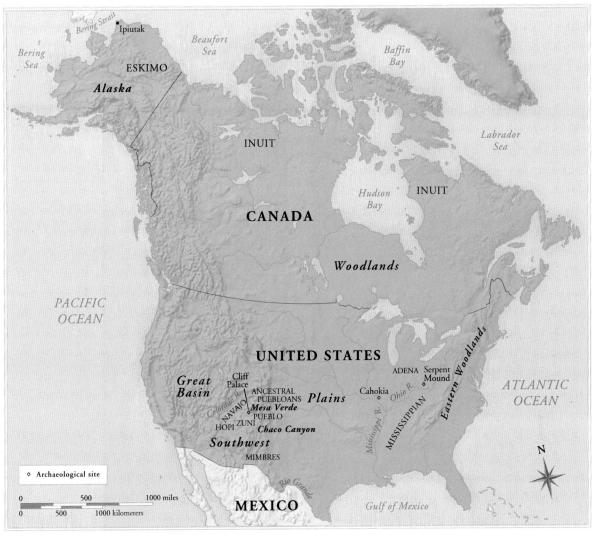

MAP 14-3 Early Native American sites in North America.

NORTH AMERICA

In many parts of the United States and Canada, archaeologists have identified indigenous cultures that date back as far as 12,000 years ago. Most of the surviving art objects, however, come from the past 2,000 years. Scholars divide the vast and varied territory of North America (MAP 14-3) into cultural regions based on the relative homogeneity of language and social and artistic patterns. Native lifestyles varied widely over the continent, ranging from small bands of migratory hunters to settled—at times even urban—agriculturalists. Among the art-producing peoples who inhabited the continent before the arrival of Europeans are the Eskimo of Alaska and the Inuit of Canada, who hunted and fished across the Arctic from Greenland to Siberia, and the maize farmers of the American Southwest, who wrested water from their arid environment and built effective irrigation systems as well as roads and spectacular cliff dwellings. Farmers also settled in the vast, temperate Eastern Woodlands-ranging from eastern Canada to Florida and from the Atlantic to the Great Plains west of the Mississippi. Some of them left behind great earthen mounds that once functioned as their elite residences or burial places.

Eskimo

The Eskimoan peoples originally migrated to North America across the Bering Strait. During the early first millennium CE, a community of Eskimo sea mammal hunters and tool makers occupied parts of Alaska during the Norton, or Old Bering Sea, culture that began around 500 BCE.

IPIUTAK MASK Archaeologists have uncovered major works of Eskimo art at the Ipiutak site at Point Hope. The finds include a variety of burial goods as well as tools. A burial mask (FIG. 14-27) datable to ca. 100 CE is of special interest. The artist fashioned the mask out of walrus ivory, the material used for most Arctic artworks because of the scarcity of wood in the region. The mask consists of nine carefully shaped parts that are interrelated to produce several faces, both human and animal, echoing the transformation theme noted in other ancient American cultures. The confident, subtle composition in shallow relief is a tribute to the artist's imaginative control over the material. The mask's abstract circles and curved lines are common motifs on the decorated tools discovered at Point Hope. For centuries, the Eskimo also carved human and animal figures, always at small scale, reflecting a nomadic lifestyle that required the creation of portable objects.

Woodlands

Early Native American artists also excelled in working stone into a variety of utilitarian and ceremonial objects. Some early cultures, such as those of the woodlands east of the Mississippi River, also established great urban centers with populations sometimes exceeding 20,000.

14-27 Burial mask, Ipiutak, from Point Hope, Alaska, ca. 100 CE. Ivory, greatest width $9\frac{1}{2}$ ". American Museum of Natural History, New York.

Carved out of walrus ivory, this mask consists of nine parts that can be combined to produce several faces, both human and animal, echoing the transformation theme common in ancient American art.

ADENA The Adena culture of Ohio is documented at about 500 sites in the Central Woodlands. An Adena pipe (FIG. 14-28) in the shape of a man, carved between 500 BCE and the end of the millennium, is related in form and costume (note the prominent ear spools) to some Mesoamerican sculptures. The Adena buried their elite in great earthen mounds and often placed ceremonial pipes such as this one in the graves. Smoking was an important social and religious ritual in many Native American cultures, and pipes were treasured status symbols that men took with them into the afterlife. The standing figure on the pipe in FIG. 14-28 has naturalistic joint articulations and musculature, a lively flexed-leg pose, and an alert facial expression—all combining to suggest movement.

MISSISSIPPIAN The Adena were the first great mound builders of North America, but the Mississippian culture, which emerged around 800 CE and eventually encompassed much of the eastern United States, surpassed all earlier Woodlands peoples in the size and complexity of their communities. One Mississippian mound site, Cahokia in southern Illinois, was the largest city in North America in the early second millennium CE, with a population of at least 20,000 and an area of more than six square miles. There were approximately 120 mounds at Cahokia. The grandest, 100 feet tall and built in stages between about 900 and 1200 CE, was Monk's Mound. It is aligned with the position of the sun at the equinoxes and may have served as an astronomical observatory as well as the site of agricultural ceremonies. Each stage was topped by wooden structures that then were destroyed in preparation for the building of a new layer.

14-28 Pipe, Adena, from a mound in Ohio, ca. 500–1 BCE. Stone, 8" high. Ohio Historical Society, Columbus.

Smoking was an important ritual in ancient North America, and the Adena often buried pipes with men for use in the afterlife. This example resembles some Mesoamerican sculptures in form and costume.

1

The Mississippians also constructed *effigy mounds* (mounds built in the form of animals or birds). One of the best preserved is Serpent Mound (FIG. **14-29**), a twisting earthwork on a bluff overlooking a creek in Ohio. It measures nearly a quarter mile from its open jaw (FIG. **14-29**, *top right*), which seems to clasp an oval-shaped mound in its mouth, to its tightly coiled tail (*far left*). Both its date and meaning are controversial (see "Serpent Mound," page 389).

The Mississippian peoples, like their predecessors in North America, also manufactured small portable art objects. The shell *gorget*, or neck pendant, was a favorite item. One example (FIG. 14-30), found at a site in Tennessee, dates from about 1250 to 1300 CE and depicts a running warrior, shown in the same kind of composite profile and frontal view with bent arms and legs used to suggest motion in other ancient cultures (FIG. 5-17). The Tennessee warrior wears an elaborate headdress incorporating an arrow. He carries a mace in his left hand and a severed human head in his right. On his face is the painted forked eye of a falcon. Most Mississippian gorgets come from burial and temple mounds, and archaeologists believe they were gifts to the dead to ensure their safe arrival and prosperity in the land of the spirits. Other art objects found in similar contexts include fine mica cutouts and embossed copper cutouts of hands, bodies, snakes, birds, and other presumably symbolic forms.

Serpent Mound

erpent Mound (FIG. 14-29) is one of the largest and best known of the Woodlands effigy mounds, but it is the subject of considerable controversy. The mound was first excavated in the 1880s and represents one of the first efforts at preserving a Native American site from destruction at the hands of pot hunters and farmers. For a long time after its exploration, archaeologists attributed its construction to the Adena culture, which flourished in the Ohio area during the last several centuries BCE. Radiocarbon dates taken from the mound, however, indicate that the people known as Mississippians built it much later. Unlike most other ancient mounds, Serpent Mound contained no evidence of burials or temples. Serpents, however, were important in Mississippian iconography, appearing, for example, etched on shell gorgets similar to the one illustrated in FIG. 14-30. These Native Americans strongly associated snakes with the

earth and the fertility of crops. A stone figurine found at one Mississippian site, for example, depicts a woman digging her hoe into the back of a large serpentine creature whose tail turns into a vine of gourds.

Some researchers have proposed another possible meaning for the construction of Serpent Mound. The date suggested for it is 1070, not long after the brightest appearance in recorded history of Halley's Comet in 1066. Could Serpent Mound have been built in response to this important astronomical event? Scholars have even suggested that the serpentine form of the mound replicates the comet itself streaking across the night sky. Whatever its meaning, such a large and elaborate earthwork could have been built only by a large labor force under the firm direction of powerful elites eager to leave their mark on the landscape forever.

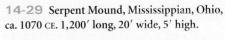

The Mississippians constructed effigy mounds in the form of animals and birds. This well-preserved example seems to depict a serpent. Some scholars, however, think it replicates the path of Halley's Comet in 1066.

Southwest

In the Southwest, Native Americans have been producing pottery since the late first millennium BCE, but the most impressive examples of decorated pottery date after 1000 CE.

MIMBRES The Mimbres culture of southwestern New Mexico, which flourished between approximately 1000 and 1250 CE, is renowned for its black-on-white painted bowls. Mimbres bowls have been found in burials under house floors, inverted over the head of the deceased and ritually "killed" by puncturing a small hole at the base, perhaps to allow the spirits of the deceased to join their ancestors in the sky (which contemporary Southwestern peoples view as a dome). The

14-30 Incised gorget with running warrior, Mississippian, from Sumner County, Tennessee, ca. 1250–1300 CE. Shell, 4" wide. National Museum of the American Indian, Smithsonian Institution, Washington, D.C.

This neck pendant was probably a gift to the dead to ensure safe passage to the afterlife. It represents a Mississippian warrior running. He holds a mace in one hand and a severed human head in the other.

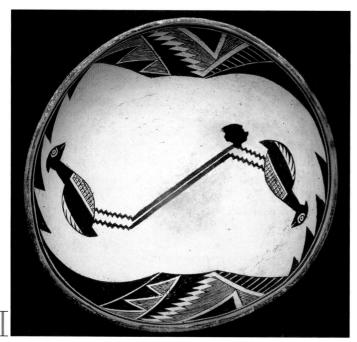

14-31 Bowl with two cranes and geometric forms, Mimbres, from New Mexico, ca. 1250 CE. Ceramic, black-on-white, $1'\frac{1''}{2}$ diameter. Art Institute of Chicago, Chicago (Hugh L. and Mary T. Adams Fund).

Native Americans have been producing pottery for more than 2,000 years, long before the introduction of the potter's wheel. Mimbres bowls feature black-and-white animals and abstract patterns.

bowl illustrated here (FIG. 14-31) dates to about 1250 and features an animated graphic rendering of two black cranes on a white ground. The contrast between the bowl's abstract border designs and the birds creates a dynamic tension. Thousands of different compositions appear on Mimbres pottery. They range from lively and complex geometric patterns to abstract pictures of humans, animals, and composite mythological beings. Almost all are imaginative creations by artists who seem to have been bent on not repeating themselves. Their designs emphasize linear rhythms balanced and controlled within a clearly defined border. Because the potter's wheel was unknown in the Americas, the artists constructed their pots out of coils of clay, creating countless

sophisticated shapes of varied size, always characterized by technical excellence. Although historians have no direct knowledge about the potters' identities, the fact that pottery making was usually women's work in the Southwest during the historical period (see "Gender Roles in Native American Art," Chapter 32, page 863) suggests that the Mimbres potters also may have been women.

ANCESTRAL PUEBLOANS The Ancestral Puebloans, formerly known as the Anasazi, northern neighbors of the Mimbres, emerged as an identifiable culture around 200 CE, but the culture did not reach its peak until about 1000. (Anasazi, Navajo for "enemy ancestors," is a name that the descendants of these early Native Americans dislike, hence the new designation.) The many ruined *pueblos* (urban settlements) scattered throughout the Southwest reveal the masterful building skills of the Ancestral Puebloans. In Chaco Canyon, New Mexico, they built a great semicircle of 800 rooms reaching to five stepped-back stories, the largest of several such sites in and around the canyon. Chaco Canyon was the center of a wide trade network extending as far as Mexico.

Sometime in the late 12th century, a drought occurred, and the Ancestral Puebloans largely abandoned their open canyon-floor dwelling sites to move farther north to the steep-sided canyons and lusher environment of Mesa Verde in southwestern Colorado. Cliff Palace (FIG. 14-32) is wedged into a sheltered ledge above a valley floor. It contains about 200 rectangular rooms (mostly communal dwellings) of carefully laid stone and timber, once plastered inside and out with adobe. The location for Cliff Palace was not accidental. The Ancestral Puebloans designed it to take advantage of the sun to heat the pueblo in winter and shade it during the hot summer months. Scattered in the foreground of FIG. 14-32 are two dozen large circular semisubterranean structures, called kivas, which once were roofed over and entered with a ladder through a hole in the flat roof. These chambers were the spiritual centers of native Southwest life, male council houses where ritual regalia were stored and private rituals and preparations for public ceremonies took place—and still do.

The Ancestral Puebloans did not disappear but gradually evolved into the various Pueblo peoples who still live in Arizona, New Mexico, Colorado, and Utah. They continue to speak their native languages, practice deeply rooted rituals, and make pottery in the traditional manner. Their art is discussed in Chapter 32.

14-32 Cliff Palace, Ancestral Puebloan, Mesa Verde National Park, Colorado, ca. 1150–1300 CE.

Cliff Palace is wedged into a sheltered ledge to heat the pueblo in winter and shade it during the hot summer months. It contains about 200 stoneand-timber rooms plastered inside and out with adobe.

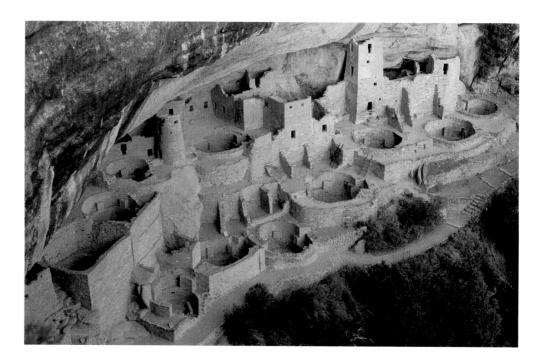

NATIVE ARTS OF THE AMERICAS BEFORE 1300

MESOAMERICA

- The Olmec (ca. 1200–400 BCE) is often called the "mother culture" of Mesoamerica. At La Venta and elsewhere, the Olmec built pyramids and ball courts and carved colossal basalt portraits of their rulers during the Preclassic period.
- In contrast to the embryonic civic centers of the Olmec, Teotihuacan in the Valley of Mexico was a huge metropolis laid out on a strict grid plan. Its major pyramids and plazas date to the late Preclassic period, ca. 50–250 CE.
- The Maya occupied parts of Mexico, Belize, Guatemala, and Honduras. During the Classic period (ca. 300–900 cE), they built vast complexes of temple-pyramids, palaces, plazas, and ball courts and decorated them with monumental sculptures and mural paintings glorifying their rulers and gods. The Maya also left extensive written records and possessed a sophisticated knowledge of astronomy and mathematical calculation.

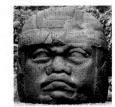

Colossal head, La Venta, Olmec,

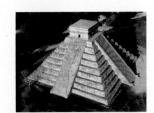

Castillo, Chichén Itzá, Maya, ca. 800–900 ce

SOUTH AMERICA

- The ancient civilizations of South America are even older than those of Mesoamerica. The earliest Andean sites began to develop around 3000 BCE.
- Between ca. 800 and 200 BCE, during the Early Horizon period, U-shaped temple complexes were erected at Chavín de Huántar in Peru, where archaeologists have also uncovered monumental statues and reliefs.
- The Paracas (ca. 400 BCE-200 CE), Nasca (ca. 200 BCE-600 CE), and Moche (ca. 1-700 CE) cultures of the Early Intermediate period in Peru produced extraordinary textiles, distinctive painted ceramics, and turquoise-inlaid goldwork. The subjects range from composite human-animals to ruler portraits.
- The Tiwanaku (ca. 100–1000 cE) and Wari (ca. 500–800 cE) cultures of northern Bolivia and southern Peru flourished during the Middle Horizon period. The Tiwanaku culture is noteworthy for its monumental stone architecture. The Wari produced magnificent tapestries.

Ear ornament, from Sipán, Moche, ca. 300 cE

Gateway of the Sun, Tiwanaku, ca. 375–700 ce

NORTH AMERICA

- The indigenous cultures of the United States and Canada date as far back as 10,000 BCE, but most of the surviving art objects date from the past 2,000 years.
- The Eskimo produced small-scale artworks in ivory beginning in the early first millennium CE, reflecting a nomadic lifestyle that required portable objects.
- The peoples of the Mississippian culture (ca. 800–1500 cE) were great mound builders. Cahokia in Illinois encompassed about 120 mounds and was the largest city in North America during the early second millennium cE.
- In the Southwest, Native Americans have been producing pottery for more than 2,000 years. The black-and-white painted bowls of the Mimbres (ca. 1000–1250 cE) are among the finest.
- The Ancestral Puebloans were master builders of pueblos. The pueblo at Chaco Canyon, New Mexico, had about 800 rooms. Cliff Palace, Colorado, is noteworthy for its sophisticated design, wedged into a sheltered ledge to take advantage of the winter sun and the summer shade.

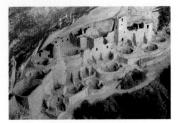

Cliff Palace, Colorado, Ancestral Puebloan, ca. 1150–1300 CE

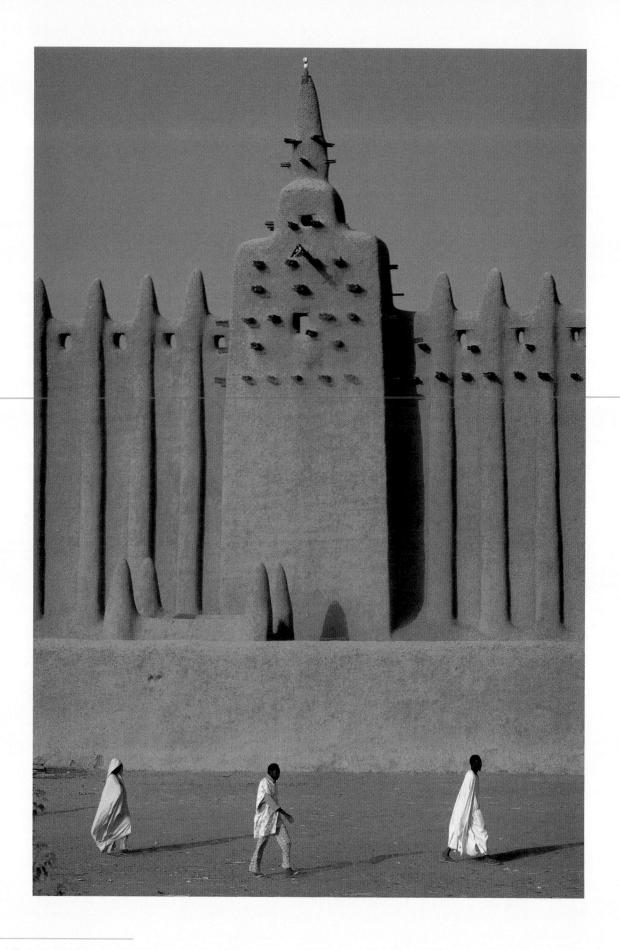

15-1 Detail of the eastern facade of the Great Mosque (FIG. 15-8), Djenne, Mali, begun 13th century, rebuilt 1906–1907.

Africa is a vast continent with a diverse population and myriad art forms. Native forms exist side by side with imported ones, such as this mosque marking the arrival of Islam in Mali.

AFRICA BEFORE 1800

A frica (MAP 15-1) is a vast continent of 52 nations comprising more than one-fifth of the world's land mass and many distinct topographical and ecological zones. Parched deserts occupy northern and southern regions, high mountains rise in the east, and three great rivers—the Niger, the Congo, and the Nile—and their lush valleys support agriculture and large settled populations. More than 2,000 distinct ethnic, cultural, and linguistic groups, often but inaccurately called "tribes," long have inhabited this enormous continent. These population groups historically have ranged in size from a few hundred, in hunting and gathering bands, to 10 to 20 million or more. Councils of elders often governed smaller groups, whereas larger populations sometimes formed a centralized state under a king.

Despite this great variety, African peoples share many core beliefs and practices. These include honoring ancestors, worshiping nature deities, and elevating rulers to sacred status. Most peoples also consult diviners or fortune tellers. These beliefs have given rise to many richly expressive art traditions, including rock engraving and painting, body decoration, masquerades and other lavish festivals, figural sculpture, and sacred and secular architecture. Given the size of the African continent and the diversity of ethnic groups, it is not surprising that African art varies enormously in subject, materials, and function. Nomadic and seminomadic peoples excelled in the arts of personal adornment and also produced rock engravings and paintings depicting animals and rituals. Farmers, in contrast, often created figural sculpture in terracotta, wood, and metal for display in shrines to legendary ancestors or nature deities held responsible for the health of crops and the well-being of the people. The regalia, art, and architecture of kings and their courts, as elsewhere in the world, celebrated the wealth and power of the rulers themselves. Nearly all African peoples lavished artistic energy on the decoration of their own bodies to express their identity and status, and many communities mounted richly layered festivals, including masquerades, to celebrate harvests and the New Year and to commemorate the deaths of leaders.

This chapter surveys the art and architecture of sub-Saharan Africa from prehistoric times through the 18th century (see "Dating African Art and Identifying African Artists," page 395), including the first contacts with Europeans, which began along the seacoasts in the late 15th century. Chapter 34 treats the art of the past two centuries, from the beginning of European colonization to the present. The art and architecture of Egypt and of Roman and Islamic North Africa were examined in Chapters 3, 10, and 13, respectively.

MAP 15-1 African peoples and sites before 1800.

PREHISTORY AND EARLY CULTURES

Thousands of rock engravings and paintings found at hundreds of sites across the continent constitute the earliest known African art. Some painted animals (FIG. 1-3) from the Apollo 11 Cave in southwestern Africa date to perhaps as long ago as 25,000 years, earlier than all but the oldest Paleolithic art of Europe (see Chapter 1). As humankind apparently originated in Africa, archaeologists may yet discover the world's earliest art there as well.

Rock Art

The greatest concentrations of rock art are in the Sahara Desert to the north, the Horn of Africa in the east, and the Kalahari Desert to the south, as well as in caves and on rock outcroppings in southern Africa. Accurately naturalistic renderings as well as stylized images on rock surfaces show animals and humans in many different positions and activities, singly or in groups, stationary or in motion. Most of these works date to within the past 4,000 to 6,000 years, but some may have

been created as early as 8000 BCE. They provide a rich record of the environment, human activities, and animal species in prehistoric times.

TASSILI N'AJJER A 7,000-year-old painting (FIG. 15-2) from Tassili n'Ajjer in southeastern Algeria in the central Sahara (at that time a verdant savanna) is one of the earliest and finest surviving examples of rock art. The painter depicted a running woman with convincing animation and significant detail. The dotted marks on her shoulders, legs, and torso probably indicate that she is wearing body paint applied for a ritual. Her face, however, is featureless, a common trait in the earliest art (see Chapter 1). The white parallel patterns attached to her arms and waist appear to represent flowing raffia decorations and a raffia skirt. Horns—shown in the twisted perspective, or composite view, typical of prehistoric art (see Chapter 1)—are also part of her ceremonial attire. Notably, the artist painted this detailed image over a field of much smaller painted human beings, an indication of why it is often so difficult to date and interpret art on rock surfaces, as subsequent superimpositions are frequent. Nonetheless, scholars have been able to establish a rough chronology for African rock art, an art form that continues to this day.

Dating African Art and Identifying African Artists

ost African objects bear neither labels nor signatures, and consequently it is nearly impossible to date them precisely or to identify their makers definitively. Early collectors did not bother to ask the names of artists or when the works were made. Although a firm chronology is currently beyond reach, broad historical trends are reasonably clear. But until archaeologists conduct more extensive fieldwork in sub-Saharan Africa, many artworks will remain difficult to date and interpret, and even whole cultures will continue to be poorly documented. Some African peoples, however, have left written documents that help date their artworks, even when their methods of measuring time differ from those used today. Other cultures, such as the Benin kingdom (FIGS. 15-12 and 15-13), have preserved complex oral records of past events. Historians can check these against the accounts of European travelers and traders who visited the kingdom.

When artists are members of craft or occupational guilds—such as blacksmiths and brass casters in the western Sudan—commissions for artwork go to the head of the guild, and the specific artist who worked on the commission may never be known. Nevertheless, art historians can identify individual hands if their work is distinctive. Documentation now exists for several hundred individual artists, even if their names are lost. For some sculptors who worked in the late 19th or early 20th centuries, scholars have been able to compile fairly detailed biographies (see "African Artists," Chapter 34, page 897).

Where documentation on authorship or dating is fragmentary or unavailable, art historians sometimes try to establish chronology from an object's style, although, as discussed in the Introduction, stylistic analysis is a subjective tool. Scientific techniques such as *radiocarbon dating* (measuring the decay rate of carbon isotopes in organic matter to provide dates for wood, fiber, and ivory) and *thermoluminescence* (dating the amounts of radiation found in fired clay objects) have proved useful but cannot provide precise dates. Nonetheless, art historians are slowly writing the history of African art, even if there are still large gaps to fill.

One of the major problems impeding compilation of an accurate history is illegal and uncontrolled excavation. By removing artworks from the ground, treasure hunters disturb or ruin their original contexts and reduce or eliminate the possibility of establishing accurate chronologies. This phenomenon is not unique to Africa, however (see "Archaeology, Art History, and the Art Market," Chapter 4, page 83). Archaeologists on all continents have to confront the problem of looting and the consequent loss of knowledge about the provenance and original function of objects that collectors wish to acquire. That is the unfortunate result of the worldwide appreciation of African art that began in the early 20th century, when many European artists looked to "primitive art" for inspiration (see "Primitivism," Chapter 35, page 920).

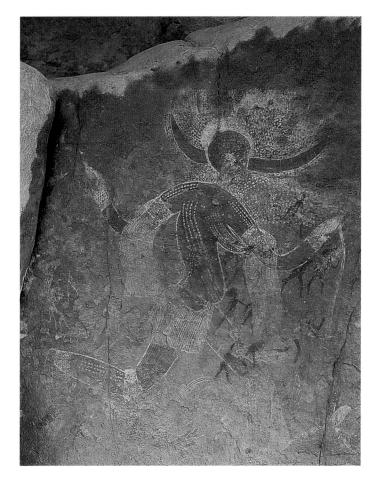

Although the precise meaning of most African rock art also remains uncertain, a considerable literature exists that describes, analyzes, and interprets the varied human and animal activities shown, as well as the evidently symbolic, more abstract patterns. The human and humanlike figures may include representations of supernatural beings as well as mortals. Some scholars have, in fact, interpreted the woman from Tassili n'Ajjer as a horned deity instead of a human wearing ceremonial headgear.

Nok and Lydenburg

Outside Egypt and neighboring Nubia (see Chapter 3), the earliest African sculptures in the round have been found at several sites in central Nigeria that archaeologists collectively call the Nok culture. Scholars disagree on whether the Nok sites were unified politically or socially. Named after the site where these sculptures were first discovered in 1928, Nok art dates between 500 BCE and 200 CE. Hundreds of Nok-style human and animal heads, body parts, and figures have been found accidentally during tin-mining operations but not in their original context.

15-2 Running horned woman, rock painting, from Tassili n'Ajjer, Algeria, ca. 6000–4000 BCE.

This early rock painting is thousands of years older than the first African sculptures. It represents a running woman with body paint, raffia skirt, and horned headgear, apparently in a ritual context.

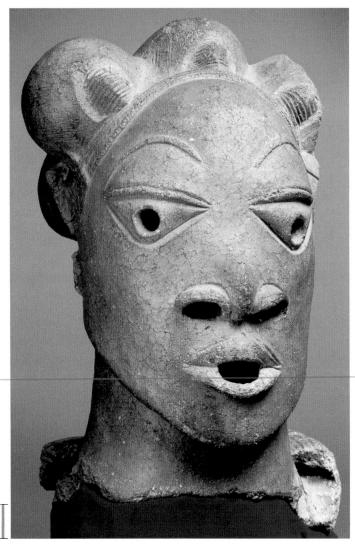

15-3 Nok head, from Rafin Kura, Nigeria, ca. 500 BCE–200 CE. Terracotta, 1' $2\frac{3}{16}$ " high. National Museum, Lagos.

The earliest African sculptures in the round come from Nigeria. The Nok culture produced expressive terracotta heads with large eyes, mouths, and ears. Piercing equalized the heat during the firing process.

RAFIN KURA HEAD A representative Nok terracotta head (FIG. 15-3), found at Rafin Kura, is a fragment of what was originally a full figure. Preserved fragments of other Nok statues indicate that sculptors fashioned standing, seated, and kneeling figures. The heads are disproportionately large compared with the bodies. The head shown here has an expressive face with large alert eyes, flaring nostrils, and parted lips. The pierced eyes, mouth, and ear holes are characteristic of Nok sculpture and probably helped to equalize the heating of the hollow clay head during the firing process. The coiffure with incised grooves, the raised eyebrows, the perforated triangular eyes, and the sharp jaw line suggest that the sculptor carved some details of the head while modeling the rest. Researchers are unclear about the function of the Nok terracottas, but the broken tube around the neck of the Rafin Kura figure may be a bead necklace, an indication that the person portrayed held an elevated position in Nok society. The gender of the Nok artists is unknown. Because the primary ceramists and clay sculptors across the continent are women, Nok sculptors may have been as well (see "Gender Roles in African Art Production," Chapter 34, page 896).

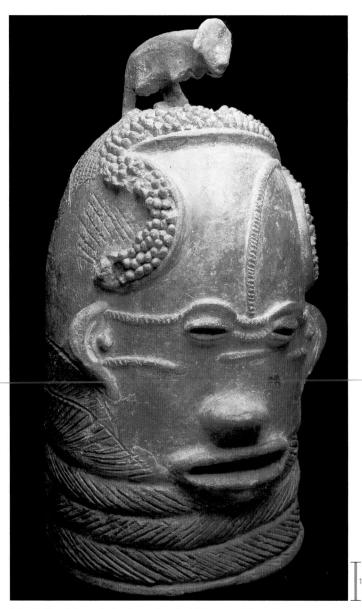

15-4 Head, from Lydenburg, South Africa, ca. 500 CE. Terracotta, 1' $2\frac{15''}{16}$ high. South African Museum, Iziko Museums of Cape Town, Cape Town.

This Lydenburg head resembles an inverted terracotta pot and may have been a helmet mask. The sculptor depicted the features by applying thin clay fillets. The scarification marks are signs of beauty in Africa.

LYDENBURG HEAD Later than the Nok examples are the seven life-size terracotta heads discovered carefully buried in a pit outside the town of Lydenburg in present-day South Africa. Radiocarbon evidence indicates the heads date to about 500 CE. One of the Lydenburg heads (FIG. **15-4**), reconstructed from fragments, has a humanlike form, although its inverted pot shape differs markedly from the more naturalistic Nok heads. The artist created the eyes, ears, nose, and mouth, as well as the hairline, by applying thin clay fillets onto the head. The same method produced what are probably *scarification* marks (scars intentionally created to form patterns on the flesh) on the forehead, temples, and between the eyes. Incised linear patterns also adorn the back of the head. The horizontal neck bands, with their incised surfaces, resemble the ringed or banded necks that are considered signs of beauty in many parts of the continent. A small, unidentifiable animal sits atop the head (compare

Art and Leadership in Africa

The relationships between leaders and art forms are strong, complex, and universal in Africa. Political, spiritual, and social leaders—kings, chiefs, titled people, and religious specialists—have the power and wealth to command the best artists and to require the most expensive and durable materials to adorn themselves, furnish their homes, and make visible the cultural and religious organizations they lead. Leaders also possess the power to dispense art or the prerogative to use it.

Several formal or structural principles characterize leaders' arts and thus set them off from the popular arts of ordinary Africans. Leaders' arts—for example, the sumptuous and layered regalia of chiefs and kings—tend to be durable and are often made of costly materials, such as ivory, beads, copper alloys, and other luxurious

metals. Some of the objects made specifically for African leaders, such as stools or chairs (FIG. 34-5), ornate clothing (FIG. 34-21), and special weaponry, draw attention to their superior status. Handheld objects—for example, staffs, spears, knives, scepters, pipes, and fly whisks (FIG. 15-5)—extend a leader's reach and magnify his or her gestures. Other objects associated with leaders, such as fans (FIG. I-15), shields, and umbrellas, protect the leaders both physically and spiritually. Sometimes the regalia and implements of an important person are so heavy that they render the leader virtually immobile (FIG. 34-21), suggesting that the temporary holder of an office is less significant than the eternal office itself.

Although leaders' arts are easy to recognize in centralized, hierarchical societies, such as the Benin (FIGS. I-15, 15-12, and 15-13) and Bamum (FIG. 34-5) kingdoms, leaders among less centralized peoples are just as conversant with the power of art to move people and effect change. For example, African leaders often establish and run masquerades and religious cults in which they may be less visible than the forms they commission and manipulate: shrines, altars, festivals, and rites of passage such as funerals, the last being espe-

15-5 Equestrian figure on fly-whisk hilt, from Igbo Ukwu, Nigeria, 9th to 10th century CE. Copperalloy bronze, figure $6\frac{3}{16}$ " high. National Museum, Lagos.

The oldest known
African lost-wax cast
bronze is this flywhisk hilt, which a
leader used to extend
his reach and magnify
his gestures. The
artist exaggerated
the size of the ruler
compared with his

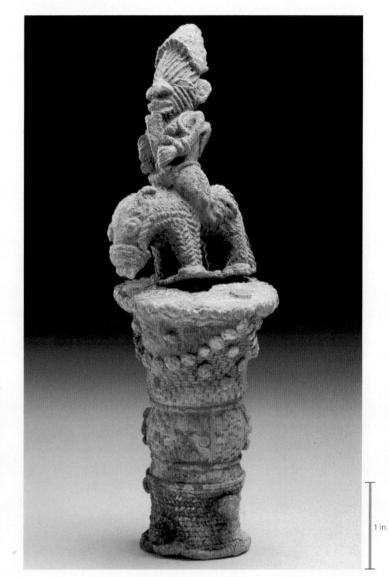

cially elaborate and festive in many parts of Africa. The arts that leaders control thus help create pageantry, mystery, and spectacle, enriching and changing the lives of the people.

FIG. 4-12). In the absence of contemporaneous written documents, scholars can only guess at the use and meaning of a head like this one, but it is noteworthy that animals appear only on those Lydenburg heads large enough to have served as helmet masks. The head, therefore, probably had a ceremonial function.

Igbo Ukwu

By the 9th or 10th century CE, a West African bronze-casting tradition of great sophistication had developed in the Lower Niger area, just east of that great river. Dozens of refined, varied objects in an extremely intricate style have been unearthed at Igbo Ukwu. The ceramic, copper, bronze, and iron artifacts include basins, bowls, altar

stands, staffs, swords, scabbards, knives, and pendants. One grave held numerous prestige objects—copper anklets, armlets, spiral ornaments, a fan handle, and more than 100,000 beads, which may have been used as a form of currency. The tomb also contained three elephant tusks, a crown, and a bronze leopard's skull. These items, doubtless the regalia of a leader (see "Art and Leadership in Africa," above), whether secular or religious, are the earliest cast-metal objects known from regions south of the Sahara.

EQUESTRIAN FLY WHISK A lost-wax cast bronze (FIG. 15-5), the earliest yet found in Africa, came from the same grave at Igbo Ukwu. It depicts an equestrian figure on a fly-whisk handle. The African artist made the handle using a casting method similar to

Idealized Naturalism at Ile-Ife

ust after the turn of the 19th century, the German anthropologist Leo Frobenius "discovered" the sculpture of Ile-Ife in the Lower Niger River region. Because of the refinement and naturalism of Ile-Ife statuary, he could not believe that these works were locally made. Rather, he ascribed authorship to ancient Greece, where similarly lifelike art was well known. Other scholars traced these works to ancient Egypt, along with patterns of sacred kingship that they also believed originated several thousand miles away in the Nile Valley. But excavations in and around Ile-Ife, especially near the king's palace, have established that local sculptors were indeed the

15-6 King, from Ita Yemoo (Ife), Nigeria, 11th to 12th century. Zinc-brass, 1' $6\frac{L''}{2}$ high. Museum of Ife Antiquities, Ife. Unlike most African

Unlike most African sculptures, this royal figure has a naturalistically modeled torso and facial features that approach portraiture. The head, however, the locus of wisdom, is disproportionately large.

artists who made the extraordinary sculptures in stone, terracotta, and copper alloys found at Ile-Ife. Radiocarbon dating places these works as early as the 11th or 12th century. A number of these sculptures served the kings in ceremonies of installation, in funerals, and probably in annual festivals that reaffirmed the sacred power of the ruler and the allegiance of his people.

As is the case with the figure of the king illustrated here (FIG. 15-6), If esculptors modeled most heads and figures with focused attention on naturalistic detail, apart from blemishes or signs of age, which they intentionally omitted. Thus Ife style is lifelike but at the same time idealized. The artists portrayed most people as young adults in the prime of life and without any disfiguring warts or wrinkles. Some life-size heads, although still idealized, take naturalism to the point that they give the impression of being individual portraits. This is especially true of a group of 19 heads cast in copper alloys that scholars are quite certain record the features of specific persons, although nearly all their names are lost. Among the most convincing portraits, however, is a mask of almost pure copper that has long carried the name of a famous early king, Obalufon. Now in the Ife museum, the mask resided for centuries in the oni's palace. Several very naturalistic heads have small holes above the forehead and around the lips and jaw, where black beads were found. These suggest that some heads were fitted with beaded veils, such as those known among Yoruba kings today, and perhaps human hair as well. Elaborate beadwork, a Yoruba royal prerogative, is also present on the Ife king's image in FIG. 15-6.

The hundreds of terracotta and copper-alloy heads, body parts and fragments, animals, and ritual vessels from Ile-Ife attest to a remarkable period in African art history, a period during which sensitive, meticulously rendered, idealized naturalism prevailed. To this day, works in this style stand in contrast to the vast majority of African objects, which show the human figure in many different,

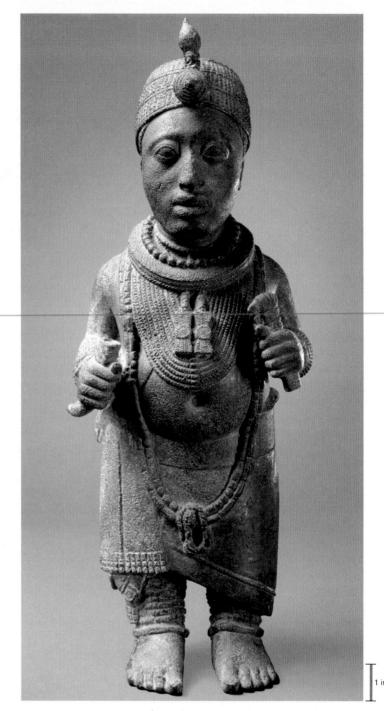

quite strongly conventionalized styles. Diversity of style in the art of a continent as vast and ancient as Africa, however, should surprise no one.

that documented much earlier in the Mediterranean and Near East (see "Hollow-Casting," Chapter 5, page 122). The sculpture's upper section consists of a figure seated on a horselike animal, perhaps a donkey, and the lower is an elaborately embellished handle with

beaded and threadlike patterns. The rider's head is of exaggerated size, a common trait in the art of many early cultures. The prominent facial stripes probably represent marks of titled status, as can still be found among Igbo-speaking peoples today.

11TH TO 18TH CENTURIES*

Although kings ruled some African population groups from an early date, the best evidence for royal arts in Africa comes from the several centuries between about 1000 and the beginning of European colonization in the 19th century. This period also brought the construction of major houses of worship for the religions of Christianity and Islam, both of which originated in the Middle East but quickly gained adherents in Africa.

Ile-Ife

Africans have long considered Ile-Ife, about 200 miles west of Igbo Ukwu in southwestern Nigeria, the cradle of Yoruba civilization, the place where the gods Oduduwa and Obatala created earth and its peoples. Tradition also names Oduduwa the first *oni* (ruler) of Ile-Ife and the ancestor of all Yoruba kings.

IFE KING Ife artists often portrayed their sacred kings in sculpture. One of the most impressive examples is a statuette (FIG. 15-6), cast in a zinc-brass alloy, datable to the 11th or 12th century. This and many similar representations of Ife rulers are exceptional in Africa because of their naturalism in recording facial features and fleshy anatomy (see "Idealized Naturalism at Ile-Ife," page 398). The naturalism does not extend to body proportions, however. The head of the statue, for example, is disproportionately large. For modern Yoruba, the head is the locus of wisdom, destiny, and the essence of being, and these ideas probably developed at least 800 years ago, accounting for the emphasis on the head in Ife statuary. Indicating that the man portrayed was a sacred ruler was also a priority, and the sculptor of the statue illustrated here accurately recorded the precise details of the heavily beaded costume, crown, and jewelry.

Djenne and Lalibela

The inland floodplain of the Niger River was for the African continent a kind of "fertile crescent," analogous to that of ancient Mesopotamia (see Chapter 2). By about 800, a walled town, Djenne in present-day Mali, had been built on high ground left dry during the flooding season. Archaeologists have uncovered evidence of many specialist workshops of blacksmiths, sculptors, potters, and other artisans.

DJENNE TERRACOTTAS Hundreds of accomplished, confidently modeled terracotta sculptures, most dating to between 1100 and 1500, have been found at numerous sites in the Djenne region. Production tapered off sharply with the arrival of Islam. Unfortunately, as is true of the Nok terracottas, the vast majority of these sculptures came from illegal excavations, and contextual information about them has been destroyed. The subject matter includes equestrians, male and female couples, people with what some scholars interpret as lesions and swellings, and snake-entwined figures. There are seated, reclining, kneeling, and standing human figures. Some wear elaborate jewelry, but many are without adornment. The range of subjects and postures is extraordinary at this date.

The terracotta figure illustrated here (FIG. 15-7) dates to the 13th to 15th centuries and represents a Djenne warrior with a quiver of arrows on his back and knives strapped to his left arm. The proportions of the figure present a striking contrast to those from Ile-Ife (FIG. 15-6). The Djenne archer is thin and tall with tubular limbs and an elongated head with a prominent chin, bulging eyes, and large nose—characteristic features of Djenne style.

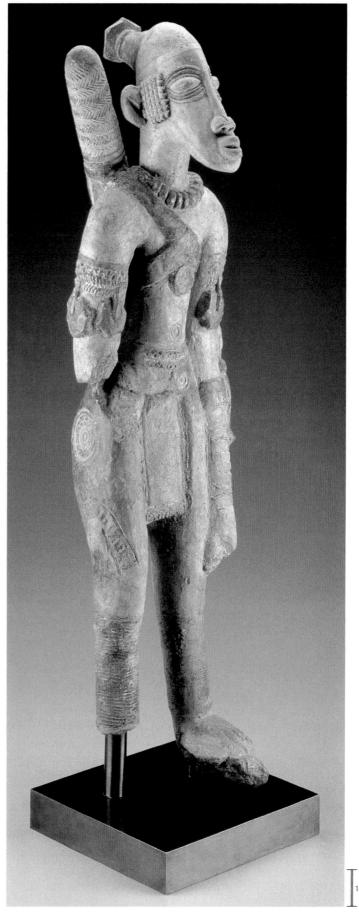

15-7 Archer, from Djenne, Mali, 13th to 15th century. Terracotta, $2'\frac{3}{8}''$ high. National Museum of African Art, Washington, D.C.

Djenne terracottas present a striking contrast to the statues from Ile-Ife (FIG. 15-6). This archer is thin with tubular limbs and an elongated head featuring a prominent chin, bulging eyes, and large nose.

^{*}From this point on, all dates in this chapter are CE unless otherwise stated.

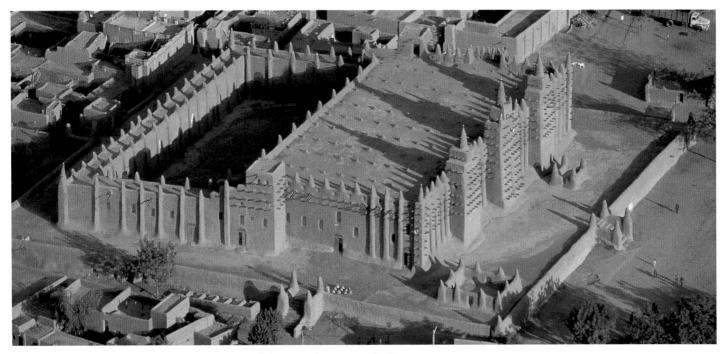

15-8 Aerial view of the Great Mosque, Djenne, Mali, begun 13th century, rebuilt 1906–1907.

The Great Mosque at Djenne resembles Middle Eastern mosques in plan (large courtyard next to a roofed prayer hall), but the construction materials—adobe and wood—are distinctly African.

GREAT MOSQUE, DJENNE Djenne is also the site of one of the most ambitious examples of adobe architecture in the world, the city's Great Mosque (FIG. 15-8), first built in the 13th century and reconstructed in 1906–1907 after a fire destroyed the earlier building in 1830. The mosque has a large courtyard and a roofed prayer hall, emulating the plan of many of the oldest mosques known (see "The Mosque," Chapter 13, page 345). The facade (FIG. 15-1), however, is unlike any in the Middle East and features soaring adobe towers and vertical buttresses resembling engaged columns that produce a majestic rhythm. The many rows of protruding wooden beams further enliven the walls but also serve a practical function as perches for workers undertaking the essential recoating of sacred clay on the exterior that occurs during an annual festival.

BETA GIORGHIS, LALIBELA Many of the early African cultures maintained trade networks that sometimes extended well beyond the continent. The exchange of goods also brought an exchange of artistic ideas and forms. One of the most striking examples is found at Lalibela in the rugged highlands of present-day Ethiopia, where land travel is difficult. Christianity arrived in Ethiopia in the early fourth century, when the region was part of the indigenous Aksum Empire. In the early 13th century, Lalibela, a ruler of the Zagwe dynasty, commissioned 11 churches to be cut from the bedrock at his capital, which still bears his name.

Not the largest but in many ways the most interesting of these rock-cut churches is Beta Giorghis (FIG. 15-9), the Church of Saint George, which was cut out of the tufa in the form of a Greek cross, revealing that the architect was familiar with contemporary Byzantine architecture (see Chapter 12). The roof of the structure has a Greek cross sculpted in relief, underscoring the sacred shape of the church. Inside are a carved dome and frescoes. Rock-cut buildings are rare worldwide, but they are documented in Egypt, India, and Jordan (see Chapters 3, 6, and 10). Some of the most complex designs are at Lalibela. Carving from the bedrock a complex building such as Beta Giorghis, with all its details, required careful planning

and highly skilled labor. The bedrock tufa is soft and easily worked, but the designer had to visualize all aspects of the complete structure before the work began because there was no possibility of revision or correction.

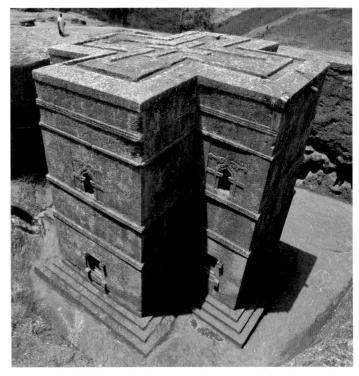

15-9 Beta Giorghis (Church of Saint George), Lalibela, Ethiopia, 13th century.

During the 13th century, the Christian kingdom of Lalibela cut many churches out of the Ethiopian bedrock. This one emulates Byzantine models and has a Greek-cross plan and interior frescoes.

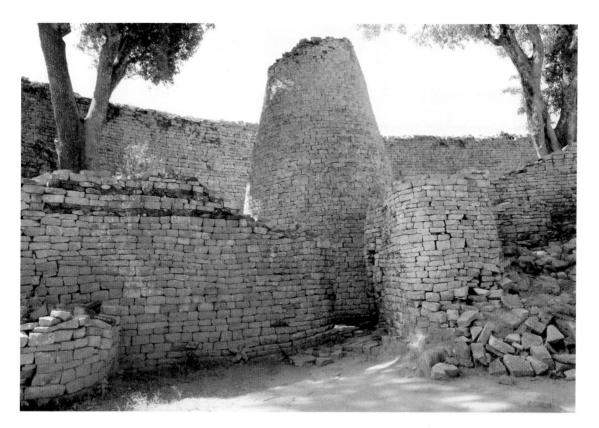

15-10 Walls and tower, Great Enclosure, Great Zimbabwe, Zimbabwe, 14th century.

The Great Zimbabwe empire in southern Africa had a trade network that extended to the Near East and China. The royal residence was surrounded by 30-foot-high stone walls and conical towers.

Great Zimbabwe

Many of the earliest artworks found in Africa come from the southern part of the continent (for example, Fig. 1-3). The most famous southern African site is a complex of stone ruins at the large southeastern political center called Great Zimbabwe. First occupied in the 11th century, the site features walled enclosures and towers that date from about the late 13th century to the middle of the 15th century. At that time, the Great Zimbabwe empire had a wide trade network. Finds of beads and pottery from the Near East and China, along with copper and gold objects, underscore that Great Zimbabwe was a prosperous trade center well before Europeans began their coastal voyaging in the late 15th century.

GREAT ENCLOSURE Most scholars agree that Great Zimbabwe was a royal residence with special areas for the ruler (the royal hill complex), his wives, and nobles, including an open court for ceremonial gatherings. At the zenith of the empire's power, as many as 18,000 people may have lived in the surrounding area, with most of the commoners living outside the enclosed structures reserved for royalty. Although the actual habitations do not survive, the remaining enclosures are unusual for their size and the excellence of their stonework. Some perimeter walls reach heights of 30 feet. One of these, known as the Great Enclosure (FIG. 15-10), houses one large and several small conical towerlike stone structures, which have been interpreted symbolically as masculine (large) and feminine (small) forms, but their precise significance is unknown. The form of the large tower suggests a granary. Grain bins were symbols of royal power and generosity, as the ruler received tribute in grain and dispensed it to the people in times of need.

SOAPSTONE MONOLITHS Explorations at Great Zimbabwe have yielded eight soapstone *monoliths* (sculptures carved from a single block of stone). Seven came from the royal hill complex and probably were set up as part of shrines to ancestors. The eighth monolith (FIG. 15-11), found in an area now considered the ancestral

15-11 Monolith with bird and crocodile, from Great Zimbabwe, Zimbabwe, 15th century. Soapstone, bird image $1' 2\frac{1}{2}''$ high. Great Zimbabwe Site Museum, Great Zimbabwe.

This soapstone monolith stood in the ancestral shrine of a Great Zimbabwe ruler's wife. The bird and crocodile may symbolize previous rulers who act as messengers between the living and dead.

1 in.

shrine of the ruler's first wife, stands several feet tall. Some have interpreted the bird at the top as symbolizing the first wife's ancestors. (Ancestral spirits among the present-day Shona-speaking peoples of the area take the form of birds, especially eagles, believed to communicate between the sky and the earth.) The crocodile on the front of the monolith may represent the wife's elder male ancestors. The circles beneath the bird are called the "eyes of the crocodile" in Shona and may symbolically represent elder female ancestors. The double- and single-chevron motifs may represent young male and young female ancestors, respectively. The bird perhaps signifies some form of bird of prey, such as an eagle, although this and other bird sculptures from the site have feet with five humanlike toes rather than an eagle's three-toed talons. In fact, experts cannot identify the species of the birds. Some researchers have speculated that the bird and crocodile symbolize previous rulers who would have acted as messengers between the living and the dead, as well as between the sky and the earth.

Benin

The Benin kingdom (not to be confused with the modern Republic of Benin; see MAP 15-1) was established before 1400, most likely in the 13th century, just west of the lower reaches of the Niger River in what is today Nigeria. According to oral tradition, the first king of the new dynasty was the grandson of a Yoruba king of Ile-Ife. Benin reached its greatest power and geographical extent in the 16th century. The kingdom's vicissitudes and slow decline thereafter culminated in 1897, when the British burned and sacked the Benin palace and city. Benin City thrives today, however, and the palace, where the Benin king continues to live, has been partially rebuilt. Benin artists have produced many complex, finely cast copper-alloy sculptures, as well as artworks in ivory, wood, ceramic, and wrought iron. The hereditary *oba*, or sacred king, and his court still use and dispense art objects as royal favors to title holders and other chiefs (see "Art and Leadership," page 397).

QUEEN MOTHER IVORY One of the masterworks of Benin ivory carving is a woman's head (FIG. 15-12) in the Metropolitan Museum of Art, which a Benin king almost certainly wore at his waist. A nearly identical pendant, fashioned from the same piece of ivory, is in the British Museum. Oba Esigie (r. ca. 1504–1550), under whom, with the help of the Portuguese, the Benin kingdom flourished and expanded, probably commissioned the pair. Esigie's mother, Idia, helped him in warfare, and in return he created for her the title of Queen Mother, Iy'oba, and built her a separate palace and court. The pendant, remarkable for its sensitive naturalism, most likely represents Idia. On its crown are alternating Portuguese heads and mudfish, symbolic allusions, respectively, to Benin's trade and diplomatic relationships with the Portuguese and to Olokun, god of the sea, wealth, and creativity. Another series of Portuguese heads also adorns the lower part of the carving. In the late 15th and 16th centuries, Benin people probably associated the Portuguese, with their large ships from across the sea, their powerful weapons, and their wealth in metals, cloth, and other goods, with Olokun, the deity they deemed responsible for abundance and prosperity.

ALTAR TO THE HAND AND ARM The centrality of the sacred oba in Benin culture is well demonstrated by his depiction twice on a cast-brass royal shrine called an *ikegobo* (FIG. **15-13**). It features symmetrical hierarchical compositions centered on the dominant king, probably Oba Eresonyen (r. 1735–1750). At the

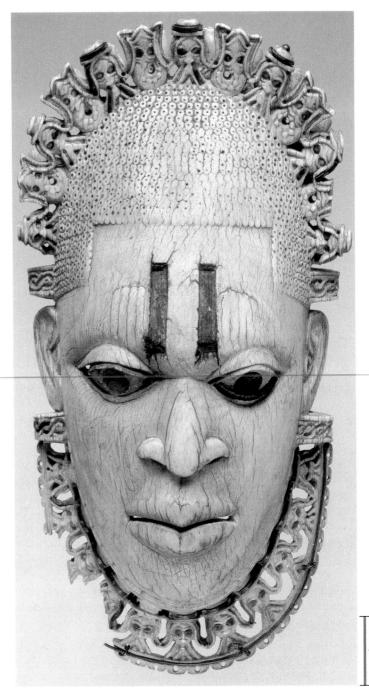

15-12 Waist pendant of a Queen Mother, from Benin, Nigeria, ca. 1520. Ivory and iron, $9\frac{3}{8}''$ high. Metropolitan Museum of Art, New York (Michael C. Rockefeller Memorial Collection, gift of Nelson A. Rockefeller, 1972).

This ivory head probably portrays Idia, mother of Oba Esigie, who wore it on his waist. Above Idia's head are Portuguese heads and mudfish, symbols, respectively, of trade and of Olokun, god of the sea.

top, flanking and supporting the king, are smaller, lesser members of the court, usually identified as priests, and in front, a pair of leopards, animals the sacred king sacrificed and symbolic of his power over all creatures. Similar compositions are common in Benin arts, as exemplified by the royal plaque (FIG. I-15) discussed in the Introduction. Notably, too, the artist distorted the king's proportions to emphasize his head, the seat of his will and power. Benin men celebrate a festival of the head called Igue. One of the king's praise

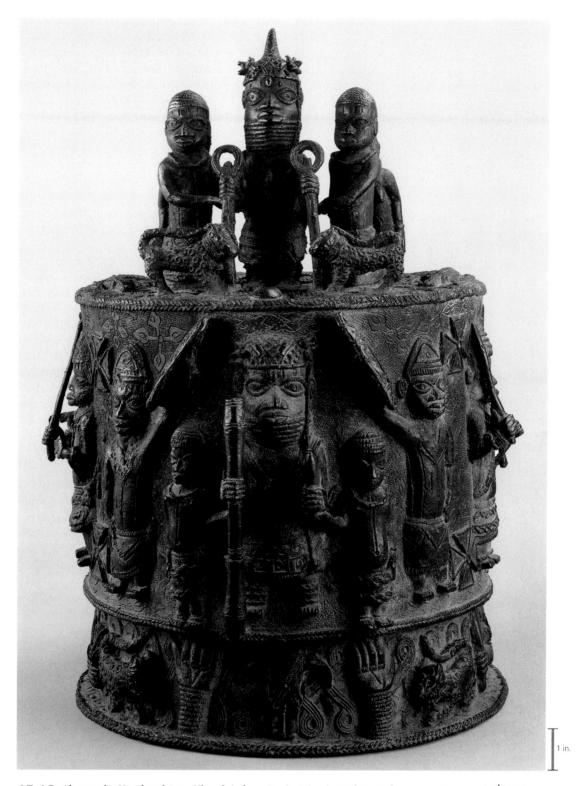

15-13 Altar to the Hand and Arm (*ikegobo*), from Benin, Nigeria, 17th to 18th century. Bronze, 1' $5\frac{1}{2}$ " high. British Museum, London.

One of the Benin king's praise names is "great head," and on this cast-bronze royal shrine, he is represented larger than all other figures and his proportions are distorted to emphasize his head.

names is "great head." At such personal altars, the king and other high-ranking officials made sacrifices to their own power and accomplishments—symbolized by the hand and arm. The inclusion of leopards on the top and around the base, along with ram and elephant heads and crocodiles (not all visible in FIG. 15-13), reiterates royal power.

Sapi

Between 1490 and 1540, some peoples on the Atlantic coast of Africa in present-day Sierra Leone, whom the Portuguese collectively called the Sapi, created art not only for themselves but also for Portuguese explorers and traders, who took the objects back to Europe.

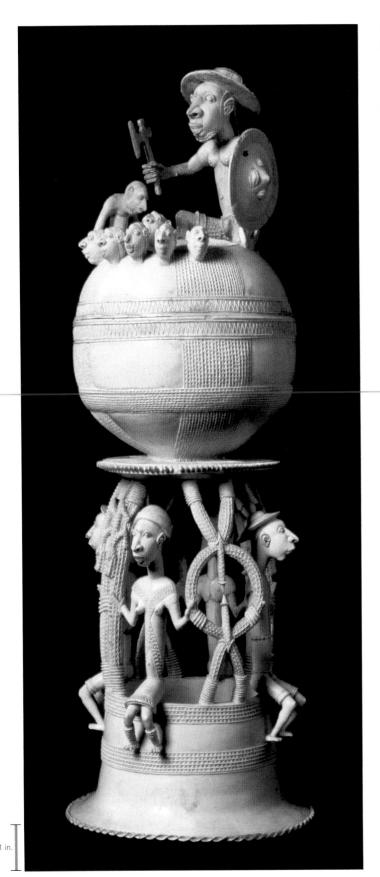

SAPI SALTCELLARS The Portuguese commissions included delicate spoons, forks, and elaborate containers usually referred to as saltcellars, as well as boxes, hunting horns, and knife handles. Salt was a valuable commodity, used not only as a flavoring but also to keep food from spoiling. Costly saltcellars were prestige items that graced the tables of the European elite (for example, FIG. 22-51). The Sapi export items were all meticulously carved from elephant tusk ivory with refined detail and careful finish. Ivory was plentiful in those early days and was one of the coveted exports in early West and Central African trade with Europe. The Sapi export ivories, the earliest examples of African tourist art, are a fascinating hybrid art form.

Art historians have attributed the saltcellar shown here (FIG. **15-14**), almost 17 inches high, to the MASTER OF THE SYMBOLIC EXECUTION, one of the three major Sapi ivory carvers during the period. This saltcellar, which depicts an execution scene, is one of his best pieces and the source of his modern name. A kneeling figure with a shield in one hand holds an ax (restored) in the other hand over another seated figure about to lose his head. On the ground before the executioner, six severed heads (FIG. **15-14**) grimly testify to the executioner's power. A double zigzag line separates the lid of the globular container from the rest of the vessel. This vessel rests in turn on a circular platform held up by slender rods adorned with crocodile images. Two male and two female figures sit between these rods, grasping them. The men wear European-style pants and have long, straight hair. The women wear skirts, and the elaborate raised patterns on their upper chests surely represent decorative scars.

The European components of this saltcellar are the overall design of a spherical container on a pedestal and some of the geometric patterning on the base and the sphere, as well as certain elements of dress, such as the shirts and hats. Distinctly African are the style of the human heads and figures and their proportions, the latter skewed here to emphasize the head, as so often seen in African art. Identical large noses with flaring nostrils, as well as the conventions for rendering eyes and lips, characterize Sapi stone figures from the same region and period. Scholars cannot be sure whether the African carver or the European patron specified the subject matter and the configurations of various parts, but the Sapi works testify to a fruitful artistic interaction between Africans and Europeans during the early 16th century.

The impact of European art became much more pronounced in the late 19th and especially the 20th centuries. These developments and the continuing vitality of the native arts in Africa are examined in Chapter 34.

15-14 Master of the Symbolic Execution, saltcellar, Sapi-Portuguese, from Sierra Leone, ca. 1490–1540. Ivory, 1' $4\frac{7}{8}$ " high. Museo Nazionale Preistorico e Etnografico Luigi Pigorini, Rome.

The Sapi saltcellars made for export combine African and Portuguese traits. This one represents an execution scene with an African-featured man, who wears European pants, seated among severed heads.

AFRICA BEFORE 1800

PREHISTORY AND EARLY CULTURES, ca. 25,000 BCE-1000 CE

- Humankind apparently originated in Africa, and some of the oldest known artworks come from the Apollo 11 Cave (FIG. 1-3) in southwestern Africa. Most African rock art, however, is no earlier than about 6000 BCE.
- The Nok culture of central Nigeria produced the oldest African examples of sculpture in the round between 500 BCE and 200 CE. The pierced eyes, noses, and mouths helped equalize the heat during the firing process.
- Bronze-casting using the lost-wax method is first documented in Africa in the 9th or 10th century ce at Igbo Ukwu (Nigeria).

Running woman, Tassili n'Ajjer, ca. 6000-4000 BCE

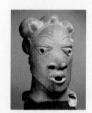

Nok terracotta head, ca. 500 BCE-200 CE

11TH TO 15TH CENTURIES

- The sculptors of Ile-Ife (Nigeria) fashioned images of their kings in an unusually naturalistic style during the 11th and 12th centuries, but the heads of the figures are disproportionately large, as in most African artworks.
- The terracotta sculptures of Djenne (Mali), datable ca. 1100–1500, encompass an extraordinary variety of subjects and display a distinctive style with tubular limbs and elongated heads.
- This period brought the construction of major shrines for Islamic and Christian worship that emulate foreign models but employ African building methods. Examples include the adobe Great Mosque at Djenne and the rock-cut church of Beta Giorghis at Lalibela (Ethiopia).
- In southern Africa, the Great Zimbabwe empire conducted prosperous trade with the Near East and China well before the first contact with Europeans. Impressive stone walls and towers enclosed the royal palace complex.

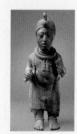

Ife king, 11th to 12th century

Great Mosque, Djenne, 13th century

16TH TO 18TH CENTURIES

- The Benin kingdom in the Lower Niger region was probably founded in the 13th century but reached its zenith in the 16th century. Benin sculptors excelled in ivory carving and bronze-casting, producing artworks that glorified the royal family.
- An early example of the interaction between African artists and European patrons is the series of Sapi ivory saltcellars from Sierra Leone datable between 1490 and 1540.

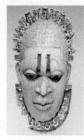

Benin ivory waist pendant, ca. 1520

¹⁶⁻¹ Cross-inscribed carpet page, folio 26 verso of the *Lindisfarne Gospels*, from Northumbria, England, ca. 698–721. Tempera on vellum, $1'1\frac{1}{2}''\times 9\frac{1}{4}''$. British Library, London.

Missionaries brought Christianity to the British Isles. The greatest examples of Hiberno-Saxon art are the Gospel books in which illuminators married Christian imagery with the native animal-interlace style.

EARLY MEDIEVAL EUROPE

The half millennium between 500 and 1000 was the great formative period of western medieval art,* a time of great innovation that produced some of the most extraordinary artworks in world history. Early medieval art in western Europe (MAP 16-1) was the result of a unique fusion of the Greco-Roman heritage of the former northwestern provinces of the Roman Empire, the cultures of the non-Roman peoples north of the Alps, and Christianity. Although the Romans called everyone who lived beyond the classical world's frontiers "barbarians," many northerners had risen to prominent positions within the Roman army and government during the later Roman Empire. Others established their own areas of rule, sometimes with Rome's approval, sometimes in opposition to imperial authority. Over the centuries the various population groups merged, and a new order gradually replaced what had been the Roman Empire, resulting eventually in the foundation of today's European nations.

ART OF THE WARRIOR LORDS

As Rome's power waned in Late Antiquity, armed conflicts and competition for political authority became commonplace among the Huns, Vandals, Merovingians, Franks, Goths, and other non-Roman peoples of Europe. As soon as one group established itself in Italy or in one of Rome's European provinces, another often pressed in behind and compelled it to move on. The Visigoths, for example, who at one time controlled part of Italy and formed a kingdom in what is today southern France, were forced southward into Spain under pressure from the Franks, who had crossed the lower Rhine River and established themselves firmly in France, Switzerland, the Netherlands, and parts of Germany. The Ostrogoths moved from Pannonia (at the junction of modern Hungary, Austria, and the former Yugoslavia) to Italy. Under Theodoric, they established their kingdom there, only to have it fall less than a century later to the Lombards, the last of the early Germanic powers to occupy land within the limits of the old Roman Empire

^{*}The adjective medieval and the noun Middle Ages are very old terms stemming from an outmoded view of the roughly 1,000 years between the adoption of Christianity as the Roman Empire's official religion and the rebirth (Renaissance) of interest in classical antiquity. Earlier historians, following the lead of the humanist scholars of Renaissance Italy, viewed this period as a long and artistically crude interval between (in the middle of) two great civilizations. The force of tradition dictates the retention of both terms to describe this period and its art, although scholars long ago ceased to see medieval art as unsophisticated or inferior.

(see Chapter 12). Anglo-Saxons controlled what had been Roman Britain. Celts inhabited France and parts of the British Isles, including Ireland. In Scandinavia, the seafaring Vikings held sway.

Art historians do not know the full range of art and architecture these non-Roman peoples produced. What has survived is not truly representative and consists almost exclusively of small portable "status symbols"—weapons and lavish items of personal adornment such as bracelets, pendants, and belt buckles that archaeologists have discovered buried with the dead. Earlier scholars, who viewed medieval art through a Renaissance lens, ignored these "minor arts" because of their small scale, seeming utilitarian nature, and abstract ornament, and because the people who made them rejected the classical notion that the representation of organic nature should be the focus of artistic endeavor. In their own time, people regarded these objects, which often display a high degree of technical and stylistic sophistication, as treasures. They enhanced the prestige of their owners and testified to the stature of those buried with them. In the great early (possibly seventh-century) Anglo-Saxon epic *Beowulf*, his comrades cremate the hero and place his ashes in a huge tumulus (burial mound) overlooking the sea. As an everlasting tribute to Beowulf's greatness, they "buried rings and brooches in the barrow, all those adornments that brave men had brought out from the hoard after Beowulf died. They bequeathed the gleaming gold, treasure of men, to the earth."1

MEROVINGIAN FIBULAE Most characteristic, perhaps, of the prestige adornments was the *fibula*, a decorative pin the Romans wore (and the Etruscans before them; FIG. 9-2). Men and women alike used fibulae to fasten their garments. Made of bronze, silver, or gold, the pins often feature profuse decoration, sometimes incorporating inlaid precious or semiprecious stones. The pair of fibulae illustrated here (FIG. 16-2) is part of a larger find of jewelry of the mid-sixth century, when Merovingian kings (r. 482–751) ruled large parts of what is France today. The pins once must have been the proud possession of a wealthy Merovingian woman and seem to have been buried with her. They resemble, in general form, the roughly contemporaneous but plain fibulae used to fasten the outer garments of some of the attendants flanking the Byzantine emperor Justinian in the apse mosaic (FIG. 12-10) of San Vitale in Ravenna. (Note how much more elaborate is the emperor's clasp. In Rome, Byzantium, and early medieval Europe alike, these fibulae were emblems of office and of prestige.)

Covering almost the entire surface of each of the Merovingian fibulae are decorative patterns adjusted carefully to the basic shape of the object. They thus describe and amplify the fibula's form and structure, becoming an organic part of the pin itself. Often the early medieval metalworkers so successfully integrated zoomorphic elements into this type of highly disciplined, abstract decorative design that the animal forms became almost unrecognizable. For example, the fibulae in FIG. 16-2 incorporate a fish just above the center of each pin. The looped forms around the edges are stylized eagles' heads with red garnets forming the eyes.

SUTTON HOO SHIP BURIAL The *Beowulf* saga also recounts the funeral of the warrior lord Scyld, who was laid to rest in a

MAP 16-1 The Carolingian Empire at the death of Charlemagne in 814.

16-2 Pair of Merovingian looped fibulae, from Jouy-le-Comte, France, mid-sixth century. Silver gilt worked in filigree, with inlays of garnets and other stones, 4" high. Musée d'Archéologie nationale, Saint-Germain-en-Laye.

Jeweled fibulae were status symbols among the warlords of the early Middle Ages. This pair belonged to a Merovingian woman and features eagle heads and fish integrated into a highly decorative design.

16-3 Purse cover, from the Sutton Hoo ship burial in Suffolk, England, ca. 625. Gold, glass, and cloisonné garnets, $7\frac{1}{2}''$ long. British Museum, London.

This purse cover is one of many treasures found in a ship beneath a royal burial mound. The combination of abstract interlace ornament with animal figures is the hallmark of early medieval art in western Europe.

ship set adrift in the North Sea overflowing with arms and armor and costly adornments:

They laid their dear lord, the giver of rings, deep within the ship by the mast in majesty; many treasures and adornments from far and wide were gathered there. I have never heard of a ship equipped more handsomely with weapons and war-gear, swords and corselets; on his breast lay countless treasures that were to travel far with him into the waves' domain.²

In 1939, archaeologists uncovered a treasure-laden ship in a burial mound at Sutton Hoo, near the sea, in Suffolk, England. Although the Sutton Hoo ship was not sent out to sea, it epitomizes the early medieval tradition of burying great lords in ships with rich furnishings, as recorded in *Beowulf*. Among the many precious finds were a gold belt buckle, 10 silver bowls, a silver plate with the imperial stamp of the Byzantine emperor Anastasius I (r. 491–518), and 40 gold coins (perhaps to pay the 40 oarsmen who would row the deceased across the sea on his final voyage). Also placed in the ship were two silver spoons inscribed "Saulos" and "Paulos," Saint Paul's names in Greek before and after his baptism. They may allude to a conversion to Christianity. Some historians have associated the site with the East Anglian king Raedwald (r. 599?–625), who was baptized a Christian before his death in 625, but the identity of the king buried at Sutton Hoo is uncertain.

Most extraordinary of all the Sutton Hoo finds is a purse cover (FIG. 16-3) decorated with *cloisonné* plaques. The cloisonné technique, a favorite of the early medieval "treasure givers," is documented at least as early as the New Kingdom in Egypt. Metalworkers produced cloisonné jewelry by soldering small metal strips, or *cloisons* (French for "partitions"), edge up, to a metal background, and then filling the

compartments with semiprecious stones, pieces of colored glass, or glass paste fired to resemble sparkling jewels. The edges of the cloisons are an important part of the design. Cloisonné is a cross between mosaic (see "Mosaics," Chapter 11, page 303) and stained glass (see "Stained-Glass Windows," Chapter 18, page 472), but medieval artists used it only on a miniature scale.

On the Sutton Hoo purse cover, four symmetrically arranged groups of figures make up the lower row. The end groups consist of a man standing between two beasts. He faces front, and they appear in profile. This heraldic type of grouping has a venerable heritage in the ancient world (FIG. 2-10, *right*), but must have delivered a powerful contemporary message. It is a pictorial parallel to the epic sagas of the era in which heroes like Beowulf battle and conquer horrific monsters. The two center groups represent eagles attacking ducks. The animal figures are cunningly composed. For example, the convex beaks of the eagles (compare the Merovingian fibulae, FIG. 16-2) fit against the concave beaks of the ducks. The two figures fit together so snugly that they seem at first to be a single dense abstract design. This is true also of the man-animals motif.

Above these figures are three geometric designs. The outer ones are purely linear, although they also rely on color contrasts for their effect. In the central design, an interlace pattern, the interlacements evolve into writhing animal figures. Elaborate intertwining linear patterns are characteristic of many times and places, notably in the art of the Islamic world (see Chapter 13). But the combination of interlace with animal figures was uncommon outside the realm of the early medieval warlords. In fact, metalcraft with interlace patterns and other motifs beautifully integrated with the animal form was, without doubt, the premier art of the early Middle Ages in western Europe. Interest in it was so great that artists imitated the colorful

effects of jewelry designs in the painted decorations of manuscripts, in the masonry of churches, and in sculpture in stone and in wood, the last an especially important medium of Viking art.

VIKINGS In 793 the pre-Christian traders and pirates of Scandinavia known as Vikings (named after the *viks*—coves or "trading places"—of the Norwegian shoreline) landed in the British Isles. They destroyed the Christian monastic community on Lindisfarne Island off the Northumbrian (northeastern) coast of England. Shortly after, these Norsemen (North men) attacked the monastery at Jarrow in England as well as that on Iona Island, off the west coast of Scotland. From this time until the mid-11th century, the Vikings were the terror of western Europe. From their great ships they seasonally harried and plundered European coasts, harbors, and river settlements. Their fast, seaworthy longboats took them on wide-ranging voyages, from Ireland eastward to Russia and westward to Iceland and Greenland and even, briefly, to Newfoundland in North America, long before Columbus arrived in the "New World."

The Vikings were not intent merely on a hit-and-run strategy of destruction but on colonizing the lands they occupied by conquest. Their exceptional talent for organization and administration, as well as for war, enabled them to take and govern large territories in Ireland, England, and France, as well as in the Baltic regions and Russia. For a while, in the early 11th century, the whole of England was part of a Danish empire. When Vikings settled in northern France in the early 10th century, their territory came to be called Normandy—home of the Norsemen who became Normans. (Later, a Norman duke, William the Conqueror, sailed across the English Channel and invaded and became the master of Anglo-Saxon England; FIG. 17-35.)

OSEBERG SHIP BURIAL Much of the preserved art of the Viking sea rovers consists of decoration of their great wooden ships. Striking examples of Viking woodcarving come from a ship burial near the sea at Oseberg, Norway. The ship, discovered beneath an

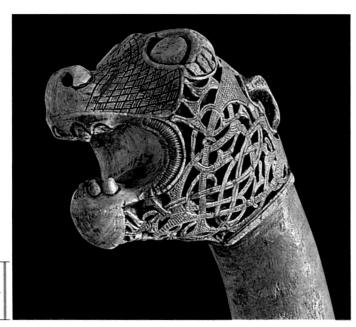

16-4 Animal-head post, from the Viking ship burial, Oseberg, Norway, ca. 825. Wood, head 5" high. University Museum of National Antiquities, Oslo.

The Vikings were master wood carvers. This post from a Viking ship combines in one composition the head of a roaring beast with surface ornamentation in the form of tightly interwoven writhing animals.

earthen mound as was the earlier Sutton Hoo burial, was more than 70 feet long. The vessel contained the remains of two women. The size of the burial alone and the lavishly carved wooden ornament of the sleek ship attest to the importance of those laid to rest there. The vessel also once must have carried many precious objects that robbers removed long before its modern discovery.

An animal-head post (FIG. 16-4) is characteristic of the masterfully carved wood ornamentation of the Oseberg ship. It combines in one composition the image of a roaring beast with protruding eyes and flaring nostrils and the deftly carved, controlled, and contained pattern of tightly interwoven animals that writhe, gripping and snapping, in serpentine fashion. The Oseberg animal head is a powerfully expressive example of the union of two fundamental motifs of warrior-lord art on the northern frontiers of the former Roman Empire—the animal form and the interlace pattern.

CHRISTIAN ART: SCANDINAVIA, BRITISH ISLES, SPAIN

At the same time that powerful warlords were amassing artworks dominated by abstract and animal motifs, elsewhere in northern Europe Christian missionaries were establishing monasteries and sponsoring artworks of Christian content. The early medieval art of northern Europe, however, is dramatically different in character from contemporaneous works produced in Italy and the Byzantine Empire. These Christian artworks are among the most distinctive ever created and testify to the fruitful fusion of native and imported artistic traditions.

STAVE CHURCH, URNES By the 11th century, much of Scandinavia had become Christian, but Viking artistic traditions persisted. Nowhere is this more evident than in the decoration of the portal (FIG. 16-5) of the stave church (*staves* are wedge-shaped timbers placed vertically) at Urnes, Norway. The portal and a few staves are almost all that remain from a mid-11th-century church whose fragments were incorporated in the walls of a 12th-century church. Gracefully elongated animal forms intertwine with flexible plant stalks and tendrils in spiraling rhythm. The effect of natural growth is astonishing, yet the designer subjected it to a highly refined abstract sensibility. This intricate Urnes style was the culmination of three centuries of Viking inventiveness.

HIBERNO-SAXON ART In Ireland, the Christianization of the Celts began in the fifth century. The new converts, although nominally subject to the popes of Rome, quickly developed a form of monastic organization that differed from the Church of Rome. The relative independence of the Irish monasteries was due in part to their isolation. The monks often selected inaccessible and inhospitable places where they could carry on their duties far from worldly temptations and distractions. Before long, Irish monks, filled with missionary zeal, set up monastic establishments in Britain and Scotland. In 563, Saint Columba founded an important monastery on the Scottish island of Iona, where he successfully converted the native Picts to Christianity. Iona monks established the monastery at Lindisfarne off the northern coast of Britain in 635. These foundations became great centers of learning as well as the most important centers of artistic production of the early medieval period in northern Europe.

A style that art historians designate as *Hiberno-Saxon* (Hibernia was the Roman name of Ireland), or sometimes as *Insular* to denote

Medieval Books

The central role books played in the medieval Christian Church led to the development of a large number of specialized types for priests, monks and nuns, and laypersons.

The primary sacred text came to be called the Bible ("the Book"), consisting of the Old Testament of the Jews, originally written in Hebrew, and the Christian New Testament, written in Greek. In the late fourth century, Saint Jerome produced the canonical Latin, or Vulgate (vulgar, or common tongue), version of the Bible, which incorporates 46 Old and 27 New Testament books. Before the invention of the printing press in the 15th century, all books were written by hand ("manuscripts," from the Latin *manu scriptus*). Bibles were extremely difficult to produce, and few early medieval monasteries possessed a complete Bible. Instead, scribes often gathered several biblical books in separate volumes.

The *Pentateuch* contains the first five books of the Old Testament, beginning with the Creation of Adam and Eve (Genesis). The *Gospels* ("good news") are the New Testament works of Saints Matthew, Mark, Luke, and John (see "The Four Evangelists," page 412) and tell the story of the life of Christ (see "The Life of Jesus in Art," Chapter 11,

pages 296–297). Medieval Gospel books often contained *canon tables*—a concordance, or matching, of the corresponding passages of the four Gospels that Eusebius of Caesarea compiled in the fourth century. *Psalters* contained the 150 psalms of King David, written in Hebrew and translated into both Greek and Latin.

The Church also frequently employed other types of books. The *lectionary* contains passages from the Gospels reordered to appear in the sequence that priests read them during the celebration of Mass throughout the year. *Breviaries* include the texts required for the monks' daily recitations. *Sacramentaries* incorporate the prayers priests recite during Mass. *Benedictionals* contain bishops' blessings. In the later Middle Ages, scribes developed books for the private devotions of the laity, patterned after monks' readers. The most popular was the *Book of Hours*, so called because it contains the prayers to be read at specified times of the day.

Scribes produced many other types of books in the Middle Ages—theological treatises, secular texts on history and science, and even some classics of Greco-Roman literature—but these contained illustrations less frequently than the various sacred texts.

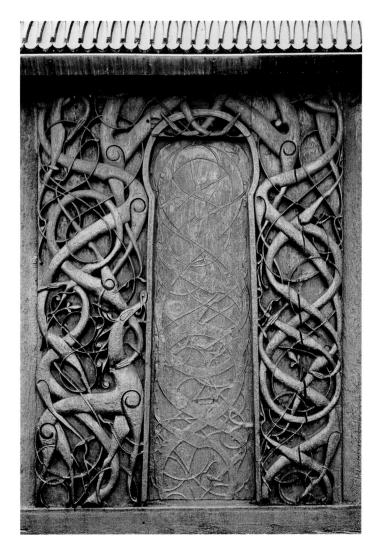

the Irish-English islands where it was produced, flourished within the monasteries of the British Isles. Its most distinctive products were the illuminated manuscripts of the Christian Church (see "Medieval Books," above). Books were the primary vehicles in the effort to Christianize the British Isles. They literally brought the Word of God to a predominantly illiterate population who regarded the monks' sumptuous volumes with awe. Books were scarce and jealously guarded treasures of the libraries and *scriptoria* (writing studios) of monasteries and major churches. Illuminated books are the most important extant monuments of the brilliant artistic culture that flourished in Ireland and Northumbria during the seventh and eighth centuries.

BOOK OF DURROW Among the earliest Hiberno-Saxon illuminated manuscripts is the *Book of Durrow*, a Gospel book that may have been written and decorated in the monastic scriptorium at Iona, although its provenance is not documented. In the late Middle Ages it was in the monastery in Durrow, Ireland—hence its modern name. The Durrow Gospels already display one of the most characteristic features of Insular book illumination: full pages devoted neither to text nor to illustration but to pure embellishment. The Hiberno-Saxon painters must have felt that such ornament lent prestige to books just as ornamental jewelry lent status to those who wore it. Interspersed between the Durrow text pages are so-called *carpet pages*, resembling textiles, made up of decorative panels of abstract and zoomorphic forms (compare FIG. 16-1). The *Book of Durrow*

16-5 Wooden portal of the stave church at Urnes, Norway, ca. 1050–1070.

By the 11th century, Scandinavia had become mostly Christian, but Viking artistic traditions persisted, as seen in the intertwining animal-and-plant decoration of the portal of this Norwegian church.

The Four Evangelists

The English word *evangelist* derives from the Greek word for "one who announces good news," namely the Gospel of Christ. The authors of the Gospels, the first four books of the New Testament, are Saints Matthew, Mark, Luke, and John, collectively known as the Four Evangelists. The Gospel books provide the authoritative account of the life of Jesus, differing in some details but together constituting the literary basis for the iconography of Christian art (see "The Life of Jesus in Art," Chapter 11, pages 296–297). Each evangelist has a unique symbol derived from passages in Ezekiel (1:5–14) and the Apocalypse (4:6–8).

- *Matthew* was a tax collector in Capernaum before Jesus called him to become one of his apostles. Little else is known about him, and there are differing accounts as to how he became a martyr. Matthew's symbol is the winged man or angel, because his Gospel opens with a description of the human ancestry of Christ.
- Mark was the first bishop of Alexandria in Egypt, where he suffered martyrdom. He was a companion of both Saint Peter and Saint Paul. One tradition says that Peter dictated the Gospel to Mark, or at least inspired him to write it. Because Mark's Gospel begins with a voice crying in the wilderness, his symbol is the lion, the king of the desert.
- Luke was a disciple of Saint Paul, who refers to him as a physician. A later tradition says that Luke painted a portrait of the Virgin Mary and the Christ Child. Consequently, late-medieval painters' guilds often chose Luke as their patron saint. Luke's symbol is the ox, because his Gospel opens with a description of the priest Zacharias sacrificing an ox.
- *John* was one of the most important apostles. He sat next to Jesus at the Last Supper and was present at the Crucifixion, Lamentation, and Transfiguration. John was also the author of the Apocalypse, the last book of the New Testament, which he wrote in exile on the Greek island of Patmos. The Apocalypse records John's visions of the end of the world, the Last Judgment, and the Second Coming. John's symbol is the eagle, the soaring bird connected with his apocalyptic visions.

The Four Evangelists appear frequently in medieval art, especially in illuminated Gospel books where they regularly serve as frontispieces to their respective Gospels. Often, artists represented them as seated authors, with or without their symbols (FIGS. I-7, 16-7,

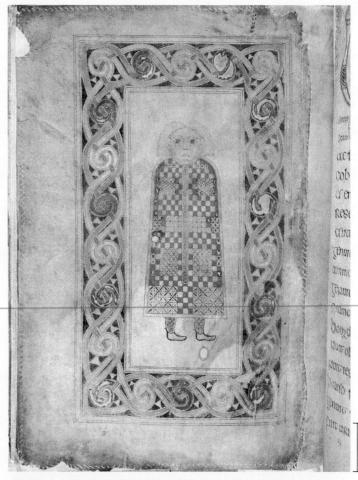

16-6 Man (symbol of Saint Matthew), folio 21 verso of the *Book of Durrow*, possibly from Iona, Scotland, ca. 660–680. Ink and tempera on parchment, $9\frac{5}{8}$ " $\times 6\frac{1}{8}$ ". Trinity College Library, Dublin.

The early Hiberno-Saxon *Book of Durrow* includes four pages devoted to the symbols of the Four Evangelists. The cloak of Saint Matthew's man resembles a cloisonné brooch filled with abstract ornament.

16-13, and 16-14). In some instances, all Four Evangelists appear together (FIG. I-7). Frequently, both in painting and in sculpture, artists represented only the symbols (FIGS. 12-17, 16-6, 17-1, 17-7, 17-17, and 18-6).

also contains pages where the illuminator enormously enlarged the initial letters of an important passage of sacred text and transformed those letters into elaborate decorative patterns (compare FIG. 16-8). These kinds of manuscript pages have no precedents in classical art. They reveal the striking independence of Insular artists from the classical tradition.

In the *Book of Durrow*, each of the four Gospel books has a carpet page facing a page dedicated to the symbol of the evangelist who wrote that Gospel. An elaborate interlace design like those found on contemporaneous belt buckles and brooches frames each symbol. These pages served to highlight the major divisions of the text. The

symbol of Saint Matthew (FIG. 16-6) is a man (more commonly represented later as winged; see "The Four Evangelists," above), but the only human parts that the artist, a seventh-century monk, chose to render are a schematic frontal head and two profile feet. A cloak of yellow, red, and green squares resembling cloisons filled with intricate abstract designs and outlined in dark brown or black envelops the rest of the "body." The *Book of Durrow* weds the abstraction of early medieval personal adornment with Early Christian pictorial imagery. The vehicle for the transmission of those Mediterranean forms was the illustrated book itself, which Christian missionaries brought to northern Europe.

LINDISFARNE GOSPELS The marriage between Christian imagery and the animal-interlace style of the northern warlords is evident in the cross-inscribed carpet page (FIG. 16-1) of the Lindisfarne Gospels. Produced in the Northumbrian monastery on Lindisfarne Island, the book contains several ornamental pages and exemplifies Hiberno-Saxon art at its best. According to a later colophon (an inscription, usually on the last page, providing information regarding a book's manufacture), Eadfrith, bishop of Lindisfarne between 698 and his death in 721, wrote the Lindisfarne Gospels "for God and Saint Cuthbert." Cuthbert's relics (see "Pilgrimages and the Cult of Relics," Chapter 17, page 432) recently had been deposited in the Lindisfarne church.

The patterning and detail of the Lindisfarne ornamental page are much more intricate than those of the *Book of Durrow*. Serpentine interlacements of fantastic animals devour each other, curling over and returning on their writhing, elastic shapes. The rhythm of expanding and contracting forms produces a most vivid effect of motion and change, but the painter held it in check by the regularity of the design and by the dominating motif of the inscribed cross. The cross—the all-important symbol of the imported religion—stabilizes the rhythms of the serpentines and, perhaps by contrast with its heavy immobility, seems to heighten the effect of motion. The illu-

16-7 Saint Matthew, folio 25 verso of the *Lindisfarne Gospels*, from Northumbria, England, ca. 698–721. Tempera on vellum, $1'\frac{1}{2}'' \times 9\frac{1}{4}''$. British Library, London.

The inspiration for this author portrait may have been a Mediterranean book. The illuminator converted the model's fully rounded forms into the linear flat-color idiom of northern European art.

minator placed the motifs in detailed symmetries, with inversions, reversals, and repetitions that the viewer must study closely to appreciate not so much their variety as their mazelike complexity. The zoomorphic forms intermingle with clusters and knots of line, and the whole design vibrates with energy. The color is rich yet cool. The painter adroitly adjusted shape and color to achieve a smooth and perfectly even surface.

Like most Hiberno-Saxon artworks, the Lindisfarne cross page displays the artist's preference for small, infinitely complex, and painstaking designs. Even the Matthew symbol (FIG. 16-6) in the Book of Durrow reveals that the illuminator's concern was abstract design, not the depiction of the natural world. But exceptions exist. In some Insular manuscripts, the northern artists based their compositions on classical pictures in imported Mediterranean books. This is the case with the author portrait of Saint Matthew (FIG. **16-7**) in the *Lindisfarne Gospels*. The Hiberno-Saxon illuminator's model must have been one of the illustrated Gospel books a Christian missionary brought from Italy to England. Author portraits were familiar features of Greek and Latin books, and similar representations of seated philosophers or poets writing or reading (FIGS. 10-71 and 11-6) abound in ancient art. The Lindisfarne Matthew sits in his study composing his account of the life of Christ. A curtain sets the scene indoors, as in classical art (FIG. 5-58), and the evangelist's seat is at an angle, which also suggests a Mediterranean model employing classical perspective. The painter (or the scribe) labeled Matthew in a curious combination of Greek (O Agios, saint-written, however, using Latin rather than Greek letters) and Latin (Mattheus), perhaps to lend the prestige of two classical languages to the page. The former was the language of the New Testament, the latter that of the Church of Rome. Accompanying Matthew is his symbol, the winged man (labeled *imago hominis*, image of the man). The identity of the figure—actually just a disembodied head and shoulders—behind the curtain is uncertain. Among the possibilities are Christ, Saint Cuthbert, and Moses holding the closed book of the Old Testament in contrast with the open book of Matthew's New Testament, a common juxtaposition in medieval Christian art and thought.

Although a southern manuscript inspired the Lindisfarne composition, the Northumbrian painter's goal was not to copy the model faithfully. Instead, uninterested in the emphasis on volume, shading, and perspective that are the hallmarks of the pictorial illusionism of Greco-Roman painting, the Lindisfarne illuminator conceived his subject in terms of line and color exclusively. In the Hiberno-Saxon manuscript, the drapery folds are a series of sharp, regularly spaced, curving lines filled in with flat colors. The painter converted fully modeled forms bathed in light into the linear idiom of northern art. The result is a vivid new vision of Saint Matthew.

BOOK OF KELLS The greatest achievement of Hiberno-Saxon art is the *Book of Kells*, which boasts an unprecedented number of full-page illuminations, including carpet pages, evangelist symbols, portrayals of the Virgin Mary and of Christ, New Testament narrative scenes, canon tables, and several instances of monumentalized and embellished words from the Bible. One medieval commentator described the *Book of Kells* in the *Annals of Ulster* for the year 1003 as "the chief relic of the western world." The manuscript (named after the monastery in central Ireland that owned it) was written and decorated either at Iona or a closely related Irish monastery. From an early date, the book was housed in an elaborate metalwork box, befitting a greatly revered "relic." The monks probably displayed the book on a church altar.

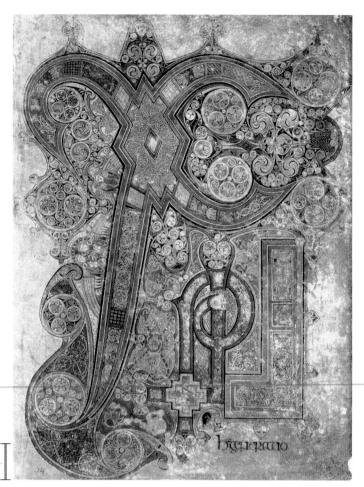

16-8 Chi-rho-iota (XPI) page, folio 34 recto of the *Book of Kells*, probably from Iona, Scotland, late eighth or early ninth century. Tempera on vellum, $1' 1'' \times 9\frac{1}{2}''$. Trinity College Library, Dublin.

In this opening page to the Gospel of Saint Matthew, the painter transformed the biblical text into abstract pattern, literally making God's words beautiful. The intricate design recalls early medieval metalwork.

The page reproduced here (FIG. 16-8) opens the account of the nativity of Jesus in the Gospel of Saint Matthew. The initial letters of Christ in Greek (XPI, chi-rho-iota) occupy nearly the entire page, although two words—autem (abbreviated simply as h) and generatio appear at the lower right. Together they read: "Now this is how the birth of Christ came about." The page corresponds to the opening of Matthew's Gospel, the passage read in church on Christmas Day. The illuminator transformed the holy words into extraordinarily intricate abstract designs that recall Celtic and Anglo-Saxon metalwork. But the cloisonné-like interlace is not purely abstract pattern. The letter rho, for example, ends in a male head, and animals are at its base to the left of h generatio. Half-figures of winged angels appear to the left of chi, accompanying the monogram as if accompanying Christ himself. Close observation reveals many other figures, human and animal. When the priest Giraldus Cambrensis visited Ireland in 1185, he described a manuscript he saw that, if not the Book of Kells itself, must have been very similar:

Fine craftsmanship is all about you, but you might not notice it. Look more keenly at it and you . . . will make out intricacies, so delicate and subtle, so exact and compact, so full of knots and links, with colors so fresh and vivid, that you might say that all this was the work of an angel, and not of a man. For my part, the oftener I see the book, the more carefully I study it, the more I am lost in ever fresh amazement, and I see more and more wonders in the book.³

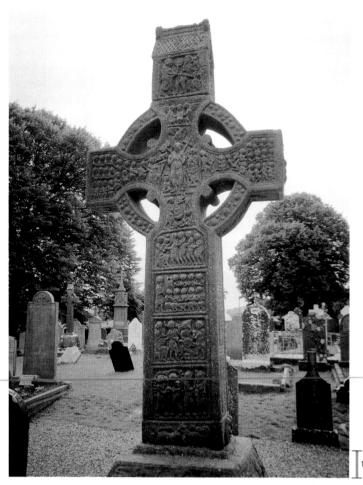

16-9 High Cross of Muiredach (east face), Monasterboice, Ireland, 923. Sandstone, 18' high.

Early medieval Irish high crosses are exceptional in size. Muiredach's cross marked his grave and bears reliefs depicting the Crucifixion and Last Judgment, themes suited to a Christian funerary monument.

HIGH CROSS OF MUIREDACH As noted, the preserved art of the early Middle Ages consists almost exclusively of small and portable works. The high crosses of Ireland and northern England, erected between the 8th and 10th centuries, are exceptional in their mass and scale. These majestic monuments, some more than 20 feet in height, preside over burial grounds adjoining monasteries. Freestanding and unattached to any architectural fabric, the high crosses have the imposing unity, weight, and presence of both building and statue—architecture and sculpture combined.

The High Cross of Muiredach (FIG. 16-9) at Monasterboice, Ireland, is one of the largest and finest early medieval crosses. An inscription on the bottom of the west face of the shaft asks a prayer for a man named Muiredach. Most scholars identify him as the influential Irish cleric of the same name who was abbot of Monasterboice and died in 923. The monastery he headed was one of Ireland's oldest, founded in the late fifth century. The cross probably marked the abbot's grave. The concave arms of Muiredach's cross are looped by four arcs that form a circle. The arms expand into squared terminals (compare FIG. 16-1). The circle intersecting the cross identifies the type as Celtic. At the center of the west side is a depiction of the crucified Christ. On the east side (FIG. 16-9) the risen Christ stands as judge of the world, the hope of the dead. Below him the souls of the dead are being weighed on scales—a theme that sculptors of 12thcentury church portals (FIGS. I-6 and 17-12) pursued with extraordinary intensity.

16-10 San Juan Bautista, Baños de Cerrato, Spain, 661.

This three-aisled basilican church dedicated to Saint John the Baptist is typical of Visigothic architecture in Spain. It features three square apses and an entrance portal crowned by a horseshoe arch.

VISIGOTHIC SPAIN When Muslim armies crossed into Spain from North Africa in 711 (see Chapter 13), they brought Islam to a land the Romans had ruled for centuries. Roman sovereignty had brought new roads to the Iberian Peninsula and new cities with Roman temples, forums, theaters, and aqueducts. But in the early fifth century, the Roman cities fell to Germanic invaders, most notably the Visigoths, who had converted to Christianity. Many of the stone churches the Visigoths built in the sixth and seventh centuries still stand. An outstanding example is the church of San Juan Bautista (Saint John the Baptist, FIG. 16-10) at Baños de Cerrato, which the Visigothic king Recceswinth (r. 649-672) erected in 661 in thanksgiving for a cure after bathing in the waters there. The Visigothic churches are basilican in form but often have multiple square apses. (The Baños de Cerrato church has three.) They also regularly incorporate horseshoe arches, a form usually associated with Islamic architecture (FIG. 13-11) but that in Spain predates the Muslim conquest.

MOZARABIC SPAIN Although the Islamic caliphs of Córdoba swept the Visigoths from power, they never succeeded in gaining control of the northernmost parts of the peninsula. There, the Christian culture called Mozarabic (referring to Christians living in Arab territories) continued to flourish. One northern Spanish monk, Beatus, abbot of San Martín at Liébana, wrote Commentary on the Apocalypse around 776. This influential work was widely copied and illustrated in the monastic scriptoria of medieval Europe. One copy was produced at the monastery of San Salvador at Tábara in the kingdom of Léon in 970. The colophon (FIG. 16-11) to the illustrated Commentary presents the earliest known depiction of a medieval scriptorium. Because the artist provided a composite of exterior and interior views of the building, it is especially informative. At the left is a great bell tower with a monk on the ground floor ringing the bells. The painter carefully recorded the Islamicstyle glazed-tile walls of the tower, its interior ladders, and its elegant windows with their horseshoe arches, the legacy of the Visigoths. To the right, in the scriptorium proper, three monks perform their respective specialized duties. The colophon identifies the two monks in the main room as the scribe Senior and the painter EMETERIUS. To the right, a third monk uses shears to cut sheets of parchment. The colophon also pays tribute to Magius, "the worthy master

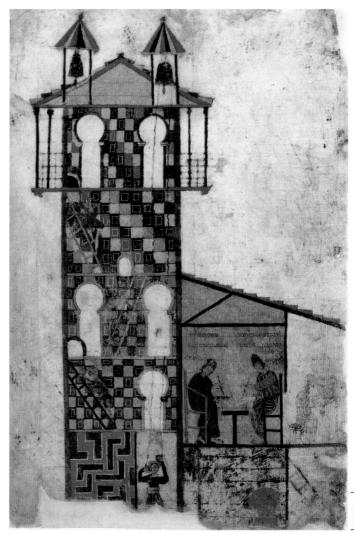

16-11 EMETERIUS, the tower and scriptorium of San Salvador de Tábara, colophon (folio 168) of the *Commentary on the Apocalypse* by Beatus, from Tábara, Spain, 970. Tempera on parchment, $1' 2\frac{1}{8}'' \times 10''$. Archivo Histórico Nacional, Madrid.

In this earliest known depiction of a medieval scriptorium, the painter carefully recorded the Islamic-style glazed-tile walls of the tower and its elegant windows with their horseshoe arches, a legacy of the Visigoths.

painter . . . May he deserve to be crowned with Christ,"⁴ who died before he could complete his work on the book. His pupil Emeterius took his place and brought the project to fruition. He must be the painter of the colophon.

CAROLINGIAN ART

On Christmas Day of the year 800, Pope Leo III crowned Charles the Great (Charlemagne), king of the Franks since 768, as emperor of Rome (r. 800–814). In time, Charlemagne came to be seen as the first Holy (that is, Christian) Roman Emperor, a title his successors did not formally adopt until the 12th century. The setting for Charlemagne's coronation, fittingly, was Saint Peter's basilica (FIG. 11-9) in Rome, built by Constantine, the first Roman emperor to embrace Christianity. Born in 742, when northern Europe was still in chaos, Charlemagne consolidated the Frankish kingdom his father and grandfather bequeathed him and defeated the Lombards in Italy (MAP 16-1). He thus united Europe and laid claim to reviving the glory of the ancient Roman Empire. He gave his name (Carolus Magnus in Latin) to an entire era, the *Carolingian* period.

Charlemagne's Renovatio Imperii Romani

harlemagne's official seal bore the words renovatio imperii Romani (renewal of the Roman Empire). As the papally designated Roman emperor, Charlemagne sought to revive the glory of Early Christian Rome. He accomplished this in part through artistic patronage, commissioning imperial portrait statues (FIG. 16-12) and large numbers of illustrated manuscripts (FIG. 16-13), but also by fostering a general revival of learning.

To make his empire as splendid as Rome's, Charlemagne invited to his court at Aachen the best minds and the finest artisans of western Europe and the Byzantine East. Among them were Paulinus of Aquileia (ca. 726–804), Theodulf of Orléans (ca. 750–821), and Alcuin (ca. 735–804), master of the cathedral school at York, the center of Northumbrian learning. Alcuin brought Anglo-Saxon scholarship to the Carolingian court.

Charlemagne himself, according to Einhard, his biographer, could read and speak Latin fluently, in addition to Frankish, his native tongue. He also could understand Greek, and he studied rhetoric and mathematics with the learned men he gathered around him. But he never learned to write properly. That was a task best left to professional scribes. In fact, one of Charlemagne's dearest projects was the recovery of the true text of the Bible, which, through centuries of errors in copying, had become quite corrupt. Various scholars undertook the great project, but Alcuin of York's revision of the Bible, prepared at the new monastery at Tours, became the most widely used.

Charlemagne's scribes also were responsible for the development of a new, more compact, and more easily written and legible version of Latin script called *Caroline minuscule*. The letters on this page are descendants of the alphabet Carolingian scribes perfected. Later generations also owe to Charlemagne's patronage the restoration and copying of important classical texts. The earliest known manuscripts of many Greek and Roman authors are Carolingian in date.

16-12 Equestrian portrait of Charlemagne or Charles the Bald, from Metz, France, ninth century. Bronze, originally gilt, $9\frac{1}{2}$ high. Louvre, Paris.

The Carolingian emperors sought to revive the glory and imagery of the ancient Roman Empire. This equestrian portrait depicts a crowned emperor holding a globe, the symbol of world dominion.

The "Carolingian Renaissance" was a remarkable historical phenomenon, an energetic, brilliant emulation of the art, culture, and political ideals of Early Christian Rome (see "Charlemagne's *Renovatio Imperii Romani*," above). Charlemagne's (Holy) Roman Empire, waxing and waning for a thousand years and with many hiatuses, existed in central Europe until Napoleon destroyed it in 1806.

Sculpture and Painting

When Charlemagne returned home from his coronation in Rome, he ordered the transfer of an equestrian statue of the Ostrogothic king Theodoric from Ravenna to the Carolingian palace complex at Aachen. That portrait is lost, as is the grand gilded-bronze statue of the Byzantine emperor Justinian that once crowned a column in Constantinople (see "The Emperors of New Rome," Chapter 12, page 323). But in the early Middle Ages, both statues stood as reminders of ancient Rome's glory and of the pretensions and aspirations of the medieval successors of Rome's Christian emperors.

EQUESTRIAN STATUETTE The portrait of Theodoric may have been the inspiration for a ninth-century bronze statuette (FIG. 16-12) of a Carolingian emperor on horseback. Charlemagne greatly admired Theodoric, the first Germanic ruler of Rome. Many scholars have identified the small bronze figure as Charlemagne himself, although others think it portrays his grandson, Charles the Bald (r. 840–877). The ultimate model for the statuette was the equestrian portrait (FIG. 10-59) of Marcus Aurelius in Rome. In the Middle Ages, people mistakenly thought the bronze statue represented Constantine, another revered predecessor of Charlemagne and his Carolingian successors. Both the Roman and the medieval sculptor portrayed their emperor as overly large so that the ruler, not the horse, is the center of attention. But unlike Marcus Aurelius, who extends his right arm in a gesture of clemency to a foe who once cowered beneath the raised foreleg of his horse, Charlemagne (or Charles the Bald) is on parade. He wears imperial robes rather than a general's cloak, although his sheathed sword is visible. On his head is a crown, and in his outstretched left hand he holds a globe, symbol of world domin-

16-13 Saint Matthew, folio 15 recto of the *Coronation Gospels* (*Gospel Book of Charlemagne*), from Aachen, Germany, ca. 800–810. Ink and tempera on vellum, $1'\frac{3''}{4} \times 10''$. Schatzkammer, Kunsthistorisches Museum, Vienna.

The painted manuscripts produced for Charlemagne's court reveal the legacy of classical art. The Carolingian painter used light and shade and perspective to create the illusion of three-dimensional form.

ion. The portrait proclaimed the *renovatio* of the Roman Empire's power and trappings.

CORONATION GOSPELS Charlemagne was a sincere admirer of learning, the arts, and classical culture. He, his successors, and the scholars under their patronage placed high value on books, both sacred and secular, importing many and producing far more. One of these is the purple vellum Coronation Gospels (also known as the Gospel Book of Charlemagne), which has a text written in handsome gold letters. The major full-page illuminations show the four Gospel authors at work. The page depicting Saint Matthew (FIG. 16-13) reveals that the Carolingian painter's technique differs markedly from that of the Northumbrian painter of the Matthew portrait (FIG. 16-7) in the Lindisfarne Gospels. Deft, illusionistic brushwork defines the massive drapery folds wrapped around the body beneath. The Carolingian illuminator used color and modulation of light and shade, not line, to create shapes. The cross-legged chair, the lectern, and the saint's toga are familiar Roman accessories. The landscape background has many parallels in Roman painting, and the frame consists of the kind of acanthus leaves found in Roman temple capitals and friezes (FIG. 10-32). Almost nothing is known in the Hiberno-Saxon British Isles or Frankish Europe that could have prepared the way for this portrayal of Saint Matthew. If a Frank, rather than an Italian or a Byzantine, painted the Saint Matthew and the other evangelist portraits of the Coronation Gospels, the Carolingian artist had fully absorbed the classical manner. Classical painting style was one of the many components of Charlemagne's program to establish Aachen as the capital of a renewed Christian Roman Empire.

16-14 Saint Matthew, folio 18 verso of the *Ebbo Gospels* (*Gospel Book of Archbishop Ebbo of Reims*), from Hautvillers (near Reims), France, ca. 816–835. Ink and tempera on vellum, $10\frac{1}{4}'' \times 8\frac{3}{4}''$. Bibliothèque Municipale, Épernay.

Saint Matthew writes frantically, and the folds of his drapery writhe and vibrate. Even the landscape behind him rears up alive. The painter merged classical illusionism with the northern linear tradition.

EBBO GOSPELS The classical-revival style evident in the Coronation Gospels was by no means the only one that appeared suddenly in the Carolingian world. Court schools and monasteries employed a wide variety of styles derived from Late Antique prototypes. Another Saint Matthew (FIG. 16-14), in a Gospel book made for Archbishop Ebbo of Reims, France, may be an interpretation of an author portrait very similar to the one the Coronation Gospels master used as a model. The Ebbo Gospels illuminator, however, replaced the classical calm and solidity of the Coronation Gospels evangelist with an energy that amounts to frenzy. Matthew (the winged man in the upper right corner identifies him) writes in frantic haste. His hair stands on end, his eyes open wide, the folds of his drapery writhe and vibrate, the landscape behind him rears up alive. The painter even set the page's leaf border in motion. Matthew's face, hands, inkhorn, pen, and book are the focus of the composition. This presentation contrasts strongly with the settled pose of the Saint Matthew of the Coronation Gospels with its even stress so that no part of the composition jumps out at viewers to seize their attention. Just as the painter of the Lindisfarne Gospels Matthew (FIG. 16-7) transformed an imported model into an original Hiberno-Saxon idiom, so the Ebbo Gospels artist translated a classical prototype into a new Carolingian vernacular. This master painter brilliantly merged classical illusionism and the northern linear tradition.

16-15 Psalm 44, detail of folio 25 recto of the *Utrecht Psalter*, from Hautvillers (near Reims), France, ca. 820–835. Ink on vellum, full page, $1' 1'' \times 9\frac{7}{8}''$; detail, $4\frac{1}{2}''$ high. University Library, Utrecht.

The drawings in the *Utrecht Psalter* are rich in anecdotal detail and show figures acting out—literally—King David's psalms. The vivid animation resembles that of the *Ebbo Gospels* Saint Matthew (FIG. 16-14).

Surrounding Christ are pearls and jewels (raised on golden claw feet so that they can catch and reflect the light even more brilliantly and protect the delicate metal relief from denting). The statuesque openeyed figure, rendered in *repoussé* (hammered or pressed relief),

brings to mind the beardless unsuffering Christ of the fifth-century

UTRECHT PSALTER One of the most extraordinary medieval manuscripts is the *Utrecht Psalter*. The text reproduces the Psalms of David in three columns of Latin capital letters emulating the script and page organization of ancient books. The artist illustrated each psalm with a pen-and-ink drawing stretching across the entire width of the page. Some scholars have argued that the costumes and other details indicate that the artist followed one or more manuscripts compiled 400 years before. Even if the *Utrecht Psalter* is not a copy, the artist's intention was to evoke earlier artworks and to make the book appear "ancient."

The painter of the *Utrecht Psalter* displays a genius for anecdotal detail throughout the manuscript. On one page (FIG. 16-15) the figures act out—literally—Psalm 44 (Psalm 43 of the Vulgate text of the Carolingian era), in which the psalmist laments the plight of the oppressed Israelites. Where the text says, "we are counted as sheep for slaughter," the artist drew some slain sheep fallen to the ground in front of a walled city reminiscent of cities on the Column of Trajan (FIG. 10-44) in Rome and in Early Christian mosaics and manuscripts (FIG. 11-20). At the left, the faithful grovel on the ground before a temple because the psalm reads "our soul is bowed down to the dust; our belly cleaveth unto the earth." The artist's response to "Awake, why sleepest thou, O Lord" was to depict the Lord (as Christ instead of the Hebrew God, complete with cruciform halo), flanked by six pleading angels, reclining in a canopied bed overlooking the slaughter below. The drawing shows a vivid animation of much the same kind as in the Saint Matthew of the Ebbo Gospels (FIG. 16-14). The bodies of the Utrecht Psalter figures are tense, shoulders hunched, heads thrust forward. As in the Ebbo Gospels, even the earth heaves up around the figures. The rapid, sketchy techniques used to render the figures convey the same nervous vitality as the Ebbo evangelists.

LINDAU GOSPELS The taste for sumptuously wrought and portable objects, shown previously in the art of the early medieval warlords, persisted under Charlemagne and his successors. They commissioned numerous works employing costly materials, including book covers made of gold and jewels and sometimes also ivory or pearls. Gold and gems not only glorified the Word of God but also evoked the heavenly Jerusalem. One of the most luxurious Carolingian book covers (FIG. 16-16) is the one later added to the Lindau Gospels. The gold cover, fashioned in one of the workshops of Charles the Bald's court, is monumental in conception. A youthful Christ in the Early Christian tradition, nailed to the cross, is the central motif.

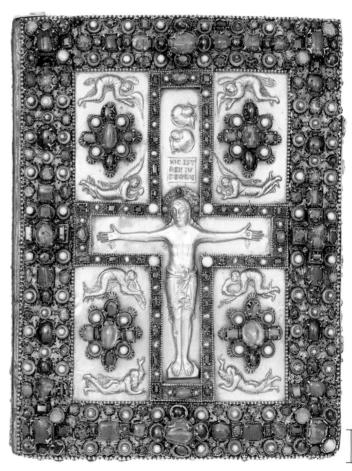

16-16 Crucifixion, front cover of the *Lindau Gospels*, from Saint Gall, Switzerland, ca. 870. Gold, precious stones, and pearls, 1' $1\frac{3}{8}$ " \times $10\frac{3}{8}$ ". Pierpont Morgan Library, New York.

This sumptuous Carolingian book cover revives the Early Christian imagery of the youthful Christ. The statuesque figure of the crucified Savior, heedless of pain, is classical in both conception and execution.

ivory plaque (FIG. 11-22) from Italy in the British Museum. In contrast, the four angels and the personifications of the Moon and the Sun above and the crouching figures of the Virgin Mary and Saint John (and two other figures of uncertain identity) in the quadrants below display the vivacity and nervous energy of the *Utrecht Psalter* figures. This eclectic work highlights the stylistic diversity of early medieval art in Europe. Here, however, the translated figural style of the Mediterranean prevails, in keeping with the classical tastes and imperial aspirations of the Frankish "emperors of Rome."

Architecture

In his eagerness to reestablish the imperial past, Charlemagne also encouraged the use of Roman building techniques. In architecture, as in sculpture and painting, innovations made in the reinterpretation of earlier Roman Christian sources became fundamental to the subsequent development of northern European architecture. For his models, Charlemagne went to Rome and Ravenna. One was the former heart of the Roman Empire, which he wanted to "renew." The other was the long-term western outpost of Byzantine might and splendor, which he wanted to emulate in his capital at Aachen, a site chosen because of its renowned hot springs.

AACHEN Charlemagne often visited Ravenna, and the equestrian statue of Theodoric he brought from there to display in his palace complex at Aachen served as a model for Carolingian equestrian portraits (FIG. 16-12). Charlemagne also imported porphyry (purple marble) columns from Ravenna to adorn his Palatine Chapel, and historians long have thought he chose one of Ravenna's churches as the model for the new structure. The plan (FIG. 16-17) of the Aachen chapel resembles that of San Vitale (FIG. 12-7), and a direct relationship very likely exists between the two.

A comparison between the Carolingian chapel, the first vaulted structure of the Middle Ages north of the Alps, and its southern counterpart is instructive. The Aachen plan is simpler. Omitted were San Vitale's apselike extensions reaching from the central octagon into the ambulatory. At Aachen, the two main units stand in greater independence of each other. This solution may lack the subtle sophis-

16-17 Restored plan of the Palatine Chapel of Charlemagne, Aachen, Germany, 792-805.

Charlemagne often visited Ravenna and sought to emulate Byzantine splendor in Germany. The plan of his Aachen palace chapel is based on that of San Vitale (FIG. 12-7), but the Carolingian plan is simpler.

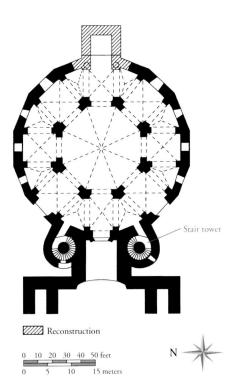

tication of the Byzantine building, but the Palatine Chapel gains geometric clarity. A view of the interior (FIG. 16-18) of the Palatine Chapel shows that the architect converted the "floating" quality of San Vitale (FIG. 12-8) into massive geometric form.

The Carolingian conversion of a complex, subtle Byzantine prototype into a building that expresses robust strength and clear structural articulation foreshadows the architecture of the 11th and 12th centuries and the style called Romanesque (see Chapter 17). So, too, does the treatment of the Palatine Chapel's exterior, where two cylindrical towers with spiral staircases flank the entrance portal (FIG. 16-17). This was a first step toward the great dual-tower facades of western European churches from the 10th century to the present. Above the portal, Charlemagne could appear in a large framing arch and be seen by those gathered in the atrium in front of the chapel. (The plan includes only part of the atrium.) Directly behind that second-story arch was Charlemagne's marble throne. From there he could peer down at the altar in the apse. Charlemagne's imperial gallery followed the model of the imperial gallery at Hagia Sophia (FIGS. 12-3 and 12-4) in Constantinople. The Palatine Chapel was in every sense a royal chapel. The coronation of Charlemagne's son, Louis the Pious (r. 814–840), took place there when he succeeded his father as emperor.

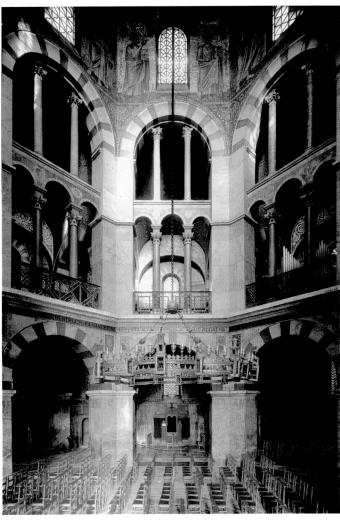

16-18 Interior of the Palatine Chapel of Charlemagne, Aachen, Germany, 792–805.

Charlemagne's palace chapel is the first vaulted structure of the Middle Ages north of the Alps. The architect transformed the complex, glittering interior of San Vitale (FIG. 12-8) into simple and massive geometric form.

Medieval Monasteries and Benedictine Rule

onastic foundations appeared in western Europe beginning in Early Christian times. The monks who established monasteries also made the rules that governed them. The most significant of these monks was Benedict of Nursia (Saint Benedict), who founded the Benedictine order in 529. By the ninth century, the "Rule" Benedict wrote (*Regula Sancti Benedicti*) had become standard for all European monastic establishments, in part because Charlemagne had encouraged its adoption throughout the Frankish territories.

Saint Benedict believed the corruption of the clergy that accompanied the increasing worldliness of the Christian Church had is roots in the lack of firm organization and regulation. As he saw it, idleness and selfishness had led to neglect of the commandments of God and of the Church. The cure for this was communal association in an *abbey* under the absolute rule of an *abbot* the monks elected (or an *abbess* the nuns chose), who would see to it that the monks

spent each hour of the day in useful work and in sacred reading. The emphasis on work and study and not on meditation and austerity is of great historical significance. Since antiquity, manual labor had been considered disgraceful, the business of the lowborn or of slaves. Benedict raised it to the dignity of religion. The core idea of what many people today call the "work ethic" found early expression here as an essential feature of spiritual life. By thus exalting the virtue of manual labor, Benedict not only rescued it from its age-old association with slavery but also recognized it as the way to self-sufficiency for the entire religious community.

16-19 Schematic plan for a monastery at Saint Gall, Switzerland, ca. 819. Red ink on parchment, $2' 4'' \times 3' 8\frac{1}{8}''$. Stiftsbibliothek, Saint Gall.

The purpose of this plan for an ideal, self-sufficient Benedictine monastery was to separate the monks from the laity. Near the center stands the church with its cloister, an earthly paradise reserved for the monks.

Whereas some of Saint Benedict's followers emphasized spiritual "work" over manual labor, others, most notably the Cistercians (see "Bernard of Clairvaux," Chapter 17, page 420), put his teachings about the value of physical work into practice. These monks reached into their surroundings and helped reduce the vast areas of daunting wilderness of early medieval Europe. They cleared dense forest teeming with wolves, bear, and wild boar; drained swamps and cultivated wastelands; and built roads, bridges, and dams as well as monastic churches and their associated living and service quarters.

The ideal monastery (FIG. 16-19) provided all the facilities necessary for the conduct of daily life—a mill, bakery, infirmary, vegetable garden, and even a brewery—so that the monks felt no need to wander outside its protective walls. These religious communities

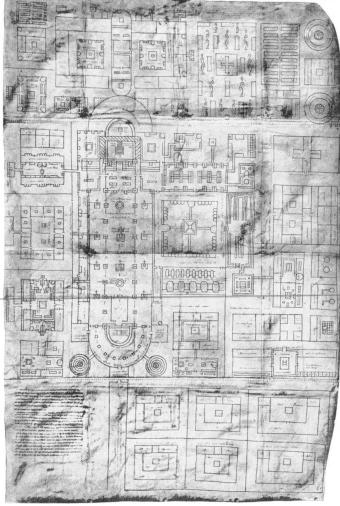

1 in.

were centrally important to the revival of learning. The clergy, who were also often scribes and scholars, had a monopoly on the skills of reading and writing in an age of almost universal illiteracy. The monastic libraries and scriptoria (FIG. 16-11), where the monks read, copied, illuminated, and bound books with ornamented covers, became centers of study. Monasteries were almost the sole repositories of what remained of the literary culture of the Greco-Roman world and early Christianity. Saint Benedict's requirements of manual labor and sacred reading came to include writing and copying books, studying music for chanting the day's offices, and—of great significance—teaching. The monasteries were the schools of the early Middle Ages as well as self-sufficient communities and production centers.

SAINT GALL The construction and expansion of many monasteries also characterized the Carolingian period. A unique document, the ideal plan (FIG. 16-19) for a Benedictine monastery (see "Medieval Monasteries and Benedictine Rule," above) at Saint Gall in Switzerland, provides precious information about the design of Carolingian monastic communities. Haito, the abbot of Reichenau and bishop of Basel, commissioned the drawing and sent it to the abbot of

Saint Gall around 819 as a guide for the rebuilding of the Saint Gall monastery. The design's fundamental purpose was to separate the monks from the laity (nonclergy) who also inhabited the community. Variations of the scheme may be seen in later monasteries all across western Europe. Near the center, dominating everything, was the church with its *cloister*, a colonnaded courtyard not unlike the Early Christian atrium (FIG. 11-9) but situated to the side of the church

rather than in front of its main portal. Reserved for the monks alone, the cloister, a kind of earthly paradise removed from the world at large, provided the peace and quiet necessary for contemplation. Clustered around the cloister were the most essential buildings: dormitory, refectory, kitchen, and storage rooms. Other structures, including an infirmary, school, guest house, bakery, brewery, and workshops, were grouped around this central core of church and cloister.

Haito invited the abbot of Saint Gall to adapt the monastery plan as he saw fit, and, indeed, the Saint Gall builders did not follow the Reichenau model exactly. Nonetheless, if the abbot had wished, Haito's plan could have served as a practical guide for the Saint Gall masons because it was laid out using a *module* (standard unit) of two and a half feet. Parts or multiples of this module were employed consistently throughout the plan. For example, the nave's width, indicated on the plan as 40 feet, was equal to 16 modules; the length of each monk's bed to two and a half modules; and the width of paths in the vegetable garden to one and a quarter modules.

The models that carried the greatest authority for Charlemagne and his builders were those from the Christian phase of the Late Roman Empire. The widespread adoption of the Early Christian basilica, at Saint Gall and elsewhere, rather than the domed central plan of Byzantine churches, was crucial to the subsequent development of western European church architecture. Unfortunately, no Carolingian basilica has survived in anything approaching its original form. Nevertheless, it is possible to reconstruct the appearance of some of the structures with fair accuracy. Several appear to have followed their Early Christian models quite closely. But in other instances, Carolingian builders significantly modified the basilica plan, converting it into a much more complex form. The monastery church at Saint Gall, for example, was essentially a traditional basilica, but it had features not found in any Early Christian church. Most obvious is the addition of a second apse on the west end of the building, perhaps to accommodate additional altars and relics (see "Pilgrimages and the Cult of Relics," Chapter 17, page 432). Whatever its purpose, this feature remained a characteristic regional element of German churches until the 11th century.

Not quite as evident but much more important to the subsequent development of church architecture north of the Alps was the presence of a transept at Saint Gall, a very rare feature but one that characterized the two greatest Early Christian basilicas in Rome, Saint Peter's (FIG. 11-9) and Saint Paul's. The Saint Gall transept is as wide as the nave on the plan and was probably the same height. Early Christian builders had not been concerned with proportional relationships. On the Saint Gall plan, however, the various parts of the building relate to one another by a geometric scheme that ties them together into a tight and cohesive unit. Equalizing the widths of nave and transept automatically makes the area where they cross (the crossing) a square. Most Carolingian churches shared this feature. But Haito's planner also used the crossing square as the unit of measurement for the remainder of the church plan. The transept arms are equal to one crossing square, the distance between transept and apse is one crossing square, and the nave is four and a half crossing squares long. The fact that the two aisles are half as wide as the nave integrates all parts of the church in a rational and orderly plan.

The Saint Gall plan also reveals another important feature of many Carolingian basilicas: towers framing the end(s) of the church. Haito's plan shows only two towers, both cylindrical and on the west side of the church, as at Charlemagne's Palatine Chapel (FIG. 16-17), but they stand apart from the church facade. If a tower existed above the crossing, the silhouette of Saint Gall would have shown three towers altering the horizontal profile of the traditional basilica and identifying the church even from afar.

CORVEY Other Carolingian basilicas had towers incorporated in the fabric of the west end of the building, thereby creating a unified monumental facade that greeted all those who entered the church. Architectural historians call this feature of Carolingian and some later churches the westwork (German Westwerck, "western entrance structure"). In contemporaneous documents, writers refer to it as a castellum (Latin, "castle" or "fortress") or turris ("tower"). The sole surviving example is the abbey church (FIG. 16-20) at Corvey. The uppermost parts are 12th-century additions (easily distinguishable from the original westwork by the differing masonry technique). Stairs in each tower provided access to the upper stories of the westwork. On the second floor was a two-story chapel with an aisle and a gallery on three sides. As at Aachen, the chapel opened onto the nave, and from it, on occasion, the emperor and his entourage could watch and participate in the service below. Not all Carolingian westworks, however, served as seats for the visiting emperor. They also functioned as churches within churches, housing a second altar for special celebrations on major feast days. Boys' choirs stationed in the westwork chapel participated from above in the services conducted in the church's nave.

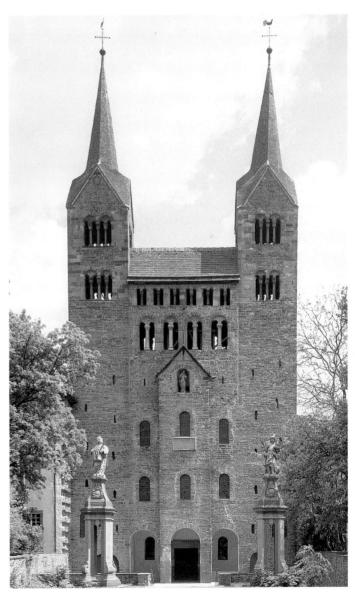

16-20 Westwork of the abbey church, Corvey, Germany, 873-885.

An important new feature of Carolingian church architecture is the westwork, a monumental western facade incorporating two towers. The sole surviving example is the abbey church at Corvey.

OTTONIAN ART

Charlemagne was buried in the Palatine Chapel at Aachen. His empire survived him by fewer than 30 years. When his son Louis the Pious died in 840, Louis's sons—Charles the Bald, Lothair, and Louis the German—divided the Carolingian Empire among themselves. After bloody conflicts, the brothers signed a treaty at Verdun in 843 partitioning the Frankish lands into western, central, and eastern areas, very roughly foreshadowing the later nations of France and Germany and a third realm corresponding to a long strip of land stretching from the Netherlands and Belgium to Rome. Intensified Viking incursions helped bring about the collapse of the Carolingians. The empire's breakup into weak kingdoms, ineffectual against the invasions, brought a time of confusion to Europe. Complementing the Viking scourge in Europe were the invasions of the Magyars in the Byzantine East and the plundering and piracy of the Saracens (Muslims) in the Mediterranean.

Only in the mid-10th century did the eastern part of the former empire consolidate under the rule of a new Saxon line of German emperors called, after the names of the three most illustrious family members, the Ottonians. The pope crowned the first Otto (r. 936–973) in Rome in 962, and Otto assumed the title of emperor of Rome that Charlemagne's weak successors held during most of the previous century. The three Ottos made headway against the invaders from the East, remained free from Viking attacks, and not only preserved but also enriched the culture and tradition of the Carolingian period. The Christian Church, which had become corrupt and disorganized, recovered in the 10th century under the influence of a great monastic reform that the Ottonians encouraged and sanctioned. The new German emperors also cemented ties with Italy and the papacy. By the time the last of the Ottonian line, Henry II, died in the early 11th century, the pagan marauders had become Christianized and settled, and the monastic reforms had been highly successful.

Architecture

Ottonian architects followed the course of their Carolingian predecessors, building basilican churches with towering spires and imposing westworks, but they also introduced new features that would have a long future in western European church architecture.

GERNRODE The best preserved 10th-century Ottonian basilica is Saint Cyriakus at Gernrode. The church was the centerpiece of a convent founded in 961. Construction of the church began the same year. In the 12th century, a large apse replaced the western entrance, but the upper parts of the westwork, including the two cylindrical towers, were left intact. The interior (FIG. 16-21), although heavily restored in the 19th century, retains its 10th-century character. Saint Cyriakus reveals how Ottonian architects enriched the form of the Early Christian basilica. The church has a transept at the east with a square choir in front of the apse. The nave is one of the first in western Europe to incorporate a gallery between the ground-floor arcade and the clerestory, a design that became very popular in the succeeding Romanesque era (see Chapter 17). Scholars have reached no consensus on the function of these galleries in Ottonian churches. They cannot have been reserved for women, as some think they were in Byzantium, because Saint Cyriakus is a nuns' church. One suggestion is that the galleries housed additional altars, as in the westwork at Corvey. They may also have been where the choirs sang. The Gernrode builders also transformed the nave arcade itself by adopting the alternate-support system, in which heavy square piers alternate with columns, dividing the nave into vertical units. The division continues into the gallery level, breaking the smooth rhythm of the

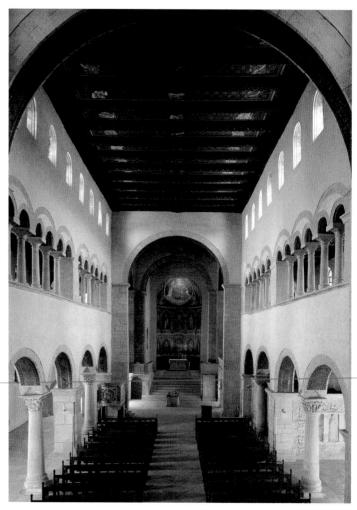

16-21 Nave of the church of Saint Cyriakus, Gernrode, Germany, 961-973.

Ottonian builders modified the interior elevation of the Early Christian basilica. The Gernrode designer added a gallery above the nave arcade and adopted an alternate-support system of piers and columns.

all-column arcades of Early Christian and Carolingian basilicas and leading the eye upward. Later architects would carry this "verticalization" of the basilican nave much further (FIG. 18-19).

HILDESHEIM One of the great patrons of Ottonian art and architecture was Bishop Bernward of Hildesheim, Germany. He was the tutor of Otto III (r. 983–1002) and builder of the abbey church of Saint Michael (FIG. 16-22) at Hildesheim. Bernward, who made Hildesheim a center of learning, was an eager scholar, a lover of the arts, and, according to Thangmar of Heidelberg, his biographer, an expert craftsman and bronze caster. In 1001, Bernward traveled to Rome as the guest of Otto III. During this stay, he studied at first hand the monuments of the empire the Carolingian and Ottonian emperors revered.

Constructed between 1001 and 1031 (and rebuilt after being bombed during World War II), Saint Michael's has a double-transept plan (Fig. 16-23, *bottom*), tower groupings, and a westwork. The two transepts create eastern and western centers of gravity. The nave merely seems to be a hall that connects them. Lateral entrances leading into the aisles from the north and south additionally make for an almost complete loss of the traditional basilican orientation toward the east. Some ancient Roman basilicas, such as the Basilica Ulpia (Fig. 10-43, no. 4) in Trajan's Forum, also had two apses and

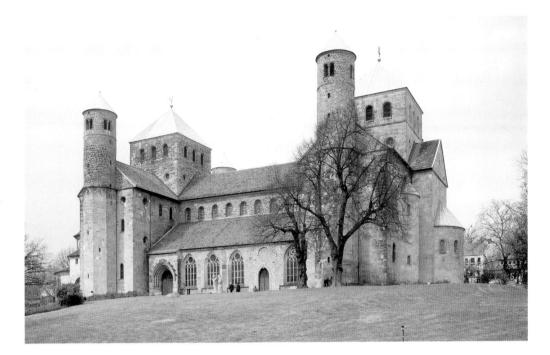

16-22 Saint Michael's, Hildesheim, Germany, 1001–1031.

Built by Bishop Bernward, a great art patron, Saint Michael's is a masterpiece of Ottonian basilica design. The church's two apses, two transepts, and multiple towers give it a distinctive profile.

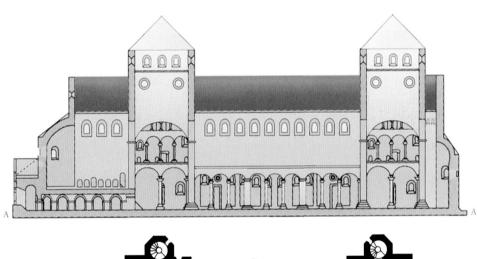

16-23 Longitudinal section (*top*) and plan (*bottom*) of the abbey church of Saint Michael's, Hildesheim, Germany, 1001–1031.

Saint Michael's entrances are on the side. Alternating piers and columns divide the space in the nave into vertical units. These features transformed the tunnel-like horizontality of Early Christian basilicas.

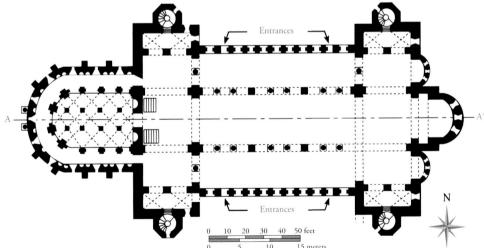

entrances on the side, and Bernward probably was familiar with this variant basilican plan.

At Hildesheim, as in the plan of the monastery at Saint Gall (FIG. 16-19), the builders adopted a modular approach. The crossing squares, for example, are the basis for the nave's dimensions—three

crossing squares long and one square wide. The placement of heavy piers at the corners of each square gives visual emphasis to the three units. These piers alternate with pairs of columns (FIG. 16-23, *top*) as wall supports in a design similar to that of Saint Cyriakus (FIG. 16-21) at Gernrode.

Sculpture and Painting

In 1001, when Bishop Bernward was in Rome visiting the young Otto III, he resided in Otto's palace on the Aventine Hill in the neighborhood of Santa Sabina (FIG. 11-10), an Early Christian church renowned for its carved wooden doors. Those doors, decorated with episodes from both the Old and New Testaments, may have inspired the remarkable bronze doors the bishop had cast for his new church in Germany.

HILDESHEIM DOORS The colossal doors (FIG. 16-24) for Saint Michael's, dated by inscription to 1015, are more than 16 feet tall. Each was cast in a single piece with the figural sculpture, a technological marvel. Carolingian sculpture, like most sculpture since Late Antiquity, consisted primarily of small-scale art executed in ivory and precious metals, often for book covers (FIG. 16-16). The Hildesheim doors are huge in comparison, but the 16 individual panels stem from this tradition.

Bernward placed the bronze doors at the entrance to Saint Michael's from the cloister, where the monks would see them each time they walked into the church. The panels of the left door illustrate highlights from the biblical book of Genesis, beginning with the creation of Eve (at the top) and ending with the murder of Adam and Eve's son Abel by his brother Cain (at the bottom). The right door recounts the life of Christ (reading from the bottom up), starting with the Annunciation and terminating with the appearance to Mary Magdalene of Christ after the Resurrection (see "The Life of Jesus in Art," Chapter 11, pages 296–297). Together, the doors tell the story of Original Sin and ultimate redemption, showing the expulsion from the Garden of Eden and the path back to Paradise through the Christian Church. As in Early Christian times, the Old Testament was interpreted as prefiguring the New Testament (see "Jewish Subjects in Christian Art," Chapter 11, page 293). The panel depicting the Fall of Adam and Eve, for example, is juxtaposed with the Crucifixion on the other door. Eve nursing the infant Cain is opposite Mary with the Christ Child in her lap.

The composition of many of the scenes on the doors derives from Carolingian manuscript illumination, and the style of the figures has an expressive strength that brings to mind the illustrations in the *Utrecht Psalter* (FIG. 16-15). For example, in the fourth panel from the top on the left door, God, portrayed as a man, accuses Adam and Eve after their fall from grace. He jabs his finger at them with the force of his whole body. The force is concentrated in the gesture, which becomes the psychic focus of the whole composition. The frightened pair crouch, not only to hide their shame but also to escape the lightning bolt of divine wrath. Each passes the blame—Adam pointing backward to Eve and Eve pointing downward to the deceitful serpent. The starkly flat setting throws into relief the gestures and attitudes of rage, accusation, guilt, and fear. The sculptor presented the story with simplicity, although with great emotional impact, as well as a flair for anecdotal detail. Adam and Eve both struggle to point with one arm while attempting to shield their bodies from sight with the other. With an instinct for expressive pose and gesture, the artist brilliantly communicated their newfound embarrassment at their nakedness and their unconvincing denials of wrongdoing.

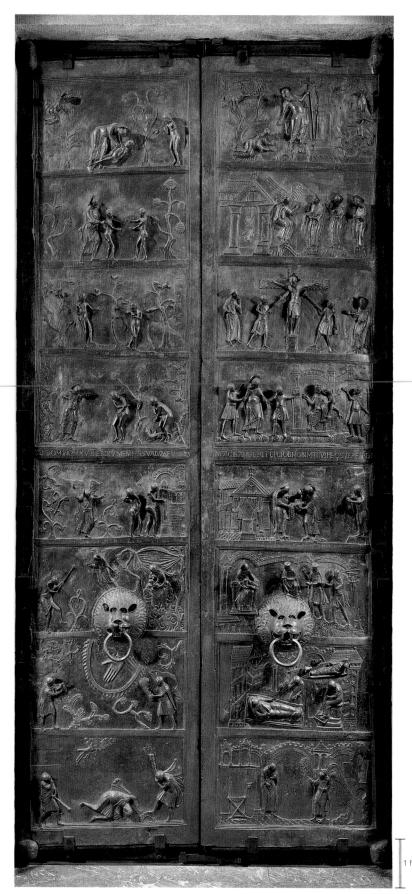

16-24 Doors with relief panels (Genesis, left door; life of Christ, right door), commissioned by Bishop Bernward for Saint Michael's, Hildesheim, Germany, 1015. Bronze, 16' 6" high. Dom-Museum, Hildesheim.

Bernward's doors vividly tell the story of Original Sin and ultimate redemption, and draw parallels between the Old and New Testaments, as in the expulsion from Paradise and the infancy and suffering of Christ.

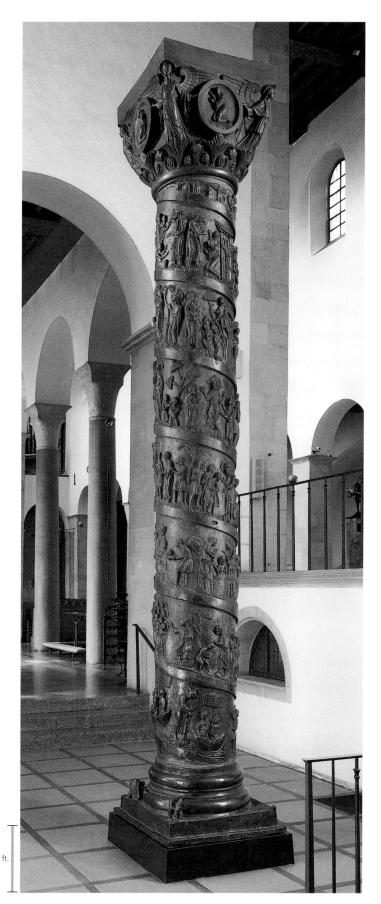

16-25 Column with reliefs illustrating the life of Christ, commissioned by Bishop Bernward for Saint Michael's, Hildesheim, Germany, ca. 1015–1022. Bronze, 12′ 6″ tall. Dom-Museum, Hildesheim.

Modeled on the Column of Trajan (FIG. 10-44) in Rome, the seven spiral bands of the Hildesheim column relate the life of Jesus from his baptism to his entry into Jerusalem, episodes Bernward's doors omitted.

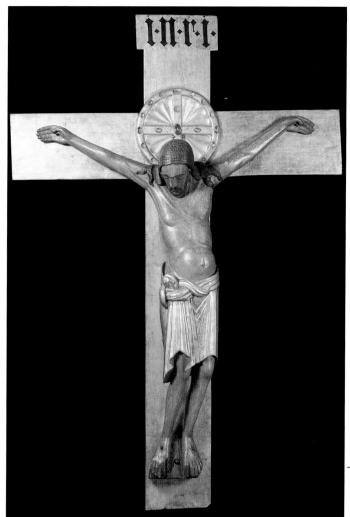

16-26 Crucifix commissioned by Archbishop Gero for Cologne Cathedral, Cologne, Germany, ca. 970. Painted wood, height of figure 6' 2". Cathedral, Cologne.

In this early example of the revival of monumental sculpture in the Middle Ages, an Ottonian sculptor depicted with unprecedented emotional power the intense agony of Christ's ordeal on the cross.

HILDESHEIM COLUMN The great doors of Saint Michael's were not the only large-scale examples of bronze-casting Bernward commissioned. Within the church stood a bronze spiral column (FIG. 16-25) that survives intact, save for its later capital and missing surmounting cross. The seven spiral bands of relief tell the story of Jesus' life in 24 scenes, beginning with his baptism and concluding with his entry into Jerusalem. These are the missing episodes from the story told on the church's doors. The narrative reads from bottom to top, exactly as on the Column of Trajan (FIG. 10-44) in Rome. That triumphal column was unmistakably the model for the Hildesheim column, even though the Ottonian narrative unfolds from right to left instead of from left to right. Once again, a monument in Rome provided the inspiration for the Ottonian artists working under Bernward's direction. Both the doors and the column of Saint Michael's lend credence to the Ottonian emperors' claim to be the heirs to Charlemagne's renovatio imperii Romani.

GERO CRUCIFIX Nowhere was the revival of interest in monumental sculpture more evident than in the crucifix (FIG. 16-26) Archbishop Gero commissioned and presented to Cologne Cathedral

16-27 Abbess Uta dedicating her codex to the Virgin, folio 2 recto of the *Uta Codex*, from Regensburg, Germany, ca. 1025. Tempera on parchment, $9\frac{5}{8}" \times 5\frac{1}{8}"$. Bayerische Staatsbibliothek, Munich.

The *Uta Codex* illustrates the important role that women could play both in religious life and as patrons of the arts. The dedicatory page shows Uta presenting her codex to the Virgin Mary.

their limit—those of his right shoulder and chest seem almost to rip apart. The halo behind Christ's head may foretell his subsequent Resurrection, but all the worshiper can sense is his pain. Gero's crucifix is the most powerful characterization of intense agony of the early Middle Ages.

in 970. Carved in oak and then painted and gilded, the six-foot-tall image of Christ nailed to the cross is both statue and *reliquary* (a shrine for sacred relics; see "Pilgrimages and the Cult of Relics," Chapter 17, page 432). A compartment in the back of the head held the Host. A later story tells how a crack developed in the wood of Gero's crucifix but miraculously healed. Similar tales of miracles are attached to many sacred Christian objects, for example, some Byzantine icons (see "Icons and Iconoclasm," Chapter 12, page 326).

The Gero crucifix presents a dramatically different conception of the Savior from that seen on the *Lindau Gospels* cover (FIG. 16-16), with its Early Christian imagery of the youthful Christ triumphant over death. The bearded Christ of the Cologne crucifix is more akin to Byzantine representations (FIG. 12-23) of the suffering Jesus, but the emotional power of the Ottonian work is greater still. The sculptor depicted Christ as an all-too-human martyr. Blood streaks down his forehead from the (missing) crown of thorns. His eyelids are closed, and his face is contorted in pain. Christ's body sags under its own weight. The muscles stretch to

UTA CODEX Ottonian artists carried on the Carolingian tradition of producing sumptuous books for the clergy and royalty alike. One of the finest is the lectionary produced at Regensburg, Germany, for Uta, abbess of Niedermünster. The Uta Codex illustrates the important role that women could play both in religious life and as patrons of the arts during the early Middle Ages. Uta was instrumental in bringing Benedictine reforms to the Niedermünster convent, whose nuns were usually the daughters of the local nobility. Uta herself was well known in Ottonian royal circles. Near the end of her life, she presented the nunnery with a luxurious codex containing many full-page illuminations interspersed with Gospel readings. The lectionary's gold, jewel, and enamel case also survives, underscoring the

16-28 Annunciation to the Shepherds, folio in the *Lectionary of Henry II*, from Reichenau, Germany, 1002–1014. Tempera on vellum, $1'5'' \times 1'1''$. Bayerische Staatsbibliothek, Munich.

The golden background of the illuminations in the *Lectionary of Henry II* reveals Byzantine influence on Ottonian art, which received added impetus when Otto II married the Byzantine princess Theophanu.

nature of medieval books as sacred objects to be venerated in their own right as well as embodiments of the eternal Word of God.

The dedicatory page (FIG. 16-27) at the front of the *Uta Codex* depicts the Virgin Mary with the Christ Child in her lap in the central medallion. Labeled *Virgo Virginum* (Virgin of Virgins), Mary is the model for Uta and the Niedermünster nuns. Uta is the full-length figure presenting a new book—*this* book—to the Virgin. An inscription accompanies the dedicatory image: "Virgin Mother of God, happy because of the divine Child, receive the votive offerings of your Uta of ready service." The artist painted Uta last, superimposing her figure upon the design and carefully placing it so that Uta's head touches the Virgin's medallion but does not penetrate it, suggesting the interplay between, but also the separation of, the divine and human realms.

LECTIONARY OF HENRY II Uta presented her codex to the Niedermünster convent about the time the last Ottonian emperor, Henry II (r. 1002–1024), died. The *Lectionary of Henry II*, a book of Gospel readings for the Mass, was a gift to Bamberg Cathedral. In the

full-page illumination (FIG. 16-28) of the Annunciation of Christ's birth to the shepherds, the angel has just alighted on a hill, his wings still beating, and the wind of his landing agitates his robes. The angel looms immense above the startled and terrified shepherds, filling the golden sky, as he extends his hand in a gesture of authority and instruction. Emphasized more than the message itself are the power and majesty of God's authority. The painting is a highly successful fusion of the Carolingian-Ottonian anecdotal narrative tradition, elements derived from

Late Antique painting—for example, the rocky landscape setting with grazing animals (FIG. 11-16)—and the golden background of Byzantine book illumination and mosaic decoration. Byzantine influence on Ottonian art had received added impetus when Otto II (r. 973–983) married a Byzantine princess (see "Theophanu: A Byzantine Princess in Ottonian Germany," page 428).

GOSPEL BOOK OF OTTO III Henry II's predecessor was his cousin, Otto III, son of Otto II and Theophanu. Of the three Ottos, the last dreamed the most of a revived Christian Roman Empire. Indeed, it was his life's obsession. Otto III was keenly aware of his descent from both German and Byzantine imperial lines. It is said that he was prouder of his Constantinopolitan than his German roots. He moved his court, with its Byzantine rituals, to Rome and there set up theatrically the symbols and trappings of Roman imperialism. Otto's romantic dream of imperial unity for Europe never materialized. He died prematurely, at age 21, and, at his own request, was buried beside Charlemagne at Aachen.

Theophanu, a Byzantine Princess in Ottonian Germany

The bishop of Mainz crowned Otto I king of the Saxons at Aachen in 936, but it was not until 962 that Pope John XII conferred the title of emperor of Rome upon him in Saint Peter's basilica. Otto, known as the Great, had ambitions to restore the glory of Charlemagne's Christian Roman Empire and to enlarge the territory under his rule. In 951 he defeated a Roman noble who had taken prisoner Adelaide, the widow of the Lombard king Lothar. Otto then married Adelaide, assumed the title of king of the Lombards, and extended his power south of the Alps. Looking eastward, in 972 he arranged the marriage of his son, Otto II, to Theophanu (ca. 955–991), the niece of the Byzantine emperor Nikephoros II Phokas. Otto was 60, Theophanu 17. They wed in Saint Peter's, with Pope John XIII presiding. When Otto the Great died the next year, Otto II succeeded him. The second Otto died in Italy in 983 and was buried in the atrium of Saint

Peter's. His son, Otto III, only three years old at the time, nominally became king, but it was his mother, Theophanu, co-regent with Adelaide until 985 and sole regent thereafter, who wielded power in the Ottonian Empire until her own death in 991. Adelaide then served as regent until Otto III was old enough to rule on his own. He became emperor of Rome in 996.

Theophanu brought not only the prestige of Byzantium to Germany but also Byzantine culture and art. The Ottonian court emulated much of the splendor and pomp of Constantinople and imported Byzantine luxury goods in great quantities. One surviving ivory panel, probably carved in the West but of Byzantine style and labeled in Greek, depicts Christ simultaneously blessing Otto II and Theophanu. The impact of Byzantine art in Ottonian Germany can also be seen in manuscript illumination (FIG. 16-28).

Otto III is portrayed in a Gospel book (FIG. 16-29) that takes his name. The illuminator represented the emperor enthroned, holding the scepter and cross-inscribed orb that represent his universal authority, conforming to a Christian imperial iconographic tradition that went back to Constantine (FIG. 10-81, right). At his sides are the clergy and the barons (the Christian Church and the state), both aligned in his support. On the facing page (not illustrated), also derived from ancient Roman sources, female personifications of Slavinia, Germany, Gaul, and Rome—the provinces of the Ottonian Empire—bring tribute to the young emperor.

The ideal of a Christian Roman Empire gave partial unity to western Europe from the 9th through early 11th centuries. To this extent, ancient Rome lived on to the millennium, culminating in the frustrated ambition of Otto III. But with the death of Henry II in 1024, a new age began, and Rome ceased to be the deciding influence. Romanesque Europe instead found unity in a common religious heritage (see Chapter 17).

16-29 Otto III enthroned, folio 24 recto of the *Gospel Book of Otto III*, from Reichenau, Germany, 997–1000. Tempera on vellum, $1' 1'' \times 9\frac{3}{8}''$. Bayerische Staatsbibliothek, Munich.

Emperor Otto III, descended from both German and Byzantine imperial lines, appears in this Gospel book enthroned and holding the scepter and cross-inscribed orb that signify his universal authority.

1 in

EARLY MEDIEVAL EUROPE

ART OF THE WARRIOR LORDS, 5th to 10th Centuries

- After the fall of Rome in 410, the Huns, Vandals, Merovingians, Franks, Goths, and other non-Roman peoples competed for power and territory in the former northwestern provinces of the Roman Empire.
- The surviving art of this period consists almost exclusively of small-scale status symbols, especially portable items of personal adornment such as bracelets, pins, and belt buckles, often featuring cloisonné ornament. The decoration of these early medieval objects displays a variety of abstract and zoomorphic motifs. Especially characteristic are intertwined animal and interlace patterns.

Sutton Hoo purse cover, ca. 625

CHRISTIAN ART: SCANDINAVIA, BRITISH ISLES, SPAIN, 6th to 10th Centuries

- The Christian art of the early medieval British Isles is called Hiberno-Saxon (or Insular). The most important extant artworks are the illuminated manuscripts produced in the monastic scriptoria of Ireland and Northumbria. The most distinctive features of these Insular books are the full pages devoted neither to text nor to illustration but to pure embellishment in the form of carpet pages made up of decorative panels of abstract and zoomorphic motifs. Some Hiberno-Saxon books also have full pages depicting each of the Four Evangelists or their symbols. Text pages often feature enlarged initial letters of important passages transformed into elaborate decorative patterns.
- In Spain, Visigothic churches of the sixth and seventh centuries were basilican in plan but had square apses and often incorporated horseshoe arches, a form usually associated with Islamic architecture.
- Scandinavian churches of the 11th century are notable for their carved wooden decoration recalling the pre-Christian art of the Vikings.

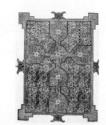

Lindisfarne Gospels, ca. 698-721

CAROLINGIAN ART, 768-877

- Charlemagne, king of the Franks since 768, expanded the territories he inherited from his father, and in 800, Pope Leo III crowned him emperor of Rome (r. 800–814). Charlemagne reunited much of western Europe and initiated a revival of the art and culture of Early Christian Rome.
- Carolingian illuminators merged the illusionism of classical painting with the northern linear tradition, replacing the calm and solid figures of their models with figures that leap from the page with frenzied energy.
- Carolingian sculptors revived the imperial Roman tradition of equestrian ruler portraiture and the Early Christian tradition of depicting Christ as a statuesque youth.
- Carolingian architects looked to Ravenna and Early Christian Rome for models, but transformed their sources, introducing, for example, the twin-tower western facade for basilicas and employing strict modular plans in their buildings.

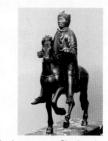

Charlemagne or Charles the Bald, ninth century

OTTONIAN ART, 919-1024

- In the mid-10th century, a new line of emperors, the Ottonians, consolidated the eastern part of Charlemagne's former empire and sought to preserve and enrich the culture and tradition of the Carolingian period.
- Ottonian architects built basilican churches with the towering spires and imposing westworks of their Carolingian models but introduced the alternate-support system and galleries into the interior elevation of the nave.
- Ottonian sculptors also began to revive the art of monumental sculpture in works such as the Gero crucifix and the colossal bronze doors of Saint Michael's at Hildesheim.
- Ottonian painting combines motifs and landscape elements from Late Antique art with the golden backgrounds of Byzantine art. Byzantine influence on Ottonian art became especially pronounced after Otto II married Theophanu in 972.

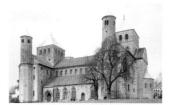

Saint Michael's, Hildesheim, 1001–1031

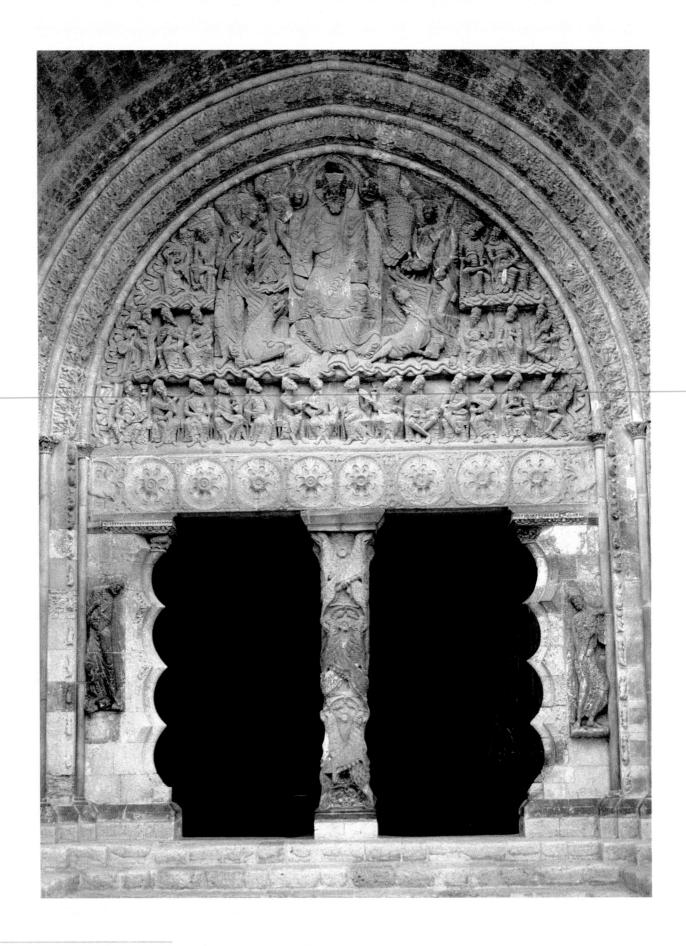

17-1 South portal of Saint-Pierre, Moissac, France, ca. 1115–1135.

Art historians first used the term *Romanesque* (Roman-like) to describe stone-vaulted churches of the 11th and 12th centuries, but the adjective also applies to the revival of monumental stone sculpture.

ROMANESQUE EUROPE

The Romanesque era is the first since Archaic and Classical Greece to take its name from an artistic style rather than from politics or geography. Unlike Carolingian and Ottonian art, named for emperors, or Hiberno-Saxon art, a regional term, *Romanesque* is a title art historians invented to describe medieval art that appeared "Roman-like." Architectural historians first employed the adjective in the early 19th century to describe European architecture of the 11th and 12th centuries. Scholars noted that certain architectural elements of this period, principally barrel and groin vaults based on the round arch, resembled those of ancient Roman architecture. Thus, the word distinguished most Romanesque buildings from earlier medieval timber-roofed structures, as well as from later Gothic churches with vaults resting on pointed arches (see Chapter 18). Scholars in other fields quickly borrowed the term. Today "Romanesque" broadly designates the history and culture of western Europe between about 1050 and 1200 (MAP 17-1).

In the early Middle Ages, the focus of life was the *manor*, or estate, of a landholding *liege lord*, who might grant rights to a portion of his land to *vassals*. The vassals swore allegiance to their liege and rendered him military service in return for use of the land and the promise of protection. But in the Romanesque period, a sharp increase in trade encouraged the growth of towns and cities, gradually displacing *feudalism* as the governing political, social, and economic system of late medieval Europe. Feudal lords granted independence to the new towns in the form of charters, which enumerated the communities' rights, privileges, immunities, and exemptions beyond the feudal obligations the vassals owed the lords. Often located on navigable rivers, the new urban centers naturally became the nuclei of networks of maritime and overland commerce.

Separated by design from the busy secular life of Romanesque towns were the monasteries (see "Medieval Monasteries," Chapter 16, page 420) and their churches. During the 11th and 12th centuries, thousands of ecclesiastical buildings were remodeled or newly constructed. This immense building enterprise was in part a natural by-product of the rise of independent cities and the prosperity they enjoyed. But it also was an expression of the widely felt relief and thanksgiving that the conclusion of the first Christian millennium in the year 1000 had not brought an end to the world, as many had feared. In the Romanesque age, the construction of churches became almost an obsession. Raoul Glaber (ca. 985–ca. 1046), a monk

Pilgrimages and the Cult of Relics

The cult of *relics* was not new in the Romanesque era. For centuries, Christians had traveled to sacred shrines that housed the body parts of, or objects associated with, the holy family or the saints. The faithful had long believed that bones, clothing, instruments of martyrdom, and the like had the power to heal body and soul. The veneration of relics reached a high point in the 11th and 12th centuries.

In Romanesque times, pilgrimage was the most conspicuous feature of public devotion, proclaiming the pilgrim's faith in the power of saints and hope for their special favor. The major shrines—Saint Peter's and Saint Paul's in Rome and the Church of the Holy Sepulchre in Jerusalem—drew pilgrims from all over Europe, just as Muslims journeyed from afar to Mecca (see "Muhammad and Islam," Chapter 13, page 343). To achieve salvation, Christian pilgrims braved bad roads and hostile wildernesses infested with robbers who preyed on innocent travelers. The journeys could take more than a year to completewhen they were successful. People often undertook pilgrimage as an act of repentance or as a last resort in their search for a cure for some physical disability. Hardship and austerity were means of increasing pilgrims' chances for the remission of sin or of dis-

ease. The distance and peril of the pilgrimage were measures of pilgrims' sincerity of repentance or of the reward they sought.

For those with insufficient time or money to make a pilgrimage to Rome or Jerusalem (in short, for most people at the time), holy destinations could be found closer to home. In France, for example, the church at Vézelay housed the bones of Mary Magdalene. Pilgrims could also view Saint Foy's remains at Conques, Lazarus's at Autun, Saint Martin's at Tours, and Saint Saturninus's at Toulouse. Each of these great shrines was also an important way station en route to the most venerated Christian shrine in western Europe, the tomb of Saint James at Santiago de Compostela in northwestern Spain.

Large crowds of pilgrims paying homage to saints placed a great burden on the churches that stored their relics and led to changes in church design, principally longer and wider naves and aisles, transepts and ambulatories with additional chapels (FIG. 17-5), and secondstory galleries (FIG. 17-6). Pilgrim traffic also established the routes that later became the major avenues of commerce and communication in western Europe. The popularity of pilgrimages gave rise to travel guides akin to modern guidebooks. These provided pilgrims with information about saints and shrines and also about roads, accommodations, food, and drink. How widely circulated these handwritten books were is a matter of debate, but the information they provide modern scholars is still invaluable. The most famous Romanesque guidebook described the four roads leading to Santiago de Compostela through Arles and Toulouse, Conques and Moissac, Vézelay and Périgueux, and Tours and Bordeaux (MAP 17-1). Saint James was the symbol of Christian resistance to Muslim expansion in western Europe, and his relics, discovered in the ninth century, drew pilgrims to Santiago de Compostela from far and wide. The guidebook's anonymous 12th-century author, possibly Aimery Picaud, a Cluniac

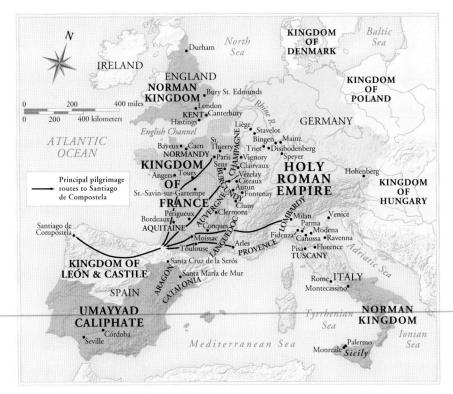

MAP 17-1 Western Europe around 1100.

monk, was himself a well-traveled pilgrim. According to the guide, the author wrote it "in Rome, in the lands of Jerusalem, in France, in Italy, in Germany, in Frisia and mainly in Cluny."*

Pilgrims reading the guidebook learned about the saints and their shrines at each stop along the way to Spain. Saint Saturninus of Toulouse, for example, endured a martyr's death at the hands of pagans when he

was tied to some furious and wild bulls and then precipitated from the height of the citadel. . . . His head crushed, his brains knocked out, his whole body torn to pieces, he rendered his worthy soul to Christ. He is buried in an excellent location close to the city of Toulouse where a large basilica [FIGS. 17-4 to 17-6] was erected by the faithful in his honor.

Given the competition among monasteries and cities for the possession of saints' relics, the *Pilgrim's Guide to Santiago de Compostela* also included comments on authenticity. For example, about Saint James's tomb, the author stated:

May therefore the imitators from beyond the mountains blush who claim to possess some portion of him or even his entire relic. In fact, the body of the Apostle is here in its entirety, divinely lit by paradisiacal carbuncles, incessantly honored with immaculate and soft perfumes, decorated with dazzling celestial candles, and diligently worshipped by attentive angels.[‡]

^{*} William Melczer, *The Pilgrim's Guide to Santiago de Compostela* (New York: Italica Press, 1993), 133.

[†] Ibid., 103.

[‡] Ibid., 127.

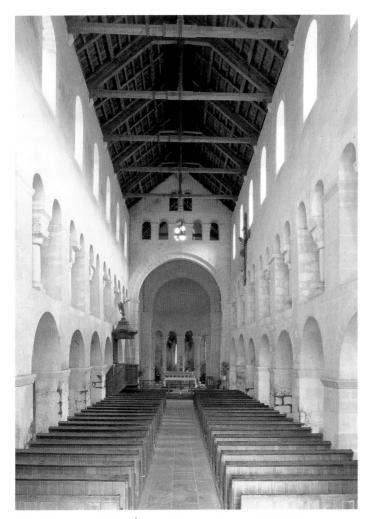

17-2 Interior of Saint-Étienne, Vignory, France, 1050–1057.

The timber-roofed abbey church of Saint Stephen at Vignory reveals a kinship with the three-story naves of Ottonian churches (FIG. 16-21), which also feature an alternate-support system of piers and columns.

who witnessed the coming of the new millennium, described the sudden boom in church building:

[After the] year of the millennium, which is now about three years past, there occurred, throughout the world, especially in Italy and Gaul, a rebuilding of church basilicas. Notwithstanding, the greater number were already well established and not in the least in need, nevertheless each Christian people strove against the others to erect nobler ones. It was as if the whole earth, having cast off the old by shaking itself, were clothing itself everywhere in the white robe of the church.¹

The enormous investment in ecclesiastical buildings and furnishings also reflected a significant increase in pilgrimage traffic in Romanesque Europe (see "Pilgrimages and the Cult of Relics," page 432). Pilgrims, along with wealthy landowners, were important sources of funding for monasteries that possessed the relics of venerated saints. The clergy of these monasteries vied with one another to provide magnificent settings for the display of their relics. Justification for such heavy investment in buildings and furnishings could be found in the Bible itself, for example in Psalm 26:8, "Lord, I have loved the beauty of your house, and the place where your glory dwells." Traveling pilgrims fostered the growth of towns as well as monasteries. Pilgrimages were, in fact, a major economic as well as conceptual catalyst for the art and architecture of the Romanesque period.

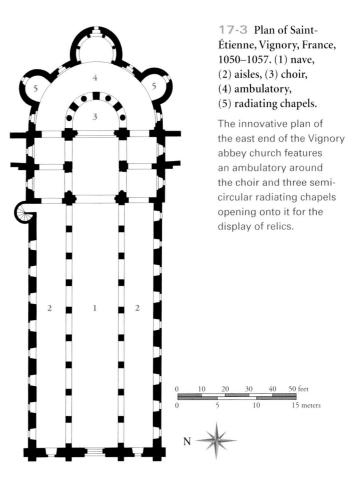

FRANCE AND NORTHERN SPAIN

Although art historians use the adjective "Romanesque" to describe 11th- and 12th-century art and architecture throughout Europe, pronounced regional differences exist. The discussion in this chapter deals in turn with Romanesque France and Spain, the Holy Roman Empire, Italy, and Normandy and England. To a certain extent, Romanesque art and architecture parallel European Romance languages, which vary regionally but have a common core in Latin, the language of the Romans.

Architecture and Architectural Sculpture

The regional diversity of the Romanesque period is very evident in architecture. For example, some Romanesque churches, especially in Italy, retained the wooden roofs of their Early Christian predecessors long after stone vaulting had become commonplace elsewhere. Even in France and northern Spain, home of many of the most innovative instances of stone vaulting, some Romanesque architects still built timber-roofed churches.

SAINT-ÉTIENNE, VIGNORY The mid-11th-century church of Saint-Étienne (Saint Stephen) at Vignory in the Champagne region of central France has strong ties to Carolingian-Ottonian architecture but already incorporates features that became widely adopted only in later Romanesque architecture. The interior (FIG. 17-2) reveals a kinship with the three-story wooden-roofed churches of the Ottonian era, for example, Saint Cyriakus (FIG. 16-21) at Gernrode. At Vignory, however, the second story is not a true *tribune* (upper gallery over the aisle opening onto the nave) but rather a screen with alternating piers and columns opening onto very tall flanking aisles. The east end of the church, in contrast, has an innovative plan (FIG. 17-3) with an

17-4 Aerial view (looking northwest) of Saint-Sernin, Toulouse, France, ca. 1070–1120.

Pilgrimages were a major economic catalyst for the art and architecture of the Romanesque period. The clergy vied with one another to provide magnificent settings for the display of holy relics.

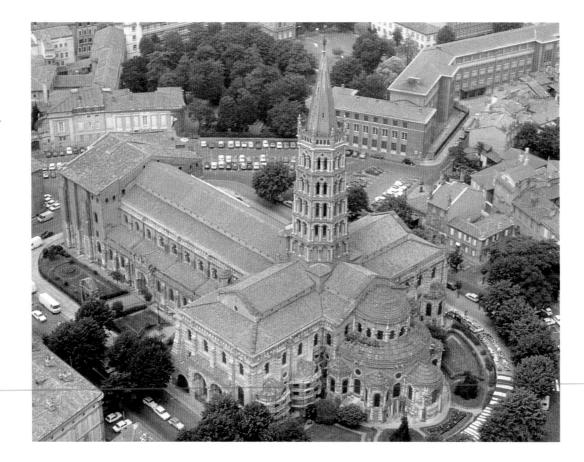

ambulatory around the choir and three semicircular chapels opening onto it. These *radiating chapels* probably housed the church's relics, which the faithful could view without having to enter the choir where the main altar stood.

Saint-Étienne is also an early example of the introduction of stone sculpture into Romanesque ecclesiastical architecture, one of the period's defining features. At Vignory, however, the only sculpture is the relief decoration of the capitals of the ambulatory and false tribunes where abstract and vegetal ornament, lions, and other quadrupeds are the exclusive motifs.

SAINT-SERNIN, TOULOUSE One of the earliest Romanesque examples of stone vaulting is the church of Saint-Sernin (Saint Saturninus; FIGS. 17-4 to 17-6) at Toulouse. Construction began

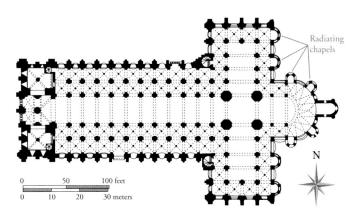

17-5 Plan of Saint-Sernin, Toulouse, France, ca. 1070–1120 (after Kenneth John Conant).

Increased traffic led to changes in church design. "Pilgrimage churches" such as Saint-Sernin have longer and wider naves and aisles, as well as transepts and ambulatories with radiating chapels for viewing relics.

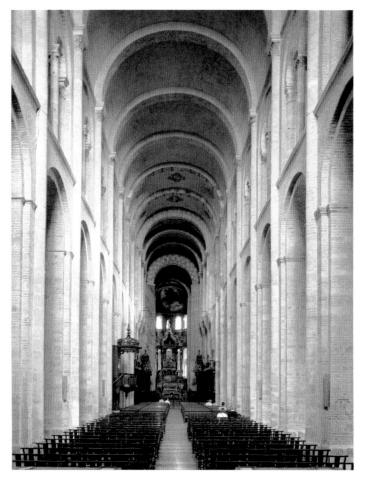

17-6 Interior of Saint-Sernin, Toulouse, France, ca. 1070-1120.

Saint-Sernin's groin-vaulted tribune galleries housed overflow crowds and buttressed the stone barrel vault over the nave. The transverse arches continue the lines of the compound piers.

Timber Roofs and Stone Vaults

The perils of wooden construction were the subject of frequent commentary among chroniclers of medieval ecclesiastical history. In some cases, churches burned repeatedly in the course of a single century and often had to be extensively repaired or completely rebuilt. In September 1174, for example, Canterbury Cathedral, which had been dedicated only 44 years earlier, was accidentally set ablaze and destroyed. Gervase of Canterbury (1141–1210), who entered the monastery at Canterbury in 1163 and wrote a history of the archbishopric from 1100 to 1199, provided a vivid eyewitness account of the disastrous fire in his *Chronica*:

[D] uring an extraordinarily violent south wind, a fire broke out before the gate of the church, and outside the walls of the monastery, by which three cottages were half destroyed. From thence, while the citizens were assembling and subduing the fire, cinders and sparks carried aloft by the high wind, were deposited upon the church, and being driven by the fury of the wind between the joints of the lead, remained there amongst the half-rotten planks, and shortly glowing with increased heat, set fire to the rotten rafters; from these the fire was communicated to the larger beams and their braces, no one yet perceiving or helping. For the well-painted ceiling below, and the sheet-lead covering above, concealed between them the fire that had arisen within.... But beams and braces burning, the flames arose to the slopes of the roof; and the sheets of lead yielded to the increasing heat and began to melt. Thus the raging wind, finding a freer entrance, increased the fury of the fire. . . . And now that the fire had loosened the beams from the pegs that bound them together, the half-burnt timbers fell into the choir below upon the seats of the monks; the seats, consisting of a great mass of woodwork, caught fire, and thus the mischief grew worse and worse. And it was marvellous, though sad, to behold how that glorious choir itself fed and assisted the fire that was destroying it. For the flames multiplied by this mass

of timber, and extending upwards full fifteen cubits [about twenty-five feet], scorched and burnt the walls, and more especially injured the columns of the church.... In this manner the house of God, hitherto delightful as a paradise of pleasures, was now made a despicable heap of ashes, reduced to a dreary wilderness.*

After the fire, the Canterbury monks summoned a master builder from Sens, a French city 75 miles southeast of Paris, to supervise the construction of their new church. Gervase reported that the first task William of Sens tackled was "the procuring of stone from beyond the sea."

A quest for fireproof structures, however, seems not to have been the primary rationale for stone vaulting. Although protection from devastating conflagrations was no doubt one of the attractions of building stone roofs in an age when candles provided interior illumination, other factors probably played a greater role in the decision to make the enormous investment that stone masonry required. The rapid spread of stone vaulting throughout Romanesque Europe is most likely the result of the clergy's desire to provide a suitably majestic setting for the display of relics as well as enhanced acoustics for the Christian liturgy and the music that accompanied it. Some contemporaneous texts, in fact, comment on the visual impact of costly stone vaults. For example, in 1150 at Angers in northwestern France, a church chronicler explained what the bishop sought to achieve by replacing the timber roof of his cathedral with stone vaults: "[He] took down the timber beams of the nave of the church, threatening to fall from sheer old age, and began to build stone vaults of wondrous effect."

* Translated by Robert Willis. Quoted in Elizabeth Gilmore Holt, *A Documentary History of Art*, 2d ed. (Princeton, N.J.: Princeton University Press, 1981), 1:52–54.
† Translated by John Hooper Harvey, *The Medieval Architect* (London: Waylan, 1972), 39.

around 1070 to honor the city's first bishop, a martyr saint of the middle of the third century. Toulouse was an important stop on the pilgrimage road through southwestern France to Santiago de Compostela (MAP 17-1). Large congregations were common at the shrines along the great pilgrimage routes, and the unknown architect designed Saint-Sernin to accommodate them. The grand scale of the building is apparent in the aerial view (FIG. 17-4), which includes automobiles, trucks, and nearly invisible pedestrians. The church's 12th-century exterior is still largely intact, although the two towers of the western facade (at the left in FIG. 17-4) were never completed, and the prominent crossing tower dates to the Gothic and later periods. Saint-Sernin's plan (FIG. 17-5) closely resembles those of the churches of Saint James at Santiago de Compostela and Saint Martin at Tours, and exemplifies the building type that has come to be called the "pilgrimage church." At Toulouse, the designer increased the length of the nave, doubled the side aisles, and added a transept, ambulatory, and radiating chapels to provide additional space for pilgrims and the clergy. Radiating chapels opening onto an ambulatory already were a feature of Vignory's abbey church (FIG. 17-3), but at Toulouse the chapels are greater in number and attached to the transept as well as to the ambulatory.

The Saint-Sernin plan is extremely regular and geometrically precise. The crossing square, flanked by massive piers and marked off by heavy arches, served as the module for the entire church. Each nave bay, for example, measures exactly one-half of the crossing square, and each aisle bay measures exactly one-quarter. The builders employed similar simple ratios throughout the church. The first suggestion of this kind of planning scheme in medieval Europe was the Saint Gall monastery plan (FIG. 16-19), almost three centuries earlier. The Toulouse solution was a crisply rational and highly refined realization of an idea first seen in Carolingian architecture. This approach to design became increasingly common in the Romanesque period.

Another telling feature of Saint-Sernin's design is the insertion of tribunes over the inner aisle and opening onto the nave (FIG. 17-6). These galleries housed overflow crowds on special occasions and played an important role in buttressing the continuous semicircular cut-stone *barrel vault* that covers Saint-Sernin's nave, in contrast to the timber roof over the nave (FIG. 17-2) of the smaller abbey church at Vignory (see "Timber Roofs and Stone Vaults," above). *Groin vaults* (indicated by Xs on the plan, FIG. 17-5) in the tribunes as well as in the ground-floor aisles absorbed the pressure exerted by the barrel

vault along the entire length of the nave and transferred the main thrust to the thick outer walls.

The builders of Saint-Sernin were not content with just buttressing the massive nave vault. They also carefully coordinated the design of the vault with that of the nave arcade below and with the modular plan of the building as a whole. The geometric floor plan (FIG. 17-5) is fully reflected in the nave walls (FIG. 17-6), where engaged columns (attached half-columns) embellish the piers marking the corners of the bays. Architectural historians refer to piers with columns or pilasters attached to their rectangular cores as compound piers. At Saint-Sernin the engaged columns rise from the bottom of the compound piers to the vault's springing (the lowest stone of an arch) and continue across the nave as transverse arches. As a result, the Saint-Sernin nave seems to be composed of numerous identical vertical volumes of space placed one behind the other, marching down the building's length in orderly procession. Saint-Sernin's spatial organization corresponds to and renders visually the plan's geometric organization. The articulation of the building's exterior walls (FIG. 17-4), where buttresses frame each bay, also reflects the segmentation of the nave. This rationally integrated scheme, with repeated units decorated and separated by moldings, had a long future in later church architecture in the West.

CHRIST IN MAJESTY Saint-Sernin also features one of the earliest precisely dated series of large Romanesque figure reliefs a group of seven marble slabs representing angels, apostles, and Christ. An inscription states that the reliefs date to the year 1096 and that the artist was Bernardus Gelduinus. Today the plaques are affixed to the church's ambulatory wall. Their original location is uncertain. Some scholars have suggested they once formed part of a shrine dedicated to Saint Saturninus that stood in the crypt (a vaulted underground chamber) of the grand pilgrimage church. Others believe the reliefs once decorated a choir screen or an exterior portal. The relief illustrated here (FIG. 17-7), the centerpiece of the group, depicts Christ in Majesty seated in a mandorla, his right hand raised in blessing, his left hand resting on an open book inscribed with the words Pax vobis ("peace be unto you"). The signs of the four evangelists (see "The Four Evangelists," Chapter 16, page 412) occupy the corners of the slab. Art historians debate the sources of Bernardus's style, but such a composition could have been used earlier for a Carolingian or Ottonian work in metal or ivory, perhaps a book cover. The polished marble has the gloss of both materials, and the sharply incised lines and ornamentation of Christ's aureole are characteristic of pre-Romanesque metalwork.

Stone sculpture, with some notable exceptions, such as the great crosses (FIG. 16-9) of the British Isles, had almost disappeared from the art of western Europe during the early Middle Ages. The revival of stonecarving is a hallmark of the Romanesque age—and one reason the period is aptly named. The inspiration for stone sculpture no doubt came, at least in part, from the abundant remains of ancient statues and reliefs throughout Rome's northwestern provinces. Yet these models had been available for centuries, so their presence cannot explain the sudden proliferation of stone sculpture in Romanesque churches. Many art historians have noted that the reemergence of monumental stone sculpture coincided with the introduction of stone vaulting in Romanesque churches. But medieval builders had erected stone-walled churches and monumental westworks for centuries, even if the structures bore timber ceilings and roofs. The earliest Romanesque sculptures, in fact, appear in timber-roofed churches, such as Saint-Étienne (FIG. 17-2) at Vignory. Therefore, the addition of stone vaults to basilican churches cannot explain the resurgence of

17-7 Bernardus Gelduinus, Christ in Majesty, relief in the ambulatory of Saint-Sernin, Toulouse, France, ca. 1096. Marble, 4' 2" high.

One of the earliest series of large Romanesque figure reliefs decorated the pilgrimage church of Saint-Sernin. The models were probably Carolingian and Ottonian book covers in metal or ivory.

stonecarving in the Romanesque period. But just as stone vaulting reflects the greater prosperity of the age, so too does decorating churches with large-scale sculptures. Both are consistent with the widespread desire in the Romanesque period to beautify the house of God and make it, in the words of Gervase of Canterbury, "a paradise of pleasures."

The popularity of stone sculpture in the 12th century also reflects the changing role of many churches in western Europe. In the early Middle Ages, most churches served small monastic communities, and the worshipers were primarily or exclusively clergy. With the rise of towns in the Romanesque period, churches, especially those on the major pilgrimage routes, increasingly served the lay public. The display of sculpture both inside and outside Romanesque churches was a means of impressing—and educating—a new and largely illiterate audience.

CLUNY III The primary patrons of Romanesque sculpture were the monks of the Cluniac order. In 909 William the Pious, duke of Aquitaine (r. 893–918), donated land near Cluny in Burgundy to a community of reform-minded Benedictine monks under the leadership of Berno of Baume (d. 927). Because William waived his feudal rights to the land, the abbot of Cluny was subject only to the pope in Rome, a unique privilege. Berno founded a new order at Cluny according to the rules of Saint Benedict (see "Medieval Monasteries and Benedictine Rule," Chapter 16, page 420). Under Berno's successors, the Cluniac monks became famous for their scholarship,

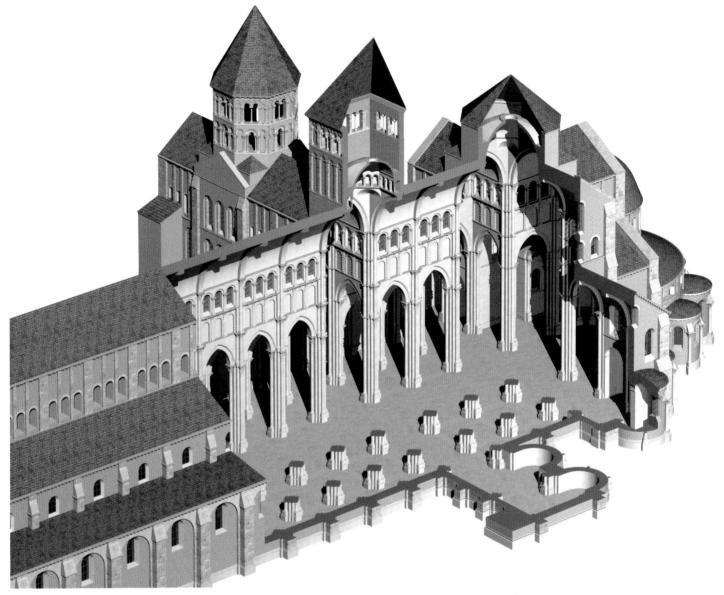

17-8 Restored cutaway view of the third abbey church (Cluny III), Cluny, France, 1088–1130 (John Burge).

Cluny III was the largest church in Europe for 500 years. It had a 500-foot-long, three-story (arcade-tribune-clerestory) nave, four aisles, radiating chapels, and slightly pointed stone barrel vaults.

music, and art. Their influence and wealth grew rapidly, and they built a series of increasingly elaborate monastic churches at Cluny.

Abbot Hugh of Semur (1024-1109) began construction of the third church at Cluny in 1088. Called Cluny III by art historians, the building is, unfortunately, largely destroyed today, although scholars have reconstructed it on paper (FIG. 17-8). At the time of its erection, Cluny III was the largest church in Europe, and it retained that distinction for almost 500 years until the completion of the new Saint Peter's (FIG. 24-4) in Rome in the early 17th century. Contemporaries considered Cluny III a place worthy for angels to dwell if they lived on earth. The church had a bold and influential design, with a barrel-vaulted nave, four aisles, and radiating chapels, as at Saint-Sernin, but with a three-story nave elevation (arcade-tribuneclerestory) and slightly pointed nave vaults. With a nave more than 500 feet long and more than 100 feet high (both dimensions are about 50 percent greater than at Saint-Sernin), Cluny III epitomized the grandiose scale of the new stone-vaulted Romanesque churches and was a symbol of the power and prestige of the Cluniac order. SAINT-PIERRE, MOISSAC Moissac, an important stop in southwestern France along the pilgrimage route to Saint James's tomb at Santiago de Compostela, boasts the most extensive preserved ensemble of early Romanesque sculpture. The monks of the Moissac abbey had joined the Cluniac order in 1047. Enriched by the gifts of pilgrims and noble benefactors, they adorned their church with an elaborate series of relief sculptures, the oldest of which are in the cloister (FIG. 17-9). "Cloister" (from the Latin claustrum, "enclosed place") connotes being shut away from the world. Architecturally, the medieval church cloister embodied the seclusion of the spiritual life, the vita contemplativa. At Moissac, as elsewhere, the cloister provided the monks (and nuns) with a foretaste of Paradise. In its garden or the timber-roofed columnar walkway that framed the garden (FIG. 17-9, left), they could read their devotions, pray, and meditate in an atmosphere of calm serenity, each monk withdrawn into the private world where the soul communes only with God. The physical silence of the cloister matched the vow of silence that the more austere monastic communities required of their members.

Bernard of Clairvaux on Cloister Sculpture

The most influential theologian of the Romanesque era was Bernard of Clairvaux (1090–1153). A Cistercian monk and abbot of the monastery he founded at Clairvaux in northern Burgundy, he embodied not only the reforming spirit of the Cistercian order but also the new religious fervor awakening in western Europe. Bernard's impassioned eloquence made him a European celebrity and drew him into the stormy politics of the Romanesque era. He intervened in high ecclesiastical and secular matters, defended and sheltered embattled popes, counseled kings, denounced heretics, and preached Crusades against the Muslims (see "The Crusades," page 442)—all in defense of papal Christianity and spiritual values. The Church declared Bernard a saint in 1174, barely two decades after his death.

In a letter Bernard wrote in 1127 to William, abbot of Saint-Thierry, he complained about the rich outfitting of non-Cistercian churches in general and the sculptural adornment of monastic cloisters in particular:

I will overlook the immense heights of the places of prayer, their immoderate lengths, their superfluous widths, the costly refinements,

and painstaking representations which deflect the attention ... of those who pray and thus hinder their devotion.... But so be it, let these things be made for the honor of God [But] in the cloisters, before the eyes of the brothers while they read—what ... are the filthy apes doing there? The fierce lions? The monstrous centaurs? The creatures, part man and part beast? ... You may see many bodies under one head, and conversely many heads on one body. On one side the tail of a serpent is seen on a quadruped, on the other side the head of a quadruped is on the body of a fish. Over there an animal has a horse for the front half and a goat for the back Everywhere so plentiful and astonishing a variety of contradictory forms is seen that one would rather read in the marble than in books, and spend the whole day wondering at every single one of them than in meditating on the law of God. Good God! If one is not ashamed of the absurdity, why is one not at least troubled at the expense?*

* Apologia 12.28–29. Translated by Conrad Rudolph, The "Things of Greater Importance": Bernard of Clairvaux's Apologia and the Medieval Attitude toward Art (Philadelphia: University of Pennsylvania Press, 1990), 279, 283.

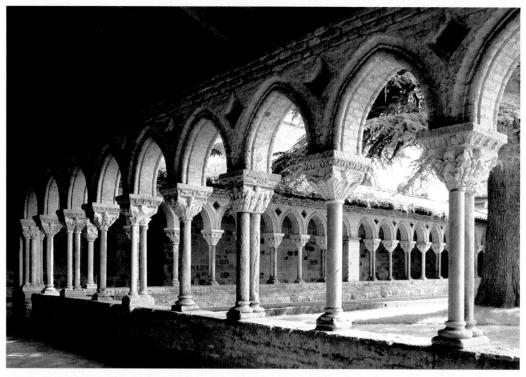

1 ft.

17-9 General view of the cloister (*left*) and detail of the pier with the relief of Abbot Durandus (*right*), Saint-Pierre, Moissac, France, ca. 1100–1115. Relief: limestone, 6' high.

The revived tradition of stonecarving seems to have begun with decorating capitals with reliefs. The most extensive preserved ensemble of sculptured early Romanesque capitals is in the Moissac cloister.

The monastery cloisters of the 12th century are monuments to the vitality, popularity, and influence of monasticism at its peak.

Moissac's cloister sculpture program consists of large figural reliefs on the piers as well as *historiated* (ornamented with figures) capitals on the columns. The pier reliefs (FIG. 17-9, *right*) portray the 12 apostles and the first Cluniac abbot of Moissac, Durandus

(1047–1072), who was buried in the cloister. The 76 capitals alternately crown single and paired column shafts. They are variously decorated, some with abstract patterns, many with biblical scenes or the lives of saints, others with fantastic monsters of all sorts—basilisks, griffins, lizards, gargoyles, and more. *Bestiaries*—collections of illustrations of real and imaginary animals—became very

The Romanesque Church Portal

ne of the most significant and distinctive features of Romanesque art is the revival of monumental sculpture in stone. Large-scale carved Old and New Testament figures were extremely rare in Christian art before the Romanesque period. But in the late 11th and early 12th centuries, rich ensembles of figural reliefs began to appear again, most often in the grand stone portals (FIG. 17-1) through which the faithful had to pass. The clergy had placed sculpture in church doorways before. For example, carved wooden doors greeted Early Christian worshipers as they entered Santa Sabina in Rome, and Ottonian bronze doors (FIG. 16-24) decorated with Old and New Testament scenes marked the entrance to Saint Michael's at Hildesheim. But these were exceptions, and in the Romanesque era (and during the Gothic period that followed), sculpture usually appeared in the area surrounding the doors, not on them.

Shown in Fig. 17-10 are the parts of church portals that Romanesque sculptors regularly decorated with figural reliefs:

- *Tympanum* (FIGS. 17-1, 17-12, and 17-13), the prominent semi-circular *lunette* above the doorway proper, comparable in importance to the triangular pediment of a Greco-Roman temple.
- *Voussoirs* (FIG. 17-13), the wedge-shaped blocks that together form the *archivolts* of the arch framing the tympanum.
- Lintel (FIGS. 17-12 and 17-13), the horizontal beam above the doorway.
- *Trumeau* (FIGS. 17-1 and 17-11), the center post supporting the lintel in the middle of the doorway.
- **■** *Jambs* (FIG. 17-1), the side posts of the doorway.

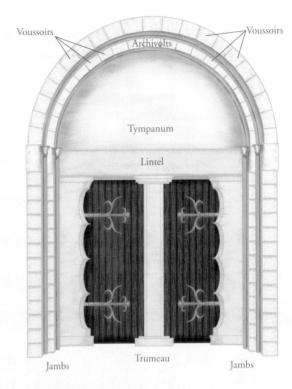

17-10 The Romanesque church portal.

The clergy considered the church doorway the beginning of the path to salvation through Christ. Many Romanesque churches feature didactic sculptural reliefs above and beside the entrance portals.

popular in the Romanesque age. The monstrous forms were reminders of the chaos and deformity of a world without God's order. Medieval artists delighted in inventing composite beasts, often with multiple heads, and other fantastic creations. Historiated capitals were also a feature of Moissac's mother church, Cluny III, and were common in Cluniac monasteries.

Not everyone shared the enthusiasm of the Cluniac monks for stone sculpture. One group of Benedictine monks founded a new order at Cîteaux in eastern France in 1098. The Cistercians (so called from the Latin name for Cîteaux) split from the Cluniac order to return to the strict observance of the Rule of Saint Benedict, changing the color of their habits from Cluniac black to unbleached white. These so-called White Monks emphasized productive manual labor, and their systematic farming techniques stimulated the agricultural transformation of Europe. The Cistercian movement expanded with astonishing rapidity. Within a half century, more than 500 Cistercian monasteries had been established. The Cistercians rejected figural sculpture as a distraction from their devotions. The most outspoken Cistercian critic of church sculpture was Abbot Bernard of Clairvaux (see "Bernard of Clairvaux on Cloister Sculpture," page 438).

SOUTH PORTAL, MOISSAC Bernard directed his tirade against figural sculpture primarily at monks who allowed the carvings to distract them from their meditations. But at Moissac and other Cluniac churches, sculpture also appears outside the cloister. Saint-Pierre's south portal (FIG. 17-1), facing the town square, fea-

tured even more lavish decoration than did its cloister. The portal's vast tympanum (see "The Romanesque Church Portal," above) depicts the Second Coming of Christ as King and Judge of the world in its last days. As befits his majesty, the enthroned Christ is at the center, reflecting a compositional rule followed since Early Christian times. The signs of the four evangelists flank him. To one side of each pair of signs is an attendant angel holding scrolls to record human deeds for judgment. The figures of crowned musicians, which complete the design, are the 24 elders who accompany Christ as the kings of this world and make music in his praise. Each turns to face him, much as would the courtiers of a Romanesque monarch in attendance on their lord. Two courses of wavy lines symbolizing the clouds of Heaven divide the elders into three tiers.

Christ was the most common central motif in sculptured Romanesque portals. The pictorial programs of Romanesque church facades reflect the idea—one that dates to Early Christian times—that Christ is the door to salvation ("I am the door; who enters through me will be saved"—John 10:9). An inscription on the tympanum of the late 11th-century monastic church of Santa Cruz de la Serós in Spain made this message explicit: "I am the eternal door. Pass through me faithful. I am the source of life."²

Many variations exist within the general style of Romanesque sculpture, as within Romanesque architecture. The figures of the Moissac tympanum (FIG. 17-1) contrast sharply with those of the Saint-Sernin ambulatory reliefs (FIG. 17-7). The extremely elongated bodies of the recording angels, the cross-legged dancing pose of

17-11 Lions and Old Testament prophet (Jeremiah or Isaiah?), trumeau of the south portal of Saint-Pierre, Moissac, France, ca. 1115–1130.

This animated prophet displays the scroll recounting his vision. His position below the apparition of Christ as Last Judge is in keeping with the tradition of pairing Old and New Testament themes.

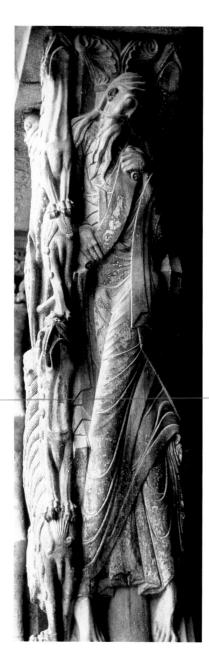

Saint Matthew's angel, and the jerky, hinged movement of the elders' heads are characteristic of the nameless Moissac master's style of representing the human figure. The zigzag and dovetail lines of the draperies, the bandlike folds of the torsos, the bending back of the hands against the body, and the wide cheekbones are also common features of this distinctive style. The animation of the individual figures, however, contrasts with the stately monumentality of the composition as a whole, producing a dynamic tension in the tympanum.

Below the tympanum are a richly decorated trumeau (FIG. 17-11) and elaborate door jambs with scalloped contours (FIG. 17-1), the latter a borrowing from Islamic architecture (FIG. 13-12). On the trumeau's right face is a prophet identified as Jeremiah by some scholars, as Isaiah by others. Whoever the prophet is, he displays the scroll where his prophetic vision is written. His position below the apparition of Christ as the apocalyptic Judge is yet another instance of the pairing of Old and New Testament themes. This is in keeping with an iconographic tradition established in Early Christian times (see "Jewish Subjects in Christian Art," Chapter 11, page 293). The prophet's figure is very tall and thin, in the manner of the tympanum angels, and, like Matthew's angel, he executes a cross-legged

step. The animation of the body reveals the passionate nature of the soul within. The flowing lines of the drapery folds ultimately derive from manuscript illumination and here play gracefully around the elegant figure. The long, serpentine locks of hair and beard frame an arresting image of the dreaming mystic. The prophet seems entranced by his vision of what is to come, the light of ordinary day unseen by his wide eyes.

Six roaring interlaced lions fill the trumeau's outer face (FIG. 17-1). The animal world was never far from the medieval mind, and people often associated the most fiercely courageous animals with kings and barons—for example, Richard the Lionhearted, Henry the Lion, and Henry the Bear. Lions were the church's ideal protectors. In the Middle Ages, people believed lions slept with their eyes open. But the notion of placing fearsome images at the gateways to important places is of ancient origin. Ancestors of the interlaced lions at Moissac include the lions and composite monsters that guarded the palaces of Near Eastern and Mycenaean kings (FIGS. 2-18, 2-21, and 4-19) and the panthers and leopards in Greek temple pediments (FIG. 5-17) and Etruscan tombs (FIG. 9-9).

SAINT-LAZARE, AUTUN In 1132, the Cluniac bishop Étienne de Bage consecrated the Burgundian cathedral of Saint-Lazare (Saint Lazarus) at Autun. For its tympanum (FIG. 17-12), he commissioned the sculptor GISLEBERTUS to carve a dramatic vision of the Last Judgment, which four trumpet-blowing angels announce. In the tympanum's center, far larger than any other figure, is Christ, enthroned in a mandorla. He dispassionately presides over the separation of the Blessed from the Damned. At the left, an obliging angel boosts one of the Blessed into the heavenly city. Below, the souls of the dead line up to await their fate. Two of the men near the center of the lintel carry bags emblazoned with a cross and a shell. These are the symbols of pilgrims to Jerusalem and Santiago de Compostela. Those who had made the difficult journey would be judged favorably. To their right, three small figures beg an angel to intercede on their behalf. The angel responds by pointing to the Judge above. On the right side (FIG. I-6) are those who will be condemned to Hell. Giant hands pluck one poor soul from the earth. Directly above, in the tympanum, is one of the most unforgettable renditions of the weighing of souls in the history of art (compare FIG. 16-9). Angels and devils compete at the scales, each trying to manipulate the balance for or against a soul. Hideous demons guffaw and roar. Their gaunt, lined bodies, with legs ending in sharp claws, writhe and bend like long, loathsome insects. A devil, leaning from the dragon mouth of Hell, drags souls in, while above him a howling demon crams souls headfirst into a furnace. The resources of the Romanesque imagination conjured an appalling scene.

The Autun tympanum must have inspired terror in the believers who passed beneath it as they entered the cathedral. Even those who could not read could, in the words of Bernard of Clairvaux, "read in the marble." For the literate, the Autun clergy composed explicit written warnings to reinforce the pictorial message and had the words engraved in Latin on the tympanum. For example, beneath the weighing of souls (FIG. I-6), the inscription reads, "May this terror terrify those whom earthly error binds, for the horror of these images here in this manner truly depicts what will be."³ The admonition echoes the sentiment expressed in the colophon of a mid-10th-century illustrated copy of Beatus of Liébana's Commentary on the Apocalypse. There, the painter Magius (teacher of Emeterius; see FIG. 16-11) explained the purpose of his work: "I have painted a series of pictures for the wonderful words of [the Apocalypse] stories, so that the wise may fear the coming of the future judgment of the world's end."4

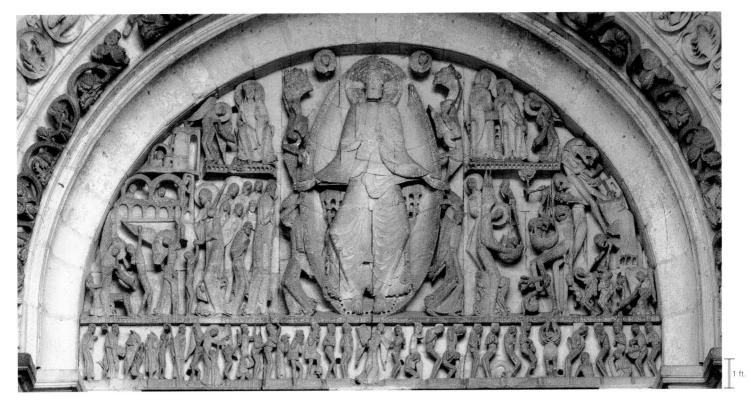

17-12 GISLEBERTUS, Last Judgment, west tympanum of Saint-Lazare, Autun, France, ca. 1120-1135. Marble, 21' wide at base.

Christ in a mandorla presides over the separation of the Blessed from the Damned in this dramatic vision of the Last Judgment, designed to terrify those guilty of sin and beckon them into the church.

LA MADELEINE, VÉZELAY While Gislebertus was at work at Autun, nearby at the church of La Madeleine (Mary Magdalene) at Vézelay an unnamed sculptor was busy carving an even more elaborate tympanum (FIG. 17-13) over the central portal to the church's narthex. Vézelay is more closely associated with the Cru-

sades (see "The Crusades," page 442) than any other church in Europe. Pope Urban II had intended to preach the launching of the First Crusade at Vézelay in 1095, although he delivered the sermon at Clermont instead. In 1147, Bernard of Clairvaux called for the Second Crusade at Vézelay, and King Louis VII of France took up the

17-13 Pentecost and Mission of the Apostles, tympanum of the center portal of the narthex of La Madeleine, Vézelay, France, 1120-1132.

The light rays emanating from Christ's hands represent the instilling of the Holy Spirit in the apostles. On the lintel and in eight compartments around the tympanum, the heathen wait to be converted.

The Crusades

n 1095, Pope Urban II (r. 1088–1099) delivered a stirring sermon at the Council of Clermont in which he called for an assault on the Holy Land:

[Y]our brethren who live in the East are in urgent need of your help ... [because] the Turks and Arabs have attacked them ... They have killed and captured many, and have destroyed the churches ... I, or rather the Lord, beseech you as Christ's heralds ... to persuade all people of whatever rank, foot-soldiers and knights, poor and rich, to carry aid promptly to those Christians and to destroy that vile race from the lands of our friends. ... All who die by the way ... shall have immediate remission of sins. ... Let those who go not put off the journey, but rent their lands and collect money for their expenses ... [and] eagerly set out on the way with God as their guide.*

Between 1095 and 1190, Christians launched three great Crusades from France. The *Crusades* ("taking of the Cross") were mass armed pilgrimages whose stated purpose was to wrest the Christian shrines of the Holy Land from Muslim control. Similar vows bound Crusaders and pilgrims. They hoped not only to atone for sins and win salvation but also to glorify God and extend the power of the Christian Church. The joint action of the papacy and the mostly French feudal lords in this type of holy war strengthened papal authority over the long run and created an image of Christian solidarity.

The symbolic embodiment of the joining of religious and secular forces in the Crusades was the Christian warrior, the fighting

* As recorded by Fulcher of Chartres (1059–ca. 1127). Translated by O. J. Thatcher and E. H. McNeal, quoted in Roberta Anderson and Dominic Aidan Bellenger, eds., *Medieval Worlds: A Sourcebook* (New York: Routledge, 2003), 88–90.

priest, or the priestly fighter. From the early medieval warrior evolved the Christian knight, who fought for the honor of God rather than in defense of his chieftain. The first and most typical of the crusading knights were the Knights Templar. After the Christian conquest of Jerusalem in 1099, they stationed themselves next to the Dome of the Rock (FIG. 13-2), that is, on the site of Solomon's Temple, the source of their name. Their mission was to protect pilgrims visiting the recovered Christian shrines. Formally founded in 1118, the Knights Templar order received the blessing of Bernard of Clairvaux, who gave them a rule of organization based on that of his own Cistercians. Bernard justified their militancy by declaring that "the knight of Christ" is "glorified in slaying the infidel . . . because thereby Christ is glorified," and the Christian knight then wins salvation. The Cistercian abbot saw the Crusades as part of the general reform of the Church and as the defense of the supremacy of Christendom. He himself called for the Second Crusade in 1147. For the Muslims, however, the Crusaders were nothing more than violent invaders who slaughtered the population of Jerusalem (Jewish as well as Muslim) when they took the city in July 1099.

In the end, the Muslims expelled the Christian armies. The Crusaders failed miserably in their attempt to regain the Holy Land. But in western Europe, the Crusades had much greater impact by increasing the power and prestige of the towns. Italian maritime cities such as Pisa (FIG. 17-25) thrived on the commercial opportunities presented by the transportation of Crusaders overseas. Many communities purchased their charters from the barons who owned their land when the latter needed to finance their campaigns in the Holy Land, and a middle class of merchants and artisans arose to rival the power of the feudal lords and the great monasteries.

cross there. Finally, the Vézelay church was the site where King Richard the Lionhearted of England and King Philip Augustus of France set out on the Third Crusade in 1190.

The Vézelay tympanum depicts the Pentecost and the Mission of the Apostles. As related in Acts 1:4–9, Christ foretold that the 12 apostles would receive the power of the Holy Spirit and become the witnesses of the truth of the Gospels throughout the world. The light rays emanating from Christ's hands represent the instilling of the Holy Spirit in the apostles (Acts 2:1-42) at the Pentecost (the seventh Sunday after Easter). The apostles, holding the Gospel books, receive their spiritual assignment to preach the Gospel to all nations. The Christ figure is a splendid essay in calligraphic line. The drapery lines shoot out in rays, break into quick zigzag rhythms, and spin into whorls, wonderfully conveying the spiritual light and energy that flow from Christ over and into the equally animated apostles. The overall composition, as well as the detailed treatment of the figures, contrasts with the much more sedate representation of the Second Coming (FIG. 17-1) at Moissac, where a grid of horizontal and vertical lines contains almost all the figures. The sharp differences between the two tympana once again highlight the regional diversity of Romanesque art.

The world's heathen peoples, the objects of the apostles' mission, appear on the lintel below and in eight compartments around the tympanum. The portrayals of the yet-to-be-converted constitute

a medieval anthropological encyclopedia. Present are the legendary giant-eared Panotii of India, Pygmies (who require ladders to mount horses), and a host of other races, some characterized by a dog's head, others by a pig's snout, and still others by flaming hair. The assembly of agitated figures also includes hunchbacks, mutes, blind men, and lame men. Humanity, still suffering, awaits the salvation to come. As at Moissac and Autun, as worshipers entered the building, the tympanum established God's omnipotence and presented the Church as the road to salvation.

NOTRE-DAME, FONTENAY Although the costly decoration of Cluniac churches like those at Moissac, Autun, and Vézelay appalled Bernard of Clairvaux, Cistercian monks were themselves great builders. Some of their churches were among the largest erected in Romanesque Europe. Nonetheless, the austerity of their buildings reflects the Cistercians' rejection of worldly extravagance and their emphasis on poverty, labor, and prayer. The abbey at Cîteaux itself no longer stands, but at nearby Fontenay, the church of Notre-Dame (FIG. 17-14) does. It is representative of the Cistercian approach to architectural design. The church has a square east end without an ambulatory or chapels. The walls are devoid of ornament, and the column capitals are plain. The nave has a single-story elevation with neither clerestory nor gallery. Light, however, reaches the nave

17-14 Interior of the abbey church of Notre-Dame, Fontenay, France, 1139–1147.

The Cistercians were great builders but rejected sculptural ornament. The Fontenay church is typically austere, with its single-story nave and square east end lacking ambulatory or chapels.

through the large windows in the flat east wall and because the aisle bays have *transverse barrel vaults* (tunnel-like vaults perpendicular to the nave) that channel light from outside to the center of the building. The architect used *pointed arches*—a feature of Cluny III (FIG. 17-8)—both in the nave arcade and in the barrel vaults. Romanesque builders may have thought this feature gave churches the look and feel of the architecture of the Holy Land, but pointed arches also brought structural advantages. Pointed arches transfer the thrust of the vaults more directly downward to the piers and require less buttressing on the sides than do round arches. This forward-looking structural device would permit Gothic architects to increase the height of the nave dramatically (see Chapter 18).

Painting and Other Arts

Unlike the practices of placing vaults over naves and aisles and decorating building facades with monumental stone reliefs, the art of painting did not need to be "revived" in the Romanesque period. Monasteries produced illuminated manuscripts in large numbers in the early Middle Ages, and even the Roman tradition of mural painting had never died. But the quantity of preserved frescoes and illustrated books from the Romanesque era is unprecedented.

MORALIA IN JOB One of the major Romanesque scriptoria was at the abbey of Cîteaux, mother church of the Cistercian order. Just

before Bernard joined the monastery in 1112, the monks completed work on an illuminated copy of Saint Gregory's (Pope Gregory the Great, r. 590–604) Moralia in Job. It is an example of Cistercian illumination before Bernard's passionate opposition to figural art in monasteries led in 1134 to a Cistercian ban on elaborate paintings in manuscripts as well as sculptural ornamentation in monasteries. After 1134 the Cistercian order prohibited full-page illustrations, and even initial letters had to be nonfigurative and of a single color. The historiated initial reproduced here (FIG. 17-15) clearly would have been in violation of Bernard's ban had it not been painted before his prohibitions took effect. A knight, his squire, and two roaring dragons form an intricate letter R, the initial letter of the salutation Reverentissimo. This page is the opening of Gregory's letter to "the very reverent" Leander (ca. 534–600), bishop of Seville, Spain. The knight is a slender, regal figure who raises his shield and sword against the dragons while the squire, crouching beneath him, runs a lance through one of the monsters. Although the clergy viewed the duel between knight and dragons as an allegory of the spiritual struggle of monks against the devil for the salvation of souls, Bernard opposed this kind of illumination, just as he condemned carvings of monstrous creatures and "fighting knights" on contemporary cloister capitals (see "Bernard of Clairvaux on Cloister Sculpture," page 438).

Ornamented initials date to the Hiberno-Saxon period (FIG. 16-8), but in the *Moralia in Job* the artist translated the theme into

17-15 Initial R with knight fighting dragons, folio 4 verso of the *Moralia in Job*, from Cîteaux, France, ca. 1115–1125. Ink and tempera on vellum, 1' $1\frac{3}{4}$ " \times $9\frac{1}{4}$ ". Bibliothèque Municipale, Dijon.

Ornamented initials date to the Hiberno-Saxon era (FIG. 16-8), but this artist translated the theme into Romanesque terms. The duel between knight and dragons symbolized a monk's spiritual struggle.

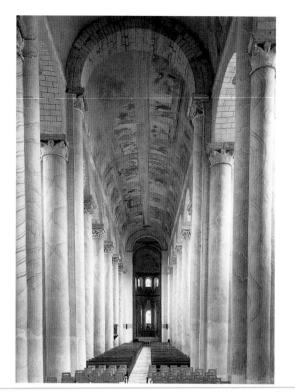

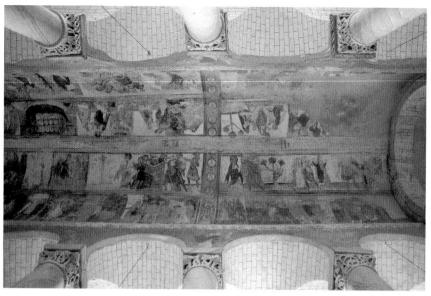

17-16 Nave (*left*) and painted nave vault (*right*) of the abbey church, Saint-Savinsur-Gartempe, France, ca. 1100.

Saint-Savin is a hall church with aisles approximately the same height as the nave. The tall aisle windows provide ample illumination for the biblical paintings on the nave's continuous barrel vault.

Romanesque terms. The page with the initial *R* may be a reliable picture of a medieval baron's costume. The typically French Romanesque banding of the torso and partitioning of the folds are evident (compare Fig. 17-11), but the master painter deftly avoided stiffness and angularity. The partitioning actually accentuates the knight's verticality and elegance and the thrusting action of his servant. The flowing sleeves add a spirited flourish to the swordsman's gesture. The knight, handsomely garbed, cavalierly wears no armor and calmly aims a single stroke, unmoved by the ferocious dragons lunging at him.

SAINT-SAVIN-SUR-GARTEMPE Although the art of fresco painting never died in early medieval Europe, the murals (not true frescoes, however) of the Benedictine abbey church of Saint-Savinsur-Gartempe have no Carolingian or Ottonian parallels, because the murals decorate the church's stone-vaulted nave (FIG. 17-16). Saint-Savin is a hall church (from German Hallenkirche), a church where the aisles are approximately the same height as the nave. The tall windows in the aisles provided more illumination to the nave than in churches that had low aisles and tribunes. The abundant light coming into the church may explain why the monks chose to decorate the nave's continuous barrel vault with paintings. (They also painted the nave piers to imitate rich veined marble.) The subjects of Saint-Savin's nave paintings all come from the Pentateuch, the opening five books of the Old Testament, but New Testament themes appear in the transept, ambulatory, and chapels, where the painters also depicted the lives of Saint Savin and another local saint. The elongated, agitated cross-legged figures have stylistic affinities both to the reliefs of southern French portals and to illuminated manuscripts such as the Moralia in Job.

SANTA MARÍA DE MUR In the Romanesque period, northern Spain, home to the great pilgrimage church of Saint James at Santiago de Compostela, was an important regional artistic center. In fact, Catalonia in northeastern Spain has more Romanesque mural paintings today than anywhere else. One of the most

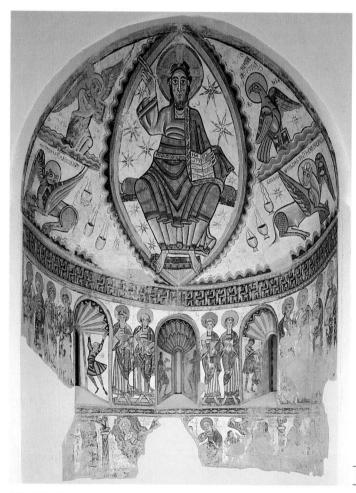

17-17 Christ in Majesty, apse, Santa María de Mur, near Lérida, Spain, mid-12th century. Fresco, 24′ × 22′. Museum of Fine Arts, Boston.

The Apocalypse fresco of the Santa María de Mur apse resembles the reliefs of French and Spanish Romanesque tympana. Christ appears in a mandorla between the signs of the four evangelists.

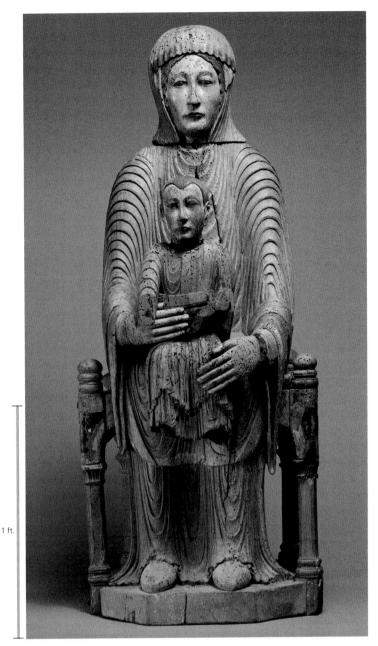

17-18 Virgin and Child (*Morgan Madonna*), from Auvergne, France, second half of 12th century. Painted wood, 2′ 7″ high. Metropolitan Museum of Art, New York (gift of J. Pierpont Morgan, 1916).

The veneration of relics brought with it a demand for small-scale images of the holy family and saints to be placed on chapel altars. This wooden statuette depicts the Virgin as the Throne of Wisdom.

impressive is the fresco (FIG. 17-17), now in Boston, that once filled the apse of Santa María de Mur, a monastery church not far from Lérida. The formality, symmetry, and placement of the figures are Byzantine (compare FIGS. 12-13 and 12-25). But the Spanish artist rejected Byzantine mosaic in favor of direct painting on plaster-coated walls.

The iconographic scheme in the semidome of the apse echoes the designs of contemporary French and Spanish Romanesque church tympana (FIG. 17-1). The signs of the four evangelists flank Christ in a star-strewn mandorla—the Apocalypse theme that so fascinated the Romanesque imagination. Seven lamps between Christ and the evangelists' signs symbolize the seven Christian com-

munities where Saint John addressed his revelation (the Apocalypse) at the beginning of his book (Rev. 1:4, 12, 20). Below stand apostles, paired off in formal frontality, as in the Monreale Cathedral apse (FIG. 12-25). The Spanish painter rendered the principal figures with partitioning of the drapery into volumes, here and there made tubular by local shading, and stiffened the irregular shapes of actual cloth into geometric patterns. The effect overall is one of simple, strong, and even blunt directness of statement, reinforced by harsh, bright color, appropriate for a powerful icon.

MORGAN MADONNA Despite the widespread use of stone relief sculptures to adorn Romanesque church portals, resistance to the creation of statues in the round—in any material—continued. The avoidance of creating anything that might be construed as an idol was still the rule, in keeping with the Second Commandment. Two centuries after Archbishop Gero commissioned a monumental wooden image of the crucified Christ (FIG. 16-26) for Cologne Cathedral, freestanding statues of Christ, the Virgin Mary, and the saints were still quite rare. The veneration of relics, however, brought with it a demand for small-scale images of the holy family and saints to be placed on the chapel altars of churches along the pilgrimage roads. Artisans began producing reliquaries in the form of saints (or parts of saints), tabletop crucifixes, and small wooden devotional images in great numbers.

One popular type, a specialty of the workshops of Auvergne, France, was a wooden statuette depicting the Virgin Mary with the Christ Child in her lap. The Morgan Madonna (FIG. 17-18), so named because it once belonged to the American financier and art collector J. Pierpont Morgan, is one example. The type, known as the Throne of Wisdom-sedes sapientiae in Latin-is a western European freestanding version of the Byzantine Theotokos theme popular in icons and mosaics (FIGS. 12-18 and 12-19). Christ holds a Bible in his left hand and raises his right arm in blessing (both hands are broken off). He is the embodiment of the divine wisdom contained in the Holy Scriptures. His mother, seated on a wooden chair, is in turn the Throne of Wisdom because her lap is the Christ Child's throne. As in Byzantine art, both Mother and Child sit rigidly upright and are strictly frontal, emotionless figures. But the intimate scale, the gesture of benediction, the once-bright coloring of the garments, and the soft modeling of the Virgin's face make the group seem much less remote than its Byzantine counterparts.

HOLY ROMAN EMPIRE

The Romanesque successors of the Ottonians were the Salians (r. 1027–1125), a dynasty of Franks of the Salian tribe. They ruled an empire that corresponds roughly to present-day Germany and the Lombard region of northern Italy (MAP 17-1). Like their predecessors, the Salian emperors were important patrons of art and architecture, although, as elsewhere in Romanesque Europe, the monasteries remained great centers of artistic production.

Architecture

The continuous barrel-vaulted naves of Saint James at Santiago de Compostela, Cluny III (FIG. 17-8), Saint-Sernin (FIG. 17-6) at Toulouse, and Notre-Dame (FIG. 17-14) at Fontenay admirably met the goals that northern Spanish and French Romanesque architects had of making the house of the Lord beautiful and providing excellent acoustics for church services. In addition, the churches were relatively fireproof compared with timber-roofed structures such as Saint-Étienne (FIG. 17-2) at Vignory. But the barrel vaults often failed in one critical

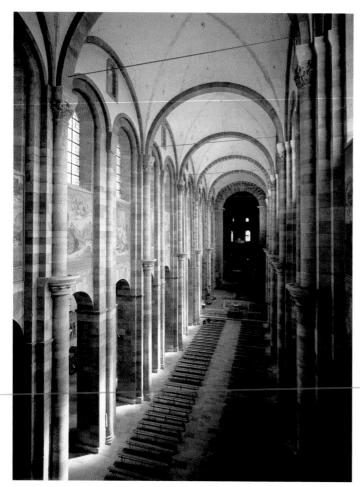

17-19 Interior of Speyer Cathedral, Speyer, Germany, begun 1030; nave vaults, ca. 1082–1105.

The imperial cathedral at Speyer is one of the earliest examples of the use of groin vaulting in a nave. Groin vaults made possible the insertion of large clerestory windows above the nave arcade.

requirement—lighting. Due to the great outward thrust barrel vaults exert along their full length, even when pointed instead of semicircular, a clerestory is difficult to construct. (The Santiago de Compostela, Toulouse, and Fontenay designers did not even attempt to introduce a clerestory, although their counterparts at Cluny III did and succeeded.) Structurally, the central aim of northern Romanesque architects was to develop a masonry vault system that admitted light and was also aesthetically pleasing.

Covering the nave with groin vaults instead of barrel vaults became the solution. Ancient Roman builders had used the groin vault widely, because they realized that its concentration of thrusts at four supporting points permitted clerestory windows (FIGS. 10-6*b*–*c*, 10-67, and 10-78). The great Roman vaults were made possible by the use of concrete, which could be poured into forms, where it solidified into a homogeneous mass (see "Roman Concrete Construction," Chapter 10, page 241). But the technique of mixing concrete had not survived into the Middle Ages. The technical problems of building groin vaults of cut stone and heavy rubble, which had very little cohesive quality, at first limited their use to the covering of small areas, such as the individual bays of the aisles of Saint-Sernin (FIG. 17-5). But during the 11th century, masons in the Holy Roman Empire, using cut-stone blocks joined by mortar, developed a groin vault of monumental dimensions.

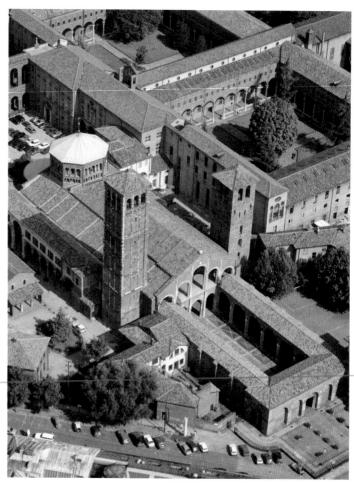

17-20 Aerial view of Sant'Ambrogio, Milan, Italy, late 11th to early 12th century.

With its atrium and low, broad proportions, Sant'Ambrogio recalls Early Christian basilicas. Over the nave's east end, however, is an octagonal tower that resembles Ottonian crossing towers.

SPEYER CATHEDRAL Construction of Speyer Cathedral (FIG. 17-19) in the German Rhineland, far from the pilgrimage routes of southern France and northern Spain, began in 1030. The church was the burial place of the Holy Roman emperors until the beginning of the 12th century, and funding for the building campaign came from imperial patrons, not traveling pilgrims and local landowners. Like all cathedrals, Speyer was also the seat (cathedra in Latin) of the powerful local bishop. In its earliest form, Speyer Cathedral was a timber-roofed structure. When the emperor Henry IV (r. 1084-1105) rebuilt it between 1082 and 1105, his masons covered the nave with stone groin vaults. The large clerestory windows above the nave arcade provided ample light to the interior. Scholars disagree about where the first comprehensive use of groin vaulting occurred in Romanesque times, and nationalistic concerns sometimes color the debate. But no one doubts that the large groin vaults covering the nave of Speyer Cathedral represent one of the most daring and successful engineering experiments of the time. The nave is 45 feet wide, and the crowns of the vaults are 107 feet above the floor.

Speyer Cathedral employs an alternate-support system in the nave, as in the Ottonian churches of Saint Cyriakus (FIG. 16-21) at Gernrode and Saint Michael's (FIG. 16-23) at Hildesheim. At Speyer, however, the alternation continues all the way up into the vaults, with the nave's more richly molded compound piers marking the

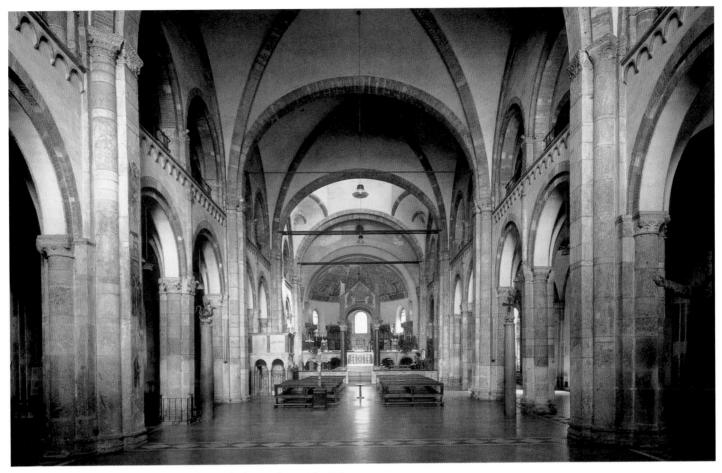

17-21 Interior of Sant'Ambrogio, Milan, Italy, late 11th to early 12th century.

Sant'Ambrogio's nave reveals the northern character of Lombard architecture. Each groin-vaulted nave bay corresponds to two aisle bays. The alternate-support system complements this modular plan.

corners of the groin vaults. Speyer's interior shows the same striving for height and the same compartmentalized effect seen in Saint-Sernin (FIG. 17-6), but by virtue of the alternate-support system, the rhythm of the Speyer nave is more complex. Because each compartment is individually vaulted, the effect of a sequence of vertical spatial blocks is even more convincing.

SANT'AMBROGIO, MILAN After Charlemagne crushed the Lombards in 773, German kings held sway over Lombardy, and the Rhineland and northern Italy cross-fertilized each other artistically. No agreement exists as to which source of artistic influence was dominant in the Romanesque age, the northern or the southern. The question, no doubt, will remain the subject of controversy until the construction date of Sant'Ambrogio (FIG. 17-20) in Milan can be established unequivocally. The church, erected in honor of Saint Ambrose, Milan's first bishop (d. 397), is the central monument of Lombard Romanesque architecture. Some scholars think the church was a prototype for Speyer Cathedral, but Sant'Ambrogio is a remarkable structure even if it wasn't a model for Speyer's builders. The Milanese church has an atrium in the Early Christian tradition (FIG. 11-9)—one of the last to be built—and a two-story narthex pierced by arches on both levels. Two bell towers (campaniles) join the building on the west. The shorter one dates to the 10th century, and the taller north campanile is a 12th-century addition. Over the nave's east end is an octagonal tower that recalls the crossing towers of Ottonian churches (FIG. 16-22).

Sant'Ambrogio has a nave (FIG. 17-21) and two aisles but no transept. Each bay consists of a full square in the nave flanked by two small squares in each aisle, all covered with groin vaults. The main vaults are slightly domical, rising higher than the transverse arches. The windows in the octagonal dome over the last bay—probably here, as elsewhere, a reference to the Dome of Heaven—provide the major light source (the building lacks a clerestory) for the otherwise rather dark interior. The emphatic alternate-support system perfectly reflects the geometric regularity of the plan. The lightest pier moldings are interrupted at the gallery level, and the heavier ones rise to support the main vaults. At Sant'Ambrogio, the compound piers even continue into the ponderous vaults, which have supporting arches, or *ribs*, along their groins. This is one of the first instances of rib vaulting, a salient characteristic of mature Romanesque and of later Gothic architecture (see "The Gothic Rib Vault," Chapter 18, page 464).

The regional diversity of Romanesque architecture becomes evident by comparing the proportions of Sant'Ambrogio with those of both Speyer Cathedral (FIG. 17-19) and Saint-Sernin (FIGS. 17-4 to 17-6) at Toulouse. The Milanese building does not aspire to the soaring height of the French and German churches. Save for the later of the two towers, Sant'Ambrogio's proportions are low and broad and remain close to those of Early Christian basilicas. Italian architects, even those working within the orbit of the Holy Roman Empire, had firm roots in the venerable Early Christian style and never accepted the verticality found in northern architecture, not even during the Gothic period.

Romanesque Countesses, Queens, and Nuns

man's world, but women could and did have power and influence. Countess Matilda of Canossa (1046–1115), who ruled Tuscany after 1069, was sole heiress of vast holdings in northern Italy. She was a key figure in the political struggle between the popes and the German emperors who controlled Lombardy. With unflagging resolution, she defended Pope Gregory's reforms and at her death willed most of her lands to the papacy.

More famous and more powerful was Eleanor of Aquitaine (1122–1204), wife of Henry II of England. She married Henry after the annulment of her marriage to Louis VII, king of France.

She was queen of France for 15 years and queen of England for 35 years. During that time she bore three daughters and five sons. Two became kings—Richard I (the Lionhearted) and John. She prompted her sons to rebel against their father, so Henry imprisoned her. Released at Henry's death, she lived on as dowager queen, managing England's government and King John's holdings in France.

Of quite different stamp was Hildegard of Bingen (1098–1179), the most prominent nun of the 12th century and one of the greatest religious figures of the Middle Ages. Hildegard was born into an aristocratic family that owned large estates in the German Rhineland. At a very early age she began to have visions. When she was eight, her parents placed her in the Benedictine double monastery (for both monks and nuns) at Disibodenberg. She became a nun at 15. In 1141, God instructed Hildegard to disclose her visions to the world. Before then she had revealed them only to close confidants at the monastery. One of these was the monk Volmar, and Hildegard chose to dictate her visions to him (FIG. 17-22) for posterity. No less a figure than Bernard of Clairvaux certified in 1147 that her visions were authentic, and Archbishop Heinrich of Mainz joined in the endorsement. In 1148 the Cistercian pope Eugenius III (r. 1145-1153) formally authorized Hildegard "in the name of Christ and Saint Peter to publish all that she had learned from the Holy Spirit." At this time Hildegard became the abbess of a new convent built for her near Bingen. As reports of Hildegard's visions spread, kings, popes, barons, and prelates sought her counsel. All of them were attracted by her spiritual insight into the truth of the mysteries of the Christian faith. In addition to her visionary works—the most important is

17-22 Hildegard receives her visions, detail of a facsimile of a lost folio in the Rupertsberger *Scivias* by Hildegard of Bingen, from Trier or Bingen, Germany, ca. 1150–1179. Abbey of St. Hildegard, Rüdesheim/Eibingen.

Hildegard of Bingen, the most prominent nun of her time, experienced divine visions, shown here as five tongues of fire entering her brain. She also composed music and wrote scientific treatises.

the *Scivias* (FIG. 17-22)—Hildegard wrote two scientific treatises. *Physica* is a study of the natural world, and *Causae et curae* (*Causes and Cures*) is a medical encyclopedia. Hildegard also composed the music and wrote the lyrics of 77 songs, which appeared under the title *Symphonia*.

Hildegard was the most famous Romanesque nun, but she was by no means the only learned woman of her age. A younger contemporary, the abbess Herrad (d. 1195) of Hohenberg, Austria, was also the author of an important medieval encyclopedia. Herrad's *Hortus deliciarum* (*Garden of Delights*) is a history of the world intended for instructing the nuns under her supervision, but it reached a much wider audience.

Painting and Other Arts

The number and variety of illuminated manuscripts dating to the Romanesque era attest to the great demand for illustrated religious tomes in the abbeys of western Europe. The extraordinarily productive scribes and painters who created these books were almost exclusively monks and nuns working in the scriptoria of those same isolated religious communities.

HILDEGARD OF BINGEN One of the most interesting of these religious manuscripts is the *Scivias* (*Know the Ways* [*Scite vias*] of *God*) of Hildegard of Bingen. Hildegard was a German nun and eventually the abbess of the convent at Disibodenberg in the Rhineland (see "Romanesque Countesses, Queens, and Nuns," above). The manuscript, lost in 1945, exists today only in a facsimile. The original probably was written and illuminated at the monastery of Saint

Matthias at Trier between 1150 and Hildegard's death in 1179, but it is possible that Hildegard supervised production of the book at Bingen. The *Scivias* contains a record of Hildegard's vision of the divine order of the cosmos and of humankind's place in it. The vision came to her as a fiery light that poured into her brain from the open vault of Heaven.

On the opening page (FIG. 17-22) of the Trier manuscript, Hildegard sits within the monastery walls, her feet resting on a footstool, in much the same way the painters of the *Coronation* and *Ebbo Gospels* (FIGS. 16-13 and 16-14) represented the evangelists. This Romanesque page is a link in a chain of author portraits with roots in classical antiquity. The artist showed Hildegard experiencing her divine vision by depicting five long tongues of fire emanating from above and entering her brain, just as she describes the experience in the accompanying text. Hildegard immediately sets down what has been revealed to her on a wax tablet resting on her left knee. Nearby, the monk Volmar, Hildegard's confessor, copies into a book all she has written. Here, in a singularly dramatic context, is a picture of the essential nature of ancient and medieval book manufacture—individual scribes copying and recopying texts by hand (compare FIG. 16-11).

RAINER OF HUY In the Holy Roman Empire, as in France, the names of some Romanesque sculptors are known. One is RAINER OF HUY, a bronzeworker from the Meuse River valley in Belgium, an area renowned for its metalwork. Art historians have attributed an 1118 bronze baptismal font (FIG. 17-23) to him. Made for Notre-Dame-des-Fonts in Liège, the bronze basin rests on the foreparts of a

17-23 RAINER OF HUY, baptism of Christ, baptismal font from Notre-Dame-des-Fonts, Liège, Belgium, 1118. Bronze, 2' 1" high. Saint-Barthélémy, Liège.

In the work of Rainer of Huy, the classical style and the classical spirit lived on in the Holy Roman Empire. His baptismal font at Liège features idealized figures and even a nude representation of Christ.

dozen oxen. The oxen refer to the "molten sea . . . on twelve oxen" cast in bronze for King Solomon's Temple (1 Kings 7:23–25). The Old Testament story prefigured Christ's baptism (medieval scholars equated the oxen with the 12 apostles), which is the central scene on the Romanesque font. Rainer's work, as that of so many earlier artists in the Holy Roman Empire beginning in Carolingian times, revived the classical style and the classical spirit. The figures are softly rounded, with idealized bodies and faces and heavy clinging drapery. One figure (at the left in FIG. 17-23) is even shown in a three-quarter view from the rear, a popular motif in classical art, and some of Rainer's figures, including Christ himself, are naked. Nudity is very rare in the art of the Middle Ages. Adam and Eve (FIGS. 11-7 and 16-24) are exceptions, but medieval artists represented the first man and woman as embarrassed by their nudity, the opposite of the value the classical world placed on the beauty of the human body.

RELIQUARY OF SAINT ALEXANDER As noted, Romanesque church officials competed with one another in the display of relics and often expended large sums on elaborate containers to house them. The reliquary of Saint Alexander (FIG. 17-24), made in 1145 for Abbot Wibald of Stavelot in Belgium to house the hallowed

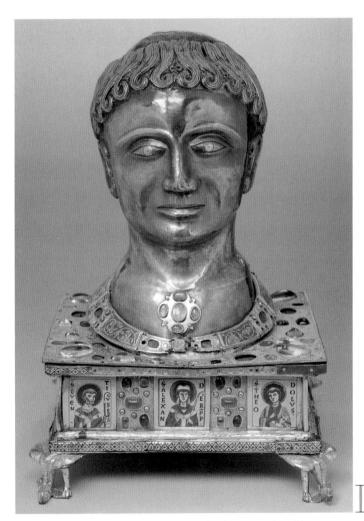

17-24 Head reliquary of Saint Alexander, from Stavelot Abbey, Belgium, 1145. Silver repoussé (partly gilt), gilt bronze, gems, pearls, and enamel, 1' $5\frac{1}{2}''$ high. Musées Royaux d'Art et d'Histoire, Brussels.

Saint Alexander's reliquary is typical in the use of costly materials. The combination of an idealized classical head with Byzantine-style enamels underscores the stylistic diversity of Romanesque art.

pope's relics, is one of the finest examples. The almost life-size head, fashioned in repoussé silver with bronze gilding for the hair, gives worshipers the impression that the saint is alive and present. The idealized head resembles portraits of youthful Roman emperors such as Augustus (FIG. I-9) and Constantine (FIG. 10-77), and the Romanesque metalworker may have used an ancient sculpture as a model. The saint wears a collar of jewels and enamel plaques around his neck. Enamels and gems also adorn the box on which the head is mounted. The reliquary rests on four bronze dragons—mythical animals of the kind that populated Romanesque cloister capitals. Not surprisingly, Bernard of Clairvaux was as critical of lavish church furnishings like the Alexander reliquary as he was of Romanesque cloister sculpture:

[Men's] eyes are fixed on relics covered with gold and purses are opened. The thoroughly beautiful image of some male or female saint is exhibited and that saint is believed to be the more holy the more highly colored the image is. People rush to kiss it, they are invited to donate, and they admire the beautiful more than they venerate the sacred. . . . O vanity of vanities, but no more vain than insane! The Church . . . dresses its stones in gold and it abandons its children naked. It serves the eyes of the rich at the expense of the poor.⁵

The central plaque on the front of the Stavelot reliquary depicts Pope Alexander II (r. 1061–1073). Saints Eventius and Theodolus flank him. The nine plaques on the other three sides represent female allegorical figures—Wisdom, Piety, and Humility among them. Although a local artist produced these enamels in the Meuse River region, the models were surely Byzantine. Saint Alexander's reliquary underscores the multiple sources of Romanesque art as well as its stylistic diversity. Not since antiquity had people journeyed as exten-

sively as they did in the Romanesque period, and artists regularly saw works of wide geographic origin. Abbot Wibald himself epitomized the well-traveled 12th-century clergyman. He was abbot of Montecassino in southern Italy and participated in the Second Crusade. Frederick Barbarossa (Holy Roman Emperor, r. 1152–1190) sent him to Constantinople to arrange Frederick's wedding to the niece of the Byzantine emperor Manuel Comnenus. (Two centuries before, another German emperor, Otto II, married the Byzantine princess Theophanu, which also served to promote Byzantine style in the Holy Roman Empire; see "Theophanu," Chapter 16, page 428.)

ITALY

Nowhere is the regional diversity of Romanesque art and architecture more readily apparent than in Italy, where the ancient Roman and Early Christian heritage was strongest. Although Tuscany, the ancient Etruscan heartland (see Chapter 9), and other regions south of Lombardy were part of the territory of the Salian emperors, Italy south of Milan represents a distinct artistic zone during the Romanesque period.

Architecture and Architectural Sculpture

Italian Romanesque architects designed buildings that were for the most part structurally less experimental than those erected in Germany and Lombardy. Italian builders adhered closely to the Early Christian basilican type of church.

PISA CATHEDRAL COMPLEX The cathedral complex (FIG. 17-25) at Pisa dramatically testifies to the prosperity that busy maritime city enjoyed. The spoils of a naval victory over the

17-25 Cathedral complex, Pisa, Italy; cathedral begun 1063; baptistery begun 1153; campanile begun 1174.

Pisa's cathedral more closely resembles Early Christian basilicas than the structurally more experimental northern Romanesque churches. Separate bell towers and baptisteries are characteristically Italian.

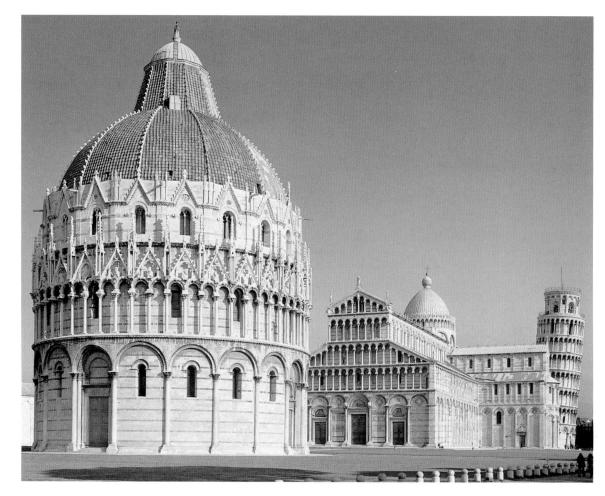

17-26 Baptistery of San Giovanni, Florence, Italy, dedicated 1059.

The Florentine baptistery is a domed octagon descended from Roman and Early Christian central-plan buildings. The distinctive Tuscan Romanesque marble paneling stems from Roman wall designs.

began a daring project to remove soil from beneath the north side of the tower. The soil extraction has already moved the tower more than an inch closer to vertical and ensured the stability of the structure for at least 300 years. (Because of the touristic appeal of the Leaning Tower, there are no plans to restore the campanile to its original upright position.)

BAPTISTERY, FLORENCE The public always associates Florence with the Renaissance of the 15th and 16th centuries, but Florence was already an important independent city-state in the Romanesque period. The gem of Florentine Romanesque architecture is the baptistery (Fig.

17-26) of San Giovanni (Saint John), the city's patron saint. Pope Nicholas II dedicated the building in 1059. It thus predates Pisa's baptistery (FIG. 17-25, *left*), but construction of the Florentine baptistery continued into the next century. Both baptisteries face their city's cathedral. These freestanding Italian baptisteries are unusual and reflect the great significance the Florentines and Pisans attached to baptisms. On the day of a newborn child's anointment, the citizenry gathered in the baptistery to welcome a new member into the community. The Tuscan baptisteries therefore were important civic as well as religious structures. Some of the most renowned artists of the late Middle Ages and the Renaissance provided the Florentine and Pisan baptisteries with pulpits (FIG. 19-2), bronze doors (FIGS. 21-2, 21-3, and 21-10), and mosaics.

The simple and serene classicism of San Giovanni's design recalls ancient Roman architecture. The baptistery stands in a direct line of descent from the Pantheon (FIG. 10-49) and imperial mausoleums such as Diocletian's (FIG. 10-74), the Early Christian Santa Costanza (FIG. 11-11), the Byzantine San Vitale (FIG. 12-6), and other central-plan structures, pagan or Christian, including Charlemagne's Palatine Chapel (FIG. 16-18) at Aachen. The distinctive Tuscan Romanesque marble incrustation that patterns the walls stems ultimately from Roman wall designs (FIGS. 10-17 and 10-51). The simple oblong and arcuated panels assert the building's structural lines and its elevation levels. In plan, San Giovanni is a domed octagon, wrapped on the exterior by an elegant arcade, three arches to a bay. It has three entrances, one each on the north, south, and east sides. On the west side an oblong sanctuary replaces the original semicircular apse. The domical vault is some 90 feet in diameter, its construction a remarkable feat for its time.

Muslims off Palermo in Sicily in 1062 provided the funds for the Pisan building program. The cathedral, its freestanding bell tower, and the baptistery, where infants and converts were initiated into the Christian community, present a rare opportunity to study a coherent group of three Romanesque buildings. Save for the upper portion of the baptistery, with its remodeled Gothic exterior, the three structures are stylistically homogeneous.

Construction of Pisa Cathedral began first—in 1063, the same year work began on Saint Mark's (FIG. 12-24) in Venice, another powerful maritime city. Pisa Cathedral is large, with a nave and four aisles, and is one of the most impressive and majestic of all Romanesque churches. According to a document of the time, the Pisans wanted their bishop's church not only to be a monument to the glory of God but also to bring credit to the city. At first glance, the cathedral resembles an Early Christian basilica with a timber roof, columnar arcade, and clerestory. But the broadly projecting transept with apses, the crossing dome, and the facade's multiple arcaded galleries distinguish it as Romanesque. So too does the rich marble incrustation (wall decoration consisting of bright panels of different colors, as in the Pantheon's interior, FIG. 10-51). The cathedral's campanile, detached in the standard Italian fashion, is Pisa's famous Leaning Tower (FIG. 17-25, right). Graceful arcaded galleries mark the tower's stages and repeat the cathedral's facade motif, effectively relating the round campanile to its mother building. The tilted vertical axis of the tower is the result of a settling foundation. The tower began to "lean" even while under construction and by the late 20th century had inclined some 5.5 degrees (about 15 feet) out of plumb at the top. In 1999 an international team of scientists

17-27 Interior of San Miniato al Monte, Florence, Italy, ca. 1062–1090.

The design of San Miniato is close to that of Early Christian basilicas, but diaphragm arches divide the nave into three equal compartments, and compound piers alternate with columns in the arcade.

SAN MINIATO AL MONTE Contemporaneous with the San Giovanni baptistery and also featuring elaborate marble incrustation is the Benedictine abbey church of San Miniato al Monte (FIG. 17-27). It sits, as its name implies, on a hillside overlooking the Arno River and the heart of Florence. The builders completed the body of the church by 1090, its facade not until the early 13th century. Even more than Pisa Cathedral, the structure recalls the Early Christian basilica, but *diaphragm arches* divide its nave into

three equal compartments. The arches rise from compound piers and brace the rather high, thin walls. They also provide firebreaks beneath the wooden roof and compartmentalize the basilican interior in the manner so popular with most Romanesque builders. The compound piers alternate with pairs of simple columns with Roman-revival Composite capitals.

MODENA CATHEDRAL Despite the pronounced structural differences between Italian Romanesque churches and those of France, Spain, and the Holy Roman Empire, Italian church officials also frequently employed sculptors to adorn the facades of their buildings. In fact, one of the first examples of fully developed narrative relief sculpture in Romanesque art is the marble frieze (FIG. 17-28) on the facade of Modena Cathedral in northern Italy. Carved around 1110, it represents scenes from Genesis set against an architectural backdrop of a type common on Roman and Early Christian sarcophagi, which were plentiful in the area. The segment in FIG. 17-28 illustrates the creation and temptation of Adam and Eve (Gen. 2, 3:1–8), the theme employed almost exactly a century earlier on Bishop Bernward's bronze doors (FIG. 16-24) at Hildesheim. At Modena, as at Saint Michael's, the faithful entered the Lord's house with a reminder of Original Sin and the suggestion that the only path to salvation is through the Christian Church.

On the Modena frieze, Christ is at the far left, framed by a mandorla held up by angels—a variation on the motif of the Saint-Sernin ambulatory relief (FIG. 17-7). The creation of Adam, then Eve, and the serpent's temptation of Eve are to the right. The relief carving is high, and some parts are almost entirely in the round. The frieze is the work of a master craftsman whose name, WILIGELMO, is given in an inscription on another relief on the facade. There he boasts, "Among sculptors, your work shines forth, Wiligelmo." The inscription is also an indication of the pride Wiligelmo's patrons had in obtaining the services of such an accomplished sculptor for their city's cathedral.

BENEDETTO ANTELAMI The reawakening of interest in stone sculpture in the round also may be seen in northern Italy, where the sculptor Benedetto Antelami was active in the last quarter of the 12th century. Several reliefs by his hand exist, including Parma Cathedral's pulpit and the portals of that city's baptistery. But his most unusual works are the monumental marble statues of two Old Testament figures he carved for the west facade of Fidenza Cathedral. Benedetto's King David (Fig. 17-29) seems confined within his niche, and he holds his elbows close to his body. Absent is

17-28 WILIGELMO, creation and temptation of Adam and Eve, detail of the frieze on the west facade, Modena Cathedral, Modena, Italy, ca. 1110. Marble, 3' high.

For Modena's cathedral, Wiligelmo represented scenes from Genesis against an architectural backdrop of a type common on Roman and Early Christian sarcophagi, which were plentiful in the area.

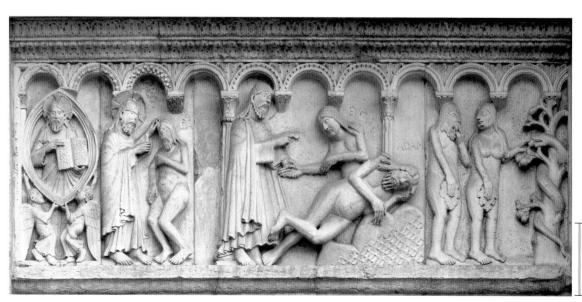

1 ft.

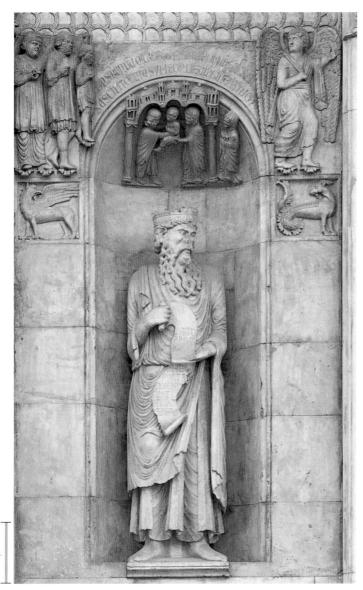

17-29 BENEDETTO ANTELAMI, King David, statue in a niche on the west facade of Fidenza Cathedral, Fidenza, Italy, ca. 1180–1190. Marble, life-size.

Benedetto Antelami's King David on the facade of Fidenza Cathedral is a rare example of life-size statuary in the Romanesque period. The style is unmistakably rooted in Greco-Roman art.

the weight shift that is the hallmark of classical statuary. Yet the sculptor's conception of this prophet is unmistakably rooted in Greco-Roman art. Comparison of the Fidenza David with the prophet on the Moissac trumeau (FIG. 17-11), who also displays an unfurled scroll, reveals how much the Italian sculptor freed his figure from its architectural setting. Other sculptors did not immediately emulate Antelami's classical approach to portraying biblical figures in stone. But the idea of placing freestanding statues in niches would be taken up again in Italy by Early Renaissance sculptors (FIGS. 21-4 to 21-6).

17-30 West facade of Saint-Étienne, Caen, France, begun 1067.

The division of Saint-Étienne's facade into three parts corresponding to the nave and aisles reflects the methodical planning of the entire structure. The towers also have a tripartite design.

NORMANDY AND ENGLAND

After their conversion to Christianity in the early 10th century, the Vikings (see Chapter 16) settled on the northern coast of France in present-day Normandy. Almost at once, they proved themselves not only aggressive warriors but also skilled administrators and builders, active in Sicily (FIG. 12-25) as well as in northern Europe.

Architecture

The Normans quickly developed a distinctive Romanesque architectural style that became the major source of French Gothic architecture.

SAINT-ÉTIENNE, **CAEN** Most critics consider the abbey church of Saint-Étienne at Caen the masterpiece of Norman Romanesque architecture. Begun by William of Normandy (William the Conqueror; see page 455) in 1067, work must have advanced rapidly, because he was buried there in 1087. Saint-Étienne's west facade (FIG. 17-30) is a striking design rooted in the tradition of Carolingian and Ottonian westworks, but it reveals a new unified

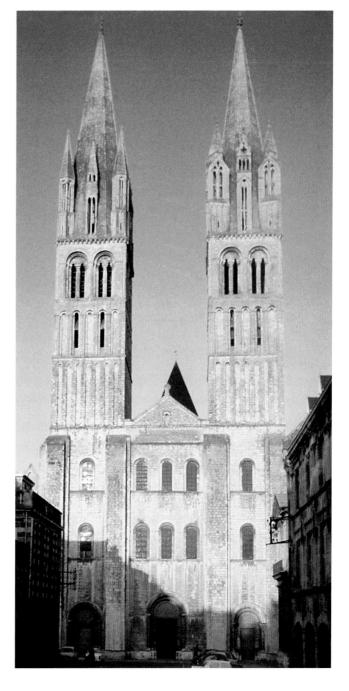

17-31 Interior of Saint-Étienne, Caen, France, vaulted ca. 1115–1120.

The groin vaults of Saint-Étienne made possible an efficient clerestory. The three-story elevation with its large arched openings provides ample light and makes the nave appear taller than it is.

design. Four large buttresses divide the facade into three bays that correspond to the nave and aisles. Above the buttresses, the towers also display a triple division and a progressively greater piercing of their walls from lower to upper stages. (The culminating spires are a Gothic addition.) The tripartite division extends throughout the facade, both vertically and horizontally, organizing it into a closeknit, well-integrated design that reflects the careful and methodical planning of the entire structure.

The original design of Saint-Étienne called for a wooden roof, as originally at Speyer Cathedral. But the Caen nave (FIG. 17-31) had compound piers with simple engaged half-columns alternating with piers with half-columns attached to pilasters. When the builders decided to install groin vaults around 1115, the existing alternating compound piers in the nave proved a good match. Those piers soar all the way to the vaults' springing. Their branching ribs divide the large square-vault compartments into six sections, making a sexpartite vault (FIG. 17-32). The vaults rise high enough to provide room for an efficient clerestory. The resulting three-story elevation, with its large arched openings, admits more light to the interior. It also makes the nave appear even taller than it is. As in the Milanese church of

Sant'Ambrogio (FIG. 17-21), the Norman building has rib vaults. The diagonal and transverse ribs compose a structural skeleton that partially supports the still fairly massive paneling between them. Despite the heavy masonry, the large windows and reduced interior wall surface give Saint-Étienne's nave a light and airy quality that is unusual in the Romanesque period.

DURHAM CATHEDRAL William of Normandy's conquest of Anglo-Saxon England in 1066 began a new epoch in English history. In architecture, it signaled the importation of Norman Romanesque building and design methods. Durham Cathedral (FIGS. 17-33 and 17-34) sits majestically on a cliff overlooking the Wear River in northern England, the centerpiece of a monastery, cathedral, and fortified-castle complex on the Scottish frontier. Unlike Speyer Cathedral and Saint-Étienne, Durham Cathedral, begun around 1093—earlier than the remodeled Caen church—was a vaulted structure from the very beginning. Consequently, the pattern of the ribs of the nave's groin vaults corresponds perfectly to the design of the arcade below. Each seven-part nave vault covers two bays. Large,

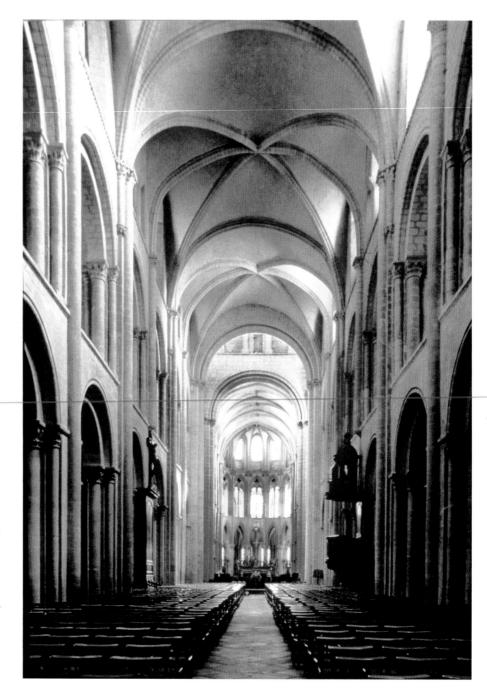

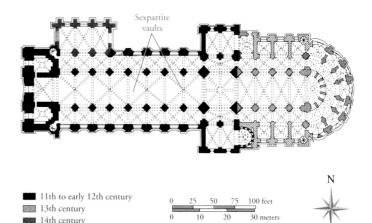

17-32 Plan of Saint-Étienne, Caen, France.

The early-12th-century nave vaults of Saint-Étienne spring from compound piers with alternating half-columns and pilasters. The diagonal and transverse ribs divide the vaults into six compartments.

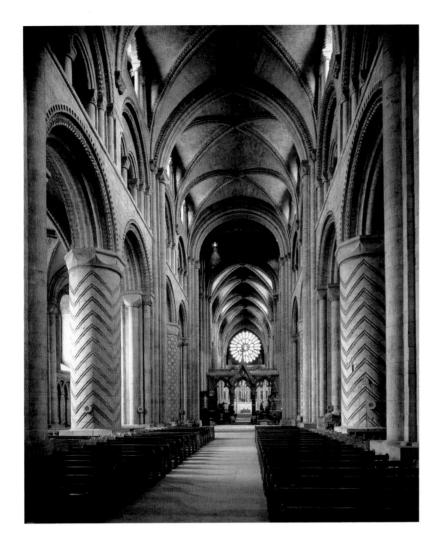

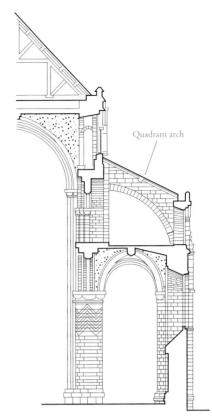

17-33 Interior (*left*) and lateral section (*right*) of Durham Cathedral, England, begun ca. 1093.

Durham Cathedral is the first example of a ribbed groin vault placed over a three-story nave. Quadrant arches were used in place of groin vaults in the tribune to buttress the nave vaults.

simple pillars ornamented with abstract designs (diamond, chevron, and cable patterns, all originally painted) alternate with compound piers that carry the transverse arches of the vaults. The pier-vault relationship scarcely could be more visible or the building's structural rationale better expressed.

The bold surface patterning of the Durham nave is a reminder that the raising of imposing stone edifices such as the Romanesque churches of England and Normandy required more than just the talents of master designers. A corps of expert masons had to transform rough stone blocks into the precise shapes necessary for their specific place in the church's fabric. Although thousands of simple quadrangular blocks make up the great walls of these buildings, the builders needed large numbers of blocks in much more complex shapes. To cover the nave and aisles, the stonecutters had to carve blocks with concave faces to conform to the curve of the vault. Also required were blocks with projecting moldings for the ribs, blocks with convex surfaces for the pillars or with multiple profiles for the compound piers, and so forth. It was an immense undertaking, and it is no wonder that medieval building campaigns often lasted for decades.

The plan (FIG. 17-34) of Durham Cathedral is typically English with its long, slender proportions. It does not employ the modular scheme with the same care and logic seen at Caen. But in other ways this English church is even more innovative than the French church. It is the earliest example known of a ribbed groin vault placed over a three-story nave. And in the nave's western parts, completed before 1130, the rib vaults have slightly pointed arches, bringing together for the first time two of the key elements that determined the struc-

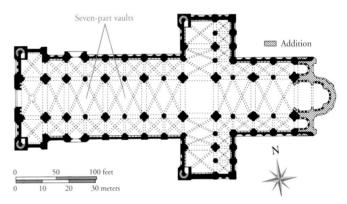

17-34 Plan of Durham Cathedral, England (after Kenneth John Conant).

Durham Cathedral is typically English in its long, slender proportions. In the nave, simple pillars alternate with compound piers that support the transverse arches of the seven-part groin vaults.

tural evolution of Gothic architecture. Also of great significance is the way the English builders buttressed the nave vaults. The lateral section (Fig. 17-33, *right*) reveals that simple *quadrant arches* (arches whose curve extends for one quarter of a circle's circumference) take the place of groin vaults in the tribune. The structural descendants of these quadrant arches are the flying buttresses that epitomize the mature Gothic solution to church construction (see "The Gothic Cathedral," Chapter 18, page 469).

Embroidery and Tapestry

The most famous embroidery of the Middle Ages is, ironically, known as the *Bayeux Tapestry* (FIG. 17-35). Embroidery and tapestry are related but different means of decorating textiles. *Tapestry* designs are woven on a loom as part of the fabric. *Embroidery* patterns are sewn onto fabric with threads.

The needleworkers who fashioned the *Bayeux Tapestry* were either Norman or English women. They employed eight colors of dyed wool—two varieties of blue, three shades of green, yellow, buff, and terracotta red—and two kinds of stitches. In *stem stitching*, short overlapping strands of thread form jagged lines. *Laid-and-*

couched work creates solid blocks of color. In the latter technique, the needleworker first lays down a series of parallel and then a series of cross stitches. Finally, the stitcher tacks down the cross-hatched threads using couching (knotting). On the *Bayeux Tapestry*, the embroiderers left the natural linen color exposed for the background, human flesh, building walls, and other "colorless" design elements. Stem stitches define the contours of figures and buildings and delineate interior details, such as facial features, body armor, and roof tiles. The clothing, animal bodies, and other solid areas are laid-and-couched work.

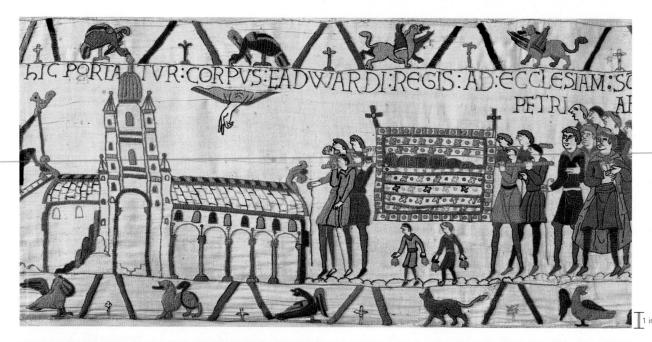

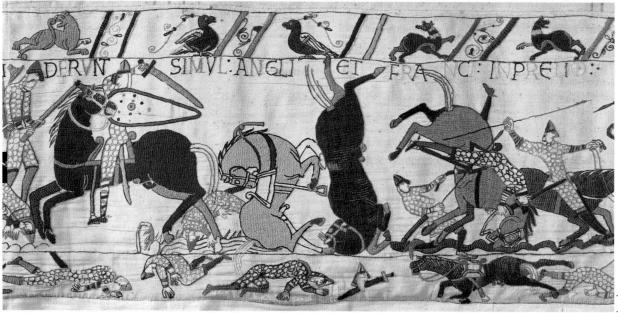

17-35 Funeral procession to Westminster Abbey (*top*) and Battle of Hastings (*bottom*), details of the *Bayeux Tapestry*, from Bayeux Cathedral, Bayeux, France, ca. 1070–1080. Embroidered wool on linen, 1' 8" high (entire length of fabric 229' 8"). Centre Guillaume le Conquérant, Bayeux.

The Bayeux Tapestry is unique in medieval art. Like historical narratives in ancient Roman art, it depicts contemporaneous events in full detail, as in the scroll-like frieze of Trajan's Column (Fig. 10-44).

Painting and Other Arts

Many of the finest illustrated manuscripts of the Romanesque age were the work of monks in English scriptoria, following in the tradition of Hiberno-Saxon book production (see Chapter 16). But the most famous work of English Romanesque art is neither a book nor Christian in subject.

BAYEUX TAPESTRY The so-called Bayeux Tapestry (FIG. 17-35) is unique in medieval art. It is an embroidered fabric—not, in fact, a woven tapestry—made of wool sewn on linen (see "Embroidery and Tapestry," page 456). Closely related to Romanesque manuscript illumination, its borders contain the kinds of real and imaginary animals found in contemporaneous books, and an explanatory Latin text sewn in thread accompanies many of the pictures. Some 20 inches high and about 230 feet long, the Bayeux Tapestry is a continuous, friezelike, pictorial narrative of a crucial moment in England's history and of the events that led up to it. The Norman defeat of the Anglo-Saxons at Hastings in 1066 brought England under the control of the Normans, uniting all of England and much of France under one rule. The dukes of Normandy became the kings of England. Commissioned by Bishop Odo, the half brother of the conquering Duke William, the embroidery may have been sewn by women at the Norman court. Many art historians, however, believe it was the work of English stitchers in Kent, where Odo was earl after the Norman conquest. Odo donated the work to Bayeux Cathedral (hence its nickname), but it is uncertain whether it was originally intended for display in the church's nave, where the theme would have been a curious choice.

The circumstances leading to the Norman invasion of England are well documented. In 1066, Edward the Confessor, the Anglo-Saxon king of England, died. The Normans believed Edward had recognized William of Normandy as his rightful heir. But the crown went to Harold, earl of Wessex, the king's Anglo-Saxon brother-inlaw, who had sworn allegiance to William. The betrayed Normans, descendants of the seafaring Vikings, boarded their ships, crossed the English Channel, and crushed Harold's forces.

Illustrated here are two episodes of the epic tale as represented in the Bayeux Tapestry. The first detail (FIG. 17-35, top) depicts King Edward's funeral procession. The hand of God points the way to the church in London where he was buried-Westminster Abbey, consecrated December 28, 1065, just a few days before Edward's death. The church was one of the first Romanesque buildings erected in England, and the embroiderers took pains to record its main features, including the imposing crossing tower and the long nave with tribunes. Here William was crowned king of England on Christmas Day, 1066. (The coronation of every English monarch since then also has occurred in Westminster Abbey.) The second detail (FIG. 17-35, bottom) shows the Battle of Hastings in progress. The Norman cavalry cuts down the English defenders. The lower border is filled with the dead and wounded, although the upper register continues the animal motifs of the rest of the embroidery. The Romanesque artist co-opted some of the characteristic motifs of Greco-Roman battle scenes, for example, the horses with twisted necks and contorted bodies (compare FIG. 5-70). But the artists rendered the figures in the Romanesque manner. Linear patterning and flat color replaced classical three-dimensional volume and modeling in light and dark hues.

The *Bayeux Tapestry* stands apart from all other Romanesque artworks in that it depicts an event in full detail at a time shortly after it occurred, recalling the historical narratives of ancient Roman art. Art historians have often likened the Norman embroidery to the scroll-like frieze of the Column of Trajan (FIG. 10-44). Like the Roman account, the story told on the *Bayeux Tapestry* is the conqueror's version

of history, a proclamation of national pride. And as in the ancient frieze, the narrative is not confined to battlefield successes. It is a complete chronicle of events. Included are the preparations for war, with scenes depicting the felling and splitting of trees for ship construction, the loading of equipment onto the vessels, the cooking and serving of meals, and so forth. In this respect, the *Bayeux Tapestry* is the most *Roman*-esque work of Romanesque art.

BURY BIBLE The Bury Bible (FIG. 17-36), produced at the Bury Saint Edmunds abbey in England around 1135, exemplifies the sumptuous illustration common to the large Bibles produced in wealthy Romanesque abbeys not subject to the Cistercian ban on luxurious illuminated manuscripts. These costly books lent prestige to monasteries that could afford them (see "Medieval Books," Chapter 16, page 411). The artist responsible for the Bury Bible is known: MASTER HUGO, who was also a sculptor and metalworker. With Bernardus Gelduinus (FIG. 17-7), Gislebertus (FIG. 17-12), Rainer of Huy (FIG. 17-23), Wiligelmo (FIG. 17-28), and Benedetto Antelami (FIG. 17-29),

17-36 Master Hugo, Moses expounding the Law, folio 94 recto of the *Bury Bible*, from Bury Saint Edmunds, England, ca. 1135. Ink and tempera on vellum, 1' 8" \times 1' 2". Corpus Christi College, Cambridge.

Master Hugo was a rare Romanesque lay artist, one of the emerging class of professional artists and artisans who depended for their livelihood on commissions from well-endowed monasteries.

Hugo is one of the small but growing number of Romanesque artists who signed their works or whose names were recorded. In the 12th century, artists, illuminators as well as sculptors, increasingly began to identify themselves. Although most medieval artists remained anonymous, the contrast of the Romanesque period with the early Middle Ages is striking. Hugo seems to have been a secular artist, one of the emerging class of professional artists and artisans who depended for their livelihood on commissions from well-endowed monasteries. These artists resided in towns rather than within secluded abbey walls, and they traveled frequently to find work. They were the exception, however, and the typical Romanesque scribes and illuminators continued to be monks and nuns working anonymously in the service of God. The Benedictine Rule, for example, specified that "artisans in the monastery . . . are to practice their craft with all humility, but only with the abbot's permission."6

One page (FIG. 17-36) of the Bury Bible shows two scenes from Deuteronomy framed by symmetrical leaf motifs in softly glowing harmonized colors. The upper register depicts Moses and Aaron proclaiming the Law to the Israelites. Master Hugo represented Moses with horns, consistent with Saint Jerome's translation of the Hebrew word that also means "rays" (compare Michelangelo's similar conception of the Hebrew prophet, FIG. 22-15). The lower panel portrays Moses pointing out the clean and unclean beasts. The slow, gentle gestures convey quiet dignity. The figures of Moses and Aaron seem to glide. This presentation is quite different from the abrupt emphasis and spastic movement seen in earlier Romanesque paintings. The movements of the figures appear more integrated and smooth. Yet patterning remains in the multiple divisions of the draped limbs, the lightly shaded volumes connected with sinuous lines and ladderlike folds. Hugo still thought of the drapery and body as somehow the same. The frame has a quite definite limiting function, and the painter carefully fit the figures within it.

EADWINE PSALTER The Eadwine Psalter is the masterpiece of an English monk known as Eadwine the Scribe. It contains 166 illustrations, many of which are variations of those in the Carolingian Utrecht Psalter (FIG. 16-15). The last page (FIG. 17-37), however, presents a rare picture of a Romanesque artist at work. The style of the Eadwine portrait resembles that of the Bury Bible, but although the patterning is still firm (notably in the cowl and the thigh), the drapery falls more softly and follows the movements of the body beneath it. Here, the abstract patterning of many Romanesque painted and sculpted garments yielded slightly, but clearly, to the requirements of more naturalistic representation. The Romanesque artist's instinct for decorating the surface remained, as is apparent in the gown's whorls and spirals. Significantly, however, the artist painted in those interior lines very lightly so that they would not conflict with the functional lines that contain them.

The "portrait" of Eadwine—it is probably a generic type and not a specific likeness—is in the long tradition of author portraits in ancient and medieval manuscripts (FIGS. 16-7, 16-13, 16-14, and 17-22), although the true author of the Eadwine Psalter is King David. Eadwine

17-37 EADWINE THE SCRIBE, Eadwine the Scribe at work, folio 283 verso of the Eadwine Psalter, ca. 1160-1170. Ink and tempera on vellum. Trinity College, Cambridge.

Although he humbly offered his book as a gift to God, the English monk Eadwine added an inscription to his portrait declaring himself a "prince among scribes" whose fame would endure forever.

exaggerated his importance by likening his image to that of an evangelist writing his gospel and by including an inscription within the inner frame that identifies him and proclaims himself a "prince among scribes." He declares that, due to the excellence of his work, his fame will endure forever and that he can offer his book as an acceptable gift to God. Eadwine, like other Romanesque sculptors and painters who signed their works, may have been concerned for his fame, but these artists, whether monks or laity, were not yet aware of the concepts of fine art and fine artist. To them, their work existed not for its own sake but for God's. Nonetheless, works such as this one are an early sign of a new attitude toward the role of the artist in society that presages the emergence of the notion of individual artistic genius in the Renaissance.

ROMANESQUE EUROPE

FRANCE AND NORTHERN SPAIN

- Romanesque takes its name from the Roman-like barrel and groin vaults based on round arches employed in many European churches built between 1050 and 1200. Romanesque vaults, however, are made of stone, not concrete.
- Numerous churches sprang up along the pilgrimage roads leading to the shrine of Saint James at Santiago de Compostela. These churches were large enough to accommodate crowds of pilgrims who came to view the relics displayed in radiating chapels off the ambulatory and transept.
- The Romanesque period also brought the revival of monumental stone relief sculpture, especially on church facades, where scenes of Christ as Last Judge often greeted the faithful as they entered the doorway to salvation.
- The leading patrons of Romanesque sculpture and painting were the monks of the Cluniac order. The Cistercians, under the leadership of Bernard of Clairvaux, condemned figural art in churches and religious books.

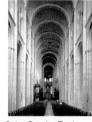

Saint-Sernin, Toulouse, ca. 1070–1120

Saint-Pierre, Moissac, ca. 1115–1135

HOLY ROMAN EMPIRE

- In the Romanesque period, the Salian dynasty (r. 1027–1125) ruled an empire that corresponds roughly to present-day Germany and northern Italy.
- Architects in the Holy Roman Empire built structurally innovative churches. Speyer Cathedral and Sant'Ambrogio in Milan are two of the earliest examples of the use of groin vaults in naves.
- In Belgium, sculptors excelled in metalwork, producing costly reliquaries of silver, jewels, and enamel. Rainer of Huy, one of several Romanesque artists whose name is known, cast a baptismal font in a single piece.

Rainer of Huy, baptismal font, 1118

ITALY

- The regional diversity of Romanesque art and architecture is especially evident in Italy, where the ancient Roman and Early Christian heritage was strongest.
- Romanesque churches in Pisa and Florence have wooden roofs in contrast to the vaulted interiors of northern buildings. The exteriors often feature marble paneling of different colors. Church campaniles were usually freestanding, and baptisteries were independent central-plan buildings facing the cathedral.

Cathedral complex, Pisa, 11th–12th centuries

NORMANDY AND ENGLAND

- After their conversion to Christianity in the early 10th century, the Vikings settled on the northern coast of France. From there, Duke William of Normandy crossed the channel and conquered England in 1066. The Bayeux Tapestry chronicles that war—a unique example of contemporaneous historical narrative art in the Middle Ages.
- Norman and English Romanesque architects introduced new features to church design that greatly influenced French Gothic architecture. Saint-Étienne at Caen and Durham Cathedral are the earliest examples of the use of rib groin vaults over a three-story nave elevation (arcade-tribune-clerestory). The Durham builders also experimented with quadrant arches in the tribune to buttress the nave vaults.

Bayeux Tapestry, ca. 1070-1080

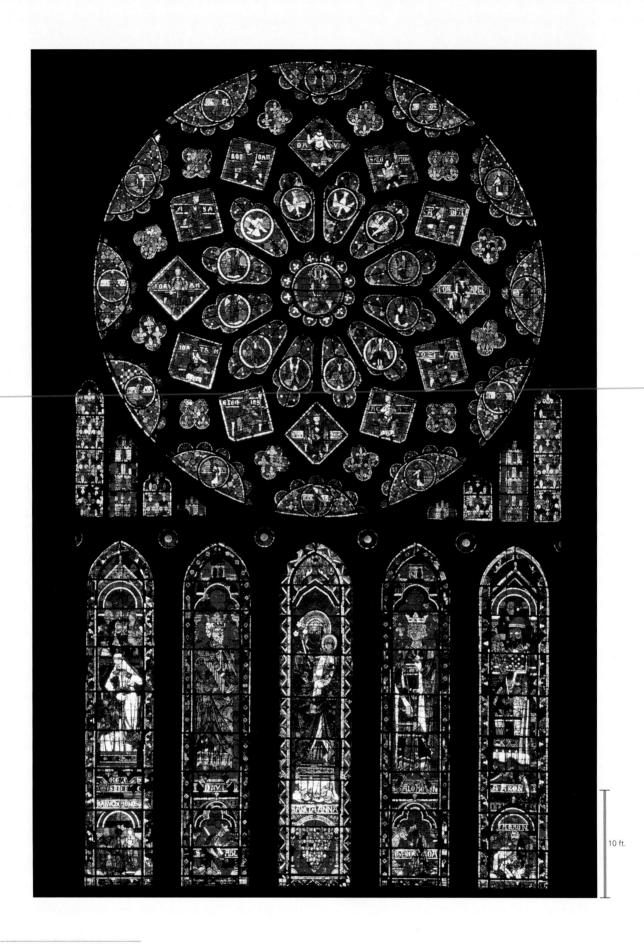

18-1 Rose window and lancets, north transept, Chartres Cathedral, Chartres, France, ca. 1220. Stained glass, rose window 43' in diameter.

The use of flying buttresses in Gothic cathedrals made possible the replacement of stone walls with immense stained-glass windows, which transformed natural sunlight into Abbot Suger's divine *lux nova*.

GOTHIC EUROPE

In 1550, Giorgio Vasari (1511–1574), the "father of art history," first used *Gothic* as a term of ridicule to describe late medieval art and architecture, which he attributed to the Goths and regarded as "monstrous and barbarous." With the publication in that year of his influential *Introduction to the Three Arts of Design*, Vasari codified for all time the notion the early Renaissance artist Lorenzo Ghiberti (1378–1455) had already advanced in his *Commentarii*, namely, that the Middle Ages was a period of decline. The humanists of the Italian Renaissance, who placed Greco-Roman art on a pedestal, believed that the uncouth Goths were responsible for both the downfall of Rome and the destruction of the classical style in art and architecture. They regarded "Gothic" art with contempt and considered it ugly and crude. In the 13th and 14th centuries, however, when the Gothic style was the rage in most of Europe, contemporaries admired Gothic buildings as *opus modernum* ("modern work"). The clergy and the lay public alike recognized that the great cathedrals towering over their towns displayed an exciting new style. For them, Gothic cathedrals were not distortions of the classical style but images of the City of God, the Heavenly Jerusalem, which they were privileged to build on earth.

As in the Romanesque period, the great artistic innovations of the Gothic age were in part the outgrowth of widespread prosperity, but the era was also a time of turmoil in Europe (MAP 18-1). In 1337 the Hundred Years' War began, shattering the peace between France and England. In the 14th century, a great plague, the Black Death, swept over western Europe and killed at least a quarter of its people. From 1378 to 1417, opposing popes resided in Rome and in Avignon in southern France during the political-religious crisis known as the Great Schism (see "The Great Schism," Chapter 19, page 501). Above all, the Gothic age was a time of profound change in European society. The focus of both intellectual and religious life shifted definitively from monasteries in the countryside to rapidly expanding secular cities. In these new Gothic urban centers, prosperous merchants made their homes and *guilds* (professional associations) of scholars founded the first modern universities. Although the papacy was at the height of its power, and knights throughout Europe still gathered to wage Crusades against the Muslims, the independent secular nations of modern Europe were beginning to take shape. Foremost among them was France.

MAP 18-1 Europe around 1200.

FRENCH GOTHIC

The Gothic style first appeared in northern France around 1140, and some late medieval writers called Gothic art in general *opus franci-genum* ("French work"). By the 13th century, the opus modernum of the region around Paris had spread throughout western Europe, and in the next century it expanded still farther. Saint Vitus Cathedral in Prague (Czech Republic), for example, begun in 1344, closely emulates French Gothic architecture. Today, Gothic architecture lives on in the chapels, academic buildings, and dormitories of college campuses throughout North America. But although the Gothic style achieved international acclaim, it was a regional phenomenon. To the east and south of Europe, the Byzantine and Islamic styles still held sway. And many regional variants existed within European Gothic, just as distinct regional styles characterized the Romanesque period.

Architecture and Architectural Decoration

Art historians generally agree that the birthplace of Gothic architecture was at Saint-Denis, a few miles north of Paris. Saint Dionysius (Denis in French) was the apostle who brought Christianity to Gaul and who died a martyr's death there in the third century. The Benedictine order founded the abbey at Saint-Denis in the seventh century on the site of the saint's burial. In the ninth century, the monks constructed a basilica at Saint-Denis, which housed the saint's tomb and those of almost all of the French kings dating back to the sixth century, as well as the crimson military banner said to have belonged to Charlemagne. The Carolingian basilica became France's royal church, the very symbol of the monarchy (just as Speyer Cathedral, FIG. 17-19, was the burial place of the German rulers of the Holy Roman Empire).

SUGER AND SAINT-DENIS By 1122, when a monk named Suger became abbot of Saint-Denis, the old church was in disrepair and had become too small to accommodate the growing number of pilgrims. Suger also believed the basilica was of insufficient grandeur to serve as the official church of the French kings (see "Abbot Suger

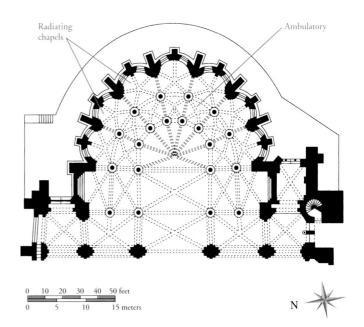

18-2 Plan of the east end, abbey church, Saint-Denis, France, 1140–1144 (after Sumner Crosby).

The innovative plan of the east end of Saint-Denis dates to Abbot Suger's lifetime. By using lightweight rib vaults, the builders were able to eliminate the walls between the radiating chapels.

Abbot Suger and the Rebuilding of Saint-Denis

bbot Suger of Saint-Denis (1081–1151) rose from humble parentage to become the right-hand man of both Louis VI (r. 1108–1137) and Louis VII (r. 1137–1180). When the latter, accompanied by his queen, Eleanor of Aquitaine, left to join the Second Crusade (1147–1149), Suger served as regent of France. From his youth, Suger wrote, he had dreamed of the possibility of embellishing the church in which most French monarchs had been buried for nearly 500 years. Within 15 years of becoming abbot of Saint-Denis, Suger began rebuilding its Carolingian basilica. In Suger's time, the power of the French kings, except for scattered holdings, extended over an area not much larger than the Île-de-France, the region centered on Paris. But the kings had pretensions to rule all of France. Suger aimed to increase the prestige both of his abbey and of the monarchy by rebuilding France's royal church in grand fashion.

Suger wrote three detailed treatises about his activities as abbot of Saint-Denis. He recorded that he summoned masons and artists

18-3 Ambulatory and radiating chapels, abbey church, Saint-Denis, France, 1140–1144.

Abbot Suger's remodeling of Saint-Denis marked the beginning of Gothic architecture. Rib vaults with pointed arches spring from slender columns. The radiating chapels have stained-glass windows.

from many regions to help design and construct his new church. In one important passage, he described the special qualities of the new east end (FIGS. 18-2 and 18-3) dedicated in 1144:

[I]t was cunningly provided that—through the upper columns and central arches which were to be placed upon the lower ones built in the crypt—the central nave of the old [Carolingian church] should be equalized, by means of geometrical and arithmetical instruments, with the central nave of the new addition; and, likewise, that the dimensions of the old side-aisles should be equalized with the dimensions of the new side-aisles, except for that elegant and praiseworthy extension in [the form of] a circular string of chapels, by virtue of which the whole [church] would shine with the wonderful and uninterrupted light of most sacred windows, pervading the interior beauty.*

The abbot's brief discussion of Saint Denis's new ambulatory and chapels is key to the understanding of Early Gothic architecture. But he wrote at much greater length about his church's glorious golden and gem-studded furnishings. Here, for example, is Suger's description of the *altar frontal* (the decorative panel on the front of the altar) in the choir:

Into this panel, which stands in front of [Saint Denis's] most sacred body, we have put . . . about forty-two marks of gold [and] a multifarious wealth of precious gems, hyacinths, rubies, sapphires, emeralds and topazes, and also an array of different large pearls. †

The costly furnishings and the light-filled space caused Suger to "delight in the beauty of the house of God" and "called [him] away from external cares." The new church made him feel as if he were "dwelling... in some strange region of the universe which neither exists entirely in the slime of the earth nor entirely in the purity of Heaven." In Suger's eyes, then, his splendid new church, permeated with light and outfitted with gold and precious gems, was a way station on the road to Paradise, which "transported [him] from this inferior to that higher world." He regarded a lavish investment in art as a spiritual aid, not as an undesirable distraction for the pious monk, as did Bernard of Clairvaux (see "Bernard of Clairvaux," Chapter 17, page 438). Suger's forceful justification of art in the church set the stage for the proliferation of costly stained-glass windows and sculptures in the cathedrals of the Gothic age.

and the Rebuilding of Saint-Denis," above). Thus, Suger began to rebuild the church in 1135 by erecting a new west facade with sculptured portals. In 1140 work began on the east end (FIGS. 18-2 and 18-3). Suger died before he could remodel the nave, but he attended the dedication of the new choir, ambulatory, and radiating

chapels on June 11, 1144. Also in attendance were King Louis VII of France, Queen Eleanor of Aquitaine, and five archbishops.

Because the French considered the old church a relic in its own right, the new east end had to conform to the dimensions of the crypt below it. Nevertheless, the remodeled portion of Saint-Denis

^{*} Translated by Erwin Panofsky, Abbot Suger on the Abbey Church of Saint-Denis and Its Art Treasures, 2d ed. (Princeton: Princeton University Press, 1979), 101.

[†] Ibid., 55.

[‡] Ibid., 65.

The Gothic Rib Vault

he ancestors of the Gothic rib vault are the Romanesque vaults found at Caen (FIG. 17-31), Durham (FIG. 17-33), and elsewhere. The rib vault's distinguishing feature is the crossed, or diagonal, arches under its groins, as seen in the Saint-Denis ambulatory and chapels (FIG. 18-3; compare FIG. 18-20). These arches form the armature, or skeletal framework, for constructing the vault. Gothic vaults generally have more thinly vaulted webs (the masonry between the ribs) than found in Romanesque vaults. But the chief difference between the two styles of rib vaults is the pointed arch, an integral part of the Gothic skeletal armature. The first wide use of pointed arches was in Sasanian architecture (FIG. 2-27), and Islamic builders later adopted them. French Romanesque architects (FIGS. 17-1 and 17-14) borrowed the form from Muslim Spain and passed it to their Gothic successors. Pointed arches allowed Gothic builders to make the crowns of all the vault's arches approximately the same level, regardless of the space to be vaulted. The Romanesque architects could not achieve this with their semicircular arches.

The drawings here (FIG. 18-4) illustrate this key difference. In FIG. 18-4a, the rectangle ABCD is an oblong nave bay to be vaulted. AC and DB are the diagonal ribs; AB and DC, the transverse arches; and AD and BC, the nave arcade's arches. If the architect uses semi-

circular arches (*AFB*, *BJC*, and *DHC*), their radii and, therefore, their heights (*EF*, *IJ*, and *GH*) will be different, because the width of a semicircular arch determines its height. The result will be a vault (FIG. 18-4b) with higher transverse arches (*DHC*) than the arcade's arches (*CJB*). The vault's crown (*F*) will be still higher. If the builder uses pointed arches (FIG. 18-4c), the transverse (*DLC*) and arcade (*BKC*) arches can have the same heights (*GL* and *IK* in FIG. 18-4a). The result will be a Gothic rib vault where the points of the arches (*L* and *K*) are at the same level as the vault's crown (*F*).

A major advantage of the Gothic vault is its flexibility, which permits the vaulting of compartments of varying shapes, as may be seen at Saint-Denis (FIG. 18-2). Pointed arches also channel the weight of the vaults more directly downward than do semicircular arches. The vaults therefore require less buttressing to hold them in place, in turn permitting builders to open up the walls and place large windows beneath the arches. Because pointed arches also lead the eye upward, they make the vaults appear taller than they are. In FIG. 18-4, the crown (F) of both the Romanesque (b) and Gothic (c) vaults is the same height from the pavement, but the Gothic vault seems taller. Both the physical and visual properties of rib vaults with pointed arches aided Gothic builders in their quest for soaring height in church interiors.

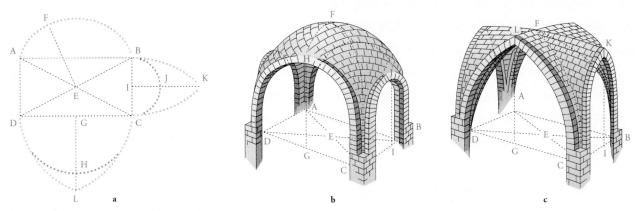

18-4 Diagram (a) and drawings of rib vaults with semicircular (b) and pointed (c) arches.

Pointed arches channel the weight of the rib vaults more directly downward than do semicircular arches, requiring less buttressing. Pointed arches also make the vaults appear taller than they are.

represented a sharp break from past practice. Innovative rib vaults resting on pointed, or *ogival*, arches (see "The Gothic Rib Vault," above, and FIG. 18-4) cover the ambulatory and chapels (FIG. 18-3). These pioneering, exceptionally lightweight vaults spring from slender columns in the ambulatory and from the thin masonry walls framing the chapels. The lightness of the vaults enabled the builders to eliminate the walls between the chapels (FIG. 18-2) and open up the outer walls and fill them with stained-glass windows (see "Stained-Glass Windows," page 472). Suger and his contemporaries marveled at the "wonderful and uninterrupted light" that poured in through the "most sacred windows." The abbot called the colored light *lux nova*, "new light." The multicolored rays coming through the windows shone on the walls and columns, almost dissolving them. Both the new type of vaulting and the use of stained glass became hallmarks of French Gothic architecture.

Saint-Denis is also the key monument of Early Gothic sculpture. Little of the sculpture that Suger commissioned for the west facade of the abbey church survived the French Revolution of the late 18th century (see Chapter 29), but much of the mid-12th-century structure is intact. It consists of a double-tower westwork, as at Saint-Étienne (FIG. 17-30) at Caen, and has massive walls in the Romanesque tradition. A restored large central *rose window* (a circular stained-glass window), a new feature that became standard in French Gothic architecture, punctuates the facade's upper story. For the three portals, Suger imported sculptors to carry on the rich Romanesque heritage of southern France (see Chapter 17). But at Saint-Denis, the sculptors introduced statues of Old Testament kings, queens, and prophets attached to columns, which screened the jambs of all three doorways.

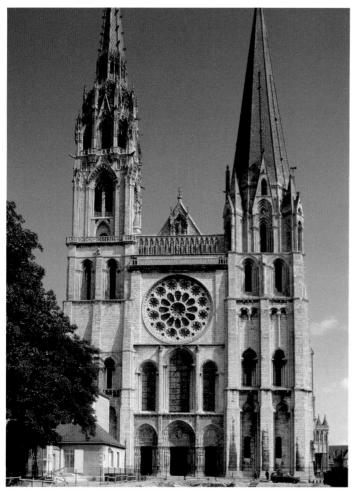

18-5 West facade, Chartres Cathedral, Chartres, France, ca. 1145–1155.

The Early Gothic west facade was all that remained of Chartres Cathedral after the fire of 1194. The design still has much in common with Romanesque facades. The rose window is an example of plate tracery.

ROYAL PORTAL, CHARTRES This innovative treatment of the portals of Suger's church appeared immediately afterward at Chartres, also in the Île-de-France, in the new cathedral dedicated to Notre Dame ("Our Lady," that is, the Virgin Mary). Work on the west facade (FIG. 18-5) began around 1145. The lower parts of the massive west towers at Chartres and the portals between them are all that remain of the cathedral destroyed by fire in 1194 before it had been completed. Reconstruction of the church began immediately but in the High Gothic style (discussed later). The west entrance, the Royal Portal (FIG. 18-6; so named because of the statue-columns of kings and queens flanking its three doorways) constitutes the most complete surviving ensemble of Early Gothic sculpture. Thierry of Chartres, chancellor of the Cathedral School of Chartres from 1141 until his death 10 years later, may have conceived the complex iconographical program. The archivolts of the right portal, for example, depict the seven female Liberal Arts and their male champions. The figures represent the core of medieval learning and symbolize human knowledge, which Thierry and other "Schoolmen" believed led to true faith (see "Scholasticism and Gothic Art and Architecture," page 466).

The sculptures of the Royal Portal (FIG. 18-6) proclaim the majesty and power of Christ. To unite the three doorways iconographically and visually, the sculptors carved episodes from Christ's life on the capitals, which form a kind of frieze linking one entrance to the next. In the tympanum of the right portal, Christ appears in the lap of the Virgin Mary (Notre Dame). Scenes of his birth and early life fill the lintel below. The tympanum's theme and composition recall Byzantine representations of the Theotokos (FIGS. 12-18 and 12-19), as well as the Romanesque Throne of Wisdom (FIG. 17-18). But Mary's prominence on the Chartres facade has no parallel in the decoration of Romanesque church portals. At Chartres the designers gave her a central role in the sculptural program, a position she maintained throughout the Gothic period. The cult of the Virgin Mary reached a high point in the Gothic age. As the Mother of Christ, she stood compassionately between the Last Judge and the horrors of Hell, interceding for all her faithful. Worshipers in the later 12th and 13th centuries

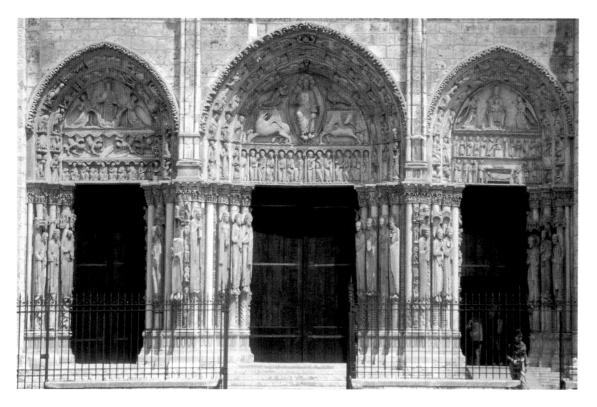

18-6 Royal Portal, west facade, Chartres Cathedral, Chartres, France, ca. 1145–1155.

The sculptures of the Royal Portal proclaim the majesty and power of Christ. The tympana depict, from left to right, Christ's Ascension, the Second Coming, and Jesus in the lap of the Virgin Mary.

Scholasticism and Gothic Art and Architecture

few years before the formal consecration of the church altar at Notre-Dame (FIG. 18-11) in Paris, Philip II Augustus (r. 1180–1223) succeeded to the French throne. Philip brought the feudal barons under his control and expanded the royal domains to include Normandy in the north and most of Languedoc in the south, laying the foundations for the modern nation of France. Renowned as "the maker of Paris," he gave the city its walls, paved its streets, and built the palace of the Louvre (now one of the world's great museums) to house the royal family. Although Rome remained the religious center of Western Christendom, Paris became its intellectual capital. The University of Paris attracted the best minds from all over Europe. Virtually every thinker of note in the Gothic world at some point studied or taught at Paris.

Even in the Romanesque period, Paris was a center of learning. Its Cathedral School professors, known as Schoolmen, developed the philosophy called Scholasticism. The greatest of the early Schoolmen was Peter Abelard (1079-1142), a champion of logical reasoning. Abelard and his contemporaries had been introduced to the writings of the Greek philosopher Aristotle through the Arabic scholars of Islamic Spain. Abelard applied Aristotle's system of rational inquiry to the interpretation of religious belief. Until the 12th century, both clergy and laymen considered truth the exclusive property of divine revelation as given in the Holy Scriptures. But the Schoolmen, using Aristotle's method, sought to demonstrate that reason alone could lead to certain truths. Their goal was to prove the central articles of Christian faith by argument (disputatio). A person using Scholastic argument first states a possibility, then cites an authoritative view in objection, next reconciles the positions, and, finally, offers a reply to each of the rejected original arguments.

One of Abelard's greatest critics was Bernard of Clairvaux (see "Bernard of Clairvaux," Chapter 17, page 438), who believed Scholas-

ticism was equivalent to questioning Christian dogma. Although Bernard succeeded in 1140 in having the Catholic Church officially condemn Abelard's doctrines, the Schoolmen's philosophy developed systematically until it became the dominant Western philosophy of the late Middle Ages. By the 13th century, the Schoolmen of Paris already had organized as a professional guild of master scholars, separate from the numerous Church schools the bishop of Paris oversaw. The structure of the Parisian guild served as the model for many other European universities.

The greatest exponent of Abelard's Scholasticism was Thomas Aquinas (1225–1274), an Italian monk who became a saint in 1323. Aquinas settled in Paris in 1244. There, the German theologian Albertus Magnus instructed him in Aristotelian philosophy. Aquinas went on to become an influential teacher at the University of Paris. His most famous work, *Summa Theologica* (left unfinished at his death), is a model of the Scholastic approach to knowledge. Aquinas divided his treatise into books, the books into questions, the questions into articles, each article into objections with contradictions and responses, and, finally, answers to the objections. He set forth five ways to prove the existence of God by rational argument. Aquinas's work remains the foundation of contemporary Catholic teaching.

The earliest manifestations of the Gothic spirit in art and architecture—the sculptured portals and vaulted east end of Suger's Saint-Denis (FIGS. 18-2 and 18-3)—appeared concurrently with the first stages of Scholastic philosophy. Both originated in Paris and its environs. Many art historians have noted the parallels between them—how the logical thrust and counterthrust of Gothic construction, the geometric relationships of building parts, and the systematic organization of the iconographical programs of Gothic church portals coincide with Scholastic principles and methods. No documents exist, however, linking the scholars, builders, and sculptors.

sang hymns to her, put her image everywhere, and dedicated great cathedrals to her. Soldiers carried the Virgin's image into battle on banners, and her name joined that of Saint Denis as part of the French king's battle cry. Mary became the spiritual lady of chivalry, and the Christian knight dedicated his life to her. The severity of Romanesque themes stressing the Last Judgment yielded to the gentleness of Gothic art, in which Mary is the kindly Queen of Heaven.

Christ's Ascension into Heaven appears in the tympanum of the left portal. All around, in the archivolts, are the signs of the zodiac and scenes representing the various labors of the months of the year. They are symbols of the cosmic and earthly worlds. The Second Coming is the subject of the central tympanum. The signs of the four evangelists, the 24 elders of the Apocalypse, and the 12 apostles appear around Christ or on the lintel. The Second Coming—in essence, the Last Judgment theme—was still of central importance, as it was in Romanesque portals. But at Early Gothic Chartres, the theme became a symbol of salvation rather than damnation.

Statues of Old Testament kings and queens decorate the jambs flanking each doorway of the Royal Portal (FIGS. 18-6 and 18-7). They are the royal ancestors of Christ and, both figuratively and literally, support the New Testament figures above the doorways. They wear 12th-century clothes, and medieval observers also regarded

them as images of the kings and queens of France. (This was the motivation for vandalizing the comparable figures at Saint-Denis during the French Revolution.) The figures stand rigidly upright with their elbows held close against their hips. The linear folds of their garments-inherited from the Romanesque style, along with the elongated proportions—generally echo the vertical lines of the columns behind them. (In this respect, Gothic jamb statues differ significantly from classical caryatids; FIG. 5-54. The Gothic figures are attached to columns; the classical statues replaced the columns.) And yet, within and despite this architectural straitjacket, the statues display the first signs of a new naturalism. The sculptors conceived and treated the figures as three-dimensional volumes, not reliefs, and they stand out from the plane of the wall. As was true of all stone sculpture on church facades, artists originally painted the Royal Portal statues in vivid colors, enhancing their lifelike appearance. The new naturalism is noticeable particularly in the statues' heads, where kindly human faces replace the masklike features of most Romanesque figures. At Chartres, a personalization of appearance began that led first to idealized portraits of the perfect Christian and finally, by 1400, into the portraiture of specific individuals. The sculptors of the Royal Portal statues initiated an era of artistic concern with personality and individuality.

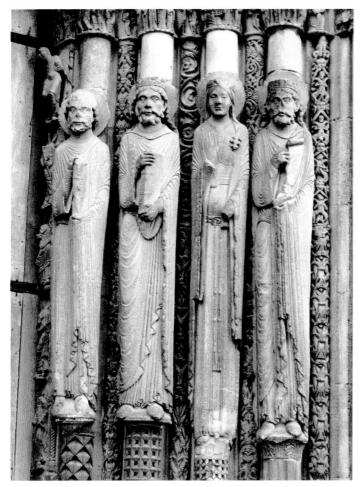

18-7 Old Testament kings and queen, jamb statues, central doorway of Royal Portal, Chartres Cathedral, Chartres, France, ca. 1145–1155.

The biblical kings and queens of the Royal Portal are the royal ancestors of Christ. These Early Gothic statue-columns display the first signs of a new naturalism in European sculpture.

LAON CATHEDRAL Both Chartres Cathedral and the abbey church of Saint-Denis had long construction histories, and only small portions of the structures date to the Early Gothic period. Laon Cathedral (FIGS. 18-8 and 18-9), however, completed shortly after 1200, provides a comprehensive picture of French church architecture of the second half of the 12th century. Although the Laon builders retained many Romanesque features in their design, they combined them with the rib vault resting on pointed arches, the essential element of Early Gothic architecture.

Among the Laon plan's Romanesque features are the nave bays with their large sexpartite rib vaults, flanked by two small groinvaulted squares in each aisle. The vaulting system (except for the pointed arches), as well as the vaulted gallery above the aisles, derived from Norman Romanesque churches such as Saint-Étienne (FIG. 17-31) at Caen. The Laon architect also employed the Romanesque alternate-support system of compound and simple piers in the nave arcade. Above, alternating bundles of three and five shafts frame the aisle bays. A new feature found in the Laon interior, however, is the *triforium*, the band of arcades below the clerestory

18-9 Interior of Laon Cathedral (looking northeast), Laon, France, begun ca. 1190.

The insertion of a triforium at Laon broke up the nave wall and produced the characteristic four-story Early Gothic interior elevation: nave arcade, vaulted gallery, triforium, and clerestory.

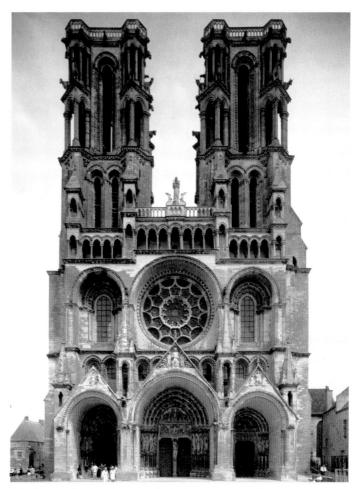

18-8 West facade of Laon Cathedral, Laon, France, begun ca. 1190.

The huge central rose window, the deep porches in front of the doorways, and the open structure of the towers distinguish Laon's Early Gothic facade from Romanesque church facades.

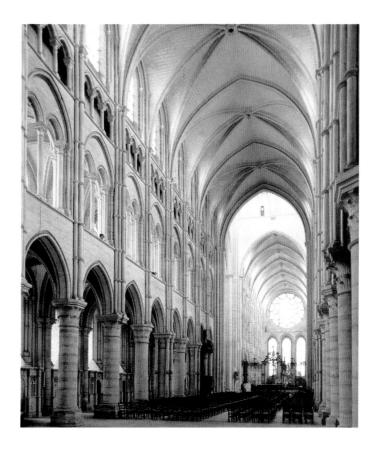

18-10 Nave elevations of four French Gothic cathedrals at the same scale (after Louis Grodecki).

Gothic nave designs evolved from the Early Gothic fourstory elevation to the High Gothic three-story elevation (arcade, triforium, and clerestory). The height of the vaults also increased from 80 to 144 feet.

(FIGS. 18-9 and 18-10a). The triforium occupies the space corresponding to the exterior strip of wall covered by the sloping timber roof above the galleries. The insertion of the triforium into the Romanesque threestory nave elevation reflected a growing desire to break up all continuous wall surfaces. The new horizontal zone produced the characteristic four-story Early Gothic interior elevation: nave arcade, vaulted gallery, triforium, and clerestory with single lancets (tall, narrow windows ending in pointed arches). Shown in FIG. 18-10 is a comparison of the Laon nave elevation

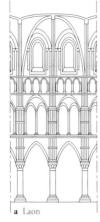

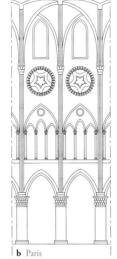

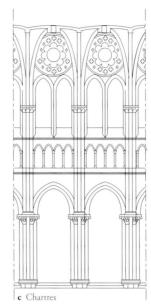

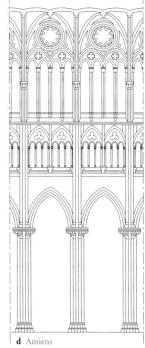

with that of another four-story Early Gothic cathedral (FIG. 18-10*b*) and with elevations of two three-story High Gothic cathedrals (FIGS. 18-10*c* and 18-10*d*).

Laon Cathedral's west facade (FIG. 18-8) signals an even more pronounced departure from the Romanesque style still lingering at Saint-Denis and the Chartres Royal Portal. Typically Gothic are the huge central rose window, the deep porches in front of the doorways, and the open structure of the towers. A comparison of the facades of Laon Cathedral and Saint-Étienne (FIG. 17-30) at Caen reveals a much deeper penetration of the wall mass in the later building. At Laon, as in Gothic architecture generally, the guiding principle was to reduce sheer mass and replace it with intricately framed voids.

NOTRE-DAME, PARIS About 1130, Louis VI moved his official residence to Paris, spurring much commercial activity and a great building boom. Paris soon became the leading city of France, indeed of all northern Europe, making a new cathedral a necessity. Notre-Dame (FIG. 18-11) occupies a picturesque site on an island in the Seine River called the Île-de-la-Cité. The Gothic church, which replaced a

large Merovingian basilica, has a complicated building history. The choir and transept were completed by 1182, the nave by about 1225, and the facade not until around 1250–1260. Sexpartite vaults cover the nave, as at Laon. The original elevation (the builders modified the design as work progressed) had four stories, but the scheme (FIG. 18-10*b*) differed from Laon's (FIG. 18-10*a*). In place of the triforium over the gallery, stained-glass *oculi* (singular *oculus*, a small round window) open up the wall below the clerestory lancets. As a result, windows fill two of the four stories, further reducing the

18-11 Notre-Dame (looking north), Paris, France, begun 1163; nave and flying buttresses, ca. 1180–1200; remodeled after 1225.

Architects first used flying buttresses on a grand scale in the Cathedral of Notre-Dame in Paris. The buttresses countered the outward thrust of the nave vaults and held up the towering nave walls.

masonry area. (This four-story nave elevation can be seen in only one bay in FIG. 18-11, immediately to the right of the south transept and partially hidden by it.)

To hold the much thinner—and taller (compare FIGS. 18-10a and 18-10b)—walls of Notre-Dame in place, the unknown architect introduced flying buttresses, exterior arches that spring from the lower roofs over the aisles and ambulatory (FIG. 18-11) and counter the outward thrust of the nave vaults. Gothic builders employed flying buttresses as early as 1150 in a few smaller churches, but at Notre-Dame in Paris they circle a great urban cathedral. At Durham, the internal quadrant arches (FIG. 17-33, right) beneath the aisle roofs, also employed at Laon, perform a similar function and may be regarded as precedents for exposed Gothic flying buttresses. The combination of precisely positioned flying buttresses and rib vaults with pointed arches was the ideal solution to the problem of constructing towering naves with huge windows. The flying buttresses, like slender extended fingers holding up the walls, are key components of the distinctive "look" of Gothic cathedrals (see "The Gothic Cathedral," page 469, and FIG. 18-12).

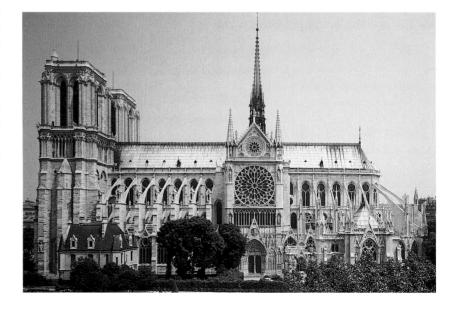

The Gothic Cathedral

These towering structures are eloquent testimonies to the extraordinary skill of the architects, engineers, carpenters, masons, sculptors, glassworkers, and metalsmiths who constructed and decorated the buildings. Most of the architectural components of Gothic cathedrals appeared in earlier structures, but the way Gothic architects combined the elements made the buildings unique expressions of medieval faith. The essential ingredients of the Gothic "recipe" were rib vaults with pointed arches (see "The Gothic Rib Vault," page 464), flying buttresses, and huge colored-glass windows (see "Stained-Glass Windows," page 472). These and the other important Gothic architectural terms listed here are illustrated in Fig. 18-12.

- *Pinnacle* A sharply pointed ornament capping the piers or flying buttresses; also used on cathedral facades.
- Flying buttresses Masonry struts that transfer the thrust of the nave vaults across the roofs of the side aisles and ambulatory to a tall pier rising above the church's exterior wall. (Compare FIG. I-18, right.)
- *Vaulting web* The masonry blocks that fill the area between the ribs of a groin vault.
- *Diagonal rib* In plan, one of the ribs that form the X of a groin vault. In FIG. 18-4, the diagonal ribs are the lines AC and DB.
- *Transverse rib* A rib that crosses the nave or aisle at a 90-degree angle (lines *AB* and *DC* in FIG. 18-4).
- *Springing* The lowest stone of an arch; in Gothic vaulting, the lowest stone of a diagonal or transverse rib.
- Clerestory The windows below the vaults that form the nave elevation's uppermost level. By using flying buttresses and rib vaults on pointed arches, Gothic architects could build huge clerestory windows and
- 18-12 Cutaway view of a typical French Gothic cathedral (John Burge). (1) pinnacle,
- (2) flying buttress, (3) vaulting web, (4) diagonal rib,
- (5) transverse rib, (6) springing, (7) clerestory,
- (8) oculus, (9) lancet, (10) triforium, (11) nave arcade, (12) compound pier with responds.

Rib vaults with pointed arches, flying buttresses, and stained-glass windows are the major ingredients in the "recipe" for constructing Gothic cathedrals, but other elements also contributed to the distinctive "look" of these churches.

fill them with *stained glass* held in place by ornamental stonework called *tracery*.

- **Oculus** A small round window.
- **Lancet** A tall, narrow window crowned by a pointed arch.
- *Triforium* The story in the nave elevation consisting of arcades, usually *blind arcades* (FIG. 18-9), but occasionally filled with stained glass (FIG. I-2).
- *Nave arcade* The series of arches supported by piers separating the nave from the side aisles.
- Compound pier with shafts (responds) Also called the cluster pier, a pier with a group, or cluster, of attached shafts, or responds, extending to the springing of the vaults.

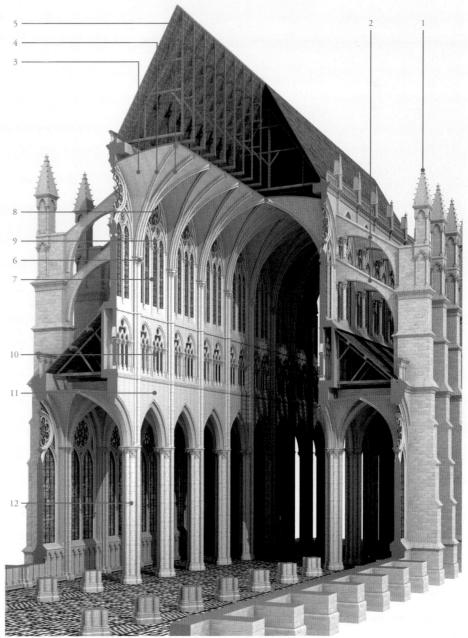

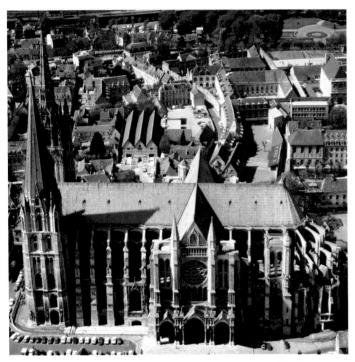

18-13 Aerial view of Chartres Cathedral (looking north), Chartres, France, as rebuilt after 1194.

Architectural historians consider the rebuilt Chartres Cathedral the first great monument of High Gothic architecture. It is the first church to have been planned from the beginning with flying buttresses.

CHARTRES AFTER 1194 Churches burned frequently in the Middle Ages (see "Timber Roofs," Chapter 17, page 435), and church officials often had to raise money suddenly for new building campaigns. In contrast to monastic churches, which usually were small and completed fairly quickly, construction of urban cathedrals often extended over decades and sometimes over centuries. Their financing depended largely on collections and public contributions (not always voluntary), and a lack of funds often interrupted building programs. Unforeseen events, such as wars, famines, or plagues, or friction between the town and cathedral authorities would often stop construction, which then might not resume for years. At Reims (FIG. 18-23), the clergy offered indulgences (pardons for sins committed) to those who helped underwrite the enormous cost of erecting the cathedral. The rebuilding of Chartres Cathedral (FIG. 18-13) after the devastating fire of 1194 took a relatively short 27 years, but at one point the townspeople revolted against the prospect of a heavier tax burden. They stormed the bishop's residence and drove him into exile for four years.

Chartres Cathedral's mid-12th-century west facade (FIG. 18-5) and the masonry of the crypt to the east were the only sections left standing after the 1194 conflagration. The crypt housed the most precious relic of Chartres—the mantle of the Virgin, which miraculously survived the fire. For reasons of piety and economy, the builders used the crypt for the foundation of the new structure. The retention of the crypt and west facade determined the new church's dimensions, but not its plan or elevation. Architectural historians usually consider the post-1194 Chartres Cathedral the first High Gothic building.

The Chartres plan (FIG. 18-14) reveals a new kind of organization. Rectangular nave bays replaced the square bays with sexpartite vaults and the alternate-support system, still present in Early Gothic churches such as Laon Cathedral (FIG. 18-9). The new system, in which a single square in each aisle (rather than two, as before) flanks a single rectangular unit in the nave, became the High Gothic norm.

Royal Portal

25 50 75 100 feet

10 20 30 meter

18-14 Plan of Chartres Cathedral, Chartres, France, as rebuilt after 1194 (after Paul Frankl).

The Chartres plan, in which a single square in each aisle (rather than two squares) flanks a single rectangular unit in the nave with a four-part vault, became the norm for High Gothic church architecture.

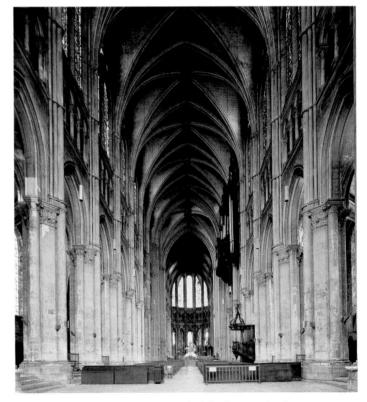

18-15 Interior of Chartres Cathedral (looking east), Chartres, France, begun 1194.

Chartres Cathedral became the model for High Gothic churches also in its tripartite elevation consisting of nave arcade, triforium, and clerestory with stained-glass windows almost as tall as the main arcade.

A change in vault design and the abandonment of the alternate-support system usually accompanied this new bay arrangement. The High Gothic nave vault, which covered just one bay and therefore could be braced more easily than its Early Gothic predecessor, had only four parts. The visual effect of these changes was to unify the interior (FIG. 18-15). The High Gothic architect aligned identical units so that viewers saw them in too rapid a sequence to perceive them as individual volumes of space. The level crowns of the successive nave vaults, which pointed arches made possible, enhanced this effect. The nave became a vast, continuous hall.

The 1194 Chartres Cathedral was also the first church to have been planned from the beginning with flying buttresses, another key High Gothic feature. The flying buttresses allowed the builders to eliminate the tribune above the aisle, which had partially braced Romanesque and Early Gothic naves (compare FIG. 18-10*a* with FIGS. 18-10*a* and 18-10*b*). The new High Gothic tripartite nave elevation consisted of arcade, triforium, and clerestory with greatly enlarged windows. The Chartres windows are almost as tall as the main arcade and consist of double lancets with a single crowning oculus. The strategic placement of flying buttresses permitted the construction of nave walls with so many voids that heavy masonry played a minor role.

CHARTRES STAINED GLASS Despite the vastly increased size of the clerestory windows, the Chartres nave (FIG. 18-15) is relatively dark. The explanation for this seeming contradiction is that light-suppressing colored glass fills the windows. The purpose of these windows was not to illuminate the interior with bright sunlight but to transform natural light into Suger's mystical lux nova (see "Stained-Glass Windows," page 472). Chartres retains almost the full complement of its original stained glass, which, although it has a dimming effect, transforms the character of the interior in dramatic fashion. Gothic churches that have lost their original stained-glass windows give a false impression of what their designers intended.

One Chartres window that survived the fire of 1194 and was subsequently reused in the High Gothic cathedral is the tall single lancet the French call Notre Dame de la Belle Verrière (Our Lady of the Beautiful Window, FIG. 18-16). The central section, depicting against a red background the Virgin Mary enthroned with the Christ Child in her lap, dates to about 1170. Glaziers added the framing angels seen against a blue ground when they reinstalled the window in the 13thcentury choir. The frontal composition is traditional, but Mary is now the beautiful, young, rather worldly Queen of Heaven, haloed, crowned, and accompanied by the dove of the Holy Spirit. Comparing this Virgin and Child with the Theotokos and Child (FIG. 12-19) of Hagia Sophia highlights not only the greater severity and aloofness of the Byzantine image but also the sharp difference between the lightreflecting mosaic medium and Gothic light-filtering stained glass. Gothic and Byzantine builders used light to transform the material world into the spiritual, but in opposite ways. In Gothic architecture, light entered from outside the building through a screen of stone-set colored glass. In Byzantine architecture, light reflected off myriad glass tesserae set into the thick masonry wall.

Chartres's 13th-century Gothic windows are even more spectacular than the *Belle Verrière* because, thanks to the introduction of flying buttresses, the builders could plan from the outset to fill entire walls with stained glass. The immense rose window (approximately 43 feet in diameter) and tall lancets of Chartres Cathedral's north transept (Fig. 18-1) were the gift of the French queen Blanche of Castile, around 1220. The royal motifs of yellow castles on a red ground and yellow *fleurs-de-lis*—three-petaled iris flowers—on a blue ground fill the eight narrow windows in the rose's lower spandrels. The iconography is also fitting for a queen. The enthroned Virgin and Child appear in the

18-16 Virgin and Child and angels (*Notre Dame de la Belle Verrière*), detail of a window in the choir of Chartres Cathedral, Chartres, France, ca. 1170, with 13th-century side panels. Stained glass, full height 16'.

This stained-glass window miraculously survived the devastating Chartres fire of 1194. It has an armature of iron bands that forms a grid over the whole design, an Early Gothic characteristic.

roundel at the center of the rose, which resembles a gem-studded book cover or cloisonné brooch. Around her are four doves of the Holy Spirit and eight angels. Twelve square panels contain images of Old Testament kings, including David and Solomon (at the 12 and 1 o'clock positions respectively). These are the royal ancestors of Christ. Isaiah (11:1–3) had prophesied that the Messiah would come from the family of the patriarch Jesse, father of David. The genealogical "tree of Jesse" is a familiar motif in medieval art. Below, in the lancets, are Saint Anne and the baby Virgin. Flanking them are four of Christ's Old Testament ancestors, Melchizedek, David, Solomon, and Aaron, echoing the royal genealogy of the rose but at a larger scale. Many Gothic stained-glass windows also present narrative scenes, and their iconographical programs are sometimes as complex as those of the sculptured church portals.

The rose and lancets change in hue and intensity with the hours, turning solid architecture into a floating vision of the celestial heavens. Almost the entire mass of wall opens up into stained glass, held in place by an intricate stone armature of bar tracery. Here, the

Stained-Glass Windows

though not a Gothic invention, *stained-glass* windows are almost synonymous with Gothic architecture. No other age produced windows of such rich color and beauty. The technology of manufacturing colored glass is very old, however. Egyptian artists excelled at fashioning colorful glass objects for both home and tomb, and archaeologists have also uncovered thousands of colored-glass artifacts at classical sites. But Gothic artists used stained glass in new ways. In earlier eras, the clergy introduced color and religious iconography into church interiors with mural paintings and mosaics, often with magnificent effect. Stained-glass windows differ from those techniques in one all-important respect. They do not conceal walls. They replace them. And they transmit rather than reflect light, filtering and transforming the natural sunlight.

Abbot Suger called this colored light lux nova (see "Abbot Suger," page 463). Suger's contemporary, Hugh of Saint-Victor (1096–1142), a prominent Parisian theologian, also commented on the special mystical quality of stained-glass windows: "Stained-glass windows are the Holy Scriptures . . . and since their brilliance lets the splendor of the True Light pass into the church, they enlighten those inside."* William Durandus, bishop of Mende, expressed a similar sentiment at the end of the 13th century: "The glass windows in a church are Holy Scriptures, which expel the wind and the rain, that is, all things hurtful, but transmit the light of the True Sun, that is, God, into the hearts of the faithful." † As early as the fourth century, architects used colored glass for church windows, and the stained-glass windows of Saint-Denis (FIG. 18-3) already show a high degree of skill. According to Suger, they were "painted by the exquisite hands of many masters from different regions,"‡ proving that the art was well established at that time. In fact, several fine Romanesque examples survive.

The manufacture of stained-glass windows was costly and laborintensive. A Benedictine monk named Theophilus recorded the full process around 1100. First, the master designer drew the exact composition of the planned window on a wooden panel, indicating all the linear details and noting the colors for each section. Glassblowers provided flat sheets of glass of different colors to glaziers (glassworkers), who cut the windowpanes to the required size and shape with special iron shears. Glaziers produced an even greater range of colors by flashing (fusing one layer of colored glass to another). Next, painters added details such as faces, hands, hair, and clothing in enamel by tracing the master design on the wood panel through the colored glass. Then they heated the painted glass to fuse the enamel to the surface. At that point, the glaziers "leaded" the various fragments of glass-that is, they joined them by strips of lead called cames. The leading not only held the pieces together but also separated the colors to heighten the effect of the design as a whole. The

Detail of stained-glass rose window, north transept Chartres Cathedral, Chartres, France, ca. 1220 (see FIG. 18-1).

distinctive character of Gothic stained-glass windows is largely the result of this combination of fine linear details with broad flat expanses of color framed by black lead. Finally, the glassworkers strengthened the completed window with an armature of iron bands, which in the 12th century formed a grid over the whole design (FIG. 18-16). In the 13th century, the bands followed the outlines of the medallions and of the surrounding areas (FIGS. 18-1 and 18-25).

The form of the stone frames for the stained-glass windows also evolved. On Chartres Cathedral's 12th-century west facade (FIG. 18-5), plate tracery holds the rose window in place. The glass fills only the "punched holes" in the heavy ornamental stonework. Bar tracery, a later development, is much more slender. The 13th-century stained-glass windows (FIG. 18-1) of the Chartres transepts fill almost the entire opening, and the stonework is unobtrusive, more like delicate leading than masonry wall.

- * Hugh of Saint-Victor, Speculum de mysteriis ecclesiae, Sermon 2.
- † William Durandus, *Rationale divinorum officiorum*, 1.1.24. Translated by John Mason Neale and Benjamin Webb, *The Symbolism of Churches and Church Ornaments* (Leeds: T. W. Green, 1843), 28.
- [‡] Translated by Erwin Panofsky, Abbot Suger, 73.

Gothic passion for luminous colored light led to a most daring and successful attempt to subtract all superfluous material bulk just short of destabilizing the structure. That this vast, complex fabric of stone-set glass has maintained its structural integrity for almost 800 years attests to the Gothic builders' engineering genius.

CHARTRES SOUTH TRANSEPT The sculptures adorning the portals of the two new Chartres transepts erected after the 1194

fire are also prime examples of the new High Gothic spirit. As at Laon (FIG. 18-8) and Paris (FIG. 18-11), the Chartres transept portals project more forcefully from the church than do the Early Gothic portals of its west facade (compare FIGS. 18-5 and 18-13). Similarly, the statues of saints on the portal jambs are more independent of the architectural framework. Three figures (FIG. 18-17) from the Porch of the Confessors in the south transept reveal the great changes Gothic sculpture underwent since the Royal Portal statues (FIG. 18-7) of the

18-17 Saints Martin, Jerome, and Gregory, jamb statues, Porch of the Confessors (right doorway), south transept, Chartres Cathedral, Chartres, France, ca. 1220–1230.

In contrast to the Royal Portal statues (FIG. 18-7), the south-transept statues have individual personalities and turn slightly to left or right, breaking the rigid vertical lines of their 12th-century predecessors.

mid-12th century. These changes recall in many ways the revolutionary developments in ancient Greek sculpture during the transition from the Archaic to the Classical style (see Chapter 5). The south-transept statues date from 1220 to 1230 and represent Saints Martin, Jerome, and Gregory. Although the figures are still attached to columns, the architectural setting does not determine their poses as much as it did on the west portals. The saints communicate quietly with one another, like waiting dignitaries. They turn slightly toward and away from each other, breaking the rigid vertical lines that fix the Royal Portal figures immovably. The drapery folds are not stiff and shallow vertical accents, as on the west facade. The fabric falls and laps over the bodies in soft, if still regular, folds.

The treatment of the faces is even more remarkable. The sculptor gave the figures individualized features and distinctive personalities and clothed them in the period's liturgical costumes. Saint Martin is a tall, intense priest with gaunt features (compare the spiritually moved but not particularized face of the Moissac prophet in Fig. 17-11). Saint Jerome appears as a kindly, practical administrator-scholar, holding his copy of the Scriptures. At the right, the introspective Saint Gregory seems lost in thought as he listens to the dove

18-18 Saint Theodore, jamb statue, Porch of the Martyrs (left doorway), south transept, Chartres Cathedral, Chartres, France, ca. 1230.

Although the statue of Theodore is still attached to a column, the setting no longer determines its pose. The High Gothic sculptor portrayed the saint swinging out one hip, as in Greek statuary (FIG. 5-40).

of the Holy Ghost on his shoulder. Thus, the sculptor did not contrast the three men simply in terms of their poses, gestures, and attributes but as persons. Personality, revealed in human faces, makes the profound difference.

The south-transept figure of Saint Theodore (FIG. 18-18), the martyred warrior on the Porch of the Martyrs, presents an even sharper contrast with Early Gothic jamb statues. The sculptor portrayed Theodore as the ideal Christian knight and clothed him in the cloak and chain-mail armor of Gothic Crusaders. The handsome, long-haired youth holds his spear firmly in his right hand and rests his left hand on his shield. He turns his head to the left and swings out his hip to the right. The body's resulting torsion and pronounced sway call to mind Greek statuary, especially the contrapposto stance of Polykleitos's *Spear Bearer* (FIG. 5-40). The changes that occurred in 13th-century Gothic sculpture could appropriately be labeled a second "Classical revolution."

18-19 ROBERT DE LUZARCHES, THOMAS DE CORMONT, and RENAUD DE CORMONT, interior of Amiens Cathedral (looking east), Amiens, France, begun 1220.

The concept of a self-sustaining skeletal architecture reached full maturity at Amiens Cathedral. The four-part High Gothic vaults on pointed arches rise an astounding 144 feet above the nave floor.

AMIENS CATHEDRAL Chartres Cathedral was one of the most influential buildings in the history of architecture. Its builders set a pattern that many other Gothic architects followed, even if they refined the details. Construction of Amiens Cathedral (FIGS. 18-19 to 18-21) began in 1220, while work was still in progress at Chartres. The architects were Robert de Luzarches, Thomas de Cormont, and Renaud de Cormont. The builders finished the nave by 1236 and the radiating chapels by 1247, but work on the choir continued until almost 1270. The Amiens elevation (FIGS. 18-10d and 18-19) derived from the High Gothic formula of Chartres (FIGS. 18-10c and 18-15). But Amiens Cathedral's proportions are even more elegant, and the number and complexity of the lancet windows in both its clerestory and triforium are even greater. The whole design reflects the builders' confident use of the complete High Gothic structural vocabulary: the rectangular-bay system, the four-part rib vault, and a buttressing system that permitted almost complete dissolution of heavy masses and thick weight-bearing walls. At Amiens, the concept of a self-sustaining skeletal architecture reached full maturity. The remaining stretches of wall seem to serve no purpose other than to provide a weather screen for the interior (FIG. 18-20).

Amiens Cathedral is one of the most impressive examples of the French Gothic obsession with constructing ever taller churches. Using

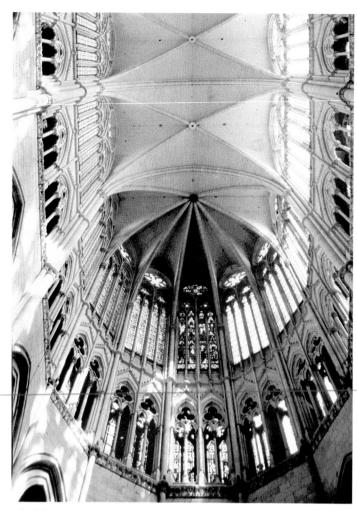

18-20 ROBERT DE LUZARCHES, THOMAS DE CORMONT, and RENAUD DE CORMONT, vaults, clerestory, and triforium of the choir of Amiens Cathedral, Amiens, France, begun 1220.

The Amiens choir vaults resemble a canopy suspended from bundled masts. The sunlight entering from the clerestory creates the effect of a buoyant lightness not normally associated with stone architecture.

their new skeletal frames of stone, French builders attempted goals almost beyond limit, pushing to new heights with increasingly slender supports. The nave vaults at Laon rise to a height of about 80 feet, at Paris 107 feet, and at Chartres 118 feet. Those at Amiens are 144 feet above the floor (FIG. 18-10). The tense, strong lines of the Amiens vault ribs converge at the colonnettes and speed down the shell-like walls to the compound piers. Almost every part of the superstructure has its corresponding element below. The overall effect is of effortless strength, of a buoyant lightness not normally associated with stone architecture. Viewed directly from below, the choir vaults (FIG. 18-20) seem like a canopy, tentlike and suspended from bundled masts. The light flooding in from the clerestory makes the vaults seem even more insubstantial. The effect recalls another great building, one utterly different from Amiens but where light also plays a defining role: Hagia Sophia (FIG. 12-4) in Constantinople. Once again, the designers reduced the building's physical mass by structural ingenuity and daring, and light further dematerializes what remains. If Hagia Sophia is the perfect expression of Byzantine spirituality in architecture, Amiens, with its soaring vaults and giant windows admitting divine colored light, is its Gothic counterpart.

Work began on the Amiens west facade (FIG. 18-21) at the same time as the nave (1220). Its lower parts reflect the influence of Laon

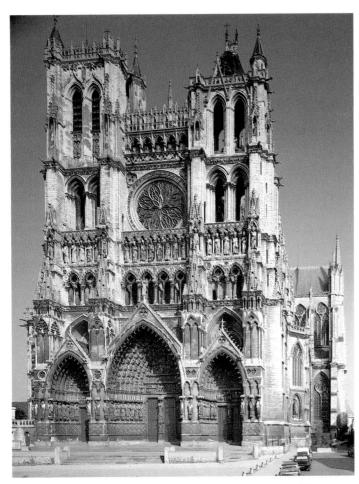

18-21 ROBERT DE LUZARCHES, THOMAS DE CORMONT, and RENAUD DE CORMONT, west facade of Amiens Cathedral, Amiens, France, begun 1220.

The deep piercing of the Amiens facade left few surfaces for decoration, but sculptors covered the remaining ones with colonnettes, pinnacles, and rosettes that nearly dissolve the structure's solid core.

Cathedral (FIG. 18-8) in the spacing of the funnel-like and gable-covered portals. But the Amiens builders punctured the upper parts of the facade to an even greater degree than did the Laon designer. The deep piercing of walls and towers at Amiens left few surfaces for decoration, but sculptors covered the ones that remained with a network of colonnettes, arches, pinnacles, rosettes, and other decorative stonework that visually screens and nearly dissolves the structure's solid core. Sculpture also extends to the areas above the portals, especially the band of statues (the so-called kings' gallery) running the full width of the facade directly below the rose window (with 15th-century tracery). The uneven towers were later additions. The shorter one dates from the 14th century, the taller one from the 15th century.

BEAU DIEU The most prominent statue on the Amiens facade is the Beau Dieu (Beautiful God; FIG. 18-22) on the central doorway's trumeau. The sculptor fully modeled Christ's figure, enveloping his body with massive drapery folds cascading from his waist. The statue stands freely and is as independent of its architectural setting as any Gothic facade statue ever was. Nonetheless, the sculptor still placed an architectural canopy over Christ's head. It is in the latest Gothic style, mimicking the east end of a 13th-century cathedral having a series of radiating chapels with elegant lancet windows. Above the canopy is the great central tympanum with the representation of Christ as Last Judge. The Beau Dieu, however, is a handsome, kindly

18-22 Christ (Beau Dieu), trumeau statue of central doorway, west facade, Amiens Cathedral, Amiens, France, ca. 1220–1235.

The Beau Dieu is a kindly figure who blesses all who enter Amiens Cathedral. He tramples a lion and dragon symbolizing the evil forces in the world. The Gothic Christ gives humankind hope in salvation.

figure who does not strike terror into sinners. Instead he blesses those who enter the church and tramples a lion and a dragon symbolizing the evil forces in the world. This image of Christ gives humankind hope in salvation. The *Beau Dieu* epitomizes the bearded, benevolent Gothic image of Christ that replaced the youthful Early Christian Christ (FIG. 11-8) and the stern Byzantine Pantokrator (FIGS. 12-1 and 12-25) as the preferred representation of the Savior in later European art. The figure's quiet grace and grandeur also contrast sharply with the emotional intensity of the twisting Romanesque prophet (FIG. 17-11) carved in relief on the Moissac trumeau.

18-23 West facade of Reims Cathedral, Reims, France, ca. 1225–1290.

The facade of Reims Cathedral displays the High Gothic architect's desire to reduce sheer mass and replace it with intricately framed voids. Stained-glass windows, not stone reliefs, fill the tympana.

REIMS CATHEDRAL Construction of Reims Cathedral (FIG. 18-23), where the coronations of the kings of France took place, began only a few years after work commenced at Amiens. The Reims builders carried the High Gothic style of the Amiens west facade still further, both architecturally and sculpturally. The two facades, although similar, display some significant differences. The kings' gallery of statues at Reims is above the great rose window, and the figures stand in taller and more ornate frames. In fact, the designer "stretched" every detail of the facade. The openings in the towers and those to the left and right of the rose window are taller, narrower, and more intricately decorated, and they more closely resemble the elegant lancets of the clerestory within. A pointed arch also frames the rose window itself, and the pinnacles over the portals are taller and more elaborate than those at Amiens. Most striking, however, is the treatment of the tympana over the doorways, where stained-glass windows replaced the stone relief sculpture of earlier facades. The contrast with Romanesque heavy masonry construction (FIG. 17-30) is extreme. But no less noteworthy is the rapid transformation of the Gothic facade since the 12th-century designs of Saint-Denis and Chartres (FIG. 18-5) and even Laon (FIG. 18-8).

Reims Cathedral is also a prime example of the High Gothic style in sculpture. The statues and reliefs of the west facade celebrate the Virgin Mary. Above the central gable, Mary is crowned as Queen of Heaven. On the trumeau, she appears in her role as the New Eve above reliefs depicting the Original Sin. The jamb statues relate episodes from the Infancy cycle (see "The Life of Jesus in Art," Chapter 11, pages 296–297), including the *Annunciation* and *Visitation* (FIG. 18-24). All four illustrated statues appear to be completely detached from their architectural background. The sculptors shrank the supporting columns into insignificance so that they in no way restrict the free and easy movements of the full-bodied figures. These 13th-century statue-columns contrast strikingly with those of the Early Gothic Royal Portal (FIG. 18-7), where the background columns occupy a volume equal to that of the figures.

The Reims statues also vividly illustrate that the sculptural ornamentation of Gothic cathedrals took decades to complete and required many sculptors often working in diverse styles. Art historians

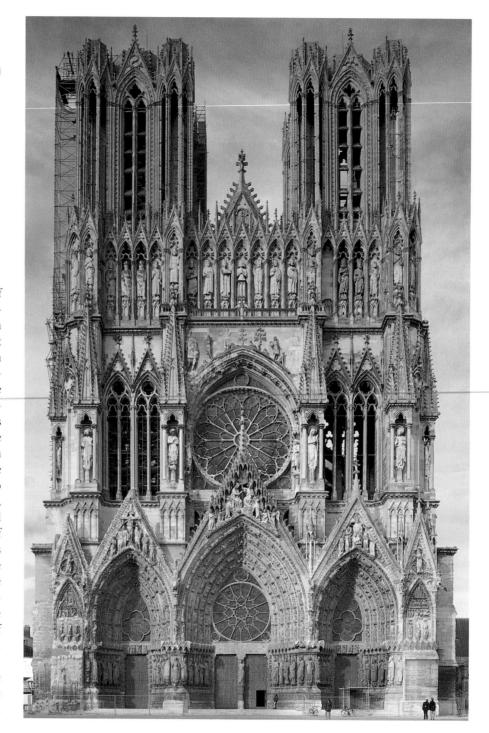

believe that three different sculptors carved the four statues in Fig. 18-24 at different times during the quarter century from 1230 to 1255. The *Visitation* group (Fig. 18-24, *right*) is the work of an artist who probably studied classical statuary. Reims was an ancient Roman city, and the heads of both Mary and Saint Elizabeth resemble Roman portraits. The Gothic statues are astonishing approximations of the classical naturalistic style and incorporate contrapposto postures that go far beyond the stance of the Chartres Saint Theodore (Fig. 18-18). The swaying of the hips is much more pronounced. The right legs bend, and the knees press through the rippling folds of the garments. The sculptor also set the figures' arms in motion. Mary and Elizabeth turn their faces toward each other, and they converse through gestures. In the Reims *Visitation* group, the formerly isolated Gothic jamb statues became actors in a biblical narrative.

The Annunciation group (FIG. 18-24, left) also features statues liberated from their architectural setting, but they are products of

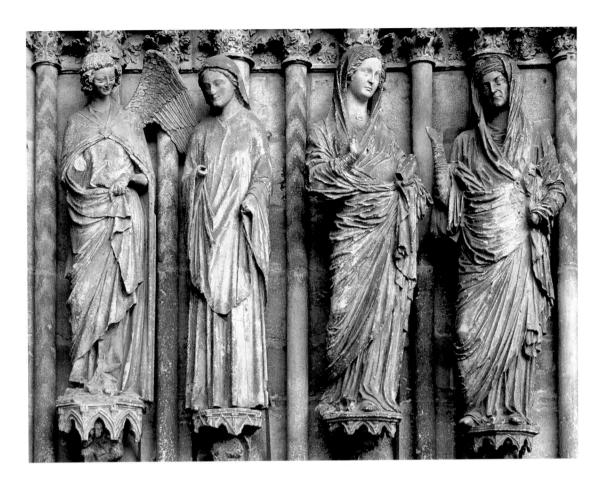

18-24 Annunciation and Visitation, jamb statues of central doorway, west facade, Reims Cathedral, Reims, France, ca. 1230–1255.

Different sculptors working in diverse styles carved the Reims jamb statues, but all detached their figures from the columns and set the bodies and arms in motion. The figures converse through gestures.

different workshops and one—the angel Gabriel—was first set in the left portal and then moved to its present location, which explains the stylistic dichotomy of the pair. Mary is a slender figure with severe drapery. The artist preferred broad expanses of fabric to the multiplicity of folds of the *Visitation* Mary. Gabriel, the latest of the four statues, has a much more elongated body and is far more animated. He exhibits the elegant style of the Parisian court at the middle of the 13th century. He pivots gracefully, almost as if dancing, and smiles broadly. Like a courtier, he exudes charm. Mary, in contrast, is serious and introspective and does not respond overtly to the news the angel has brought.

SAINTE-CHAPELLE, PARIS The stained-glass windows inserted into the portal tympana of Reims Cathedral exemplify the wall-dissolving High Gothic architectural style. The architect of Sainte-Chapelle (FIG. 18-25) in Paris extended this style to an entire building. Louis IX built Sainte-Chapelle, joined to the royal palace, as a repository for the crown of thorns and other relics of Christ's Passion he had purchased in 1239 from his cousin Baldwin II (r. 1228–1261), the last Latin emperor of Constantinople. The chapel is a master-piece of the so-called *Rayonnant* (radiant) style of the High Gothic age, which dominated the second half of the century. It was the preferred style of the royal Parisian court of Saint Louis (see "Louis IX, the Saintly King," page 482). Sainte-Chapelle's architect carried the dissolution of walls and the reduction of the bulk of the supports to the point that some 6,450 square feet of stained glass make up more

18-25 Interior of the upper chapel, Sainte-Chapelle, Paris, France, 1243–1248.

At Louis IX's Sainte-Chapelle, the architect succeeded in dissolving the walls to such an extent that 6,450 square feet of stained glass account for more than three-quarters of the Rayonnant Gothic structure.

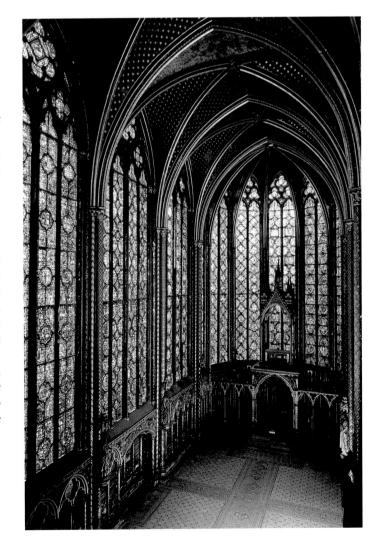

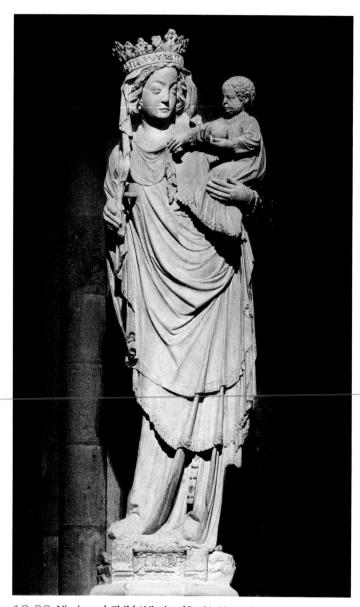

18-26 Virgin and Child (*Virgin of Paris*), Notre-Dame, Paris, France, early 14th century.

Late Gothic sculpture is elegant and mannered. Here, the solemnity of Early and High Gothic religious figures gave way to a tender and anecdotal portrayal of Mary and Jesus as royal mother and son.

than three-quarters of the structure. The supporting elements are hardly more than large *mullions*, or vertical stone bars. The emphasis is on the extreme slenderness of the architectural forms and on linearity in general. Although the chapel required restoration in the 19th century (after suffering damage during the French Revolution), it retains most of its original 13th-century stained glass. Sainte-Chapelle's enormous windows filter the light and fill the interior with an unearthly rose-violet atmosphere. Approximately 49 feet high and 15 feet wide, they were the largest designed up to their time.

VIRGIN OF PARIS The "court style" of Sainte-Chapelle has its pictorial parallel in the mannered elegance of the roughly contemporaneous Gabriel of the Reims Annunciation group (FIG. 18-24, left), but the style long outlived Saint Louis and his royal artists and architects. The best example of the court style in Late Gothic sculpture is the early-14th-century statue nicknamed the Virgin of Paris (FIG. 18-26) because of its location in Paris at Notre-Dame. The sculptor portrayed Mary in an exaggerated S-curve posture typical of Late Gothic sculpture. She is a worldly queen, decked out in royal garments and wearing

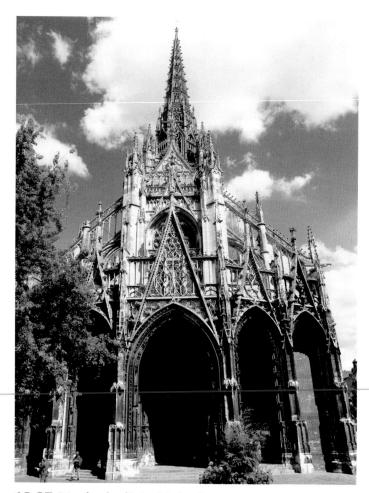

18-27 West facade of Saint-Maclou, Rouen, France, ca. 1500–1514.

Saint-Maclou is the masterpiece of Late Gothic Flamboyant architecture. Its ornate tracery features curves and countercurves that form brittle decorative webs masking the building's structure.

a heavy gem-encrusted crown. The Christ Child is equally richly attired and is very much the infant prince in the arms of his young mother. The tender, anecdotal characterization of mother and son represents a further humanization of the portrayal of religious figures in Gothic sculpture. Late Gothic statuary is very different in tone from the solemnity of most High Gothic figures, just as Late Classical Greek statues of the Olympian gods (compare FIG. 18-26 with FIG. 5-63) differ from High Classical depictions.

SAINT-MACLOU, ROUEN Late French Gothic architecture also represents a departure from the norms of High Gothic. The change from Rayonnant architecture to the so-called Flamboyant style (named for the flamelike appearance of its pointed bar tracery) occurred in the 14th century. The style reached its florid maturity nearly a century later in Normandy in the church of Saint-Maclou (FIG. 18-27) in Rouen, its capital. The church is tiny (only about 75 feet high and 180 feet long) compared with the cathedrals of the High Gothic age. Its facade breaks sharply from the High Gothic style (FIGS. 18-21 and 18-23) of the 13th century. The five portals (two of them false doors) bend outward in an arc. Ornate gables crown the doorways, pierced through and filled with wiry, "flickering" Flamboyant tracery made up of curves and countercurves that form brittle decorative webs and mask the building's structure. The transparency of the pinnacles over the doorways permits visitors to see the central rose window and the flying buttresses, even though they are set well back from the facade. The overlapping of all features, pierced as they are, confuses the structural lines and produces

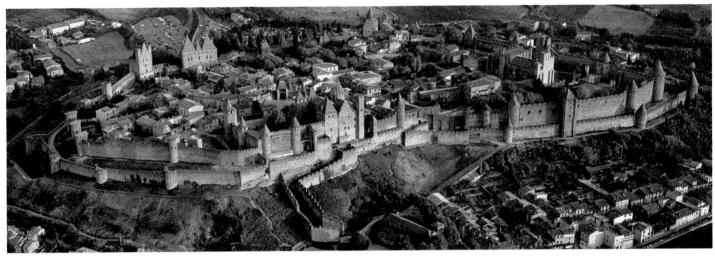

18-28 Aerial view of the fortified town of Carcassonne, France. Bastions and towers, 12th–13th centuries, restored by Eugène Viollet-le-Duc in the 19th century.

Carcassonne provides a rare glimpse of what was once a familiar sight in Gothic France: a tight complex of castle, cathedral, and town with a crenellated and towered wall circuit for defense.

a bewildering complexity of views that is the hallmark of the Flamboyant style.

CARCASSONNE The Gothic period has been called "the age of great cathedrals," but people, of course, also needed and architects also built secular structures such as town halls, palaces, and private residences. In an age of frequent warfare, the feudal barons often constructed fortified castles in places enemies could not easily reach. Sometimes thick defensive wall circuits, or *ramparts*, enclosed entire towns. In time, however, purely defensive wars became obsolete due to the invention of artillery and improvements in siege craft. The fortress era gradually passed, and throughout Europe once-mighty ramparts fell into ruin.

One of the most famous Gothic fortified towns is Carcassonne (FIG. 18-28) in Languedoc in southern France. It was the regional center of resistance to the northern forces of royal France. Built on a hill bounded by the Aude River, Carcassonne had been fortified since Roman times. It had Visigothic walls dating from the 6th century, but in the 12th century masons reinforced them. Battlements (low parapets) with crenellations (composed of alternating solid merlons and open crenels) protected guards patrolling the stone ring surrounding the town. Carcassonne might be forced to surrender but could not easily be taken by storm. Within the town's double walls was a fortified castle (FIG. 18-28, left) with a massive attached keep, a secure tower that could serve as a place of last refuge. Balancing that center of secular power was the bishop's seat, the Cathedral of Saint-Nazaire (FIG. 18-28, right). The small church, built between 1269 and 1329, may have been the work of an architect brought in from northern France. In any case, Saint-Nazaire's builders were certainly familiar with the latest developments in architecture in the Île-de-France. Today, Carcassonne—as restored in the 19th century by Eugène VIOLLET-LE-DUC (1814-1879)—provides a rare glimpse of what was once a familiar sight in Gothic France: a tightly contained complex of castle, cathedral, and town within towered walls.

18-29 Hall of the cloth guild, Bruges, Belgium, begun 1230.

The Bruges cloth guild's meeting hall is an early example of a new type of secular architecture in the late Middle Ages. Its lofty tower competed for attention with the towers of the city's cathedral.

GUILD HALL, BRUGES One of the many signs of the growing secularization of urban life in the late Middle Ages was the erection of monumental meeting halls and warehouses for the increasing number of craft guilds being formed throughout Europe. An early example is the imposing market and guild hall (FIG. 18-29) of the

18-30 House of Jacques Coeur, Bourges, France, 1443–1451.

The house of the immensely wealthy Bourges financier Jacques Coeur is both a splendid example of Late Gothic architecture with elaborate tracery and a symbol of the period's new secular spirit.

clothmakers of Bruges, begun in 1230. Situated in the city's major square, it testifies to the important role of artisans and merchants in Gothic Europe. The design combines features of military (the corner "watchtowers" with their crenellations) and church (lancet windows with crowning oculi) architecture. The uppermost, octagonal portion of the tower with its flying buttresses and pinnacles dates to the 15th century, but even the origi-

nal two-story tower is taller than the rest of the hall. Lofty towers were a common feature of late medieval guild and town halls, designed to compete for attention and prestige with the towers of city cathedrals.

HOUSE OF JACQUES COEUR The fortunes of the new class of wealthy merchants who rose to prominence throughout Europe in the late Middle Ages may not have equaled those of the hereditary royalty, but their power and influence were still enormous. The career of the French financier Jacques Coeur (1395–1456) illustrates how enterprising private citizens could win-and quickly losewealth and power. Coeur had banking houses in every city of France and many cities abroad. He employed more than 300 agents and competed with the great trading republics of Italy. His merchant ships filled the Mediterranean, and with the papacy's permission, he imported spices and textiles from the Muslim Near East. He was the treasurer of King Charles VII (r. 1422-1461) of France and a friend of Pope Nicholas V (r. 1447-1455). In 1451, however, his enemies framed him on an absurd charge of having poisoned Agnes Sorel, the king's mistress. The judges who sentenced Coeur to prison and confiscated his vast wealth and property were among those who owed him money. Coeur escaped in 1454 and made his way to Rome, where the pope warmly received him. He died of fever while leading a fleet of papal war galleys in the eastern Mediterranean.

Jacques Coeur's great town house still stands in his native city of Bourges. Built between 1443 and 1451 (with special permission to encroach upon the town ramparts), it is the best-preserved example of Late Gothic domestic architecture. The house's plan is irregular, with the units arranged around an open courtyard (FIG. 18-30). The service areas (maintenance shops, storage rooms, servants' quarters, and baths—a rare luxury in Gothic Europe) occupy the ground level. The upper stories house the great hall and auxiliary rooms used for offices and family living rooms. Over the main entrance is a private chapel. One of the towers served as a treasury. The exterior and interior facades have very steep pyramidal roofs of different heights. The decorative details include Flamboyant tracery and large pointed-arch stained-glass windows. An elegant canopied niche facing the street once housed a royal equestrian statue. A comparable statue of Coeur on horseback dominated the facade opening onto the interior courtyard. Jacques Coeur's house is both a splendid example of Late Gothic architecture and a monumental symbol of the period's new secular spirit.

Book Illumination and Luxury Arts

Paris's claim as the intellectual center of Gothic Europe (see "Scholasticism," page 466) did not rest solely on the stature of its university faculty and on the reputation of its architects, masons, sculptors, and stained-glass makers. The city was also a renowned center for the production of fine books. The famous Florentine poet Dante Alighieri (1265–1321), in fact, referred to Paris in his *Divine Comedy* of about 1310–1320 as the city famed for the art of illumination.² During the Gothic period, book manufacture shifted from monastic scriptoria shut off from the world to urban workshops of professional artists—and Paris had the most and best workshops. The owners of these new, for-profit secular businesses sold their products to the royal family, scholars, and prosperous merchants. The Parisian shops were the forerunners of modern publishing houses.

VILLARD DE HONNECOURT One of the most intriguing Parisian manuscripts preserved today was not, however, a book for sale but a personal sketchbook. Compiled by VILLARD DE HONNECOURT, an early-13th-century master mason, its pages contain details of buildings, plans of choirs with radiating chapels, church towers, lifting devices, a sawmill, stained-glass windows, and other subjects of obvious interest to architects and masons. But also sprinkled liberally

throughout the pages are drawings depicting religious and worldly figures, as well as animals, some realistic and others purely fantastic. On the page reproduced here (FIG. 18-31), Villard demonstrated the value of the *ars de geometria* ("art of geometry") to artists. He showed that both natural forms and buildings are based on simple geometric shapes such as the square, circle, and triangle. Even where he claimed to have drawn his animals from nature, he composed his figures around a skeleton not of bones but of abstract geometric forms. Geometry was, in Villard's words, "strong help in drawing figures."

GOD AS ARCHITECT Geometry also played a symbolic role in Gothic art and architecture. Gothic artists, architects, and theologians alike thought the triangle, for example, embodied the idea of the Trinity of God the Father, Christ, and the Holy Spirit. The circle, which has neither a beginning nor an end, symbolized the eternity of the one God. When Gothic architects based their designs on the art of geometry, building their forms out of abstract shapes laden with symbolic meaning, they believed they were working according to the divinely established laws of nature.

A vivid illustration of this concept appears as the frontispiece (FIG. 18-32) of a moralized Bible produced in Paris during the

18-31 VILLARD DE HONNECOURT, figures based on geometric shapes, folio 18 verso of a sketchbook, from Paris, France, ca. 1220–1235. Ink on vellum, $9\frac{1}{4}$ " × 6". Bibliothèque Nationale, Paris.

On this page from his private sketchbook, the master mason Villard de Honnecourt sought to demonstrate that simple geometric shapes are the basis of both natural forms and buildings.

18-32 God as architect of the world, folio 1 verso of a moralized Bible, from Paris, France, ca. 1220–1230. Ink, tempera, and gold leaf on vellum, $1' 1\frac{1}{2}'' \times 8\frac{1}{4}''$. Österreichische Nationalbibliothek, Vienna.

Paris was the intellectual capital of Europe and the center of production of fine books. This artist portrayed God as an industrious architect creating the universe using the same tools as Gothic builders.

Louis IX, the Saintly King

The royal patron behind the Parisian Rayonnant "court style" of Gothic art and architecture was King Louis IX (1214–1270; r. 1226–1270), grandson of Philip Augustus. Louis inherited the throne when he was only 12 years old, so until he reached adulthood six years later, his mother, Blanche of Castile (FIG. 18-33), granddaughter of Eleanor of Aquitaine (see "Romanesque Countesses, Queens, and Nuns," Chapter 17, page 448), served as France's regent.

The French regarded Louis as the ideal king, and 27 years after Louis's death, in 1297, Pope Boniface VIII (r. 1294–1303) declared him a saint. In his own time, Louis was revered for his piety, justice, truthfulness, and charity. His almsgiving and his donations to religious foundations were extravagant. He especially favored the *mendicant* (begging) orders, the Dominicans and Franciscans. He admired their poverty, piety, and self-sacrificing disregard of material things.

Louis launched two unsuccessful Crusades, the Seventh (1248–1254, when, in her son's absence, Blanche was again French regent) and the Eighth (1270). He died in Tunisia during the latter. As a crusading knight who lost his life in the service of the Church, Louis personified the chivalric virtues of courage, loyalty, and self-sacrifice. Saint Louis united in his person the best qualities of the Christian knight, the benevolent monarch, and the holy man. He became the model of medieval Christian kingship.

Louis's political accomplishments were also noteworthy. He subdued the unruly French barons, and between 1243 and 1314 no one seriously challenged the crown. He negotiated a treaty with Henry III, king of France's traditional enemy, England. Such was his reputation for integrity and just dealing that he served as arbiter in at least a dozen international disputes. So successful was he as peacekeeper

18-33 Blanche of Castile, Louis IX, and two monks, dedication page (folio 8 recto) of a moralized Bible, from Paris, France, 1226-1234. Ink, tempera, and gold leaf on vellum, $1'3'' \times 10\frac{1}{2}''$. Pierpont Morgan Library, New York.

The costly gold-leaf dedication page of this royal book depicts Saint Louis, his mother Blanche of Castile, and two monks. The younger monk is at work on the paired illustrations of a moralized Bible.

1 in

that despite civil wars through most of the 13th century, international peace prevailed. Under Saint Louis, medieval France was at its most prosperous, and its art and architecture were admired and imitated throughout Europe.

1220s. Moralized Bibles are heavily illustrated, each page pairing paintings of Old and New Testament episodes with explanations of their moral significance. (The page reproduced here does not conform to this formula because it is the introduction to all that follows.) Above the illustration, the scribe wrote (in French rather than Latin): "Here God creates heaven and earth, the sun and moon, and all the elements." God appears as the architect of the world, shaping the universe with the aid of a compass. Within the perfect circle already created are the spherical sun and moon and the unformed matter that will become the earth once God applies the same geometric principles to it. In contrast to the biblical account of Creation, in which God created the sun, moon, and stars after the earth had been formed, and made the world by sheer force of will and a simple "Let there be" command, on this page the Gothic artist portrayed God as an industrious architect, creating the universe with some of the same tools mortal builders used.

BLANCHE OF CASTILE Not surprisingly, most of the finest Gothic books known today belonged to the French monarchy. Saint Louis in particular was an avid collector of both secular and religious books. The vast library he and his royal predecessors and successors formed eventually became the core of France's national library, the Bibliothèque Nationale. One of the books the royal family commissioned is a moralized Bible now in the collection of New York's Pierpont Morgan Library. Louis's mother, Blanche of Castile, ordered the Bible during her regency (1226–1234) for her teenage son. The dedication page (FIG. 18-33) has a costly gold background and depicts Blanche and Louis enthroned beneath triple-lobed arches and miniature cityscapes. The latter are comparable to the architectural canopies above the heads of contemporaneous French portal statues (FIG. 18-22). Below, in similar architectural frames, are a monk and a scribe. The older clergyman dictates a sacred text to

18-34 Abraham and the three angels, folio 7 verso of the Psalter of Saint Louis, from Paris, France, 1253-1270. Ink, tempera, and gold leaf on vellum, $5'' \times 3\frac{1}{2}''$. Bibliothèque Nationale, Paris.

The architectural settings in the Psalter of Saint Louis reflect the screenlike lightness and transparency of royal buildings such as Sainte-Chapelle (Fig. 18-25). The colors emulate those of stained glass.

> can add initials and signs of division. Still another can arrange the leaves and attach the binding. Another of you can prepare the covers, the leather, the buckles and clasps. All sorts of assistance can be offered the scribe to help him pursue his work without interruption. He needs many things which can be prepared by others: parchment cut, flattened and ruled for script, ready ink and pens. You will always find something with which to help the scribe.³

The preparation of the illuminated pages also involved several hands. Some artists, for example, specialized in painting borders or initials.

Only the workshop head or one of the most advanced assistants would paint the main figural scenes. Given this division of labor and the assembly-line nature of Gothic book production, it is astonishing how uniform the style is on a single page, as well as from page to page, in most illuminated manuscripts. PSALTER OF SAINT LOUIS The golden background of

Blanche's Bible is unusual and has no parallel in Gothic windows. But the radiance of stained glass probably inspired the glowing color of other 13th-century Parisian illuminated manuscripts. In some cases, masters in the same urban workshop produced both glass and books. Many art historians believe that the *Psalter of Saint Louis* (FIG. 18-34) is one of several books produced in Paris for Louis IX by artists associated with those who made the stained glass for his Sainte-Chapelle. Certainly, the painted architectural setting in Louis's book of Psalms reflects the pierced screenlike lightness and transparency of royal Rayonnant buildings such as Sainte-Chapelle. The intense colors, especially the blues, emulate stained glass. The lines in the borders resemble leading. And the gables, pierced by rose windows with bar tracery, are standard Rayonnant architectural features.

The page from the Psalter of Saint Louis shown here (FIG. 18-34) represents Abraham and the three angels, the Old Testament story believed to prefigure the Christian Trinity (see "Jewish Subjects in Christian Art," Chapter 11, page 293). The Gothic artist included two episodes on the same page, separated by the tree of Mamre mentioned in the Bible. At the left, Abraham greets the three angels. In

his young apprentice. The scribe already has divided his page into two columns of four roundels each, a format often used for the paired illustrations of moralized Bibles. The inspirations for such designs were probably the roundels of Gothic stained-glass windows (compare the borders of the Belle Verrière window, FIG. 18-16, at Chartres and the windows of Louis's own, later Sainte-Chapelle, FIG. 18-25).

The dedication page of Blanche of Castile's moralized Bible presents a very abbreviated portrayal of Gothic book production, similar to the view of a monastic scriptorium discussed earlier (FIG. 16-11). The manufacturing process used in the workshops of 13th-century Paris did not differ significantly from that of 10th-century Tábara. It involved many steps and numerous specialized artists, scribes, and assistants of varying skill levels. The Benedictine abbot Johannes Trithemius (1462–1516) described the way books were still made in his day in his treatise In Praise of Scribes:

If you do not know how to write, you still can assist the scribes in various ways. One of you can correct what another has written. Another can add the rubrics [headings] to the corrected text. A third

the other scene, he entertains them while his wife Sarah peers at them from a tent. The figures' delicate features and the linear wavy strands of their hair have parallels in Blanche of Castile's moralized Bible, as well as in Parisian stained glass. The elegant proportions, facial expressions, theatrical gestures, and swaying poses are characteristic of the Parisian court style admired throughout Europe. Compare, for example, the angel in the left foreground with the Gabriel statue (FIG. 18-24, *left*) of the Reims *Annunciation* group.

BREVIARY OF PHILIPPE LE BEL As in the Romanesque period, some Gothic manuscript illuminators signed their work. The names of others appear in royal accounts of payments made and similar official documents. One artist who produced books for the French court was Master Honoré, whose Parisian workshop was on the street known today as rue Boutebrie. Honoré illuminated a breviary (see "Medieval Books," Chapter 16, page 411) for Philippe le Bel (Philip the Fair, r. 1285–1314) in 1296. The page illustrated here (FIG. 18-35) features two Old Testament scenes involving David. In the upper panel, Samuel anoints the youthful David. Below, while King Saul looks on, David prepares to aim his slingshot at his most famous opponent, the giant Goliath (who already touches the wound on his forehead). Immediately to the right, David slays Goliath with his sword.

Master Honoré's linear treatment of hair, his figures' delicate hands and gestures, and their elegant swaying postures are typical of Parisian painting of the time. But this painter was much more interested than most of his colleagues in giving his figures sculptural volume and showing the play of light on their bodies. Honoré was not concerned with locating his figures in space, however. The Goliath panel in the *Breviary of Philippe le Bel* has a textilelike decorative background, and the feet of Honoré's figures frequently overlap the border. Compared with his contemporaries, Master Honoré pioneered naturalism in figure painting. But he still approached the art of book illumination as a decorator of two-dimensional pages. He did not embrace the classical notion that a painting should be an illusionistic window into a three-dimensional world.

BELLEVILLE BREVIARY David and Saul also are the subjects of a miniature painting at the top left of an elaborately decorated text page (FIG. 18-36) in the Belleville Breviary, which JEAN PUCELLE of Paris painted around 1325. Pucelle far exceeded Honoré and other French artists by placing his fully modeled figures in three-dimensional architectural settings rendered in convincing perspective. For example, he painted Saul as a weighty figure seated on a throne seen in a three-quarter view, and he meticulously depicted the receding coffers of the barrel vault over the young David's head. Such "stage sets" already had become commonplace in Italian painting, and scholars think Pucelle visited Italy and studied Duccio's work (FIGS. 19-10 and 19-11) in Siena. Pucelle's (or an assistant's) renditions of plants, a bird, butterflies, a dragonfly, a fish, a snail, and a monkey also reveal a keen interest in and close observation of the natural world. Nonetheless, in the Belleville Breviary, the text still dominates the figures, and the artist (and his patron) delighted in ornamental flourishes, fancy initial letters, and abstract patterns. In that respect, comparisons with monumental panel paintings are inappropriate. Pucelle's breviary remains firmly in the tradition of book illumination.

The *Belleville Breviary* is of special interest because Pucelle's name and those of some of his assistants appear at the end of the book, in a memorandum recording the payment they received for their work. Inscriptions in other Gothic illuminated books regularly state the production costs—the prices paid for materials, especially gold, and for the execution of initials, figures, flowery script, and

18-35 Master Honoré, David anointed by Samuel and battle of David and Goliath, folio 7 verso of the *Breviary of Philippe le Bel*, from Paris, France, 1296. Ink and tempera on vellum, $7\frac{7}{8}$ " $\times 4\frac{7}{8}$ ". Bibliothèque Nationale, Paris.

Master Honoré was one of the Parisian secular artists who produced books for the French monarchy. Notably, he gave his figures sculptural volume and showed the play of light on their bodies.

other embellishments. By this time, illuminators were professional guild members, and their personal reputation, as with modern "brand names," guaranteed the quality of their work. Although the cost of materials was still the major factor determining a book's price, individual skill and reputation increasingly decided the value of the illuminator's services. The centuries-old monopoly of the Christian Church in book production had ended.

VIRGIN OF JEANNE D'EVREUX The royal family also patronized goldsmiths, silversmiths, and other artists specializing in the production of luxury works in metal and enamel for churches, palaces, and private homes. Especially popular were statuettes of sacred figures, which the wealthy purchased either for private devotion or as gifts to churches. The Virgin Mary was a favored subject, reflecting her new prominence in the iconography of Gothic portal sculpture.

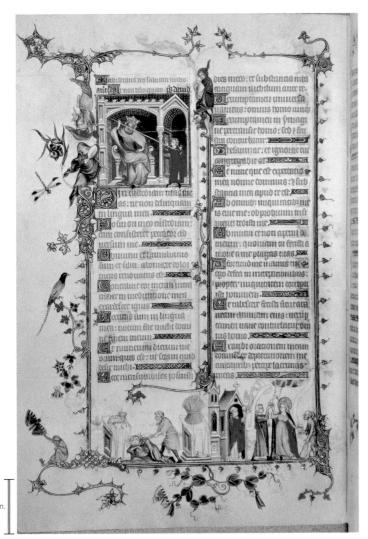

18-36 Jean Pucelle, David before Saul, folio 24 verso of the *Belleville Breviary*, from Paris, France, ca. 1325. Ink and tempera on vellum, $9\frac{1}{2}$ " \times $6\frac{3}{4}$ ". Bibliothèque Nationale, Paris.

Jean Pucelle's fully modeled figures in architectural settings rendered in convincing perspective reveal his study of contemporary painting in Italy. He was also a close observer of plants and fauna.

Perhaps the finest of these costly statuettes is the large silver-gilt figurine known as the Virgin of Jeanne d'Evreux (FIG. 18-37). The queen, wife of Charles IV (r. 1322-1328), donated the image of the Virgin and Child to the royal abbey church of Saint-Denis in 1339. Mary stands on a rectangular base decorated with enamel scenes of Christ's Passion. (Some art historians think the enamels are Jean Pucelle's work.) But no hint of grief appears in the beautiful young Mary's face. The Christ Child, also without a care in the world, playfully reaches for his mother. The elegant proportions of the two figures, Mary's emphatic swaying posture, the heavy drapery folds, and the intimate human characterization of mother and son are also features of the roughly contemporary Virgin of Paris (FIG. 18-26). The sculptor of large stone statues and the royal silversmith working at small scale approached the representation of the Virgin and Child in a similar fashion. In the Virgin of Jeanne d'Evreux, as in the Virgin of Paris, Mary appears not only as the Mother of Christ but also as the Queen of Heaven. The Saint-Denis Mary also originally had a crown on her head, and the scepter she holds is in the form of the fleur-delis, the French monarchy's floral emblem. The statuette also served

18-37 *Virgin of Jeanne d'Evreux*, from the abbey church of Saint-Denis, France, 1339. Silver gilt and enamel, $2' 3\frac{1}{2}''$ high. Louvre, Paris.

Queen Jeanne d'Evreux donated this luxurious reliquary-statuette to the royal abbey church of Saint-Denis. The intimate human characterization of the holy figures recalls that of the *Virgin of Paris* (FIG. 18-26).

as a reliquary. The Virgin's scepter contained hairs believed to come from Mary's head.

THE CASTLE OF LOVE Gothic artists produced luxurious objects for secular as well as religious contexts. Sometimes they decorated these costly pieces with stories of courtly love inspired by the romantic literature of the day, such as the famous story of Lancelot and Queen Guinevere, wife of King Arthur of Camelot. The French poet Chrétien de Troyes recorded their love affair in the late 12th century.

18-38 The Castle of Love and knights jousting, lid of a jewelry casket, from Paris, France, ca. 1330–1350. Ivory and iron, $4\frac{1}{2}'' \times 9\frac{3}{4}''$. Walters Art Museum, Baltimore.

French Gothic artists also produced luxurious objects for secular use. This jewelry casket features ivory reliefs inspired by the romantic literature of the day in which knights joust and storm the Castle of Love.

One of the most interesting objects of this type is a woman's jewelry box adorned with ivory relief panels. The theme of the panel illustrated here (FIG. 18-38) is related to the allegorical poem Romance of the Rose by Guillaume de Lorris, written about 1225-1235 and completed by Jean de Meung between 1275 and 1280. At the left the sculptor carved the allegory of the siege of the Castle of Love. Gothic knights attempt to capture love's fortress by shooting flowers from their bows and hurling baskets of roses over the walls from catapults. Among the castle's defenders is Cupid, who aims his arrow at one of the knights while a comrade scales the walls on a ladder. In the lid's two central sections, two knights joust on horseback. Several maidens survey the contest from a balcony and cheer the knights on, as trumpets blare. A youth in the crowd holds a hunting falcon. The sport was a favorite pastime of the leisure class in the late Middle Ages. At the right, the victorious knight receives his prize (a bouquet of roses) from a chastely dressed maiden on horseback. The scenes on the sides of the box include the famous medieval allegory of female virtue, the legend of the unicorn, a white horse with a single ivory horn. Only a virgin could attract the rare animal, and any woman who could do so thereby also demonstrated her moral purity. Religious themes may have monopolized artistic production for churches in the Gothic age, but secular themes figured prominently in private contexts. Unfortunately, very few examples of the latter survive.

GOTHIC OUTSIDE OF FRANCE

In 1269 the prior (deputy abbot) of the church of Saint Peter at Wimpfen-im-Tal in the German Rhineland hired "a very experienced architect who had recently come from the city of Paris" to rebuild his monastery church.⁴ The architect reconstructed the church *opere francigeno* ("in the French manner")—that is, in the Gothic style, the *opus modernum* of the Île-de-France. The Parisian Gothic style had begun to spread even earlier, but in the second half of the 13th century, the new style became dominant throughout western Europe. European architecture did not turn Gothic all at once or even uniformly. Almost everywhere, patrons and builders modified the Rayonnant court style of the Île-de-France according to local preferences. Because the old Romanesque traditions lingered on in many places, each area, marrying its local Romanesque design to the new style, developed its own brand of Gothic architecture.

England

Beginning with the Norman conquest in 1066 (see Chapter 17), French architectural styles quickly made an impact in England, but in the Gothic period, as in the Romanesque, no one could have mistaken an English church for a French one.

to 18-41) embodies the essential characteristics of the English Gothic style. Begun in 1220, the same year work started on Amiens Cathedral (FIGS. 18-19 to 18-21), construction of Salisbury Cathedral required about 40 years. The two cathedrals are therefore almost exactly contemporaneous, and the differences between them are very instructive. Although Salisbury's facade has lancet windows and blind arcades with pointed arches, as well as statuary, it presents a striking contrast to French High Gothic designs (FIGS. 18-21 and 18-23). The English facade is a squat screen in front of the nave, wider than the building behind it. The soaring height of the French facades is absent. The Salisbury facade also does not correspond to

18-39 Aerial view of Salisbury Cathedral, Salisbury, England, 1220–1258; west facade completed 1265; spire ca. 1320–1330.

Exhibiting the distinctive regional features of English Gothic architecture, Salisbury Cathedral has a squat facade that is wider than the building behind it. The architects used flying buttresses sparingly.

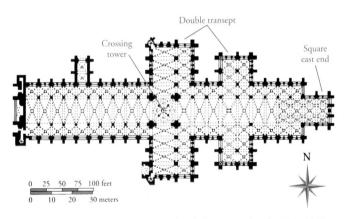

18-40 Plan of Salisbury Cathedral, Salisbury, England, 1220-1258.

The long rectilinear plan of Salisbury Cathedral, with its double transept and flat eastern end, is typically English. The four-part rib vaults of the nave follow the Chartres model (Fig. 18-14).

the three-part division of the interior (nave and two aisles). Different too is the emphasis on the great crossing tower (added about 1320–1330), which dominates the silhouette. Salisbury's height is modest compared with that of Amiens and Reims. And because height is not a decisive factor in the English building, the architect used the flying buttress sparingly and as a rigid prop, rather than as

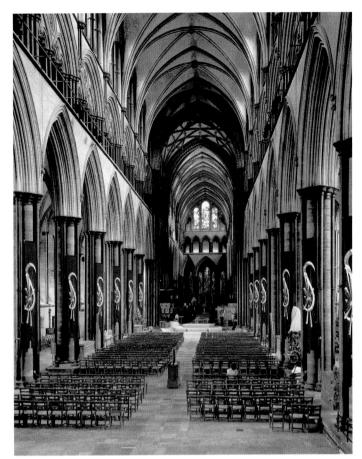

18-41 Interior of Salisbury Cathedral (looking east), Salisbury, England, 1220–1258.

Salisbury Cathedral's interior differs from contemporaneous French Gothic designs in the strong horizontal emphasis of its three-story elevation and the use of dark Purbeck marble for moldings.

an integral part of the vaulting system within the church. In short, the English builders adopted some of the superficial motifs of French Gothic architecture but did not embrace its structural logic or emphasis on height.

Equally distinctive is the long rectilinear plan (FIG. 18-40) with its double transept and flat eastern end. The latter feature was characteristic of Cistercian (FIG. 17-14) and English churches since Romanesque times. The interior (FIG. 18-41), although Gothic in its three-story elevation, pointed arches, four-part rib vaults, compound piers, and the tracery of the triforium, conspicuously departs from the French Gothic style. The pier colonnettes stop at the springing of the nave arches and do not connect with the vault ribs (compare FIGS. 18-19 and 18-20). Instead, the vault ribs rise from corbels in the triforium, producing a strong horizontal emphasis. Underscoring this horizontality is the rich color contrast between the light stone of the walls and vaults and the dark Purbeck marble used for the triforium moldings and corbels, compound pier responds, and other details.

GLOUCESTER CATHEDRAL Early on, English architecture found its native language in the elaboration of architectural pattern for its own sake (for example, the decorative patterning of the Romanesque piers of Durham Cathedral; FIG. 17-33, *left*). The pier, wall, and vault elements, still relatively simple at Salisbury, became increasingly complex and decorative in the 14th century, culminating in what architectural historians call the *Perpendicular* style. This

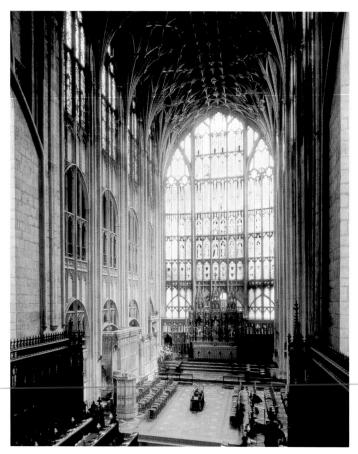

18-42 Choir of Gloucester Cathedral (looking east), Gloucester, England, 1332–1357.

The Perpendicular style of English Late Gothic architecture takes its name from the pronounced verticality of its decorative details. The multiplication of ribs in the vaults is also a characteristic feature.

late English Gothic style is on display in the choir (FIG. 18-42) of Gloucester Cathedral, remodeled about a century after Salisbury. The Perpendicular style takes its name from the pronounced verticality of its decorative details, in contrast to the horizontal emphasis of Salisbury and Early English Gothic.

A single enormous window divided into tiers of small windows of like shape and proportion fills the characteristically flat east end of Gloucester Cathedral. At the top, two slender lancets flank a wider central section that also ends in a pointed arch. The design has much in common with the screen facade of Salisbury, but the proportions are different. Vertical, as opposed to horizontal, lines dominate. In the choir wall, the architect also erased Salisbury's strong horizontal accents, as the vertical wall elements lift directly from the floor to the vaulting, unifying the walls with the vaults in the French manner. The vault ribs, which designers had begun to multiply soon after Salisbury, are at Gloucester a dense thicket of entirely ornamental strands serving no structural purpose. The choir, in fact, does not have any rib vaults at all but a continuous Romanesque barrel vault with applied Gothic ornament. In the Gloucester choir, the taste for decorative surfaces triumphed over structural clarity.

CHAPEL OF HENRY VII The structure-disguising and decorative qualities of the Perpendicular style became even more pronounced in its late phases. A primary example is the early-16th-century ceiling (FIG. 18-43) of the chapel of Henry VII (r. 1485–1509) adjoining Westminster Abbey in London. Here, ROBERT and WILLIAM VERTUE turned the earlier English linear play of ribs into a kind of ar-

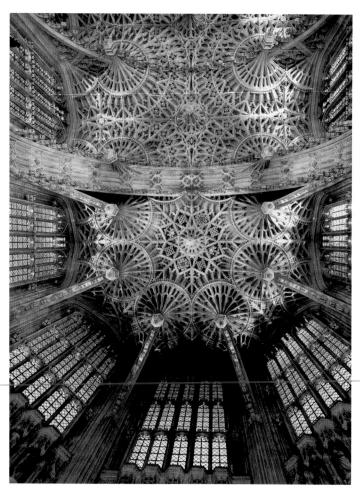

18-43 ROBERT and WILLIAM VERTUE, fan vaults of the chapel of Henry VII, Westminster Abbey, London, England, 1503–1519.

The chapel of Henry VII epitomizes the decorative and structuredisguising qualities of the Perpendicular style in the use of fan vaults with lacelike tracery and hanging pendants resembling stalactites.

chitectural embroidery. The architects pulled the ribs into uniquely English *fan vaults* (vaults with radiating ribs forming a fanlike pattern) with large hanging *pendants* resembling stalactites. The vault looks as if it had been some organic mass that hardened in the process of melting. Intricate tracery recalling lace overwhelms the cones hanging from the ceiling. The chapel represents the dissolution of structural Gothic into decorative fancy. The architects released the Gothic style's original lines from their function and multiplied them into the uninhibited architectural virtuosity and theatrics of the Perpendicular style. A contemporaneous phenomenon in France is the Flamboyant style of Saint-Maclou (FIG. 18-27) at Rouen.

ROYAL TOMBS Henry VII's chapel also houses the king's tomb in the form of a large stone coffin with sculpted portraits of Henry and his queen, Elizabeth of York, lying on their backs. This type of tomb is a familiar feature of the churches of Late Gothic England—indeed, of Late Gothic Europe. Though not strictly part of the architectural fabric, as are tombs set into niches in the church walls, freestanding tombs with recumbent images of the deceased are permanent and immovable units of church furniture. They preserve both the remains and the memory of the person entombed and testify to the deceased's piety as well as prominence.

Services for the dead were a vital part of the Christian liturgy. The Christian hope for salvation in the hereafter prompted the dying faithful to request masses sung, sometimes in perpetuity, for

18-44 Tomb of Edward II, Gloucester Cathedral, Gloucester, England, ca. 1330–1335.

Edward II's tomb resembles a miniature Perpendicular English Gothic chapel with its forest of gables, ogee arches, and pinnacles. The shrinelike form suggests that the deceased is worthy of veneration.

the eternal repose of their souls. Toward that end, the highborn and wealthy endowed whole chapels for the chanting of masses (chantries), and made rich bequests of treasure and property to the Church. Many also required that their tombs be as near as possible to the choir or some other important location in the church. Sometimes, patrons built a chapel especially designed and endowed to house their tombs, such as Henry's chapel at Westminster Abbey. Freestanding tombs, accessible to church visitors, had a moral as well as a sepulchral and memorial purpose. The silent image of the deceased, cold and still, was a solemn reminder of human mortality, all the more effective because the remains of the person depicted were directly below the portrait. The tomb of an illustrious person could bring distinction, pilgrims, and patronage to a church, just as relics of saints attracted pilgrims from far and wide (see "Pilgrimages," Chapter 17, page 432).

An elaborate example of a freestanding tomb (FIG. 18-44) is that of Edward II (r. 1307–1327), installed in Gloucester Cathedral several years after the king's murder. Edward III (r. 1327–1357) paid for the memorial to his father, who reposes in regal robes with his crown on his head. The sculptor portrayed the dead king as an idealized Christlike figure (compare FIG. 18-22). On each side of Edward's head is an attentive angel tenderly touching his hair. At his feet is a guardian lion, emblem also of the king's strength and valor. An intricate Perpendicular Gothic canopy encases the coffin, forming a kind of miniature chapel protecting the deceased. It is a fine example of the English manner with its forest of delicate alabaster and

Purbeck marble gables, buttresses, and pinnacles. A distinctive feature is the use of *ogee arches* (arches made up of two double-curved lines meeting at a point), a characteristic Late Gothic form. Art historians often have compared tombs like Edward's to reliquaries. Indeed, the shrinelike frame and the church setting transform the deceased into a kind of saintly relic worthy of veneration.

Holy Roman Empire

The architecture of the Holy Roman Empire remained conservatively Romanesque well into the 13th century. In many German churches, the only Gothic feature was the rib vault, buttressed solely by the heavy masonry of the walls. By midcentury, though, the French Gothic style began to make a profound impact.

COLOGNE CATHEDRAL Cologne Cathedral (FIG. 18-45), begun in 1248 under the direction of Gerhard of Cologne, was not completed until more than 600 years later, making it one of the longest building projects on record. Work halted entirely from the mid-16th to the mid-19th centuries, when the 14th-century design for the facade was unexpectedly found. Gothic Revival architects (see Chapter 30) then completed the building according to the Gothic plans, adding the nave, towers, and facade to the east end that had stood alone for several centuries. The Gothic/Gothic

18-45 GERHARD OF COLOGNE, aerial view of Cologne Cathedral (looking northwest), Cologne, Germany, begun 1248; nave, facade, and towers completed 1880.

Cologne Cathedral, the largest church in northern Europe, took more than 600 years to build. Only the east end dates to the 13th century. The 19th-century portions follow the original Gothic plans.

18-46 GERHARD OF COLOGNE, interior of Cologne Cathedral (looking east), Cologne, Germany, choir completed 1322.

The nave of Cologne Cathedral is 422 feet long. The 150-foothigh choir, a taller variation on the Amiens Cathedral choir (FIG. 18-20), is a prime example of Gothic architects' quest for height.

Revival structure is the largest cathedral in northern Europe and boasts a giant (422-footlong) nave (FIG. 18-46) with two aisles on each side.

The 150-foot-high 14th-century choir is a skillful variation of the Amiens Cathedral choir (FIGS. 18-19 and 18-20) design, with double lancets in the triforium and tall, slender single windows in the clerestory above and choir arcade below. Completed four decades after Gerhard's death but according to his plans, the choir expresses the Gothic quest for height even more emphatically than many French Gothic buildings. Despite the cathedral's seeming lack of substance, proof of its stability came during World War II, when the city of Cologne sustained extremely heavy aerial bombardments. The church survived the war by virtue of its Gothic skeletal design. Once the first few bomb blasts blew out all of its windows, subsequent explosions had no adverse effects, and the skeleton remained intact and structurally sound.

SAINT ELIZABETH, MARBURG A different type of design, also probably of French origin (FIG. 17-16, left) but developed especially in Germany, is the Hallenkirche, in which the aisles are the same height as the nave. Hall churches, consequently, have no tribune, triforium, or clerestory. An early German example of this type is the church of Saint Elizabeth (FIG. 18-47) at Marburg, built between 1235 and 1283. It incorporates French-inspired rib vaults with pointed arches and tall lancet windows. The facade has two spirecapped towers in the French manner but no tracery arcades or portal sculpture. Because the aisles provide much of the bracing for the nave vaults, the exterior of Saint Elizabeth is without the dramatic parade of flying buttresses that typically circles French Gothic churches. But the German interior, lighted by double rows of tall windows in the aisle walls, is more unified and free flowing, less narrow and divided, and more brightly illuminated than the interiors of French and English Gothic churches.

STRASBOURG CATHEDRAL In the German Rhineland, which the successors of the Carolingian and Ottonian emperors still ruled, work began in 1176 on a new cathedral for Strasbourg, today a French city. The apse, choir, and transepts were in place by around 1240. Stylistically, these sections of the new church are Romanesque. But the reliefs of the two south-transept portals are fully Gothic and reveal the impact of contemporary French sculpture, especially that of Reims.

18-47 Interior of Saint Elizabeth (looking west), Marburg, Germany, 1235–1283.

This German church is an early example of a Hallenkirche, in which the aisles are the same height as the nave. Because of the tall windows in the aisle walls, sunlight brightly illuminates the interior.

The subject of the left tympanum (FIG. 18-48) is the death of the Virgin Mary. A comparison of the Strasbourg Mary on her deathbed with the Mary of the Reims *Visitation* group (FIG. 18-24, *right*) suggests that the German master had studied the recently installed French jamb statues. The 12 apostles gather around the

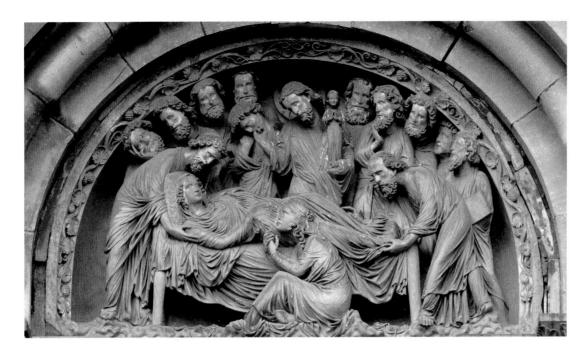

18-48 Death of the Virgin, tympanum of left doorway, south transept, Strasbourg Cathedral, Strasbourg, France, ca. 1230.

Stylistically akin to the *Visitation* group (FIG. 18-24, *right*) of Reims Cathedral, the figures in Strasbourg's south-transept tympanum express profound sorrow through dramatic poses and gestures.

Virgin, forming an arc of mourners well suited to the semicircular frame. The sculptor adjusted the heights of the figures to fit the available space (the apostles at the right are the shortest), and, as in many depictions of crowds throughout history, some of the figures have no legs or feet. At the center, Christ receives his mother's soul (the doll-like figure he holds in his left hand). Mary Magdalene, wringing her hands in grief, crouches beside the deathbed. The sorrowing figures express emotion in varying degrees of intensity, from serene resignation to gesturing agitation. The sculptor organized the group by dramatic pose and gesture but also by the rippling flow of deeply incised drapery that passes among the figures like a rhythmic electric pulse. The sculptor's objective was to imbue the sacred figures with human emotions and to stir emotional responses in observers. In Gothic France, as already noted, art became increasingly humanized and natural. In Gothic Germany, artists carried this humanizing trend even further by emphasizing passionate drama.

EKKEHARD AND UTA The Strasbourg style, with its feverish emotionalism, was particularly appropriate for narrating dramatic events in relief. The sculptor entrusted with the decoration of the west choir of Naumburg Cathedral faced a very different challenge. The task was to carve statues of the 12 benefactors of the original 11th-century church on the occasion of a new fundraising campaign. The vivid gestures and agitated faces in the Strasbourg tympanum contrast with the quiet solemnity of the Naumburg statues. Two of the figures (FIG. 18-49) stand out from the group because of their exceptional quality. They represent the margrave (military governor) Ekkehard II of Meissen and his wife Uta. The statues are attached to columns and stand beneath architectural canopies, following the pattern of French Gothic portal statuary. Their location indoors accounts for the preservation of much of the original paint. Ekkehard and Uta suggest the original appearance of the facade and transept sculptures of Gothic cathedrals.

18-49 Ekkehard and Uta, statues in the west choir, Naumburg Cathedral, Naumburg, Germany, ca. 1249–1255. Painted limestone, Ekkehard 6′ 2″ high.

The period costumes and individualized features of these donor portraits give the impression that Ekkehard and Uta posed for their statues, but they lived long before the Naumburg sculptor's time.

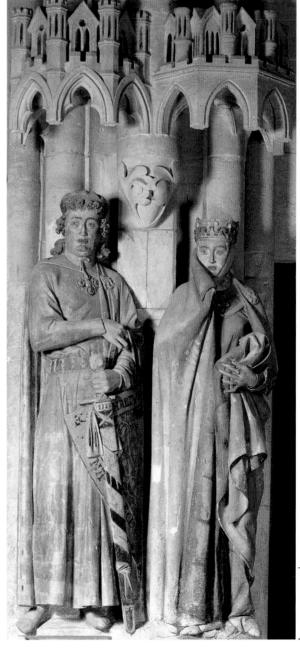

1 f

18-50 Equestrian portrait (*Bamberg Rider*), statue in the east choir, Bamberg Cathedral, Germany, ca. 1235–1240. Sandstone, 7' 9" high.

Probably a portrait of a German emperor, perhaps Frederick II, the *Bamberg Rider* revives the imagery of the Carolingian Empire. The French-style architectural canopy cannot contain the entire statue.

The period costumes and the individualized features and personalities of the margrave and his wife give the impression that they posed for their own portraits, although the subjects lived well before the sculptor's time. Ekkehard, the intense knight, contrasts with the beautiful and aloof Uta. With a wonderfully graceful gesture, she draws the collar of her gown partly across her face while she gathers up a soft fold of drapery with a jeweled, delicate hand. The sculptor subtly revealed the shape of Uta's right arm beneath her cloak and rendered the fall of drapery folds with an accuracy that indicates the use of a model. The two statues are arresting images of real people, even if they bear the names of aristocrats the artist never met. By the mid-13th century, in the Holy Roman Empire as well as in England (FIG. 18-44) and elsewhere, life-size images of secular personages had found their way into churches.

BAMBERG RIDER Somewhat earlier in date than the Naumburg "portraits" is the equestrian statue known as the Bamberg Rider (FIG. 18-50). For centuries this statue has been mounted against a pier in Bamberg Cathedral beneath an architectural canopy that frames the rider's body but not his horse. Scholars debate whether the statue was made for this location or moved there, perhaps from the church's exterior. Whatever the statue's original location, it revives the imagery of the Carolingian Empire (FIG. 16-12), derived in turn from that of ancient Rome (FIG. 10-59).

Like Ekkehard and Uta, the *Bamberg Rider* seems to be a true portrait. Some believe it represents a Holy Roman emperor, perhaps Frederick II (r. 1220–1250), who was a benefactor of Bamberg Cathedral. The many other identifications include Saint George and one of the three magi, but a historical personality is most likely the subject. The presence of a Holy Roman emperor in the cathedral would have underscored the unity of church and state in 13th-century Germany. The artist carefully represented the rider's costume, the high saddle, and the horse's trappings. The proportions of horse and rider are correct, although the sculptor did not quite understand the animal's anatomy, so its shape is rather stiffly schematic. The rider turns toward the observer, as if presiding at a review of troops. The torsion of this figure seems to reflect the same impatience with subordination to architecture found in the Reims portal statues (FIG. 18-24).

RÖTTGEN PIETÀ The confident 13th-century figures at Naumburg and Bamberg stand in marked contrast to a haunting 14th-century German painted wooden statuette (FIG. 18-51) of the Virgin

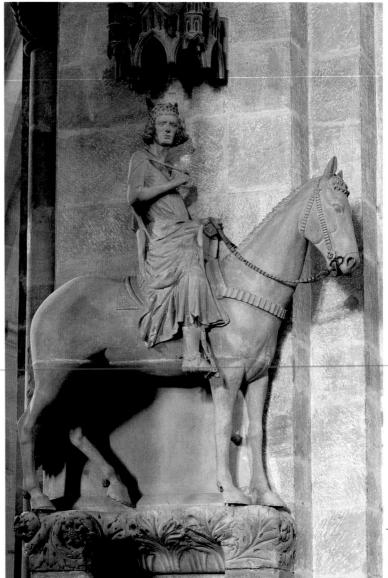

1 ft.

Mary holding the dead Christ in her lap. The widespread troubles of the 14th century—war, plague, famine, and social strife—brought on an ever more acute awareness of suffering. This sensibility found its way readily into religious art. The Dance of Death, Christ as the Man of Sorrow, and the Seven Sorrows of the Virgin Mary became favorite themes. A fevered and fearful piety sought comfort and reassurance in the reflection that Christ and the Virgin Mother shared humanity's woes. To represent this, artists emphasized the traits of human suffering in powerful, expressive exaggeration. In the illustrated group, a Pietà ("pity" or "compassion" in Italian), the sculptor portrayed Christ as a stunted, distorted human wreck, stiffened in death and covered with streams of blood gushing from a huge wound. The Virgin Mother, who cradles him like a child in her lap, is the very image of maternal anguish, her oversized face twisted in an expression of unbearable grief. This statue expresses nothing of the serenity of Romanesque and earlier Gothic depictions of Mary (FIGS. 17-18 and 18-16). Nor does the Röttgen Pietà (named after a collector) have anything in common with the aloof, iconic images of the Theotokos with the infant Jesus in her lap common in Byzantine art (FIGS. 12-18 and 12-19). Here the artist forcibly confronts the devout with an appalling icon of agony, death, and sorrow that humanizes, lmost to the point of heresy, the sacred personages. The work calls out to the horrified believer, "What is your suffering compared to this?"

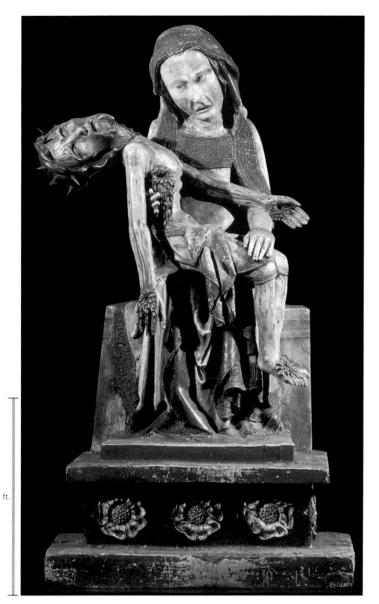

18-51 Virgin with the Dead Christ (*Röttgen Pietà*), from the Rhineland, Germany, ca. 1300–1325. Painted wood, 2' $10\frac{1}{2}''$ high. Rheinisches Landemuseum, Bonn.

This statuette of the Virgin grieving over the distorted dead body of Christ in her lap reflects the widespread troubles of the 14th century and the German interest in emotional imagery.

Throughout Europe, the humanizing of religious themes and religious images accelerated steadily from the 12th century. By the 14th century, art addressed the private person (often in a private place) in a direct appeal to the emotions. The expression of feeling accompanied the representation of the human body in motion. As the figures of the church portals began to twist on their columns, then move within their niches, and then stand independently, their details became more outwardly related to the human audience as expressions of recognizable human emotions.

NICHOLAS OF VERDUN As part of his plan to make his new church at Saint-Denis an earthly introduction to the splendors of Paradise (see "Abbot Suger," page 463), Suger selected artists from the Meuse River valley to fashion a magnificent crucifix for the choir. This region long had been famous for the quality of its metalworkers and enamelers (FIGS. 17-23 and 17-24). Suger described the Saint-Denis cross as standing on a sumptuous base decorated with 68

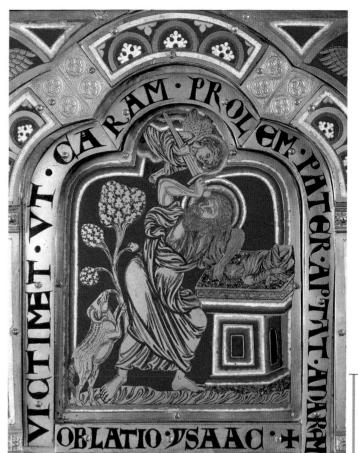

18-52 NICHOLAS OF VERDUN, sacrifice of Isaac, detail of the *Kloster-neuburg Altar*, from the abbey church at Klosterneuburg, Austria, 1181. Gilded copper and enamel, $5\frac{1}{2}$ high. Stiftsmuseum, Klosterneuburg.

Nicholas of Verdun was the leading artist of the Meuse valley region, renowned for its metal- and enamelwork. His emotionally charged gold figures stand out vividly from the blue enamel background.

enamel scenes pairing Old and New Testament episodes. The enamel work of the leading Meuse valley artist of the late 12th and early 13th centuries, Nicholas of Verdun, suggests the appearance of the biblical enamels on Suger's lost crucifix.

In 1181, Nicholas completed work on a gilded-copper and enamel ambo (a pulpit for biblical readings) for the Benedictine abbey church at Klosterneuburg, near Vienna in Austria. After a fire damaged the pulpit in 1330, the church hired artists to convert the pulpit into an altarpiece (a decorative panel above and behind the altar). The pulpit's sides became the wings of a triptych (three-part altarpiece). The 14th-century artists also added six scenes to Nicholas's original 45. The Klosterneuburg Altar in its final form has a central row of enamels depicting New Testament episodes, beginning with the Annunciation, and bearing the label sub gracia, or the world "under grace," that is, after the coming of Christ. The upper and lower registers contain Old Testament scenes labeled, respectively, ante legem, "before the law" Moses received on Mount Sinai, and sub lege, "under the law" of the Ten Commandments. In this scheme, prophetic Old Testament events appear above and below the New Testament episodes they prefigure. For example, framing the Annunciation to Mary of the coming birth of Jesus are enamels of angels announcing the births of Isaac and Samson. In the central section of the triptych, the Old Testament counterpart of Christ's Crucifixion is Abraham's sacrifice of Isaac (FIG. 18-52), a parallel already established in Early Christian times in both art (FIG. 11-7)

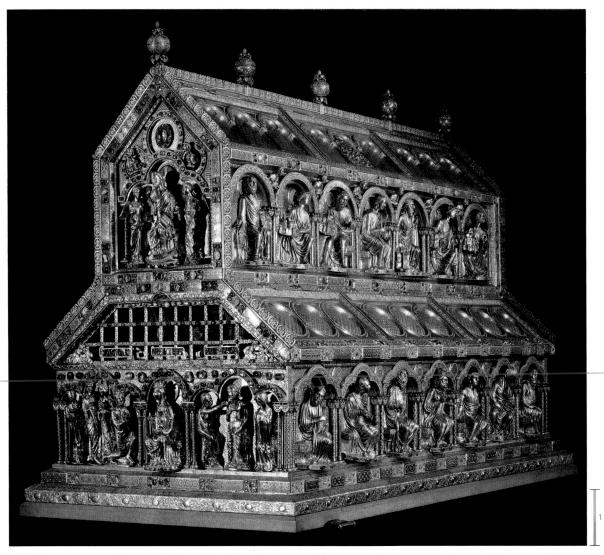

18-53 NICHOLAS OF VERDUN, *Shrine of the Three Kings*, from Cologne Cathedral, Cologne, Germany, begun ca. 1190. Silver, bronze, enamel, and gemstones, 5' $8'' \times 6' \times 3'$ 8''. Cathedral Treasury, Cologne.

Cologne's archbishop commissioned this huge reliquary in the shape of a church to house relics of the three magi. The figures are sculpted versions of those on the *Klosterneuburg Altar* (FIG. 18-52).

and literature (see "Jewish Subjects in Christian Art," Chapter 11, page 293). Nicholas of Verdun's gold figures stand out vividly from the blue enamel background. The biblical actors twist and turn, make emphatic gestures, and wear garments that are almost overwhelmed by the intricate linear patterns of their folds. In the Abraham and Isaac panel, the angel flies in at the very last moment to grab the blade of Abraham's sword before he can kill the bound Isaac on the altar. The intense emotionalism of the representation and the linear complexity of the garments foreshadowed the tone and style of the Strasbourg tympanum depicting the death of the Virgin (FIG. 18-48).

Sculpted versions of the Klosterneuburg figures appear on the Shrine of the Three Kings (FIG. 18-53) in Cologne Cathedral. Nicholas of Verdun probably began work on the huge reliquary (six feet long and almost as tall) in 1190. Philip von Heinsberg, archbishop of Cologne from 1167 to 1191, commissioned the shrine to contain relics of the three magi. The Holy Roman Emperor Frederick Barbarossa acquired them in the conquest of Milan in 1164 and

donated them to the German cathedral. Possession of the magi's relics gave the Cologne archbishops the right to crown German kings. Nicholas's reliquary, made of silver and bronze with ornamentation in enamel and gemstones, is one of the most luxurious ever fashioned, especially considering its size. The shape resembles that of a basilican church. Repoussé figures of the Virgin Mary, the three magi, Old Testament prophets, and New Testament apostles in arcuated frames are variations of those on the Klosterneuburg pulpit. The deep channels and tight bunches of the drapery folds are hallmarks of Nicholas's style.

Nicholas of Verdun's *Klosterneuburg Altar* and his *Shrine of the Three Kings*, together with Suger's treatises on the furnishings of Saint-Denis, are welcome reminders of how magnificently outfitted medieval church interiors were. The so-called minor arts played a defining role in creating a special otherworldly atmosphere for Christian ritual. These Gothic examples continued a tradition that dates to the Roman emperor Constantine and the first imperial patronage of Christianity (see Chapter 11).

GOTHIC EUROPE

FRANCE

- The birthplace of Gothic art and architecture was Saint-Denis, where Abbot Suger used rib vaults with pointed arches and stained-glass windows to rebuild the Carolingian royal church. The west facade of Suger's church also introduced statue-columns on the portal jambs, which appeared shortly later on the Royal Portal of Chartres Cathedral. Laon Cathedral is another important example of Early Gothic (1140–1194) architecture.
- After a fire in 1194, Chartres Cathedral was rebuilt with flying buttresses, four-part nave vaults, and a three-story elevation of nave arcade, triforium, and clerestory, setting the pattern for High Gothic (1194–1300) cathedrals, including Amiens with its 144-foot-high vaults.
- Flying buttresses made possible huge stained-glass windows. High Gothic windows employ delicate lead cames and bar tracery. The divine colored light (*lux nova*) they admitted transformed the character of church interiors.
- High Gothic statue-columns broke out of the architectural straitjacket of their Early Gothic predecessors. At Chartres, Reims, and elsewhere, the sculpted figures move freely and sometimes converse with their neighbors.
- The High Gothic Rayonnant court style of Louis IX gave way in the Late Gothic (1300–1500) period to the Flamboyant style seen at Saint-Maclou at Rouen.
- Several important examples of secular architecture survive from the Gothic period, including the bastions and towers of Carcassonne, the hall of the cloth guild in Bruges, and the house of Jacques Coeur in Bourges.
- In the 13th century, Paris was the center of production of costly moralized Bibles and other illuminated manuscripts in urban workshops of professional artists, which usurped the role of monastic scriptoria.

Royal Portal, Chartres Cathedral, ca. 1145–1155

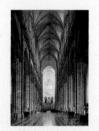

Amiens Cathedral, begun 1220

God as architect of the world, ca. 1220–1230

ENGLAND

- The Parisian Gothic style became the rage in most of Europe during the 13th century, but many regional styles developed, as in the Romanesque period. English Gothic churches like Salisbury Cathedral differ from their French counterparts in their wider and shorter facades, flat east ends, double transepts, and sparing use of flying buttresses.
- Especially characteristic of English Gothic architecture is the elaboration of architectural patterns, which often disguise the underlying structure of the buildings. Constructed in the Late Gothic Perpendicular style, the fan vaults of the chapel of Henry VII transform the logical rib vaults of French buildings into decorative fancy.

Salisbury Cathedral, Salisbury, 1220–1258

HOLY ROMAN EMPIRE

- German architects eagerly embraced the French Gothic architectural style at Cologne Cathedral and elsewhere. German originality manifested itself most clearly in the Gothic period in sculpture, which often features emotionally charged figures in dramatic poses.
- Statues of secular historical figures decorate the interiors of Naumburg and Bamberg cathedrals, signaling a revival of interest in the art of portraiture.
- Nicholas of Verdun was the leading artist of the Meuse River valley, an area renowned for metaland enamelwork. Nicholas's altars and shrines provide an idea of how sumptuous were the furnishings of Gothic churches.

Nicholas of Verdun, Shrine of the Three Kings, ca. 1190

19-1 GIOTTO DI BONDONE, Arena Chapel (Cappella Scrovegni; interior looking west), Padua, Italy, 1305–1306.

Giotto, widely regarded as the first Renaissance painter, was a pioneer in pursuing a naturalistic approach to representation based on observation. The frescoes in the Arena Chapel show his art at its finest.

ITALY, 1200 TO 1400

When the Italian humanists of the 16th century condemned the art of the late Middle Ages in northern Europe as "Gothic" (see Chapter 18), they did so by comparing it with the contemporary art of Italy, which was a conscious revival of classical* art. Italian artists and scholars regarded medieval artworks as distortions of the noble art of the Greeks and Romans. But interest in the art of classical antiquity was not entirely absent during the medieval period, even in France, the center of the Gothic style. For example, on the west front of Reims Cathedral, the statues of Christian saints and angels (FIG. 18-24) reveal the unmistakable influence of Roman art on French sculptors. However, the classical revival that took root in Italy during the 13th and 14th centuries (MAP 19-1) was much more pervasive and long-lasting.

THE 13TH CENTURY

Italian admiration for classical art surfaced early on at the court of Frederick II, king of Sicily (r. 1197–1250) and Holy Roman Emperor (r. 1220–1250). Frederick's nostalgia for the past grandeur of Rome fostered a revival of Roman sculpture in Sicily and southern Italy not unlike the neoclassical *renovatio* (renewal) that Charlemagne encouraged in Germany four centuries earlier (see Chapter 16).

Sculpture

NICOLA PISANO The sculptor Nicola d'Apulia (Nicholas of Apulia), better known as NICOLA PISANO (active ca. 1258–1278) after his adopted city (see "Italian Artists' Names," page 498), received his early training in southern Italy under Frederick's rule. In 1250, Nicola traveled northward and eventually settled in Pisa. Then at the height of its political and economic power, Pisa was a magnet for artists seeking lucrative commissions. Nicola specialized in carving marble reliefs and ornamentation for large *pulpits* (raised platforms from which priests lead church services), completing the first (FIG. 19-2) in 1260 for Pisa's baptistery (FIG. 17-25, *left*). Some elements of the pulpit's design carried on medieval traditions (for example, the *trefoil arches* and the lions supporting some of the *columns*), but Nicola also incorporated

^{*} In Art through the Ages the adjective "Classical," with uppercase C, refers specifically to the Classical period of ancient Greece, 480–323 BCE. Lowercase "classical" refers to Greco-Roman antiquity in general, that is, the period treated in Chapters 5, 9, and 10.

Italian Artists' Names

n contemporary societies, people have become accustomed to a standardized method of identifying individuals, in part because of the proliferation of official documents such as driver's licenses, passports, and student identification cards. Given names are coupled with family names, although the order of the two (or more) names varies from country to country. This kind of regularity in names was not, however, the norm in premodern Italy. Many individuals were known by their place of birth or adopted hometown. Nicola Pisano was known as "Nicholas the Pisan," Giulio Romano was "Julius the Roman," and Domenico Veneziano was "the Venetian." Leonardo da Vinci ("Leonard from Vinci") hailed from the small town of Vinci. Art historians therefore refer to these artists by their given name, not the name of their town: "Leonardo," not "da Vinci."

Nicknames were also common. Giorgione was "Big George." People usually referred to Tommaso di Cristoforo Fini as Masolino ("Little Thomas") to distinguish him from his more famous pupil Masaccio ("Brutish Thomas"). Guido di Pietro was called Fra Angelico (the Angelic Friar). Cenni di Pepo is remembered as Cimabue ("bull's head"). Names were also impermanent and could be changed at will. This flexibility has resulted in significant challenges for historians, who often must deal with archival documents and records that refer to the same artist by different names.

classical elements. The large, bushy capitals are a Gothic variation of the highly ornate Corinthian capital. The arches are round, as in Roman architecture, rather than pointed (ogival) as in Gothic buildings. And each of the large rectangular relief panels resembles the sculptured front of a Roman sarcophagus, or coffin (for example, FIG. 10-70).

The densely packed large-scale figures of the individual panels also seem to derive from the compositions found on Roman sarcophagi. One of these panels (FIG. 19-3) depicts scenes from the Infancy cycle of Christ (see "The Life of Jesus in Art," Chapter 11, pages 296-297, or xxvi-xxvii in Volume II), including the Annunciation (top left), the Nativity (center and lower half), and the Adoration of the Shepherds (top right). Mary appears twice, and her size varies. The focus of the composition is the reclining Virgin of the *Nativity*, whose posture and drapery are reminiscent of those of the lid figures on Etruscan (FIGS. 9-5 and 9-15) and Roman (FIG. 10-61) sarcophagi. The face types, beards, and coiffures as well as the bulk and weight of Nicola's figures also reveal the influence of classical relief sculpture. Scholars have even been able to pinpoint the models of some of the pulpit figures on Roman sarcophagi in Pisa.

MAP 19-1 Italy about 1400.

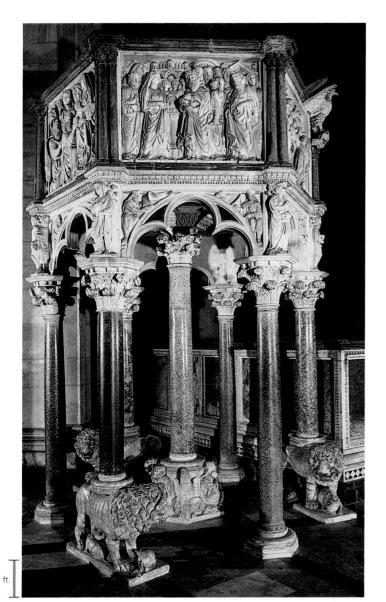

19-2 NICOLA PISANO, pulpit of the baptistery, Pisa, Italy, 1259–1260. Marble, 15' high.

Nicola Pisano's baptistery pulpit at Pisa retains many medieval design elements, for example, the trefoil arches and the lions supporting columns, but the panels draw on ancient Roman sarcophagus reliefs.

GIOVANNI PISANO Nicola Pisano's son, GIOVANNI PISANO (ca. 1250–1320), likewise became a sought-after sculptor of church pulpits. Giovanni's pulpit in Sant'Andrea at Pistoia also has a panel (FIG. 19-4) featuring the Nativity and related scenes. The son's version of the subject is in striking contrast to his father's thick carving and placid, almost stolid, presentation of the religious narrative. Giovanni arranged the figures loosely and dynamically. They twist and bend in excited animation, and the spaces that open deeply between them suggest their motion. In the Annunciation episode (top left), the Virgin shrinks from the angel's sudden appearance in a posture of alarm touched with humility. The same spasm of apprehension contracts her supple body as she reclines in the Nativity scene (center). The drama's principals share in a peculiar nervous agitation, as if they all suddenly are moved by spiritual passion. Only the shepherds and the sheep (right) do not yet experience the miraculous event. The swiftly turning, sinuous draperies, the slender figures they enfold, and the general emotionalism of the scene are features not found in Nicola Pisano's interpretation. The father worked in the classical tradition, the son in a style derived from French Gothic. Both styles were important ingredients in the formation of the distinctive and original art of 14th-century Italy.

Painting and Architecture

A third contributing component of 14th-century Italian art was the Byzantine tradition (see Chapter 12). Throughout the Middle Ages, the Byzantine style dominated Italian painting, but its influence was especially strong after the fall of Constantinople in 1204, which precipitated a migration of Byzantine artists to Italy.

19-3 NICOLA PISANO, Annunciation, Nativity, and Adoration of the Shepherds, relief panel on the baptistery pulpit, Pisa, Italy, 1259–1260. Marble, $2' 10'' \times 3' 9''$.

Classical sculpture inspired the face types, beards, coiffures, and draperies, as well as the bulk and weight of Nicola's figures. The Madonna of the *Nativity* resembles lid figures on Roman sarcophagi.

19-4 GIOVANNI PISANO, Annunciation, Nativity, and Adoration of the Shepherds, relief panel on the pulpit of Sant'Andrea, Pistoia, Italy, 1297–1301. Marble, $2'10''\times3'4''$.

The French Gothic style had a greater influence on Giovanni Pisano, Nicola's son. Giovanni arranged his figures loosely and dynamically. They display a nervous agitation, as if moved by spiritual passion.

499

19-5 Bonaventura Berlinghieri, panel from the *Saint Francis Altarpiece*, San Francesco, Pescia, Italy, 1235. Tempera on wood, $5' \times 3' \times 6'$.

Berlinghieri was one of the leading painters working in the Italo-Byzantine style, or *maniera greca*. The frontal pose of Saint Francis and the use of gold leaf reveal the painter's Byzantine sources.

BONAVENTURA BERLINGHIERI

One of the leading painters working in the Italo-Byzantine style, or maniera greca (Greek style), was Bonaventura Berlin-GHIERI (active ca. 1235-1244) of Lucca. He created the Saint Francis Altarpiece (FIG. 19-5) for the church of San Francesco (Saint Francis) in Pescia in 1235. Painted in tempera on wood panel (see "Tempera and Oil Painting," Chapter 20, page 523), the altarpiece honors Saint Francis of Assisi (ca. 1181-1226). Francis wears the coarse clerical robe, tied at the waist with a rope, which became the costume of Franciscan monks. The saint displays the stigmata marks resembling Christ's wounds-that appeared on his hands and feet. Flanking Francis are two angels, whose frontal poses, prominent halos, and lack of modeling reveal the Byzantine roots of Berlinghieri's style. So too does his use of gold leaf (gold beaten into tissue-paper-thin sheets, then applied to surfaces), which emphasizes the image's flatness and spiritual nature. The narrative scenes that run along the sides of the panel provide an active contrast to the stiff formality of the large central image of Francis. At the upper left, taking pride of

place at the saint's right, Francis miraculously acquires the stigmata. Directly below, the saint preaches to the birds. These and the scenes depicting Francis's miracle cures strongly suggest that Berlinghieri's source was one or more Byzantine *illuminated manuscripts* (compare FIG. 12-17) having biblical narrative scenes.

Berlinghieri's Saint Francis Altarpiece also highlights the increasingly prominent role of religious orders in late medieval Italy (see "The Great Schism, Mendicant Orders, and Confraternities," page 501). Saint Francis's Franciscan order worked diligently to impress on the public the saint's valuable example and to demonstrate its monks' commitment to teaching and to alleviating suffering. Berlinghieri's Pescia altarpiece, painted nine years after Francis's death, is the earliest known signed and dated representation of the saint. Appropriately, the panel focuses on the aspects of the saint's life that the Franciscans wanted to promote, thereby making visible (and thus more credible) the legendary life of this holy man. Saint Francis believed he could get closer to God by rejecting worldly

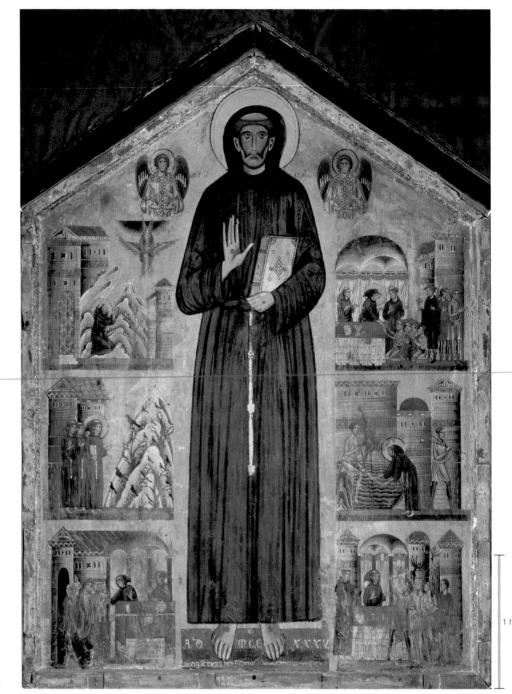

goods, and to achieve this he stripped himself bare in a public square and committed himself to a strict life of fasting, prayer, and meditation. The appearance of stigmata on his hands and feet (clearly visible in the saint's frontal image, which resembles an *icon*) was perceived as God's blessing and led some followers to see Francis as a second Christ. Fittingly, four of the six narrative scenes on the altarpiece depict miraculous healings, connecting him more emphatically to Christ.

SANTA MARIA NOVELLA The increased importance of the mendicant orders during the 13th century led to the construction of large churches in Florence by the Franciscans (Santa Croce; FIG. I-3) and the Dominicans. The Florentine government and contributions from private citizens subsidized the commissioning of the Dominicans' Santa Maria Novella (FIG. 19-6) around 1246. The large congregations these orders attracted necessitated the expansive scale of this church. Small *oculi* (round windows) and marble striping along

The Great Schism, Mendicant Orders, and Confraternities

n 1305 the College of Cardinals (the collective body of all cardinals) elected a French pope, Clement V, who settled in Avignon. Subsequent French popes remained in Avignon, despite their announced intentions to return to Rome. Understandably, this did not please the Italians, who saw Rome as the rightful capital of the universal church. The conflict between the French and Italians resulted in the election in 1378 of two popes-Clement VII, who resided in Avignon (and who does not appear in the Catholic Church's official list of popes), and Urban VI (r. 1378–1389), who remained in Rome. Thus began what became known as the Great Schism. After 40 years, the Holy Roman Emperor Sigismund (r. 1410-1437) convened a council that managed to resolve this crisis by electing a new Roman pope, Martin V (r. 1417-1431), who was acceptable to all.

The pope's absence from Italy during much of the 14th century (the Avignon papacy) contributed to an increase in prominence of monastic orders. The Augustinians, Carmelites, and Servites became very active, ensuring a constant religious presence in the daily life of Italians, but the largest and most influential monastic orders were the mendicants (begging friars)—the Franciscans, founded by Francis of Assisi (FIG. 19-5), and the Dominicans, founded by the Spaniard Dominic de Guzman (ca. 1170-1221). These mendicants renounced all worldly goods and committed themselves to spreading God's word, performing good deeds, and ministering to the sick and dying. The Dominicans, in particular, contributed significantly to establishing urban educational institutions. The Franciscans and Dominicans became very popular among Italian citizens because of their devotion to their faith and the more personal relationship with God they encouraged. Although both mendicant orders were working for the same purpose—the glory of God—a degree of rivalry nevertheless existed between the two. They established their churches on opposite sides of Florence—Santa Croce (FIG. I-3), the Franciscan church, on the eastern side, and the Dominicans' Santa Maria Novella (FIG. 19-6) on the western (MAP 21-1).

Confraternities, organizations consisting of laypersons who dedicated themselves to strict religious observance, also grew in popularity during the 14th and 15th centuries. The mission of confraternities included tending the sick, burying the dead, singing hymns, and per-

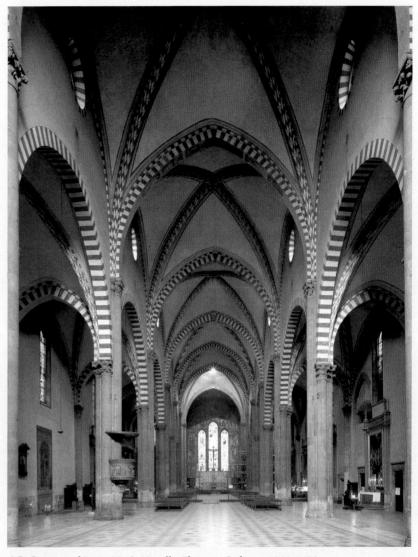

19-6 Nave of Santa Maria Novella, Florence, Italy, ca. 1246-1470.

The basilicas of Santa Maria Novella and Santa Croce (FIG. I-3) testify to the growing influence of the Dominican and Franciscan mendicant orders, respectively, in 13th-century Florence.

forming other good works. The confraternities as well as the mendicant orders continued to play an important role in Italian religious life through the 16th century. Further, the numerous artworks and monastic churches they commissioned ensured their enduring legacy.

the ogival arches punctuate the *nave*, or central *aisle*. (For the nomenclature of *basilican* church architecture, see FIG. 11-9 or pages xxxii–xxxiii in Volume II.) Originally, a screen (*tramezzo*) placed across the nave separated the friars from the lay audience. The priests performed the *Mass* at separate altars on each side of the screen. Church officials removed this screen in the mid-16th century to encourage greater lay participation in the Mass.

CIMABUE One of the first artists to begin to break away from the Italo-Byzantine style that dominated 13th-century Italian painting was Cenni di Pepo, better known as CIMABUE (ca. 1240–1302). Although his works reveal the unmistakable influence of Gothic sculpture, Cimabue challenged some of the conventions that dominated late medieval art in pursuit of a new *naturalism*, the close observation of the natural world that was at the core of the classical

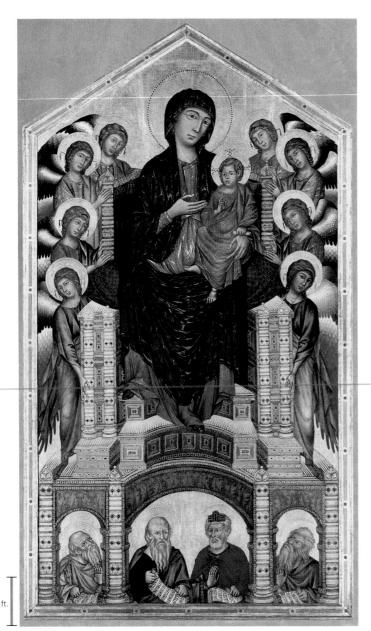

19-7 CIMABUE, Madonna Enthroned with Angels and Prophets, from Santa Trinità, Florence, Italy, ca. 1280–1290. Tempera and gold leaf on wood, 12' $7'' \times 7'$ 4''. Galleria degli Uffizi, Florence.

Cimabue was one of the first artists to break away from the Italo-Byzantine style. Although he relied on Byzantine models, Cimabue depicted the Madonna's massive throne as receding into space.

tradition. Cimabue's Madonna Enthroned with Angels and Prophets (FIG. 19-7), created for the church of Santa Trinità (Holy Trinity) in Florence, nonetheless reveals the painter's reliance on Byzantine models for the composition as well as the gold background (compare FIG. 12-18). Cimabue used the gold embellishments common to Byzantine art for the folds of the Madonna's robe, but they are no longer merely decorative patterns. Here they enhance the three-dimensionality of the drapery. Cimabue also constructed a deeper space for the Madonna and the surrounding figures to inhabit than is common in Byzantine art. The Virgin's throne, for example, is a massive structure that Cimabue convincingly depicted as receding into space. The overlapping bodies of the angels on each side of the throne and the half-length prophets who look outward or upward from beneath it reinforce the sense of depth.

THE 14TH CENTURY

In the 14th century, Italy consisted of numerous independent *city-states*, each corresponding to a geographic region centered on a major city (MAP 19-1). Most of the city-states, such as Venice, Florence, Lucca, and Siena, were republics. These republics were constitutional oligarchies—governed by executive bodies, advisory councils, and special commissions. Other powerful 14th-century states included the Papal States, the Kingdom of Naples, and the Duchies of Milan, Modena, Ferrara, and Savoy. As their names indicate, these states were politically distinct from the republics, but all the states shared in the prosperity of the period. The sources of wealth varied from state to state. Italy's port cities expanded maritime trade, whereas the economies of other cities depended on banking or the manufacture of arms or textiles.

The eruption of the Black Death (bubonic plague) in the late 1340s threatened this prosperity, however. Originating in China, the Black Death swept across the entire European continent. The most devastating natural disaster in European history, the plague killed between 25 and 50 percent of Europe's population in about five years. Italy was particularly hard hit. In large cities, where people lived in relatively close proximity, the death tolls climbed as high as 50 or 60 percent of the population. The Black Death had a significant effect on art. It stimulated religious bequests and encouraged the commissioning of devotional images. The focus on sickness and death also led to a burgeoning in hospital construction.

Another significant development in 14th-century Italy was the blossoming of a vernacular (commonly spoken) literature, which dramatically affected Italy's intellectual and cultural life. Latin remained the official language of church liturgy and state documents. However, the creation of an Italian vernacular literature (based on the Tuscan dialect common in Florence) expanded the audience for philosophical and intellectual concepts because of its greater accessibility. Dante Alighieri (1265–1321; author of *The Divine Comedy*), poet and scholar Francesco Petrarch (1304–1374), and Giovanni Boccaccio (1313–1375; author of *Decameron*) were among those most responsible for establishing this vernacular literature.

RENAISSANCE HUMANISM The development of a vernacular literature was one important sign that the essentially religious view of the world that dominated medieval Europe was about to change dramatically in what historians call the Renaissance. Although religion continued to occupy a primary position in the lives of Europeans, a growing concern with the natural world, the individual, and humanity's worldly existence characterized the Renaissance period the 14th through the 16th centuries. The word renaissance in French and English (rinascità in Italian) refers to a "rebirth" of art and culture. A revived interest in classical cultures—indeed, the veneration of classical antiquity as a model—was central to this rebirth. The notion that the Renaissance represented the restoration of the glorious past of Greece and Rome gave rise to the concept of the "Middle Ages" as the era spanning the time between antiquity and the Renaissance. The transition from the medieval to the Renaissance, though dramatic, did not come about abruptly, however. In fact, much that is medieval persisted in the Renaissance and in later periods.

Fundamental to the development of the Italian Renaissance was humanism, a concept that emerged during the 14th century and became a central component of Italian art and culture in the 15th and 16th centuries. Humanism was more a code of civil conduct, a theory of education, and a scholarly discipline than a philosophical system. As their name suggests, Italian humanists were concerned chiefly with human values and interests as distinct from—but not opposed to—religion's otherworldly values. Humanists pointed to

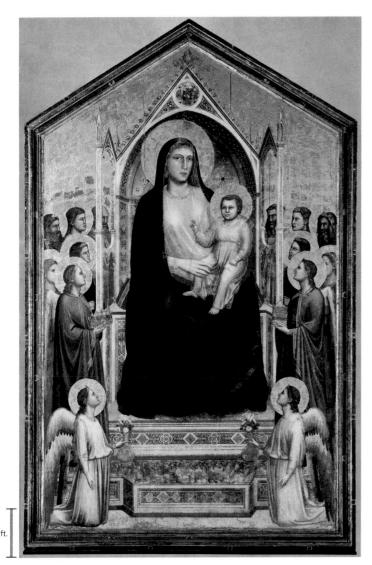

19-8 Giotto di Bondone, *Madonna Enthroned*, from the Church of Ognissanti, Florence, Italy, ca. 1310. Tempera and gold leaf on wood, 10' 8" \times 6' 8". Galleria degli Uffizi, Florence.

Giotto displaced the Byzantine style in Italian painting and revived the naturalism of classical art. His figures have substance, dimensionality, and bulk and give the illusion that they could throw shadows.

classical cultures as particularly praiseworthy. This enthusiasm for antiquity, represented by the elegant Latin of Cicero (106–43 BCE) and the Augustan age, involved study of Latin literature and a conscious emulation of what proponents thought were the Roman civic virtues. These included self-sacrificing service to the state, participation in government, defense of state institutions (especially the administration of justice), and stoic indifference to personal misfortune in the performance of duty. With the help of a new interest in and knowledge of Greek, the humanists of the late 14th and 15th centuries recovered a large part of the Greek as well as the Roman literature and philosophy that had been lost, left unnoticed, or cast aside in the Middle Ages. Indeed, classical cultures provided humanists with a model for living in this world, a model primarily of human focus that derived not from an authoritative and traditional religious dogma but from reason.

Ideally, humanists sought no material reward for services rendered. The sole reward for heroes of civic virtue was fame, just as the reward for leaders of the holy life was sainthood. For the educated, the lives of heroes and heroines of the past became as edifying as the

lives of the saints. Petrarch wrote a book on illustrious men, and his colleague Boccaccio complemented it with biographies of famous women—from Eve to his contemporary, Joanna, queen of Naples. Both Petrarch and Boccaccio were famous in their own day as poets, scholars, and men of letters—their achievements equivalent in honor to those of the heroes of civic virtue. In 1341 in Rome, Petrarch received the laurel wreath crown, the ancient symbol of victory and merit. The humanist cult of fame emphasized the importance of creative individuals and their role in contributing to the renown of the city-state and of all Italy.

Giotto

GIOTTO DI BONDONE (ca. 1266-1337) of Florence made a much more radical break with the past than did Cimabue. Art historians from Giorgio Vasari† to the present day have regarded Giotto as the first Renaissance painter, a pioneer in pursuing a naturalistic approach to representation based on observation. Scholars still debate the sources of Giotto's style, however. One formative influence must have been the work of the man Vasari said was his teacher, Cimabue, although Vasari lauded Giotto as having eclipsed Cimabue by abandoning the "crude maniera greca." Some late-13th-century murals in Rome with fully modeled figures of saints may also have influenced the young Giotto. French Gothic sculpture (which Giotto may have seen, but certainly familiar to him from the work of Giovanni Pisano, who had spent time in Paris) and ancient Roman art must also have contributed to Giotto's artistic education. Yet no mere synthesis of these varied influences could have produced the significant shift in artistic approach that has led some scholars to describe Giotto as the father of Western pictorial art. Renowned in his own day, he established a reputation that has never faltered. Regardless of the other influences on his artistic style, his true teacher was nature—the world of visible things.

Giotto's revolution in painting did not consist only of displacing the Byzantine style, establishing painting as a major art form for the next seven centuries, and restoring the naturalistic approach the ancients developed and medieval artists largely abandoned. He also inaugurated a method of pictorial expression based on observation and initiated an age that might be called "early scientific." By stressing the preeminence of sight for gaining knowledge of the world, Giotto and his successors contributed to the foundation of empirical science. They recognized that the visual world must be observed before it can be analyzed and understood. Praised in his own and later times for his fidelity to nature, Giotto was more than a mere imitator of it. He revealed nature while observing it and divining its visible order. In fact, he showed his generation a new way of seeing. With Giotto, Western artists turned resolutely toward the visible world as their source of knowledge of nature.

MADONNA ENTHRONED On nearly the same great scale as Cimabue's enthroned Madonna (FIG. 19-7) is Giotto's panel (FIG. 19-8) depicting the same subject, painted for the high altar of the Ognissanti (All Saints) church in Florence. Although still seen against the traditional gold background, Giotto's Madonna rests within her Gothic throne with the unshakable stability of an ancient

[†]Giorgio Vasari (1511–1574) established himself as both a painter and architect during the 16th century. However, people today usually associate him with his landmark book *Lives of the Most Eminent Painters, Sculptors, and Architects*, first published in 1550. Scholars long have considered this book a major source of information about Italian art and artists, although many of the details have proven inaccurate. Regardless, Vasari's *Lives* remains a tour de force—an ambitious, comprehensive book dedicated to recording the biographies of artists.

resco painting has a long history, particularly in the Mediterranean region, where the Minoans (FIGS. 4-7 to 4-9) used it as early as 1650 BCE. Fresco (Italian for "fresh") is a mural-painting technique that involves applying permanent limeproof pigments, diluted in water, on freshly laid lime plaster. Because the surface of the wall absorbs the pigments as the plaster dries, fresco is one of the most permanent painting techniques. The stable condition of frescoes such as those in the Arena Chapel (FIGS. 19-1 and 19-9) and in the Sistine Chapel (FIGS. 22-1, 22-18, and 22-19), now hundreds of years old, attest to the longevity of this painting method. The colors have remained vivid (although dirt and soot have necessitated cleaning) because of the chemically inert pigments the artists used. In addition to this buon fresco ("true" fresco) technique, artists used fresco secco (dry fresco). Fresco secco involves painting on dried lime plaster. Although the finished product visually approximates buon fresco, the plaster wall does not absorb the pigments, which simply adhere to the surface. Thus fresco secco does not have buon fresco's longevity.

The buon fresco process is time-consuming and demanding and requires several layers of plaster. Although buon fresco methods vary, generally the artist prepares the wall with a rough layer of lime plaster called the *arriccio* (brown coat). The artist then transfers the composition to the wall, usually by drawing directly on the arriccio with a burnt-orange pigment called *sinopia* (most popular during the 14th century) or by transferring a

cartoon (a full-sized preparatory drawing). Cartoons increased in usage in the 15th and 16th centuries, largely replacing sinopia underdrawings. Finally, the painter lays the *intonaco* (painting coat) smoothly over the drawing in sections (called *giornate*, Italian for "days") only as large as the artist expects to complete in that session. The buon fresco painter must apply the colors fairly quickly, because once the plaster is dry, it will no longer absorb the pigment. Any

Fresco Painting

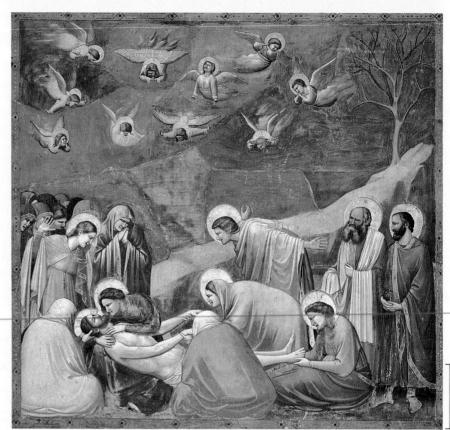

19-9 Giotto di Bondone, *Lamentation*, Arena Chapel (Cappella Scrovegni), Padua, Italy, ca. 1305. Fresco, 6' $6\frac{3}{4}'' \times 6' \frac{3}{4}''$.

In this fresco painted in several sections, Giotto used the diagonal slope of the rocky landscape to direct the viewer's attention toward the head of the sculpturesque figure of the dead Christ.

areas of the intonaco that remain unpainted after a session must be cut away so that fresh plaster can be applied for the next giornata.

In areas of high humidity, such as Venice, fresco was less appropriate because moisture is an obstacle to the drying process. Over the centuries, fresco became less popular, although it did experience a revival in the 1930s with the Mexican muralists (FIGS. **35-67** and **35-68**).

marble goddess. Giotto replaced Cimabue's slender Virgin, fragile beneath the thin ripplings of her drapery, with a weighty, queenly mother. In Giotto's painting, the Madonna's body is not lost. It is asserted. Giotto even shows Mary's breasts pressing through the thin fabric of her white undergarment. Gold highlights have disappeared from her heavy robe. Giotto aimed, before all else, to construct a figure that has substance, dimensionality, and bulk—qualities suppressed in favor of a spiritual immateriality in Byzantine and Italo-Byzantine art. Works painted in the new style portray sculpturesque figures—projecting into the light and giving the illusion that they could throw shadows. Giotto's *Madonna Enthroned* marks the end of medieval painting in Italy and the beginning of a new naturalistic approach to art.

ARENA CHAPEL, PADUA To project onto a flat surface the illusion of solid bodies moving through space presents a double challenge. Constructing the illusion of a body also requires constructing the illusion of a space sufficiently ample to contain that body. In his *fresco* cycles (see "Fresco Painting," above), Giotto constantly strove to reconcile these two aspects of illusionistic painting. His murals in the Arena Chapel (Cappella Scrovegni; FIG. 19-1) at Padua show his art at its finest. Enrico Scrovegni, a wealthy Paduan banker, built the chapel on a site adjacent to his now-razed palace. Consecrated in 1305, the Arena Chapel takes its name from an ancient Roman amphitheater nearby. Scrovegni erected the chapel, which he intended for his family's private use, in part to expiate the bankers' sin of usury. Some scholars have suggested that Giotto him-

self may have been the chapel's architect because its design is so perfectly suited to its interior decoration.

The rectangular barrel-vaulted hall has six narrow windows only in its south wall (FIG. 19-1, left), which left the entire north wall an unbroken and well-illuminated surface for painting. The building seems to have been designed to provide Giotto with as much flat surface as possible for presenting one of the most impressive and complete Christian pictorial cycles ever rendered. In 38 framed pictures, arranged on three levels, the artist related the most poignant incidents from the lives of the Virgin and her parents, Joachim and Anna (top level), the life and mission of Christ (middle level), and his Passion, Crucifixion, and Resurrection (bottom level). These three pictorial levels rest on a coloristically neutral base. Imitation marble veneer—reminiscent of ancient Roman decoration (FIG. 10-51), which Giotto may have seen—alternates with the Virtues and Vices painted in grisaille (monochrome grays, often used for modeling in paintings) to resemble sculpture. The climactic event of the cycle of human salvation, the Last Judgment, covers most of the west wall above the chapel's entrance (FIG. 19-1).

The hall's vaulted ceiling is blue, an azure sky dotted with golden stars symbolic of Heaven. Medallions bearing images of Christ, Mary, and various prophets also appear on the vault. Giotto painted the same blue in the backgrounds of the narrative panels on the walls below. The color thereby functions as a unifying agent for the entire decorative scheme and renders the scenes more realistic.

Decorative borders frame the individual panels. They offer a striking contrast to the sparse simplicity of the images they surround. Subtly scaled to the chapel's space (only about half life-size), Giotto's stately and slow-moving actors present their dramas convincingly and with great restraint. Lamentation (FIG. 19-9) reveals the essentials of his style. In the presence of boldly foreshortened angels, seen head-on with their bodies receding into the background and darting about in hysterical grief, a congregation mourns over the dead body of the Savior just before its entombment. Mary cradles her son's body, while Mary Magdalene looks solemnly at the wounds in Christ's feet and Saint John the Evangelist throws his arms back dramatically. Giotto arranged a shallow stage for the figures, bounded by a thick diagonal rock incline that defines a horizontal ledge in the foreground. Though narrow, the ledge provides firm visual support for the figures, and the steep slope indicates the picture's dramatic focal point at the lower left. The rocky setting, which recalls that of a 12th-century Byzantine mural (FIG. 12-27), also links this scene with the adjoining one. Giotto connected the framed scenes throughout the fresco cycle with such formal elements. The figures are sculpturesque, simple, and weighty, but this mass did not preclude motion and emotion. Postures and gestures that might have been only rhetorical and mechanical convey, in Lamentation, a broad spectrum of grief. They range from Mary's almost fierce despair to the passionate outbursts of Mary Magdalene and John to the philosophical resignation of the two disciples at the right and the mute sorrow of the two hooded mourners in the foreground. Giotto constructed a kind of stage that served as a model for artists who depicted human dramas in many subsequent paintings. His style broke sharply from the isolated episodes and figures seen in art until the late 13th century. In Lamentation, a single event provokes an intense response. Painters before Giotto rarely attempted, let alone achieved, this combination of compositional complexity and emotional resonance.

The formal design of the *Lamentation* fresco—the way the figures are grouped within the constructed space—is worth close study. Each group has its own definition, and each contributes to the

rhythmic order of the composition. The strong diagonal of the rocky ledge, with its single dead tree (the tree of knowledge of good and evil, which withered at the fall of Adam), concentrates the viewer's attention on the group around the head of Christ, whose positioning is dynamically off center. The massive bulk of the seated mourner in the painting's left corner arrests and contains all movement beyond this group. The seated mourner to the right establishes a relation with the center figures, who, by gazes and gestures, draw the viewer's attention back to Christ's head. Figures seen from the back, which are frequent in Giotto's compositions, represent an innovation in the development away from the formal Italo-Byzantine style. These figures emphasize the foreground, aiding the visual placement of the intermediate figures farther back in space. This device, the very contradiction of the old frontality, in effect puts viewers behind the "observer figures," who, facing the action as spectators, reinforce the sense of stagecraft as a model for painting.

Giotto's new devices for depicting spatial depth and body mass could not, of course, have been possible without his management of light and shade. He shaded his figures to indicate both the direction of the light that illuminates them and the shadows (the diminished light), giving the figures volume. In *Lamentation*, light falls upon the upper surfaces of the figures (especially the two central bending figures) and passes down to dark in their draperies, separating the volumes one from the other and pushing one to the fore, the other to the rear. The graded continuum of light and shade, directed by an even, neutral light from a single steady source—not shown in the picture—was the first step toward the development of *chiaroscuro* (the use of contrasts of dark and light to produce modeling) in later Renaissance painting.

The stagelike settings made possible by Giotto's innovations in perspective (the depiction of three-dimensional objects in space on a two-dimensional surface) and lighting suited perfectly the dramatic narrative the Franciscans emphasized then as a principal method for educating the faithful in their religion. In the age of humanism, the old stylized presentations of the holy mysteries had evolved into what were called mystery plays. The drama of the Mass was extended into one- and two-act tableaus and scenes and then into simple narratives offered at church portals and in city squares. (Eventually, confraternities also presented more elaborate religious dramas called sacre rappresentazioni—holy representations.) The great increase in popular sermons addressed to huge city audiences prompted a public taste for narrative, recited as dramatically as possible. The arts of illusionistic painting, of drama, and of sermon rhetoric with all their theatrical flourishes developed simultaneously and were mutually influential. Giotto's art masterfully synthesized dramatic narrative, holy lesson, and truth to human experience in a visual idiom of his own invention, accessible to all. Not surprisingly, Giotto's frescoes served as textbooks for generations of Renaissance painters.

Siena

Among 14th-century Italian city-states, the Republics of Siena and Florence were the most powerful. Both Siena and Florence (the major cities of these two republics) were urban centers of bankers and merchants with widespread international contacts and large sums available for the commissioning of artworks (see "Artists' Guilds, Commissions, and Contracts," page 506).

DUCCIO The works of Duccio di Buoninsegna (active ca. 1278–1318) represent Sienese art in its supreme achievement. His most famous painting, the immense altarpiece called the *Maestà*

Artists' Guilds, Commissions, and Contracts

The structured organization of economic activity during the 14th century, when Italy had established a thriving international trade and held a commanding position in the Mediterranean world, extended to many trades and professions. *Guilds* (associations of master craftspeople, apprentices, and tradespeople), which had emerged during the 12th century, became prominent. These associations not only protected members' common economic interests against external pressures, such as taxation, but also provided them with the means to regulate their internal operations (for example, work quality and membership training).

Because of today's international open art market, the notion of an "artists' union" may seem strange. The general public tends to see art as the creative expression of an individual artist. However, artists did not always enjoy this degree of freedom. Historically, artists rarely undertook major artworks without a patron's concrete commission. The patron could be a civic group, religious entity, private individual, or even the artists' guild itself. Guilds, although primarily economic commercial organizations, contributed to their city's religious and artistic life by subsidizing the building and decoration of numerous churches and hospitals. For example, the Arte della Lana (wool manufacturers' guild) oversaw the start of Florence Cathedral (FIGS. 19-18 and 19-19) in 1296, and the Arte di Calimala (wool merchants' guild) supervised the completion of its dome.

Monastic orders, confraternities, and the popes were also major art patrons. In addition, wealthy families and individuals commissioned artworks for a variety of reasons. Besides the aesthetic pleasure these patrons derived from art, the images often served as testaments to the patron's wealth, status, power, and knowledge. Because artworks during this period were the product of what was, in effect, a service contract, a patron's needs or wishes played a crucial role in the final form of any painting, sculpture, or building. Some contracts between patrons and artists are preserved in European municipal and church archives. The patrons normally asked artists to submit drawings or models for approval, and they expected the artists they hired to adhere to the approved designs fairly closely. These contracts usually stipulated certain conditions, such as the insistence on the artist's own hand in the production of the work, the quality of pigment and amount of gold or other precious items to be used, completion date, payment terms, and penalties for failure to meet the contract's terms.

A few extant 13th- and 14th-century painting contracts are especially illuminating. Although they may specify the subject to be represented, the focus of these binding legal documents is always the financial aspects of the commission and the responsibilities of the painter to the patron (and vice versa). In a contract dated November 1, 1301, between Cimabue and another artist and the Hospital of Santa Chiara in Pisa, the artists agree to supply an altarpiece

with colonnettes, tabernacles, and predella, painted with histories of the divine majesty of the Blessed Virgin Mary, of the apostles, of the angels, and with other figures and pictures, as shall be seen fit and shall please the said master of or other legitimate persons for the hospital.*

Other contract terms specify the size of the panel and require that gold and silver gilding be used for parts of the altarpiece.

The contract for the construction of an altarpiece was usually a separate document, for that required the services of a master carpenter. For example, Duccio's April 15, 1285, contract with the rectors of the Confraternity of the Laudesi, the lay group associated with the Dominican church of Santa Maria Novella (FIG. 19-6) in Florence, specifies only that he is to provide the painting, not its frame—and it imposes conditions that he must meet if he is to be paid.

[The rectors] promise . . . to pay the same Duccio . . . as the payment and price of the painting of the said panel that is to be painted and done by him in the way described below . . . 150 lire of the small florins. . . . [Duccio, in turn, promises] to paint and embellish the panel with the image of the blessed Virgin Mary and of her omnipotent Son and other figures, according to the wishes and pleasure of the lessors, and to gild [the panel] and do everything that will enhance the beauty of the panel, his being all the expenses and the costs. . . . If the said panel is not beautifully painted and it is not embellished according to the wishes and desires of the same lessors, they are in no way bound to pay him the price or any part of it. †

Sometimes patrons furnished the materials and paid artists by the day instead of a fixed amount. That was the arrangement Duccio made on October 9, 1308, when he agreed to paint the *Maestà* (FIG. 19-10) for the high altar of Siena Cathedral.

Duccio has promised to paint and make the said panel as well as he can and knows how, and he further agreed not to accept or receive any other work until the said panel is done and completed. . . . [The church officials promise] to pay the said Duccio sixteen solidi of the Sienese denari as his salary for the said work and labor for each day that the said Duccio works with his own hands on the said panel . . . [and] to provide and give everything that will be necessary for working on the said panel so that the said Duccio need contribute nothing to the work save his person and his effort. ‡

In all cases, the artists worked for their patrons and could count on being compensated for their talents and efforts only if the work they delivered met the standards of those who ordered it.

^{*} Translated by John White, *Duccio: Tuscan Art and the Medieval Workshop* (London: Thames & Hudson, 1979), 34.

[†] Translated by James H. Stubblebine, *Duccio di Buoninsegna and His School* (Princeton, N.J.: Princeton University Press, 1979), 1: 192.

[‡] Stubblebine, Duccio, 1: 201.

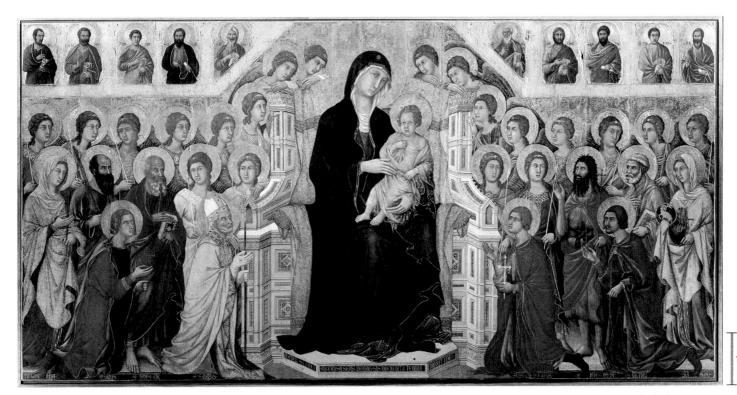

19-10 Duccio di Buoninsegna, Virgin and Child Enthroned with Saints, principal panel of the Maestà altarpiece, from Siena Cathedral, Siena, Italy, 1308–1311. Tempera and gold leaf on wood, $7' \times 13'$ (center panel). Museo dell'Opera del Duomo, Siena.

Duccio derived the formality and symmetry of his composition from Byzantine tradition, but relaxed the rigidity and frontality of the figures, softened the drapery, and individualized the faces.

(Virgin Enthroned in Majesty; FIG. 19-10), replaced a much smaller painting of the Virgin Mary on the high altar of Siena Cathedral. The Sienese believed the Virgin had brought them their victory over the Florentines at the battle of Monteperti in 1260, and she was the focus of the religious life of the republic. Duccio and his assistants began work on the prestigious commission in 1308 and completed the Maestà in 1311. As originally executed, it consisted of a seven-foothigh central panel (FIG. 19-10), surmounted by seven pinnacles above, and a predella, or raised shelf, of panels at the base, altogether some 13 feet high. Painted in tempera front and back, the work unfortunately is no longer viewable in its entirety because of its dismantling in subsequent centuries. Many of Duccio's panels are now scattered as single masterpieces among the world's museums.

The main panel of the front side represents the Virgin enthroned as Queen of Heaven amid choruses of angels and saints. Duccio derived the composition's formality and symmetry, along with the figures and facial types of the principal angels and saints, from Byzantine tradition. But the artist relaxed the strict frontality and rigidity of the figures. They turn to each other in quiet conversation. Further, Duccio individualized the faces of the four saints kneeling in the foreground, who perform their ceremonial gestures without stiffness. Similarly, he softened the usual Byzantine hard body outlines and drapery patterning. The drapery, particularly that of the female saints at both ends of the panel, falls and curves loosely. This is a feature familiar in northern Gothic works (FIG. 18-37) and is a mark of the artistic dialogue between Italy and the north in the 14th century.

Despite these changes that reveal Duccio's interest in the new naturalism, he respected the age-old requirement that as an altarpiece, the *Maestà* would be the focus of worship in Siena's largest

and most important church, its *cathedral*, the seat of the bishop of Siena. As such, Duccio knew the *Maestà* should be an object holy in itself—a work of splendor to the eyes, precious in its message and its materials. Duccio thus recognized that he could not be too radical—that the function of this work naturally limited experimentation with depicting narrative action and producing illusionistic effects (such as Giotto's) by modeling forms and adjusting their placement in pictorial space.

Instead, the Queen of Heaven panel is a miracle of color composition and texture manipulation, unfortunately not apparent in a photograph. Close inspection of the original reveals what the Sienese artist learned from other sources. In the 13th and 14th centuries, Italy was the distribution center for the great silk trade from China and the Middle East (see "Silk and the Silk Road," Chapter 7, page 188). After processing the silk in city-states such as Lucca and Florence, the Italians exported the precious fabric throughout Europe to satisfy an immense market for sumptuous dress. (Dante, Petrarch, and many of the humanists decried the appetite for luxury in costume, which to them represented a decline in civic and moral virtue.) People throughout Europe (Duccio and other artists among them) prized fabrics from China, Persia, Byzantium, and the Islamic realms. In the Maestà panel, Duccio created the glistening and shimmering effects of textiles, adapting the motifs and design patterns of exotic materials. Complementing the luxurious fabrics and the (lost) gilded wood frame are the gold haloes of the holy figures, which feature tooled decorative designs in gold leaf (punchwork). But Duccio, like Giotto (FIG. 19-8), eliminated almost all the gold patterning of the figures' garments in favor of creating three-dimensional volume. Traces remain only in the Virgin's red dress.

19-11 DUCCIO DI BUONINSEGNA, Betrayal of Jesus, detail from the back of the Maestà altarpiece, from Siena Cathedral, Siena, Italy, 1309–1311. Tempera and gold leaf on wood, detail $1' 10\frac{1}{2}'' \times 3' 4''$. Museo dell'Opera del Duomo, Siena.

On the back of the *Maestà*, Duccio painted a religious drama in which the actors display a variety of individual emotions. Duccio here took a decisive step toward the humanization of religious subject matter.

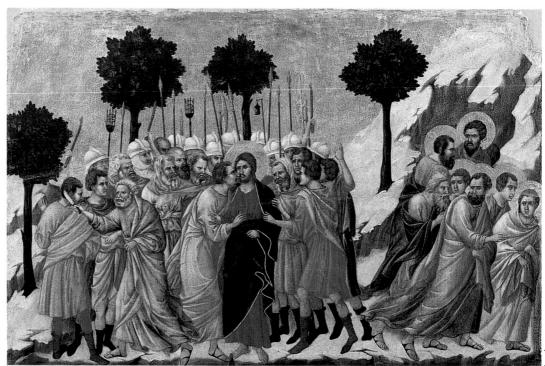

T_{1 in}

On the front panel of the Maestà, Duccio showed himself as the great master of the formal altarpiece. However, he allowed himself greater latitude for experimentation in the small accompanying panels, front and back. (Both sides of the altarpiece were always on view because the high altar stood at the very center of the sanctuary.) These images reveal Duccio's powers as a narrative painter. In the numerous panels on the back, he illustrated the later life of Christ—his ministry (on the predella), his Passion (on the main panel), and his Resurrection and appearances to the disciples (on the pinnacles). On one of the small panels, Betrayal of Jesus (FIG. 19-11), the artist represented several episodes of the event—the betrayal of Jesus by Judas's false kiss, the disciples fleeing in terror, and Peter cutting off the ear of the high priest's servant. Although the background, with its golden sky and rock formations, remains traditional, the style of the figures before it has changed quite radically. The bodies are not the flat frontal shapes of Italo-Byzantine art. Duccio imbued them with mass, modeled them with a range from light to dark, and arranged their draperies around them convincingly. Even more novel and striking is the way the figures seem to react to the central event. Through posture, gesture, and even facial expression, they display a variety of emotions. Duccio carefully differentiated among the anger of Peter, the malice of Judas (echoed in the faces of the throng about Jesus), and the apprehension and timidity of the fleeing disciples. These figures are actors in a religious drama that the artist interpreted in terms of thoroughly human actions and reactions. In this and similar narrative panels, Duccio took a decisive step toward the humanization of religious subject matter.

ORVIETO CATHEDRAL While Duccio was working on the *Maestà* for Siena Cathedral, a Sienese architect, LORENZO MAITANI, was called to Orvieto to design that city's cathedral (FIG. 19-12). The Orvieto *facade* imitates some elements of the French Gothic

19-12 LORENZO MAITANI, west facade of Orvieto Cathedral, Orvieto, Italy, begun 1310.

The pointed gables over the doorways, the rose window, and the large pinnacles derive from French architecture, but the facade of Orvieto Cathedral is merely a Gothic overlay masking a timber-roofed basilica.

architectural vocabulary (see Chapter 18), especially the pointed gables over the three doorways, the *rose window* and statues in niches in the upper zone, and the four large *pinnacles* that divide the facade into three bays. The outer pinnacles serve as miniature substitutes for the large northern European west-front towers. Maitani's facade, however, is merely a Gothic overlay masking a marble-revetted basil-

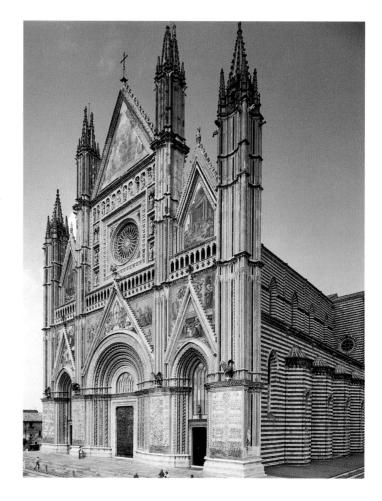

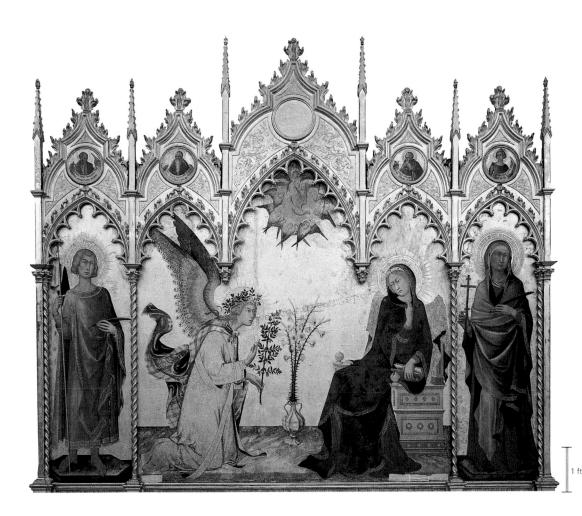

19-13 Simone Martini and Lippo Memmi(?), Annunciation altarpiece, from Siena Cathedral, Siena, Italy, 1333 (frame reconstructed in the 19th century). Tempera and gold leaf on wood, center panel $10' 1'' \times 8' 8\frac{3}{4}''$. Galleria degli Uffizi, Florence.

A pupil of Duccio, Martini was instrumental in the creation of the International Style. Its hallmarks are elegant shapes, radiant color, flowing line, and weightless figures in golden, spaceless settings.

ican structure in the Tuscan Romanesque tradition, as the three-quarter view of the cathedral in Fig. 19-12 reveals. Few Italian architects fully accepted the northern Gothic style. Some architectural historians even have questioned whether it is proper to speak of late medieval Italian buildings as Gothic structures. The Orvieto facade resembles a great altar screen, its single plane covered with carefully placed carved and painted ornament. In principle, Orvieto belongs with Pisa Cathedral (Fig. 17-25) and other Italian buildings rather than with the French cathedrals at Amiens (Fig. 18-21) and Reims (Fig. 18-23). Inside, Orvieto Cathedral has a timber-roofed nave with a two-story elevation (columnar *arcade* and *clerestory*) in the Early Christian manner. Both the *chancel arch* framing the semicircular *apse* and the nave arcade's arches are round as opposed to pointed.

SIMONE MARTINI Duccio's successors in the Sienese school also produced innovative works. Simone Martini (ca. 1285–1344) was a pupil of Duccio and may have assisted him in painting the Maestà. Martini was a close friend of Petrarch, and the poet praised him highly for his portrait of "Laura" (the woman to whom Petrarch dedicated his sonnets). Martini worked for the French kings in Naples and Sicily and, in his last years, produced paintings for the papal court at Avignon, where he came in contact with Northern European painters. By adapting the insubstantial but luxuriant patterns of the French Gothic manner to Sienese art and, in turn, by acquainting painters north of the Alps with the Sienese style, Martini was instrumental in creating the so-called International Style. This new style swept Europe during the late 14th and early 15th centuries because it appealed to the aristocratic taste for brilliant colors, lavish costumes, intricate ornamentation, and themes involving splendid processions.

Martini's Annunciation altarpiece (FIG. 19-13) features elegant shapes and radiant color, fluttering line, and weightless figures in a spaceless setting—all hallmarks of the artist's style. The complex etiquette of the European chivalric courts probably dictated the presentation. The angel Gabriel has just alighted, the breeze of his passage lifting his mantle, his iridescent wings still beating. The gold of his sumptuous gown is representative of the celestial realm from which he has descended to deliver his message. The Virgin, putting down her book of devotions, shrinks demurely from Gabriel's reverent genuflection, an appropriate gesture in the presence of royalty. She draws about her the deep blue, golden-hemmed mantle, the heraldic colors she wears as Queen of Heaven. Between the two figures is a vase of white lilies, symbolic of the Virgin's purity. Despite the Virgin's modesty and diffidence and the tremendous import of the angel's message, the scene subordinates drama to court ritual, and structural experimentation to surface splendor. The intricate *tracery* of the richly tooled (reconstructed) French Gothic-inspired frame and the elaborate punchwork halos, now a characteristic feature of Sienese panel painting, enhance the tactile magnificence of the Annunciation.

Simone Martini and his student and assistant, LIPPO MEMMI (active ca. 1317–1350), signed the altarpiece and dated it (1333). The latter's contribution to the *Annunciation* is still a matter of debate, but art historians now generally agree he painted the two lateral saints. These figures, which are reminiscent of the jamb statues of Gothic church portals, have greater solidity and lack the linear elegance of Martini's central pair. Given the nature of medieval and Renaissance workshop practices, it is often next to impossible to distinguish the master's hand from that of an assistant, especially if the master corrected or redid part of the latter's work (see "Artistic Training in Renaissance Italy," page 510).

Artistic Training in Renaissance Italy

n 14th- through 16th-century Italy, training to become a professional artist (earning membership in the appropriate guild) was a laborious and lengthy process. Because Italians perceived art as a trade, they expected artists to be trained as they would be in any other profession. Accordingly, aspiring artists started their training at an early age, anywhere from 7 to 15 years old. Their fathers would negotiate arrangements with specific master artists whereby each youth lived with a master for a specified number of years, usually five or six. During that time, they served as apprentices to the masters in the workshop, learning the trade. (This living arrangement served as a major obstacle for aspiring female artists, as it was considered inappropriate for young girls to live in a master's household.)

The skills apprentices learned varied with the type of studio they joined. Those apprenticed to painters learned to grind pigments, draw, prepare wood panels for painting, gild, and lay plaster for fresco. Sculptors in training learned to manipulate different materials (for example, wood, stone, *terracotta* [baked clay], wax, bronze, or stucco), although many sculpture workshops specialized in only one or two of these materials. For stone carving, apprentices learned their craft by blocking out the master's designs for statues.

The guilds supervised this rigorous training. They wanted not only to ensure their professional reputations by admitting only the most talented members but also to control the number of artists (to limit undue competition). Toward this end they frequently tried to regulate the number of apprentices working under a single master. Surely, the quality of the apprentices a master trained reflected the master's competence. When encouraging a prospective apprentice to join his studio, the Paduan painter Francesco Squarcione (1397–1468) boasted he could teach "the true art of perspective and everything necessary to the art of painting. . . . I made a man of Andrea Mantegna [see Chapter 21] who stayed with me and I will also do the same to you."*

As their skills developed, apprentices took on increasingly difficult tasks. After completing their apprenticeships, artists entered the appropriate guilds. For example, painters, who ground pigments, joined the guild of apothecaries; sculptors were members of the guild of stoneworkers; and goldsmiths entered the silk guild, because gold often was stretched into threads wound around silk for weaving. Such memberships served as certification of the artists' competence. Once "certified," artists often affiliated themselves with established workshops, as assistants to master artists. This was largely for practical reasons. New artists could not expect to receive many commissions, and the cost of establishing their own workshops was high. In any case, this arrangement was not permanent, and workshops were not necessarily static enterprises. Although well-established and respected studios existed, workshops could be organized around individual masters (with no set studio locations) or organized for a specific project, especially an extensive decoration program.

Generally, assistants were responsible for gilding frames and backgrounds, completing decorative work, and, occasionally, rendering architectural settings. Artists regarded figures, especially those central to the represented subject, as the most important and difficult parts of a painting, and the master therefore reserved these for himself. Sometimes assistants painted secondary or marginal figures, but only under the master's close supervision.

Eventually, of course, artists hoped to attract patrons and establish themselves as masters. Artists, who were largely anonymous during the medieval period, began to enjoy greater emancipation during the 15th and 16th centuries, when they rose in rank from artisan to artist-scientist. The value of their individual skills—and their reputations—became increasingly important to their patrons and clients.

* Quoted in Giuseppe Fiocco, Mantegna: La cappella Ovetari nella chiesa degli Eremitani (Milan: A. Pizzi, 1974), 7.

PIETRO LORENZETTI One of Duccio's students, PIETRO LORENZETTI (active 1320–1348), contributed significantly to the general experiments in pictorial realism that characterized the 14th century. Going well beyond his master, Lorenzetti achieved a remarkable degree of spatial illusionism in his large triptych (three-part panel painting) Birth of the Virgin (FIG. 19-14), created for the altar of Saint Savinus in Siena Cathedral. Lorenzetti painted the wooden architectural members that divide the panel as though they extend back into the painted space. Viewers seem to look through the wooden frame (apparently added later) into a boxlike stage, where the event takes place. That one of the vertical members cuts across one of the figures, blocking part of it from view, strengthens the illusion. In subsequent centuries, artists exploited this use of architectural elements to enhance the pictorial illusion that the painted figures are acting out a drama just a few feet away. This kind of pictorial illusionism characterized ancient Roman mural painting (FIGS. 10-18 and 10-19, right), but had not been practiced in Italy for a thousand years.

Lorenzetti's setting for his holy subject also represented a marked step in the advance of worldly realism. Saint Anne—who, like Nicola Pisano's Virgin of the *Nativity* (FIG. 19-3), resembles a reclining figure on the lid of a Roman sarcophagus (FIG. 10-61)—props herself up

wearily as the midwives wash the child and the women bring gifts. She is the center of an episode that occurs in an upper-class Italian house of the period. A number of carefully observed domestic details and the scene at the left, where Joachim eagerly awaits the news of the delivery, place the event in an actual household, as if viewers had moved the panels of the walls back and peered inside. Lorenzetti joined structural innovation in illusionistic space with the new curiosity that led to careful inspection and recording of what lay directly before the artist's eye in the everyday world.

PALAZZO PUBBLICO Not all Sienese painting of the early 14th century was religious in character. One of the most important fresco cycles of the period (discussed next) was a civic commission for Siena's Palazzo Pubblico ("public palace" or city hall). Siena was a proud commercial and political rival of Florence. As the secular center of the community, the civic meeting hall in the main square (the Campo, or Field; FIG. 19-15) was almost as great an object of civic pride as the city's cathedral. The Palazzo Pubblico has a slightly concave facade (to conform to the irregular shape of the Campo) and a gigantic tower visible from miles around. The imposing building and tower must have earned the admiration of Siena's citizens as well as of

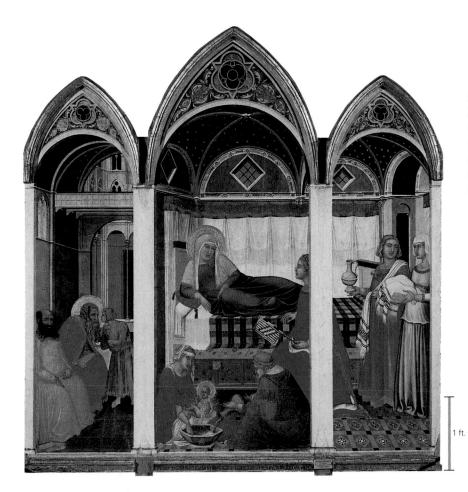

19-14 PIETRO LORENZETTI, *Birth of the Virgin*, from the altar of Saint Savinus, Siena Cathedral, Siena, Italy, 1342. Tempera on wood, $6'\ 1'' \times 5'\ 11''$. Museo dell'Opera del Duomo, Siena.

In this triptych, Pietro Lorenzetti revived the pictorial illusionism of ancient Roman murals and painted the architectural members that divide the panel as though they extend back into the painted space.

19-15 Aerial view of the Campo with the Palazzo Pubblico, Siena, Italy, 1288–1309.

Siena's Palazzo Pubblico has a slightly concave facade and a gigantic tower visible from miles around. The tower served both as a defensive lookout over the countryside and a symbol of the city-state's power.

visitors to the city, inspiring in them respect for the republic's power and success. The tower served as lookout over the city and the countryside around it and as a bell tower (*campanile*) for ringing signals of all sorts to the populace. Siena, like other Italian city-states, had to defend itself against neighboring cities and often against kings and emperors. In addition, it had to be secure against the internal upheavals

common in the history of the Italian city-republics. Class struggle, feuds between rich and powerful families, and even uprisings of the whole populace against the city governors were constant threats. The heavy walls and *battlements* (fortified *parapets*) of the Italian town hall eloquently express how frequently the city governors needed to defend themselves against their own citizens. The Sienese tower, out

19-16 Ambrogio Lorenzetti, Peaceful City, detail from Effects of Good Government in the City and in the Country, Sala della Pace, Palazzo Pubblico, Siena, Italy, 1338–1339. Fresco.

In the Hall of Peace of Siena's city hall, Ambrogio Lorenzetti painted an illusionistic panorama of the bustling city. The fresco served as an allegory of good government in the Sienese republic.

of reach of most missiles, includes *machicolated galleries* (galleries with holes in their floors to allow the dumping of stones or hot liquids on enemies below) built out on *corbels* (projecting supporting architectural members) for defense of the tower's base.

AMBROGIO LORENZETTI The painter entrusted with the vast fresco program in Siena's Palazzo Pubblico was Pietro Lorenzetti's brother, Ambrogio Lorenzetti (active 1319–1348), who both elabo-

rated Pietro's advances in illusionistic representation in spectacular fashion and gave visual form to Sienese civic concerns. Ambrogio produced three frescoes for the walls of the Sala della Pace (Hall of Peace) in the Palazzo Pubblico: Allegory of Good Government, Bad Government and the Effects of Bad Government in the City, and Effects of Good Government in the City and in the Country. The turbulent politics of the Italian cities—the violent party struggles, the overthrow and reinstatement of governments—certainly would have called for solemn

19-17 Ambrogio Lorenzetti, Peaceful Country, detail from Effects of Good Government in the City and in the Country, Sala della Pace, Palazzo Pubblico, Siena, Italy, 1338–1339. Fresco.

This sweeping view of the Sienese countryside is one of the first appearances of landscape in Western art since antiquity. An allegorical figure of winged Security promises safety to all who live under the rule of law.

reminders of fair and just administration. And the city hall was just the place for paintings such as Ambrogio Lorenzetti's. Indeed, the leaders of the Sienese government who commissioned this fresco series had undertaken the "ordering and reformation of the whole city and countryside of Siena."

In Effects of Good Government in the City and in the Country, the artist depicted the urban and rural effects of good government. Peaceful City (FIG. 19-16) is a panoramic view of Siena, with its clustering palaces, markets, towers, churches, streets, and walls, reminiscent of the townscapes of ancient Roman murals (FIG. 10-19, left). The city's traffic moves peacefully, guild members ply their trades and crafts, and several radiant maidens, hand in hand, perform a graceful circling dance. Dancers were regular features of festive springtime rituals. Here, their presence also serves as a metaphor for a peaceful commonwealth. The artist fondly observed the life of his city, and its architecture gave him an opportunity to apply Sienese artists' rapidly growing knowledge of perspective.

As an entourage passes through the city gate to the countryside beyond its walls, Ambrogio Lorenzetti's *Peaceful Country* (FIG. 19-17) presents a bird's-eye view of the undulating Tuscan countryside—its villas, castles, plowed farmlands, and peasants going about their seasonal occupations. An allegorical figure of Security hovers above the landscape, unfurling a scroll that promises safety to all who live under the rule of law. In this sweeping view of an actual countryside, *Peaceful Country* represents one of the first appearances of *landscape* in Western art since antiquity (FIG. 10-20). Whereas earlier depictions were fairly generic, Lorenzetti particularized the landscape—as well as the city view—by careful observation and endowed the painting with the character of a specific place and environment.

The Black Death may have ended the careers of both Lorenzettis. They disappear from historical records in 1348, the year that brought so much horror to defenseless Europe.

Florence

Like Siena, the Republic of Florence was a dominant city-state during the 14th century. The historian Giovanni Villani (ca. 1270–1348), for example, described Florence as "the daughter and the creature of Rome," suggesting a preeminence inherited from the Roman Empire. Florentines were fiercely proud of what they perceived as their economic and cultural superiority. Florence controlled the textile industry in Italy, and the republic's gold *florin* was the standard coin of exchange everywhere in Europe.

FLORENCE CATHEDRAL Florentines translated their pride in their predominance into landmark buildings, such as Florence Cathedral (FIG. 19-18), recognized as the center for the most important religious observances in the city. Arnolfo di Cambio (ca. 1245–1302) began work on the cathedral in 1296. Intended as the "most beautiful and honorable church in Tuscany," this structure reveals the competitiveness Florentines felt with cities such as Siena and Pisa. Cathedral authorities planned for the church to hold the city's entire population, and although it holds only about 30,000 (Florence's population at the time was slightly less than 100,000), it seemed so large that even the noted architect Leon Battista Alberti (see Chapter 21) commented that it seemed to cover "all of Tuscany with its shade." The builders ornamented the church's surfaces, in the old Tuscan fashion, with marble-encrusted geometric designs, matching the cathedral's revetment (decorative wall paneling) to that

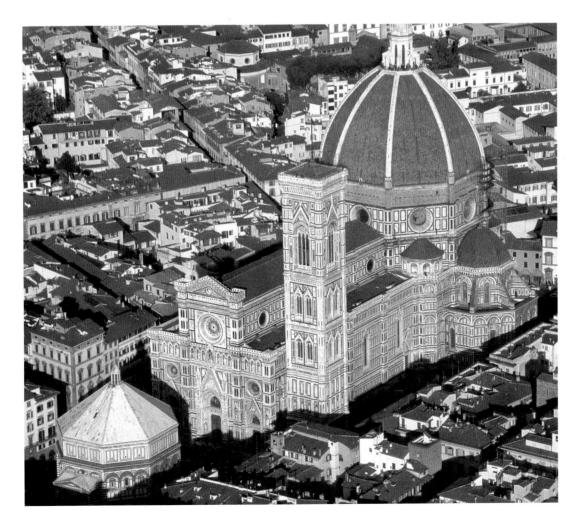

19-18 Arnolfo di Cambio and others, Florence Cathedral (aerial view looking northeast), Florence, Italy, begun 1296.

This basilican church with its marble-encrusted walls carries on the Tuscan Romanesque architectural tradition, linking Florence Cathedral more closely to Early Christian Italy than to contemporaneous France.

19-19 Arnolfo di Cambio and others, interior of Florence Cathedral (looking east), Florence, Italy, begun 1296.

Designed to hold 30,000 worshipers, Florence Cathedral has fewer but wider and deeper nave and aisle bays than do northern Gothic cathedrals. The result is an interior of unmatched spaciousness.

of the neighboring 11th-century Romanesque baptistery of San Giovanni (FIGS. 17-26 and 19-18, *bottom left*).

The vast gulf that separates Florence Cathedral from its northern European counterparts becomes evident in a comparison between the Italian church and a full-blown German representative of the High Gothic style, such as Cologne Cathedral (FIG. 18-45). Cologne Cathedral's emphatic stress on the vertical produces an awe-inspiring upward rush of almost unmatched vigor and intensity. The building has the character of an organic growth shooting heavenward, its toothed upper portions engaging the sky. The pierced, translucent stone tracery of the spires merges with the atmosphere. Florence Cathedral, in contrast, clings to the ground and has no aspirations toward flight. All emphasis is on the horizontal elements of the design, and the building rests firmly and massively earthbound. The clearly defined simple geometric volumes of the cathedral show no tendency to merge either into each other or into the sky.

Giotto di Bondone designed the cathedral's campanile in 1334. In keeping with Italian tradition (FIGS. 17-20 and 17-25), it stands apart from the church. In fact, it is essentially self-sufficient and could stand anywhere else in Florence without looking out of place. The same hardly can be said of the Cologne towers. They are essential elements of the building behind them, and it would be unthinkable to detach one of them and place it elsewhere. No individual element in the Cologne grouping seems capable of an independent existence. One form merges into the next in a series of rising movements that pull the

eye ever-upward and never permit it to rest until it reaches the sky. The Italian tower is entirely different. Neatly subdivided into cubic sections, Giotto's tower is the sum of its component parts. Not only could this tower be removed from the building without adverse effects, but also each of the parts—cleanly separated from each other by continuous moldings—seems capable of existing independently as an object of considerable aesthetic appeal. This compartmentalization is reminiscent of the Romanesque style, but it also forecasts the ideals of Renaissance architecture. Artists hoped to express structure in the clear, logical relationships of the component parts and to produce self-sufficient works that could exist in complete independence. Compared with Cologne's towers, Giotto's campanile has a cool and rational quality that appeals more to the intellect than to the emotions.

In Florence Cathedral's plan, the nave (FIG. 19-19) appears to have been added to the *crossing* complex almost as an afterthought. In fact, the nave was the first section to be built, mostly according to Arnolfo di Cambio's original plans (except for the vaulting). Midway through the 14th century, the Florentines redesigned the crossing to increase the cathedral's interior space. In its present form, the area beneath the *dome* is the design's focal point, and the nave leads to it. To visitors from north of the Alps, the nave may have seemed as strange as the plan. Neither has a northern European counterpart. The Florence nave *bays* are twice as deep as those of Amiens (FIG. 18-19), and the wide arcades permit the shallow aisles to become part of the central nave. The result is an interior of unmatched spaciousness. The accent here, as it is on the exterior, is on the horizontal elements. The substantial capitals of the *piers* prevent them from soaring into the vaults and emphasize their function as supports.

The facade of Florence Cathedral was not completed until the 19th century and then in a form much altered from its original design. In fact, until the 17th century, Italian builders exhibited little concern for the facades of their churches, and dozens remain unfinished to this day. One reason for this may be that Italian architects did not conceive the facades as integral parts of the structures but, as in the case of Orvieto Cathedral (FIG. 19-12), as screens that could be added to the church exterior at any time.

Pisa, Venice, and Milan

Italy's port cities—Genoa, Pisa, and Venice—controlled the ever busier and more extended avenues of maritime commerce that connected the West with the lands of Islam, with Byzantium and Russia, and overland with China. As a port city, Pisa established itself as a major shipping power and thus as a dominant Italian city-state. Yet Pisa was not immune from the disruption that the Black Death wreaked across all of Italy and Europe in the late 1340s. Concern with death was a significant theme in art even before the onset of the plague and became more prominent in the years after midcentury.

CAMPOSANTO, PISA Triumph of Death (FIG. 19-20) is a tour de force of death imagery. The creator of this large-scale (over 18 × 49 feet) fresco remains disputed. Some attribute the work to Francesco Traini (active ca. 1321–1363), while others argue for Buonamico Buffalmacco (active 1320–1336). Painted on the wall of the Camposanto (Holy Field), the enclosed burial ground adjacent to Pisa's cathedral (FIG. 17-25), the fresco captures the horrors of death and forces viewers to confront their mortality. In the left foreground (FIG. 19-20, left), young aristocrats, mounted in a stylish cavalcade, encounter three coffin-encased corpses in differing stages of decomposition. As the horror of the confrontation with death strikes them, the ladies turn away with delicate disgust, while a gentleman holds his nose (the animals, horses and dogs, sniff excitedly). At the far left, the hermit Saint Macarius unrolls a scroll bearing an inscription commenting on

19-20 Francesco Traini or Buonamico Buffalmacco, two details of $\it Triumph$ of $\it Death$, 1330s. Full fresco, 18' $\it 6'' \times 49'$ 2". Camposanto, Pisa.

Befitting its location on a wall in Pisa's Camposanto, the enclosed burial ground adjacent to the city's cathedral, this fresco captures the horrors of death and forces viewers to confront their mortality.

the folly of pleasure and the inevitability of death. On the far right (FIG. 19-20, *right*), ladies and gentlemen ignore dreadful realities, occupying themselves in an orange grove with music and amusements while all around them angels and demons struggle for the souls of the corpses heaped in the foreground.

In addition to these direct and straightforward scenes, the mural contains details that convey more subtle messages. For example, the painter depicted those who appear unprepared for death—and thus unlikely to achieve salvation—as wealthy and reveling in luxury. Given that the Dominicans—an order committed to a life of poverty—participated in the design for this fresco program, the imagery surely was a warning against greed and lust. Although *Triumph of Death* is a compilation of disparate scenes, the artist rendered each scene with natural-

ism and emotive power. It is an irony of history that as Western humanity drew both itself and the world into ever sharper visual focus, it perceived ever more clearly that corporeal things were perishable.

DOGE'S PALACE, VENICE One of the wealthiest cities of late medieval Italy—and of Europe—was Venice, renowned for its streets of water. Situated on a lagoon on the northeastern coast of Italy, Venice was secure from land attack and could rely on a powerful navy for protection against invasion from the sea. Internally, Venice was a tight corporation of ruling families who, for centuries, provided stable rule and fostered economic growth. The Venetian republic's seat of government was the Doge's (Duke's) Palace (FIG. 19-21). Begun around 1340–1345 and significantly remodeled

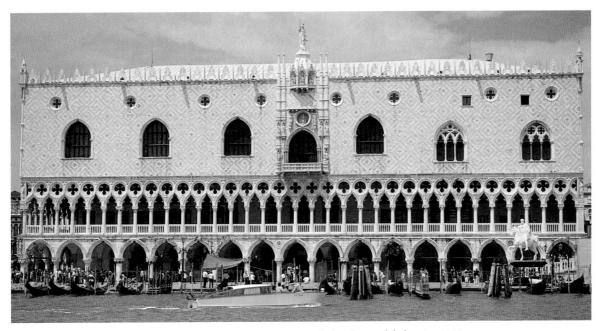

19-21 Doge's Palace, Venice, Italy, begun ca. 1340-1345; expanded and remodeled, 1424-1438.

The delicate patterning in cream- and rose-colored marbles, the pointed and ogee arches, and the quatrefoil medallions of the Doge's Palace constitute a distinctive Venetian variation of northern Gothic architecture.

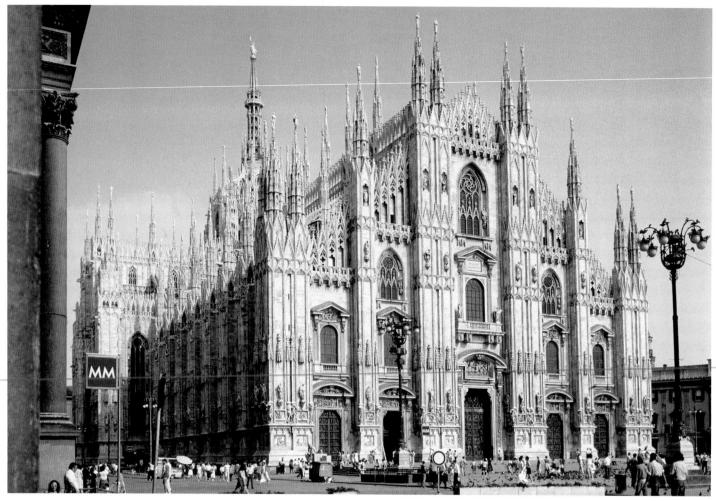

19-22 Milan Cathedral, Milan, Italy, begun 1386.

Milan Cathedral's elaborate facade is a confused mixture of Late Gothic pinnacles and tracery and Renaissance pediment-capped rectilinear portals. It marks the waning of the Gothic style.

after 1424, it was the most ornate public building in medieval Italy. In a stately march, the first level's short and heavy columns support rather severe pointed arches that look strong enough to carry the weight of the upper structure. Their rhythm doubles in the upper arcades, where slimmer columns carry ogee arches (made up of double-curving lines), which terminate in flamelike tips between medallions pierced with quatrefoils (cloverleaf-shaped). Each story is taller than the one beneath it, the topmost as high as the two lower arcades combined. Yet the building does not look top-heavy. This is due in part to the complete absence of articulation in the top story and in part to the walls' delicate patterning, in cream- and rose-colored marbles, which makes them appear paper-thin. The Doge's Palace represents a delightful and charming variant of Late Gothic architecture. Colorful, decorative, light and airy in appearance, the Venetian Gothic is ideally suited to Venice, which floats between water and air.

MILAN CATHEDRAL Since Romanesque times, northern European influences had been felt more strongly in Lombardy than in

the rest of Italy. When Milan's citizens decided to build their own cathedral (FIG. 19-22) in 1386, they invited experts from France, Germany, and England, as well as from Italy. These masters argued among themselves and with the city council, and no single architect ever played a dominant role. The result of this attempt at "architecture by committee" was, not surprisingly, a compromise. The building's proportions, particularly the nave's, became Italian (that is, wide in relation to height), and the surface decorations and details remained Gothic. Clearly derived from France are the cathedral's multitude of pinnacles and the elaborate tracery on the facade, flank, and transept. But long before the completion of the building, the new classical style of the Italian Renaissance had been well launched (see Chapter 21), and the Gothic design had become outdated. Thus, Milan Cathedral's elaborate facade represents a confused mixture of Late Gothic and Renaissance elements. With its pediment-capped rectilinear portals amid Gothic pinnacles, the cathedral stands as a symbol of the waning of the Gothic style and the advent of the Renaissance.

ITALY, 1200 TO 1400

THE 13TH CENTURY

- Diversity of style characterizes the art of 13th-century Italy, with some artists working in the newly revived classical tradition, some in the mode of Gothic France, and others in the *maniera greca*, or Italo-Byzantine style.
- Trained in southern Italy in the court style of Frederick II (r. 1197–1250), Nicola Pisano was a master sculptor who settled in Pisa and carved pulpits incorporating marble panels that, both stylistically and in individual motifs, depend on ancient Roman sarcophagi.
- Nicola's son, Giovanni Pisano, also was a sculptor of church pulpits, but his work more closely reflects the Gothic sculpture of France.
- The leading painters working in the Italo-Byzantine style were Bonaventura Berlinghieri and Cimabue. Both artists drew inspiration from Byzantine icons and illuminated manuscripts. Berlinghieri's Saint Francis Altarpiece is the earliest dated portrayal of Saint Francis of Assisi, who died in 1226.

Nicola Pisano, Pisa baptistery pulpit

Berlinghieri, Saint Francis Altarpiece, 1235

THE 14TH CENTURY

- During the 14th century, Italy suffered the most devastating natural disaster in European history—the Black Death that swept through Europe—but it was also the time when Renaissance humanism took root. Although religion continued to occupy a primary position in Italian life, scholars and artists became much more concerned with the natural world.
- Giotto di Bondone of Florence, widely regarded as the first Renaissance painter, was a pioneer in pursuing a naturalistic approach to representation based on observation, which was at the core of the classical tradition in art. The Renaissance marked the rebirth of classical values in art and society.

■ The 14th-century architecture of Italy underscores the regional character of late medieval art. Some architectural historians even have questioned whether it is proper to speak of Italian buildings of this period as Gothic structures. Orvieto Cathedral's facade, for example, imitates some elements of the French Gothic vocabulary, but it is merely an overlay masking a traditional timber-roofed structure with round arches in the nave arcade.

Giotto, Arena Chapel, Padua, ca. 1305

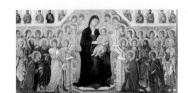

Duccio, *Maestà*, Siena Cathedral, 1308–1311

Orvieto Cathedral, begun 1310

NOTES

Introduction

- Quoted in George Heard Hamilton, Painting and Sculpture in Europe, 1880–1940, 6th ed. (New Haven, Conn.: Yale University Press, 1993), 345.
- Quoted in Josef Albers: Homage to the Square (New York: Museum of Modern Art, 1964), n.p.

Chapter 2

 Translated by Françoise Tallon, in Prudence O. Harper et al., The Royal City of Susa (New York: Metropolitan Museum of Art, 1992), 132.

Chapter 3

- 1. Herodotus, Histories, 2.35.
- The chronology adopted in this chapter is that of John Baines and Jaromír Malék, Atlas of Ancient Egypt (Oxford: Oxford University Press, 1980), 36–37. The division of kingdoms is that of, among others, Mark Lehner, The Complete Pyramids (New York: Thames & Hudson, 1997), 8–9, and David P. Silverman, ed., Ancient Egypt (New York: Oxford University Press, 1997), 20–39.

Chapter 4

1. Homer, Iliad, 2.466-649.

Chapter 5

- 1. Plutarch, Life of Pericles, 12.
- 2. Pliny, Natural History, 34.74.
- 3. Ibid., 36.20.
- 4. Lucian, Amores, 13-14; Imagines, 6.
- Plutarch, Moralia, 335A-B. Translated by J. J. Pollitt, The Art of Ancient Greece: Sources and Documents (New York: Cambridge University Press, 1990), 99.
- 6. Pliny, Natural History, 35.110.

Chapter 10

- 1. Livy, *History of Rome*, 25.40.1–3.
- Recorded by the Venerable Bede, the great English scholar, monk, and saint, who died in 735. Translated by Lord Byron in *Childe Harold's Pilgrimage* (1817), 4.145.
- 3. Juvenal, Satires, 3.225, 232.

Chapter 11

 Translated by Raymond Davis, The Book of Pontiffs (Liverpool: Liverpool University Press, 1989), 18–19.

Chapter 12

 Paulus Silentarius, Descriptio Sanctae Sophiae, 617–646. Translated by Cyril Mango, The Art of the Byzantine Empire, 312–1453: Sources and Documents (reprint of 1972 ed., Toronto: University of Toronto Press, 1986), 85–86.

- 2. Procopius, De aedificiis, 1.1.23ff. Translated by Mango, 74.
- 3. Paulus Silentarius, 489, 668. Translated by Mango, 83, 86.
- Translated by Colin Luibheid, Pseudo-Dionysius: The Complete Works (New York: Paulist, 1987), 68ff.
- 5. Procopius, 1.1.23ff. Translated by Mango, 75.
- Libri Carolini 4.2. Translated by Herbert L. Kessler, Spiritual Seeing: Picturing God's Invisibility in Medieval Art (Philadelphia: University of Pennsylvania Press, 2000), 119
- 7. Nina G. Garsoïan, "Later Byzantium," in John A. Garraty and Peter Gay, eds., The Columbia History of the World (New York: Harper & Row, 1972), 453.
- 8. Ibid., 460.

Chapter 16

- 1. *Beowulf*, 3162–3164, translated by Kevin Crossley-Holland (New York: Farrar, Straus & Giroux, 1968), 119.
- 2. Beowulf, 33.
- 3. Translated by Françoise Henry, The Book of Kells (New York: Knopf, 1974), 165.
- Translated by John W. Williams, in *The Art of Medieval Spain A.D. 500–1200* (New York: Metropolitan Museum of Art, 1993), 156.
- Translated by Adam S. Cohen, *The Uta Codex* (University Park: Pennsylvania State University Press, 2000), 11, 41.

Chapter 17

- 1. Translated by Charles P. Parkhurst Jr., in Elizabeth G. Holt, *A Documentary History of Art*, 2d ed. (Princeton, N.J.: Princeton University Press, 1981), 1: 18.
- 2. Translated by Giovanna De Appolonia, Boston University.
- Translated by Calvin B. Kendall, The Allegory of the Church: Romanesque Portals and Their Verse Inscriptions (Toronto: University of Toronto Press, 1998), 207.
- Translated by John Williams, A Spanish Apocalypse: The Morgan Beatus Manuscript (New York: Braziller, 1991), 223.
- Bernard of Clairvaux, Apologia 12.28. Translated by Conrad Rudolph, The "Things of Greater Importance": Bernard of Clairvaux's Apologia and the Medieval Attitude toward Art (Philadelphia: University of Pennsylvania Press, 1990), 281, 283.
- 6. Rule of Saint Benedict, 57.1. Translated by Timothy Fry, The Rule of St. Benedict (Collegeville, Minn.: Liturgical, 1981), 265.

Chapter 18

- Giorgio Vasari, Introduzione alle tre arti del disegno (1550), ch. 3. Translated by Paul Frankl, The Gothic: Literary Sources and Interpretation through Eight Centuries (Princeton, N.J.: Princeton University Press, 1960), 290–291, 859–860.
- 2. Dante, Divine Comedy, Purgatory, 11.81.
- Translated by Roland Behrendt, Johannes Trithemius, in Praise of Scribes: De laude scriptorum (Lawrence, Kans.: Coronado, 1974), 71.
- 4. Frankl, 55.

GLOSSARY

- à la grecque-French, "in Greek style."
- **abacus**—The uppermost portion of the *capital* of a *column*, usually a thin slab.
- abbess—See abbey.
- abbey—A religious community under the direction of an abbot (for monks) or an abbess (for nuns).
- abbot—See abbey.
- abhaya—See mudra.
- **abrasion**—The rubbing or grinding of stone or another material to produce a smooth finish.
- acropolis—Greek, "high city." In ancient Greece, usually the site of the city's most important temple(s).
- **additive light**—Natural light, or sunlight, the sum of all the wavelengths of the visible *spectrum*. See also *subtractive light*.
- **additive sculpture**—A kind of sculpture *technique* in which materials (for example, clay) are built up or "added" to create form.
- adobe—The clay used to make a kind of sundried mud brick of the same name; a building made of such brick.
- **agora**—An open square or space used for public meetings or business in ancient Greek cities.
- aisle—The portion of a basilica flanking the nave and separated from it by a row of columns or piers.
- **ala** (pl. **alae**)—A rectangular recess at the back of the *atrium* of a Roman house.
- **album leaf**—A painting on a single sheet of paper for a collection stored in an album.
- **altar frontal**—A decorative panel on the front of a church altar.
- **altarpiece**—A panel, painted or sculpted, situated above and behind an altar. See also *retable*.
- alternate-support system—In church architecture, the use of alternating wall supports in the *nave*, usually *piers* and *columns* or *compound piers* of alternating form.
- **amalaka**—In Hindu temple design, the large flat disk with ribbed edges surmounting the beehive-shaped tower.
- **Amazonomachy**—In Greek mythology, the battle between the Greeks and Amazons.

- ambo—A church *pulpit* for biblical readings.
- ambulatory—A covered walkway, outdoors (as in a church *cloister*) or indoors; especially the passageway around the *apse* and the *choir* of a church. In Buddhist architecture, the passageway leading around the *stupa* in a *chaitya hall*.
- **amphiprostyle**—A *classical* temple *plan* in which the *columns* are placed across both the front and back but not along the sides.
- amphitheater—Greek, "double theater." A Roman building type resembling two Greek theaters put together. The Roman amphitheater featured a continuous elliptical cavea around a central arena.
- amphora—An ancient Greek two-handled jar used for general storage purposes, usually to hold wine or oil.
- amulet—An object worn to ward off evil or to aid the wearer.
- **antae**—The molded projecting ends of the walls forming the *pronaos* or *opisthodomos* of an ancient Greek temple.
- **ante legem**—Latin, "before the law." In Christian thought, the period before Moses received the Ten Commandments. See also *sub lege*.
- **apadana**—The great audience hall in ancient Persian palaces.
- **apostle**—Greek, "messenger." One of the 12 disciples of Jesus.
- **apotheosis**—Elevated to the rank of gods, or the ascent to heaven.
- **apoxyomenos**—Greek, "athlete scraping oil from his body."
- apse—A recess, usually semicircular, in the wall of a building, commonly found at the east end of a church.
- apsidal—Rounded; apse-shaped.
- **arcade**—A series of *arches* supported by *piers* or *columns*.
- arch—A curved structural member that spans an opening and is generally composed of wedgeshaped blocks (voussoirs) that transmit the downward pressure laterally. See also thrust.
- **Archaic**—The artistic style of 600–480 BCE in Greece, characterized in part by the use of the

- composite view for painted and relief figures and of Egyptian stances for statues.
- Archaic smile—The smile that appears on all *Archaic* Greek statues from about 570 to 480 BCE. The smile is the Archaic sculptor's way of indicating that the person portrayed is alive.
- **architrave**—The *lintel* or lowest division of the *entablature*; also called the epistyle.
- archivolt—The continuous molding framing an arch. In Romanesque or Gothic architecture, one of the series of concentric bands framing the tympanum.
- arcuated—Arch-shaped.
- **arena**—In a Roman *amphitheater*, the central area where bloody *gladiatorial* combats and other boisterous events took place.
- armature—The crossed, or diagonal, arches that form the skeletal framework of a Gothic rib vault. In sculpture, the framework for a clay form
- **arriccio**—In *fresco* painting, the first layer of rough lime plaster applied to the wall.
- asceticism—Self-discipline and self-denial.
- **ashlar masonry**—Carefully cut and regularly shaped blocks of stone used in construction, fitted together without mortar.
- **atlantid**—A male figure that functions as a supporting *column*. See also *caryatid*.
- **atlatl**—Spear-thrower, the typical weapon of the Toltecs of ancient Mexico.
- atmospheric perspective—See perspective.
- atrium—The central reception room of a Roman house that is partly open to the sky. Also the open, colonnaded court in front of and attached to a Christian basilica.
- **attic**—The uppermost story of a building, *triumphal arch*, or city gate.
- attribute—(n.) The distinctive identifying aspect of a person, for example, an object held, an associated animal, or a mark on the body. (v.) To make an *attribution*.
- **attribution**—Assignment of a work to a maker or makers.
- **avatar**—A manifestation of a deity incarnated in some visible form in which the deity performs

a sacred function on earth. In Hinduism, an incarnation of a god.

axial plan—See plan.

backstrap loom—A simple Andean loom featuring a belt or backstrap encircling the waist of the seated weaver.

baldacchino—A canopy on *columns*, frequently built over an altar.

baptism—The Christian bathing ceremony in which an infant or a convert becomes a member of the Christian community.

baptistery—In Christian architecture, the building used for *baptism*, usually situated next to a church. Also, the designated area or hall within a church for baptismal rites.

bar tracery—See tracery.

baray—One of the large reservoirs laid out around Cambodian wats that served as means of transportation as well as irrigation. A network of canals connected the reservoirs.

barrel vault—See vault.

base—In ancient Greek architecture, the molded projecting lowest part of *Ionic* and *Corinthian* columns. (Doric columns do not have bases.)

basilica—In Roman architecture, a public building for legal and other civic proceedings, rectangular in plan with an entrance usually on a long side. In Christian architecture, a church somewhat resembling the Roman basilica, usually entered from one end and with an *apse* at the other.

bas-relief—See relief.

battlement—A low parapet at the top of a circuit wall in a fortification.

bay—The space between two columns, or one unit in the *nave arcade* of a church; also, the passageway in an *arcuated* gate.

beam—A horizontal structural member that carries the load of the superstructure of a building; a timber *lintel*.

ben-ben—A pyramidal stone; a fetish of the Egyptian god Re.

benedictional—A Christian religious book containing bishops' blessings.

bent-axis plan—A *plan* that incorporates two or more angular changes of direction, characteristic of Sumerian architecture.

bestiary—A collection of illustrations of real and imaginary animals.

bhumisparsha—See *mudra*.

bi—In ancient China, jade disks carved as ritual objects for burial with the dead. They were often decorated with piercings that extended entirely through the object, as well as with surface carvings.

bichrome—Two-color.

bilateral symmetry—Having the same forms on either side of a central axis.

bilingual vases—Experimental Greek vases produced for a short time in the late sixth century BCE; one side featured *black-figure* decoration, the other *red-figure*.

black-figure painting—In early Greek pottery, the silhouetting of dark figures against a light background of natural, reddish clay, with linear details *incised* through the silhouettes.

blind arcade—An *arcade* having no true openings, applied as decoration to a wall surface.

block statue— In ancient Egyptian sculpture, a cubic stone image with simplified body parts.

bodhisattva—In Buddhist thought, a potential Buddha who chooses not to achieve enlightenment in order to help save humanity.

Book of Hours—A Christian religious book for private devotion containing prayers to be read at specified times of the day.

boss—A circular knob.

breviary—A Christian religious book of selected daily prayers and psalms.

brocade—The weaving together of threads of different colors.

bucranium (pl. bucrania)—Latin, "bovine skull." A common motif in classical architectural ornament.

Buddha triad—A three-figure group with a central Buddha flanked on each side by a *bodhisattva*.

buon fresco—See fresco.

burin—A pointed tool used for engraving or incising.

buttress—An exterior masonry structure that opposes the lateral thrust of an arch or a vault. A pier buttress is a solid mass of masonry. A flying buttress consists typically of an inclined member carried on an arch or a series of arches and a solid buttress to which it transmits lateral thrust.

Byzantine—The art, territory, history, and culture of the Eastern Christian Empire and its capital of Constantinople (ancient Byzantium).

caduceus—In ancient Greek mythology, a magical rod entwined with serpents, the attribute of Hermes (Roman, Mercury), the messenger of the gods.

caldarium—The hot-bath section of a Roman bathing establishment.

caliph(s)—Islamic rulers, regarded as successors of Muhammad.

calligrapher—One who practices *calligraphy*.

calligraphy—Greek, "beautiful writing." Handwriting or penmanship, especially elegant writing as a decorative art.

came—A lead strip in a *stained-glass* window that joins separate pieces of colored glass.

campanile—A bell tower of a church, usually, but not always, freestanding.

canon—A rule, for example, of proportion. The ancient Greeks considered beauty to be a matter of "correct" proportion and sought a canon of proportion, for the human figure and for buildings. The fifth-century BCE sculptor Polykleitos wrote the *Canon*, a treatise incorporating his formula for the perfectly proportioned statue.

canon table—A concordance, or matching, of the corresponding passages of the four *Gospels* as compiled by Eusebius of Caesarea in the fourth century.

canopic jar—In ancient Egypt, the container in which the organs of the deceased were placed for later burial with the mummy.

capital—The uppermost member of a *column*, serving as a transition from the *shaft* to the *lintel*. In classical architecture, the form of the capital varies with the *order*.

Capitolium—An ancient Roman temple dedicated to the gods Jupiter, Juno, and Minerva.

cardo—The north-south street in a Roman town, intersecting the *decumanus* at right angles.

Caroline minuscule—The alphabet that *Carolingian* scribes perfected, from which the modern English alphabet was developed.

Carolingian (adj.)—Pertaining to the empire of Charlemagne (Latin, "Carolus Magnus") and his successors.

carpet page—In early medieval manuscripts, a decorative page resembling a textile.

cartoon—In painting, a full-size preliminary drawing from which a painting is made.

carving—A *technique* of sculpture in which the artist cuts away material (for example, from a stone block) in order to create a *statue* or a *relief*.

caryatid—A female figure that functions as a supporting *column*. See also *atlantid*.

castellum—See westwork.

casting—A sculptural *technique* in which the artist pours liquid metal, plaster, clay or another material into a *mold*. When the material dries, the sculptor removes the cast piece from the mold.

castrum—A Roman military encampment.

catacombs—Subterranean networks of rock-cut galleries and chambers designed as cemeteries for the burial of the dead.

cathedra—Latin, "seat." See cathedral.

cathedral—A bishop's church. The word derives from *cathedra*, referring to the bishop's chair.

cavea—Latin, "hollow place or cavity." The seating area in ancient Greek and Roman theaters and amphitheaters.

celadon—A Chinese-Korean pottery *glaze*, fired in an oxygen-deprived kiln to a characteristic gray-green or pale blue color.

cella—The chamber at the center of an ancient temple; in a classical temple, the room (Greek, *naos*) in which the *cult statue* usually stood.

celt—In Olmec Mexico, an ax-shaped form made of polished jade; generally, a prehistoric metal or stone implement shaped like a chisel or ax head.

centaur—In ancient Greek mythology, a creature with the front or top half of a human and the back or bottom half of a horse.

centauromachy—In ancient Greek mythology, the battle between the Greeks and *centaurs*.

central plan—See plan.

cestrum—A small spatula used in *encaustic* painting.

chacmool—A Mesoamerican statuary type depicting a fallen warrior on his back with a receptacle on his chest for sacrificial offerings.

chaitya hall—A South Asian rock-cut temple hall having a votive *stupa* at one end.

chakra—The Buddha's wheel, set in motion at Sarnath.

chakravartin—In South Asia, the ideal king, the Universal Lord who ruled through goodness.

chamfer—The surface formed by cutting off a corner of a board or post; a bevel.

Chan—See Zen.

chancel arch—The arch separating the chancel (the *apse* or *choir*) or the *transept* from the *nave* of a basilica or church.

chantry—An endowed chapel for the chanting of the mass for the founder of the chapel.

- **chaplet**—A metal pin used in hollow-casting to connect the *investment* with the clay core.
- **characters**—In Chinese writing, signs that record spoken words.
- charun—An Etruscan death demon.

chatra—See yasti.

- chiaroscuro—In drawing or painting, the treatment and use of light and dark, especially the gradations of light that produce the effect of modeling.
- **chigi**—Decorative extensions of the *rafters* at each end of the roof of a Japanese shrine.
- chimera—A monster of Greek invention with the head and body of a lion and the tail of a serpent. A second head, that of a goat, grows out of one side of the body.
- chisel—A tool with a straight blade at one end for cutting and shaping stone or wood.
- **chiton**—A Greek tunic, the essential (and often only) garment of both men and women, the other being the *himation*, or mantle.
- choir—The space reserved for the clergy and singers in the church, usually east of the transept but, in some instances, extending into the nave.
- Christogram—The three initial letters (chi-rhoiota, or) of Christ's name in Greek, which came to serve as a monogram for Christ.
- chryselephantine—Fashioned of gold and ivory. circumambulation—In Buddhist worship, walking around the *stupa* in a clockwise direction, a process intended to bring the worshiper into harmony with the cosmos.
- cire perdue—See lost-wax process.
- cista (pl. cistae)—An Etruscan cylindrical container made of sheet bronze with cast handles and feet, often with elaborately engraved bodies, used for women's toiletry articles.
- city-state—An independent, self-governing city. Classical—The art and culture of ancient Greece between 480 and 323 BCE. Lowercase classical refers more generally to Greco-Roman art and culture.
- clerestory—The fenestrated part of a building that rises above the roofs of the other parts. The oldest known clerestories are Egyptian. In Roman basilicas and medieval churches, clerestories are the windows that form the nave's uppermost level below the timber ceiling or the vaults.
- cloison—French, "partition." A cell made of metal wire or a narrow metal strip soldered edge-up to a metal base to hold *enamel*, semiprecious stones, pieces of colored glass, or glass paste fired to resemble sparkling jewels.
- cloisonné—A decorative metalwork technique employing cloisons; also, decorative brickwork in later Byzantine architecture.
- cloister—A monastery courtyard, usually with covered walks or ambulatories along its sides.
- **cluster pier**—See *compound pier*.
- codex (pl. codices)—Separate pages of vellum or parchment bound together at one side; the predecessor of the modern book. The codex superseded the rotulus. In Mesoamerica, a painted and inscribed book on long sheets of bark pa-

- per or deerskin coated with fine white plaster and folded into accordion-like pleats.
- **coffer**—A sunken panel, often ornamental, in a *vault* or a ceiling.
- **collage**—A composition made by combining on a flat surface various materials, such as newspaper, wallpaper, printed text and illustrations, photographs, and cloth.
- **colonnade**—A series or row of *columns*, usually spanned by *lintels*.
- colonnette—A thin column.
- **colophon**—An inscription, usually on the last page, giving information about a book's manufacture. In Chinese painting, written texts on attached pieces of paper or silk.
- color The value, or tonality, of a color is the degree of its lightness or darkness. The intensity, or saturation, of a color is its purity, its brightness or dullness. See also primary colors, secondary colors, and complementary colors.
- column—A vertical, weight-carrying architectural member, circular in cross-section and consisting of a base (sometimes omitted), a shaft, and a capital.
- complementary colors—Those pairs of colors, such as red and green, that together constitute the entire spectrum. The complement of one of the three primary colors is a mixture of the other two.
- **compose**—See *composition*.
- **Composite capital**—A capital combining *Ionic* volutes and *Corinthian* acanthus leaves, first used by the ancient Romans.
- **composite view**—A convention of representation in which part of a figure is shown in profile and another part of the same figure is shown frontally; also called twisted perspective.
- **composition**—The way in which an artist organizes *forms* in an artwork, either by placing shapes on a flat surface or arranging forms in space.
- **compound pier**—A *pier* with a group, or cluster, of attached *shafts*, or *responds*, especially characteristic of *Gothic* architecture.
- conceptual representation—The representation of the fundamental distinguishing properties of a person or object, not the way a figure or object appears in space and light at a specific moment. See *composite view*.
- concrete—A building material invented by the Romans and consisting of various proportions of lime mortar, volcanic sand, water, and small stones
- confraternity—In Late Antiquity, an association of Christian families pooling funds to purchase property for burial. In late medieval Europe, an organization founded by laypersons who dedicated themselves to strict religious observances.
- **congregational mosque**—A city's main mosque, designed to accommodate the entire Muslim population for the Friday noonday prayer. Also called the great mosque or Friday mosque.
- **connoisseur**—An expert in *attributing* artworks to one artist rather than another. More generally, an expert on artistic *style*.
- **consuls**—In the Roman Republic, the two chief magistrates.
- **contour line**—In art, a continuous line defining the outer shape of an object.

- contrapposto—The disposition of the human figure in which one part is turned in opposition to another part (usually hips and legs one way, shoulders and chest another), creating a counterpositioning of the body about its central axis. Sometimes called "weight shift" because the weight of the body tends to be thrown to one foot, creating tension on one side and relaxation on the other.
- corbel—A projecting wall member used as a support for some element in the superstructure. Also, courses of stone or brick in which each course projects beyond the one beneath it. Two such walls, meeting at the topmost course, create a corbeled arch or corbeled vault.

corbeled arch—See *corbel*.

- **corbeled vault**—A *vault* formed by the piling of stone blocks in horizontal *courses*, cantilevered inward until the two walls meet in an *arch*.
- Corinthian capital—A more ornate form than *Doric* or *Ionic*; it consists of a double row of acanthus leaves from which tendrils and flowers grow, wrapped around a bell-shaped *echinus*. Although this *capital* form is often cited as the distinguishing feature of the Corinthian *order*, no such order exists, in strict terms, but only this style of capital used in the *Ionic* order.
- **cornice**—The projecting, crowning member of the *entablature* framing the *pediment*; also, any crowning projection.
- **corona civica**—Latin, "civic crown." A Roman honorary wreath worn on the head.
- **course**—In masonry construction, a horizontal row of stone blocks.
- crenel—See crenellation.
- crenellation—Alternating solid merlons and open crenels in the notched tops of walls, as in battlements.
- cross vault—See vault.
- **crossing**—The space in a *cruciform* church formed by the intersection of the *nave* and the *transept*.
- **crossing square**—The area in a church formed by the intersection (*crossing*) of a *nave* and a *transept* of equal width, often used as a standard *module* of interior proportion.
- **crossing tower**—The tower over the *crossing* of a church.
- **cruciform**—Cross-shaped.
- **Crusades**—In medieval Europe, armed pilgrimages aimed at recapturing the Holy Land from the Muslims.
- **crypt**—A *vaulted* space under part of a building, wholly or partly underground; in churches, normally the portion under an *apse*.
- **cubiculum** (pl. **cubicula**)—A small cubicle or bedroom that opened onto the *atrium* of a Roman house. Also, a chamber in an Early Christian *catacomb* that served as a mortuary chapel.
- **cuerda seca**—A type of polychrome tilework used in decorating Islamic buildings.
- cuirass—A military leather breastplate.
- **cult statue**—The statue of the deity that stood in the *cella* of an ancient temple.
- cuneiform—Latin, "wedge-shaped." A system of writing used in ancient Mesopotamia, in which wedge-shaped characters were produced by

pressing a *stylus* into a soft clay tablet, which was then baked or otherwise allowed to harden.

cuneus (pl. **cunei**)—In ancient Greek and Roman theaters and *amphitheaters*, the wedge-shaped section of stone benches separated by stairs.

cutaway—An architectural drawing that combines an exterior view with an interior view of part of a building.

Cycladic—The prehistoric art of the Aegean Islands around Delos, excluding Crete.

Cyclopean masonry—A method of stone construction, named after the mythical *Cyclopes*, using massive, irregular blocks without mortar, characteristic of the Bronze Age fortifications of Tiryns and other *Mycenaean* sites.

Cyclops (pl. **Cyclopes**)—A mythical Greek oneeyed giant.

cylinder seal—A cylindrical piece of stone usually about an inch or so in height, decorated with an *incised* design, so that a raised pattern is left when the seal is rolled over soft clay. In the ancient Near East, documents, storage jars, and other important possessions were signed, sealed, and identified in this way. Stamp seals are an earlier, flat form of seal used for similar purposes.

Daedalic—The Greek *Orientalizing* sculptural style of the seventh century BCE named after the legendary artist Daedalus.

damnatio memoriae—The Roman decree condemning those who ran afoul of the Senate. Those who suffered damnatio memoriae had their memorials demolished and their names erased from public inscriptions.

darshan—In Hindu worship, seeing images of the divinity and being seen by the divinity.

decumanus—The east-west street in a Roman town, intersecting the *cardo* at right angles.

decursio—The ritual circling of a Roman funerary pyre.

Deësis—Greek, "supplication." An image of Christ flanked by the figures of the Virgin Mary and Saint John the Baptist, who intercede on behalf of humankind.

demos—Greek, "the people," from which the word *democracy* is derived.

demotic—Late Egyptian writing.

denarius—The standard Roman silver coin from which the word *penny* ultimately derives.

dharma—In Buddhism, moral law based on the Buddha's teaching.

dharmachakra—See mudra.

dhyana—See mudra.

diagonal rib—See rib.

diaphragm arch—A transverse, wall-bearing arch that divides a vault or a ceiling into compartments, providing a kind of firebreak.

dictator—In the Roman Republic, the supreme magistrate with extraordinary powers, appointed during a crisis for a specified period. Julius Caesar eventually became dictator perpetuo, dictator for life.

dictator perpetuo—See dictator.

dipteral—See peristyle.

diptych—A two-paneled painting or altarpiece; also, an ancient Roman, Early Christian, or Byzantine hinged writing tablet, often of ivory and carved on the external sides. **disputatio**—Latin, "logical argument." The philosophical methodology used in *Scholasticism*.

documentary evidence—In art history, the examination of written sources in order to determine the date of an artwork, the circumstances of its creation, or the identity of the artist(s) who made it.

doge—Duke; a ruler of the Republic of Venice, Italy.
dome—A hemispherical vault; theoretically, an arch rotated on its vertical axis. In Mycenaean architecture, domes are beehive-shaped.

domus—A Roman private house.

Doric—One of the two systems (or *orders*) invented in ancient Greece for articulating the three units of the elevation of a *classical* building—the platform, the *colonnade*, and the superstructure (*entablature*). The Doric order is characterized by, among other features, *capitals* with funnel-shaped *echinuses*, *columns* without *bases*, and a *frieze* of *triglyphs* and *metopes*. See also *lonic*.

doryphoros—Greek, "spear bearer."

dotaku—Ancient Japanese bronze ceremonial bells, usually featuring raised decoration.

double monastery—A *monastery* for both monks and nuns.

dressed masonry—Stone blocks shaped to the exact dimensions required, with smooth faces for a perfect fit.

dromos—The passage leading to a *tholos tomb*.

drum—One of the stacked cylindrical stones that form the *shaft* of a *column*. Also, the cylindrical wall that supports a *dome*.

earthenware—Pottery made of clay that is fired at low temperatures and is slightly porous. Also, clay figurines and statues produced in the same manner.

eaves—The lower part of a roof that overhangs the wall.

echinus—The convex element of a *capital* directly below the *abacus*.

effigy mounds—Ceremonial mounds built in the shape of animals or birds by native North American peoples.

elevation—In architecture, a head-on view of an external or internal wall, showing its features and often other elements that would be visible beyond or before the wall.

emblema—The central framed figural panel of a *mosaic* floor.

embroidery— The technique of sewing threads onto a finished ground to form contrasting designs. Stem stitching employs short overlapping strands of thread to form jagged lines. Laidand-couched work creates solid blocks of color.

enamel—A decorative coating, usually colored, fused onto the surface of metal, glass, or ceramics.

encaustic—A painting technique in which pigment is mixed with melted wax and applied to the surface while the mixture is hot.

engaged column—A half-round *column* attached to a wall. See also *pilaster*.

engraving—The process of *incising* a design in hard material, often a metal plate (usually copper); also, the *print* or impression made from such a plate.

ensi-A Sumerian ruler.

entablature—The part of a building above the *columns* and below the roof. The entablature has three parts: *architrave*, *frieze*, and *pediment*.

entasis—The convex profile (an apparent swelling) in the *shaft* of a *column*.

Eucharist—In Christianity, the partaking of the bread and wine, which believers hold to be either Christ himself or symbolic of him.

evangelist—One of the four authors (Matthew, Mark, Luke, John) of the New Testament Gospels.

exedra—Recessed area, usually semicircular.

facade—Usually, the front of a building; also, the other sides when they are emphasized architecturally.

faience—A low-fired opaque glasslike silicate.

fan vault—See vault.

fauces—Latin, "jaws." In a Roman house, the narrow fover leading to the *atrium*.

fenestrated—Having windows.

fenestration—The arrangement of the windows of a building.

feudalism—The medieval political, social, and economic system held together by the relationship between landholding *liege lords* and the *vassals* who were granted tenure of a portion of their land and in turn swore allegiance to the liege lord.

fibula (pl. **fibulae**)—A decorative pin, usually used to fasten garments.

findspot—Place where an artifact was found; provenance.

finial—A crowning ornament.

First Style mural—The earliest style of Roman mural painting. Also called the Masonry Style, because the aim of the artist was to imitate, using painted stucco relief, the appearance of costly marble panels.

Flamboyant—A Late French *Gothic* style of architecture superseding the *Rayonnant* style and named for the flamelike appearance of its pointed bar *tracery*.

flashing—In making *stained-glass* windows, fusing one layer of colored glass to another to produce a greater range of colors.

fleur-de-lis—A three-petaled iris flower; the royal flower of France.

florin—The denomination of gold coin of Renaissance Florence that became an international currency for trade.

flute or **fluting**—Vertical channeling, roughly semicircular in cross-section and used principally on *columns* and *pilasters*.

flying buttress—See buttress.

folio—A page of a manuscript or book.

foreshortening—The use of *perspective* to represent in art the apparent visual contraction of an object that extends back in space at an angle to the perpendicular plane of sight.

form—In art, an object's shape and structure, either in two dimensions (for example, a figure painted on a surface) or in three dimensions (such as a statue).

formal analysis—The visual analysis of artistic *form.*

forum—The public square of an ancient Roman city.

Fourth Style mural—In Roman mural painting, the Fourth Style marks a return to architectural illusionism, but the architectural vistas of the Fourth Style are irrational fantasies.

freedmen, freedwomen—In ancient and medieval society, men and women who had been freed from servitude, as opposed to having been born free.

freestanding sculpture—See sculpture in the round.

fresco—Painting on lime plaster, either dry (dry fresco, or fresco secco) or wet (true, or buon, fresco). In the latter method, the pigments are mixed with water and become chemically bound to the freshly laid lime plaster. Also, a painting executed in either method.

fresco secco—See fresco.

Friday mosque—See congregational mosque.

frieze—The part of the *entablature* between the *architrave* and the *cornice*; also, any sculptured or painted band in a building. See *register*.

frigidarium—The cold-bath section of a Roman bathing establishment.

garbha griha—Hindi, "womb chamber." In Hindu temples, the *cella*, the holy inner sanctum, for the cult image or symbol.

genre—A style or category of art; also, a kind of painting that realistically depicts scenes from everyday life.

Geometric—The style of Greek art during the ninth and eighth centuries BCE, characterized by abstract geometric ornament and schematic figures.

gigantomachy—In ancient Greek mythology, the battle between gods and giants.

giornata (pl. **giornate**)—Italian, "day." The section of plaster that a *fresco* painter expects to complete in one session.

gladiator—An ancient Roman professional fighter, usually a slave, who competed in an amphitheater.

glaze—A vitreous coating applied to pottery to seal and decorate the surface. It may be colored, transparent, or opaque, and glossy or *matte*. In oil painting, a thin, transparent, or semitransparent layer applied over a color to alter it slightly.

glazier—A glassworker.

gold leaf—Gold beaten into tissue-paper-thin sheets that then can be applied to surfaces.

gorget—A neck pendant, usually made of shell.

gorgon—In ancient Greek mythology, a hideous female demon with snake hair. Medusa, the most famous gorgon, was capable of turning anyone who gazed at her into stone.

Gospels—The four New Testament books that relate the life and teachings of Jesus.

Gothic—Originally a derogatory term named after the Goths, used to describe the history, culture, and art of western Europe in the 12th to 14th centuries. Typically divided into periods designated Early (1140–1194), High (1194–1300), and Late (1300–1500).

granulation—A decorative technique in which tiny metal balls (granules) are fused to a metal surface.

graver—An *engraving* tool. See also *burin*.

great mosque—See congregational mosque.

Greek cross—A cross with four arms of equal length.

grisaille—A monochrome painting done mainly in neutral grays to simulate sculpture.

groin—The edge formed by the intersection of two barrel *vaults*.

groin vault—See vault.

ground line—In paintings and reliefs, a painted or carved baseline on which figures appear to stand.

guang—An ancient Chinese covered vessel, often in animal form, holding wine, water, grain, or meat for sacrificial rites.

guild—An association of merchants, craftspersons, or scholars in medieval and Renaissance Europe.

hall church—See Hallenkirche.

Hallenkirche—German, "hall church." A church design favored in Germany, but also used elsewhere, in which the *aisles* rise to the same height as the *nave*.

handscroll—In Asian art, a horizontal painted scroll that is unrolled right to left, section by section, and often used to present illustrated religious texts or landscapes.

hanging scroll—In Asian art, a vertical scroll hung on a wall with pictures mounted or painted directly on it.

haniwa—Sculpted fired pottery cylinders, modeled in human, animal, or other forms and placed on Japanese *tumuli* of the Kofun period.

harmika—In Buddhist architecture, a stone fence or railing that encloses an area surmounting the dome of a stupa that represents one of the Buddhist heavens; from the center arises the yasti.

Helladic—The prehistoric art of the Greek mainland (*Hellas* in Greek).

Hellas—The ancient name of Greece.

Hellenes (adj. **Hellenic**)—The name the ancient Greeks called themselves as the people of *Hellas*.

Hellenistic — The term given to the art and culture of the roughly three centuries between the death of Alexander the Great in 323 BCE and the death of Queen Cleopatra in 30 BCE, when Egypt became a Roman province.

henge—An arrangement of *megalithic* stones in a circle, often surrounded by a ditch.

heraldic composition—A *composition* that is symmetrical on either side of a central figure.

herm—A bust on a quadrangular pillar.

Hiberno-Saxon—An art style that flourished in the monasteries of the British Isles in the early Middle Ages. Also called Insular.

hierarchy of scale—An artistic convention in which greater size indicates greater importance.

hieroglyphic—A system of writing using symbols or pictures.

high relief—See relief.

Hijra—The flight of Muhammad from Mecca to Medina in 622, the year from which Islam dates its beginnings.

himation—An ancient Greek mantle worn by men and women over the *chiton* and draped in various ways.

Hippodamian plan—A city plan devised by Hippodamos of Miletos ca. 466 BCE, in which a

strict grid was imposed on a site, regardless of the terrain, so that all streets would meet at right angles.

hiragana—A sound-based writing system developed in Japan from Chinese characters; it came to be the primary script for Japanese court poetry.

historiated—Ornamented with representations, such as plants, animals, or human figures, that have a narrative—as distinct from a purely decorative—function.

hubris—Greek, "arrogant pride."

hue—The name of a *color*. See also *primary colors*, *secondary colors*, and *complementary colors*.

humanism—In the Renaissance, an emphasis on education and on expanding knowledge (especially of classical antiquity), the exploration of individual potential and a desire to excel, and a commitment to civic responsibility and moral duty.

hydria—An ancient Greek three-handled water pitcher.

hypaethral—A building having no *pediment* or roof, open to the sky.

hypostyle hall—A hall with a roof supported by *columns*.

icon—A portrait or image; especially in Byzantine churches, a panel with a painting of sacred personages that are objects of veneration. In the visual arts, a painting, a piece of sculpture, or even a building regarded as an object of veneration.

iconoclasm—The destruction of religious or sacred images. In Byzantium, the period from 726 to 843 when there was an imperial ban on such images. The destroyers of images were known as iconoclasts. Those who opposed such a ban were known as iconophiles.

iconoclast—See iconoclasm.

iconography—Greek, the "writing of images." The term refers both to the content, or subject, of an artwork and to the study of content in art. It also includes the study of the symbolic, often religious, meaning of objects, persons, or events depicted in works of art.

iconophile—See iconoclasm.

iconostasis—Greek, "icon stand." In Byzantine churches, a screen or a partition, with doors and many tiers of *icons*, separating the sanctuary from the main body of the church.

ikegobo—A Benin royal shrine.

illuminated manuscript—A luxurious handmade book with painted illustrations and decorations.

illusionism (adj. **illusionistic**)—The representation of the three-dimensional world on a two-dimensional surface in a manner that creates the illusion that the person, object, or place represented is three-dimensional. See also *perspective*.

imagines—In ancient Rome, wax portraits of ancestors.

imam—In Islam, the leader of collective worship.imperator—Latin, "commander in chief," from which the word *emperor* derives.

impluvium—In a Roman house, the basin located in the *atrium* that collected rainwater.

impost block—The uppermost block of a wall or *pier* beneath the *springing* of an *arch*.

in antis—In ancient Greek architecture, the area between the *antae*.

incise—To cut into a surface with a sharp instrument; also, a method of decoration, especially on metal and pottery.

incrustation—Wall decoration consisting of bright panels of different colors.

indulgence—A religious pardon for a sin committed.

insula (pl. **insulae**)—In Roman architecture, a multistory apartment house, usually made of brickfaced *concrete*; also refers to an entire city block.

Insular—See Hiberno-Saxon.

intensity—See color.

interaxial or intercolumniation—The distance between the center of the lowest *drum* of a *col-umn* and the center of the next.

intercolumniation—See interaxial.

internal evidence—In art history, the examination of what an artwork represents (people, clothing, hairstyles, and so on) in order to determine its date. Also, the examination of the *style* of an artwork to identify the artist who created it.

International Style—A *style* of 14th- and 15th-century painting begun by Simone Martini, who adapted the French *Gothic* manner to Sienese art fused with influences from Northern Europe. This style appealed to the aristocracy because of its brilliant color, lavish costumes, intricate ornamentation, and themes involving splendid processions of knights and ladies. Also, a style of 20th-century architecture associated with Le Corbusier, whose elegance of design came to influence the look of modern office buildings and skyscrapers.

intonaco— In fresco painting, the last layer of smooth lime plaster applied to the wall; the painting layer.

investment—In hollow-casting, the final clay mold applied to the exterior of the wax model.

Ionic—One of the two systems (or orders) invented in ancient Greece for articulating the three units of the elevation of a classical building: the platform, the colonnade, and the superstructure (entablature). The Ionic order is characterized by, among other features, volutes, capitals, columns with bases, and an uninterrupted frieze.

iron-wire lines—In ancient Chinese painting, thin brush lines suggesting tensile strength.

iwan—In Islamic architecture, a vaulted rectangular recess opening onto a courtyard.

jambs—In architecture, the side posts of a doorway. jataka—Tales of the past lives of the Buddha. See also sutra.

jomon—Japanese, "cord markings." A type of Japanese ceramic technique characterized by ropelike markings.

junzi—Chinese, "superior person" or "gentleman." A person who is a model of Confucian behavior.

ka—In ancient Egypt, the immortal human life force.

Kaaba—Arabic, "cube." A small cubical building in Mecca, the Islamic world's symbolic center.

kami—Shinto deities or spirits, believed in Japan to exist in nature (mountains, waterfalls) and in charismatic people.

karma—In Vedic religions (see *Veda*), the ethical consequences of a person's life, which determine his or her fate.

katsuogi—Wooden logs placed at right angles to the *ridgepole* of a Japanese shrine to hold the thatched roof in place.

keep—A fortified tower in a castle that served as a place of last refuge.

keystone—See voussoir.

kiva—A square or circular underground structure that is the spiritual and ceremonial center of Pueblo Indian life.

kline (pl. klinai)—A couch or funerary bed. A type of sarcophagus with a reclining portrait of the deceased on its lid.

kondo—Japanese, "golden hall." The main hall for worship in a Japanese Buddhist temple complex. The kondo contained statues of the Buddha and the bodhisattvas to whom the temple was dedicated.

Koran—Islam's sacred book, composed of *surahs* (chapters) divided into verses.

kore (pl. **korai**)—Greek, "young woman." An *Archaic* Greek statue of a young woman.

kouros (pl. **kouroi**)—Greek, "young man." An *Archaic* Greek statue of a young man.

krater—An ancient Greek wide-mouthed bowl for mixing wine and water.

Kufic—An early form of Arabic script, characterized by angularity, with the uprights forming almost right angles with the baseline.

labyrinth—Maze. The English word derives from the mazelike plan of the *Minoan* palace at Knossos.

lacquer—A varnishlike substance made from the sap of the Asiatic sumac tree, used to decorate wood and other organic materials. Often colored with mineral pigments, lacquer cures to great hardness and has a lustrous surface.

laid-and-couched work—See embroidery.

lakshana—One of the distinguishing marks of the Buddha. The lakshanas include the urna and ushnisha.

lalitasana—In Buddhist iconography, the body pose with one leg folded and the other hanging down, indicating relaxation.

lamassu—Assyrian guardian in the form of a man-headed winged bull.

lancet—In *Gothic* architecture, a tall narrow window ending in a *pointed arch*.

landscape—A picture showing natural scenery, without narrative content.

lateral section—See section.

leading—In the manufacture of *stained-glass* windows, the joining of colored glass pieces using lead *cames*.

lectionary—A book containing passages from the *Gospels*, arranged in the sequence that they are to be read during the celebration of religious services, including the *Mass*, throughout the year.

lekythos (pl. **lekythoi**)—A flask containing perfumed oil; lekythoi were often placed in Greek graves as offerings to the deceased.

liege lord—In *feudalism*, a landowner who grants tenure of a portion of his land to a *vassal*.

line—The extension of a point along a path, made concrete in art by drawing on or chiseling into a *plane*.

linear perspective—See *perspective*.

linga—In Hindu art, the depiction of Shiva as a phallus or cosmic *pillar*.

lintel—A horizontal *beam* used to span an opening. **liturgy** (adj. **liturgical**)—The official ritual of public worship.

loculi—Openings in the walls of *catacombs* to receive the dead.

lohan—A Buddhist holy person who has achieved enlightenment and nirvana by suppression of all desire for earthly things.

longitudinal plan—See plan.

longitudinal section—See section.

lost-wax (cire perdue) process—A bronzecasting method in which a figure is modeled in wax and covered with clay; the whole is fired, melting away the wax (French, cire perdue) and hardening the clay, which then becomes a mold for molten metal.

low relief—See relief.

lunette—A semicircular area (with the flat side down) in a wall over a door, niche, or window; also, a painting or *relief* with a semicircular frame.

lux nova—Latin, "new light." Abbot Suger's term for the light that enters a Gothic church through stained-glass windows.

machicolated gallery—A gallery in a defensive tower with holes in the floor to allow stones or hot liquids to be dumped on enemies below.

madrasa—An Islamic theological college adjoining and often containing a *mosque*.

maebyong—A Korean vase similar to the Chinese meiping.

magus (pl. magi)—One of the three wise men from the East who presented gifts to the infant Jesus.

mandala—Sanskrit term for the sacred diagram of the universe; Japanese, mandara.

mandapa—Pillared hall of a Hindu temple.

mandara—See mandala.

mandorla—An almond-shaped *nimbus* surrounding the figure of Christ or other sacred figure. In Buddhist Japan, a lotus-petal-shaped nimbus.

maniera greca—Italian, "Greek manner." The Italo-Byzantine painting style of the 13th century.

manor—In feudalism, the estate of a liege lord.

mantra—Sanskrit term for the ritual words or syllables recited in *Shingon* Buddhism.

maqsura—In some *mosques*, a screened area in front of the *mihrab* reserved for a ruler.

martyr—A person who chooses to die rather than deny his or her religious belief. See also *saint*.

martyrium—A shrine to a Christian martyr *saint*. Masonry Style—See *First Style mural*.

mass—The bulk, density, and weight of matter in space.

Mass—The Catholic and Orthodox ritual in which believers understand that Christ's redeeming sacrifice on the cross is repeated when the priest consecrates the bread and wine in the Eucharist.

mastaba—Arabic, "bench." An ancient Egyptian rectangular brick or stone structure with sloping sides erected over a subterranean tomb chamber connected with the outside by a shaft.

matte—In painting, pottery, and photography, a dull finish.

mausoleum—A monumental tomb. The name derives from the mid-fourth-century BCE tomb

- of Mausolos at Halikarnassos, one of the Seven Wonders of the ancient world.
- meander—An ornament, usually in bands but also covering broad surfaces, consisting of interlocking geometric motifs. An ornamental pattern of contiguous straight lines joined usually at right angles.
- **medium** (pl. **media**)—The material (for example, marble, bronze, clay, *fresco*) in which an artist works; also, in painting, the vehicle (usually liquid) that carries the pigment.
- megalith (adj. megalithic)—Greek, "great stone." A large, roughly hewn stone used in the construction of monumental prehistoric structures.
- **megaron**—The large reception hall and throne room in a *Mycenaean* palace, fronted by an open, two-*columned* porch.
- **meiping**—A Chinese vase of a high-shouldered shape; the *sgrafitto technique* was used in decorating such vases.
- mendicants—In medieval Europe, friars belonging to the Franciscan and Dominican orders, who renounced all worldly goods, lived by contributions of laypersons (the word *mendicant* means "beggar"), and devoted themselves to preaching, teaching, and doing good works.
- **menorah**—In antiquity, the Jewish sacred sevenbranched candelabrum.
- merlon—See crenellation.
- **Mesoamerica**—The region that comprises Mexico, Guatemala, Belize, Honduras, and the Pacific coast of El Salvador.
- **Mesolithic**—The "middle" Stone Age, between the *Paleolithic* and the *Neolithic* ages.
- **Messiah**—The savior of the Jews prophesied in the Old Testament. Christians believe that Jesus of Nazareth was the Messiah.
- **metope**—The square panel between the *triglyphs* in a *Doric frieze*, often sculpted in *relief*.
- **mihrab**—A semicircular niche set into the *qibla* wall of a *mosque*.
- minaret—A distinctive feature of *mosque* architecture, a tower from which the faithful are called to worship.
- **minbar**—In a *mosque*, the *pulpit* on which the *imam* stands.
- **Minoan**—The prehistoric art of Crete, named after the legendary King Minos of Knossos.
- **Minotaur**—The mythical beast, half man and half bull, that inhabited the *labyrinth* of the *Minoan* palace at Knossos.
- mithuna—In South Asian art, a male-female couple embracing or engaged in sexual intercourse.
- modeling—The shaping or fashioning of threedimensional forms in a soft material, such as clay; also, the gradations of light and shade reflected from the surfaces of matter in space, or the illusion of such gradations produced by alterations of value in a drawing, painting, or print.
- module (adj. modular)—A basic unit of which the dimensions of the major parts of a work are multiples. The principle is used in sculpture and other art forms, but it is most often employed in architecture, where the module may be the dimensions of an important part of a building, such as the diameter of a *column*.

moksha—See nirvana.

mold—A hollow form for casting.

- molding—In architecture, a continuous, narrow surface (projecting or recessed, plain or ornamented) designed to break up a surface, to accent, or to decorate.
- **monastery**—A group of buildings in which monks live together, set apart from the secular community of a town.
- monastic—Relating to life in a monastery.
- **monastic order**—An organization of monks living according to the same rules, for example, the Benedictine, Franciscan, and Dominican orders.
- monochrome (adj. monochromatic)—One-color. monolith (adj. monolithic)—A stone *column* shaft that is all in one piece (not composed of *drums*); a large, single block or piece of stone used in *megalithic* structures. Also, a colossal statue carved from a single piece of stone.
- **monotheism**—The worship of one all-powerful god.
- moralized Bible—A heavily illustrated Bible, each page pairing paintings of Old and New Testament episodes with explanations of their moral significance.
- mortise-and-tenon system—See tenon.
- **mortuary temple**—In Egyptian architecture, a temple erected for the worship of a deceased *pharaoh*.
- mosaic—Patterns or pictures made by embedding small pieces (tesserae) of stone or glass in cement on surfaces such as walls and floors; also, the technique of making such works.
- mosaic tilework—An Islamic decorative technique in which large ceramic panels are fired, cut into smaller pieces, and set in plaster.
- moschophoros—Greek, "calf bearer."
- **mosque**—The Islamic building for collective worship. From the Arabic word *masjid*, meaning a "place for bowing down."
- Mozarabic Referring to the Christian culture of northern Spain during the time Islamic *caliphs* ruled southern Spain.
- mudra—In Buddhist and Hindu iconography, a stylized and symbolic hand gesture. The dhyana (meditation) mudra consists of the right hand over the left, palms upward, in the lap. In the bhumisparsha (earth-touching) mudra, the right hand reaches down to the ground, calling the earth to witness the Buddha's enlightenment. The dharmachakra (Wheel of the Law, or teaching) mudra is a two-handed gesture with right thumb and index finger forming a circle. The abhaya (do not fear) mudra, with the right hand up, palm outward, is a gesture of protection or blessing.
- Muhaqqaq A cursive style of Islamic *calligraphy*. mullion — A vertical member that divides a window or that separates one window from another.
- mummification—A technique used by ancient Egyptians to preserve human bodies so that they may serve as the eternal home of the immortal ka.
- muqarnas—Stucco decorations of Islamic buildings in which stalactite-like forms break a structure's solidity.
- mural—A wall painting.
- Mycenaean The prehistoric art of the Late Helladic period in Greece, named after the citadel of Mycenae.

- mystery play—A dramatic enactment of the holy mysteries of the Christian faith performed at church portals and in city squares.
- naos—See cella.
- narthex—A porch or vestibule of a church, generally colonnaded or arcaded and preceding the nave
- **natatio**—The swimming pool in a Roman bathing establishment.
- naturalism—The style of painted or sculptured representation based on close observation of the natural world that was at the core of the classical tradition.
- **nave**—The central area of an ancient Roman *basilica* or of a church, demarcated from *aisles* by *piers* or *columns*.
- **nave arcade**—In *basilica* architecture, the series of *arches* supported by *piers* or *columns* separating the *nave* from the *aisles*.
- **necropolis**—Greek, "city of the dead." A large burial area or cemetery.
- **nemes**—In ancient Egypt, the linen headdress worn by the *pharaoh*, with the *uraeus* cobra of kingship on the front.
- Neolithic—The "new" Stone Age.
- **niello**—A black metallic alloy.
- **nimbus**—A halo or aureole appearing around the head of a holy figure to signify divinity.
- nirvana—In Buddhism and Hinduism, a blissful state brought about by absorption of the individual soul or consciousness into the supreme spirit. Also called moksha.
- **Nun**—In ancient Egypt, the primeval waters from which the creator god emerged.
- **nymphs**—In *classical* mythology, female divinities of springs, caves, and woods.
- oba—An African sacred king.
- **oculus** (pl. **oculi**)—Latin, "eye." The round central opening of a *dome*. Also, a small round window in a *Gothic cathedral*.
- **ogee arch**—An *arch* composed of two double-curving lines meeting at a point.
- **ogive** (adj. **ogival**)—The diagonal *rib* of a *Gothic vault*; a pointed, or Gothic, *arch*.
- Olympiad—The four-year period defined by the staging of the Olympic Games in ancient Greece. oni—An African ruler.
- opere francigeno—See opus francigenum.
- **opisthodomos**—In ancient Greek architecture, a porch at the rear of a temple, set against the blank back wall of the *cella*.
- opus francigenum—Latin, "French work." Architecture in the style of *Gothic* France; opere francigeno (adj.), "in the French manner."
- **opus modernum**—Latin, "modern work." The late medieval term for *Gothic* art and architecture. Also called *opus francigenum*.
- **orant**—In Early Christian art, a figure with both arms raised in the ancient gesture of prayer.
- oratory—The church of a Christian monastery.
- orchestra—Greek, "dancing place." In ancient Greek theaters, the circular piece of earth with a hard and level surface on which the performance took place.
- order—In classical architecture, a style represented by a characteristic design of the columns and entablature. See also superimposed orders.

525

Orientalizing—The early phase of *Archaic* Greek art (seventh century BCE), so named because of the adoption of forms and motifs from the ancient Near East and Egypt. See also *Daedalic*.

orthogonal plan—The imposition of a strict grid *plan* on a site, regardless of the terrain, so that all streets meet at right angles. See also *Hippodamian plan*.

Ottonian (adj.)—Pertaining to the empire of Otto I and his successors.

oxidizing—The first phase of the ancient Greek ceramic firing process, which turned both the pot and the clay *slip* red. During the second (reducing) phase, the oxygen supply into the kiln was shut off, and both pot and slip turned black. In the final (reoxidizing) phase, the pot's coarser material reabsorbed oxygen and became red again, whereas the smoother slip did not and remained black.

pagoda—An East Asian tower, usually associated with a Buddhist temple, having a multiplicity of winged *eaves*; thought to be derived from the Indian *stupa*.

palaestra—An ancient Greek and Roman exercise area, usually framed by a colonnade. In Greece, the palaestra was an independent building; in Rome, palaestras were also frequently incorporated into a bathing complex.

Paleolithic—The "old" Stone Age, during which humankind produced the first sculptures and paintings.

palette—A thin board with a thumb hole at one end on which an artist lays and mixes colors; any surface so used. Also, the colors or kinds of colors characteristically used by an artist. In ancient Egypt, a slate slab used for preparing makeup.

Pantokrator—Greek, "ruler of all." Christ as ruler and judge of heaven and earth.

papyrus—A plant native to Egypt and adjacent lands used to make paperlike writing material; also, the material or any writing on it.

parapet—A low, protective wall along the edge of a balcony, roof, or bastion.

parchment—Lambskin prepared as a surface for painting or writing.

parekklesion—The side chapel in a Byzantine church.

parinirvana—Image of the reclining Buddha, a position often interpreted as representing his death.

parthenos—Greek, "virgin." The epithet of Athena, the virgin goddess.

passage grave—A prehistoric tomb with a long stone corridor leading to a burial chamber covered by a great tumulus.

paten—A large shallow bowl or plate for the bread used in the *Eucharist*.

patrician—A Roman freeborn landowner.

patron—The person or entity that pays an artist to produce individual artworks or employs an artist on a continuing basis.

pebble mosaic—A *mosaic* made of irregularly shaped stones of various colors.

pectoral—An ornament worn on the chest.

pediment—In *classical* architecture, the triangular space (gable) at the end of a building, formed by the ends of the sloping roof above the *colonnade*; also, an ornamental feature having this shape.

pendant—The large hanging terminal element of a *Gothic* fan *vault*.

pendentive—A concave, triangular section of a hemisphere, four of which provide the transition from a square area to the circular base of a covering *dome*. Although pendentives appear to be hanging (pendant) from the dome, they in fact support it.

Pentateuch—The first five books of the Old Testament.

peplos—A simple, long belted garment of wool worn by women in ancient Greece.

period style—See style.

peripteral—See peristyle.

peristyle—In classical architecture, a colonnade all around the cella and its porch(es). A peripteral colonnade consists of a single row of columns on all sides; a dipteral colonnade has a double row all around.

Perpendicular—A Late English *Gothic* style of architecture distinguished by the pronounced verticality of its decorative details.

personal style—See style.

personification—An abstract idea represented in bodily form.

perspective (adj. perspectival)—A method of presenting an illusion of the three-dimensional world on a two-dimensional surface. In linear perspective, the most common type, all parallel lines or surface edges converge on one, two, or three vanishing points located with reference to the eye level of the viewer (the horizon line of the picture), and associated objects are rendered smaller the farther from the viewer they are intended to seem. Atmospheric, or aerial, perspective creates the illusion of distance by the greater diminution of color intensity, the shift in color toward an almost neutral blue, and the blurring of contours as the intended distance between eye and object increases.

pharaoh (adj. pharaonic)—An ancient Egyptian
king.

physical evidence—In art history, the examination of the materials used to produce an artwork in order to determine its date.

pictograph — A picture, usually stylized, that represents an idea; also, writing using such means; also, painting on rock. See also hieroglyphic.

pier—A vertical, freestanding masonry support.

Pietà—A painted or sculpted representation of the Virgin Mary mourning over the body of the dead Christ.

pilaster—A flat, rectangular, vertical member projecting from a wall of which it forms a part. It usually has a base and a capital and is often fluted.

pillar—Usually a weight-carrying member, such as a pier or a column; sometimes an isolated, freestanding structure used for commemorative purposes.

pinakotheke—Greek, "picture gallery." An ancient Greek building for the display of paintings on wood panels.

pinnacle—In Gothic churches, a sharply pointed ornament capping the piers or flying buttresses; also used on church facades.

plan—The horizontal arrangement of the parts of a building or of the buildings and streets of a

city or town, or a drawing or diagram showing such an arrangement. In an axial plan, the parts of a building are organized longitudinally, or along a given axis; in a central plan, the parts of the structure are of equal or almost equal dimensions around the center.

plane—A flat surface.

plate tracery—See tracery.

plebeian—The Roman social class that included small farmers, merchants, and freed slaves.

pointed arch—A narrow *arch* of pointed profile, in contrast to a semicircular arch.

polis (pl. **poleis**)—An independent *city-state* in ancient Greece.

polytheism—The belief in multiple gods.

pontifex maximus—Latin, "chief priest." The high priest of the Roman state religion, often the emperor himself.

porcelain—Extremely fine, hard, white ceramic. Unlike *stoneware*, porcelain is made from a fine white clay called kaolin mixed with ground petuntse, a type of feldspar. True porcelain is translucent and rings when struck.

portico—A roofed *colonnade*; also an entrance porch.

post-and-lintel system—A system of construction in which two posts support a *lintel*.

pouncing — The method of transferring a sketch onto paper or a wall by tracing, using thin paper or transparent gazelle skin placed on top of the sketch, pricking the contours of the design into the skin or paper with a pin, placing the skin or paper on the surface to be painted, and forcing black pigment through the holes.

prasada—In Hindu worship, food that becomes sacred by first being given to a god.

pre-Columbian (adj.)—The cultures that flourished in the Western Hemisphere before the arrival of Christopher Columbus and the beginning of European contact and conquest.

predella—The narrow ledge on which an *altar*-*piece* rests on an altar.

prefiguration—In Early Christian art, the depiction of Old Testament persons and events as prophetic forerunners of Christ and New Testament events.

primary colors—Red, yellow, and blue—the colors from which all other colors may be derived.

princeps—Latin, "first citizen." The title Augustus and his successors as Roman emperor used to distinguish themselves from Hellenistic monarchs.

pronaos—The space, or porch, in front of the *cella*, or naos, of an ancient Greek temple.

proportion—The relationship in size of the parts of persons, buildings, or objects, often based on a *module*.

prostyle—A classical temple plan in which the columns are only in front of the cella and not on the sides or back.

provenance—Origin or source; findspot.

psalter—A book containing the Psalms.

pseudoperipteral—In Roman architecture, a pseudoperipteral temple has a series of engaged *columns* all around the sides and back of the *cella* to give the appearance of a *peripteral colonnade*.

- pueblo—A communal multistoried dwelling made of stone or adobe brick by the Native Americans of the Southwest. Upper-case Pueblo refers to various groups that occupied such dwellings.
- **pulpit**—A raised platform in a church on which a priest stands while leading the religious service.
- **punchwork**—Tooled decorative work in *gold leaf*. **purlins**—Horizontal *beams* in a roof structure, parallel to the *ridgepoles*, resting on the main *rafters* and giving support to the secondary rafters.
- putto (pl. putti)—A cherubic young boy.
- **pylon**—The wide entrance gateway of an Egyptian temple, characterized by its sloping walls.
- **qibla**—The direction (toward Mecca) Muslims face when praying.
- **quadrant arch**—An *arch* whose curve extends for one quarter of a circle's circumference.
- **quatrefoil**—A shape or plan in which the parts assume the form of a cloverleaf.
- **radiating chapels**—In medieval churches, chapels for the display of *relics* that opened directly onto the *ambulatory* and the *transept*.
- radiocarbon dating—A method of measuring the decay rate of carbon isotopes in organic matter to determine the age of organic materials such as wood and fiber.
- **rafters**—The sloping supporting timber planks that run from the *ridgepole* of a roof to its edge.
- **raking cornice**—The *cornice* on the sloping sides of a *pediment*.
- ramparts—Defensive wall circuits.
- **ratha**—Small, freestanding Hindu temple carved from a huge boulder.
- Rayonnant—The "radiant" style of *Gothic* architecture, dominant in the second half of the 13th century and associated with the French royal court of Louis IX at Paris.
- **red-figure painting**—In later Greek pottery, the silhouetting of red figures against a black background, with painted linear details; the reverse of *black-figure painting*.
- reducing—See oxidizing.
- **refectory**—The dining hall of a Christian *monastery*.
- regional style—See style.
- **register**—One of a series of superimposed bands or *friezes* in a pictorial narrative, or the particular levels on which motifs are placed.
- relics—The body parts, clothing, or objects associated with a holy figure, such as the Buddha or Christ or a Christian saint.
- relief—In sculpture, figures projecting from a background of which they are part. The degree of relief is designated high, low (bas), or sunken. In the last, the artist cuts the design into the surface so that the highest projecting parts of the image are no higher than the surface itself. See also *repoussé*.
- relieving triangle—In *Mycenaean* architecture, the triangular opening above the *lintel* that serves to lighten the weight to be carried by the lintel itself.
- reliquary—A container for holding relics.
- **ren**—Chinese, "human-heartedness." The quality that the ideal Confucian *junzi* possesses.

- Renaissance—French, "rebirth." The term used to describe the history, culture, and art of 14th-through 16th-century western Europe during which artists consciously revived the *classical* style.
- renovatio—Latin, "renewal." During the *Carolingian* period, Charlemagne sought to revive the culture of ancient Rome (renovatio imperi Romani)
- reoxidizing—See oxidizing.
- **repoussé**—Formed in *relief* by beating a metal plate from the back, leaving the impression on the face. The metal sheet is hammered into a hollow *mold* of wood or some other pliable material and finished with a *graver*. See also *relief*.
- **respond**—An engaged *column*, *pilaster*, or similar element that either projects from a *compound pier* or some other supporting device or is bonded to a wall and carries one end of an *arch*.
- **retable**—An architectural screen or wall above and behind an altar, usually containing painting, sculpture, carving, or other decorations. See also *altarpiece*.
- **revetment**—In architecture, a wall covering or facing.
- rib—A relatively slender, molded masonry *arch* that projects from a surface. In *Gothic* architecture, the ribs form the framework of the *vaulting*. A diagonal rib is one of the ribs that form the X of a *groin vault*. A transverse rib crosses the *nave* or *aisle* at a 90-degree angle.
- rib vault—A vault in which the diagonal and transverse ribs compose a structural skeleton that partially supports the masonry web between them
- **ridgepole**—The beam running the length of a building below the peak of the gabled roof.
- Romanesque—"Roman-like." A term used to describe the history, culture, and art of medieval western Europe from ca. 1050 to ca. 1200.
- **roof comb**—The elaborately sculpted vertical projection surmounting a Maya temple-pyramid.
- rose window—A circular stained-glass window.
 rotulus—The manuscript scroll used by Egyptians, Greeks, Etruscans, and Romans; prede-
- **rotunda**—The circular area under a *dome*; also a domed round building.
- roundel—See tondo.

cessor of the codex.

- **rubbing**—An impression of a relief made by placing paper over the surface and rubbing with a pencil or crayon.
- rusticate (n. rustication) To give a rustic appearance by roughening the surfaces and beveling the edges of stone blocks to emphasize the joints between them. Rustication is a technique employed in ancient Roman architecture, and was also popular during the *Renaissance*, especially for stone *courses* at the ground-floor level.
- sacra rappresentazione (pl. sacre rappresentazioni)—Italian, "holy representation." A more elaborate version of a mystery play performed for a lay audience by a confraternity.
- **sacramentary**—A Christian religious book incorporating the prayers priests recite during *Mass*.
- saint—From the Latin word sanctus, meaning "made holy by God." Applied to persons who suffered and died for their Christian faith or

- who merited reverence for their Christian devotion while alive. In the Roman Catholic Church, a worthy deceased Catholic who is canonized by the pope.
- **samsara**—In Hindu belief, the rebirth of the soul into a succession of lives.
- sarcophagus (pl. sarcophagi)—Latin, "consumer of flesh." A coffin, usually of stone.
- saturation—See color.
- satyr—A Greek mythological follower of Dionysos having a man's upper body, a goat's hindquarters and horns, and a horse's ears and tail.
- scarab—An Egyptian gem in the shape of a beetle. scarification—Decorative markings on the human body made by cutting or piercing the flesh to create scars.
- **Scholasticism**—The *Gothic* school of philosophy in which scholars applied Aristotle's system of rational inquiry to the interpretation of religious belief.
- **school**—A chronological and stylistic classification of works of art with a stipulation of place.
- **scriptorium** (pl. **scriptoria**)—The writing studio of a *monastery*.
- **sculpture** in the round—Freestanding figures, carved or modeled in three dimensions.
- secco-Italian, "dry." See also fresco.
- Second Style mural—The style of Roman mural painting in which the aim was to dissolve the confining walls of a room and replace them with the illusion of a three-dimensional world constructed in the artist's imagination.
- **secondary colors**—Orange, green, and purple, obtained by mixing pairs of *primary colors* (red, yellow, blue).
- section—In architecture, a diagram or representation of a part of a structure or building along an imaginary plane that passes through it vertically. Drawings showing a theoretical slice across a structure's width are lateral sections. Those cutting through a building's length are longitudinal sections. See also *elevation* and *cutaway*.
- sedes sapientiae—Latin, "throne of wisdom."

 A Romanesque sculptural type depicting the Virgin Mary with the Christ Child in her lap.
- senate—Latin senatus, "council of elders." The Senate was the main legislative body in Roman constitutional government.
- **serdab**—A small concealed chamber in an Egyptian *mastaba* for the statue of the deceased.
- **Severe Style**—The Early *Classical* style of Greek sculpture, ca. 480–450 BCE.
- sexpartite vault—See vault.
- **sgrafitto**—A Chinese ceramic technique in which the design is *incised* through a colored *slip*.
- **shaft**—The tall, cylindrical part of a *column* between the *capital* and the *base*.
- shakti—In Hinduism, the female power of the deity Devi (or Goddess), which animates the matter of the cosmos.
- **sherd**—A fragmentary piece of a broken ceramic vessel.
- **shikara**—The beehive-shaped tower of a northernstyle Hindu temple.
- **Shingon**—The primary form of Buddhism in Japan through the mid-10th century. Lowercase *shingon* is the Japanese term for the words or syllables recited in Buddhist ritual.

527

- shogun—In 12th- through 19th-century Japan, a military governor who managed the country on behalf of a figurehead emperor.
- **shogunate**—The Japanese military government of the 12th through 19th centuries.
- **sinopia**—A burnt-orange pigment used in *fresco* painting to transfer a *cartoon* to the *arriccio* before the artist paints the plaster.
- **siren**—In ancient Greek mythology, a creature that was part bird and part woman.
- **skene**—Greek, "stage." The stage of a *classical* theater.
- **skenographia**—Greek, "scene painting"; the Greek term for *perspective* painting.
- **skiagraphia**—Greek, "shadow painting." The Greek term for shading, said to have been invented by Apollodoros, an Athenian painter of the fifth century BCE.
- slip—A mixture of fine clay and water used in ceramic decoration.
- **space**—In art history, both the actual area an object occupies or a building encloses, and the *illusionistic* representation of space in painting and sculpture.
- spandrel—The roughly triangular space enclosed by the curves of adjacent *arches* and a horizontal member connecting their vertexes; also, the space enclosed by the curve of an *arch* and an enclosing right angle. The area between the arch proper and the framing *columns* and *entablature*.
- **spectrum**—The range or band of visible colors in natural light.
- **sphinx**—A mythical Egyptian beast with the body of a lion and the head of a human.
- **springing**—The lowest stone of an *arch*, resting on the *impost block*. In *Gothic vaulting*, the lowest stone of a diagonal or transverse *rib*.
- **squinch**—An architectural device used as a transition from a square to a polygonal or circular base for a *dome*. It may be composed of *lintels*, *corbels*, or *arches*.
- **stained glass**—In *Gothic* architecture, the colored glass used for windows.
- stamp seal—See cylinder seal.
- statue—A three-dimensional sculpture.
- stave—A wedge-shaped timber; vertically placed staves embellish the architectural features of a building.
- **stele** (pl. **stelae**)—A carved stone slab used to mark graves or to commemorate historical events.
- stem stitching—See embroidery.
- **stigmata**—In Christian art, the wounds Christ received at his crucifixion that miraculously appear on the body of a *saint*.
- **still life**—A picture depicting an arrangement of inanimate objects.
- stoa—In ancient Greek architecture, an open building with a roof supported by a row of columns parallel to the back wall. A covered colonnade or portico.
- **Stoic**—A philosophical school of ancient Greece, named after the *stoas* in which the philosophers met
- **stoneware**—Pottery fired at high temperatures to produce a stonelike hardness and density.
- strategos—Greek, "general."
- **strigil**—A tool Greek athletes used to scrape oil from their bodies after exercising.

- **strut**—A timber plank or other structural member used as a support in a building. Also a short section of marble used to support an arm or leg in a statue.
- stucco—A type of plaster used as a coating on exterior and interior walls. Also used as a sculptural medium.
- stupa—A large, mound-shaped Buddhist shrine.
 style—A distinctive artistic manner. Period style is the characteristic style of a specific time. Regional style is the style of a particular geo-
- graphical area. Personal style is an individual artist's unique manner.
- **stylistic evidence**—In art history, the examination of the *style* of an artwork in order to determine its date or the identity of the artist.
- stylobate—The uppermost course of the platform of a classical Greek temple, which supports the columns.
- stylus—A needlelike tool used in engraving and incising; also, an ancient writing instrument used to inscribe clay or wax tablets.
- **sub gracia**—Latin, "under grace." In Christian thought, the period after the coming of Christ.
- sub lege—Latin, "under the law." In Christian thought, the period after Moses received the Ten Commandments and before the coming of Christ. See also sub gracia.
- **subtractive light**—The painter's light in art; the light reflected from pigments and objects. See also *additive light*.
- **subtractive sculpture**—A kind of sculpture technique in which materials are taken away from the original mass; carving.
- sultan—A Muslim ruler.
- sunken relief—See relief.
- Sunnah—The collection of the Prophet Muhammad's moral sayings and descriptions of his deeds
- superimposed orders—Orders of architecture that are placed one above another in an arcaded or colonnaded building, usually in the following sequence: Doric (the first story), Ionic, and Corinthian. Superimposed orders are found in later Greek architecture and were used widely by Roman and Renaissance builders.
- surah—A chapter of the Koran, divided into verses.
 sutra—In Buddhism, an account of a sermon by
 or a dialogue involving the Buddha. A scriptural account of the Buddha. See also jataka.
- **symbol**—An image that stands for another image or encapsulates an idea.
- **symmetria**—Greek, "commensurability of parts." Polykleitos's treatise on his *canon* of proportions incorporated the principle of symmetria.
- symposium—An ancient Greek banquet attended solely by men (and female servants and prostitutes).
- **taberna**—In Roman architecture, a single-room shop usually covered by a barrel *vault*.
- tablero—See talud-tablero construction.

ture in Mesoamerica.

- tablinum—The study or office in a Roman house. talud-tablero construction—The alternation of sloping (talud) and vertical (tablero) rubble layers, characteristic of Teotihuacan architec-
- **tapestry**—A weaving technique in which the *weft* threads are packed densely over the *warp*

- threads so that the designs are woven directly into the fabric.
- **technique**—The processes artists employ to create *form*, as well as the distinctive, personal ways in which they handle their materials and tools.
- **tempera**—A *technique* of painting using pigment mixed with egg yolk, glue, or casein; also, the *medium* itself.
- **templon**—The columnar screen separating the sanctuary from the main body of a Byzantine church.
- **tenon**—A projection on the end of a piece of wood that is inserted into a corresponding hole (mortise) in another piece of wood to form a joint.
- **tephra**—The volcanic ash produced by the eruption on the *Cycladic* island of Thera.
- **tepidarium** The warm-bath section of a Roman bathing establishment.
- terracotta—Hard-baked clay, used for sculpture and as a building material. It may be *glazed* or painted
- **tessera** (pl. **tesserae**)—Greek, "cube." A tiny stone or piece of glass cut to the desired shape and size for use in forming a *mosaic*.
- tetrarch—One of four corulers.
- **tetrarchy**—Greek, "rule by four." A type of Roman government established in the late third century CE by Diocletian in an attempt to foster order by sharing power with potential rivals.
- **texture**—The quality of a surface (rough, smooth, hard, soft, shiny, dull) as revealed by light. In represented texture, a painter depicts an object as having a certain texture even though the paint is the actual texture.
- **theatron**—Greek, "place for seeing." In ancient Greek theaters, the slope overlooking the *or-chestra* on which the spectators sat.
- **Theotokos**—Greek, "she who bore God." The Virgin Mary, the mother of Jesus.
- thermoluminescence—A method of dating by measuring amounts of radiation found within the clay of ceramic or sculptural forms, as well as in the clay cores from metal castings.
- Third Style mural—In Roman mural painting, the style in which delicate linear fantasies were sketched on predominantly monochromatic backgrounds.
- **tholos** (pl. **tholoi**)—A temple with a circular plan. Also, the burial chamber of a *tholos tomb*.
- **tholos tomb**—In *Mycenaean* architecture, a beehive-shaped tomb with a circular plan.
- **thrust**—The outward force exerted by an *arch* or a *vault* that must be counterbalanced by a *buttress*. **tonality** See *color*.
- tondo (pl. tondi)—A circular painting or relief
- **Torah**—The Hebrew religious scroll containing the *Pentateuch*.
- **torana**—Gateway in the stone fence around a *stupa*, located at the cardinal points of the compass.
- **torque**—The distinctive necklace worn by the Gauls.
- tracery—Ornamental stonework for holding stained glass in place, characteristic of Gothic cathedrals. In plate tracery, the glass fills only the "punched holes" in the heavy ornamental stonework. In bar tracery, the stained-glass

- windows fill almost the entire opening, and the stonework is unobtrusive.
- **tramezzo**—A screen placed across the *nave* of a church to separate the clergy from the lay audience.
- **transept**—The part of a church with an axis that crosses the *nave* at a right angle.
- **transverse arch**—An *arch* separating one *vaulted bay* from the next.
- **transverse barrel vault**—In medieval architecture, a semicylindrical *vault* oriented at a 90-degree angle to the *nave* of a church.

transverse rib—See rib.

- **treasury**—In ancient Greece, a small building set up for the safe storage of *votive offerings*.
- **trefoil**—A cloverlike ornament or symbol with stylized leaves in groups of three.
- **tribune**—In church architecture, a gallery over the inner *aisle* flanking the *nave*.
- triclinium—The dining room of a Roman house.
 trident—The three-pronged pitchfork associated with the ancient Greek sea god Poseidon (Roman, Neptune).
- **triforium**—In a *Gothic* cathedral, the *blind ar-caded* gallery below the *clerestory*; occasionally, the arcades are filled with *stained glass*.
- **triglyph**—A triple projecting, grooved member of a *Doric frieze* that alternates with *metopes*.
- **trilithons**—A pair of *monoliths* topped with a *lintel*; found in *megalithic* structures.
- **Trinity**—In Christianity, God the Father, his son Jesus Christ, and the Holy Spirit.
- **tripod**—An ancient Greek deep bowl on a tall three-legged stand.
- **triptych**—A three-paneled painting, ivory plaque, or *altarpiece*. Also, a small, portable shrine with hinged wings used for private devotion.
- triumphal arch—In Roman architecture, a freestanding *arch* commemorating an important event, such as a military victory or the opening of a new road
- **trumeau**—In church architecture, the *pillar* or center post supporting the *lintel* in the middle of the doorway.

tubicen—Latin, "trumpet player."

tumulus (pl. tumuli)—Latin, "burial mound." In Etruscan architecture, tumuli cover one or more subterranean multichambered tombs cut out of the local tufa (limestone). Also characteristic of the Japanese Kofun period of the third and fourth centuries.

tunnel vault—See vault.

turris—See westwork.

- **Tuscan column**—The standard type of Etruscan *column*. It resembles ancient Greek *Doric* columns but is made of wood, is unfluted, and has a *base*.
- twisted perspective—See composite view.
- **tympanum** (pl. **tympana**)—The space enclosed by a *lintel* and an *arch* over a doorway.
- **typology**—In Christian theology, the recognition of concordances between events, especially between episodes in the Old and New Testaments.

- **Upanishads**—South Asian religious texts of ca. 800–500 BCE that introduced the concepts of *samsara*, *karma*, and *moksha*.
- **uraeus**—An Egyptian cobra; one of the emblems of *pharaonic* kingship.
- urna—A whorl of hair, represented as a dot, between the brows; one of the *lakshanas* of the Buddha.
- ushabti—In ancient Egypt, a figurine placed in a tomb to act as a servant to the deceased in the afterlife.
- **ushnisha**—A knot of hair on the top of the head; one of the *lakshanas* of the Buddha.
- valley temple—The temple closest to the Nile River associated with each of the Great Pyramids at Gizeh in ancient Egypt.

value—See color.

- vassal—In feudalism, a person who swears allegiance to a liege lord and renders him military service in return for tenure of a portion of the lord's land.
- vault (adj. vaulted)—A masonry roof or ceiling constructed on the arch principle, or a concrete roof of the same shape. A barrel (or tunnel) vault, semicylindrical in cross-section, is in effect a deep arch or an uninterrupted series of arches, one behind the other, over an oblong space. A quadrant vault is a half-barrel vault. A groin (or cross) vault is formed at the point at which two barrel vaults intersect at right angles. In a ribbed vault, there is a framework of ribs or arches under the intersections of the vaulting sections. A sexpartite vault is one whose ribs divide the vault into six compartments. A fan vault is a vault characteristic of English Perpendicular Gothic architecture, in which radiating ribs form a fanlike pattern.

vaulting web—See web.

- Veda—Sanskrit, "knowledge." One of four secondmillennium BCE South Asian compilations of religious learning.
- velarium—In a Roman amphitheater, the cloth awning that could be rolled down from the top of the cavea to shield spectators from sun or rain.
- **vellum**—Calfskin prepared as a surface for writing or painting.
- **venationes**—Ancient Roman wild animal hunts staged in an *amphitheater*.
- veristic—True to natural appearance; super-realistic.
- vihara—A Buddhist monastery, often cut into a hill.
- vimana—A pyramidal tower over the garbha griha of a Hindu temple of the southern, or Dravida, style.
- **vita contemplativa**—Latin, "contemplative life." The secluded spiritual life of monks and nuns.
- **volume**—The *space* that *mass* organizes, divides, or encloses.
- **volute**—A spiral, scroll-like form characteristic of the ancient Greek *Ionic* and the Roman *Composite capital*.

- votive offering—A gift of gratitude to a deity.
- **voussoir**—A wedge-shaped stone block used in the construction of a true *arch*. The central voussoir, which sets the arch, is called the keystone.
- warp—The vertical threads of a loom or cloth.

wat—A Buddhist monastery in Cambodia.

- **web**—The masonry blocks that fill the area between the *ribs* of a *groin vault*. Also called vaulting web.
- **wedjat**—The eye of the Egyptian falcon-god Horus, a powerful *amulet*.
- weft—The horizontal threads of a loom or cloth.
- **weld**—To join metal parts by heating, as in assembling the separate parts of a *statue* made by *casting*.
- were-jaguar—A composite human-jaguar; a common motif in Olmec art.
- westwork—German, "western entrance structure." The *facade* and towers at the western end of a medieval church, principally in Germany. In contemporary documents the westwork is called a castellum (Latin, "castle" or "fortress") or turris ("tower").
- white-ground painting—An ancient Greek vasepainting *technique* in which the pot was first covered with a *slip* of very fine white clay, over which black *glaze* was used to outline figures, and diluted brown, purple, red, and white were used to color them.
- yaksha (m.), yakshi (f.)—Lesser local male and female Buddhist and Hindu divinities. Yakshis are goddesses associated with fertility and vegetation. Yakshas, the male equivalent of yakshis, are often represented as fleshy but powerful males
- yamato-e—Also known as native-style painting, a purely Japanese style that often involved colorful, decorative representations of Japanese narratives or *landscapes*.
- yang—In Chinese cosmology, the principle of active masculine energy, which permeates the universe in varying proportions with yin, the principle of passive feminine energy.
- yasti—In Buddhist architecture, the mast or pole that arises from the dome of the *stupa* and its *harmika* and symbolizes the axis of the universe; it is adorned with a series of chatras (stone disks).

yin—See yang.

- yoga—A method for controlling the body and relaxing the mind used in later Indian religions to yoke, or unite, the practitioner to the divine
- **Zen**—A Japanese Buddhist sect and its doctrine, emphasizing enlightenment through intuition and introspection rather than the study of scripture. In Chinese, Chan.
- **ziggurat**—In ancient Mesopotamian architecture, a monumental platform for a temple.

BIBLIOGRAPHY

This list of books is very selective but comprehensive enough to satisfy the reading interests of the beginning art history student and general reader. The resources listed range from works that are valuable primarily for their reproductions to those that are scholarly surveys of schools and periods or monographs on individual artists. The emphasis is on recent in-print books and on books likely to be found in college and municipal libraries. No entries for periodical articles appear, but the bibliography begins with a list of some of the major journals that publish art historical scholarship in English.

SELECTED PERIODICALS

African Arts American Art American Indian Art

American Journal of Archaeology

Antiquity Archaeology Archives of American Art Archives of Asian Art Ars Orientalis

Art Bulletin

Art History Art in America

Art Journal

Artforum International

Burlington Magazine

Gesta

History of Photography Journal of Roman Archaeology

Journal of the Society of Architectural Historians Journal of the Warburg and Courtauld Institutes

Latin American Antiquity

Oxford Art Journal

Women's Art Journal

GENERAL STUDIES

- Baxandall, Michael. *Patterns of Intention: On the Histori*cal Explanation of Pictures. New Haven, Conn.: Yale University Press, 1985.
- Bindman, David, ed. *The Thames & Hudson Encyclopedia* of British Art. London: Thames & Hudson, 1988.
- Boström, Antonia. *The Encyclopedia of Sculpture*. 3 vols. London: Routledge, 2003.
- Broude, Norma, and Mary D. Garrard, eds. *The Expanding Discourse: Feminism and Art History.* New York: Harper Collins, 1992.
- Bryson, Norman. Vision and Painting: The Logic of the Gaze. New Haven, Conn.: Yale University Press, 1983.
- Bryson, Norman, Michael Ann Holly, and Keith Moxey. Visual Theory: Painting and Interpretation. New York: Cambridge University Press, 1991.
- Büttner, Nils. *Landscape Painting: A History*. New York: Abbeville, 2007.
- Chadwick, Whitney. Women, Art, and Society. 4th ed. New York: Thames & Hudson, 2007.
- Cheetham, Mark A., Michael Ann Holly, and Keith Moxey, eds. The Subjects of Art History: Historical Objects in Contemporary Perspective. New York: Cambridge University Press, 1998.
- Chilvers, Ian, and Harold Osborne, eds. The Oxford Dictionary of Art. 3d ed. New York: Oxford University Press, 2004.

- Corbin, George A. Native Arts of North America, Africa, and the South Pacific: An Introduction. New York: Harper Collins, 1988.
- Crouch, Dora P., and June G. Johnson. *Traditions in Architecture: Africa, America, Asia, and Oceania*. New York:
 Oxford University Press, 2000.
- Curl, James Stevens. Oxford Dictionary of Architecture and Landscape Architecture. 2d ed. New York: Oxford University Press, 2006.
- Encyclopedia of World Art. 17 vols. New York: McGraw-Hill, 1959–1987.
- Fielding, Mantle. Dictionary of American Painters, Sculptors, and Engravers. 2d ed. Poughkeepsie, N.Y.: Apollo, 1986.
- Fine, Sylvia Honig. Women and Art: A History of Women Painters and Sculptors from the Renaissance to the 20th Century. Rev. ed. Montclair, N.J.: Alanheld & Schram, 1978.
- Fleming, John, Hugh Honour, and Nikolaus Pevsner. *The Penguin Dictionary of Architecture and Landscape Architecture*. 5th ed. New York: Penguin, 2000.
- Frazier, Nancy. *The Penguin Concise Dictionary of Art History*. New York: Penguin, 2000.
- Freedberg, David. The Power of Images: Studies in the History and Theory of Response. Chicago: University of Chicago Press, 1989.
- Gaze, Delia., ed. *Dictionary of Women Artists*. 2 vols. London: Routledge, 1997.
- Hall, James. Illustrated Dictionary of Subjects and Symbols in Eastern and Western Art. New York: Icon Editions, 1994.
- Harris, Anne Sutherland, and Linda Nochlin. Women Artists: 1550–1950. Los Angeles: Los Angeles County Museum of Art; New York: Knopf, 1977.
- Hauser, Arnold. *The Sociology of Art.* Chicago: University of Chicago Press, 1982.
- Hults, Linda C. *The Print in the Western World: An Introductory History.* Madison: University of Wisconsin Press, 1996.
- Kemp, Martin. The Science of Art: Optical Themes in Western Art from Brunelleschi to Seurat. New Haven, Conn.: Yale University Press, 1990.
- Kostof, Spiro, and Gregory Castillo. A History of Architecture: Settings and Rituals. 2d ed. Oxford: Oxford University Press, 1995.
- Kultermann, Udo. *The History of Art History*. New York: Abaris, 1993.
- Lucie-Smith, Edward. The Thames & Hudson Dictionary of Art Terms. 2d ed. New York: Thames & Hudson, 2004
- Moffett, Marian, Michael Fazio, and Lawrence Wadehouse. A World History of Architecture. Boston: McGraw-Hill, 2004.

- Murray, Peter, and Linda Murray. A Dictionary of Art and Artists. 7th ed. New York: Penguin, 1998.
- Nelson, Robert S., and Richard Shiff, eds. Critical Terms for Art History. Chicago: University of Chicago Press, 1996.
- Penny, Nicholas. *The Materials of Sculpture*. New Haven, Conn.: Yale University Press, 1993.
- Pevsner, Nikolaus. A History of Building Types. London: Thames & Hudson, 1987. Reprint of 1979 ed.
- ——. An Outline of European Architecture. 8th ed. Baltimore: Penguin, 1974.
- Pierce, James Smith. From Abacus to Zeus: A Handbook of Art History. 7th ed. Upper Saddle River, N.J.: Pearson Prentice Hall, 1998.
- Placzek, Adolf K., ed. *Macmillan Encyclopedia of Architects*. 4 vols. New York: Macmillan, 1982.
- Podro, Michael. *The Critical Historians of Art.* New Haven, Conn.: Yale University Press, 1982.
- Pollock, Griselda. Vision and Difference: Femininity, Feminism, and Histories of Art. London: Routledge,
- Preziosi, Donald, ed. The Art of Art History: A Critical Anthology. New York: Oxford University Press, 1998.
- Read, Herbert. The Thames & Hudson Dictionary of Art and Artists. Rev. ed. New York: Thames & Hudson, 1994.
- Reid, Jane D. The Oxford Guide to Classical Mythology in the Arts 1300–1990s. 2 vols. New York: Oxford University Press, 1993.
- Roth, Leland M. Understanding Architecture: Its Elements, History, and Meaning. 2d ed. Boulder, Colo.: Westview, 2006.
- Schama, Simon. *The Power of Art*. New York: Ecco, 2006. Slatkin, Wendy. *Women Artists in History: From Antiquity to the 20th Century.* 4th ed. Upper Saddle River, N.J.: Prentice Hall, 2000.
- Steer, John, and Antony White. Atlas of Western Art History: Artists, Sites, and Monuments from Ancient Greece to the Modern Age. New York: Facts on File, 1994.
- Stratton, Arthur. The Orders of Architecture: Greek, Roman, and Renaissance. London: Studio, 1986.
- Sutton, Ian. Western Architecture: From Ancient Greece to the Present. New York: Thames & Hudson, 1999.
- Trachtenberg, Marvin, and Isabelle Hyman. Architecture, from Prehistory to Post-Modernism. 2d ed. Upper Saddle River, N.J.: Prentice Hall, 2003.
- Turner, Jane, ed. *The Dictionary of Art.* 34 vols. New ed. New York: Oxford University Press, 2003.
- Wittkower, Rudolf. Sculpture Processes and Principles. New York: Harper & Row, 1977.
- Wren, Linnea H., and Janine M. Carter, eds. Perspectives on Western Art: Source Documents and Readings from

the Ancient Near East through the Middle Ages. New York: Harper & Row, 1987.

ANCIENT ART, GENERAL

- Aruz, Joan, and Ronald Wallenfels, eds. Art of the First Cities: The Third Millennium BC from the Mediterranean to the Indus. New York: Metropolitan Museum of Art. 2003.
- Beard, Mary, and John Henderson. *Classical Art: From Greece to Rome*. New York: Oxford University Press, 2001.
- Boardman, John. *The World of Ancient Art.* London: Thames & Hudson, 2006.
- ———, ed. *The Oxford History of Classical Art.* New York: Oxford University Press, 1997.
- Clayton, Peter A., and Martin J. Price, eds. *The Seven Wonders of the Ancient World*. New York: Routledge, 1988.
- Connolly, Peter, and Hazel Dodge. The Ancient City: Life in Classical Athens and Rome. New York: Oxford University Press, 1998.
- De Grummond, Nancy Thomson, ed. An Encyclopedia of the History of Classical Archaeology. 2 vols. Westport, Conn.: Greenwood, 1996.
- Dunbabin, Katherine. *Mosaics of the Greek and Roman World*. New York: Cambridge University Press, 1999.
- Gates, Charles. Ancient Cities: The Archaeology of Urban Life in the Ancient Near East and Egypt, Greece, and Rome. London: Routledge, 2003.
- Kampen, Natalie B., ed. Sexuality in Ancient Art. New York: Cambridge University Press, 1996.
- Lexicon Iconographicum Mythologiae Classicae. 10 vols. Zurich: Artemis, 1981–1999.
- Ling, Roger. *Ancient Mosaics*. Princeton, N.J.: Princeton University Press, 1998.
- Lloyd, Seton, and Hans Wolfgang Muller. Ancient Architecture: Mesopotamia, Egypt, Crete. New York: Electa/Rizzoli, 1980.
- Oliphant, Margaret. The Atlas of the Ancient World: Charting the Great Civilizations of the Past. New York: Simon & Schuster, 1992.
- Onians, John. Classical Art and the Cultures of Greece and Rome. New Haven, Conn.: Yale University Press, 1999.
- Renfrew, Colin, and Paul G. Bahn. Archaeology: Theories, Methods, and Practices. London: Thames & Hudson, 1991
- Stillwell, Richard, William L. MacDonald, and Marian H. McAllister, eds. The Princeton Encyclopedia of Classical Sites. Princeton, N.J.: Princeton University Press, 1976.
- Trigger, Bruce. Understanding Early Civilizations: A Comparative Study. New York: Cambridge University Press, 2003.
- Ward-Perkins, John B. Cities of Ancient Greece and Italy: Planning in Classical Antiquity. Rev. ed. New York: Braziller, 1987.
- Wolf, Walther. The Origins of Western Art: Egypt, Mesopotamia, the Aegean. New York: Universe, 1989.

CHAPTER 1: ART BEFORE HISTORY

- Bahn, Paul G. *The Cambridge Illustrated History of Prehistoric* Art. New York: Cambridge University Press, 1998.
- Bahn, Paul G., and Jean Vertut. *Journey through the Ice Age.* Berkeley: University of California Press, 1997.
- Beltrán, Antonio, ed. *The Cave of Altamira*. New York: Abrams, 1999.
- Burl, Aubrey. *Great Stone Circles*. New Haven, Conn.: Yale University Press, 1999.
- Chauvet, Jean-Marie, Eliette Brunel Deschamps, and Christian Hillaire. *Dawn of Art: The Chauvet Cave.* New York: Abrams, 1996.
- Chippindale, Christopher. Stonehenge Complete. New York: Thames & Hudson, 1994.
- Cunliffe, Barry, ed. The Oxford Illustrated Prehistory of Europe. New York: Oxford University Press, 1994.
- Hodder, Ian. *The Leopard's Tale: Revealing the Mysteries of Çatalhöyük*. London: Thames & Hudson, 2006.

- Kenyon, Kathleen M. *Digging up Jericho*. New York: Praeger, 1974.
- Leroi-Gourhan, André. The Dawn of European Art: An Introduction to Paleolithic Cave Painting. Cambridge: Cambridge University Press, 1982.
- Marshack, Alexander. The Roots of Civilization: The Cognitive Beginnings of Man's First Art, Symbol and Notation. 2d ed. Wakefield, R.I.: Moyer Bell, 1991.
- Pfeiffer, John E. The Creative Explosion: An Inquiry into the Origins of Art and Religion. New York: Harper & Row, 1982.
- Renfrew, Colin, ed. *British Prehistory: A New Outline*. London: Noves, 1975.
- Ruspoli, Mario. *The Cave of Lascaux: The Final Photographs.* New York: Abrams, 1987.
- Scarre, Chris. *Exploring Prehistoric Europe*. New York: Oxford University Press, 1998.
- Wainwright, Geoffrey. The Henge Monuments: Ceremony and Society in Prehistoric Britain. London: Thames & Hudson, 1990.
- White, Randall. Prehistoric Art: The Symbolic Journey of Humankind. New York: Abrams, 2003.

CHAPTER 2: The Ancient Near East

- Akurgal, Ekrem. Art of the Hittites. New York: Abrams, 1962.
- Allen, Lindsay. *The Persian Empire*. Chicago: University of Chicago Press, 2005.
- Amiet, Pierre. Art of the Ancient Near East. New York: Abrams, 1980.
- Bahrani, Zainab. The Graven Image: Representation in Babylonia and Assyria. Philadelphia: University of Pennsylvania Press, 2003.
- Bienkowski, Piotr, and Alan Millard, eds. Dictionary of the Ancient Near East. Philadelphia: University of Pennsylvania Press, 2000.
- Collon, Dominique. *Ancient Near Eastern Art.* Berkeley: University of California Press, 1995.
- ——. First Impressions: Cylinder Seals in the Ancient Near East. 2d ed. London: British Museum, 1993.
- ——. Near Eastern Seals. Berkeley: University of California Press, 1990.
- Crawford, Harriet. Sumer and the Sumerians. New York: Cambridge University Press, 1991.
- Curatola, Giovanni. *The Art and Architecture of Mesopotamia*. New York: Abbeville, 2007.
- Curtis, John E. *Ancient Persia*. Cambridge, Mass.: Harvard University Press, 1990.
- Curtis, John E., and Julian E. Reade. *Art and Empire: Trea*sures from Assyria in the British Museum. New York: Metropolitan Museum of Art, 1995.
- Curtis, John E., and Nigel Tallis. Forgotten Empire: The World of Ancient Persia. Berkeley: University of California Press, 2005.
- Frankfort, Henri. *The Art and Architecture of the Ancient Orient.* 5th ed. New Haven, Conn.: Yale University Press, 1996.
- Ghirshman, Roman. The Arts of Ancient Iran: From Its Origins to the Time of Alexander the Great. New York: Golden, 1964.
- ———. Persian Art: The Parthian and Sassanian Dynasties, 249 BC-AD 651. New York: Golden, 1962.
- Gunter, Ann C., ed. Investigating Artistic Environments in the Ancient Near East. Washington, D.C.: Arthur M. Sackler Gallery, 1990.
- Harper, Prudence O., Joan Aruz, and Françoise Tallon, eds. The Royal City of Susa: Ancient Near Eastern Treasures in the Louvre. New York: Metropolitan Museum of Art, 1992.
- Lloyd, Seton. The Archaeology of Mesopotamia: From the Old Stone Age to the Persian Conquest. London: Thames & Hudson, 1984.
- Macqueen, James G. The Hittites and Their Contemporaries in Asia Minor. Rev. ed. New York: Thames & Hudson, 1986.

- Meyers, Eric M., ed. *The Oxford Encyclopedia of Archaeology in the Near East.* 5 vols. New York: Oxford University Press, 1997.
- Moortgat, Anton. *The Art of Ancient Mesopotamia*. New York: Phaidon, 1969.
- Oates, Joan. Babylon. Rev. ed. London: Thames & Hudson,
- Parrot, André. *The Arts of Assyria*. New York: Golden, 1961.

 ——. *Sumer: The Dawn of Art.* New York: Golden, 1961.
- Porada, Edith. Man and Images in the Ancient Near East. Wakefield, R.I.: Moyer Bell, 1995.
- Porada, Edith, and Robert H. Dyson. *The Art of Ancient Iran: Pre-Islamic Cultures.* Rev. ed. New York: Greystone, 1969.
- Postgate, J. Nicholas. Early Mesopotamia: Society and Economy at the Dawn of History. London: Routledge, 1992.
- Potts, Daniel T. *The Archaeology of Elam: Formation and Transformation of an Ancient Iranian State.* New York: Cambridge University Press, 1999.
- Reade, Julian E. *Assyrian Sculpture*. Cambridge, Mass.: Harvard University Press, 1999.
- ———. Mesopotamia. Cambridge, Mass.: Harvard University Press, 1991.
- Roaf, Michael. Cultural Atlas of Mesopotamia and the Ancient Near East. New York: Facts on File, 1990.
- Russell, John M. Sennacherib's Palace without Rival at Nineveh. Chicago: University of Chicago Press, 1991.
- Saggs, H.W.F. Babylonians. London: British Museum, 1995.
 Sasson, Jack M., ed. Civilizations of the Ancient Near East.
 4 vols. New York: Scribner, 1995.
- Snell, Daniel C. *Life in the Ancient Near East: 3100–332 BC.* New Haven, Conn.: Yale University Press, 1997.
- Strommenger, Eva, and Max Hirmer. 5,000 Years of the Art of Mesopotamia. New York: Abrams, 1964.
- Zettler, Richard L., and Lee Horne. *Treasures from the Royal Tombs of Ur.* Philadelphia: University of Pennsylvania Museum of Archaeology and Anthropology, 1998.

Chapter 3: Egypt under the Pharaohs

- Arnold, Dieter. Building in Egypt: Pharaonic Stone Masonry. New York: Oxford University Press, 1991.
- Arnold, Dorothea. *The Royal Women of Amarna*. New York: Metropolitan Museum of Art, 1996.
- ——. When the Pyramids Were Built: Egyptian Art of the Old Kingdom. New York: Rizzoli, 1999.
- Baines, John, and Jaromír Málek. Atlas of Ancient Egypt. New York: Facts on File, 1980.
- Bard, Kathryn A. An Introduction to the Archaeology of Ancient Egypt. Oxford: Blackwell, 2007.
- ——, ed. Encyclopedia of the Archaeology of Ancient Egypt. London: Routledge, 1999.
- Bianchi, Robert S. *Cleopatra's Egypt: Age of the Ptolemies*. Brooklyn: Brooklyn Museum, 1988.
- Splendors of Ancient Egypt from the Egyptian Museum, Cairo. London: Booth-Clibborn, 1996.
 Capel, Anne K., and Glenn E. Markoe, eds. Mistress of the
- House, Mistress of Heaven: Women in Ancient Egypt. New York: Hudson Hills, 1996.
- D'Auria, Sue, Peter Lacovara, and Catharine H. Roehrig. Mummies and Magic: The Funerary Arts of Ancient Egypt. Boston: Museum of Fine Arts, 1988.
- Davis, Whitney. The Canonical Tradition in Ancient Egyptian Art. New York: Cambridge University Press, 1989.
- Egyptian Art in the Age of the Pyramids. New York: Abrams, 1999.
- Hawass, Zahi. Valley of the Golden Mummies. New York: Abrams, 2000.
- Ikram, Salima, and Aidan Dodson. The Mummy in Ancient Egypt: Equipping the Dead for Eternity. New York: Thames & Hudson, 1998.
- Kemp, Barry J. Ancient Egypt: Anatomy of a Civilization. 2d ed. New York: Routledge, 2006.
- Kozloff, Arielle P., and Betsy M. Bryan. Egypt's Dazzling Sun: Amenhotep III and His World. Cleveland: Cleveland Museum of Art, 1992.

- Lange, Kurt, and Max Hirmer. Egypt: Architecture, Sculpture, and Painting in Three Thousand Years. 4th ed. London: Phaidon, 1968.
- Lehner, Mark. *The Complete Pyramids: Solving the Ancient Mysteries.* New York: Thames & Hudson, 1997.
- Mahdy, Christine, ed. The World of the Pharaohs: A Complete Guide to Ancient Egypt. London: Thames & Hudson, 1990.
- Málek, Jaromír. *Egypt: 4,000 Years of Art.* New York: Phaidon, 2003.
- ———, ed. Egypt: Ancient Culture, Modern Land. Norman: University of Oklahoma Press, 1993.
- Redford, Donald B. Akhenaton, the Heretic King. Princeton, N.J.: Princeton University Press, 1984.
- ———, ed. *The Oxford Encyclopedia of Ancient Egypt.* 3 vols. New York: Oxford University Press, 2001.
- Reeves, C. Nicholas. *The Complete Tutankhamun: The King, the Tomb, the Royal Treasure.* London: Thames & Hudson, 1990.
- Robins, Gay. *The Art of Ancient Egypt.* Cambridge, Mass.: Harvard University Press, 1997.
- ——— Egyptian Painting and Relief. Aylesbury: Shire, 1986.
- ——. Proportion and Style in Ancient Egyptian Art. Austin: University of Texas Press, 1994.
- ——. Women in Ancient Egypt. London: British Museum, 1993.
- Romer, John. Valley of the Kings: Exploring the Tombs of the Pharaohs. New York: Holt, 1994.
- Russmann, Edna R. *Egyptian Sculpture: Cairo and Luxor.* Austin: University of Texas Press, 1989.
- Schäfer, Heinrich. *Principles of Egyptian Art.* Rev. ed. Oxford: Clarendon, 1986.
- Schulz, Regina, and Matthias Seidel, eds. *Egypt: The World of the Pharaohs*. Cologne: Könemann, 1999.
- Shafer, Byron E., ed. *Temples of Ancient Egypt.* Ithaca, N.Y.: Cornell University Press, 1997.
- Shaw, Ian, and Paul Nicholson. *The Dictionary of Ancient Egypt.* London: British Museum, 1995.
- Silverman, David P., ed. *Ancient Egypt*. New York: Oxford University Press, 1997.
- Smith, William Stevenson, and William Kelly Simpson. The Art and Architecture of Ancient Egypt. Rev. ed. New Haven, Conn.: Yale University Press, 1998.
- Weeks, Kent R., ed. Valley of the Kings. Vercelli: White Star, 2001.
- Wildung, Dietrich. *Egypt: From Prehistory to the Romans*. Cologne: Taschen, 1997.

Chapter 4: The Prehistoric Aegean

- Barber, R. L. N. *The Cyclades in the Bronze Age.* Iowa City: University of Iowa Press, 1987.
- Betancourt, Philip P. A History of Minoan Pottery. Princeton, N.J.: Princeton University Press, 1965.
- Cadogan, Gerald. Palaces of Minoan Crete. London: Methuen, 1980.
- Chadwick, John. *The Mycenaean World*. New York: Cambridge University Press, 1976.
- Cullen, Tracey, ed. *Aegean Prehistory: A Review.* Boston: Archaeological Institute of America, 2001.
- Demargne, Pierre. *The Birth of Greek Art.* New York: Golden, 1964.
- Dickinson, Oliver P.T.K. *The Aegean Bronze Age.* New York: Cambridge University Press, 1994.
- Doumas, Christos. Thera, Pompeii of the Ancient Aegean: Excavations at Akrotiri, 1967–1979. New York: Thames & Hudson, 1983.
- The Wall-Paintings of Thera. Athens: Thera Foundation, 1992.
- Fitton, J. Lesley. *Cycladic Art.* Cambridge, Mass.: Harvard University Press, 1989.
- ——. *The Discovery of the Greek Bronze Age.* London: British Museum, 1995.

- Forsyth, Phyllis Young. *Thera in the Bronze Age*. New York: Peter Lang, 1997.
- Getz-Preziosi, Patricia. Sculptors of the Cyclades: Individual and Tradition in the Third Millennium BC. Ann Arbor: University of Michigan Press, 1987.
- Graham, James W. *The Palaces of Crete.* Princeton, N.J.: Princeton University Press, 1987.
- Hampe, Roland, and Erika Simon. The Birth of Greek Art: From the Mycenaean to the Archaic Period. New York: Oxford University Press, 1981.
- Higgins, Reynold. *Minoan and Mycenaean Art.* Rev. ed. New York: Thames & Hudson, 1997.
- Hood, Sinclair. *The Arts in Prehistoric Greece*. New Haven, Conn.: Yale University Press, 1992.
- Immerwahr, Sarah A. Aegean Painting in the Bronze Age. University Park: Pennsylvania State University Press, 1990
- MacGillivray, J. A. Minotaur: Sir Arthur Evans and the Archaeology of the Minoan Myth. New York: Hill and Wang, 2000.
- Marinatos, Nanno. Art and Religion in Thera: Reconstructing a Bronze Age Society. Athens: Mathioulakis, 1984.
- Marinatos, Spyridon, and Max Hirmer. Crete and Mycenae. London: Thames & Hudson, 1960.
- McDonald, William A., and Carol G. Thomas. Progress into the Past: The Rediscovery of Mycenaean Civilization. 2d ed. Bloomington: Indiana University Press, 1990.
- Preziosi, Donald, and Louise A. Hitchcock. Aegean Art and Architecture. New York: Oxford University Press,
- Taylour, Lord William. *The Mycenaeans*. London: Thames & Hudson, 1990.
- Vermeule, Emily. *Greece in the Bronze Age*. Chicago: University of Chicago Press, 1972.
- Warren, Peter. *The Aegean Civilisations from Ancient Crete to Mycenae*. 2d ed. Oxford: Elsevier-Phaidon, 1989.

CHAPTER 5: Ancient Greece

- Arias, Paolo. A History of One Thousand Years of Greek Vase Painting. New York: Abrams, 1962.
- Ashmole, Bernard. Architect and Sculptor in Classical Greece. New York: New York University Press, 1972.
- Berve, Helmut, Gottfried Gruben, and Max Hirmer. *Greek Temples, Theatres, and Shrines*. New York: Abrams, 1963.
- Biers, William. *The Archaeology of Greece: An Introduction*. 2d ed. Ithaca, N.Y.: Cornell University Press, 1996.
- Boardman, John. *Athenian Black Figure Vases*. Rev. ed. New York: Thames & Hudson, 1985.
- ———. Athenian Red Figure Vases: The Archaic Period. New York: Thames & Hudson, 1988.
- ———. Athenian Red Figure Vases: The Classical Period. New York: Thames & Hudson, 1989.
- ——. Early Greek Vase Painting, 11th–6th Centuries BC. New York: Thames & Hudson, 1998.
- Greek Sculpture: The Archaic Period. Rev. ed. New York: Thames & Hudson, 1985.
- ———. *Greek Sculpture: The Classical Period.* New York: Thames & Hudson, 1987.
- Greek Sculpture: The Late Classical Period and Sculpture in Colonies and Overseas. New York: Thames & Hudson, 1995.
- ——. The Parthenon and Its Sculpture. Austin: University of Texas Press, 1985.
- Camp, John M. *The Archaeology of Athens*. New Haven, Conn.: Yale University Press, 2001.
- Carpenter, Thomas H. *Art and Myth in Ancient Greece*. New York: Thames & Hudson, 1991.
- Charbonneaux, Jean, Roland Martin, and François Villard. *Archaic Greek Art*. New York: Braziller, 1971.
- ———. Classical Greek Art. New York: Braziller, 1972.
- ———. Hellenistic Art. New York: Braziller, 1973.
- Coldstream, J. Nicholas. Geometric Greece. New York: St. Martin's. 1977.

- Coulton, J. J. Ancient Greek Architects at Work. Ithaca, N.Y.: Cornell University Press, 1982.
- Fullerton, Mark D. *Greek Art.* New York: Cambridge University Press, 2000
- Haynes, Denys E. L. *The Technique of Greek Bronze Statu-ary.* Mainz: von Zabern, 1992.
- Houser, Caroline. *Greek Monumental Bronze Sculpture*. New York: Vendome, 1983.
- Hurwit, Jeffrey M. *The Art and Culture of Early Greece*, 1100–480 BC. Ithaca, N.Y.: Cornell University Press, 1985
- The Athenian Acropolis: History, Mythology, and Archaeology from the Neolithic Era to the Present. New York: Cambridge University Press, 1999.
- Jenkins, Ian. *Greek Architecture and Its Sculpture*. Cambridge, Mass.: Harvard University Press, 2006.
- ——. The Parthenon Frieze. Austin: University of Texas Press, 1994.
- Lawrence, Arnold W., and R. A. Tomlinson. *Greek Architecture*. Rev. ed. New Haven, Conn.: Yale University Press, 1996.
- Martin, Roland. *Greek Architecture: Architecture of Crete, Greece, and the Greek World.* New York: Electa/Rizzoli,
- Mattusch, Carol C. Classical Bronzes: The Art and Craft of Greek and Roman Statuary. Ithaca, N.Y.: Cornell University Press, 1996.
- Greek Bronze Statuary from the Beginnings through the Fifth Century BC. Ithaca, N.Y.: Cornell University Press, 1988.
- Mee, Christopher, and Tony Spawforth. *Greece: An Oxford Archaeological Guide*. New York: Oxford University Press, 2001.
- Morris, Sarah P. *Daidalos and the Origins of Greek Art.* Princeton, N.J.: Princeton University Press, 1992.
- Osborne, Robin. Archaic and Classical Greek Art. New York: Oxford University Press, 1998.
- Palagia, Olga. *The Pediments of the Parthenon*. Leiden: E. J. Brill, 1993.
- , ed. Greek Sculpture: Functions, Materials, and Techniques in the Archaic and Classical Periods. New York: Cambridge University Press, 2006.
- Palagia, Olga, and Jerome J. Pollitt. *Personal Styles in Greek Sculpture.* New York: Cambridge University Press, 1996.
- Pedley, John Griffiths. *Greek Art and Archaeology.* 4th ed. Upper Saddle River, N.J.: Prentice Hall, 2007.
- Pollitt, Jerome J. *Art and Experience in Classical Greece*. New York: Cambridge University Press, 1972.
- ———. Art in the Hellenistic Age. New York: Cambridge University Press, 1986.
- Pugliese Carratelli, G. *The Greek World: Art and Civilization* in Magna Graecia and Sicily. New York: Rizzoli, 1996.
- Reeder, Ellen D., ed. *Pandora: Women in Classical Greece.* Baltimore: Walters Art Gallery, 1995.
- Rhodes, Robin F. Architecture and Meaning on the Athenian Acropolis. New York: Cambridge University Press, 1995.
- Richter, Gisela M. *The Portraits of the Greeks*. Rev. ed. by R.R.R. Smith. Ithaca, N.Y.: Cornell University Press, 1984.
- Ridgway, Brunilde S. *The Archaic Style in Greek Sculpture*. 2d ed. Chicago: Ares, 1993.
- ——. Fifth-Century Styles in Greek Sculpture. Princeton, N.J.: Princeton University Press, 1981.
- ——. Fourth-Century Styles in Greek Sculpture. Madison: University of Wisconsin Press, 1997.
- ------. Hellenistic Sculpture I: The Styles of ca. 331–200 BC. Madison: University of Wisconsin Press, 1990.
- ------. Hellenistic Sculpture II: The Styles of ca. 200–100 BC. Madison: University of Wisconsin Press, 2000.
- ———. Prayers in Stone: Greek Architectural Sculpture.
 Berkeley: University of California Press, 1999.

- ——. Roman Copies of Greek Sculpture: The Problem of the Originals. Ann Arbor: University of Michigan Press, 1984.
- Robertson, Martin. *The Art of Vase-Painting in Classical Athens*. New York: Cambridge University Press, 1992.
- ——. *A History of Greek Art.* Rev. ed. 2 vols. New York: Cambridge University Press, 1986.
- ——. A Shorter History of Greek Art. New York: Cambridge University Press, 1981.
- Shapiro, H. Alan. Art and Cult in Athens under the Tyrants. Mainz: von Zabern, 1989.
- ———. Myth into Art: Poet and Painter in Classical Greece. New York: Routledge, 1994.
- Smith, R. R. R. Hellenistic Sculpture. New York: Thames & Hudson, 1991.
- Spawforth, Tony. *The Complete Greek Temples*. London, Thames & Hudson, 2006.
- Spivey, Nigel. Greek Art. London: Phaidon, 1997.
- Stansbury-O'Donnell, Mark D. Pictorial Narrative in Ancient Greek Art. New York: Cambridge University Press, 1999.
- Stewart, Andrew. Art, Desire, and the Body in Ancient Greece. New York: Cambridge University Press, 1997.
- ——. Greek Sculpture: An Exploration. 2 vols. New Haven, Conn.: Yale University Press, 1990.
- Wycherley, Richard E. How the Greeks Built Cities. New York: Norton, 1976.

Chapter 6:

SOUTH AND SOUTHEAST ASIA BEFORE 1200

- Asher, Frederick M. *The Art of Eastern India*, 300–800. Minneapolis: University of Minnesota Press, 1980.
- Blurton, T. Richard. *Hindu Art*. Cambridge, Mass.: Harvard University Press, 1993.
- Chaturachinda, Gwyneth, Sunanda Krishnamurty, and Pauline W. Tabtiang. *Dictionary of South and South*east Asian Art. Chiang Mai, Thailand: Silkworm Books, 2000.
- Chihara, Daigoro. *Hindu-Buddhist Architecture in Southeast Asia*. Leiden: E. J. Brill, 1996.
- Craven, Roy C. *Indian Art: A Concise History*. Rev. ed. London: Thames & Hudson, 1997.
- Dehejia, Vidya. *Early Buddhist Rock Temples*. Ithaca, N.Y.: Cornell University Press, 1972.
- Desai, Vishakha N., and Darielle Mason. Gods, Guardians, and Lovers: Temple Sculptures from North India AD 700–1200. New York: Asia Society Galleries, 1993.
- Encyclopedia of Indian Temple Architecture. 8 vols. New Delhi: American Institute of Indian Studies; Philadelphia: University of Pennsylvania Press, 1983–1996.
- Fisher, Robert E. *Buddhist Art and Architecture*. New York: Thames & Hudson, 1993.
- Frederic, Louis. Borobudur. New York: Abbeville, 1996.
- Gopinatha Rao, T. A. Elements of Hindu Iconography. 2d ed. 4 vols. New York: Paragon, 1968.
- Harle, James C. The Art and Architecture of the Indian Subcontinent. 2d ed. New Haven, Conn.: Yale University Press, 1994.
- Huntington, Susan L., and John C. Huntington. *The Art of Ancient India: Buddhist, Hindu, Jain.* New York: Weatherhill, 1985.
- Jacques, Claude, and Michael Freeman. *Angkor: Cities and Temples*. Bangkok: River Books, 1997.
- Jessup, Helen Ibbitson, and Thierry Zephir, eds. Sculpture of Angkor and Ancient Cambodia: Millennium of Glory. Washington, D.C.: National Gallery of Art, 1997.
- McIntosh, Jane R. A Peaceful Realm: The Rise and Fall of the Indus Civilization. Boulder, Colo.: Westview, 2002.
- Michell, George. *Hindu Art and Architecture*. New York: Thames & Hudson, 2000.
- ——. The Hindu Temple: An Introduction to Its Meaning and Forms. Chicago: University of Chicago Press, 1988.

- Mitter, Partha. *Indian Art*. New York: Oxford University Press. 2001.
- Possehl, Gregory L. *The Indus Civilization: A Contempo*rary Perspective. Lanham, Md.: AttaMira, 2002.
- Rawson, Phillip. *The Art of Southeast Asia.* New York: Thames & Hudson, 1990.
- Srinivasan, Doris Meth. Many Heads, Arms, and Eyes: Origin, Meaning, and Form of Multiplicity in Indian Art. Leiden: E. J. Brill, 1997.
- Stierlin, Henri. *Hindu India from Khajuraho to the Temple City of Madurai*. Cologne: Taschen, 1998.
- Williams, Joanna G. The Art of Gupta India: Empire and Province. Princeton, N.J.: Princeton University Press, 1982.

Chapter 7: China and Korea to 1279

- Bush, Susan, and Shio-yen Shih. Early Chinese Texts on Painting. Cambridge, Mass.: Harvard University Press, 1985.
- Cahill, James. The Painter's Practice: How Artists Lived and Worked in Traditional China. New York: Columbia University Press, 1994.
- Clunas, Craig. *Art in China*. New York: Oxford University Press, 1997.
- Fahr-Becker, Gabriele, ed. *The Art of East Asia*. Cologne: Könemann, 1999.
- Fisher, Robert E. *Buddhist Art and Architecture*. New York: Thames & Hudson, 1993.
- Fong, Wen C. Beyond Representation: Chinese Painting and Calligraphy, 8th–14th Century. New Haven, Conn.: Yale University Press, 1992.
- The Great Bronze Age of China: An Exhibition from the People's Republic of China. New York: Metropolitan Museum of Art, 1980.
- Fong, Wen C., and James C. Y. Watt. Preserving the Past: Treasures from the National Palace Museum, Taipei. New York: Metropolitan Museum of Art, 1996.
- Howard, Angela Falco, Li Song, Wu Hong, and Yang Hong. *Chinese Sculpture*. New Haven, Conn.: Yale University Press, 2006.
- Li, Chu-tsing, ed. Artists and Patrons: Some Social and Economic Aspects of Chinese Painting. Lawrence, Kans.: Kress Department of Art History, in cooperation with Indiana University Press, 1989.
- Little, Stephen, and Shawn Eichman. *Taoism and the Arts of China*. Chicago: Art Institute of Chicago, 2000.
- Portal, Jane. *Korea: Art and Archaeology.* New York: Thames & Hudson, 2000.
- Powers, Martin J. Art and Political Expression in Early China. New Haven, Conn.: Yale University Press, 1991.
- Rawson, Jessica. *Ancient China: Art and Archaeology.* New York: Harper & Row, 1980.
- ———, ed. *The British Museum Book of Chinese Art*. New York: Thames & Hudson, 1992.
- Sickman, Laurence, and Alexander C. Soper. *The Art and Architecture of China*. 3d ed. New Haven, Conn.: Yale University Press, 1992.
- Silbergeld, Jerome. Chinese Painting Style: Media, Methods, and Principles of Form. Seattle and London: University of Washington Press, 1982.
- Steinhardt, Nancy S., ed. *Chinese Architecture*. New Haven, Conn.: Yale University Press, 2002.
- Sullivan, Michael. *The Arts of China*. 4th ed. Berkeley: University of California Press, 2000.
- The Birth of Landscape Painting. Berkeley: University of California Press, 1962.
- Thorp, Robert L., and Richard Ellis Vinograd. *Chinese Art and Culture*. New York: Abrams, 2001.
- Vainker, S. J. Chinese Pottery and Porcelain: From Prehistory to the Present. New York: Braziller, 1991.
- Watson, William. *The Arts of China to AD 900.* New Haven, Conn.: Yale University Press, 1995.
- ——. *The Arts of China 900–1620.* New Haven, Conn.: Yale University Press, 2000.

- Weidner, Marsha, ed. Flowering in the Shadows: Women in the History of Chinese and Japanese Painting. Honolulu: University of Hawaii Press, 1990.
- Whitfield, Roger, and Anne Farrer. Caves of the Thousand Buddhas: Chinese Art of the Silk Route. New York: Braziller, 1990.
- Wu, Hung. *Monumentality in Early Chinese Art.* Stanford, Calif.: Stanford University Press, 1996.
- The Wu Liang Shrine: The Ideology of Early Chinese Pictorial Art. Stanford, Calif.: Stanford University Press, 1989.
- Xin, Yang, Nie Chongzheng, Lang Shaojun, Richard M. Barnhart, James Cahill, and Hung Wu. *Three Thousand Years of Chinese Painting*. New Haven, Conn.: Yale University Press, 1997.

Chapter 8: Japan before 1333

- Aikens, C. Melvin, and Takayama Higuchi. *Prehistory of Japan*. New York: Academic, 1982.
- Coaldrake, William H. Architecture and Authority in Japan. London: Routledge, 1996.
- Elisseeff, Danielle, and Vadime Elisseeff. *Art of Japan*. Translated by I. Mark Paris. New York: Abrams, 1985.
- Kidder, J. Edward, Jr. *The Art of Japan*. New York: Park Lane, 1985.
- Kurata, Bunsaku. Horyu-ji: Temple of the Exalted Law. Translated by W. Chie Ishibashi. New York: Japan Society, 1981.
- Mason, Penelope. *History of Japanese Art.* New York: Abrams, 1993.
- Nishi, Kazuo, and Kazuo Hozumi. What Is Japanese Architecture? Translated by H. Mack Horton. New York: Kodansha International, 1985.
- Nishikawa, Kyotaro, and Emily Sano. *The Great Age of Japanese Buddhist Sculpture AD 600–1300.* Fort Worth, Tex.: Kimbell Art Museum, 1982.
- Okudaira, Hideo. *Narrative Picture Scrolls*. Adapted by Elizabeth ten Grotenhuis. New York: Weatherhill, 1973.
- Pearson, Richard J. Ancient Japan. New York: Braziller, 1992.
- Pearson, Richard J., Gina Lee Barnes, and Karl L. Hutterer, eds. Windows on the Japanese Past. Ann Arbor: Center for Japanese Studies, University of Michigan, 1986.
- Rosenfield, John M. *Japanese Art of the Heian Period*, 794–1185. New York: Asia Society, 1967.
- Shimizu, Yoshiaki, ed. *The Shaping of Daimyo Culture* 1185–1868. Washington, D.C.: National Gallery of Art,
- Stanley-Baker, Joan. *Japanese Art.* Rev. ed. New York: Thames & Hudson, 2000.
- Suzuki, Kakichi. Early Buddhist Architecture in Japan. Translated and adapted by Mary Neighbor Parent and Nancy Shatzman Steinhardt. New York: Kodansha International, 1980.
- Weidner, Marsha, ed. Flowering in the Shadows: Women in the History of Chinese and Japanese Painting. Honolulu: University of Hawaii Press, 1990.

Chapter 9: The Etruscans

- Banti, Luisa. *The Etruscan Cities and Their Culture*. Berkeley: University of California Press, 1973.
- Barker, Graeme, and Tom Rasmussen. The Etruscans. Oxford: Blackwell. 1998.
- Boethius, Axel. *Etruscan and Early Roman Architecture*. 2d ed. New Haven, Conn.: Yale University Press, 1978.
- Bonfante, Larissa, ed. Etruscan Life and Afterlife: A Handbook of Etruscan Studies. Detroit: Wayne State University Press, 1986.
- Brendel, Otto J. *Etruscan Art.* 2d ed. New Haven, Conn.: Yale University Press, 1995.
- Cristofani, Mauro. *The Etruscans: A New Investigation*. London: Orbis, 1979.

- De Grummond, Nancy Thomson. Etruscan Myth, Sacred History, and Legend. Philadelphia: University of Pennsylvania Museum, 2006.
- Haynes, Sybille. *Etruscan Civilization: A Cultural History*. Los Angeles: J. Paul Getty Museum, 2000.
- Heurgon, Jacques. *Daily Life of the Etruscans*. London: Weidenfeld & Nicolson, 1964.
- Pallottino, Massimo. The Etruscans. Harmondsworth: Penguin, 1978.
- Richardson, Emeline. *The Etruscans: Their Art and Civilization*. Rev. ed. Chicago: University of Chicago
- Ridgway, David, and Francesca Ridgway, eds. *Italy before* the Romans. New York: Academic, 1979.
- Spivey, Nigel. *Etruscan Art.* New York: Thames & Hudson, 1997.
- Spivey, Nigel, and Simon Stoddart. Etruscan Italy: An Archaeological History. London: Batsford, 1990.
- Sprenger, Maja, Gilda Bartoloni, and Max Hirmer. The Etruscans: Their History, Art, and Architecture. New York: Abrams, 1983.
- Steingräber, Stephan. Abundance of Life: Etruscan Wall Painting. Los Angeles: J. Paul Getty Museum, 2006.
- Torelli, Mario, ed. The Etruscans. New York: Rizzoli, 2001.

CHAPTER 10: The Roman Empire

- Anderson, James C., Jr. *Roman Architecture and Society*. Baltimore: Johns Hopkins University Press, 1997.
- Andreae, Bernard. *The Art of Rome.* New York: Abrams, 1977.
- Bianchi Bandinelli, Ranuccio. *Rome: The Center of Power: Roman Art to AD 200*. New York: Braziller, 1970.
- ———. Rome: The Late Empire: Roman Art AD 200–400. New York: Braziller, 1971.
- Brendel, Otto J. *Prolegomena to the Study of Roman Art.* New Haven, Conn.: Yale University Press, 1979.
- Claridge, Amanda. Rome: An Oxford Archaeological Guide. New York: Oxford University Press, 1998.
- Clarke, John R. *The Houses of Roman Italy, 100 BC–AD 250.* Berkeley: University of California Press, 1991.
- Cornell, Tim, and John Matthews. *Atlas of the Roman World*. New York: Facts on File, 1982.
- D'Ambra, Eve. *Roman Art.* New York: Cambridge University Press, 1998.
- ——, ed. *Roman Art in Context*. Upper Saddle River, N.J.: Prentice Hall, 1994.
- Dobbins, John J., and Pedar Foss, eds. *The World of Pom-*
- peii. London: Routledge, 2007. Gazda, Elaine K., ed. Roman Art in the Private Sphere.
- Ann Arbor: University of Michigan Press, 1991. Grant, Michael. *Cities of Vesuvius: Pompeii and Hercula-neum.* Harmondsworth: Penguin, 1976.
- Hannestad, Niels. Roman Art and Imperial Policy. Aarhus:
- Aarhus University Press, 1986. Henig, Martin, ed. *A Handbook of Roman Art.* Ithaca,
- N.Y.: Cornell University Press, 1983.
- Kent, John P. C., and Max Hirmer. *Roman Coins*. New York: Abrams, 1978.
- Kleiner, Diana E. E. *Roman Sculpture*. New Haven, Conn.: Yale University Press, 1992.
- Kleiner, Diana E. E., and Susan B. Matheson, eds. I Claudia: Women in Ancient Rome. New Haven, Conn.: Yale University Art Gallery, 1996.
- Kleiner, Fred S. *A History of Roman Art*. Belmont, Calif.: Wadsworth, 2007.
- Kraus, Theodor. *Pompeii and Herculaneum: The Living Cities of the Dead.* New York: Abrams, 1975.
- Lancaster, Lynne. Concrete Vaulted Construction in Imperial Rome. New York: Cambridge University Press, 2006.
- Ling, Roger. *Roman Painting*. New York: Cambridge University Press, 1991.
- L'Orange, Hans Peter. *The Roman Empire: Art Forms and Civic Life*. New York: Rizzoli, 1985.
- MacCormack, Sabine G. Art and Ceremony in Late Antiquity. Berkeley: University of California Press, 1981.

- MacDonald, William L. *The Architecture of the Roman Empire I: An Introductory Study.* Rev. ed. New Haven, Conn.: Yale University Press, 1982.
- The Architecture of the Roman Empire II: An Urban Appraisal. New Haven, Conn.: Yale University Press, 1986.
- ——. The Pantheon: Design, Meaning, and Progeny. Cambridge, Mass.: Harvard University Press, 1976.
- Mazzoleni, Donatella. *Domus: Wall Painting in the Roman House*. Los Angeles: J. Paul Getty Museum, 2004.
- McKay, Alexander G. Houses, Villas, and Palaces in the Roman World. Ithaca, N.Y.: Cornell University Press, 1975
- Nash, Ernest. *Pictorial Dictionary of Ancient Rome*. 2d ed. 2 vols. New York: Praeger, 1962.
- Pollitt, Jerome J. The Art of Rome, 753 BC—AD 337: Sources and Documents. Rev. ed. New York: Cambridge University Press, 1983.
- Richardson, Lawrence, Jr. A New Topographical Dictionary of Ancient Rome. Baltimore: Johns Hopkins University Press, 1992.
- ——. *Pompeii: An Architectural History.* Baltimore: Johns Hopkins University Press, 1988.
- Sear, Frank. *Roman Architecture*. Rev. ed. Ithaca, N.Y.: Cornell University Press, 1989.
- Stambaugh, John E. *The Ancient Roman City*. Baltimore: Johns Hopkins University Press, 1988.
- Taylor, Rabun. Roman Builders. New York: Cambridge University Press, 2003.
- Toynbee, Jocelyn M. C. *Death and Burial in the Roman World*. London: Thames & Hudson, 1971.
- Wallace-Hadrill, Andrew. Houses and Society in Pompeii and Herculaneum. Princeton, N.J.: Princeton University Press, 1994.
- Ward-Perkins, John B. Roman Architecture. New York: Electa/Rizzoli, 1988.
- ——. Roman Imperial Architecture. 2d ed. New Haven, Conn.: Yale University Press, 1981.
- Wilson-Jones, Mark. *Principles of Roman Architecture*. New Haven, Conn.: Yale University Press, 2000.
- Wood, Susan. *Roman Portrait Sculpture AD 217–260*. Leiden: E. J. Brill, 1986.
- Yegül, Fikret. Baths and Bathing in Classical Antiquity. Cambridge, Mass.: MIT Press, 1992.
- Zanker, Paul. *Pompeii: Public and Private Life.* Cambridge, Mass.: Harvard University Press, 1998.
- ——. The Power of Images in the Age of Augustus. Ann Arbor: University of Michigan Press, 1988.

Chapter 11: Late Antiquity

- Bowersock, G. W., Peter Brown, and Oleg Grabar, eds. *Late Antiquity: A Guide to the Postclassical World.* Cambridge, Mass.: Harvard University Press, 1998.
- Elsner, Jaś. Art and the Roman Viewer: The Transformation of Art from the Pagan World to Christianity. New York: Cambridge University Press, 1995.
- ——. Imperial Rome and Christian Triumph. New York: Oxford University Press, 1998.
- Finney, Paul Corby. *The Invisible God: The Earliest Christians on Art.* New York: Oxford University Press, 1994.
- Grabar, André. *The Beginnings of Christian Art*, 200–395. London: Thames & Hudson, 1967.
- ———. *Christian Iconography.* Princeton, N.J.: Princeton University Press, 1980.
- Gutmann, Joseph. Sacred Images: Studies in Jewish Art from Antiquity to the Middle Ages. Northampton, Mass.: Variorum, 1989.
- Janes, Dominic. God and Gold in Late Antiquity. New York: Cambridge University Press, 1998.
- Jensen, Robin Margaret. *Understanding Early Christian Art.* New York: Routledge, 2000.
- Koch, Guntram. Early Christian Art and Architecture. London: SCM, 1996.
- Krautheimer, Richard. *Rome, Profile of a City: 312–1308*. Princeton, N.J.: Princeton University Press, 1980.

- Krautheimer, Richard, and Slobodan Curcić. Early Christian and Byzantine Architecture. 4th ed. New Haven, Conn.: Yale University Press, 1986.
- Lowden, John. Early Christian and Byzantine Art. London: Phaidon, 1997.
- Mathews, Thomas P. *The Clash of Gods: A Reinterpreta*tion of Early Christian Art. Rev. ed. Princeton, N.J.: Princeton University Press, 1999.
- Milburn, Robert. *Early Christian Art and Architecture*. Berkeley: University of California Press, 1988.
- Nicolai, Vincenzo Fiocchi, Fabrizio Bisconti, and Danilo Mazzoleni. *The Christian Catacombs of Rome: History, Decoration, Inscriptions.* Regensburg: Schnell & Steiner, 2006.
- Perkins, Ann Louise. *The Art of Dura-Europos*. Oxford: Clarendon, 1973.
- Volbach, Wolfgang, and Max Hirmer. *Early Christian Art*. New York: Abrams, 1962.
- Webster, Leslie, and Michelle Brown, eds. *The Transformation of the Roman World*, AD 400–900. Berkeley: University of California Press, 1997.
- Weitzmann, Kurt. Late Antique and Early Christian Book Illumination. New York: Braziller, 1977.
- ——, ed. Age of Spirituality: Late Antique and Early Christian Art, Third to Seventh Century. New York: Metropolitan Museum of Art, 1979.

CHAPTER 12: Byzantium

- Barber, Charles. Figure and Likeness: On the Limits of Representation in Byzantine Iconoclasm. Princeton, N.J.: Princeton University Press, 2002.
- Borsook, Eve. Messages in Mosaic: The Royal Programmes of Norman Sicily. Oxford: Clarendon, 1990.
- Cormack, Robin. *Byzantine Art.* New York: Oxford University Press, 2000.
- ------. Painting the Soul: Icons, Death Masks, and Shrouds. London: Reaktion, 1997.
- ———. Writing in Gold: Byzantine Society and Its Icons. New York: Oxford University Press, 1985.
- Cutler, Anthony. The Hand of the Master: Craftsmanship, Ivory, and Society in Byzantium, 9th–11th Centuries. Princeton, N.J.: Princeton University Press, 1994.
- Demus, Otto. *The Mosaic Decoration of San Marco, Venice.* Chicago: University of Chicago Press, 1990.
- Evans, Helen C., and William D. Wixom, eds. The Glory of Byzantium: Art and Culture of the Middle Byzantine Era AD 843–1261. New York: Metropolitan Museum of Art, 1997.
- Grabar, André. The Golden Age of Justinian: From the Death of Theodosius to the Rise of Islam. New York: Odyssey, 1967.
- Grabar, André, and Manolis Chatzidakis. Greek Mosaics of the Byzantine Period. New York: New American Library, 1964.
- Lowden, John. Early Christian and Byzantine Art. London: Phaidon, 1997.
- Maguire, Henry. Art and Eloquence in Byzantium. Princeton, N.J.: Princeton University Press, 1981.
- —. The Icons of Their Bodies: Saints and Their Images in Byzantium. Princeton, N.J.: Princeton University Press, 1996.
- Mainstone, Rowland J. Hagia Sophia: Architecture, Structure, and Liturgy of Justinian's Great Church. London: Thames & Hudson, 1988.
- Mango, Cyril. Art of the Byzantine Empire, 312–1453: Sources and Documents. Toronto: University of Toronto Press, 1986. Reprint of 1972 ed.
- ——. Byzantine Architecture. New York: Electa/Rizzoli, 1985.
- Mark, Robert, and Ahmet S. Cakmak, eds. *Hagia Sophia* from the Age of Justinian to the Present. New York: Cambridge University Press, 1992.
- Mathews, Thomas F. *Byzantium: From Antiquity to the Renaissance*. New York: Abrams, 1998.

- Ousterhout, Robert. *Master Builders of Byzantium*. Princeton, N.I.: Princeton University Press, 2000.
- Pelikan, Jaroslav. *Imago Dei: The Byzantine Apologia for Icons*. Princeton, N.J.: Princeton University Press, 1990.
- Rodley, Lyn. *Byzantine Art and Architecture: An Introduction.* New York: Cambridge University Press, 1994.
- Von Simson, Otto G. Sacred Fortress: Byzantine Art and Statecraft in Ravenna. Princeton, N.J.: Princeton University Press, 1986.
- Weitzmann, Kurt. The Icon. New York: Dorset, 1987.
 - ——. Illustrations in Roll and Codex. Princeton, N.J.: Princeton University Press, 1970.

CHAPTER 13: The Islamic World

- Allan, James, and Sheila R. Canby. *Hunt for Paradise: Court Arts of Safavid Iran 1501–76*. Geneva: Skira, 2004.
- Atil, Esin. *The Age of Sultan Suleyman the Magnificent.* Washington, D.C.: National Gallery of Art, 1987.
- Baker, Patricia L. *Islamic Textiles*. London: British Museum, 1995.
- Blair, Sheila S., and Jonathan Bloom. The Art and Architecture of Islam 1250–1800. New Haven, Conn.: Yale University Press, 1994.
- Bloom, Jonathan, and Sheila S. Blair. *Islamic Arts*. London: Phaidon, 1997.
- Brend, Barbara. *Islamic Art*. Cambridge, Mass.: Harvard University Press, 1991.
- Canby, Sheila R. *Persian Painting*. London: British Museum, 1993.
- Dodds, Jerrilynn D., ed. *Al-Andalus: The Art of Islamic Spain*. New York: Metropolitan Museum of Art, 1992.
- Ettinghausen, Richard, Oleg Grabar, and Marilyn Jenkins-Madina. *The Art and Architecture of Islam, 650–1250*. Rev. ed. New Haven, Conn.: Yale University Press, 2001.
- Ferrier, Ronald W., ed. *The Arts of Persia*. New Haven, Conn.: Yale University Press, 1989.
- Frishman, Martin, and Hasan-Uddin Khan. The Mosque: History, Architectural Development, and Regional Diversity. New York: Thames & Hudson, 1994.
- Goodwin, Godfrey. A History of Ottoman Architecture. 2d ed. New York: Thames & Hudson, 1987.
- Grabar, Oleg. *The Alhambra*. Cambridge, Mass.: Harvard University Press, 1978.
- ——. The Formation of Islamic Art. Rev. ed. New Haven, Conn.: Yale University Press, 1987.
- Grube, Ernst J. Architecture of the Islamic World: Its History and Social Meaning. 2d ed. New York: Thames & Hudson, 1984.
- Hattstein, Markus, and Peter Delius, eds. *Islam: Art and Architecture.* Cologne: Könemann, 2000.
- & Hudson, 1999. Irwin, Robert. *Islamic Art in Context: Art, Architecture,* and the Literary World. New York: Abrams, 1997.
- Michell, George, ed. *Architecture of the Islamic World*. New York: Thames & Hudson, 1978.
- Necipoglu, Gulru. *The Age of Sinan: Architectural Culture* in the Ottoman Empire. Princeton, N.J.: Princeton University Press, 2005.
- Porter, Venetia. *Islamic Tiles*. London: British Museum, 1995.
- Robinson, Frank. Atlas of the Islamic World. Oxford: Equinox, 1982.
- Schimmel, Annemarie. *Calligraphy and Islamic Culture*. New York: New York University Press, 1984.
- Stierlin, Henri. *Islam I: Early Architecture from Baghdad to Cordoba*. Cologne: Taschen, 1996.
- ———. Islamic Art and Architecture from Isfahan to the Taj Mahal. New York: Thames & Hudson, 2002.
- Ward, Rachel M. *Islamic Metalwork*. New York: Thames & Hudson, 1993.
- Welch, Anthony. *Calligraphy in the Arts of the Islamic World*. Austin: University of Texas Press, 1979.

Chapter 14: Native Arts of the Americas before 1300

- Alva, Walter, and Christopher Donnan. *Royal Tombs of Sipán*. Los Angeles: Fowler Museum of Cultural History, 1993.
- Benson, Elizabeth P., and Beatriz de la Fuente, eds. *Olmec Art of Ancient Mexico*. Washington, D.C.: National Gallery of Art, 1996.
- Berlo, Janet Catherine, ed. Art, Ideology, and the City of Teotihuacan. Washington, D.C.: Dumbarton Oaks, 1992.
- Berlo, Janet Catherine, and Ruth B. Phillips. *Native North*American Art. New York: Oxford University Press,
 1998
- Berrin, Kathleen, ed. *The Spirit of Ancient Peru: Treasures* from the Museo Arqueologico Rafael Larco Herrera.
 San Francisco: Fine Arts Museums of San Francisco, 1997.
- Brody, J. J., and Rina Swentzell. *To Touch the Past: The Painted Pottery of the Mimbres People.* New York: Hudson Hills, 1996.
- Brose, David. Ancient Art of the American Woodland Indians. New York: Abrams, 1985.
- Bruhns, Karen O. *Ancient South America*. New York: Cambridge University Press, 1994.
- Burger, Richard. *Chavín and the Origins of Andean Civilization*. New York: Thames & Hudson, 1992.
- Carrasco, David. The Oxford Encyclopedia of Mesoamerican Cultures: The Civilizations of Mexico and Central America. New York: Oxford University Press, 2001.
- Clark, John E., and Mary E. Pye, eds. Olmec Art and Archaeology in Mesoamerica. Washington, D.C.: National Gallery of Art, 2000.
- Coe, Michael D. *The Maya*. 7th ed. New York: Thames & Hudson, 2005.
- ——. *Mexico: From the Olmecs to the Aztecs.* 5th ed. New York: Thames & Hudson, 2002.
- Cordell, Linda S. *Ancient Pueblo Peoples*. Washington, D.C.: Smithsonian Institution, 1994.
- Fagan, Brian. Ancient North America: The Archaeology of a Continent. 4th ed. New York: Thames & Hudson, 2005.
- Fash, William. Scribes, Warriors, and Kings: The City of Copan and the Ancient Maya. New York: Thames & Hudson, 1991.
- Feest, Christian F. *Native Arts of North America*. 2d ed. New York: Thames & Hudson, 1992.
- Foster, Michael S., and Shirley Gorenstein, eds. Greater Mesoamerica: The Archaeology of West and Northwest Mexico. Salt Lake City: University of Utah Press, 2000.
- Grube, Nikolai, ed. *Maya: Divine Kings of the Rain Forest.* Cologne: Könemann, 2000.
- Kolata, Alan. *The Tiwanaku: Portrait of an Andean Civilization*. Cambridge: Blackwell, 1993.
- Kubler, George. *The Art and Architecture of Ancient America: The Mexican, Maya, and Andean Peoples.* 3d ed. New Haven, Conn.: Yale University Press, 1992.
- Miller, Mary Ellen. *The Art of Mesoamerica, from Olmec to Aztec.* 4th ed. New York: Thames & Hudson, 2006.
- ———. *Maya Art and Architecture*. New York: Thames & Hudson, 1999.
- Miller, Mary Ellen, and Karl Taube. *The Gods and Symbols of Ancient Mexico and the Maya: An Illustrated Dictionary of Mesoamerican Religion.* New York: Thames & Hudson, 1993.
- Morris, Craig, and Adriana von Hagen. *The Inka Empire* and Its Andean Origins. New York: Abbeville, 1993.
- Nabokov, Peter, and Robert Easton. *Native American Architecture*. New York: Oxford University Press, 1989.
- Pasztory, Esther. *Pre-Columbian Art.* New York: Cambridge University Press, 1998.
- Paul, Anne. Paracas Ritual Attire: Symbols of Authority in Ancient Peru. Norman: University of Oklahoma Press, 1990.

- Penney, David, and George C. Longfish. *Native American Art*. Hong Kong: Hugh Lauter Levin and Associates, 1994.
- Schele, Linda, and Peter Mathews. The Code of Kings: The Language of Seven Sacred Maya Temples and Tombs. New York: Scribner, 1998.
- Schele, Linda, and Mary E. Miller. *The Blood of Kings: Dynasty and Ritual in Maya Art.* Fort Worth, Tex.:
 Kimbell Art Museum, 1986.
- Schmidt, Peter, Mercedes de la Garza, and Enrique Nalda, eds. *Maya*. New York: Rizzoli, 1998.
- Stone-Miller, Rebecca. *Art of the Andes from Chavín to Inca*. 2d ed. New York: Thames & Hudson, 2002.
- Townsend, Richard F., ed. *Ancient West Mexico*. Chicago: Art Institute of Chicago, 1998.
- Von Hagen, Adriana, and Craig Morris. *The Cities of the Ancient Andes*. New York: Thames & Hudson, 1998.
- Wardwell, Allen. Ancient Eskimo Ivories of the Bering Strait. New York: Rizzoli, 1986.
- Whiteford, Andrew H., Stewart Peckham, and Kate Peck Kent. I Am Here: Two Thousand Years of Southwest Indian Arts and Crafts. Santa Fe: Museum of New Mexico Press, 1989.

CHAPTER 15: AFRICA BEFORE 1800

- Bacquart, Jean-Baptiste. *The Tribal Arts of Africa*. New York: Thames & Hudson, 2002.
- Bassani, Ezio. Arts of Africa: 7,000 Years of African Art. Milan: Skira, 2005.
- Ben-Amos, Paula. *The Art of Benin*. New York: Thames & Hudson, 1980.
- Blier, Suzanne P. Royal Arts of Africa: The Majesty of Form. New York: Abrams, 1998.
- Campbell, Alec, and David Coulson. African Rock Art: Paintings and Engravings on Stone. New York: Abrams, 2001.
- Connah, Graham. *African Civilizations*. 2d ed. Cambridge: Cambridge University Press, 2001.
- Dewey, William J. Legacies of Stone: Zimbabwe Past and Present. Tervuren: Royal Museum for Central Africa,
- Drewal, Henry J., John Pemberton, and Rowland Abiodun. Yoruba: Nine Centuries of African Art and Thought. New York: Center for African Art, in association with Abrams, 1989.
- Eyo, Ekpo, and Frank Willett. *Treasures of Ancient Nigeria*. New York: Knopf, 1980.
- Fagg, Bernard. Nok Terracottas. Lagos: Ethnographica,
- Garlake, Peter. Early Art and Architecture of Africa. Oxford: Oxford University Press, 2002.
- ——. *Great Zimbabwe*. London: Thames & Hudson, 1973.
- Huffman, Thomas N. Snakes and Crocodiles: Power and Symbolism in Ancient Zimbabwe. Johannesburg: Witwatersrand University Press, 1996.
- Lajoux, Jean-Dominique. *The Rock Paintings of Tassili*. Cleveland: World Publishing, 1963.
- Phillips, Tom, ed. Africa, the Art of a Continent. New York: Prestel, 1995.
- Phillipson, D. W. *African Archaeology*. 2d ed. New York: Cambridge University Press, 1993.
- ——. Ancient Ethiopia: Aksum, Its Antecedents and Successors. London: British Museum Press, 1998.
- Schädler, Karl-Ferdinand. Earth and Ore: 2,500 Years of African Art in Terra-Cotta and Metal. Munich: Panterra Verlag, 1997.
- Shaw, Thurstan. *Nigeria: Its Archaeology and Early History.* London: Thames & Hudson, 1978.
- —. Unearthing Igbo-Ukwu: Archaeological Discoveries in Eastern Nigeria. New York: Oxford University Press, 1977.
- Visonà, Monica Blackmun, ed. *A History of Art in Africa*. Upper Saddle River, N.J.: Prentice Hall, 2003.
- Willett, Frank. *Ife in the History of West African Sculpture*. New York: McGraw-Hill, 1967.

MEDIEVAL ART, GENERAL

- Alexander, Jonathan J. G. Medieval Illuminators and Their Methods of Work. New Haven, Conn.: Yale University Press, 1992.
- *The Art of Medieval Spain, AD 500–1200.* New York: Metropolitan Museum of Art, 1993.
- Benton, Janetta Rebold. *Art of the Middle Ages*. New York: Thames & Hudson, 2002.
- Binski, Paul. *Painters (Medieval Craftsmen)*. Toronto: University of Toronto Press, 1991.
- Calkins, Robert G. *Illuminated Books of the Middle Ages*. Ithaca, N.Y.: Cornell University Press, 1983.
- ———. Medieval Architecture in Western Europe: From AD 300 to 1500. New York: Oxford University Press, 1998.
- Coldstream, Nicola. Masons and Sculptors (Medieval Craftsmen). Toronto: University of Toronto Press, 1991.
- ——. Medieval Architecture. New York: Oxford University Press, 2002.
- Cross, Frank L., and Livingstone, Elizabeth A., eds. *The Oxford Dictionary of the Christian Church.* 3d ed. New York: Oxford University Press, 1997.
- De Hamel, Christopher. A History of Illuminated Manuscripts. Oxford: Phaidon, 1986.
- ———. Scribes and Illuminators (Medieval Craftsmen).
 Toronto: University of Toronto Press, 1992.
- Kessler, Herbert L. Seeing Medieval Art. Toronto: Broadview, 2004.
- Spiritual Seeing: Picturing God's Invisibility in Medieval Art. Philadelphia: University of Pennsylvania Press, 2000.
- Lasko, Peter. *Ars Sacra*, 800–1200. 2d ed. New Haven, Conn.: Yale University Press, 1994.
- Murray, Peter, and Linda Murray. *The Oxford Companion* to Christian Art and Architecture. New York: Oxford University Press, 1996.
- Pelikan, Jaroslav. Mary through the Centuries: Her Place in the History of Culture. New Haven, Conn.: Yale University Press, 1996.
- Prache, Anne. *Cathedrals of Europe*. Ithaca, N.Y.: Cornell University Press, 1999.
- Raguin, Virginia Chieffo. Stained Glass from Its Origins to the Present. New York: Abrams, 2003.
- Ross, Leslie. *Medieval Art: A Topical Dictionary*. Westport, Conn.: Greenwood, 1996.
- Schütz, Bernard. Great Cathedrals. New York: Abrams, 2002.
- Sekules, Veronica. *Medieval Art*. New York: Oxford University Press, 2001.
- Snyder, James, Henry Luttikhuizen, and Dorothy Verkerk. *Art of the Middle Ages.* 2d ed. Upper Saddle River, N.J.: Prentice Hall, 2006.
- Stokstad, Marilyn. *Medieval Art.* 2d ed. Boulder, Colo.: Westview, 2004.
- Tasker, Edward G. Encyclopedia of Medieval Church Art. London: Batsford, 1993.

CHAPTER 16: EARLY MEDIEVAL EUROPE

- Alexander, Jonathan J. G. *Insular Manuscripts, Sixth to the Ninth Century.* London: Miller, 1978.
- *The Art of Medieval Spain, AD 500–1200.* New York: Metropolitan Museum of Art, 1993.
- Backhouse, Janet, D. H. Turner, and Leslie Webster, eds. The Golden Age of Anglo-Saxon Art, 966–1066. Bloomington: Indiana University Press, 1984.
- Barral i Altet, Xavier. *The Early Middle Ages: From Late Antiquity to AD 1000.* Cologne: Taschen, 1997.
- Brown, Katharine Reynolds, Dafydd Kidd, and Charles T. Little, eds. *From Attila to Charlemagne*. New York: Metropolitan Museum of Art, 2000.
- Collins, Roger. *Early Medieval Europe*, 300–1000. New York: St. Martin's, 1991.

- Conant, Kenneth J. Carolingian and Romanesque Architecture, 800–1200. 4th ed. New Haven, Conn.: Yale University Press, 1992.
- Davis-Weyer, Caecilia. Early Medieval Art, 300–1150: Sources and Documents. Toronto: University of Toronto Press, 1986. Reprint of 1971 ed.
- Diebold, William J. Word and Image: An Introduction to Early Medieval Art. Boulder, Colo.: Westview Press, 2000.
- Dodwell, Charles R. *Anglo-Saxon Art: A New Perspective*. Ithaca, N.Y.: Cornell University Press, 1982.
- ——. The Pictorial Arts of the West, 800–1200. New Haven, Conn.: Yale University Press, 1993.
- Harbison, Peter. The Golden Age of Irish Art: The Medieval Achievement 600–1200. New York: Thames & Hudson, 1999.
- Henderson, George. From Durrow to Kells: The Insular Gospel-Books, 650–800. London: Thames & Hudson, 1987.
- Hubert, Jean, Jean Porcher, and Wolfgang Fritz Volbach. *The Carolingian Renaissance*. New York: Braziller, 1970.
- ——. Europe of the Invasions. New York: Braziller, 1969.Klindt-Jensen, Ole, and David M. Wilson. Viking Art. 2d ed. Minneapolis: University of Minnesota Press, 1980.
- Mayr-Harting, Henry. Ottonian Book Illumination: An Historical Study. 2 vols. London: Miller, 1991–1993.
- McClendon, Charles. The Origins of Medieval Architecture: Building in Europe, AD 600–900. New Haven, Conn.: Yale University Press, 2005.
- Megaw, Ruth, and John Vincent Megaw. Celtic Art: From Its Beginning to the Book of Kells. New York: Thames & Hudson, 1989.
- Mütherich, Florentine, and Joachim E. Gaehde. *Carolingian Painting*. New York: Braziller, 1976.
- Nees, Lawrence J. *Early Medieval Art.* New York: Oxford University Press, 2002.
- Nordenfalk, Carl. Celtic and Anglo-Saxon Painting: Book Illumination in the British Isles, 600–800. New York: Braziller, 1977.
- O'Brien, Jacqueline, and Peter Harbison. Ancient Ireland: From Prehistory to the Middle Ages. New York: Oxford University Press, 2000.
- Richardson, Hilary, and John Scarry. *An Introduction to Irish High Crosses*. Dublin: Mercier, 1996.
- Stalley, Roger. *Early Medieval Architecture*. New York: Oxford University Press, 1999.
- Wilson, David M. Anglo-Saxon Art: From the Seventh Century to the Norman Conquest. London: Thames & Hudson, 1984.

CHAPTER 17: Romanesque Europe

- Armi, C. Edson. Masons and Sculptors in Romanesque Burgundy: The New Aesthetics of Cluny III. 2 vols. University Park: Pennsylvania State University Press, 1983
- Barral i Altet, Xavier. *The Romanesque: Towns, Cathedrals, and Monasteries*. Cologne: Taschen, 1998.
- Cahn, Walter. Romanesque Bible Illumination. Ithaca, N.Y.: Cornell University Press, 1982.
- ——. Romanesque Manuscripts: The Twelfth Century. 2 vols. London: Miller, 1998.
- Conant, Kenneth J. Carolingian and Romanesque Architecture, 800–1200. 4th ed. New Haven, Conn.: Yale University Press, 1992.
- Demus, Otto. *Romanesque Mural Painting*. New York: Thames & Hudson, 1970.
- Dodwell, Charles R. *The Pictorial Arts of the West*, 800–1200. New Haven, Conn.: Yale University Press, 1993.
- Fergusson, Peter. Architecture of Solitude: Cistercian Abbeys in Twelfth-Century Europe. Princeton, N.J.: Princeton University Press, 1984.
- Grape, Wolfgang. The Bayeux Tapestry: Monument to a Norman Triumph. New York: Prestel, 1994.

- Hearn, Millard F. Romanesque Sculpture: The Revival of Monumental Stone Sculpture in the Eleventh and Twelfth Centuries. Ithaca, N.Y.: Cornell University Press, 1981
- Kahn, Deborah, ed. *The Romanesque Frieze and Its Spectator.* London: Miller, 1992.
- Male, Émile. Religious Art in France: The Twelfth Century. Rev. ed. Princeton, N.J.: Princeton University Press,
- Minne-Sève, Viviane, and Hervé Kergall. Romanesque and Gothic France: Architecture and Sculpture. New York: Abrams, 2000.
- Nichols, Stephen G. Romanesque Signs: Early Medieval Narrative and Iconography. New Haven, Conn.: Yale University Press, 1983.
- Nordenfalk, Carl. *Early Medieval Book Illumination*. New York: Rizzoli, 1988.
- Petzold, Andreas. Romanesque Art. New York: Abrams, 1995. Schapiro, Meyer. The Sculpture of Moissac. New York: Thames & Hudson, 1985.
- Stalley, Roger. *Early Medieval Architecture*. New York: Oxford University Press, 1999.
- Tate, Robert B., and Marcus Tate. *The Pilgrim Route to Santiago*. Oxford: Phaidon, 1987.
- Toman, Rolf, ed. *Romanesque: Architecture, Sculpture, Painting.* Cologne: Könemann, 1997.
- Zarnecki, George, Janet Holt, and Tristram Holland, eds. English Romanesque Art, 1066–1200. London: Weidenfeld & Nicolson, 1984.

CHAPTER 18: GOTHIC EUROPE

- Bony, Jean. The English Decorated Style: Gothic Architecture Transformed, 1250–1350. Ithaca, N.Y.: Cornell University Press, 1979.
- French Gothic Architecture of the Twelfth and Thirteenth Centuries. Berkeley: University of California Press, 1983.
- Branner, Robert. Manuscript Painting in Paris during the Reign of St. Louis. Berkeley: University of California Press, 1977.
- ------. St. Louis and the Court Style in Gothic Architecture. London: Zwemmer, 1965.
- , ed. *Chartres Cathedral*. New York: Norton, 1969.

 Brown, Sarah, and David O'Connor. *Glass-Painters (Me*
- Brown, Sarah, and David O'Connor. Glass-Painters (Medieval Craftsmen). Toronto: University of Toronto Press, 1991.
- Camille, Michael. *Gothic Art: Glorious Visions*. New York: Abrams, 1996.
- The Gothic Idol: Ideology and Image-Making in Medieval Art. New York: Cambridge University Press, 1989.
- Courtenay, Lynn T., ed. *The Engineering of Medieval Cathedrals*. Aldershot: Scolar, 1997.
- Erlande-Brandenburg, Alain. The Cathedral: The Social and Architectural Dynamics of Construction. New York: Cambridge University Press, 1994.
- -----. Gothic Art. New York: Abrams, 1989.
- Favier, Jean. *The World of Chartres*. New York: Abrams, 1990.
- Fitchen, John. *The Construction of Gothic Cathedrals: A Study of Medieval Vault Erection*. Chicago: University of Chicago Press, 1981.
- Frankl, Paul, and Paul Crossley. *Gothic Architecture*. New Haven, Conn.: Yale University Press, 2000.
- The Gothic: Literary Sources and Interpretations through Eight Centuries. Princeton, N.J.: Princeton University Press, 1960.
- Frisch, Teresa G. *Gothic Art 1140–c. 1450: Sources and Documents.* Toronto: University of Toronto Press, 1987. Reprint of 1971 ed.
- Gerson, Paula, ed. *Abbot Suger and Saint-Denis*. New York: Metropolitan Museum of Art, 1986.
- Grodecki, Louis. *Gothic Architecture*. New York: Electa/Rizzoli, 1985.

- Grodecki, Louis, and Catherine Brisac. Gothic Stained Glass, 1200–1300. Ithaca, N.Y.: Cornell University Press, 1985.
- Jantzen, Hans. High Gothic: The Classic Cathedrals of Chartres, Reims, Amiens. Princeton, N.J.: Princeton University Press, 1984.
- Male, Émile. Religious Art in France: The Thirteenth Century. Rev. ed. Princeton, N.J.: Princeton University Press, 1984.
- Minne-Sève, Viviane, and Hervé Kergall. Romanesque and Gothic France: Architecture and Sculpture. New York: Abrams, 2000.
- Nussbaum, Norbert. *German Gothic Church Architecture*. New Haven, Conn.: Yale University Press, 2000.
- Panofsky, Erwin. Abbot Suger on the Abbey Church of St.

 Denis and Its Art Treasures. 2d ed. Princeton, N.J.:
 Princeton University Press, 1979.
- Radding, Charles M., and William W. Clark. Medieval Architecture, Medieval Learning. New Haven, Conn.: Yale University Press, 1992.
- Rudolph, Conrad. Artistic Change at St-Denis: Abbot Suger's Program and the Early Twelfth-Century Controversy over Art. Princeton, N.J.: Princeton University Press, 1990.
- Sauerländer, Willibald, and Max Hirmer. *Gothic Sculpture* in France, 1140–1270. New York: Abrams, 1973.
- Scott, Robert A.. The Gothic Enterprise: A Guide to Understanding the Medieval Cathedral. Berkeley and Los Angeles:: University of California Press, 2003.
- Simson, Otto G. von. The Gothic Cathedral: Origins of Gothic Architecture and the Medieval Concept of Order. 3d ed. Princeton, N.J.: Princeton University Press, 1988.
- Toman, Rolf, ed. *The Art of Gothic: Architecture, Sculpture, Painting.* Cologne: Könemann, 1999.
- Williamson, Paul. *Gothic Sculpture*, 1140–1300. New Haven, Conn.: Yale University Press, 1995.
- Wilson, Christopher. *The Gothic Cathedral: The Architecture of the Great Church*, 1130–1530. London: Thames & Hudson, 1990.

RENAISSANCE ART, GENERAL

Adams, Laurie Schneider. *Italian Renaissance Art.* Boulder, Colo.: Westview, 2001.

- Andrés, Glenn M., John M. Hunisak, and Richard Turner. *The Art of Florence*. 2 vols. New York: Abbeville, 1988.
- Campbell, Gordon. *Renaissance Art and Architecture*. New York: Oxford University Press, 2005.
- Campbell, Lorne. Renaissance Portraits: European Portrait-Painting in the Fourteenth, Fifteenth, and Sixteenth Centuries. New Haven, Conn.: Yale University Press, 1990.
- Cole, Bruce. Italian Art, 1250–1550: The Relation of Renaissance Art to Life and Society. New York: Harper & Row, 1987.
- ———. The Renaissance Artist at Work: From Pisano to Titian. New York: Harper Collins, 1983.
- Frommel, Christoph Luitpold. *The Architecture of the Italian Renaissance*. London: Thames & Hudson, 2007.
- Hall, Marcia B. Color and Meaning: Practice and Theory in Renaissance Painting. Cambridge: Cambridge University Press, 1992.
- Hartt, Frederick, and David G. Wilkins. *History of Italian Renaissance Art.* 6th ed. Upper Saddle River, N.J.: Prentice Hall, 2006.
- Haskell, Francis, and Nicholas Penny. Taste and the Antique: The Lure of Classical Sculpture 1500–1900. New Haven, Conn.: Yale University Press, 1981.
- Kent, F. W., and Patricia Simons, eds. Patronage, Art, and Society in Renaissance Italy. Canberra: Humanities Research Centre and Clarendon Press, 1987.
- Levey, Michael. *Florence: A Portrait.* Cambridge, Mass.: Harvard University Press, 1998.
- Lubbock, Jules. Storytelling in Christian Art from Giotto to Donatello. New Haven, Conn.: Yale University Press, 2006.
- Paoletti, John T., and Gary M. Radke. Art, Power, and Patronage in Renaissance Italy. Upper Saddle River, N.J.: Prentice Hall, 2005.
- Pope-Hennessy, John. *Introduction to Italian Sculpture*. 3d ed. 3 vols. New York: Phaidon, 1986.
- Richardson, Carol M., Kim W. Woods, and Michael W. Franklin. Renaissance Art Reconsidered: An Anthology of Primary Sources. Oxford: Blackwell, 2007.
- Smith, Jeffrey Chipps. *The Northern Renaissance*. New York: Phaidon, 2004.
- Snyder, James, Larry Silver, and Henry Luttikhuizen. Northern Renaissance Art: Painting, Sculpture, the

- *Graphic Arts from 1350 to 1575.* Upper Saddle River, N.J.: Prentice Hall, 2005.
- Thomson, David. Renaissance Architecture: Critics, Patrons, and Luxury. Manchester: Manchester University Press, 1993.
- Wittkower, Rudolf. Architectural Principles in the Age of Humanism. 4th ed. London: Academy, 1988.

Chapter 19: Italy, 1200 to 1400

- Bomford, David. *Art in the Making: Italian Painting before* 1400. London: National Gallery, 1989.
- Borsook, Eve, and Fiorelli Superbi Gioffredi. *Italian Altarpieces 1250–1550: Function and Design.* Oxford: Clarendon, 1994.
- Cole, Bruce. Sienese Painting: From Its Origins to the Fifteenth Century. New York: Harper Collins, 1987.
- Hills, Paul. *The Light of Early Italian Painting*. New Haven, Conn.: Yale University Press, 1987.
- Maginnis, Hayden B. J. Painting in the Age of Giotto: A Historical Reevaluation. University Park: Pennsylvania State University Press, 1997.
- ——. The World of the Early Sienese Painter. University Park: Pennsylvania State University Press, 2001.
- Meiss, Millard. Painting in Florence and Siena after the Black Death. Princeton, N.J.: Princeton University Press, 1976.
- Moskowitz, Anita Fiderer. Italian Gothic Sculpture, c. 1250-c. 1400. Cambridge: Cambridge University Press, 2001.
- Norman, Diana, ed. Siena, Florence, and Padua: Art, Society, and Religion 1280–1400. New Haven, Conn.: Yale University Press, 1995.
- Pope-Hennessy, John. *Italian Gothic Sculpture*. 3d ed. Oxford: Phaidon, 1986.
- Stubblebine, James H. *Duccio di Buoninsegna and His School.* Princeton, N.J.: Princeton University Press, 1979.
- White, John. *Art and Architecture in Italy: 1250–1400.* 3d ed. New Haven, Conn.: Yale University Press, 1993.
- ——. Duccio: Tuscan Art and the Medieval Workshop. London: Thames & Hudson, 1979.

CREDITS

The author and publisher are grateful to the proprietors and custodians of various works of art for photographs of these works and permission to reproduce them in this book.

Sources not included in the captions are listed here.

Introduction—I-1: Clifford Still, 1948-C, PH-15, 80-7/8 x 70-3/4 inches, Oil on canvas, © The Clyfford Still Estate. Photo: akg images; I-2: © English Heritage; I-3: akg-images/ Rabatti-Domingie; I-4: National Gallery of Art, Alfred Stieglitz Collection, Bequest of Georgia O'Keeffe; 1987.58.3. © 2007 The Georgia O'Keefe Foundation/Artist's Rights Society (ARS), NY; I-5: Art © Estate of Ben Shahn/Licensed by VAGA, NY, NY. Whitney Museum of American Art, NY. (gift of Edith and Milton Lowenthal in memory of Juliana Force); I-6: www.bednorzphoto.de; I-7: akg images; I-8: Metropolitan Museum of Art, Gift of Junius S. Morgan, 1919 (19.73.209) Image © The Metropolitan Museum of Art; I-9: Courtesy Saskia Ltd., © Dr. Ron Wiedenhoeft; I-10: Photo © Whitney Museum of American Art /© 2007 The Josef and Anni Albers Foundation/Artists Rights Society (ARS), NY; I-11: National Gallery, London. NG14. Bought, 1824; I-12: MOA Art Museum, Shizuoka-ken, Japan; I-13: Bayerische Staatsgemäldesammlungen, Alte Pinakothek, Munich and Kunstdia-Archiv ARTOTHEK, Weilheim, Germany; I-14: Jürgen Liepe, Berlin; I-15: Metropolitan Museum of Art, Michael C. Rockefeller Memorial Collection, Gift of Nelson A. Rockefeller, 1965. (1987.412.309) Photograph © 1983 The Metropolitan Museum of Art; I-16: © Nimatallah/Art Resource, NY; I-17: © Scala/Art Resource, NY; I-19a: © National Library of Australia, Canberra, Australia/The Bridgeman Art Library, NY; I-19b: From The Childhood of Man by Leo Frobenius (New York: J.B. Lippincott, 1909).

Chapter 1—1-1: © Bob Krist/CORBIS; 1-2: Photo: Paul G. Bahn; 1-3: With permission: Namibia Archaeological Trust; 1-4: © Ulmer Museum. Photo: Thomas Stephan; 1-5: © Archivo Iconografico, S.A./CORBIS; 1-6: © Musee des Antiquites Nationales, St. Germain-en-Laye, France, Lauros/Giraudon/The Bridgeman Art Library, NY; 1-7: Jean Vertut; 1-18: © Réunion des Musées Nationaux/Art Resource, NY; 1-9: Jean Vertut; 1-10: Jean Vertut; 1-11: Jean Vertut; 1-11: French Ministry of Culture and Communication, Regional Direction for Cultural Affairs, Rhone-Alpes region, Regional Department of Archaeology; 1-13: Jean Vertut; 1-14: Archivio e Studio Folco Quilici, Roma; 1-15: ANCIENT STATUES FROM JORDAN. These life-size, humanform figures made of plaster and bitumen date from 6500 B.C. And were recovered in 1985 from the statue pit at Ain Ghazal the Neolithic site located on the outskirts of Amman the capital of Jordan. Courtesy of the Hashemite Kingdom of Jordan, Dept. of Antiquities Statues from Ain Ghazal; 1-16: John Swogger/© Catalhoyuk Research Project; 1-17: © Gianni Dagli Orti/CORBIS; 1-18: James Mellaart; 1-19: © Sandro Vannini/CORBIS; 1-20: © Adam Woolfitt/

Chapter 2—2-1: © Réunion des Musées Nationaux/Art Resource, NY; 2-2: © Robert Harding Picture Library; 2-4: © Aladin Abdel Naby/Reuters/CORBIS; 2-5: Erwin Bohm; 2-6: © Erich Lessing/Art Resource, NY; 2-7: © Réunion des Musées Nationaux/Art Resource, NY; 2-8: © British Museum, London, UK/The Bridgeman Art Library, NY; 2-9: © British Museum, London, UK/The Bridgeman Art Library, NY; 2-10 both: University of Pennsylvania Museum of Archaeology and Anthropology, Philadelphia; 2-11: © Copyright the Trustees of The British Museum; 2-12: © Joseph Scherschel/National Geographic Image Collection; 2-13: © Réunion des Musées Nationaux/Art Resource, NY; 2-14: University of Pennsylvania Museum of Archaeology and Anthropology, Philadelphia; 2-15: Erwin Bohm; 2-16: © Erich Lessing/Art Resource, NY; 2-17: © Réunion des Musées Nationaux/Art Resource, NY; 2-18: © Borromeo/Art Resource, NY; 2-19: © Réunion des Musées Nationaux/Art Resource, NY; 2-21: Courtesy Saskia Ltd., © Dr. Ron Wiedenhoeft; 2-22: © British Museum/HIP/Art Resource, NY; 2-23: © Copyright the Trustees of The British Museum; 2-24: © Bildarchiv Preussischer Kulturbesitz/Art Resource, NY; 2-25: The Art Archive/Dagli Orti (A); 2-26: © David Poole/Robert Harding Picture Library; 2-27: akg-images/Gérard Degeorge; 2-28: Courtesy Saskia Ltd., © Dr. Ron Wiedenhoeft

Chapter 3—3-1: © Robert Harding Picture Library; 3-2: J. E. Quibell and F. W. Geen, Hierakonpolis vol. 2 (London 1902) p. 76; 3-3: Hirmer Fotoarchiv, Munich; 3-5: © Werner Forman/Art Resource, NY; 3-7: © Erich Lessing/Art Resource, NY; 3-8: © Yann Arthus-Bertrand/CORBIS; 3-10: Courtesy of the Semitic Museum, Harvard University; 3-11: © Robert Harding Picture Library; 3-12: © Araldo de Luca; 3-13: Museum of Fine Arts, Boston. Harvard University—Boston Museum of Fine Arts Expedition, 11.1738. Photograph © 2008 Museum of Fine Arts, Boston; 3-14: © Erich Lessing/Art Resource, NY; 3-15: Jean Vertut; 3-16: Maurice Babey; 3-17: The Metropolitan Museum of Art, Purchase, Edward S.

Harkness Gift, 1926 (26.7.1394) Photograph © 1979 The Metropolitan Museum of Art; 3-18: © Marburg/Art Resource, NY; 3-19: akg-images/Francois Guenet; 3-20: Getty Research Library, Wim Swaan Photograph Collection, 96.P.21; 3-21: The Metropolitan Museum of Art, Rogers Fund, 1929. (29.3.1) Photograph by Schecter Lee, Photograph © 1986 The Metropolitan Museum of Art; 3-22: © Carmen Redondo/CORBIS; 3-23: © Robert Harding Picture Library; 3-24: Jean Claude Golvin; 3-25: © Robert Harding Picture Library; 3-26: Metropolitan Museum of Art, Levi Hale Willard Bequest, 1890 (90.35.1), and the Frank H. McClung Museum, The University of Tennessee; 3-27: © Bildarchiv Preussischer Kulturbesitz/Art Resource, NY; 3-28: © Archivo Iconografico, S.A./CORBIS; 3-29: © Werner Forman/CORBIS; 3-30: © Araldo de Luca; 3-31: © Bildarchiv Preussischer Kulturbesitz/Art Resource, NY; 3-33: © Bildarchiv Preussischer Kulturbesitz/Art Resource, NY; 3-35: © Robert Harding Picture Library; 3-36: © British Museum/HIP/Art Resource, NY; 3-37: © British Museum/HIP/Art Resource, NY; 3-38: © Yann Arthus-Bertrand/CORBIS.

Chapter 4—4-1: © Pete Saloutos/zefa/CORBIS; 4-2: © Erich Lessing/Art Resource, NY; 4-3: The Art Archive/National Archaeological Museum Athens/Dagli Orti; 4-4: © Yann Arthus-Bertrand/CORBIS; 4-6: © Roger Wood/CORBIS; 4-7: Courtesy Saskia Ltd., © Dr. Ron Wiedenhoeft; 4-8: The Art Archive/Heraklion Museum/Dagli Orti; 4-9: © Nimatallah/Art Resource, NY; 4-10: Hans Hinz; 4-11: © Scala/Art Resource, NY; 4-12: © Nimatallah/Art Resource, NY; 4-13: © British School at Athens; 4-14: © Roger Wood/CORBIS; 4-15: Photo by Raymond V. Schoder, © 1987 by Bolchazy-Carducci Publishers, Inc.; 4-16: © Paul Almasy/CORBIS; 4-19: Copyright © SIME s.a.s /eStock Photo—All rights reserved; 4-20: © Vanni Archive/CORBIS; 4-21: © Vanni Archive/CORBIS; 4-22: © Archivo Iconografico, S.A./CORBIS; 4-23: The Art Archive/National Archaeological Museum Athens/Dagli Orti; 4-24: The Art Archive/National Archaeological Museum Athens/Dagli Orti; 4-25: akg-images.

Chapter 5-5-1: @ Araldo de Luca/CORBIS; 5-2: The Metropolitan Museum of Art, Rogers Fund, 1914. (14.130.14) Photograph © 1996 The Metropolitan Museum of Art; 5-3: The Metropolitan Museum of Art, Gift of J. Pierpont Morgan, 1917. (17.190.2072). Photograph © 1996 The Metropolitan Museum of Art; 5-4: © Museum of Fine Arts, Boston, MA, USA, Denman Waldo Ross Collection/The Bridgeman Art Library, NY; 5-5: © Copyright the Trustees of The British Museum; 5-7: © Réunion des Musées Nationaux/Art Resource, NY; 5-8: The Metropolitan Museum of Art, Fletcher Fund, 1932 (32.11.1). Photograph © 1997 The Metropolitan Museum of Art; 5-9: © Nimatallah/Art Resource, NY; 5-10: © Gianni Dagli Orti/CORBIS; 5-11: © Nimatallah/Art Resource, NY; 5-12: Studio Kontos; 5-15: © Vanni/Art Resource, NY; 5-17: @ Vanni/Art Resource, NY; 5-19: Photo, Henri Stierlin; 5-20: Canali Photobank, Italy; 5-20a: @ Scala/Art Resource, NY; 5-21: @ Scala/Art Resource, NY; 5-22: Museum of Fine Arts, Boston. Henry Lillie Pierce Fund, 01.8037. Photograph © 2008 Museum of Fine Arts, Boston; 5-23: © Réunion des Musées Nationaux/Art Resource, NY; 5-24: Courtesy Saskia Ltd., © Dr. Ron Wiedenhoeft; 5-25: Photo, Henri Stierlin; 5-26: Courtesy Saskia Ltd., © Dr. Ron Wiedenhoeft; 5-27b: © Gianni Dagli Orti/CORBIS; 5-28: Courtesy Saskia Ltd., © Dr. Ron Wiedenhoeft; 5-29: Courtesy Saskia Ltd., © Dr. Ron Wiedenhoeft; 5-30: Canali Photobank, Italy; 5-31: Studio Kontos; 5-32: © Erich Lessing/Art Resource, NY; 5-33: The Art Archive/Olympia Museum Greece/Dagli Orti; 5-34: Studio Kontos; 5-35: © Scala/Art Resource, NY; 5-37: © Erich Lessing/Art Resource, NY; 5-38: © Nimatallah/Art Resource, NY; 5-39: © Scala/Art Resource, NY; 5-40: © Scala/Art Resource, NY; 5-41: © Bildarchiv Preussischer Kulturbesitz/Art Resource, NY; 5-42: @ Yann Arthus-Bertrand/CORBIS; 5-44: Studio Kontos; 5-46: Royal Ontario Museum, Toronto; 5-47: © British Museum, London, UK/The Bridgeman Art Library, NY; 5-48: @ Scala/Art Resource, NY; 5-49: @ Ancient Art and Architecture Collection Ltd.; 5-50a: © British Museum, London, UK/The Bridgeman Art Library, NY; 5-50b: © Scala/Art Resource, NY; 5-50c: © Ancient Art and Architecture Collection Ltd.; 5-51: Photo, Henri Stierlin; 5-52: @ Scala/Art Resource, NY; 5-54: @ Copyright the Trustees of The British Museum; 5-55: Courtesy Saskia Ltd., © Dr. Ron Wiedenhoeft; 5-56: © Nimatallah/Art Resource, NY; 5-57: © Nimatallah/Art Resource, NY; 5-58: © Scala/Art Resource, NY; 5-59: © Réunion des Musées Nationaux/Art Resource, NY; 5-60: © Scala/Art Resource, NY; 5-61: @ Mimmo Jodice/CORBIS; 5-62: @ Scala/Art Resource, NY; 5-63: @ Archivo Iconografico, S.A./CORBIS; 5-64: Studio Kontos; 5-65: Canali Photobank, Italy; 5-66: © Scala/Art Resource, NY; 5-67: © Art Resource, NY; 5-68: Studio Kontos; 5-69: Studio Kontos; 5-70: Canali Photobank, Italy; 5-71: Photo by Raymond V. Schoder, © 1987 by Bolchazy-Carducci Publishers, Inc.; 5-72: Courtesy Saskia Ltd., © Dr. Ron Wiedenhoeft; 5-73: © Vanni/Art Resource, NY; 5-74: Courtesy Saskia Ltd., © Dr. Ron Wiedenhoeft; 5-75b: © Georg Gerster/Photo Researchers, Inc.; 5-77: Studio Kontos; 5-78: © Bildarchiv Preussischer Kulturbesitz/Art Resource, NY; 5-79: © Bildarchiv Preussischer Kulturbesitz/Art Resource, NY; 5-81: © Araldo de Luca/CORBIS; 5-82: © Reiunion des Musées Nationaux/Art Resource, NY; 5-83: © Réunion des Musées Nationaux/Art Resource, NY; 5-84: Courtesy Saskia Ltd., © Dr. Ron Wiedenhoeft; 5-85: © Erich Lessing/Art Resource, NY; 5-86: The Metropolitan Museum of Art, Rogers Fund, 1909 (09.39) Photograph © 1997 The Metropolitan Museum of Art; 5-87: Ny Carlsberg Glyptotek, Copenhagen; 5-88: © Araldo de Luca/CORBIS; 5-89: © Araldo de Luca/CORBIS; 5-89: © Araldo de Luca.

Chapter 6—6-1: © ephotocorp.com; 6-2: © Borromeo/Art Resource, NY; 6-3: © John C. Huntington; 6-4: © Borromeo/Art Resource, NY; 6-5: © National Museum of India, New Delhi/Bridgeman Art Library; 6-6: © Benoy K. Behl; 6-7b: © Scala/Art Resource, NY; 6-8: akg-images/Jean-Louis Nou; 6-10: © The Trustees of the National Museums of Scotland; 6-11: Freer Gallery of Art, Smithsonian Institution, Washington, D.C. Purchase, F1949.9a-d; 6-12: © Benoy K. Behl; 6-13: © John C. Huntington; 6-14: © Lindsay Hebberd/CORBIS; 6-15: © Benoy K. Behl; 6-16: Courtesy Saskia Ltd., © Dr. Ron Wiedenhoeft; 6-17: akg-images/Jean-Louis Nou; 6-18: © Werner Forman/CORBIS; 6-19: © Borromeo/Art Resource, NY; 6-20: akg-images/Jean-Louis Nou; 6-21: © James Davis; Eye Ubiquitous/CORBIS; 6-22: © JC Harle Collection; 6-23a: © David Cumming; Eye Ubiquitous/CORBIS; 6-24: © Jack Fields/CORBIS; 6-55: Robert L. Brown; 6-26: © Yadid Levy/ Robert Harding Picture Library; 6-27: © Charles & Josette Lenars/CORBIS; 6-28: © Luca L. Tettoni/CORBIS; 6-29: © John Gollings; 6-30: © Christophe Loviny/CORBIS; 6-31: © John Gollings; 6-32: © Giraudon/Art Resource, NY.

Chapter 7-7-1: The Art Archive/National Palace Museum, Taiwan; 7-2: © Cultural Relics Publishing House, Beijing; 7-3: @ Asian Art Museum of San Francisco, The Avery Brundage Collection, B60B1032. Used by permission.; 7-4: @ ChinaStock/Sanxingdui Museum of China; 7-5: The Nelson-Atkins Museum of Art, Kansas City, Missouri. Purchase, Nelson Trust, 33-81. Photo: E. G. Schempf; 7-6: akg-images/Laurent Lecat; 7-7: © Hunan Provincial Museum, Changsa City; 7-8: Niche, South Wall Rubbing, h. 68.5 cm, w. 143.3 cm, Far Eastern Seminar Collection, Princeton University Art Museum. Photo: Bruce M. White. @ 2006 Trustees of Princeton University; 7-9: The Nelson-Atkins Museum of Art, Kansas City, Missouri. Purchase, Nelson Trust, 33-521. Photo: Robert Newcombe; 7-11: © Asian Art Museum of San Francisco, The Avery Brundage Collection, B60B1034. Used by permission.; 7-12: © British Museum/HIP/Art Resource, NY; 7-13: © Réunion des Musées Nationaux/Art Resource, NY; 7-14: © Lowell Georgia/CORBIS; 7-15: © Cultural Relics Publishing House, Beijing; 7-17: © Museum of Fine Arts, Boston, MA, USA, Denman Waldo Ross Collection/The Bridgeman Art Library, NY; 7-18: © ChinaStock/Liu Liqun; 7-19: © Victoria & Albert Museum, London/ Art Resource, NY; 7-20: © Lee & Lee Communications/Art Resource, NY; 7-21: © Cultural Relics Publishing House, Beijing; 7-22: @ Asian Art Museum of San Francisco, The Avery Brundage Collection, B60B161. Used by permission; 7-23a: © Liu Liqun/CORBIS; 7-24: © Collection of the National Palace Museum, Taiwan, Republic of China; 7-25: Toyko National Museum. Image © TNM Image Archives. Source: http://TnmArchives.jp; 7-26: © Museum of Fine Arts, Boston, MA, USA, General Funds/The Bridgeman Art Library, NY; 7-27: © Kyongju National Museum, Kyongju; 7-28: @ Archivo Iconografico, S.A./CORBIS; 7-29: National Treasure No. 68, Kansong Museum of Fine Arts. © Kansong Museum, Seoul, Korea.

Chapter 8—8-1: © Sakamoto Photo Research Laboratory/CORBIS; 8-2: Toyko National Museum. Image © TNM Image Archives. Source: http://TnmArchives.jp; 8-3: Toyko National Museum. Image © TNM Image Archives. Source: http://TnmArchives.jp; 8-4: © Georg Gerster/Photo Researchers, Inc.; 8-5: Toyko National Museum. Image © TNM Image Archives. Source: http://TnmArchives.jp; 8-6: Jingu-Shicho, Mie; 8-7: © Archivo Iconografico, S.A./CORBIS; 8-8: Yakushiji Temple, Nara; 8-9a: © Archivo Iconografico, S.A./CORBIS; 8-9b: © DAJ/Getty Images; 8-10: Horyuji, Nara. Photo:Benrido; 8-11: © Sakamoto Photo Research Laboratory/CORBIS; 8-12: Kyoogokokuji (Toji), Kyoto; 8-13: © Sakamoto Photo Research Laboratory/CORBIS; 8-14: © The Gotoh Art Museum, Tokyo; 8-15: © Chogosonshiji Temple, Nara, Japan; 8-16: Todaiji, Nara; 8-17: © Museum of Fine Arts, Boston, MA, USA, Fenollosa-Weld Collection/The Bridgeman Art Library, NY; 8-18: © Zenrin-ji Temple, Kyoto.

Chapter 9—9-1: © Scala/Art Resource, NY; 9-2: Hirmer Fotoarchiv, Munich; 9-3: © David Lees/CORBIS; 9-4: © Araldo de Luca/CORBIS; 9-5: © Mike Andrews/Ancient Art and Architecture Collection Ltd.; 9-6: © Scala/Art Resource, NY; 9-8: © Archivo Iconografico, S.A./CORBIS; 9-9: © Ancient Art and Architecture Collection Ltd.; 9-10: Hirmer Fotoarchiv, Munich; 9-11: © Araldo de Luca/CORBIS; 9-12: © Scala/Art Resource, NY; 9-13: © Araldo de Luca/CORBIS; 9-16: © Scala/Art Resource, NY.

Chapter 10-10-1: @ Roy Rainford/Robert Harding Picture Library; 10-2: @ Charles & Josette Lenars/CORBIS; 10-3: James E. Packer; 10-4: © Scala/Art Resource, NY; 10-7: Photo © Valentino Renzoni, Osimo; 10-8: © 2006 Fred S. Kleiner; 10-9: © Bettmann/CORBIS; 10-10: © Alinari/Art Resource, NY; 10-11: The American Numismatic Society, NY; 10-12: © Alinari/ Art Resource, NY; 10-13: Pubbli Aer Foto; 10-14: © Erich Lessing/Art Resource, NY; 10-15: Photo, Henri Stierlin; 10-17: Photo Archives Skira, Geneva, Switzerland; 10-18: © Scala/Art Resource, NY; 10-19 a/b: Metropolitan Museum of Art, Rogers Fund, 1903. (03.14.13a-g). Photograph © 1986 The Metropolitan Museum of Art; 10-20: © foto Luciano Romano; 10-21: Metropolitan Museum of Art, Rogers Fund, 1920. (20.192.1). Photograph © 1987 The Metropolitan Museum of Art; 10-22: Canali Photobank, Italy; 10-23: Canali Photobank, Italy; 10-24: © Werner Forman/CORBIS; 10-25: © Scala/Art Resource, NY; 10-26: Canali Photobank, Italy; 10-27: © Scala/Art Resource, NY; 10-28: Ny Carlsberg Glyptotek, Copenhagen; 10-29: Courtesy Saskia Ltd., © Dr. Ron Wiedenhoeft; 10-30: Courtesy Saskia Ltd., © Dr. Ron Wiedenhoeft; 10-31: Courtesy Saskia Ltd., © Dr. Ron Wiedenhoeft; 10-32: © Giraudon/Art Resource, NY; 10-33: © Oliver Benn/Getty Images/Stone; 10-34: Photo, Henri Stierlin; 10-36: © Robert Harding Picture Library; 10-37: Ny Carlsberg Glyptotek, Copenhagen; 10-38: © Araldo de

Luca/CORBIS; 10-39: Courtesy Saskia Ltd., © Dr. Ron Wiedenhoeft; 10-40: © 2006 Fred S. Kleiner; 10-41: © 2006 Fred S. Kleiner; 10-42: Photo by Friedrich Rakob; 10-44: Canali Photobank, Italy; 10-45: Photo Marcello Bertinelli/White Star; 10-46: @ Scala/Art Resource, NY; 10-47: © Alinari/Art Resource, NY; 10-48: © 2006 Fred S. Kleiner; 10-49: © Scala/ Art Resource, NY; 10-51: Photo, Henri Stierlin; 10-52: Hervé Champollion/akg-images; 10-53: © Jose Fuste Raga/CORBIS; 10-54: © Scala/Art Resource, NY; 10-55: © 2006 Fred S. Kleiner; 10-56: © Erich Lessing/Art Resource, NY; 10-57: © Scala/Art Resource, NY; 10-58: © Scala/Art Resource, NY; 10-59: © 2006 Fred S. Kleiner; 10-60: Sarcogaphus, Italy, Roman empire, c. 100-125. Greek marble, L. 210 cm. © Cleveland Museum of Art. Gift of the John Huntington Art and Polytechnic Trust, 1928.856; 10-61: @ Scala/Art Resource, NY; 10-62 @ The Trustees of the British Museum; 10-63: © Bildarchiv Preussischer Kulturbesitz/Art Resource, NY; 10-64: The Metropolitan Museum of Art, NY, Samuel D. Lee Fund, 1940. (40.11.1a) Photograph © 1986 The Metropolitan Museum of Art; 10-65: © Araldo de Luca; 10-67: © Scala/Art Resource, NY; 10-68: © Araldo de Luca; 10-69: The Metropolitan Museum of Art, NY, Rogers Fund, 1905. (05.30) Photograph © 1983 The Metropolitan Museum of Art; 10-70: © Araldo de Luca/COR-BIS; 10-71: © Scala/Art Resource, NY; 10-73: Canali Photobank, Italy; 10-74: © 2006 Fred S. Kleiner; 10-75: @ Index/ Artphoto; 10-76: Istituto Centrale per il Catalogo e la Documentazione, (ICCD); 10-77: © 2006 Fred S. Kleiner; 10-79: Courtesy Saskia Ltd., © Dr. Ron Wiedenhoeft; 10-80: Courtesy Saskia Ltd., © Dr. Ron Wiedenhoeft; 10-81b: Staatliche Munzsammlung, Munich; 10-81a: The American Numismatic Society, NY.

Chapter 11—11-1: © Cameraphoto Arte, Venice/Art Resource, NY; 11-2: © Erich Lessing/Art Resource, NY; 11-3: © Art Resource, NY; 11-5: Pontificia Commissione per l'Archeologia Sacra; 11-6: Photo by Darius Arya; 11-7: Foto Archivio di San Pietro in Vaticano; 11-8: Courtesy Saskia Ltd., © Dr. Ron Wiedenhoeft; 11-10: Courtesy Saskia Ltd., © Dr. Ron Wiedenhoeft; 11-11: © Scala/Art Resource, NY; 11-13: Canali Photobank, Italy; 11-14: © Scala/Art Resource, NY; 11-15: © Vanni/Art Resource, NY; 11-16: © Scala/Art Resource, NY; 11-17: © Scala/Art Resource, NY; 11-18: © Scala/Art Resource, NY; 11-19: Copyright © Biblioteca Apostolica Vaticana; 11-20: Österreichische Nationalbibliothek, Vienna, Bildarchiv. folio 7 recto of the Vienna Genesis; 11-21: © Scala/Art Resource, NY; 11-22: © British Museum/HIP/Art Resource, NY; 11-23: © Victoria & Albert Museum, London, UK/The Bridgeman Art Library, NY

Chapter 12—12-1: The Art Archive/Dagli Orti; 12-2: © Yann Arthus-Bertrand/CORBIS; 12-4: Photo, Henri Stierlin; 12-6: Archivio e Studio Folco Quilici, Roma; 12-8: Canali Photobank, Italy; 12-9: © Scala/Art Resource, NY; 12-10: Canali Photobank, Italy; 12-11: Canali Photobank, Italy; 12-12: © Scala/Art Resource, NY; 12-13: © Ronald Sheraton/Ancient Art and Architecture Collection Ltd.; 12-14: © Réunion des Musées Nationaux/Art Resource, NY; 12-15: © British Museum/HIP/Art Resource, NY; 12-16: Österreichische Nationalbibliothek, Vienna, Bildarchiv, Cod.med.gr. 1, fol. 6v; 12-17: Firenze, Biblioteca Medicea Laurenziana, Ms. Laur. Plut. 1.56, c. 13v; 12-18: © Ronald Sheraton/Ancient Art and Architecture Collection Ltd.; 12-19: © Erich Lessing/Art Resource, NY; 12-20: © Scala/Art Resource, NY; 12-22: © Vanni/Art Resource, NY; 12-23: Studio Kontos; 12-24: © Alinari/Art Resource, NY; 12-25: © Scala/Art Resource, NY; 12-26: © Réunion des Musées Nationaux/Art Resource, NY; 12-27: Josephine Powell; 12-28: © Snark/Art Resource, NY; 12-29: © Scala/Art Resource, NY; 12-30: Kariye Camii, Istanbul, Turkey, © Held Collection/The Bridgeman Art Library, NY; 12-31: Icon Gallery of Saint Clement, Ohrid; 12-32: © Erich Lessing/Art Resource, NY; 12-33: © Scala/Art Resource, NY;

Chapter 13—13-1: The Art Archive/Dagli Orti; 13-2: © Moshe Shai/CORBIS; 13-3: © Erich Lessing/Art Resource, NY; 13-4: Photo Archives Skira, Geneva, Switzerland; 13-5: Photo, Henri Stierlin; 13-7: © Bildarchiv Preussischer Kulturbesitz/Art Resource, NY; 13-8a: © Yann Arthus-Bertrand/CORBIS; 13-9: Photo, Henri Stierlin; 13-10: © E. Simanor/Robert Harding Picture Library; 13-11: www.bednorz-photo.de; 13-12: www.bednorz-photo.de; 13-13: @ Adam Woolfit/Robert Harding Picture Library; 13-14: @ Musée Lorrain, Nancy, France/photo G. Mangin; 13-15: © The State Hermitage Museum, St. Petersburg; 13-16: © The Trustees of the Chester Beatty Library, Dublin; 13-17: © Toyohiro Yamada/Getty Images/Taxi; 13-18: Photo, Henri Stierlin; 13-20: Photo, Henri Stierlin; 13-21: Photo, Henri Stierlin; 13-22: Photo Henri Stierlin; 13-24: @ SEF/Art Resource, NY; 13-25: Metropolitan Museum of Art, Harris Brisbane Dick Fund, 1939 (39.20) Photograph © 1982 The Metropolitan Museum of Art; 13-26: © Erich Lessing/Art Resource, NY; 13-27: AKTC 2005.01 [M200] © Aga Khan Trust for Culture, formerly in the collection of Prince and Princess Sadruddin Aga Khan; 13-28: © Victoria & Albert Museum, London/Art Resource, NY; 13-29: © Copyright the Trustees of The British Museum; 13-30: © Réunion des Musées Nationaux/Art Resource, NY; 13-31: Freer Gallery of Art Washington, D.C., Purchase, F1941.10.

Chapter 14—14-1: © The British Museum/HIP/The Image Works; 14-2: © Danny Lehman/CORBIS; 14-3: © Werner Forman/Art Resource NY; 14-4: Los Angeles County Museum of Art, The Proctor Stafford Collection, purchased with funds provided by Mr. and Mrs. Allan C. Balch. Photograph © 2006 Museum Associates/LACMA; 14-5: © Georg Gerster/Photo Researchers, Inc.; 14-6: @ Gianni Dagli Orti/CORBIS; 14-7: The Art Archive/Dagli Orti; 14-8: © Philip Baird www.anthroarcheart.org; 14-9: © Sean Sprague/The Image Works; 14-10: © Enzo and Paolo Rogazzini/CORBIS; 14-11: akg-images/François Guénet; 14-12: © 2007 Peabody Museum of Archaeology and Ethnology , Harvard University, Cambridge. 48-63-20/17561 T1021.2 (detail); 14-13: © Danny Lehman/CORBIS; 14-14: © Yann Arthus-Bertrand/CORBIS; 14-15: © Scala/Art Resource, NY; 14-16: © Yann Arthus-Bertrand/ CORBIS; 14-17: © Jonathan Blair/CORBIS; 14-18: Metropolitan Museum of Art, NY, Jan Mitchell and Sons Collection. Gift of Jan Mitchell, 1991 (1991.419.31) Photography by Justin Kerr. Photograph © 1984 The Metropolitan Museum of Art; 14-19: © Instituto Nacional de Cultura, Lima, Peru; 14-20: Museum of Fine Arts, Boston, William A. Paine Fund, 1931, 31.501. Photograph © 2008 Museum of Fine Arts, Boston; 14-21: Peru, South Coast, Nazca Culture, Dome-shaped jar depicting ceremonial figure, 50–200 A.D., ceramic, 15 \times 15 cm, Kate S. Buckingham Endowment, 1955.2128, The Art Institute of Chicago. Photography © The Art Institute of Chicago; 14-22: © Charles & Josette Lenars/CORBIS; 14-23: © Nathan Benn/ CORBIS; 14-24: Museo Tumbas Reales de Sipan/Lambayeque, Peru; 14-25: © Hubert Stadler/ CORBIS; 14-26: © National Museum of Archaeology, Anthropology, and History of Peru;

14-27: © Werner Forman/CORBIS; 14-28: © Ohio Historical Society; 14-29: © Tony Linck/ SuperStock; 14-30: © Werner Forman/Art Resource, NY; 14-31: Southwest, Mimbres Culture, Bowl, c. 1100–1250, ceramic, pigment, Purchased from Mr. George Teraski. Hugh L. and Mary T. Adams Fund income, 1976-306. Photography © The Art Institute of Chicago; 14-32: © Kevin Fleming/CORBIS.

Chapter 15—15-1: © Charles & Josette Lenars/CORBIS; 15-2: © Jean-Dominique Lajoux; 15-3: Photograph © 1980 Dirk Bakker; 15-4: © IZIKO Museum of Cape Town; 15-5: Photograph © 1980 Dirk Bakker; 15-6: Photograph © 1980 Dirk Bakker; 15-7: Photograph by Franko Khoury, National Museum of African Art, Smithsonian Institution, Museum purchase, 86-12-1; 15-8: © Yann Arthus-Bertrand/CORBIS; 15-9: © Gavin Hellier/Getty Images/Robert Harding Picture Library; 15-10: © I. Vanderharst/Getty Images/Robert Harding Picture Library; 15-11: © Great Zimbabwe Site Museum, Great Zimbabwe; 15-12: Metropolitan Museum of Art. The Michael C. Rockefeller Memorial Collection, Gift of Nelson A. Rockefeller, 1972. (1978.412.323) Photograph © 1995 The Metropolitan Museum of Art; 15-13: © British Museum/HIP/Art Resource, NY; 15-14: © Museo Nazionale Preistorico e Etnografico Luigi Pigorini, Rome.

Chapter 16—16-1: © British Library/HIP/Art Resource, NY; 16-2: © Réunion des Musées Nationaux/Art Resource, NY; 16-3: © British Museum/HIP/Art Resource, NY; 16-4: University Museum of National Antiquities, Oslo, Norway. Eirik Irgens Johnsen; 16-5: © Erich Lessing/Art Resource, NY; 16-6: © The Board of Trinity College, Dublin, Ireland/The Bridgeman Art Library, NY; 16-7: akg-images/British Library; 16-8: © The Board of Trinity College, Dublin, Ireland/The Bridgeman Art Library, NY; 16-9: Courtesy Saskia Ltd., © Dr. Ron Wiedenhoeft; 16-10: The Art Archive/Dagli Orti; 16-11: Archivo Historico Nacional, Madrid; 16-12: © Louvre, Paris, France, Lauros/Giraudon/The Bridgeman Art Library, NY; 16-13: University Library, Utrecht; 16-16: © The Pierpont Morgan Library/Art Resource, NY; 16-15: University Library, Utrecht; 16-16: © The Pierpont Morgan Library/Art Resource, NY; 16-19: akg-images; 16-20: www.bednorz-photo.de; 16-21: www.bednorz-photo.de; 16-22: www.bednorz-photo.de; 16-24: Photo: Dom-Museum, Hildesheim (Frank Tomio); 16-25: Photo: Dom-Museum, Hildesheim (Frank Tomio); 16-29: Bayerische Staatsbibliothek, Munich; 16-28: Bayerische Staatsbibliothek, Munich; 16-29: Bayerische Staatsbibliothek,

Chapter 17—17-1: © Vanni/Art Resource, NY; 17-2: Claude Huber; 17-4: Jean Dieuzaide; 17-6: akg-images/Stefan Drechsel; 17-7: The Art Archive /Dagli Orti; 17-9a: © Michael Busselle/ Robert Harding Picture Library; 17-9b: © St. Pierre, Moissac, France, Peter Willi/The Bridgeman Art Library, NY; 17-11: akg-images/Elizabeth Disney; 17-12: akg-images/Paul M.R. Maeyaert; 17-13: Hervé Champollion/ akg-images; 17-14: www.bednorz-photo.de; 17-15: © Erich Lessing/Art Resource, NY; 17-16a: www.bednorz-photo.de; 17-16b: © Vanni/Art Resource, NY; 17-17: Museum of Fine Arts, Boston, Maria Antoinette Evans Fund, 21.1285. Photograph © 2008 Museum of Fine Arts, Boston; 17-18: The Metropolitan Museum of Art, Gift of J. Pierpont Morgan, 1916. (16.32.194) Photograph © 1999 The Metropolitan Museum of

Art; 17-19: © Florian Monheim, www.bildarchiv-monheim.de; 17-20: Pubbli Aer Foto; 17-21: Canali Photobank, Italy; 17-22: Abtei St. Hildegard; 17-23: © Scala/Art Resource, NY; 17-24: Photograph Speldoorn © Musées royaux d'Art et d'Histoire - Brussels; 17-25: © Scala/Art Resource, NY; 17-26: akg-images/Rabatti-Domingie; 17-27: © Massimo Listri/CORBIS; 17-28: www.bednorz-photo.de; 17-29: www.bednorz-photo.de; 17-30: Universal Art Images; 17-31: © Anthony Scibilia/Art Resource, NY; 17-33a: © Angelo Hornak/CORBIS; 17-35: By special permission of the City of Bayeux; 17-36: The Master and Fellows of Corpus Christi College, Cambridge; 17-37: Trinity College, Cambridge, England. MS R.17.1.f.283, Eadwine the Scribe.

Chapter 18-1: @ Angelo Hornak/CORBIS; 18-3: www.bednorz-photo.de; 18-5: © Vanni/Art Resource, NY; 18-6: © Vanni/Art Resource, NY; 18-7: © SuperStock, Inc./Super-Stock; 18-8: © Angelo Hornak/CORBIS; 18-9: Courtesy Saskia Ltd., © Dr. Ron Wiedenhoeft; 18-11: Hirmer Fotoarchiv, Munich; 18-13: @ Marc Garanger/CORBIS; 18-15: @ Chartres Cathedral, Chartres, France, Paul Maeyaert/The Bridgeman Art Library, NY; 18-16: © Giraudon/Art Resource, NY; Page 472: © Angelo Hornak/CORBIS; 18-17: www.bednorzphoto.de; 18-18: @ Anthony Scibilia/Art Resource, NY; 18-19: Hirmer Fotoarchiv, Munich; 18-20: © Anthony Scibilia/Art Resource, NY; 18-21: Hirmer Fotoarchiv, Munich; 18-22: © Anthony Scibilia/Art Resource, NY; 18-23: www.bednorz-photo.de; 18-24: © Scala/Art Resource, NY; 18-25: © Giraudon/Art Resource, NY; 18-26: www.bednorz-photo.de; 18-27: Courtesy Saskia Ltd., © Dr. Ron Wiedenhoeft; 18-28: © Adam Woolfitt/CORBIS; 18-29: www.bednorz-photo.de; 18-30: © Giraudon/Art Resource, NY; 18-32: Österreichische Nationalbibliothek, Vienna. Bildarchiv. folio 1 verso of a moralized Bible; 18-31: Bibliotheque Nationale, Paris, France; 18-33: © The Pierpont Morgan Library/Art Resource, NY; 18-34: Bibliotheque Nationale, Paris, France; 18-35: Bibliotheque Nationale, Paris, France; 18-36: © Snark/Art Resource, NY; 18-37: © Réunion des Musées Nationaux/Art Resource, NY; 18-38: Photo © The Walters Art Museum, Baltimore. Acquired by Henry Walters, 1923. Accession No. 71.264; 18-39: © English Heritage; 18-41: © Archivo Iconografico, S.A./CORBIS; 18-42: © Scala/Art Resource, NY; 18-43: © Werner Forman/CORBIS; 18-44: © Angelo Hornak/CORBIS; 18-45: © Felix Zaska/CORBIS; 18-46: © Svenja-Foto/zefa/CORBIS; 18-47: www.bednorz-photo.de; 18-48: www.bednorz-photo.de; 18-49: www.bednorz-photo.de; 18-50: © Erich Lessing/Art Resource, NY; 18-51: © Erich Lessing/Art Resource, NY; 18-52: © Erich Lessing/Art Resource, NY; 18-53: © Erich Lessing/Art Resource, NY.

Chapter 19—19-1: © Scala/Art Resource, NY; 19-2: Canali Photobank, Italy; 19-3: © Scala/Art Resource, NY; 19-4: © Scala/Art Resource, NY; 19-5: © Scala/Art Resource, NY; 19-6: Photo by Ralph Lieberman; 19-7: © Scala/Art Resource, NY; 19-8: © Summerfield Press/CORBIS; 19-9: © Scala/Art Resource, NY; 19-10: © Scala/Art Resource, NY; 19-11: © Scala/Art Resource, NY; 19-12: Canali Photobank, Italy; 19-13: Canali Photobank, Italy; 19-13: Canali Photobank, Italy; 19-14: © Scala/Art Resource, NY; 19-15: © MUZZI FABIO/CORBIS SYGMA; 19-16: © Scala/Art Resource, NY; 19-17: © Scala/Art Resource, NY; 19-18: © MUZZI FABIO/CORBIS SYGMA; 19-19: Photo by Ralph Lieberman; 19-20 both: © Scala/Art Resource, NY; 19-21: www.bednorz-photo.de; 19-22: © Scala/Art Resource, NY.

INDEX

Boldface names refer to artists. Page numbers in italics refer to illustrations.

Aachen, 416, 417, 427; Palatine Chapel, 332, 419, 419, 421, 422, 451 Aachen Gospels, folio from, 5 Abbasids, 342, 347, 348, 353, 356, 363 Abbey of Citeaux, 439, 443 Abd al-Malik, 344; Dome of the Rock and, 342, 343 Abd al-Rahman, 348, 363 Abelard, Peter: and Scholasticism, 466 Abraham and Lot, mosaic of, 301,301 Abstract painting, 4 Abu Simbel, 70, 71, 77; Temple of Ramses II, 68-69, 69 Achaemenid dynasty, 48, 51, 162 Achilles, 112, 114, 115 Achilles and Ajax playing a dice game (Andokides Painter), 115; (Exekias), 115 Achilles Painter, 5; work of, 134-135, 135 Acropolis, 91, 109, 125-134, 127, 128, 129, 130, 131, 132, 133, 143, 147; aerial view of, 126; Persian sack of, 48, 125, 128, 155; restored view of, 126 Actium, 145, 254, 255, 287 Adad, 33; bull of, 47 Adam and Eve, 294, 336, 410, 424, 449; art about, 293; death of, 331 Adam and Eve (Wiligelmo), 452, 452 Adena culture, 388, 389 Admonitions of the Instructress to the Court Ladies (Gu Kaizhi), 190, 191, 216

Adoration of the Shepherds (Giovanni Pisano), 499 Adoration of the Shepherds (Nicola Pisano), 498, 499 Aegean, 84, 87, 90; archaeology of, 82; map of, 82 Aegina: Classical period transition and, 117-118; Temple of Aphaia, 117-118, 117, 118, 119, 149 Aegisthus, 119, 274 Aelian, on Polykleitos, 124 Aeneas, 256, 263 Aeneid (Vergil), 154, 304 Aeschylus, 100, 119, 143, 155; Oresteia trilogy and, 118 Aesculapius (Asklepios), 101, 143 Africa: early cultures of, 394-398; European colonization of, 399; peoples/sites of, 394 (map); prehistory of, 394-398, 405 African art, 16; dating, 395; leadership and, 397; worldwide appreciation of, 395 African rock art, 394-395, 395, 405 Agamemnon, King, 80, 81, 92, 93, 94, 96, 119, 274 Age of art, questions about, 2–3 Agora, 100, 130, 146, 147, 153 Agra, Taj Mahal, 342 Ain Ghazal, 24, 25, 29; human figure from, 25 Ajanta, 167, 169, 179; Buddha images at, 167, 169 Akhenaton, 75; Amarna period and, 73-75; artistic revolution of, 79; colossus of, 74; statue of, 73, Akkad, 44; Third Dynasty of Ur and, 39-42

Akkadian ruler, head of, 40

Akkadians, 39, 41, 43; art of, 40, 51

Akrotiri, excavation at, 86, 87 Alaric, King, 301, 309 **Albers, Josef:** work of, 7, 7 Alberti, Leon Battista, 514 Alexander Mosaic, 142, 252 Alexander the Great, 48, 147, 153, 160; death of, 145, 155; Dura-Europos and, 289; Egypt and, 77, 78, 79; head of, 140; India and, 157; Lysippos and, 139, 140; Macedonian court art and, 140-142; Persian conquest by, 49, 51, 137; portraits of, 140 Alexander II, Pope, 450 Alexandria, 145, 155, 269, 327; abandonment of, 341; lighthouse Alexandros of Antioch-on-the-Meander: work of, 150-151, 150 Alhambra, Granada (Spain), 340, 352-353, 363 Al-Khazneh ("Treasury"), 270, 270, 280 Alkyoneos (giant), 148, 154 Allegory of Good Government (Lorenzetti), 512 Altamira (Spain), 22, 23; animal images at, 21; bison at, 19, 22, 56; cave paintings at, 19-20 Altar of Peace, 257 Altar of Zeus, 147-148, 149, 154; detail from, 148; west front Altarpieces, 493, 500 Altar to the Hand and Arm (ikegobo), 402-403, 403 Amarna period (Egypt), 73-75, 77 Amaterasu, shrine of, 210, 211 Amenemhet, tomb of, 66, 66 Amenhotep III, 73, 74

Amenhotep IV, 73

Amen-Re, 68; temple of, 70-71, 70, 71, 78 American School of Classical Studies, 146 Amida (Japan), 214, 216, 220, 220 Amida Descending over the Mountains, 220, 220 Amiens Cathedral (France) (Luzarches, Cormont, and Cormont), 474–475, 476, 486, 487, 495, 509, 514; choir of, 474, 490; interior of, 474; west facade of, 475 Amitabha Buddha (Japan), 161, 193, 194, 214 Amphiprostyle, 109, 133 Amphitheater, Pompeii, 245, 253, 261; aerial view of, 245; brawl in, 246 Amphitheaters, 237, 254, 260, 287 Amphitrite, 253, 253 Amphora, 116-117; black-figure, 104, 105; orientalizing, 104, 104 Ananta, 170, 170 Anasazi, 390 Anastasis, 331, 336, 336 Anastasius I, 409 Anatolia, 335; Neolithic sites in, 24 (map) Anavysos kouros, 107, 107, 108 Ancestral Puebloans, 390, 391 Andean chronology, 380 Andean South America: art in, 380-386; map of, 379 Andhra dynasty, 162, 179 Andokides Painter, 134; work of, 115, 115, 155 Angel Gabriel, 338, 477, 478, 484 Angelico, Fra (Guido di Pietro), 498 Angkor dynasty, 175

Angkor Wat, 176, 179; aerial view of, 177 Anicia Juliana, 324, 325; portrait of, 325, 327 Anicia Juliana between Magnanimity and Prudence, 325 Animal-head post (Viking ship), 410,410 Annunciation, 296, 337, 337, 427, 427 Annunciation (Giovanni Pisano), 499, 499 Annunciation (Martini and Memmi), 509, 509 Annunciation (Nicola Pisano), 493, 499 Annunciation group (Reims Cathedral), 476-477, 477, 478,484 Annunciation to the Shepherds, 427 Antelami, Benedetto, 457; work of, 452-453, 453 Anthemius of Tralles: work of, 313-314, 313, 314 Antioch, 145, 327 Antonines, 263, 272-276, 277, 287 Antoninus Pius, 239, 272, 273 Anubis, 54, 57 Anyang, 183, 184 Apadana, 48, 49 Apartment houses, 270-271; model of, 270 Aphrodite (Venus), 101, 129, 129, 130, 138, 155, 254, 255, 256, 275; statue of, 137, 150 Aphrodite of Knidos (Praxiteles), 137, 137 Apocalypse, 412, 440, 444, 445, 466 Apollo, 101, 113, 225, 254; sanctuary of, 274; statue of, 103, 146 Apollo 11 Cave, 18, 23, 405; stone plaques from, 16, 16 Apollodorus of Damascus, 141, 269, 275; work of, 238, 264-265, 264, 266 Apotheosis of Antoninus Pius and Faustina, 272 Apoxymenos (Lysippos), 139 Apprentices, 510 Apulu of Veii, 225, 226, 226, 227, 228 Aqueducts, 258, 258, 344 Ara Pacis Augustae (Altar of Augustan Peace), 256, 262, 263, 320; described, 256-257; female personification panel of, 256 Arcadius, 301, 311 Archaic period (Greece), 105-118, 224; architecture of, 109, 111–13; art of, 155, 235, 473; sculpture of, 109, 111–113; statuary of, 106-109, 122

Archaic smile, 106, 107, 151, 155 Archangel Michael, ivory of, 324 Arches, 315, 353; chancel, 385, 509; corbeled, 91, 92; diaphragm, 452, 452; ogee, 489, 515; ogival, 464; pointed, 443, 464, 464, 469; semicircular, 464, 464; transverse, 436, 455, 464; triumphal, 262, 282 Architecture, 2; landscape, 48; orders of, 110 Arch of Constantine, 238, 282-283, 283, 291; detail from, 283 Arch of Septimius Severus, 277, 291; relief from, 277 Arch of Titus, 238, 262-263, 262, 266, 277; relief panel from, 263 Arch of Trajan, 266-267, 267 Ardabil carpets, 360 Arena Chapel (Giotto), 496, 504-505 Aristotle, 139, 227, 342, 466; Hippodamos and, 146 Arnolfo di Cambio: work of, 513-514, 514 Artaxerxes I, 49 Arte de Calimala, 506 Arte della Lana, 506 Artemis and Apollo slaying the children of Niobe (Niobid Painter), 135 Artemision Zeus, 122, 123, 123, 124 Art history, 1-2; art market and, 83; in 21st century, 2-12 Art market: archaeology/art history and, 83 Artumes, 225, 226 Ascension of Christ, Rabbula Gospels, 325, 325 Ashlar masonry, 60, 315 Ashoka, 163; Buddhism and, 161-162; Great Stupa and, 179 Ashur, 33, 45 Ashurbanipal: relief of, 46, 135; Susa and, 47 Ashurnasirpal II, 46 Asklepios (Aesculapius), 101, 143 Assur, 33 Assyria, 32, 44, 45-47; animal reliefs of, 231 Assyrians, 31, 45, 51 Asuka period, 210, 212, 214, 221 Athanadoros: work of, 153–154, 153, 154 Athena (Minerva), 101, 118, 120, 120, 147, 149, 154; battling Alkyoneos, 148; defeat of, 137; Poseidon and, 129, 132; statue of,

126, 130, 176

Athena Parthenos (Phidias), 128,

128, 144, 147, 155, 307

Athens: Acropolis, 48, 91, 109, 125-134, 126, 127, 128, 129, 130, 131, 132, 133, 143, 147, 155; Choragic Monument, 144, 145; Hegeso stele, 133-134, 134, 135, 138, 227; Parthenon, 126–127, 126, 127, 128-129, 128, 129, 130-131, 130, 132, 133, 137, 146, 148, 155, 176, 308; Propylaia, 126, 126, 131, 131, 133, 135; Stoa of Attalos II, 146, 147; Stoa Poikile, 135, 146; Temple of Athena Nike, 126, 126, 133, 133, 134, 144 Atlantids, 69, 378, 379 Atlas, 120 Atmospheric perspective, 250 Aton, 75, 79; temple of, 73, 74 Atreus, King, 93, 119 Atrium, 246, 247, 253, 420 Attalids, 147, 148, 154, 239 Attalos I–III (kings), 147, 148 Attribution of authorship or provenance, questions of, 5-6 Augusta Treverorum, 285 Augustus, Emperor, 6, 145, 239, 250, 256, 261, 275, 287, 304, 320; forum of, 257; as Imperator, 255; Livy and, 227; Pax Romana and, 276; portrait of, 6, 12, 254, 254, 255, 267; Roman Empire and, 263 Aula Palatina, 285, 299; exterior of, 285; interior of, 285 Aule Metele, 234, 255; portrait of, 227, 234 Aurelian, 278 Aurochs, 22 Auspicious Cranes (Huizong), 198 Autun: pilgrimage to, 432, 442; Saint-Lazare, 4, 440, 441 Avenue of the Dead (Mexico), 368, 369, 370 Ayyubids, 362, 363 Aztecs, 376; ball game and, 372; culture of, 366; Quetzalcoatl and, 370; sacrifices by, 369; Teotihuacan and, 368; Toltecs and, 378 281, 282

Baalbek, Temple of Venus, 280, 281, 282
Babylon: Ishtar Gate, 33, 47, 47, 51; Marduk ziggurat, 48; Tower of Babel, 33, 47, 48, 348; wonders of, 48, 51
Babylonian Empire, 43
Babylonians, 45, 47, 49, 51
Bacchus (Dionysos), 101, 129, 129, 136, 136, 138, 138, 143, 151, 248
Bad Government and the Effects of Bad Government in the City (Lorenzetti), 512

Badami, 169, 173, 179 Baghdad, 342, 346-347 Bahariya oasis, cemetery at, 57 Ball courts, 368, 371, 372, 372, 376, 391 Ball players, ceramic, 374, 374 Bamberg Cathedral, 427, 492, 495; statue at, 492 Bamberg Rider, 492, 492 Banditaccia necropolis, 228, 228 Banos de Cerrato, San Juan Bautista, 415, 415 Banquet scene, cylinder seal, 39 Baptismal font (Rainer of Huy), 449 Baptistère de Saint Louis (Muhammad ibn al-Zayn), 361-362, 361 Barberini, Cardinal, 322 Barberini Faun, 150, 151 Barberini Ivory, 322, 323, 323, 324 Baroque, architecture of, 270, 271,298 Basil I, 327, 339 Basilica, Paestum, 111–113 Basilica Nova, 238, 284-285; restored cutaway view of, 284 Basilica of Constantine, 313 Basilica Ulpia, 264, 265, 299, 422

Basilicas, 237, 244, 245, 285, 433, 446 Basketry, 365 Bat-faced man pendant, 380, 380 Baths of Caracalla, 277-278, 313; plan of, 277 Baths of Diocletian, 285; frigidarium of, 278 Battle of Issus (Altdorfer), 271 Battle of Issus (Philoxenos), 142, 142; detail from, 98 Battle of Romans and barbarians, 279 Bayeux Cathedral, 457 Bayeux Tapestry, 456, 457, 459; details from, 456 Bayon, 178, 178 Beatus of Liébana, Abbot, 415, 440 Beau Dieu, 475, 475 Beauvais Cathedral, 3; choir of, 2; lateral section of, 12; plan of, 12 Belisarius, 312, 315, 316 Belleville Breviary (Pucelle), 484;

folio from, 485

266-267, 267

records of, 395

Benin king, 10, 10, 11

Beowulf, 408, 409

Berbers, 263, 352

66, 71

Benedictines, 420, 439, 493

Benevento, Arch of Trajan,

Beni Hasan, 69; tombs at, 66-67,

Benin, 397, 402–403, 405; oral

Bering Strait, 365, 387 Berlinghieri, Bonaventura, 517; work of, 500, 500 Bernard of Clairvaux, Abbot, 439, 440, 441, 443, 459; Abelard and, 466; Alexander reliquary and, 450; on cloister sculpture, 438; Hildegard and, 448; Knights Templar and, 442 Bernini, Gianlorenzo, 151 Berno of Baume, 436 Bernward of Hildesheim, 422, 423, 452; commission by, 424, 425; Hildesheim doors and, 424 Beta Giorghis, 400, 400, 405 Bethlehem, 295, 335, 362 Betrayal of Jesus (Duccio di Buoninsegna), 508, 508 Bhaisajyaguru Buddha, 212 Bhudevi, 169 Bible, 410, 481 Bibliothèque Nationale, 482 Bi disks, 184, 185, 187 **Bihzad**: work of, 358–359, 358 Bilingual vases, 115, 115 Birth of the Virgin (Lorenzetti), 510,511 Bison, 18, 19, 22, 23, 56 Black Death, 461, 502, 513, 514, 517 Black-figure technique, 104, 105, 114-115 Black-on-white painted bowls, 389, 390, 391 Blanche of Castile, 471, 482-483, 484 Blind arcades, 50, 348 Block statues, 71-72 Blouet, Guillaume-Abel: view by, 117 Blue Period (Picasso), 4 Boccaccio, Giovanni, 502, 503 Bodh Gaya, 161, 165, 203 Bodhi tree, 161, 165, 166 Bonampak, murals at, 374 Boniface VIII, Pope, 482 Book of Durrow, 410-412, 413; folio from, 412 Book of Kells, 413-414, 414 Book of the Dead, 57, 76, 77 Book of the Pontiffs, 299 Books: Christian Church and, 410; making, 483; medieval, 305, 410 Borobudur, 174-175, 180; aerial view of, 175 Boscoreale, Villa of Publius Fannius Synistor, 248, 249 Boscotrecase, Villa of Agrippa Postumus, 250, 251 Bourges, House of Jacques Coeur, 480, 480, 495 Brahma, 170, 176 Brahmins, 160, 168, 172

Brass canteens, 362, 362

Breviary of Philippe le Bel (Master Honoré), 484; folio from, 484 Bridge-spouted vessel, 383 British Museum, 54, 402, 419; Elgin Marbles and, 126; Layard and, 31 Bronze Age, 100, 102; China and, 183, 184, 205; Korea and, 202 Bronze casting, 121, 122, 122, 123, 405; Shang dynasty, 183, 183, 184, 198, 205; Zhou dynasty, 198 Bubonic plague. See Black Death Bucrania, 26 Buddha, 163, 164, 190; iconography of, 179; life and death of, 165; meditating, 165; recumbent, 174, 174; representations of, 161, 179 Buddha of Boundless Space and Time, 192 Buddha of Healing, 212 Buddha of Infinite Light and Life, 161 Buddha of the Future, 201 Buddha seated on lion throne, 166 Buddha triad (Tori Busshi), 212, 212 Buddha's Law, 193 Buddhism, 159, 167, 169, 178; iconography of, 161; Japan and, 210-220; patronage of, 162, 179; Silk Road and, 188; spread of, 160, 161, 170, 174, 204 Buddhist Law, 201 Buffalmacco, Buonamico: work of, 514-515, 515 Bukhara, Samanid Mausoleum, 348, 348, 355 Bull-headed lyre, 38, 38 Bull-leaping fresco, 86, 86 Bulls, 21 Burial mask, Ipiutak, 388 Burial mounds, 228, 408, 409 Bury Bible, 457-458; folio from, 457 Bustan (Sadi), Bihzad and, 358-359 Byzantine architecture, 315, 474 Byzantine art, 312, 428, 429, 504; churches and, 300, 421; Early Christian art and, 316, 320; golden age of, 339; Greco-Roman roots of, 328; Middle Ages and, 323; painting, 322-325, 327, 338; style, 462 Byzantine culture, renovation of, 327 Byzantine Empire, 410; collapse of, 341; map of, 312 Byzantine Orthodox Church, 335 Byzantium, 282, 311, 336, 408, 419;

Caen, Saint-Etienne, 453–454, 453, 454, 459, 464, 468
Cahill, James, 191

religious/cultural mission of, 335

end of, 336; Islam and, 341;

Cahokia, 388, 391 Cairo, Mausoleum of Sultan Hasan, 353, 353 Calf bearer, 106-107, 107 Calligraphy, 197-198, 200, 340, 350, 352, 358, 361, 363; described, 351; tilework and, 357 Calvert, Frank, 81 Cambodia, art of, 175-178 Cambrensis, Giraldus, 414 Campo, 510; aerial view of, 511 Camposanto, Pisa, 514-515 Campus Martius, 272 Canon (Polykleitos), 124, 125, 127, 137, 146 Canopus, 57, 269, 269 Canterbury Cathedral, fire at, 435 Capitals, 59, 110, 111; composite, 262, 278, 452; Corinthian, 143-144, 144, 155, 280, 281, 498; lion, 162, 162 Capitoline Hill, 226, 237 Capitoline Wolf, 231, 231, 232 Caracalla, 239, 276-277; baths of, 277-278, 277, 313; portrait of, 277 Caracol, aerial view of, 378 Carcassonne, 495; Cathedral of Saint-Nazaire, 479, 479 Carolingian alphabet, 416 Carolingian architecture, 419-421, 429, 435 Carolingian art, 415-421, 429, 431 Carolingian Empire, 492; map of, 408 Carolingian Renaissance, 416 Carolus Magnus, 415 Carpet pages, 406, 410, 429 Carpets, 350, 360, 363 Carter, Howard, 75 Cartoons, 504 Carving, 10-11 Caryatids, 69, 111, 113, 132-133, 132, 257 Castillo, Chichén Itzá, 376, 377; aerial view of, 377 Casting, 10 Castle of Love, The, 485-486, 486 Catacomb of Saints Peter and Marcellinus, 293; cubiculum in, 292, 292 Catacombs, 291-295, 309 Çatal Höyük, 24, 35, 55; deer hunt mural at, 26; excavations at, 25-27; landscape at, 26-27, 27; Level VI of, 25; statuettes at, 26 Cathedral of Saint-Nazaire, 479 Cathedral School of Chartres, 465 Cathedral School of Paris, 466

Catona, ball court at, 372

Cave 19, Ajanta, interior of, 167

Cave 1, Ajanta, 167

Cave painting, 19-20, 21, 21, 22-23, 23, 26, 56 Caves of a Thousand Buddhas, 192 Celadon wares, 204 Celer, 275; work of, 258–259, 259 Cenni de Pepo. See Cimabue Centaurs, 102, 103, 114, 128 Central-plan buildings, 299-300, 315, 345, 451, 459; first examples of, 355 Ceramics, 2, 12, 368, 368; Maya, 374, 374; Tang dynasty, 195–196, 203 Ceremonial ax, 367 Cerveteri, 224, 232, 235; Banditaccia necropolis, 228, 228, 291; sarcophagus, 226-228, 277; tombs at, 229, 230, 247 Chacmools, 377, 377 Chaco Canyon, 390, 391 Chaeronea, 137, 153 Chaitva halls, 162, 164, 167, 179; interior of, 156; plan of, 164 Champollion, Jean-François, 54 Chan Buddhism, 200, 201 Chandragupta II, 160, 166, 169 Chang'an, 184, 205, 212; layout of, 192 Chan Muwan, Lord, 374, 375 Chapel of Henry VII (Vertue and Vertue), 488, 488, 495 Charioteer of Delphi, 122, 122, 123 Charlemagne (Charles the Great), 341, 347, 408, 418, 420, 425, 427, 428, 429, 451, 462; architecture and, 419, 421; arts/culture and, 417; burial of, 422; equestrian portrait of, 416, 416; Leo III and, 415; Lombards and, 447; official seal of, 416; renovation and, 497 Charles IV, King, 485 Charles VII, King, 480 Charles the Bald, 418, 422; equestrian portrait of, 416, 416 Chartres Cathedral, 460, 465-466, 465, 467, 470–471, 470, 472–473, 472, 474, 476, 495; after 1194, 470-471; aerial view of, 470; influence of, 474; plan of, 469, 470, 471; rose window at, 460, 472, 472; Royal Portal, 465-466, 465, 466, 467, 468, 472-473, 476, 495; south transept of, 472–473; west facade of, 465 Chauvet, Jean-Marie, 22 Chauvet Cave, paintings in, 22, 22 Chavín de Huántar, 380-381, 391; Old Temple of, 381; Raimondi Stele from, 381, 381 Chavín staff god, 385 Chichén Itzá, 376-378; ball court at, 372 Chimera of Arezzo, 231-232, 231

Chi-rho-iota (XPI) page, 414, 414 Choir, 11 Chola dynasty, 170, 171, 173, 174 Choragic Monument (Lysikrates), 144, 145 Christ, 293, 301, 304, 308, 335, 412; baptism of, 293, 294; childhood of, 296; crucifixion of, 5, 309; death of, 306, 334; images of, 326; incarnation of, 296; life of, 296-297, 303, 425; martyrdom of, 320; passion of, 297, 335; prefiguration of, 292; transfiguration of, 321, 322, 325 Christ as Good Shepherd, 292, 292, 293, 294, 295; mosaic of, 302,302 Christ as Last Judge, 439, 440, 459,475 Christ as Pantokrator, 310, 330, 332,339 Christ as Savior of Souls, 337, 337 Christ before Pilate, 306 Christian art: Constantine and, 309; Jewish subjects in, 293; symbols in, 4-5Christian community house, 291, 309; cutaway view of, 291 Christianity, 31, 168, 169, 290; establishment of, 291; in Ethiopia, 400; Islam and, 343; missionaries and, 406; patronage of, 494; recognition of, 282, 287, 312; Roman Empire and, 407; sponsorship of, 295; Visigoths and, 415 Christ in Majesty, 436, 444 Chronica (Gervase of Canterbury), 435 Chronology, 2, 3 Chryselephantine sculpture, 89, 89 Church of Christ in Chora, 336, 337, 339; fresco from, 336 Church of Saint George, 400, 400 Church of Saints Sergius and Bacchus, 316 Church of the Dormition, 330; mosaic from, 310, 330 Church of the Holy Apostles, 331 Church of the Holy Sepulchre, 342, 432 Church of the Holy Wisdom. See Hagia Sophia Church of the Theotokos, 329; plan of, 328 Church of the Virgin, 322; mosaic from, 322 Cimabue (Cenni de Pepo), 498, 503, 504, 517; contract with, 506;

Cistercians, 420, 438, 439, 443, 459, 487; Crusades and, 442 Citadel, 368, 369, 370, 370 City of God, 461 City of Peace, 347 City-states, 32, 36, 43, 50, 118, 155, 223; decline of, 145; Etruscan, 234; Italian, 502, 503, 507, 511 Classical art, 235, 283; decline of, 287; Etruscans and, 231-232; revival of, 497 Classical Greece, 82, 100, 431 Classical order, 461, 473; Augustan art and, 287 Classical period: Etruscan, 224; transition to, 117-118 Claudius, 239, 260 Clement V, Pope, 501 Clement VII, Pope, 501 Cleopatra, Queen, 53, 255, 287; death of, 145, 155, 254 Clerestory, 71, 446, 467, 468, 469; described, 469 Cliff Palace, 390, 391 Cloisonné technique, 329, 409, 429 Cloisters, 437, 438; detail from, 438; view of, 438 Cluniac order, 436, 439, 459 Cluny III, 436-437, 439, 443, 445, 446; restored cutaway view of, 437 Clytaemnestra, 119, 274 Codices, 305, 426-427, 427 Coeur, Jacques: house of, 480, 480, 495 Coins: bronze, 184; Constantinian, 286, 286; Roman, 244, 254 Colima tombs (Mexico), contents of, 368 Collage, 7 College of Cardinals, Great Schism and, 501 Cologne Cathedral (Gerhard of Cologne), 445, 489-490, 489, 494, 495, 514; choir of, 489, 490; Gero crucifix and, 425-426 Colors: complementary, 7; flat, 221; primary, 7 Colossal heads, 367, 367 Colosseum, 238, 260-261, 287; aerial view of, 260; detail of, 236 Colossus of Constantine, 283-284 Colossus of Nero, 238, 261, 275 Colossus of Rhodes, 48 Columbus, Christopher, 366, 410 Column of Antoninus Pius, 272-273, 280, 281; pedestal of, 272 Column of Trajan, 238, 264, 265, 265, 287, 418, 425, 456, 457

Columns, 10; Corinthian, 240, 245,

268, 269; Doric, 146, 225;

engaged, 348, 436; fluted, 66-67, 79; monolithic, 110 Commentarii (Ghiberti), 461 Commentary on the Apocalypse (Beatus), 415, 440; colophon of, 415 Commodus, 239, 276 Composite view, 23, 394 Composition, 6 Computer art, 12 Concrete construction, 241, 241, 245 Confraternities, 292, 501, 506 Confronting lions and palm tree (textile), 350 Confucianism, 184, 186, 204, 205, 210 Constantine I ("the Great"), 239, 282-286, 298, 308, 326, 415, 450, 494; baptism of, 294, 309; Basilica Nova and, 284; Christian art and, 309; Christianity and, 295, 312; Constantinople and, 309; edict by, 291; iconographic tradition and, 428; New Rome and, 311; portrait of, 284; relief of, 283; rise of, 287; Rome of, 238; Santa Constanza and, 300 Constantine XI, 311 Constantinian churches, 295, 298-300 Constantinople, 301, 312, 332, 450; attacks on, 327; Basilica of Constantine, 313; building/ restoration in, 339; Church of Christ in Chora, 336, 336, 337, 339; Church of Saints Sergius and Bacchus, 316; Church of the Holy Apostles, 331; Church of the Holy Sepulchre, 342, 432; Constantine and, 309; Crusaders in, 335, 339; establishment of, 282, 287, 311; fall of, 338, 499; Hagia Sophia, 313-314, 313, 315, 324, 327-328, 329, 339, 354, 355, 363, 419, 471, 474; Ottoman Turks and, 311, 336, 339, 341, 355, 363; patriarch of, 320; Ravenna and, 316 Constantius Chlorus, 282, 285 Contrapposto, 127, 155 Copàn: ball court at, 372, 372; Great Plaza, 373; Stele D, Ruler 13, 373, 373 Córdoba, 352, 363, 415; Great Mosque, 348-349, 348, 349, 363 Corfu, Temple of Artemis, 48, 112, 112, 230 Corinthians, black-figure technique and, 104, 114 Cormont, Renaud de: work of, 474, 474, 475 Cormont, Thomas de: work of,

474, 474, 475

Coronation Gospels, 417, 449; folio of, 417 Cortés, Hernán, 366 Corvey, 421; westwork of, 421, 422 Cosmic Buddha, 214 Council of Clermont, 442 Council of Ephesus, 301 Council of Nicaea, 282 Court of Gayumars (Sultan-Muhammad), 359 Crete, palace sites on, 84 Crossing square, 421 Crossing towers, 302, 446, 447 Crucifixion, 294-295, 306, 308, 315, 330, 331, 412, 414, 418, 424; art about, 297; mosaic of, 330; representation of, 307; symbolism of, 5 Cruciform, 302, 331 Crusades, 335, 339, 362, 438, 441, 442, 450, 463, 482 Ctesiphon, 49, 347, 353; palace at, 50 Cubiculum, 246, 247, 248, 249, 270, 292, 292 Cult statues, 109, 295 Cuneiform, 32, 36, 39 Cupid (Eros, Amor), 255, 275, 486 Cutaways, 12 Cycladic figurines, 82-83, 83, 84, 95,97 Cyclopean masonry, 91, 97 Cyclopes, 91, 92 Dacian Wars, 264, 265 Daedalus, 105, 106 Daggers, 94-95, 95, 97 Daibutsuden, 214, 214, 221 Damascus, Great Mosque, 344-345,

344, 345 Dante Alighieri, 481, 502, 507 Daodejing (The Way and Its Power) (Laozi), 186 Daoism, 184, 186, 205 Daphni, Church of the Dormition, 310, 330, 330 Daphni Crucifixion, 330, 330 Daphni Pantokrator, 330 Daphnis of Miletos: work of, 145-146, 145 Darius I, King, 48, 51 Darius III, King, 48, 98, 142 Dark Ages, 96, 100 David and Samuel, mural of, 291, 304 David composing the Psalms, 334 Death, personification of, 5 Death of the Virgin, 491 Decameron (Boccaccio), 502 Decursio, 272, 272, 273 Deer Park, 161, 165, 167 De Honnecourt, Villard:

sketchbook by, 481, 481

work of, 501-502, 502

Cire perdue (lost-wax) process, 122

Circus Maximus, 238, 264

Deir el-Bahri, Temple of Hatshepsut, 67-68, 67 Delhi sultanate, 174, 342 Delian League, 125, 127, 129 Delphi, Siphnian Treasury, 113, 113, 133, 148 Demosthenes (Polyeuktos), 152-153, 152 Denarius, 244 Deogarh, Vishnu Temple, 170, 170, 176, 179 Devi, 168, 171 Diamond World mandara, 215, 221 Didyma, Temple of Apollo, 145-146, 145, 155 Dio Cassius, 260; on Hadrian/Apollodorus, 269 Diocletian, 239, 287, 300, 311; abdication of, 282; Christianity and, 291; mausoleum of, 282, 451; palace of, 346; tetrarchy and, 280-282 Dione, 101, 129, 129 Dionysius of Halicarnassus: on Tusci, 223 Dionysos (Bacchus), 101, 129, 129, 136, 136, 138, 138, 143, 151, 248 Dioscurides, 275, 304 Dioskorides (Vienna), 324 Diptych of the Symmachi, 308; leaf of, 308 Dipylon cemetery, 102, 134 Dipylon Gate, 130 Dipylon krater, 102, 102 Disibodenberg, double monastery at, 448 Diskolobos (Discus Thrower) (Myron), 123-125, 123 Divine Comedy (Dante), 481, 502 Djenne, 399-400; archer, 399, 399; Great Mosque, 392, 400, 400, 405; terracottas, 399, 399, 405 Dioser: funerary temple of, 58, 60; Imhotep and, 57–59; mortuary precinct of, 58, 58, 59; pyramid of, 58, 79 Documentary evidence, in art history, 2 Dome of the Rock, 342, 344, 351, 363; aerial view of, 343; interior of, 344; mosaics at, 345, 357 Domes, 94; concrete, 241, 241; hemispherical, 241, 241; mugarnas, 352-353, 352 Dominicans, 482, 500, 515; influence of, 501 Domitian, 239, 260, 262, 263 Domus Aurea (Severus and Celer), 258-259, 260, 275; plan of, 259 Doric order, 85, 111, 112, 144, 146, 155, 225; described, 110; elevation of, 110; example of, 117

Doryphoros (Spear Bearer) (Polykleitos), 124, 125, 138, 139, 255, 473 Dotaku, 209, 209, 221 Dravidian, 157 Drawings, 2; architectural, 11, 12; elevation, 12 Duccio di Buoninsegna, 484, 509, 510, 517; contract with, 506; work of, 505, 507-508, 507, 508 Duchamp, Marcel: Fountain and, 15 Dunhuang Grottoes, 192-193, 194, 205, 214 Dura-Europos, 289-291, 295; Christian community house, 291, 291, 309; murals at, 291, 291; synagogue, 290-291, 290, 304, 309 Durandus, William, bishop of Mende: on stained-glass windows, 472 Dürer, Albrecht, 7; personification and, 5; work of, 5 Durga, 168, 171 Durham Cathedral, 454-455, 459, 487; interior/lateral section of, 455; plan of, 455, 455; vaults of, 464 Durrow Gospels, 411-412 Dying Gauls, 148-149 Dying warrior, 118, 118 Eadwine Psalter (Eadwine the Scribe), 458; folio from, 458 Eadwine the Scribe: work of, 458, 458 Eannatum, victory stele of, 36, 36 Early Byzantine, 331; architecture of, 312-322; art of, 312-327, 339; mosaics of, 312-322 Early Christian: architecture, 295, 298-304; art, 309, 312, 316, 320, 322, 416, 418, 429; mosaics, 295, 298-304; painting, 292; sculpture, 293-295 Early Classical period, 118–121, 123-137, 155; architecture of, 119–120; painting of, 134–137; sculpture of, 119-120; statuary of, 121, 123–125 Early Dynastic period, 79; architecture of, 56-59; painting of, 54-56; sculpture of, 54-56 Early Gothic: architecture, 463, 465, 467, 470, 471, 472; sculpture, 465 Early Horizon period, 380, 391 Early Intermediate period, 380, 391 Early Islamic: architecture, 342, 344-349, 352; art, 342-351, 352 Early Medieval period, 170-171,

173-174; art of, 407

Early Roman Empire, 239, 287; art of, 254-263 Ear ornament, Moche, 384 Earthen mounds, 221, 388, 391 Earthenwares: Chinese, 182, 196, 205; Neolithic, 208 Eastern Jin dynasty, 190 Eastern Pure Land, 212 Eastern Zhou, 184, 205 Ebbo Gospels, 417, 418, 449; folio of, 417 Ecclesius, Bishop, 316, 318, 332 Eclecticism, Byzantine, 337, 338, 339 Edfu, Temple of Horus, 78, 78, 79 Edict of Milan, 282, 286, 291 Edirne, Mosque of Selim II, 354, 354, 355, 363 Edward II, King: tomb of, 489, 489 Edward III, King, 489 Edward the Confessor, 457 Effects of Good Government in the City and in the Country (Lorenzetti), 512-513; detail from, 512 Effigy mounds, 388 Egypt: gods/goddesses of, 54; map of, 54; Roman Empire and, 155, 254, 275, 333 Ekkehard II, statue of, 491-492, 491 Elamites, 43, 44, 45, 47, 48 El Dorado, legend of, 379 Eleanor of Aquitaine, 448, 463, 482 Elephanta, 169-170, 173, 179 Elevation drawings, 12 El Tajín, 376 Embarkation of the Queen of Sheba (Lorrain), 8,8 Embroidery, 188, 382, 382, 456 Emeterius, 440; work of, 415, 415 English Romanesque: architecture, 453-455; art, 453-458, 459; painting, 455, 457-458 Enheduanna, 41, 51; votive disk of, 41 Enlil, 33, 36 Epidauros theater, 143, 143 **Epigonos,** 149; work of, 148 Equestrian fly whisks, 397-398, 397 Erechtheion, 126, 126, 130, 131–133, 131; capitals at, 144; caryatids from, 257; plan of, 132, 132 Ergotimos, 114, 114 Eshnunna statuettes, 35, 35, 42 Eskimos, 387, 391 Esoteric Buddhism, 215, 221 Etruria, 224, 225, 226, 231, 234; decline of, 235 Etruscan architecture, 225-230, 235 Etruscan art: early, 224-230; Greek art and, 223, 224, 235; later, 231-234; Rome and, 226,

232-234

Etruscan plans, 239, 240, 245, 287 Etruscan sarcophagi, 233, 234, 243 Etruscan temples, 225, 225 Etruscan tombs, 228, 231, 291, 440; vases in, 104, 114, 227 Etruscans, 104, 239, 241, 301, 450; apex of, 235; seafaring by, 224; trading by, 235 Eugenius III, Pope, 448 Euphronios, 118, 136; foreshortening and, 155; work of, 116-117, 116 Euripedes, 100, 119, 143, 155 Europe, map of, 16, 462 Eusebius of Caesarea, 410 Euthymides, 136, 142; amphora by, 116-117; foreshortening and, 155; work of, 116 Events of the Heiji Period, 220, 221; illustration from, 220 Evidence in art history, types of, 2–3 Ewer in the form of a bird (Sulayman), 350 Ewers, 350, 350 Exekias, 114–115; work of, 115 Faiyum district, mummy portraits from, 275, 276 Fan Kuan, 200, 205; work of, 180, 197, 197 Farnese Herakles (Lysippos), 139-140, 139 Fatimids, 342, 363 Faustina the Elder, 239, 272, 273 Feng, Lady, 190, 191, 191 Fengxian Temple, 193 Ferdinand, King, 341 Feudalism, 431 Fibula, 224, 408; with orientalizing lions, 224 Ficoroni Cista (Plautios), 232, 232 Fidenza Cathedral, 452, 453 Figures, relative size of, 10 Fine art, 2 First Emperor (China), 184-185, 195; army of, 185, 186, 205, 210; Jing Ke and, 187 First Style (Masonry Style), 251, 252, 287; described, 248; wall paintings in, 248 Five Dynasties period (China), 196 Flamboyant style, 478, 479, 480, 488, 495 Flavian portraiture, 261-262, 261 Flavians, 260-263; Colosseum and, 287 Florence, 223, 502, 505, 507; architecture in, 513-514; Florence Cathedral, 506, 513-514, 514; Santa Croce, 3, 3, 302, 501; Santa Maria Novella, 500-501, 501, 506

Etruscan Italy, map of, 224

Florence Cathedral (Arnolfo di Cambio), 506, 513-514; interior of, 514 Flying buttresses, 460, 468, 469, 487, 495; described, 11, 469 Foguang Si (Buddha Radiance Temple), 194; drawing of, 194 Foguang Si Pagoda, 199, 199, 205; cross-section of, 199 Fontenay, Notre-Dame abbey church, 443, 445 Foreshortening, 43, 51, 98, 116, 155; described, 8–9; perspective and, 9 Form, concept in art, 6 Forum, Pompeii, 245; aerial view of, 244 Forum of Augustus, 238, 257, 264 Forum of Julius Caesar, 238 Forum of Trajan (Apollodorus of Damascus), 238, 264-265, 264, 269, 275, 299 Forum Romanum, 238, 262

Fountain (Duchamp), 15 Four Evangelists, 296, 325, 412, 429, 436 Four Horsemen of the Apocalypse, The (Dürer), 5, 5, 7 Fourth Style, 253, 262, 287; described, 251; wall paintings in, 251, 252, 253 Fra Angelico. See Angelico, Fra

Franciscans, 482, 500; influence of, 501; perspective and, 505

François Vase (Kleitias and Ergotimos), 114 Franks, 316, 341, 407, 415, 429 Frederick II, 497, 517; equestrian portrait of, 492

Freedmen/freedwomen, art for, 243, 243

French Gothic, 487, 517; architectural decoration, 462-480; architecture, 459, 462-480, 495; art, 462-486, 495 French Revolution, 464, 478 French Romanesque: architecture, 433-443; sculpture, 433-443 Fresco painting, 97, 246, 504 Fresco secco, 72, 73, 86 Frigidarium, Baths of Diocletian, 278 Frobenius, Leo, 398 Fu Hao, tomb of, 183 Fujiwara family, 216, 217 Funerary art, 64, 243, 271, 271,

Gaia/Ge, 101, 120 Galerius, edict by, 291 Galla Placidia, mausoleum of, 288, 302, 302, 304, 321

Funerary masks, 94-95, 94, 97

Gallic chieftain killing himself and wife (Epigonis), 148 Gandhara, Buddha prototypes from, 164-166, 179, 190, 190 Garbha griha, 171, 172, 179 Garden of Eden, 31, 424 Gate of All Lands, 48 Gateway of the Sun, 385, 385 Gauls, 155, 239; defeat of, 147, 148-149 Gayumars, King (Iran), 359 Gelduinus, Bernardus, 436, 457; work of, 436

Gellée, Claude. See Lorrain, Claude Genghis Khan, 353, 355, 358 Genji, Prince, 217 Geometric art, 102, 122, 155, 243 Geometric period, 100-105 Gerhard of Cologne: work of,

489-490, 489, 490 Gernrode, Saint Cyriakus, 422, 422, 433, 466

Gero, Archbishop, 425, 445 Gero crucifix, 425-426, 425, 429 Gervase of Canterbury, 435, 436 Gessii, tomb reliefs of, 243 Ghiberti, Lorenzo: Middle Ages and, 461 Gigantomachy, 112, 113, 113, 147,

148, 149 Gilgamesh, Huwara and, 32

Giotto di Bondone, 517; work of, 496, 503-505, 503, 504 Girsu (Iraq), 33, 36, 42, 62

Gislebertus, 457; work of, 4, 441,441

Giulio Romano, 498

Gizeh: Great Pyramids, of Khafre, Khufu, and Menkaure, 48, 59-61, 59, 71, 79; Great Sphinx, 61, 61, 62; Pyramid of Unas, 60 Gloucester Cathedral, 487-488; choir of, 488, 488

Glykon of Athens, 140 Gnosis: work of, 140, 141 God as architect of world, 481-482, 481 God-kings, 63, 64 Gods/goddesses: Greek/Roman, 101; Egyptian, 54; Etruscan, 225; Hindu, 168; Mesopotamian, 33

Golden Age, 256 Golden Hall, 212, 213 Golden House (Severus and Celer), 251, 258-259, 260, 264, 287; plan of, 259; wall paintings at, 251 Goldsmiths, 379-380, 391

Gordion, mosaics at, 303 Gorgets, Mississippian, 388, 389 Gospel Book of Charlemagne. See Coronation Gospels

Gospel Book of Otto III, 427-428; folio from, 428

Gothic architecture, 455, 468, 489-490; Scholasticism and, 466; stained-glass windows and, 472

Gothic cathedrals, 461, 468, 514; elements of, 469, 469; nave elevations of, 468

Gothic style, 462, 497, 509 Goths, 280, 407, 429, 461

Granada (Spain), 341; Alhambra, 340, 352-353, 352, 363

Grave Circle A, funerary mask from, 94,94

Grave stele, 134, 138, 138 Great Bath, 158, 158 Great Buddha Hall, 214, 214

Great Enclosure, 401; walls/tower of, 401

Great Mosque, Córdoba, 348-349, 363; dome of, 349; prayer hall

Great Mosque, Damascus, 344-345; aerial view of, 345; mosaics of, 344, 344, 345

Great Mosque, Djenne, 400, 405; aerial view of, 400; eastern façade of, 392

Great Mosque, Isfahan, 355-356; aerial view of, 355; plan of, 356

Great Mosque, Kairouan, 347; aerial view of, 347; plan of, 347

Great Mosque, Samarra, 347; minaret of, 347; magsura of, 349 Great Plains, 387

Great Plaza, Copàn, 373 Great Plaza, Tikal, 373

Great Pyramids, Gizeh, 48, 59-61, 59, 71, 79

Great Schism, 461, 501 Great Sphinx, 61, 61, 62

Great Stupa, 162, 163, 163, 164, 179; diagram of, 163; torana at, 164

Great Wall, 184

Great Zimbabwe, 401-402, 405; Great Enclosure, 401, 401

Greco-Roman art, 2, 461 Greco-Roman mythology, 273

Greek art: Etruscan art and, 223, 224, 235; Roman art and, 239,

287; Western civilization and, 99 Greek cross, 331, 339, 400, 400

Greek temples, 225, 245, 274, 440 Gregory the Great, Pope, 443, 448

Gudea of Lagash, 42, 51, 62; statue

Guido di Pietro. See Angelico, Fra Guild hall, 479-480, 479 Guilds, 461; described, 506; training by, 510

Gu Kaizhi, 191, 216; work of, 190, 191

Gupta period, 166-167, 169-170, 174, 179

Hades abducting Persephone, 141 Hadrian, 239, 263, 273, 282, 283, 287; Antoninus Pius and, 272; Apollodorus of Damascus and, 269; architectural designs and, 269; Greek culture and, 267-270; portrait of, 267, 267 Hadrian's Villa, 269, 269

Hagar Qim, 14, 29; temple of, 28 Hagesandros: work of, 153-154,

153, 154 Hagia Sophia (Anthemius of Tralles and Isidorus of Miletus), 313-314, 313, 324, 327-328, 354, 355, 363, 471, 474; design of, 315; dome of, 329; imperial gallery at, 419; mosaics at, 339; pendentives at, 315; plan and cutaway view of, 313

Halikarnassos tomb, 48 Hall church. See Hallenkirche Hallenkirche, 444, 490 Hall of the Bulls, 21, 23 Hall of the Two Sisters, 352, 352 Hammurabi: Shamash and, 30, 33; stele of, 30 Hammurabi's Law Code, 43, 51; stele with, 43, 44 Handprints, 20, 22

Handscrolls, 195, 198, 218; described, 190

Han dynasty, 185, 187-188, 195, 202, 205; houses/palaces, 188, 189

Hanging gardens, 48 Hanging scrolls, 190 Haniwa, 210, 210, 221

Harappa, 157, 159

Harbaville Triptych, 333, 335

Harihara, 175, 175 Harvester Vase, 89-90, 90, 96

Hasan, Sultan, 354, 356, 358, 363; mausoleum of, 353

Hatshepsut, Queen, 41, 72, 276; portraits of, 68, 68; story of, 68; temple of, 67-68, 67, 71, 79

Hattusa, Lion Gate, 43-44, 44 Hawes, Harriet Boyd, 82

Hegeso stele, 133-134, 134, 135, 138, 227

Heian period, 170, 215, 220, 221; court culture of, 217; Kamakura artistic workshops and, 219

Helen of Egypt, 142 Helen of Troy, 81, 96, 275 Helios (Sol), 101, 129, 129 Hellas, 82, 99

Hellenistic period, 145–154; architecture of, 145-146; art of, 153-154, 235; Etruscan, 224

291-295

Henry II, King, 427, 428, 448; death of, 422 Henry III, King, 482 Henry IV, King, 446 Henry VII, King: chapel of, 488, 488 Hera (Juno), 101, 111, 120, 136, 225, 252 Herakles (Hercules), 120, 129, 129, 155, 225, 226, 278; Antaios and, 16, 116–117, 116; heroism of, 120; Olympic Games and, 120; statue of, 102, 103, 139-140, 139 Herakles wrestling Antaios (Euphronios), 116-117, 116 Herculaneum, 246, 253, 287; Samnite House, 248, 248 Hercules. See Herakles Hermes and the infant Dionysos (Praxiteles), 138, 138 Hermes bringing the infant Dionysos to Papposilenos (Phiale Painter), 136 Herodotus, 155, 223; on Babylonian temple complex, 48; on Egypt, 53 Hesiod, gods/goddesses and, 101 Hesire: portrait of, 11; relief of, 9, 9 Hesperides, 120, 140; apples of, 120 Hestia (Vesta), 101, 129, 129 Hiberno-Saxon art, 406, 410-411, 412, 429, 431, 443, 455 Hierakonpolis, Tomb 100 of, 54–55 Hieroglyphics, 54; Maya, 366, 371 High Classical period, 118-121, 123-137, 155, 478; architecture of, 119-120; painting of, 134–137; sculpture of, 119–120; statuary of, 121, 123-125 High Cross of Muiredach (Ireland), 414, 414 High Gothic, 465, 472, 478, 495; architecture of, 470, 471, 474, 476, 477 High Roman Empire, 239, 287; art of, 263-276 Hildegard of Bingen, 448-449, 448 Hildesheim, 422-423; column and doors, 425, 425; Saint Michael's, 422, 423, 424, 429, 439, 446, 452 Hinayana Buddhism, 161 Hinduism, 167, 169, 174, 178; described, 168; iconography of, 168; origins of, 160 Hindu temples, 172, 179 Hippodamian plan, 146, 264 Hippodamos of Miletos, 146 Hittites, 43, 44, 45 Hohlenstein-Stadel, 18, 23; sculpture from, 17, 17, 25 Hollow-casting, 40, 51, 122 Holy Roman Empire, 323, 416, 459, 462; architecture of, 445-447,

489-494, 495; art of, 445-450; founding of, 415 Homage to the Square: "Ascending" (Albers), 7, 7 Homer, 32, 80, 82, 93, 96, 114, 154, 155; epics of, 100; gods/goddesses and, 101; Herakles and, 120; on Mycenaeans, 90, 94; Trojan War and, 157; on Troy, 81 Honoré, Master: work of, 484, 484 Honorius, 301, 302, 309, 311 Horus, 54, 56, 62, 73; temple of, 78, 78, 79; wedjat eye of, 57 Horyuji kondo, 212, 214, 221 Hosios Loukas, 332, 339; Church of the Theotokos, 328, 329; Katholikon, 328, 328, 329, 330 House of Jacques Coeur, 480, 480, 495 House of Neptune and Amphitrite, 252, 253 House of the Vettii, 246; atrium of, 246 Hue, in art, 7 Hugh of Saint-Victor, on stainedglass windows, 472 Hugo, Master, 457, 458; work of, 457 Huizong, 199; calligraphy and, 197-198; work of, 198, 198 Humanism: Italian, 497; Renaissance, 502-503, 517 Human sacrifice, 370, 372 Hummingbird, Nasca plain, 383 Hundred Years' War, 461 Hu-Nefer, last judgment of, 76 Hunter-gatherers, 31, 365, 393 Hunting-magic theory, 21 Hwangnamdong (Korea), tomb Hypostyle hall, 70, 71, 79, 345, 347, 348, 363; model of, 71 Iaia of Cyzicus, encaustic painting and, 275 Ice Age, 15, 17 Iconoclasm, 326, 339; end of, 327, 328, 329 Iconoclasts, 326, 328; iconophiles and, 327, 339 Iconography, 287, 428; Buddhist, 179; Chavín, 381; described, 4-5 Iconophiles, 326; iconoclasts and, 327, 339 Iconostasis, 337, 339 Icons, 326, 328, 335, 337; Byzantine, 283, 326, 327, 426; Early Byzantine, 337-338, 339; opposition to, 326; veneration of, 326, 327 Ife king, 398, 399 Igbo Ukwu, 397-398, 399, 405

Ikegobo (Benin shrine), 402, 403

Iktinos, 128, 133, 155; work of, 126, 127, 127, 146 Île-de-France, 463, 465, 479, 486 Île-de-la-Cité, 468 Ile-Ife, 398, 399, 402, 405 Iliad (Homer), 32, 80, 81, 114, 140; gods/goddesses and, 101 Illumination, 333, 410, 416, 417, 427, 448, 481, 495, 500, 517; Gothic, 481–486; Late Antique, 304-306; preparation of, 483 Illusionism, 253, 287, 327, 337, 429; pictorial, 510, 511 Imam Mosque, tilework in, 357 Imhotep, 79; Djoser and, 57–59; Stepped Pyramid and, 57 Inanna female head, 33, 34, 34 Indra, 160, 165 Indravarman, Angkor and, 176 Indus civilization, 157-160, 168, 179 Inka, weaving by, 382 Inka Empire, 366, 380 Insula, 270-271; model of, 270 Intensity, in art, 7 Intermediate Area, 379–380 Internal evidence, 2-3 International Style, 509 Introduction to the Three Arts of Design (Vasari), 461 Iona Island, 410, 413 Ionic order, 111, 113, 144, 155; described, 110; elevation of, 110 Ipiutak mask, 387 Iron-wire lines, 190, 214 Isaac, 294; art about, 293 Isabella, Queen, 341 Ise complex, 210, 211; Shrine of Amaterasu, 210, 211 Isfahan: Great Mosque, 355–356, 355, 356; Shahi Mosque, 356, 357 Ishtar Gate, 33, 47, 47, 51 Isidorus of Miletus: work of, 313-314, 313, 314 Islam, 31, 50, 168, 169, 174, 311, 514; Byzantium and, 341; Judaism/Christianity and, 342, 343; Muhammad and, 343; rise of, 341, 392; Spain and, 415 Islamic architecture, 363, 429 Islamic world, map of, 342 Italian Renaissance, 154, 461; architecture of, 298; humanism and, 502 Italian Romanesque: architecture of, 450-453, 459; art of, 450-453, 459; sculpture of, 450-453 Italo-Byzantine art, 504, 505, 517 Italy, map of, 498 Ivory carving, 323, 324; Late Antique, 306-308; Byzantine, 322-325, 327, 333-335 Iwans, 50, 345, 356, 363

Ixion Room, 252; wall paintings at, 252 *Jack in the Pulpit No. 4* (O'Keeffe), Jade: celts, 367; Chinese and, 184, 185, 185; masks, 370, 371; Zhou, 184, 185, 185 Jambs, 440, 466, 467, 473, 473, 476, 477, 477, 490; described, 439 Japan, map of, 208 Japanese culture, 215; Buddhism and, 207; Chinese writing systems and, 207 Java, art of, 174-175 Jayavarman II, King, 175 Jayavarman VII, King, 178 Jericho, 24–25; stone tower at, 24, 25 Ierusalem, 327, 362; Dome of the Rock, 342, 343, 344, 344, 345, 351, 357, 363; Islam in, 363; pilgrimage to, 432, 440; Temple of Solomon, 262, 263, 313, 342 Jesus. See Christ Jewelry, 2, 12; orientalizing, 224-225, 224 Jin dynasty, 190, 197, 199 John the Baptist, 296, 331, 333, 335,336 John the Evangelist, 297, 325, 505 John the Lydian, on Theodora, 320 Jomon period, 207-209 Jonah, 292, 292, 293, 295 Judaism, 31, 169, 290, 295; Christianity and, 342; Islam and, 342, 343 Judas, 297, 306, 508 Judgment Day: symbolism of, 5; proportion and, 10 Julia Domna, 239, 254, 277 Julio-Claudians, 260, 287 Julius Caesar, 239, 244, 257; denarius with, 244; murder of, 254 Junius Bassus sarcophagus, 294-295 Juno (Hera), 101, 111, 120, 136, 225, 252 Jupiter (Zeus), 101, 111, 112, 119, 120, 123, 136, 140, 149, 225, 233, 245, 252, 254, 267, 284; altar of, 147-148; statue of, 48, 226 Justinian, 301, 319, 331, 416; blessing for, 323; Byzantine art and, 312, 313, 339; Christianity and, 312; Constantinople and, 312, 339; ivory carving of, 323; mosaic of, 319; Mount Sinai and, 321, 322, 339; portrait of, 332; Ravenna and, 316, 339; Theodora and, 317, 320

Ka (life force), 54, 57, 62, 63, 64 Kairouan, Great Mosque, 347, 347 Kairve Museum, fresco from, 336 Kalachuri dynasty, 169 Kalhu, Palace of Ashurnasirpal II, 46-47, 46 Kalingas, 162 Kallikrates, 155; work of, 126, 127, 133, 133 Kallimachos, 144 Kamakura period, 218, 219, 220, 221 Kamakura priest, portrait statue of, 219,219 Kamares-ware vessels, 88, 88 Karle, chaitya hall at, 156, 164, 167 Karnak, 109, 265; Temple of Amen-Re, 70-71, 70, 71, 78 Katholikon, 328, 328; interior of, 329; mosaic at, 330; plan of, 328 Kato Zakro, palace at, 84 Kawa, temple at, 77 Kei School (sculpture), 218, 219 Khafre: Great Sphinx and, 61; Pyramid of, 60, 61; statue of, 62-63, 62; temple of, 71; tomb of, 59 Khajuraho, Vishvanatha Temple, 171, 172, 173, 173, 176, 179 Khamerernebty, statue of, 62, 63 Khmer, 175, 176, 178, 179 Khufu: Pyramid of, 60; Sphinx and, 61; tomb of, 59, 60 King David (Antelami), 452, 453 King on horseback with attendants, 10,10 King Solomon's Temple, 449 Kivas, 390 Kleitias, 114, 114 Klosterneuburg Altar (Nicholas of Verdun), 493, 494 Knights Templar, 442 Knossos, 82; Kamares-ware vessels at, 88; palace at, 84-85, 84, 85-86, 85, 86, 87, 88, 90, 97 Kofun period, 209–210, 221; Shinto and, 211 Koguryo kingdom, 202 Kondo, 212, 213, 214; aerial view of, 213 Korai, 105, 109, 112, 113, 121, 133,226 Koran (Qur'an), 343, 345, 357, 363; calligraphy for, 351; page from, 351 Kore in Ionian dress, 108-109, 108 Korin, Ogata, 9; work of, 8 Koryo dynasty, 204 Kouroi, 106, 106, 107, 107, 108, 109, 112, 121, 134, 151, 155, 281 Kresilas: work of, 125-126, 125, 153, 242, 267 Krishna, 168

Kritios: work of, 121, 121 Kritios Boy, 121, 121, 123, 125 Kronos, 101 Kukulkan, 376; temple to, 377, 378 Kushan dynasty, 162, 166, 179 Kushinagara, 161, 165, 179 Labyrinth, 85, 97 Lady of Auxerre, 105, 105, 106, 108, 130 Lalibela, 399-400; Church of Saint George, 400, 400 La Madeleine, bison at, 18, 19 La Madeleine, church of, Vézelay, 441-442; tympanum of, 441 Lamassu, 45-46, 45, 51 Lamentation (Giotto), 504, 505 Lamentation over the dead Christ, 334 Landscape with volcanic eruption, 26-27, 26 Laocoön and his sons (Athanadoros, Hagesandros, and Polydoros of Rhodes), 153-154, 153 Laon Cathedral, 469, 470, 472, 474-475, 476, 495; facade of, 467, 468; interior of, 467; nave elevation of, 468 Lapiths, 114, 128, 128 Lars Pulena, 265, 305; sarcophagus of, 233-234, 233, 235 Lascaux, 22-23, 26; animal images at, 21; bison at, 23; bulls at, 21; cave paintings at, 20, 23; rhinoceros at, 23 Last Judgment, 330, 412, 414, 465, 466,505 Last Judgment (Gislebertus), 4, 441,441 Last Supper, 297, 412 Late Antiquity, 291, 335, 424; art of, 301, 312, 342, 344, 429; Jewish/Christian art of, 287; painting of, 230, 427; plans of, 302; religious crosscurrents Late Byzantine, 3; art of, 335-338, 339; painting of, 336-338, 393 Late Classical period, 137-145, 155, 478; architecture of, 143-145; sculpture of, 137-140 Late Gothic, 488, 489, 495 Late Horizon period, 380 Lateral section, 11, 12 Later Islamic architecture and art, 352-353, 355-358, 352-362 Late Roman Empire, 239, 287, 421; art of, 276-286 Laussel (France), female figure

from, 18, 18

La Venta (Mexico), 367, 391

Legalism, 184, 185 Legends of Mount Shigi, 217-218; flying storehouse from, 218 Leo III, Emperor: iconoclasm and, 327, 339 Leo III, Pope, 415, 429 Leonardo da Vinci, 498 Lepcis Magna, Arch of Septimus Severus, 277, 277, 291 Lérida, Santa María de Mur, 444-445, 444 Leto, 101, 135, 136 Le Tuc D'Audoubert, bison at, Liang Kai, work of, 200-201, 201 Liao dynasty, 199, 205 Liber pontificalis, 299 Liberty, 5 Libon of Elis, work of, 119 Light: additive, 7, 10; natural, 7 Lima Tapestry, 386, 386 Lindau Gospels, 418, 426; front cover of, 418 Lindisfarne Gospels, 413, 417; carpet page of, 406; Saint Matthew from, 413 Line, in art, 6-7 Linear A and B, 82 Linear perspective, 248 Lintong army, 185-186, 186 Lion Gate, Hattusa, 43-44, 44 Lion Gate, Mycenae, 92-93, 92, 94, 95, 97; detail of, 80 Lion Hunt (Rubens), 9, 9, 10 Lions and Old Testament prophet, 440 Lives of the Most Eminent Painters, Sculptors, and Architects (Vasari), 503 Livia, 239, 250, 251, 255; portrait of, 254, 255 Livy, Titus, 227, 239 Lohans, 201, 203 Lohans Giving Alms to Beggars (Zhou Jichang), 201, 202 Lombards, 315, 407-408, 415, 428, 445, 447; Ravenna and, 331 Lombardy, 447, 448, 450, 516 London: Chapel of Henry VII, 488, 488, 495; Westminster Abbey, 457, 489 Longinus, 297, 330 Longitudinal section, 11 Longmen Caves (China), 192, 203 Lorenzetti, Ambrogio, 517; work of, 512-513, 512 Lorenzetti, Pietro, 512; work of, 510,511

Leaning Tower: Pisa Cathedral

Lectionary of Henry II, 427; folio

and, 451

from, 427

Lorrain, Claude (Claude Gellée), 8; work of, 8 Lost-wax process, 122, 122, 380, 397, 405 Lotus Sutra, 192, 215 Louis VI, King: Suger and, 463 Louis VII, King, 441, 448; Suger and, 463 Louis IX, King, 362, 483; Crusades and, 482; Rayonnant style and, 482, 495; Sainte-Chapelle and, 477 Louvre, 466 Lower Egypt, 54, 55, 56, 58, 59; Upper Egypt and, 79 Lucian: on Aphrodite statue, 137 Lucius Verus, 239, 272 Ludovisi, Cardinal, 278 Ludovisi Battle Sarcophagus, 278, 279, 280 Lumbini, 161, 165, 179 Luoyang, 184, 205 Lux nova, 460, 464, 495 Luxury arts: Gothic, 481-486; Islamic, 350–351, 358–362; Late Antique, 304-308 Luzarches, Robert de: work of, 474, 474, 475 Lydenburg, 395-397 Lydenburg head, 396-397, 396 Lyre player from Keros, 83, 83 Lysikrates, monument by, 144, 145 Lysippos of Sikyon, 149, 153, 155, 278; work of, 139-140 Maat, 54, 57, 77 Macedonian court art, 140-142 Macedonian Renaissance, 334, 335 Macedonians, 100, 153, 328, 335 Machicolated galleries, 512 Madonna, 499, 502 Madonna Enthroned (Giotto), 503-504, 503 Madonna Enthroned with Angels and Prophets (Cimabue), 502, 502, 503 Madrasa Imami, 357–358; mihrab from, 357 Madrasa-mosque-mausoleum complex, 353, 353; plan of, 353

Maebyong vase, 204, 204 Maestà (Duccio di Buoninsegna), 505, 506, 507-508, 507, 508, 509,517 Mahayana Buddhism, 161 Mahayana Cosmic Buddha, 192, 193 Maison Carrée, 257-258, 257 Maitani, Lorenzo: work of, 508-509, 509 Makapansgat pebble art, 15, 16, 16 Malik Shah I, Sultan, 355, 356 Mallia, palace at, 84

Malwiya Minaret, 347-348, 347 Mamluks, 353, 358, 361, 363 Mandapas, 171, 172, 215, 221 Manetho, 53; on Imhotep, 57 Maniera greca, 500, 503, 517 Mantiklos, 103, 105, 106 Mantiklos Apollo, 103, 103 Manuscript painting, 322 Maqsud of Kashan, 360; carpet Maqsura, 345, 349, 349, 356 Marburg, Saint Elizabeth church at, 490, 490 Marcus Aurelius, 239, 254, 272, 275, 276, 277, 282, 283, 323; Dura and, 289; equestrian statue of, 273, 273; portrait of, 416 Marduk, 33, 45, 47 Marduk ziggurat, 48 Marinatos, Spyridon: theory of, 87 Marine Style octopus jar, 88, 88 Mark Antony, 145, 239, 254, 255, 287 Markets of Trajan (Apollodorus of Damascus), 238, 266; aerial view of, 266; great hall of, 266 Martin V, Pope: Great Schism and, 501 Martini, Simone: work of, 509, 509 Martyrdom, 292, 295, 432 Martyrium, 331 Mary. See Virgin Mary Mary Magdalene, 297, 424, 432, 441, 491, 505 Masaccio (Tommaso di ser Giovanni di Mone Cassai), 498 Masonry Style. See First Style Mass, 7-8, 315, 501 Mastaba, 56-57, 56, 59, 66 Master of the Symbolic Execution: work of, 404, 404 Materials, in art, 6 Mathura, Buddha images of, 166 Mau, August: Pompeian Styles and, 246 Maurya dynasty, 160-162, 164-166, 179 Mausoleum of Galla Placidia, 302, 321; interior of, 288; mosaic from, 302, 304 Mausoleum of Sultan Hasan, 353; plan of, 353 Mawangdui banner, 187, 188 Maxentius, 282, 286, 295; Basilica Nova and, 284-285 Maximianus, Bishop, 316, 317; mosaic of, 319 Maya, 365, 370, 376; architecture of, 371, 374; building by, 364; calendar of, 371; culture of, 366, 391; Classic, 370–371, 391; decline of, 379; language of, 371;

Maya blue color, 374; society of, 375 Ma Yuan: work of, 200, 200 Mecca, 342, 343, 344, 345, 353 Medes, 40, 47 Medina, 343, 345, 347, 348, 350 Mediterranean, map of, 100, 290 Medusa, 112, 135, 230 Megaliths, 27 Megaron, 92, 109 Meiping vase, 198, 199, 204 Melfi sarcophagus, 274-275 **Memmi, Lippo:** work of, 509, 509 Memphis, temple at, 105 Mencius, 186 Mendicant orders, 482, 500, 501 Menkaure, 59; statue of, 62, 63 Mentuhotep II, 64, 79 Merovingian fibulae, 408, 408, 409 Merovingians, 407, 408, 429 Mesa Verde, 390; Cliff Palace, 390, 391 Mesoamerica, 391; art of, 366-378; Classic, 375; human sacrifice and, 370; landscape of, 366; map Mesoamerican chronology, 366 Mesolithic period, 16, 24 Metalwork, 2, 365, 409, 450, 459, 493, 495; Celtic/Anglo-Saxon, 414; Islamic, 350–351; Mycenaean, 94-96 Metopes, 112, 120, 128-129, 144, 147 Metropolitan Museum of Art (New York), 248, 402 Michael VIII Paleologus, 336, 339 Michelangelo Buonarroti, 154, 355; work of, 10, 11, 11, 278 Middle Ages, 407, 408, 431; art/ architecture of, 287; Byzantine art and, 323; concept of, 502; condemnation of, 497; decline during, 461; historical narrative art in, 459 Middle Byzantine: architecture of, 327-332; art of, 327-335, 339; churches, 328, 339; ivory carving, 333-335; mosaics, 327-332; painting, 333-335 Middle Horizon period, 380, 391 Middle Kingdom, 59, 64-67; architecture of, 66-67; sculpture of, 65; tombs of, 79 Middle Minoan period, 84 Middle Stone Age art, 16 Mihrabs, 345, 347, 349, 356, 357, 357, 358 Milan, 502; art of, 514-516; Cathedral of, 516, 516; Sant'Ambrogio, 446, 447, 447, 454, 459

Miletos, 128, 145; Persians at, 118; reconstruction of, 146 Mimbres culture, 389-390 Minarets, 313, 345, 347-348, 347, 355, 357 Minerva (Athena), 101, 118, 120, 120, 147, 149, 154; battling Alkyoneos, 148; defeat of, 137; Poseidon and, 129, 132; statue of, 126, 130, 176 Minoans: architecture of, 84-85; art of, 82, 84-90, 97; painting of, 85-86, 88, 504; sculpture of, 88-90,97 Minor arts, 304, 408, 494 Minos, King, 82, 96, 248; labyrinth of, 97; palace at Knossos and, 84 Minotaur, 82, 84, 85, 97, 105 Miracle of the loaves and fishes, 304 Mississippian culture, 388, 389, 391; iconography, 389; mounds, 388, 389, 391 Mithras, emblem of, 280 Mithuna reliefs, 173, 173 Mixtecs, 366 Miyanomae, vessel from, 208, 208 Mnesikles, 135; work of, 131, 131 Moche culture, 380, 381, 385, 391; painted vessels by, 384 Modena Cathedral, 452; frieze from, 452 Module, application in art, 10 Mogao Grottoes, 192 Mohenjo-daro, 157, 158-159, 179; Great Bath, 158, 158 Moissac: pilgrimage to, 442; Saint-Pierre, 430, 437-440, 438, 440, 453, 473, 475 Monasteries, 410, 420, 431 Monastic orders, 321, 322, 501; patronage by, 506 Mongols, 335, 355 Monolith with bird and crocodile, 401 Monophysite heresy, 312, 327 Monreale cathedral, 333, 445; mosaics at, 332, 332 Monte Albán, 376 Moralia in Job (Saint Gregory), 443-444; folio from, 443 Moralized Bibles, 482, 483, 495 Morgan Madonna, 445, 445 Mortuary precinct, 57, 58, 59, 59, 60 Mosaics, 309, 357, 363, 427; beginning of, 303; black-and-white, 271; Early Byzantine, 312-322; Early Christian, 295, 298-304; floor, 140-141; Islamic, 344; pebble, 140-141, 140, 142, 303 Moses expounding the Law (Master Hugo), 457 Mosque lamps, 360-361

Mosque of Selim II, 354, 355, 363; interior of, 354; Sinan and, 354 Mosques: architecture of, 344, 345; types of, 345 Mother of God, 301, 322, 325, 338; images of, 326; mosaic of, 339 Mount Ida: Kamares-ware vessels at, 88 Mount of Olives, 297, 325 Mount Olympus, 33, 120, 129, 138; gods/goddesses of, 101 Mount Sinai, 33, 321-322, 337, 339; Church of the Virgin, 322, 322; icons and, 327, 328, 335; Saint Catherine's monastery, 321, 322, 327 Mount Vesuvius, 252, 275, 287; Pompeii and, 244-246, 248-253 Mount Wutai, Foguang Si, 194, 194 Mshatta, Umayyad Palace, 346, 346 Muhammad, 341, 342, 350; burials and, 348; death of, 50, 343; house of, 345, 347; Islam and, 343; opposition to, 343 Muhammad V, 352 Muhammad ibn al-Zayn, 363; work of, 361-362, 361 Muiredach, cross of, 414, 414 Mummy portraits, 275-276, 275, 277 Mugarnas, 352-353, 352, 357, 363 Mural painting, 504; Chinese, 190; Mesoamerican, 370; Pompeiian, 304 Murasaki Shikubu: work of, 216-217, 217, 221 Mycenae: architecture of, 91–94; art of, 90-96, 97; civilization of, 96, 99; culture of, 90; excavations at, 81; gateway to, 80, 92; Lion Gate, 80, 92-93, 92, 94, 95, 97; painting of, 94-96; sculpture of, 94-96, 95; Treasury of Atreus, 93-94, 93, 97, 228, 241; Troy and, 81-83, 97 Myron: work of, 123-125, 123 Mystery plays, 505 Nabu, 33, 45; dragon of, 47 Náhuatl, 366, 372 Namibian plaques, 16, 16 Nanna (moon god at Ur), 33, 41 Napir-Asu of Elam, Queen: statue

Nabu, 33, 45; dragon of, 47 Náhuatl, 366, 372 Namibian plaques, 16, 16 Nanna (moon god at Ur), 33, 41 Napir-Asu of Elam, Queen: statue of, 44, 44 Naples, 502; Archaeological Museum, 246 Napoleon Bonaparte, 60, 416; Egypt and, 54 Naram-Sin, 39, 43, 47; victory stele of, 40–41, 40, 44 Nara period, 170, 212, 213, 214, 215, 221; court culture of, 217; rebuilding, 218

Olympia, 121, 155, 174; Temple of Nîmes, 257-258 Narmer, King, 55-56, 64 Hera, 109, 137-138; Temple of Nasca culture, 380, 381, 383-384 1948-C (Still), xvi Nasca Lines, 383-384, 383 Nineveh, 40; Palace of Zeus, 119-120, 119, 120, 140 Olympic Games, 99, 102, 119, 155, Nativity (Giovanni Pisano), 499, 499 Ashurbanipal, 46, 47 301; establishment of, 100; Nativity (Nicola Pisano), 498, 499 Ningirsu, 33, 36, 42 Naturalism, 335, 339, 517; Cimabue Ningzong, 199, 200 Herakles and, 120 Nintoku, Emperor, 221; tomb of, On a Mountain Path in Spring (Ma and, 501; idealized, 398; Master 209, 209, 210 Yuan), 200, 200 Honoré and, 484 Niobid Painter, 137; work of, Oresteia trilogy (Aeschylus), 118, 119 Naumburg Cathedral, 491, 492, 495; Orestes, 119, 274 statues at, 491 135-136, 135 Orestes sarcophagus, 273–274 Navajo, 390 Nirvana, 160, 161, 201 Orientalizing art, 100-105, 155, Nok, 395-397 Nave, 468 Near East, Neolithic art in, 24–27, Nok statues, 396, 396, 399 235, 224-225 Orpheus, 335 Norman Romanesque: architecture, 24 (map) Orthogonals, 146 453-455; art, 453-458, 459; Nebamun, tomb of, 72-73, 72 Orvieto Cathedral (Maitani), painting, 455, 457-458 Nebuchadnezzar II, 47, 48, 51 508-509, 508, 514, 517 Nefertiti, 75; portrait head of, Normans, 410; Islamic art and, 332 North America, indigenous cultures Oseberg ship burial, 410; animal-74-75,74 of, 387-390, 391 head post from, 410 Nefertiti (Thutmose), 74 Northern and Southern dynasties Osiris, 69, 73, 75, 76, 77; mummi-Nefrura, statue of, 71-72, 71 fication and, 57; Seth and, 54 Neighing horse (Tang dynasty), 196 (China), 188 Osman I, 355, 363 Neo-Babylonia, 51; Persia and, Northern Song period, 196, 197, 198, 199. See also Southern Ostia, 266, 278; architecture of, 47 - 50270-271; Baths of Neptune, 271, Neoclassicism, 258 Song period 271; Isola Sacra, 271-272, 271 Neo-Confucianism, 200, 201 Notre-Dame, Paris, 466, 468, 468, 472 Ostrogoths, 301, 303, 312, 407 Notre-Dame abbey church, Neolithic: art of, 16, 24-28, 29; China and, 181-184; culture of, Fontenay, 445; interior of, 443 Otto I, 422, 428 25; Mesopotamia and, 31 Notre Dame de la Belle Verrière, 471, Otto II, 428, 450; Theophanu and, 483; detail from, 471 427, 429 Neo-Sumerians, 42, 51 Neptune (Poseidon), 101, 123, Notre-Dame-des-Fonts, baptismal Otto III, 422, 424, 427; portrayal of, 428, 428 font from, 449, 449 148, 253, 253, 296; Athena and, Ottoman Empire: architecture of, 129, 132 Novios Plautios, 226; work of, 232, 232 355; rise of, 355, 363 Nerezi, 333-334; Saint Ottoman Turks, 358; Nubia, 65, 67, 77, 79, 395 Pantaleimon, 333, 334 Constantinople and, 311, 336, Nero, 176, 239, 261; Golden House 339, 341, 355, 363 Objects, relative size of, 10 and, 251, 258-259, 260, 264, 287; Ottonians, 422; architecture of, suicide of, 260 Octavian, 239, 254 Odysseus (Athanadoros, 422-423, 429; art of, 422-428, Nerva, 239, 263 Hagesandros, and Polydoros 429, 431, 439; painting of, Newgrange, 91; passage grave at, 424-428, 429; sculpture of, of Rhodes), 154 27 - 28, 27Odyssev (Homer), 154 424-428, 429 New Kingdom, 59, 79; architecture Oinomaos, King, 119 of, 67-77; painting of, 71-73; sculpture of, 71-73 O'Keeffe, Georgia, 4; style of, 3, 3 Padmapani, 167, 167 Old farmer of Corycus, The, 305 Padua, Arena Chapel, 496, 504-505 New Persian Empire, 49, 50 Old Kingdom, 59-64, 79; Paekche kingdom, 202, 210 New Rome, 282, 295, 311, 312; Paestum: Basilica, 111–113; Temple architecture of, 59-61; sculpture emperors of, 323 of Hera I, 111, 111, 117; Temple New Saint Peter's (Bramante), 437 of, 62-64Old man, head of, 242 of Hera II, 111, 119, 119 New Stone Age art, 16, 29 Old market woman, 152, 152 Paganism, 308, 312 New Testament, 242, 290, 292, 294, Pagodas, 199 Old Masters, 252 296; authors of, 5; Christian art Old Saint Peter's, 298-299; Christian Painted caves, Ajanta, 167, 167 and, 293; figures from, 439 Painted Stoa, 135, 146 Nicholas of Verdun, 495; work of, art at, 309; cutaway view/plan of, 298 Painting, 2; materials/formats, 493-494, 493, 494 Old Stone Age: art of, 21; creativity Chinese, 190 Nicodemus, 297, 334 Paionios of Ephesos: work of, of, 15; female figures of, 18 Night attack on the Sanjo Palace, Old Testament, 53, 290, 292, 294, 145-146, 145 220, 220 Nika revolt, 312, 313, 320 296; Christian art and, 293; Palace at Knossos, 84–85, 84, 90, 97; Nike, 128, 133, 148, 149-150; statue figures from, 439; statues of, 466 bull-leaping fresco at, 86, 86; murals at, 85-86, 87, 88; Olmec, 370; ball game and, 372; of, 149 celts, 367, 367; colossi, 367, 367; stairwell at, 85 Nike of Samothrace, 149-150, 149 culture, 366-368, 375, 380, 391; Palace of Ashurbanipal, 47; relief Nile River, 45, 51, 54, 398; Egyptian Sophia, 313-314 culture and, 53; flood of, 54 ruler portraits, 367 from, 46

Palace of Ashurnasirpal II, 46–47; relief from, 46 Palace of Diocletian, 281-282; restored view of, 282 Palace of the Lions, 340, 352, 352 Palaikastro youth, 89, 89 Palatine Chapel, 332, 419, 421, 422, 451; interior of, 419; restored plan of, 419 Palatine Hill, 237, 238 Palazzo Pubblico, 517; aerial view of, *511*; painting for, 510–513 Paleolithic art, 15-23, 24, 29, 394; cave painting, 20 Palestrina, 232, 266; Sanctuary of Fortuna Primigenia, 240-241, 240 Palette of King Narmer, 55-56, 55, 79 Palettes, 20, 55 Pallava kingdom, 170, 171 Panathenaic Festival, 130, 131, 133; procession, 130, 132, 256 Pantheon, Rome, 94, 238, 267-269, 267, 278, 280, 287, 300, 313, 314, 451; cutaway view of, 268; interior of, 268, 269; lateral section of, 268 Pantokrator, 310, 330, 332, 332, 339, 475 Papal States, 502 Papposilenos, 136, 138 Papyrus, 53, 59, 64, 305 Paracas culture, 380, 381, 383, 391 Paracas weavers, 382, 385, 386 Paradise of Amitabha, 193, 193 Parinirvana group, 174, 175 Paris: Louvre, 466; Notre-Dame, 466, 468, 468, 472; Sainte-Chapelle, 477-478, 477, 483 Parisienne, La, 85-86, 85, 88 Paris Psalter, 334-335, 339; folio from, 334 Parma Cathedral, 452 Parthenon, 126, 127, 132, 133, 137, 148, 155, 176, 308; architecture of, 126-127; Iktinos and, 146; ionic frieze from, 130-131, 130; metopes at, 128-129, 128; pediments at, 129, 129; plan of, 127; refinements in, 127; symmetry of, 127 Parthians, 49, 263, 289 Passage grave, 27-28, 27 Passion of Sacco and Vanzetti, The (Shahn), 4, 4; symbolism in, 5 Pataliputra, 160, 161, 166 Patronage, 155, 162, 179; portraiture and, 6 Patrons, 1, 2, 506; role of, 6 Paul the Silentiary, on Hagia

Pax Augusta, 254, 256 Pax Romana, 254-255, 263, 276 Peaceful City (Lorenzetti), 512, 513 Peaceful Country (Lorenzetti), 512, 513 Pech-Merle: animal images at, 21; cave painting at, 20, 22; horses/handprints at, 20, 23 Peloponnesian War, 126, 131, 137, 155 Peloponnesos, 99, 119 Pendentives, 314, 315, 315, 329 Pentateuch, 410, 444 Pentecost and Mission of the Apostles, 441 Peplos, 108, 120 Peplos Kore, 108, 108 Performance Art, 2 Pergamon, 145, 147-153, 155, 239; sculpture of, 149-153 Pericles, 128, 131, 144, 153, 242, 256; patronage of, 155; portrait of, 125-126, 125, 267 Pericles (Kresilas), 125-126, 125 Period of Disunity (China), 188, 192, 193, 197, 205; secular arts and, 190 Period style, 3 Periods, in art history, 4 Perpendicular style, 487, 488, 489, 495 Persepolis, 49, 51; apadana at, 49; Persian art/architecture at, 48 Persia, Neo-Babylonia and, 47-50 Persians, 118, 263; art of, 51 Personal style, in art, 3-4, 6 Personification, 5; of female, 256; of Pestilence, 5 Perspective, 505, 513; described, 8-9; foreshortening and, 9. See also Atmospheric perspective; Linear perspective; Twisted perspective Perugia, Porta Marzia, 232-233, 233, 235, 261 Petén region, 366, 376 Petra, Al-Khazneh, 270, 270, 280 Petrarch, Francesco, 502, 503, 507,509 Phaistos, 82; Kamares-ware vessels at, 88; palace at, 84 Pharaohs, 53; divinity of, 64; female, 68 Phiale Painter, 138; work of, 136, 136 Phidias, 129, 155; statue by, 48; work of, 126, 128, 128, 130, 144, 147, 307 Philip II, King, 153; assassination of, 137 Philip II Augustus, 442, 466, 482 Philoxenos of Eretria, work of, 98, 142, 142

Phoenix Hall, 215-216, 216, 217, 221 Photography, 2, 12 Physical evidence, in art history, 2 Picasso, Pablo: periods of, 4 Pictorial arts, 2 Pierpont Morgan Library, 482 Pietà, 492 Pilgrimage churches, 434, 435 Pilgrimages, 432, 433, 434, 436, 442, 459 Pilgrim's Guide to Santiago de Compostela, 432 Pinakotheke, 126, 131 Pipe, Adena, 388, 388 Pisa: art of, 514-516; Camposanto, 514-515; Crusades and, 442; Leaning Tower, 451. See also Pisa Cathedral Pisa Cathedral, 450–451, 450, 452, 459, 509; baptistery of, 497, 499; construction of, 451 Pisano, Giovanni, 503, 516; work of, 499, 499 Pisano, Nicola (Nicola d'Apulia), 499, 510, 517; work of, 497-498, 499 Pizarro, Francisco, 366 Plans (architectural), 11, 12, 12 Plaster sculpture, 95-96, 95 Platform of the Eagles, chacmool from, 377 Plato, 100 Pliny the Elder, 124, 126, 137, 149, 154, 226; on Iaia, 275; Mount Vesuvius and, 245; on Philoxenos, 142 Plutarch, 125, 140 Polydoros of Rhodes: work of, 153-154, 153, 154 **Polyeuktos:** work of, 152–153, *152* Polygnotos of Thasos, 135, 275 Polykleitos, 126–127, 137, 138, 139, 146, 255, 473; prescription by, 124, 155; work of, 124, 125 Polykleitos the Younger, work of, 143, 143, 144 Polyphemos, 154 Pompeian painting styles, 246 Pompeii, 264, 271, 278; Amphitheater, 245, 245, 246, 253, 261; architecture of, 244; burial of, 287; Forum, 244, 245; House of the Vettii, 246, 246; Mount Vesuvius and, 244–246, 248–253; painting in, 246, 248-253; Temple of Jupiter (Capitolium), 244, 245, 282; Villa of the Mysteries, 248, 249, 263 Pont-du-Gard, 258, 258 Porcelain, 196. See also Pottery Porch of the Confessors, 472, 473

Porch of the Martyrs, 473

439; Romanesque, 439, 439, 445; stone, 439; wooden, 411 Porta Maggiore, 258, 258 Porta Marzia, 232-233, 233, 235, 261 Portrait head, vessel in shape of, 384 Portrait of husband and wife, 253 Portrait of Te Pehi Kupe (Sylvester), 13 Portraiture, 416; patronage and, 6 Poseidon (Neptune), 101, 123, 148, 253, 253, 296; Athena and, 129, 132 Post-and-lintel architecture, 28, 91, 127, 261, 266 Post-Amarna period, 75–77 Postclassic period, 366, 376-378 Post-Gupta period, 166–167, 169-170, 179 Pottery: Cizhou, 198-199, 198; Jomon, 208, 221; Mimbres, 390, 390, 391; Minoan, 88; Yangshao, 181-182, 182; Yayoi, 208. See also Porcelain Prabhutaratna Buddha, 192, 192 Prague, Saint Vitus Cathedral, 462 Praxiteles, 140, 149, 150, 155, 275; work of, 137-138, 137, 138, 151 Preclassic period, 366–368, 370; ceramic sculpture from, 368, 368 Predynastic period, 54-59, 79; architecture of, 56-59; painting of, 54–56; sculpture of, 54–56 Presentation of captives to Lord Chan Muwan, 375 Priam, King, 81, 112 Priene, 146; restored view of, 146 Primaporta, Villa of Livia, 250, 250, 255 Primitive art, 395 Prinas, Temple A, 105, 105, 112 Printmaking, 2 Private portraits, 252-253 Procopius, 312, 314, 323 Proportion, 10, 109 Propylaia (Mnesikles), 126, 126, 131, 131, 133, 135 Provenance, 3 Proxenos, 134, 227 Psalter of Saint Louis, 483-484; folio from, 483 Psalters, 410 Pseudoperipteral temples, 239, 257, 258 Ptolemy, 78 Pu-abi (Queen or Lady), 38 Pucelle, Jean: work of, 484, 485 Pueblo Indians, 390 Pure Land Buddhism, 212, 214, 215, 216; artwork of, 220 Pure Land of the West, 161, 214, 215, 216, 221

Portals, 430, 439–440, 440; parts of,

Pure Land Paradise, 193, 220 Purse cover, 409 Pylons, 70, 71, 79 Pyramid B, 378, 379 Pyramid of Khafre, 60, 61 Pyramid of Khufu, section of, 60 Pyramid of the Moon, 368, 369, 369 Pyramid of the Niches, 376, 376 Pyramid of the Sun, 368, 369, 369 Pyramid of Unas, 60 Pyramid Texts, 60 Pythagoras, 124 Qin dynasty, 184-186, 187, 205 Qin Shi Huangdi, 184 Queen Mother (Nigeria), waist pendant of, 402, 402 Queen of Heaven, 466, 471, 476, 485, 507, 509

pendant of, 402, 402
Queen of Heaven, 466, 471, 476, 485, 507, 509
Quetzalcoatl, 376
Qur'an. See Koran

Rabbula Gospels, 325, 327; folio from, 325
Radiating chapels, 434, 435, 437, 459, 463
Radiocarbon dating, 22, 395, 398
Rafin Kura head, 396, 396

Rainer of Huy, 457, 459; work of, 449, 449
Raised-beam construction, 189
Rajarajeshvara Temple, 171, 172, 173
Ramses II, 164; family of, 69–70; temple of, 68–69, 69, 79
Rathas, 171, 171
Ravenna, 301–304, 306, 309, 311, 315–316, 331, 333, 334; Constantinople and, 316; Mausoleum of

Raimondi Stele, 381, 381, 383

Galla Placidia, 288, 302, 304, 321; mosaics at, 324, 339; San Vitale, 316–317, 316, 317, 318, 319, 320, 321, 329, 332, 342, 408, 419, 451; Sant'Apollinare in Classe, 320–321, 321; Sant'Apollinare Nuovo, 303–304, 303, 304, 306, 309

Rayonnant style, 477, 478, 482, 495 Re, 54, 59, 60 Readymades, 15 Realism, 510 Red-figure painting, 115, 155 Regional style, 3 Registers, 35, 50 Regolini-Galassi tomb, jewelry from, 224–225, 224 Reims Cathedral, 476–477, 487,

490, 495, 497; jamb statues at, 477; west facade of, 476 Relics, 299, 331, 350; cult of, 432; veneration of, 445. See also Reliquaries Reliquaries, 163, 426, 449-450, 449, 489 Rembrandt van Rijn, 6 Renaissance, 278, 296, 311, 407, 408; classical tradition and, 517; style, 516 Renaissance architecture, 514, 516 Renaissance art, 223 Renaissance Italy, 323, 407 Repoussé, 94, 224, 304, 305 Resurrection, 292, 293, 297, 331, 424, 426, 505, 508 Riace warrior, 121, 121, 122, 123, 125, 151 Richard the Lionhearted, 440, 442,448 Rock-cut buildings, 400, 400 Roma, 272-273, 286 Roman Empire, 12, 46, 162, 166, 327, 419; barbarians and, 407; Christianity and, 407; diversity of, 289; Egypt and, 53, 79, 155, 254, 275; Greek artists and, 153; map of, 238; rise of, 237 Roman history, outline of, 239 Roman house, 247; restored view/plan of, 247 Roman monarchy, 239, 287 Roman portraiture: propagandistic ends of, 255; role playing in, 254 Roman Republic, 231, 254; architecture of, 239-241; art of, 239-244; Greek art and, 287; sculpture of, 242-244 Romanesque period, 419, 422, 428, 430, 431, 461, 462, 466, 495; architecture of, 447; art of, 439, 443-445, 459; regional diversity of, 433; sculpture of, 459 Rome: Arch of Constantine, 238, 282-283, 283, 291; Arch of Titus, 238, 262–263, 262, 263, 266, 277; Basilica Nova, 238, 284-285, 284; Basilica Ulpia, 264, 265, 299, 422; Baths of Caracalla, 277-278, 277, 313; Baths of Diocletian, 278, 285; Catacomb of Saints Peter and Marcellinus, 292, 292, 293; Circus Maximus, 238, 264; Colosseum, 236, 238, 260-261, 260, 287; Column of Antoninus Pius, 272-273, 272, 280, 281; Column of Trajan, 238, 264, 265, 265, 287, 418, 425, 456, 457; Domus Aurea, 258-259, 259, 260, 275; fall of, 311, 429; Forum of Augustus, 238, 257, 264; Forum of Julius Caesar, 238; Forum of Trajan, 238, 264-265, 264, 269, 275, 299; Forum Romanum, 238, 262; founding

Relief sculptures, 11

of, 287; Golden House, 251, 251, 258-259, 259, 260, 264, 287; Markets of Trajan, 238, 266, 266; model of, 238; New Saint Peter's, 437; Old Saint Peter's, 298-299, 298, 309; Pantheon, 94, 238, 267-269, 267, 268, 269, 278, 280, 287, 300, 313, 314, 451; Saint Paul's, 421, 432; Saint Peter's, 421, 432; Saint Peter's basilica, 415, 428; Santa Constanza, 299-301, 300, 302, 315, 329, 344, 451; Santa Maria degli Angeli, 278, 278; Santa Maria Maggiore, 301, 301, 303, 305, 309; Santa Sabina, 299, 424, 439; Temple of Fortuna Virilis, 238, 239, 240; Temple of Portunus, 238, 239, 240; Temple of Venus and Roma, 238, 269 Romulus and Remus, 231, 237, 239, 241, 272, 286, 287, 343

Rose windows, 460, 464, 467, 472, 472, 508 Roshana Buddha, 214 Rossano Gospels, 306; folio from, 306 Röttgen Pietà, 492–493, 493 Rouen, Saint-Maclou, 478–479,

488, 495 Royal Cemetery at Ur, 31, 36, 58, 183; cylinder seal from, 39 Royal Portal, Chartres, 465, 468, 476, 495; jamb statues of, 466, 467, 472–473

Rubens, Peter Paul, 10; work of, 9, 9

Rublyev, Andrei: work of, 338, 338, 339

Rufus, Quintus Curtius: on Babylon's hanging gardens, 48 Rule of Saint Benedict, 420, 436, 439, 458 Ruler 13 (Waxaklajuun-Ub'aah-

K'awiil), stele portraying, 373, 373

Safavids (Iran), 357, 358, 359, 363 Saint Agnes church, 300 Saint Alexander, reliquary of, 449-450, 449 Saint Ambrose, 447 Saint Amon, relics of, 350 Saint Anne, 471, 510 Saint Anthony, 322 Saint Apollinaris, 321 Saint Augustine, 293 Saint Benedict (Benedict of Nursia), rule of, 420, 436, 439, 458 Saint Catherine's monastery, 321; icons at, 327; mosaic from, 322 Saint Clement, icon from, 337, 337 Saint Columba, 410

Saint Cuthbert, 413 Saint Cyriakus, 422, 433, 446; nave of, 422 Saint-Denis, 467, 468, 476, 485; ambulatory/radiating chapels of, 463; cross at, 493; French Gothic and, 462; plan of, 462; rebuilding of, 463; stained-glass windows of, 472; Suger and, 462-464, 466, 493, 494, 495; vaults at, 464 Saint Dionysius, 462 Sainte-Chapelle, 477–478, 483; interior of, 477 Saint Edmunds abbey, Bury Bible and, 457 Saint Elizabeth, 490; interior of, 490 Saint-Étienne, Caen, 453-454, 454, 459; plan of, 454; vaults at, 464; west facade of, 453, 464, 468

Saint Foy, 432
Saint Francis Altarpiece
(Berlinghieri), 500, 500, 517
Saint Francis of Assisi, 500, 501;
portrayal of, 517
Saint Gall monastery, 420–421, 423, 435; plan of, 420
Saint George, 327, 492; icon of, 326
Saint Gregory, 443; statue of,

Saint-Étienne, Vignory, 433–434,

Saint Eventius, 450

436; interior of, 433; plan of, 433

473, 473 Saint James: naves of, 445; shrine of, 432, 435, 437, 444, 459

Saint Jerome, 410, 458; statue of, 473, 473 Saint John, 334, 419; Apocalypse and, 445; gospel of, 330; symbol

Saint Lawrence, 302 Saint-Lazare, Autun, 4, 440; tympanum at, 441 Saint Luke, 329; symbol of, 5 Saint-Maclou, Rouen, 478–479, 488, 495

of, 5

Saint Mark: relics of, 331; symbol of, 5

Saint Mark's, Venice, 281, 330–331, 332, 336; construction of, 451; interior of, *331*

Saint Martin, 432, 435; statue of, 473, 473

Saint Matthew, *413*, 414, *417*, 418, 440; folio of, 417; symbol of, 5, 412, *412*, 413

Saint Matthias, monastery of, 448–449

Saint Michael the Archangel, ivory panel of, 324

Saint Michael's, Hildesheim, 422, 423, 429, 439, 446, 452; doors of, 424; longitudinal section/plan of, 423

Saint Pachomius, monastic movement and, 322 Saint Pantaleimon, 333; wall painting from, 334 Saint Paul, 294, 295, 409, 412 Saint Paul's, Rome, 421, 432 Saint Peter, 294, 295, 298, 299, 412, 508; statue of, 265, 323 Saint Peter, Wimpfen-im-Tal, 486 Saint Peter's (Michelangelo), 421; pilgrims at, 432. See also New Saint Peter's; Old Saint Peter's Saint Peter's basilica, 415, 428 Saint-Pierre, Moissac, 437–439, 453, 473, 475; cloister at, 438; south portal of, 430, 439-440, 440 Saint Saturninus, 432, 436 Saint-Savin-sur-Gartempe, 444; nave/vault of, 444 Saint Savinus, altar of, 510, 511 Saint-Sernin, 434-435, 437, 445, 446, 447; aerial view of, 434; interior of, 434; plan for, 434;

446, 447; aerial view of, 434; interior of, 434; plan for, 434, relief from, 436, 439, 452 Saint Stephen, 433 Saint Theodolus, 450

Saint Theodore, 327, 476; icon of, 326; statue of, 473 Saint-Thierry, 438 Saint Vitalis, 316, 318

Saint Vitus Cathedral, 462 Sakai tumulus, 221 Sala della Pace, 512 Salamis, 118, 125 Salians, 445, 450, 459

Salisbury Cathedral, 486–487, 488; aerial view of, 487; interior of, 487; plan of, 487

Salisbury Plain, Stonehenge, 28, 28, 29

Saltcellar (Master of the Symbolic Execution), 404, 404 Saltcellars, Sapi, 404, 404, 405 Samanid Mausoleum, 348, 348, 355 Samarra: Great Mosque, 347, 347, 349; Malwiya Minaret,

347–348, 347 Samnite House, 248, 248 Samnites, 244, 245 Samuel anointing David, m

Samuel anointing David, mural of, 291, 304 San Bartolo, 374

Sanchi, 162–163; Great Stupa, 162, 163, 163, 164, 164, 179 Sanctuary of Apollo, 113 Sanctuary of Fortuna Primigenia,

Sanctuary of Hercules, 242 Sanctuary of the Great Gods, 149 San Francesco, Pescia: altarpiece for, 500

240-241, 240

San Giovanni, baptistery of, 451, 451, 513, 514 San Juan Bautista, 415, 415 San Miniato al Monte, 452; interior of, 452 San Salvador de Tábara, 415; tower/scriptorium of, 415 Sanskrit, 160, 174, 215 Santa Constanza, 299-301, 302, 315, 344, 451; interior of, 300; plan of, 300, 329; vault mosaic of, 300 Santa Croce, 3, 302, 501; interior of, 3 Santa Cruz de la Serós, portal Santa Maria Antiqua Sarcophagus, 293-294 Santa María de Mur, 444-445; apse of, 444 Santa Maria degli Angeli, 278, 278 Santa Maria Maggiore, 301, 303; mosaic at, 301, 305, 309 Santa Maria Novella (Alberti), 506; construction of, 500-501; nave of, 501 Sant'Ambrogio, 447, 454, 459; aerial view of, 446; interior of, 447 Sant'Andrea (Alberti), pulpit at, 499 Sant'Apollinare in Classe, 320–321; mosaic at, 321 Sant'Apollinare Nuovo, 303-304, 306; interior of, 303; mosaic from, 304, 309 Santa Sabina, 299, 299, 424, 439 Santa Trinità, 502 Santiago de Compostela, 435, 444, 445, 446, 459; pilgrimage to, 432, 437,440 Santorini, 82, 86, 87 San Vitale, 316-317, 321, 332, 342, 408, 451; aerial view of, 316; choir/apse of, 318; interior of, 317; mosaic from, 319; plan of, 316, 329, 419; procession at, 320 Sanxingdui, excavations at, 183-184 Sanz de Sautuola family, 19-20 Sapi saltcellars, 404, 404, 405 Saqqara, 63, 79; North Palace, 59, 59; Stepped Pyramid, 57, 58, 60,369 Saracens, 335, 336, 422 Saragon II, royal citadel of, 45, 45 Sarcophagi, 226-228, 287, 309, 498, 499; Asiatic, 294; demand for, 273; Early Christian, 293, 293, 294, 294, 295; Eastern, 274; Etruscan, 275; pagan, 293; thirdcentury, 278, 279, 280, 280; Western, 274 Sargon of Akkad, 39, 41, 42 Sarnath, 161, 165; Buddha images of, 166-167, 203

Sasanians, 50, 289, 312, 327, 341; architecture of, 353, 464 Saturation, of color, 7 Sayf al-Din Tuquztimur, lamp for, 360-361, 361 Scale, in art, 10 Scandinavia, Christian art in, 410-415, 429 Schliemann, Heinrich, 81, 82, 94 Scholasticism, Gothic art/ architecture and, 466 Schoolmen, 466 Schools, in art history, 6 Science, Greek contributions to, 100 Scivias (Hildegard of Bingen), 448, 449; folio from, 448 Scriptoria, 415, 429, 448, 495 Scroll of Hu-Nefer, 76, 77 Sculpture, 2; freestanding, 18; hollow-cast, 40, 51; relief, 11, 18; in the round, 11; subtractive/ additive, 10; types of, 11 Seals: cylinder, 38, 39, 39; Indus, 159-160, 160, 164; Mesopotamian, 39; official, 416; stamp, 39 Seated boxer, 151 Seated scribe, statue of, 63-64, 63 Second Commandment, 290, 295, 309, 326, 445 Second Style, 250, 251, 253, 270, 287; described, 248; wall paintings in, 249, 250 Section, in architectural drawing, Seduction of Yusuf (Bihzad), 358 Seeing, different ways of, 12–13 Seleucus I, 49 Self-Portrait (Te Pehi Kupe), 13 Selim II, 355, 359; mosque of, 354 Senmut, 67; statue of, 71-72, 71 Senusret III: fragmentary head of, 65, 65; tomb of, 66 Septimus Severus, 239, 254, 276; chariot procession of, 277; portrait of, 276 Serapeum, 269, 269 Serpent Mound, 388, 389, 389 Seven Wonders, 47, 48, 51, 59, 79 Severans, 276-278, 282; Late Antique style and, 287; portraiture of, 276 Severe Style, 120, 123 Severus, 275; work of, 258-259, 259 Severus Alexander, 239, 278 Shahi Mosque, 357; winter prayer hall of, 356 Shahn, Ben: work of, 4, 4 Shahnama (Book of Kings), 359 Shaka triad (Tori Busshi), 212, 212 Shakyamuni Buddha, 161, 174;

statue of, 188, 190, 190, 192, 192,

433-443

203, 204

Shamash, 30, 33, 43 Shang dynasty, 181–184, 205; art of, 182-183 Shapur I: 50, 50 Shield Jaguar, 364, 375 Shield Jaguar and Lady Xoc, 364 Shinto, 210, 212; described, 211 Shiva, 168, 170, 171, 172, 175; dancing, 169; as Lord of Beasts, 160; as Lord of the Dance, 173, 173; as Mahadeva, 169-170, 169; as Nataraja, 173-174, 173 Shiva Vishnu, 175, 175, 176 Shrine of the Three Kings (Nicholas of Verdun), 494, 494 Shunga dynasty, 162, 179 Shunjobo Chogen, 218; portrait statue of, 219, 219, 221 Siena Cathedral, 507, 508; altar for, 510; Duccio di Buoninsegna Silk, 188; painting on, 190; textiles, 350, 350 Silk Road, 187, 188, 192, 205, 350 Silla kingdom, 202, 209 Sinan the Great, 358, 359; Mosque of Selim II and, 354, 363; work of, 354, 354, 355 Sipán tomb, ear ornament from, 384-385, 384; Siphnian Treasury, 113, 133, 148; frieze detail from, 113; reconstruction drawing of, 113 Sistine Chapel, frescoes at, 504 Six canons of painting (Xie He), 191 Six Dynasties period (China), 188, 193 Sixth Chan Patriarch Chopping Bamboo (Liang Kai), 201 Skopas of Paros, 140, 149; work of, 138-139 Sleeping satyr (Barberini Faun), 150 Snake Goddess, 88-89, 89 Soapstone monoliths, 401-402, 401 Sokkuram cave temple (Korea), 202-203 Soldier emperors, 278-280, 287 Song dynasty, 170, 196-202, 205, 218 Sorel, Agnès, 480 South America: indigenous art of, 380-386, 391; map of, 379 South Asia: art of, 157; map of, 158; sculpture of, 159 Southeast Asia: art of, 157, 174-178; map of, 158 Southern Song period, 196, 199, 200, 205. See also Northern Song period Southwest, cultures of, 389-390 Space, in art, 7-8 Spanish art styles, Romanesque

Speyer Cathedral, 446-447, 454, 459, 462; interior of, 446 Sphinx, Great, 61 Split, Palace of Diocletian, 281-282, 282 Spoils of Jerusalem, 263 Spring Fresco, 86, 87, 230 Squinches, in architecture, 315, 315 Sri Lanka, art of, 174 Stag hunt (Gnosis), 140, 141 Stained-glass windows, 460, 464, 469, 471, 495; described, 11, 472 Standard of Ur, 36-38 Statues, 17, 31, 35; block, 71-72; liberating, 10, 11 Stave church, 410, 411 Stele of the Vultures, 33, 36, 36 Stepped Pyramid (Imhotep), 57, 58, 60,369 Still, Clyfford: work of, xvi, 1 Still-life painting, 4, 253; Fourth Style, 253 Stoa of Attalos II, 146, 147 Stoa Poikile, 135, 146 Stoas, 100, 135, 146, 147, 147 Stone Age art, 16, 17 Stonehenge, 28, 29; aerial view of, 28 Stoneware, 196 Strasbourg Cathedral, 490-491; tympanum at, 491, 491 Stupas, 162, 199; described, 163 Style, in art history, 6, 12, 22; questions about, 3-5 Subjects, in art history, 4-5 Suger, Abbot, 465; lux nova and, 460, 471, 472; Saint-Denis and, 462-464, 466, 493, 494, 495 Sui dynasty, 192, 195 **Sulayman,** work of, 350, 350 Sultan-Muhammad: work of, 359, 359 Sumer, 44; decline of, 41; narrative art of, 34, 50; resurgence of, 43; treasures of, 32-38 Suryavarman II, 176, 177; detail of, 177 Susa, 43, 44, 45, 47, 48 Sutton Hoo ship burial, 408-410; purse cover from, 409 Sydney Opera House (Utzon), 47 Sylvester, John Henry: work of, 13, 13 Symbols, in art, 4-5 Synagogue paintings, 290-291, 290, 291

Taharqo, sphinx of, 77
Tahmasp, Shah: and carpet weaving, 360, 363
Taizokai (Womb World) mandara, 215, 215, 221

Tajín, Pyramid of the Niches, 376, 376 Taj Mahal, 342 Tale of Genji (Murasaki Shikubu), 216-217, 217, 218, 219, 221 Tang China, map of, 182 Tang dynasty, 170, 189, 192-196, 205; ceramic sculpture of, 195-196, 203 Tapestries, 386, 386, 391, 456, 457, 459; described, 456 Tarquinia, 224, 227, 232, 233, 235; murals, 230; tombs, 229, 230 Tarquinius Superbus, 226, 227, 231, 239 Technique, in art, 6 Tellus, 256, 263 Temple A, 105, 105, 112 Temple of Amen-Re, 70–71, 70, 78; model of, 71 Temple of Aphaia, 117–118, 117, 119, 149; dying warrior from, 118; model of, 117; plan of, 117; restored view of, 117 Temple of Apollo (Paionios of Ephesos and Daphnis of Miletos), 145-146, 145, 155; plan of, 145 Temple of Artemis, 48, 112, 230; west pediment of, 112 Temple of Athena, 146 Temple of Athena Nike (Kallikrates), 126, 126, 133, 133, 134; capitals at, 144 Temple of Athena Parthenos, 126 Temple of Fortuna Virilis, 238, 239, 240 Temple of Hatshepsut, 67-68, 67 Temple of Hera, Olympia, 109, 137-138 Temple of Hera I, Paestum, 111, 111, 117, 126; plan of, 111 Temple of Hera II, Paestum, 111, 119, 119 Temple of Horus, 78, 78, 79 Temple of Jupiter (Capitolium), 244, 245, 282 Temple of Jupiter Optimus Maximus, 237 Temple of Portunus, 238, 239, 240 Temple of Quetzalcoatl, 370, 370 Temple of Ramses II, 68-69, 69 Temple of Solomon, 262, 263, 313, 342 Temple of the Giant Jaguar, 373, 373 Temple of Trajan, 264 Temple of Venus, Baalbek, 280, 282; plan of, 281 Temple of Venus and Roma, 238, 269 Temple of Vesta, 240, 240 Temple of Zeus, 119-120, 140; east pediment of, 119, 119, 120; metope from, 120, 120

Temple plans, Greek, 109, 109 Temple-pyramids, 372 Ten Commandments, 33, 321 Teotihuacan, 366, 368-370, 373, 376, 391; aerial view of, 369; Avenue of the Dead, 368, 369, 370; ball game and, 372; Citadel, 368, 369, 370, 370; colonies of, 370; expansion of, 370; murals at, 370; Preclassic scheme at, 368; Pyramid of the Moon, 368, 369, 369; Pyramid of the Sun, 368, 369, 369; Temple of Quetzalcoatl, 370,370 Te Pehi Kupe, work of, 13, 13 Terracotta army, Lintong, 185-186, 186, 205, 210 Tetrarchs, 283; Diocletian and, 280-282; portraits of, 281; statues of, 287 Textiles, 2, 12, 350, 386 171, 172, 173 the Younger), 143, 143

Texture, in art, 7 Thanjavur, Rajarajeshvara Temple, Theater of Epidauros (Polykleitos Theodora, 319; Justinian and, 317, 320; life of, 320; mosaic of, 319; portrait of, 332 Theodoric, 301, 303, 316, 407; equestrian statue of, 419; palace-church of, 320; portrait of, 416-417; Ravenna and, 315

Theodoros of Phokaia, tholos of, 143, 143 Theodosius I, 301, 304, 311;

Christianity and, 309, 312 Theophanu, 450; Otto II and, 427, 429; story of, 428

Theotokos, 322, 327–328, 327, 328, 329, 332, 333, 335, 445, 465, 471, 492; icon of, 326; mosaic of, 339

Theotokos, Hagia Sophia, 327-328, 327

Theotokos and Child, 332, 471 Theravada Buddhism, 161, 174, 178 Theseus, King (Athens), 114, 128; Minotaur and, 84, 85

Third Dynasty of Ur, 51; Akkad and, 39-42; Elamites and, 43

Third Style, 250, 252, 253, 287; described, 251; wall paintings in, 250

Thirteen Emperors, The (Yan Liben), 194, 195, 205

Tholos, 143, 143, 249, 270; beehiveshaped, 241; temples, 240, 250; tombs, 93, 93, 97, 228, 300

Three angels (Rublyev), 338, 338 Three Kingdoms period (Korea), 202, 210

Three revelers (Euthymides), 116

Thutmose, bust by, 74, 74 Thutmose I, II, III: 68, 70, 71, 276 Ti, 72; relief of, 64; tomb of, 64, 65, 73

Tikal, 376; Great Plaza, 373; Temple I (Temple of the Giant Jaguar), 373, 373

Tilework, Islamic cuerda seca, 356, 357, 363

Timgad, 264; aerial view of, 264 Timur (Tamerlane), 358 Timurids, 358, 359, 363

Tiryns citadel, 91–92, 97, 105; aerial view of, 90; corbelled gallery in, 91, 94; plan of, 92; vaulted gallery in, 94

Titus, 154, 239, 260; Colosseum and, 261; Temple of Solomon and, 342; triumph of, 262-263 Tivoli: Hadrian's Villa, 269, 269;

Temple of Vesta, 240, 240 Tiwanaku, 380, 391; Gateway to the Sun, 385, 385

Tiye (Egyptian queen), head of, 74,74

Todaiji temple, 214, 214, 218, 221 Toltecs, 366, 378-379

Tomb 100, 54-55, 55

Tomb of Emperor Nintoku, 209, 209 Tomb of Hunting and Fishing, 230, 230

Tomb of Nebamun, 72–73, 72 Tomb of Nintoku, 209

Tomb of the Diver, 136–137, 136, 230 Tomb of the Leopards, 222, 229-230, 229

Tomb of the Reliefs, interior of, 229 Tomb of the Shields and Chairs, 228, 228, 229, 247

Tomb of Ti, Saggara, 64, 64, 65 Tomb of Tutankhamen, 75–77, 76 Tomb of Yongtai, 195, 195 Tonality, in art, 7

Tori Busshi, 213, 221; work of, 212, 212

Toulouse, 432; Saint-Sernin church, 434-435, 434, 436, 437, 439, 445, 446, 447, 452

Tower of Babel, 33, 47, 48, 348

Traini, Francesco: work of,

514-515,515 Trajan, 238, 239, 245, 263–267, 282,

283, 287, 323; forum of, 422; market hall of, 285; statue of, 264, 273

Trajan Decius, 239, 280, 291; portraits of, 278, 279

Transfiguration of Christ, 296, 322, 322, 325, 412

Travelers among Mountains and Streams (Fan Kuan), 180, 197, 200; described, 197

Treasury of Atreus, 93-94, 93, 97, 228, 241; vault of tholos of, 93 Treasury of Petra, 280 Trebonianus Gallus, 239, 278; portrait of, 279 Trier, Aula Palatina, 285, 285, 289 Triforium, 467-468, 467, 469, 471, 474, 487, 490, 495; described, 469 Triptychs, 333, 510 Triumph of Death (Traini or Buffalmaccio), 514-515, 515 Triumph of Shapur I over Valerian, 50 Triumph of Titus, 263 Trumeau, 440, 440, 453, 475; described, 439 Tula: Pyramid B, 378, 379; statuecolumns of, 378, 379 Tumulus, 209, 209, 210, 228, 228, 408 Tuscany, Romanesque art and society in, 223, 448, 450, 509, 514 Tutankhamen, 31; coffin of, 75; mask of, 52, 94; tomb of, 75-77

Twisted perspective, 23, 394

described, 439

Tympanum, 440, 441, 441, 491;

Udayagiri, 169; Hindu cave temples at, 168; reliefs of, 179 Uji, Phoenix Hall, 215-216, 216, 217, 221 Umayyad dynasty, 342, 344, 346, 348, 352, 353, 363 Umayyad Palace, 346; frieze of, 346 Unfinished captive (Michelangelo), 11 Unified Silla Kingdom, 202-203, 204, 205 Upanishadic period, 160 Upper Egypt, 54, 55, 58, 67; Lower Egypt and, 79 Ur: Royal Cemetery, 31, 36, 39, 58, 183; ziggurat, 41-42, 41, 51 Uruk, White Temple and ziggurat, 32, 33, 33, 45 Uta Codex, 426-427; folio of, 426 Utrecht Psalter, 418, 419, 424; folio of, 418

Vairocana Buddha, 192, 193, 214 Valley of the Golden Mummies, 57 Valley of the Kings, 70 Value, of color, 7 Vasari, Giorgio, 197; on Gothic art, 461; work of, 503 Vases: bilingual, 115, 115; blackfigure, 155; tomb, 104, 114, 227; painted, 97, 104, 114-115, 134, 155 Vatican City, Sistine Chapel, 504

Vatican Hill, 298

Vatican Vergil, 304; folio from, 305 Vaults, 50, 91–92, 94, 444; barrel (tunnel), 241, 241, 245, 260, 285, 302, 443, 445–446, 459, 488, 505; concrete, 241; corbeled, 28; described, 11; fan, 488, 495; Gothic, 464; groin (cross), 241, 241, 266, 278, 435, 446, 446, 447, 447, 454, 455, 459; nave, 454, 455, 459, 471; Romanesque, 464; rib, 454, 455, 464, 464, 467, 469, 487, 488, 489, 495; sexpartite, 454, 468; Vedic period, 160, 168 Vegetable seller, funerary relief of,

Venice, 502; art of, 514–516; Doge's Palace, 515–516, *515*; independence of, 331; Saint Mark's, 281, 330–331, *331*, 332, 336, 451

271,271

Venus (Aphrodite), 101, 129, 129, 130, 138, 155, 254, 255, 256, 275; statue of, 137, 150

Venus de Milo (Alexandros of Antioch-on-the-Meander), 150–151, 150

Venus of Willendorf, 17–18, 17, 25, 29

Veracruz, Classic, 366, 375–376 Verism, 242

Vertue, Robert and William:

work of, 488, 488 Victory, portrayal in art, 323, 324

Vienna Dioskorides, 324–325, 325, 327

Vienna Genesis, 304–306, 309 Vignory, 435; Saint-Étienne church, 433–434, 433, 436

Vikings, 332, 408, 422, 457, 459; art of, 410, 429

Villa of Agrippa Postumus, 251; wall painting at, 250

Villa of Livia, 250, 255; wall painting at, 250

Villa of Publius Fannius Synistor, 248, 250; cubiculum M of, 249

Villa of the Mysteries, 248, 263; wall painting at, 249

Vimana, 171, 172, 179

Viollet-le-Duc, Eugène: work of, 479, 479

Virgin and Child, 327–328, 327, 335, 335, 445, 445, 471, 471, 478, 485, 485, 507

Virgin and Child, Hagia Sophia, 327–328, *327*

Virgin and Child Enthroned with the Saints (Duccio di Buoninsegna), 507

Virgin Mary, 296, 297; Annunciation and, 338; ascension of, 330; church dedicated to, 301, 322, 324; Crucifixion and, 308, 330; cult of, 465; death of, 490; icon of, 326, 337; portrayal of, 413; as Virgin of Compassion, 335

Virgin of Jeanne d'Evreux, 484–485, 485

Virgin of Paris, 478, 478, 485 Vishnu, 168, 169, 170, 170, 171, 175, 177; boar avatar of, 168; reclining, 176, 176; temple, 170, 170, 176, 179

Vishvanatha Temple, 171, *172*, 173, 176, 179; Mithuna reliefs at, *173*; plan of, *172*

Visigoths, 301, 348, 407, 415; architecture of, 349, 429; Christianity and, 415

Visitation group, Reims Cathedral, 476, 477, 477, 490 Vitruvius, 144; Etruscan temple and, 225; Parthenon and, 127 Vladimir Virgin, 335, 335 Volume, in art, 7–8 Votive figurines, 35

Wari art and culture, 380, 382, 385–386, 391 *Warka Vase* (Iraq), 34–35, 34 Warring States period (China), 184, 186

Warrior, head of, 11 Warrior, as theme in art: lords, art

Vulca of Veii, 226

of, 407–410, 429; priest, 384; warrior taking leave of his wife (Achilles Painter), *135; Warrior Vase*, 96, 96

Welding, 10

Westminster Abbey, 457, 489 Westworks, 421, *421*, 422, 429, 453, 464

Wet frescoes, 87 White and Red Plum Blossoms

(Korin), 8, 9 White-ground techniques, 134, 135

White Temple and ziggurat, 32, 33, 45; drawing of, 33 Wiligelmo, 457; work of, 452, 452

William II, 332 William of Normandy (William the Conqueror), 410, 453, 457, 459

Woman from Syros, 82–83, 82 Womb World. See Taizokai mandara Wooden portraits, 221 Woodlands art, 387–388, 389 Woolley, Leonard: and art finds at Ur, 31, 36–37 Wu family, shrines of, 187–188, *187* Wu Zetian, 192, 193, 195

Xerxes, 48, 51, 118, 125 Xia dynasty, 182 Xie He, six canons of painting and, 191, 202, 205

Yakshi (South Asian goddess), 164, 164, 166, 173 Yakushi triad, 212, 213, 214; detail of, 206

Yamato-e, native-style painting (Japan), 217

Yan Liben, 205; work of, 194–195, *194*

Yayoi period (Japan), 207–209, 210, 222; Shinto and, 211

Yingxian, Foguang Si Pagoda, 199, 199, 205

Yongtai, Princess, tomb of, 195, *195* Yoruba culture (Africa): Ile-Ife and, 399; kings, 398, 399, 402

Zapotec culture, 366, 368; Classic, 376
Zen Buddhism, 201, 218
Zeus (Jupiter), 101, 111, 112, 119,
120, 123, 136, 140, 149, 225, 233,
245, 252, 254, 267, 284; altar of,
147–148; statue of, 48, 226
Zhao dynasty, 188
Zhou dynasty, 184–186, 189, 205
Zhou Jichang: work of, 201–202, 202
Ziggurats, 32, 33, 33, 41–42, 41, 45,
50, 51, 57, 348
Zoomorphic forms, 344, 345, 350,
363, 413, 429

.